A
VISUAL
DICTIONARY
OF
ART

A
VISUAL
DICTIONARY
OF
ART

HEINEMANN
—————————
SECKER &
WARBURG

Originated, designed and produced by Trewin Copplestone Publishing Ltd, London

Editor:	Ann Hill
Editorial Research:	Charlotte Parry-Crooke
Illustration Research:	Ann Davies, Hazel Harrison
Designers:	Patrick Nugent, Brian Trodd
Line Illustrations:	Robert Cross
Cartography:	Pauline Billingham
Index:	Myra Clark

Printed and bound by Jarrold & Sons Ltd, Norwich, England

© William Heinemann Ltd/ Secker & Warburg Ltd 1974

434 14460 6

List of Contributors

PALAEOLITHIC ART	John Waechter
THE ANCIENT NEAR EAST	*Anatolia:* Janet Spencer; *Iran:* Michael Roaf; *Mesopotamia:* David Oates; *Syro-Palestine:* David Price-Williams
EGYPTIAN ART	J. R. Harris
GREEK AND ROMAN ART	Frank Sear
EARLY CHRISTIAN AND BYZANTINE ART	Robin Cormack, Geoffrey Haus
MEDIEVAL ART	Joanna Cannon, John Higgitt, Peter Kidson
THE ITALIAN RENAISSANCE	June Glencross, Charles McCorquodale, Francine Tyler, Laurie Schneider, Maria Shirley
THE NORTHERN RENAISSANCE	Margaret Barton, Graham Beal, James Hamilton, Marguerite Kay, Marilyn Ross, Alistair Smith
THE 17th AND 18th CENTURIES IN EUROPE	Joan Abse, Graham Beal, A. S. J. Bean, Philip Bordes, Ian Chilvers, Rosemary Clarke, J. M. Gash, J. Glaves-Smith, Lindsay Stainton, Nicholas Turner, R. F. Took
THE 19th CENTURY IN EUROPE	Julianna Borsa, John Gage, Christopher Mullen, Michael Pidgely
THE 20th CENTURY IN EUROPE	Dawn Ades, Anthony Colley, Micaela Coltofeanu, Fenella Crichton, Gillian Darley, Amanda Frost, Tetty Kadury, Jane Martineau, Malcolm Miles, Roszika Parker, Benedict Read, Denise Riley, Susan Shaw, Luckas Smith, Sally St John, Gray Watson
AMERICAN ART; CANADIAN ART; LATIN AMERICAN ART	Barbara Hope Steinberg
ISLAMIC ART	Patricia Baker, Manijeh Bayani, Daria Jones, G. R. D. King
CHINESE ART	*Painting:* Roderick Whitfield; *Sculpture:* Jessica Rawson
JAPANESE ART	*Painting:* Oliver Impey; *Sculpture:* Jessica Rawson
KOREAN ART	Byong-mo Kim
INDIAN ART	*Painting:* John Burton-Page, Joanna Strub; *Sculpture:* T. S. Maxwell
SOUTH-EAST ASIAN ART	Anthony Christie
CEYLON	E. F. C. Ludowyk
TIBET	T. S. Maxwell
NEPAL	Bernard Myers
CENTRAL ASIA	John Lowrie
MATERIALS AND TECHNIQUES	Bernard Myers
TERMINOLOGY	Gillian Darley, Jane Martineau
PRE-COLUMBIAN and NORTH AMERICAN INDIAN ART	Dale Idiens
AFRICAN ART	John Picton
OCEANIC ART	Charles Hunt

Acknowledgements

The Publishers would like to thank all the museums, galleries and owners of private collections for permission to reproduce works in their care or possession. Paintings in the Royal Collections at Buckingham Palace, Hampton Court Palace and Windsor Castle are reproduced by Gracious Permission of Her Majesty the Queen.

The caption to each illustration gives the location of the subject. However, lack of space meant that the names of some collections had to be abbreviated. A list of such abbreviations appears on page 9.

Paintings and sculptures by the following artists are copyright S.P.A.D.E.M., Paris, 1974: Bakst; Boldini; Bonnard; Bouguereau; César; Cézanne; Degas; Dufy; Epstein; Ernst; Fantin-Latour; Forain; Gauguin; Gérôme; Guillaumin; Harpignies; Hödler; Klee; Léger; Maillol; Marcoussis; Matisse; Ozenfant; Permeke; Picabia; Picasso; Redon; Renoir; Rodin; Rouault; Rousseau, Henri; Sérusier; Signac; Soutine; Utrillo; Vlaminck; Vuillard.

Works by the following are copyright A.D.A.G.P., Paris, 1974: Arp; Bauchant; Beaudin; Bellmer; Bissière; Bourdelle; Brancusi; Braque; Buffet; Calder; Camoin; Cassatt; Chagall; Delaunay, Robert; Delaunay, Sonia Terk; Derain; Dubuffet; Duchamp; Duchamp-Villon; Dufresne; Estève; Friesz; Giacometti; Gontcharova; Gris; Kandinsky; Kupka; Larionov; Laurencin; Laurens; Magritte; Masson; Metzinger; Miró; Modigliani; Pissarro; Poliakoff; Richier; Riopelle; Rousseau, Pierre; Schoffer; Soulages; de Stael; Vieira da Silva; Villon; Zadkine.

Photographs were provided by the following:

Colour

ACL, Brussels: Bruegel; Rubens. JEAN ARLAUD, Geneva: Witz. AUREL BONGERS, Recklinghausen: Nepal, Art of. FEDERICO BORROMEO: Chalukya Dynasty (both subjects); Satavahana Dynasty. BROMPTON STUDIOS, London: Egyptian Painting (Birds in an acacia tree); JOHN BURTON-PAGE: Pallava Dynasty (Mahishamardini). GEREMY BUTLER, London: Chola Dynasty. Hogarth; Sanguine. A DINGJAN, The Hague: Lucas van Leyden. C. M. DIXON, London: Laocoön Group; Minoan Art (Snake goddess); Mycenean Art (both subjects); Pisano, Andrea; Ravenna, Baptistery of the Arians. KEITH GIBSON: Art Nouveau. GIRAUDON, Paris: Chartres Cathedral; Eyck, Jan van; Evreux, Shrine of St Taurin; Ingres; Le Mans; Limbourg Brothers; Mari; Paris, Ste Chapelle; Renoir; Van Dyck. SONIA HALLIDAY, London: Istanbul, Kariye Camii; Mystra; Paris, Notre-Dame; Stained Glass. HAMLYN GROUP PICTURE LIBRARY: Hoysala Dynasty (Surya); Kangra School; Marine Style; Nessos Painter; Palace Style; Rampin Horseman; Schwitters; Siqueiros. HAWKLEY STUDIOS, London: Wang Yuan-Ch'i; Wu Li. ANDRE HELD, Lausanne: Etruscan Art (both subjects); Orans; Rome, St Peter's, Tomb of the Julii. HANS HINZ, Basel: Klee, Lascaux, Mondrian. HIRMER FOTOARCHIV: Amarna Style; Egyptian Painting (Meidum geese); Halaf; Nofretiri; Ohrid; Rahotpe and Nofret. MICHAEL HOLFORD, London: Admiralty Islands; Afro-Portuguese Ivories (both subjects); Amiens Cathedral; Aztec; Bakota; Bapende; Bernini; Blake; Bosch; Catlin; Coello; Cook Islands; Dürer (self-portrait); Exekias, Gandhara; Greco; Hooch; Ife; Lastman; Marcus Aurelius; Mausoleum; New Britain; New Caledonia; Nineveh; Papier Collé; Patenier; Peruzzi; Pollaiuolo; Rome, Sta Agnese; Rome, SS Cosmas and Damian; Rome, Sta Costanza; Teniers; Velasquez; Westminster Abbey Retable; Wilson, Richard; Wright, Joseph. ISTANBUL MUSEUM FOR TURKISH AND ISLAMIC ART: Abbasid Painting. F. A. MELLA, Milan: Aquilea. JAMES MELLAART: Çatal Huyuk (both subjects); MAS, Barcelona: Weyden. ANN MUNCHOW, Aachen: Aachen Cathedral Treasury; Reliquary (Three Towers Reliquary). INDRAJIT NALAWALLA, Bombay: Hoysala Dynasty (Hoysaleshvara temple, Halebid). PHOTOPRESS, Grenoble: Matisse. JOHN PICTON: Yoruba (both subjects). PICTUREPOINT, London: Vijayanagara Empire. JOSEPHINE POWELL, Rome: Alaça Hüyük; Pallava Dynasty (Descent of the Ganges). DR HANS RATHSCHLAG, Cologne: Cologne (Pestkreuz). ROUTHIER, Paris: Monet. M. SAKAMOTO, Tokyo: Motonobu. SCALA, Florence: Altamira; Fra Angelico; Bellini; Carpaccio; Carracci; Chirico; Cimabue; Cosmati; Cortona; Credi; Donatello; Duccio; Ghiberti; Giogione; Giotto; Goes; Leonardo; Lombardo; Luini; Mantegna; Martini; Masaccio; Melozzo da Forli; Michelangelo; Odyssey Landscape; Pala d'Oro; Perugino; Piero della Francesca; Pisano, Giovanni; Pollock (Enchanted Forest); Pordenone; Raphael; Ravenna, Mausoleum of Galla Placidia; Ravenna, S. Apollinare Nuovo (both subjects); Ravenna, S. Vitale; Reni; Sansovino; Tiepolo; Tintoretto; Torcello Cathedral; Veronese. TOM SCOTT, Edinburgh: Gauguin. DOUGLAS R. G. SELLICK, London: Ashanti. SOTHEBY & CO, London: Bakst. SPECTRUM, London: Minoan Art (House of the Frescoes, Knossos); Piazza Armerina; Sahara. G. TOMSICH, Rome: Alexander Mosaic. JEAN VERTUT, Paris: Pech Merle. JOHN B. VINCENT: Central Asia, Art of. JOHN WEBB, London: Appel; Bacon; Bonnard; Burne-Jones; Delaunay; Dubuffet; Hockney. ROGER WOOD, London: Mount Sinai.

Black and white

ACL, Brussels: Benson, Ambrosius; Ensor; Goes; Jordaens; Magritte (The Man of the Sea); Memling, Metsys (The Holy Kindred); Orley; Quellin; Rysselberghe; Servranckx; Wiertz. INSTITUTE OF SOUTH ASIAN ARCHAEOLOGY, UNIVERSITY OF AMSTERDAM: Borobudur; Madjapahit Period (Bhairava). ROYAL INSTITUTE OF THE TROPICS, AMSTERDAM: Bara; Banon; Djago. ANNAN, Glasgow: Bassano; Flicke; Furini; Garofalo; Morland; Nasmyth; Raeburn; Ramsay; Tiepolo; Witte, Emanuel de. ARTS COUNCIL OF GREAT BRITAIN: Pyon Sang-Byok; Sim Sa-Jong; Sin Yun-Bok; Tatlin. ASUKAEN, Nara: Asuka Sculpture (Kudara Kannon); Chusonji (Ichiji Kinrin); Heian Sculpture (Yakushi Nyorai); Horyuji (Yemedono Kannon, Yumetagae Kannon); Japanese Portrait Sculpture; Jocho School; Jodo Sculpture; Kakei School; Kanshitsu Sculpture; Kofukuji; Muroji (seated Shaka Nyorai); Nara Sculpture (all three subjects); Sadaiji; Shinto Sculpture (both subjects); Tachibana Fujin No Zushi; Tamamushi Shrine; Todaiji; Torii School; Toshodaiji; Yakushiji. JEANNINE AUBOYER, Paris: Shunga and Kanva Dynasties (medallion reliefs at Bharut, royal portrait and peacock). AUGSBURG STADTBILDSTELLE: Vries, Adriaen de. I BANDY, Paris: Ceylon, Art of (Shiva-sundaramurti, Reclining Buddha, Sigiriya). J. F. BARFOOT: Ghassul; Natufian Art; Palestine Bichrome Ware; Philistine Painted Pottery. EMIL BAUER, Nuremberg: Asam Brothers; Erhart, Gregor and Michael (Birth of Christ from the High Altar, Blaubeuren); Feuchtmayer (putti); Gunther, Ignaz (Virgin of the Annunciation, Weyarn); Riemenschneider (Assumption); Stoss (Annunciation detail); Zimmerman. ZOE BINSWANGER, Zürich: Senufo. FEDERICO BORROMEO: Chalukya Dynasty; Chaulukya Dynasty (Sarasvati); Ganga Dynasty (Konarak reliefs); Gupta Contemporary Minor Dynasties (Shiva from Parel); Gupta Dynasty (Birth of Brahma); Gurjara-Pratihara Dynasty (tree nymph); Indus Valley Civilisation (torso of dancing figure and male torso); Kushana Dynasty (head of bodhisattva, Shiva linga); Meketre; Rashtrakuta Dynasty (relief at Elura, three aspects of Shiva, Elephanta); Satavahana Dynasty (reliefs at Karle and Bhaja). BOUDOT-LAMOTTE, Paris: Chartres Cathedral; Maurya Dynasty (lion capital). BRENWASSER STUDIO, New York: Popova. BRUNEL, Lugano: Kalf. BULLOZ, Paris: Boucicaut Master; Dufy; Gleizes; Hugo; Moreau, Gustave; Rouault; Schongauer. RUDOLPH BURKHARDT, New York: Chamberlain; Johns; Judd; Poons. GEREMY BUTLER, London: Bigaud; Block-Printing; Blot-Drawing; Calvert; Chola Dynasty (Shiva and Parvati): Engraving (all seven subjects and enlarged details); Lithography; Martin, Kenneth; Modelling; Pochade; Steel Engraving; Wood Engraving. CAMERA PRESS, London: Annigoni. J. CAMPONOGARA, Lyon: Prud'hon. J. ALLAN CASH: Rashtrakuta Dynasty (hermaphrodite Shiva, Elephanta). JACK CASSIDY, Ely: Ely Cathedral. RAYMOND CAUCHETIER, Paris: Bakong, Cambodia (both subjects). ANTHONY CHRISTIE: Cham Art (both subjects). GEOFFREY CLEMENTS, Staten Island, NY: Albers; Burchfield; Evergood; Frankenthaler; Kuhn; Marisol; Marsh; Miller, Kenneth Hayes; Nevelson; Rivers; Roszak; Segal; Shahn; Tobey; Weinberg; Wood, Grant. YVES COFFIN, Grigny: Banteay Srei, Chen-la (Buddha); Phnom Da; Prasat Kravan; Vat Ko. COLLEGE DES HAUTES ETUDES, Paris: Chludov Psalter. A. C. COOPER, London: Bellotto; Conversation Piece. H. COOPER & SON, Northampton: Saqqara. DOMINIQUE DARBOIS, Paris: Mai Chi Shan (bodhisattva in Cave 100, Buddha in Cave 127). J. E. DAYTON, London: Damascus; Khirbat Al-Mafjar. ROBERT DESCHARNES, Paris: Aegina; Kouros (from Sunion). A. DINGJAN, The Hague: Dou; Engelbrechtsz; Fabritius (Goldfinch); Heemskerck: Potter; Vermeer (View of Delft). C. M. DIXON, London: Boxer of Apollonios. DORNAUF GRAPHIK, Frankfurt: Bushman Painting. WALTER DRAYER, Zürich: Giacometti (Pointe à l'œil); Marini. DEUTSCHE FOTOTHEK, Dresden: Wolgemut. JOHN EVANS, Ottawa: Lismer. ROBERT ESTALL, London: Gilbert. FOTO FLUGEL, Vienna: Rottmayr. FRANCOIS FOLLIOT, Paris: Houdon. WERNER FORMAN, London: Sin Saim-Dang; Tibet, Art of (both subjects); Yi Chong. JOHN R. FREEMAN, London: Coldstream. GIRAUDON, Paris: Arles, St Trophime; Bellegambe; Berzé-la-Ville; Charonton; Colombe, Jean; David, Gerard; Derain; Froment; Gerard; Goujon; Hammurapi, Stele of; Ingeborg Psalter; Leonardo (Virgin and Child with St Anne); Marcoussis; Master of Moulins; Matteo di Viterbo; Melendez; Metsys (Banker and Wife); Paris, Ste Chapelle (sculpture); Pilon; Piero di Cosimo; Primaticcio; Reims Cathedral (Visitation); Rigaud; Rosso, Giovanni Battista; Rude; St-Gilles-du-Gard; Sassanian Art; Sassetta; Toulouse-Lautrec; Vézelay; Victory of Samothrace; Villeneuve-lès Avignon; Weyden. JOHN GOLDBLATT, London: Annesley. GUNDERMANN, Würzburg: Riemenschneider (Eve); Tiepolo (Kaisersaal). MUSEE GUIMET, Paris: Angkor Thom (all three subjects); Chen-la (Vishnu, Lakshmi); Dong-Son; Kashmir (bodhisattva); West Mebon. S. HALLGREN, Stockholm: Notke. SONIA HALLIDAY, London: Cyprus (Church of Panagia tou Arakou); Daphni (Christ Pantocrator); Hosios Loukas. HAMLYN GROUP PICTURE LIBRARY: Alexander Sarcophagus; Elgin Marbles (both subjects); Geometric Art; Palermo, Cappella Palatina (King Roger of Sicily); Pompeii, Villa of the Mysteries; Qasr Al-Hayr Al-Gharbi; Rashtrakuta Dynasty (Ravana shaking Mt Kailasa); Umayyad Painting. HANS HINZ, Basel: Penthisilea Painter; HIRMER FOTOARCHIV: Agade (both subjects); Akhenaten; Alaça Hüyük (orthostat relief); Aqar Quf; Aristion, Stele of; Dexileos Stele; Egyptian Reliefs (Temple of Karnak, Thebes, Tomb of Thy, Saqqara); Giza; Gudea of Lagash; Hesyre; Istanbul, Haghia Sophia; Kouros (from Anavyssos); Lagash; Memnon Colossi; Narmer Palette; Nefertiti; Neo-Hittite Art; Nimrud; Oltos;

6

Pergamene School (*Dying Gaul*); Praxiteles; Ramose, tomb of; Ravenna, S. Apollinare in Classe; Rekhmire, tomb of; Rossano Codex; Sarcophagi, Early Christian; Sety I; Thessaloniki (*St George*); Thutmose III; Tutankhamun; Warka (*both subjects*). PHOTOHAUS HIRSCH, Nordlingen: Herlin. MICHAEL HOLFORD, London: Achilles Painter; Apollo of Veii; Audubon; Bayeux Tapestry; Benin (*bronze head of a king*); Corinthian Pottery; Cycladic Art; Daedalic Style; Easter Island; Friedrich; Indonesia (*Nias figure*); Le Nain, Louis; Meidias Painter; Miro (*Triptych*); Morris, William; Mosaic (*Ulysses*); Napirasu; New Ireland (*Uli figure*); Peleus Painter; Phoenician Art; Ur; Wallis, Alfred; Zoffany (*Willoughby family*). HOLLE VERLAG: Gupta Dynasty (*relief showing birth, enlightenment and teaching of the Buddha*). ARCHAEOLOGICAL SURVEY OF INDIA: Chaulukya Dynasty (*Mount Abu ceiling*); Hoysala Dynasty (*dancer, Belur*). JAN JACH-NIEWICZ, New York: Bertoia. ANSELM JAENICKE, Frankfurt: Vijay-anagara Empire (*pillar capital, Shiva as hunter, Rati*). VIPIN KUMAR JAIN, New Delhi: Chandella Dynasty (*mithuna couple, Khajuraho*); Gupta Dynasty (*Vishnu liberating elephant, Deogargh*); Pallava Dynasty (*Vishnu, Mamalla-puram*); Satavahana Dynasty (*dancing couple, Karle*). RUTH KEISER: Heckel. KERSTING, London: Bewcastle Cross; Canterbury Cathedral; Southwell Minster; Torrigiano; Vischer (*Shrine of St Sebaldus*). WALTER KLEIN, Dusseldorf: Beckman. W. KOHLHAMMER, Stuttgart: Picasso (*metal sculpture*). KONISHI, Kyoto: Tohaku. LARKIN BROS, London: Pala Dynasty (*gilt-bronze Avalokiteshvara*). PAULUS LEESER, New York: Tabriz School. STUDIO LESSMANN, Hanover: Wunderlich. LUDOWYK: Ceylon, Art of (*Anuradhapura*). MANSELL COLLECTION, London: Albani, Francesco; Altichiero; Algardi; Ammanati; Andrea de Cione; Fra Angelico; Ara Pacis; Arnolfo di Cambio; Il Bamboccio; Bari Throne; Barocci; Bellini, Gentile; Berlinghieri Family; Bernini (*Apollo and Daphne*); Bles, Herri met de; Bluebeard Pediment; Bologna, Giovanni da; Bronzino; Bruegel, Pieter the Elder (*Parable of the Blind*); Caccini; Calvaert; Canova; Capitoline Wolf; Caracci, Annibale (*Flight into Egypt*); Caracci, Ludovico (*Madonna degli Scalzi*); Caravaggio; Carpaccio; Catacomb Painting; Cavallini; Cefalu; Cimabue; Constantine, Arch of; Lippi Filippino; Lippi, Fra Filippo; Correggio (*all three subjects*); Crivelli (*Coronation of the Virgin, Annunciation and detail*); Daguerreotype; Desiderio da Settignano; Domenichino; Domenico Vene-ziano; Donatello (*both subjects*); Doryphoros of Polykleitos; Dossi; Duccio di Buoninsegna; Duquesnoy; Gaulli; Gentile da Fabriano; Gericault (*Officer of the Imperial Guard*); Ghiberti; Ghirlandaio; Giordano; Giorgione; Giotto (*Raising of Drusiana*); Gislebertus (*Eve*); Gozzoli; Hegeso, Stele of; Honthorst; Junius Bassus, Sarcophagus of; Kore; Kritian Boy; Leonardo (*drawing*); Lombardo, Pietro; Longhi; Lorenzetti; Lotto; Ludovisi Throne; Magnasco; Maiano; Martini; Masaccio; Masolino; Master of the Life of the Virgin; Mazzoni; Mengs; Michelangelo (*Pietà, Last Judgement, Medici Chapel*); Mochi; Monreale Cathedral; Moschophoros; Mycenean Art (*Lion Gate*); Nanni di Banco; Nectanebo Lions; Neo-Attics; Neroccio; Oderisi; Overbeck; Padua, Arena Chapel; Palermo, Cappella Palatina (*The Three Fathers of the Church*); Parmigianino; Patenier; Piazzetta; Piero della Francesca (*Annuncia-tion, Federigo da Montefeltro*); Piombo; Pintoricchio; Pisano, Nicola (*both subjects*); Pollaiuolo; Pontormo; Pozzo; Quercia; Raggi; Raphael (*Trans-figuration, cartoon for the School of Athens*); Ravenna, Mausoleum of Galla Placidia; Riccio; Robbia; Romano; Rome, Arch of Titus; Rome, Sta Maria Maggiore; Rossellino; Sacchi; Sano di Pietro; Sansovino, Andrea; Sansovino, Jacopo; Sarto (*Madonna of the Harpies*); Seghers; Serpotta; Sienese Painting; Signorelli; Solimena; Spinario; Stanzione; Tibaldi; Tino da Camaino; Tintoretto (*Massacre of the Innocents*): Titian (*Pietà*); Torcello Cathedral; Torriti; Tura; Vasari; Venice, St Mark's (*Salome*); Verona, San Zeno; Ver-rocchio; Vien; Vivarini, Antonio; Wall Mosaics; Wiligelmo; Zuccarelli; Zuccaro. BILDARCHIV FOTO MARBURG: Amarna Style (*limestone relief*); Egyptian Statuary (*statue of Khertyhotpe*); Erhart, Gregor and Michael (High Altar, Blaubeuren); Feuchtmayr (*Ottobeuren Church*); Freiberg, Saxony; Gerhaerts van Leyden (*tomb of Archbishop von Sierck*); Gunther, Ignaz (Annunciation Group, Weyarn); Kraft; Magdeburg Cathedral; Master H.W.; Master of the Tucher Altar; Moser; Sluter (*Well of Moses*); Straub; Werden Crucifix. MAS, Barcelona: Bassa; Ferrer; Berruguete, Pedro; Borrassa; Bosch (*Adoration of the Magi*); Fernandez; Gregorio; Leoni, Pompeo; Machuca; Montanes; Osona, Roderigo the Elder; Pannini; Paret y Alcazar; Ribalta; Roelas; Santiago da Compostela; Tacca; Valdes Leal; Veronese; Zurbaran.

BARRY MASON, Dublin: John, Augustus. F. A. MELLA, Milan: Maximian, Throne of. E. MEYER, Vienna: Pacher (*St Wolfgang Altar*). JOHN MILLS, Liverpool: Hilliard (attr); Mostaert; Watts. MICHAEL MOORE, Chichester: Flaxman. ANDRE MORAIN, Paris: Boto. NATIONAL TRUST, London: Gibbons. SYDNEY NEWBERY, London: Troy. FRANCES NIFFLE Liege: Rainer of Huy. FEDERAL DEPARTMENT OF ANTIQUITIES, Nigeria: Cross River Monoliths; Ibo (*mud figures, Owerri*); Nigeria, Northern (*terracotta model of animal*). GERMANISCHES NATIONALMUSEUM, Nuremberg: Stoss (*Annunciation, Virgin and Child*). CLAUDE O'SUGHRUE, Montpellier: Delacroix. PEABODY MUSEUM, Harvard: Tiahuanaco. PENGUIN BOOKS: Kashmir (*head of a girl*); Lung Men (*both subjects*); Masanobu; Shunga Kanva Dynasty (*pillar from Bodh Gaya*); T'ien Lung Shan; Urartu. PHILIPSON STUDIOS, Newcastle: Martin, John. PHOTO-PRESS, Grenoble: Zadkine. JOHN PICTON: Esie; Nok. AXEL POIGNANT, London: Australian Aboriginal Art. PAUL POPPER, London: Angkor Wat. JOSEPHINE POWELL, Rome: Aght'Amar Church; Alaça Hüyük (*group of metal objects*); Cappadocian Churches (*Elmale Kilise*); Chan-della Dynasty (*relief of lady applying kohl, relief of gods, nymphs and lovers, Khajuraho*); Daphni (*Angel appearing to Joachim*); Ganga Dynasty (*Surya figure, Konarak*); Gupta Dynasty (*Sarnath Buddha*); Hasanlu; Indus Valley Civilisation (*bust of priest*); Istanbul, Great Palace Mosaics (*both subjects*); Kushana Dynasty (*Kanishka, Seated Buddha*); Marcus Aurelius, Column of; Maurya Dynasty (*Yaksha from Parkham*); Nerezi, St Panteleimon; Phrygian Art; Ravenna, Baptistery of the Orthodox; Satavahana Dynasty (*Prince hunt-ing deer, Khandagiri*); Susa; Thessaloniki (*St Demetrios*); Vaphio Cups; Yazili-kaya (*both subjects*); Ziwiye Treasure. PRESSES UNIVERSITAIRES DE FRANCE; Vix. JEAN ROUBIER: Paris: Gislebertus (*Weighing of the Souls*); Reims Cathedral (*Joseph*). ROYAL ACADEMY OF ARTS, London: Eworth. WALTER RUSSELL, New York: Kienholz. M. SAKAMOTO, Tokyo: Asuka Sculpture (*bodhisattva*); Eitoku; Enichi-Bo-Jonon; Horyuji (*Tama-mushi Shrine*); Japanese Buddhist Painting (*both subjects*); Japanese Stone Sculpture; Jomon Figurines (*both subjects*); Josetsu; Kamakura Sculpture; Korin; Kuroda Kiyoteru; Kyoogokokuji; Li T'ang; Mitsuoki; Muroji (*Shaka Nyorai*); Niten; Okyo; Sanraku; Seiho; Sesshu; Sesson; Sotatsu; Takanobu; Yosegi Sculpture; Yusho. STUDIO SANTVOORT, Wuppertal: Marees. OSCAR SAVIO, Rome: Sosos. SCALA, Florence: Agostino di Duccio; Antwerp Mannerists (*Jan de Beer*); Arringatore; Fra Bartolommeo; Beccafumi; Bordone; Botticelli (*Birth of Venus*); Brunelleschi; Castagno; Castelseprio; Cellini; Cossa; Foppa; Lorenzo Monaco; Master of Naumberg; Mino da Fiesole; Niccolo dell'Arca; Paolo Veneziano; Saraceni; Sarto (*Birth of the Virgin*); Venice, St Mark's (*Entry into Jerusalem*); Vivarini, Alvise. HELGA SCHMIDT-GLASSNER: Vischer (*detail, Shrine of St Sebaldus*). TOM SCOTT, Edinburgh: Batoni; Chavin; Chimu; Diaguita; Eskimo Art (*both subjects*); Guetar; Haida; Inca; Mazca; Plains Indian Art (*both subjects*); Tlingit; Vera Cruz; Veraguas; Western Mexico; Zapotec. PROFESSOR THURSTON SHAW, University of Ibadan: Ibo (*altar stand*). NIHON KEIZAI SHIMBAN: Chinese Bronze Figurines (*Seated Buddha*); Yin Hua Hsien (*Eastern Wei Style*). SICKMAN, Lawrence: Yun Kang (*both subjects*). SKIRA, Geneva: Egyptian Reliefs (*temple of Hathor, Dendera*); Egyptian Statuary (*statue of standard bearer*); Karnak; Wife of Nakhtmin. E. A. SOLLARS, Winchester: Winchester Bible; SOTHEBY & CO, London: Fang. SPECTRUM: Minoan Art (*Verandah of the Royal Guard, Palace of Knossos*). WALTER STEINKOPF, Berlin: Barlach; Daret; Eyck, Jan van (*Madonna in a Church*); Geertgen Tot Sint Jans; Kolbe; Ouwater; Soulages; Terborch; Velde, Esaias van de. NATIONAL MUSEUM, Stockholm: Audran Family. HANS J. STRAUSS, Altotting: Altotting, Goldenes Rossel. WIM SWAN, London: Vijayanagara Empire (*mounted warriors*). JOSEPH SZASZFA, Yale: Trumbull. JIN-ICHI TAKAMURA, Kyoto: Chu Yung Kuan. CHARLES UHT, New York: Fang; Merida; Torres Straits mask; Tuamotu Islands; Warhol. VAGHI, Parma: Guttoso. VIEWPOINT PRO-JECTS: Cyprus (*Church of the Virgin, Asinou*); Mosaic (*Battle of Neptune, Ostia*); Myron; Rome, Column of Trajan. ROGER VIOLLET, Paris: Olympia, Temple of Zeus. JOSE VERDEO, Mexico City: Goitia. JOHN WEBB, London: Heartfield; Hoyland; Rodin. ACHILLE WEIDER: Tuc d'Audoubert. ROGER WOOD, London: Bisutun; Naqsh-i-Rustam; Perse-polis (*both subjects*); Taq-i Bustan. YAN, Toulouse: Strasbourg Cathedral. W. L. YOUNG, Lincoln: Lincoln Cathedral, Angel Choir.

Preface

It is the purpose of this dictionary to cover comprehensively, and yet as concisely as possible, the history of the fine arts throughout the world. Essentially, it is a handbook for the non-specialist. A large proportion of illustrations to text has been included to provide a broad visual documentation for a subject which is primarily visual. Technical information has been kept to a minimum, and a thorough use of cross-references enables the reader not only to look up an individual artist, but to refer quickly to other artists with whom he was linked, the techniques which he used, or to movements with which he was associated.

All dictionaries are selective, however extensive they may be. It has been the intention here to include as many individual artists as was practical, rather than devote lengthy passages to major figures. Thus there are more separate entries than in other single-volume works, and it has been considered justifiable to make the entries on famous artists comparatively short, so as to include a greater number of the lesser known.

A Visual Dictionary of Art deals with painting and sculpture only. The decorative arts are represented when they provide the sole source of our knowledge, as in the case of Ancient Near Eastern painted pottery, or when by its sheer quality the work can be regarded as 'fine' art, as with some medieval metalwork, or ceramic sculpture such as Bustelli's. Chinese and Islamic calligraphy have a place here because calligraphy is regarded as a fine art in both cultures. The same applies to Islamic bookbinding. Architecture is featured when it is a vehicle for sculpture.

By far the greatest number of entries is devoted to biographies of known artists. The biographies give dates and places of birth and death, details of careers, and they also attempt, in a sentence or two, to describe the character of the artist's work and his influence. There are also biographies of significant writers on art. Archaeological and ethnographical entries are listed by site or geographical location, eg Samarra, Sepik River. Works and monuments produced by unidentified painters or sculptors are usually listed by title, eg the Laocöon group, or by location, eg Paris, Ste Chapelle. There are a number of general introductory articles on styles, schools and movements, eg T'ang dynasty painting, Isfahan school, Cubism. Finally a separate group of entries is devoted to techniques and terminology. The methods of printmaking,

engraving, bronze casting etc are described, and specifically art historical terms such as illusionism, *sfumato*, *sotto in sù*, are explained.

Apart from the dictionary proper, there is a substantial section of introductory matter, consisting principally of a collection of thirty essays placed in chronological order, which together constitute a self-contained history of art. The essays deal in general terms with the nature of Indian art, Oceanic art, Baroque art, etc, and are cross-referenced to entries in the alphabetical sequence. An index provides further coverage. Listed in it are the names of artists, patrons and institutions whose names occur in the body of the text, but for whom there are no separate entries. A short guide to further reading is also included.

The space devoted to different cultures and periods was established by the editor with the advice of the editorial board, and generally follows an accepted pattern. However, it will be noticed that a greater proportion of the whole work is devoted to the art of South, South-East and East Asia than is usual in western dictionaries.

A Visual Dictionary of Art is a work of reference which can be studied at several levels. It can be used quite simply to discover the important dates in an artist's life. It can be used to acquire more general information about stylistic periods or historical sequences. Finally it could be the source for a series of study courses. Taking as a starting-point, for instance, the stimulating essay on 20th-century art, the reader can proceed to the shorter articles on the modern movements, Futurism, Constructivism, Surrealism, etc, which in turn lead to the biographies of the participants in those movements and reproductions of their work.

The editor would like to thank members of the advisory board for their warm interest in the project from its inception, and for their courtesy and patience at every stage. Particular thanks are due to Mrs Daria Jones, Professor Dr van Lohuizen de Leeuw, Mr T. S. Maxwell and Dr Roderick Whitfield, whose kindness went far beyond formal requirements. The Art Information Registry, the Centre National d'Art Contemporain and Research Unlimited were most helpful in providing information. Finally, Miss Parry-Crooke was an able assistant and welcome support throughout the compilation of this book.

ANN HILL
June, 1973

Contents

Abbreviations

Albertina	Graphische Sammlung Albertina, Vienna
Ashmolean	Ashmolean Museum, Oxford
AP, Munich	Alte Pinakothek, Munich
b.	born
Bargello	Bargello (Museo Nazionale, Florence)
B–A	Musée des Beaux Arts
Birmingham	Birmingham City Museum and Art Galley
BM, London	British Museum, London
Boston	Boston Museum of Fine Arts
Brera	Pinacoteca di Brera, Milan
Carlisle	Carlisle City Art Gallery
Chantilly	Musée Condé, Chantilly
c.	circa
Coll	Collection
d.	died
Fitzwilliam	Fitzwilliam Museum, Cambridge
Frankfurt	Städelsches Kunstinstitut, Frankfurt-am-Main
Frick	Frick Collection, New York
Gardner	Isabella Gardner Museum, Boston
Glasgow	Glasgow Art Galleries and Museum
Hermitage	State Hermitage Museum, Leningrad
KH, Vienna	Kunsthistorisches Museum, Vienna
Kroller-Muller Museum	Rijksmuseum Kroller-Muller, Otterlo
Louvre	Musée du Louvre, Paris
MM, New York	Metropolitan Museum of Art, New York
MOMA, New York	Museum of Modern Art, New York
Musées Royaux, Brussels	Musées Royaux des Beaux Arts, Brussels
NG	National Gallery
NG, Berlin	Neue Nationalgalerie, Berlin
NG, London	National Gallery, London
NPG, London	National Portrait Gallery, London
NP, Munich	Neue Pinakothek and Neue Staatsgalerie, Munich
Pitti	Palazzo Pitti, Florence
Prado	Museo del Prado, Madrid
Rijksmuseum	Rijksmuseum, Amsterdam
Sheffield	Graves Art Gallery, Sheffield
Tate	Tate Gallery, London
Tretyakov	State Tretyakov Gallery, Moscow
Uffizi	Galleria degli Uffizi, Florence
Vatican	Vatican Museums and Galleries
V & A, London	Victoria and Albert Museum, London
Walker Art Gallery	Walker Art Gallery, Liverpool
Wallace	Wallace Collection, London
Wallraf-Richartz Museum	Wallraf-Richartz Museum, Cologne
Whitworth	Whitworth Art Gallery, Manchester

Note

* Asterisks denote references to entries in the main text.
† Daggers refer to the essays in the fore-matter. These symbols appear the first time a person or a subject is mentioned within an entry, not on the subsequent occasions. Surnames precede Christian names, although common practice has established some exceptions, for example Piero appears under P and not under Francesca. In such cases there is usually a cross-reference. With dates the system has been to use an oblique stroke if in doubt, eg if an individual was in Rome 1515/17, it means that he was there at some time between the two dates. 1515–17 means that he was precisely there from the first date to the second. Prefixes have usually been ignored: Jan van Eyck appears under Eyck, Jan van, and Pieter de Hooch under Hooch, Pieter de.

PALAEOLITHIC ART

Palaeolithic, or, less precisely, prehistoric art is a term generally applied to art covering the period roughly from 30,000 to 10,000 BC and largely confined to Europe. For convenience prehistorians divide this art into two categories: cave art and home or chattel art, the former on cave walls and the latter decorating small utilitarian objects or small pieces of limestone and thus being portable. As far as dating and establishing sequences and development are concerned this division is important. Very rarely is the cave art directly associated with dateable archeological material, whereas the chattel art is found in its correct cultural context. Various techniques were employed: painting and engraving (sometimes the two combined); carving, either in the round or in relief on suitable materials such as bone, ivory or stone; and, more rarely, modelling either in clay or some similar plastic material. The colours used were earth pigments, red or yellow ochre, black from manganese or carbon and white from china clay, the last being very rare. The medium was probably animal fat. Although the early manifestations of the art are simple and there is a clear development in the later periods, there are a number of cultural differences involved whose inter-relationship is by no means clear. In view of this and the time span it is not possible to see this as the growth of the art of a single people, but rather the steady mental progress of prehistoric man as a whole and the slow enrichment of his culture.

In the Upper Palaeolithic sequence in Europe which coincides with the last stage of the final European Ice Age there are three groups of archeologically recognised phases: the Perigordian/Aurignacian (30,000–24,000 BC), and the Solutrean and Magdalenian (18,000–11,000 BC). The first two, though different in their tool assemblages, are broadly contemporary and can be considered together. Very little chattel art has been found in these early stages but it includes simple engravings of animals on limestone and painting on the same material. Crude though these are, the animals depicted are perfectly recognisable. Particularly associated with the late Perigordian are the female figurines either carved in the round in various materials, or in relief eg at *Laussel. In the following Solutrean period are added sculpture in relief on small slabs. (Those on larger blocks will be dealt with later.) As in the earlier phase, many of the engravings are superimposed on the same piece of stone giving a very confused effect. Sometimes more than one animal is represented, but more often the one drawing is covered with lines as though to obliterate it. Painted slabs occur in the late Solutrean at *Parpallo in South-East Spain. Some of the Solutrean bone tools have patterns cut on the edges, though whether this is artistic or utilitarian is not clear. The peak of chattel art is found in the Magdalenian period, where in the middle phases it reaches an astonishing standard of craftsmanship and aesthetic sense. In addition to engraving, with its sensitive drawing and great naturalism, there is

carving, mostly on bone and antler. Both the engraving and carving are simple in the first three of the six stages into which the Magdalenian is divided but in the fourth and fifth the peak is reached. In the final stage the carving almost disappears and the engraving becomes progressively more stylised and loses its sense of movement.

As has been pointed out, cave art is not so well dated and the attribution of particular works to periods in the archeological framework is not so secure. Comparisons of style with dated chattel art can often give a clue and some of the earlier cave paintings have been found covered by dated archeological deposits, as well as having fallen into them, but at most this gives the earliest date. In spite of the uncertainties, two main cycles are generally recognised: Perigordian/Aurignacian and Solutrean/Magdalenian. In the first the engravings are as simple as those of chattel art. The paintings are outlines only or in one colour flat wash. In the paintings there are some peculiarities, such as showing horns and hoof slots in different perspective to the rest of the drawing so that both are visible when the animal is depicted in full profile eg at *Lascaux. No cave art can with certainty be associated with the Solutrean but a series of large limestone blocks carved in relief were found in Solutrean deposits at *Le Roc de Sers in Charente, France. In the Magdalenian period the cave art follows closely the development of the chattel art, though this applies only to the engravings. The main development is the increasingly high standard of drawing and in the later stages the use of more than one colour in the paintings to emphasise the modelling. This technique reaches its peak in the paintings on the ceiling at *Altamira in Spain. The high standard of carving in the chattel art is reflected in the beautiful clay bison in the cave of *Tuc d'Audubert in the Pyrenees and the horses in relief on the wall at *Cap Blanc in the Dordogne. Human figures in cave and chattel art are comparatively rare and treated almost as caricatures, some apparently wearing animal skins. Reclining female figures are engraved on a cave wall in France, but with the heads missing, and there are a number of female sex organs disassociated from the rest of the body, for example at *Angle sur Anglin, but phalli have not been identified with certainty.

Cave art is far more restricted in distribution than chattel art. The main centres are west central France, centred on the Dordogne, the French Pyrenees and the Cantabric coast of Spain. There are outlyers in the centre and south of the Spanish peninsula and also in the Rhône valley. There are engravings on caves in southern Italy and Sicily. The distribution of chattel art is far wider. Many examples have come from eastern Europe. Although there are penetrations of western archeological materials into eastern Europe with comparable chattel art, eastern Europe suggests a different artistic tradition, which may in part be due to widely differing environmental conditions. What is often

called the *Eastern Gravettian, covering parts of Czechoslovakia and the southern parts of Russia, is technically comparable and contemporary with the three western Upper Palaeolithic stages. It is markedly geometric in style and the only apparent artistic link with the West is the female figurines, though these tend to become more stylised in the East. These eastern figurines occur in Czechoslovakia and particularly in south Russia, eg at *Kostenki and *Gargarino and there are examples as far east as Siberia, at *Mal'ta. Also in these areas are small animals either carved in ivory or modelled in clay. Recently cave paintings, not dissimilar to those from France, have been found in the Urals.

Various suggestions have been put forward to explain the motives behind this art, ranging from 'Art for Art's sake' through sympathetic magic to totemism and initiation ritual. While the first could cover the chattel art, the paintings and engravings in the deep recesses of the cave in total darkness are another matter. Many attempts have been made to compare motives with those of modern primitive peoples practising art, but here the motives are so varied that little can be gained. Not only is there an enormous time span involved in the early art but the probable lack of cultural continuity suggests a wide variety of motives.

In addition to the European art there are many examples of both paintings and engraving in North, East and South Africa (see AFRICAN ART). All this art is later than that in Europe and the so-called *Bushman art of South Africa probably continued until the end of the last century. In East and North Africa the art is much earlier. Cave paintings of uncertain age are known from India and painting is still practised in Australia and elsewhere (see INDIAN ART, OCEANIC ART).

JOHN WAECHTER

THE ART OF THE ANCIENT NEAR EAST

There were settled communities in the Near East eight thousand years before the conquests of Alexander the Great, and for almost three thousand years some of these communities were literate, civilised societies. Our knowledge of their art varies from region to region, and in our museums some periods are better represented than others. Discoveries may yet be made which will change the picture, especially in the field of early prehistoric art, and there are other factors that limit our knowledge and understanding. Perishable substances such as wood and textiles, which rarely survive in the soil of the Near East, were probably media of art in their own right and almost certainly contributed to the decorative repertoire of artists working in more durable materials such as stone, pottery and metal. Secondly, our interpretation of the subjects of sculpture and painting, and of their function and purpose, can in historical periods be based to some extent on contemporary texts, but in prehistoric times is little more than guesswork.

Our knowledge of the earliest prehistoric settlements, before 6000 BC, is still limited, but it is clear that in many parts of the Near East where the environment was favourable – the Levant, *Anatolia, northern *Mesopotamia and western *Iran – there was a parallel development of agricultural villages, some of which attained a size and complexity that qualifies them to be described as towns. At this time the only widespread forms of art known to us were the decoration of pottery, usually with simple painted designs, and the production of stylised terracotta and stone figurines which may have had a ritual or magical function. But at *Çatal Hüyük in western Anatolia vigorous wall-paintings have been found, including representations of animals and possibly a landscape with a volcano, which appear to have some religious significance, and in Palestine the modelling of clay masks on human skulls suggests the possibility of an ancestor cult. No doubt other examples of these more elaborate arts will be discovered, but at present they have no context that would justify more than a guess at their relevance to wider developments. The next two and a half millennia, down to about 3500 BC, saw a steady advance in the agricultural economy and an increase in wealth and population, most marked where the development of irrigation techniques made possible the exploitation of rich alluvial land in southern Mesopotamia and south-west Iran. Before 5000 BC farmers of the *Samarra culture in the valleys of the middle Euphrates and Tigris and along the foothills of the Zagros were using pottery made by specialist craftsmen and decorated with elaborate geometric and stylised animal motifs. Characteristic of the same culture are figurines of alabaster and terracotta, the latter displaying vigorous modelling and an unusual degree of realism. The painting of pottery reached its zenith in the early 5th millennium with the geometric polychrome designs of the late *Halaf culture, spread over a wide area in northern Mesopotamia and eastern Anatolia, and a thousand years later in the curvilinear motifs and stylised animals of the *Susa A phase in south-west Iran. But with the exception of the Samarra figurines, many of which were found in graves and presumably served some ritual function, the art of this period is decorative in purpose and small in scale.

At the same time contact between different regions of the Near East was increasing, and although their crafts display a variety of technical specialisation, often reflecting the availability of native materials – metal technology, for instance, seems to have developed in

the ore-bearing areas of Anatolia and Iran, and to have come only late to Mesopotamia – there was an increasing interchange of motifs and perhaps of the symbolism that they embodied. Pottery of the late 'Ubaid period, in the second half of the 5th millennium, is found outside its Mesopotamian homeland from western Iran to the Levant, and in the succeeding Uruk period artistic connections can be traced between Mesopotamia and pre-dynastic Egypt. One reason for these contacts was no doubt the growth of long-distance trade, stimulated by the demand for raw materials and for luxuries in the cities that now arose in southern Mesopotamia. These centres, the birthplace of literate Sumerian civilisation, also provided the patronage for the first large-scale works of art. Monumental temples were elaborately decorated, often with cone mosaic, sometimes with paintings of men and animals, relief carving was used for narrative representation of ritual scenes, and an example of sculpture in the round, the *'Warka head', affords our first evidence for a near life-size statue, probably representing a deity. The common feature of these works is their formal, often ritual character, and this foreshadows the most important common characteristic of Near Eastern painting and sculpture throughout the historic period.

From this time on the functions of the major arts were almost exclusively religious or official. They presented the character and attributes of divinities, the mythology that was an important part of Near Eastern religion, or the functions and achievements of rulers. Even the last, though superficially secular, depicted the ruler as the agent of his divine overlord, to whom his successes were more or less specifically attributed. Dynastic kingship is first attested in Mesopotamia soon after 3000 BC, and thereafter the king appears to have played an increasingly important part in civil as well as military organisation, superseding the priesthood who were relegated to more narrowly religious duties. But, although deification of a ruler was rare, he functioned in all things as the servant of his god and in certain circumstances as his priest. This merely reflects on a grand scale the position of the individual in most Near Eastern societies for which we have evidence; he was essentially the servant of a superhuman power, not the citizen of a state as in Greek or Roman society. The consequences for the purpose and content of art were profound. There are examples of the purely decorative use of painting and carving on buildings, on furniture and objects of personal adornment; the sumptuary arts reflect the wealth of the societies that paid for them, but here too, other than purely abstract themes commonly have a religious or mythological significance. The overall effect was conservatism, backed by official sanction. Technology improved and techniques of representation changed, particularly in art with a narrative content such as pictorial reliefs, but the range of themes was only sporadically enlarged and their treatment was circumscribed by conventions based ultimately on religion. This is most obvious in the sculptors' failure to develop the possibilities of sculpture in the round. The statues we possess, though in some cases of great technical virtuosity, represent the individual in his capacity as servant of his god, in a rigid pose of obedient attention or prayer. Neither realistic portraiture nor the representation of movement was beyond the capacity of the craftsman, but both were irrelevant to his purpose. A second effect is the anonymity of the individual artist, which probably reflects not so much a failure to appreciate art for its own sake and to honour its exponents, as a more general assumption that they were agents employing their technical skills under a higher authority to which their achievement is credited, just as the actions of generals and civil servants, equally unknown to us, were ascribed to their royal master.

These observations are based primarily on Mesopotamia, which is both the earliest and the most consistent source of documentary evidence. They are generally valid in other Near Eastern societies, but the various regions were differently affected by political and economic factors and the differences are reflected in the development of their major arts, dependent as they were on the scale of patronage and the importance of external influences. The Levant was often dominated politically by more powerful neighbours in Egypt and Mesopotamia, and rarely wealthy enough to support independent states that could maintain an artistic establishment; it was rather a centre of commerce and a melting pot of ideas. Anatolia and Iran were both potentially rich regions and at different times the centres of dominant powers, the Hittite and Urartian kingdoms in central and eastern Anatolia, the Elamite and Achaemenid monarchies in south-western Iran. But both were exposed to periodic invasions from the Central Asian steppe, and their art often combines native traditions with intrusive elements and a degree of imitation of the formal themes of Mesopotamian monarchy. Mesopotamia itself was insulated from large-scale invasion, and although foreign elements did infiltrate its population and on occasion took over political control, they were more completely assimilated by its culture and preserved with little change the traditional forms of authority, including its public image in art.

Nevertheless, shifts in political power and changes in its nature did take place, with corresponding developments in the focus and character of artistic production. The Sumerian city states of the early 3rd millennium gave way to the first imperial monarchy, the kingdom founded by the Semitic Sargon of *Agade, which controlled all Mesopotamia from the foothills of Iran and Anatolia to the Gulf, and sent its armies to the Mediterranean. This achievement is reflected in a great expansion of the theme of conquest in sculpture on free-standing stelae and rock-cut reliefs, a larger emphasis on the figure of the ruler and, technically, a greater freedom and vigour in the treatment of subjects, both the representation of action in a landscape and the modelling of the human form. Many of these developments survived the brief reversion of hegemony to a Sumerian dynasty based on *Ur, and remained a part of the Mesopotamian artistic tradition. At the beginning

of the 2nd millennium, until the rise of *Hammurapi of Babylon about 1800 BC, no single state was dominant, but there was an active network of political and commercial contacts throughout the Near East, in which one of the most powerful participants was the north Syrian kingdom of Aleppo. It is interesting to observe at this date a wall-painting at *Mari, on the Euphrates route between Babylonia and Syria, which combines formal Mesopotamian themes with a wholly different naturalistic style that is paralleled in a contemporary palace at Alalakh near Aleppo. This suggests the existence of a Syrian or Levantine school of painting, whose influence can later be seen in the *Minoan frescoes of Crete, and perhaps also in a distinctive class of painted pottery with more stylised floral motifs, the so-called Nuzi ware, which was a luxury product in Syria and northern Mesopotamia in the 16th century. This pottery is sometimes associated with the Hurrians, who were a dominant element in the population of these areas through much of the 2nd millennium, but there is no direct evidence to connect the Hurrians with any specific artistic development.

By 1500 BC the political kaleidoscope had shifted once more. The Kassites, probably of Iranian origin, now ruled southern Mesopotamia from their capital at *Aqar Quf near Baghdad. Their art followed Mesopotamian traditions with few substantial changes, although a painted frieze of courtiers in the royal palace is an apparent innovation later imitated by Assyrian kings, and a small figure of a lioness in terracotta displays a new naturalism and delicacy in modelling. To the east, in south-west Iran, the growth of the *Elamite kingdom produced a revival in the Iranian crafts of metallurgy and stone-carving, in which the native taste for natural and stylised animal figures appears along with Mesopotamian traits in statues and ritual scenes. Palestine and part of Syria were under Egyptian control, in the north a Hurrian confederacy was dominated by Aryan rulers, the Mitanni, and in central and southern Anatolia the Hittites were now a major power. The rise of the Hittite Empire brought a new form of artistic expression, the carving of crude but vigorous stone colossi that guarded the gates of the capital Boğazköy (*Hattusas) and nearby *Alaca Hüyük, and of rock reliefs depicting religious themes. A later development was the decoration of official buildings with series of carved orthostats representing royal rituals and other activities such as hunting. One motive was clearly the desire of a new empire to emulate the public presentation of Mesopotamian monarchy, and in some respects the art itself is derivative. The sphinx and the sun-disk were Egyptian symbols, perhaps transmitted through Levantine copies, there are Mesopotamian parallels for the treatment of figures, and again Hurrian influence has been suspected; it is certainly present in religion, but we know nothing of Hurrian plastic art. But whatever its origins, Hittite sculpture had a profound influence in succeeding centuries.

Another political upheaval occurred about 1200 BC with extensive movements of people that affected the whole Near East. The Hittite Empire in Anatolia was overthrown, but some of its people set up new kingdoms in northern Syria in which the tradition of monumental sculpture continued for another five centuries. At the same time the 'Peoples of the Sea' raided the Levant as far as Egypt, leaving the Philistines settled in Palestine, and Aramaean tribes penetrated the lands on the borders of the Syrian Desert, setting up independent principalities in Syria and on the Euphrates and harassing Mesopotamia. When a new pattern emerged, Assyria rapidly became the dominant power, bringing Syria, Palestine, Babylonia and in the 7th century even Egypt under her rule, and campaigning into Elam and Media on the east and the kingdom of Urartu around Lake Van on the north. A natural result was the last and greatest flowering in Mesopotamia of the official arts. Every visitor to an Assyrian palace was overawed by the winged bull or lion colossi at the gates and the vast friezes of reliefs and mural paintings that lined the royal suites. The themes – the king as high priest of Ashur, as invincible general conquering Ashur's enemies and receiving their tribute, as heroic hunter protecting his people – go back to the beginning of Mesopotamian history, and the artistic conventions are in the Mesopotamian tradition. But the stone gate colossi and the presentation of narrative on long series of orthostats, as distinct from individual stelae, have no obvious Mesopotamian precedents and must derive from the Hittites, whose north Syrian principalities were the western neighbours of Assyria during her rise to power in the 10th century and among the first targets of her imperial ambition in the 9th century. It is interesting to observe that after they became Assyrian vassals, the Syro-Hittite princes copied Assyrian motifs on their reliefs. Indeed, the effect of the political unification of this large area was the creation of an army of craftsmen, working in an amalgam of styles under one immensely wealthy patron whose taste his subjects emulated. This shows most clearly in the minor arts such as ivory-carving, in which the range of motifs was wider and their use was decorative as well as symbolic. Here we find a North Syrian school using motifs that derive from the sculpture of that area, and a *Phoenician or Levantine school that borrowed largely from Egyptian art. It was evidently the Egyptianising school that, through Phoenician commercial connections, influenced Greek art of the Orientalising period; and similarly the metal smiths of Iran and Anatolia, where *Urartu was producing bronze work exported as far as Etruria, drew many of their motifs from the Assyrian repertoire.

The fall of Assyria in 612 BC marked the end of Mesopotamian hegemony in the eyes of the ancient world, whose concept of kingship ignored the brief interlude of Babylonian supremacy under Nebuchadrezzar. We find that when the Near East and Egypt were reunited under the *Achaemenid dynasty, Darius and his successors decorated their palaces at *Persepolis with guardian figures and reliefs reproducing Assyrian ceremonial and narrative themes; the tradition was perhaps transmitted by way of the Median

kingdom whose direct heirs they were. At Susa, where connections with southern Mesopotamia were strong, reliefs were executed in the Babylonian technique with glazed and moulded brick, though they represented processions of figures in the Assyrian manner rather than the individual symbolic animals of Nebucha-drezzar's Babylon. In decoration that was less directly concerned with the theme of royalty the Achaemenids drew on the skills of peoples such as the Greeks of Asia Minor who had never been subject to Assyria, and in the minor arts, particularly metallurgy, the Iranian tradition remained dominant. This was the final fusion of Near Eastern artistic traditions under an oriental monarchy, before the Macedonian conquest added to the ruling class an element whose tastes in art and concept of its function were Greek. But despite the introduction of Hellenistic fashions the essentially oriental idea of art as a means of expressing the nature and function of royalty survived for almost a thousand years, to be seen again in the rock-cut monuments of the *Sassanian kings.

DAVID OATES

EGYPTIAN ART

The art of pharaonic Egypt cannot be categorised as primitive, but nor is it part of the classical European tradition and capable of assessment according to 'Western' standards. Emotive ideas concerning the nature of art as such and the role of the individual artist are not in any sense relevant, and the specific Egyptian standpoint has to be understood as a means to appreciating their manner of representation.

The ancient Egyptians' approach to what they regarded simply as 'handicraft' was essentially practical, and not until Saite times were purely aesthetic considerations of any importance. Artistically, there was no distinction in status between the various crafts, all of whose products were destined to serve a useful purpose, whether in daily life or in the realm of magic. With few exceptions, the furnishings and possessions of even the richest households were functional in the ordinary sense, and those who made them were free to indulge their feeling for form and ornament. By contrast, statues, reliefs and paintings performed a crucial role in re-creating, for all eternity, the magical substance of men and gods, and their vital activities, and as a result were subject to certain conventions of a peculiar character.

The basis of these conventions was the Egyptian ideal of maat, which equally governed all aspects of life and thought. Often translated as 'truth' or 'justice', maat was in fact a more fundamental concept, the expression of cosmic order as a continuum – of things as they are, and always have been, and ought to be. It might indeed be described as an overall view of the status quo, embracing past, present and future, and only in the *Amarna period was there a change in emphasis, so that maat was interpreted in a worldly and transient context, and became virtually consonant with the life and will of the king.

Since anything magically reproduced by means of a properly finished representation might in effect be brought into being, it had as an entity to conform with maat, and untoward re-creations were therefore avoided. The representations themselves were required to be both informative and intelligible, expressing a kind of rationalised actuality, independent of time and space, and free from subjective distortions. Things were depicted in what were considered their real and immutable forms – not as they might appear in particular circumstances, but as they were known to be, in an absolute sense. Significant attributes and abstract qualities were denoted symbolically (importance, for instance, being translated into appropriate size), and colour was generally treated as an intrinsic part of the representation. Descriptive 'labels', and sometimes longer inscriptions (see *hieroglyphs), were added to clarify what was otherwise open to doubt, for no figure was ever complete without name and title.

The three-dimensional representation of objects did not entail major concessions, save in depicting conventional attributes and ensuring that all was explicit and in accordance with maat. When working in two dimensions, however, the problem arose of interpreting plastic forms in a recognisable manner, and it is here that the intellectual nature of the Egyptian approach is most clearly apparent. Most compositions were drafted to cover a predetermined area, which they entirely filled, and by which they were also bounded. The subject-matter was more or less standardised from a repertoire of accepted themes of perpetual relevance, which were reproduced typically, with little attempt to relate them to a specific occasion – unless by means of inscriptions. Events were not localised, and background, if added at all, was schematic and incidental, so that the action had little identity. In the absence of any perspective, all but the simplest scenes were divided up into registers, the lowest one representing the foreground, while in the individual registers objects that actually stood behind or within another were shown to one side or above. Sometimes the division was temporal rather than spatial, and then both the registers and particular figures were used to convey successive events or parts of an action. In either case, the principle was the same: to show things descriptively, and not as they seem from a given standpoint or at a particular moment.

The conventions applied to the representation of individual objects were similar, the simplest being depicted, like *hieroglyphs, in their most readily recognised aspect, while the more complex were treated diagrammatically, to embody essential features.

The method of drafting the standard canonical human figure, with skilful incorporation of profile and frontal views is the classic example. The use of true profile, though common with animals and inanimate objects, was restricted for living persons to those of little importance, notably servants and foreigners: this limitation applied as well to full-frontal, back, and three-quarter views, which were in any case rarely attempted. A similar class distinction affected the movement of figures, the dignified calm of the principals standing in contrast to lively activity among minor folk, who could be shown in unusual poses, and were often mere hieroglyphs for the tasks performed. The portrayal of physical wretchedness and misfortune was also confined to the unimportant, as in the heaps of the fallen in scenes of pharaonic triumph.

Egyptian art being such, the artist-craftsman was greatly inhibited as an individual, and was not looked upon as a separate creative personality. His work was conditioned in various ways – by the fact that its scope was predetermined, by the use of materials meant for eternity, and by the inexorable conventions. Moreover, his training was that of an artisan, expected to work as one of a team, and in fact he was often responsible for no more than a stage in the execution of a specific item. A skilled worker might rise to a favoured position, and occasional master-craftsmen are known by name, especially from the *Amarna period; but it is seldom that any known work is attributable.

The limits imposed by the magical nature of representational art and the Egyptians' natural conservatism were obstacles to substantial change, so that, in spite of developments over the centuries, almost any pharaonic work is immediately recognisable as such. It is sometimes implied that this was the consequence of an aesthetic norm, one facet of which was a rectilinear concept of space – but without justification. The distinctive forms of Egyptian art, though presumably found acceptable to the eye, were in origin either imposed by the basic assumptions translated into conventions, or else a result of the technical methods employed in particular crafts. Like the geometry that has been read into some reliefs, the aesthetic ideal is illusory, and only among the sculptures of the Late Period are there suggestions that the Egyptians themselves were concerned to create a visual effect.

JOHN HARRIS

CHRONOLOGICAL TABLE

Badarian and Predynastic Periods	**before 3100 BC**
Protodynastic Period	**3100–2686 BC**
1st dynasty	3100–2890
2nd dynasty	2890–2686
Old Kingdom	**2686–2181 BC**
3rd dynasty	2686–2613
4th dynasty	2613–2494
5th dynasty	2494–2345
6th dynasty	2345–2181
First Intermediate Period	**2181–2040 BC**
7th–10th dynasties	
Middle Kingdom	**2040–1786 BC**
11th dynasty	2133–1991
12th dynasty	1991–1786
Second Intermediate Period	**1786–1558 BC**
13th–17th dynasties	
New Kingdom	**1558–1075 BC**
18th dynasty	1558–1321
(Amarna Period)	(1363–1345)
19th dynasty	1321–1195
20th dynasty	1195–1075

Third Intermediate Period	**1075–710 BC**
21st dynasty	1075–930
22nd dynasty	930–730
23rd dynasty	760–715
24th dynasty	725–710
Late Period	**710–341 BC**
25th dynasty (Ethiopian)	c. 750–655
26th dynasty (Saite)	664–525
27th dynasty (Persian)	525–404
28th dynasty	404–398
29th dynasty	398–378
30th dynasty	378–341
Second Persian Period	**341–333 BC**
Macedonian Period	**332–304 BC**
Ptolemaic Period	**304–30 BC**
Roman Period	**30 BC–AD 395**
Byzantine-Coptic Period	**AD 395–640**

GREEK ART

In the 3rd millennium BC a highly developed Bronze-Age civilisation flourished in Greece and the Aegean. Its main centres were the Greek mainland, the *Cyclades and *Minoan Crete. Crete enjoyed the most advanced civilisation, perhaps because of its proximity to Egypt. By 2000 BC the island was organised under the rule of kings who built a series of splendid palaces of which the best-known is the Palace of Minos at Knossos. No large-scale art is associated with these early palaces, but the artistic skill and decorative sense of the Minoans of this period is shown by a most attractive painted pottery, called *Kamares ware. About 1700 BC the palaces were destroyed and rebuilt, and this time decorated with lively and colourful frescoes. These frescoes, with scenes of rituals and games or marine and plant life, show a strong sense of form and colour, although perspective and illusion were little understood, and are rendered with charm and simplicity. To this period belongs some very fine pottery, including the so-called *Marine style, with hosts of sea-creatures used to superb decorative effect. By 1450 BC at Knossos a more formal decorative style took its place, the *Palace style.

About the time of the palace building in Crete, the Greek mainland was invaded by the first Greek-speaking people (c. 1900 BC). The Bronze Age culture of the mainland, termed *Helladic, was given fresh impetus by these invaders, and soon Mycenae and Tiryns became leading centres of a powerful new civilisation. Cretan power appears to have collapsed about 1400 BC and the Mycenaeans became the masters of the Aegean world. They were a fierce, warrior race in contrast to the peaceful, sea-loving Minoans, and it was their king, Agamemnon, who sacked Troy. At Mycenae and Tiryns tombs and walls were built of stone blocks so large that the Greeks called them 'Cyclopean' believing that only giants could have built them. Most representative of *Mycenaean art are the rich objects found in the shaft graves, including exquisitely inlaid gold daggers, the gold death-masks of the kings and vessels of precious metal. The Lion Gate at Mycenae is a rare example of Mycenaean monumental sculpture and nothing on a similar scale has survived. Mycenaean painting lacks the spontaneity and naturalism of Minoan. Figures tend to be simpler and more linear, and later Mycenaean painting becomes increasingly abstract and geometric.

Mycenaean civilisation came to an abrupt end about 1100 BC. Our knowledge of the art of the succeeding period is largely based on pottery. Vases were plainly decorated with loops, checkers and bands. Gradually by the 9th century BC the last loops and curves were tied down into a series of angular *Geometric motifs which covered the entire pot in a tight, regular network. The earliest pottery of this type lacked figured decoration, but by the end of the 9th century a few silhouette figures began to appear, and by the 8th century human figures became more clearly defined. A particularly fine group of Geometric vases was found in the *Dipylon cemetery at Athens, with rudimentary figures of mourners standing beside the bier of the deceased. Sometimes more complex subjects, such as ships, chariot processions and mythological scenes were attempted. The vases themselves are sometimes of monumental size and probably represent the first attempts at large-scale painting in early Greece. Surviving sculpture of the period is confined to small clay or bronze figurines – long-legged figures, full of charm and individuality.

During the 8th century BC, poverty and a growing population forced the Greeks to found colonies abroad, and this movement, coupled with growing trade, introduced to the mainland other artistic currents, especially eastern ones. In pottery and sculpture of the late 8th century BC a host of eastern monsters appeared, lions, chimeras, sphinxes and gorgons. Figures were the dominant theme of this *Orientalising style, although they were largely animal and not human. Motifs became bigger and bolder, and unified design took the place of overall patterning. Some of the finest Orientalising pottery was produced at *Corinth towards the middle of the 7th century BC. Vases were filled with rows of real or imaginary animals, rendered with great surety of touch and a strong vibrant outline, set in a field sprinkled with dot rosettes. By the second half of the century increased demand resulted in hasty work. Animals were distorted to fit the field and the background strewn with heavy solid rosettes. The 7th century BC probably saw the start of wall-painting in Greece, but our knowledge of it is largely pieced together from literary references, and contemporary sculpture and vase-painting.

No monumental sculpture has survived from the early 7th century BC, although we hear of wooden cult-statues or *Xoana, being produced. Around 660 BC a well-proportioned, but rather rigidly conceived type of statue, the *Daedalic, began to appear as a result of oriental influence. In the second half of the 7th century the Greeks made contact with Egypt as the result of trading concessions and were greatly impressed by the large Egyptian standing statue in porphyry or granite. Possessing neither of these materials themselves, they turned to the Cyclades, especially Naxos, where there was a ready supply of fine white marble, and it was there that the first large statues were made. Marble statues based on Egyptian types are found in several parts of Greece by the end of the 7th century BC. An over life-size *kouros found at Cape Sounion in Attica dating to about 600 BC well illustrates the type. It is a statue of a naked youth, standing stiff and frontal with one leg advanced and hands clenched at his sides. It was this type of statue and its female equivalent, the *kore, that was the basis for Greek sculptural types for over a hundred years.

By the end of the 7th century BC the period of oriental and Egyptian influence was over and Greece

began to shape her own art. The 6th century was a period of experiment and achievement both in painting and sculpture. In sculpture we are fortunate that a large number of votive korai and kouroi survive at Athens. We owe their preservation to the fact that hundreds of these statues were mutilated by the Persians when they invaded Athens in 480 BC. The broken statues were subsequently incorporated into the platform of the Acropolis and only came to light at the end of the last century. From these we are able to observe the painstaking progression from the rigidly stylised works of the early 6th century BC to the more supple and lifelike works of the end of the century. At first the kouros, or male type, stood stiffly upright. The kore, or female type, was again rather stiff with one hand clutching her drapery and the other outstretched holding an offering. Gradually technical advances and an increasing knowledge of drapery and anatomy were applied to sculpture. The richness and studied attention to detail of *archaic sculpture is seen in the *Moschophoros or calf-bearer, the *Rampin horseman, and the *Siphnian treasury at Delphi. Throughout the 6th century there was a tendency to solve a particular sculptural problem by means of a formula. The results are seen, for example, in the elaborate hair patterns and the set 'smiles' of archaic figures. Refinements were often made piecemeal, and there was little attempt to conceive the figure as a whole but as an assembly of constituent parts.

The 6th century BC saw many developments in painting too, although we can only study them through the medium of pot-painting, as no large-scale wall-paintings have survived. By the end of the 7th century the initiative in vase-painting had passed from Corinth to Athens. Already the animal style had been competently handled there by the *Nessos painter and the *Gorgon painter. Athenian pot-painters showed greater interest in individual figures than their Corinthian counterparts and paid more attention to detail. Nor did they confine their interests to animals, but began painting human figures on their vases. Their skill in handling large numbers of human figures is well attested by the *François vase of about 570 BC. One of the most attractive features of *Attic pottery of the 6th century is the way the black silhouette figures were painted directly onto the bright red fabric of the pot. Attic red clay was much admired by Corinthian pot-painters who tried to emulate it by covering their pots with a red wash. This *black-figure technique reached a high degree of sophistication at Athens by the middle of the 6th century BC. Perhaps the greatest black-figure painters were *Amasis and *Exekias, who worked around 550–530 BC.

About 525 BC a new vase-painting technique, *red-figure, appeared at Athens. At first sight this seems nothing more than a reversal of black-figure, with the figures left in the red colour of the clay and the background painted in black. But it was more than that. The new style gave painters the full scope of the painted line to indicate details of dress and anatomy, whereas before they had to incise inner details with a sharp tool. With red-figure they could use shading and experiment with perspective, foreshortening and other devices. One of the first painters to use the new method was the *Andokides painter, who often used both red- and black-figure on opposite sides of the same vase. As the possibilities of the new technique became clear, more and more painters went over to it, until by about 500 BC black-figure passed out of use except for a few ceremonial vases.

By the beginning of the 5th century BC Greek painters and sculptors had steadily improved their technique to a point where they were ready to break away from the restraints of the archaic formulae. During this century Greek art began to fulfil the ideals it had striven so long to attain. This period, called the 'Classical' period, is regarded by art historians as a revolutionary one. It is a revolution which we take for granted from our standpoint of 2,500 years away. Yet it was in this period that so many of the conventions of art as we know it were evolved. Sculpture began to move and have life. Drapery clung to a living figure beneath. The face was capable of expression, and the limbs could feel tension and relaxation. In short, sculpture ceased to be concerned with the detailed rendering of externals, but began to capture the human figure as a living, moving organism. The Greek achievement was no less important in painting. Paintings began to have spatial depth. The use of light and shade gave figures fullness and body. Perspective and foreshortening allowed them to move freely and easily in space. This ability to convey the human body convincingly in a variety of positions seems to have been completely achieved by the end of the 4th century BC. The Classical period therefore was not only the climax of Greek art, but the basis of all Western art.

The change that came over Greek sculpture at the beginning of the 5th century BC is well illustrated by the *Kritian boy. Instead of standing stiffly erect with the weight of the body evenly distributed over the two legs, the figure leans slightly on one leg and the head is turned a little to the right. The face no longer has the archaic 'smile', but wears a quiet, pensive expression. The style has been called the *Severe style, but it was more than a change of facial expression. All at once the bodily components which had been so painstakingly refined during the archaic period had been combined into a unified living body, which was capable of movement as well as expression. The absolute stillness of the figures in the east pediment of the temple of Zeus at *Olympia is not rigidity, but tense, controlled expectancy. The famous *Tyrannicide group has the same tension, alternating with relaxation. Female statues lost much of their archaic prettiness and wore simpler clothing. There was less interest in carving exquisite drapery, than modelling the form beneath it. A fine example of modelling through drapery is the figure of Aphrodite rising from the waves in the *Ludovisi throne.

Towards the end of the 6th century BC several red figure painters had begun to make experiments with foreshortening and perspective. Painters like

*Euphronios and *Euthymides delighted in drawing figures in complex poses. By the beginning of the 5th century the days of experimentation were over, and painters like the *Berlin painter used single figures or small groups to great effect. The *Kleophrades painter filled his vases with scenes of pathos and drama. Some painters, like the *Niobid painter and the *Penthesilea painter, attempted large-scale compositions and battle scenes, and it is in their work that we can perhaps see something of the great wall-paintings of *Mikon and *Polygnotos. Another school that flourished in the early 5th century BC was a school of mannerists, led by the *Pan painter, who deliberately distorted figures for effect. Some of the most charming and accomplished paintings are on cups, such as those of *Douris, the *Panaitios painter and the *Brygos painter.

By the middle of the 5th century BC, Athens reached the height of her power under the rule of the far-seeing statesman, Pericles. Pericles was also a patron of the arts, and during his period of power, 450–430 BC, the great buildings of the Acropolis were erected. One of these was the *Parthenon. The building and the sculptures that adorned it embodied the Greek ideal of perfect form. The pedimental sculptures and friezes, the *Elgin marbles, are the embodiment of grace and idealised beauty. They were inspired if not actually sculpted by *Pheidias, who was famed in antiquity for the sublime beauty of his sculpture. Pheidias was called the sculptor of the gods, while his Argive contemporary, *Polykleitos, was called the sculptor of men. Polykleitos' figures embodied the canon of proportion, and in ancient times he was criticised for having too mathematical an approach. His most famous work, the *Doryphoros, expresses the ideal of athletic beauty. The figure also achieves a perfect harmony of pose by a subtle alternation of tension and relaxation through the body, with one foot lightly touching the ground and all the weight of the body poised over the other.

We can perhaps see something of the idealised abstraction and quiet nobility of Periclean painting in the vases of the *Achilles painter and *Polygnotos the vase-painter. However, in the last years of the 5th century BC vase-painting does not seem to have shared any of the great advances made in wall-painting. The richly languid figures of the *Meidias painter mark the decline of vase-painting in Athens. Thereafter the red-figure style was to find new masters in south Italy and Sicily. In the latter we can occasionally find echoes of illusionistic wall-painting, but it is nonetheless difficult to imagine the work of the great painters of the late 5th century who, according to *Pliny, 'opened the door of art' for later generations. We hear of *Agatharchos using large-scale perspective in the stage-sets he painted. *Zeuxis was famed in antiquity as the master of light and shade. *Parrhasios of Ephesos was renowned for the subtlety of his outlining, and *Apollodoros for his rendering of shadows. The advances made by these artists and those of the early 4th century must have been very rapid to judge by the *Alexander mosaic, which is apparently a copy in

mosaic of a 4th-century painting. Its powerful groupings, the use of rows of spears to add depth and perspective, the subtle toning and use of light and shade indicate that astonishing technical advances had been made in the intervening period.

Late 5th-century BC sculptors made increasing use of light, fluttering drapery which sometimes became so thin as to be almost transparent. *Paionios used it to make his statue of Victory appear to float above the ground. In this period and throughout the 4th century figures became softer and more sensuous. This sensuous beauty is particularly evident in the work of *Praxiteles, whose *Aphrodite of Knidos was one of the most famous statues of antiquity. Sculptors of the 4th century were rather overawed by the achievements of the 5th century and turned to other themes which had been overlooked or ignored before. Expression became important. Statues by *Kephisodotos had a 'sweet' expression, and those of *Skopas appeared surprised or anguished. This interest in human feeling led to an interest in the individual, and the result was the growth of portraiture. Famous portraits of the period include the colossal statue of Mausolus sculpted for his *Mausoleum, perhaps by *Bryaxis, and the portrait of Plato by *Silanion, erected in the Academy at Athens. The concentration of power into the hands of the Hellenistic kings fostered the growth of court portraiture. It is said that Alexander the Great would only allow three men to reproduce his features, *Lysippos in sculpture, *Apelles in painting and *Pyrgoteles on gems.

The death of Alexander the Great in 323 BC resulted in the break-up of his vast empire into four kingdoms. The period that followed, known as the *Hellenistic period, lasted until the Romans took over the Greek world in the 2nd century BC. The main centres of Hellenistic art were *Rhodes, *Alexandria, Athens and *Pergamon. Although Hellenistic art followed in the tradition of Greek art, there were important differences. Whereas Greek art developed in a steady progression up to the 4th century BC, in Hellenistic art there was a greater divergence of types and schools, combined with a constant harking back to earlier models. This makes the progression harder to follow, although the dominant themes are the development of expression and emotion in sculpture, and a growing realism sometimes reflected in uncompromisingly lifelike portraiture. The Hellenistic kings were also avid collectors and the idea of sculpture as a 'work of art' stems from this period. It was the great art patrons who fostered eclectic sculpture which borrowed from 'famous' works of the past or copied them outright.

The noble Dying Gaul, and the Gaul killing himself to avoid capture show the Pergamene school at its best. During the 3rd century BC Chares of Lindos produced the *Colossus of Rhodes. In Ionia *Doidalsas created the crouching Aphrodite type, and *Boethos of Chalcedon made the Boy with the goose. To the 2nd century BC belong the Great Altar of Eumenes at Pergamon and the *Victory of Samothrace. Later comes the *Laocoön group and the *Borghese warrior,

sculpted by *Agasias of Ephesos. In the 2nd century BC there was a strong Classical revival. Eclectic works like the *Venus de Milo combined Classical and later features. By the 1st century BC Athens was the centre of a *neo-Attic revival. The Belvedere torso, signed by *Apollonios, is in this tradition.

Hellenistic houses appear to have been richly decorated inside. Their floors were covered with *mosaics composed of very small tesserae and their subject-matter was sometimes taken from wall-painting, as the famous *Alexander mosaic shows. The earliest Hellenistic wall-paintings were simple ones imitating marble wall incrustations, a style which also appears in *Pompeian painting. This style of painting was later superseded by an illusionistic style with rows of columns and architectural vistas adding an extra perspective, 'depth', to the wall. Landscapes often appeared in wall-painting. A fine copy of a Hellenistic landscape scene was found in a house on the Esquiline at Rome, the so-called *Odyssey landscapes. Other Roman wall-paintings which seem to have been based on Hellenistic originals include the paintings in the Villa of the Mysteries at *Pompeii and the house of *Livia at Rome.

FRANK SEAR

ROMAN ART

The art of the Roman empire was a blend of earlier traditions, including the †Greek and *Hellenistic traditions. The term 'Roman art' is as difficult to define as the art itself, and a few words should be said about its background and nature before proceeding to a more detailed discussion of its development. Rome inherited the Hellenistic tradition, but had an artistic tradition of her own. *Etruscan art forms the background to Roman art. Before Rome came to power the cities of Etruria dominated central Italy both militarily and artistically. The Etruscans were clearly influenced by contemporary art in Greece, and this factor probably contributed to the Romans' ready acceptance of Greek art later on. At the same time Etruscan art had strong individual characteristics, as can be seen, for example, in the *Apollo of Veii which, although based on a Greek type, has little in common with a contemporary Greek *kouros. As Etruscan power declined, Rome began to dominate central Italy, and by the late 3rd century BC she came into contact with the Greek cities of south Italy and Sicily. As a result of the Punic wars she extended her interests to the Mediterranean, and Greece and the Hellenistic kingdoms were absorbed into her growing empire. Greek art treasures flooded into Italy and the Romans became enthusiastic collectors of Greek art. Greek artists were also much in demand, and the Romans used their skill to shape an art which corresponded to Roman aims and ideals. Roman power was reflected in temples, altars, honorific columns, *triumphal arches and other monuments. These often bore dedicatory inscriptions, Imperial busts and statues, and relief sculpture which described Roman achievement. Most of the artists who worked on these monuments were Greek, although the works they produced were not in keeping with the Greek ideal. As the empire grew and became consolidated under Imperial rule, the great provincial cities began to follow the artistic fashions of the capital, and to produce an art closely based on that in vogue at Rome. Thus Roman Imperial art cannot be defined as the art of a single city or country, but as the art of the whole Roman world. In this sense it was the first manifesta-tion of a world art, and as such has been a major influence in the later history of art.

The above remarks must serve to preface a more detailed account of the complex development of Roman art. It is as well to begin the story of Roman art in the year 753 BC, the date when, according to tradition, Rome was founded. At that time Greek cities were being established all over Sicily and in Italy as far north as Cumae. The Carthaginians were beginning their great westward expansion, and to the north of Rome the cities of Etruria were developing a strong unified culture distinct from the rest of Iron Age Italy. During the 7th century BC these wealthy Etruscan cities imported goods from Greece, Egypt, Syria and Phoenicia. As a result of these trading contacts they began to produce an art which was based on the *Orientalising style then current in Greece. Some fine pottery and funerary sculpture mostly of terracotta, a medium in which Etruscan sculptors excelled, date to this period. By the end of the 7th century BC Etruscan art began to be influenced by Ionian Greece, and it was during the 6th century that large-scale painting made its appearance. Towards the end of the 6th century an important sculptural school flourished in southern Etruria, at Veii. The name of *Vuica of Veii has been associated with this school and with the great terracotta statue, the Apollo of Veii. The artist who created the Apollo was evidently interested in expression and in the individual, and it is these characteristics which mark his sculpture out from the contemporary Greek *kouros. Another non-Greek masterpiece of the period is the bronze *Capitoline wolf. The large number of painted tombs that have survived at Tarquinia give us an excellent insight into Etruscan painting of the 6th and 5th centuries BC. Although based on Greek models they show an interest in landscape and realistic detail which does not appear to have a parallel in Greece at that period. The 5th century was a period of decline for the Etruscans. In 474 BC they suffered a shattering defeat in the Battle of Cumae, and by the 3rd century BC they were at the mercy of the growing power of Rome. Their cities were ruthlessly sacked and looted,

and little more is heard of the Etruscans or the Etruscan language, except for a 1st-century BC statue, the *Arringatore, a striking portrait of a Roman orator, which bears an Etruscan inscription. By the 3rd century BC Rome was the leading power of central Italy, and a force to be reckoned with in Mediterranean politics. A dispute with Carthage led to the Punic wars, and as a result of Rome's victory in the 2nd Punic War (218–201 BC) Sicily was annexed. During the 2nd century BC Rome found herself increasingly involved in Greek politics, and finally in 146 BC Greece was taken over. In 133 BC Rome inherited the kingdom of Pergamon, and one by one absorbed the other Hellenistic kingdoms. Works of art poured into Italy from the Greek cities and Roman taste for Greek art grew. By the 1st century BC there was great demand for copyists to produce statuary, furniture and painting in the Greek tradition. A Neapolitan sculptor, called *Pasiteles, was the founder of a school which produced hundreds of copies and adaptations of Greek originals. Another school, the *neo-Attics, signed themselves 'Athenians' and copied Classical works of the 5th and 4th centuries BC.

The 1st century BC was a period of great achievement in Roman commemorative portraiture. There had always been a strong realistic strain in Roman portrait sculpture, probably a continuation of the Etruscan tradition. The early Romans used to fashion 'imagines' or likenesses of their dead from wax. These were kept in the atria of their houses and brought out to be worn by actors at family funerals, and the tradition continued throughout the Republic. Realistic portraiture reached its peak about the middle of the 1st century BC. The tradition of direct realistic portraiture was considerably modified in the Augustan period, as can be seen, for example, in the famous *Prima Porta statue of Augustus. Here the portrait is a strong, idealised representation of the emperor's features, while the figure is based on Classical prototypes. However, the tradition of realistic portraiture never died, and we see a return to it, for example, in the bust of the emperor Vespasian, who is shown as a solid, unaffected middle-class man. This portrait, straightforward and unflattering, is fully in the old Roman tradition.

The 1st-century BC Altar of *Domitius Ahenobarbus is an early example of narrative sculpture. Throughout the Empire the Romans used narrative sculpture as a vehicle for Imperial propaganda, and historical and military events were chronicled on triumphal arches, columns and other honorific monuments. The panel on the passageway of the Arch of *Titus, showing Vespasian and Titus returning in triumph from the sack of Jerusalem, is perhaps the best-known example of a Roman historical relief. The masterpiece of historical narrative is the reliefs on the columns of *Trajan, with the events of the Dacian wars unfolding in an unbroken spiral up the column. It is a model of Classical clarity in its language, composition and the way the figures are expressed, and contains a wealth of historical detail. Trajan's successor, Hadrian,

was the most phil-Hellene of emperors and his villa at Tivoli bears witness to his tastes. Statues of his favourite, Antinoous, gave new inspiration to sculpture, and a number of portraits of him survive, notably the relief signed by *Antonianos. Hadrian introduced the Greek fashion of wearing a beard and the fashion persisted throughout the 2nd century. Beards and hair were deeply undercut and drilled as in the equestrian statue of *Marcus Aurelius. In the field of relief sculpture it is instructive to compare the column of Marcus Aurelius with that of Trajan. The column of Marcus Aurelius is full of strong emotional content in contrast to the factual narrative of Trajan's column. The figures stand out in higher relief and the horrors of the war they are fighting are emphasised.

The earlier phases of Roman painting have been discussed under the heading of Greek art because of the light they throw on Greek painting. The second style of *Pompeian painting, which was in vogue until the time of Augustus, had attempted to give an illusionistic depth to a wall by means of columns and architectural vistas. At the time of Augustus the attempt to produce an illusion was abandoned in favour of flat panels decorated with delicate ornament and elements derived from architectural motifs. Later still the fourth style combined flat panels with architectural vistas, or sometimes fantastic architectural schemes on several tiers. At the end of the second style fantasy landscapes with villas, harbours and small figures began to appear. They are rendered in a sketchy impressionistic technique which is sometimes thought to be a Roman innovation. It was used for colour and light effects, and the result was often a strongly 'atmospheric' painting.

At the time of Hadrian inhumation became more common than cremation, and the period marks the beginning of the fine tradition of carved *sarcophagi. A rare survival of an earlier carved sarcophagus is the fine *Cafarelli sarcophagus which dates to the early 1st century AD. Sarcophagi from the 2nd century AD onwards are often richly decorated with hosts of relief figures and mythological scenes. As sarcophagi became bigger the groupings became more complex, and highly involved scenes were handled with remarkable skill. Sarcophagi are of great importance in the history of Roman sculpture generally, but of fundamental importance in the 3rd century AD when they are almost our only source of knowledge about contemporary sculptural trends.

*Mosaics turn up with great frequency all over the Roman empire. They were used to adorn the floors and sometimes the walls and vaults of villas, baths, palaces and a variety of public and private buildings. The earliest Roman mosaics were the work of Greek mosaicists and fully in the Hellenistic tradition. They took the form of mosaic pictures in small polychrome tesserae. In the 1st century AD they gave way to a tradition of black and white geometric and figured mosaics which prevailed throughout the period especially at Rome and Pompeii. Polychrome mosaics began to appear again at Rome in the 2nd century AD, but the

finest examples come from provincial sites. Splendid late polychrome mosaics have been found at Antioch, *Piazza Armerina and North Africa. During the 2nd and 3rd centuries AD many big vaults were decorated with glass mosaics, and there can be little doubt that †Byzantine vault mosaics follow in the same tradition.

As the 3rd century progressed, an anti-Classical movement gathered momentum. Some early signs of the change can be detected in the arch of *Septimius Severus at Leptis Magna, with its rows of frontal figures, their garments and hair deeply undercut with the drill. In the arch of Septimius Severus at Rome figures which are supposed to be behind each other are placed on top of each other. Conventions of composition and rendering become simpler. By the middle of the 3rd century AD all the baroque curls have dis-

appeared from portrait heads. Details of hair and beards are sketchily engraved on skull-like heads. All the attention is focused on the expression of the eyes and mouth. In the colossal statue of the emperor Constantine (306–37 AD) the face is frontal and formalised to the extent that it is not recognisable as any particular individual. Yet the gaze of the statue carries an impersonal, almost divine majesty that has little to do with humanism or the Classical tradition. The relief scenes on the arch of *Constantine are represented in a style which seems to have nothing in common with Classical modelling and composition, but rather to foreshadow the modes of representation which we think of as typical of post-Classical and Byzantine art.

FRANK SEAR

EARLY CHRISTIAN AND BYZANTINE ART

The earliest surviving works with Christian subject-matter which merit the name art, like the paintings in the Roman *catacombs and at *Dura-Europos or the 3rd-century *sarcophagi from Rome, have an entirely traditional look. Their painters and sculptors must have been artisans trained to decorate the tombs or houses of the wealthier class of pagan citizens or to make sarcophagi along standard patterns, who were now adapting their ingrained methods to accommodate a new type of patron whose illegal religious faith could not be too publicly declared. The beliefs of the new religion did not demand new modes of representation, for they had been moulded into a scheme intelligible in terms of Late Roman attitudes. When the first two apocalyptic centuries of Christianity were over, and converts wished to express in art their trust in their religion and their hopes for everlasting life, they found a suitable language in the existing formulae of Roman art. Christ could be shown as the Good Shepherd in the form, already centuries old, of Hermes Kriophorus; angels could be shown like Victories; and other figures or scenes could be translated into symbols of the new religion which only the initiated could correctly decode. In this period before Constantine there was no stimulus to develop a public monumental art, nor any need to revolutionise current artistic means. Yet the future mould of Christian art was already cast.

From the time of Constantine, art became one vehicle for the public declaration of the Christian message. Imperial patronage encouraged the grandest and most expensive decoration in vast churches; vaults shining with mosaics and walls with marble revetments impressed contemporaries by their overall richness rather than by the meaning of any details. With the acceptance of Christianity as the conventional form of religion, art had to become more than a simple sign language and was required to convey the whole

narrative of church history and the concepts not just of salvation after death but the triumph of the church as well as more moral and metaphysical ideas. In the 4th century, when baptism on the death-bed was socially acceptable and allowed for a choice of affiliations during a man's lifetime, Christian art, at least among the richest patrons, was syncretist and combined spiritually incompatible themes. Dionysiac putti scramble over the columns between scenes illustrating Christian dogma on the sarcophagus of *Junius Bassus, and a Dionysiac paradise setting obscures the Christian message in the cupola mosaics of *Sta Costanza.

The 'ascetic movement' of the early 5th century seems to have had its parallel in the history of art. Nilus of Ancyra in the East and Paulinus of Nola in the West both justify the type of church decoration which they recommend to charm and at the same time to educate an observer. Nilus wants the focus of the decoration to be a great cross in the conch of the apse, and he deplores any dissipation of the power of this symbol, such as by the sort of hunting or river scenes which we know from the mausolea of Constantine's family. Paulinus describes his church, and we learn that he has commissioned a cycle of biblical scenes for his martyrium of St Felix. These are not just to attract the eyes of pilgrims, though he does expect them to spend some time contemplating the iconography; nor are they simply to edify them by portraying the history of the church, though he hopes that art may divert them from mindless revelry; finally their choice is not purely narrative, but themes are selected which can form the nucleus for a set of prayers for the salvation of the donor which he hopes will be formulated by the pilgrims. Such texts show that by the 5th century three main uses for art had been realised by Christians: it could be used to impress the observer with an overwhelming sight of the human vision of heaven; it

could be used to educate people through a direct rendering in visual form of the Christian message; and it could be used as the vehicle for prayers.

The 5th and 6th centuries were a time of continued experiment, as if these three categories were being refined by artists, although there is no reason to assume that theologians had yet analysed the implications of the developments. The *Ravenna mosaics show how a choice of scenes was made to conform with the function of the building (eg in the two Baptisteries and in the 'Mausoleum of Galla Placidia'), and also how attempts were developing to unify and clarify the elements of decoration – so that the mosaics of S. Vitale reach the spectator in a direct way which underlines the visual failure of the small panels in the nave and triumphal arch of Sta Maria Maggiore in Rome (despite the ingenious attempt to silhouette the principal figures against gold highlights).

Early Christian art developed particularly in civic settings, following the pattern of public decoration of the Late Roman world. After Justinian, when this kind of civilisation was more than ever before threatened by invasions of northern barbarians, by the Persian Empire, and by the Arab expansion, the nature of its art was realised and questioned by the church. The various factions which developed within the church formed themselves into pressure groups with varying success in winning over to their views successive emperors, whose motives for support were not necessarily limited to theological considerations. The reign of Justinian II (685–95 and 705–11) saw the advancement of those theologians who underwrote the superstitious practices of icon adoration of the time in a canon of the Quinisext Council of 692. An opposing party received the support of the powerful emperor Leo III (717–41) and the ensuing period of *Iconoclastic art forced the Byzantine church to formulate the reasons for and against the use of figurative religious art. In the event the most traditional faction prevailed, the party which espoused the now long established Greco-Roman type of art, which, as we have seen, had been grafted onto Christianity without theological justification. The 9th century saw the new vigorous religious art of Islam developing in the east Mediterranean beside a massive revival of pre-iconoclastic forms in Byzantium after 843.

The first great patron after Iconoclasm was Basil I (867–86), and in his biography it is emphasised that his work was of renovation rather than of extensive new building and decoration. Basil established his family, the so-called Macedonian dynasty, as the legitimate successors to the throne into the 11th century; and an interpretation of this period has been made in terms of a 'Macedonian Renaissance' with the suggestion that there was a conscious revival of Antiquity, especially in the 10th century. The label does draw attention to a key period of medieval art, which set its seal on the future form of Byzantine art; yet it is a misnomer, for Byzantine art on several other occasions reorientated itself by looking backwards – indeed at some time in every century – but on no occasion is there evidence to

suppose that artists looked with understanding or even interest at the surviving art of pagan Antiquity. The miniaturists of the *Joshua Rotulus or the *Paris Psalter are not inspired by Antiquity but composed from models from the highly productive period shortly before Iconoclasm. Since the message of the Rotulus is the rescue of the Holy Land, its model is likely to be from the court of Heraclius (610–41) after his victories over the Persians in the 620s and re-erection of the Cross in Jerusalem in 630. A similar connection of periods may account for the similarities between *Castelseprio and the Paris Psalter; the correlation is seen in terms of iconography in the *Koimesis church at Nicaea, where the sanctuary Virgin and Angels were replacements of similar figures torn out by the Iconoclasts.

Middle Byzantine art in the reigns of the Macedonian (867–1056) and Comnenian (1081–1185) dynasties had rediscovered the ideas and forms which the Iconoclasts interrupted but did not eradicate and developed them in new circumstances. Hence the medieval art of the Greek East is primarily a positive development of the vocabulary of Antique Greco-Roman art in new media and settings. Byzantine writers, if ever stimulated to characterise their art, see it in terms of classical ideas of the imitation of reality; they praise the lifelike representation of the Virgin and Christ and compare the skill of the artist with great predecessors like Apelles. They speak as if the subject-matter is new but not its treatment. Because of such texts it is hard to know how spectators (or the artists) viewed such major mosaics as *Hosios Loukas or *Nea Moni on Chios; or how far they could recognise that, in comparison with these, the mosaics of *Daphni were far closer to the illusionistic ideals of the Ancient World. Apparently their contemporaries were unable to formulate the achievements of Byzantine artists in creating a unique type of religious art. In it we today see an 'objective' manner of conveying to all observers alike the unchanging attributes of their God and the workings of their universe, and what their society believed good and evil, and what was the aim of a Christian life. This type of art is devalued when attempts are made to show less the intellectual content of church history but instead to interpret events in terms of ordinary human interest. The increasing number of narrative elements (among others) in the art of the time of the Palaeologan dynasty (1261–1453), eg in the Kariye Camii and in S. Nicholas Orphanos at *Thessaloniki, marks a slide into a different aesthetic which the West, unlike Byzantium, had the time and licence to develop.

In trying to appreciate the achievement of Byzantine artists, we have a dilemma. There is no informed criticism within the culture, and no statements by artists which enable us to understand their terms of reference. Theologians did claim official jurisdiction over art – the Council of Nicaea in 787 decided that the responsibility of the painter was limited to his 'art' and that the theologian should decide the 'disposition' – but it is unrealistic to deduce

that in Byzantine art form could be divorced from content. Interpretations of Byzantine art as a process of purely formal evolution are unsatisfactory. The idea that art history moves in formal cycles with a rotation from calm 'classical' phases to agitated 'baroque' phases cannot be scientifically justified. It is equally unreasonable to imagine that Byzantine art had some metaphysical mission as a catalyst, eg to dehydrate the essence of the art of classical Antiquity and in the course of time to surrender the package to be re-constituted by the artists of the Italian Renaissance, after which moment Byzantine art shrivelled away with its historical purpose fulfilled.

The highpoint of the art of the Eastern Orthodox church may with some justification be placed as between the 9th and 12th centuries, but the assessment would depend on a 20th-century attitude about the visual effectiveness of this form of art; for it would be on the assumption that this period achieved the best expression of the religious message of the culture, and that its importance lies in this sphere. This assessment would reject the idea that Byzantine art had genuine illusionistic aims and would commend its conservatism and traditionalism as ensuring an awareness of a religion meant to be unchanging in dogma. In any case the taste and interests of the patrons did affect the quality and manner of the artist selected; and the artists on their side were able to achieve endless variations on the key themes. Whatever other attractive qualities are seen in this art today, its historical importance must lie in its success in portraying the beliefs and aspirations of its society.

In the Palaeologan period some changes in Byzantine art must have been due to a knowledge of Western developments – this could account for a greater interest in illusionism as well as its positive rejection in the *Ivanovo frescoes. But the major factor in change was social. This can be seen likewise in the development of Russian art, which is quite wrongly treated as a mere formal decline of Byzantine art or as an art losing itself in the decorative mazes of folk art. It was a developing art with turning points in the work of *Rublev, *Dionisy, and the *Stroganov School. A decline in creativity only came under Peter the Great (1682–1725) who caused aristocratic patronage to support Western art forms. The decline of East European religious art needs explanation in terms of social and historical reasons and not metaphysical laws of style. At its peak, the culture offered an alternative conception of Christian art from that developed in Western Europe.

ROBIN CORMACK

MIGRATION PERIOD ART

In its widest sense the Migration Period is taken to have extended from c. 1500 BC to c. AD 1000. Traces have been identified from the borders of China to Central Europe. It has survived mainly in the form of ornamental metalwork, but it must also have been applied to perishable materials, such as wood, leather and textiles. Its unifying theme is the animal interlace – a natural preoccupation among nomadic people who lived by animal husbandry. The range and variety of patterns is great, and this distinctive art form may have evolved spontaneously in several regions of Central Asia. On the other hand the extreme mobility of the people who practised it, has encouraged diffusionist theories of development. Nearly all the important stylistic modifications of early Migration art are to be explained by encounters with the more stable societies which appeared around the fringes of the Great Eurasian plain, eg the *Hittites of Anatolia, *Assyrians, †Greeks, *Achaemenid Persians, *Parthians and †Chinese. Thus where the human figure was introduced into *Scythian art, contacts with the Greeks on the north coast of the Black Sea provide the explanation.

In a narrower sense the Migration Period refers to the Volkwanderung of European barbarians, mainly Germans between the 2nd and 10th centuries AD. Here the distribution of finds extends from the Crimea to Spain, the British Isles and Scandinavia. Among its various sub-divisions are included Visigothic, Merovingian (ie pre-Carolingian Frankish), Lombard, Hiberno-Saxon and Viking art.

It is not easy to define German taste in art before the Volkwanderung. The two principal influences under which their earliest known tastes were moulded, were brought to bear on them during their travels. These were the decorative arts of Central Asia which had been inherited by the Huns and which the Goths encountered when they moved into the Ukraine; and the art of the Roman Empire which they met in various forms on several occasions, eg when they took service in the Roman army; when they conquered and occupied the western provinces, and when they became Christian. To these may be added the art of the *Celts which had not only survived in Ireland but come to life again in Britain after the Roman withdrawal. By and large it was the decorative elements in this repertory to which the Germans responded. Like the Scythians and the Huns before them they thought of art primarily as an exercise of craftsmanship. It was something which added rarity and distinction to objects of utility like weapons, and it was therefore an index of social importance or exclusiveness. Hence a constant preoccupation with trinkets, and a disposition to evaluate art in terms of the materials used. Once they became interested in the symbolism and propaganda aspects of figure art, the Migration Period was over – even though individual patterns lingered on in subordinate roles in †Carolingian and even †Romanesque art.

The German debt to earlier Migration Period art

took two forms: technical and thematic. The practice of adorning ornamental metalwork with jewels, coloured stones and pieces of glass either in isolation or in *cloisonné patterns, has been recognised in a number of objects that have emerged from hoards buried as far apart as Petrossa in Roumania and Guarrazan near Toledo in Spain. The Petrossa diadems seem to date from the 4th century, whereas the votive crowns from Guarrazan were dedicated by 7th-century Visigothic kings of Spain. The technique seems to have been Scythian rather than Roman in origin. It is interesting that the Visigoths who ended up in Spain, went east before they turned west, and no doubt crossed the Danube plain on their way. The Spanish examples, however, may also betray a desire to emulate the material splendour of †Byzantine court ceremonial. Cloisonné techniques were also employed in the Frankish jewellery found in the tomb of the 5th-century King Childeric at Tournai; and in the 7th-century ship excavated at Sutton Hoo in England. They were equally familiar in Lombardy, and may be regarded as part of the common heritage of all the Germans who took part in the Volkwanderung.

The thematic debt was the animal interlace. It cannot be maintained that the connection was very strong or direct, for in the west zoomorphic ornament was much affected by the conditions of filigree work, a technique which was presumably derived from the Greek parts of the Mediterranean where it had been popular since *Hellenistic times. How this particular variety of the goldsmith's art came to be established among the Germans, is quite obscure. But in the Ålleberg collar at Stockholm we can already see the beginning of a filigree animal style in Scandinavia. Once established, this kind of pattern developed rapidly and it is possible to recognise a succession of stylistic phases. It also spread far afield, although no trace has yet appeared in Visigothic art. It became particularly important in England, where it was perhaps the most conspicuous of the English contributions to the Hiberno-Saxon amalgam, best represented in the so-called 'carpet' pages of the *Lindisfarne Gospels.

Viking art may be regarded as a late manifestation of Migration Period art. Although the Vikings shared the same artistic traditions as the rest of Scandinavia, they seem to have lacked both the taste for fine ornament, and the skill to produce it, until they took to overseas raiding at the end of the 8th century. Then they began to acquire English and Irish loot. The effect of this can already be discerned in the superb decorative work of the *Oseberg ship (early 9th century). With the establishment of Viking Kingdoms in the North and East of England, conditions were created under which English artists as well as objects could contribute to the formation of new styles. These have acquired Scandinavian names: Jellinge, Mammen, Ringerike etc, largely because they have been studied and identified by Scandinavian scholars. But they are all species of interlaced ornament with animal themes predominant; and they evolved during the period when the North Sea was a Viking lake. Viking art flourished when the rest of Europe was beginning to move in the direction of monumental art forms, ie †Romanesque, and when the Viking kingdoms were at last assimilated into Christendom, their purely decorative art forms were obliged to compromise also. But in the Urnes style of the mid-11th century we can see that if they failed to survive into the new era, it was not for lack of quality.

PETER KIDSON

CAROLINGIAN AND OTTONIAN ART

The replacement of the *Merovingians by the Carolingians as the ruling dynasty of the Frankish Kingdom in 751 was followed by a period of intense military activity, directed against the Lombards, the Bavarians and Saxons; which ended with the temporary unification of nearly all the German States in western Europe under a single government – the only exceptions being on the remote fringes: in North Spain, the British Isles and Scandinavia. This process was accompanied, and in a sense made possible, by a far-reaching understanding between the new secular rulers and the rulers of the Catholic church. The ultimate consequence was the resurrection of the long defunct Western Empire, epitomised in the coronation of Charlemagne by the Pope at Rome in 800. Although from a political point of view this turned out to be a deceptive hotch-potch of incompatible ideas, the cultural repercussions proved to be of incalculable importance. The kings of the Franks had originated as petty German chieftains whose tastes in art were indistinguishable from those of other patrons of the †Migration period. In aspiring to the imperial title, the Carolingians found themselves committed to patronage of a totally different order. So far as lay within their power, their new, exalted status had to be proclaimed to the world. This was done by means of art, first and foremost in buildings whose functions, forms, decoration and equipment would invite comparison with imperial establishments at Constantinople, Rome, or Ravenna. The models on which Carolingian palaces at Aachen or Ingelheim were based, the talents capable of conceiving such works, and even some of the materials used in their construction, could hardly be found elsewhere than in the Mediterranean world; and in turning back to these sources for their inspiration, Carolingian artists and architects gave to western art a new and momentous

orientation. The preoccupation with Classical and Early Christian themes, once re-established, was to prove its most consistent feature for over a thousand years.

Carolingian art was made for the court, or those close to the court. On the other hand it would not do to stress the imperial theme to the exclusion of everything else. Apart from the task of surrounding the ruler with visual splendours appropriate to his condition, works of art were lavished upon churches and churchmen, partly as manifestations of piety, partly as instruments of policy. These gifts took many forms, but insofar as we can judge from the few that have survived their value lay in the materials used, ie gold and precious stones; and in the craftsmanship of their execution, rather than in the consistent presence of any favoured style. Indeed, in their quality and the actual detail of their design, Carolingian reliquaries and bookbindings often remind us of the splendid personal effects found in the graves of earlier barbarian warriors. What has changed is the purpose for which the objects were made, and the profession of the recipients, rather than notions of the nature of art. From this point of view much Carolingian art included a large element of compromise between old and new.

Nevertheless, our estimate tends to be coloured by the innovations, and among these pride of place must go to the rehabilitation of the human figure in art. While ivories and metalwork tell us something about this, it is perhaps not inappropriate that accidents of survival compel us to form our impression of Carolingian figure art largely from the evidence of illuminated manuscripts. Much of what is called the Carolingian Renaissance was taken up with the copying of books. Publicity has tended to concentrate on the Classical texts, but a far greater number must have been works of a religious nature. Among these high-quality service books, eg *gospels and *psalters, formed a small but distinguished elite. The illustrations are almost certainly faithful reflections of their models; and it is here, more vividly than in any other context that we can see the extent to which Carolingian artists were prepared to use any suitable models that came their way. The range of style which we observe when we compare the *Godescalc and the Schatzkammer Gospels is simply an indication of the resources at their disposal.

Carolingian art was both exclusive and personal. It was at its zenith for about two generations at the end of the 8th and beginning of the 9th centuries. But little was needed to wreck the conditions under which it could flourish. It was still alive c. 875, when Charles the Bald made his gifts to St Denis. But this was the time when the Empire finally fell apart into its eastern, western and southern components, which were to become the later kingdoms of Germany, France and Italy. What happened then, so far as the arts were concerned, is obscure. There is no question of a total suspension of activity. It is merely impossible for us to see clearly how Carolingian styles evolved during the next two generations. All we can say is that when circumstances were again auspicious, as they were in Germany under the Saxon and Salian dynasties, ie between c. 950 and c. 1050, what emerges into the light of history is not a revival of Carolingian art, but something quite distinct. This new art is called Ottonian, after three kings of the Saxon period, although it persisted for fifty years after the death of Otto III in 1003.

In certain general respects Carolingian and Ottonian art resembled one another: in each case an enterprising dynasty of German kings aspired to the title of Roman Emperor, and in endeavouring to play the part, commissioned works intended to convey appropriate magnificence. The structure of patronage was essentially similar, with church treasuries once more emerging as the principal benefactors of artistic enterprise. Expensive metalwork and prestigious manuscripts still represent the bulk of what has survived, and no doubt accurately reflect the personal and aristocratic bias of what was actually made. Italian artists and Byzantine objects contributed their particular qualities. Moreover, it is in precisely these respects, or most of them, that Ottonian art is to be distinguished from the †Romanesque style, with which it was fundamentally out of sympathy. Yet there are also important ways in which Ottonian art kept abreast of the times. The religious mood was more serious than it had been in the 9th century and the art which gave expression to its more profound intuitions, eg the *Gero Crucifix at Cologne, has a tragic quality which anticipates the finest achievements of the later Middle Ages in Germany.

Ottonian art was also in a sense more professional. The production of illuminated manuscripts was concentrated in a number of important centres: eg Trier, Cologne and perhaps *Reichenau; and certain persistent uniformities of style appear which suggest a kind of art-school training. At least one artist of considerable technical precocity emerged: the *Master of the Letters of St Gregory. Skill in the working of metal likewise came to be associated during this period with particular places: *Hildesheim in Saxony during the time of Bishop Bernward (early 11th century), and later in the valley of the Meuse, where a master/apprentice system must have been in operation from the 11th century. It was these aspects of Ottonian art, rather than its courtly associations which enabled it to survive the collapse of the particular patronage structure which called it into being, and to influence, especially through *Mosan metalwork, the stylistic formation of early †Gothic art.

PETER KIDSON

25

ROMANESQUE ART

The term Romanesque was coined early in the 19th century to apply to all art between the end of antiquity and the invention of †Gothic. It was borrowed for architecture and the figure arts from literary studies, ie it was meant to be roughly analogous to the term 'Romance' as applied to languages like Italian, Provençal, etc, and to mean Roman, but with a vernacular quality that made it different. It is now usually limited to European art of the 11th and 12th centuries, characterised in the figurative arts by stylisation and distortion of figures, due as much to a sophisticated decorative sense as to an incomplete mastery of representational techniques. Much of the present appeal of Romanesque art lies in its naïveté, its childlike tendency to exaggerate the most interesting or expressive details.

The rise of Romanesque art is linked with a general reawakening and expansion in Europe after the invasions and depression of the 10th century. One manifestation of this was the reform of the church, especially the foundation of *Cluny and the revival of monasticism. Romanesque is particularly associated with the monasteries. This revival expressed itself in an outburst of building (which continued into Gothic times) unrivalled since the Roman Empire. Politically this new expansiveness can be seen in the Normans who founded dynasties in England and Sicily and sought their fortunes from Ireland to the Holy Land, or in the Crusades or the reconquest of Spain from the Arabs. The cultural results of this were the so-called 12th century Renaissance, the revival of theological, legal and literary studies, and at a different level the birth of vernacular literatures. The *Chanson de Roland* and the Provencal troubadours date from this period.

Romanesque art, however, is not a Classical revival, although antique art is frequently recalled for example in *St-Gilles, *Toulouse or *Modena and waves of classical and Byzantine influence are discernible. It remains distinct from the more overtly classicising tradition of the Empire in which a more or less continuous tradition unites †Ottonian and *Mosan art with Frederick II's imperially inspired antiquarianism (gate of *Capua). Romanesque art in the main centres in the second half of the 12th century merges into this classicising tradition in an art variously known as the Transitional or Early Gothic style, but in some areas (especially in smaller churches) the style survives into the 13th century. The 15th-century Leschman chantry in Hexham Abbey still has some claim to be considered as Romanesque.

The principal employer of Romanesque artists was the church, especially the monasteries. The *Bayeux Tapestry, perhaps the most important 11th-century work with a secular theme, was probably commissioned by a bishop for his cathedral. Secular manuscripts, the classics or chronicles, were generally monastic. The fortified residences of the nobility must often have lacked all artistic refinement, although much has been destroyed. When artists were called in, the chapel would usually receive most of the attention – not always in a spirit of Christian humility. Direct secular patronage at this period must have been insignificant in comparison to that of the church.

In the Romanesque period the various arts reacted on each other. Master Hugo, artist of the *Bury Bible, is known also to have been a metalworker. The most important achievement of Romanesque figurative art, the revival of monumental sculpture, was influenced by metalwork and painting, but its special development was due to the revival of the antique practice of systematically fitting sculpture into an architectural complex. In the Romanesque period figures are usually bent to fit their architectural role. They support the *Bari throne or act as the volutes of a capital. The Romanesque spirit is exemplified by the Prior's Doorway at *Ely on which angels have one arm three times the length of the other in order to fill the available space. Romanesque sculpture develops from the decorative emphasis of architectural features, capitals, doors, to the complex iconographies of *Vézelay or later *St Denis where the use of column figures presents the possibility for sculpture to free itself from architecture. The typical vehicle for Romanesque sculpture is the monumental doorway surmounted by a *tympanum. There were greater and lesser regional schools of sculpture. Burgundy, the Languedoc, Western France, Spain, Sicily, Lombardy are perfectly distinct, but Western French influence in England, Norman influence in Apulia or the spreading of styles and ideas along the pilgrimage routes (*Santiago de Compostela) bear witness to a frequently mobile society. The influence of Islamic decoration can be seen in sculpture in Spain, Sicily (*Monreale) and West France.

Mural and book painting were not Romanesque inventions but both flourished under these conditions. There is no litmus test for Romanesque style, but the distinction between pre-conquest English manuscripts (*Anglo-Saxon art) whose nervous drawing style derives from the *Utrecht Psalter and the hard lines and rich, opaque colours of 12th-century English illumination (*Bury Bible, *Albani Psalter) has often been shown. Peculiarly Romanesque are the decorative stylisations of drapery derived from Byzantine models known as the 'damp-fold' style (*Bury Bible, *Lambeth Bible). Painted decoration in churches was the rule, but only a fraction of this now remains, for example in areas like Catalonia where there has been little development since the 13th century. The great monumental paintings which may, for example, have existed at *Cluny have gone, but may be reflected in the chapel at *Berzé-la-Ville.

Stained glass which reaches its apogee in *Chartres and the *Ste Chapelle has roots in pre-Carolingian times, but becomes important in Romanesque times. Here again most of the evidence is missing, but *St

Denis, Augsburg and *Le Mans are partially extant examples.

The 'minor arts' of metalwork, ivory-carving, enamelling etc were not at the time considered minor. *Reliquaries, antependia, crosses, croziers and liturgical plate represented major investments and were considered as important as the architecture that housed them. Such works, because they represent realisable capital, have a particularly high casualty rate and survivals have to be eked out with literary descriptions.

JOHN HIGGITT

GOTHIC ART

The term Gothic was originally applied only to architecture. It referred to particular constructional techniques and decorative motifs which originated in the Ile de France in the early 12th century, and spread throughout Europe during the later Middle Ages. The word was first used in a disparaging sense, to describe the supposedly barbarous Northern constructions which preceded the rational calm of the early Renaissance. Since then the term has had different connotations in each succeeding period, and it has come to be applied to the painting, sculpture and the decorative arts which were contemporary with Gothic architecture. The number of works surviving from the later Middle Ages represents a very small proportion of what must have been produced. Works of extremely high quality, generally produced for royal or other very rich patrons, must be balanced against many mediocre objects which still exist. This confusing lack of evidence, coupled with the wide time span to which the word Gothic refers, makes the definition of a single Gothic style impossible. Instead one must use the term Gothic only as the description of a historical period, lasting from the second half of the 12th century to, in Northern Europe, the mid-15th century. Within these limits may be identified stylistically recognisable phases, such as those labelled Transitional, High Gothic and International Gothic. The progress of ideas about subjects such as the relationship between object and spectator, or the treatment of narrative painting, may also be traced.

At the beginning of the Gothic period the major centres of artistic activity were cathedral churches, and the most important developments, falling outside the scope of this essay, were in architecture. In the Ile de France, achievements in engineering produced a progression of vast churches: Laon, Bourges, *Chartres, *Reims, *Amiens and others. Within these buildings the decorative vocabulary of Gothic Art, its iconography and its narrative style, began to develop. The creation of large cathedral workshops, in which artists from many parts of France and from abroad gathered, stimulated progress and change. Reims, with its rapidly changing and widely influential sculptural styles, drawn from sources as diverse as *Mosan metalwork, Classical sculpture and work in Chartres, *Paris, and Amiens, is a striking example. The development from stiff, strangely proportioned, essentially two-dimensional figures, to the graceful, fashionable work of the Joseph Master, fully emancipated from the idea of the column figure, took place within about twenty-five years. The itinerant life of many medieval artists helped to spread new ideas quickly within France and across Europe. The great sculptural programmes of the Ile de France influenced each other, and also work in Germany, England, Spain and Italy.

Much 13th-century Northern Gothic painting took the form of cathedral stained glass. Elaborately patterned frameworks were filled with small scenes depicted by means of dark lines superimposed on flat patches of brilliant colour. The constant 13th-century use of red and blue was established. Both stained glass and sculptural programmes required new subject-matter, so encyclopaedic theological programmes, often linking Old and New Testament scenes, were evolved. These programmes were probably worked out by the clergy, rather than by the artists who executed them.

The decorative motifs employed in the Ile de France cathedrals became dominant in the Gothic period. Pointed arches and windows, gables over windows and doorways and the proliferation of spiky finials and pinnacles, all repeated a vertical emphasis. With the introduction of bar tracery at Reims, the designer of geometrical patterns assumed a new importance, which was to become paramount in the ubiquitous application of tracery in Rayonnant architecture. Tracery patterns and other architectural motifs were adopted in stained glass, manuscripts, metalwork, ivories, picture frames, textiles, tombs and other church furniture.

By the middle of the 13th century, as illumination and the decorative arts adopted architectural decorative motifs, a single recognisable style, decorative, courtly and delicate, began to embrace all the arts. This style, centering around Paris, is sometimes linked with the patronage of St Louis. The Ste Chapelle in *Paris, built by Louis to house the Crown of Thorns, functions as a large reliquary. Its external elevation is reflected in the *St Louis Psalter, as a framing for biblical scenes. The frame of the *Westminster Retable has much in common with Edmund Crouchback's tomb in the Abbey, which in turn shares motifs with the English Decorated style of architecture. This interchange of ideas between different media, coincides with a change in patronage. The cathedral chapters, with their need for an impressive, monumental art, were superseded by royal and other lay patrons, who demanded a refined, elaborate, small-scale art typified by ivories and Books of *Hours. Castles, built almost as much as grand

residences as places of defence, reflect the power of the laity. The cathedrals, built to the glory of God, began to be filled with elaborate tombs, glorifying royalty and nobility, whilst some families endowed extensions to churches specifically to house their own tombs. Effigies, weepers and small-scale metal and ivory figures began, around 1300, to replace the monumental sculpture of church façades.

The development of a truly Gothic style of illumination began in the mid-13th century. Manuscripts such as the *Westminster and *Ingeborg Psalters, produced in north-east France and England, are the successors of the Transitional style which came between the †Romanesque and Gothic periods. With the growth of universities such as Paris and Bologna, manuscripts were often produced by groups of professional scribes. When the centre of French illumination moved from the north-east to Paris, the style of the St Louis Psalter emerged. In both France and England new types of religious manuscripts, such as Books of Hours and *Apocalypses, were developed. In the second half of the century various experiments in the decorative and representational fields took place, culminating in France in the *Honoré style and in England in the beginning of the East Anglian school of illuminators.

Art is often discussed under three major headings: painting, sculpture and architecture, whilst other art forms are often described collectively as the *minor* or *decorative* arts. Yet in the Middle Ages these distinctions did not exist. Illuminated manuscripts far outnumbered panel paintings.

Until the later 13th century stone sculpture existed almost exclusively as architectural embellishment. In the Ste Chapelle, architecture was treated as a frame for varied decorative effects. Church ceremonial and private devotions helped to emphasise the importance of metalwork, ivories and textiles. Because of the intrinsic value of its materials, metalwork from the Middle Ages has often subsequently been melted down. However, some *reliquaries, chalices, *monstrances, *nefs and other objects have survived. During the Gothic period their appearance varied from the rather standardised productions of *Limoges art to the delicate, skeletal elegance of the Three Towers reliquary at Aachen. The change from enclosing a relic in a casket and displaying it within a framework of metal, crystals and gems, took place in the late 13th century. The intricate gabling, finials, geometric patterns and repeated verticals of later Gothic architecture, find their most fitting expression in metalwork. Patterns of architectural origin also appeared on carved ivory tablets which served as portable altarpieces for personal use. Scenes on ivories were often stylistically related to manuscripts. Ivories became increasingly popular in the 14th century when, with the decline in commissions for large-scale sculpture, small three-dimensional figures were carved in this material. The ivory Virgin and Child at *Villeneuve lès Avignon has the pose referred to as the *Gothic Sway*. The broad drapery folds which emphasised this elegant stance, and the fashionable prettiness of the figures, were also adopted in small-scale metalwork and stone sculptures. Elaborately embroidered ecclesiastical vestments have survived from the Gothic period. During the 14th century particularly fine examples, called *Opus Anglicanum*, were produced in England. Typical designs consisted of architectural framing patterns containing biblical scenes and decorative details, executed in coloured, gold and silver thread. Stylistically, *Opus Anglicanum* is related to certain East Anglian manuscripts. These textiles were widely exported and helped to spread the influence of English art throughout Europe.

In an age in which almost every commission was of a religious nature, secular themes still thrived. The margins of manuscripts which belonged to lay patrons, unobtrusive *misericords and the gutter spouts of churches, were all places in which the anecdotal and the grotesque could be depicted. To a 20th-century observer this mixture of the sacred and the profane may seem surprising, but the iconography of the decorative programme of a cathedral was, to the medieval mind, a mirror of life in all its aspects. The Gothic artist was often a careful observer of nature. His portrayals of holy persons and stories were largely dictated by tradition, but this somewhat conservative aspect of medieval art was by no means the only one.

The album of *Villard d'Honnecourt, compiled before the mid-13th century, shows us an individual artist recording what he considered interesting in the contemporary world, in a manner comparable to *Leonardo da Vinci. Architectural projects, sculpture and manuscript designs, are mixed with drawings of existing architecture and sculpture, studies of animals, stylised life drawings and numerous geometrical, arithmetical and scientific experiments. Interest in plants prompted the carving of remarkably naturalistic foliage designs on the capitals of Reims and *Naumburg cathedrals and *Southwell Minster Chapter House. Interest in animal life was displayed throughout the period, by artists such as *Matthew Paris, the East Anglian school of illuminators, Jean *Pucelle and Giovannino dei Grassi. Their observations were not consistent so that, for example, a detailed and accurate study of a bird might appear in the border of a scene lacking perspective, and containing stereotyped figures. Growing interest in narrative painting, particularly in Italy, encouraged a more consistent attitude in recording the natural world.

In Northern Europe long narrative cycles appeared in manuscripts such as the *St Louis Psalter and the *Bible Moralisée, and in the stained glass and relief sculpture of the cathedrals. However, it was in Italy that the Holy Stories were most realistically visualised. *Cavallini's work in repairing Early Christian narrative cycles in Rome, revived the practice of narrative fresco painting. Soon the Franciscans, recognising the value of this type of decoration in emphasising the immediacy of scenes from the Bible and from the life of St Francis, commissioned various cycles for S. Francesco, *Assisi. The fresco tradition grew quickly in central Italy,

encouraged by the patronage of the cathedral chapters, town councils and private donors, reaching its zenith in the works of *Giotto. Panel-painting also developed rapidly in Italy, in the late 13th century. Probably under the stimulus of Byzantine influence, Siena and other centres produced elaborately ornamented altarpieces, of which the finest is *Duccio's *Maestà*. Achievements in the rendering of perspective, light, volume, movement and dramatic content, made in fresco painting, affected the more decorative style of panel-painters as well. Italian sculpture, particularly as practised by Nicola and Giovanni *Pisano and *Arnolfo di Cambio, learnt from Classical, Italian Romanesque and Northern Gothic sculpture, when forming new monumental and narrative relief styles.

The emphatic individuality of artists such as Giovanni Pisano and Giotto, and their conscious manipulation of the relationship between art and the spectator, are constant themes in Gothic art. During this period the number of artists' names or distinctive artistic personalities known to us, is far greater than in preceding periods. The Joseph Master at Reims is an early example of this self-awareness. His figures, breaking with the tradition of the column figure, bend their heads in order to look downwards at the spectators, or to communicate with one another. The Naumburg *Master, again working in a recognisable and individual style, creates what appear to be portraits of real people, rather than the customary idealised types. The spectator also became involved in a more specific manner as the fashion for donor portraits grew. Contemporary figures were now shown closely involved with holy people and stories. At the same time artists began to sign their work more frequently. Simone *Martini's signed painting of St Louis of Toulouse crowning Robert of Anjou, is an example of both developments.

Simone's style, and the fact that he spent his last years working at the Papal court in Avignon, indicate the exchange of ideas occurring between France and Italy. The Gothic art of the 13th century developed largely from the interchange of ideas between different parts of France and then between different parts of Europe. Each country retained something of its own national styles, often with many regional variations, whilst adopting, and often adapting, new foreign ideas. 13th-century Italy, although using some Northern decorative motifs, contributed little to developments north of the Alps. It was only at the turn of the century that the newly naturalistic narrative art which Italy was developing, attracted the attention of Northern artists. Jean *Pucelle may well have visited Siena, an important centre for the exchange of ideas, situated on the road between France and Rome. His work shows the influence of Duccio's *Maestà*, from which he learnt much about perspective. The *De Lisle Psalter in England, and the work of Ferrer *Bassa in Spain, also reflect varying degrees of Italian influence.

During the Black Death, a terrible outbreak of the plague which reached Europe in 1348, many leading artists seem to have died. After the mid century, art in Italy entered a less vigorous phase, in which old formulae were repeated and the decorative was stressed above the naturalistic. At the same time Northern Gothic Art evolved a mannered, highly decorative style, which also elaborated established forms, rather than creating new ones. The demands of private patronage were becoming increasingly extravagant, and the fashionable, courtly aspects of art were constantly emphasised. Around 1400, the interaction of this new Northern style with the achievements of Italian art, and activity in Prague, briefly the seat of the Imperial Court, helped to create what is called the *International Gothic style. The objects produced during the period, such as the Book of Hours made for the Dukes of Berry, and the reliquary of the *Holy Thorn, represent the last flowering of Gothic art. By the middle of the 15th century, †Renaissance art was firmly established in Italy. Gothic architecture, and much Gothic art, survived for longer in Northern Europe, particularly in Germany, where an intensely emotional style prevailed in sculpture such as the *Pestkreuz in Cologne, and also in painting. However, here too Renaissance styles were gradually adopted.

The repertoire of forms and ideas which had begun to develop in France in the late 12th century, were a living force in European art for nearly three hundred years. During this period the role of the artist as craftsman, executing a preordained programme in traditional styles, changed to that of a self-conscious individual, creating a personal artistic style, and occupying a place in the intellectual life of the period. This metamorphosis prepared the ground for the rationalism of Renaissance art. The rich complexity of Gothic art became a thing of the past.

JOANNA CANNON

THE ITALIAN RENAISSANCE

Renaissance literally means rebirth, and in 15th- and 16th-century Italy this renewal of the imagination was centred in Classical Antiquity. Around 1395 the first stirrings occurred in Florence, but they were intellectual rather than artistic, inspired by the teaching of a recently arrived Greek pedant, Manuel Chrysoloras. However, in 1403 the Florentines made a superb catalytic gesture when they commissioned *Ghiberti to devise new bronze doors for the Cathedral Baptistery.

Stylistically the doors are Gothic, but the little heads that peer out of the roundels on the frame are those of ancient Romans cast from Classical *sarcophagi. *Vasari tells us that *Brunelleschi and *Donatello also dug among the ruins seeking to recover

pieces of Roman statuary, and by 1500 most Italian artists of note had visited the Eternal City. Indeed Rome was to prove an inexhaustible quarry of forms and ideas for two hundred years, linking the aims of the Early and High Renaissance and *Mannerist periods. Archeological excavations gave rise to a steady stream of finds, including the *Belvedere Torso*, the *Apollo Belvedere discovered in *c.* 1479, the *Farnese Bull* unearthed in the Baths of Caracalla in 1546 and, above all, the *Laocoön exhumed on January 14th, 1506. We can imagine *Michelangelo's emotions when he beheld, and identified, the piece that *Pliny had confessed he 'preferred above all else in painting and sculpture'.

But in an age when works of art were commissioned it was essential that this delight in Antiquity should be shared by the artists' patrons. The Renaissance rapidly spread over a wide area of Italy due to the peripatetic activities of the humanists (a term which meant a scholar versed in Greek and Latin) such as Vittorino da Feltre of Mantua, *Guarino of Verona, *Fazio at Naples or the Florentine Ficino, all of whom were responsible for stretching the intellects and tastes of the patrons of the day. Artists also travelled widely, ensuring the speedy dissemination of new forms, imaginative range and, from *c.* 1475, the technical advances in the use of the oil medium and the recently invented skill of engraving. So by *c.* 1460 most artists introduced some Classical motifs into their works.

Allied to the rediscovery of Antiquity was an overwhelming desire to make their creations appear real, so that *Alberti in 1435 exhorted artists to strive so 'The members of the dead should be dead to the very nails; of live persons every member should be alive in the smallest part.' Naturally with the inception of the Renaissance everything did not change overnight and Ghiberti shared the *International Gothic artist's passion for meticulous detail and this obsession with the appearance of things remained a constant feature of the Early Renaissance; sparkling gems, elaborate hairstyles, lavish brocades and an ever-increasing range of Classical detailing occur equally in such widely dispersed pictures as those by Filippo *Lippi, *Matteo di Giovanni, *Mantegna or Cosimo *Tura.

Tempering these allurements was a new intellectual stringency manifest in linear perspective. By this means the artist was able to set his figures in a lucid spatial environment. At first it was purely a way of investing the scene with greater reality but from *c.* 1450 adventurous artists like *Donatello, Mantegna, *Melozzo da Forli or *Signorelli recognised its dramatic possibilities, while those like *Perugino or *Giorgione saw it as an instrument in the evocation of a mood of immutable harmony. Aerial perspective became an essential feature of landscape with painters sensitively memorising shifting nuances of light and atmosphere. Indeed their landscapes were remarkable; familiar contours of local hills, terraced vineyards, pastures, copses, lively streams or the evening light glancing on crenellated walls, all were freshly observed and cherished.

But everything was subservient to their central preoccupation, the human figure. Partly this rested in the lure of personal fame which is shown in the increasing aggrandisement of the humanist tomb and is more intimately revealed in the contrast implicit in the modest presentation of the individual by Early Renaissance portraitists and the self-conscious projection of the personality by those of the High Renaissance. Nevertheless, it would be mistaken to see this search for visible immortality as the sole impulse underlying their concern with man, rather it is to be sought in deeper metaphysical speculations which informed almost every aspect of Renaissance art, from the proportion and the geometry of their pictorial compositions to the structure of churches. Luca Pacioli, the mathematician and friend of *Piero della Francesca and *Leonardo, summed it up admirably: 'from the human body derive all measures and their denominations and in it is to be found all and every ratio and proportion by which God reveals the innermost secrets of nature.' These notions can be traced back to the discovery in the monastery of St Gall of *Vitruvius' *Ten Books of Architecture* in which the Latin author suggested that the perfect human figure could be contained within a circle and a square; geometrical shapes which in the Renaissance became equated with the indivisible perfection of God and the four elements of earthly existence. Many artists strove to solve the Vitruvian riddle and the most successful attempt was Leonardo's famous drawing.

However, the mastery of the human figure did not rely primarily upon geometrical exercises but upon close, accurate observation. Life models were not generally employed until the 16th century and so they turned their attention to antique sculpture for information about the nude and carefully scrutinised the clad figures of their friends and neighbours. They discovered too that a logical play of chiaroscuro, or light and shade, upon the body enhanced its solidity. In short the effect was sculptural, and the grave sobriety of *Nanni di Banco's *Quattro Coronati*, Donatello's campanile Prophets, *Masaccio's Apostles or Piero's Solomon and Sheba have much in common.

But curiosity about the structure of the human body could not be repressed for long. Originally it was released in the innocent bodies of small children, and the poses of the naked Christ Child in His Mother's arms represent some of the most complex pieces of figure design from the Early Renaissance. Next came the youthful hero of the Old Testament, David, nakedly triumphant. Confronted, however, by the problems of depicting the *Labours of Hercules*, *Pollaiuolo was driven to inquisitively examine the bulge of flexed muscles and the insertion of stringy tendons and by 1500 Michelangelo and Leonardo were dissecting corpses in a scientific study of anatomy.

At the turn of the century artists seemed uncertain of their true direction, there seemed nothing new to solve and, besides, they shared the apocalyptic foreboding of their contemporaries and politically the future was uncertain: the little courts which provided a focus for the attractive regional diversity of artistic

styles in the Renaissance were threatened by larger forces; the French had invaded Italy; the wily Cesare Borgia was striking terror in the hearts of the citizens of Central Italy; while in the north the Emperor Maximilian I was campaigning on the frontiers of Venetian territory.

Yet despite these misgivings suddenly artists were braced by a new confidence. The centre of artistic endeavour moved to Rome under the Papacy of Julius II. The scale became heroic as enshrined in Michelangelo's *David*, actions were strenuous or gracefully relaxed, the flesh warm and soft to the touch due to the sensuous qualities of the oil medium. Light caressed the forms investing them with mystery or drama in the paintings by Leonardo, *Raphael, del *Sarto or *Correggio. Above all chiaroscuro served to unify the composition and whereas Early Renaissance art represented an amalgam of parts, the High Renaissance was marked by a new intellectual grasp of how to invest huge schemes with a homogeneity never realised before. To reach this goal much was sacrificed, costume became simple, a quasi-classical garment chastely ornamented by a brooch or single string of coral, architectural settings were austerely grand while landscape was not only more generalised but rapidly receded in importance save in Venice where the mountains, verdant thickets and lush meadows invented by Giorgione, *Titian, *Palma and *Bassano continued to satisfy some inner need of the patrons of that sea-girt city.

By the mid-15th century rulers began to pay attention to the decoration of their private study rooms, and this led to an increase in mythological painting. At first this was made respectable through the introduction of an elaborate moral message invented by the humanists who were usually responsible for devising the programme, but in the 16th century schemes were often directly based upon pagan themes such as Titian's decoration of Sala dell'Alabastro for Alfonso d'Este; sometimes they were overtly erotic as in Raphael's portrayal of the loves of the gods on the walls of Cardinal Bibbiena's bathroom or Titian's *Poesie* for Philip II.

This interest in mythology was accompanied by an impressive extension of their knowledge of antique works of art now being avidly collected everywhere and proudly displayed. For the creative giants such as Michelangelo or Titian encounters with these masterpieces of the past afforded them a clue as to how to turn the human body into a vehicle expressing spiritual tragedy or exaltation, but for many less gifted individuals the pursuit of an elegant physical perfection became an end in itself. Initially they revelled in spirited movement with daring foreshortening and tortuous *contrapposto partly inspired by the violent foreshortening in Michelangelo's *Worship of the Brazen Serpent*, but later this was transformed into the sophisticated undulations of the *linea serpentinata*

derived from the supple twists and slender elongation of *Hellenistic statues. They pored over Roman cameos and stared amazed at the decorative extravagance dimly glimpsed in the newly excavated recesses of Nero's *Golden House. Fired by a desire to emulate these marvels and to show off their inventive wit a new generation arose, among them Raphael's pupils, who admired idealised bodies, affected gestures, faintly titillating diaphanous draperies. They liked to shock too by introducing disquieting changes of scale such as the diminutive prophet in *Parmigianino's *Madonna del Collo Lungo* or the double system of perspective in *Pontormo's later version of the *Visitation*. All these features are associated with Mannerism.

The emergence of Mannerism does not imply an abrupt end to the Renaissance but rather indicates a discernible trend from *c.* 1516 onwards. In one important respect it differed from the High Renaissance: there was frequently an undercurrent of unease which is implicit in the way in which frontality (ie figures confronting the spectator) was used. In the Renaissance it expressed certitude or revelation but in many Mannerist paintings these figures stare hopelessly before them, lost in some inward melancholy; revelation has been replaced by a spirit of psychic withdrawal. Several of the artists were themselves unstable: Pontormo was an introverted hypochondriac and Parmigianino went mad. Both had lived under the shadow of the spiritual crisis of the Reformation and the military calamities of the Imperial invasion culminating in the Sack of Rome.

From about 1545 Mannerism was more closely linked with court circles, reflecting the precious tastes of despotic rulers. Great store was set upon the meticulous finish achieved in *Cellini's *Perseus*, Giovanni da *Bologna's gilded statuettes or *Bronzino's famous *Allegory*. The latter also embodies the unhealthy emotions of the court and its claustrophobic design recalls the strangely negative attitude to space which prevailed; even sharply receding vistas tended to lead nowhere, stopping abruptly. In portraiture the sitter's elaborate personal toilet and rigid deportment were stressed while the personality remained concealed, enmeshed in the strict rules of a Spanish dictated etiquette; only the sidelong glance betrayed fear, cunning or sadness. Rules abounded: the rules of bureaucracy, spiritual rules whether they be the Spiritual Exercises of St Ignatius Loyola, the redefinition of dogma at the Council of Trent or the watchdog role of the Inquisition. No wonder that even artists and writers on art were seized by this mania! *Academies were formed laying down rules for the achievement of artistic excellence and an astonishing number of aesthetic treatises were published. Only in Venice was this trend effectively resisted and her artists were the residuary legatees of Renaissance expansiveness.

MARIA SHIRLEY

THE FIFTEENTH AND SIXTEENTH CENTURIES OUTSIDE ITALY

The study of 15th- and 16th-century art outside Italy involves a far greater and more heterogeneous area and a complex interplay of social, political and above all religious factors. Yet if we regard the Netherlands in the 15th century as the counterpart of Florence in quattrocento Italy this can provide some understanding of the general development. Flemish painting was the focal point of all progressive art in central and western Europe just as Florence was the artistic centre of Italy but, as in Italy, there was no lack of talent in other centres, notably in Germany. There the invention of printing and the emphasis on graphic art were decisive. Admittedly, Florence was far richer in creative personalities of all kinds, a centre for philosophers, scientists, writers and scholars as well as of enlightened patrons, and the artists themselves were intellectually involved, contributed to the new ideas and were thus an integral part of Italian Renaissance. In fact the term Renaissance can be applied only with considerable reservations to 15th-century art outside Italy. In the first place knowledge of Classical Antiquity, a vital factor in Italian art, was almost completely lacking. Secondly the continuity of Gothic tradition was not, as in Italy, consciously or even unconsciously set aside but formed the common heritage of the artists and determined their training and their social status. Indeed in some respects 15th-century art is the culmination of the Gothic. This is not to say that new ideas, a new conception of nature and a keen new interest in man and his physical surroundings were not developing. In these respects the North was in step with and often even ahead of the Italians. But the attitude was different. Man was not idealised, not regarded as the centre of the universe nor conceived as a heroic 'superman', he was simply a part of life and to some extent a consciously minor aspect of creation as a whole.

Inevitably religion maintained its dominant hold on art far longer and more exclusively than in Italy. The main purpose of sculptor or painter was to give a visual expression to his religious story that would inspire and instruct the faithful. And yet it was in the North that the urgent need for a reassessment of religious doctrine was most keenly felt. Discontent with the prevailing order had been simmering throughout the 15th century before it finally came to a head early in the 16th century in the person of Martin Luther. The religious, political and social struggles that led to the Reformation were so far-reaching and intensive that they eventually shattered the medieval world. The birth pangs of modern man were perhaps more violent and more painful than in Italy.

Sculpture and painting had been subordinated to architecture during the 14th century but the increasing demand by individual patrons for illustrated manuscripts, especially *Books of Hours, and small panel-paintings for devotional purposes led to a more independent style. The Dukes of Burgundy and Berry were in close contact and exchanged artists. The latter in particular was one of the greatest connoisseurs and collectors of manuscripts which he commissioned not from ordinary craftsmen but from the greatest artists whom he was able to attract to his court. Works such as the *Très Riches Heures* formed a point of departure for the unprecedented rise in landscape painting in the Southern Netherlands which, at the end of the 14th century was part of the powerful and wealthy Duchy of Burgundy. Indeed artists from the Low Countries who in the 14th century had moved from their home towns to work for French patrons now began to concentrate in the prosperous Flemish cities where they found excellent patrons not only among the Burgundian princes but also among wealthy merchants, often foreigners, including Italians. Giovanni Arnolfini and Tommaso Portinari are among the best known, both of whom commissioned important works which still survive, as for example, the wedding portrait of Arnolfini and his wife by Jan van *Eyck and the Portinari altarpiece by Hugo van der *Goes. Not only the patrons, the artists, too, were of widely different regions. The van Eycks came from the north, Robert *Campin (the Master of Flémalle) and Rogier van der *Weyden from the south but all gave powerful stimulus to the new aims of 15th-century painting. They painted portraits with individual characterisation and, especially Rogier, deep psychological penetration far in advance of anything produced in Italy at the time. They studied people in everyday surroundings which they used for their religious pictures. Jan van Eyck went further than Campin in his study of light and atmosphere. His new use of the oil medium was a decisive factor in the development of that technique and influenced Italian, especially Venetian painting, whilst his intuitive feeling for light and shade enabled him to unify three-dimensional space and to set figures in interiors surrounded by atmosphere and air. His innovations were carried on by following generations of gifted painters and by the end of the century landscape assumed major importance and eventually became an independent field for specialists. Artists of the *Patenier circle developed the 'panoramic' or world landscape for which there was a great future in the 16th century. Other artists, though not specialists, contributed independently, notably *Geertgen tot Sint Jans and Jerome *Bosch whose landscapes, as well as his more fantastic world of monsters, influenced the elder *Bruegel.

Robert Campin and Rogier van der Weyden placed their religious figures either in landscapes or in middle-class Flemish houses, the details of which were accurately rendered. But, especially with Rogier, everything was subordinated to the content. The aim was to give maximum expression and drive home with

ruthless realism the events depicted. His inventive genius gave rise to many original compositions which were imitated far and wide and even left their mark on Italy. The art of Hugo van der Goes, too, had strong repercussions in Italy. His Portinari altarpiece had been sent to Florence immediately on completion and themes borrowed from it, notably the three shepherds in the *Adoration*, soon appeared in Italian painting (*Ghirlandaio's *Adoration* in the Uffizi is an example), though with little concern for the psychological and social implications.

Well before the turn of the century knowledge of Italian art was beginning to spread to the Netherlands, partly directly (Flemish artists visited Italy, studied the new styles and noted the changing status of the artists there) and partly through the influx of engravings of the works of the great Italian masters – notably *Raimondi's engravings after *Raphael. These were disseminated by the newly established publishing houses which soon came to play a great part in the development of Flemish artists.

In addition to Italy a new factor was becoming increasingly important for Flemish art at the turn of the century, namely Germany. With few exceptions the many German sculptors and painters in the earlier 15th century had remained conservative, content to follow first the Franco-Burgundian and later the Flemish lead. But during the second half of the century the situation began to change. The initial interest in Italian humanism had been restricted to university circles. The first generation of wealthy merchants sent their sons to universities to study the humanities, and these educated young men looked at Italian art with very different eyes than had their fathers and soon demanded works of art at home in the new Italian manner. The German artists were at first ill-equipped to satisfy these demands. Medieval workshop conditions were still dominant, which meant that education was restricted to a minimum and the majority of artists however talented in their craft were untrained intellectually. In this respect the appearance of Albrecht *Dürer at the end of the 15th century was of far-reaching importance for he did possess intellectual qualities that enabled him to appreciate Italian humanism, and, on two brief visits to Venice, to grasp something of the aims of Italian quattrocento artists. Like so many of his countrymen he devoted much of his time to the graphic arts in which he was brilliantly proficient and was able to spread his ideas through a large number of prints, which as his style matured soon outstripped earlier masters such as Martin *Schongauer or the *Master of the Housebook. In his mature work he successfully blended Italian style with German expression. His influence outside Germany was immense, especially in the Netherlands where his treatment of the nude figure and his ever inventive compositions made a deep impression.

Before Dürer, knowledge of Italian art had come to Germany mainly via the Netherlands but in the 16th century it became common for German artists to visit Italy and this resulted in a greater interest in problems of volume and space and the introduction of Italian Classical subject-matter, while Classical architectural forms were common adjuncts to pictorial settings. Nevertheless, it was a period of great creativity and even the growing religious tensions did not prevent a great flowering of the arts as a whole during the first half of the 16th century. Many artists sympathised with Luther, including Dürer and the great mystic painter Matthias *Grünewald. Perhaps religious doubt encouraged the development of landscape painting as an independent subject, for it was during the first decades of the 16th century that the *Danube School flourished. One of its early pioneers, Lucas *Cranach the Elder, was appointed Court Painter to the Elector of Saxony who supported Luther and established him at the University of Wittenberg. Cranach became the great friend of Luther, painted many portraits of him and of his family and, through his workshop, spread propaganda material in woodcuts, some of them of a polemic character, far and wide. Cranach himself was the great painter for Protestant collectors and evolved a form of mythological *'cabinet picture' of great originality and charm. The growing bitterness of the religious struggles, however, did make it increasingly difficult for artists to find scope for their talents in cities supporting the Reformation where there was often bitter iconoclasm. Hans *Holbein the Younger was forced to leave Basle, where he had enjoyed the patronage of one of the most enlightened humanist circles in the North, headed by Erasmus of Rotterdam, and had to settle in England as Court Painter to Henry VIII. English art throughout the 15th and 16th centuries was at a low ebb and largely dependent on foreign artists. But it was not Holbein who had the main influence on English painting. After his early death in 1543, Flemish and French court portraiture determined the English taste and that style, derived from *Titian, assumed an international character which was accepted at every court in Europe, including France and Spain. Spain, where in the 15th century the Flemish influence had been decisive, turned more and more to Italy during the 16th century, and under Philip II, Titian's art was decisive.

France, which had long adhered to Gothic traditions was slow to accept the Renaissance. It was not until François I had attracted *Leonardo da Vinci to his court that serious interest began. The same king was responsible for the famous 'School of *Fontainebleau', which flourished in France from c. 1530, and he was also responsible for the introduction of Italian *Mannerism when he called leading Italian Mannerists to decorate the royal palaces. Naturally French artists followed the Italian lead and by the middle of the century Mannerist art had spread throughout Europe and was in demand at the courts of Germany and, under Rudolf II, of Prague.

The position was slightly different in the Netherlands. Here the strong native tradition established by the great masters of the 15th century never entirely died out. Even the most internationally minded artists retained some links with the past. The earlier Italianate

painters such as Jan *Mabuse, Quentin *Metsys or the *'Antwerp Mannerists' were followed in the second half of the 16th century by the Romanist painters, eg Frans *Floris, Martin de *Vos or Bartholomeus *Spranger and they were sponsored by wealthy patrons enamoured of humanism. But there was still interest among the intellectual middle classes in the vigorous realism of more traditional artists who were developing new popular subjects, peasant scenes, depictions of everyday life and landscape. Pictures and prints *naer het leven* ('after life') were assured of a ready market and publishing houses such as that of Jerome Cock specialised in popular as well as Italianate prints. It was in this milieu that an artist of genius appeared, Peter *Bruegel the Elder, who was able to adapt native tradition in a new, modern way. Following the general custom he spent some years in Italy but what he learnt there was not superficial Classicism – in fact he is often described as an anti-classical artist – but a new monumentality of composition which he adapted to his personal style. He was perhaps the only artist of his day who was able to give an objective rendering of life as it then was and at the same time to inaugurate a new concept of man and of nature.

MARGUERITE KAY

THE BAROQUE

The word 'Baroque' probably derives from the Italian 'barocco', meaning 'strange'. As a chronological label it is applied to that period of European culture between *c.* 1600 and the early 18th century; it stands between the period known as *Mannerism and the 18th-century †Rococo (the latter, however, is sometimes considered to be merely the last phase of Baroque). As a stylistic term Baroque is not confined to this period, as its characteristics of ample, plastic mass, and of movement have been recurring features in Western art. The sculpture and architecture of late Imperial Rome, for instance, are very 'Baroque' in feeling, and indeed it was the many surviving examples of these that 17th-century painters, sculptors and architects used as a jumping-off point in the creation of the contemporary Baroque style.

It is important to bear in mind that only part of the artistic production of the age was stylistically Baroque. If the supporters of the new style, in their respect for the art of Antiquity, could point to the full modelling and dynamic style of the *Laocoön sculpture (Vatican) as their precedent, the supporters of a rival, classical school had many less plastic and centrifugal, less emotional examples, of Roman tomb sculpture in particular, to give their art validity. Throughout the 17th century there were arguments in the *Academies as to what was the most effective means of expression, the most famous being that between the 'Rubenistes' and the 'Poussinistes' in the *Académie Royale at Paris. And there were some artists, such as *Rembrandt, who by their originality transcended these stylistic arguments.

The age of the Baroque was one of intense interest in optics; in 1609 Galileo constructed his first telescope, and this interest was shared by the visual arts. *Rubens experimented with primary and secondary colour groups in his compositions. Generally among artists there was an interest in the naturalistic rendering of atmosphere, and the texture of objects. Still-life and landscape art were the two categories of painting most purely related to these qualities, and became immensely popular during the Baroque period. There had, of course, been landscape painting in the 16th century (particularly by Flemish artists) and still-life had developed as part of the 'kitchen-scene' (also popularised by Flemish artists), but it was not until the art market had developed that this type of art – offered for sale rather than produced on commission – could expand to the enormous levels that it reached in the 17th century. Other categories of painting also established themselves firmly in the early years of the century, such as architectural fantasies, topographical views, tavern scenes, peasant scenes, bathers and seascapes, to mention but a few. To a certain extent the artist was already detached from direct contact with the people who bought his work, though naturally large-scale work was still executed on commission. Traditionally patronage had centred round the Church, but the Reformation significantly affected this pattern. The Protestant churches to a greater or lesser degree all condemned images as idolatry, and religious painting in Holland and England (the main Protestant areas) formed a very minor part of artistic output. In the Roman Catholic countries, however, the aggressive policy of the Counter Reformation had crystallised in the years following the Council of Trent (ended 1572); frontal assault proved unsuccessful in England and the Netherlands, and the attack moved on to more subtle levels of persuasion, with massive church building and redecoration programmes, spearheaded by the completion and decoration of St Peter's, Rome at immense cost, and in strongly 'Baroque' style. Unquestionably this style derived its inspiration and impetus from religious feeling, however secular the subjects to which it was ultimately applied. In Germany, also a Protestant stronghold, geographical conditions and internal politics made frontal assault more practicable, and the cultural life of central Europe was shattered for many decades by the horrific wars of 1618–48.

Early Baroque style accordingly originated in Rome, spearhead and symbol of the Counter Reformation. The core of art theory in the Mannerist period had been that the painter should rely on *disegno interno*, that is, imagination and not nature; so the new style

attacked under the broad banner of Realism. The defiant naturalism of *Caravaggio marked him as an extremist; his *Death of the Virgin* (Louvre) created a scandal when it was unveiled in a parish church due to the Virgin being placed on a rough bier, rather than a throne, with her eyes closed in death, and in circumstances of evident poverty. It was almost inevitably rumoured that the artist's model had been a prostitute. Stylistically, however, it must have made a considerable impression through its unity and visual impact on the spectator; the mourners are carefully placed, in three stages of grief, their substantial forms held together by the diagonal lines of the composition and the raking light.

But Caravaggio's view of religious art was too personal to secure him a permanent following, and it was the *Carracci brothers, Annibale and Ludovico, whose style was more influential (*see also* CARAVAGGISTI). Their art, while based on observation – they ran a drawing school in Bologna – kept within the convention that the artist's task was to select and improve on nature towards 'ideal' form. They gave their figures great weight and fullness, setting them along lines of force more dynamic than High †Renaissance painting, with dramatic foreshortening, and diagonal composition to give the impression of movement. Ludovico in particular allowed *chiaroscuro to break up his forms and partially dissolve their outline. This characteristic appealed to *Guercino, who carried it much further to become one of the most important Baroque artists in Italy, and by his time the style had spread northwards, through Rubens and his two great altarpieces at Antwerp (The Elevation of, and Descent from, the Cross). In Spain, the Baroque style appears to have developed quite independently in the work of Luis *Tristan and the sculptor Martinez *Montañes, though it received impetus from the visits of Italian Caravaggists in the early years of the 17th century.

The Baroque striving for the unified, dramatic effect found its fullest expression in painting in great decorative works, particularly ceiling painting. Again it was Italy and Annibale Carracci that led the way, but his decoration of the Farnese Gallery, Rome (1597–1604) retained in part the traditional arrangement of individual scenes set within painted frames. The tendency was towards greater *illusionism, and the presentation of an apparently open sky filled with hovering figures. The idea was not new, since both *Veronese and *Correggio had used it for ceilings and domes, but it became universally fashionable, and illusionism was carried to much greater lengths. Pietro da *Cortona's ceiling for the Saloon of the Barberini Palace, Rome (1633–9) was a major landmark in the creation of a type – the family (whether Earthly or Celestial) Apotheosis. Its highpoint was probably the two ceilings painted for the Jesuit churches in Rome, the Gesù and S. Ignazio, respectively by *Gaulli (1674–9) and *Pozzo (1691–4). In the latter, the genuine architecture is continued upwards in paint, thronged by clusters of hovering figures. The problem with this extreme form

of illusionism is that the effect remains undistorted only when seen from the midpoint of the floor below. Baroque ceilings were soon to be found throughout Europe. Vouet was the first to carry the idea back to France, and at Wilton in England, the Cube Rooms were given illusionist ceilings by de Critz in the 1630s. By 1700 England could boast of a large number of ceilings painted by Antonio *Verrio and Louis *Laguerre, and the two great commissions of St Paul's Dome and Greenwich Hospital Hall were executed by the English artist, James *Thornhill. Later Baroque ceilings tended to be more restrained in style than those of the Roman High Baroque, in accordance with the tenets of the more classically aligned *Académie Royale, headed by *Lebrun.

The other major achievement of Baroque painting was the development of landscape art from the brown-green-blue planar division and fantasy of subject in the Flemish landscape, to a subtle rendering of atmosphere and recession and an immensely varied subject-matter. Two main streams developed: one, more or less naturalistic, through *Coninxloo and the group of Dutch and German artists associated with Adam *Elsheimer to the early Dutch realists Esaias van der *Velde and Jan van *Goyen; the other stream included Paul *Bril, Agostino *Tassi and his pupil *Claude Lorraine (also influenced by Elsheimer), who together with the important figure artists Annibale Carracci and *Domenichino can be described as the creators of ideal landscape – a poetic world inhabited by shepherds and mythological figures, which according to contemporary art theory had a respectability which more naturalistic landscape lacked.

Baroque portraiture evolved a number of interesting types, ranging from openshirted informality to the pomp of the whole figure framed by Classical architecture, and the equestrian portrait. It also produced genius in *Rembrandt, *Van Dyck, *Velasquez and Philippe de *Champaigne.

Two other aspects of Baroque painting ought to be mentioned briefly: first, the interest in candle-lighting and illumination from a single source, with its dramatic possibilities. It affected many artists from Rembrandt to *Honthorst, and was one of the main elements in the extremely individual art of Georges de *La Tour. Second, and connected with the development of optical instruments like the *camera obscura, was an interest in the visual limitations of the human eye: a deliberate 'blurring' effect in less important areas of focus occurs in the work of Velasquez and *Vermeer. Certainly till about 1670, Baroque painting was very fertile in invention of new modes and new techniques. The late Baroque is by comparison a period of decadence, with growing Academicism, and the copying of stereotypes relieved by only a few artists, like the brilliantly inventive Neapolitan, *Solimena.

Baroque sculpture passed through a classical and naturalistic phase at the beginning of the 17th century – again as a reaction to the convolutions of *Mannerist form – but was rapidly dominated by the

genius of Gianlorenzo *Bernini. He was employed by one pope after another on the decoration of St Peter's (eg the Baldacchino and Cathedra Petri) and the aggrandisement, through art, of the papal city. In the design of papal tombs, wall monuments, portrait busts and fountains he showed extraordinary and continuous invention. The Cornaro Chapel, Sta Maria della Vittoria, Rome, is one of the great works of the High Baroque (1645–52), with its use of concealed lighting to add to the effect of the ecstatic, unreal miracle of St Teresa, while on either side family members are sculpted as though seated in theatre boxes. While Bernini was able, in his late work, to produce highly sensitive sculptures of ecstasy and religious feeling, those who imitated him were by no means so capable, and it is this which makes much late Baroque work difficult for modern taste to accept. Late Baroque also concentrated its attention on illusionism to the extent that painting and sculpture could become inseparable. Throughout the Baroque period the best sculptors were to be found in Rome, influencing all other parts of Europe, except Spain. Here a very distinctive school of religious sculpture flourished, influencing of course the art developing in the American territories.

A. S. J. BEAN

THE ROCOCO

The Rococo style, like its immediate predecessor, the Baroque, and that of the High Renaissance itself, began with the century. Its emergence has been symbolically located in 1699 when J. H. Mansart's decorative scheme for a small room in the Château de la Ménagerie was rejected by Louis XIV on the grounds that it was too serious. His stipulation that 'il faut de l'enfance répandu partout', though in one sense merely symptomatic of traditional taste in the field of private commissions, soon became almost axiomatic for the style which gained wide acceptance during the consciously informal atmosphere of the Regency (1715–23).

Yet while a contrived and not altogether innocent concern with youth was to characterise the erotic fantasies of *Boucher, *Fragonard and, in fiction, Laclos, the Rococo first gained currency as a development in interior decoration, and was to remain a fundamentally decorative style, despite its evolution from the more intellectually conscious Baroque. In fact, its relationship to the Baroque is analogous to that of Mannerism to the High Renaissance, and like Mannerism it has some claim to be called 'the stylish style'. Yet it was a less purely cerebral style than Mannerism, and more concerned with the elegance and artistry inherent in the aristocratic ideal of polite society. Life, but particularly social life, was increasingly thought of as a self-validating form of art, and it was such a concern with elegance for its own sake which united the stagey interiors of Boffrand and Cuvilliés with *Watteau's melancholy *'fêtes galantes' and Boucher's amusingly dehydrated mythologies.

The decorative revolution began at almost precisely the same time as the painterly one, and dates from Pierre Lepautre's use of curved scrolls, arabesques and leaf-forms in his designs for the wall-panels and carved wooden mirror frames of the King's apartment at Marly (1699). This type of decoration – augmented by the introduction of what was to become the most distinctive Rococo 'motif', the 'S' pattern – was known as 'rocaille', or rock-work, from which the stylistic term itself was derived. In addition to luxuriating decoration, Rococo designers sought to multiply such effects through the use of mirrors (eg Boffrand's 'Salon de la Princesse' in the Hôtel de Soubise, Paris, 1735–40, and Cuvilliés' Amalienburg at Schloss Nymphenburg, Munich, 1734–9), and it was in their obsession with the interplay of surfaces rather than structures, that they deviated most noticeably from the Baroque. Even after the style had infiltrated Germany, and ecclesiastical architecture, as it did with considerable success from the 1720s onwards, it was apparent that despite the German architects' continued interest in the spatial possibilities of staircases, for example, they were simultaneously extending the decorative vocabulary of the French Rococo to such an extent, and so asymmetrically, that it was no longer possible even here to talk in terms of any real interdependence of function and decoration. Teams of brothers, like the *Zimmermanns and the *Asams, both in Bavaria, pooled their individual skills in architecture, painting and sculpture in the attempt to manufacture a 'Gesamtkunstwerk' (total art-work); but in so doing they tended to compromise the integrity of the separate art forms.

Rococo painting was in itself an aspect of this compromise, which permeated all the traditional genres, and provided one new one in Watteau's 'fêtes galantes'. Watteau's paintings – from which the whole Rococo concern with fashionable elegance and theatricality stems – are, in fact, less of a compromise in this sense than the works of his successors. They reveal a refined awareness not only of social *mores*, but of personality, and as such presage the 18th century's artistic discovery of individual character, as opposed to 'ideal' or 'official' character. But in their equally obvious concern with the decorative aspects of human behaviour they anticipate the more light-hearted productions of Boucher, Fragonard and *Nattier. Though often in the case of Boucher and Fragonard of the highest technical quality, these paintings frequently took their mood from the interiors they were planned to decorate, so that frivolity of sentiment was soon added to lightness of colour and vapidity of form. Indeed, a widespread lightening of the palette was a characteristic feature of the period throughout Europe, and, though it soon acquired a momentum of its own, its initial impetus may well have been derived from

the pastel colours of interior decoration. Even *Chardin, whose still-lifes were otherwise so un-Rococo, was decidedly pastel as a colourist.

Although there was an internationally recognisable Rococo style in painting – and especially in mythological painting – it was far less rigorous than that of Rococo decoration. Its unity was one of mood, which made it all the more capable of being grafted onto differing national traditions. In Venice, the third great centre of the Rococo after France and South Germany, Giambattista *Tiepolo, perhaps the outstanding painter of the century, responded to Rococo colouring and attenuation of forms, while remaining emotionally attached to the Baroque; and his 'vedutista' contemporary *Canaletto applied Rococo lightness and clarity to his views of Palladian architecture in Venice and London.

The Rococo, in fact, spawned many strange offspring, including the highly successful porcelain factories at Meissen, in Saxony, and Sèvres, in France, and the allegedly realistic, though profoundly sentimental, sculpture of *Falconet and *Clodion. Even *Goya began his career as a painter of Rococo elegance. Yet, despite its diversity, it was never really accepted by art critics and scholars like Mariette, Cochin and Algarotti, who regarded it as the epitome of frivolity; and the almost inevitable Neo-classical and Romantic reaction which occurred during the second half of the century was as much a rebellion of the intellect as of the brush.

J. M. GASH

NEO-CLASSICISM

Neo-classicism refers to a multilateral movement in European art which flourished in the second half of the 18th century and at the beginning of the 19th century. The paintings, sculpture and architecture of the period which formed part of the movement are extremely varied and abundant, but apparent in every work is a conscious awareness and use of antique art. In France and Germany the interest in the *Antique complemented a dissatisfaction with †Rococo art, which from around 1750 came to be considered decadent by such critics as La Font de Saint-Yenne. In Italy, particularly in Rome, the spiritual centre of the Neo-classical movement, the desire for change occured as a reaction to the prevalent edulcorated version of the Baroque which persisted up to the end of the 18th century as in the painting of *Batoni. Antiquarian research, a scholarly facet of the interest in the Antique, continued steadily from as early as the 1730s to enthral Englishmen, and somewhat later Continental devotees, so that by 1760, after several closely observed excavations, amateurs and artists such as Count Caylus and *Piranesi published books of engravings after antique sculpture, pottery, ornament and architecture, which became visual dictionaries for artists.

The movement attained an international doctrinaire status by the publication of the influential and highly exclusive art theories of the German archeologist *Winckelmann in 1755 and throughout the rest of the century in numerous translations. Notwithstanding his single passion for Classical sculpture, Winckelmann does not depart from the 18th-century tradition of reverence for nature: antique sculpture is the desirable means for contact with nature at its most pure and profound, since according to Winckelmann the art of the ancients records the most intimate as well as aesthetically and morally elevated contact with nature in the history of civilisation. The early painters of the Neo-classical movement arrived in Rome from many countries and gathered around the painter *Mengs in the 1760s and 1770s: *West, *Kauffman, *Hamilton, *Vien and many others. Except for the severe and expurgated art of certain Northern European painters, the paintings of the artists of this and the subsequent generation reflect, in conjunction with the avowed passion for the simplicity and grandeur of the Antique, a sympathetic familiarity with the art of the High †Renaissance and of the classical seicento.

In France classical subject-matter in *history painting for the purpose of presenting exemplars of moral rectitude was very common many years before a suitably heroic style of painting could be found which would visually complement the nature of the deeds of the virtuous Greeks and Romans depicted. The paintings of *Poussin provided the necessary practical information which the painter confronted with classical sculpture required to convey the spirit of the Antique; the success of this approach is seen in the paintings of the 1780s by *David and his less well-known contemporaries of the Académie des Beaux-Arts in Paris. Appropriately this style, conceived as a reaction to the Rococo, was chosen to express the ideals of the new Revolutionary government; yet the urgency of contemporary subject-matter during the Revolutionary and Napoleonic periods resulted in the decline of the earlier pre-eminence of Classical subjects. The Antique remained the standard in the official art schools and to varying degrees in the preparatory drawings of many artists during the first half of the 19th century, most evident, however, in the art of *Ingres.

In England the frieze-like compositions of *Hamilton had only temporary influence on history painters. This essentially alien approach to painting is quickly subverted by two interrelated factors: a tendency of many artists such as the *Runciman brothers, *Mortimer and the Swiss *Fuseli to personalise their style, usually in the direction of greater expressive content and a national tendency to depict more familiar non-Classical subjects ranging from local legend to scenes from Shakespeare. This latter development is paralleled in France by a new and

equally non-Classical fascination with the medieval history of France.

The sculpture of the Neo-classical period, even at its most inspired in the art of *Canova, *Flaxman and *Banks, always remains a conscious derivative of antique sculpture. It is nevertheless infused with a refreshing 18th-century sense of subtlety and remarkable compositional invention. However ideal the intentions of the sculptors, they were usually unable to ignore completely the preceding period's progress towards naturalism.

The effect of the conscious return in the arts to Classical models was felt throughout the whole of Europe to a great extent on account of the simple communicativeness of the basic tenets of the movement. The leading painters, sculptors and architects taught foreign pupils who eagerly applied the new principles in their homelands. This international transference was particularly important for the development of architecture in Germany, Denmark and Russia during the late 18th century and much of the 19th century.

The use of classical models is a primary factor in painting as different as that of Fuseli and David. The passion with which David painted his *Oath of the Horatii* was no less intense than the emotion expressed by *Delacroix, the decreed Romantic. And yet David could also produce in his *Marat* a naturalistic and profoundly human work. Thus, although it may not always be immediately apparent to the modern observer, there is a strong personal element in the art of Neo-classicism. Rather than approach the movement in a manner radially different from Romanticism, it is perhaps more enlightening to consider those elements of personal choice and personal statement which are to be found within Neo-classicism's precisely drawn frame of reference.

PHILIP BORDES

ROMANTICISM

The Romantic Movement, at its peak between 1790 and 1830, began and spread chiefly as a literary manifestation, and its incorporation of the visual arts is difficult to plot. No major artist accepted willingly the description 'Romantic', nor does 'Romantic' in painting or sculpture carry any connotation of style. From the Neo-classicists, whose orientation had indeed been thoroughly visual, the Romantics took over and extended a preoccupation with naturalism (in contradistinction to artifice); with the primitive forms of art, which were often exotic; with 'sentiment', and an emphasis generally in evoking a subjective response in the spectator; and with understanding the arts as the organic outgrowth of a style of life. More important, the Romantics inherited the institutions of Neo-classicism: the academies, with their exaltation of intellectualism above craftsmanship and their promotion of an artist- rather than patron-based Establishment, their machinery of travelling scholarships, galleries and exhibitions. Hence, paradoxically, in spite of their cult of simplicity and immediacy, the Romantics were by far the most visually literate of any generation of artists there had ever been. The characteristic Romantic *cliques*: the *Primitifs* in the studio of *David about 1800; the German *Nazarenes in Rome from 1810; Samuel *Palmer's Shoreham circle in the 1820s, would have been inconceivable without the academies which brought them together, and gave them methods (chiefly routine procedures of teaching) against which to react. Visual literacy, derived from the study of an incomparably wide range of earlier models, was matched by verbal literacy to an astonishing degree: the letters of P. O. *Runge, of *Palmer and *Constable, and the diaries of *Delacroix are among the most moving literary documents of the period; and the ancient ambition to assimilate the natures of poetry and painting, which had been attacked vigorously by the Neo-classical critic G. E. *Lessing, was pursued with renewed intensity by, for example, *Blake and *Goya, who issued a good deal of their most original work in the form of engraved books, for which they created both text and illustrations. In Germany, with Runge and *Friedrich, there were serious attempts to evolve an art form embracing painting, architecture and music outside the theatrical context, although no complete examples have survived. Painting and the theatre did, indeed, enjoy a particularly fruitful relationship at this time: the most important preferred themes of both were medieval and exotic (chiefly African and oriental), often filtered through the medium of modern literature, notably the work of Byron, Scott and *Goethe.

But perhaps the most essentially and self-consciously 'Romantic' art form was landscape painting. Romantic painters took over the early 18th-century use of landscape as a vehicle of feeling, which had been expressed chiefly in the form of gardens, together with the wish for a more intensive study of Nature in the field, which had characterised the procedure of landscape painters in Rome since the middle of the 17th century. These tendencies were extended and refined, and landscape came to fulfil functions that had been proper only to figure painting. *Constable and, to a lesser extent, T. *Rousseau, used it for the exploration of their personal lives; Friedrich, Palmer and *Turner for the articulation of religious and social ideals on the broadest possible front; *Martin and *Danby for a type of apocalyptic pulpit oratory. All of them, with the exception of Palmer, who, like his master, Blake, was fascinated by the infinity of smallness, presented

their work on a scale far more monumental than had hitherto been common for this genre. At the other end of the scale, a vogue for sketching and touring among amateurs stimulated a taste for landscape art throughout middle-class society, gave employment to landscape specialists like *Crome and *Isabey, who worked as tutors in private families or schools, and developed the art of watercolour into perhaps the most quintessentially Romantic medium. It occasioned, too, the rise of a considerable body of landscape theory, not simply by professionals, but also by gifted amateurs like Goethe and *Carus, and writers like Chateaubriand and John Clare. Landscape is thus perhaps the completest expression of Romanticism in the visual arts.

Romanticism remained alive in painting longest in England, notably in the early work of the *Pre-Raphaelites; but by 1840 in Europe it had ceased to dominate the scene. The peculiar balance of observation and imagination was upset, first by the preponderance of *Realism, and then, later in the century, by a far more aggressive re-assertion of the imaginative faculty, especially in the *Symbolist movement. Romanticism persisted, and persists simply as a general tendency of sensibility among other tendencies.

JOHN GAGE

REALISM

Realism is the aesthetic tendency which dominates the art of the 19th century, just as positivism and materialism are the leading currents of 19th-century thought, but which is at its height in the 1850s and 1860s in the painting of *Courbet, who set out its basic tenets in painterly terms in 1861:

> 'I hold that painting is essentially a *concrete* art and does not consist of anything but the representation of *real* and *existing* things. It is a completely physical language using for words all visible objects. An abstract object, one which is invisible, non-existent, is not of the domain of painting.'

Courbet also claimed that 'Historical art is in its essence contemporary', although the distinctly realistic, minutely researched historical subject-painting of the period, in the late work of *Wilkie, of the *Pre-Raphaelites, of *Alma-Tadema, of *Delaroche, *Meissonier and *Menzel shows that non-contemporary material was deeply affected by the aesthetic climate of Realism as well. But for the most part the emphasis fell on the contemporary scene, and for some artists, Courbet, *Daumier, *Fildes and *Doré among them, on the plight of the masses, the problems of the city and its depressing effect upon the country population. The Industrial Revolution had been oddly neglected by earlier artists, although there are hints of a socially-oriented art in *David, *Goya and *Géricault, in *Turner and even, in a less direct form, in *Constable; but, as in the case of †Romanticism, it seems to have been chiefly the stimulus of literature, here the realist writings of the 1830s and 1840s, that turned the interests of painters more centrally to such themes. Courbet was close to the Socialist thinker P. J. Proudhon, whose *Du Principe de l'Art* (1865), advocated the subordination of aesthetics to political and social ends. Courbet himself took a leading part in the art-organisation of the Paris Commune of 1871, and was later imprisoned for his political activities. *Zola was an intimate of the *Impressionist circle, perhaps the last great group of Realists, although, in spite of the fact that *Pissarro was a notable anarchist, they were hardly concerned with social objectives. *Baudelaire, who shared at least the Realist belief in the validity of the ugly, was a friend of both Courbet and *Manet, although, characteristically, he settled upon the minor illustrator *Guys as *the* Painter of Modern Life.

All this is hardly surprising, for the painters (and, to a lesser extent the sculptors of Realism, like Daumier and *Carpeaux) could not escape completely from the demands of formal study, and from the traditions of their media, into the pure documentation of the life around them. Their greatest achievement was perhaps to monumentalise a type of subject-matter that had hitherto been confined to small *cabinet-pictures (Goya had already done this to a degree in his remarkable *Forge* in the Frick Collection). Courbet's *Burial at Ornans* (1849), Manet's *Bar aux Folies-Bergères* (1882) and *Herkomer's *On Strike* (1891) are equally astonishing in this way; but none of them develop a significantly new language of forms, or, rather, the formal interest of these pictures is hardly in step with the freshness of the material. Their monumentality itself is a function of the public character of most Realist art, a character fully in line with the expectations and exhibiting machinery inherited from *Neo-classicism. They stand in marked contrast to the brilliant formal invention and vastly extended range that Daumier brought to the lithographic cartoon.

For a movement which claimed to occupy itself with contemporary life, Realism in art seems to have had a remarkably narrow field of concern. It had almost nothing to present on the nature of mass-culture, on the particular problems of industrialisation, on the plight of the peasant, ground down at home or deracinated in the city, for although *Millet, often regarded as a peasant painter, occasionally produces a striking image in witness to the harshness of French rural life (eg *The Man with the Hoe*, 1859–62), he is more often idealising in the manner of a townsman looking nostalgically towards his country origins. The ordinary, usually urban or suburban settings of the Impressionist

repertory seem designed less to underline the subject than to allow it to be taken for granted, to concentrate the attention on the real stuff of style. Even Courbet's most original *vision* emerges in the landscapes and marines which account for the bulk of his paintings, and the tendency to prize aesthetic investigation above a commitment to documenting the environment has continued into the 20th century, where with the brief exception of the Mexican mural painters around *Rivera, Realism has aligned itself consistently against the mainstream.

JOHN GAGE

IMPRESSIONISM

Like so many artistic movements, Impressionism derives its name from an accident and a critical attack. In 1874, at the first exhibition of the *Société anonyme coopérative des artistes peintres* in Paris, *Monet, needing for the catalogue a title to a view of Le Havre, which would hardly have been recognised as such, said, 'Put *Impression*.' The whole group, which included more than fifty exhibitors, among them *Cézanne, *Degas, *Renoir, *Pissarro, *Sisley, *Morisot, *Boudin, *Bracquemond, and *Lepine, was at once abused as 'Impressionist' by some critics; but by 1877 the designation had become sufficiently accepted for it to be used as the title of a magazine published by Renoir's friend Georges Rivière. The word *impression* has a long history associated with 19th-century landscape painting; among the theorists and artists to whom members of the group acknowledged a debt, it had been used, for example, by *Turner, *Corot and *Chevreul, all of them to emphasise the first sensation inspired by a landscape subject, and the need for speed of execution to render it before it faded.

Hence the stress on a far simpler painting procedure than had been traditional, and the abolition of the distinction between sketch and painting when working out of doors. The large, distinct and obviously painty brush-strokes, developed from a study of late *Delacroix (who had also been particularly concerned with painterly speed), the abolition of *glazing, and the consequent reliance on opaque pigments, directly applied in a fresh and preferably little-mixed form are also functions of this endeavour; they characterise the style of the central personalities of the movement in the 1870s: Monet, Renoir and Pissarro. Degas and *Manet, although they shared many of the *Realist preoccupations of the group, and were looked up to by them, were hardly concerned with the essentially open-air and naturalistic emphasis of the style, although Manet took to it through the influence of Morisot towards the end of the decade. Degas preferred the far more artificial world of the theatre, the racecourse and the boudoir, and the astonishing formal originality of his and Manet's styles owes less to the direct perception of nature and the attempt to render its effects, than to a fascination with such newly introduced artifacts as the photograph and the Japanese print.

In the late 1860s and early 1870s Monet and Renoir had been personally very close, and in their style they, and Sisley and Pissarro are barely distinguishable from each other. But during the 1870s their interests progressively diverged, and only Monet remained centrally concerned with the problems of rendering light and colour in landscape in the open air. His serial paintings: the *Haystacks*, *Poplars* and *Rouen Cathedral* of the late 1880s and early 1890s, are perhaps the ultimate development of the Impressionist method. Each canvas was in use for only a few minutes at the same time on successive days until the whole run was finished – seven minutes was one figure Monet gave for the *Poplars* series. But even he came to work more and more in the studio, and by about 1900, *plein-air* was no longer the most important issue. Renoir, stimulated by visits to Italy in the 1880s, turned increasingly to a more traditional area of painterly problems in the nude, and to portraiture; and Pissarro was attracted successively by the anti-Impressionist developments of Cézanne and *Seurat, although it is arguable that Cézanne remained true to some central Impressionist commitments even longer than Monet. By 1886, the year of the last group exhibition of the *Société anonyme*, the Impressionist style as representing the greatest spontaneity in painting was dead.

Emphasising as it did the supreme qualities of light and movement revealed most clearly in landscape, Impressionism was hardly adapted to sculpturesque expression, although some sculptors, notably Degas, *Rodin and Medardo *Rosso were much affected by some aspects of the aesthetic. It was perhaps the most purely painterly of the 19th-century art movements, and although, seen in terms of that century it is the last great manifestation of Realism, in a broader view it is important as the first movement to crystallise around an attitude towards physical perception, just as *Neo-Impressionism (Divisionism) was the first movement to be based upon a painterly method.

JOHN GAGE

THE TWENTIETH CENTURY: ART IN PROGRESS

In 1900 there were nearly 3,000 motor-cars in France; by 1913 there were nearly 100,000. In 1903 Orville Wright flew an extraordinary contraption like a giant, inebriated locust for twelve seconds; in 1909 Blériot flew across the English Channel: and in 1913 the air speed record reached 200 kilometres per hour. The history of the first fifteen years of the 20th century in Europe and America can read like a melodrama whose central plot is change and whose heroes are inventors – inventors not merely of new contraptions for transporting humans at unprecedented speeds for unprecedented distances, but inventors also of entirely new attitudes to men and to things. Between 1900 and 1914 Sigmund Freud published his *Interpretation of Dreams*, Röntgen developed the X-ray, and Einstein published his first Relativity Theory. And yet, in a sense these first years of the century were no more than a prelude. For us now, looking back, progress is a central if not *the* central theme of 20th-century history in Europe and America, and so it has been for its participants from the beginning until at least the late sixties. Progress too is the central theme of 20th-century art history in Europe and America: innovation and change with an unconscious, or even at times a conscious sense of direction.

This is not to say that there have been no artists over the past six decades concerned with old means and old attitudes, but the dominant idea of the art of this century shared by commentators and artists excludes such individuals as irrelevant, as throw-backs like the ox-drawn plough or the horse and cart in a time which has moved beyond them – charming but negligible. Two terms which seem unavoidable in any account of the art of this century act especially well as symptoms of this obsession with progress: the terms 'avant-garde' and 'modern'. Almost every style which commands respect is 'avant-garde', and at the time of its conception was therefore quintessentially 'modern'. It is for this reason that the term 'modern art' still seems usable when writing of aesthetic events which occurred as much as fifty years ago. If *Cubism and *Surrealism are no longer modern, their one-time modernity remains crucial to their historical image. In New York, the Museum of Modern Art, and in Paris, the Musée National d'Art Moderne, with their great permanent collections of art from the beginning of the century bear witness to this revealing paradox. The art that they contain is the art of the 20th-century 'avant-garde' – that which at any particular time, in Paris or Munich, Milan, London or New York was truly modern: their exhibits are like the points on a graph recording cultural change, or, as we shall see, on several graphs.

'The oldest among us are thirty,' wrote F. T. *Marinetti, generalissimo of the *Futurists, in 1909. 'We have therefore at least ten years to accomplish our task. When we are forty let others, younger and more valiant, throw us into the waste-paper basket like useless manuscripts.' Art historians have taken him at his word: Marinetti, Carlo *Carra and Gino *Severini, all of whom survived well beyond 1919 are virtually ignored after that date in the accounts that have been given of art in the 20th century. Only when essential to the broader motion of aesthetic progress, only when he is an innovator of influence is the individual artist elevated into a position of historical prominence. The often deflationary attention given to the last fifty years of Giorgio de *Chirico's career and to the last fifteen of *Picasso's is further evidence of this fact. There has evolved an idea of art in the 20th century as a pattern of clearly demarcated lines of development, containing movements even more than individuals, a pattern which is never complete, of developments which can never be halted. Innovation is fundamental to this idea and all the movements which it focuses on, though not so obviously as with Futurism, were driven forward by an underlying need for something new. Cubism, Surrealism, *De Stijl, *Constructivism, *Abstract Expressionism were all selfconsciously new, involving artists, from Picasso to *Pollock, who were selfconsciously innovators, and engaging the support of commentators, from *Apollinaire to Rosenberg, who were unselfconsciously thrilled by innovation. Even the Neoclassicism of Picasso in the twenties and the *Euston Road naturalism of Victor *Pasmore in the thirties, though emphatically anti-progressive, were given the appearance of novelty because they occurred in a setting of change. There may have been a recurrent tendency in the 'avant-garde' to stabilise the new by means of long-established aesthetic formulae – the classical systems of proportion applied at times by the Cubists, the classical ideals of balance applied by *Mondrian, the Romantic concern with the irrational disinterred by the Surrealists – but these did not temper the novelty of the forms and methods evolved. The 'avant-garde' has always been a willing 'avant-garde', knowingly taking its place in the developing pattern of an art-historical picture focused above all on progress.

What then does the pattern actually look like? What are the different lines which give it shape, and how have they evolved? There are fundamentally five lines of development: the formalist, the Constructivist, the *Expressionist, the Surrealist and the *conceptual. Often they cross, occasionally they tangle, but yet they clearly emerge as separate lines of development with separate directions.

The formalist starting-point was in France, its heroes at the beginning were Georges *Seurat and Paul *Cézanne, its great innovators were *Matisse, Picasso and *Braque, and the scope of its impact was and is international, involving France, England and the USA above all. The central concern here has been with evolving a kind of painting which is in its own right

real, which is about form, colour and scale, which denies illusion. Seurat and Cézanne are the starting-point because, although both aimed at an effective illusion of 'motifs' selected from nature, their means of achieving this accentuated the reality of coloured marks flat on the canvas, and in Cézanne's case seemed to prefigure a kind of pictorial space which was invented by the artist in defiance of appearances. Matisse took to new extremes the artificiality of Seurat's colour; Picasso and Braque took to new extremes the dislocations of Cézanne's space and of the forms within it. The result of the latter development was Cubism, certainly the most seminal aesthetic invention of the first fifteen years of the century. Cubism was never – at least in Paris – so obsessed by pictorial form and space that it obliterated the world of appearances; the Cubists maintained an uneasy truce between art and reality, creating in their painting and their sculpture a tension which is still riveting, and the post-Cubist art of England and the USA during the thirties and the forties, the art of Ben *Nicholson in England or of Stuart *Davis in the USA, only at times broke that truce. However, out of a Cubist beginning there developed in Holland during World War I a geometric style in painting and sculpture which utterly rejected appearances. Mondrian was its great exponent and behind it lay a sweet and sour blend of Theosophical mysticism and Calvinist rigour, but, during the late twenties and the thirties other artists whose apprenticeship had been in Cubism – Jean *Hélion, César *Domela, Hans *Hoffman and others – followed the Dutch lead to develop a kind of geometric abstraction which was without mysticism, which was in effect a pragmatic exploration of the properties of painting reduced to the most basic terms possible – lines and flat colour-planes in relation to the shape of the canvas. It is this development that was taken further in the fifties and the sixties by such artists as Auguste *Herbin in France, Robyn *Denny in England, and, in the USA Frank *Stella, Kenneth *Noland and, as a sculptor, David *Smith. Especially in England and the USA the work of these new men *was* new because it was concerned much less with the balancing of compositional components and much more with the physical relationship between image and spectator, but it remained, like the work of Picasso and Braque in 1910, committed above all to accentuate the reality of the art-object at the expense of illusion: it remained part of the same line of development.

The essence of the formalist attitude – the abolition of illusion in art – was also basic to the Constructivist line of development. What is special to the Constructivist line is a commitment to the newest in technology. It therefore began where Cubist attitudes were in collusion with the Futurists' optimistic faith in the modern world and perhaps most specifically of all with *Boccioni's 1912 call for new materials in sculpture. Russia was the place where the Constructivist approach first gelled; here it was between 1915 and 1922 that Vladimir *Tatlin, Alexander *Rodchenko, Naum *Gabo and many others began to construct first reliefs and then three-dimensional sculptures using metals, glass and primitive transparent plastics, building up their images in space like the designers of radio-masts and bridges, aiming for an openness unprecedented in sculpture. They shared a common admiration for the wonders of engineering and a common awareness of the new ideas about space and time opened up so dramatically by Einstein, but, where Tatlin and Rodchenko offered their art uncompromisingly to industry, Gabo did not. He and his brother Antoine *Pevsner wished to make images for contemplation, not things for use. It was this more aesthetic attitude that came during the twenties and thirties to dominate Constructivism as it developed in the West, Gabo, Pevsner and, even more effectively, El *Lissitzky acting as missionaries in Germany, Holland, France and England. An art emerged, at first backed by de Stijl and the Dessau *Bauhaus, which was abstract, technologically aware and infinitely spatial, made by men in overalls who drew plans like product-designers and yet whose priorities were to the highest degree aesthetic. The common concern of Constructivists with the relationship between space and time led logically to a deepening interest in movement as part of the aesthetic experience, and thus during the fifties and sixties the Constructivist line moved increasingly in a *Kinetic direction, culminating in the spectacular inventions of such as Nicholas *Schöffer and Julio *Le Parc. Like the formalist art of those decades this new Constructivism *was* new – it too was more than ever before concerned with the physical relationship between art-object and spectator; but once again it was emphatically the latest stage in a clear and unbroken line of development, as committed to the newest in technology as was the Constructivism of Tatlin, Rodchenko and Gabo before 1922.

*Expressionism from its 20th-century beginning may have always been hostile to illusion in art, but it was neither concerned with the reality of the art-object alone nor committed to progress in the material world – the progress of science and technology. Although it took indiscriminately from the French *Post-Impressionists, Matisse and the Cubists, its heroes were mostly German and Nordic – Goethe, Arnold *Böcklin, Edvard *Munch; it was, indeed, at its outset in Dresden and Munich a modern †Romanticism. Colour, line and form were conceived of as vehicles of expression, for the *Brücke painters capable of conveying their deepest feelings in response to life at its most mundane, for *Kandinsky and the artists of the *Blaue Reiter their deepest feelings in response to spiritual experiences far beyond the mundane. Mondrian was in this latter sense Expressionist and it is a paradox essential to the theme as it developed during the twenties that, though in pursuit of the spiritual, Expressionists could apply a severely rational approach to pictorial language. Kandinsky and *Klee even found a place for the paint brush guided by Expressionist ideas among the product-designs and the machine-tools of the Bauhaus. The inter-war years produced a proliferation of manifestations in painting

and sculpture which can in a sense be called Expressionist – works capable of conveying strong inner feeling through colour, line and form – but here increasingly the two lines of Expressionism and Surrealism cross, on occasion to tangle as in the metal sculpture of Julio *Gonzalez or in the sadistic figurative distortions of Picasso. It is in a mesh of tangled relationships between Expressionism and Surrealism that the line of development, begun in Dresden and Munich before 1914, was taken further during the forties and fifties, for the Abstract Expressionism of *Pollock and *De Kooning in the USA was, as will become clear, openly Surrealist. Starting with a clearly defined line of development, Expressionism finally lost its independence to cement an alliance with Surrealism.

Surrealism has produced anti-illusionistic art – the work of *Arp and *Miró for instance – but the rejection of illusion has never been a central Surrealist concern. Indeed, its art has often been programmatically illusionistic, aggressively anti-abstract – in the work of *Magritte and *Dali for instance. Its beginning lay not in visual images but in literary images, in ideas, and in a generalised feeling of rage against convention. Its heroes were not painters but poets – Lautréamont and Rimbaud – and, of course, the great inventor of psychoanalysis, Sigmund Freud. Its initiators – André *Breton, Philippe Soupault and Luis Aragon were poets. In effect, Surrealism came of an attempt to apply the clinical methods of psychoanalysis – hypnosis, dream analysis and free association – within the context of a French literary tradition devoted to the irrational, the sexually disturbing, the fantastic, to the life of the imagination. It was concerned from the beginning with an inner world, but not a spiritual inner world like that of Kandinsky. After the frantic prelude of *Dada, its aim, established between 1923 and 1925, was systematically, even scientifically, to explore the subconscious. The painters and sculptors who became involved were thus most essentially concerned with the development of working methods which would skirt the obstructions of the conscious mind – morality and reason. André *Masson attempted automatic drawing, intending to free the movement of his pencil from the control of his will, Max *Ernst used various rubbing techniques to evoke images by association, *Arp set up chance situations by dropping string or paper on the floor, and Dali developed his paranoiac-critical method. It was because of this emphasis on the creative process that so many apparently different styles in painting and sculpture – illusionistic and anti-illusionistic – could be called Surrealist, and it was the development of automatic, non-rational working methods that led in the USA to the development of gestural painting – Abstract Expressionism – a kind of painting which was as much about the act of applying paint as about the composition of coloured marks thus made. In Abstract Expressionism the fundamental Surrealist aim – to explore the subconscious – was taken to new ends during the forties and fifties, but, with the development in England and the USA of Pop Art, artists began to apply Surrealist techniques for altogether other purposes, to explore in a fresh way the gap between art and the reality of everyday life. Here once again the lines of development cross and are entangled, so that, once again, what began as a clearly separate line finally loses its autonomy.

There is a sense in which Pop Art is more than anything formalist – a point underlined by the post-Cubist art of its most powerful precursors, Fernand *Léger and Stuart *Davis. But there is too an important sense in which it is conceptual, because at the root of the conceptual line of development is a fundamental questioning of aesthetic values, a need to explore, like Pop, the relationship between art and reality. Indeed, the present recrudescence of conceptual art has its more recent origins at least partially in the work of such Pop artists as *Rauschenberg, Jasper *Johns and Richard *Hamilton, for especially Johns and Hamilton have given creative support to a sudden burgeoning of the reputation and therefore the significance of Marcel *Duchamp who was perhaps the greatest innovator among the conceptual artists of the early 20th century. The conceptual line of development grew out of the nihilistic side of Dada, above all in New York, Berlin and Paris, out of the distrust felt by Duchamp, Francis *Picabia and Tristan *Tzara for all visual art. Its roots lay in the philosophy of Schopenhauer and in the poetry of the French Symbolists, and its enduring commitment has been to the reality of ideas as against the reality of the senses. Duchamp's 'ready-mades' have no meaning as compositions of line and form or as images dredged from the subconscious, their meaning comes of the questions that they raise about the very nature of art. The mental activity thus provoked is far more 'real' than their material presence. Contemporary conceptual art is new because it seeks to explore new areas – especially linguistic – because it seeks more than ever before to frustrate the workings of the commercial art world, and because it has devised new means – the marking of landscape and the recording of journeys for instance – but it remains essentially concerned with the reality of ideas as against the reality of the senses. It remains attached to the line of development initiated during World War I by Duchamp and the Dadaists.

The pattern of lines drawn here in so small a space can be no more than a sketch, and it is a sketch whose subject is not static or finite but dynamic, always changing, its shape constantly modified by historians and critics. It is enough to demonstrate that the image we have of art in the present and in the recent past is founded very firmly on the modern idea of progress with its concomitants, accelerating change and innovation. However directly linked the art of Robyn Denny may be with that of Mondrian, of Schöffer with that of Gabo, or of Hamilton with that of Duchamp, the earlier phases in each line of development are now considered obsolete. It is the new means and the new ends that matter, the newest points on the several graphs that record cultural change. Our obsession with progress insistently prompts the question – 'What happens next?' – because the future seems more real than the past and the past seems no more than a way

into the future. But although the answer to that question may for decades depend on what happens to formalist or Constructivist or Surrealist or Expressionist or conceptual art, ultimately it depends on the future of the idea of progress itself. If that idea in its present form were to weaken its hold on artists, on commentators and on their audience, were to be challenged by alien ideas or were to be transformed, then an altogether new pattern embracing both the recent past and the present would emerge, as it did in Russia between the Wars with the victory over progressive art of a popularist ideology. In Europe and the USA our belief in aesthetic progress is still strong, even passionate, but it is not without rivals and those rivals may not always be isolated, ostracised and therefore weak.

CHRISTOPHER GREEN

AMERICAN ART

The outstanding feature of the history of American art is its evolution from the transplanting of European civilisation in the New World. Instead of building upon the culture of the native inhabitants or assimilating their *mores*, the European settlers retained their own culture, the late †Renaissance culture of the 16th and 17th centuries. There was, of course, a gap between the way of life achieved in Europe and the primitive conditions the settlers found in the wilderness, and the bridging of this gap has been one of the main problems of the American artist from the founding days to our own.

Similarities between the old and the new worlds were perpetuated by the tendency of settlers to gravitate towards areas similar in climate to those they had left behind. Thus the Dutch, French, English, and Scandinavian immigrants favoured the north, while people from the Mediterranean area created a Latin-American culture to the south-west. These communities developed regional or provincial patterns which differentiated ways of life within America along lines similar to divisions on the home continent.

The newer cultures also followed the old in stylistic developments. The same style names †Baroque, †Rococo, †Neo-classical, †Romantic, †Realistic, †Impressionist, and the large assortment of 'isms' within the modernist art of our own time are applied to American art, in the same sequence and for roughly the same periods, as to European art. There was sometimes a certain cultural time lag in America, but Europe had no monopoly on progressive viewpoints – Thomas *Eakins, for example, was far more progressive than his French contemporary *Cabanel. In the main, however, Europe was the great creative fountain-head and America strove to emulate her achievements. From *Copley in the 18th century to Marsden *Hartley in the 20th, American artists looked to Europe, and especially in the comparatively conservative art of sculpture, the primacy of the old world was not challenged. Not until American engineers developed the skyscraper was Europe forced into imitation. In our day America has joined the vanguard in painting and sculpture and New York has become a major art centre of the Western world.

American culture was in important ways an extension of European forms and ideas, just as Roman civilisation was an extension of the Hellenic. But like Rome, American culture developed a character of its own and was never a mirror reflection of Europe. In De Tocqueville's *Democracy in America* (1835), the French aristocrat identified with prophetic insight the conditions of life in the new world that differentiated it from its European model: the absence of an entrenched aristocracy and opportunity to expand towards new horizons, which fostered practicality, materialism, realism and optimism, and the hopes of the common man, which soared far beyond those of his European counterpart.

These traits manifested themselves in various aspects of American culture. The practicality and ambition to conquer the physical world were reflected on the one hand in the advancement of applied science, in the inventions of Benjamin Franklin, Robert Fulton, Samuel *Morse, Edison, Henry Ford and the Wright brothers, and on the other in the nature of much of American painting – the works of the extraordinary *Peale family with their scientific bent, the Philadelphia school, the paintings of Thomas Eakins. Realism is a major strain and the naturalistic genre painting is a particularly American idiom, from Henry Sargent and *Krimmel, to *Woodville and *Mount, to painters of the present century, who have merely shifted their locale from the rural scene to the cityscape. The same love of detailed, realistic description was expressed in still-life from the time of the Peales, and was carried to an illusionistic extreme in the *trompe l'œil of *Harnett and *Peto; the superrealism of Andrew *Wyeth has a long ancestry in American art.

The sense of hope inspired by the unexplored vastness of America created a landscape school in the 19th century that echoed the general development of European landscape but offered – in the paintings of the *Hudson River School, from *Doughty to *Kensett, and in the later heroic landscapes of *Bierstadt and *Church – a sense of freshness, anticipation, awe and discovery not paralleled in the art of frontierless Europe. Indeed the art of *Catlin, *Audubon and *Bingham, as well as Frederic *Remington's world of cowboys and Indians, arose from conditions that were paramount, if not unique, in America.

The pre-eminence of the common man was in De Tocqueville's eyes more a social strength than a weakness, but it meant that in the realm of ideas Americans were more often moral and ethical than

philosophically profound. In art, attempts to surmount this common base by flights of allegory, symbolism, mysticism and religious fervour were neither typical nor completely successful, even in the hands of a Thomas *Cole. Throughout the 18th century and well into the 19th, the practical genre of portraiture dominated American art. Colonel *Trumbull's attempt to break portraiture's stranglehold by painting scenes of the Revolution in the historical grand manner were frustrated by an indifferent Congress. Samuel Morse, who had returned from Europe with ambitions to paint the ideal Classical world exemplified by his *Dying Hercules*, fulfilled his mother's prophecy that he would starve if he tried to paint anything but portraits; he deserted painting for invention.

The same Puritanical and Calvinistic narrowness caused the majority of Americans to give a cold and suspicious reception to John *Vanderlyn's innocent, idealised nude, *Ariadne on Naxos*. In the face of such taboos, artists had little chance to develop the sensuous side of art. As late as the 1880s, Eakins was obliged to mask the face of a nude model before he could pose her for his class at the Pennsylvania Academy of the Fine Arts. Other inhibitions made the majority of gallery-goers uncomfortable before lofty flights of imagination but at home with sentimental and anecdotal portrayals of everyday life. Mural painting, consequently, rarely reached a high level in America, and the sculpture created under the aegis of Neo-classicism now appears cold and inhibited. Genuine aesthetic qualities, meanwhile, went unappreciated. Winslow *Homer met critical resistance and popular misunderstanding when he presented nature and the visual elements of light, colour and texture without benefit of story or sentimental theme.

If American artists persevered, it was in spite of restrictions: Puritan taboos, the narrowness of subject-matter permitted during colonial times, and the lack of support from the privileged classes. During the so-called Gilded Age of the late 19th century, cautious millionaires confined their purchases largely to European art; at the great world's fairs of Philadelphia and Chicago in 1876 and 1893, American art was overwhelmed by European imports. Winslow *Homer gained some recognition but Eakins received almost none. The problem for black artists was truly grievous long after their release from slavery.

Painting is both an art and a craft, and this distinction further served to constrain American artists and to separate American from European art. Art derives from talent, temperament and powers of imagination that are probably inborn; craft is learned, and it profits from opportunities to receive instruction and to study the best of proven traditions. There was no lack of talent in America, but opportunities for talented people to learn their craft were severely restricted. The young Copley began his career with nothing but European engravings for guidance, as did many others in the backwoods for nearly a century afterwards (a fact that may account for the predilection for detail found in so many landscapes prior to the period of Impressionism). It is well known that Copley yearned to paint *'history pictures' as well as portraits, and also that his notion of European painting was gained from a few oil copies that *Smibert had brought to Boston. Copley's letters show how isolated he felt and how much he longed to study the work of the masters at first hand. His situation was typical as long as travel to the old world was costly and difficult.

However, opportunities for American artists to learn their craft at home improved in the 19th century. A number of training centres opened: the Pennsylvania Academy of Fine Arts (1805), the American Academy of the Fine Arts (1816) and the National Academy of Design (1826). These schools were followed by the *Art Students' League in New York and the Art Institute of Chicago, and many others. There were also increased opportunities to study art in the museums with the opening in the second half of the century of large, and growing, public collections like those in Boston, New York and Philadelphia. Gradually the handicap of isolation from Europe diminished.

A dramatic breakthrough in transportation, the appearance of steam-propelled ocean liners in the mid-19th century, suddenly made it comparatively easy to visit the great centres of the old world. After the *Great Eastern*'s historic voyage of 1858, crossing the Atlantic became a matter of days rather than weeks or months. An army of artists took advantage of this new accessibility. In Paris, Americans thronged the studios of *Gérôme, *Cabanel and *Bouguereau at the Académie Julian and the Ecole des Beaux-Arts; others worked in the studios of Munich and Düsseldorf. Unfortunately this internationalising process came at a time when European academic art was at a low ebb intellectually and spiritually, though not technically, with insipid content treated with the most meticulous realism. Whether a prolonged sojourn at the Ecole des Beaux-Arts was a blessing or a curse was debatable, and the influence on weak spirits was often baleful. Eakins was strong enough to surmount apprenticeship under Gérôme, while others, like Winslow Homer, distrusted European academicism and avoided the subservience that ran at that time equally through American painting and sculpture. Architecture in the United States was then in the era of eclectic revivalism against which progressive architects rebelled before the end of the century.

The phenomenon of expatriatism arising from the yearning of American artists to drink directly from the fountain of old-world culture extends throughout the history of American art. Benjamin *West arrived in Europe in 1760, soon followed by Copley, with Gilbert *Stuart close behind. In the 19th century the flow increased to a flood. Stuart returned home to finish out his career (and most Americans trained abroad also rejected Europeanisation), but West, Copley, *Sargent, *Whistler, *Cassatt and the sculptors *Powers and *Greenough became virtually Europeans. Conversely, Hendrick Couturier in 1661 and Smibert, followed by Augustus *Saint-Gaudens and others in the 19th century, and in the 20th, great numbers of artists who

fled Europe in the 1930s and 1940s. Fortunately for America's development, expatriatism was two-directional.

During the 19th century the majority of painters and sculptors in America and Europe moved from Neo-classicism and Romanticism to an excessively academic realism or to †Impressionism at the expense of a balanced concern for formal values. At the time, the masters of *Post-Impressionism who were striving to restore this balance were little known, if not submerged. Thus the message of *Cézanne, *Van Gogh, *Gauguin, *Seurat, *Matisse and *Picasso was delayed, and it descended like a bombshell when presented to the American art world at the *Armory Show of 1913 in New York. The critical nature of this event cannot be over-estimated. The Armory Show, those who participated in it and those who spent the balance of their careers assimilating its meaning, runs like a refrain through 20th-century American art. The careers of *Henri, *Sloan, *Bellows, Hartley and numerous others cannot be understood without reference to its innumerable effects, for and against.

The main effect of the Armory Show was to provide a watershed between the descriptive thrust of 19th-century art, called 'objective realism', and the post-Impressionist involvement with structural and formal values and the more abstract visual means of expressionism – an involvement central to *Cubism, *Abstract Expressionism and the many other variations of abstract art in the 20th century. These are the problems that engaged *Pollock, *Rothko, *Kline, *Motherwell and their followers. The key stylistic words are related to an earlier movement known as 'art for art's sake' that was championed and articulated by the brilliant, colourful American expatriate Whistler at the turn of the century.

There are those who believe that the pendulum has swung too far away from the descriptive. Some balance has been preserved by the ingrained strength of American pragmatism, materialism and practicality. The popularity of Andrew Wyeth's extraordinary realism proves that a love of brilliant description did not die after the Armory Show. Edward *Hopper's strong appeal established another middle ground. The historical role of the Armory Show was to call attention to artistic qualities that had been neglected and to add a new and necessary dimension to America's developmental history. Its shock waves lasted for nearly half a century.

PHILIP C. BEAM

CHINESE ART

The earliest entries in this work for China are those of *Shang dynasty stone and *Chou dynasty bronze sculpture, with the bulk of the entries necessarily beginning with those devoted to the arts of the Han dynasty. China has, however, a continuous history of artistic development which may be traced back to the painted pottery of the Yang Shao stage of the neolithic period, which the latest radio-carbon estimates date c. 4000 BC. Undoubtedly the mastery of ceramic technology of the neolithic period made possible the rapid development of bronze casting in the Shang dynasty, using pottery piece moulds and tempered pottery crucibles. Excavations at the late Shang capital of Anyang show a highly developed civilisation, with writing, calendar, and many other features which were to be lasting features of Chinese culture. The bronze vessels, already developed to a pitch of technical excellence since unrivalled in the late Shang period, continued as the dominant artistic form during the succeeding Chou dynasty, which conquered the Shang in 1027 BC.

Chou royal power ceased except in name at the end of the Western Chou period; during the Eastern Chou, from 770 BC until 256 BC, China was divided into a number of rival kingdoms. Among them the Southern state of Ch'u displays a distinctive culture and a high level in the arts. The decoration of the ritual bronzes was by this time largely in the form of surface patterns; animal forms which in the Shang and Western Chou had stood out in high relief became stylized flat patterns. These could be produced by stamping the mould with a repetitive design, or they might be inlaid in gold and silver and polished flush with the surface of the vessel. Other products from Ch'u, such as lacquer utensils and pottery vessels, were painted in red and black with the same sinuous designs. The earliest known paintings on silk belong to the Ch'u culture, and many features of the art of the *Han dynasty derive from this source. Many of the legends described in the Songs of Ch'u are depicted in the rare examples of Western Han dynasty painting that have survived (see the illustration to the entry for *Han dynasty painting); paintings and engravings of the Eastern Han show the results of Han standardisation of these legends, eg the animals of the four directions (replacing a variety of earlier mythical beasts), which were to remain extremely popular from Eastern Han until the T'ang dynasty and later. The wooden figurines of Ch'u tombs, substitutes for the slaves buried with their masters in Shang and Chou times, were during the Han dynasty replaced in their turn by *ceramic figurines which also long remained popular and which reached a high artistic level.

The long era of disunity of the Eastern Chou had ended in the unification of China under the brief and harsh rule of Ch'in (221–206 BC), followed in its turn by the long rule of Han (206 BC–AD 220) broken only by a few years of usurpation. This was a period of Confucian dominance and a strong central bureaucracy. But the centuries following the Han were ones of

political disruption, with a succession of native and foreign dynasties until the final establishment of the Sui dynasty in AD 589. Buddhism, which had been introduced to China in the mid-2nd century AD or earlier with the arrival of monks and translators of sutras from the West along the Silk Road, was promoted both by the emperors of the Chinese dynasties in the South, and most spectacularly by the emperors of the To-ba Wei people who ruled in the north from AD 386. Northern Wei (386–535) cave temple complexes such as *Yün-kang and *Lung-mên are major monuments of the acceptance and success of Buddhism. Others of the Eastern Wei (534–50) and later are at *T'ien-lung shan, of the Liang (502–57) and Northern Chou (557–81) at *Wan-fo ssǔ, and there are regional variants in the sculptures from *Mai-chi shan, *Yin-hua hsien and *Ch'ü-yang. At several of these sites the creation of cave temples continued into the *T'ang dynasty (618–906), the most important site in this category being the Caves of the Thousand Buddhas at *Tun-huang, because of the large number of surviving caves with sculpture and wall-paintings, and on account of the discovery there of an ancient sealed library with hundreds of paintings on silk and paper, with thousands of other documents.

In addition to the large-scale excavation of cave temples, Chinese Buddhist sculpture also occurs as free-standing stone stelae and as figures or groups of figures in gilt-bronze. Those of the latter that survive are relatively small in scale and few in number, owing to the hazards of melting-down or the destruction by fire or decay of the wooden temples in which they were kept, but their high quality is an unmistakable indication of their original importance.

Outside the field of Buddhist art, the most important developments are to be found in the period of the Eastern Chin (317–420), one of the southern dynasties under Chinese rule with its capital at Nanking. This period was a brilliant one for the arts of calligraphy (*Wang Hsi-chih) and painting (*Ku K'ai-chih) as well as for Taoist speculation, literature and literary criticism, the last of which was to furnish many concepts for the criticism of calligraphy and painting also (*Hsieh Ho).

The persecution of Buddhism throughout China in AD 845 effectively ended its dominance. Countless temples, and with them, wall-paintings and sculptures also, were destroyed in the cities of Lo-yang and Ch'ang-an. For sculpture in the Sung and Yüan period, the reader may consult the entries on *Fei-lai-feng and *Ch'ü-yung-kuan, but in the history of Chinese art subsequent to the T'ang dynasty sculpture plays only a minor role. Imperial patronage, apart from calligraphy and painting, was to foster especially the further development of ceramics, in which the sophistication of materials and techniques was to continue to increase until the 18th century. Other arts reached levels of particular excellence at different periods. As examples we may take gold and silver work at the T'ang court, while the efforts of the early Ming emperors to emulate the artistic achievements of the

Sung dynasty produced carved lacquer and cloisonné enamels of superb quality during the 15th century in addition to the unrivalled excellence of the porcelain produced at the same time in the imperial kilns. However, as the minor arts are outside the scope of this dictionary we must return to the T'ang dynasty to summarise the subsequent course of the fine arts of calligraphy and painting.

After the political expansion and far-reaching influence of the T'ang dynasty, China was once more divided in the period of the Five Dynasties, from AD 918 until the establishment of the Sung dynasty in 960. But despite the disruption in the political scene, the arts flourished, and an academy of painting was established at the court of one of the Five Dynasties rulers, Li Hou-chu. More important still was the great tradition of *landscape painting established by such masters as *Tung Yüan and *Li Ch'eng, a tradition which continued to gain strength under the Northern Sung (960–1126). Although the imperial academy continued as a Sung institution, reaching its height in the reign of Emperor Hui-tsung (see *Chao Chi) and surviving under the Southern Sung (1127–1279) at Hangchow, it was landscape painting, not *flower and bird painting or courtly narrative scenes, that became established as the dominant genre, whereas figure painting had held this position in the T'ang and earlier.

Under the Sung an efficient grain transport system brought economic prosperity to the Northern Sung capital established at Pien-chin (modern Kaifeng), and some 150 years of peace only ended when this system had been eroded by the requisition of vessels for luxury items for Emperor Hui-tsung's court. In 1126 the capital was ransacked by the Chin Tartars, and the Sung court sought temporary refuge in the south at Hangchow, and in fact remained there for a further 150 years until the Mongol conquest and the establishment of Mongol rule of all China with the *Yüan dynasty (1280–1368).

Important developments, especially in landscape painting, followed in Chinese art and literature as a reaction to alien rule (see especially *Chao Mêng-fu, *Four Masters of Late Yüan). These developments, which were to have far-reaching consequences for the later history of Chinese painting, contrast strongly with the art of the early *Ming dynasty (1368–1644), conceived in the rather narrow mould of the restoration of the academic standards and institutions of the Southern Sung. Imperial patronage of crafts such as ceramics and lacquer was more successful than in the field of painting, but outside the court there were notable calligraphers and painters (*Shen Chou, *Wên Cheng-ming), and the closing years of the dynasty brought a new awareness of the history of both calligraphy and painting which set the course for the early *Ch'ing dynasty (1644–1912) and later (*Tung Ch'i-ch'ang).

The decline of imperial power in the late Ming dynasty had already made itself felt in the arts through the parallel decline of imperial patronage, both of the academy, which ceased to exist, and of such crafts as

ceramics and lacquer. The Manchu conquest of 1644 brought new energies which were manifest in every field of scholarship and artistic endeavour, even among those who, like the *Individualist painters, were bitterly opposed to alien rule. Unlike their predecessors the Mongols, the Manchus were anxious to acquire Chinese culture. The imperial kilns were re-opened in 1683 and produced new wares as well as fine copies of classic Sung and Ming porcelains. Scholarly activity in the compilation of encyclopaedias and in the study of archeology and epigraphy was greater than at any time since the Sung dynasty. Scholarly interest in ancient inscriptions was reflected in the appearance of archaic styles in the works of 18th- and 19th-century calligraphers (*Chin Nung, *Chao Chih-ch'ien). In painting in the 17th century, those who were prepared to serve the new dynasty (*Wang Hui, *Wang Yüan-ch'i) enjoyed an enormous contemporary success. But their versions of traditional styles easily became insipid in the hands of later painters, who no longer had access to the Sung and Yüan original master-works, which had ironically become inaccessible through the collecting zeal of one Manchu in particular, the Ch'ien-lung emperor (r. 1736–95). The lasting contributions to the development of Chinese painting were those of the Individualist painters, who have continued to inspire Chinese painters down to the present century.

Finally, after so many renewals in the history of Chinese art, today, under the watchword 'Make the past serve the present', a new and active interest is being taken in China's past by her people. This has already resulted in spectacular additions to our knowledge of ancient Chinese art, and we may hope that it will be reflected in future achievements also.

See also CALLIGRAPHY AND PAINTING IN CHINA; INSCRIPTIONS AND SEALS ON CHINESE PAINTINGS; MATERIALS AND FORMAT IN CHINESE PAINTING; NARRATIVE PAINTING IN CHINA

RODERICK WHITFIELD

JAPANESE ART

Before the introduction of Buddhism to Japan in the mid-6th century AD Japan had had a relatively primitive tribal society in which crude native art had co-existed with imported Korean goods, and tribal chiefs had built enormous tumuli as their mausolea, guarded by the pottery models called *Haniwa. With Buddhism came the ideas and methods of the mainland cultures of †Korea and then of †China, which were rapidly assimilated in the culture of Japan. In the *Asuka period, Buddhism became the state religion under the more centralised government of the Regent, Prince Shōtoku (592–622), who encouraged the foundation of many monasteries and the building of many temples. One of these, the *Hōryūji, still stands and still contains many treasures of the Asuka and *Nara periods. In the early Asuka period, the influence was mainly Korean, though ultimately derived from China, but after the conquest of Korea by China, the Chinese influence was more direct.

In the Asuka period there first arose the situation of dual government that was to persist, in various guises, until, and indeed after, the *Meiji revolution. The Emperor was considered to be divine and above politics: this meant that in effect actual government was removed from him by the political or military manœuvring of one or other of the great feudal families, in favour of themselves. In 645 the Fujiwara family seized power: Fujiwara Kamatari was a Chinese enthusiast and it was he who fostered the close imitation of the great *T'ang dynasty of China. Documents and treasures preserved in the 8th-century storehouse, the *Shōsō-in, show that not only the art of that time but also the court procedure and the governmental system, down to the smallest details, were closely copied from Chinese methods. Even the capital city, Nara, was laid out in imitation of Ch'ang-an the T'ang capital, while sculpture and painting were very close to T'ang originals.

In 794 the capital was moved to Heian-Kyō (modern Kyōto) under the threat of the growing political power of the great Nara monasteries. Heian-Kyō was an even more ambitious copy of Ch'ang-an, and gave its name to the *Heian period. During the Heian period, the power of the Fujiwara family grew until they were governors of Japan even in name, under a puppet hereditary emperor. Court life and court art became ritualised and sophisticated: this is best reflected in the non-religious art of the time and finds expression in the masterpiece *Genji Monogatari* (the 'Tale of Genji'), a novel of court life by the court lady Murasaki Shikibu, written in the first part of the 11th century. This elegant court art was for a small hereditary coterie and grew further and further away from its Chinese origins. This demonstrates a pattern which is often repeated in Japanese history; certain aspects of Chinese art are developed into a sophisticated but somewhat stylised elegance with a distinctly Japanese flavour, where Chinese austerity is overtaken by the Japanese flair for the decorative.

But by the end of the 11th century the Fujiwara family were losing control of the centralised government, so that distant clans became more autonomous and more powerful, based on military might rather than political astuteness, as had been the Fujiwara. Eventually, power was seized from the Fujiwara by the Taira family, only to be lost by them to the Minamoto in 1185. But the Fujiwara had started a tradition of respect for the arts that became a feature of even the most military-minded, and is still an enduring quality of the Japanese people. Minamoto Yoritomo set up

his military government in *Kamakura while the emperor's court remained in Kyōto, with the Fujiwara as now powerless hereditary retainers. In 1192 Yoritomo was given the title of *Sei-i tai-shōgun* 'Barbarian-subduing great general', a title which persisted, as *Shōgun*, until the *Meiji period. However, the Minamoto soon lost political power to the Hōjō family who held it until 1333.

In the Kamakura period (1185–1392) Japan was invaded twice by the Mongol emperor Kublai Khan, in 1274 and 1281. The second invasion was the most serious, but was repelled when a typhoon (called afterwards the 'Kamikaze', the divine wind) destroyed the Mongol fleet. Preparations for defence against a possible third attack weakened the Hōjō, who were ousted from office by the forces of an abdicated emperor, Go-Daigo.

Buddhistic art had not flourished in the Kamakura period, in spite of the introduction of Zen Buddhism, but two forms of secular art were important. The first of these is the continuation of the court art tradition of the Heian period, with the painting of the famous handscrolls as the best example, and the rise of the *Yamato school of painting followed by its successor the *Tosa. The second is the secular portraiture, in both painting and sculpture, that grew from Buddhistic portraits to become a remarkable, if short-lived, style.

The ex-emperor Go-Daigo was soon deposed by a former ally, Ashikaga Takauji, and the *Muromachi period began, as it continued, with civil war. During the Muromachi period, renewed contacts with mainland culture led to Zen monk painters visiting China and learning for themselves the art of ink-painting from painters of the *Chê school in China, and starting the *Muromachi suiboku school: most prominent among these are *Shūbun and *Sesshū. While originally a preserve of monks only – the imperial academy was based in the monasteries – secular ink-painting began with the *Ami school, and the important *Kanō school, founded by Kanō *Masanobu. The Kanō school was to become increasingly important in the *Momoyama and *Edo periods.

Thus another wave of influence from China starts another style of artistic endeavour and like its predecessing and following waves of influence is softened and altered into a Japanese style, with little to remind one of its Chinese origins. The Kanō school is a prime example. Beginning from a Chinese style it becomes colourful under *Motonobu, very strongly decorative under *Eitoku and *Sanraku and almost static as the 'classical' school under the successors of *Tannyū. It remained the style of the military men as opposed to the *Tosa style of the courtiers, of the court of the Shōgun rather than that of the emperor.

The Muromachi period was a time of almost continual civil war between various clans and their factions and was brought to an end by the rise to power of a new type of ruler, almost an upstart, Oda Nobunaga. Nobunaga was successful partly because he was the first general to make serious use of the smooth-bore musket, introduced shortly before by the Portuguese traders at Nagasaki, and he almost succeeded in reunifying Japan.

There followed a period looked back to in Japan as a Golden Age, the *Momoyama period (1573–1616). The arts were encouraged partly as a legacy of the Fujiwara tradition, partly as a method of display, and partly as a manifestation of the tea ceremony.

The tea ceremony calls for simplicity of surroundings and of utensils: it creates an atmosphere where a man can escape from the world in the contemplation of higher thoughts. At its best the 'philosophy of tea' is capable of inspiring great works of art and architecture such as the *raku* tea bowls of *Koētsu or the Ginkakuji pavilion. Unfortunately it also led to the laying down of rules by tea masters and of a studied crudeness and rusticity that sometimes became trite. The tea ceremony exerted an enormous influence on taste in general – particularly is this true in ceramics, where the traditions of whole pottery-producing areas were changed under the influence of such tea masters as Oribe or Sen-no-Rikyu. While the later Ashikaga Shōguns had taken a great interest in the tea ceremony, Nobunaga was most interested in display, and he had the good fortune to have the ideal artist available, Kanō *Eitoku. His successor, Hideyoshi, also employed Eitoku and *Sanraku, but was greatly under the influence of Sen-no-Rikyu who, however, only partly controlled Hideyoshi's artistic excesses.

Shortly before his death, Hideyoshi had twice invaded Korea, and from the second expedition had brought back Korean potters. These potters settled in Kyushu, and in the early Edo period started the porcelain industry in Japan.

Hideyoshi's successor was Tokugawa Ieyasu whose family were Shōguns until 1868. The Tokugawa governmental policy was one of tight political hold of the people: this was aided by the earlier expulsion of Christian converts and the closing of the country to all outside trade except that at the carefully and rigidly controlled port of Nagasaki. In general the Tokugawa or *Edo period (1616–1868) was peaceful.

It was a period of an enormously expanding internal market for works of art. The rise of a new moneyed merchant class (hitherto deeply despised) fostered new styles of art. The first of these was that of the *Rimpa school: the decorative school of the painters *Sōtatsu, *Kōrin and their followers, where the tradition of Yamato-e was adapted to create new ideas of decorative design. But in the capital city Edo (modern Tokyo) another new and much more radically different art form appeared – *Ukiyo-e, the art of the woodblock-print designers. This was the first truly popular Japanese art.

Side by side with these, the Kanō and Tosa traditions continued, though at a low level of artistic achievement, and new schools sprang up. Under renewed influence from China, the *Nanga school of scholar-painters started, and also the 'return to nature' of the realist school, the *Maruyama. The Shijō school was started by *Goshun, who had first studied with *Buson and then with *Okyo – as the Shijō school

progressed it became more and more like Nanga again in the hands of such men as *Nanrei, and by the time of the Meiji revolution the differences between the old 'school' traditions were breaking down. The wave of Western influence that followed the opening of Japan to the outside world in 1868, after 250 years of isolation, caused most canons of Japanese art temporarily to disappear, and since then Western influence has greatly affected all Japanese arts. It is only in the middle of this century that there has been a conscious return to native values and traditions.

See also JAPANESE BUDDHIST PAINTING; JAPANESE EARLY PORTRAITURE; JAPANESE PAINTING: MATERIALS, FORMAT AND CONVENTIONS; JAPANESE PRE-BUDDHIST PAINTING; JAPANESE WESTERN STYLES

OLIVER IMPEY

KOREAN ART

Korea's history has been shaped principally by her geographical position between the great empire of China and the island kingdom of Japan. Through Korea, Chinese culture became known to the Japanese. But while Korea's cultural contribution has been made for the most part under Chinese influence, at various periods a distinct Korean style can be discerned in both painting and sculpture. During the Three Kingdoms period (57 BC–AD 668) the country was divided into three independent states: Koguryo in the north extending into Southern Manchuria; Paekche in the south-west; and Silla to the south-east of the peninsula. It is in the north near the ancient capitals of T'ungkon and P'yongyang that several hundred tombs have been discovered, many of them decorated with wall-paintings dating from the 4th to the 7th centuries. The tombs are square, the granite surfaces being faced with lime plaster. A typical Koguryo decorative formula would comprise a ceiling decorated with clouds and lotus flowers while on the four walls the four cardinal deities were painted – the Red Phoenix, the Green Dragon, the White Tiger and the tortoise entwined with a serpent. While owing much to contemporary *Han China these paintings have a vigour and spirited fantasy which can be regarded as Korean. Other subjects include genre and hunting scenes and stylised geometric motifs. The kingdom of *Paekche was important at this period in exporting Chinese Buddhist ideas to Japan. In 577 and again in 588 Paekche craftsmen were sent to Japan and their work in both architecture and sculpture can be seen at the *Hōryūgi. Their skill in metalwork and stone carving, in relief and free-standing sculpture is clearly evident. Little remains from the early Silla period. Many of the tombs have been looted, although some interesting finds in jewellery and metalwork have been made. In 668 Korea was unified when the Silla army, with help from T'ang China, defeated Koguryo and Paekche. The United Silla Period lasted until 918. This was a time of relative prosperity in which the cultivation of the arts was regarded as an essential part of political life. Young noblemen and Buddhist monks were sent to China to study and even stayed to take the state examinations like any Chinese official. From this period date two important temple complexes at Pulguk-sa (see SOKKULAM) and *Sach'onwang-sa. Bronze casting reached a high level and many Maitreya figures were cast varying in size from tiny figurines to monumental sculpture.

With the collapse of the Silla dynasty, Korea was again unified after a period of civil war by the Koryo dynasty (935–1392). Koryo sculpture was mainly religious and many Buddhist images survive in bronze, stone, wood and lacquer. The idealism of the Silla period was replaced by a more realistic trend and cruder approach. Koryo painting generally followed the style of the Northern *Sung though there were some attempts to emulate the Southern style. Monochrome paintings of bamboo and plum blossom survive as well as figure compositions. The Yi dynasty (1392–1910) reflected the political and cultural life of Ming China. A strongly centralised Confucian state with its capital at Seoul produced a class of scholar-officials. In painting two distinct schools can be distinguished, that of the Northern school and a more individual, Southern school. Outstanding artists of the Northern school were the landscapists *An Kyon, *Kang Hui-an and *Pyon Sang-byok. Flower and bird painting is represented by *Sin saim-dang. *Yi Chong and O Myong-yong were painters of the four 'gentlemen' – plum, orchid, pine and bamboo. The Southern period is marked by a move away from monochrome ink-painting to a much freer use of colour. Artists include *Kim Myong-kuk, *Chong Son the famous landscapist, *Sim Sa-jong, *Kim Hong-do and *Sin Yun-bok. Landscape, flower painting and genre scenes were equally popular and portrait painting was developed with an extreme simplification of the figure to a few telling lines. During this period Korean painting finally broke away from Chinese influence to produce individual works of high quality and with a distinct national character.

BYONG-MO KIM

ISLAMIC ART

The richness and variety of expression within the world of Islamic art is in many ways a direct and often brilliant reflection of the turbulent history of that religion. It is the purpose of this article to outline the historical development of Islam and to highlight those factors which gave rise to the splendours of its culture. It is essential to realise that Islam is not a religion of complex beliefs – its creed states simply that there is no God but God and that Muhammad is his prophet – but it is one that demands complex observance. The idea of a religious community and of expressing one's belief by constant and active participation in that community is what gives meaning to the phrase 'the Islamic world'. Man's relation to God in Islam is one of total and undeniable dependence and, because of this, the Divine rules for the organisation of the Islamic community are all-embracing. It might seem, at first glance, that the combination of a simple creed, detailed regulations for the conduct of daily life, and an overwhelming emphasis on the transient nature of worldly existence are poor grounds for the growth of a rich culture; and had Islam been confined to its original and austere desert home this premise might well have been true. What gave Islamic culture its depth and variety of expression was the territorial expansion which the faith enjoyed; an expansion which took it across half the known civilised world within a century of its revelation, and which brought it into intimate and continuous contact with other great civilisations.

The propagation of Islam began in July AD 622 when Muhammad left his home city of Mecca after finding himself unable to convert the powerful leaders of that place and went to Medina some 200 miles to the north. There his preaching was much more successful and the numbers of his adherents grew. By the time of the Prophet's death in AD 632 Islam had established an effective hold in north-western Arabia and was just about to begin its dramatic expansion. For Muhammad was not only a Prophet he was also the political leader, transmitter of the law, judge and general of his people. His death left the community without a head and, as he had no son, leadership devolved upon his father-in-law Abu Bakr. This man's period of rule was brief and on his death in 634 the Prophet's other father-in-law Omar became Caliph. Now occurred the great period of expansion to the north, east and west. Syria was conquered in 636 and this brought the Muslim Arabs into contact with the Roman and Hellenistic culture of the Eastern Mediterranean lands. After internal political disputes, concerned primarily with the right of succession, the family of Umayya emerged as the dominant party and established a strong dynasty with its capital in Damascus. Already the process of cultural fusion and enrichment had begun.

Within a century Islam had conquered the valley lands of Mesopotamia, had swept across the high plateau of Iran, had taken the cities of Samarkand and Bukhara in Central Asia, and was reaching down into the Western Punjab. Egypt and North Africa quickly fell under Islamic sway and the *Umayyad armies pushed on across Spain and over the Pyrenees. This European expansion was halted exactly one hundred years after the Prophet's death by Charles Martel when the Muslim armies were less than 200 miles from Paris. Thereafter Western Europe was no longer menaced by an Islamic invasion but Ottoman troops were later to conquer much of Eastern Europe and to besiege Vienna several times. In the middle of the 8th century a new Arab dynasty, the *Abbasids, took power in the eastern part of the Arab world and built a new capital city – Baghdad. The cultural flowering of this period shows a shift towards the assimilation of eastern civilizations with Persian and Central Asian elements being taken over and made part of a distinctive Islamic tradition. The great cultural role played by the Abbasids was not merely – as is often asserted – the preservation of earlier skills and classical fields of knowledge, but rather the great embellishment, development and synthesis of this heritage. In the field of medical knowledge, for instance, Arab scholars not only translated, and thus preserved for Europe later, the works of Galen and Hippocrates, they also added to them with a wealth of clinical observation and experience. Mathematical ideas were taken from India and applied to the study of astronomy in observatories whose accuracy would not be rivalled in Europe for another eight or nine centuries. When much of Europe lay engulfed by the barbarism of the Dark Ages, classical and eastern civilisations were being studied and reformulated to produce new modes of artistic expression in the Islamic lands. It was in terms of colour and design that this fusion and transformation process was most obvious and most successful. The early Islamic reluctance to portray the human form or to develop representational arts often led the Muslim craftsmen in the direction of abstract design and this trait can be seen in all fields of artistic activity from carpet weaving to architectural decoration. The varieties of Arabic calligraphy and the beauty of the formal signatures appended to the most mundane official documents show also this love of geometric design, a tradition influenced both by the close study of mathematical sciences and the rhythms represented in the wonderful wealth of pre-Islamic poetry.

From the 9th century onwards, however, it becomes less and less true to speak of an Abbasid Empire – for several of the frontier districts began to break away from the control of Baghdad. In Spain the Umayyads retained their power and ruled from the magnificent city of Cordoba. In the north-east the *Samanids ruled during the 10th century from the city of Bukhara, patronised poets such as Rudaki and also encouraged many other artists in the cultural centres of Nishapur and Samarkand. Further east, in present-day Afghanistan, the *Ghaznavid dynasty also encouraged the arts and made possible the extension

of Muslim power in India; while in Egypt the Tulunids, and later the *Fatimids, gave Cairo a dominant role in the cultural life of Islam.

By the middle of the 11th century, however, the first of a series of great Central Asian migrations was under way and many of the local dynasties that had established themselves in the East were swept away by the invasion of the Seljuq Turks. This tribal group established itself first in the Iranian plateau and then, in the 12th and 13th centuries, moved into Anatolia and the heartlands of the Middle East. The Seljuqs' great contribution was in bringing new Turkish elements into Islamic culture – particularly in the fields of architecture and lustre-painted pottery. Representational elements began to appear more and more in pottery decoration. Fragmentary wall-decorations and the tantalisingly brief *Warkah wa Gulshah manuscript show the existence of a highly developed and very skilful tradition of Seljuq painting in the 13th century.

The next great invasion from central Asia began early in the 13th century under Jenghiz Khan. The Mongols reached Rayy, the Seljuq capital in Iran, in 1220 and destroyed Baghdad, killing the last Abbasid caliph there in 1258. The Eastern Islamic world then went through a period of political troubles and disturbances but the Mongols brought with them a strong cultural heritage and introduced new elements of Far Eastern civilisation into the Islamic world. Their monumental mosques of this period are in contrast with the exquisite delicacy of much of the interior plasterwork decoration which often makes use of calligraphic designs. The evidence of Chinese influences is, however, most marked in the field of painting where not only facial features but also techniques and style reflect Far Eastern origins. Many examples of *Mongol miniature painting survive. The great epic poem of Firdausi, the *Shah Nama, recounting the exploits of both legendary and historic Persian kings, was a favourite subject and magnificent examples exist from both the school of *Tabriz and of *Shiraz.

This Far Eastern influence later spread to the Western Islamic world and the painters of the *Mamluk dynasty in Egypt learned much from the Mongol artists in Baghdad. This is particularly noticeable in the wealth of decorative detail used, particularly in the new richness of floral scrollwork. The Mamluk period provides an excellent example of how the artist could combine many traditions – in this case those of the Fatimids, Seljuqs, Ayyubids and Mongols – and yet produce something which is new and constitutes a distinct contribution to the development of Islamic culture.

A new era in Eastern Islamic art began in the second half of the 14th century when Timur led his Chagatay Turks out of Central Asia, across the Iranian plateau and into Mesopotamia and Anatolia. Once again, after an initial period of destruction, a cultural renaissance occurred drawing heavily on the traditional skills of the courts of two minor dynasties – the Jalairids in Baghdad and the Muzaffavids of Yazd and Kerman. Both these dynasties had arisen after the decay of

Mongol power in Iran, but both had retained much of their Mongol cultural heritage. The new dynasty – the Timurids – however, moved their capital from Samarkand to *Herat and there developed a new and distinctive style of painting represented in several very beautiful works commissioned by patrons such as Baysunghur, the youngest son of Shah Rukh who ruled in the early 15th century. Baysunghur was in fact a renowned calligrapher in his own right and several examples of his work are still extant. In the southern Persian city of Shiraz too a brilliant school of artists flourished at the same period and was also influenced by Chinese styles and motifs.

The continuity between Timurid and Safavid painting is largely due to the work of one man – *Bihzad – whose art, as so often in Islamic history, flourished at a time of political strife. He maintained Herat, under Sultan Husayn, as a centre of the highest artistic excellence, and one whose influence on *Indian Mughal painting was profound. The *Safavids emerged at the beginning of the 16th century and rescued Iran from political chaos and fragmentation. Indeed in many ways the Safavid dynasty marks the beginnings of modern Iranian history for they secured the north-eastern frontier and no longer was Iran troubled by massive invasions from Central Asia and beyond. By the end of the 16th century *Isfahan had become Persia's capital and its present magnificence reflects the central role which it then played in the development of so many facets of Iranian art.

In the western part of the Islamic world too a process of consolidation had begun as the Ottomans began to establish their power in the wake of the Seljuq collapse in the late 13th and early 14th centuries. Ottoman power, unlike that of the local dynasties in Persia, suffered only a minor setback from Timur's invasions and with the conquest of Constantinople in 1453 its hold was greatly strengthened. Now new European elements began to enter the great stream of Islamic art – those derived from the Renaissance – which complemented those already derived from Byzantium. Painters such as *Gentile Bellini visited Istanbul to paint portraits by commission at the highest level – a portrait of Sultan Mehmet II by Bellini exists in the National Gallery, London – and Turkish artists visited Europe in return. As the tides of Islamic fortune ebbed and European political encroachments upon Muslim territory – in Africa, the Middle East and the Indian subcontinent – grew in number and intensity so too did the pressures which led Islamic artists to greater and greater cultural eclecticism. In this process much of value has been lost but one of the great strengths of Islamic art has always been its ability to absorb so many different traditions and yet retain its vital individuality. By fusing successfully so many diverse Asian and European elements Islamic art never became the sole creation of a particular people at a particular time; it was constantly renewed and refreshed.

R. M. BURRELL

INDIAN ART

The 20th century has seen the discovery of the enigmatic *Indus Valley Civilisation of the 3rd and 2nd millennia BC. Between the expiry of that civilisation *c.* 1500 BC and the coming to power on the lower Ganges of the *Maurya dynasty, the first to sponsor a coherent hieratic Indian art, there lies a period of more than 1000 years which cannot be dealt with in terms of art history. Yet during this period the Aryan tribes entered the Indian North-west, burned the forests and established the first Gangetic kingdoms where religious developments took place which to the present day have formed the basis of indigenous Indian religion. The fact is that the cultural inheritance from that period is not material but literary.

The hymns of the early nomadic tribes in India were collated to form a single work, the *Rig-veda*. Other *vedas* were composed as social and ritual forms evolved. Parallel and subsidiary texts were later created, including the mystical *Upanishads*. The religions of this turbulent period required few material paraphernalia. The highly sophisticated ritual of the *vedas* took place upon a fenced-off area of cleared ground with brick-built fire altars (*vedi*), the utensils necessary to preparation and libation of the sacred intoxicant *soma*, and the sacrificial stake (*yupa*), none of which remain. Such effigies as may have played a part in vedic sacrifices were small, probably clay or copper manufactures without canonical definition and not designed to outlast their ritual usefulness.

Numerous philosophies arose in the cities and forest hermitages while this sacrificial cult remained the traditional aristocratic religion. Of these, Buddhism and Jainism were to survive as well as the eclectic mainstream of *veda*-based philosophy from which the cults of Hinduism were to evolve. At the time of their inception a few centuries before Mauryan rule, the reformist religions of Buddhism and Jainism had no use even for the few material accessories required by vedic ritualism. Not until Ashoka Maurya elevated his own interpretation of Buddhist doctrine to the level of a State religion did art in India receive the unifying patronage necessary to generate articulate and lasting creations in stone. The creative forces stimulated by Mauryan patronage, however, by no means stopped short at Buddhist and imperial symbolism. Nature spirits of the folk-cults and the elemental gods of the *vedas*, until this time restricted to the realms of imagination and poetic metaphor, were realised in plastic form. Here lie the origins of classical Indian art.

The spiritual aspects of this art have been repeatedly emphasised. It is certainly true that most of the art which remains from the pre-Islamic dynasties is of a religious nature, consisting for the most part of sculpture and painting adorning cave-shrines and temples. These structures belonged to the Hindu, Buddhist or Jaina faiths. Buddhism died out in India early in the present millennium, while Jainism and Hinduism continued to thrive. There are large complexes of Jaina temples in various parts of India, but the overwhelming majority of religious structures are Hindu. This religion has ramified into so many cults and sub-cults that a temple may be dedicated to any one of a number of deities, although one may expect them for the most part to be the shrines of one or other aspect of Shiva, Vishnu or the Goddess, or one of these primary deities under a local name.

To the orthodox Indian mind, however, the visual arts represented the lowest manifestation of religious activity. The layman may start by worshipping images, but they are merely aids to a spiritual realisation ultimately achievable only through strict discipline and profound meditation. Indeed, the artist is enjoined to practise meditation (*dhyana*) in the first place upon the abstract qualities of a deity, with the help of mnemonic verses and eulogistic hymns, before attempting to plan the exact form (*rupa*) which the image should take. From this point he is guided by canons of iconography and iconometry, and mention is often made in the texts of the emotion (*rasa*) which the image should be calculated to evoke in the worshipper. The techniques of then creating the form arrived at are described as threefold: the image may be true sculpture, ie sculpture in the round (*chitra*), 'half sculpture' (*ardha-chitra*) or relief, and painting (*abhasa*). The first category is aesthetically and ritually the most important, this being the preferred method for producing the central image in the temple shrine-room, while reliefs are mainly intended for the depiction of myth-tableaux, secondary deities, protective spirits, symbols of fertility and prosperity, and ornamentation. Painting refers not only to individual works but also to the painting of the temple images in symbolic colours and to mural work.

The theory of the creative process may be summarised as follows:

(1) *dhyana*, meditation 'in the heart' upon the deity to be symbolised in the art form; this spiritual state is then filtered through (2) the *bhavas*, the human emotions, to single out (3) the *rasa*, the particular sentiment to be evoked through (4) the *artha*, the intellectually apprehensible structure of the work which may be expressed in terms of (5) the *tala*, the rhythm or balance of proportions and colours which can be concretely planned out using (6) the *matra* or exact dimensions suitable to produce (7) the *rupa*, the realised visual form as sculpture, relief and/or painting.

The worshipper is expected to approach the vision of the artist (or a more profound vision, if he is sufficiently advanced) when in the presence of the image by the reverse process, starting with the objective visual form and penetrating to the depths of his own heart wherein alone lies the ultimate revelation of spirit. The fact that virtually all Indian art works of this kind are anonymous indicates the primary importance given to the religious vision itself which, like

the symbols by which it is expressed, was considered fixed and eternal; the artist was merely the instrument of the vision and as such warranted no individual recognition.

The greater part of pre-Islamic art, then, was sacred by definition, being an essential part of temple-centred religion, but it was by no means all spiritual in content. The amorous couple in various stages of love-making was a favourite motif, as were other secular scenes from aristocratic life such as warfare, the hunt and the feminine pastimes. Decoration mainly took the form of animal and floral designs, more or less formally rendered. These secular works most frequently show all the exuberance of artists whose delight in the natural world was disciplined only by their inherited local artistic idiom. It is true that classical poetic images (particularly those of the Guptan poet Kalidasa and his successors) appear to have conventionalised the sculptural representation of secular themes, but there is an ever-present element of inventiveness. Hedged about as he was by the iconological dictates of the priests, which were essential to the symbolical unity of the elements of the temple, and by the classical tastes of the aristocracy, which it was imperative to follow since royalty controlled the financing of the major structures, the artist yet succeeded in preserving his own integrity to a remarkably high degree. Not only in matters of significant detail but also in inspired conceptions of whole compositions, from a single panel to an entire temple, the artists have left proof of original genius in every generation in every kingdom of ancient India.

From the 2nd to the 16th century, painting throughout India kept pace with and conformed to the themes of temple sculpture. In individual paintings, of course, secular themes could be treated separately from religious icons and used for the adornment of palaces and private houses.

A basic colour symbology was well worked out in the Deccan by the 7th century AD, as Sanskrit texts on the subject indicate. Thus mysterious, dark hues were to be used to arouse the *rasa* of eroticism; an amusing theme should be dominated by white; sympathy was elicited in the observer by grey, passion by red, heroic sentiments by yellowish white, and fear by black; the supernatural should be portrayed in yellow, the repulsive in blue. In more naturalistic terms, the texts advise a range of colours limited only by the observed hues in the subjects to be portrayed, or indeed by the artist's imagination. It is abundantly clear that in early Indian painting, a prejudiced view was taken in the matter of skin colour: the rich and high-born should be represented as white, the criminal and the hapless as dark. On the other hand, simple observation governs the prescribed skin colour of tribal people, Southerners, the ill and those engaged in labour. The various postures in which the human figure might be portrayed were scrupulously categorised and delineated, and the techniques of foreshortening and depth-contour were discussed and put into practice as at *Ajanta.

By the time of the *Mughal schools, therefore, painting in India had already a long and sophisticated tradition, although examples are unfortunately fragmentary. During the Islamic domination of India, the viewpoint of the Mughal artist was predominantly secular and directly influenced by Persian attitudes and techniques. As a result, we have in these paintings a much more full picture of life in contemporary India than is to be gained from a study of temple sculpture and painting. Being professionally non-sectarian, the artist portrayed not only the aristocratic life of his patron but also the life of his subjects of whatever faith. A great deal of personalism also enters into the art: portraits of nobles at court, of the emperor himself, and even representations of the ruler's dreams were produced. Meanwhile, as Hindu temple building waned, painting to a certain extent replaced sculpture and schools of painting developed which illustrated Hindu themes, although in some cases much influenced by Mughal style.

There is a problem, in much of Indian art, of attribution – a problem made the more vexing in the case of sculpture by the fact that works which once were integral parts of places of living worship are now scattered in museums across the world. In dealing with such fragments, as even complete sculptures must be regarded, the difficulty naturally arises of understanding the context in which these now isolated pieces originally contributed to a total symbolical scheme. This can be reconstructed only if the exact provenance of the piece is known and if the temple still stands, which is often not the case. However, this is a specialist question of iconology which need not detract from appreciation of the specific meaning and aesthetic effectiveness inherent in a decontextualised work, since the general principles of Hindu, Buddhist and Jaina iconography and aesthetics are known from textual sources and from extant temples which remain more or less intact. It should also be remembered that, in the case of Hinduism and Jainism, we are fortunate in that these religions still live in the country of their origin, and that the scholars of India stand mostly within their inherited religious traditions and are thus able to provide the foreign observer with insights which would otherwise be hardly won. Debate continues, on the subject of painting as of sculpture, as to the attribution of certain works to particular artists, dynasties and regional schools.

The works of art described in the entries which follow were produced over a period of more than four millennia, from 2500 BC until the last century. They are all grouped under the heading *Indian*, which refers to a cultural rather than to a political entity. The culture-area defined by the works which are described here on a modern map would cover eastern Afghanistan, Pakistan, Bharat (India) and Bangladesh. Reference is also made to the peripheral territories of *Nepal, *Tibet and *Sri Lanka (formerly Ceylon) to which separate sections are devoted.

T. S. MAXWELL

THE ART OF SOUTH-EAST ASIA

The region consists of the Philippines, North and South Vietnam, Cambodia, Laos, Thailand, Burma, Malaysia, Singapore and Indonesia. Lying as it does between the Indian sub-continent and China, where most of its peoples seem to have originated, it has been strongly influenced by both these major cultural zones. Nonetheless, the underlying cultures, the expressions of local genius, have never been wholly swamped, and it is their interaction with elements from abroad (later including those from the Middle East, Western Europe and, most recently, the USA) which has modified and adapted the region to produce characteristic local forms of a distinctive vitality and significance.

Although South-East Asia has produced evidence of early hominid occupation (*Meganthropus javanicus*, *Homo erectus*, *Homo modjokertensis*), its peripheral location on Eurasia probably explains the relatively late emergence of later stone cultures and the very delayed introduction of metal in the region. Once this took place, a striking and distinctive culture emerged, named after the type site, *Dong-Son, Thanh Hoa, North Vietnam. The earliest artifacts do not seem to be earlier than *c.* 200 BC, but the tradition persisted until the last century in some highland areas. Megalithic cultures seem to have existed side by side with the metal-using one, though much of the material is insecurely dated. The most notable complex is that of *Pasemah, South Sumatra; other concentrations of interest are the Plain of Jars, Laos and Sulawesi. Again, the artistic tradition has persisted, though sometimes wood replaces stone as the medium.

Towards the beginning of the Christian era the Chinese movement southwards from the Yangtze brought them to the frontiers of South-East Asia. At the same time disruption of the Central Asian trade routes led to an increase in maritime traffic between India and China. The two developments brought South-East Asia into much closer contact with those countries, and led to the introduction of Hinduism and Buddhism. Chinese campaigns brought about the annexation of parts of *Vietnam, an annexation which lasted for nine centuries. One area which broke away from Chinese domination was Lin-i, the precursor of *Champa. We also learn from Chinese historical sources of Funan (early 3rd century–?600) located in the Mekong Delta and at its height controlling most of the Gulf of Siam's littoral. It had a major commercial centre at Go Oc-eo. Its successor was *Chen-la from which the great *Khmer empire derived.

By about the 5th century AD Indian influence had made a significant impact on several of the coastal chieftainships of South-East Asia, to which a number of Buddha figures in *Amaravati and *Gupta styles testify. By the end of the next century, many more objects deriving from Indian styles are known (*Pnomh da, *Vat Ko). Within the next two centuries there was a marked growth of building in permanent materials in local styles: Sambhor Prei Kuk in Cambodia; Mi-Son and Tra-Kieu in South Vietnam; *Borobudur and *Prambanan in Java. In Java there was a remarkable growth of narrative bas-reliefs, depicting Hindu and Buddhist texts. By the 9th century Khmer art emerges in Cambodia to flourish for some four centuries. Scattered finds testify to high bronze-casting skill (*Chaiya), while the ability of stone-carvers to undertake large-scale works is demonstrated by statues from *Bakong, Cambodia, and *Banon and *Mendut, Java. In the area of the Menam Delta sculpture of a markedly eastern Indian style has been found, but there is also evidence for a flourishing school of genre work in terracotta. Eastern Indian influences are also apparent in *Burma.

In the 10th century, Java furnished a number of examples of fine metalwork: a bronze bell, a statue of *Dewi Shri as a rice goddess and a Manjushri in *Pala style, which some consider to be of Indian origin, from *Ngamplak Semongan. In Cambodia there are the cut-brick reliefs from Pravan and the ornate masterpiece of *Banteay Srei, while much of the finest *Cham art also dates from this century. It also marks the beginning of three centuries of buildings at *Pagan in Burma, where brick temples were covered with stucco and painting showed a major development. The next century saw the first stone temple in Cambodia, Takeo, far less exuberant than Banteay Srei or *Baphuon. Obviously the prototype for *Angkor Wat, its reliefs illustrate stories of Krishna. A giant bronze statue of Vishnu, only surviving in part, shows how much has been lost (*West Mebon). In Java, where the centre of power had shifted from the centre to the east, new shrines were built on Mount *Penanggungan, some of which are related to the site of Goa Gadjah in *Bali. The following century saw the building of Angkor Wat, whose low reliefs contrast sharply in their elegance with the cryptic figures from *Yeh Pulu, Bali. There are few survivals from Java, but the growth of sculpture is demonstrated by the examples from *Singasari and the magnificent Ganesha from *Bara, both contemporary with 13th-century *Angkor Thom. From this point Cambodian art appears to decline, the result perhaps of over-production and economic exhaustion. As Cambodia declined, Thailand advanced and the next two centuries saw the emergence of *Sukhodaya and Sawankalok as artistic centres.

Meanwhile, in Java the empire of *Madjapahit marked the final synthesis of native and Indian influences, particularly in the theomorphic figures of dead kings and narrative reliefs where the figures are in the so-called *wayang* style (*Djago, Djawi, Kidal, Panataran, *Surawana, Tulung Agung). Also notable is the art from the rather later Sukuh. When Madjapahit fell to a Muslim alliance towards the end of the 15th

century, there was a natural diminution in religious art, but such minor arts as batik, kris-making and puppetry began to occupy craftsmen. It was not until the end of the 19th century that there was a revival of painting, under Western influences, though in the island of Bali which Islam did not reach, this art had continued in traditional styles. Modern Balinese art is best known from examples which stem from a revival starting in Ubud in the 1930s. A somewhat similar artistic revival had begun in Cambodia in the beginning of the 20th century, while in the Philippines painting as a fine art showed a similar activity.

The course of events in Vietnam has been rather different, because the dominant influence was for so long Chinese. Here again, Western influence played a major part in the late 19th and 20th centuries, most notably in the growth of lacquer panel work. Since the end of World War II, in Vietnam as elsewhere in South-East Asia, artists have shown considerable interest in the development of new native styles, based on the old, but striving to express new national attitudes and aspirations.

<div align="right">ANTHONY CHRISTIE</div>

PRE-COLUMBIAN ART

Pre-Columbian art derives from that part of the Americas between Mexico in the northern hemisphere and Peru in the south, and belongs in time to the period before European contact which ended with the Spanish Conquest in the 16th century. During the Pre-Columbian period this immense region saw the rise and fall of a variety of impressive cultures and art styles, and when the invaders from the Old World arrived they were awestruck to discover the immensity and wealth of the New World civilisations. Unfortunately, Spanish colonialism brought about the destruction of these traditional cultures, and most of what we know today of their art and history has had to be reconstructed upon the basis of archeological evidence, which is by its very nature fragmentary and tends to be limited to imperishable materials such as pottery, stone and metal. Very little is known about the art of some areas owing to the unequal concentration of archeological investigations, and although all Pre-Columbian art is archeological in nature, it has regrettably not always been recovered by controlled archeological methods, and as a result it is sometimes difficult to establish more than a tentative time-scale.

The chronology of Pre-Columbian Mexico, Guatemala and Honduras, described collectively as Middle America, is divided into three stages: the Pre-Classic Period (2000 BC–AD 300), the Classic Period (AD 300–900) and the Post-Classic Period (AD 900–1519).

The beginning of the Pre-Classic Period was marked by the development of a farming economy carried on by village-dwellers with a stone technology. Early art forms included textiles and little pottery figurines like those found at *Tlatilco. By 1000 BC a typical feature of Middle American culture, the 'ceremonial centre', began to appear. These are elaborate complexes of stone pyramids, temples and palaces which have been found in various regions, the earliest being the important sites belonging to the *Olmec civilisation on the Gulf Coast.

During the Classic period a number of great civilisations developed in different parts of Middle America. In the Valley of Mexico the immense city of *Teotihuacan, which covered an area of almost 15 square miles, was the focus of an influential empire. To the east of Teotihuacan the *Vera Cruz culture was active on the Gulf Coast, and in the south-west the *Zapotec and *Mixtec peoples occupied Oaxaca. In Western Mexico the chronology of the various cultures is uncertain, although most of the varied pottery styles are thought to belong to the Classic Period. The outstanding Classic civilisation was that of the *Maya, whose achievements in art, architecture, mathematics and astronomy were unparalleled in Middle America. Numerous magnificent Maya sites have been uncovered in southern Mexico, Guatemala and Honduras, but the reasons for their apparently sudden and almost simultaneous decline at the end of the Classic Period are still the subject of conjecture.

The beginning of the Post-Classic Period was marked by upheaval in many areas although some of the Classic art styles persisted in modified form, and indeed *Huastec art did not reach its peak until this period. Mexico appears to have been overrun by invaders from the north, including the *Toltecs and *Aztecs, who introduced new and aggressive elements into Middle American culture. The Aztecs eventually achieved domination in the 14th century which they maintained until the Spanish Conquest in AD 1519.

In Central America, the area now called Nicaragua, Costa Rica and Panama, there has been so little archeological work that it is only possible to put forward approximate dates for the different cultures. However, the objects produced clearly indicate a high level of craftsmanship and artistic appreciation: cast gold ornaments from *Veraguas and *Chiriqui, *Guetar stonework, and painted *Coclé pottery are notable examples. Evidently Central America was an important crossroads for trade between the regions to the north and south in early times. Gold objects from Panama and Colombia have been found in the Maya area, pottery from Honduras appears in Nicaragua and it is clear that the people of Panama traded to Ecuador and possibly beyond.

Archeological work in South America has concentrated upon Peru with the result that the Pre-Columbian art and history of a very large area still requires investigation. Apart from the megalithic site of *San Agustín in Colombia there is so far little

evidence of great ceremonial centres outside Peru. Smaller stone carvings have been found in the *Manabí district of Ecuador, and the unusual 'zemi' stones attributed to the *Arawak of the West Indies are well known. The Spanish legend of 'El Dorado' stems from Colombia, which was an important centre for gold-working in ancient times, and the *Quimbaya and *Chibcha made distinctive gold jewellery. The most important art forms at present known from South America are the remarkable range of pottery styles recovered from tombs : curious figurines from *Valencia in Venezuela, *Tuncahuan and *Rio Napo wares in Ecuador, *Aguada, *Santa María, and *Belén funerary urns from Argentina, *Diaguita in Chile, and *Marajoara and Santarém in Brazil. A great deal still remains to be discovered concerning these fascinating works of art and the relationships between the different styles.

The Pre-Columbian history of Peru is marked by a profusion of remarkable cultures, each distinguished by a characteristic art style. Peruvian art is particularly noted for a great diversity of pottery styles, but textiles and objects made in stone, bone, shell, wood and metal are also important.

The earliest major styles are *Chavin in the north of Peru and *Paracas in the south. Paracas pottery exhibits distinct Chavin characteristics although the nature of the relationship between the two groups is not clear. Chavin was followed at the beginning of our Christian era by the civilisation of the Mochica, whose pottery is one of the unique achievements of early Peruvian art. The Mochica built their temples and palaces in adobe, or mud-brick. They also practised intensive agriculture, and skilled Mochica engineers constructed elaborate irrigation schemes which may still be seen today.

The Mochica in turn yielded to pressure from the *Tiahuanaco empire which expanded from highland Bolivia to the coast of Peru and also overwhelmed the *Nazca to the south. By AD 1000 Tiahuanaco culture began to give way to a revival of local developments, *Chimu in the north, and smaller cultures such as *Chancay in the south. Finally, during the 15th century *Inca domination extended to cover the entire Central Andean region from Ecuador to Chile, an area united neither before nor since. The achievements of the Inca empire were more spectacular in the fields of communications, engineering and architecture than in art, although textiles, pottery, stone-carvings and metalwork of a high standard were produced. Inca rule came to an end in AD 1532 when a Spanish adventurer named Pizarro, with less than 200 soldiers, succeeded in capturing the Lord Inca and holding him to ransom for the price of the empire. Peru became a colony of the Spanish Crown, and just as in Mexico, the traditional forms of art and culture were suppressed.

DALE IDIENS

NORTH AMERICAN INDIAN ART

The native arts of the North American continent are less well known than the products of the ancient civilisations of Mexico and Central and South America (see PRE-COLUMBIAN ART). Yet the diverse cultures of this immense land-mass have produced a wide variety of styles and forms which are of a high standard, both in terms of technical accomplishment and artistic conception, and which deserve more attention than they generally receive.

The dating of art objects from North America presents difficult problems owing to the uneven distribution of archeological investigations. In some areas it has been possible to arrive at a fairly well-defined cultural time-sequence, while in others it is at present only possible to speak in terms of very imprecise periods. Because traditional North American art and culture generally declined after European contact it is convenient to take this point and refer to pre- and post-European contact and prehistoric and post-historic periods. Of course European intrusion in North America occured at different times and in different places. The earliest settlements were established by the Spanish in New Mexico during the 16th century, and by the end of the 18th century Europeans had penetrated to almost every part of the continent. European cultural influences often travelled ahead of the white man's actual presence, and in many places the Indians had obtained white trade-goods from other tribes before making physical contact with the traders themselves.

North America consists of six broad cultural areas : the *Eskimo region comprising the Arctic coasts of North America and Greenland; the Pacific coast and off-shore islands between Alaska and Oregon, otherwise known as the *Northwest Coast; the *Plains area between the Rocky Mountains and the Mississippi; the Eastern United States and Canada; the *Southwest area which includes the arid plateau and desert zone of Arizona, New Mexico, Colorado and Utah; and *California. Some of these areas, such as the Northwest Coast and Plains, are characterised by relatively homogeneous art styles and the differences between objects produced by the individual tribes are so slight as to be negligible. But other areas, the *Southwest, and *Eastern United States and Canada for example, consist of a number of diverse styles.

An interesting feature is the tendency for each area to concentrate upon one or two specialised art forms. This is partly due to the effect of environmental factors in determining available materials. Although exotic trade materials appear in several cultures during pre-European times it is only in a few that there is

evidence of a widespread and sophisticated trade network.

The Eskimo succeeded in surviving under severe conditions with only a limited number of materials, of which the most important in pre-European times was ivory. The characteristic art of the Eskimo area is carving in walrus ivory, and a number of prehistoric sites indicate that this was an old-established tradition.

Woodcarving is the major Northwest Coast art, and the most famous single form in native North American art is probably the Northwest Coast totem pole. The poles, which were erected as memorials to important men and usually stood before the house of the dead man's family, were carved with family crests and narrative legends. They are probably a fairly late feature of Northwest Coast culture, and an influential factor in their development is thought to have been the introduction of iron tools by Europeans in the late 18th century which facilitated the carving of large sculptures.

The characteristic post-European art of the California region is basketry, but in prehistoric times some of the coastal tribes carved small and extremely lifelike stone sculptures of fish and other animals.

The nomadic bison-hunting culture of the Plains tribes developed its unique form during the 18th century as the result of two features introduced by white men, the horse and the gun. The bison provided the Plains Indian with nearly all his raw materials, and the distinctive art of this area consists mainly of painted and quilled decoration to hide and skin articles.

Apart from the masking tradition of the *Iroquois tribes, the most striking arts produced in the extensive region of the Eastern United States and Canada belong to the prehistoric period and consist of a number of diverse styles and an unusually wide range of materials. *Hopewell art, for example, employed sophisticated designs and a variety of exotic materials such as copper and mica, indicating the existence of a developed trade system. Carvings in wood and stone and pottery also appear in this region.

In the Southwest a similar variety of styles and forms is found. The early chronology of this area has been well defined upon the basis of tree-ring dating and the dry desert soil has ensured good archeological survival. In addition to outstanding artistic achievements, particularly in pottery and wall-painting, some of the Indian tribes of the Southwest developed a striking form of architecture. The *Pueblo villages and towns consisted of multi-storied apartment complexes built mainly from mud. Several are still standing and some continue to be inhabited today.

DALE IDIENS

AFRICAN ART

Within the context of this book African art means only certain two- and three-dimensional forms. Ancient Egypt and Roman North Africa are covered elsewhere but also a wide range of forms in wood, metal, pottery, textiles and so on, as well as architecture are excluded because in Europe we define them as 'decorative' rather than 'fine' art. By limiting our attention, therefore, to sculpture and the rock art of the Sahara and southern Africa we have selected those things which seem important to us. We cannot, however, assume that they are of equivalent importance in the cultures which made and used them, just as we cannot really understand a piece of African sculpture simply by the silent contemplation of it in a museum (delightful though this may be) but rather by first understanding something of the habitat, culture and society in which and for which it was made.

The history of African art as here defined, therefore, begins with the paintings and engravings on rock surfaces at various sites in the *Sahara. These appear to exhibit a continuous development through some 5000 years to the present century. Other examples of rock art occur in western and eastern Africa, and especially in southern Africa where they are presumed to be *Bushman work. Two-dimensional art, in the form of murals in houses and shrines, also occurs throughout much of Africa.

The earliest known sculptures are the pottery or terracotta heads and figurines of the *Nok culture of some 2000 years ago discovered in the central area of northern Nigeria. Later examples in terracotta include the heads and figures of *Ife (11th century) and of the *Sao culture, as well as figures recently discovered in Mali (probably 16th century) and the as yet undated Luzira figure from Uganda. Terracotta sculpture is equally widespread at the present day, and the unfired mud statuary of the *Edo and *Ibo peoples may represent a related tradition.

The Nok Culture also provides the earliest evidence of iron-working in sub-Saharan Africa. Iron follows directly upon stone without an intervening Bronze Age. When it does appear, bronze is almost exclusively for ceremonial use. The earliest evidence for this comes from the Ibo village of Igbo-Ukwu where cast bronze regalia and other ceremonial objects were discovered at a site of 9th-century date. They do not seem to be related in style, however, to the famous bronze castings of *Ife (11th century) or *Benin (15th–19th centuries). Benin is, of course, particularly interesting for the historian of African art as it is possible to correlate the vast corpus of works with oral tradition and the writings of European visitors over a period of more than 400 years.

Stone sculptures probably of the 16th century occur in Sierra Leone (the *nomoli figures) and among the *Bakongo. Large groups of stone statuary also occur at Ife where they are presumed to be older than the bronzes and terracottas, and at the Yoruba village

of *Esie and in the middle *Cross River area, although neither group can be certainly dated. Ivory was also being carved in the 16th century at Benin and among the *Sherbro.

The earliest wood sculptures are the portrait figures of *Bakuba kings from the 17th century onwards (assuming they are the originals), a *Yoruba divination tray (Ulm Museum) collected in the early 17th century and the ancestral figures carved by the *Ibibio-speaking Oron clan, the oldest of which could be late 18th century. Wood does not survive for long in Africa and most of the sculptures belong to the past hundred years, although it is reasonable to assume that they represent the tail end of traditions which are as ancient as any other. Nevertheless, some of the finest pieces known to us date only from the 1920s, for example the work of the famous Yoruba sculptor Areogun (? 1880–1954).

African sculpture is, of course, the work of individuals. Among some peoples woodcarving is essentially a self-taught spare-time activity at which anyone can try his hand. It brings a man no special status in his community. Elsewhere a woodcarver may have learned his art by apprenticeship to a master for some years. He will belong to a professional guild perhaps and will work more or less full time at his art. A fine carver is likely to be recognised as such in his community and his works may be well known over a relatively wide area. Metalworking, however, is almost everywhere a full-time occupation. Sculptors in wood and metal are always men whereas terracotta is usually produced by women except at Benin (and at Ife?) where it is the work of the bronze-casters. In addition to wood, metal and clay there are many less enduring sculptures in fabric, beads, basketry, feathers, leaves, wax and so on which are often *ad hoc* creations of a somewhat ephemeral nature. However, even wood sculptures are likely to be decorated and redecorated by their owners with beads, seeds, pieces of mirror, paint and so on such that an object can hardly be described as finished when it leaves the carver for it is then subject to a variety of subtle changes throughout its life (reflecting, perhaps, a greater interest in Africa in process rather than form).

It is often said there is no art for art's sake in Africa. A sculpture may indeed represent an ancestor, it may represent a god or (more often) one of its devotees, it may represent some impersonal magic force manipulated for curing the sick; but it may equally well serve as the ornament for a rich man's house. Masks serve to disguise someone who impersonates an ancestral or other spirit and yet within a masking society one often finds that while some masked figures have great ritual significance others are just entertainers.

African sculpture is broadly speaking concentrated around the two great river systems of sub-Saharan Africa, the Niger in West Africa and the Congo. Beyond the Congo basin, wood sculpture is found among the Bantu peoples of south-east Africa, and also in the north-east among, for example, the Bari of southern Sudan and the Konso of southern Ethiopia. In both cases the style is highly schematic. The Shilluk, also in the Sudan, have produced some terracotta sculpture, including at least one mask.

In west Africa, it is usual to distinguish two style regions, the Western Sudan and the Guinea Coast. The Western Sudan is the region of steppe and savanna between the Sahara and the coastal forests. Its sculpture tends towards geometric simplification and abstraction of forms, whereas Guinea Coast sculpture tends towards fuller and more naturalistic treatment. The Western Sudan has, of course, been dominated by Islam for more than a thousand years and it is sometimes suggested, though it has not been proved, that geometric forms may represent an accommodation to Islam on the part of those peoples who retained their pre-Islamic traditions. Another difference between the two regions is that in the Western Sudan woodcarving is largely produced by the blacksmiths, whereas in the Guinea Coast sculptures in wood and metal are usually executed by different craftsmen so that independent artistic traditions may appear to co-exist among one people.

The uneven distribution of sculpture in Africa needs some explanation. One obvious factor is the presence or absence in a particular area of the appropriate raw materials. Another factor would be the type of economy, whether agricultural or pastoral; people who are continually on the move with their livestock, carrying all their belongings with them, are unlikely to see the need for sculpture. Even among agricultural communities, however, there will be some for whom sculpture is unnecessary within the terms of their culture. In west Africa and the Congo there are peoples who produce no sculpture either because they do not need it or because they are satisfied with the work of neighbouring peoples. Finally it should not be assumed that because people have no sculpture they have no art. Sculpture is, after all, only one among many arts in Africa, including music and song, dancing and poetry and other forms of oral literature.

For the arts of the Western Sudan *see* BAMBARA, BOBO, DOGON, GURUNSI, KURUMBA, LOBI, MOSSI, NIGERIA-NORTHERN, and SENUFO. For the Guinea Coast *see* AFRO-PORTUGUESE IVORIES, ASHANTI, BAGA, BAMILEKE, BIJUGO, BAULE, DAN-NGERE, EDO, EKOI, FON, GURO, IBIBIO, IBO, IJO, MENDE, SHERBRO, and YORUBA. For the Congo basin and southern Africa *see* ASALAMPASU, AZANDE, BAJOKWE, BAKONGO, BAKOTA, BAKUBA, BAKWELE, BALEGA, BALUBA, BAMBOLE, BAPENDE, BAROTSE, BATEKE, BAPUNU, BAYAKA, BATETELA, DUALA, FANG, KUYU, MAKONDE, ZIMBABWE and ZULU; *see also* MADAGASCAR

JOHN PICTON

OCEANIC ART

The islands of the South Pacific were peopled by successive migrations of sea-faring folk moving eastwards from *Indonesia and, ultimately, from the Asian land-mass. Some evidence for the original relationship between Indonesia and Oceania is provided by the art styles of ancestor-worshipping peoples in Sumatra, Borneo and the Moluccas. On the basis of physical type and cultural similarities Oceania can be divided into four areas: *Australia, *Melanesia, *Polynesia and *Micronesia. The only generalisation that can usefully be applied to the area as a whole is that it is characterised by a great variety of environments, races, technologies, social systems and art styles.

The art of Oceania includes sculpture and painting and a host of decorative arts and crafts. Australian aborigines produced little sculpture but painted and engraved many types of surface – weapons, rock faces, trees, the ground and their own bodies – with geometric, naturalistic or magical-religious designs. In Melanesia sculpture might be painted or daubed with clay, shells, feathers, hair and fibre to enhance its theatrical effectiveness. The gable-ends of men's houses in the Maprik Hills area of New Guinea were decorated with gigantic paintings. Colours were obtained from earth pigments, lime, and charcoal or soot; yellow and red ochres were frequently so rare that they were bartered over hundreds of miles.

The sculptor can either build up his concept in clay or another pliable material, or cut down to it in wood, stone or ivory. Both methods appear in Oceanic art. Skulls from *New Guinea, *New Britain and the *New Hebrides were over-modelled with clay or vegetable paste. Complex pottery finials adorned the roof-tops of houses in the Middle *Sepik district of New Guinea. Masks of painted bark cloth were worn at ceremonies in the *Papuan Gulf and New Britain and grotesque tapa figures guarded the homes of *Easter islanders. Stone figures varying in size from the pendant Heitiki of *New Zealand to the colossal images of the *Marquesas islands, but always of monumental proportions, were shaped with a hammer-stone and bow-drill, and polished on boulders or with fine river sand. But it was in the shaping of wood for houses, furniture, weapons, masks and figures, and numerous other objects that Oceanic art excelled. The classic woodcarving tool was the elbow-hafted adze with a blade of polished stone or tridachua shell; today it is used with an imported steel blade. Finer work was carried out with stone flakes, sharp-edged shells, and shark or rat teeth.

The Oceanic artist was limited by his tools, by his materials, but most of all by his experience, his world view, which was a gift of the society in which he lived and was limited to that society. In some areas every man was an artist. In others it was the prerogative of certain specialists to carve or paint for the community. Among the Namau of the Papuan Gulf any man might attempt to decorate his own canoe or bark-belt, but he was more likely to call in a recognised expert at least to add the final touches. Only a man who had taken an enemy's head was entitled to make sacred carvings for use during Washkuk initiation ceremonies. In most cases these carvers were farmers and villagers like their neighbours; they would be well fed for as long as they worked and their chief reward lay in enhanced prestige. Only in parts of Polynesia were woodcarvers and stone-masons full-time professionals accorded the privileges of noble rank.

Most sculptures served a religious function, but were effective only if the carver adhered rigidly to traditionally prescribed forms. Thus, in *New Ireland the right to particular types of malanggan carving was vested in kin groups: each malanggan ceremony was the occasion for the carving of new images, and the work was scrutinised by the elders to ensure that their pattern was accurately reproduced. In such circumstances there was little scope for the artist to express new ideas.

In recent years anthropologists and art-historians have become increasingly interested in the role of the artist as a creative individual, and in the aesthetic response of particular societies towards their own art and artists. Two long-standing protagonists of this approach in the field of African art are Hans Himmelheber in his studies of Ivory Coast carvers, and William Fagg for the Yoruba of Nigeria. In a study of eight Asmat woodcarvers (Wow-Ipits) in south-west New Guinea, Doctor Adrian Gerbrands was able to relate the personality of each man to an individual style developed within the framework of traditional demands. Every Asmat village had its connoisseurs who could distinguish the work of one carver from that of another, and would praise some and criticise others.

In isolated parts of Melanesia and Australia it is still possible to study the creation and use of art objects in their proper social context. In Polynesia contact with Europeans in the early 19th century destroyed the social demand for religious sculpture, and the rarity of Polynesian carvings today attests to the efficiency of iconoclastic missionaries. The impersonal, fundamentally naturalistic qualities of Polynesian sculpture contrast with the dramatic polychrome effects achieved by many Melanesian styles. A few carvings, which predate more typical examples, may represent the existence of an earlier, more realistic art style in Melanesia. In New Zealand, too, a less ornate style seems to have preceded the rococo florescence of 19th-century Maori art. In this case both the great quantities of sculpture produced and their extravagant ornamentation seem directly attributable to the introduction of European iron tools.

CHARLES HUNT

CHINA

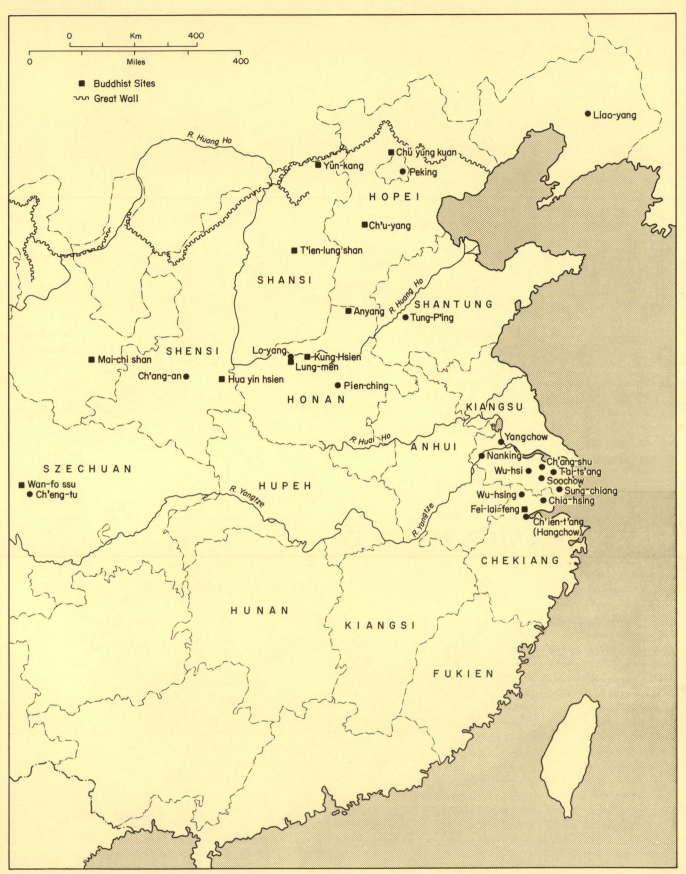

Km scale: 0 — 400
Miles scale: 0 — 400

■ Buddhist Sites
〜 Great Wall

R. Huang Ho

Liao-yang

Chü yung kuan
Yün-kang
Peking

HOPEI

Ch'u-yang

T'ien-lung'shan

SHANSI

R. Huang Ho

SHANTUNG

Anyang
Tung-P'ing

SHENSI

Lo-yang
Kung Hsien
Lung-men

Mai-chi shan

Ch'ang-an
Hua yin hsien

Pien-ching

HONAN

KIANGSU

R. Huai Ho

ANHUI

Yangchow

Nanking

Ch'ang-shu

SZECHUAN

Wu-hsi
T'ai-ts'ang
Soochow

Wan-fo ssu
Ch'eng-tu

HUPEH

R. Yangtze

Wu-hsing
Sung-chiang
Chia-hsing

Fei-lai-feng
Ch'ien-t'ang
(Hangchow)

R. Yangtze

CHEKIANG

HUNAN

KIANGSI

FUKIEN

THE ANCIENT NEAR EAST

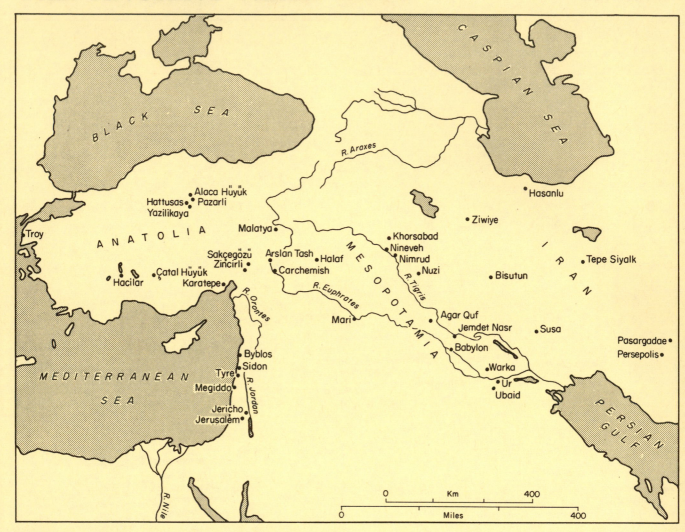

THE ISLAMIC WORLD

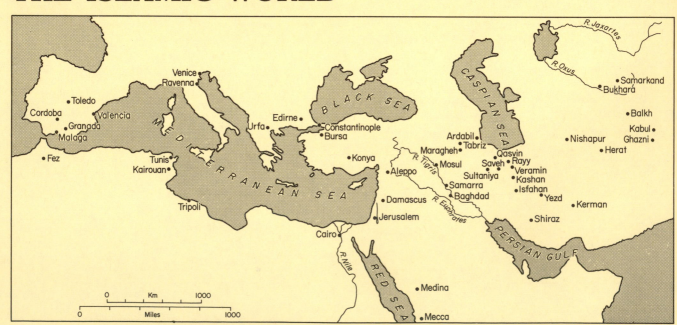

INDIA

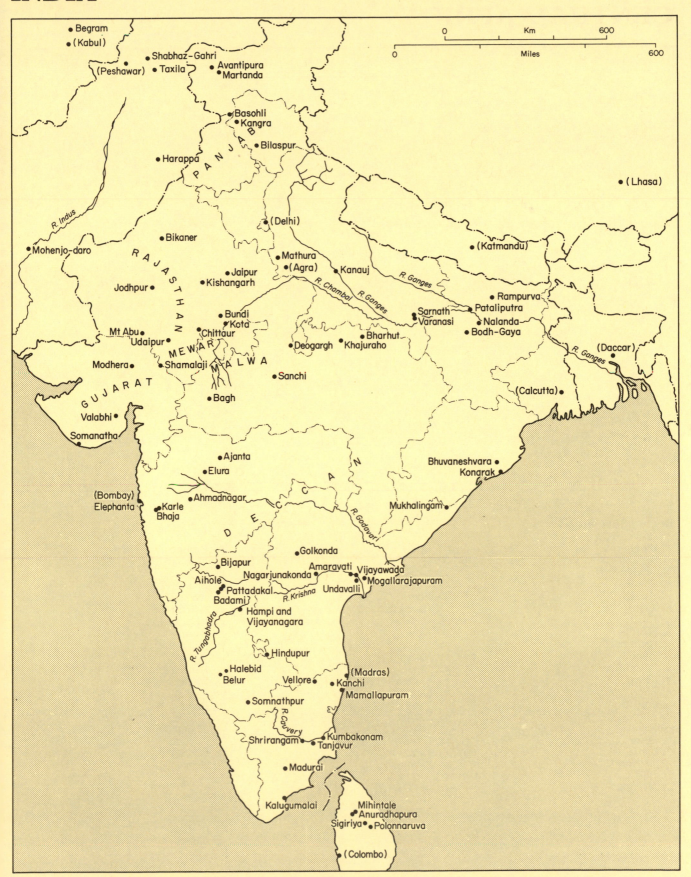

• Begram
• (Kabul)
• Shabhaz-Gahri
(Peshawar) • Taxila
• Avantipura
• Martanda
• Basohli
• Kangra
• Bilaspur
PANJAB
• Harappa
(Lhasa)
R. Indus
• (Delhi)
• Bikaner
(Katmandu)
• Mohenjo-daro
RAJASTHAN
• Mathura
• (Agra)
• Kanauj
R. Ganges
• Rampurva
• Pataliputra
• Sarnath
• Varanasi
• Nalanda
• Bodh-Gaya
• Jaipur
• Kishangarh
R. Chambal
R. Ganges
• Jodhpur
• Bundi
• Kota
Mt Abu • • Chittaur
• Udaipur
MEWAR
• Bharhut
• Deogargh • Khajuraho
(Daccar)
R. Ganges
• Modhera
MALWA
• Shamalaji
• Bagh
• Sanchi
(Calcutta)
GUJARAT
• Valabhi
• Somanatha
• Ajanta
• Elura
DECCAN
• Bhuvaneshvara
• Konarak
(Bombay)
Elephanta
• Ahmadnagar
• Karle
• Bhaja
• Mukhalingam
R. Godavari
• Golkonda
• Bijapur
• Amaravati
• Vijayawada
• Aihole
• Nagarjunakonda
• Mogallarajapuram
• Pattadakal
• Badami
R. Krishna
• Undavalli
• Hampi and
Vijayanagara
R. Tungabhadra
• Hindupur
• Halebid
• Belur
• Vellore
(Madras)
• Somnathpur
• Kanchi
• Mamallapuram
R. Cauvery
• Shrirangam
• Kumbakonam
• Tanjavur
• Madurai
• Kalugumalai
• Mihintale
• Anuradhapura
• Sigiriya • Polonnaruva
(Colombo)

63

WESTERN AND CENTRAL AFRICA

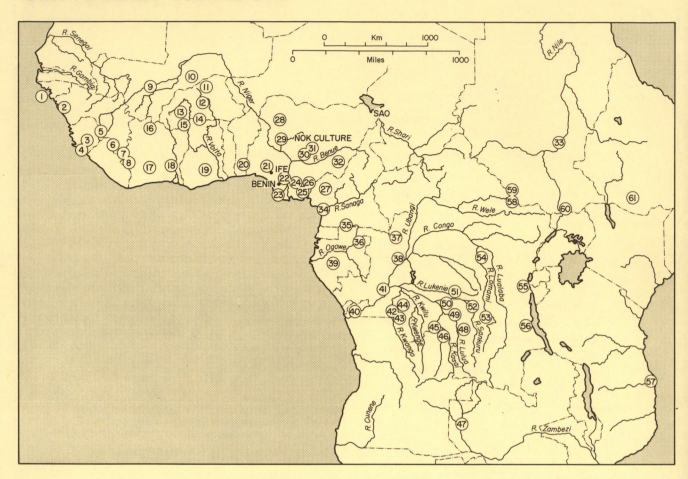

Key to tribal locations:

1. Bijugo
2. Baga
3. Mende
4. Sherbro
5. Kissi
6. Toma
7. Dan
8. Ngere
9. Bambara
10. Dogon
11. Kurumba
12. Mossi
13. Bobo
14. Gurunsi
15. Lobi
16. Senufo
17. Guro
18. Baule
19. Ashanti
20. Fon
21. Yoruba

22. Edo
23. Ijo
24. Ibo
25. Ibibio
26. Ekoi
27. Bamileke
28. Dakakari
29. Nupe
30. Afo
31. Mama
32. Chamba
33. Shilluk
34. Duala
35. Fang
36. Bakota
37. Bakwele
38. Kuyu
39. Bapunu
40. Bakongo
41. Bateke
42. Bayaka

43. Basuku
44. Bambala
45. Bapende
46. Bajokwe
47. Barotse
48. Aslampasu
49. Bena Lulua
50. Bakuba
51. Ndengese
52. Batetela
53. Basonge
54. Bambole
55. Balega
56. Baluba
57. Makonde
58. Mangbetu
59. Azande
60. Bari
61. Konso

A

AACHEN, Hans von (1552–1615)

b. Cologne d. Prague. German painter, known mainly for his vivid, quicksilver interpretations of mythological or allegorical subjects. He also produced portraits and religious pieces. Although trained in the Netherlands his formative influence came during a visit to Venice and Rome (1574/88), when he developed a *Mannerist ability to pastiche the *Antique in a svelte, elongated (and highly personal) figure style (eg *The Victory of Truth*, signed and dated 1598, AP, Munich).

 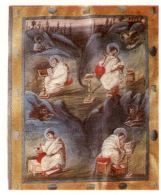

Left: HANS VON AACHEN *The Victory of Truth*. 1598. 22½×18½ in (56×47 cm). AP, Munich
Right: AACHEN CATHEDRAL TREASURY, Carolingian Gospel Book. *The Evangelists*. c. 759–810

AACHEN CATHEDRAL TREASURY, Carolingian Gospel Book

One of a fine group of manuscripts made c. 759–810 for use at the Carolingian court, and known collectively as the New Palace School. Several artists may have been involved, and they all make use of illusionistic landscapes and details of classical architecture, which suggests that the †Early Christian models from which they worked contained some late antique features.

AALTONEN, Waino (1894–1966)

b. Kaarina, Finland. Self-taught sculptor whose work embodies the strong nationalist feeling in Finland between the wars. He revived the practice of direct carving in stone, and his granite figures combine the Neo-classical Finnish tradition with a new feeling for truth to material.

ABBASID PAINTING

Abbasid painting is represented by the wall-paintings found during the excavation of Samarra in Iraq, the Abbasid royal capital, founded in 836. The paintings of Samarra owe more to the pre-Islamic traditions of Iran than to classical traditions. This Iranian influence reflects the eastward shift of power in Islam under the Abbasid Caliphate. The paintings at Samarra are characterised by the symmetry of their compositions, the frontality and the formal rigidity of the figures, and the absence of a recessive space. All of these features are found in a scene of female dancers pouring wine from bottles into cups held in their hands, an illustration of a royal pastime, found in a private apartment at Samarra. Upon wine-jars there appear figures which include monks, once more shown with a severe frontality. Fragments found at Nishapur in eastern Persia, at Fustat in Egypt and in the ceiling decoration of the Capella Palatina in *Palermo, Sicily suggest that the Orientalising nature of painting at Samarra continued later elsewhere, and that the style was peculiar neither to Samarra nor to Abbasid art.

GIUSEPPE ABBATI *The Cloister*. c. 1862. 7¾×9¾ in (19·7×24·8 cm). Galleria d'Arte Moderna, Florence

ABBATE, Niccolò dell' (1512–71)

b. Modena d. Paris. Italian painter who worked in Modena and Bologna until his departure for France where, from 1552, he assisted *Primaticcio at *Fontainebleau. There his frescoes of triumphal progresses and landscapes introduced a *Mannerist style which was new to France. His best frescoes are in Bologna and present a vivid record of fashionable life.

ABBATI, Giuseppe (1836–68)

b. Naples d. Florence. Italian painter, a student of Grigoletti in Venice. By 1860 was working in Florence. He was a member of the *Macchiaioli group. His precisely observed but broadly painted pictures of everyday life show an interest in tonality and the relationships of formal shapes.

ABBEY, Edwin Austin (1852–1911)

b. Philadelphia d. London. American illustrator and painter who studied at Pennsylvania Academy and went to England in

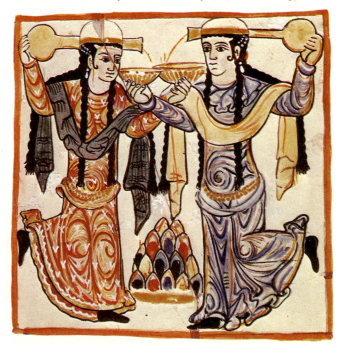

ABBASID PAINTING *Two Dancing Girls*. Reconstruction by Ernst Herzfeld of wall-painting at the Jausak Palace, Samarra

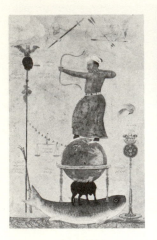
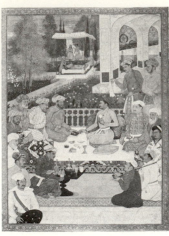

Left: ABU'L-HASAN *Jahangir shooting at the severed head of Malik Ambar.* Chester Beatty Collection, Dublin
Right: BICHITTAR *Young Prince in a Garden with Sages.* $11\frac{1}{8} \times 8$ in (28×20·2 cm). Jahangir Album 7, Chester Beatty Collection, Dublin

1878. A master of delicate, graceful, pen line, with instinctive imaginative grasp of England's past, he is best known for illustrations for Shakespeare, Herrick, and Goldsmith's *She Stoops To Conquer.*

ABBOT, John White (1763–after 1827)

b. Exeter. English landscapist. A disciple of Francis *Towne, he also produced 'tinted' drawings with flat washes over a pen and ink outline.

ABD AL-BAQI TABRIZI (d. 1630)

The famous Islamic scholar and calligrapher of the Safavid period. He was a master of Thulth, *Naskhi, Riqa and *Nasta'liq. He spent most of his life in Baghdad. Shah Abbas called him to Isfahan to write the inscriptions on the Masjid-i Jami' which still survive.

ABD AL-MAJID TALEQANI (d. 1771)

b. Taleqan. Islamic calligrapher who started with the *Nasta'liq script but later became the master in *Shikasta Nasta'liq. He spent most of his life in Isfahan. He perfected the rules of Shikasta and succeeded in writing this script in various sizes.

ABELAM *see* SEPIK RIVER

ABHAYA *see* MUDRA

ABILGAARD, Nicolai Abraham (1743–1809)

b. Copenhagen d. Frederiksdal. Danish †Neo-classical artist, who became Professor of the Danish Academy after studying in Rome, Pompeii and Paris. As crown *history painter, he decorated Christiansborg Castle (1780–91; burnt 1794). He then turned to architecture, sculpted small bronzes and wrote theoretical studies.

ABRAMTSEVO COLONY

An artists' colony established on the Russian railway tycoon, Savva Mamontov's estate near Moscow in the 1870s. The most progressive personalities of various fields of art, among them *Levitan, met and worked there, encouraging the survival of traditional crafts and challenging the St Petersburg Academy, founded in 1754, for control of artistic life.

ABSORBENT GROUND *see* GROUND

ABSTRACT ART, ABSTRACTION *see* introductory essay 20TH-CENTURY ART

ABSTRACT EXPRESSIONISM

By far the most important artistic movement of the late 1940s and 1950s. The term was coined by the American critic, Greenberg. It is sometimes confined to American painting, but can include the parallel movement in Europe (also called 'lyrical abstraction'). Whereas inter-war abstract painting was primarily rationalist, Abstract Expressionism combined its quest for universality with the *Surrealist aim of liberating the unconscious, particularly via direct 'automatic' improvisation. The formal relationships between different parts of a painting became irrelevant: the painting *as a whole* became concrete evidence of the state of the painter's soul while he was painting it. The classic Abstract Expressionist works are *Pollock's 'drip' paintings from 1947 onwards, executed in a trance-like state, and more comparable in certain respects to choreography of a ritual dance than to painting as previously understood. Other leading 'gestural' painters are the Americans, *De Kooning, *Kline, *Tobey, *Motherwell, *Francis, and the Europeans, *Wols, *Hartung, *Mathieu and *Sonderborg. Also Abstract Expressionist are the colour-field painters *Newman, *Rothko and *Still, whose vast canvases justaposing simple colour areas evoke the infinite and the sublime. Immense scale, also used by many 'gestural' painters, gave the artist a space *within* which he could act, and overwhelmed the spectator, thus freeing him from other concerns. Abstract Expressionism was a heroic assertion of the value of the individual creative act, and had affinities with Existentialist philosophy. The movement found supporters throughout the world and many separate groups were formed based on Abstract Expressionist principles, eg the Canadian Refus Global and Painters Eleven.

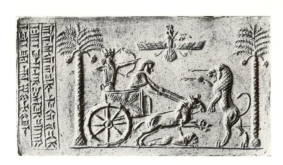

ACHAEMENIAN ART Cylinder-seal impression, showing King Darius in his chariot hunting lions. BM, London

ABSTRACTION-CREATION

Group of artists, founded 1931 in Paris, at one time numbering four hundred members. It published an annual (1932–6) and acted as a nucleus for all major abstract artistic activity in the 1930s. Thoroughly international and diversified, it combined Dutch *Neo-Plasticism, Russian *Constructivism, the *Bauhaus, *Kandinsky's mysticism and *Arp's biomorphism. The only French members of any importance were *Hélion and *Herbin.

ABU *see* CHAULUKYA DYNASTY

ABU'L-HASAN and BICHITTAR

Two artists at the court of *Jahangir (1605–27) who were especially distinguished in the symbolic representation of Jahangir's dreams: Jahangir in an imaginary banquet with Shah Abbas of Persia; embracing the same monarch; seated on an hour-glass table accepting a Shaykh's gift while rejecting those of the kings of the world (including James VI); receiving the orb of universal dominion from a Shaykh; holding the orb; reviewing a vast army; discharging an arrow at the severed head of his Deccan enemy Malik Ambar. Jahangir's nimbate figure always dominates the scene, and much of the symbolism derives from Europe.

ABYDOS

One of the great religious centres of Egypt, the legendary burial-place of the god Osiris and site of the tombs of the earliest kings. Most notable of the surviving monuments are the great temple of *Sety I, his neighbouring cenotaph (the so-called Osireion), and the ruined temple of *Ramesses II.

ACADEMIE ROYALE (DE PEINTURE ET DE SCULPTURE)

Founded in 1648, on Italian models, the Académie Royale was merged in 1651 with the artists' guild organisation (Académie de St Luc). This was a necessary step towards the dominant position it achieved in Louis XIV's reign, when artists were trained there to carry out the royal artistic programmes planned by the Académie's protector (Colbert) and its Director (*Lebrun). A branch academy was established in Rome in 1666, and from 1667 the Académie Royale held annual exhibitions, which evolved into salons in the 18th century. Theoretical questions were discussed and its members were arranged in a hierarchy corresponding to the type of picture they specialised in. The Académie was dissolved at the Revolution.

ACADEMY

Name adopted by groups of 15th-century Italian humanists in emulation of Plato's Athenian Academy. During the 16th century, artistic academies were founded in an attempt to free artists from the structure of the *guilds and to achieve recognition of painting and sculpture as liberal arts. In both these aims *Leonardo and *Michelangelo were precursors, Leonardo's insistence that painters should learn theory as well as technique becoming a basic precept in academies. The first official academy was the Accademia del Disegno, founded in Florence by *Vasari in 1563 with Duke Cosimo de' Medici. Teaching was both theoretical and practical and dilettanti were allowed to join classes. Although it superseded the Florentine guilds in importance it failed to realise its ideals. Cardinal Borrommeo instigated the Academy of St Luke (1593) in Rome with Federigo *Zuccari as President. Imbued with Counter-Reformation zeal, the Roman academy put much emphasis on theory and debate. The rest of Italy remained under the guild system for much longer, although by the 17th century many private academies for life classes were founded throughout Italy; the most famous being the *Carraccis' Accademia degli Incamminati in Bologna. A private academy was founded in Haarlem by van *Mander (c. 1600) emulating the Italian academies. The Académie de France in Rome was an offshoot of the *Académie Royale and brought the influence of the French academies to bear on the Italian system. The earliest British academies were studios with a master and pupils (Sir Godfrey *Kneller's was the first) and until the foundation of the *Royal Academy were private establishments. In the 17th and 18th centuries academies sprang up throughout Europe and later in the USA. After the mid-18th century they began to fragment, archaeology becoming a separate category with its own institutions. Academies offered a complete education based on classical standards. Reaction in the 19th century began in Germany and within fifty years Academicism stood for a tradition of outmoded art teaching and for a style of painting outside the current of the times.

ACHAEMENIAN ART

The Achaemenids ruled Iran and the Near East 550–330 BC. Their empire stretched from the Nile to the Indus and from the Oxus to the Bosporus. Their art did not evolve autochthonously but was a synthesis of styles of other regions: this is described in the foundation inscription of a palace at *Susa: 'the stoneworkers were Ionians and Sardians, the goldsmiths were Medes and Egyptians, the carpenters were Sardians and Egyptians, those who made the baked bricks were Babylonians, those who decorated the walls were Medes and Egyptians'. Despite this eclecticism it does have a distinctive character of its own which was the same throughout the empire perhaps because the style was patronised by the Achaemenid court. There is no art for art's sake; most of the reliefs are subservient to the architecture as at *Pasargadae, *Susa, *Naqsh-i Rustam and *Persepolis, and sculpture in the round is rare. Apart from this architectural art the Achaemenians were fine jewellers. Especially handsome are the armlets, torques and bracelets made of gold and often inlaid with coloured stones and ending in animal heads such as those from the *Oxus treasure. *See also* BISUTUN

ACHILLES PAINTER (active 460/430 BC)

Athenian *red-figure vase painter, a pupil of the *Berlin Painter, he also produced white-ground *lekythoi. He often showed two figures on the main side, and one on the back of the vase. His style is marked by a broad profile head, a strong straight nose and deeply penetrating eyes. His figures have much of the nobility of *Pheidian sculpture.

 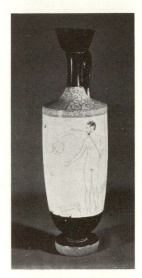

Left: ABU'L-HASAN *Jahangir's Dream of Shah Abbas I's Visit.* 1618–19. 9½×6 in (24×15·3 cm). Freer Gallery of Art, Washington, D.C.
Right: ACHILLES PAINTER White-ground lekythos showing a woman handing a soldier his helmet. c. 440 BC. h. 15½ in (39 cm). BM, London

ACID

A corrosive fluid used in etching to bite an image into a metal plate by dissolving away exposed metal. *See also* ENGRAVING

ACRYLIC RESIN

A synthetic polymer resin-like substance used in making water-based emulsion paints.

ACTION PAINTING

Term first used by American critic Rosenberg describing post-1947 painting method of *Pollock and those who followed him, whereby the canvas, instead of being merely a surface on which a picture was painted, became a field 'in which the painter could act' and on which were visible the marks of his physical movements. Now more usually referred to under *Abstract Expressionism.

ADAMS, Herbert (1858–1945)

b. West Concord, Vermont d. New York. Sculptor who studied in Massachusetts, and Paris at Ecole des Beaux-Arts with Mercie (c. 1885–90); visited Italy and Paris (1898); taught at Pratt Institute. Although fame brought him monumental commissions, Adams excelled in his French-influenced portraits, from his early, graceful, animated women to later, bolder works.

ADAMS, Wayman (1883–1959)

b. Muncie, Indiana d. Austin, Texas. Painter who studied at John Herron Art Institute (1905–9), with *Chase in Italy (1910) and *Henri in Spain (1912). Primarily a popular portraitist, Adams painted in a fluently †Impressionist style that owes a large debt to *Sargent.

ADENA see EASTERN UNITED STATES AND CANADA

ADLER, Jankel (1895–1949)

b. Tuszyn, Poland. Painter who trained at the Düsseldorf Academy (1911–14) and first exhibited in Warsaw and Lodz about 1920. During World War II he lived in Britain gaining an international reputation by 1943. Influenced by *Cubist composition, Adler's figure-paintings possess an underlying sense of tragedy.

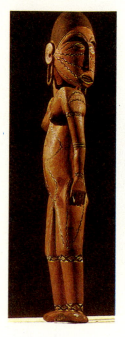 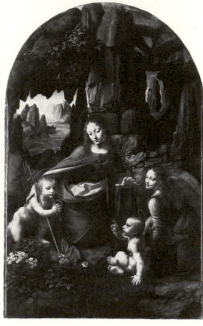

Left: ADMIRALTY ISLANDS Ancestor figure. Early 20th century. Wood. h. 23¾ in (60 cm). Museum für Völkekunde, Munich
Right: AERIAL PERSPECTIVE *The Virgin of the Rocks* by Leonardo da Vinci. *c.* 1507. Oil on panel. 74⅝×47¼ in (189×120 cm). NG, London

ADMIRALTY ISLANDS

The inhabitants of this *Melanesian island group are divided into coastal fishermen and inland farmers. The fishermen produced no carvings but obtained them through trade with inland folk. Large human figures, painted red, white and black, and distinguished by a high headdress ending in a topknot, were used in ancestor ceremonies. Smaller figures adorn the handles of lime spatulae. War charms kept as heirlooms within a family consist of a carved wood head with a train of long frigate bird feathers. Best-known carvings are great wood bowls up to seven feet in diameter and fitted with mortised handles carved with openwork spirals.

AEGINA, Temple of Aphaia

The temple has two sculpted pediments. The west (*c.* 510 BC) is late *Archaic, and the east (*c.* 490 BC) is early *Severe style. In the west the figures are skilfully rendered with much detail and the bodies in a variety of poses, but with the Archaic 'smile' still lingering. In the east the figures are fuller and have assumed a more serious expression. Their bodies are treated with greater anatomical understanding.

AEKEN, Jerome van see BOSCH, Hieronymous

AELST, Willem van (1625/6–1683)

b. Delft d. Amsterdam. Dutch still-life painter of fish, game and other objects connected with shooting. He visited France (1649) and Italy (1656), where he worked for the Grand Duke of Tuscany. His pictures were much admired in his day.

AERIAL PERSPECTIVE

The effect of distance in a painting implying the thickening of atmosphere. The more distant the colours, the paler and bluer they become.

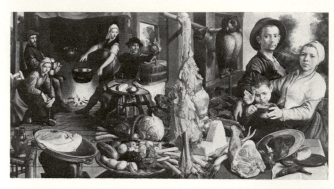

PIETER AERTZEN *A Kitchen Scene.* Copenhagen Museum

AERTZ, Pieter see AERTZEN

AERTZEN (AERTZ), Pieter (1508–75)

b. d. Amsterdam. Netherlandish painter principally of genre scenes in which robustly treated still-life detail plays a large part. Guild member in Antwerp (1535), citizen in Amsterdam (1563). Some religious work remains although much (according to van *Mander) was destroyed. In these works, the narrative part of the picture is often pointedly submerged in a hectic scene of busy figures. His pupil, Joachim *Beuckelaer, produced paintings often difficult to distinguish from those of his master.

AESTHETIC MOVEMENT

A culmination of the decorative tendencies in English painting of the 1860s. Applicable to painting, graphics and the applied arts, and to be seen generally in a preference for pale, clear colours and sinuous forms, for the evocative, and for an avoidance of the anecdotal or didactic. Influenced by the writings of *Gautier and *Baudelaire, later by *Pater, *Whistler and Wilde. Crystallised in the opening of the *Grosvenor Gallery in London in 1877, when admiration for works by Albert Moore, Whistler and particularly *Burne-Jones began a cult for affecting a heightened artistic awareness that was mercilessly satirised in a philistine press.

AESTHETIC MOVEMENT *Affiliating an Aesthete* by Du Maurier. Published in *Punch*, June 1880

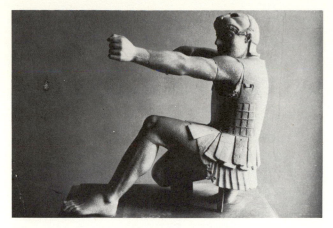

AEGINA Temple of Aphaia. Figure of Herakles from east pediment. c. 490 BC. Marble. h. 29 in (73·7 cm). Antikensammlungen, Munich

AFO see **NIGERIA, NORTHERN**

AFRICAN ROCK ART see **BUSHMAN; SAHARA**

AFRICAN SCULPTURE see introductory essay and cross references therein

AFRO, Basaldella (1912–)

b. Udine. Italian painter whose early work was still-life. In the 1940s he began to simplify his imagery and to introduce an element of abstraction. In 1950 he visited America, where the influences of *Miró and *Gorky led to his mature abstract work. He uses vivid colour and strong 'gestural' marks in large compositions.

Left: AFRO-PORTUGUESE IVORIES Salt-cellar carved by a Sherbro craftsman for the Portuguese. 16th century. Ivory. h. about 8 in (20 cm). BM, London
Right: AFRO-PORTUGUESE IVORIES Salt-cellar carved at Benin for the Portuguese. 16th century. Ivory. h. 11¾ in (30 cm). BM, London

AFRO-PORTUGUESE IVORIES

A group of about a hundred objects in a hybrid style clearly the work of African craftsmen after European models. They include elaborate salt-cellars, hunting-horns, spoons and forks of essentially 16th-century form. Some are probably the work of *Benin sculptors, but most are in a style resembling

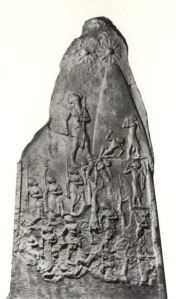
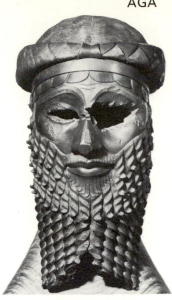

Left: AGADE Stele of Naram-Sin. c. 2300 BC. Red sandstone. h. 78¾ in (200 cm). Louvre
Right: AGADE Copper head from Nineveh. c. 2350–2150 BC. h. 14¾ in (36·6 cm). Iraq Museum, Baghdad

the *nomoli figures of Sierra Leone and were probably the work of *Sherbro carvers.

AGADE

The art of the Agade dynasty, Semitic rulers of southern Mesopotamia (c. 2370–2250 BC), shows a gradual departure from Sumerian rigidity in relief and portrait-sculpture. The Stele of Naram-Sin commemorates the victory of Naram-Sin over a mountain tribe on his eastern borders. It departs from the Early Dynastic convention in using the whole space in a more realistic manner, although the wooded mountainside is still formally depicted, and the whole scene is dominated by the king, wearing the horns of divinity on his head. By contrast with the Stele of the Vultures (*LAGASH) the king rather than the god is the predominant figure. Also from this period comes a head in copper, cast by the *cire perdue process and finished by chasing. The eyes were originally inlaid with semi-precious stone. Though stylised, it shows much greater vigour and realism than any preceding work. Often said to represent Sargon I, it is more probably a later member of his dynasty.

YAACOV AGAM Moods. 1971. Brass. Galerie Denise René, Paris

AGAM, Yaacov (1928–)

b. Israel. *Kinetic artist who studied at Bezalel Academy, Jerusalem, travelled extensively in Europe and lectured in America. Has interpreted 'time and reality' in terms of movement, producing work which breaks with an art of static relationships by developing in the art object a facility for indeterminate movement.

AGASIAS, SON OF DOSITHEOS (active 1st century BC)

Greek sculptor from Ephesos who signed the *Borghese Warrior* in the Louvre.

AGASSE, Jacques Laurent (1767–1849)

b. Geneva d. London. Swiss animal painter, *David's pupil in Paris (1787). Coming to London in 1800, he exhibited thirty works at the *Royal Academy (1800–45), branching out into animal portraiture, and historical subjects which included animals. Widely engraved and lithographed.

AGATHARCHOS OF SAMOS (active 5th century BC)

Greek painter renowned for his theatrical stage sets. He painted scenery for a play of Aeschylus and wrote a book about scene-painting. He also painted the house of Alcibiades (c. 430 BC). He was the first to make large-scale use of perspective.

AGELADAS (active end of 6th century BC)

Greek sculptor from Argos, said to be the master of *Myron, *Polykleitos and *Pheidias. His works include statues of athletes at Olympia executed between 520 and 507 BC. His most famous work was a bronze statue for the sanctuary of Zeus at Ithome commissioned by the Messenians. It appears on the coins of Messene.

AGGREGATE see CONCRETE

AGHT'AMAR CHURCH, Lake Van. Relief of King Gagik with a model of the church

AGHT'AMAR CHURCH, Lake Van

Armenian Church of the Holy Cross built as part of the palace of King Gagik (915–21) on a small island (now Ahtamar in East Turkey). The stone church, a central plan with a pyramidal dome, was intended to impress all visitors (including Muslims who would not be allowed inside) by its complete exterior covering of relief sculptures representing the Christian Paradise. See also CAUCASIAN ART

AGNOLO, Andrea d' see SARTO

AGORAKRITOS (active late 5th century BC)

Greek sculptor from Paros and pupil of *Pheidias. He is said to have sold the statue of Aphrodite, which he had unsuccessfully entered in a competition, to the people of Rhamnous, who used it as a statue of Nemesis. A fragment of a head corresponding to *Pausanias's description of it was found at Rhamnous and is now in the British Museum.

AGOSTINO DI DUCCIO (1418–81)

b. Florence. Florentine sculptor and architect, his early style was influenced by the Sienese Jacopo della *Quercia. In 1446 he may have collaborated with Bartolommeo *Buon in Venice. Agostino's Tempio Malatestiano reliefs in Rimini (1450–7) are his major work. He was in Perugia from 1457 (façade of

S. Bernardino Oratory), and 1462–73 in Florence. His mature style, characterised by graceful, lively lines, reflects his interest in antique reliefs.

AGUADA

Argentine culture, c. AD 600–1000, featuring painted and incised pottery decorated with feline motifs and human and animal figures, and distinctive copper plaques cast with feline and human figures in relief.

AGUCCHI, Giovanni Battista (1570–1632)

Italian dilettante and theorist. He wrote a treatise on painting between 1606 and 1615 (unpublished at the time but known to *Bellori), in which he expounded afresh the classical theory that artists should select only the most beautiful parts from an imperfect nature.

AIHOLE see CHALUKYA DYNASTY

AIRBRUSH

A mechanical paint-spray by which paint can be applied in a fine mist. This makes it possible to blend, mix and overspray paint in very fine gradations and mixtures of tone and colour.

AITCHISON, Craigie (1926–)

b. Edinburgh. Studied law until he began to paint in 1951. His style is intensely personal, a poetic vision painted with gentle linearity. Although he employs an essentially flat picture plane, his soft and luminous colour produces a feeling of deep space and felt silence.

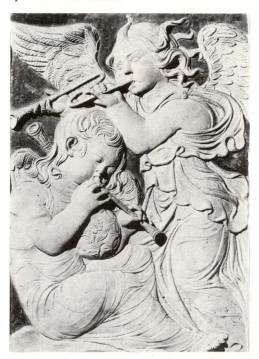

AGOSTINO DI DUCCIO *Putti blowing trumpets*. 1450–7. Relief from the Tempio Malatesta, Rimini

AIRBRUSH

AJANTA PAINTING (2nd–6th centuries AD)

The Buddhist caves at Ajantā in the North Indian Deccan are famous for the large-scale tempera murals to be found in most of the caves. The lives of the Buddha are depicted in friezes on the walls, while the ceilings are decorated with flowers and animals. A limited palette was used – red and yellow ochre, terra verde, lampblack and white of lime. The murals are characterised by naturalism, sensitivity of treatment, rhythmic composition and soft, curving lines. Perspective in the Western sense is not known, but a three-dimensional effect is achieved in most cases.

Left: AJANTA PAINTING Lustration of a Prince. Part of the Mahajanaka Jataka. Cave 1, Ajantā
Left: AKBAR Hanuman carries the mountain of healing herbs. From the Ramayana painted by Zayn al-Abidin. 1598–9. 10¼×5⅜ in (26·2×13·7 cm). Freer Gallery of Art, Washington, D.C.

AKBAR (1556–1605)

The Mughal emperor at Delhi, Agra and Lahore was a great patron of painting. His Indian artists, trained on the *Hamza-nama*, worked on three classes of books: (a) story-book narratives and fables such as the SOAS *Anwar-i Suhayli* (1570), the Cleveland *Tuti-nama*, *Diwans* of Hafiz and Anwari, *khamsa* of Amir Khusrau; all these have naturalistic animals and trees, but human figures are stiff. Later works show the influence of Europe, brought through the Jesuit missions (eg of 1580), such as the Bodleian *Baharistan* of Jami: a greater expression of depth, Europeanised clothing and attitudes, use of a landscape or distant city as background, and competent chiaroscuro; (b) histories of Akbar's forebears, such as the *Tarikh-i Alfi*, or the Tehran *Jami al-tawarikh*, history of Genghis Khan's line, more Persian in style; the *Babur-nama*, a history of his grandfather, of which several versions are known; and especially of his own time and the events of his reign in the *Akbar-nama* (V & A, London) – battles, hunts, scenes of court and camp; (c) translations of the Hindu classics *Ramayana* and *Mahabharata* (Persian title *Razm-nama*), both at Jaipur; the Chester Beatty *Jog-Bashisht*; in these there is little trace of the ideals of pre-*Mughal Hindu religious painting, although the gods appear in the conventional colours and wear Hindu-style coronets. Most of Akbar's painters are known by name; but regularly a single painting might be the work of two, three or even four artists, responsible for outline, composition, portrait detail, costume.

AKHENATEN (Amenhotpe IV)

Egyptian king of the late 18th dynasty, the central figure of the *Amarna period, who changed his name from Amen-hotpe (Amenophis), and moved the royal residence to a new city at Akhetaten, the present (Tell) el-Amarna. His strange

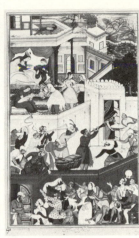

Left: AKBAR The Dervish wondering at the Divine Mercy. Folio 36 of the Anwar-i-Suhayli album, 1570. School of Oriental and African Studies. London
Right: AKBAR-NAMA The Birth of Prince Salim painted by Chatar and Keshav. c. 1602. 15⅜×9 in (39×23 cm) V & A, London

appearance in many representations cannot be taken as evidence that he was deformed, since in early reliefs he is depicted as normal; the rather grotesque exaggeration of certain features, notably the full hips and protruding belly, is clearly conventional, and seems to symbolise the king's close connection with the life-giving Aten.

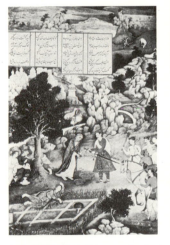
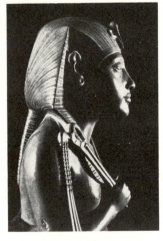

Left: AKBAR A Prince submits to Justice having accidentally killed a shepherd boy. Anonymous illustration to Amin Khusrau's Matla al-anwar. 1595–1600. 9¾×6¼ in (28·7×15·8 cm). MM, New York
Right: AKHENATEN Portrait-sculpture of the King, originally part of a group with Queen Nefertiti. 1364–1347 BC. Steatite. h. 24 in (61 cm). Louvre

ALABASTER

A soft, easily worked translucent *marble. It is easily stained with colours.

ALACA HUYUK

Central *Anatolian site with remains from several periods but noted chiefly for thirteen royal tombs of the Early Bronze Age, representing the Hattian, or pre-Hittite, non-Indo-European population of Anatolia. In addition to weapons, vessels and jewellery in gold and silver, the tombs contained a number of magnificent solid-cast bronze stags and bulls and a collection of openwork discs or grills, some incorporating animal figures. Thought to have been mounted on staffs, these so-called

'standards' probably formed finials for canopy or baldachin supports. The animal figures, large and often plated or inlaid with precious metals, are dynamic and keenly observed but also incorporate certain stylised elements such as angularity and an elongation of the muzzle. Similar finds at Mahmatlar and Horoztepe north-east of Alaca point to the Pontic province as the original home of this culture. *See also* TROY. Remains from the *Hittite Empire period at Alaca include part of an enclosing wall with a gateway fronted by a pair of colossal stone sphinxes. There are also remnants of public buildings whose foundation-blocks are decorated with relief carvings. Musicians, jugglers, acrobats and a sword-swallower are represented, as well as hunting and cult scenes. The flat, relatively crude carving lacks the high plastic relief which distinguishes the art of the Hittite capital. *See also* HAT-TUSAS; YAZILIKAYA

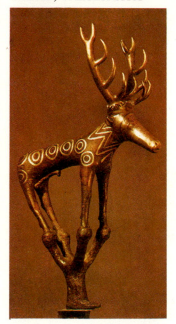

Left: ALACA HUYUK Stag standard. *c.* 2400–2200 BC. Bronze inlaid with silver. h. 20½ in (52 cm). Archaeological Museum, Ankara

Below: ALACA HUYUK Orthostat relief of a king and queen making libations before a bull. Hittite period. 14th century BC. Archaeological Museum, Ankara

Bottom: ALACA HUYUK Group of objects including a gold flagon and chalice, an openwork bronze disc, gold jewellery. *c.* 2400–2200 BC. h. (of disc) 9⅛ in (23·3 cm). Archaeological Museum, Ankara

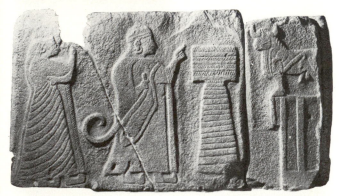

ALBANI, Francesco (1578–1660)

b. d. Bologna. Italian painter, he was taught by *Calvaert and at the *Carracci Academy. In 1602 he went to Rome. He painted the Gallery in the Verospi Palace (*c.* 1616) using the then fashionable method of *quadri riportati. Returning to Bologna, from the 1620s he specialised in mythological scenes set in ideal landscape, further emphasising the Venetian-*Titianesque qualities already inherent in the work of Annibale *Carracci.

ALBANI PSALTER

This manuscript of *c.* 1130 is connected with St Albans and contains work by two or three hands. The principal artist executed a series of full-page paintings of Biblical subjects. His elongated, monumental figures and deeper colours drawn ultimately from †Ottonian and †Byzantine sources were influential in England, preparing the way for the *Bury Bible. The Albani Psalter gives an importance to narrative illustration not seen in England since the Norman Conquest. (Library of St Godehard, Hildesheim.)

ALBERS, Josef (1888–)

b. Westphalia. Painter of pure geometric abstractions, authority on colour relations, photographer and typographer. Important pioneer of experimental design teaching, first at the *Bauhaus, Weimar, Dessau and Berlin (1923–33); then at Black Mountain College, North Carolina (1933–49), and Yale University, Connecticut (1950–9).

ALBERTI, Leon Battista (1404–72)

b. Genoa d. Rome. Architect and writer whose activities as a painter and sculptor (sole surviving work is a self-portrait) were those of a gifted amateur. The most influential theorist of the 15th century, he was educated by the Paduan humanist Barzizza, studied Canon Law at Bologna, travelled to France with Cardinal Albergati (1431) returning to the Curia, Rome.

HEINRICH ALDEGREVER *A Wedding Dance*. 1538. Engraving. 2×1½ in (5·3× 3·7 cm). V & A, London

IVAN ALBRIGHT *That Which I Should Have Done and Did Not Do*. 1931–41. 97×36 in (246·4×91·4 cm). Art Institute of Chicago

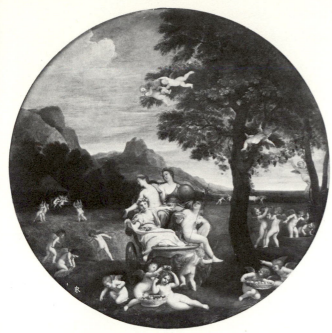

FRANCESCO ALBANI *Air* from the Elements series. *c.* 1625. dia. 71 in (180 cm). Turin

There he studied the ruins with *Donatello and *Brunelleschi, thus laying the foundation for *Della Pittura*, the first †Renaissance treatise on painting (1453/6). In it he recommends the pre-eminence of history-painting, ideal beauty, a classification of primary colours derived from the Greeks, the mastery of chiaroscuro, proportion and perspective. Also wrote a treatise on sculpture, *De Statua*, and on architecture, *De Re Aedificatoria*, which he presented to Pope Nicholas V (1452). Alberti's views on architecture are mirrored in the paintings and sculptures by other artists from the mid-1430s onwards. Employed by the rulers of Milan, Rimini and Mantua he accelerated the spread of Renaissance ideas beyond the confines of Florence and Rome.

ALBERTINELLI, Mariotto (1474–1515)

b. Florence. Florentine artist whose style parallels that of Fra *Bartolommeo with whom he entered into partnership in 1508. The clarity and balance of his style is best seen in the *Visitation* (1503, Uffizi). In *c.* 1511 he abandoned painting.

ALBERTINI, Francesco (d. 1520)

d. Rome. Italian writer on art and a Florentine priest, he produced the first artistic guide-book to Florence, *Memoriale di molte statue e pitture che sono nell' in clyta ciptà di Florentia* (1510), which if it lacks profundity, does reveal the attitude of cultivated Florentines towards their city's treasures. Albertini also wrote a guide-book to Rome, which departs from the purely reverential, becoming more aesthetically discriminating.

JOSEF ALBERS *Homage to the Square: 'Ascending'*. 1953. 43½×43½ in (110·5× 110·5 cm). Whitney Museum of American Art, New York

ALBRIGHT, Ivan Le Lorraine (1897–)

b. Chicago. American painter who studied in Nantes, Chicago, Philadelphia, and New York, and was Army Surgical Artist in World War I. His *Magic Realist paintings, marriages of funeral sermon and surgery, anatomise physical corruption, decay and death in morbid detail heightened by harsh, *Surrealist light.

ALCOPLEY (Dr Alfred L. COPLEY) (1910–)

b. Dresden. Abstract painter who moved to United States in 1937, but has lived in Paris since 1952. The Oriental influence on his work, in its use of calligraphy, belongs to the movement propagated by *Kline and *Tobey, but its delicate asymmetrical colour composition more closely resembles a non-representational *Dufy.

ALDEGREVER, Heinrich (Hans TRIPPENMEKER) (1502–1556/61)

b. Paderborn d. Soest. German painter, printmaker and designer of woodcuts. Chiefly known for about three hundred engravings made mainly 1527–41 and 1549–55. Portrait engravings of Luther and Melanchthon (1540) testify to his being deeply affected by the Reformation. His monogram appears on works where the main influence is *Dürer.

ALECHINSKY, Pierre (1927–)

b. Brussels. Belgian painter who has lived in Paris since 1951. Joined the *Cobra group (1949). Studied engraving with *Hayter in Paris (1952). Alechinsky's work is *Expressionist and his imagery highly grotesque. His graphics are often accompanied by texts – as poetic illustrations.

ALEUT *see* ESKIMO ART

ALEXANDER, John White (1856–1915)

b. Allegheny City, Pennsylvania d. New York. Painter, illustrator and muralist who went to New York (1872), to Europe (1877–81), studying at Munich Royal Gallery, Venice, Florence, Holland, Paris, to America (1881), and again to Europe (1891). He is known for his Congressional Library murals and distinguished portraits, characterised by tasteful academicism.

ALEXANDER MOSAIC (*c.* 100 BC)

A *mosaic in the House of the Faun at Pompeii. It is in the *opus vermiculatum* technique, using very small coloured stone *tesserae. It is thought to be based on a 4th-century painting by *Philoxenos of Eretria.

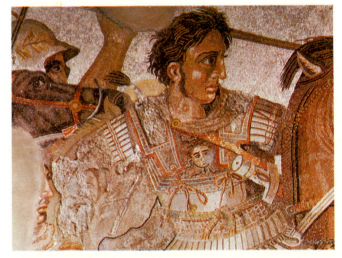

ALEXANDER MOSAIC Detail showing Alexander the Great preparing to engage Darius in battle. *c.* 1st century BC. h. (of complete mosaic) 11 ft 3 in (3·42 m). National Museum, Naples

ALEXANDER SARCOPHAGUS (350/325 BC)

A *sarcophagus with high relief sculptures of Alexander the Great fighting the Persians. There is a great sense of movement in the sculpture, and this is perhaps inspired by *Lysippos. (Archaeological Museum, Istanbul.)

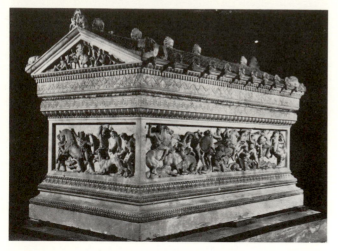

ALEXANDER SARCOPHAGUS 350/325 BC. Marble. h. 6 ft 4¾ in (1·95 m). Archaeological Museum, Istanbul

ALEXANDRIAN SCHOOL

School of art in Alexandria, the city founded by Alexander the Great. It rapidly became a flourishing trade centre, although little is known about its position in *Hellenistic art. Pottery of good quality was produced, for instance the *Hadra vases, but scarcity of *marble meant that there was no important sculpture, although some works have been attributed to the school by scholars.

ALFONSO, Maese see BRU, Anye

ALGARDI, Alessandro (1598–1654)

b. Bologna d. Rome. Italian sculptor and stylistic opponent of *Bernini (from whom, nevertheless, much of his technique and composition derive). Pupil of Ludovico *Carracci, he arrived in Rome in 1625, at first restoring antiques and copying small devotional works for the market. His *Decapitation of St Paul* (1641–7, S. Paolo, Bologna) shows his characteristic style of restrained composition, using types close to antique statues, which made him a leader of Baroque classicism. A very fine portraitist, his most important commission was the twenty-five-foot-high *Leo and Attila* relief (1646–53, St Peter's) whose enormous scale resulted in a reconciliation with Bernini's grand approach.

ALKAMENES (active 450/400 BC)

Greek sculptor, probably of Athens, and pupil of *Pheidias. His most famous works include a seated statue, the *Aphrodite of the Gardens*, for the sanctuary of Dionysos near the theatre of Dionysos at Athens and the *Hermes of the Gateway* at the entrance to the Acropolis.

ALKEN Family

Four generations of Alkens were connected with English art, the best known being Henry Thomas Alken (1785–1841), son of the engraver Samuel Alken. The former painted, drew and etched field-sports and contemporary manners and customs, and also fox-hunting scenes. Two brothers and two sons were also artists.

ALLA PRIMA

Italian: at first. The art of painting a picture in one go without any *underpainting or repainting. The technique makes full use of the brilliant reflective power of the white *ground.

ALLEGRI, Antonio see CORREGGIO

ALLORI, Alessandro (1535–1607)
Cristofano (1577–1621)

Alessandro, b. d. Florence, trained under his uncle, *Bronzino. On an early visit to Rome he saw *Michelangelo's *Last Judgement* and both Bronzino and Michelangelo's influence is apparent in his work. He collaborated with *Vasari and others in the *studiolo of Francesco I de' Medici in the Palazzo Vecchio, Florence. His activities ranged from court portraits to tapestry cartoons. His son, Cristofano, also b. d. Florence, worked in the same vein, showing an interest in depicting rich materials. His *Judith with the Head of Holofernes* (c. 1616, Pitti) is strictly *Mannerist in style.

ALLSTON, Washington (1779–1843)

b. Waccanaw, South Carolina d. Cambridge, Massachusetts. American †Romantic painter, graduated by Harvard (1800), who lived thereafter in Boston area apart from two European stays (1801–8, 1811–18). Studied under *West in England and visited France and Italy, developing characteristic rich colour and taste for religious/historical painting. His picturesque, mysterious visions were limited by puritanical moral myopia.

ALMA-TADEMA, Sir Lawrence (1836–1912)

b. Dronryp d. Wiesbaden. English painter, chiefly of subjects from the domestic lives of peoples of ancient civilisations. In 1858, he studied under Henri Leys who emphasised archaeological accuracy in *history painting. In 1864, he met *Gérôme who, as well as giving him technical advice, encouraged him to abandon the scenes of Merovingian history he was painting for more popular reconstructions of life in classical antiquity. He settled permanently in London in 1869. A certain repetitiveness in his work is tempered by the sensitivity and luminosity of his brushwork, and by inventive spatial arrangements that reflect his admiration for Japanese art.

ALTAMIRA

Probably the most famous prehistoric cave and the first painted cave to be discovered (1879). It is south of Santander, not far from *Castillo. The ceiling of the entrance chamber is covered with bison, horse and deer, painted in red and black. The paintings are dated to late *Magdalenian and there are *Solutrian and Magdalenian archaeological deposits.

ALTDORFER, Albrecht (c. 1480–1538)

b. d. Regensburg. German painter, draughtsman and printmaker. Citizen of Regensburg (1505), thereafter concerned in local government there. He made two journeys down the Danube (1503–5 and 1511). First known to be active c. 1506, Altdorfer's early works (eg *Crucifixion*, Kassel) have figures derived from Italian prints, eg *Mantegna. He soon developed his own brand of anthropomorphic landscape which became the mark of the *Danube School of which he is the leading member. His trees have excited linear rhythms (created by drawing with the brush) which give his teeming forests a definite living personality, far in excess of *Dürer's naturalistic but atmospheric descriptions. This distorted *Mannerist character was also lent to the figures in his mature work. Despite this, his vision of landscape is classic in its unity and depth (eg *Battle of Alexander*, 1529 AP, Munich), creating a new kind of art. His younger brother and pupil, Erhard Altdorfer, mainly known for his prints, carried on the style.

ALTICHIERO (c. 1330–c. 1395)

b. Verona. Documented as having worked on fresco cycles in Verona and in Padua with a certain Avanzo, whose exact contribution is controversial. This major northern Italian painter developed *Giotto's work to achieve a truly monumental style. His frescoes comprise landscape and elaborate architectural settings with great space and depth, containing numerous Giottesque figures. His naturalism and classicism separate him from the nascent *International Gothic style.

ALTÖTTING, Goldenes Rössel (1404)

The Church Treasury at Altötting, Bavaria, contains perhaps the most elaborate surviving late †Gothic miniature *tabernacle, made of precious metals and enamelled. It depicts the Virgin and Child in a rose bower, with donors and a waiting horse below (from which it takes its name). It is Parisian work, and the combination of toy-like figures with sumptuous craftsmanship was typical of the taste of high society throughout Europe at the end of the Gothic period.

ALUMINIUM

Light-weight silver-grey non-ferrous metal used in sculpture. Can be cast and machined, but it is difficult to weld without special apparatus.

AMADEO, Giovanni Antonio (1447–1552)

b. Pavia d. ?Milan. Italian sculptor and architect, originally a modeller in terracotta. His early work shows an affinity with the *Mantegazza, his later, eg the Cremona Cathedral reliefs, some Tuscan influence. His other principal works are at Pavia (Certosa) and Bergamo (Colleoni Chapel).

AMALTEO, Pomponeo (1505–84)

North Italian painter, the son-in-law of *Pordenone under whom he trained and whose style he imitated. He worked mainly in fresco, as in the series from the life of the Virgin in the Hospital Church of S. Vito, Friuli for which he received a patent of nobility in 1535.

AMARAVATI see SATAVAHANA DYNASTY

AMARNA PERIOD

The Amarna period may be said to mark the only substantial break in the continuity of the Egyptian approach to art. With the accession of Amenhotpe IV (*Akhenaten), the solar cult of Rē as the Aten became the official religion, to the exclusion, eventually, of all other deities. The move towards quasi-monotheism was gradual, but the development of the new theology undermined long-established beliefs, affecting particularly the interpretation of *maat* and ideas of the after-life. In consequence, the principles governing re-creative art were no longer valid, and fundamental changes were soon introduced. At el-Amarna, traditional themes were largely avoided, and artists like *Bak transformed the manner of representation after the king's instructions. Essentially, the Egyptian ideal of a timeless objective truth gave way to a more immediate realism, though this in turn was conventionalised, as in the depiction of royalty. The change is most evident in two-dimensional art, where scenes are frequently localised through the elaboration of background or the inclusion of a specific building as reference, and there is also greater precision in time, in showing actual incidents and suggesting momentary action. Tableaux that represent a coherent whole are mostly preferred to compositions made up of individual registers. Registers are still used, but more often as simple base-lines, while sometimes the ground is undefined and mounts to a high horizon – though never attaining true perspective. A certain appreciation of space as such is evident in attempts to distinguish distances, but overall unity is as a rule maintained through points of contact, physical or implied (and on occasion exaggerated). The sense of hieratic stiffness is somewhat relaxed by the use of sloping lines and curves, and by the peculiarly feminine treatment of drapery, with a fondness for streamers and garlands. There are modifications too in the draughting of individuals, though some conventions persist, such as relative size and the 'frontal' view of the eye. The usual composite form is retained for the human figure, but profile is also common, and feet and hands are often correctly paired. In general, people are posed more naturally, with appropriate gestures, and some attention is given to physical characteristics – though the final impression is seldom wholly convincing. The effect upon sculpture in the round is less obvious, and (the Karnak statues apart) the representation of the king is generally more restrained than in relief, but with similar languid contours and effeminate softness, which also apply to the very few private statues. The modelling of the body, especially that of the queen, is well observed, and there are variations in pose, the head being turned occasionally and the arms extended, even in stone. Impressive fragments survive of statues composed from separate elements made in suitably coloured materials, and some independent heads belong to this category, while others, including the polychrome bust of *Nefertiti, were sculptors' models. A striking feature of all Amarna art is the prominence of the king and queen, not only in statuary, but in temple and tomb reliefs, in palace murals, on private altars and elsewhere. The queen, moreover, is frequently represented as virtually equal in status, even assuming a dominant masculine role, and the princesses too are very conspicuous. Curiously, some of the most accomplished products of the Amarna movement date from its closing phases, returning partially to the orthodox elegance of the preceding reign. Outstanding examples of statuary are the goddesses from the canopic shrine used for Tutankhamūn, and the strangely sensual figure of the *wife of Nakhtmin, while among reliefs a number from Memphite tombs are remarkable for their quality. There is exquisite work in miniature also, exemplified by the carved ivory panels on one of Tutankhamūn's boxes and the vignettes on another. Nor was the influence of Amarna art confined to this period, for some of its gentle softness and flowing elegance still survived in the 18th dynasty.

AMASIS PAINTER (active 550 BC)

*Black-figure vase painter whose best works are comic scenes with maenads and drunken satyrs. His heroic scenes have none of the pathos of his contemporary, *Exekias, and are inclined to be irreverent. He made no innovations, but his drawing is quite skilled. His subject-matter is extremely varied.

AMBERGER, Christoph (c. 1500–62)

b. Swabia d. Augsburg. German portrait painter, influenced by *Burgkmair, *Holbein the Younger and the Venetians. His portraits usually show the subject standing and half-length, set in a characteristic environment, rather as in some works by *Bronzino.

AMBROGIO DA PREDIS (Giovanni Ambrogio PREDA) (c. 1455–after 1508)

Milanese painter, miniaturist, medallist and tapestry designer. His early work was influenced by *Foppa and *Butinone. Employed by Ludovico Sforza and became a member of *Leonardo's circle. His only authenticated work is a portrait of the Emperor Maximilian I, dated 1502.

AMENEMHET III (AMMENEMES) see SENWOSRET III

AMENHOTPE II (AMENOPHIS) see THUTMOSE III; VALLEY OF THE KINGS

AMENHOTPE III (Amenophis)

Egyptian king of the late 18th dynasty, during whose reign pharaonic civilisation achieved its most brilliant level in a material sense. With the vast wealth at his disposal, Amenhotpe III engaged in exceptional building activity, chiefly at *Thebes and in Nubia, and statuary, relief sculpture (tomb of *Ramose) and painting (*Theban tombs) were sophisticated in style and technically very accomplished. See also MEMNON COLOSSI

AMERICAN SCENE PAINTING

Movement of the 1920s and 1930s, encouraged greatly by the *WPA's emphasis on painting the 'American Scene'. The term includes independents such as *Burchfield and *Hopper, and urban realists such as the *Soyer brothers, *Bishop and *Marsh. The only artists conscious of being part of a movement, however, were the Regionalists, each painting the history, life

and legend of his particular area. Best known were the Midwestern Regionalists, led by *Benton, Grant *Wood and *Curry. At their worst, their work was politically and aesthetically isolationist, rebelling against international modern art and eastern cosmopolitanism, and characterised by bombastic chauvinism. At their best, they evoked the fast-disappearing rural and small-town America and the tawdry, exciting city with nostalgia or satire, affection and vigour.

AMI GROUP *see* NOAMI

AMIATINUS CODEX (*c.* 700)

Copy made in Northumbria for Ceolfrid, Abbot of Jarrow (690–716), after an Italian manuscript of the Bible. Eighth-century Northumbria enjoyed a partial renaissance of literature, script, painting and sculpture which through Alcuin and others contributed much to the †Carolingian Renaissance. The painting of Ezra still retains some of the antique sense of space and shading. (Biblioteca Laurenziana, Florence.)

AMICO DI SANDRO

Literally 'friend of Sandro', ie *Botticelli. A *Berenson appellation for an artist of apparently uncertain style, close to both Botticelli and Filippino *Lippi. Paintings formerly attributed to him have now been reattributed in the light of research by Berenson and others.

AMIENS CATHEDRAL

Started in 1220, the three west portals contain one of the largest displays of 13th-century figure sculpture in France, standing chronologically between *Chartres and Notre-Dame, *Paris on the one hand and *Reims on the other. Under the figures, is an important series of reliefs in *quatrefoils with Biblical and allegorical figures in lively groups. The south transept portal is later and includes the famous *Vierge Dorée*.

AMIGONI, Jacopo (1682–1752)

b. Naples d. Madrid. Italian painter who began his career in Venice where he was influenced by *Giordano and *Ricci; from 1717 at the Bavarian court (fresco cycles at Nymphenburg, Ottobeuren and Schleissheim). He visited England (1730–9) where he painted decorative cycles in the Venetian †Rococo style for Moor Park and Covent Garden, and portraits of the royal family and aristocracy. From 1747 until his death he was Court Painter in Madrid.

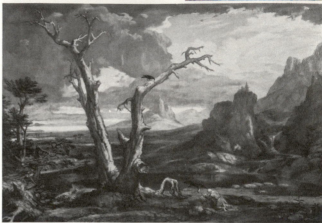

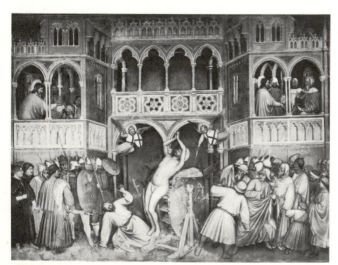

Above: ALTICHIERO *Martyrdom of St George. c.* 1377. Fresco. Oratory of St George, Padua
Right: ALESSANDRO ALGARDI *Decapitation of St Paul.* 1641–7. Marble. h. 112¾ in (286 cm). S. Paolo, Bologna
Far right: AMENHOTPE III Standing wooden statuette. Late 18th dynasty. h. 10⅜ in (26·4 cm). Brooklyn Museum, NY

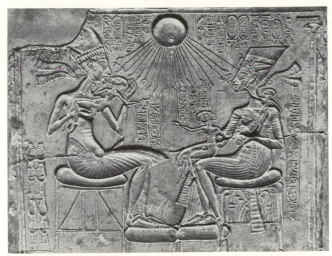

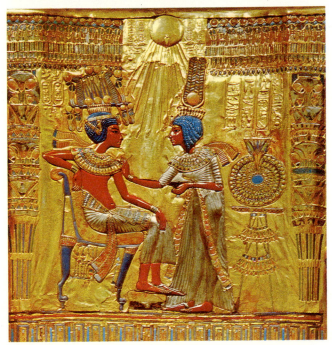

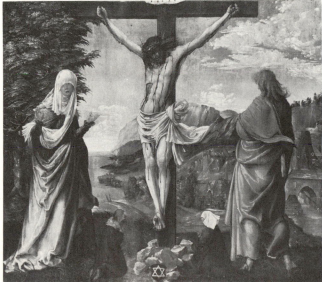

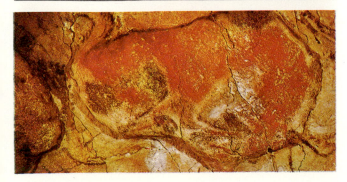

Top: AMARNA STYLE Akhenaten, Nefertiti and three of their daughters. Amarna period. Painted limestone. h. 17 in (43·5 cm). Staatliche Museen, Berlin-Dahlem
Above: AMARNA STYLE Tutankhamun and Queen Ankhesenamun. Late 18th dynasty. Back of wooden throne, gilded and inlaid with silver, glass and faience. About 21 in (53 cm) square. Egyptian Museum, Cairo
Top left: ALBRECHT ALTDORFER *Battle of Alexander.* 1529. 63×46 in (159×117 cm). AP, Munich
Centre left: ALBRECHT ALTDORFER *Crucifixion.* $40\frac{1}{4}×45\frac{7}{8}$ in (102×116 cm). Gemäldegalerie, Kassel
Left: ALTAMIRA Cave-painting of bison. c. 12,000 BC

Opposite page, top left: ALTOTTING, Church Treasury. The Goldenes Rössel. 1404. Gold, pearls and gemstones
Opposite page, top right: AMIENS CATHEDRAL *The Vierge Dorée.* c. 1280. Stone. h. 120 in (340 cm)
Opposite page, middle above: WASHINGTON ALLSTON *Elijah in the Desert.* $48\frac{3}{4}×72\frac{1}{2}$ in (123·8×184·2 cm). Boston
Opposite page, middle below: LAWRENCE ALMA-TADEMA *Pheidias Completing the Parthenon frieze.* 1869. $28\frac{1}{2}×43$ in (72·4×109·2 cm). Birmingham

AMLASH CULTURE

The cemeteries of Gilan, south of the Caspian Sea, at Marlik and elsewhere have produced a wealth of metal vessels, metal statuettes of animals and pottery .dating from between 1200 and 800 BC. Particularly pleasing are the Amlash bulls – pottery vessels in the shape of a humped bull.

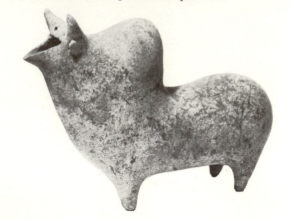

AMLASH CULTURE Amlash bull. *c.* 1200–1000 BC. Baked clay. Ashmolean

AMMAN, Jost (1539–91)

b. Zürich d. Nuremberg. German painter and engraver. In 1560 he established himself in Nuremberg, where he produced remarkable stained-glass windows. He worked in leather and wood. His pen drawings are remarkable for their line and composition and are done in a style taken from *Dürer, *Aldegrever and *Beham. Although his output was considerable, only one authenticated work has survived, the *Portrait of a Wise Man* (Basle).

AMMANATI, Bartolommeo (1511–92)

b. Settignano d. Florence. Florentine sculptor, whose masterpiece, the *Neptune Fountain* (1560–75) in Florence's Piazza della Signoria, is a highlight of Italian *Mannerist sculpture. Influenced by *Michelangelo and *Sansovino, Ammanati was also involved with architectural projects such as the Nympheum at the Villa Giulia, Rome (1551–5) and the proposed interior fountain for the Gran Salone of the Palazzo Vecchio, Florence. Later, he destroyed some of his works regretting their erotic character.

BARTOLOMMEO AMMANATI *Neptune Fountain.* 1560–75. Piazza della Signoria, Florence

AMSTEL, Jan van (active 1527–d. before 1543)

Netherlandish painter from Amsterdam. Master in Antwerp (1528); citizen there in 1536. He is usually thought to be the

Jan de Hollander who was known as a landscape painter and who was active in Antwerp in 1538. A picture in Brunswick (the *Parable of the Banquet*) carries a monogram which may be Amstel's, but this picture has also been attributed to Jan van *Hemessen and Meyken Verhulst, wife of *Coecke van Aelst. From this confused situation, the pictures usually attributed to Amstel are brothel scenes or many-figured compositions alive with rustic bustle.

AMSTERDAM, Cornelisz van *see* CORNELISZ VAN OOSTSANEN

AMULIUS *or* FABULLUS (active AD 50/70)

Roman painter of the time of Nero, mentioned by *Pliny. He was said to have painted a Minerva whose eyes always followed the spectator wherever he was in the room. He also worked in the *Golden House of Nero.

AN Kyŏn (Hyon-dong-ja) (active mid-15th century)

Korean painter, the leading landscapist of the early Yi period. Influenced by the Chinese *Kuo Hsi, *Ma Yuan and *Hsia Kuei, his most famous work represents the 'dream of a happy life'. His work has great depth of feeling.

ANALYTICAL AND SYNTHETIC CUBISM

A term first used by *Kahnweiler, a close friend of *Picasso, *Braque and *Gris in *The Rise of Cubism* (1920) to distinguish between a Cubism based on the analysis of the subject by observation of its parts and a Cubism based on the construction of the subject from invented (synthetic) forms. As Gris put it (1921): Cubism is 'synthetic' when the artist progresses from a cylinder to a bottle, 'analytic' when he proceeds from a bottle to a cylinder. (The distinction is complicated by the fact that – especially between 1912 and 1916 – Picasso, Gris and Braque often mixed the two approaches in a single work.)

ANASAZI *see* PUEBLO; SOUTHWEST, AMERICAN ART OF THE

ANATOLIA, Art of

From the Neolithic to the Iron Age, Anatolian art consists of a series of distinct episodes of production, often widely separated in space and time, and showing little or no continuity. This is owing both to lack of excavated evidence and to the history and character of the region. Anatolia was never the domain of a single culture but rather of a group or series of cultures which appear discontinuously in the archaeological record. The art of the Neolithic period (*c.* 7000–5600 BC) is represented at the sites of Hacilar and especially of *Çatal Hüyük. Here wall-paintings and reliefs, incorporating a rich and provocative symbolism, are the expression of a religious cult centred round a mother goddess, who is herself represented in a series of outstanding figurines. This culture had no successors beyond the Early Chalcolithic (ie after *c.* 5000 BC) but discoveries at Çatal Hüyük have dramatically revised modern concepts of Neolithic achievement. From the ensuing Middle and Late Chalcolithic (*c.* 5000–3200 BC) – a period marked by the emergence of new peoples – no art objects have yet been recovered. Towards the end of the period, however, as the Late Chalcolithic led into the Early Bronze Age (*c.* 3200–1900 BC), there are signs of accelerated development and widening horizons. The prosperity that created Sumer in Mesopotamia and the Old Kingdom in Egypt is reflected in Anatolia in the splendid metalwork of the royal tombs of *Alaca Hüyük, Horoztepe and Mahmatlar. Also dating from this period is the hoard of precious objects which Schliemann discovered at *Troy and called (erroneously) 'Priam's Treasure'. For the greater part of the second millennium BC Anatolia was occupied by the *Hittites, an intrusive, Indo-European-speaking people whose empire was, at its height, one of the great powers of the ancient world. Of their early art little is known, but from the so-called 'Empire Period' (*c.* 1500–1200 BC) examples of a distinctive and vigorous sculpture have been found at *Alaca Hüyük, at *Hattusas, the capital, and at the shrine of *Yazilikaya.

Other isolated examples can be seen on rock façades in various parts of Anatolia. Following the collapse of their empire (*c.* 1200 BC) and the dispersion of the Hittites, new cultures appeared in Anatolia. *Phrygian invaders occupied the western part of the plateau; the Phrygian nexus with Greek art is being explored but still has largely to be elucidated. In the east, around Lake Van, the kingdom of *Urartu became prominent, its art showing strong Assyrian influence. And, finally, some Hittite traditions survived in a series of small *Neo-Hittite kingdoms or principalities in south-east Anatolia and adjacent parts of northern Syria. Here styles and motifs similar to those of the Hittite Empire continued well into the Iron Age – although with increasing Mesopotamian influence – until that area was absorbed into the Assyrian Empire.

ANDARZ-NAMA (1090)

A book of instruction for princes, this Islamic manuscript with 109 miniatures appeared in Paris in 1950, and is now in the USA. Its genuineness has been questioned as although the human figures show similarities with those of Nishapur slip-painted ware and the Pandjikent paintings, the spatial treatment, iconographic and textual details with the use of some pigments point to a later date.

ANDHRAS *see* SATAVAHANA DYNASTY

ANDOKIDES PAINTER (active 530/500 BC)

Greek vase painter credited with having invented the red-figure style. He used a lot of *black-figure ornament in borders and in drapery, and was fond of rich colours. His figures were tall and vertical with clinging *Archaic drapery, long, tapering fingers and frontal eyes.

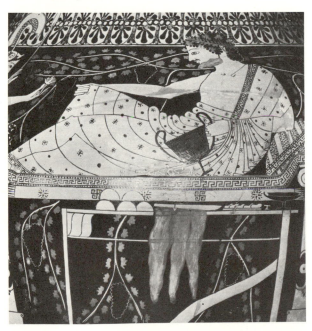

ANDOKIDES PAINTER Bilingual amphora. Late 6th century. h. 21 in (53·5 cm). Antikensammlugen, Munich

ANDREA DA FIRENZE (*c.* 1320–after 1377)

Florentine painter of the generation active after the Black Death. In 1365 he began work on the Spanish Chapel (former Chapter-House of the Dominican Friary of Sta Maria Novella) in Florence. The scenes on the walls and vaults are crowded and the realistic space characteristic of *Giotto and Ambrogio *Lorenzetti is abandoned. The subject-matter is original and originally treated – the protection of orthodoxy by the *domini canes* ('hounds of God' – a pun on Dominicani). He includes an 'artist's impression' of the then incomplete Cathedral of Florence.

ANDREA DI CIONE (ORCAGNA) (active 1343–?1368)

Italian painter and architect, an adviser on the construction of Florence Cathedral, he was also Capomaestro of Orvieto Cathedral and Orsanmichele, for which he designed and carved a large *tabernacle. As a painter he was associated with his younger brothers Nardo and Jacopo. The Strozzi Chapel altarpiece in Sta Maria Novella shows the severe, formalised, technically accomplished style of his polyptychs. A major fresco cycle in the same church was later replaced by *Ghirlandaio's work. Fragments from the Sta Croce fresco cycle of the *Triumph of Death* and the *Last Judgement* are powerful, detailed studies of disaster and despair.

ANDREA DI CIONE *Triumph of Death* (detail). *c.* 1348. Fresco. Sta Croce, Florence

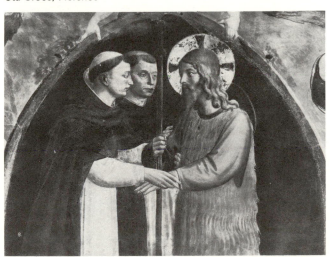

FRA ANGELICO *Christ as Pilgrim received by two Dominicans.* Fresco. S. Marco, Florence

ANGELICO, Fra (1387–1455)

b. Mugello d. Rome. Florentine painter and Dominican friar who possibly received his initial training in the monastic schools of manuscript illumination. Influenced by Don *Lorenzo Monaco, *Masolino and *Ghiberti. His early works are distinguished by a mood of †Gothic piety and felicitous colours. However in the *predella of the *Cortona Altarpiece* (1432) the Visitation is enacted on the shores of Lake Trasimene; thus he depicted the first identifiable landscape of the †Renaissance. The *Linaiuoli Altarpiece* (1433, S. Marco, Florence) shows an attempt to invest his figures with a greater plasticity. Five years later when he began the celebrated frescoes in the cells of S. Marco, slightly less than half of which are executed by him, he is revealed as a powerful Renaissance

artist; the touch is broad, the drawing assured and the pigments limited but often combined to suggest a spiritual radiance, fusing material and celestial experience. The panel-paintings of the 1440s (eg *Coronation of the Virgin*, Louvre) show his increased confidence in the handling of large figure groups. He was in Orvieto (1447–9) and Rome where he executed frescoes in Old St Peter's (destroyed) and the private chapel of Pope Nicholas V in which a firm intellectual grasp of architectural space, lively gesture and the deployment of sumptuous colour brings to his art a new sophistication, which is tempered in the famous *Annunciation* (S. Marco) by an innocent spirituality recalling the cell-paintings.

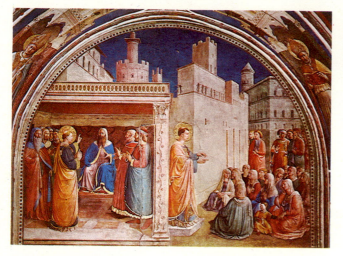

FRA ANGELICO *St Stephen Preaching and Addressing the Council. c.* 1447–55. Fresco. Chapel of Nicholas V, Vatican

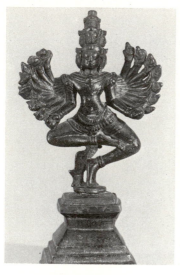 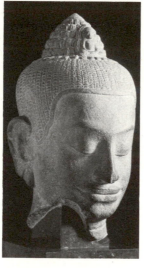

Left: ANGKOR THOM Bronze statue of Hevajra. Late 12th century. h. 12 in (30·5 cm). National Museum, Phnom Penh
Right: ANGKOR THOM *Prajnaparamita*. Bayon style. Late 12th century. Sandstone. h. 11$\frac{7}{8}$ in (30 cm). Musée Guimet, Paris

ANGKOR THOM, Cambodia (late 12th–early 13th centuries)

This is the last of the great complexes in the region of Siemreap; it has been reasonably suggested that it was economic exhaustion which led to the decline of the *Khmer Empire since the people could no longer sustain the burden of such expensive structures. The enclosure is surrounded by an enormous representation of the Churning of the Ocean, the churning stick being the Bayon, a gigantic Mahāyanist temple whose builder, Jayavarman VII (1181–1219) is represented on its towers as the Bodhisattva Avalokiteshvara whose beneficent

gaze brings prosperity to the Empire. Numerous small reliefs give vivid impressions of everyday life. A bronze statue of Hevajra demonstrates clearly the style which statuary had reached by this time, but the simple austerity of a Buddha from the Bayon shows that the stone-carvers still retained their former ability to portray contemplative tranquillity. It is probable that another Buddha image from Krol Romeas is a portrait of the king himself.

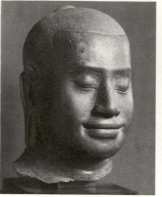 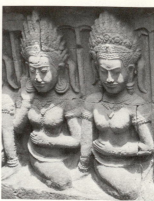

Left: ANGKOR THOM Head of Jayavarman VII as Avalokiteshvara. Late 12th century. Grey sandstone. h. 16 in (40·6 cm). Musée Guimet, Paris
Right: ANGKOR WAT Relief of apsarases. 1st half 12th century

ANGKOR WAT, Siemreap, Cambodia

The best known of *Khmer temples was the conception of a single ruler, Suryavarman II, and seems to have occupied the whole of his reign (AD 1113–50) to construct. Its derivation from the Baphuon, a century older, cannot be disputed: its magnificence reflects a hundred years of increasing ability to handle that style of architectural and artistic symbolism. The whole complex is enclosed in a rectangle (1750 × 1500 yards) encircled by a moat 200 yards wide. The entrance is on the western side, with the central tower of the main quincunx lying to the east of the mid point of the long axis. The proportions of approach road, façade and tower are calculated with an astonishing degree of understanding to create from an essentially horizontal structure the impression of a triumphal pyramid: this is indeed *Sumeru*, the axis of the world. The whole structure is covered with carvings in low relief, lintels, colonettes, pilasters are everywhere, often without any obvious architectural function: leaf patterns, almost certainly deriving from Chinese brocades, cover vast areas, among whose foliage tiny figures enact epic stories. There are more than two thousand *apsarases, whose complex headdresses and frozen poses serve to accentuate the enigma of their smiles, the sensuality of their naked breasts. No two are alike. But the greatest glory of Angkor Wat is the great colonnaded cloister which surrounds the first storey of the central complex. Here on the inner wall a series of reliefs, six feet high and a mile in length, the Churning of the Ocean, a Krishna legend and scenes from the *Ramayana* and *Mahabharata* are depicted, together with a scene of the Last Judgement. This, together with the orientation to the west and the fact that the reliefs are to be read anti-clockwise, makes it almost certain that the temple was intended as the King's mortuary shrine where, after death, he would become one with his tutelary deity Vishnu. He is depicted thereon himself, first enthroned, then leading his army, mounted on the royal elephant. Technically the reliefs are of interest because of their extremely shallow cutting: an inch at most, with variations achieved by shallow incisions into the background. There are no dividers: the spaces between the colonnades determine the 'frame' for each scene. Perspective is achieved either by superimposition or by the use of inclined planes which also serve to indicate a change of scene. What has survived of statuary from this period is of little merit, though a few bronzes (Harihara, Porsat) suggest that much may have been lost.

ANGLE-SUR-ANGLIN (Magdalenian III)

†Palaeolithic site in Vienne, France. Reliefs include female sex organs, a fine ibex head and the head and shoulders of a man with hair and clothing painted. The man's profile is similar to some from *La Marche.

ANGLO-SAXON ART

English art before the Norman conquest of 1066 retained through all its various stages a love of intricate ornament. Pagan English art as represented by the *Sutton Hoo jewellery provided the model for the exuberant pattern-making of the *Lindisfarne Gospel. The Christian art of the Northumbrian Renaissance also embraces such elements of the classical tradition as were available, as can be seen in the crosses of *Bewcastle and *Ruthwell and in the *Amiatinus Codex. The Scandinavian incursions seem to have caused a hiatus in Anglo-Saxon art, although the invaders also indirectly contributed something during the 10th and 11th centuries. The national and literary revival under Alfred and the 10th-century monastic revival led to the formation of a school of manuscript illustration, the playful draperies of the line-drawing deriving from the †Carolingian style of the *Utrecht Psalter and the luxuriant acanthus borders of the *Benedictional of St Aethelwold also reinterpreting a Carolingian style. There is some attractive metalwork and ivory. The surviving sculpture of the period is disappointing in comparison with 8th-century work, but the *Harrowing of Hell* at Bristol or the *Angels* at Bradford-on-Avon are not without interest. Recently it has been shown that Anglo-Saxon styles in manuscripts, sculpture and architecture were not immediately or uniformly replaced by the continental influence of the Normans.

ANGUIANO, Raúl (c. 1909–)

b. Guadalajara. Painter who went to Mexico City (1934); was co-founder of Taller de Gráfica Popular; taught at Esmeralda School and National University of Mexico; was member of Bonampak expedition (1949). Influenced by *Rivera, Anguiano portrays the Indians with simplified, stern solidity and emphatic line, often seeming more polished than powerful.

DAVID ANNESLEY *Big Ring*. 1965. Painted Steel. 70×110×12 in (177·8×279·4×30·5 cm). Lutterworth School, Leicestershire

ANNESLEY, David (1936–)

b. London. Sculptor who studied at St Martin's Art School where he was influenced by *Caro (1958–62) and he has since taught at the school. His constructions of thin, colourfully painted steel, buckled into waves, possess a quality of strain contained with a hard lightness.

ANNIGONI, Pietro (1910–)

b. Milan. Famous as a portraitist (particularly *Queen Elizabeth II*, 1955 and 1969), he also paints religious and allegorical subjects using his considerable technical skill in a version of †Renaissance painting that is stylishly *Surrealistic in effect.

ANQUETIN, Louis (1861–1932)

b. Etrépagny d. Paris. French artist and the pupil of Cormon in Paris. Influenced by †Impressionism and Japanese prints he developed a style comparable with the *Synthetism of *Gauguin and *Bernard. Dujardin coined the term *cloissonisme* in 1888 to characterise his art with its flat colours outlined like *cloisonné enamels. He later became more academic.

ANSANO DI PIETRO see SANO DI PIETRO

ANTELAMI, Benedetto (late 12th–early 13th century)

Italian sculptor, most of whose work is to be found in Parma where he was responsible for a relief of the Deposition in the Cathedral (signed and dated 1178) and for the internal and external sculptural decoration of the Baptistery. The iconographic complexity and use of *tympana with sculpture rationally linked to architecture are probably French; there are definite stylistic links with Provence. Subjects include the Last Judgement, Adoration of the Magi, Baptism of Christ, Death of the Baptist and Solomon and Sheba. Benedetto's solid, rather dumpy figures are distinctive.

ANTENOR (active late 6th century BC)

Athenian sculptor famed for his *Tyrannicide group, carved to commemorate the expulsion of the Peisistratidae. It was carried away to Persia following Xerxes's invasion in 480 BC, and a replacement was subsequently commissioned from Kritios and Nesiotes. One of the Acropolis *korai was also sculpted by him.

ANTICO (Piero Jacopo Alari BONACOLSI) (?1460–1528)

b. ?Mantua. Italian sculptor who enjoyed the patronage of the Gonzaga family all his life. Reflecting their humanistic tastes, he was a close student of the *Antique, reinterpreting rather than copying classical motifs in elegant, highly finished bronze statuettes.

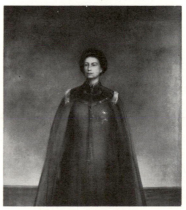

Left: PIETRO ANNIGONI *Queen Elizabeth II*. 1969. Tempera. 78×70 in (198·1×177·8 cm). NPG, London
Right: ANTICO *Meleager*. c. 1510. Bronze and gilt. h. 12⅛ in (31 cm). V & A, London

ANTIQUE, The

Classical art and architecture served both as a source of inspiration, and as an ideal to which to aspire, both in technique and spirit, for many later generations of artists and sculptors, for whom the title 'The Antique' served as a comprehensive term covering all classical achievements. Perhaps the greatest medieval sculptor to revitalise classical forms was Nicola *Pisano (active 1258–78). In 15th-century Italy the predominant aim was to follow the antique vocabulary of forms, while in the 16th century it was to add to that vocabulary and surpass the Antique. To *Poussin the Antique was as much a source of inspiration for his philosophy as for his painting. Eighteenth-century †Neo-classicism was based on a desire to

recreate the classical past partially inspired by recent archaeological discoveries. From the 16th to 19th centuries casts of classical statues were copied by students in *academies, and it is only in the 20th century that this practice has finally been abandoned.

ANTOLINEZ, José Claudio (1635–75)
b. d. Madrid. Spanish painter, and a brilliant colourist, specialising in religious subjects, such as the Immaculate Conception and Mary Magdalene, and combining *Titianesque colour with the swirling compositions of *Tintoretto. His portrait compositions are influenced by *Velasquez's *Las Meninas*. Died from duelling wounds.

ANTONELLO DA MESSINA (c.1430–79)
b. Messina d. Venice. Sicilian painter who studied in Naples where Flemish painting was known and admired. The first painter in Italy to master Northern oil technique, his style combined an Italian grasp of simplified volumes and perspective allied to a Flemish mastery of detail especially visible in landscape (eg *Crucifixion*, 1475, Antwerp). His most significant work was the *San Cassiano Altarpiece* executed in Venice (1475/6, fragments only extant in Vienna). It showed the Virgin and Child enthroned accompanied by saints and grouped within a chapel. Antonello influenced Venetians, eg Giovanni *Bellini, in his treatment of detail.

ANTONELLO DA MESSINA *St Jerome in his Study*. 18×14¼ in (46×36·5 cm). NG, London

ANTONIANOS (active 2nd century AD)
Greek portrait sculptor who signed several works including a portrait of Hadrian's favourite, Antinöos.

ANTWERP MANNERISTS
The so-called 'Antwerp Mannerists' were a group of painters active c. 1515–25 perhaps for the most part in Antwerp. Their style was certainly *Mannerist in that it rejected purely

naturalistic intent, substituting fantasy in setting and an over-developed interest in eccentric detail and colouring. The main figures, Jan de *Beer, the Master of the Groote Adoration, the Master of 1518 and the 'Pseudo Bles' (once thought to be Herri met de *Bles) are defined as a group, not due to any actual workshop connection but simply because of their similar styles. Scenes of the Adoration of the Magi were very popular with these artists, allowing for much architectural elaboration.

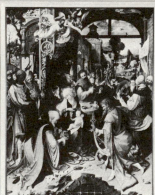

Top: ANTWERP MANNERISTS, Master of 1518. *Christ in the house of Simon*. Musées Royaux, Brussels
Above: ANTWERP MANNERISTS, Jan de Beer. *Adoration of the Magi*. Brera

ANURADHAPURA see CEYLON

ANYANG see SHANG DYNASTY STONE SCULPTURE

ANYI see BAULE

APACHE see SOUTHWEST, AMERICAN ART OF THE

APELLES (active 4th century BC)
An Ionian who became the Court Painter of Macedon. He painted a picture of Alexander the Great holding a thunderbolt, and is said to have darkened Alexander in order to enhance the

brightness of the thunderbolt. He was greatly interested in light effects in painting and introduced several new techniques.

APHRODISIAS, School of

A number of sculptures from all over the Roman world are signed by sculptors from Aphrodisias, a city of Caria in Asia Minor where the large amounts of *marble available probably fostered the art of sculpture. Most of the sculptures come from Rome, the earliest dating to the end of the 1st century AD. The school seems to have reached its peak at the time of Hadrian and to have flourished throughout the 2nd century AD, continuing even into the 4th and 5th centuries AD. Its products had a baroque richness full of chiaroscuro and were a blend of Asiatic and *Hellenistic traditions.

APHRODITE OF KNIDOS (c. 350 BC)

A statue sculpted by *Praxiteles for the people of Knidos. The goddess, naked and standing, is shown laying aside her drapery on an urn beside her. It was the most famous statue of the goddess in antiquity. There are numerous Roman copies.

APOCALYPSES

During the 13th century, illustrated manuscripts of the Apocalypse, often with scenes from the life of St John appended, became popular in England. Texts were written in Latin or French, often rhymed or with a gloss, or were omitted entirely. A scheme of half-page pen and wash illustrations was developed from the decoration of the Trinity College Apocalypse and often copied. The Douce Apocalypse brought a more elegant and colourful style to the traditional iconography. The problem of finding visual equivalents for the fantastic events described in the Revelation of St John, was never fully resolved.

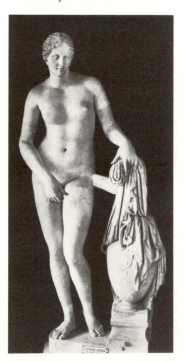

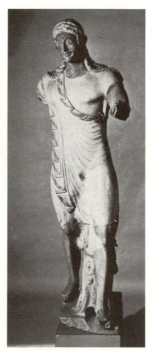

Left: APHRODITE OF KNIDOS Roman copy of mid-4th-century original. Vatican
Right: APOLLO OF VEII c. 490 BC. h. 5 ft 9 in (1·75 m). Villa Giulia, Rome

APOLLINAIRE, Guillaume (1880–1918)

b. Rome d. Paris. Poet and writer of Polish origin who became the literary figure most closely involved with artistic movements in Paris in the early years of this century. Wrote *Cubist*

Painters; invented the term *Surrealism; joined the *Dadaists (1917). He was the link between literary Symbolism and the avant-garde, a personal friend of many leading artists, particularly *Picasso.

APOLLO BELVEDERE

Roman copy of a Hellenistic bronze original, thought to show Apollo fighting the Pythian dragon, or, according to another view, driving back the Celts from his temple at Delphi when they invaded Greece in 279 BC. The original is sometimes attributed to *Leochares. (Vatican.)

APOLLO OF VEII (c. 490 BC)

A painted terracotta statue of Apollo found at Veii, north of Rome and considered to be the finest piece of *Etruscan sculpture. In style it has affinities with Ionian *Archaic sculpture. The mouth is turned up in a smile, the hair falls in thick twisted locks over the shoulders and it is clothed in an Archaic *peplos. (Villa Giulia, Rome.) *See also* VULCA OF VEII

APOLLODOROS OF ATHENS (active end 5th century BC)

Greek painter who was known as the 'shadow painter'. He is said to have discovered the gradations and changes of colour in shadows, and to have made advances in the rendering of perspective.

APOLLONIOS, SON OF NESTOR (1st century BC)

Athenian sculptor who signed the Belvedere torso in the Vatican, and the *Boxer in the National Museum, Rome.

APOTROPAIC

Designed to avert evil.

APOXYOMENOS (late 4th century BC)

A famous statue by *Lysippos of a youth scraping oil from his body. It is a boldly three-dimensional sculpture with the right arm stretched out in front of the body and the left arm running across the body. (Vatican.)

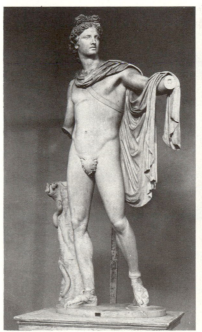

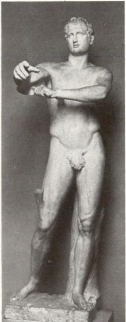

Left: APOLLO BELVEDERE Roman copy in marble of bronze original. Vatican
Right: APOXYOMENOS Marble. h. 6 ft 9 in. (2·05 m). Vatican

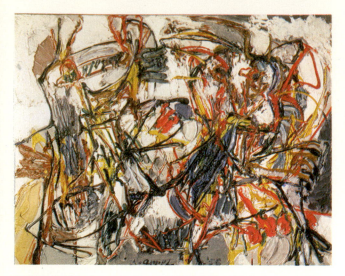

KAREL APPEL *Amorous Dance*. 1955. 44⅞×57½ in (114×146·1 cm). Tate

APPEL, Karel (1921–)

b. Amsterdam. Dutch painter who founded the *Cobra group (1948), achieving international fame in early 1950s. His early savagely distorted figures protest strongly against war. From these have developed large-scale compositions whose thick impasto paint-surface, aggressive gestural lines and bright whirlpools of colour, invite comparison with American *Abstract Expressionism – especially *De Kooning. Lives in Paris.

APSARAS

Literally 'water-going'; originally a female water-sprite; in Indian mythology generally, a seductive nymph of the spirit world.

APT, Ulrich the Elder (c. 1460–1532)

d. Augsburg. Master in 1481. In 1491 painted large fresco of St Christopher in Augsburg Cathedral. His *Adoration of the Shepherds* (altar-wing in Karlsruhe) shows a style full of Italian †Renaissance amplitude of form as do his twelve portraits of office-bearers in the Weavers' Guild.

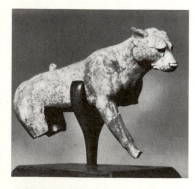

AQAR QUF Terracotta figurine of a lioness. *c.* 1400 BC. Iraq Museum, Baghdad

AQAR QUF, Lioness from

Little is known of the large-scale art of the Kassite dynasty who controlled southern Mesopotamia c. 1600–1150 BC, although the remains of wall-paintings in their palace at Aqar Quf seem to foreshadow Late Assyrian palace decoration. In smaller works, their craftsmen achieved a natural realism never equalled in Mesopotamian art. The terracotta figurine of a lioness (c. 1400 BC) displays accurate observation of bodily form and minute detail, combined with exceptional skill in modelling. There was also at this time a considerable increase in the range of materials employed, including glass, glazed faience and terracotta.

AQUARELLE

French for *watercolour painting, but used by English critics to describe the purest form of transparent watercolour-painting without the addition of inks or *body white.

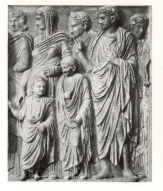

Left: ARA PACIS Detail of frieze on south side showing the Imperial procession. h. 63 in (1·60 m)
Right: AQUARELLE Detail of *Greta Bridge* by John Cotman. 1805. BM, London

AQUATINT see ENGRAVING

AQUILEIA, Basilica Theodoriana, Italy

Parts of the Constantinian 'double' cathedral survive in the 11th-century cathedral on the site. An extensive floor mosaic (?313–19) mixes ornamental panels framing donors' portraits with Christian narrative scenes, eg the story of Jonah – a clear adaptation of pagan forms for the adornment of an †Early Christian church.

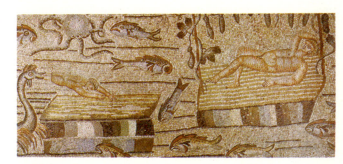

AQUILEIA, Basilica Theodoriana. Detail of floor mosaic showing Jonah's sleep. 4th century

ARA PACIS

A great altar in Rome, begun in 13 BC and dedicated in 9 BC to celebrate Augustus's pacification of Spain and Gaul. The building consists of a sacrificial altar within a rectangular enclosure. The enclosure is decorated with friezes showing the Imperial procession, allegorical panels and rich ornament of acanthus scrolls and garlands.

ARABESQUE

Formal surface decoration consisting of fluid linear patterns of foliage, scrolls or animal forms. Originating in the classical period (*grotesque), it reappears in the †Renaissance and †Rococo times. Much used in *stucco work.

ARAPAHO see PLAINS INDIAN ART

ARAWAK

A West Indies culture (c. AD 700–1550) noted for grotesque wood and stone figure-carvings called 'zemis' connected with Arawak animistic religion, and four-legged wooden stools carved with animal heads in relief and sometimes inlaid with gold and shell.

ARC WELDING

Fusing metals together at a point of contact by the use of an electric arc.

ARCHAIC ART (650–480 BC)

The Archaic Greek period began with renewed contact between Greece and Egypt. The stiff Egyptian standing figure with arms pressed to its side and staring straight ahead was the chief influence. First came the series of small *Daedalic sculptures, and later, about 600 BC, work of a larger size appeared. Most Archaic sculptures are either the *kouros, the unclothed standing male, or the *kore, the clothed standing female. These sculptures are typified by the stiff, frontal stance, heavily stylised hair and the set, artificial 'smile'. The Greeks concentrated on perfecting these two forms until, by the end of the period, sculpture attained a high level of technical competence. *Corinth was an early centre of Archaic art, especially of pot-painting, but the 6th century witnessed its decline. In Athens the human-figure style took over from the animal style of the previous period and the *black-figure technique reached its peak. Towards the end of the 6th century, however, the Athenians evolved the *red-figure style and in painting, as well as sculpture, the artistic initiative passed to Athens.

ARCHAMBAULT, Louis (1915–)

b. Montreal. Canadian sculptor who studied at Ecole des Beaux-Arts, Montreal; worked in Paris and Venice (1953–4); taught at Ecole du Meuble, Museum of Fine Arts, *Montreal and Ecole des Beaux-Arts, Montreal. Influenced by *Etruscan art and *Surrealism via the Automatistes, Archambault's metal sculptures suggest spiky, sometimes elegant, figures.

ARCHIPENKO, Alexander (1887–1964)

b. Kiev, Ukraine d. New York. Sculptor who attended the Kiev Academy. In 1908 he left for Paris, where he later opened his own art school. He became an American citizen in 1928. His work consistently tries to catch the dynamics of movement, using an inventive variety of media – collage, relief, 'sculpto-painting'. Polychromatic sculptures illustrate his theory of the intimacy of form and colour, outlined in the Polychromatic Manifesto (1959). His *Archipentura* machine (1928) produced the illusion of a moving painting. An extremely energetic and independent worker, Archipenko has been somewhat underestimated.

Above: ARAWAK Three-pointed carved stone sculpture representing a 'zemi' spirit. *c.* AD 700–1550, West Indies. l. 9⅛ in (23 cm). University Museum of Archaeology and Ethnology, Cambridge
Right: ALEXANDER ARCHIPENKO *Walking Woman.* 1912. Bronze. h. 26½ in (67·3 cm). Denver Art Museum

Left: GIUSEPPE ARCIMBOLDO *Summer.* 1563. 26⅜×20 in (67×50·8 cm). KH, Vienna
Right: ARISTION, Stele of. Marble. h. 8 ft (2·4 m). National Museum, Athens

ARCIMBOLDO, Giuseppe (1527–93)

b. d. Milan. Italian *Mannerist painter. Designed stained glass and tapestries in Milan until 1562. He was in Prague (1562–87) as Court Painter to Ferdinand I and later Rudolf II. His fame rests on his assemblage of fruits, flowers and animals to resemble a human portrait. His puns are ancestors to those of *Surrealism.

ARENA CHAPEL *see* PADUA

ARENTZ (CABEL), Arent (1585/6–1635)

b. d. Amsterdam. Dutch landscapist, specialising in the flat landscape of Holland. His work is sometimes confused with that of *Avercamp but his colours and figures (fishermen, bird-hunters) tend to be cruder.

ARETINO, Pietro (1492–1556)

b. Arezzo. Italian writer on art. Educated in Rome, where he encountered *Raphael and *Michelangelo, his writings are a development of *Leonardo's artistic theory; he favoured spontaneity rather than pedantry in painting, and understood the value of sketching. He sympathised with Venetian taste, admiring the typically Venetian virtues in art of liveliness, a feeling for nature, colour and light. As a collector he often compelled artists to yield up their works for fear of his lacerating comments, and is remembered for a notable attack on Michelangelo. His letters to artists are enthusiastic, almost racy, and he started an informal academy with his friends *Titian and *Sansovino.

ARISTION, Stele of (*c.* 510 BC)

A fine grave stele signed by *Aristokles. It shows an armed warrior in a profile view reminiscent of contemporary late 6th-century vase-painting. There are traces of the original colouring in blue, green and yellow. (National Museum, Athens.)

ARISTOKLES

1. Greek sculptor (active *c.* 550–500 BC) who signed the Stele of *Aristion in Athens.
2. Greek sculptor who worked in bronze (active *c.* 500–450 BC). He came from Sikyon and was a brother of *Kanachos.

ARKESILAOS (active 1st century BC)

Greek sculptor working in Rome and friend of Lucullus. His works include a statue of Venus Genetrix for the temple dedicated by Julius Caesar in 46 BC, and a statue of Felicitas for Lucullus. His chief output seems to have been adaptations from Greek originals.

ARLES, St Trophîme

With *St Gilles, St Trophîme contains some of the masterpieces of Provençal †Romanesque sculpture. This is located in the west portal and the north and east arms of the cloister. The technique is superb and the style distinguished by a strong interest in antiquity. The date has been the subject of much discussion and has fluctuated over most of the 12th century. It is now generally put at c. 1170. The sources are not local. The *tympanum owes much to *Chartres, and Tuscany was the most probable source of the classical elements.

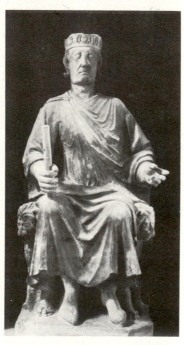

Top left: ARLES, St Trophîme. Figure of St Trophîme in the cloister. c. 1170
Top right: ARNOLFO DI CAMBIO *Charles of Anjou. c.* 1277. Marble. Over life-size. Capitoline Museum, Rome
Above: FERNANDEZ ARMAN, *Collection.* 1964. Assemblage, toy automobiles in boxes. Case: $16\frac{7}{8} \times 27\frac{3}{4} \times 2\frac{7}{8}$ in (40·6×70·5×7·8 cm). MOMA, Promised gift and extended loan from Mr and Mrs William N. Copley

ARMAN, Fernandez (1928–)

b. Nice. Object-maker who studied in Paris and was a founder-member of *Nouveau Réalisme (1961). At first close to *Schwit-

ters, Arman's distinctive works are 'accumulations' of a single item, enclosed in clear plastic, usually box-shaped. The repetition creates both a *Surrealist feeling of frustration and an abstract optical pattern. He now works in New York.

ARMATURE

ARMATURE

The internal framework upon which a sculptor builds his modelling.

ARMENIAN ART *see* CAUCASIAN ART

ARMENINI, Giovanni Battista (1530–1609)

b. Faenza. Italian writer on art, and mediocre painter who lived principally in Rome. He deplored over-decoration and liberal use of gold in much Italian provincial painting. His *De' veri precetti della pittura* (1587, Rimini) is a useful source of technical information and also contains some lively anecdotes.

ARMITAGE, Kenneth (1916–)

b. Leeds. English sculptor who studied at Leeds and the Slade School, London. His sculpture developed from wood and stone carving into three-dimensional human figures emphasising architectonic qualities of underlying structure and balance. His work when cast in bronze promotes contradictory interactions between block and armature.

ARMORY SHOW (International Exhibition of Contemporary Art) (1913)

Modern art exhibition held at 69th Regiment Armory, New York, selected works later being shown in Chicago and Boston. It was organised by the Association of American Painters and Sculptors, *Davies being President and *Kuhn publicist, and including many members of The *Eight and *Ash Can School; *Maurer and *Pach provided Parisian contacts. The show of about sixteen hundred works comprised American works ranging from the more conservative to the most radical, and foreign works, predominantly French. French work included *Ingres and *Delacroix, but emphasised later trends – †Impressionism, *Fauvism and *Cubism. German *Expressionism and sculpture were poorly represented, and *Futurism omitted. Despite its limitations, the show made an enormous impact. Major attractions were *Picasso, *Kandinsky, *Redon, *Matisse and *Duchamp. The attendance and publicity were enormous, as were the scandal and controversy aroused; critics and public attacked and mocked the work, often associating it with anarchist politics. Nevertheless, the show made its mark on artists and collectors. Sales were low, but formed the basis of major American modern collections. Galleries showing new work sprang up. Most important, American artists were forced to learn new lessons from their more advanced European contemporaries. The Armory Show accomplished its purposes: it introduced modern art to the American public, patrons and artists, break-

ing the Academy's restraint on independence forever and marking a watershed in the development of American art.

ARNHEM LAND *see* AUSTRALIAN ABORIGINAL ART

ARNOLFO DI CAMBIO (active 1265–?1302)

Central Italian sculptor and architect, trained in the *Pisano workshop, documented as having worked on the Siena Cathedral pulpit and the Arca di S. Domenico. He worked for Charles of Anjou in Rome making a large-scale seated portrait figure, made tombs in Rome and in Orvieto and designed *ciboria (stone altar-canopies) for Sta Cecilia in Trastevere and S. Paolo Fuori Le Mura. Returning to Florence he designed the uncompleted first project for the Cathedral façade and was the architect of Sta Croce and the Badia. His sculptural style was influenced both by new Northern †Gothic motifs and by the classical remains of ancient Rome. He carved massive figures with clearly characterised features and often used Gothic decorative elements. His tomb designs set a new standard of elaboration in Italy.

ARP, Hans (Jean) (1886–1966)

b. Strasbourg d. Basle. French artist who attended schools in Strasbourg, Weimar and Paris. He participated in Zürich *Dada (1916–18), at the same time creating a new abstract language. Collages of geometric simplicity and purity gave way to a series of wood reliefs (eg *Flower Hammer*, 1917) which prefigure the fluid, organic shapes of his later sculpture. During the 1920s he settled in Paris, exhibiting with the *Surrealists who found the visual humour of his reliefs sympathetic (eg *Plate, Fork and Navel*, 1923). In 1930/1 he turned to sculpture. His flexible morphology maintains a delicate balance between abstract (which he preferred to call 'concrete') and natural forms. His poetry (eg *Le Siège de l'air*, 1946) is closely related to his plastic works.

Left: JEAN ARP *Dada Relief*. 1916. Wood. 9½×6⅛ in (24×15·5 cm). Kunsthaus, Basle
Right: JEAN ARP *Hybrid Fruit called Pagoda*. 1934. Bronze. 35×26¾×30 in (88·9×67·9×76·2 cm). Tate

ARPINO, Cavaliere d' (Giuseppe CESARI) (1568–1640)

b. d. Rome. Italian painter, employed by successive popes on fresco decorations in Rome between 1590 and 1615. He also worked in the Certosa di S. Martino, Naples. Though much esteemed at the time, his elegant late *Mannerist style was outmoded by the work of *Caravaggio and Annibale *Carracci.

ARRINGATORE (1st century BC)

A life-size statue found in 1573 at Sanguineta near Lake Trasimene, showing a careworn public man of the 1st century BC. The statue is unusual because the name of the man, Aulus Metellus, is written in Etruscan, and his parents too have an Etruscan name. (Archaeological Museum, Florence.)

ARRINGATORE Bronze.
h. 5 ft 11 in (1·80 m).
Archaeological Museum,
Florence

ARSLAN TASH

Arslan Tash is the site of an Assyrian palace in North Syria which has yielded highly ornamented *Canaanite ivory carvings. One such ivory plaque (8th century BC) from a wall or piece of furniture shows the typical motif of a woman at a window looking over the temple balustrade and may represent the sacred prostitute of Canaanite religion. The original would probably have been fully painted and possibly ornamented with inlay and gold-leaf. *See also* NIMRUD

ART BRUT

*Dubuffet's term for non-professional art of which he made a collection. Dubuffet contends that there is, or should be, no essential division between the art of amateurs, children, psychotics, etc. and that of artists. Many 20th-century artists seeking a more instinctive, less intellectual approach, have been inspired by *L'art brut* (eg the *Blaue Reiter artists, *Klee, *Miró).

ART CONCRET

Short-lived movement launched by *Van Doesburg, *Hélion, *Carlsund and Tutundjan in 1930, called 'concrete' because 'nothing is more concrete, more real, than a line, a colour, a surface'. It produced a single issue of a magazine calling for an abstract art conceived and executed to objective 'scientific' rather than personal standards.

ART NOUVEAU

An international movement beginning in the 1880s, and reaching its peak at the turn of the century, to reform the state of the decorative arts by creating a new vocabulary of forms, and new relationships of those forms. This vocabulary, for painting, architecture and the applied arts, emphasised the asymmetrical and the two-dimensional. Its linear dynamics distantly suggested the passage of a flame, wave, or whip. Colours chosen tended to be muted. The mood evoked was one of mystery and luxuriance. The style was, however, marked by a strong sense of structure, of an invisible armature, implied by constant reference to the principles of natural growth. Sufficiently inventive and flexible, the movement accommodated the chasteness of *Mackintosh, the exuberance of Gaudí, the sinuosity of Guimard and the angularity of *Hodler. The force of the movement was dissipated after 1900, its inventive powers seemingly bankrupt, leaving a residue of facile affectation. Art Nouveau was called 'Modern Style' in America, while in Germany it was labelled 'Jugendstil' after the magazine *Jugend* (Youth; 1896–). In Italy it was known as the 'Stile Liberty' after the London furnishers who propagated it.

ART NOUVEAU The door of the Room de Luxe of the Willow Tea Rooms, Glasgow by Charles Rennie Mackintosh. 1902–4

ART STUDENTS' LEAGUE

Founded in 1875, New York, in rebellion against the ossified National Academy of Design, the oldest independent American art school is based on a totally democratic system. Students choose classes at will, and are expected to help each other; teachers help when asked. All styles and ideas are represented. This independence of thought and organisation has attracted many famous artists as teachers and students, from *Eakins to *Pollock.

ARTS AND CRAFTS MOVEMENT Cromer Bird Design by Mackmurdo on cretonne. c. 1884. William Morris Gallery, Walthamstow

ARTS AND CRAFTS MOVEMENT

The English reflection of a strong desire all over Europe after 1850, to revitalise the state of the industrial arts. The system of the medieval *guild had been revived by *Ruskin in the 1850s, and during the 1880s many similar associations were established, eg the Century Guild by Mackmurdo and Image in 1882, the Art Workers' Guild by *Crane and Day in 1884, culminating in the formation of the Arts and Crafts Exhibition Society in 1888. The movement promoted a sense of corporate life among artists and workmen, both of whom would be accredited for the production of an article. Their artistic aims, encouraged by the dominating example of William *Morris, were to restore the applied arts, interior decoration, pottery, glass painting, carving and metalwork, to the parity they enjoyed in the Middle Ages with painting and architecture. Despite a strong accent on social reform, the movement failed to come to terms with industrial production.

ASALAMPASU

A small tribe in the southern Kasai region of Zaire (the former Belgian Congo) best known for their masks, frequently covered with copper sheet, which all have a bulbous forehead over a triangular face.

ASAM, Cosmas Damian (1686–1739)
Egid Quirin (1692–1750)

Brothers, respectively b. Benediktbeuern d. Weltenburg and b. Tegernsee d. Mannheim. Bavarian architects and decorators (Cosmas Damian a painter and Egid Quirin a sculptor) who trained in Rome and developed further the illusionistic effects of Italian †Baroque. St John Nepomuk Church, Munich, is the finest example of their fusion of architecture and decoration.

Left: ASAM BROTHERS St George and the Dragon. 1721. Gold and silver-gilt stucco. Monastery Church, Weltenburg

Below: ASHANTI Pendant mask, possibly an ornament for a stool. 19th century. Gold. h. 7 in (18 cm). Wallace

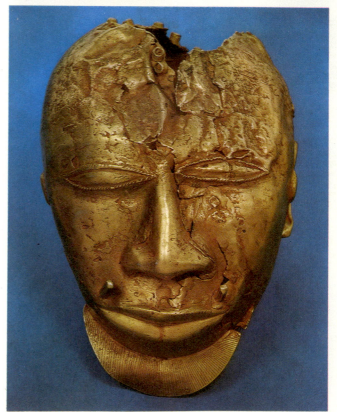

ASHANTI

A confederacy of Akan-speaking chiefdoms covering the greater part of southern Ghana (an area which includes rich gold-mines). With rare exceptions (such as the gold mask now in the Wallace Collection), sculpture in wood and metal is confined to miniatures, eg the wooden dolls for children, akuaba, and the small brass figures for weighing gold-dust. This restriction on size does not, however, apply to the heads and figures in terracotta (some of which are known to be more than two hundred years old) placed on the graves of deceased chiefs.

ASH CAN SCHOOL

Also called 'The Revolutionary Black Gang' and 'Apostles of Ugliness', *Henri, *Luks, *Glackens, *Shinn and *Sloan got their names when they exhibited with The *Eight (1908). Soon joined by *Bellows, *Marsh and others, their influence persists today. The original five were Philadelphians who moved to New York (c. 1904); excepting Henri, all began as newspaper artists, learning to describe the city in a few, quick, telling strokes. Formally, they rebelled against †Impressionism, looking back to *Hals, *Velasquez, *Daumier, *Goya and *Manet, and using a characteristically sombre palette. Conceptually, they originated in *Eakins's realism and the American genre tradition. What drew public pejoratives was their insistence on painting urban America as it really was: its backyards, bedrooms and drunks. Though politically radical, they did not create political art: rather, they were sympathetic, witty and objective. To America, they were revolutionary because they rejected 19th-century pseudo-classicism and milksop idealism, embracing instead the contemporary city's vital reality.

ASMAT see NEW GUINEA, SOUTH-WEST

ASPER Family

An important family of artists and sculptors, who worked in Zürich in the 16th century, the most talented of whom was Hans Asper (1499–1571). The City Painter of Zürich, he was elected member of the Grand Council in 1545. None of his many works for public buildings have survived, and he is best known for his portraits in the style of Hans *Holbein.

ASPETTI, Tiziano (1565–1607)

b. ?Padua d. Pisa. Italian sculptor, largely influenced by *Sansovino. He worked in Venice (1582–90), Padua (1591–1603), Pisa (1604–7) and also at Carrara. He executed busts for the Council of Ten, but preferred working on the gigantic scale of the bronze Moses and St Paul for S. Francesco della Vigna.

ASSELIN, Maurice (1882–1947)

b. Orléans. Studied in the Ecole des Beaux-Arts and influenced by †Impressionism, *Cézanne and *Fauvism. While lending his imagery of landscape, figures and still-life a romantic and pastoral quality, his simple figurative style is lacking in innovation or distinction.

ASSELYN, Jan (1610–52)

b. Dieppe d. Amsterdam. Italianate Dutch landscape painter probably in Italy in the early 1640s. He was among those who introduced the landscape ideals of *Claude to Holland, satisfying a Northern nostalgia for Italian light and classical ruins.

ASSISI, S. Francesco (founded 1228, consecrated 1253)

Founded two years after St Francis's death, in the town where he had lived and which was the centre of his Order. It comprises an upper and a lower church, architecturally influenced by French †Gothic buildings. It was very important as a meeting-place for the late 13th-century Roman and Tuscan styles and as a centre of advanced artistic activity in the 14th century. The St Francis Master, *Cimabue, *Torriti, the Isaac Master, *Giotto and his followers, *St Cecilia Master, Simone *Martini and the *Lorenzetti brothers all worked there, generally painting cycles from the Old and New Testaments and the life of St Francis. S. Francesco also contained Northern stained glass, manuscripts and metalwork. It formed a repository of potential artistic influences, introducing fresco painting to Tuscany, disseminating some Northern Gothic motifs, stimulating the practice of narrative cycle painting and establishing a formula for the depiction of the life of St Francis.

ASSYRIAN ART see MESOPOTAMIA, ART OF; KHORSABAD; NIMRUD; NINEVEH

ASTROLOBE BAY

A style area of north-east *New Guinea comprising the coast of the Bay and offshore islands. Large wood ancestor figures were set up in front of the men's houses. Masks representing spirits appeared during initiation ceremonies of the Asa, a male cult association.

 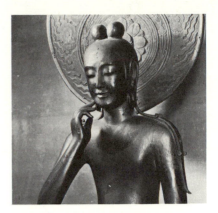

Left: ASUKA SCULPTURE Kudara Kannon. 7th century AD. Wood. h. 6 ft 10¾ in (209 cm). Hōryūji, Nara
Right: ASUKA SCULPTURE Meditating Bodhisattva. Mid 7th century AD. Wood. h. 52⅜ in (133 cm). Chūgūji, Nara

ASUKA SCULPTURE (AD 538–671)

Buddhism together with the early sculpture styles associated with the religion were introduced into Japan in the 6th century AD from the Korean state of Paekche. Korean influence is evident both in the prevalence of certain image types such as the meditating Bodhisattva in the Chūgūji and in some sculptural conventions including the fin-like edges to the hanging scarves on the Yumedono Kannon in the *Hōryūji and the heavy folds with their insistent patterned symmetry in the bronzes cast by *Tori. The flatness of the sculpture is most pronounced in the works by Tori but is present in most other Asuka sculpture, except the Kudara Kannon, which represents a contrasting tradition with its columnar body and small rounded head.

ATELIER

French for 'workshop'. Thus an artist's workshop or studio. Also a printmaker's printing-shop.

ATL, Dr (Gerardo MURILLO) (c. 1873–1964)

b. Guadalajara. Mexican painter who studied and taught at Academy of San Carlos; worked in Europe (c. 1900–3); organised dissident Mexican exhibition (1910). A leader of the popular art movement in revolutionary Mexican muralism, Atl was influenced by the †Renaissance, *Art Nouveau, and *Fauvism, evidenced in his brooding, fiery *Expressionist landscapes.

DR ATL Volcanic Landscape. 1933. Marte R. Gomez Collection

ATLAN, Jean (1913–60)

b. Constantine, Algeria. Initially studying philosophy, he turned to painting in 1941. Working largely in isolation, he evolved a style in which lyrical imagery is simplified to produce near-abstract compositions. He painted boldly and with strong colour.

ATOMISER

A simple blowpipe mouth-operated spray used for applying *fixative to a soft drawing.

ATTIC

Of Attica, whose centre was Athens. Attic art was once used as a term to describe anything Greek, but it now describes only the art of the Attic region. *Also* the storey above the main orders of a façade.

AU PREMIER COUP *see* ALLA PRIMA

AUDRAN Family

French 17th- and 18th-century family of engravers, the most important of whom was Gérard (1640–1703) b. Lyons d. Paris, pupil of *Lebrun. He twice visited Rome, and specialised in engraving his master's *history paintings. His great-nephew Michel (1707–71), b. d. Paris, designed tapestries for the Gobelins.

Left: AUDRAN FAMILY Singerie design. Stockholm
Right: AUSTRAL ISLANDS The deity Tangaroa. 18th century. Ironwood. ♞. 44 in (112 cm). BM, London

AUDUBON, John James (1785–1851)

b. Les Cayes, Haiti d. New York. American painter raised in France, he studied drawing under *David about 1802, settling in USA about 1807. Explored USA and Canada (1820–51), seeking, drawing and writing about wildlife; often in Britain (1826–39) having work engraved and published. Gifted designer and self-made naturalist, renowned for series *Birds of America*, he loved the wilderness and recorded its creatures with artistry and exactitude.

AUERBACH, Frank (1931–)

b. Berlin. Painter who came to Britain in 1939, subsequently adopting British nationality. Attended classes given by *Bomberg, by whom he was much influenced. His style is characterised by a use of such thick impasto that it is almost relief. He often paints nudes lying on beds, and North London townscapes slightly reminiscent of *Sickert. Leon *Kossoff's paintings are very similar to Auerbach's, though less structured.

AUREUS CODEX (2nd half 8th century)

A Gospel Book written and illuminated in the South of England showing in the portrait of the Evangelist St Matthew a partial retention of antique modelling and space combined with Insular decoration (eg the interlace on the throne). (Royal Library, Stockholm.)

AURIGNACIAN (30,000 BC)

Contemporary with Middle Perigordian and mainly centred in France, the Perigordian/Aurignacian period represents the first cycle of †Palaeolithic art.

AUSTRAL ISLANDS

A central *Polynesian island group with an art style related to neighbouring *Cook and *Society islands. Figures are extremely rare. Surfaces of drums, bailers, paddles and bowls are carved with bands of small human figures and geometric motifs derived from the human form.

Left: JOHN JAMES AUDUBON *Chinese Blue-pie.* Page 39½ × 29½ in (100·3 × 74·9 cm). BM, London

Below: AUSTRALIAN ABORIGINAL ART Bark-painting by the artist Bunia from Groote Eylandt showing a battle between a dingo and a wallaby

AUSTRALIAN ABORIGINAL ART

The Australian aborigines subsisted by hunting and foraging – the men taking emu and kangaroo, and fishing where possible, and the women gathering roots and berries. Their technology was very simple, except for specialised hunting equipment. Most of their time was spent searching for food or wandering from one temporary camp to the next. In all these things they differed from the other peoples of *Oceania who were agriculturalists living in permanent or semi-permanent villages, with a wealth of material culture including large ceremonial houses and great seagoing canoes. Despite a barren environment, and technology that was barely adequate to exploit it, aboriginal life was enhanced by a rich and colourful mythology and a system of social relations as complex as any in the world. Art, myth and the social order were interrelated and mutually supporting. Like most hunting and gathering peoples the aborigines produced little sculpture. Their art lay in painting and engraving any available surfaces: rocks, trees, skin-rugs,

weapons, shells, the ground and their own bodies. Earth pigments – black, white, red and yellow – were ground on a stone palette and mixed with water or a fixing medium such as beeswax or the whites of sea-turtle eggs. The colours were applied with the palm of the hand or the forefinger or, where finer lines were required, with a brush made from a twig or strip of bark chewed at one end. Rock paintings and engravings are found in many parts of Australia. Unlike *Palaeolithic European paintings these are not found deep inside complex cave systems but on the walls and ceilings of shallow rock-shelters. They may represent events in real life or incidents in the mythological past. Some sites became sacred during ceremonies at which the totemic ancestors of the group were revitalised by renovation of the paintings. Most interesting are the Wandjinas from the north-west coast: tall white figures with mouthless faces surrounded by haloes representing beings from the creation time. Farther south scenes of everyday life were drawn for all to see. As in the cave-paintings of Europe human hands are commonly represented. A paint-covered hand may be applied to the wall or, as in most cases, paint is squirted from the mouth over a hand to produce a stencil effect. In eastern Australia rock faces are covered with engravings of men, fish and reptiles made by pounding the rock surface with a smooth pebble. Elsewhere totemic rituals or initiation ceremonies involve the ground being painted with elaborate patterns or scored with symbolic devices. In Arnhem Land hand-paintings on eucalyptus bark were used to instruct the young in esoteric lore. The insides of bark huts were also painted; much of this was decoration simply for pleasure. In the River Darling area of New South Wales bark was removed from trees and geometric designs cut into the living wood. Symbolic motifs were engraved and painted on sacred objects, bull-roarers, tchuringa, etc. Pearl-shell pubic ornaments engraved with an interlocking key pattern were traded over long distances. Shields, boomerangs, spear-throwers, spears and clubs were decorated with abstract totemic symbols.

HENDRIK AVERCAMP *Winter Scene with Skaters near a Castle.* *c.* 1609. Diameter 16 in (40·7 cm). NG, London

AUTOMATISM *see* SURREALISM

AUTUN *see* GISELBERTUS

AUXERRE, St Germain

The east end of the abbey was extended between 840 and 859 and parts of this work survive in the present crypt. The †Carolingian walls were painted, and although now mutilated

the fragments provide us with some notion of what monumental art was like in Carolingian times. The frescoes include two bishops of Auxerre and three episodes from the life of St Stephen.

AVANTIPURA *see* KASHMIR

AVA-TARA

Sanskrit: literally 'downward-crossing', 'descent'; incarnation of a deity, especially *Vishnu on earth.

AVED, Jacques (1702–66)

b. Douai d. Paris. Flemish portrait painter who trained in Amsterdam under the French engraver, Picart. In Paris, after 1721, he associated with *Boucher and later *Chardin. His famous portrait, the *Sultan Mehemet Effendi,* was shown at the Salon of 1742.

AVERCAMP, Hendrik (1585–1634)

b. Amsterdam d. Kampen. Dutch painter, specialising in winter landscapes which he was among the first to treat purely as genre scenes. His compositions, filled with gaily coloured skaters bright against the ice and white sky, are often reproduced as Christmas cards. He was dumb.

AVERLINO, Antonio *see* FILARETE

AVERY, Milton (1893–1965)

b. Altmar, New York d. New York. Painter who studied briefly at Connecticut League of Art Students, went to Europe (1952), and lived in New York, spending much time in Provincetown. Influenced by *Matisse, Avery's stylised figurative painting grew increasingly abstract, becoming a rhythmic pattern of flat areas of evocative, resonant colour.

AVIGNON, Papal Palace (1340s)

The palace-fortress of the 14th-century popes, then exiled in Avignon, contains a number and variety of wall-paintings. Two chapels were decorated under the direction of *Matteo di Viterbo and show a strong Italian influence. The private apartments of the popes are painted with tapestry-like scenes of gardens, hunting and fishing.

AVIGNON PIETA *c.* 1460. 63¾×85⅞ in (162×218 cm). Louvre

AVIGNON PIETA (*c.* 1460)

This austere and moving *Pietà* from Villeneuve-lès-Avignon, now in the Louvre, is painted in tempera on panel and has exotic architecture in the background. The work is considered the masterpiece of the School of Avignon, and is now attributed by some scholars to *Charonton.

AYRES, Gillian (1932–)

b. London. Painter who studied at Camberwell School of Art. She recently produced very large-scale works retaining elements of her earlier interest in the paint mark or gesture on the canvas surface. These stencil-like shapes of vibrant juxtaposed colour are sometimes suggestive of recognisable forms.

AYRTON, Michael (1921–)

b. London. Sculptor and painter who travelled extensively; wrote several books, including *The Maze Maker* and *Giovanni Pisano, Sculptor*; created enormous labyrinth, Arkville, New York. An erudite, versatile classicist in a romantic, expressionist era, Ayrton symbolises this tension in works preoccupied with Daedalus and Icarus (1956–69), entangling bronze figures in reflecting mazes.

MICHAEL AYRTON *Icarus Transformed I*. 1961. Bronze. 8×23×12½ in (20·3×58·4×31·8 cm). Tate

AZANDE

A large tribe on the border area of Zaire, the Central African Republic and the Sudan. Much of the sculpture found among the Azande is in fact from the neighbouring Mangbetu tribe and emphasises the elongation of the skull which they, unlike the Azande, practise. However there is a distinctive group of figures and anthropomorphic musical instruments from the Azande of southern Sudan.

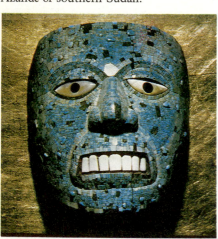
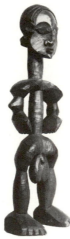

Left: AZTEC Post Classic Period, AD 1300–1520. Mexico. Cedarwood mask covered with turquoise mosaic and inlaid with shell. h. 6⅝×5⅞ in (16·8×14·9 cm). BM, London
Right: AZANDE Figure of a man. South-western Sudan. Late 19th century. Wood. h. 31½ in (80 cm). BM, London

AZTEC

Late-comers to the Valley of Mexico, the Aztecs achieved their empire by conquest and were in their turn conquered by Cortez in AD 1519. Typically Aztec are powerful stone sculptures representing the bloodthirsty gods worshipped by this warrior society. Some woodcarvings, drums, gongs and spearthrowers survive, but much of the finest craftsmanship, particularly in pottery and mosaics, appears to have been imported from the *Mixtec centre at Puebla.

B

BABANKI *see* **BAMILEKE**

BABUREN, Dirck van (1590/5–1624)

b. d. Utrecht. Dutch painter, a principal *Caravaggesque artist of the *Utrecht School. Probably in Rome by 1612, he contributed (1615–20) to the decoration of S. Pietro in Montorio, then returned to Utrecht. He painted both religious and genre scenes.

BABYLON *see* **MESOPOTAMIA, ART OF; HAMMURAPI**

BACCHIACCA (Francesco d'UBERTINO) (1495–1557)

b. d. Florence. Florentine painter, possibly a pupil of *Perugino and a friend of Andrea del *Sarto. His narrative paintings with small figures have a hard clarity. He also produced portraits.

BACICCIA, Giovanni Battista *see* **GAULLI**

BACKER, Jacob Adriaensz (1608–51)

b. Harlingen d. Amsterdam. Dutch painter who studied in Leeuwarden and in the early 1630s in Amsterdam with *Rembrandt whose influence is apparent in his portraiture, including group portraits. Later he was influenced by van der *Helst.

BACKHOFFEN, Hans (d. 1519)

German sculptor, active chiefly in Mainz and Frankfurt, best known for works on a very large scale in an early classicist style, eg *Crucifixion* (Wimpfen-am-Berg).

BACKHUYSEN, Ludolf (1631–1708)

b. Emden d. Amsterdam. The last of the great Dutch marine painters, his style was based on that of his teacher, Hendrik Dubbels, and on *Everdingen and van de *Velde the Younger.

BACO, Jacomart (d. 1461)

Spanish painter from Valencia. Called to Naples in 1440 by Alfonso of Aragon. Worked on all kinds of commissions, conspicuously on an altarpiece for Sta Maria della Pace (1444, destroyed in 1528) and on banners (1447) for the journey of the king to Tuscany. Back in Valencia in 1451. His style is a fairly direct emulation of Jan van *Eyck's, fused with fiery Valencian elements.

BACON, Francis (1909–)

b. Dublin. British figurative painter, self-taught. Had evolved mature style by 1944, involving a sophisticated use of oil paint on canvas. His vision is one of profound despair, destruction and agony. Nearly all his paintings are of distorted, perhaps mutilated figures, set within a claustrophobic space, sometimes isolated within a cage-like structure. They possess a ruthless grandeur. Bacon has drawn inspiration from slaughterhouses, illustrations in medical textbooks and press photographs as well as from *Velasquez, and has influenced much contemporary British and European painting.

BADAMI *see* **CHALUKYA DYNASTY**

BADGER, Joseph (1708–65)

b. Charlestown, Massachusetts d. Boston. Self-taught American painter, who was principal Boston portraitist between *Smibert and *Copley. Basically a *limner, he painted adults with stiff, muddy formality, but could sometimes capture the essence of childhood.

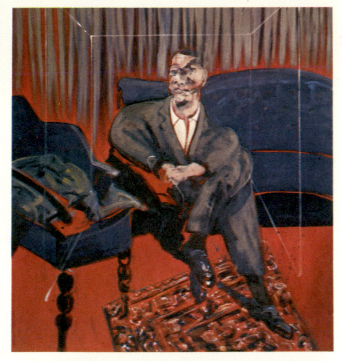

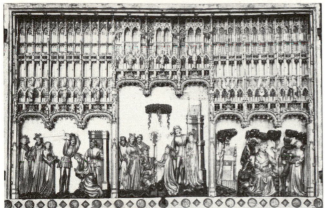

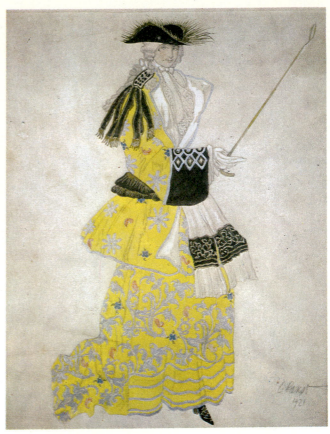

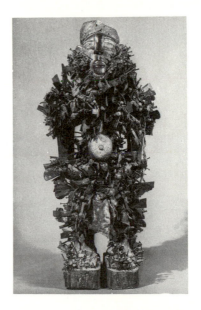

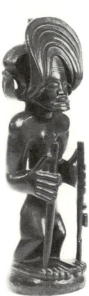

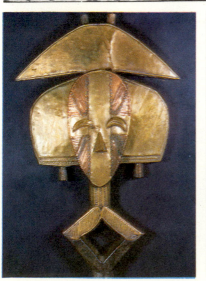

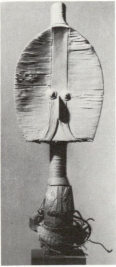

Above left: BAKOTA Figure from an ancestral reliquary. Wood with brass and copper sheet. h. 26½ in (68 cm). BM, London

Above right: BAKOTA Figure from an ancestral reliquary. Wood with brass strips. h. 19¼ in (49 cm). Musée de l'Homme, Paris

Top left: FRANCIS BACON *Seated Figure.* 1961. 65×56 in (165·1×142·2 cm). Tate
Centre left: JACQUES DE BAERZE Detail from the Retable of Saints and Martyrs. Carved by de Baerze and gilded by Melchior Broederlam for the Charterhouse at Dijon. 1391
Top: LEON BAKST Costume Design for the Countess in Scene II of *The Sleeping Princess.* 1921. Watercolour. 11½×8½ in (29·2×21·6 cm). Sotheby and Co
Above left: BAKONGO Fetish figure from the Lower Congo. Wood with iron nails. h. 36¼ in (92 cm). Musée Royale de l'Afrique Centrale, Tervuren, Belgium
Above right: BAJOKWE Figure of a chief. South-western Zaire. Wood. h. 13½ in (34 cm). BM, London

BAERZE, Jacques de (active end of 14th century)

Flemish woodcarver from Termonde whose only surviving works are two altarpieces for the Charterhouse at Dijon, made for Philip the Bold, Duke of Burgundy and completed in 1391. Said to be copies of earlier versions in his home town, they show certain advances on the *schnitzältare of the 14th century in respect of the theatrical arrangement of figures; but the figures themselves are still slight and doll-like by comparison with *Sluter's work. One altarpiece has wings painted by Melchior *Broederlam.

BAGA

A tribe in the Konakry region of Guinea best known for their *nimba* mask, an extraordinary cantilevered head upon an enormous bust which the dancer wears as a helmet seeing out through a small hole between the breasts. The Nalu and Landuma on the Lower and Upper Rio Núñez respectively are closely related to the Baga, all three sharing to a large extent a common culture. Another mask typical of this group is the elaborate therianthropic *banda* mask sometimes nearly six feet long carried horizontally on the wearer's head.

BAGH PAINTING (c. AD 550–650)

These Buddhist cave-paintings in Central India possess the same tempera technique and limited palette as is used at *Ajantā, but the style and expression are somewhat different. The feeling displayed is one of power, and the tone is more secular than religious. Like the sculpture of the period, there is a monumental quality in the chief figures. The best-preserved fragments, all too few in number, depict a royal procession and a group of musicians and dancers.

BAGLIONE, Giovanni (c. 1573–1644)

b. d. Rome. Italian painter and biographer of 16th- and early 17th-century Roman artists (1642). His painting was chiefly late academic *Mannerist, though it was briefly affected by his enemy, *Caravaggio.

BAIITSU (Yamamoto Baiitsu) (1783–1856)

Japanese artist of the *Nanga School who produced detailed, almost *Shijō-like flower-paintings as well as more typical Nanga work.

BAILLAIRGE, François (1759–1830)

b. d. Quebec. Canadian sculptor who studied with Stouf at the Paris Academy (1778–81); was son of carver and assisted by brother Florent (1761–1812) and son Thomas (1792–1859). The Baillairgé woodcarvings, mainly ecclesiastical and influential in Quebec, are solid, volumetric, well composed, but undistinguished by any real refinement.

BAJ, Enrico (1924–)

b. Milan. Italian painter who with Dangelo launched Nuclear Art (1950), opposing abstraction with an expressionist automatism derived from *Abstract Expressionism and contributing to *Tachisme (1954). In the tradition of *Picasso and *Dubuffet, Baj makes imaginative use of collage to create a grotesque, whimsical, fantasy world.

BAJOKWE

A people found throughout mid-Angola and the adjacent area of Zaire. They were noted hunters and warriors but were subject to the great Balunda Empire (which was finally destroyed, by rebellious Bajokwe, in 1887). The Bajokwe supplied much of the sculpture found among the Lunda peoples, and their work includes wooden figures of chiefs wearing elaborate headdresses, ornamental chairs, and a variety of masks some of wood and others of bark. The easternmost Lunda peoples, such as the Mambunda, stretch into Zambia where they are now subject to the *Barotse.

BAK

Egyptian sculptor of the *Amarna period, allegedly taught by *Akhenaten himself. The names of other contemporary artists, among them Iuti, Thutmose and Parennefer, are also preserved, whose relative prominence may reflect the importance attached to their role in interpreting the revised conventions. Like his father Men (responsible for the *Memnon colossi), Bak was in charge of the quartzite quarries, and this material was extensively used at el-Amarna.

BAKONG, Roluos, Cambodia

The temple founded by King Indravarman in AD 881 is the first of the classical *Khmer temple-mountains which mark the centre of the kingdom considered as a cosmos. The decoration exhibits much Javanese influence – Cambodia only broke away from Java in AD 802. The reliefs show highly formalised mannerisms in a markedly sinuous style while the free-standing statuary is much less vital than that of *Chen-La. A remarkable group at the main entrance to the temple shows the king flanked by his two chief wives, presumably portrayed as Shiva with Uma and Ganga. See also BANTEAY SREI

BAKONGO

A tribal complex, including the Mayombe, Bawoyo and Bavili round the mouth of the River Congo in Zaire, Angola, Congo-Brazzaville and Cabinda. These tribes are the successors of the kingdom of Kongo which the Portuguese discovered in 1482. Bakongo sculpture includes figures in wood (and a few in stone) of chiefs and their wives or mothers, although perhaps their best known works are the nail fetishes, human or animal figures in wood, totally obscured by hundreds of iron nails driven into them.

BAKOTA

Apparently an arbitrary term chosen by French administrators to cover a diverse group of tribes, including the Bakota proper, in eastern Gabon and the adjacent area of Congo-Brazzaville. The most striking sculptures from this area are two-dimensional wooden images covered with copper and brass which are placed upon boxes containing the bones of ancestors. There are two types. One, called *mbulu-ngulu*, has an oval head upon a lozenge (the arms of the figure) covered in front with sheet-metal; it is always described as 'Bakota'. The other type, called *bwiti*, is somewhat leaf-shaped and is covered on both sides with metal wire; it has been found among the Mahongwe, Shamayi and Shake tribes, all of which belong to the 'Bakota' group.

BAKST, Leon (Nicolajevitsch ROSENBERG) (1866–1924)

b. St Petersburg d. Paris. Painter and designer who studied at the St Petersburg Academy. He founded the *World of Art movement (1898) with Diaghilev with whom he introduced the Ballets Russes to Paris (1909). His major success came in 1910 with the designs for *Scheherezade* while he also contributed non-academic paintings to the Salon. He was influenced by *Matisse and caused a breakthrough in theatrical décor with his expressionistic use of intense colour.

BAKUBA

A once-powerful kingdom between the Kasai and Sankuru rivers in Zaire, a federation of eighteen tribes including the *Bambala, Bangongo, Bangende, etc. The Bakuba ruling class call themselves the 'Beni-Bushongo'. Neighbouring tribes such as the *Ndengese have also come under Bakuba influence. In the 16th century many cultural elements seem to have been imported by the Bakuba from the Kingdom of Kongo. The wooden figures of Bakuba kings which have been carved since the reign of Shamba Bolongongo, the ninety-third king, in the early 17th century may be derived from somewhat similar *Bakongo figures. Bakuba masks represent mythological figures such as Mwaash-a-Mbooy, their first ancestor, and are made of many different materials including wood, bark, raffia, sheet-copper, glass beads and cowrie shells.

BAKWELE

A tribe in the north of Congo-Brazzaville well known for their beautifully simple masks, usually more or less circular in outline with a heart-shaped face.

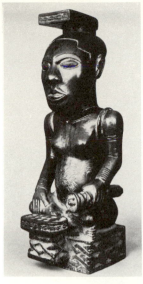

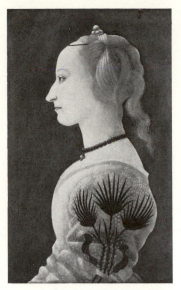

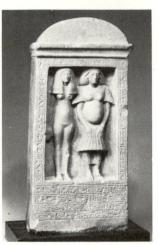

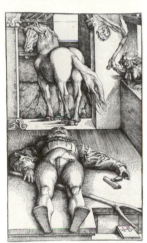

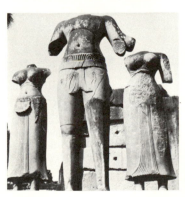

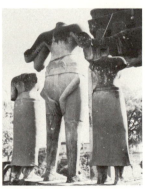

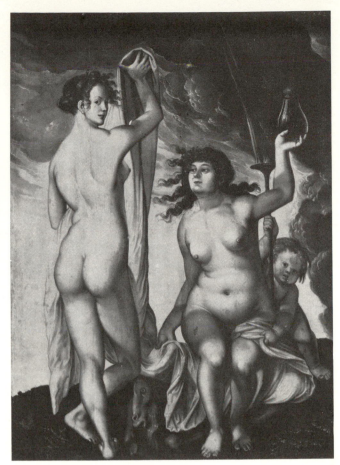

Above: HANS BALDUNG GRIEN *Witches.* 1523. $25\frac{5}{8} \times 18\frac{1}{8}$ in (65×46 cm). Frankfurt

Top left: BAKUBA Effigy of King Shamba Bolongongo. Said to be carved from life in the early 17th century. Wood. h. $24\frac{1}{4}$ in (54 cm). BM, London
Top right: ALESSO BALDOVINETTI *A Lady in Yellow.* $24\frac{3}{4} \times 16$ in (63×40·5 cm). NG, London
Centre left: BAK *Stele of Bak and his Wife.* 18th dynasty, *c.* 1355 BC. Quartzite. h. 25 in (63·5 cm). Staatliche Museen, Berlin-Dahlem
Centre right: HANS BALDUNG GRIEN *Sleeping Groom and a Sorceress.* 1544. Woodcut. $13\frac{1}{4} \times 7\frac{3}{4}$ in (33·7×19·7 cm). BM, London
Above left and right: BAKONG, Cambodia. Entrance group depicting King Indravarman with his two wives. 9th century. Sandstone. h. $51\frac{1}{4}$ in (130 cm).

BALDACCHINO

Italian: 'canopy'. Free-standing structure consisting of a canopy supported by columns, usually placed over an altar. Also called a *ciborium. A portable baldacchino is sometimes shown in Italian paintings shading the Virgin and Child.

BALDACCINI, César *see* CESAR

BALDINUCCI, Filippo (1625–96)

b. d. Florence. Italian scholar and biographer of artists from *Cimabue to the 17th century. He is notable for his biography of *Bernini and his respect for historical documentation. He catalogued the Medici drawings collection for Cardinal Leopold de' Medici.

BALDOVINETTI, Alesso (c. 1426–99)

b. d. Florence. Italian painter, mosaicist and stained-glass worker. His curvilinear style was influenced by *Domenico Veneziano and Fra *Angelico. His major Florentine activity includes the lost S. Egidio frescoes (1461) and the apsidal chapel of Sta Trinità.

BALDUNG GRIEN, Hans (1484/5–1545)

b. ?Gmünd, Swabia d. Strasbourg. Painter, printmaker and designer of stained glass. Perhaps worked when young in *Dürer's workshop. First recorded at Strasbourg in 1508. After a period of work for the cathedral in Freiburg-im-Breisgau, he regained his citizenship at Strasbourg in 1517, and settled there. Although affected by *Dürer's classicism and by the excited landscapes of the *Danube School, Baldung developed a highly emotional means of expression embracing hitherto unknown subject-matter. His interest in witches'

covens and in themes showing man being controlled by the supernatural was perfectly expressed in his dramatically coloured, excited paintings or in the bold linearity of his woodcuts.

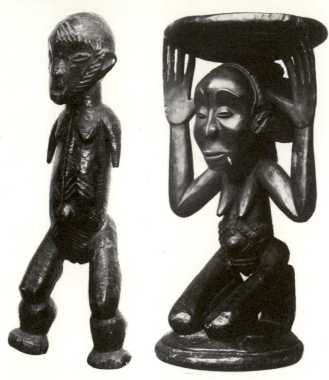

Left: BALEGA Figure used in rites of the Bwami society. Ivory. h. 9½ in (24 cm). Collection M. Charles Ratton, Paris
Right: BALUBA Stool carved by the Master of Buli. Late 19th century. Wood. h. 20½ in (52 cm). BM, London

BALEGA

A tribe of elephant-hunters living in the tropical rain forest in the east of Zaire towards the frontier with Rwanda and Burundi. The miniature masks and figures in ivory and wood for which the Balega are best known are the insignia of rank within the Bwami society, the central institution of Balega life. They also make larger masks which are worn at initiation rites.

BALEN, Hendrik van (?1575–1632)

b. d. Antwerp. Flemish painter. A pupil of Adam van Noort, he painted decorative mythological scenes in the manner of and sometimes in collaboration with Jan *Bruegel. After 1610 he was influenced by *Rubens.

BALI, ART OF

Of all the areas of South-East Asia, Bali is perhaps the most famous as a centre of artistic production, though much of the painting and carving has passed into the world's museums. Our familiarity with Balinese art is largely due to the efforts of two men, Bonnet and Spies who in the 1930s started a revival of the arts of Ubud, encouraging traditional skills and seeking new subjects for artists. Earlier cult centres such as Goa Gadjah (early 13th century) and Yeh Pulu (14th century) show both the formal cult of water sources connected with rice cultivation and the horrific element which also finds expression in the conflict between Barong and Rangda. (This usually takes the form of dance drama and represents basically a struggle between good and evil.) Traditional painting was concerned with narration and calendrical themes (on a 210-day cycle). Although old statues of deities are treated with reverence, the Balinese do not make images for the altars of their temples; the gods are invited to occupy empty thrones at times of festival and are then treated as spiritually present.

The temples themselves, on the other hand, are richly decorated with both narrative and genre scenes.

BALL, Thomas (1819–1911)

b. Charlestown, Massachusetts d. Montclair, New Jersey. American sculptor, apprenticed to wood-engraver, then painted, from 1851 making sculpture. Lived in Boston (1837–53, 1857–64), studying (1854–7) and working (1864–97) in Italy, then settling in Montclair. He specialised in portraits characterised by flatfooted Yankee factualness.

GIACOMO BALLA *Swifts: Paths of Movement and Dynamic Sequences.* 1913. 38⅛×47¼ in (96·8×120 cm). MOMA, New York

BALLA, Giacomo (1871–1958)

b. Turin d. Rome. Italian painter and interior decorator who studied at evening classes in Turin. It was he who showed *Severini and *Boccioni the *Divisionistic technique he had learnt in Paris and with them he signed the 1910 Futurist Manifesto. He tried, in his *Futurist work, to convey the dynamism and rhythm of a moving subject.

BALSAM

Natural *resin used in *varnish-making. A sap which exudes from coniferous trees and solidifies.

BALTHUS (Balthus KLOSSOWSKI DE ROLA) (1908–)

b. Paris. French painter of Polish descent. His paintings are in a traditional representational style, often with thick, sensuous brushwork. They usually purvey a mood of calm stillness mixed with foreboding. Favourite subjects include cats, and semi-dressed adolescent girls, reading books, playing cards or stretched in positions suggesting a sort of erotic trance. Related to *Pittura Metafisica and the illusionistic wing of *Surrealism, his work also possesses a monumentalism showing the influence of *Piero della Francesca and *Courbet.

BALUBA

A large group of related peoples in Katanga, Zaire, united in a military confederacy from the 16th to the 19th century. At least ten distinct sub-styles are known. The best known of these is probably the Baluba-Hemba style which emphasises spherical forms in its human figures and masks. Another is the long-faced style of the Master of Buli, a village near Albertville. Another is the Baluba-Shankadi style with its cascading coiffures. Yet another group, the Baluba-Kasai, settled round Luluabourg about 1888 and became known as the Bena

Lulua; their sculptures are usually enriched by the decorative enhancement of surface areas in imitation of cicatrisation.

BAMBAIA (Agostino BUSTI) (1483–1548)

b. Busto Arsizio. Italian sculptor, probably trained under Benedetto Briosco at the Certosa at Pavia. He worked chiefly in Milan. His art combines some classical influences with a North Italian love of decoration which finds its most lyrical expression in the tomb of Gaston de Foix (1515–22, Museo Civico, Milan).

BAMBALA

1. A tribe of the Kwango River area of Zaire; they are particularly known for their mother and child sculptures.
2. A sub-group of the *Bakuba, unrelated to the above.

BAMBARA (BAMANA)

A people inhabiting a large area round Bamako, Mali, on both sides of the River Niger, the heirs to the 17th–19th-century kingdoms of Kaarta north of the river, and Segou on the Niger north-east of Bamako. Complementing the system of age stratification among the Bambara are six initiation societies through which men passed in the following order: *ntomo*, *komo*, *nama*, *kono*, *tyi wara* and *kwore*. These all use masks and other sculptures, the best known of which are the *ntomo* society masks with several projections on top, and especially the *tyi wara* (*chi wara*) antelope headdresses worn at rites commemorating the mythical origins of agriculture. In addition to masks, figures and wooden puppets, the Bambara also have sacred figures of bulls (*boli*) which are heavily encrusted with a mixture of ashes, blood and beer. The Bambara are one of several Manding peoples in the western Sudan, the heirs to the medieval empire of Mali, who all speak related forms of the same language. The Bambara have proved the most resistant to Islam of all the Manding, but sculptures are also found among the Marka of the San area east of Segou, whose masks, covered with brass sheet, are worn at Muslim festivals, and the Malinke (Mandingo) in Guinea. The Vai in Liberia are yet another Manding people but their sculpture is closely related to the *Mende of Sierra Leone.

BAMBERG CATHEDRAL

This cathedral in East Franconia possesses some of the best 13th-century sculpture in Germany. It is located in two portals, the Gnadenpforte and the Furstentor round the eastern choir (the cathedral has reversed orientation) and in the adjacent diocesan museum. The sources are French, mainly *Reims, but the handling has a distinct German character, in which the direct representation of emotional attitudes assumes unprecedented importance. The outstanding pieces are the *Visitation* group and the unidentified *Rider*.

BAMBOCCIATE see BAMBOCCIO, IL

BAMBOCCIO, IL (Pieter van LAER) (1592–1642)

b. d. Haarlem. Dutch painter of low-life genre scenes who worked in Rome (*c.* 1627–39). He acquired his nickname 'little clumsy one' in Rome. A friend of *Poussin and of *Claude, he popularised paintings at once realistic and picturesque of peasants and street scenes. While in Rome, van Laer collected round him a coterie of artists – mostly fellow Northerners – who were collectively known as the *Bamboccianti*. They included Michelangelo Cerquozzi (1602–66, b. d. Rome) and Jan Miel (1599–1663/4, b. Antwerp d. Turin). Their paintings are called *bambocciate* or *bambochades*. The group was attacked by the upholders of 'high art' who abhorred their subject-matter and their bohemian way of life. Their works were popular however with collectors and their figure style infiltrated landscape (the early Claude, *Both, *Berchem, etc).

BAMBOCHADE see BAMBOCCIO, IL

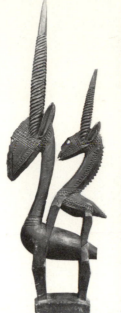

Left: BAMBARA Tyi Wara wooden headdress representing the mythical antelopes which taught people agriculture. BM, London
Right: BALTHUS *Joan Miró and his Daughter Dolores.* 1937–8. $51\frac{1}{4} \times 35$ in ($129 \cdot 5 \times 88 \cdot 9$ cm). MOMA, New York

BAMBOLE

A tribe south-west of Stanleyville (now Kisangani), Zaire, whose elongated gently curving figures are said to represent persons executed for breaking the rules of secrecy of the Lilwa society. These figures are usually pierced through the shoulders and buttocks so that they can be hung on the walls of the cult house.

IL BAMBOCCIO *The Cake Vendor.* Gall Naz, Rome

BAMILEKE

The southernmost of three groups of numerous small tribes in the grasslands of western Cameroun, an area noted for its vigorous and extrovert sculpture. The Bangwa, perhaps the most vigorous and extrovert carvers of the whole area, are among the Bamileke tribes. The two other groups are the Bamum, centred on Foumban in the east of the grasslands, and the Tikar round Bamenda, and including the Babanki tribe among others, in the north-west. The sculpture of this area includes massive house-posts and door-frames, ancestor

figures, masks in human (often with enormously inflated cheeks especially among the Bamum) and animal (especially the buffalo) form, as well as thrones, drums and other objects. Embroidery in glass beads is also commonly employed to make masks in this area and to cover wooden objects such as masks and thrones. Finally, Foumban and Bamenda are centres of *cire perdue brass-casting, and among the work produced are large elaborate pipe-bowls.

BAMUM see BAMILEKE

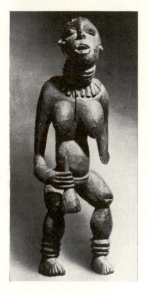
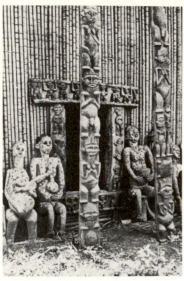

Left: BAMILEKE Figure of a dancing woman. Bangwa sub-tribe. Wood. h. 33 in (84 cm). Mr and Mrs Harry Franklin Collection, Beverly Hills
Right: BAMILEKE Ancestral figures, veranda posts and carved door-frame at a chief's house, Bafussam, Cameroun

BANDINELLI, Baccio (1493–1560)

b. d. Florence. Florentine sculptor, goldsmith and painter. Favoured by the Medici, he was the rival of *Cellini who attacked him, and his work was dismissed by Galileo as bric-à-brac. His *Adam and Eve* (Bargello, Florence) shows his somewhat lifeless academic style. His is chiefly important to art history as the founder of two proto-academies, the first in the Vatican (1531), the second in Florence (c. 1550).

BANDINI, Giovanni di Benedetto, da Castello (Giovanni dell'Opera del Duomo) (1540–99)

b. Florence. Italian sculptor, a pupil of *Baccio Bandinelli, he was given his nickname because he had a workshop in the Piazza del Duomo, Florence. He executed low reliefs in the Cathedral choir and, later, statues of St Philip and St James the Less. His rather staid figure representing Architecture (1568) adorns *Michelangelo's tomb (Sta Croce, Florence).

BANGWA see BAMILEKE

BANON, Central Java (9th century AD)

Little has survived of the Shaivite temple at this site not far from Borobudur apart from five pieces of statuary representing *Shiva Mahadeva, *Ganesha, *Brahma, *Vishnu and Mahaguru (usually called Agastya in Java) the Divine Teacher par excellence. They show an astonishing technical mastery of sculpture in the round. A certain immobility is characteristic of Javanese concepts of true divine dignity.

BANTEAY SREI, Cambodia

Probably the most beautiful of all *Khmer temples, founded in AD 967. Free-standing sandstone figures of animals protect all the terraces while the long niches in the walls house figures of

celestial maidens and warriors. The pediments are carved in low relief with scenes taken from the Hindu epics. Rich ornamentation combines with architectural balance to provide an admirable setting for the sensuously treated sculptures. A fine seated *Shiva with his wife *Uma on his left thigh shows the full development of Khmer local genius in the portrayal of Hindu deities.

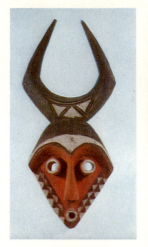
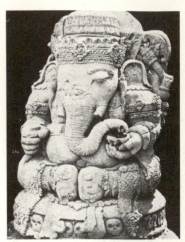

Left: BAPENDE Horned mask. Painted wood. BM, London
Right: BARA *Ganesha.* AD 1239. h. 59⅛ in (150 cm). Rijksmuseum voor Volkenkunde, Leiden

BAPENDE

A tribe in Zaire in two sections, a western group in the Kwilu River and an eastern group on the Kasai. The western Bapende style is well known for its masks; eastern Bapende masks are more abstract in character. They also carve wooden figures for the roof pinnacles of chiefs' houses.

BAPHUON, Cambodia

Built by King Udayadityavarman II (AD 1050–66) the Baphuon is as large as the main complex of *Angkor Wat. The narrative reliefs are displayed against very simple, almost bare backgrounds. The free-standing statuary is sober, the figures slim, the garments highly stylised with finely pleated skirts

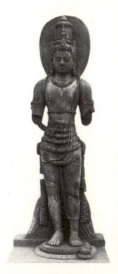
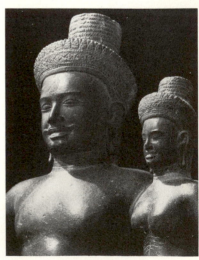

Left: BANON, Central Java. Stone statue of Vishnu. 9th century
Right: BANTEAY SREI *Shiva and Uma.* Late 10th century. Sandstone. h. 23⅝ in (60 cm). National Museum, Phnom Penh

above which rises the torso to a rounded, smiling face. *See* KHMER ART

BAPUNU

A tribe in southern Gabon often said to be responsible for a well-known type of white-faced mask. This type of mask is, however, found among almost every tribe in the area including the *Bakota, Mpongwe, Bapunu, Ashira, Mitshogo, etc, and the location of its place of origin is still uncertain.

BARA, Java (AD 1239)

This magnificent stone image of *Ganesha from Bara which is dated 1161 (AD 1239) almost certainly protected a river crossing, as was also the case of a standing figure of the same deity at Karang Kates, higher up the Brantas. The god is protected from danger from the rear by a grotesque *kala* mask whose claws are composed of the deity's own upper hands. *See also* SINGASARI

BARBARI, Jacopo de' (c. 1440/50–c. 1516)

b. ?Venice. Italian painter and engraver. An admirer of *Dürer, he spent the last sixteen years of his life in Germany and Burgundy as Portrait and Miniature Painter to the Emperor Maximilian I. His engravings probably influenced Lucas van *Leyden. Credited with having painted the first still-life since antiquity, *The Dead Bird* (1504, Munich).

BARBIERI, Francesco *see* GUERCINO

BARBIZON SCHOOL

The name given to a group of French artists who worked in and around Barbizon near the Forest of Fontainebleau from the 1830s when they began to exhibit. They included *Rousseau, *Dupré, Jacque, *Diaz and *Troyon, while *Daubigny, *Corot and *Millet were associated with them. They broke away from the classical tradition and sought inspiration directly from nature. In this they were influenced by *Constable and English landscape. They pioneered the idea of French landscape as a theme worthy for exhibition pictures. Their republican sympathies brought them some success and a few state commissions after the Revolution of 1848, when †Realism supplanted †Romantic subjects. Their interest in changing light effects and their vigorous technique were important in the early stages of †Impressionism. Their subjects, often reflecting solitude and melancholy, link them to the old

Arcadian ideal of landscape rather than to the Impressionists' love of modern life and the city.

BARENDSZ, Dirk (1534–92)

Netherlandish painter, the son and probably the pupil of Barend Dircksz. Said, by van *Mander, to have studied under *Titian in Venice, before returning to Amsterdam (c. 1562). His large triptych with its centre panel showing the Nativity (Gouda) is strong in Italian influence but has a Northern concern for homely emotion and observation of varying human character, also seen in his portraits.

BARI, Niccolò da *see* NICCOLO DELL' ARCA

BARI THRONE, Apulia

The Archbishop's throne in the main apse of the Pilgrimage Church of St Nicholas was completed c. 1098 and is made of marble with coloured inlay. The fully rounded, struggling slaves who Atlas-like support the throne, look back to antiquity but also have affinities with *Wiligelmo's work in Modena. The ornamental openings in the sides are Islamic in origin.

BARK-PAINTING *see* AUSTRALIAN ABORIGINAL ART

ERNEST BARLACH *Monks Reading.* 1932. Wood. NG, Berlin

BARLACH, Ernest (1870–1938)

b. Wedel d. Rostock. German sculptor and dramatist who, unimpressed by French modernism, was a typical *Expressionist inspired by the forms and sentiments of medieval religious art. However his sculptures, in contrast to his graphic work, have a classical stability and simplicity reminiscent of *Manzù.

BARLOW, Francis (1626–1702)

b. d. Lincolnshire. English animal painter and engraver, particularly of birds with which he decorated several country-house ceilings. He also painted landscapes and illustrated books, including Aesop's *Fables*.

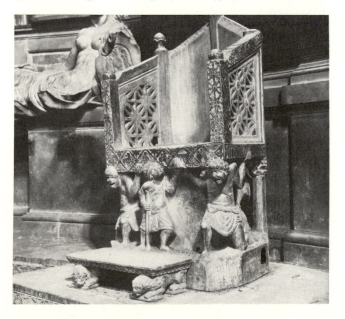

BARI THRONE *c.* 1098. Marble with coloured inlay. St Nicholas, Bari

BARNABA DA MODENA (active 1361–83)

Active mainly in Liguria and Piedmont, this archaicising artist combined †Byzantine decorative motifs with a heavy Emilian style. Working usually in Genoa, he received commissions throughout Italy. He produced many paintings of the Virgin and Child.

BARNARD, George Grey (1863–1938)

b. Bellefonte, Pennsylvania d. New York. American sculptor who studied at Chicago Art Institute, in Paris at Ecole des Beaux-Arts (1883–7), Atelier Cavelier and under *Rodin. Taught at *Art Students' League (1900–3), worked at Moret-sur-Loing (1903–11), and exhibited romantic, energetic, monumental figures at *Armory Show.

FRA BARTOLOMMEO *Apparition of the Virgin to St Bernard.* 1517. Accademia, Florence

Left: FEDERICO BAROCCI *Descent from the Cross.* 1567–9. Duomo, Perugia
Right: LEONARD BASKIN *Man with a Dead Bird.* 1951–6. Walnut. h. 64 in (163·8 cm). MOMA, New York, A Conger Goodyear Fund

BAROCCI, Federico (c. 1535–1612)

b. d. Urbino. Italian painter, trained in Urbino and Pesaro, his early work was influenced by both Roman and Venetian styles. In Rome in the 1550s he was deeply affected by *Raphael and his friend, *Zuccaro. He decorated the ceiling of a casino for Pius IV (1560–3), then returned to Urbino and until 1567 produced nothing owing to illness. After 1567 the influence of *Correggio – though Barocci is never recorded in Parma – permeated his work, and his many altarpieces, commissioned for widely scattered places in Italy, were infused with an emotionalism which inaugurated the †Baroque, although their bright colours are typical of their *Mannerist date.

BAROTSE (LOZI)

The dominant tribe of western Zambia which established its political authority over many of the eastern Lunda peoples. The Barotse language is related to that of the Basotho of Lesotho; their sculpture is mostly in the form of human and animal figures carved on the lids of food-bowls. One of the subject Lunda peoples is the Mambunda whose masks of wood or bark are used for *makishi* dances which accompanied the ceremonies of initiation and circumcision but which are now performed mainly for the entertainment of the Barotse and of European visitors.

BARRET, George the Elder (?1732–84)

b. Dublin d. London. Anglo-Irish painter of picturesque landscapes and castles usually for noble patrons. In London from 1762, he became enormously successful. His son, George Barret (1767–1842), b. d. London, painted ideal landscapes and subtle watercolours. He wrote *The Theory and Practice of Watercolour Painting* (1840).

BARRY, James (1741–1806)

b. Cork d. London. Irish painter, he was taken to London by Edmund Burke in 1764, then visited Italy (1766–71). Elected RA (1773), he conflicted with that body and was expelled (1799). His conception of the *Grand Manner, faithful to *Reynolds's recommendations, is seen in *The Progress of Human Culture* painted for the Society of Arts (1777–83).

BARTHOLOME, Albert (1848–1928)

b. Thiverval d. Paris. French painter and sculptor who studied in Geneva, and under *Gérôme in Paris. He exhibited genre-type portraits influenced by *Bastien-Lepage. In the 1880s he took up sculpture, making portrait busts and tomb monuments with figures full of melancholy and despair. His greatest work is the *Monument to the Dead* at the Père-Lachaise Cemetery (1899).

BARTOLA, Sebastiano di *see* MAINARDI

BARTOLI, Pietro Santi (c. 1635–1700)

b. Perugia d. Rome. Italian artist. Pupil of Nicolas *Poussin, he worked as an engraver and specialised in etching. He was Queen Christina of Sweden's Antiquary, and engraved illustrations for many publications on antique painting, sculpture and architecture.

BARTOLINI, Luigi (1892–1963)

b. Ancona d. Cupramontana. Italian engraver who studied in Rome, Siena and Florence. An admirer of *Rembrandt's technique, he also worked as a magazine and newspaper illustrator, critic and poet. His naturalistic etchings are tentatively delicate and careful.

BARTOLO DI FREDI (2nd half 14th century)

Minor *Sienese painter of the less-innovatory generation of artists working after the Black Death (1348) in which the *Lorenzetti probably died. In 1367 he painted a series of Old Testament scenes in the Collegiata in S. Gimignano. His

paintings, eg the *Presentation* panel, are close to the Lorenzetti but more tense and brittle.

BARTOLOMMEO, Fra (della PORTA) (c. 1474–c. 1517)

b. d. Florence. Italian painter; Savonarola probably influenced his decision to become a monk. Significantly, one of his earliest works was the *Last Judgement* (1499, S. Marco, Florence) which influenced *Raphael's *Disputà*. By 1506 the *Vision of St Bernard* shows clarity of design and a distant shimmering landscape, bathed in light. An outcome of his friendship with Raphael and a visit to Venice in 1508 was the altarpiece *God the Father and two Saints* (Lucca) whose harmonious repose anticipates Raphael's *Sistine Madonna*. In 1514/15 he went to Rome, renewing his contact with Raphael and confirming his classicising tendencies as evinced in the Roman High Renaissance character of his *Risen Christ and Four Evangelists* (1517, Pitti). His drawings exerted a wide influence on the younger generation of Florentine artists.

BARTOLOZZI, Francesco (1727–1815)

b. Florence d. Lisbon. Celebrated Italian engraver who was invited to England by George III and appointed Court Engraver. He popularised *stipple-engraving, introducing colour and softness into the medium. In 1802 he became Director of the National Academy of Portugal.

BARYE, Antoine-Louis (1796–1875)

b. d. Paris. French sculptor. Employed by a goldsmith, he gained his extensive knowledge of animal forms making models of animals at the Jardin des Plantes. He became famous for his sculptures of wild beasts struggling and devouring their prey. He executed the bronze equestrian statue of Napoleon for Ajaccio, and taught drawing at the Musée d'Histoire Naturelle.

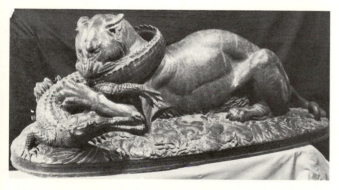

ANTOINE-LOUIS BARYE *Panther devouring a crocodile*. Bronze. Louvre

BASAITI, Marco (c. 1470–1530)

Venetian painter, influenced by Giovanni *Bellini and *Giorgione. He seems to have been an eclectic painter. His *Christ Calling the Sons of Zebedee* (1510, Accademia, Venice) shows his compositional skill and a sensitive use of light.

BASIL II, Menologian of

A †Byzantine manuscript produced about AD 1000 for the Emperor Basil II, giving an uncompleted cycle of notices of saints' days and feasts with illustrations done by a team of eight named artists. We see in this manuscript the development of a new unnaturalistic style in which the jewel-like miniatures contain attenuated figures set in unreal landscapes. There is a lack of concern for modelling, folds in garments have become gold patterns like combs. Movement however is still vigorously expressed. (Vatican.)

BASCHENIS, Evaristo (1617–77)

d. b. Bergamo. Italian still-life painter specialising in the depiction of musical instruments in which he brings out the

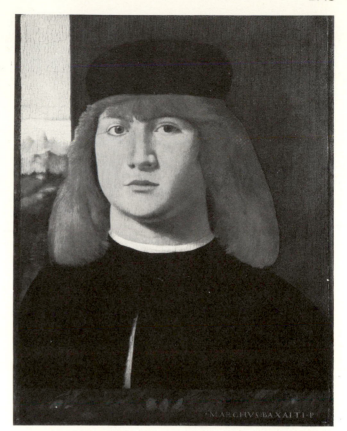

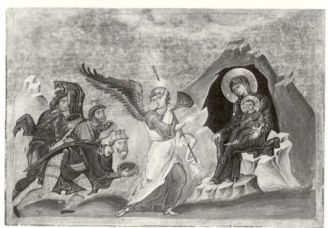

Top: MARCO BASAITI *Portrait of a Young Man.* $14\frac{1}{4} \times 10\frac{3}{4}$ in (36.5×27 cm). NG, London
Above: BASIL II, Menologian of *Adoration of the Magi.* c. 1000. Vatican

quality of polished wood and the geometrical shape of the objects. He was ordained in 1647.

BASE

An inert mineral powder used as a filler to augment intense and expensive *pigments in *paint mixtures.

BASKIN, Leonard (1922–)

b. New Brunswick, New Jersey. Sculptor and printmaker who studied with Maurice Glickman (1937–9), at Yale University (1941–3), in New York (1940–1, 1943–9), Paris (1950) and Florence (1951), and has taught at Smith College since 1953. Influenced by *Expressionists from *Grünewald to *Goya, Baskin's figures monumentalise tortured humanity's capacity to endure.

BASOHLI SCHOOL

The Basohli School of the *Panjab Hills arose as a result of the mixing of the Hill folk-art with the techniques of *Mughal painting, although the former element is always the predominant one. The characteristics of the style are the vigorous use of primary colours in flat planes, a wide red border and a yellow or brown background. Colours were used symbolically (eg yellow for spring and sunshine, red for passion). Gold and silver were extensively used for ornaments and embroidery. The main themes, boldly depicted, are the Krishna legends, and heroines in all moods, with some sets of *Ragamala* paintings. The human figures have large, prominent eyes, receding foreheads and high noses. Landscapes are decorative and the high horizon gives the impression of depth and space.

BASOLONGO *see* BAKONGO

BASONGE (BASONGYE)

A large tribe between the Lomami and Sankuru rivers in Zaire. The main subjects of their sculpture – standing figures, masks, stools and so on – are broadly similar to the *Baluba although their style is altogether distinct emphasising rectangular rather than spherical forms. This is especially true of their *kifwebe* masks.

BAS-RELIEF

Low *relief sculpture carved on a plane background; usually in the form of a panel.

BASSA

A tribe round the confluence of the Niger and Benue rivers in Nigeria. *See also* DAN-NGERE

BASSA, Ferrer (c. 1285/90–1348)

Catalan painter, active in Aragon and founder of the Catalan School, who worked at the Aragonese court. His only surviving documented work, the decoration of the Chapel of S. Miguel in the monastery of Sta Maria de Pedralbes, was executed in 1345–6. These frescoes show his great debt to contemporary *Sienese and Florentine painting, particularly to the *Lorenzetti. He was the first Spanish painter to show such understanding of Italian advances in the use of perspective, light and movement and the arrangement of narrative cycles.

BASSANO (DA PONTE) Family
Francesco da Ponte the Elder (c. 1475–1539)
Jacopo (1510/18–1592)
Francesco the Younger (1549–92)
Gerolamo (1566–1621)
Leandro (1557–1622)

Venetian family of painters of whom Jacopo was the most important. The son of Francesco da Ponte, a minor painter who worked in Bassano, Jacopo worked there too, but throughout his life was strongly influenced by Venetian art. A good example of his easily recognisable style is the *Adoration of the Magi* (NG, Edinburgh) which combines many of his characteristic elements – stocky virile males, lovingly observed animals, rich stuffs and attractive landscape. His *Earthly Paradise* (Pamphili, Rome) shows his interest in stormy settings, with brightly lit figures (often seen from behind) and a rich paint texture. His three sons, Francesco, Gerolamo and Leandro, were also painters, active in Venice. Francesco was head of the family workshop in Venice until his suicide, when Leandro took over, completing several of Francesco's pictures. Successful as a portraitist, he was granted a knighthood by the Doge. In style his portraits are close to *Tintoretto's. Gerolamo was insignificant.

BASTIANI, Lazzaro (c. 1430–1512)

Venetian painter, a pupil of Bartolommeo *Vivarini, whose early work reveals the influence of Gentile *Bellini. His rather stiff style later relaxed and the decorative elements call to mind *Carpaccio whose teacher he may have been.

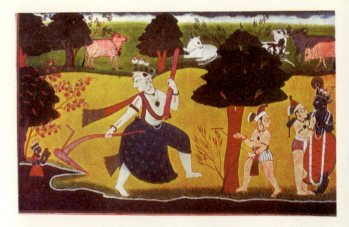

Top: BASOHLI SCHOOL *The Diversion of the Jamuna. c.* 1730. 12⅛×8⅜ in (30·8×21·3 cm). Punjab Museum, Patiala
Centre left: FERRER BASSA *The Three Marys in front of the Sepulchre.* 1346. Fresco. Chapel of S. Miguel, Monastery of Sta Maria de Pedralbes, Barcelona
Centre right: POMPEO BATONI *General Gordon.* 1766. Fyrie Castle, Aberdeen
Above: JACOPO BASSANO *Adoration of the Magi.* 70¾×92 in (108·5×203·5 cm). NG, Edinburgh

BASTIEN-LEPAGE, Jules (1848–84)

b. Damvillers d. Paris. French painter, a pupil of *Cabanel at the Ecole des Beaux-Arts, he first exhibited at the Salon of 1867. By the mid 1870s he had struck a balance between the academic painters and the avant-garde, by emphasising solid figure-drawing, chiefly of peasant subjects, while using colour and brushwork derived from the †Impressionists. His *plein-air painting was influential throughout Europe.

BASUKU see **BAYAKA**

BATAKS see **INDONESIA, ART OF**

BATEKE

A large tribe round Brazzaville and mostly on the northern bank of the Congo River. Their figures are carved in an angular style with vertical scarification over the face and they usually have a lump of 'medicine' (compounded of leaves and other materials with symbolic value in the magical curing of disease and prevention of witchcraft) applied to the abdomen.

BATETELA

A large tribal complex east of the *Bakuba. Their art is generally similar to the *Basonge to the south of them.

BATONI, Pompeo (1708–87)

b. Lucca d. Rome. Italian painter, he was in Rome by 1727 where classical influences and contemporaries like *Conca and Imperiali affected his work. In these years he painted several altarpieces but from 1740 onwards he took to portraiture, specialising in foreign visitors to Rome.

BATTISTELLO see CARACCIOLO

BAUCHANT, André (1873–1958)

b. Château-Renault d. Touraine. Gardener and amateur painter whose work attracted *Le Corbusier's attention (1920s). Combining the mythological and the mundane, his subjects are more genuinely imaginative than either *Bombois's or *Vivin's. He is one of the most individual and complex of 20th-century primitives.

ANDRE BAUCHANT *Obsequies of Alexander*. 1940. 44⅞×76¾ in (114×194·9 cm). Tate

BAUDELAIRE, Charles (1821–67)

b. d. Paris. French poet, critic and essayist. His quest for beauty even in the evil and macabre had great influence on the *Symbolist movements in literature and art as did his theory of 'correspondence'; that sounds could suggest colours and vice versa, and that colours could evoke ideas of their own. He sponsored *Delacroix and *Guys with vigour and was a friend of *Courbet and *Manet.

BAUDRY, Paul (1828–86)

b. La-Roche-sur-Yon d. Paris. French painter who went to Italy in 1850 having won the Rome Prize. There he made a close study of *Correggio and the Venetian masters which proved valuable for his major achievement, the decoration of the Paris Opéra realised in an elegant †Baroque style. A project to paint the life of St Joan for the Panthéon, Paris, obsessively researched, was not carried out.

BAUHAUS

School, teaching architecture, fine arts and crafts. Founded 1919 in Weimar by Walter Gropius through the amalgamation of the Kunstakademie and van de Velde's Kunstgewerbeschule. Although the background of van de Velde's *Art Nouveau ideas was significant, Gropius's conception was daringly original. He sought not only to promote the unity of all visual arts and crafts, but to bring them into the middle of the contemporary industrial world, thus ending art's isolation: 'to bridge the gulf between the world of spirit and the world of everyday'. Architecture was to be the principal and co-ordinating art. Prominent teachers, with Gropius, were architects Meyer and Breuer and painters *Albers, *Feininger, *Kandinsky, *Klee, *Moholy-Nagy and *Schlemmer. Phenomena like light, colour and space were systematically explored. Great importance was given to specific potentialities of all materials employed. The problems of aesthetic philosophy were also tackled at the most fundamental level. However, there were strong differences of opinion. In particular, the conflict between spiritual expression and practical utility was never satisfactorily resolved. In 1925 the Bauhaus moved to Dessau, where its new building was by Gropius himself. In 1928, Gropius resigned as principal, replaced by Meyer, under whom the Constructivist, almost anti-art element was completely in the ascendant. In 1930 Mies van der Rohe took over. In 1933 the school was closed by the National Socialist government. Gropius, Mies, Albers, Feininger and others emigrated to the United States. Moholy-Nagy founded a New Bauhaus in Chicago (1937). The Bauhaus spirit of constructive inquiry and synthesis has exercised inestimable influence in architecture, the fine arts, industrial design and related fields.

BAULE

An Akan-speaking tribe of Ivory Coast related to the *Ashanti of Ghana from whom they separated about 250 years ago. Unlike the Ashanti their sculpture is well developed (if sometimes insipid – though probably the most immediately attractive to the European eye of all African sculpture) and they were probably influenced by the *Guro and *Senufo. Their work includes masks and figures in wood as well as miniature *cire perdue castings in brass and gold. The Anyi (Agni) are another important Akan-speaking tribe south of the Baule known for their sculptures in wood and terracotta.

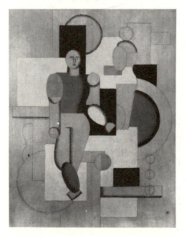

WILLI BAUMEISTER *Monteure*. 1927. 17½×13 in (45·3×33·2 cm). Staatliche Kunsthalle, Karlsruhe

BAUMEISTER, Willi (1889–1955)

b. d. Stuttgart. German painter who studied with *Hölzel at the Stuttgart Academy (1906); visited Paris (1912/14); early *Constructivist compositions (1919). In 1924 in contact with the *Purists, and later on with the *Bauhaus painters. His compositions are populated by robot-like figures close to those of *Schlemmer. Fully rounded forms float on flat colour surfaces as strong contrasts. He worked mostly in oil paint, occasionally mixing it with sand.

BAVILI see BAKONGO

BAWDEN, Edward (1903–)

b. Essex. English painter who studied at Cambridge School of Art (1919–21). Assisted by Paul *Nash in his early career. Appointed Official War Artist (1940). His activities cover painting, drawing, printing, murals, book illustrations and tile decoration. His themes include Oriental landscapes, battle scenes and English churches.

BAWOYO see BAKONGO

BAYAKA

The Bayaka and Basuku are adjacent tribes east of the Kwango River, Zaire. Their masks and figures have frequently been confused and it is indeed clear from research in the field that, despite the turned-up nose typical of Bayaka sculpture, no hard-and-fast line can be drawn between them.

BAYER, Herbert (1900–)

b. Haag. Austrian painter, designer and architect who studied in Linz (1919–21) and at the *Bauhaus (1921–5), continuing there as teacher (1925–8). Bayer's work illustrates the Bauhaus fusion of 'fine' and 'applied' art. In America (from 1938) he helped introduce the Bauhaus style into architecture.

BAYEU, Francisco (1734–95)
Ramón (1746–93)

Brothers, b. Saragossa d. Madrid. Francisco worked in Madrid from 1763, painting the royal palaces, under *Mengs's supervision, with fresco decorations. The drawings for these are far warmer and livelier than the Academy-inspired frescoes themselves, and are indebted to *Tiepolo. His brother-in-law *Goya was his pupil. Ramón, whose style was less finished and more imaginative, worked with Goya from 1775 in producing cartoons for the royal tapestry factory.

BAYEUX TAPESTRY

Probably executed c. 1070, perhaps in Kent, this is a 230-foot linen hanging embroidered in wool with a vivid pictorial narrative of the nearly contemporary events which led to the Norman conquest of England in 1066. The decorative borders provide a grotesque and often irrelevant commentary. This secular monument was probably made to adorn Bayeux Cathedral and is now in the Musée de la Reine Mathilde.

BAYON see ANGKOR THOM

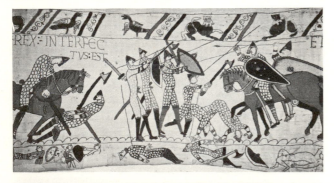

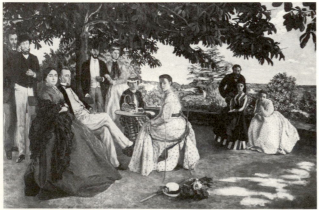

Top: BAYEUX TAPESTRY Detail. *c.* 1070. Wool embroidery on linen. Musée de la Reine Mathilde, Bayeux
Above: FEDERIC BAZILLE *Family Reunion.* 1867. 60×91½ in (152×232 cm). Louvre

BAZAINE, Jean (1904–)

b. Paris. Painter who studied at the Ecole des Beaux-Arts. He has done commissions for mosaics and stained-glass windows. Working from nature to arrive at abstraction, he is concerned, like *Cézanne, with the interior geometry of form. He has followed a slow, steady evolution.

BAZILLE, Jean-Frédéric (1841–70)

b. Montpellier d. Beaune-la-Rolande. French painter met *Renoir, *Sisley and *Monet in *Gleyre's studio in 1862. Despite intimate contacts with them, and the influence of Monet on his early work, Bazille sought a classical solidity and permanence of form, distilled from comprehensive studies. The final work would however be painted in the open air.

BAZIOTES, William (1912–63)

b. Pittsburgh, Pennsylvania d. New York. Abstract *Surrealist painter who lived in New York from 1933, studied at National Academy (1933), worked for *WPA (1936–41) and taught at various New York art schools from 1948. Primitivist, flat, organic shapes and calligraphic lines within an undersea atmosphere characterise his exquisite, mature style. Sometimes called the 'American Paul *Klee'.

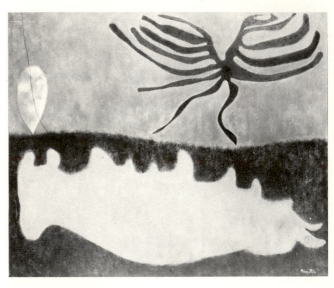

WILLIAM BAZIOTES *Primeval Landscape.* 1953. 62¾×74½ in (159·4×189·2 cm). Philadelphia Museum of Art, Samuel S. Fleischer Art Memorial

BAZZI, Giovanni Antonio see SODOMA, IL

BEAL, Gifford (1879–1956)

b. d. New York. Painter and graphic artist who studied with *Chase and at *Art Students' League, exhibited at *Armory Show (1913), and taught at Art Students' League (1931–2). He first painted realistic city scenes, but gradually brightened his subject and colours in gay holiday pictures.

BEARDSLEY, Aubrey Vincent (1872–98)

b. Brighton d. Menton. An English illustrator, largely self-taught, who supplemented a natural talent as draughtsman with extensive borrowings from *Botticelli and *Mantegna. His early manner was much influenced by *Burne-Jones, eg illustrations to Dent's edition of Malory's *Morte d'Arthur* (1893/4). He also worked for the *Pall Mall Budget* and, in 1894, became Art Editor of the notorious *Yellow Book*. Under the influence of the Japanese print and the 18th-century pastoral, his work became more decorative, but always retained that atmosphere of depravity that made his name controversial. Through reproductions in the *Studio* magazine, his highly original sense of line and interval were influential throughout Europe.

Top left: AUBREY BEARDSLEY Frontispiece to *The Pierrot of the Minute* by Ernest Dowson. First published by Leonard Smithers, 1897
Top right: DOMENICO BECCAFUMI *St Michael quelling the Rebel Angels. c.* 1525. 11 ft 5⅛ in×7 ft 4⅝ in (348×225 cm). Church of the Carmine, Siena
Above: ANDRE BEAUDIN *Les Chevaux de Soleil.* 1953. 44½×76⅜ in (113×194 cm). Moderna museet, Stockholm.

BEAUDIN, André (1895–)

b. Mennecy. French painter whose abstractions of women, animals and plants are a calm, lyrical and charming reflection, first of *Cubism, then *Masson's *Automatism and *Picasso's angular style of the 1930s. His qualities and his limitations make him a typical *School of Paris painter.

BEAUGRANT, Guyot de (d. 1551)

Sculptor who worked for the Regent Margaret of Austria (1526–31); went to Bilbao (1533). The chimneypiece in the Franc at Bruges commissioned by Margaret (1528–31) was made by a team under his control. It is lavish and elaborate, a work of supreme craftsmanship and a symbol of bombastic royal aspirations.

BEAULIEU ABBEY CHURCH, Languedoc

The †Romanesque south porch of the Cluniac Abbey Church derives in many respects from *Moissac. Here the subject is the Last Judgement, stressing redemption through the Cross. The visionary quality, the pointed arch, the jamb figures and the placing of scenes in relief in the side walls of the porch all have parallels at Moissac. Beaulieu has been thought to have influenced the sculpture at *St Denis.

BEAUNEVEU, André (active 1390–1403/13)

b. Valenciennes. French illuminator and sculptor employed by the French court, the Count of Flanders and the Duc de Berry.

He carved several figures for the royal tombs at *St Denis (c. 1360–74), among them a recumbent figure of Charles V. As art adviser to the Duc de Berry he assisted him in assembling a fine collection of manuscripts. He was a prolific and versatile master whose contemporary reputation was considerable.

BEAUX, Cecilia (1863–1942)

b. Philadelphia d. Gloucester, Massachusetts. Painter who studied in Paris at Académie Julian (1889–90) and Lazar School, and travelled in Italy and England. Her fashionable portraits are characterised by bravura technique and the same good-natured sympathy for the subjects she revealed in her written accounts of the period.

BECCAFUMI, Domenico (1485/6–1551)

b. d. Siena. Beccafumi was one of the most original of the first-generation *Mannerists, and the last major *Sienese artist. Although influenced by *Michelangelo in later paintings (eg *Moses Breaking the Tables*, Pisa Cathedral), his finest works are entirely his own, eg his *Last Judgement* (Carmine, Siena) where a strong sense of the supernatural and sinister is accentuated by the brilliant acid colour, often infused into other hues. This insistence on other-worldliness is at the opposite end of the Mannerist scale from *Parmigianino's secular refinement.

BECERRA, Gaspar (c. 1520–70)

b. Baeza, Andalusia d. Madrid. Spanish painter, draughtsman, sculptor and architect. In Italy (1540–56) he worked as an assistant to *Vasari while in Rome. His profound admiration for the huge contorted figures of *Michelangelo affected his style earning him, on his return to Spain, the title of Court Painter and the reputation for being a leading force in the Spanish †Renaissance.

MAX BECKMANN *The Night.* 1918–19. 52⅜×60¼ in (133×154 cm). Kunstsammlung Nordrhein, Westfalen

BECKMANN, Max (1884–1950)

b. Leipzig d. New York. Painter who studied in Weimar (1900–3). Reacting, like *Grosz and *Dix, against the escapist sentimentality of pre-war *Expressionism, Beckmann was the leading painter of the *Neue Sachlichkeit movement. Avoiding Nazi persecution he moved to Amsterdam (1937–48) then New York (1948–50). His determined individualism and firm attachment to things, particularly figures endowed with often disturbing force established his style from the 1920s. Professing disinterest in Paris, Beckmann's crowded build-up of forms in an often vertical format certainly owes something to *Cubism.

BEDFORD MASTER

French miniaturist who worked in Paris for the bibliophile John, Duke of Bedford, during his Regency of France (1422–

35). His work includes a Breviary (Paris, Bib. Nat. 17294) and a Book of Hours (London, BM Add. 18850), one miniature of which shows John's duchess, Anne of Burgundy, kneeling before the Virgin and Child. Characteristically this page also has appropriate badges, mottoes and a coat of arms worked into the highly decorative whole. The architecture has Italian origins.

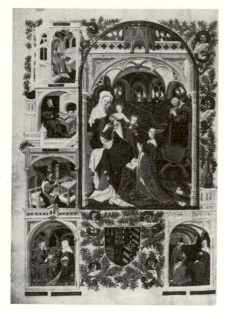

BEDFORD MASTER *Anne of Burgundy kneeling before the Virgin and Child.* 1423. BM, London

BEER, Jan de (b. c. 1475)

Early Netherlandish painter and leading figure amongst the *Antwerp Mannerists. Probably born in Antwerp, he was Master there (1504); guild official (1515). His name appears on a drawing (BM, London) which allows the attribution of a painted œuvre (eg the *Adoration of the Magi* triptych, Brera) which typifies the excited but elegant fantasy of the *Mannerist style.

BEERSTRATEN, Jan Abrahamsz (1622–66)

b. d. Amsterdam. Dutch painter, specialising in topographical views of Dutch castles and towns, and imaginary seaports. The topographical views – some accurate, some rearranged – are frequently portrayed as winter scenes, eg *The Castle of Muiden in Winter* (1658, NG, London).

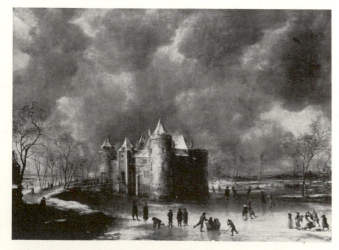

JAN ABRAHAMSZ BEERSTRATEN *The Castle of Muiden in Winter.* 1658. 38×51 in (96·5×129·5 cm). NG, London

BEGA, Cornelis (1620–64)

b. d. Haarlem. A Dutch *genre painter, pupil of Adriaen van *Ostade, he depicted peasant kitchens and taverns and in his etchings displayed an original use of *chiaroscuro to silhouette the figures against a dark background.

BEGGARSTAFF BROTHERS

Pseudonym adopted by James *Pryde and his brother-in-law William *Nicholson, who collaborated to create some of the finest English posters of the 1890s. Both artists had studied in Paris, and admired the posters of Chéret and *Toulouse-Lautrec. They produced simple, striking designs using cut-out silhouettes and bold lettering.

BEGGARSTAFF BROTHERS Pictorial Advertisement for Rowntree's Elect Cocoa. Engraved facsimile. $8\frac{1}{2}×5\frac{9}{16}$ in (21·6×14 cm) V & A, London

BEHAM, Barthel (1502–40)

b. Nuremberg d. Italy. German engraver, painter and designer of woodcuts. Younger brother of Hans Sebald *Beham, who together with *Dürer, was his main influence. He extended the range of his brother's subject-matter to include scenes of battles between naked antique warriors.

BEHAM, Hans Sebald (Sebolt) (1500–50)

b. Nuremberg d. Frankfurt-am-Main. German engraver, etcher, miniature-painter and designer for woodcuts and stained glass. Leader of the Nuremberg Kleinmeister. Trained by *Dürer. Expelled with his brother Barthel *Beham from Nuremberg in 1525, for his political and religious nonconformism. Worked after this for publishers at Augsburg and Ingolstadt. Produced many small, technically perfect engravings dealing with *genre subjects – markets, dances, peasant life – in effect the first genre pieces in German art. Also made many decorative plates much influenced by *Aldegrever, *Mantegna, *Pollaiuolo and Marcantonio *Raimondi.

BELEN

Argentine pottery style of *c.* AD 1000–1450, noted for funerary urns painted with designs of highly stylised faces in black on red.

BELL, Clive (1881–1964)

b. East Sheffard d. London. English art critic, husband of Vanessa *Bell. With Roger *Fry he helped introduce contemporary French art to the English public. His most important book *Art* (1914) introduced the concept of 'significant form', the one quality common to all works of art which alone can stir aesthetic emotions.

BELL, Vanessa (1879–1961)

b. London d. Firle, Sussex. English painter, and applied artist with *Omega Workshops. Studied at Royal Academy Schools

(1901–4). Her work generally maintained sensitive tonal control and tautly conceived design; exceptional was an interlude of greater formal schematisation and heightened colour under the influence of Roger *Fry's ideas (1910–15).

BELLA, Stefano della (1610–64)

b. d. Florence. An Italian virtuoso of etching, influenced by *Callot, he was famous for scenes of popular life, often crowded with tiny figures. In Paris (1639–49) he felt the influence of *Rembrandt and the Dutch landscapists.

BELLA COOLA see NORTHWEST COAST, AMERICAN INDIAN ART OF THE

BELLANGE, Jacques (active 1610–17)

French painter, he is recorded in Nancy (1610–17) as executing palace decorations and scenery for theatrical performances. Mainly drawings and etchings by him survive. His subjects – chiefly religious – contain elegant, distorted, *Mannerist figures incorporating a certain mystical feeling.

BELLANO, Bartolommeo (c. 1434–1496/7)

b. Padua. Italian sculptor, probably a pupil of *Donatello whom he accompanied to Florence. He returned to Padua (1469), and apart from visiting Venice (c. 1472/80), remained there. Although somewhat crude, his work (eg the ten bronze reliefs, S. Antonio, 1483–8) reflects both Paduan humanism and a humanity reminiscent of Donatello's.

BELLECHOSE, Henri (active early 15th century – d. c. 1444)

b. Brabant. One of the leading Franco-Flemish painters employed by the Dukes of Burgundy at Dijon. He succeeded *Malouel as Court Painter in 1415 and may have been responsible for parts of the *Martyrdom of St Denis* (Louvre), one of the finest surviving paintings of the Burgundian School.

BELLEGAMBE, Jean (c. 1470/80–1533/5)

Netherlandish painter, one of a family active in Douai. A large polyptych made for the Abbey of Anchin (1511–20, now Douai Museum) shows his dignified, monumental style and typical light golden tone which earned him his nickname 'Le Maître des Couleurs'.

BELLING, Rudolf (1886–)

b. Berlin. German sculptor who studied arts and crafts, Berlin (1905–7). First sculptural attempts in 1912/13. His work in bronze, wood and gesso has been concerned with space treated in a *Constructivist way as material. During the 1920s it came close to architecture.

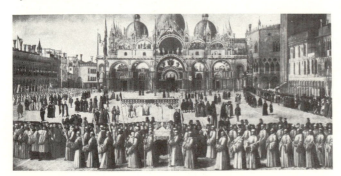

GENTILE BELLINI *Procession in the Piazza di S. Marco.* 1496. 12 ft ½ in × 24 ft 5⅜ in (367×745 cm). Accademia, Venice

BELLINI, Gentile (c. 1427/9–1507)

b. d. Venice. Venetian painter and son of Jacopo *Bellini under whom he trained. However, the sophisticated architectural perspective and classical festoons of his organ-shutters for St

Mark's (c. 1464) betray *Mantegna's influence. In his portrayal of Lorenzo Giustiniani (1465, Accademia, Venice) he endowed the lean patriarch with a rare spiritual asceticism. During his lifetime Gentile enjoyed considerable fame and was ennobled by Frederick III (1469) and by the Sultan Mehmet whom he painted during a visit to Constantinople (1479/80). Today his fame rests principally on his lively records of Venetian life and piety, superbly manifested in the *Procession in the Piazza di S. Marco* (1496, Accademia, Venice).

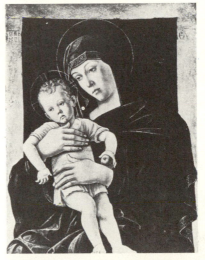
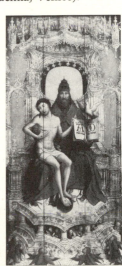

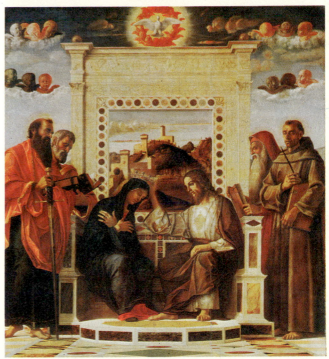

Top left: GIOVANNI BELLINI *Madonna of the Greek Inscription.* 32¼×24½ in (82×62 cm). Brera
Top right: JEAN BELLEGAMBE *Retable of the Adoration of the Trinity.* 119×63⅜ in (302×161 cm). Douai Museum
Above: GIOVANNI BELLINI *Coronation of the Virgin.* 103×94½ in (262×240 cm). Ducal Palace, Pesaro

BELLINI, Giovanni (c. 1431–1516)

b. d. Venice. The foremost Venetian painter of the Early †Renaissance, son and pupil of Jacopo *Bellini; also influenced by *Donatello, his brother-in-law *Mantegna, *Antonello da Messina and, in his old age, by his brilliant pupil *Giorgione. His early works are characterised by a wiry outline and an

emotively unifying use of light which throughout his life he minutely adjusted to suit the mood of each picture he was engaged upon. His early technique was somewhat dry and occasionally he used pure *tempera as in the *Madonna of the Greek Inscription* (Brera). One of the finest landscapists of the 15th century, the *Coronation of the Virgin* (Pesaro) shows how he often invented an excuse for including a splendid view. During his long life he painted innumerable versions of the Virgin and Child and it is a tribute to his resourcefulness that each one brings to the design a new expressive element. About 1475 he became increasingly aware of Flemish painting and by 1480 he had mastered the oil medium. From now on his colours become more resonant and the rendering of texture more sensuous. The contrast between the *S. Giobbe* altarpiece (*c.* 1487, Accademia, Venice) and that in the Church of S. Zaccaria (1506) demonstrates the way in which his conception of the *sacra conversazione has gained in mystery and is redolent of a spirit of meditative reverie inspired by Giorgione. The latter's influence and the importunings of Isabella d'Este led him at the end of his life to create a pagan mythological scene, the *Feast of the Gods* (1514, NG, Washington). Bellini's faultless colour sense brought a warmth to the gentle humanity expressed in all his work, confirming the kindness which so touched *Dürer when he wrote home to his friend Pirkheimer that Bellini was the only artist in Venice to bid him welcome.

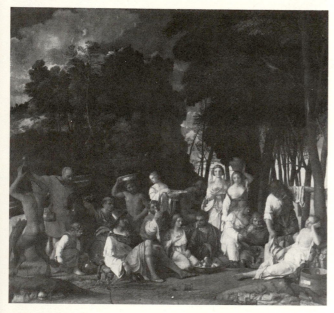

GIOVANNI BELLINI *Feast of the Gods*. 1514. 67×74 in (170×188 cm). NG, Washington, Widener Collection, 1942

BELLINI, Jacopo (c. 1400–71)

b. d. Venice. Venetian painter, recorded in Florence (1422) as the assistant of *Gentile da Fabriano whom he may have accompanied to Rome (1426). About 1430 he returned to Venice; he also worked in Verona where he painted frescoes in the Duomo (destroyed) and the *Crucifixion* (*c.* 1436, Castelvecchio, Verona), and in 1441 he was in competition with *Pisanello in Ferrara. He was the most gifted Venetian exponent of *International Gothic, and his two influential sketch-books inherited by his sons (BM, London and Louvre) rivalled those of Pisanello in the refinement of the *silverpoint technique and diversity of theme.

BELLMER, Hans (1902–)

b. Katowice, Poland. Object-maker, draughtsman and writer who began to draw under *Dadaist influence in Berlin (1924). Worked as an industrial artist until, as a protest against Fascism, he ceased 'all useful activity' (1933) to make an 'artificial girl'. Photographs of the doll, reassembled in various erotic and violent combinations 'to reveal scandalously the

interior', attracted the *Surrealists. Joining the Surrealists (1936) he moved to Paris (1938). He continues in drawings with an 1890s' flavour to explore his obsession with body feelings.

HANS BELLMER *Le Bon Sens*. 1964. Colour aquatint. Editions Graphiques Gallery, London

BELLORI, Giovanni Pietro (1615–96)

b. d. Rome. Italian antiquarian and collector, he was Librarian to Queen Christina of Sweden writing books on ancient reliefs and coins. He is well known for his *Lives of Modern Painters* (1672) and the expression there of the classic-idealist aesthetic. Selective in his book, he wrote of classicising artists like Annibale *Carracci and his contemporaries *Poussin and *Maratta.

BELLOTTO, Bernardo (1720–80)

b. Venice d. Warsaw. Italian painter and nephew of *Canaletto by whom he was trained and after whom he was called; in 1743 he was already renowned for view pictures. Besides Venice he worked in Rome, Turin, Milan, Verona, Dresden (from 1748) and Warsaw (from 1767). His style is superficially like his uncle's but in reality became increasingly distinct from it, exhibiting a more intense feeling for landscape, and the treatment of light and shade.

BERNARDO BELLOTTO *The Ponte della Navi, Verona*. 52½×92½ in (120·5×235 cm). Christie, Manson and Woods, London

BELLOWS, George Wesley (1882–1925)

b. Columbus, Ohio d. New York. American Realist painter, lithographer, cartoonist, associated with *Ash Can School, he studied under *Henri, taught at *Art Students' League (1910–11, 1917–19) and exhibited at *Armory Show. He painted common city and sporting life with forceful immediacy, often satirising social and political subjects in lithographs.

BELUR *see* HOYSALA DYNASTY

BENA LULUA *see* BALUBA

BENCI *see* POLLAIUOLO

BENEDETTO DA MAIANO see MAIANO

BENEDICTIONAL OF ST AETHELWOLD (c. 975–80)

Manuscript of high quality made for Aethelwold, Bishop of Winchester, with a rich series of miniatures, much gold and rich colouring, and an early example of the luxuriating acanthus borders of the so-called 'Winchester School'. Such manuscripts represent a revival of monasticism in which Aethelwold was deeply involved. The origins of the style are †Carolingian but the nervous, angular line is typical of pre-Conquest England. (BM, London.)

BENEDICTIONAL OF ST AETHELWOLD *The Three Marys at the Tomb*. c. 975–80. BM, London

GEORGE BELLOWS *Stag at Sharkey's*. 1907. $36\frac{1}{4} \times 48\frac{1}{4}$ in ($92 \cdot 1 \times 122 \cdot 6$ cm). Cleveland Museum of Art, Hinman B. Hurlbut Collection

BENEVENTUM, Arch of Trajan

*Triumphal arch begun in AD 114 and finished by Hadrian. It has a single-arched opening flanked by Composite columns. The sculpted reliefs facing the town show Trajan performing state duties, and those facing the country show Trajan as conqueror and ruler of the Roman world.

BENI HASAN

The site of a number of rock-cut tombs of Egyptian noblemen of the 12th dynasty, several of which have interesting mural-paintings. The most accomplished are those in the tomb of Khnemhotpe, including a representation of immigrant Semites and a colourful marsh scene with details of birds in a pair of trees.

BENIG, Simon see BENING

BENIN

Capital of the once-powerful *Edo Kingdom. At its peak its authority extended from the Lower Niger as far as Lagos incorporating the western *Ibo, the Edo-speaking peoples and a large slice of the *Yoruba. A peaceful trading-party on its way to Benin in 1897 was massacred by rebel chiefs and this led to the British Punitive Expedition after which several thousand objects in bronze, wood and ivory found their way to Europe. These included bronze heads cast as memorials to dead kings and placed on the ancestral altars in the king's palace, carved elephant tusks also placed on the altars, small bronze and ivory pectoral and pelvic masks worn on ceremonial occasions, about a thousand bronze plaques which, during the 16th and 17th centuries, were mounted on wooden pillars supporting the palace roof, carved wooden chests, boxes and stools, etc. The kings of Benin claim descent from a prince of *Ife, and the technique of *cire perdue bronze-casting is also said to have been introduced from Ife. Three periods can be distinguished in the development of Benin art: (i) the Early Period, before the mid-16th century; bronze heads and bronze and ivory masks characterised by a restricted naturalism, (ii) the Middle Period, mid-16th and 17th centuries; as well as memorial heads and figures all the bronze plaques were cast, (iii) the Late Period, 18th–19th centuries; characterised by an increase in size, weight and flamboyance (at the expense of art). Most of the surviving elephant tusks and wooden objects are also from this period. The first Europeans to visit Benin were the Portuguese in 1486 and over the next hundred years or so they exerted a considerable influence on the art not by introducing the technique of bronze-casting, which was already known probably from ancient Ife, but principally by introducing bronze manillas or bracelets as a medium of exchange thus providing a greater source of raw material for casting than had been available and making possible the development of the Middle Period including the casting of the plaques. *See also* AFRO-PORTUGUESE IVORIES and LOWER NIGER BRONZE INDUSTRY.

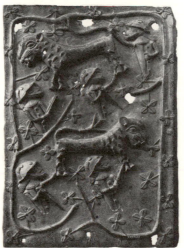

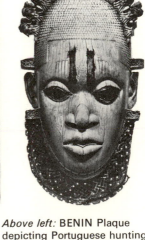

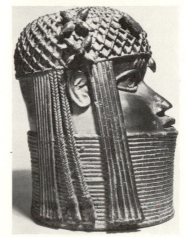

Above left: BENIN Plaque depicting Portuguese hunting leopards. Mid 16th century. Bronze. h. 21 in (53 cm). Museum für Volkerkunde, Berlin-Dahlem
Above right: BENIN Pectoral or waist mask. Early 16th century. Ivory. h. $9\frac{3}{4}$ in (25 cm). BM, London
Left: BENIN Head of a king. Late 16th century. Bronze. h. $11\frac{3}{4}$ in (30 cm). BM, London

BENING (BENIG), Simon (c. 1483/4–1561)

b. Ghent d. Bruges. Netherlandish miniaturist, from a family of manuscript-illuminators comprising his father, Alexander (d. 1519), his younger brother, Paul, and his daughter, Lievine (still alive in 1570). He was a member of the Bruges Guild from 1508; in Antwerp (c. 1514–17). Simon gave an unusual depth and convincing action to his miniatures. Probably much influenced by *Dürer's prints.

ALEXANDER BENOIS
Limburgh on the Lahn. 1894.
$14\frac{1}{8} \times 10\frac{1}{4}$ in (35·9×26 cm).
Tate

BENOIS, Alexander (1870–1960)

b. St Petersburg d. Paris. Law student, studied painting in Paris (1897–9), and became known for watercolours evoking Catherine II and Louis XV's era. He was the intellectual force behind the *World of Art movement, established art magazines, conducted research into art history (published *Histoire de l'art Russe*), worked as illustrator, critic, and with *Bakst, collaborated on Diaghilev's Ballets Russes in Paris.

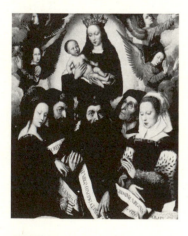

AMBROSIUS BENSON *The Deipara Virgin with Prophets and Sibyls. c.* 1530.
$51\frac{5}{8} \times 42\frac{1}{2}$ in (131×108 cm).
Musée Royal des Beaux-Arts, Antwerp

BENSON, Ambrosius (active ?1518–d. 1556)

Painter, usually classed as Netherlandish, although he came from Lombardy. Master in Bruges (1519) where he seems to have been principally active. A group of works are attributed including *The Deipara Virgin with Prophets and Sibyls* (Musée Royal des Beaux-Arts, Antwerp) and some in Segovia. Two of these are monogrammed 'AB', one dated 1527. The style shows Milanese influences, but principally relies upon the work of Gerard *David, with whose workshop Benson was associated.

BENSON, Frank Weston (1862–1951)

b. d. Salem, Massachusetts. American painter and etcher, who attended *Rimmer's artistic anatomy classes, studied at Boston Museum School and at the Académie Julian under Boulanger and Lefebvre in Paris. He painted portraits, interiors and figures in landscapes in a lukewarm, academic version of †Impressionism.

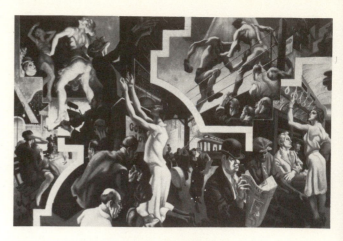

THOMAS HART BENTON *City Activities with Subway.* 1930.
Mural. $77\frac{1}{2} \times 145$ in (196·9×368·3 cm). New School for Social Research, New York

BENTON, Thomas Hart (1889–)

b. Neosho, Missouri. American painter who studied at Chicago Art Institute and Académie Julian in Paris, later teaching at *Art Students' League (1926–35). Best known of the so-called 'Regionalists', he renounced early Paris-influenced abstract work to paint *WPA murals in a Midwestern interpretation of the *American Scene – preachers, racketeers, strip-tease artists – in rhythmic, energetic, contorted complexes of bulging muscles, serpentine lines and overheated colours.

BERCHEM, Nicolaes (1620–83)

b. Haarlem d. Amsterdam. Prolific Dutch landscapist most renowned for his paintings of Italian pastoral and Arcadian scenes. In Italy probably in the 1640s, he made innumerable nature-drawings. He also occasionally painted figures and animals in the landscapes of Jacob van *Ruisdael and *Hobbema.

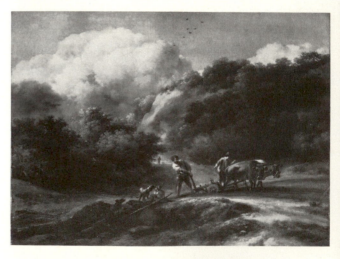

NICOLAES BERCHEM *A Man and a Youth Ploughing with Oxen.*
1658. $15\frac{1}{16} \times 20\frac{1}{4}$ in (38·2×51·5 cm). NG, London

BERCKHEYDE, Gerrit (1638–98)

b. d. Haarlem. Dutch townscape painter, influenced by *Saenredam; he specialised in small pictures of streets, canals and squares in Haarlem and Amsterdam.

BERENSON, Bernard (1865–1959)

b. Butremanz, Lithuania d. Florence. Art historian and connoisseur. Emigrated to America (1875). Educated Harvard

University. Settled in Florence. Formed Isabella Gardner's Italian collection (1885–1906), consultant to the dealer Duveen (1907–36). His most widely popular work is his collection of essays, *Italian Painters of the Renaissance* (written between 1894 and 1907, published together in 1932) while his contribution to scholarship rests with *The Drawings of the Florentine Painters* (1903) and his 'Lists' (of attributions to Italian †Renaissance painters).

BERG, Claus (b. before 1485)

b. Lübeck. German sculptor active from 1504 in Denmark, mainly at Odense whither he was summoned by the Queen. His carved altarpiece at Odense (1517–22) blends the iconographies of All Saints, the Passion and the Tree of Jesse in a huge, elaborate structure, detailed to the point of having a feeling of universal observation. It is naturalistic in figure style, yet spaceless and floating in organisation.

BERGOGNONE (FOSSANO), Ambrogio da

(c. 1455–1532)

Milanese painter whose major work was for the Certosa at Pavia. He painted there 1488–94 and in 1514, producing altarpieces and numerous frescoes. Active in Milan (S. Satiro) (1495 and from 1514) and in Lodi (1498–1500). A traditional artist, Bergognone was primarily influenced by *Foppa, avoiding *Leonardesque innovations.

BERLIN PAINTER (active 505/470 BC)

Greek vase painter and pupil of *Euthymides. He painted pots in preference to cups and often put a single large unframed figure on one side. He was very interested in anatomical detail and seems to have incorporated many of the features of contemporary sculpture into his work.

BERLINGHIERI Family

Active in Lucca, first half 13th century, they produced two main kinds of panel-painting. In their crucifixes, which show some †Byzantine influence, they replaced the side scenes of *Pisan School crucifixes with standing figures of the Virgin and St John. The popular *St Francis* panels depicted a large-scale figure of the Saint, surrounded by scenes from his life.

BERMAN, Eugène (1899–)

b. St Petersburg. Russian painter who went to Paris in 1918 where he attended the Académie Ranson and was taught by Pierre *Bonnard. In 1937 he settled permanently in the USA. His paintings, usually scenes enacted amid ancient ruins, are reminiscent of the dream-like quality in de *Chirico's work.

BERMEJO, Bartolomé (active 1474–98)

Spanish painter from Cordoba, active in Aragon (1474–7), Barcelona (1486) where he collaborated with *Hughet. In the 1490s he was occupied in Barcelona Cathedral with designs for stained glass and with his *Pietà* altarpiece (signed and dated 1490). It shows Netherlandish influence, but his control of dramatic chiaroscuro intensifies the pathos of the scene.

BERNARD, Emile (1868–1941)

b. Lille d. Paris. French artist who studied under Cormon. He met *Gauguin in *Pont-Aven (1886) and they jointly invented *Synthetism (1888). In the 1890s he visited Italy, Constantinople, Jerusalem and Cairo, where he stayed until 1904. He painted several frescoes and returned to a more classical style. He also produced carvings, book-illustrations and tapestries.

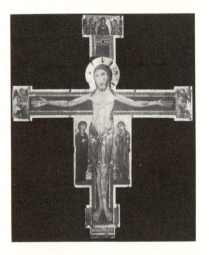

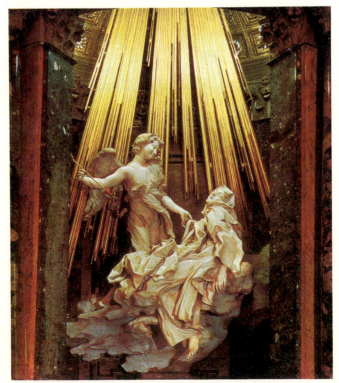

Top left: BERLINGHIERI FAMILY *Crucifix. c.* 1220. 69×55½ in (176×141 cm). Pinacoteca, Lucca
Top right: AMBROGIO DA BERGOGNONE *Agony in the Garden.* 39¼×17¾ in (99·5×45 cm). NG, London
Above: GERRIT BERCKHEYDE *The Market and Town Hall, Haarlem.* 1671. 13×16⅝ in (33×42 cm). Frans Hals Museum, Haarlem

GIANLORENZO BERNINI *Ecstasy of St Teresa.* 1645–52. Life-size. Cornaro Chapel, Sta Maria della Vittoria, Rome

BERNINI, Gianlorenzo (1598–1680)

b. Naples d. Rome. Italian sculptor and architect, he was among the main practitioners of the †Baroque style in Rome. An astonishing technician, he enlarged the traditional role of sculpture, synthesising it with architecture as well as increasing its colouristic potential. He was taught by his father Pietro Bernini after they moved to Rome (1605/6); some of his early works exist in the Villa Borghese. Under Urban VIII he was employed on official commissions gaining an enviable status thereby; in St Peter's he began the *baldacchino at the centre of the church (1624) and made the statue of S. Longinus (1628–38). With the election of Innocent X (1644), Bernini's reputation declined momentarily; yet the freedom from official responsibilities allowed his employment by private patrons; the *Ecstasy of St Teresa* in Sta Maria della Vittoria (1645–52) was commissioned by the Cornaro family. Here the arts of sculpture, painting and architecture merge as the figure floats in ecstasy. Papal favour returned with work on the *Four Rivers Fountain*, Piazza Navona. Alexander VII became pope in 1655; under him Bernini concentrated on architectural projects, working also on the Cathedra inside St Peter's. Bernini went to France at the request of Louis XIV (1665) to provide plans for the Louvre, which were never used.

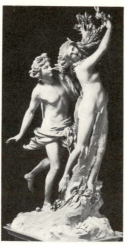

Left: GIANLORENZO BERNINI *Louis XIV*. 1665. Marble. Life-size. Versailles
Right: GIANLORENZO BERNINI *Apollo and Daphne*. 1622–5. Marble. Life-size. Villa Borghese, Rome

BERNSTEIN, Morris Louis *see* LOUIS

BERRUGUETE, Alonso (c. 1488–1561)

b. Parades de Nava. Spanish sculptor, painter and architect, son of Pedro *Berruguete. In Florence from c. 1504; returned to Spain in 1517. Employed throughout his life by the royal family. His sculpture is highly important, reflecting as it does the tense, contorted style of *Michelangelo. Altars in Valladolid, eg that for S. Benito (1527–32, now Valladolid Museum) chronicle the development of his sinuous style, strongly expressive of spiritual agony.

BERRUGUETE, Pedro (active 1477–d. 1504)

b. Parades de Nava d. Avila. Spanish painter, usually identified with 'Pietro Spagnuolo' who was working with Joos van *Ghent in Urbino (1477). Engaged on frescoes in Toledo Cathedral (1483). He is the first, and best, of the Italianising Spanish painters, marrying his precise technique with Italian amplitude of form and space, producing dignified, calm and introspective figures.

BERTHOLLE, Jean (1909–)

b. Dijon. French painter who attended the Ecole des Beaux-Arts at Lyon and Paris. He has designed church windows, and

HARRY BERTOIA *Spring*. Mixed media. The Chase Manhattan Bank, New York

was Artistic Director of the Gien Pottery until 1957. His work, strongly linear, has moved towards pure abstraction, based on interlocking planes.

BERTOIA, Harry (1915–)

b. S. Lorenzo, Italy. Sculptor who went to United States (1930), studied in Detroit, and has lived in California and Pennsylvania. Although capable of creating baroque sculptural form, Bertoia is known for his shining abstract metal 'screens', essentially *Constructivist, and much in demand as decorations for architectural interiors.

BERTOLDO DI GIOVANNI (c. 1420–91)

d. Poggio a Caiano. Italian sculptor and medallist, pupil of *Donatello and later master of *Michelangelo. His earliest known work is on the S. Lorenzo pulpits in Florence (1460–70) left uncompleted by Donatello. Befriended by Lorenzo de' Medici, he was made curator of his collection of antiquities and first director of his academy in the S. Marco Gardens. For Lorenzo too he executed his most important surviving work, the battle relief (Bargello), inspired by a Greco-Roman *sarcophagus at Pisa. A sensitive revival of the spirit of antiquity in Florence is embodied in the bronze statuette of Orpheus (Bargello).

BERTRAM OF MINDEN (c. 1345–c. 1415)

The first important individual painter to emerge in North Germany. Active chiefly in Hamburg where he enjoyed the patronage of the Hanseatic League merchants. His most important surviving work is the *Grabow Altarpiece* at Hamburg (1379–83). His style refuses to fit comfortably into a neat

Left: PEDRO BERRUGUETE *King Solomon*. Predella panel from the Retable of Sta Eulalia. Sta Eulalia, Palencia
Right: BERTRAM OF MINDEN Section of the left wing of the *Grabow Altarpiece*. 1379–83. $68\frac{1}{8} \times 66\frac{7}{8}$ in (173×169 cm). Kunsthalle, Hamburg

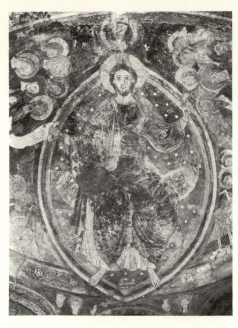

THOMAS BEWICK *Wild Bull at Chillingham*. Engraving from the *History of Quadrupeds*. 1790. $2\frac{1}{4} \times 3\frac{1}{4}$ in (5.7×8.3 cm). BM, London

Left: BERZE-LA-VILLE, Chapel of St Hugh. Apse painting of Christ in Majesty. Early 12th century
Right: BEWCASTLE CROSS, Cumberland *c.* 700

typological scheme, anticipating both the *Soft Style and the harsh realism of the 15th century.

BERZE-LA-VILLE, Chapel of St Hugh

The apse paintings in this Burgundian chapel of St Hugh, Abbot of Cluny date from the early 12th century, probably before 1109. The vault shows Christ in Majesty surrounded by Apostles and below are the figures of saints. The painting probably reflects the monumental treatment of the same subject at the now-demolished Abbey of *Cluny. The colours are full-bodied and the style is thought to derive either from the Empire or from †Byzantine and Italian work through Monte Cassino.

BESNAGAR *see* SHUNGA AND KANVA DYNASTIES

BESNARD, Paul Albert (1849–1934)

b. d. Paris. French painter who emerged from his orthodox training with an extrovert, often slick, brushstroke characteristic of the *juste-milieu* of the 1880s who were beginning to assimilate avant-garde experiments. He had an extensive practice as a portrait painter, etched and received many decorative commissions from the French government.

BESTIARY

The medieval Latin bestiary was one of the most popular types of picture-book in 12th- and 13th-century England. It contained a number of sections, each devoted to one animal or fabulous beast of which an illustration is shown and a moral pointed. The bestiary was based on the Greek *Physiologus*, a pseudo-scientific natural history with a moral content, which was translated into Latin in the 8th–10th centuries. Bestiary illustrations had a considerable influence on *manuscript-illumination and upon stone- and woodcarving, eg *misericords.

BETTO, Bernardino di *see* PINTORICCHIO

BEUCKELAER, Joachim (1530/5–1575/8)

b. Antwerp. Netherlandish painter, Master in Antwerp (1560). Related by marriage to Pieter *Aertzen, whose style he

followed. Van *Mander tells that Beuckelaer produced a great number of paintings for a very small profit and was forced, for his living, to paint the costumes in the portraits of *Mor.

BEURON, Abbey of *see* VERKADE, Jan

BEUYS, Josef (1921–)

b. Kleve. Since 1961, Professor of Sculpture at Düsseldorf Academy, and leader of the Düsseldorf group of *Conceptual artists. Beuys's works have included felt-covered objects, the founding of a 'Bureau for Direct Democracy', and various 'Happenings'; he has exhibited with the American Fluxus group (1963). He professes anarchistic individualism through art, combining humour with political conviction.

BEVERLOO, Cornelius van *see* CORNEILLE

BEWCASTLE CROSS, Cumberland (probably *c.* 700)

A large stone cross of the Northumbrian School, closely related to the cross at *Ruthwell which has similar classicising figures and vine-scroll ornament. Northumbrian monumental sculpture flourished at a time when little of merit was produced elsewhere in Europe.

BEWICK, Thomas (1753–1828)

b. Cherryburn d. Gateshead. English artist, apprenticed to a copperplate engraver at Newcastle, but turned to wood-engraving. His illustrations to Gay's *Fables* (1779) were followed by the *History of Quadrupeds* (1790) and *British Birds* (1797) through which he established his fame. He and his pupils illustrated many other books and restored the popularity of wood-engraved illustrations.

BEYEREN, Abraham (1620/1–1690)

b. The Hague. Dutch painter, master of the large banquet piece, ie compositions of drapery, tableware and food. He also painted remarkable fish pieces, his shiny, silvery tones giving them great verisimilitude.

BHAJA *see* SATAVAHANA DYNASTY

BHARHUT *see* SHUNGA AND KANVA DYNASTIES

BHUVANESHVARA *see* GANGA DYNASTY; SATAVAHANA DYNASTY

BIAGIO, Vincenzo di *see* CATENA

BIARD, Pierre-Noël (1559–1609)

b. d. Paris. French sculptor and architect who studied in Rome. Returning to Paris (1590), he was made Superintendent of Royal Buildings. His tomb for the Duc d'Epernon and his wife at Cadillac is robust and full of aggressive personality, somewhat influenced by Giovanni da *Bologna (cf his bronze *Fame* from the Epernon Monument, now Louvre).

BIBLE MORALISEE

A type of Bible, possibly created for St Louis in north-eastern France or Paris, second quarter 13th century, of which three early copies survive. The text comprises numerous events from the Old and New Testaments, each accompanied by a commentary, or moralisation. Next to each scene is an illustration in a roundel, a form borrowed from stained glass. The miniaturist technique, predominant use of red and blue, dense patterning and varied use of gilding, all helped to create a style which led to the achievements of the *St Louis Psalter.

BICCI Family

Lorenzo di Bicci (active c. 1370–after 1409)
Bicci di Lorenzo (1373–1452)
Neri di Bicci (c. 1419–after 1491)

Florentine family of painters. Lorenzo di Bicci is mentioned by *Vasari who often confused him with his son, Bicci di Lorenzo. The son, both painter and sculptor, worked in his father's workshop and was active throughout Tuscany. His wiry figures recall Agnolo *Gaddi and *Spinello Aretino and typify the work of a second-rate artist who appeals to conservative taste. Neri was Bicci di Lorenzo's son; he also worked with his father. The fresco *John Gualbertus with Ten Saints*, shows how obstinately he clung to outward formulae.

BIDDLE, George (1885–)

b. Philadelphia. American *Realist painter, etcher and sculptor, who studied at Pennsylvania Academy and the Académie Julian in Paris. His bold, socially committed *WPA murals of the *American Scene depict harsh tenement life, reflecting the influence of *Renaissance fresco-painters and muralists *Rivera and *Orozco.

BIDPAI

Pseudo-author (corruption of Sanskrit *Vidyapati*) of Indian moral fables, fused with Buddhist and Hindu stories; these were translated into Pahlavi, then into Arabic as *Kalila wa Dimna* and into modern Persian titled *Anvār-i Suhaylī*. With animals as the main characters, the stories were favourites for illustration, especially in *Mughal painting. In 17th-century England they were known as the *Fables of Pilpay*.

 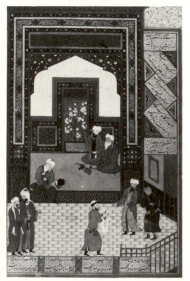

Left: BIDPAI Page from the *Anvār-i Suhayli*, an adaptation of an earlier Persian translation of Bidpai's fables. Illustrated c. 1610–11 by leading Mughal artists, perhaps including Jahangir himself. The above illustration by Durga. 9¾×6 in (24·8×15·2 cm). BM, London
Right: BIHZAD Painting in copy of Sadi's *Bustan*. Signed and dated 1488. 11⅞×8½ in (30×21·5 cm). National Library, Cairo

BIEDERMEYER PAINTING

German and Austrian style epitomising bourgeois taste between the Congress of Vienna in 1815 and the Revolution of 1848.

BIERSTADT, Albert (1830–1902)

b. Nr Düsseldorf, Germany d. New York. Painter who came to Massachusetts (1831), studied in Düsseldorf and Rome (1853–7), made sketching tour in Rocky Mountains (1857) and settled in New York (1860) with studio at Irvington-on-Hudson. Famous for melodramatic Western landscapes, vast in scale and finicky in detail.

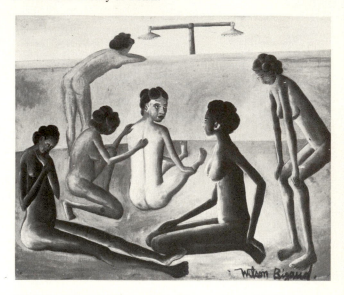

WILSON BIGAUD *Women in the Shower Room*. Sheldon Williams Collection, London

BIGAUD, Wilson (1931–)

b. Port-au-Prince. Painter who studied at Centre d'Art and with *Hyppolite. One of the finest of the sophisticated yet primitive Haitian painters, often compared with *Rousseau, Bigaud fills his pictures of Biblical and genre scenes with rich, evocative detail. His later work, torn between Voodoo and Christianity, has deteriorated.

BIGI, Francesco di Cristofano *see* FRANCABIGIO

BIGORDI *see* GHIRLANDAIO

BIGUERNY *see* VIGARNY, Felipe

BIHZAD (b. ?1440/60–d. 1533/4 or 1536/7)

Described as the 'Persian *Raphael', he was working at the *Herat court in 1488, moving later to *Tabriz and perhaps *Bukhara. His work is said to fulfil the Timurid style in its realism, attention to detail and quality of movement, while retaining the traditional conventions of high horizon, and disregard of perspective and chiaroscuro. Under his hand, landscape becomes an integral part of the drama rather than static ornament; geometrical placing of plants and trees is abandoned for a more naturalistic treatment. The scene is so accurately portrayed that the narrative becomes superfluous. Faces are no longer stereotyped but individual, often including a negro figure for colour contrast. The palette is wide-ranging with some preference for blues and green; throughout a balance of tonal qualities is maintained. Probably he was the innovator of border decoration of flora and fauna, framing a text of fine calligraphy. Generally accepted as his work are the Cairo *Bustan* (1488), the double-page of Gulistan manuscript (c. 1485–90) and some miniatures of the British Museum *Khamsa* (text dated 1442) and *Khamsa Nizami* (c. 1494/5).

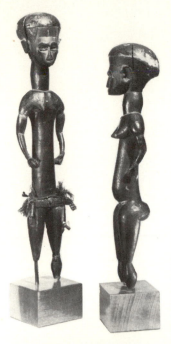

Left: BIJUGO Two figures. Wood. h. 19½ in (49·5 cm) and 17¼ in (44 cm). BM, London
Below: BIKANER SCHOOL *Krishna holding up Mount Govardhana. c.* 1690. BM, London

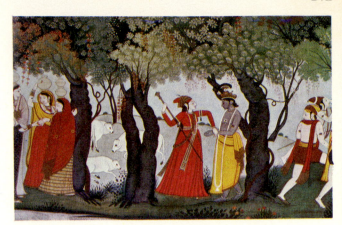

BILASPUR SCHOOL *Radha Arresting Krishna. c.* 1765–70. 6⅝×10⅝ in (16·8×27 cm). Indian Museum, Calcutta

BILASPUR SCHOOL (from *c.* 1750)

Bilaspur, one of the *Panjab Hill States, was the seat of an important school of miniature painting during the reign of Devi Chand (1741–78). The style was at first much influenced by *Mughal art but this was gradually transformed to suit Hill taste. The most popular theme was the Krishna cycle. The colours are bright with abrupt transitions from tone to tone. Gold was used a great deal, especially on scarves and girdles, even on cows, and the whole effect is enamel-like. The lines are dry and vigorous and the compositions exhibit energy and movement. Influence from the *Kangra School is noticeable in the delicacy of the women and the softly rounded hillocks. There is a characteristic fondness for gnarled and knotted tree-trunks.

BILL, Max (1908–)

b. Winterthur, Switzerland. Painter and sculptor who studied at the Dessau *Bauhaus (1927–9). He joined the *Abstraction-Création group (1932), which included *Arp and *Mondrian. Bill describes his work as the solving of problems, particularly those concerning representation of space. In the *Constructivist spirit, he has made no distinction between the tasks of fine and applied art, practising sculpture, industrial design, painting, architecture and teaching. He edited *Kandinsky's theoretical writings in the 1950s; and now works as an architect in Zürich.

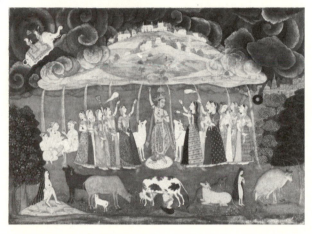

BIJUGO

The people of the Bissagos Islands on the coast of Portuguese Guinea (Guinea-Bissau). They carve a variety of human figures in wood, including a large figure with splayed legs carried by women who want children, spoons and lidded bowls decorated with human and animal figures and magnificent bull masks also sometimes used as figureheads for their canoes. The Bijugo provide the westernmost examples of sculpture in Africa.

BIKANER SCHOOL (from *c.* 1500)

The rulers of Bikaner in North *Rajasthan employed artists of the *Mughal School who were attracted by rich patrons and better prospects. There is, therefore, much Mughal influence in this school, which lasted until the middle of the 18th century. The most popular themes were *Ragamalas*, harem scenes (a Mughal taste), women showing all kinds of emotions, and scenes from Hindu mythology. One of the best-known miniatures is of Krishna holding up Mount Govardhana (*c.* 1690), which displays most of the characteristics of the school – fairly sober colours harmonising delicately, elegant and well-balanced composition and technical perfection. Later, about 1775, there was a distinct change in the style with a marked influence from the *Jodhpur School, especially in the large turbans worn by the men, their side-whiskers, and in the use of strong colours.

MAX BILL *Double Surface with Six Angles.* 1968. Brass. 9½×10×30 in (24×25×76 cm). Galerie Denise René, Paris

BINDER

The sticky drying medium which holds the granules of *pigment together in a coat of *paint.

BINGHAM, George Caleb (1811–79)

b. Augusta County, Virginia d. Kansas City, Missouri. American painter who lived largely in Missouri, studying at Pennsylvania Academy (1837) and in Düsseldorf (1856–9). His masterful organisation of space and colour, virile draughtsmanship, clarity of light and concrete, objective vision immortalised the boatmen and politicians of the frontier.

GEORGE CALEB BINGHAM *Fur Traders Descending the Missouri.* 29×36½ in (73·7×92·7 cm). MM, New York, Morris K. Jesup Fund, 1933.

BINI *see* EDO

BINNING, Bertram Charles (1909–)

b. Medicine Hat, Alberta. Canadian painter who studied at Vancouver School of Art, *Art Students' League, with *Moore and *Ozenfant; taught at Vancouver School of Art (1939–49) and University of British Columbia, travelled widely. An influential teacher, Binning creates stylised, decorative abstract seascapes, rather obviously influenced by *Miró's and *Picasso's *Surrealist forms.

BIRCH, Thomas (1779–1851)

b. London d. Philadelphia. American painter who came to Philadelphia with artist father (1794), setting up designing/ engraving business with him (1799–1800), and from 1800 painting portraits, landscapes and marine views. Careful drawing, pleasant colour and firm composition characterise his views of Philadelphia and snow scenes.

BISCHOFF, Elmer (1916–)

b. Berkeley, California. Painter who studied at University of California (Berkeley), and teaches at San Francisco Art Institute (1946–52, from 1956). Influenced by *Still and *Rothko, he was one of the first California artists to adopt *Abstract Expressionism, then abandon it for figurative painting, retaining its vibrant colour and broad, painterly technique.

BISHOP, Isabel (1902–)

b. Cincinnati, Ohio. Painter who moved to New York (1917), studied at *Art Students' League under Kenneth *Miller, and travelled extensively in Europe. Influenced by †Renaissance techniques and draughtsmanship, her sensitively drawn, subtly coloured, luminous paintings capture the essential humanity in intimate glimpses of the passing urban scene.

BISSCHOP, Jan de (1628–71)

b. Amsterdam d. The Hague. Dutch artist. Trained as a lawyer, he travelled in Italy (1649–53) making topographical drawings of Roman buildings and scenery. He copied Old Masters and contemporary artists (particularly landscape subjects) and published a collection of his engravings (1671).

BISSIERE, Roger (1888–1964)

b. Villeréal. French painter who studied in Bordeaux, settling in Paris in 1910. Significant in classicising *Cubism during the 1920s; later influenced by *Mondrian. Taught at Académie Ranson (1925–38). Temporary blindness forced him to give up painting (1939–45). In the 1950s Bissière contributed to the French *Tachiste movement with his *Images sans Titres* series.

BISTRE

A brown pigment made from soot or charred wood. It can be made into drawing chalks, or used as an ink or *watercolour wash.

BISUTUN

Carved high on the imposing rock of Bisutun overlooking the main route from Mesopotamia to the Iranian plateau is the trilingual inscription of Darius the Great (521–486 BC), which enabled Henry Rawlinson to decipher the cuneiform scripts in about 1850. The text relates how Darius gained the throne and is accompanied by a bas-relief showing the king triumphing over his defeated enemies. This is the first relief in the *Achaemenian style and owes much to *Mesopotamian art.

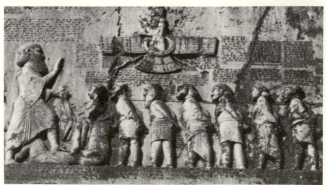

Top: ISABEL BISHOP *Two Girls.* 20×24 in (50·8×61 cm). MM, New York, Arthur H. Hearn Fund, 1936
Above: BISUTUN Relief of King Darius. 521–486 BC

BITUMEN

An asphalt compound, obtained from natural tar. It was used in the embalming of Egyptian mummies, and these in turn provided a source of bitumen for *pigments in the 18th and 19th centuries. It was employed to imitate the rich brown *patina that oil painting acquires but is very damaging because it never dries completely and penetrates right through to the *ground of a picture making it impossible to repair and clean.

BLACKBURN, Joseph (?1700–?1765)

b. Probably England. Portrait painter trained in England, active in Bermuda (1752–3), mainly in Boston and New Hampshire (1754–63), and probably later in England. Popular and influential, he imported the English †Rococo into America, sometimes approaching its elegant sensuousness, but usually given to simpering prettiness. He influenced the young *Copley and probably left Boston (c. 1760) because he could not compete with him.

Left: ROGER BISSIERE Black and Ochre. Tempera. 41½×17½ in (105·4×44·6 cm). Stedelijk Museum, Amsterdam
Right: PETER BLAKE The Toy Shop. 1962. Relief. 61¾×76¾×13⅜ in (156·8×194×34 cm). Tate

BLACK-FIGURE STYLE

Greek vase-painting style in which the figures were painted in black glaze directly on to the reddish ground of the pot. It derived from the *Geometric silhouette technique, but the inner details of the figures were shown by incised markings. The style was used at *Corinth throughout the 7th century BC and animal friezes were a favourite theme. The *Nessos Painter was one of the first to use the technique in Athens, followed by the *Gorgon Painter and *Sophilos. During the 6th century there was more interest in portraying human figures, as can be seen in the famous *François Vase of c. 570 BC. The style reached a peak 550/525 BC with *Amasis and *Exekias. By the end of the century black-figure was entirely superseded by the *red-figure style.

BLACKFOOT see PLAINS INDIAN ART

BLACKMAN, Charles (1928–)

b. Sydney, Australia. Studied privately and became press artist for the Sydney Sun. Travelled extensively. Paints in a figurative and highly decorative manner using bright †Impressionistic colour; he achieves an atmosphere of mystery in his compositions by unexpected spatial effects. His principal themes are girls and flowers which, for him, have a symbolic significance.

BLADDER

The bladder of a small animal, young sheep or pig, used as a container for artists' paints before soft metal tubes were invented.

BLAKE, Peter (1932–)

b. Dartford. English painter who studied at Gravesend (1948–51) and the Royal College of Art (1953–6), and works with his wife Jann Haworth. Blake employs an unhurried thoroughness in painting or in assembling his nostalgic trophies of yesterday, eg The Toy Shop (1962). Technique and imagery relate to *Pop Art, though the effect is of a naïve realism pervaded by an affectionate, uncynical humour.

WILLIAM BLAKE Songs of Experience. 1794. Title-page 5⅛×3⅝ in (13×9·2 cm). BM, London

BLAKE, William (1757–1827)

b. d. London. English poet, painter and engraver. Blake began his training as a draughtsman at the age of ten and by fifteen was apprenticed to an engraver, being already engaged in writing poetry. His Songs of Innocence (1789) and Songs of Experience (1794) were the first collections of his poems printed and illustrated in colour by a method devised by himself. Blake rejected oil paint and used either an original tempera technique, colour-printing, watercolour or conventional line-engraving. Besides illustrating his own poems he used the Bible, Milton, Shakespeare and Dante as textual sources, all of which he interpreted in a highly personal way. His art is noted for its esoteric symbolism, intense visionary quality and

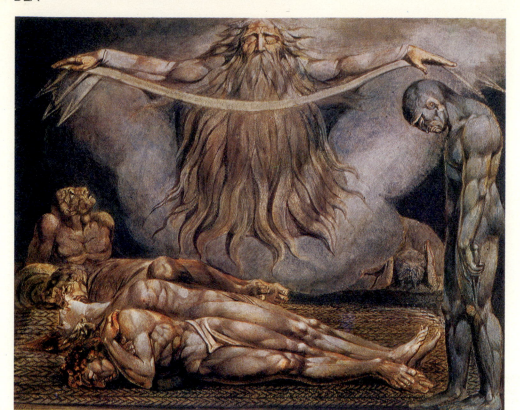

WILLIAM BLAKE *The Lazar House.* 1795. Colour printed drawing $17 \times 22\frac{1}{2}$ in $(43\cdot1 \times 57\cdot1$ cm). BM, London

uncompromising use of line. He admired all linear artists such as *Michelangelo and *Dürer and despised the 'colourists' *Titian and *Rubens. Though less isolated than has been thought, he was at odds with the official and popular art of his age. His belief in inspiration and genius puts him among the †Romantics.

RALPH BLAKELOCK *Moonlight, Indian Encampment. c.* 1889. $26\frac{1}{2} \times 33\frac{3}{4}$ in $(67\cdot3 \times 85\cdot7$ cm). Smithsonian Institution, Washington, D.C.

BLAKELOCK, Ralph Albert (1847–1919)

b. New York d. Adirondacks, New York. American painter, largely self-taught, attended Free Academy of City of New York (1864–6), travelling West (1869) to study Indians. A visionary haunted by one vision – an Indian camp, in glowing sunset, twilight, moonlight – his unpopularity drove him to poverty and madness.

BLANC, Charles (1814–81)

b. Castres d. Paris. From studying etching and engraving he turned to writing on art by the 1840s. In 1867 he published his *Grammaire des arts du dessin* which included a résumé of *Chevreul's colour theories and *Delacroix's views on colour as told to the writer. His work was an important source for the *Pointillists.

BLANCH, Arnold (1896–1968)

b. Mantorville, Minnesota. Painter who studied in Minneapolis and in New York with Kenneth *Miller, *Sloan and *Henri. Blanch's work developed from Realism to more *Surrealist, intimate and abstract paintings. He is best known for the boldly brushed, angry *Social Realism of his mid-1930s pictures of the rural South.

BLANCHARD, Jacques (1600–38)

b. d. Paris. French painter renowned for his decorative scenes done for large bourgeois houses and for his Holy Families. In Rome and Venice (1624–8). His works in Paris show Venetian influence and also that of *Rubens.

BLANCHARD, Maria (1881–1932)

b. Santander d. Paris. Physically handicapped painter who studied in Madrid and later worked in Paris with *Van Dongen. In 1916 her work became *Cubist through her association with *Gris, *Metzinger and *Lipchitz, but she retained a human tenderness towards her sitters.

BLANCHE, Jacques-Emile (1861–1942)

b. Paris d. Offranville. French painter, trained in Paris under Gervex and Humbert, also received some tuition from *Manet. A prolific portraitist, primarily of the social élite, with a style that often shows the influence of *Gainsborough and *Reynolds. With his English connections, an important link between artistic circles in London and Paris.

BLANES, Juan Manuel (1830–1901)

b. Montevideo d. Florence. Painter who studied in Florence, Venice and Paris. Using a luminous, painterly, essentially

European technique, Blanes painted Uruguayan genre and historical scenes as well as portraits, consequently becoming the founding father of Uruguayan painting.

BLASHFIELD, Edwin Howland (1848–1936)

b. New York d. South Dennis, Massachusetts. American painter who studied in Paris under Léon *Bonnât (1867), informally under *Gérôme and Chapu, returning to America in 1881. He was hailed for public murals executed in a tepid, sentimental, †Neo-classical style.

BLAST see VORTICISM

BLAUE REITER, Der

Exhibiting group of artists, founded 1911 in Munich, the principal members being *Kandinsky, *Klee, *Marc, *Macke, *Jawlensky and Gabriele *Münter. More loosely knit than the other main *Expressionist group, die *Brücke, der Blaue Reiter was also more outward-looking and open to advanced international influences, such as *Cubism and *Futurism, and there was a stronger emphasis on the spiritual and mystical. Russian and Bavarian folk-art were influential. Led by Kandinsky, several members moved towards abstraction. World War I brought the group to an end.

BLAUSTEIN, Alfred (1924–)

b. Bronx, New York. Painter and printmaker who studied at Cooper Union (1940–3, 1946–7), went to Africa on commission (1948–9), to Rome and Africa (1955–9), and teaches at Pratt Institute. His work, reminiscent of German *Expressionism in colour and imagery, sometimes loses its haunting drama in prettiness and technical display.

BLECHEN, Karl (1798–1840)

b. Kottbus d. Berlin. German †Romantic painter, he met Caspar David *Friedrich in 1823. After working for the Koningstadt theatre, and travelling in Italy, he became Professor of Landscape Painting at the Berlin Academy. His later landscapes are more pedestrian.

BLEEDING

The tendency of some *pigments to spread and tint neighbouring areas of paint or inks when wet.

BLES, Herri met de ('Civetta') (c. 1480–c. 1555)

b. Bouvignes, Dinant d. ?Ferrara. Netherlandish painter said to be the nephew of Joachim *Patenier. Certainly their styles are related, Herri's sparsely populated landscapes tending to be less rigid, more misty. A master in Antwerp, he journeyed to Italy where his paintings had great success and influence. It was here that he was given the nickname 'Civetta' (Italian: 'owl') because he often included owls in his work.

HERRI MET DE BLES Adoration of the Magi. Brera

BLOCK-PRINTING

Printing from raised *relief, usually of wood or linoleum. The 'white' parts are cut away.

BLOEMAERT, Abraham (1564–1651)

b. Dordrecht d. Utrecht. Dutch painter and engraver; in France (1580–3), and later the master of a whole generation of artists in *Utrecht. His early works are brightly coloured and *Mannerist but he later developed a classical style and also absorbed *Caravaggesque influence from his pupil, *Honthorst.

BLOEMEN, Jan Frans van ('Orizzonte') (1662–1749)

b. Antwerp d. Rome. Flemish painter and engraver of landscapes and ruins. In Rome from the early 1680s, he painted views of the Roman Campagna influenced by *Dughet. He acquired the nickname, 'Orizzonte', because of the delicacy of his distances.

BLONDEEL, Lancelot (1498–1561)

b. Poperinghe d. Bruges. Netherlandish painter, employed in decorative works for the entry of Charles V to Bruges in 1520. He produced designs for all media from architecture to maps. Accordingly his style is flamboyant and particularly suited to tapestry, with much use of gold in the usually elaborate decorative borders.

BLOOM

Whitish, foggy patch on a *varnished surface. Caused by varnishing in a damp atmosphere.

BLOOM, Hyman (1913–)

b. Brunoviski, Lithuania. Painter who moved to Boston (1920), studied there with Harold Zimmerman and Denman Ross (1929–32), worked for *WPA, and taught at Wellesley College and Harvard University. Bloom's visionary moral mysticism materialises in glowing colour and writhing forms in stained-glass religious dreams and lurid, bloodstained nightmares of carnage.

HYMAN BLOOM The Anatomist. 1953. $70\frac{1}{2} \times 40\frac{1}{2}$ in $(179.1 \times 102.9$ cm). Whitney Museum of American Art, New York

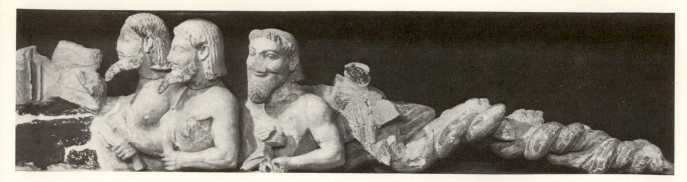

BLUEBEARD PEDIMENT 560/550 BC Limestone. l. 11 ft 4 in
(3·40 m). Acropolis Museum, Athens

BLOT-DRAWING

The use of random blots of ink and wash to stimulate the
imagination particularly in producing imaginary landscape
drawings. *See* COZENS, Alexander

BLOT-DRAWING *Landscape* by Alexander Cozens (detail).
Indian ink. 7¼×9 in (18·4×22·9 cm). V & A, London

BLOW, Sandra (1925–)

b. London. English painter who studied at St Martin's School
of Art (1942–6), Royal Academy Schools (1946–7) and the
Accademia di Belle Arte, Rome (1947–8). Since 1950 in
London. At first attracted by austere colour, she has moved
towards a phosphorescent colour range, the paint splashed on
to the canvas.

BLUE ROSE GROUP

A group of Russian painters and illustrators influenced by
*Serov, *Vrubel and *Borrissov-Mussatov, who were chiefly
concerned with a primitivist style and *Symbolist imagery.
They included Pavel *Kusnetsov, Robert Falk, Georgy
Yakulov and, most importantly, *Larionov and *Gontcharova.
They published the *Golden Fleece* magazine (1906–9), and
from 1907 arranged exhibitions of modern art, both with a
special emphasis on French *Fauve painting.

BLUEBEARD PEDIMENT (560/550 BC)

A carved limestone pediment found on the Acropolis at Athens.
The surviving part, from the right-hand side of the pediment,
is a three-headed typhon with a long twisted tail. Its three
faces are bearded and there are traces of the original blue
paint on the beards.

BLUME, Peter (1906–)

b. Smorgonic, Russia. *Magic Realist painter who emigrated to
America (1911), studied at Educational Alliance Art School
(1919–24), *Art Students' League and Beaux-Arts Institute,
and first went to Italy (1932). Influenced by *Precisionism and
*Surrealism, Blume's sharply focused complex allegories, even
when most mordantly satirical and terrifying, affirm humanity's
rebirth.

PETER BLUME *The Eternal City*. 1934–7. 34×47⅞ in
(86·4×121·6 cm). MOMA, Mrs Simon Guggenheim Fund

BOBO

Two tribes in western Upper Volta: the Bobo-Fing (Black
Bobo) and the Bwaba or Bobo-Ule (Red Bobo). Although
grouped together as Bobo these two are in reality quite distinct
peoples with different languages and art styles. Bwaba masks
are flat and circular with a tall rectangular superstructure
painted in black, white and red geometric patterns. Bobo-Fing
masks, however, are three-dimensional representations of
human and animal heads.

BOCCIONI, Umberto (1882–1916)

b. Calabria d. Verona. Italian painter and sculptor who studied
painting with *Balla in Rome. In 1909 settled in Milan and met
*Marinetti. Visited Paris and was influenced by *Cubism
(1911). Published *Technical Manifesto of Futurist Sculpture*
(1912). Enlisted in the army and died after falling from a
horse. Boccioni was one of the leading artists and theoreticians
of the *Futurist movement. He used certain aspects of Cubism
as a structural means of expressing Futurist 'force-lines' and
'dynamism' in his interrelated painting and sculpture. His

Above: UMBERTO BOCCIONI *The Street Enters the House.*
1911. 39½×39½ in (100·3×100·3 cm). Niedersachsische
Landesgalerie, Hanover
Right: UMBERTO BOCCIONI *Unique Forms of Continuity in
Space.* 1913. Bronze. 43⅞×34⅞×15¾ in (111·4×88·6×40 cm).
MOMA, New York, Lilly P. Bliss Bequest

Development of a Bottle in Space, combining interior and
exterior views of an object, precedes similar sculptures by
*Picasso and *Duchamp-Villon. Successive phases of move-
ment are simultaneously represented in the bronze striding
figure *Unique Forms of Continuity in Space* (1913). Boccioni's
revolutionary ideas for a multi-material 'sculpture of environ-
ment' anticipate *Dada and even *Kinetic sculpture.

ARNOLD BOCKLIN *Triton and Nereid.* 1874. 41½×76⅜ in
(105·3×194 cm). Schackgalerie, Munich

BOCKLIN, Arnold (1827–1901)

b. Basle d. Fiesole. Like *Feuerbach and von *Marées, a Swiss-
German painter who found his artistic inspiration in a
Mediterranean environment. He first visited Italy in 1850,
having studied under Schirmer in Düsseldorf. His early
works, in the tradition of the German †Romantic landscape,
became even more concerned with interpreting the mood of a
landscape by the presence of accessory figures. The first work
of his which successfully harmonised figure and landscape in
this way was *Villa by the Sea* (1864), which evokes a fatalistic
and melancholy atmosphere he much favoured in his work. Of
a later painting *The Island of the Dead* (1880), Böcklin admitted

to having created 'a picture for dreaming about'. Although his
painting style was rather leaden and his subject-matter –
centaurs, mermaids and satyrs – trite and vulgar, his work was
influential in *Symbolist circles and with *Chirico and the
*Surrealist painters.

BODEGON

Spanish: 'inn', 'tavern'. Interior scenes with emphasis on
*still-life details.

BODHGAYA *see* SHUNGA AND KANVA DYNASTIES

BODHISATTVA

Literally 'knowledge-being'; in Buddhist usage generally, one
(animal or human) destined to become a Buddha in a future
incarnation. In *Mahāyāna Buddhism, one who attains the
*Nirvāna state, but refrains from remaining in it in order to
help other beings towards it.

BODY COLOUR

Opaque colour. Usually describes the addition of opaque
whites to watercolour. *See* GOUACHE

BODY-PAINTING *see* AUSTRALIAN ABORIGINAL ART

BOETHOS OF CHALCEDON (active 2nd century BC)

Greek sculptor and metalworker who made a statue of Antio-
chus IV (reigned 175–164 BC) in Delos. A bronze *herm in the
*Archaic style bearing his signature was found in the sea near
Mahdia on the Tunisian coast.

BOHROD, Aaron (1907–)

b. Chicago. Painter and printmaker who studied at Chicago
Art Institute, and in New York with *Sloan, Boardman
*Robinson and Kenneth *Miller; was artist-correspondent
during World War II. Associated with the Regionalists of
*American Scene painting, Bohrod is best known for his
realistic Midwestern scenes; his later work is primarily still-
life.

Left: BOIANA, Church of SS Nicholas and Panteleimon.
Sebastocrator Kalojan and Sebastocratoress Desislava. 1259
Right: GIOVANNI DA BOLOGNA *Mercury.* 1567. Bronze. h.
69 in (175 cm). Bargello

BOIANA, Church of SS Nicholas and Panteleimon

Constructed in three stages – in the 11th, 13th and 19th
centuries – this church near Sofia contains fragments of 11th-
century frescoes. The main decorations, however, are frescoes
added in 1259 by the Sebastocrator Kalojan, cousin of the Tsar
of Bulgaria. The quality of the work is high but perhaps not
abreast of contemporary trends in †Byzantine art, though it
does exhibit certain links with Constantinople. The fresco of
Kalojan is a virtuoso piece of portraiture. *See also* BUL-
GARIAN ART

BOILED OIL

Drying *oil, usually linseed, thickened by boiling to a gummy
syrup. It dries quickly and with a high gloss. It makes oil
paint yellow with time. *See also* STAND OIL; SUN-
THICKENED OIL

Right:
RICHARD PARKES
BONINGTON *Coast
of Picardy. c.* 1824.
14¾×20 in (36×51
cm). Wallace

Left: FERDINAND
BOL *An Astronomer.*
1652. 50×53¼ in
(127×135 cm). NG,
London

BOL, Ferdinand (1616–80)

b. Dordrecht d. Amsterdam. Dutch painter, mainly of
portraits but also religious and historical pieces. A pupil of
*Rembrandt (*c.* 1635) he abandoned Rembrandt's manner for
the more fashionable Flemish style about 1650. He gave up
painting in 1669 on marrying a wealthy widow.

BOL, Hans (1534–93)

b. Malines d. Amsterdam. Netherlandish painter and minia-
turist notable for his delicate, detailed technique seen in
landscapes and views of towns.

BOLDINI, Giovanni (1845–1931)

b. Ferrara d. Paris. Italian painter who studied in Rome and
Florence (1865), London (1869), settling in Paris in 1872.
Known for his portraits of fashionable people and depictions
of Paris street scenes, painted in a vigorous impasto.

Left: GIOVANNI BOLDINI *Comte Robert de Montesquiou.* 1897.
78¾×39⅜ in (200×110 cm). Musée National d'Art Moderne,
Paris
Right: RICHARD PARKES BONINGTON *An Odalisque.* 1827
Watercolour. 8½×6 in (22×15 cm). Wallace

BOLGI, Andrea (1605–56)

b. Carrara d. Naples. Italian sculptor and follower of *Bernini.
After working in Florence he went to Rome (1626). Through
Bernini he acquired the important commission for a figure of
St Helena, one of four to stand at the crossing of St Peter's.

BOLOGNA, Giovanni da (Giambologna, Jean de Boulogne) (1529–1608)

b. Douai d. Florence. Flemish-Italian sculptor who, after
training in Flanders, came to Italy (*c.* 1555) and quickly
established himself as a formidable rival to the post-
*Michelangelo sculptors in Florence, such as *Cellini and
*Ammanati, whom he rapidly eclipsed. He collaborated with
Ammanati on the *Neptune Fountain* (1560–75, Piazza Signoria,
Florence). His obsession with problems of balance and the
expression of fleeting movement is dramatically evinced in the
Mercury (1567, Bargello), poised on tiptoe, while the *Rape of
the Sabines* epitomises the late *Mannerist concern to achieve
an exciting design from every viewpoint.

BOLTRAFFIO, Giovanni Antonio (1467–1516)

A Milanese follower of *Leonardo, his style closely followed
that of his master. He produced religious subjects and portraits
which are urbane and self-assured.

BOLUS, Michael (1934–)

b. Cape Town. South African sculptor who came to England (1957) and studied at St Martin's School of Art under Anthony *Caro (1958–62). He works principally with steel and aluminium, producing abstract configurations favouring construction rather than modelling or casting. Uses colour to emphasise the nature of his forms.

BOLUS GROUND

A *gesso *ground with red *earth pigment added; usually used as a base for *gilding.

BOMBELLI, Sebastiano (1635–1716)

b. Udine d. Venice. Italian portrait painter. He studied under *Guercino and went to Venice (1663). He introduced into aristocratic portraits a more informal pose than had hitherto been customary. He worked at Innsbruck for the Archduke Joseph and at other cities in Germany and Italy.

DAVID BOMBERG *The Mud Bath. c.* 1913–14. 60×88¼ in (152·4×224·2 cm). Tate

BOMBERG, David (1890–1957)

b. Birmingham. Painter who attended the Slade School (1911–13). Although working in a *Vorticist-like style he was in fact independent of the group. His *Dancer* (1913) retains *Cubist elements, while other canvases of that year are painted as if through a grid superimposed on representational elements (*Ju Jitsu, In the Hold*). *The Mud Bath* (c. 1913–14) is built out of interlocking forms: 'where decoration happens it is accidental'. His *Russian Ballet* lithographs provided a last return to abstraction. He lived in Jerusalem (1923–7), painting representationally. The rest of his career passed in relative obscurity in England and Spain.

BOMBOIS, Camille (1883–)

b. Vénarey-les-Laumes, France. Self-taught naïve painter who divided his time between labouring and painting until he was discovered by Wilhelm Uhde (1922). He then took up painting full-time, drawing his subject-matter from French peasant life and his own colourful experiences as a circus strongman.

BONACOLSI, Piero Jacopo Alari *see* ANTICO

BONAMPAK

A *Maya Classic Period centre (c. AD 300–900) in Chiapas, southern Mexico. Famous for a series of wall-paintings found in three small corbel-vaulted stone rooms. The paintings (dated c. AD 800) employ a wide range of colours, including an extraordinary blue which modern artists have so far been unable to reproduce. The scenes illustrate a procession of priests and musicians, and a raid to obtain captives who are subsequently tortured and sacrificed.

BONE, Sir Muirhead (1876–1953)

b. Glasgow d. Oxford. Scottish draughtsman and etcher who trained as an architect in Glasgow while studying art. He portrayed mainly architectural subjects with a combination of poetic vision and precise observation and also recorded scenes from World War I.

BONHEUR, Marie Rosalie (1822–99)

b. Bordeaux d. Melun. French animal painter of considerable talent, celebrated for her independent-mindedness. From her Salon début in 1841, her spirited brushwork revealed a vital response to painting from nature. Later, her style made the transition from the influence of *Géricault to that of the *Impressionists.

BONINGTON, Richard Parkes (1802–28)

b. Arnold, Nottingham d. London. English painter of landscapes and historical subjects, and lithographer, working chiefly in France. Studied with Louis Francia, a French watercolourist who had been influenced by *Girtin; then a pupil of *Gros in Paris, where he became the friend of *Delacroix, with whom he travelled to London (1825). Visited North Italy (1826). Bonington's vigorous handling and jewel-like colour, together with a blonde landscape palette, made him a seminal force in French painting in the 1820s (he won a gold medal at the Salon of 1824), as well as a considerable influence in England, especially in watercolour. *See also* BOYS

PIERRE BONNARD *The Window*. 1925. 42¾×34⅞ in (108·6×88·6 cm). Tate

BONNARD, Pierre (1867–1947)

b. Fontenay-aux-Roses, nr Paris d. Le Cannet. French painter who studied law (1885–8) before training at the Ecole des Beaux-Arts and the Académie Julian. With *Denis, *Vuillard, *Sérusier and others he formed the *Nabis group, exhibiting at the 1891 Salon des Indépendants small, low-keyed paintings, mainly on cardboard. In 1896 after his first one-man show, Bonnard's pictures became more brilliant in colour. The

asymmetrical arrangement of flat-patterned materials against figures reveals the influence of Japanese prints. His loose brushwork appears to be descriptive of reality, but the form edges are so imprecise as to give the pigment an autonomy divorced from natural representation. Particularly exquisite are Bonnard's nudes, the tones and lights of flesh irradiating the picture-surface into a decorative whole, yet retaining a sensuous vitality.

PIERRE BONNARD *Dining-room in the country*. 1913. 64¾×81 in (164·5×205·7 cm). Minneapolis Institute of Art

BONNAT, Léon Joseph Florentin (1833–1922)
b. Bayonne d. Mouchy-Saint-Eloi. Having trained in France and Spain, he exhibited first at the Salon of 1857. After three years in Rome, he established a reputation, from the 1860s onwards, as a history-painter and a portraitist in a sombre and realistic vein, influenced by his study of the Spanish School.

BONO, Michele di Taddeo *see* **GIAMBONO**

BONO DA FERRARA (active mid 15th century)
Ferrarese painter, a pupil of *Pisanello and influenced by *Squarcione. He decorated the Dukes of Ferrara's castles, Migliaro and Belfiore (1450–2). In 1461 he probably helped on the decoration of Siena Cathedral. His rather dry style owes something to *Mantegna.

BONTECOU, Lee (1931–)
b. Rhode Island. Sculptor and printmaker who studied with Hovannes and *Zorach at *Art Students' League (early 1950s) and travelled in Italy and Greece (1957–8). Her abstract high reliefs are constructed of metal armatures covered with stretched, stitched dark canvas, creating irregular, roughly textured concavities and convexities.

BONTEMPS, Pierre (1506–70)
French sculptor mainly employed on funerary monuments. An early example is the tomb of Philippe Chabot, Amiral de France (Louvre), where the recumbent effigy is placed on its side, contemplating the world with thoughtful melancholy.

BONVICINO, Alessandro *see* **MORETTO DA BRESCIA**

BONVIN, François (1817–87)
b. Paris d. Saint-Germain-en-Laye. French genre painter, exhibited first at the Salon of 1847. Largely self-taught in his spare time from police duties. His study of *Chardin in the Louvre, and *Metsu and de *Hooch on several trips to Holland, are evident in his non-didactic scenes of people working unobserved in tranquil interiors.

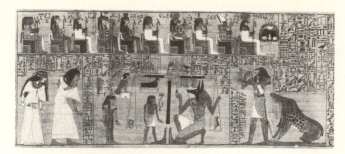

BOOK OF THE DEAD *The Weighing of the heart of the scribe, Any*. 19th dynasty. Painting on papyrus. h. 15 in (38 cm). BM, London

BOOK OF THE DEAD
The name given to an assemblage of Egyptian funerary spells and formulae derived from the earlier Coffin Texts, selections from which were composed on papyri deposited with the dead. Some of the finest examples, from the New Kingdom, are beautifully illustrated with coloured vignettes.

BOR, Paulus (*c.* 1600–69)
b. d. Amersfoort. Dutch painter of allegorical, religious and pastoral subjects. Worked in Rome (1620s) where, like many of his Dutch contemporaries, he fell under the spell of *Caravaggio. On returning to Holland this influence was temporarily replaced by that of *Rembrandt, but later as a member of the *Utrecht School, Italian idealism dominated his work.

BORCH, Gerard ter *see* **TERBORCH**

BORDONE, Paris (1500–71)
b. Treviso, but lived in Venice. A signed painting in the Louvre (1590) inscribed 'Augusta' seems to confirm that he worked in Augsburg; he may also have visited France. He was essentially a Venetian artist who elaborated the rich colours and sensuous charm associated with *Giorgione and *Titian. His most famous work, *A Fisherman Consigning a Ring to the Doge* (*c.* 1533/5, Accademia, Venice), is rich in colour and drama. His later pieces are more mannered and deliberately posed.

Left: FRANCOIS BONVIN *The Letter of Recommendation*. 1858. 25¼×21¾ in (64×55 cm). Besançon
Right: PARIS BORDONE *A Fisherman consigning a Ring to the Doge*. c. 1533/5. 143¼×117⅜ in (365×298 cm). Accademia, Venice

BORDUAS, Paul-Emile (1905–60)
b. Saint-Hilaire, Quebec d. Paris. Canadian painter who studied with Leduc, at Ecole des Beaux-Arts, Montreal (1923–7), and *Denis's Ecole d'Arts Sacrés, Paris (1928–30); taught at Ecole du Meuble (1937–48); published *Refus global* (1948); lived in New York (1953–4); settled in Paris (1955). As teacher and leader of *Automatistes Borduas greatly influenced Canadian non-representational painting. Inspired by *Pellan

Left: PAUL-EMILE BORDUAS *Froissements Délicats.* 1955.
38×47 in (96·5×119·4 cm). NG, Canada
Right: LUIS BORRASSA Scene from the *Sta Clara Altarpiece.*
1412–15. Vich Museum, Barcelona

and *Kline, Borduas's *action paintings, first intricately flickering slabs of intense colour, moved towards almost monochromatic, impasto severity.

BORGHESE WARRIOR

A 1st-century BC replica of a 2nd-century BC original, signed by *Agasias of Ephesos. It is a statue of a warrior whose body is stretched forward in a long diagonal line; his left arm, which originally held a shield, is thrust out to take a blow. (Louvre.)

BORGIANNI, Orazio (1578–1616)

b. d. Rome. Italian painter executing his earliest known work in Sicily and visiting Spain (1598–1605). *Caravaggio's influence appears in his violent foreshortenings, raking light and still-life interest, but his later work is more anecdotal, lacking the earlier's dramatic power.

BORGLUM, Gutzon (John Gutzon de la MOTHE BORGLUM) (1867–1941)

b. Nr Bear Lake, Idaho d. New York. American sculptor who first painted; studied sculpture in Paris (1890–3) at Académie Julian, Ecole des Beaux-Arts, with Linding and *Rodin, and taught at *Art Students' League (1906–7). Essentially academic, but bold and exuberant, he is famous for Mount Rushmore presidential heads.

BORISSOV-MUSSATOV, Victor (1870–1905)

b. d. Saratov. Early *Symbolist Russian painter, educated in Saratov, the Moscow College of Art and St Petersburg Academy. Worked in the studio of Gustave *Moreau in Paris (1895). Known for his blue and grey-green canvases of dream-like figures in a landscape.

BORMAN (BORREMAN), Jan the Elder

Netherlandish sculptor, the major master in Brussels after 1479. In 1493, made the extensive *St George* altar for Louvain (now Brussels) in his strong, lavish and violent style. His sons, Pasquier and Jan, carried on the workshop.

BORNEMANN, Hans (alive 1448–d. before 1474)

German painter, active in Hamburg. With his son Heinrich, b. 1450, and the slightly later Hinrik Funhof, he is the principal Hamburg painter of his time. His huge *Heiligentuler Altar* for the Church of St Nicholas at Lüneburg shows his primitive style, devoid of subtlety of facial expression. His figures are almost icon-like in their stiffness and lack of depth. However, the glorious decorative brocades and sharp contours promote a powerful kind of emotional expressionism.

BORNEO *see* INDONESIA, ART OF

BOROBUDUR, Central Java

This magnificent temple is a Buddhist *stupa of highly complex form. A redentate base of five stages is surmounted by three circular platforms which support a final stupa. A processional way surrounds the whole, and conceals a series of bas-reliefs on the lowest platform. Staircases with ornamental archways lead up to the terminal stupa from the midpoint of each side: the whole is cardinally orientated. The exterior walls of the square terraces are richly adorned with non-narrative reliefs, miniature stupas and Buddha figures in arcaded niches, ninety-two on each side, each in a different *mudra. Sixty-four more occupy the top row of the square terraces, while a series of latticed stupas arranged in circles of thirty-two, twenty-four and sixteen house further Buddha figures. The square terraces which are concealed from below by walls have reliefs upon both inner and outer faces: the lowest contain depictions of the Buddha's previous existences and the story of his coming to earth to preach. Those on the higher terraces deal with various aspects of the search for ultimate enlightenment. The circular terraces are wholly undecorated, as though the pilgrim, having made his way clockwise round the lower galleries, a distance of some kilometres, finally realises the illusory nature of the perceived world. The carving is of great technical skill, the subsidiary characters and the settings distinctively Javanese. The whole monument is an architectural statement of complex Buddhist dogma: the continuous narrative reliefs seem to be a Javanese invention which persists in that island and influenced such buildings as *Angkor Wat in Cambodia. It probably underlies such other Javanese narrative forms as the *wayang beber* (scroll theatre) and *wayang kulit* (shadow theatre).

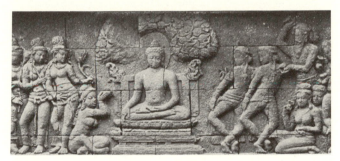

BOROBUDUR, Java. One of the 11th-century narrative reliefs

BORRASSA, Luis (active 1396–1424)

Spanish artist, active mainly round Barcelona, important in the development of Catalan painting. His work is heavily influenced by *International Gothic, perhaps encountered at Avignon. In several surviving documented or attributed works, often large *retables with complex framing, a pretty, anecdotal style can be seen. The *Sta Clara Altarpiece* (1412–15, Vich Museum, Barcelona) is typical of his work.

BORREMAN, Jan the Elder *see* BORMAN

BOSBOOM, Johannes (1817–91)

b. d. The Hague. Dutch painter who studied with van Hove and who was influenced by *Schelfhout. A leading painter of landscapes and town views but especially known for his solemn church interiors. He was a forerunner of the *Hague School.

BOSCH, Hieronymus (Jerome van AEKEN) (c. 1450–1516)

Netherlandish painter, active in his native town Hertogenbosch. Worked there for the important Confraternity of Notre Dame (from 1480/1). Paid by Philippe le Beau for his *Last Judgement* (1504). Curiously unconnected with contemporary styles, Bosch occupied himself principally with moralising subjects in which he developed a symbolism and an esoteric iconography which are still being unravelled. His *Garden of Earthly Delights* (Prado) exemplifies the fantasist side of his art, for he populates the earth with hundreds of small nudes, belaboured by various creatures – horrid organisms invented by the artist to represent various sins or misfortunes. A technical innovator, as well as an imaginative one, he

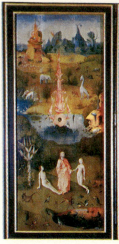
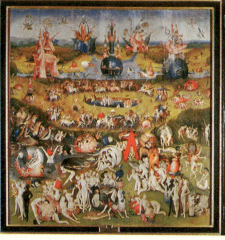
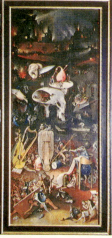
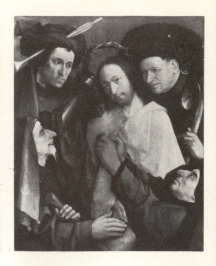

Top left: HIERONYMUS BOSCH *Garden of Earthly Delights.*
86⅝×144¾ in (220×367·6 cm). Prado

developed the use of *alla prima painting, his execution being of the highest quality (eg *Adoration of the Magi, c.* 1500, Prado). His terrible visions of spiritual torture, symbolised in the physically grotesque, had great influence on *Bruegel, as did his cunning characteristics of various mean types (eg *The Crowning with Thorns,* 1508–9, NG, London).

BOSCOREALE, Villa of

A Roman villa, one mile from Pompeii, with rooms decorated in the Second Style of *Pompeian painting. The decoration (*c.* 50 BC) consists of a series of richly coloured illusionistic scenes with vistas of colonnades and temples.

BOSHIER, Derek (1937–)

b. Portsmouth. English painter and sculptor, one of a group of students at the Royal College of Art, London in the late 1950s, early 1960s, who formed the British *Pop Art movement. Has now moved from painting to sculpture and works in perspex using groups of large-scale geometric pieces.

BOSSCHAERT, Ambrosius (1573–1645)

b. Antwerp d. Utrecht. Flemish painter, one of the earliest specialists in flower painting, working in Middleburg. Perhaps inspired by Jan *Bruegel (both were in Antwerp *c.* 1588) he painted large flower-pieces in vases. His style remained conservative.

BOSSE, Abraham (1602–76)

b. Tours d. Paris. French etcher, influenced technically by *Callot. He engraved illustrations for Francini's *Livre d'Architecture* (1633) but is best known for his depictions of domestic bourgeois life in interior scenes. He also published treatises on engraving (1645) and perspective (1665).

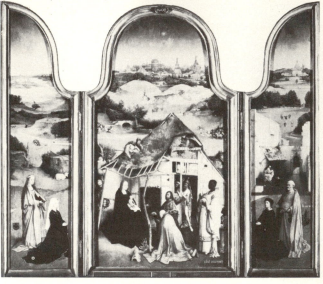

Top right: HIERONYMUS BOSCH *The Crowning with Thorns.*
1508–9. 29×23¼ in (73·5×59 cm). NG, London
Above: HIERONYMUS BOSCH *Adoration of the Magi. c.* 1500.
55×28 in (138×72 cm). Prado

BOTH, Andries (1608–?1641)
Jan (1618–52)

Dutch painters from Utrecht. Brothers; Andries b. Utrecht d. Venice, Jan b. d. Utrecht. They studied under *Bloemart and were in Rome by 1635. Andries specialised in low-life scenes

Left: ABRAHAM BOSSE *Touch.* ?1635 (from *The Five Senses* series). Engraving. 13×10¼ in (33×26 cm). BM, London

Right: JAN BOTH *Rocky Landscape with an ox-cart.* 47×63¼ in (120·5×160·5 cm). NG, London

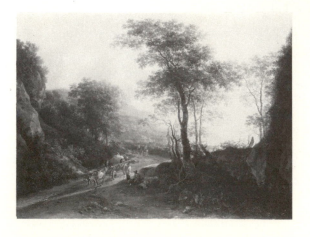

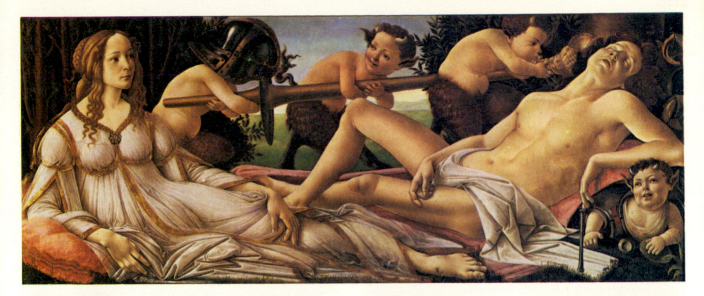

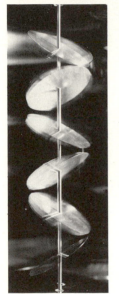

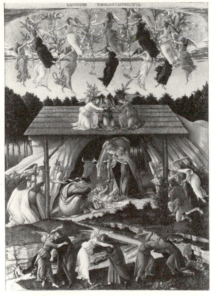

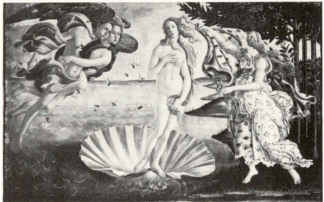

Top: SANDRO BOTTICELLI *Venus and Mars.* c. 1485–6.
$27\frac{1}{4} \times 68\frac{1}{4}$ in (69×173 cm). NG, London
Above: SANDRO BOTTICELLI *The Birth of Venus.* c. 1485–6.
Tempera. 68×109½ in (172·5×278·5 cm). Uffizi

Left: MARTHA BOTO *Chromatic Spirals.*
1967. Kinetic. $25\frac{5}{8} \times 26\frac{7}{8} \times 11\frac{5}{8}$ in (65×68×30 cm). Galerie
Denise René, Paris
Right: SANDRO BOTTICELLI *Mystic Nativity.*
1500. $42\frac{3}{4} \times 29\frac{1}{2}$ in (108·5×75 cm). NG, London

close to those of Il *Bamboccio. He occasionally painted the
figures for Jan's idyllic *Claudian landscapes. After Andries's
death in Venice, Jan returned to Holland where his Italianate
scenes exercised considerable influence.

BOTO, Martha (1925–)

b. Buenos Aires. *Kinetic artist living in Paris who, like
*Vardanega, follows the *Nouvelle Tendance programme of
chromocinéticisme. She aims for a hypnotic effect with the
repetition through light of the formal elements of her work.
Rapid movements and intense luminosity create strong after-
images.

BOTTICELLI (FILIPEPI), Sandro (1440–1510)

b. d. Florence. Florentine painter whose distinctive linear style
has made him one of the most striking embodiments of the
contention that the Florentines excel in draughtsmanship.
Early influences were Fra Filippo *Lippi, with whom he

probably trained, *Pollaiuolo whose *Virtues* series he com-
pleted with a crisply vigorous *Fortitude* (Uffizi); and he
emulated *Castagno's terse heroic style in *St Sebastian* (Berlin).
By about 1475 his highly individual vision had matured, based
upon a series of paradoxes: rigorous line encloses figures im-
bued with a languid melancholy grace; his landscapes are
schematised and quite unlike the panoramic views created by
Pollaiuolo or *Leonardo (who recalled that Botticelli recom-
mended that the artist should throw sponges steeped in colour
at a wall and see what landscapes it suggested to him), yet the
flowers in the *Primavera* (Uffizi) are masterpieces of botanical
accuracy. That and *The Birth of Venus* (Uffizi) were conceived
as a moral therapy for the temperamental young Lorenzo di
Pier Francesco de' Medici and confirm Botticelli's con-
nection with Neoplatonic circles in Florence. As a result of his
visit to Rome (1481) to decorate the Sistine Chapel, his later
paintings evince a firm grasp of the structure of classical
architecture. Towards the end of his life his work became
increasingly subjective, oscillating between moods of intense
joy and grief which reflected his fervent devotion to the cause
of Savonarola whose apocalyptic message inspired the *Mystic
Nativity* (1500, NG, London) and the visionary lyricism of the
Dante drawings

BOTTICINI, Francesco (c. 1446–97)

b. Florence. Italian painter severally influenced by *Verrocchio,
*Rosselli and *Ghirlandaio. His visionary *Assumption* (NG,

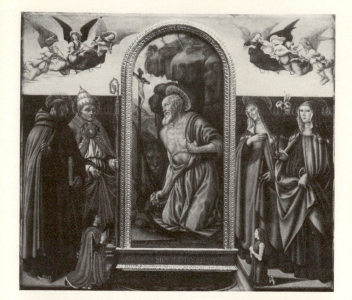

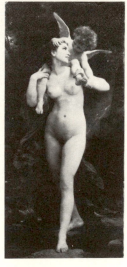

Top: FRANCESCO BOTTICINI *St Jerome in Penitence, with Saints and Donors.* After 1460. 60×68 in (152·5×173 cm). NG, London

Above left: BOUCICAUT MASTER *St George and the Dragon.* c. 1405–10. Painting on vellum. 10¾×7½ in (27·5×19 cm). Musée Jacquemart André, Paris

Above right: BOUGUEREAU, ADOLPHE *Youth and Cupid.* 1877. Louvre

London) owes a particular debt to *Botticelli in the facial types and attitudes. His works evince sharply observed detail and clear, bright colour.

BOUCHARDON, Edmé (1698–1762)

b. Chaumont d. Paris. French sculptor. He was the pupil of Guillaume Coustou and won the Rome Prize (1722); he stayed in Rome for ten years. On his return to France he was appointed Sculptor to Louis XV and died while working on an equestrian statue of the King. His pure and smooth classical style points forward to †Neo-classicism.

BOUCHER, François (1703–70)

b. d. Paris. French painter of pastoral and mythological scenes, an important exponent of the †Rococo style. He studied under François *Le Moyne and began as an engraver of *Watteau. He won the Rome Prize (1723) and was in Italy 1727–31 where he particularly admired *Tiepolo. Entering the

Academy (1734), he became its Director (1765) and at the same time First Painter to the King. He was patronised by Madame de Pompadour whose portrait he painted several times, and through whose influence he became Director of the Gobelins Manufactory (1755). Boucher was extremely prolific and his decorative talents ranged from the decoration of the royal châteaux to stage settings and even fans. His most typical paintings are lightly erotic pastoral scenes filled with rosy female nudes.

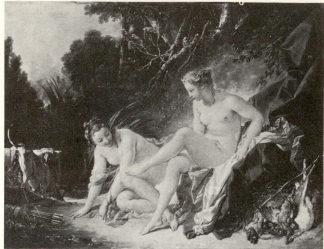

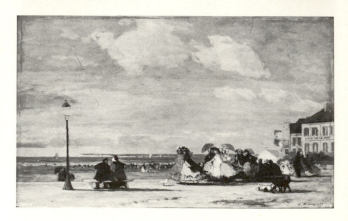

Top: FRANCOIS BOUCHER *Diana Bathing.* 1742. 22½×28¾ in (57×73 cm). Louvre

Above: EUGENE BOUDIN *The Empress Eugénie on the Beach At Trouville.* 1863. 13½×22½ in (34·3×57·8 cm). Glasgow

BOUCICAUT MASTER (early 15th century)

Responsible for the Book of Hours (Musée Jacquemart André, Paris, MS 2) written for the Maréchal de Boucicaut in the early 15th century, an example of the role of individual patronage in the later Middle Ages. The miniature *St George and the Dragon* (c. 1405–10, Musée Jacquemart André, Paris) suited the chivalrous and romantic patron. The border is a conventionalised form of the more naturalistic borders of the 14th century.

BOUDIN, Eugène (1824–98)

b. Honfleur d. Deauville. French artist who studied in Paris for three years. *Troyon, whom he met at Le Havre, influenced his early works and he also received advice from *Millet. He did much outdoor painting and became an important marine artist, working along the coasts from Holland to Bordeaux. He especially favoured the fashionable resorts of Deauville and Trouville with their noticeably middle-class visitors, who feature prominently in many of his beach scenes.

His free technique and brilliant skies link him with the †Impressionists, with whom he exhibited in 1874.

BOUGUEREAU, Adolphe William (1825–1905)

b. d. La Rochelle. French painter, studied under Picot in Paris, went to Rome (1850) where he made a wide-ranging study of Italian art. He returned to Paris (1854) and exhibited to good effect at the Universal Exposition (1855). The symbol of the rigid defence of the traditional principles of the Academy, he was nevertheless a conscientious teacher for twenty-five years at the Ecole des Beaux-Arts. His own paintings of religious and mythical subjects, and of contented peasantry, were refined to a high finish from oil studies that, in their spirited handling, confirm his confidence of execution.

BOULOGNE, Jean de *see* BOLOGNA, Giovanni da

BOURDELLE, Emile-Antoine (1861–1929)

b. Montauban d. Le Vesinet, Seine-et-Oise. French sculptor, trained under Maurette at Toulouse, at the Paris Ecole, and for a time in the studio of *Rodin, who continued to be the dominant influence on his work. He first showed at the Salon of 1885, won medals at the Paris International exhibitions of 1889 and 1900, and showed at the *Secessions of Munich (1903) and Berlin (1907). Known chiefly for his energetic small bronzes.

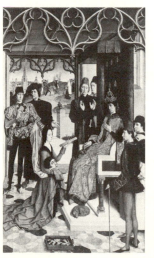

EMILE-ANTIONE BOURDELLE *Vase with a nude*. 1892. Bronze. Musée Bourdelle, Paris

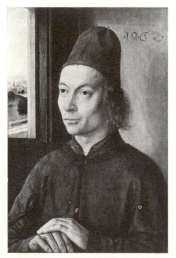

Above left: DIERIC BOUTS *The Trial by Fire* from 'The Justice of the Emperor Otho'. 1470–5. 127½×71½ in (324×182 cm). Musées Royaux, Brussels
Above right: DIERIC BOUTS *Portrait of a Man*. 1462. 12½×8 in (31·5×20·5 cm). NG, London

BOURDICHON, Jean (c. 1457–d. before August 1521)

b. d. Tours. French illuminator of manuscripts and painter. In royal service from 1479, he worked successively for Louis XI, Charles VIII, Louis XII and François I, besides being the favourite painter of Anne of Brittany for whom he made a Book

of Hours (Bib. Nat., Paris). His production comprises mainly Books of Hours, but some portraits exist. An important figure in the French †Renaissance, he has a clear, lucid narrative style. His portraits, eg that of Charles VIII, are severely naturalistic.

BOURDON, Sebastien (1616–71)

b. Montpellier d. Paris. French painter, founder-member of French Royal Academy. His Italianate style brought him rapid success and commissions throughout his career for altarpieces and decorative mythological series. Court Painter in Sweden (1652–4), he worked in Montpellier (1659–63).

BOUSSINGAULT, Jean-Louis (1883–1943)

b. d. Paris. French painter, engraver, illustrator and designer. He associated with *Dunoyer de Segonzac and Luc-Albert *Moreau at the Académie Julian depicting post-*Fauve and post-*Cubist scenes of Parisian life. He also produced designs for Poiret and the Théâtre de Chaillot.

BOUTS, Aelbrecht (c. 1455–1549)

Netherlandish painter, born at Louvain where active, the second son of Dieric *Bouts. Many attributions exist, the most certain being the *Assumption of the Virgin* (Brussels). The style is a modernised version of his father's, with some influence from Hugo van der *Goes.

BOUTS, Dieric (alive c. 1448–d. 1475)

b. ?Haarlem d. Louvain. Netherlandish painter, first mentioned 1457, active at Louvain where he became City Painter (1468). Little else of significance is known, but two works are definitely his: a large triptych (1464–c. 1468, St Peter's, Louvain) the central panel of which shows the Last Supper, and two large panels showing the Justice of Otho (Brussels, one left unfinished at Bouts's death). Bouts was associated, by van *Mander, with Albert van *Ouwater and *Geertgen, which has given rise to speculation on an early Haarlem school. The style may well be 'Dutch', with developed landscapes, emphasis upon individualised heads and a warm, sympathetic emotional quality. Although much affected by Rogier van der *Weyden, he shuns the latter's bitter pathos.

BOXER OF APOLLONIOS (1st century BC)

Bronze statue in the National Museum, Rome, signed by *Apollonios of Athens. It is a particularly vivid and brutal rendering of a seated boxer, perhaps resting between rounds. His scars and swollen eyes and nose are rendered with stark realism.

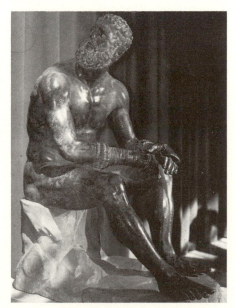

BOXER OF APOLLONIOS Bronze. h. 50 in (128 cm). National Museum, Rome

BOXWOOD

Hard, fine-grained wood used for *wood-engraving. Only obtained in small blocks because the branches of a box tree do not grow to any great thickness, so larger blocks have to be composite.

BOYD, Arthur (1920–)

b. Murrambeena, Victoria. Painter who left Australia for England when almost forty. His early themes were mythological and Biblical: he painted landscapes of a scratchy clarity. His calligraphic style later softened into a broader, more luminous use of colour. The *Half-Caste Bride* sequences (1957–9), *Chagall-influenced, depict an aborigine dream: floating lovers, nudes attracted to water, set in medieval space. A painter whose work can drift from an intense sweetness to calculated naïveté, Boyd seems to have lacked direction since he left Australia and its native themes.

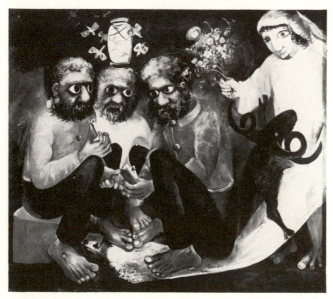

ARTHUR BOYD *Shearers playing for a Bride*. 58¾×68¾ in (149·2×174·6 cm). NG, Victoria

BOYDELL, John (1719–1804)
Josiah (1760–1817)

John b. Shropshire d. London; Josiah b. Flintshire d. Middlesex. English engravers and publishers, uncle and nephew. As publisher, John made English engraving commercially successful abroad as well as at home. He founded the Shakespeare Gallery in Pall Mall from 1786 onwards and was Lord Mayor of London. Josiah became his partner and successor. Boydell's gallery was founded with the idea of providing patronage for British *history-painters. Shakespeare was considered the ideal subject as his works had a greater appeal to the English public than the classical sources with which the *Grand Manner was traditionally associated. The scheme was (a) to commission a series of large and small Shakespeare oil paintings; (b) to build a gallery for their permanent exhibition; (c) to publish engravings of the large paintings; and (d) to publish a folio edition of Shakespeare's dramatic works embellished with engravings of the small paintings. Thirty-four artists were involved in this endeavour, notably *Fuseli, *Reynolds and *Opie, but the scheme was fraught with problems. It was widely criticised, eg by Charles Lamb, and eventually went bankrupt because the French Wars cut off Boydell's export market.

BOYS, Thomas Shotter (1803–74)

b. Islington d. Finchley. English artist, apprenticed to an engraver. In Paris in the late 1820s he met and was influenced by *Bonington. He regularly exhibited brightly coloured watercolours of continental cities, but his major achievement was in pioneering colour lithography in England with his *Picturesque Architecture in Paris, Ghent, Antwerp and Rouen* (1839).

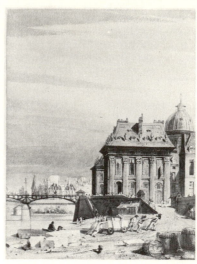

THOMAS SHOTTER BOYS *L'Institut de France*. 1830. Watercolour. 13¾×10¼ in (34·9×26 cm). Mr and Mrs Paul Mellon Collection, Virginia

BRACQUEMOND, Félix (1833–1914)

b. d. Paris. French painter who, while apprenticed to a lithographer, took drawing lessons, then studied with *Ingres's pupil, Guichard. His first exhibited portrait at the Salon of 1852 received attention, but the Salon of 1863 refused his engraving *Portrait of Erasmus*, after *Holbein. He remained independent, gaining recognition gradually, and accorded the Grand Prix for Engraving in 1900. His book, *On Drawing and Colour* (1885), was important for *Van Gogh.

BRAEKELEER, Henri de (1840–88)

b. d. Antwerp. Belgian genre painter and etcher, who attended Antwerp Academy at fourteen, and exhibited at eighteen. After travelling in Germany and Holland, he was particularly influenced by 17th-century Dutch masters. His precise realist technique in interior scenes became broader and freer after nervous troubles (1880–4) interrupted his work.

BRAHMA

Hindu god, derived from very ancient *Vedic sources; is the creator who implements *Vishnu's conception of each new universe; not widely venerated as a cult deity. Represented as four-headed, mounted on a goose; attributes are the sacrificial ladle and water-pot.

BRAMANTE, Donato (1444–1514)

b. Monte Asdruvaldo, nr Urbino d. Rome. The principal architect of the High †Renaissance. At first active as a painter and influenced by *Piero della Francesca and *Mantegna from whom he derived his skill in perspective, eg the decorations of the Palazzo del Podestà, Bergamo (1477). From the early 1480s to 1499 he was in Milan where he read *Alberti's *De Re Aedificatoria* with *Leonardo whose drawings of centrally planned churches affected his later architectural enterprises and thus influenced *Raphael's architectural painting. His Milanese buildings include Sta Maria presso S. Satiro (notable for its false perspective apse). Fled to Rome (1499) where he lived to his death. Studied antique remains with *Raphael and *Peruzzi. This collaboration was enormously important for the later development of the Renaissance adaptation of classical forms in architecture and painting.

BRAMANTINO (Bartolommeo Suardi) (c. 1460–1530)

b. Milan. Italian painter and architect, appointed to the court of Francesco Maria Sforza (1525). Influenced by *Leonardo

and *Bramante, he may have studied with *Butinone. His Vatican frescoes are lost but among extant works are the *Nativity* (Ambrosiana, Milan) and the *Adoration of the Magi* (NG, London).

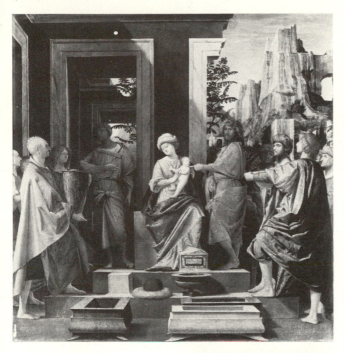

BRAMANTINO *Adoration of the Magi.* 22⅜×21⅝ in (57×55 cm). NG, London

CONSTANTIN BRANCUSI *The Kiss.* 1908. Limestone. 23×13×10 in (58·4×33×25·4 cm). Philadelphia Museum of Art, Arensberg Collection

BRAMER, Leonaert (1596–1674)

b. d. Delft. Dutch painter, travelled in France and Italy (1614–27). Influenced by *Elsheimer and *Correggio, he painted nocturnal scenes in which shafts of light pick out glowing colours. He also decorated two of the Stadtholder's palaces, and worked in fresco.

BRANCUSI, Constantin (1876–1957)

b. Pestisani Gorj, Roumania. Sculptor who studied at Craiova, Bucharest and Munich, arriving in Paris in 1904. He was briefly associated with *Rodin (1906), and formed a close and mutually influential friendship with *Modigliani (1907). He showed at the Salon des Indépendants (1912, 1913). Brancusi's works are relatively few, and often variations on themes central to him, such as repose or dynamic movement: cf the thirteen versions of the *Bird in Space*, carried out in different materials. His early *Art Nouveau tendencies gave way to a consistent pursuit of the ideals of simplicity and purity of form. Extraneous details were eliminated; the resulting streamlined effect gave rise, in the case of the *Bird in Space*, to the US Customs trial of 1927–8 over its status as work of art or object of manufacture. After 1920 Brancusi's works were symmetrically conceived: *Le Grand Coq* (1949) was his last: 'I've been concerned with flight all my life.'

BRANGWYN, Sir Frank (1867–1956)

b. Bruges, Belgium, of Welsh parentage. A mural painter and Royal Academician who initially copied tapestries as an assistant to William *Morris. In addition to his etchings and woodcuts, he undertook public commissions in a bold figurative style, including panels intended for the House of Lords (1930), and murals for the Rockefeller Center (1933).

Above: FRANK BRANGWYN *Villers Abbey.* 6⅞×4⅞ in (17·5×12·4 cm). V & A, London
Left: CONSTANTIN BRANCUSI *Bird in Space.* Bronze. h. 76⅛ in (193·3 cm). Musée National d'Art Moderne, Paris

GEORGES BRAQUE *The Billiard Table No. 1.* 1944. Oil and sand. 51¼×76½ in (130·2×194·3 cm). Musée National d'Art Moderne, Paris

BRAQUE, Georges (1882–1963)

b. Argenteuil d. Paris. Painter who trained as a decorator then studied painting in Paris (1900). By 1906 Braque was a *Fauvist, his style became increasingly structural (1906–7). He met *Picasso (1907) and saw *Les Demoiselles d'Avignon* (1907), immediately grasping its revolutionary methods of relating the illusion of reality to the flat painted surface. Together they evolved *Cubism (1907–14), gradually shifting the relationship until the subject is almost unrecognisable (1912). Collage facilitated a restatement of this relationship not as either/or, but as emphatically both; ie a piece of newspaper both repre-

sents a newspaper and is the material of the painting. A play on this relationship continued to be the basis for his post-war painting. Whereas for Picasso Cubism was somewhat outside his main interest in highly expressive and inventive figure compositions, for Braque Cubist still-life was the model for his entire work. His still-lifes and interiors reflect his most intimate involvement with reality.

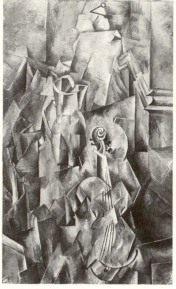

Left: GEORGES BRAQUE *Violin and Jug.* 1910. 45⅝×29 in (115·9×73·7 cm). Kunstmuseum, Basle
Right: BRASSEMPOUY Ivory female head

BRASS

An alloy of copper and zinc, very bright gold in colour, easily worked, but which tarnishes quickly.

BRASSEMPOUY (Late Perigordian)

†Palaeolithic site in the Landes, France, where the small ivory head of a girl has been found, the features and hair clearly shown.

BRATBY, John (1928–)

b. London. English painter who studied at the Royal College of Art (1951–4). Bratby departs from an exact realism only to emphasise reality. His *Kitchen Sink style was relevant in the 1950s when, part of a movement in painting and literature, it shocked the public.

BRAUN, Mathias Berhard Braun von (1684–1738)

b. Oetz d. Prague. The greatest Bohemian sculptor of the age. Trained in the tradition of *Bernini, he received the patronage in Prague of Count von Spork, a cultivated intellectual and art patron, for whom he executed many and varied commissions, including Biblical sculpture groups for the Count's forest, hewn from the rock and painted. The originality of his dynamic style can be seen in the *caryatids of his portal at Clam Gallas Palace, Prague.

BRAUNER, Victor (1903–66)

b. Piatra-Neamt d. Paris. Roumanian painter who joined the *Surrealist circle in Paris (1933). Influenced by *Klee, de *Chirico and *Ernst, he created a personal language, often exploring animal-human metamorphoses. During the 1940s experimented with sculpture and methods of working in wax.

BRAY, Jan de (c. 1627–97)

b. d. Haarlem. Dutch portrait painter. Under Frans *Hals he evolved a vigorous style, neglecting detail and concentrating on expressive brushstrokes. He lost this personal touch when he adopted the smoother manner of van der *Helst.

BRAZING

Joining two metals by the melting of a third, usually of brass or copper.

BREENBERGH, Bartholomeus (1599/1600–1657)

b. Deventer d. Amsterdam. Dutch painter and etcher. In Rome (1619–29) he painted cool, bucolic fanciful landscapes incorporating classical ruins. He also joined Il *Bamboccio's society for Dutch artists in Rome. After his return to Amsterdam he turned to painting pictures with more specific subject-matter reminiscent of *Lastman.

BARTHOLOMEUS BREENBERGH *Finding of the Infant Moses.* 1636. 16⅜×22¼ in (41·5×56·7 cm). NG, London

BREGNO, Andrea (1418–1506)

b. Osteno, nr Como d. Rome. Italian architect and sculptor, worked with *Mino da Fiesole and *Dalmata. Under Pope Sixtus IV active in Rome on tabernacles and monuments (1465–after 1480). His *Piccolomini Altar* in Siena Cathedral was finished in 1485.

BREGNO (RIZZO), Antonio (active 1465–1499/1500)

b. Verona. Italian sculptor and architect who worked from 1465 in the Certosa at Pavia. He was Chief Architect (1483–98) of the Doge's Palace, Venice for which he carved a robust but elegant group of Adam and Eve.

BREITNER, George Hendrik (1857–1923)

b. Rotterdam d. Amsterdam. Dutch painter, studied at The Hague and at Delft. The broadness of touch that characterises his work, chiefly portraits and views of Amsterdam, not only suggests a study of *Hals and *Rembrandt, but also of *Manet. Breitner visited Paris (1883). Known as the leader of the Amsterdam †Impressionists.

GEORGE BREITNER *Ladies on a ferry boat. c.* 1897. Aquarelle. 16⅛×24⅞ in (41×63 cm). Stedelijk Museum, Amsterdam

BRESDIN, Rodolphe (1825–85)

b. Ingrande d. Sèvres. One of the greatest French 19th-century printmakers. Success came only in 1861 with the publication of twelve etchings in the *Revue Fantaisiste*. Influenced initially by *Rembrandt, his works are elaborately detailed and have a sense of mystery and the macabre. At Bordeaux he was visited by the young Odilon *Redon.

BRETON, André (1896–1966)

b. Tinchebray d. Paris. French poet and founder of *Surrealism. A member of Paris *Dada and an editor of *Litterature* (1919–22), his desire for a more constructive attitude, involving the extension of Freudian techniques (eg free association) to art and poetry led to the publication of his first Surrealist manifesto (1924). He subsequently wrote many theoretical books on Surrealism including *Le Surréalisme et La Peinture* (1928). A magnetic personality who dominated Surrealism until his death, Breton's poetry (eg *Clair de Terre*, 1923) is comparatively introspective.

BRETT, John (1830–1902)

b. Bletchingley d. Putney. English painter who was influenced from 1854, as a student at the Royal Academy Schools, by the *Pre-Raphaelites. Produced minutely observed landscapes under *Ruskin's supervision, eg *Val D'Aosta* (1859). A typical example of an artist condemned by the Royal Academy for Pre-Raphaelitism, he turned to more broadly handled marine paintings after 1870.

BREU, Jörg the Elder (c. 1475/6–1537)

German painter, woodcut artist and designer of stained glass. Apprentice of *Apt; in Austria (1500–2); from 1502 onwards active in Augsburg. Important in the early development of the *Danube style, Breu is strongest in scenes of violence (eg *Crowning with Thorns*, Melk Abbey). He also had a great feeling for nature, his landscapes making an emotional counterpoint to his figure groups (eg *Flight into Egypt*, Nuremberg).

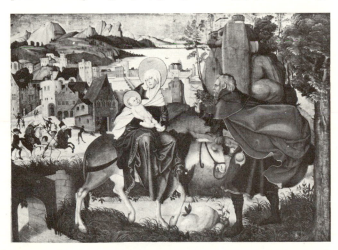

JORG BREU THE ELDER *Flight into Egypt*. 1501. 36¼×50¼ in (92·5×127·5 cm). Germanisches Nationalmuseum, Nuremberg

BREUGHEL *see* BRUEGEL

BRIANCHON, Maurice (1899–)

b. Fresnay-sur-Sarthe. French painter who studied at Ecole des Arts Décoratifs, and later taught there (1936). Minor *School of Paris artist whose paintings are sub-*Intimiste in style and subject-matter. Designed for the Paris Opéra and Aubusson and Gobelins tapestries.

BRIDGES, Charles (active 1730–50)

b. d. England. Portraitist who painted Virginia aristocracy in †Baroque manner of *Lely and *Kneller, skilfully evoking an atmosphere of grace and distinction. The portrait of Maria Taylor Byrd (MM, New York) is a good 'attributed' example of his style.

BRILL, Matthys (1550–83)
Paul (1554–1626)

Both b. Antwerp d. Rome. Flemish landscape painters. In Rome in the 1570s, Matthys painted several frescoes including the *Seasons* in the Vatican. He was joined in Rome in the early 1580s by Paul who was the most prolific landscapist in Rome of his age, working on all scales from large frescoes (Vatican, Palazzo Rospigliosi, etc) through medium-sized canvases to small copper panels. His early style is ebullient and fanciful, employing a brown–green–blue colour progression to obtain distance and incorporating masses of detail. His later work, influenced by Annibale *Carracci, *Domenichino and *Elsheimer, is simpler and calmer, leading to *Claude.

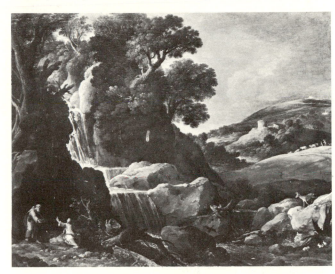

PAUL BRILL *Rocky Landscape*. Birmingham

BRIOSCO, Andrea *see* RICCIO

BROEDERLAM, Melchior (active 1381–1409)

Flemish painter who produced an altarpiece (1390s) for Philip the Bold, Duke of Burgundy, for the Chartreuse de Champmol, Dijon, on the sculptural decoration of which Claus *Sluter had been employed. The main panels (Musée des Beaux-Arts, Dijon) represent the Annunciation, Visitation, Presentation and Flight into Egypt. The style unites northern †Gothic elements in figures, folds, pinnacles, tracery and craggy landscape with Italian marble architecture, box-like with marbled floors indicating recession (cf Ambrogio *Lorenzetti's *Presentation*, 1342).

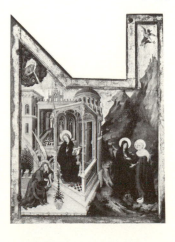

MELCHIOR BROEDERLAM *Annunciation and Visitation*. Wing from the retable of the Crucifixion. After 1392. 63¾×51¼ in (162×130 cm). B–A, Dijon

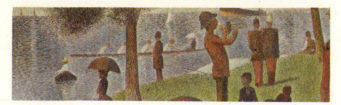

BROKEN COLOUR Detail of *Sunday afternoon on the Island of the Grande Jatte* by Georges Seurat. Art Institute of Chicago, Helen Birch Bartlett Memorial Collection

BROKEN COLOUR

Colour applied to a surface in small patches or dots that blend optically at a distance to produce colour mixtures. *See also* POINTILLISM

BRONZE

Easily worked alloy of copper and tin, long used for sculpture. Acquires a green *patina with age.

BRONZE POWDER

Can be mixed with varnish and applied to plaster to imitate solid bronze metal.

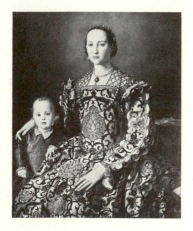

BRONZINO *Eleanor of Toledo with her Son, Giovanni de 'Medici.* 45×37½ in (115×96 cm). Uffizi

BRONZINO (Agnolo di Cosimo di MARIANO) (1503–72)

b. Monticelli d. Florence. Florentine painter, one of the most original exponents of *Mannerism. *Vasari mentions Raffaellino del *Garbo and *Pontormo as his teachers, and on whom his style was founded. He was also influenced by *Michelangelo. The taste for intricate erotic allegory current at the time is exemplified in *Venus, Cupid, Folly and Time* (NG, London) painted for François I (1545). This is in marked contrast to Pontormo's or *Rosso's spiritualism and expressionism. Typical of his manner is a clear, bright colour and enamelled perfection of surface and detail which becomes in his portraits a vehicle of acute psychological penetration.

BROOK, Alexander (1898–)

b. Brooklyn, New York. Painter who studied with Kenneth *Miller at *Art Students' League (1915–19). Although for a time an Urban Realist associated with *American Scene painting, Brook is best known for his still-lifes and female nudes, painted with concise simplicity, poetic colour and unsentimentalised warmth.

BROOKS, James (1906–)

b. St Louis, Missouri. *Abstract Expressionist painter who studied at Southern Methodist University (1923–5) and *Art Students' League (1927–30), painted murals for *WPA (late 1930s), taught at Pratt Institute and was Visiting Critic at Yale University. Brooks's large action paintings are sensuously painted in baroque, organic movements.

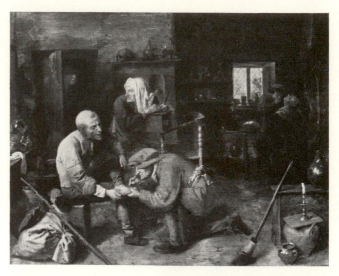

ADRIAEN BROUWER *The Operation.* 12¼×15¾ in (31×40 cm). Bayerische Staatsgemaldesammlungen, Munich

BROUWER, Adriaen (1605/6–1638)

b. Oudenarde d. Antwerp. Flemish painter of peasant genre and tavern scenes, who revived the naturalism and vitality of Pieter *Bruegel. His earliest work is violent in handling and crowded in composition, but from the beginning he was an excellent colourist. His compositions gradually became clearer, and show a greater sense of space and depth. This was due to his contact with Dutch art; he was in Holland in the late 1620s and was *Hals's pupil while at Haarlem. Returning to Antwerp by 1631, in his later work he often combined action and emotion in a triangular composition, eg *The Operation* (Munich).

BROWN, Ford Madox (1821–93)

b. Calais d. London. English painter who, before settling in England in 1846, had worked in Belgium, France, Italy and Switzerland. As a history-painter and painter of subjects from modern life, he was associated with, but not a member of, the *Pre-Raphaelite Brotherhood. A co-founder of William *Morris's decorative firm, he also designed furniture, stained glass and tiles. From the 1860s onwards, he abandoned a Pre-Raphaelite clarity of detail for a more decorative and patterned style, eg murals for Manchester Town Hall, which show a fondness for contorted pose and posture that tends to the grotesque.

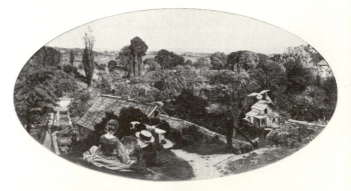

FORD MADOX BROWN *An English Autumn Afternoon.* 1852–4. 28¼×53 in (71·8×134·6 cm). Birmingham

BROWN, John George (1831–1913)

b. Durham, England d. New York. Painter who studied at Newcastle on Tyne, Edinburgh Academy and National Academy of Design in New York (1853). His popular speciality was pathetic newsboys and cheery urchins, painted with

saccharine sentimentality in niggling detail on a grandiose scale.

BROWNE, Byron (1907–61)

b. Yonkers, New York d. New York. Painter who studied at National Academy of Design and was founder-member of American Abstract Artists. Consistent only in inconsistency, Browne continuously moved from figurative to abstract art and back, sometimes influenced by *Klee, sometimes by *Picasso's Synthetic *Cubism.

BROWNE, Hablot Knight (1815–92)

b. Kensington, London d. Brighton. English book-illustrator, worked under the name 'Phiz'. Apprenticed to Finden, the engraver, he began his association with Charles Dickens in 1836. He illustrated Dickens's *Pickwick Papers* and *David Copperfield*. Despite ambitions to be an historical painter, he is best known for his freely handled, often grotesque, vignettes.

BRU, Anye (Hans BRUN)

Painter of German origin active in Catalonia. His *Martyrdom of St Cucufas* (1504–7, Barcelona) brought an unusual example of vivid naturalism to the area. The painting, once thought to be the work of a Maese Alfonso from Aragon, is clearly influenced by Netherlandish or North French work in its use of careful characterisation, spreading landscapes and architectural portraits.

BRUCE, Edward (1879–1943)

b. Dover Plains, New York d. New York. Painter who practised law until 1922, when Maurice *Sterne influenced him to become a painter; was Director of *WPA (1933). His best-known works are low-keyed landscapes, Orientally influenced in their composition, concise shapes and dominant pattern.

BRUCE, Patrick Henry (1880–1937)

b. Virginia d. Paris. Painter who studied with *Henri in New York; moved to Paris (1907), where he worked with *Matisse (1907) and *Delaunay (1912–14); exhibited at *Armory Show (1913) and abandoned painting (1932). Bruce's mature paintings are composed of overlapping geometric forms drawn in perspective, pastels contrasting with black and white.

BRUCKE, Die

Group of German artists, founded 1905 in Dresden. Its members included *Kirchner, *Pechstein, *Heckel, *Schmidt-Rottluff and *Müller. It was the beginning of *Expressionism, properly so called, and the first manifestation of a truly German avant-garde. Self-consciously revolutionary but deeply rooted in the †Gothic tradition, the Brücke artists favoured the primitive and the emotionally direct. Their paintings and woodcuts were executed in a powerful, simplified

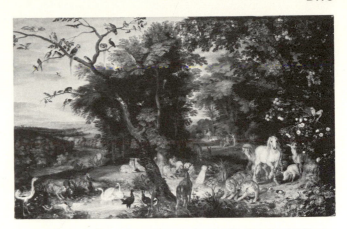

JAN BRUEGEL THE ELDER *The Garden of Eden.* 20¾×33 in (53×84 cm). NG, London

style indebted first to *Van Gogh and then to *Matisse. After moving to Berlin, the group broke up about 1913.

BRUEGEL, Jan the Elder (1568–1625)

b. Brussels d. Antwerp. Flemish painter, called 'Velvet'; son of Pieter *Bruegel the Elder. He painted exquisitely detailed, abundant landscapes and still-lifes and occasionally collaborated with *Rubens, for whose figure compositions he sometimes painted landscape settings.

BRUEGEL, Pieter the Elder (1525/30–1569)

b. ?Breda d. Brussels. Flemish painter and draughtsman who ignoring the fashionable Italianate style continued in a new and modern sense the older Flemish tradition. Little is known

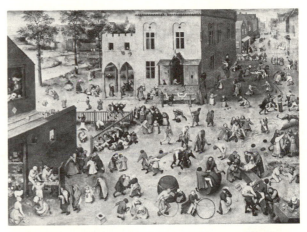

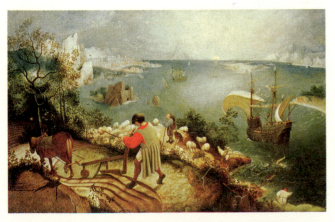

PIETER BRUEGEL THE ELDER *Landscape with the Fall of Icarus.* 28⅞×44⅛ in (73·5×112 cm). Musées Royaux, Brussels

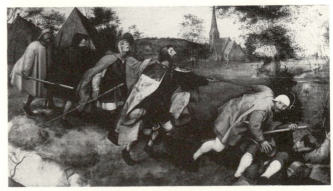

Top: PIETER BRUEGEL THE ELDER *Children's Games.* 1559–60. 46½×63⅜ in (118×161 cm). KH, Vienna
Above: PIETER BRUEGEL THE ELDER *The Parable of the Blind.* 1568. 33⅞×60⅝ in (86×154 cm). Naples Museum

of his life. According to van *Mander he was a pupil of *Coecke van Aelst. He visited Italy (c. 1551–1553/4) returning via the Alps. Splendid Alpine drawings date from 1552. In Italy he studied composition, eg of late *Michelangelo and *Raphael, ignoring the usual run of mythological scenes and portraits. He settled in Antwerp (1554) working for the famous publisher Jerome Cock, whom he supplied with drawings for engravings. His well-known series of mainly signed and dated pictures date from the late 1550s. Between 1559 and 1560 come *Netherlandish Proverbs* (Berlin), *Fight between Carnival and Lent* (KH, Vienna) and *Children's Games* (KH, Vienna), crowded small-figured compositions with a high horizon. He moved to Brussels (1563) and his celebrated *Seasons* series and peasant paintings date from this period. His fame lies in his ability to depict objectively and truthfully the everyday events around him. He saw the world in all its folly and sin, but had also a keen eye for the comic and for vitality and movement.

BRUEGEL, Pieter the Younger (1564–1638)

b. Brussels d. Antwerp. Flemish painter, the son of Pieter *Bruegel the Elder who was his major influence. Though lacking originality he was a highly skilled craftsman and vivid colourist. He copied many of his father's works and in some cases, eg *Visit to the Farm, Peasants attacked by Bandits*, these copies preserve lost originals.

BRUGGEMANN, Hans (c. 1485/90–after 1523)

b. Walsrode, nr Lüneburg d. Hulsum. North German late †Gothic sculptor who owed much to the Lübeck tradition stemming from *Notke and also to *Dürer's woodcuts. His most important work is the *Bordesholmer Altar* (1514–21, Schleswig Cathedral) which has over four hundred figures depicting scenes from the Passion of Christ.

BRUN, Hans *see* BRU, Anye

BRUNELLESCHI, Filippo (1377–1446)

b. d. Florence. Sculptor and architect, celebrated as the 'inventor' of *perspective (c. 1415) and as the designer of the dome of Florence Cathedral (from 1420). An unsuccessful competitor for the Baptistery doors (1401), his surviving sculptures are few, notably four terracotta roundels (c. 1443, Pazzi Chapel, Florence) and a wooden crucifix (Sta Maria Novella, Florence) which is remarkable for its fastidious modelling. The crucifix was said to have been created as a challenge to *Donatello whom he cautioned to remember that 'Christ was most delicate in every part', thus uttering one of the first expressions of the †Renaissance equation of formal

beauty with moral or spiritual excellence. Much of his wide influence stemmed from his profound knowledge of antique art which he culled from at least three visits to Rome.

BRUNO, Giordano (c. 1550–1600)

Italian writer on art. Bruno pioneered the theory that art is allied to magic, and wrote of the action of one soul on another by forces which he termed 'binders'. These ideas he applied to the arts in general in *De vinculis in genere*.

BRUNSWICK MONOGRAMMIST *see* AMSTEL, Jan van

BRUSH

The chief tool of the painter. Made from animal hair or bristles or synthetic fibres tied in a bundle and secured by binding or a ferrule to the brush handle. The brush can be specially shaped for various purposes; the tip can be flat or wedge-shaped, or drawn to a fine point. Every degree of size, flexibility, hard or soft can be found in brushes.

BRUSHWORK

The imprint of the brush left on the surface of a painting. From brushwork the personal manner of one artist's handling of his medium can be read, and in some works it plays a major part in the total achievement.

BRUSHWORK *An Old Man Seated* by Rembrandt (and detail). 1652. NG, London

FILIPPO BRUNELLESCHI Crucifix. *c.* 1410. Polychromed wood. Made for the Gondi Chapel, Sta Maria Novella, Florence

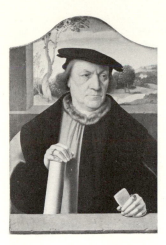

BARTHOLOMAUS BRUYN THE ELDER *Arnold von Brauweiler.* 1535. 22½×15⅛ in (57×38·5 cm). Wallraf-Richartz Museum

BRUYN, Bartholomaus the Elder (Bartel)
(1493–1555)

b. Wesel d. Cologne. German painter active in Cologne from 1515. His earliest religious work, *Nativity* (1516, Frankfurt) shows the influence of Joos van *Cleve. From about 1530 this influence was superseded by that of Jan van *Scorel and Maerten van *Heemskerck. Outstanding as a portraitist, he founded a school in Cologne, receiving many commissions from the wealthy middle class. His rather sober figures are finely and sensitively modelled. His son, Bartholomaus Bruyn the Younger (documented 1550–1606) inherited his clientele.

BRYAXIS (active mid-4th century BC)

One of the four sculptors who worked on the *Mausoleum at Halicarnassus. He is said to have sculpted the north side of the building. He also carved the famous statue of Serapis in Alexandria. Copies of this statue are similar in style to the statue of Mausolus.

BRYGOS PAINTER (active 500/475 BC)

Greek *red-figure cup painter who had a considerable following and whose output was very large. His drawing has great vigour and movement, but his last works were rather mannered and refined.

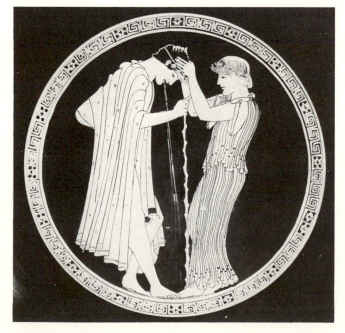

BRYGOS PAINTER Red-figure cup showing a courtesan helping a drunken youth. d. (of tondo) 6⅛ in (15·5 cm). Martin von Wagner Museum, Würzburg

BRYMNER, William (1855–1925)

b. Greenock, Scotland d. Wallasey, Cheshire. Painter who came to Quebec (1857); studied in Paris at Académie Julian and with *Carolus-Duran (1878); directed classes of Montreal Art Association (1886–1921). An important teacher, Brymner painted delicately moody †Impressionist landscapes, genre and figures with breadth and *Barbizon luminosity.

BUCHHEISTER, Carl (1890–1964)

b. Hanover. Painter whose *Klee-like beginnings gave way to a *Purist abstraction (c. 1925). Co-founder with *Schwitters of an abstract group in Hanover (1923), he contributed to *Abstraction-Création (1932). His later textured, web-like abstractions suggest plant and insect life.

BUCRANIUM

A sculpted ornament on an Ionic or Corinthian frieze consisting of the skull of an ox adorned with ribbons and garlands.

BUDDHA (c. 566–c. 486 BC)

Sanskrit: literally 'awoken', 'enlightened'. Title accorded to the historical prince Siddhartha Gautama of the Shākya tribe, hence also known as 'Shākya-muni' ('Sage of the Shākyas') who after a period of asceticism and meditation obtained a revelation, known as the 'Enlightenment', as to the nature of existence, and was known subsequently as the 'Buddha', 'the Enlightened'. The Pali scriptures of *Hinayāna Buddhism contain the legendary biography of Gautama, and the *Jātakas telling of the incarnations which he underwent prior to his birth as the Shākya prince. In *Mahāyāna Buddhism, the Buddha is elevated, along Hindu lines, to be the embodiment of a divine principle which is eternal and unchanging. Like *Vishnu he manifests himself in human form from time to time and dies in due course, appearing to pass into *Nirvāna; but in fact his nature transcends that beatific state which he taught on earth to be the ultimate goal simply because he considered man's mind incapable of grasping any broader concept. The Buddha who lived before Guatama was Dīpankara, and the Buddha yet to appear on earth was named, early in the Christian era, as Maitreya.

BUFFET, Bernard (1928–)

b. Paris. French painter who studied and lives in Paris. He was a member of the anti-abstract group L'Homme Témain (1948). He achieved recognition as a painter of depressed subjects in a slick, mannered style featuring a sharp-angled network of straight black lines.

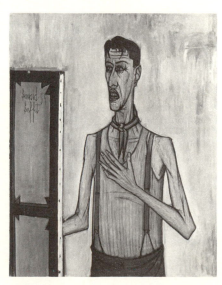

BERNARD BUFFET *Self-portrait.* 1954. 57⅝×44⅞ in (144·8×114 cm). Tate

BUGIARDINI, Giuliano (Giuliano di Piero di Simone) (1475–1554)

b. Nr Florence d. Florence. Italian *history-painter. Friend and fellow student of *Michelangelo, first in the Medici Gardens, then under *Ghirlandaio. He assisted Mariotto *Albertinelli in Florence until 1508 when Michelangelo called him to help on the Sistine Chapel. Not a painter of great originality.

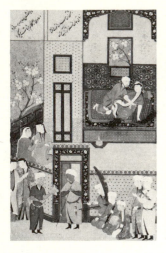

Left: BUKHARA SCHOOL Painting in copy of Asar's *Mihr-u Mushtari* showing the nuptials of Mihr and Nahid. 1523. 10½×6⅝ in (26·5×16·8 cm). Freer Galley of Art, Washington, D.C. D.C.
Right: BUNDI PAINTING *Lalita Ragini. c.* 1675. India Office Library, London

BUKHARA SCHOOL

When the Safavid Shah Ismail defeated the Uzbeks and took Herat (1510) the Uzbeks retreated north to Bukhara where they established their court, taking many *Herat painters with them. The Bukhara School continued the Herat traditions into the 16th century. It became a training-ground for some *Mughal artists and owed much in the early years to *Bihzad and his pupils, Bihzad perhaps residing there. Characterised by a tendency to simplicity and employment of strong colours, the style rapidly became stereotyped with static stocky figures with identical Mongol features in ornate compositions.

BULGARIAN ART

Modern Bulgaria was seized by a race of Turkic origins during the barbarian invasions of Byzantine Moesia and Thrace of the 5th–7th centuries. Slavs and Bulgars combined to form the First Bulgarian Empire (681–1018). Its two capitals, Pliska and later Preslav, were built with palaces and churches †Byzantine in form and in style of decoration; the aim of the Empire was to emulate and ultimately to conquer the Byzantines. Their aggression was stopped by the wars of Basil II in 1017. In the Occupation of the 11th–12th centuries, Byzantine patrons brought in their own painters (eg at Bachkovo, 1083). Byzantium remained the source of new ideas in the Second Bulgarian Empire (1187–1396), eg at *Ivanovo, but local artists developed the tradition of *Boiana. *See also* SERBIAN ART

BUMPO (Kawamura Bumpo) (1779–1821)

Japanese painter, a pupil of *Ganku, who sketched in an individual blend of the *Shijō and *Kishi styles. He published several books, the most famous being *Bumpō Gafu* (three vols, 1810–13).

BUNCHO (Ippitsusai Buncho) (1725–94)

Japanese woodblock-print artist of the *Ukiyo-e School specialising in actor prints and pretty girls in a manner some-

what akin to his great contemporary *Harunobu, but with less sweetness and more drama. Collaborated with *Shunshō in a book of actor prints (1770). His active period was 1768–72.

BUNCHO (Tani Buncho) (1763–1840)

Japanese painter who was a successful *Nanga artist. At times he also used *Kanō, *Rimpa, *Tosa or Western styles. As he was very prolific, his work is sometimes underrated.

BUNDI PAINTING

This school of Indian painting emerged in the late 16th/early 17th century from the small *Rajasthani state ruled by Rajputs. Elements of *Akbari painting such as headgear and the representation of water were adopted and there is also influence from the *Mewar School. A 17th-century illustrated manuscript depicting scenes of Krishna's life is one of the best of the school. The palette is more varied than that of earlier schools; the colours are vivid and pure: reds, blues, greens, yellows and gold. The female type is characterised by a receding forehead and chin, strong nose, plump cheeks, sharply outlined eyebrows, small breasts and tall sinuous figure. Composition and design are strong and bold.

BARTOLOMMEO BUON *Madonna della Misericordia.* 1441–5. 99¼×82¾ in (252×209 cm). V & A, London

BUON, Bartolommeo (c. 1374–1464/7)

Venetian sculptor, trained by his father, Giovanni, with whom he collaborated in the decoration of Sta Maria dell'Orto (1392), the Cà d'Oro (1422–34) and, above all, the Porta della Carta of the Doge's Palace (1438–42). Bartolommeo's style was essentially †Gothic, influenced by South German carvings, but his relaxed poses and ample forms, eg *Madonna della Misericordia* (1441–5, V & A, London) anticipate those of the Madonnas of *Bellini and *Vivarini.

BUONACCORSI, Pietro *see* VAGA

BUONAMICI, Agostino *see* TASSI

BUONARROTI *see* MICHELANGELO

BUONTALENTI, Bernardo (1536–1608)

Florentine architect, sculptor, painter and designer. He studied under *Michelangelo and was a follower of *Ammanati. Involved in many types of design from the Grotto of the Boboli Gardens, Florence to spectacular theatricals, he founded an architectural academy in Florence.

BURCHFIELD, Charles (1893–1967)

b. Ashtabula, Ohio. Painter who studied at Cleveland School of Art. Poet of nature and the small town, Burchfield moved from early fantastic visions of landscape to darker realism, associated with *American Scene painting, in which he invested buildings

with human, haunting moods, returning to fantasy with more powerful *Expressionism.

BURGKMAIR, Hans the Elder (1473–1531)

b. d. Augsburg. German painter and leading graphic artist in Augsburg. In the workshop of Martin *Schongauer (c. 1488–90), he was probably in Italy late 1490s and was certainly in Venice (c. 1515). Like *Dürer in Nuremberg, he spread the knowledge of Italian, particularly Venetian *Renaissance forms. The favoured artist of Maximilian I, he contributed extensively to the Emperor's projects (Genealogy, Triumphal Arch, Prayer Book, etc). These engravings are imaginative and lively. He pioneered woodcut portraits. His early work includes paintings of three basilicas where Renaissance architecture appears for the first time in Germany. His Virgin and Child (1509) is fully Italianate with strong *Mantegnesque influence, though spatially awkward, but in a series of altarpieces (1515–28) he gradually clarified his compositions until in Esther and Ahasuerus (1528, AP, Munich) the scene is set in a spacious Renaissance hall with flickering light and fantastic turbanned figures.

Above: BURIN

Left: HANS BURGKMAIR THE ELDER St John on Patmos. 1518. $60\frac{1}{4} \times 49\frac{1}{8}$ in (153×124.7 cm). AP, Munich

BURIN

The *engraver's tool; a sharp-pointed very hard steel tool set in a mushroom or ball-shaped handle suited to pushing the point against a metal plate.

BURLIN, Paul (1886–1969)

b. d. New York. Painter who studied in New York and London; worked in Paris (c. 1921–33); exhibited at *Armory Show (1913); worked for *WPA. Robustly versatile, Burlin moved from *Post-Impressionism to *Cubism, from *Surrealism to ironic *Social Realism. Influenced by *Kandinsky, he finally pursued aesthetic purity in vigorous *Abstract Expressionism.

BURLIUK, David (1882–1967)

b. Nr Kharkov, Russia d. Long Island. Painter who studied at Kazan, Munich and at the Moscow Art College (1911–13). He showed with *Larionov and *Gontcharova, and organised the influential 'Knave of Diamonds' exhibition (1910). Friend of *Kandinsky and Mayakovsky, Burliuk was active among the

CHARLES BURCHFIELD An April Mood. 1955. Watercolour. 40×54 in (101.6×137.2 cm). Whitney Museum of American Art, New York

Moscow and Munich avant-garde. He settled in America (1922).

BURMA, ART OF

Although Burma was annexed to the British Indian Empire and its coastline lies upon the Bay of Bengal, it does not in any real sense belong to the Indian sub-continent. At the same time, land routes which link it to the rest of South-East Asia and to China are difficult. Thus while inspiration for much of its art stems from India and is principally Buddhist, the local cults of spirits, nats, and influences from farther East, combined to produce a distinctive style whose chief glory is unquestionably architectural. The earliest historical remains in Burma do not seem to predate AD 500. By this time a group of Tibeto-Burmese from the north, known as Pyu, had begun to develop a region in Central Burma near Prome. The extensive site has revealed figures, always carved in relief against a stele, relic caskets, some in gold, and stone urns for human ashes. Glazed tiles were in use. To the south of the Pyu were the Mon; surviving material suggests a greater stress on Hinduism. As the Mon extended northwards the Pyu seem to have withdrawn, but their presence can be detected in a Mon-Pyu cultural amalgam which was checked in turn by the gradual infiltration of the Burmans. The interaction between the newcomers and the Mon-Pyu culture produced the extraordinary efflorescence of buildings at Pagan in the 11th–12th centuries. In this Sinhalese and *Pala influence played a part. Pagan extends for a distance of ten miles along the banks of the Irrawaddy. Within the area are several thousand brick buildings; stupas, temples, libraries and monasteries, all save one Buddhist. The exteriors were covered with stucco, either coloured or gilded. Doorways and windows were surrounded and surmounted by flamboyant scrolls. The interiors were usually painted with frescoes of Buddhist intention; low reliefs and glazed tiles were also used to depict *Jātakas and edifying stories. Continuous narrative is very rare; the Burmese technique called for stylised, almost ritualised single scenes, though these might sometimes take *mandala form.

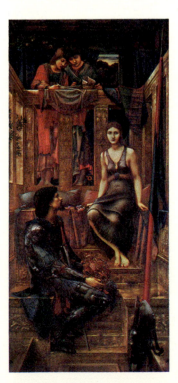

EDWARD BURNE-JONES King Cophetua and the Beggar Maid. 1884. $115\frac{1}{2} \times 53\frac{1}{2}$ in (203.4×135.9 cm). Tate

BURNE-JONES, Sir Edward Coley (1833–98)

b. Birmingham d. London. Left Oxford University, where he had met William *Morris, in 1855. His early designs were influenced by *Rossetti whom he met in 1856. After visits to

Italy in 1859, and in 1862 with *Ruskin, his work became less narrative, exploring ideal beauty in harmonies of interval and colour. Always wary of the Royal Academy, he only came to public notice after exhibiting at the *Grosvenor Gallery (from 1877). The most influential of the artists of the *Pre-Raphaelite movement, especially on European painters. As a member of Morris's decorative firm, he provided designs for stained glass and tapestries, his many commissions forcing him to employ studio assistants.

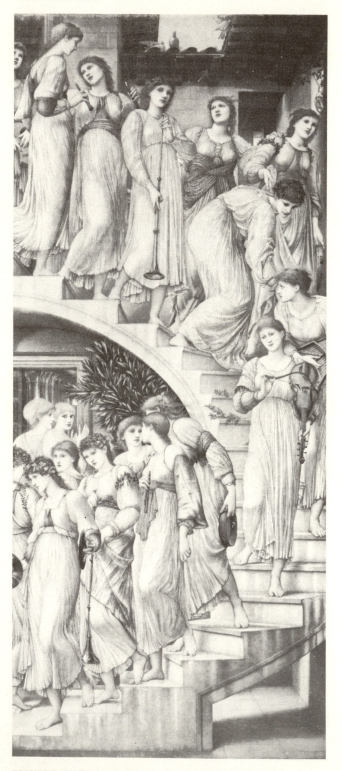

EDWARD BURNE-JONES *The Golden Stairs*. 1880. 106×46 in (269·2×116·8 cm). Tate

BURNISHER

A polishing tool, usually a smooth agate stone set in a wooden handle. *See also* GILDING

BURR

The raised edge of a furrow engraved into a metal plate. *See also* ENGRAVING

BURRA, Edward (1905–)

b. London. English painter, a member of *Unit One (1933). Influenced by *Grosz, de *Chirico and *Dali, and Latin-American popular art. His early scenes of underworld life combine sardonic humour with a *Surrealist intensity. After the Spanish Civil War his painting became more solemn and ominous. Works entirely in watercolour.

BURR

BURNISHER

EDWARD BURRA *Peter and the High Priest's Servants*. Watercolour. 52½×40½ in (133·4×102·9 cm). NG, Victoria

BURRI, Alberto (1915–)

b. Città di Castello, Perugia. Italian painter who in 1946 gave up medicine for painting which he had taken up as a prisoner-of-war. His work incorporates sacking, pitch, metal and wood, the holes and cracks giving his paintings their variety and intensely live quality.

BURROUGHS, Bryson (1869–1934)

b. Hyde Park, Massachusetts d. New York. Painter who studied at *Art Students' League, in Florence and in Paris with *Puvis de Chavannes; taught at Art Students' League (1902–3); was Curator of Paintings, Metropolitan Museum, from 1906 until his death. He painted mythological subjects in the style of Puvis, but without his authority.

BURY, Pol (1922–)

b. Haine-Saint-Pierre. Belgian painter whose early style was *Surreal under the influence of *Magritte and *Tanguy. His interest shifted to *Kinetics (1954), particularly the space-time displacements surrounding imperceptibly moving globes on plane surfaces. Made with skill, his polished wood or metal constructions are compellingly tactile.

BURY BIBLE

The first part of an English Bible (painted *c.* 1140) by Master Hugo who also worked in metal. The elegance, fine modelling and rich colours are †Byzantine in origin. The plain colour

backgrounds are distinctive. The so-called *'damp-fold' representation of drapery folds is found earlier in some *Mosan metalwork. The style is also to be found in a wall-painting at Canterbury. (Corpus Christi College, Cambridge, MS 2.)

BUSCH, Wilhelm (1832–1908)

b. Wiedensahl, Hanover d. Mechtshausen, Hanover. German painter, poet and caricaturist who worked in Antwerp, Munich and Düsseldorf. The influence of *Rubens, *Brouwer, *Hals and *Teniers is especially evident in the subject-matter and sweeping brushstrokes of his paintings, but it was for his humorous graphic work combined with poetry in picture stories that he was mainly known.

BUSH HAMMER

A blunt-headed hammer with multiple points used by sculptors for working stone by concursing and powdering the surface.

BUSH HAMMER

Left: BURY BIBLE *Moses expounding the Law of unclean beasts. c.* 1140. Corpus Christi College, Cambridge
Right: POL BURY *16 Balls, 16 Cubes on 7 Shelves.* 1966. Kinetic relief. 31½×15¾×7⅞ in (80×40×20 cm). Tate

BUSHMAN

The Bushmen of southern Africa live by hunting and gathering without domestic animals or agriculture and, until the arrival of Europeans and Bantu, without iron. They are almost certainly responsible for most of the rock-paintings and engravings in southern Africa and were still painting in the Drakensberg Mountains on the eastern border of Lesotho until about 1880 and in northern Botswana until 1917. Under pressure from European settlers in the south and Bantu expansion in the north-east, the Bushmen gradually retreated into the inhospitable Kalahari Desert where they still survive, hunting and gathering, but without any rock surfaces suitable for their art. Any estimate of the age of southern African rock art is little more than a guess. None of the paintings or engravings has yet been found in clear association with any dateable deposit or artefact and none of the animals represented has been identified as other than a species now living or which

became extinct only in the past two hundred years or so. However, an age of five hundred years for the oldest surviving examples is almost certain and an age of two thousand years is possible. Longer than that is unlikely under the conditions in which the art is found, although this does not mean that its origins are not a great deal earlier. A sequence of styles – monochrome, bichrome, unshaded polychrome and shaded polychrome – has been worked out by studying superimpositions but it is clear that earlier and later styles persist side by side. Some of the later paintings can be dated by their subject-matter as they show Europeans, Bantu, cattle, horses and sheep, the time of whose entry in a given area is roughly known. *See also* SAHARA

BUSHMAN PAINTING Copy of a large composite painting in the Mtoko Cave, Rhodesia. Date unknown. l. about 23½ ft (7·2 m)

BUSON *Three Crows in a Snow Storm.* Edo period, 4th quarter 18th century. Hanging scroll. Ink and wash on paper. 44¾×14 in (113×35 cm). Seattle Art Museum, Eugene Fuller Memorial Collection

BUSHNELL, John (c. 1630–1701)

d. London. Worked on the Continent, mainly in Italy, for at least ten years (contributing 1663/4 to the tomb of Alvise Mocenigo in Venice). He brought back a clumsy echo of *Bernini to English sculpture. He died insane.

BUSI, Giovanni de' *see* CARIANI

BUSON (Yosa Buson) (1716–83)

A poet who became one of the most famous painters of the Japanese *Nanga School. Particularly celebrated for cartoons, and for night and snow scenes.

BUSTELLI, Franz Anton (1723–63)

b. Locarno d. Nymphenburg. Bavarian sculptor, active mid 18th century, who worked for the Nymphenburg porcelain factory as Master Modeller. He accordingly specialised in small-scale work: playful *putti, often with mythological attributes, and religious pieces. A fine bust of a small girl is in Munich (Bayerisches Nationalmuseum).

BUSTI, Agostino see BAMBAIA

BUSTOS, Hermenegildo (1832–1907)

b. d. Nr Guanajuato. Self-taught Mexican painter. Primarily a portraitist, Bustos produced primitive works characterised by rigid discipline and strict, often psychologically piercing, fidelity to truth.

BUTINONE, Bernardino (c. 1450–c. 1507)

b. Milan. Italian painter influenced by *Bramante, *Mantegna and *Foppa. Major works in Milan include an altarpiece for S. Martino in Treviglio (1484–1507) and the Grifi Chapel decoration in S. Pietro in Gessate (1489–93). He collaborated with Bernardino Zenale.

BUTLER, Reg (1913–)

b. Buntingford. English sculptor engaged in sculpture since he was seven. Trained as an architect; ARIBA (1937). Gave up architecture (1950). His box-like human forms, cast in bronze with a rough-textured surface, seem to stretch and explore the space in which they are located.

BUYTEWECH, Willem Pietersz (1585–1625)

b. d. Rotterdam. Dutch painter and etcher and pioneer of elegant genre scenes and landscapes in Haarlem (c. 1620). His paintings (there are only about ten) are like *Hals's groups reduced to a smaller scale, but sprightlier.

BWABA see BOBO

Left: REG BUTLER *Girl.* 1953–4. Bronze. 70×16×9½ in (177·8×40·6×24·1 cm). Tate
Right: GIOVANNI CACCINI Figure of Autumn on the Sta Trinità bridge, Florence

C

CABANEL, Alexandre (1823–89)

b. d. Paris. Trained in the academic tradition of *Ingres, going to Picot's studio at the Ecole des Beaux-Arts, and to Rome (1845) for five years having won the Rome Prize. His first works were largely subjects on history, allegory and myth until about 1855 when he chose more popular subjects, studies of luxurious female beauty, tightly painted with a palette derived from *Boucher.

CABEL, Arent see ARENTZ

CABINET PICTURES

Domestic pictures suitable for rooms of small proportions – in particular Dutch 17th-century paintings.

CABRERA, Miguel (1695–1768)

b. Tlalixtac, Oajaca d. Mexico. Mexican painter, becoming Director of newly founded Academy (1753). An entrepreneur, his workshop produced, apart from normal commissions, two cycles of fifty paintings apiece in 1756. His portraits were more individual, and he also produced architectural drawings.

CACCINI, Giovanni (1556–1612/13)

b. Florence. Italian sculptor and restorer of antiques, trained as an architect under Dosio. He carved the *Summer* and *Autumn* figures on the Ponte Sta Trinità, Florence, also portrait sculpture (notably the Medicis). His largest commission was for reliefs on Pisa Cathedral's central door; these possess harmony and clarity if no great excitement.

CADDO see EASTERN UNITED STATES AND CANADA

CADMUS, Paul (1904–)

b. New York. Painter, son of commercial artists, who studied at National Academy of Design and *Art Students' League, abandoning commercial art for serious painting in Majorca (1928). His *WPA murals (1930s), caricaturing the raw urban *American Scene, aroused scandal, but solidity, firm composition and fine draughtsmanship made his satire art.

CAFFA, Melchiorre (1635–1667/8)

b. Malta d. Rome. Italian sculptor. Gifted imitator of *Bernini's late work, but he died too young to evolve a distinctly personal style. His main work is *St Catherine in Ecstacy* (Siena), an adaptation of Bernini's *St Teresa*.

WILLEM BUYTEWECH *A Dune Landscape.* 10⅛×13½ in (25·7×34·2 cm). NG, London

CAFFARELLI SARCOPHAGUS (early 1st century BC)

A *sarcophagus from the Palazzo Caffarelli in Rome. Its long sides are decorated with *bucrania, garlands, bowls and amphorae; and its short sides with candelabra. It is one of the earliest Roman sarcophagi.

CAGLIARI CATHEDRAL, Pulpit

The pulpit made by *Wiligelmo (c. 1160) for Pisa Cathedral was subsequently removed to Cagliari, Sardinia. Its form was influential for later Tuscan pulpits. The style of the figures and relief scenes is close to the sculpture of Provence (eg *Saint-Gilles-du-Gard), and like Provençal work looks back to the Roman sculptural tradition. It was replaced in Pisa by a new pulpit by Giovanni *Pisano.

CAHORS CATHEDRAL, Aquitaine

The †Romanesque *tympanum in the north porch of this 12th-century cathedral shows Christ in a *mandorla, surrounded by angels, above the Virgin and Apostles probably representing the Ascension. The small scenes at the sides show the Martyrdom of St Stephen. The ecstasy of the angels and the slightly pointed arch are probably derived from *Moissac and the canopies over the Apostles from *Chartres.

CAILLEBOTTE, Gustave (1848–94)

b. Paris. French painter who studied under *Bonnat and through *Degas met and was influenced by the †Impressionists. Financially independent, he bought their works, helped to arrange exhibitions and exhibited with them. He painted modern subjects and landscapes compositionally influenced by photography and Japanese prints. He left his collection to the State.

CALCAGNO, Lawrence (1916–)

b. San Francisco. Painter who studied at California School of Fine Arts; travelled in Orient, Mexico and Europe; was visiting artist at several universities. Influenced by *Rothko, Calcagno used landscape as the departure-point for controlled *Abstract Expressionist paintings, in which flat, subtle areas oppose and contain loosely brushed, brilliant colour.

CALCAR, Jan Stephan van (1499–1546/50)

b. ?Calkar d. Naples. South Netherlandish painter, best known for his woodcut illustrations for Vesalius's *Anatomy* (1538–43). In the 16th century he was regarded as a second *Titian and his portraits were sometimes confused with those of Titian. Notable is his portrait of Melchior von Brauweiler (1540, Louvre).

CALDARA, Polidoro see POLIDORO DA CARAVAGGIO

CALDECOTT, Randolph (1846–86)

b. Chester d. Florida, USA. English illustrator, largely self-taught, came to London (1872) and was successful before he met the engraver Edmund Evans for whom he designed children's illustrated books, sensitively drawn and printed in large areas of pale, unmodulated colour. His visits to France, and critical attention in the French press of the 1880s, spread his influence to *Synthetist circles.

CALDER, Alexander (1898–)

b. Philadelphia. Sculptor who studied mechanical engineering at Stevens Institute, then studied at *Art Students' League (1923–6); lived in Paris (1926–34); now lives in Connecticut and France. From mechanised wire circus figures, Calder developed hanging, floating mobiles and free-standing stabiles of interpenetrating sheets of metal. Deeply influenced by *Mondrian's colour theory and *Miró's forms, Calder evolved a *Surreal *Constructivism – organic shapes on wire tendrils, dancing through space in a combination of wit, poetry and Yankee ingenuity.

CALIARI, Paolo see VERONESE

CALIFORNIA, ART OF

Some of the most notable art forms in prehistoric and early historic California were produced by two tribes, the Chumash and Gabrieleño. Both were coastal peoples, living mainly by fishing, and their simple, naturalistic, steatite sculpture depict whales, sharks, turtles and other marine creatures. They also carved steatite vessels and smoking-tubes with animal and fish designs in low relief, and often decorated their stone-carvings with shell beads set in bitumen. During later historic times a number of small Californian tribes developed basketry to a high level. Extremely fine coiled baskets of various sizes and shapes, usually decorated with geometric designs in black or red on cream, are made by the inland Chemehuevi tribe, the Washo and the Yokut. The coastal Pomo Indians are also famous for small baskets covered with feathers and hung with pendants of pearl-shell.

CALIFORNIA, ART OF Chumash stone figure of a killer whale. Pre-European period c. AD 1200–1600, Catalina Island, California. l. 6½ in (16·5 cm). Museum of the American Indian

CALIPERS

Forked, hinged legs of metal used for measuring in sculpture.

ALEXANDER CALDER *Lobster Trap and Fish Tail*. 1939. Hanging mobile: painted steel wire and sheet aluminium. About 104×114 in (259·1×289·6 cm). MOMA, New York

CALLAHAN, Kenneth (1906–)

b. Spokane, Washington. Painter who studied at University of Washington, and in Europe and Mexico (1926–8); was Assistant Director of Seattle Art Museum (1933–53). His paintings are direct, subtly coloured landscapes, or complex symbolic compositions in which human figures and natural forms merge and interchange, mystically unifying man and nature.

CALLCOTT, Sir Augustus Wall (1779–1844)

b. Kensington d. London. English painter, a student of the Royal Academy, who achieved widespread success as a landscape painter in oils basing his large compositions and generally cool colouring on the pre-1820 works of *Turner. His range included English, Dutch, Italian and classical landscapes, and in the late 1830s he exhibited some large figure subjects. He was knighted (1837).

CALLIGRAPHIC

In the manner of writing; fluency of line in painting and drawing.

CALLIYANNIS, Manolis (1923–)

b. Lesbos. Painter who studied architecture in Johannesburg (1946–8) then settled in Paris. Calliyannis developed from *School of Paris abstractions to a rather traditional figuration. A chunky quality reminiscent of de *Staël preceded the fluid brushwork of his recent landscape and figure paintings.

Above: JACQUES CALLOT 'Breaking on the Wheel' from *Les Grandes Misères de la Guerre*. 1633 Engraving $2\frac{7}{8} \times 7\frac{1}{4}$ in (7.5×18.5 cm). BM, London

Left: DIONISIO CALVAERT *Flagellation*. $93\frac{3}{4} \times 67\frac{3}{4}$ in (238×172 cm). Pinacoteca, Bologna

CALLOT, Jacques (1592/3–1635)

b. d. Nancy, Lorraine. Etcher, trained in Rome (1608–11), then worked for the Medici in Florence, producing series of beggars, hunchbacks, courtiers and *commedia dell'arte figures in a *grotesque, late *Mannerist style, and recording festivities. Returning to Nancy (1621), his tone altered, reflecting the disastrous Thirty Years War. *Etching mainly religious subjects, his best works were, however, the recording of sieges (Breda, La Rochelle), and *Les Grandes Misères de la Guerre* (1633). His compositions were sometimes vast, extending over six plates and involving hundreds of figures; they never appear overcrowded due to his masterly grouping and use of atmospheric perspective.

CALVAERT, Dionisio (Dennis) (1545–1619)

b. Antwerp d. Bologna. Flemish *Mannerist painter who worked mainly in Italy; in Rome, where associated with *Vasari; in Bologna, where he founded an academy, his pupils including Guido *Reni and *Guercino. Blending Italian Mannerism with Flemish tradition, he used bright colours and naturalistic detail.

CALVERT, Edward (1799–1883)

b. Appledore d. London. English artist, a student at the Royal Academy, who began to exhibit in the mid 1820s and met *Blake and *Palmer, whose joint influence on him was strong. In his brief 'visionary' period he produced some remarkable miniature engravings on wood and copper and a watercolour called *The Primitive City*. From the 1830s his works lost their intensity.

EDWARD CALVERT *The Primitive City*. c. 1822. $2\frac{3}{4} \times 4\frac{1}{8}$ in (7×10.5 cm). BM, London

CAMBRIDGE, King's College Chapel

The windows of the chapel were executed by two Flemish glaziers – Barnard Flower (d. 1517) and Galyon Hone – between 1515 and 1531. The designers are unknown except for Dirick Vellert of Antwerp. They form the largest and most complete set of stained-glass windows in England, and their place in the transition from †Gothic to †Romanesque art give them particular interest.

CAMDEN TOWN GROUP (active 1911–1913/14)

A London-based group of artists. Its significant members were *Gilman, *Gore and *Ginner who made of it a clear channel for the influence of *Cézanne, *Van Gogh and *Gauguin. Other members such as *Lewis, *Innes and *John were less committed to such sympathies.

CAMEL HAIR

Soft hair used for *watercolour brushes. Actually made from squirrel.

CAMERA LUCIDA

A simpler form of *camera obscura developed in the 19th century which uses a prism to project an apparent image on to a drawing-block.

CAMERA OBSCURA

A system of lenses and mirrors that condenses and reflects an image on to a white surface. Used as an aid to drawing by tracing from the 16th century. The apparatus had to be used in a darkened box.

CAMOIN, Charles (1879–1965)

b. Marseille d. Paris. French painter who studied with

*Moreau, adopting the style of *Fauvism. He was influenced by *Cézanne, whom he knew, and by *Signac and *Cross. His work is less aggressive than that of his contemporaries, becoming more gentle under the influence of *Renoir, whom he followed after 1916.

CHARLES CAMOIN *Place de Clichy, Paris. c.* 1907. 25⅝×32 in (65·1×81·3 cm). Glasgow

CAMPAGNA, Girolamo (1549/50–?1626)

b. Verona d. ?Venice. Italian sculptor, pupil of Danese *Cattaneo, whom he assisted on the Loredano Monument (SS Giovanni e Paolo, Venice). Working principally in Venice, his many sculptures include the High Altar (1591, S. Giorgio Maggiore) and the Altar of the Sacrament (S. Giuliano). At his best on this large scale, he could achieve a quiet sensitivity.

CAMERA OBSCURA

CAMERA LUCIDA

CAMPENDONK, Heinrich (1889–1957)

b. Krefeld d. Amsterdam. German painter who worked in the *Expressionist manner, under the influence of *Fauvism. With *Marc and *Kandinsky, he was a founder of der *Blaue Reiter (1911). His forms are highly coloured and angular, and allude to the lyrical fantasies of folk-art. Later he was influenced by *Cubism and was discredited by the Nazis (1933).

CAMPHUYSEN, Govaert (1623/4–1672)

d. Amsterdam. Dutch painter of genre scenes. Stable interiors were a particular favourite. He spent most of his life in Amsterdam, apart from a stay in Sweden (1652–63) where he was Court Painter.

CAMPI Family
 Galeazzo (*c.* 1470–1536)
 Giulio (*c.* 1500–72)
 Antonio (*c.* 1525–87)
 Vincenzo (*c.* 1525/30–1591)

Cremonese family of painters. Galeazzo taught his son Giulio who in turn taught his brothers Antonio and Vincenzo. Giulio studied the *Antique and *Raphael in Rome and under Giulio *Romano in Mantua. He occupied something of Annibale *Carracci's position in relation to his family. Antonio, like Giulio, was an architect but also a sculptor, engraver and author of the *Cronaca di Cremona* (1585). Vincenzo copied Giulio's standard *Mannerist style but added Antonio's marked chiaroscuro; he was also noted for charming scenes of fruit-sellers with elaborately arranged still-life groups.

ROBERT CAMPIN *Annunciation. c.* 1425. Central panel of the Merode Altarpiece. 25½×25½ in (64·5×64·5 cm). MM, New York, Cloisters Collection Purchase

CAMPIN, Robert (1378/9–1444)

Netherlandish painter active in Tournai from 1406. Between 1427 and 1432, he had as pupils 'Roger de la Pasture' (identified with Rogier van der *Weyden) and Jacques *Daret. Although none of Campin's works are strictly documented, the known paintings of his two pupils indicate that their master's style must have been an earlier version of their own. Thus a group of works is attributed, though much disputed. The main works are (i) *Virgin and Child before a Firescreen* (NG, London); (ii) the panels supposedly from Flémalle, ascribed to the Master of Flémalle, now usually identified with Campin (Frankfurt); (iii) the *Annunciation* once owned by the

Merode family (MM, New York) attributed to the Master of Merode now usually identified with Campin. One associated work, the *Werle Wings* (Prado) is dated 1438. The style of the paintings is in reaction to the svelte courtliness of the *International Gothic and is avant-garde in its emphasis upon rustic detail and observation of everyday gesture and facial expression. This new naturalistic ability brought with it a range of emotional portrayal (eg *Thief on the Cross*, Frankfurt) which was bequeathed to Rogier van der Weyden.

CANAANITE BONE-CARVING

The long tradition of Canaanite bone-carving has its origins (c. 1750–1550 BC) among the finds at Jericho of the Middle Bronze II period. Wooden toilet-boxes found there are inlaid with strips of carved animal bone with a number of different geometric designs as a border surrounding a series of bird designs, perhaps inspired by Egyptian models. *See also* ARSLAN TASH

CANALE, Giovanni Antonio *see* CANALETTO

CANALETTO (CANALE), Giovanni Antonio (1697–1768)

b. d. Venice. The most prolific and celebrated 18th-century Italian view-painter; he came from a family of professional stage-designers and something of his early association with the theatre (which ended in 1719) filtered through into the urban stage settings of his later pictures. Canaletto's topographical views owed something to *Pannini and his Venetian predecessor, *Carlevaris, but his peculiar ability at rendering clear natural light effects endeared him to a group of British émigrés including Owen McSwinney and Consul Joseph Smith, whose patronage during the 1720s and 1730s established Canaletto as a success with foreign collectors. A work like the *View of the Carità* (1726/7) revealed his extraordinary potential, but his paintings later degenerated into mechanically peopled studio set-pieces. Visits to England (1746–c. 1756) do not seem to have significantly enriched his ailing style, and his most original later works were those *capricci which, according to Algarotti, ideally united 'nature and art'.

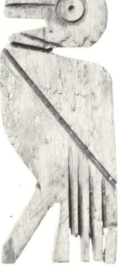

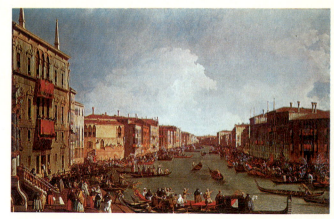

ANTONIO CANALETTO *Venice: A Regatta on the Grand Canal.* c. 1740. $48\frac{1}{16} \times 72$ in ($121 \cdot 9 \times 182 \cdot 8$ cm). NG, London

CANCELLERIA, Reliefs from (AD 81–96)

A series of state reliefs of the Domitian period, lying against the tomb of the Consul Aulus Hirtius which was found in 1937. One relief shows Vespasian commending his son Domitian; the other shows Domitian setting out for war.

CANDI KIDAL *see* SINGASARI

CANDI SUKUH *see* MADJAPAHIT PERIOD

CANDID, Pietro *see* WITTE, Pieter de

CANO, Alonzo (1601–67)

b. d. Granada. Spanish *history painter, sculptor and architect. Lived in Madrid (1634–49) where he assisted in designing the decorations for the entry of Marie-Anne of Austria. Regarded by contemporaries primarily as a sculptor, he designed the façade of Granada Cathedral and also painted in the manner of *Zurbarán.

Top: ROBERT CAMPIN *Virgin and Child before a Firescreen.* $25 \times 19\frac{1}{4}$ in ($63 \cdot 5 \times 49$ cm). NG, London
Above left: ROBERT CAMPIN *Thief on the Cross.* Fragment of a Crucifixion. $56\frac{3}{4} \times 20\frac{3}{4}$ in (114×53 cm). Frankfurt
Above right: CANAANITE BONE-CARVING Middle Bronze Age bone inlay from Jericho. Ashmolean

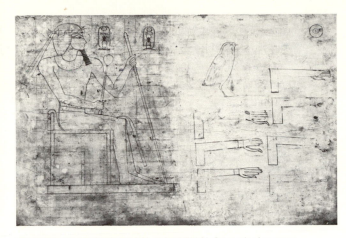

CANON OF PROPORTION, EGYPTIAN Canonical master drawing. Mid 18th dynasty. Gesso on wood. w. 21 in (53·3 cm). BM, London

CANON OF PROPORTION, EGYPTIAN

All major figures, whether in two-dimensional representation or in the round, were draughted according to a fixed canon, the height from the feet to the hair-line being divided into eighteen units, with the proper relationships of the parts of the body correctly tabulated. When constructed canonically, the standard Egyptian form for a two-dimensional figure, a combination of frontal and profile aspects, retained the proportions of nature. This was no longer the case from the Saite period, when the canon was altered for metrological reasons, a division of twenty-one units from the base-line to the root of the nose producing an elongated effect.

CANOVA, Antonio (1757–1822)

b. Venice d. Rome. Italian sculptor, the most famous †Neoclassical artist in this medium. Starting young in a conventional 18th-century manner he was introduced to Neoclassical theory (1779) and adopted the style from his removal to Rome (1781), where he lived for most of his life. He visited Paris (1802) on the invitation of Napoleon whom he came to admire and executed many portraits of him and his family (1804, *Pauline Bonaparte Borghese as Venus Victrix*, Villa Borghese, Rome). He studied the Elgin Marbles in London (1816) and helped secure the return of works of art looted from Italy by Napoleon. He is particularly noted for his great series of tombs (in St Peter's, Rome, the Augustinerkirche, Vienna, the Frari Church, Venice, etc), in which he combined the stark formal simplicity of Neo-classicism with a macabre realism. He had a world-wide reputation and was known for his generosity to younger sculptors.

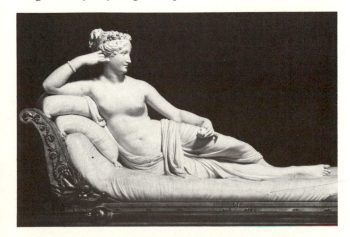

ANTONIO CANOVA *Pauline Bonaparte Borghese as Venus Victrix*. 1804. Marble. Villa Borghese, Rome

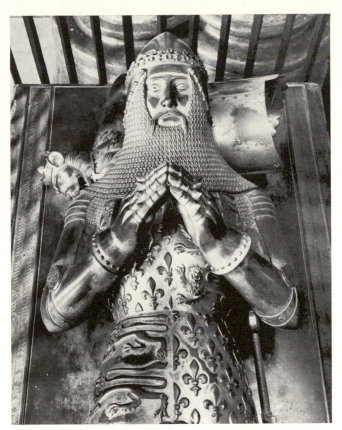

CANTERBURY CATHEDRAL Tomb of Edward, the Black Prince. 1377–80. Gilt latten

CANTERBURY CATHEDRAL

The crypt contains the best set of †Romanesque capitals in England. The subject-matter, ornamental and historiated, is not religious but was largely borrowed from illuminated manuscripts in the cathedral library. St Gabriel's Chapel, also in the crypt, has important 12th-century frescoes and St Anselm's Chapel above has the well-preserved fragment of St Paul (*Lambeth Bible). The †Gothic Cathedral (after 1175) retains many of its original windows, rearranged – these are now the only considerable collection of early glass in England. In the 14th and 15th centuries, Canterbury succeeded Westminster Abbey as a royal mausoleum. It contains the splendid effigies of the Black Prince (d. 1376) and Henry IV (d. 1423).

CANTORIA

Italian: 'singing gallery'. Although the name is usually applied to the lofts designed by Lucca della *Robbia and *Donatello for Florence Cathedral, strictly speaking the term applies to the two galleries within a church, one containing the organ, the other smaller musical instruments or singing groups.

CANVAS

A cloth woven from flax, cotton or hemp commonly used as a *support for painting.

CANVAS BOARD

Thin board of card, wood or pressed fibre upon which satin or muslin is glued to form 'canvas' *support. Sometimes the board is merely printed with a canvas texture.

CAP BLANC (Middle Magdalenian)

†Palaeolithic site near Les Eyzies, Dordogne, France. Animals, some over two metres long, are carved in high and low relief in the entrance to the cave. There are also Middle Magdalenian deposits at the cave mouth.

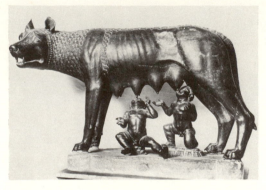

CAPITOLINE WOLF Bronze. 6th or 5th century BC. h. 29½ in (75 cm). Palazzo Conservatori, Rome

CAPITOLINE WOLF

Bronze statue of a she-wolf in the Palazzo Conservatori, Rome. She is shown standing squarely on all four legs and snarling, perhaps at an approaching foe. The two figures, Romulus and Remus, are Renaissance additions. A great deal of anatomical detail, hair, ribs and the pupils of the eyes have been incised into the body of the wolf. The statue may be *Etruscan of the 6th or 5th century BC.

CAPOGROSSI, Giuseppe (1900–72)

b. d. Rome. Painter who gave up law to study painting (1930). He lived in Paris (1927–33). Atmospheric realism gave way to abstraction (1941). His somewhat rigid, monotonous hieroglyphs have figurative associations in their clusterings and separations which remind one of *Dubuffet.

CAPPADOCIAN ROCK-CUT CHURCHES

A once-volcanic area of Central Turkey, the retreat of generations of Byzantine monks and hermits (9th–13th centuries). The best surviving painted caves are in the Göreme Valley, eg the Tokale Kilise (10th century) and three 'Churches with Columns' (12th century). Their wall-paintings may be inferior in quality but are important evidence of provincial monastic taste on the frontier between the Orthodox Christian and Muslim worlds.

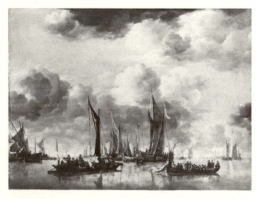

JAN VAN DE CAPPELLE Dutch Yacht firing a Salute. 1650. 33⅝×45 in (85·5×114·5 cm). NG, London

CAPPELLE, Jan van de (1624/5–1679)

b. d. Amsterdam. Dutch painter specialising in seascapes, characterised by a serene calmness. He was also a businessman of some wealth and possessed an extensive collection of drawings. His few landscapes are after the manner of Aert van de *Neer.

CAPRICCIO

Italian: 'caprice'. Imaginative scene often incorporating both factual and fanciful architectural elements. *Canaletto and the *vedutisti painted many of these views borrowing features from their topographical works. *Goya's engravings Los Caprichos are imaginative subjects but with heavy moral overtones.

CAPUA GATE, nr NAPLES (1230s)

Fragments remain of this monumental gateway built for Emperor Frederick II Hohenstaufen, the remarkable hero of the Imperial cause who knew Arabic, wrote a book on hawking and was sent to Hell by Dante. Frederick deliberately revived for political reasons antique forms and methods in the sculptures of himself, his ministers and allegorical figures which adorned the gate. Similar classicism, but in the religious sphere can later be seen in the Pisan pulpit of Nicola *Pisano, thought to have come from southern Italy.

CARACCIOLO (BATTISTELLO), Giovanni Battista (1570–1637)

b. Naples. One of the first Neapolitan painters to be influenced by *Caravaggio, he later evolved a personal style, under the influence of Bolognese art, distinct from Caravaggism. In his latest paintings he readopted strong *chiaroscuro and used a low viewpoint.

CARAVAGGIO, Michelangelo Merisi da (1573–1610)

b. Caravaggio d. Port'Ercole, Tuscany. Trained by the Milanese painter Simone *Peterzano, possibly as a still-life specialist, he went to Rome (c. 1592). After early difficult years, he painted half-lengths of adolescent boys with still-lifes, and musical scenes, and experimented with the rendering of violent expression. He was patronised by a group of patricians, including Cardinal del Monte (c. 1597) who almost certainly secured Caravaggio his first important commission, the St Matthew paintings in the Contarelli Chapel (1599–1602, S. Luigi dei Francesi). Between 1599 and 1606 he evolved a remarkable style of religious art quite distinct from the rhetorical grandeur of late *Mannerist altarpieces, using unidealised models (which caused considerable scandal) and strong, unnatural raking light. His simple compositions were frequently heightened by dramatic foreshortenings, while his violent nature is reflected in compositions like Judith and Holofernes (Coppi Coll., Rome) and David with Goliath's Head (Borghese, Rome). He fled south (1606) after killing a tennis opponent, working feverishly in Naples, Malta and Sicily, evading the Roman police, and (after 1608) Maltese agents. His late work is almost monochromatic, frieze-like and of extraordinary emotional intensity. Pardoned for the earlier murder (1610), he died of fever while returning to Rome. He influenced 17th-century artists from all countries, predominantly through his dramatic use of *chiaroscuro.

CARAVAGGISTI

Term used to denote those 17th-century artists who can be described as followers of *Caravaggio. Never a homogeneous body, their common characteristic – strongly illuminated figures against a dark background – scarcely lasted beyond 1620 in most cases. Dramatic scenes, popularised by Caravaggio, such as David and Goliath and scenes of card-sharping, were favourites. The style spread from Rome, as artists returned home, and schools flourished in *Utrecht, France, Lorraine, Spain and Naples, where a particularly strong tradition developed. See also TERBRUGGHEN; HONTHORST; VALENTIN; MANFREDI; GENTILESCHI; BORGIANNI; SARACENI; CARACCIOLO; GEORGES DE LA TOUR; VELASQUEZ

CARDUCCI see CARDUCHO

CARDUCHO (CARDUCCI)
Bartolomé (Bartolommeo) (c. 1560–1608)
Vincencio (Vincenzo) (1576–1638)

Brothers, both b. Florence d. Madrid, accompanying Federico *Zuccaro to Spain (1585). Bartolomé became Court

Painter to Philip III (1598). He probably painted the earliest recognisable †Baroque picture in Spain, the *Death of St Francis* (1593, Lisbon). Vincencio worked all over Spain, and published *Dialogue on Painting* (1633). His altarpieces are less impressive than his remarkably free and imaginative oil sketches for a series of fifty-two canvases for the Carthusian Order at El Paular.

CARIANI, Giovanni (Giovanni de' BUSI)
(c. 1480–1548)

Bergamesque painter who probably lived mainly in Venice. His style, difficult to determine, seems to depend on *Titian and *Palma Vecchio, although without their refinement.

CARLES, Arthur Beecher (1882–1952)

b. Philadelphia d. Chestnut Hill, Pennsylvania. Painter who studied at Pennsylvania Academy, in France, Italy and Spain, taught at Pennsylvania Academy and exhibited at *Armory Show. Influenced by *Fauvism in Paris (1900–10), he painted spontaneous explosions of colour, growing increasingly abstract. As teacher and artist, he pioneered *Abstract Expressionism.

CARLEVARIS, Luca 'da ca' Zenobio' (1665–1731)

b. Udine d. Venice. Italian painter and engraver. His views of Venice emphasising the perspective, narrative and pageantry make him virtually the inventor of the Venetian *veduta in its 18th-century form. He was a forerunner of *Canaletto.

CARLI, Raffaellino del *see* GARBO

CARO, Anthony (1924–)

b. London. English sculptor who read engineering at Christ's College, Cambridge (1942–6), and studied sculpture at the Royal Academy Schools (1947–52). Caro assisted Henry *Moore (1951–3), and his bronze figures show Moore's influence. After visiting America and meeting David *Smith (1959) he began making abstract works out of sheets and tubes of painted steel, often large in compass though not in bulk. Although Caro's steel sculptures aggressively reject the organic form and surface of his early work, their parts seem curiously limb-like in disposition and the whole has a peculiarly live presence. His work has extensively influenced contemporary British sculpture.

CAROLINE ISLANDS *see* MICRONESIA, ART OF

CAROLUS-DURAN, Emile Auguste (1837–1917)

b. Lille d. Paris. French painter, who after studying art in Paris, Rome and Spain, sent *Evening Prayer* to the Salon of 1866. He returned to Paris (1869), was recognised for portraiture, but exhibited also history, landscape, genre painting and sculpture (Salons of 1873/4). He was a founder and President (1898) of the Société Nationale des Beaux-Arts, and Director (1905) of the French School in Rome.

CARON, Antoine (1521–99)

b. Beauvais. French *Mannerist painter, decorator, draughtsman and tapestry-designer. He worked on the restoration of the Grande Galerie at *Fontainebleau for François I (1540). In 1560 worked there independently under *Primaticcio, his style being especially influenced by Niccolò dell' *Abbate. His art sums up the sophisticated atmosphere of the Valois court. In the religious wars he supported the Catholic League and painted *A Massacre of the Triumvirate* (1566, Louvre). He designed many festivities for the court and his paintings also reflect an interest in the fantastic and occult.

CARPACCIO, Vittore (c. 1460/5–1523/6)

Venetian painter active from 1490s. Assisted Giovanni *Bellini, but his major influence was Gentile *Bellini and

similarly his paintings abound with detailed observations of Venetian life, charmingly incorporated into his two most famous commissions, *The Legend of St Ursula* (1490, Accademia, Venice) and the decoration of the Scuola di S. Giorgio degli Schiavone (1502–7) in which colour and Oriental detail are more dominant than before. He may have visited Dalmatia and the Near East.

CARPEAUX, Jean-Baptiste (1827–75)

b. Valenciennes d. Courbevoie. French sculptor, painter, etcher, son of a mason, student of *Rude, Carpeaux exhibited at the Salon of 1852 a bas-relief, *Madame Delerne*, received the Rome Prize (1854) with *Hector and Astyanax*, and won recognition at the Salon of 1863 with his transition to sculpture in the round, *Ugolino and his Children*. The portrait busts that followed of contemporary society achieve his definitive style of painterly realism; modelling in the way he painted and sketched, he produced exuberant surfaces without loss of structure. The sculptural decorations of the Pavillon de Flore in the Louvre, *The Dance* for the Paris Opéra façade and the *Fontaine de l'Observatoire* are among his later large sculptural works.

CARR, Emily (1871–1945)

b. d. Victoria. Canadian painter who studied in San Francisco (1889–95), London (c. 1899–1904) and France (1910–11); painted western Indian villages. Influenced first by *Fauvism, later by *Tobey and the *Group of Seven (particularly *Harris), Carr pioneered western Canadian painting in her recurring *Expressionist themes, stark totems and forests swirling in her passionate emotional empathy with nature.

CARRA, Carlo (1881–1966)

b. Quargento d. Milan. Italian painter who studied in Milan and visited Paris (1900, 1911). Carrà's *Futurist work (1910–14) developed from a literal to a near-abstract interpretation of the interrelation of moving objects. His work since 1914 – related to *Pittura Metafisica (from 1917) and Valori Plastici (from 1919) – affirms opposite qualities. Inspired by *Masaccio, he seeks to evoke a reality which is solid, discreet, archaic – moving from international modernism to revived 'italianita'.

CARRACCI, Agostino (1557–1602)

b. Bologna d. Parma. Italian painter and engraver he was Annibale *Carracci's elder brother. Above all a scholar, the foundation of the Carracci Academy (1585) suited his pedagogic skills.

CARRACCI, Annibale (1560–1609)

b. Bologna d. Rome. Italian painter, taught by his cousin Ludovico *Carracci, he was the most talented of the family. Working in Bologna he visited Parma and Venice (1580s) studying *Correggio, *Titian and *Veronese, painters who stimulated his early naturalistic style, which contrasts with the complexities of prevailing *Mannerism. He was called to Rome (1595) by Cardinal Farnese; the frescoed ceiling of the Gallery in the Palazzo Farnese (finished 1600) demonstrates a more monumental style derived from the study of *Michelangelo, *Raphael and the *Antique. The decorative arrangement is of multiple figure compositions set in architecture and supported by *herms. With *Caravaggio, Annibale Carracci produced a revival of painting in Rome; his lively style was seminal to both †Baroque and classicising directions in the 17th century. Annibale made important contributions to landscape as well as caricature.

CARRACCI, Ludovico (1555–1619)

b. d. Bologna. Ludovico remained in Bologna all his life. Working as a painter he produced his best work 1585–95. His style is agitated and emotional, the irrational lighting influencing the †Baroque of *Guercino.

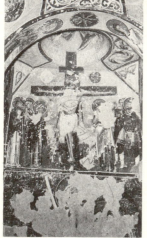

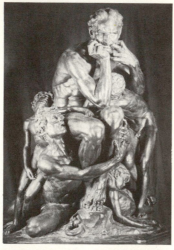

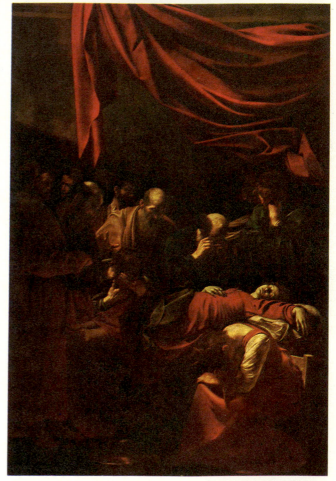

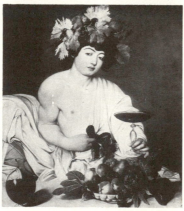

Above: CARLO CARRA *Jolts of a Cab.* 1911. 20⅜×26½ in (51·8×67·3 cm). MOMA, New York

Top row left: ANNIBALE CARRACCI *Flight into Egypt. c.* 1603. 48×90½ in (122×230 cm). Doria-Pamphili Gallery, Rome
Top row centre: CAPRICCIO *St Paul's and a Canal* by William Marlow. *c.* 1795. 51×41 in (129·5×104·1 cm). Tate
Top row right: LUDOVICO CARRACCI *Madonna degli Scalzi.* 86¼×56¾ in (219×144 cm). Pinacoteca, Bologna
Second row left: CAPPADOCIAN ROCK-CUT CHURCHES Elmaly Kilise: *Crucifixion*
Second row right: JEAN-BAPTISTE CARPEAUX *Ugolino and his Children.* 1863. Bronze. h. 76⅞ in (195 cm). Louvre
Above: MICHELANGELO DA CARAVAGGIO *Death of the Virgin.* 1605–6. 145¼×96½ in (369×245 cm). Louvre
Third row left: EMILY CARR *Forest Landscape* I. 36×24 in (91·4×61 cm). NG, Canada
Third row right: MICHELANGELO DA CARAVAGGIO *Bacchus.* After 1590. 37⅜×33½ in (95×85 cm). Uffizi

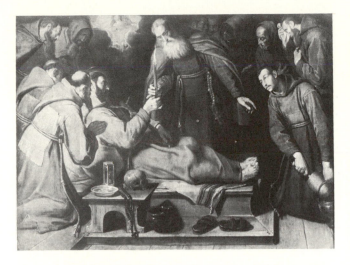

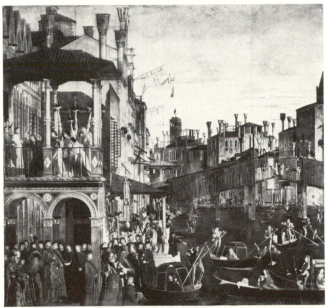

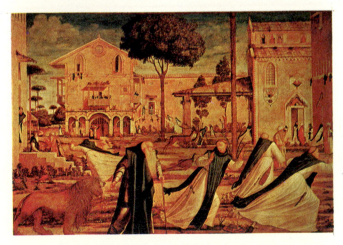

Top row left: BARTOLOME CARDUCHO *Death of St Francis.*
1593. 45⅜×60¼ in (115×153·5 cm). National Museum, Lisbon
Top row right: ARTHUR B. CARLES *Bouquet Abstraction. c.* 1930.
31¾×36 in (80·6×91·4 cm). Whitney Museum of American Art,
New York
Second row left: VITTORE CARPACCIO *Miracle of the True
Cross.* 1494–5. 143¾×153 in (365×389 cm). Accademia, Venice

Second row right: ANTHONY CARO *Early One Morning.* 1962.
Metal. 114×244×132 in (289·6×619·7×274·3 cm). Tate
Left: VITTORE CARPACCIO *St Jerome and the Lion in the
Monastery Garden.* 1502. 55½×83⅛ in (141×211 cm). Scuola di
S. Giorgio degli Schiavone, Venice
Above: ANNIBALE CARRACCI *Venus and Anchises.* Detail from
the ceiling fresco, Farnese Palace, Rome. 1595–1600

CARRENO, Mario (1913–)

b. Havana. Painter who studied in Cuba and Madrid (1932–5); worked in Mexico and Paris (1937–9); taught at New School for Social Research (1944–8); settled in Chile (1958). Influenced by *Picasso and *Guerrero Galván, Carreño first painted strictly geometric, colourful abstractions; lately he has incorporated organic, bulbous forms with *Surrealist undertones.

CARRENO DE MIRANDA, Juan (1614–85)

b. Avila d. Madrid. Spanish nobleman and most notable Court Painter after *Velasquez, he became Painter to the King (1671). He painted frescoes in the Alcazar, Madrid, and many spectacular religious and historical pieces; also a fine series of royal portraits.

CARRIERA, Rosalba (1675–1757)

b. d. Venice. Italian portrait painter. Her charming pastel technique made her one of the most sought after artists in Europe. Her visits to Paris (1721) and Vienna (1730) were phenomenal successes.

ROSALBA CARRIERA *Portrait of a Man*. 22¾×18½ in (57·8×47 cm). NG, London

CARRIERE, Eugène (1849–1906)

b. Gournay d. Paris. French painter and printmaker, a student of *Cabanel, he first exhibited at the Salon of 1876. His subsequent works, mainly portraits and scenes from family life, are largely painted in monochrome, with dragged brushstrokes that diffuse form in a mysterious, crepuscular light. Close to *Symbolist circles.

CARROLL, John (1892–1959)

b. Wichita, Kansas d. Albany, New York. Painter who studied with *Duveneck in Cincinnati, taught at *Art Students' League (1926–7, 1944–51) and Detroit Society of Arts and Crafts (1930–44). A figurative artist, Carroll gradually loosened and refined his early realistic style, heightening his colours and losing form along the way. His later paintings represent a dream-world.

CARRUCCI, Jacopo see PONTORMO

CARSTENS, Asmus Jakob (1754–98)

b. St. Jurgen d. Rome. Danish painter who worked in Copenhagen, Lübeck, Berlin and Italy. Painted portraits but main works are large historical and mythological pieces carried out in a †Romantic-†Neo-classical style comparable to *Fuseli's.

CARTOON

The final preparatory drawing for large-scale painting. In modern terms also a caricature or satirical drawing.

CARUS, Carl Gustav (1789–1869)

b. Leipzig d. Dresden. German psychologist and anatomy specialist, working in Dresden from 1814, and distinguished as art critic and landscape painter. He executed woodland and moonlit scenes, and ideal landscapes, all in a †Romantic style.

CARYATID

A draped female statue acting as a column or pilaster. An early use of caryatids may be seen at the *Siphnian Treasury at Delphi, but the most famous example of their use is at the Erechthion at Athens.

CASARES

†Palaeolithic site in Spain, north of Madrid. Rock-engravings of horse, bison, deer and a (?)mammoth exist. The human figures are generally assigned to the *Perigordian period but one horse head is *Magdalenian.

CASAS-Y-CARBO, Ramón (1866–1932)

b. d. Barcelona. Spanish painter, chiefly of portraits. With his Parisian contacts (after 1882) a spokesman for modern art in Barcelona where he was also active as a publisher of art magazines. His graphic style was influenced by *Steinlen and *Toulouse-Lautrec whose work he would have introduced to the young *Picasso.

CASILEAR, John William (1811–93)

b. New York d. Saratoga, New York. American landscape painter, who began as engraver, then studied painting in Europe (1840–3, 1857–8). Belonging to the *Hudson River School, his paintings are conventional in subject-matter and treatment, but distinguished by precise draughtsmanship.

CASSATT, Mary (1845–1926)

b. Pittsburgh, Pennsylvania d. Mesnil-Theribus, France. Painter who studied at Pennsylvania Academy, and lived in Europe from 1866, settling in Paris (1873). An †Impressionist who worked under *Degas and was influenced by *Manet, she painted domestic genre, particularly mothers and children, in lucid colour, with clear-eyed objectivity and warm affection.

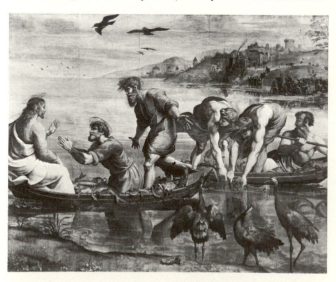

CARTOON *The Miraculous Draught of Fishes*. Tapestry cartoon by Raphael, 1515–16. V & A, London

CASSONE

Italian: 'chest'. In 15th-century Italy wedding-chests, made usually in pairs to hold the bride's dowry, were highly carved and decorated, and often incorporated paintings on the front, sides and both inside and outside of the lids, illustrating appropriate mythological or historical subjects. The coats of arms of

both bride and groom were often included. In Florence workshops were established for the exclusive production of cassoni and other painted household furniture (marriage-trays, bed heads, etc), the paintings being executed by second-rate artists, although major artists may have designed, if not executed, some cassoni. Sixteenth-century fashion reverted to carved chests.

MARY CASSATT *The Bath. c.* 1891. 39×26 in (99·1×66 cm). Art Institute of Chicago

CASTAGNO, Andrea del (c. 1421–57)

b. Castagno d. Florence. Florentine painter influenced by *Masaccio, *Domenico Veneziano and *Donatello. A major influence on later Florentines, also upon Giovanni *Bellini and *Piero della Francesca. His own monumental style is characterised by plasticity of form with clear outlines and an interest in the new developments in foreshortening. Visited Venice (1442) and worked in S. Zaccaria; executed frescoes for S. Egidio, Florence (1451–3).

ANDREA DEL CASTAGNO *Last Supper. c.* 1444–9. Fresco. 162×378 in (410×995 cm). S. Apollonio, Florence

CASTELLANOS, Julio (1905–47)

b. Mexico City. Painter who studied at Academy of San Carlos; travelled extensively in America and Europe; was head of Federal Department of Plastic Arts and influential teacher. Inspired by European †Neo-classicism and *Rodríguez Lozano, Castellanos's paintings transform Mexican types into classical sculpturesque forms, imbued with brooding, enigmatic, often lyrical feeling.

CASTELSEPRIO, nr Milan

The Church of S. Maria 'foris portas' at Castelseprio contains in the sanctuary apse a fragmentary fresco cycle of the life of the Virgin and the infancy of Christ. It is too good to be considered a product of local art, but may represent the work of travelling †Byzantine artists, possibly of the 7th or 8th century. The style is naturalistic and full of movement and the brushstrokes are sketchy, as if executed at high speed.

Left: CARYATID Porch of the Erechthion, Athens. 421–407 BC
Right: CASTELSEPRIO, Sta Maria 'foris portas' *The Journey to Bethlehem*

CASTIGLIONE, Baldassare (1478–1529)

b. Casatico, nr Mantua d. Toledo. Italian writer on art, also courtier, diplomat, scholar and soldier. As Papal Legate in Spain he helped the spread of †Renaissance culture there. Reared among the aristocracy of Mantua, and later in the service of Duke Guidobaldo of Urbino, on whose court Castiglione's life-work *Il Cortigiano* (drafted 1508–16, finally published 1528) is based. This influential book illumines Renaissance thought, ideals and preoccupations, and contains a

JULIO CASTELLANOS *The Dialogue*. 1936. Philadelphia Museum of Art

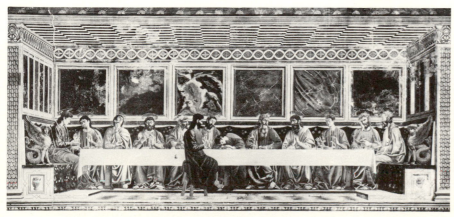

defence of the art of painting. A friend of *Raphael, he may have helped in the preparation of his archaeological report for Leo X.

CASTIGLIONE, Giovanni Benedetto (Il Grechetto) (?1610–65)

b. Genoa d. Mantua. Italian painter and engraver. He became Court Painter at Mantua (1648). His early pictures were usually landscapes with animals and he was influenced by painters as varied as *Van Dyck, *Rembrandt, *Poussin and *Bernini. He also painted some large religious compositions and mythological works. His engravings have an extraordinary fantasy reminiscent of Salvator *Rosa.

CASTILLO

Very important prehistoric site in Spain, south of Santander, notable for its art and archaeological content. The cave entrance has deposits of *Perigordian/*Aurignacian, *Solutrian and *Magdalenian. The small entrance leads into a large chamber from which lead narrow passages. The walls have both paintings and engravings (Perigordian/Aurignacian and Magdalenian). To the former period are attributed a series of stencilled hands similar to those from *Gargas and *Pech Merle. The majority of the paintings in both periods are in outline only, but there are two bichrome bison in the same style as those from the ceiling at *Altamira. This style differs from that north of the Pyrenees, suggesting two schools of late Magdalenian painting.

CASTILLO, José del (1737–93)

b. d. Madrid. Spanish painter, who studied in Rome. Returning to Spain finally in 1764, he made designs for the royal tapestry works and executed religious paintings for Madrid churches. He illustrated the Madrid Academy's edition of *Don Quixote* and also etched.

CASTING

The process by which a wax or clay model is reproduced in plastics, plaster, concrete or metal. These are poured into a mould while liquid or molten and left to harden. *See* CIRE PERDUE; SAND CASTING

CASTORIA

A lakeside town in northern Greece on the main road between Italy and Istanbul (Via Egnatia) filled with many tiny churches in the normal †Byzantine urban manner, eg at *Mystra. Many wall-paintings belong to the Turkish occupation, but a few churches were decorated between the 9th and 12th centuries. The late 12th-century paintings in the churches of St Stephanus, St Nicholas, SS Anargyroi, and the Mauriotissa Monastery are in a distinctive style of agitated figures and drapery. This style, once thought to be a local Macedonian invention, is now interpreted as belonging to a widespread contemporary fashion, which reached *Monreale and the West.

CATACOMB PAINTING

The catacombs were †Early Christian underground burial-chambers, widespread in the Mediterranean world, though the most extensive examples are just outside Rome, used from about 200 until the 6th century. Their decoration, often very crude, was usually executed in fresco, in a quick, sketchy technique and with bright colours. It consisted of symbolic representations of the resurrection of the soul and of Paradise, though occasionally scenes from the Old and New Testaments appear. Their message, before the reign of Constantine, was to convey the Christian promise of salvation. After Constantine, their new theme was the Church Triumphant. The poorer families who used the catacombs could not afford the best painters, yet in the main it is this funerary art which has survived.

CATAL HUYUK

Neolithic site in southern *Anatolia thirty miles south-east of Konya. Of extraordinary interest, the thirty-two-acre site holds the distinction of being the earliest fully fledged town yet discovered. Excavations in the religious quarter have disclosed a series of shrines decorated with wall-paintings of richly varied content, executed in a vivid naturalistic style. Geometric motifs also occur, similar to those used in modern Turkish *kilims* (rugs). The oldest yet discovered, these wall-paintings hold particular interest because of their probable connections with Upper *Palaeolithic art. Subjects illustrated include ritual dancing, the hunting and baiting of wild animals and aspects of a funeral cult. A unique 'landscape' seems to show a schematised town at the foot of an erupting volcano. The shrine also contained large wall-decorations of painted plaster modelled in high relief over a base of wood, clay or reeds. A goddess is frequently represented, sometimes giving birth to a child or to a ram's or bull's head. Other motifs include pairs of leopards, women's breasts, bull and ram heads, and rows or pairs of bull's horns, reminiscent of the 'horns of consecration' known from later Bronze Age Crete. Figurines representing a female deity have been found both at Çatal Hüyük and at Hacilar, the other major Anatolian Neolithic site. Naturalistic, often extremely well made, they show a modelling technique of considerable subtlety.

CATENA (di BIAGIO), Vincenzo (c. 1480–1531)

Venetian painter who formed a partnership with *Giorgione (1506), mentioned in an inscription on Giorgione's *Laura* (KH, Vienna). His early style was based on Giovanni *Bellini, but this gave way to the influence of *Titian and *Palma Vecchio, and the signed portrait of a man (KH, Vienna) shows a robust and less *quattrocento style which approaches the grandeur of the High †Renaissance.

CATHACH OF ST COLUMBA (?1st half 7th century)

A manuscript of the Psalms, written in Ireland in the Hiberno-Saxon majuscule derived from Italian script. There is little ornament in comparison with later manuscripts, eg the Book of *Durrow. The initials include trumpets and spirals deriving ultimately from *Celtic La Tène ornament; the letters are arranged in diminishing size after an initial. The poor condition is due to damp contracted in its metal shrine. A cathach was carried into battle to bring victory. (Royal Irish Academy, Dublin.)

CATLIN, George (1796–1872)

b. Wilkesbarre, Pennsylvania d. Jersey City, New Jersey. Painter who worked as miniaturist in Philadelphia and New York (1820–9), studied Indians in West (1832–9), lived in Europe (1839–52, 1857–70) and in South America (1852–7). He recorded the Indians' character and customs exactly and dramatically, and with respect and understanding.

CATTANEO, Danese (c. 1509–73)

b. Carrara d. Padua. Italian sculptor (also poet), pupil of Jacopo *Sansovino in Rome until the Sack, then assisted him in Venice. Large commissions included the Fregoso Monument, S. Anastasia, Verona, and the Loredano Monument, Venice (completed by *Campagna). Weak as an interpretative artist, Cattaneo was at his best with portrait sculpture and small bronzes.

CATTERMOLE, George (1800–68)

b. Dickleborough d. London. He began as an architectural draughtsman for the antiquarian publisher John Britton. Later he illustrated annuals and books, and exhibited water-colours of medieval architecture with figures in the costume of the periods represented, following a type made popular by *Bonington. His success culminated in a gold medal at the Paris Universal Exposition (1855).

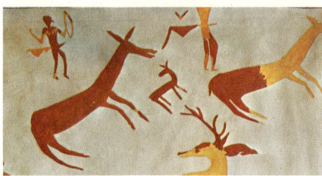

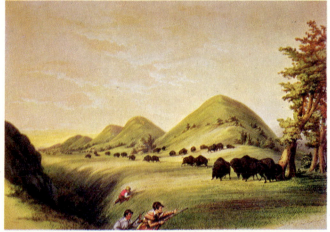

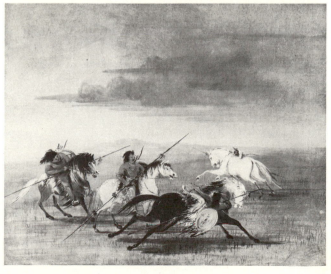

Top: CATAL HUYUK Wall-painting of a dead man's head. Level IV, *c.* 5825 BC
Above: CATAL HUYUK Wall-painting of deer hunt. Level III, *c.* 5800 BC
Left: CATACOMB PAINTING *The Good Shepherd.* Catacomb of Domitilla, Rome. 3rd century
Top right: VINCENZO CATENA *A Man with a Book.* $31\frac{3}{8} \times 23\frac{1}{2}$ in (79×59·9 cm). KH, Vienna
Centre: GEORGE CATLIN *Buffalo Hunt Approaching the Ravine.* Lithograph. BM, London
Right: GEORGE CATLIN *Comanche Feats of Horsemanship – Sham Battle.* 1834. $22\frac{5}{8} \times 27\frac{5}{8}$ in (57·5×70·2 cm). Smithsonian Institution, Washington, D.C.

CAUCASIAN ART

The neighbouring and mutually dependent countries of Armenia and Georgia were the most inventive provincial exponents of the †Byzantine type of church architecture. The expertise in the small cupola church led in turn to skill in carving the local pink stone (tufa) in which they built. The exteriors were adorned with carved figures, animals and above all crosses, eg at *Aght'amar. Similar intricate work appears in Caucasian minor arts, eg metalwork. Local versions of Byzantine style abound in fresco- and manuscript-painting.

CAULFIELD, Patrick (1936–)

b. London. English painter who, while influenced by American *Pop Art imagery, and for a time by *Gris and *Dufy, takes a more detached view, lending the familiar objects in his work an exotic flavour. He simplifies form into two-dimensional linearity, and uses flat rich colour.

PATRICK CAULFIELD
Pottery. 1969. 84×60 in
(213·4×152·4 cm). Tate

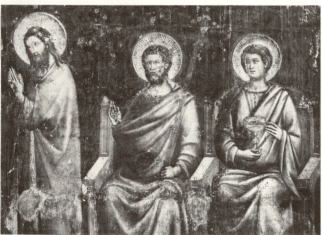

PIETRO CAVALLINI *Christ and the Apostles.* c. 1290. Fresco.
Sta Cecilia in Trastevere, Rome

CAVALLINI, Pietro (active 1273–1308)

Italian painter who revived old technical methods and narrative skills, experimenting with depth, perspective, volume, movement and a constant use of light, in his compositions. In Sta Cecilia in Trastevere he reintroduced the traditional scheme of decorating church walls with long Bible cycles, which quickly became very popular in Italy. The only surviving cycle designed by Cavallini is a mosaic series of the Last Judgement in Sta Maria in Trastevere. The inconography of the scenes is traditional, stemming largely from †Byzantine prototypes, but the bulky figures modelled by colour and light have a new realism. Frescoes, largely by Cavallini's school, exist in Sta Maria Donna Regina, Naples. His style was a major influence on *Giotto.

CAVALLINO, Bernardo (1616–56)

b. d. Naples. Italian painter. A pupil of *Stanzione, his style is broadly *Caravaggesque, but with influences also from the Venetians and *Van Dyck. He was the most sensitive 17th-century Neapolitan painter with a highly individual style distinguished by elongated figures and striking gestures and poses as is shown in his *Christ Driving the Traders from the Temple* (NG, London) in which his delight in the use of vivid colour is expressed. He died when the plague swept Naples (1656).

CAVALORI (SALINCORNO), Mirabella di Antonio (c. 1510/20–after 1572)

b. d. Florence. After studying initially under Ridolfo *Ghirlandaio, he was sufficiently noted to be one of the artists employed on the obsequies of *Michelangelo. The Pitti *Head of St John Carried to the Feast of Herod* shows his somewhat derivative style.

CAVEDONE, Giacomo (1577–1660)

b. Modena d. Bologna. Italian painter of dramatic religious subjects and a member of the Bolognese School, he worked under Guido *Reni on the Cappella dell'Annunciata frescoes (1610). His work also reflects the influence of Ludovico *Carracci and the 16th-century Venetians.

CECIONI, Adriano (1838–86)

b. Fontebuona, nr Florence d. Florence. Italian painter and caricaturist who exhibited in Paris (1872) and worked in London as an illustrator to *Vanity Fair.* A member of the *Macchiaioli, he became Professor at the Florence Academy. His art criticism was published in 1905.

CEDASPE, Paolo see CESPEDES, Pablo, Pablo de

CEFALU CATHEDRAL, Sicily

The mosaic decoration begun on a grand scale under Roger II, King of Sicily, by a team of †Byzantine workmen, was abandoned (1148) with only the apse finished. It was completed later in the 12th century on a reduced scale, possibly by Sicilian mosaicists. The *Christ as Light of the World* in the apse is an especially sensitive composition executed by the earlier, Byzantine team.

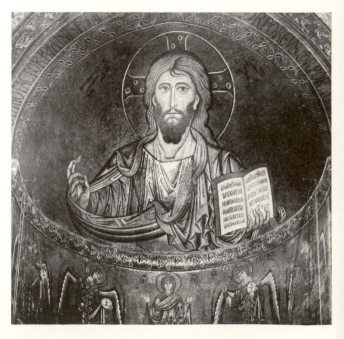

CEFALU CATHEDRAL *Christ as Light of the World.* Apse mosaic.
First half of 12th century

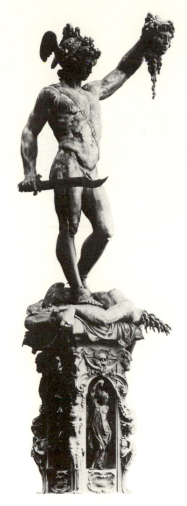

BENVENUTO CELLINI *Perseus*. 1545–54. Bronze. h. 126 in (320 cm). Loggia dei Lanzi, Florence

CELLINI, Benvenuto (1500–71)

b. d. Florence. Italian *Mannerist sculptor, goldsmith, coin-engraver and medallist. In Rome (1519–40) studying *Michelangelo, *Raphael and classical sculpture. In 1537 he visited the court of François I at Fontainebleau (1540–5) bearing his famous golden salt-cellar and for whom he devised his first large-scale piece, the *Nymph of Fontainebleau* (1543–4). Determined that the king should appreciate the refinement and elaborate conceits of his bronzes, he displayed them by candlelight – a trick which is typical of Mannerist theatricality. Returning to Florence (1545) he executed two bronzes, the bust of Cosimo I and the *Perseus* (Loggia dei Lanzi). The account of the casting of the latter is one of the most exciting passages in his highly coloured autobiography (1558–62). One of his few marble works is the Crucifix (Escorial) originally intended for his own tomb.

CELTIC ART

The movement of the Celts towards western Europe seems to have been part of a general shift of population which brought other Indo-European peoples, eg the Greeks and Phrygians to the lands around the eastern Mediterranean. The progress of the Celts has been traced by their use of distinctive burial customs. By 1300 BC the Urnfield culture of the proto-Celts had reached eastern France. This Bronze Age culture declined in the 8th century BC and was replaced by successive Iron Age manifestations which have taken their names from Halstatt in Austria and La Tène in France. The latter culture seems to have taken shape during the 5th century BC, and it was only at this stage of their history, when political institutions began to develop and large-scale military adventures became possible, that art started to play an important part in Celtic life. No doubt from time immemorial the Celts had been affected by the two basic preoccupations which induce primitive peoples to make works of art – a delight in abstract ornament and the practice of religious rituals which require symbols. But it was evidently in response to the superior craftsmanship of Mediterranean artefacts which began to reach them in large quantities during the 6th century BC (eg the Archaic Greek krater from *Vix) that their higher artistic aspirations were formed. Throughout its history, Celtic art was under relentless classical pressure, and the remarkable thing about it was the strength of the resistance which the primitive, native element in the situation contrived to maintain. We can see this clearly in their attempts at figure art, and best of all in the way they began to coin money. This resistance was perhaps made easier by the temperamental differences between the Celts and the Greeks and Romans. Celtic religion preserved gruesome and morbid features which had little use for classical naturalism and idealisation. Its monsters, eg the Tarasque, had more in common with *Mesopotamia than the Mediterranean, and indicate links with the East, perhaps via the *Scythians. This aspect of their art is known largely by accident; chance survivals uncovered by the excavation of Celtic oppida. Chance again has preserved for us the Gundestrup Cauldron (c. 100 BC). It was found in a Danish bog. The iconography of this magnificent piece of repoussé metalwork is uncertain, but immensely elaborate. But most of what we know about Celtic art is provided by grave finds. These extend from Czechoslovakia and Hungary to France and Ireland. They tend to be from personal effects: the metal ornaments attached to military equipment like shields and swords, bowls and tankards, or the trinkets of fine ladies. What these objects disclose is a continuous tradition of superb skill in the working of gold, bronze or iron. Within the tradition, various sub-styles have been recognised – early, Waldalgesheim, 'plastic' or 'sword'. But there were also certain favoured patterns such as the spiral, which cut across stylistic divisions and constitute an identity label for most Celtic art. By and large, the Roman conquest of Gaul had the effect of submerging native Celtic forms in a provincial classicism. Celtic art survived longer in Britain, where Romanisation was less intense and longer still in Ireland, where it was non-existent. After the Roman evacuation of Britain in the 5th century AD, there was a curious recrudescence of Celtic spiral ornament on hanging-bowls, and the same feature turns up even later in the context of Hiberno-Saxon manuscripts, such as the Books of *Durrow, *Lindisfarne and *Kells.

CEMENT

Calcined powdered limestone or chalk that is reconstituted into a stone-like substance after being mixed with water.

CENNINI, Cennino (active late 14th–early 15th century)

No identifiable works by this Florentine pupil of Agnolo *Gaddi exist. His fame rests on the *Libro dell' Arte*, which he wrote at the end of the 14th or early in the 15th century. Much of our knowledge about Italian late medieval artists' workshops stems from this work. It records the wide range of skills necessary to a 14th-century painter and claims to reproduce *Giotto's working methods. It includes instruction in the practice of painting and drawing, technical descriptions of the preparation of materials and sections on the decorative arts.

CENTRAL AMERICA, PRE-COLUMBIAN ART OF *see* CHIRIQUI; COCLE; GUETAR; VERAGUAS

CENTRAL ASIA, ART OF

Central Asia extends roughly from the Great Wall of China in the east to the River Oxus in the west, and from Tai-shan range in the north to the Kun-lun Mountains in the south. Its geography varies from waterless deserts to snow-capped mountains. Its history shows a similar variety in its religion, culture and political organisations. This was partly the result of the fact that the silk route, along which China exported her silk

and other wares to India and the Middle East, crossed Central Asia from east to west. Along this route lay oases, city-states and townships whose monasteries and palaces were decorated with motifs and in styles which derived from China, India, Iran and the eastern Mediterranean. *Tun-huang, lying at the eastern end of the silk route, comprises a group of monastic caves decorated with wall-paintings executed between the 5th and 8th centuries AD. Although these, and the many paintings on silk which were discovered at this site, show similarities with the Chinese painting of the *Northern Wei and early *T'ang periods, stylistic traits from farther west in Central Asia as well as from *Tibet and *Nepal are also found. To the north-west of Tun-huang, in northern Kashgaria, lies a group of important sites. At Tumshuk, sculpture shows *Gupta influence from India and *Hellenistic treatment of the human figure which may have been introduced at second hand from *Gandhara. Kyzil and Kumtura provide examples of painted rock-cut caves and some decorative objects, such as woven silk, having *Sassanian motifs. The Buddhist wall-paintings at Kyzil belonging to the earlier period (5th–7th centuries AD) group modelled figures in elegant, sensuous balance; during the 7th and 8th centuries the emphasis shifts in response to a greater interest in decoration. Indian Gupta influence is again revealed, however, in the sculpture of Shorchuk by the figure-clinging treatment of the robes of Buddha images. Not far away, at Bezeklik, the wall-paintings combine features from both China and Iran to form their own characteristic style. Thus Chinese foliage scrolls and draperies reminiscent of Chinese T'ang silver-work are used in conjunction with Iranian deities. At the same time *tantric themes originating in India are found at Bezeklik such as those decorating the dome of Temple 3. Farther to the south, at Miran, Indo-Hellenistic treatment of forms and draperies combined with Chinese decorative foliage designs are used to portray Buddhist subjects. At this site are found some of the earliest painting in Central Asia (c. 3rd–4th century AD). Here, and also at other sites in eastern and western Turkestan, sculpture modelled in clay and lime composition shows similarities with that of Gandhara in its somewhat naturalistic treatment of the human figure and the rendering of drapery. This link is continued, farther west, in the enormous Buddha figures (120 and 175 feet high) at Bamiyan in Afghanistan which was formerly one of the greatest monastic centres in Central Asia. Here also Iranian and Indian influences are strong in many of the paintings some of which, such as in the ceiling *mandala at Kakrak, deal with tantric subjects. The most characteristic examples of architecture which have survived are the rock-cut caves and *stupas. The former, such as those at Bamiyan and Tun-huang, are evolved from the elaborate Indian cave-temples represented by *Ajantā in the western Deccan. The stupas are conventional burial-mounds similar to those at Sanchi in India and in Gandhara. Painting, which was a mixture of, in varying degrees, Chinese, Indian, Iranian, and Hellenistic elements was mainly used in Central Asia to decorate the interiors of the cave-temples whereas sculpture, mainly composed of similar elements but with greater Chinese emphasis farther east, was used for the outside of stupas and for votive images.

CERANO, IL (Giovanni Battista CRESPI)
(c. 1575–1632)

b. Novara d. Milan. Italian painter of the Milanese School. He evolved his own mystical *Mannerist style. Also an architect, sculptor, writer and engraver. He was made head of the statuary works for Milan Cathedral (1629).

CERQUOZZI, Michelangelo see BAMBOCCIO, IL

CERUTI, Giacomo (Il Pitocchetto)
(active 2nd half of 18th century)

Few facts are known about this portrait and *history painter, active in Venice. He executed a number of unflinchingly descriptive, melancholy paintings of beggars, idiots and vagabonds.

CESAR (César BALDACCINI) (1920–)

b. Marseille. French sculptor who studied at the Ecole des Beaux-Arts, Marseille (1935–9) and Paris (1943–7). Following the example of *González and *Picasso, César began welding scrap-metal into figurative and semi-abstract images (1956). Using machine tools, César metamorphoses scrap-metal in a highly imaginative and humorous fashion.

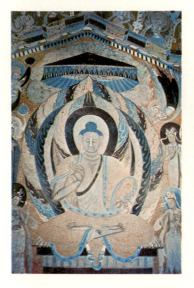

Left: CENTRAL ASIA, ART OF The Buddha Shākya-muni preaching, surrounded by bodhisattvas and apsarases. Early 6th century. Cave 288, Tun-huang
Right: CESAR *Compression 1960.* Metal. $59\frac{7}{8} \times 25\frac{1}{4} \times 17\frac{3}{4}$ in (152×64×45 cm). Denise Durand-Ruel, Paris

CESARI, Giuseppe see ARPINO

CESPEDES, Pablo de (Paolo CEDASPE)
(c. 1538–1608)

b. d. Cordoba. Spanish *Mannerist painter, also cleric, scholar, art critic and poet. In Italy (1559–77). A fervent admirer of *Michelangelo and *Raphael, he was a follower of *Daniele da Volterra. His principal work is the *Last Supper* altarpiece for Cordoba Cathedral (now Seville).

CEYLON (SRI LANKA), ART OF

The independent Sinhalese kingdom of Sri Lanka, established according to tradition just over 2500 years ago, was converted to Buddhism in the 3rd century BC by missionaries sent by the *Maurya emperor, Ashoka. As this was Theravada Buddhism, it is understandable that the art of Sri Lanka should be less florid and more restrained than that often encountered in India. Its best-known examples are to be found at Mihintale, where Buddhism was first preached, at the capital city of Anuradhapura during the reigns of two kings, Dutthagamani (161–137 BC) and Mahasena (AD 276–303) and at the later capital of Polonnaruva, made memorable artistically by Parakrama Bahu I (1153–86) and Nissanka Malla (1187–96). From this time onwards, except for the reign of Parakrama Bahu VI (1412–67), the kingdom declined, until in the early 16th century the Portuguese found Sri Lanka in a state of disintegration. A typical example of what has withstood two millennia of civil strife, invasion, the influx of the jungle and the neglect of foreign rulers is the massive *stupa, a development of the Indian Buddhist reliquary mound. There are marked differences between the early Kanthaka Cetiya at Mihintale (2nd century BC), the enormous Jetavana at Anuradhapura (3rd century AD) and the late Rankot-vehera at Polonnaruva (12th century). In the case of the stupa, as elsewhere in sculpture, the Sri Lanka artist, while recalling the Indian tradition, makes a distinctive original contribution to it.

Throughout history representative examples of Sinhalese art tend to show this trait: eg the 'moonstones' or threshold-stones (those at Anuradhapura particularly), reminiscent of Nagarjunakonda, with their semicircular slabs carved with concentric bands of animals and foliage in a distinctively Sinhalese style. A striking example of relief sculpture, clearly recalling *Pallava art is the Man and Horse carved on a boulder at the Isurumuniya Vihara in Anuradhapura. The figures have been identified as those of Pajjana, the rain-bringing deity, and Agni, the horse deity of fire and lightning, gazing over the fields they protected and were invoked to bless. Of the colossal statues of the Buddha, a characteristic Sinhalese development of a late Andhra original, the most famous are two of the 12th-century group at the Gal Vihara, Polonnaruva. The reclining Buddha image, over forty-six feet long, cut out of a rock escarpment, representing the Buddha in *parinirvāna* is remarkable for the contrast between the stylisation of the figure as a whole and the delicate naturalism of the impression of the head resting on the pillow. Beside it is a colossal standing Buddha with his arms crossed in the gesture of 'sorrowing for others'. Quite different from these but equally typical of the art of Polonnaruva, where the *Cholas ruled (1017–55), is the small bronze figure of Shiva-sundaramurti, the psalmist and devotee of *Shiva, with its intense spirituality and gracefully moulded form. Also from Polonnaruva are the unusual lotus-stem columns with their bud capitals of the Nissanka Lata-Mandapa (late 12th century). The long tradition of Sinhala painting, attested almost entirely by religious subjects in cave, relic chamber and temple, continues even today. Different in character are the remarkably well-preserved frescoes in a pocket of the high rock-face at Sigiriya. Dating from the 5th century AD, they depict golden-hued celestial maidens with their darker-complexioned attendants, reminiscent of *Ajanta, but distinctive in their sinuous form and the freedom of their line.

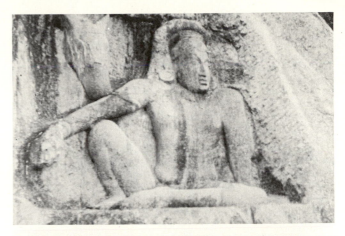

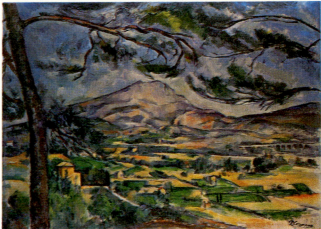

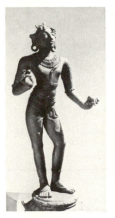

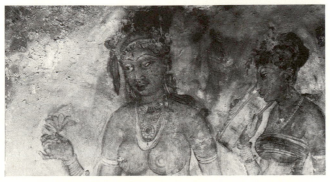

Top left: CEYLON, ART OF *Shiva-sundaramurti.* 11th–12th century. Bronze. h. 24½ (62 cm). From Polonnaruva. Colombo Museum
Top right: CEYLON, ART OF *Reclining Buddha* (detail). Length of entire figure 46 ft 4 in (14 m). 12th century. Gal Vihara, Polonnaruva.
Above: CEYLON, ART OF Sigiriya. Detail of fresco. 5th century AD

Top: CEYLON, ART OF Relief of Man and Horse. 7th century. Isurumuniya Vihara, Anuradhapura
Middle: PAUL CEZANNE *Mont-Sainte-Victoire.* 1885–7. 26×35⅜ in (66×90 cm). Courtauld Institute Galleries
Above: PAUL CEZANNE *Bathers.* 1900–5. 51¼×76⅞ in (130×195 cm). NG, London

CEZANNE, Paul (1839–1906)

b. d. Aix-en-Provence. Cézanne was the son of a wealthy banker, and thus financially independent. Having studied law in Aix he frequented the Académie Suisse in Paris. His early works, often imaginary figure subjects, have dark colours and a thick impasto applied with a palette-knife. In the early 1870s he worked with *Pissarro and began to use a lighter palette. Although he showed at two †Impressionist exhibitions his aims went beyond Impressionism. In his search for underlying

structure and solid pictorial composition he worked alone, endlessly interpreting the Provençal landscape around Mont-Sainte-Victoire and composing complicated still-lifes, using carefully placed brushstrokes to define form and space. His analytical method, utilising the whole picture surface, is especially clearly revealed in his late oils and unfinished water-colours. His modulation of colours was developed to an exquisite subtlety. His later works had a profound influence on the development, by *Picasso and *Braque, of *Cubism.

(1914–22), moved to Berlin (1922–3), Paris (1923–41), America (1941–7), Vence (1947). The Russian Jewish flavour of Chagall's interpretations of reality give him perhaps an over-exaggerated reputation for fantasy. Always a personal yet deliberate colourist, *Cubism provided the means of relating things – both thematically and formally – with more force, freedom and control. Chagall's strongest works, from the period 1910–14 and from the 1930s, are part of a prolific output which includes more domestic, whimsical works, etchings and stained glass.

PAUL CEZANNE *Basket of Apples*. 1890–4. 25¾×32 in (65·4×81·3 cm). Art Institute of Chicago

CH'A Shih-piao (1615–98)

Chinese painter from Hai-yang, Anhui. Like others of his time, Ch'a Shih-piao took up painting on the fall of the *Ming dynasty (1644). His chief sources of inspiration were the *Yüan masters *Huang Kung-wang and *Ni Tsan, and *Mi Fu and his son of the *Sung. His paintings were sparing of ink but often suggestive of mists and atmospheric effects.

CHADWICK, Lynn (1914–)

b. London. English sculptor who studied architecture before turning to sculpture (1945). His early works, influenced by *Calder, were skeletal metal structures – grounded mobiles – later spanned to create crustacean, half-human figures. Their obvious emotional appeal is absent from his recent constructions made from welded fragments of industrial equipment.

MARC CHAGALL *Calvary*. 1912. 147¼×112 in (373×284·5 cm). MOMA, New York, Lillie P. Bliss Bequest

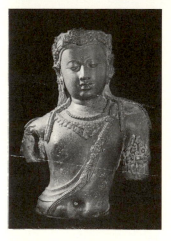

CHAIYA, Thailand. *Avalokiteshvara*. Mid 8th century. Bronze. h. 24⅞ in (63 cm). National Museum, Bangkok

CHAIYA, Thailand

The bronze bust from Chaiya of the Bodhisattva Avalokitesh-vara in royal attire dates from *c.* 8th century AD. It clearly derives from *Pala art in India, but has been influenced by Indonesian concepts, the region where it, together with other Mahāyāna figures, was discovered, having been controlled by the Shailendra dynasty which ruled a great maritime empire whose capital was probably in the neighbourhood of Palembang, Sumatra.

MARC CHAGALL *Russian Wedding*. 1925. 40×32 in (101·6×81·3 cm). Albright-Knox Art Gallery, Buffalo, New York

CHAGALL, Marc (1887–)

b. Vitebsk. Painter who studied in St Petersburg (1907–10), worked in Paris (1910–14), returned to teach in Vitebsk

CHALONS, Simon de (active 1535–d. 1561/2)

French painter, from Champagne, according to his signatures. Active in Avignon where works dated in the 1540s and 1550s exist (Musée Calvet). His *Infant Christ playing with other Children* (1543), from a seminary in Avignon, shows an Italianate (specifically *Michelangelesque) style with grave, monumental females and rational spatial description.

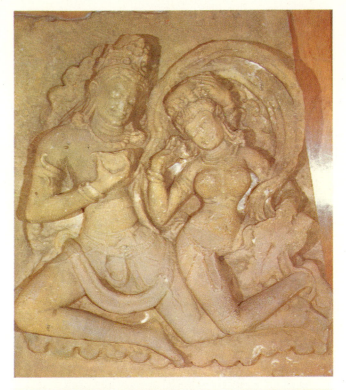

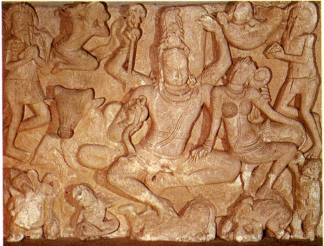

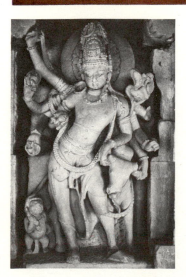

Top: CHALUKYA DYNASTY
Celestial Lovers. c. 7th
century. Sandstone. From
Aihole. Prince of Wales
Museum, Bombay
Above: CHALUKYA
DYNASTY *Shiva with Parvati
and Nandi.* 6th–7th century.
Sandstone. From Aihole.
Prince of Wales Museum,
Bombay

Left: CHALUKYA DYNASTY
Shiva with Nandi. 7th
century. Durga temple,
Aihole

CHALUKYA DYNASTY (AD 535–757)

The Deccan, untouched by the Hun invasions thanks to the powerful *Gupta defences in the north, was brought under the control of the Chalukyas with their capital at Badami early in the 6th century. Buddhist influence waned abruptly with the coming of the new dynasty, which was ardently Hindu. Being centrally located, the Chalukyan territories saw the juxta-position of northern and southern temple styles. Their domination of the Deccan lasted for some two and a half centuries, and a branch of the line persisted as feudatories to the *Rashtrakutas who toppled them, although they were to re-emerge as an independent dynasty with lesser dominions, after the downfall of their conquerors.

Inheriting the northern traditions of the *Vakataka Empire and acquiring, through their wars with the *Pallavas, southern inspiration in their later works, the Chalukyas excavated cave-temples at their capital of Badami and built structural temples at Aihole and Pattadakal. One of their earliest free-standing temples, the Ladh Khan at Aihole displays a theme common to all Chalukya temples on pillars, brackets and façades: the *mithuna, or amorous couple. The lightly clad couples are represented standing, leaning against each other in dalliance under a tree. The concept and purpose behind these couples are philosophic, but the treatment is entirely natural. In time the tree may be disposed of, but the two lovers continue to display their passion throughout the Chalukyan temple-building period without, however, attaining consummation as they do on the temples produced later under the *Chandellas at Khajuraho and under the *Gangas at Konarak. Another common motif is the *purnaghata, or pot full of blossoms, carved on balustrades.

The iconography is in the process of formation in the early temples at Aihole. In the *Durga temple (7th century) the gods and goddesses of Hinduism loom everywhere. The temple is dedicated to *Vishnu, but *Shiva icons are also well represented. A superb image of *Shiva, eight-armed and casually leaning on the bull Nandi, is the exact counterpart of the four-armed Vishnu astride his anthropomorphic eagle Garuda; while the statue of eight-armed *Mahishamar-dini, bearing the emblems of both Shiva and Vishnu, provides a triumphant counterpoint to them both. The postures of these images are graceful and the richness of their adornments – crowns, earrings, necklaces, armlets, bracelets and girdles – are intricately depicted to contrast with the naked torsos and thin, almost invisible, lower garments. The heads of all three deities are backed by the nimbus of divinity, a plain disc with a superimposed lotus-pattern. At the Badami caves, the *mithuna* motif is employed successfully on the pillar-brackets. The figures of the lovers are more refined and elongated, the man assuming a more relaxed attitude, while the foliage remains above their heads. The portrayal of the gods at the Badami caves varies in mood from furious activity to solemn passivity. The former mood is conveyed by the sixteen-armed Shiva relief on the façade of Cave 1. The god is seen in a pose expressive of violent movement; the flurry of arms and the long hair of the god, normally piled in a braided coiffure but now beginning to shake loose, augment the impression. But the face of Shiva is tranquil, with eyes downcast to avert their fury from the approaching worshipper, his expression one of utter absorption in the dance. In the *Vaishnava cave at the same site, an eight-armed Vishnu image, standing in a still, upright pose, presents the opposite in mood. The Virupaksha structural temple at Pattadakal incorporates elements trace-able to Pallava sources, notably the Kailasanatha temple at Kanchi, which the Chalukyas took in one of their campaigns against the Pallavas in the late 7th century. External adorn-ment of the walls proliferates, particularly over the niches inset between pilasters in which stand images of the gods, sometimes with a smaller myth-tableau beneath them.

CHAM ART

The kingdom of Champa grew out of a small realm which broke away from Chinese domination at the end of the 2nd century AD and was known as Lin-i. Its first centre seems to

have been at Mi-son which fell to the Vietnamese (AD 980), whereupon the capital was shifted south to Binh-dinh. The Chams finally lost their independence to the Vietnamese towards the end of the 15th century though at the height of their power they posed a serious threat to their western *Khmer neighbours whose first artistic developments probably owed much to Cham inspiration. The brick-built temples never formed the organised patterns characteristic of Khmer groups, but their most striking feature was the presence of great altars decorated with sculpture: these may owe something to Chinese inspiration. Much of the most typical statuary has been described as being of 'barbaric severity', but the dancing figures on the pedestals of such temples as Tra-kieu show an elegant sensuality. The skill with which the carvers adapt scenes to fill triangular space is noteworthy. A fine female head from Huong Qua (c. 8th century AD) is a most sophisticated example of portraiture.

Left: CHAM ART Altar of the Tra-kieu temple. 7th century. Sandstone. Tourane Museum
Right: CHAM ART Dvarapala from Binh-dinh. 8th century. Tourane Museum

CHAMBA *see* **NIGERIA, NORTHERN**

CHAMBERLAIN, John Angus (1927–)

b. Rochester, Indiana. Sculptor who studied at Chicago Art Institute (1950–2) and taught at Black Mountain College (1955–6); lived in New York (from 1956). First influenced by David *Smith, Chamberlain moved from linear abstractions to dynamic constructions of brilliantly coloured, twisted, crushed automobiles, allied both to *Abstract Expressionism and early *Pop Art.

JOHN CHAMBERLAIN *Coo Wha Zee*. 1962. Welded auto metal. 72×60×50 in (182·9×152·4×127 cm). Leo Castelli Gallery, New York

CHAMPAIGNE, Philippe de (1602–74)

b. Brussels d. Paris. Flemish painter, in Paris from 1621, becoming painter to Marie de' Medici, and working extensively for Richelieu in the 1630s. Executed many religious paintings, but particularly interesting for his bust portraits, which reflect, in their sobriety and direct contact with the

spectator (generally through an illusionist window-frame) his connection after 1643 with Jansenism. Though highly finished, even his full-lengths of aristocratic administrators have a gravity far removed from his rivals' work. His portrait of two nuns (1662, Louvre), composed geometrically and psychologically very subtle, best conveys his profoundly religious nature and classicising art.

PHILIPPE DE CHAMPAIGNE *Ex-voto*. 1662. 65×91 in (165·1×231·1 cm). Louvre

CHAMPFLEURY (Jules HUSSON) (1821–89)

b. Laon d. Sèvres. French writer and art critic who furthered the cause of the avant-garde in his reviews of the Salon exhibitions, when he supported *Delacroix (1840s) and when he defended *Courbet (1850s). He published a manifesto of †Realism (1857), supplemented by his *History of Caricature* (1864).

CHAMPLEVE The Stavelot Altar (detail). c. 1160–65. Mosan enamel. Musées Royaux d'Art et d'Histoire, Brussels

CHAMPLEVE

An enamelling technique in which indentations in a metal surface are filled with enamel and fired. *See also* REPOUSSE

CH'AN PAINTING *see* **KUAN-HSIU; LIANG K'AI; MU-CH'I; SUNG DYNASTY PAINTING; ZENGA**

CHAN Tzŭ-ch'ien (2nd half 6th century)

Chinese painter summoned to court in the Sui dynasty (589–618), he executed wall-paintings in many great Buddhist temples in the capital, Ch'ang-an, in Lo-yang and elsewhere. Early descriptions speak of the detail and lifelike quality of his figures, but his works have long been lost along with the temples in which they were painted.

CHANCAY

An early Peruvian culture (c. AD 1000–1400) characterised by a distinctive pottery style consisting mainly of ovoid jars and large hollow figurines painted with black line decoration upon a white slip.

CHANDELLA DYNASTY (AD 916–1203)

The Chandellas and other Rajput clans were engaged in constant wars with each other throughout the 10th and 11th centuries across the west from Kathiawar and Mewar to Malwa and Bundelkhand, the Chandellas' homeland. Of their architectural enterprises there remain the twenty-four temples at Khajuraho, famous for their sculptural repertory of sexual practice and perversion, most of them built at the height of Chandella power (AD 950–1050). The earliest temple, built in the late 9th century, is the so-called Chaunshat Jogini, dedicated to the demi-goddesses created by the bloodthirsty *Durga. Only four images from this once great temple of the goddess remain. The style of the sculptures is crude when compared with the true Chandella material, but the inventiveness characteristic of the later work is already noticeable. The Khandariya Mahadeva temple presents a sculptural scheme which is typical of Khajuraho. The three registers of sculpture run across a wall which is vertically stepped, like a flight of stairs turned on its side. On each of these yard-square surfaces, at each of the three levels, are carved three figures. They are sculpted in such depth of relief as to be almost freestanding, and are no longer inhibited by a surrounding frame but flow in a continuous frieze. The *apsaras figures (celestial nymphs) in these friezes are clearly idealised portraits of the aristocratic ladies of medieval Bundelkhand. They are portrayed at their toilet, dressing themselves and dancing, painting on small slates or boards, playing at ball and fondling their children. It is interesting to note that men engaged in secular pursuits are not represented in these major friezes, the male presence being restricted to images of the gods. Men do appear, however, in the minor bands of sculpture, where they are seen engaged in warfare or the chase. The images of the deities at Khajuraho display considerable experimental variation in the main image types, including even the transposition of attributes from one god to another. One of the most striking transpositions is to be seen in the three-headed *Vishnu image in the Lakshmana temple: the god wears boots, a feature otherwise restricted to northern images of the sun god *Surya. A more pronounced syncretism occurs in certain other images which must have been intended as representations of two or three separate gods in a single figure. Surya in particular, characterised by two lotuses, is found in combination with a number of other deities.

Much of the criticism of Chandella sculpture has concentrated on its stylisation. But stylisation here refers to form, which indeed is perfected and rendered in a fixed idiom; it is the flexibility of line which constitutes the original vocabulary of the Khajuraho sculptor, constantly augmented by freshly observed angles, curves and the implication of a break in a line of movement. The line of a necklace emphasises the contour of a breast, etc. The legs and feet are the least satisfactorily portrayed anatomical features; it is the relative positioning of the hands, torso and head which conveys most meaning. Of these, the hands alone are intrinsically expressive – the science of *mudra (ritual hand-gesture) takes on a new meaning at Khajuraho. The fingers are often so articulate as to express in themselves the mood of the whole sculpture. The hands of the lovers at Khajuraho exquisitely convey the most delicate of human emotions, creating a new range of secular *mudras* that have nothing to do with canonical ritual gesture.

CHANDI

Sanskrit: literally 'passionate women'. Name of Hindu goddess of *tantric cult origin. Aspect of *Durga. The name is frequently applied to the goddess as *Mahishamardini.

CHANG Jui-t'u (1576–1641)

Chinese painter from Ch'uan-chou, Fukien, best known for his bold, large-character running-style calligraphy. His paintings are generally in dark ink on satin, and show a marked individuality in style, paralleled by other late *Ming painters.

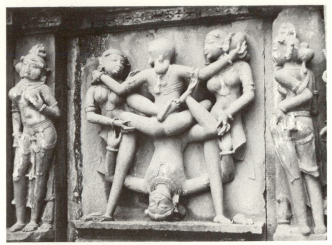

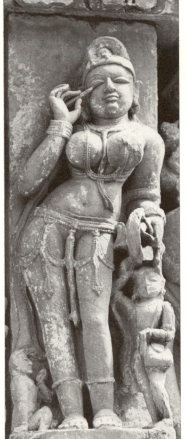

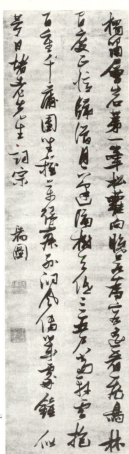

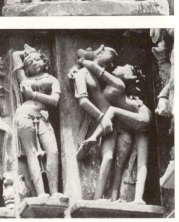

CHANDELLA DYNASTY
Top: Mithuna couple supported by courtesans.
Above left: Lady applying kohl to her eyes.
Above right:
CHANG JUI-T'U Poem in running script. Hanging scroll. Ink on satin. 74×20⅞ (188×53 cm). BM, London

Left: Gods, nymphs and lovers. All 10th–11th century, Khandariya Mahadeva temple, Khajuraho.

CHANG Sêng-yu (active late 5th–early 6th century)

From Soochow, Kiangsu. With *Ku K'ai-chih, Lu T'an-wei and *Wu Tao-tzŭ, Chang Sêng-yu was considered pre-eminent among early Chinese figure painters, but his works and even the traces of his style have long since disappeared.

CHANG Tsê-tuan (active early 12th century)

Chinese painter from Tung-wu, Shantung who worked at the capital in the reign of *Hui Tsung. His fame rests on a single narrative handscroll, *Going up the River on the Ch'ing-ming Festival*, which depicts in great detail the life of the capital, Pien-ching (modern Kaifeng). A great number of Ming and Ch'ing versions of the subject exist, but bear little resemblance to the original painting, now in Peking.

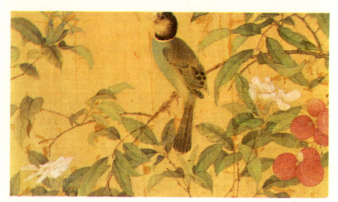

CHAO CHI (HUI TSUNG) *Birds and Flowers*. Detail of handscroll. Ink and colours on silk. $10\frac{1}{4} \times 110\frac{5}{8}$ in (26×281 cm). BM, London

CHANG Yen-yüan (active 9th century)

Author of *Li tai ming hua chi* ('Record of Famous Paintings of Successive Dynasties') published in AD 847 and the principal source of information on painting of the *T'ang dynasty and earlier.

CHANTREY, Sir Francis Leggat (1781–1841)

b. Norton d. London. English sculptor who began as a woodcarver and portrait painter, but established his reputation in 1811 when commissioned to produce a statue of George III and exhibited the bust of Horne Tooke at the Royal Academy. He visited France and Italy, and bequeathed a large fortune to the *Royal Academy of which he had been a member since 1818.

CHAO Chi (Hui Tsung) (1082–1135)

Chinese emperor (reigned 1101–26). An artist and a connoisseur, he wrote calligraphy in an exquisite style of his own invention, 'Slender Gold'. He summoned artists from all over the empire to his academy of painting, and set the themes to be painted. His own works reflect his interest in the naturalistic rendering of bird and flower subjects. He was a weak ruler, and the end of his reign came with the capture and sack of the capital, Pien-ching (*Chang Tsê-tuan), by the Chin Tartars, while the emperor himself died in exile nine years later.

CHAO Chih-ch'ien (1829–84)

Chinese painter from K'uai-chi, Chekiang. A leading calligrapher and seal-engraver, he also painted flowers.

CHAO Kan (active 10th century)

Chinese painter from Nanking, Kiangsu. A single handscroll, *Along the River after Winter's First Snow*, survives by him. It describes the daily life of fishermen, seen in a windy area of marshes and open water. Both the figures and the landscape elements are sensitively delineated. The painting is a masterpiece of a genre that has all but vanished in extant works, the principal exception being *Chang Tsê-tuan's handscroll

showing life within and without the walls of the Northern Sung capital on a festival day.

CHAO Mêng-chien (1199–1295)

Chinese painter from Hai-yen, Chekiang. He painted plumblossom and narcissus.

CHAO Mêng-fu (1254–1322)

From Wu-hsing, Chekiang. A leading figure, both in government as a lone Chinese serving the Mongols, and as calligrapher, painter and theorist. The inspiration for his *Sheep and Goat* was found in *T'ang paintings of animals; in landscape painting also, Chao sought to capture the spirit of ancient masters. *See also* YUAN DYNASTY PAINTING

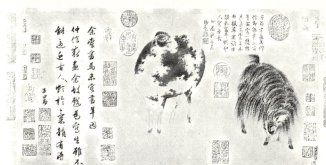

Top: CHAO KAN *Along the River after Winter's First Snow* (detail). Handscroll. Ink and slight colour on silk. Entire scroll $10\frac{1}{4} \times 148\frac{1}{4}$ in ($25 \cdot 9 \times 376 \cdot 5$ cm). National Palace Museum, Taiwan
Above: CHAO MENG-FU *Sheep and Goat*. Short handscroll. Ink on paper. Freer Gallery of Art, Washington, D.C.

CHAO Po-chü (active 12th century AD)

A member of the Chinese imperial family, Chao Po-chü painted at *Hui Tsung's academy and under Emperor Kao Tsung (reigned 1127–62) at Hangchow. He painted landscapes, flowers and figures, all in a minute and refined manner derived from *Li Ssŭ-hsün and *Li Chao-tao of the *T'ang.

CHARCOAL

Partially burnt wood; a common soft drawing medium. Artists' charcoal is generally made from thin willow twigs.

CHARDIN, Jean-Baptiste-Siméon (1699–1779)

b. d. Paris. French painter. He studied under the *history-painter Pierre-Jacques Cazes and later with Noël-Nicolas *Coypel. He was described by the Academy as a 'genre painter of animals and fruit' (1728). In the 1730s he depicted the modest life of the petit bourgeois, adapting the 17th-century Dutch cabinet picture to contemporary French taste. Both genre scenes and still-lifes are painted with extraordinary clarity and economy and they constitute a calm centre in 18th-century French painting. These quiet and simple pictures attracted the attention of the great collectors whose taste had been formed by *Watteau and *Boucher and his paintings remained in great demand throughout his life. He was elected

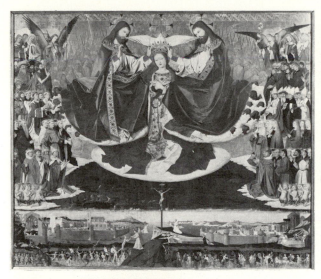

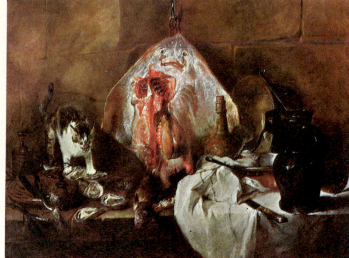

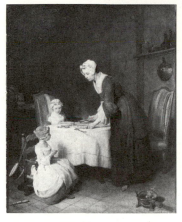

Above left: ENGUERRAND CHARONTON *Coronation of the Virgin*. 1454. 72×86½ in (183×220 cm). Hospice de Villeneuve-lès-Avignon
Above right: JEAN-BAPTISTE CHARDIN *The Skate*. 1728. 44⅛×57 in (114×146 cm). Louvre

Right: NICHOLAS TOUSSAINT CHARLET *Children at a Church Door*. 9½×13 in (24×33 cm). NG, London

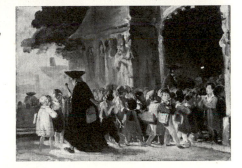

Left: JEAN-BAPTISTE CHARDIN *Grace*. 1740. 19¼×15½ in (49×41 cm). Louvre

Treasurer of the *French Academy (1755), with the task of hanging the pictures in the Salon. At the end of his career he turned to pastel.

CHARLES THE BALD, Bible of (c. 850)

This resplendent product of the †Carolingian scriptorium at Tours is known for its six full-page paintings which combine the Carolingian revival of antique illusionism and a richly decorative sense of colour. Subjects include an early representation of a contemporary event, the presentation of the Bible to Charles the Bald, and a late antique town- and seascape in the scenes from the life of St Jerome.

CHARLET, Nicolas Toussaint (1792–1845)

b. d. Paris. French painter and lithographer, entered the studio of Baron *Gros (1817), and later became associated with depictions of the Napoleonic era, from intimate scenes of barrack-life to turbulent portrayals of the battlefield, eg *Episode in the Retreat from Russia* (1836), praised by de Musset and *Delacroix.

CHARLOT, Jean (1898–)

b. Paris. Painter who studied at Ecole des Beaux-Arts; went to Mexico City (1921); went on Yucatán expedition (1928–9); taught at various American colleges, including University of Hawaii (from 1951). A pioneer of Mexican muralism and scholar of primitive art, Charlot bases his realistic paintings on primitive iconography and modern formal ideas.

CHARONTON (QUARTON), Enguerrand
(c. 1410–?1461)

b. Laon d. ?Avignon. French painter who worked in Avignon. His two documented works are *Madonna of Mercy* (1452,

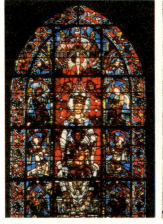

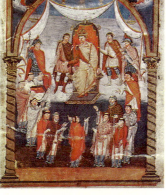

Left: CHARTRES CATHEDRAL Stained-glass window showing Madonna and Child. 13th century
Right: BIBLE OF CHARLES THE BALD *Dedication of the Bible to Charles the Bald*. 851. 18⅛×15⅜ in (46×34 cm). Bib Nat, Paris

Chantilly) painted in collaboration with Pierre Villatte and *Coronation of the Virgin* (1454, Hospice de Villeneuve-lès-Avignon). The latter is a major example of 15th-century French painting, an immense panel, richly imaginative, the lower part set in a wide Provençal landscape. The *Avignon Pietà is now attributed to him by some scholars.

CHARTRES CATHEDRAL

The Cathedral contains two outstanding sets of sculpture; the 12th-century Royal Portal on the west front and the two groups of portals and porches on the 13th-century transept façades. The former are the largest, best preserved and most beautiful of such portals, distinguished by the use of column figures in

the jambs. In their style the architectonic discipline of monumental †Romanesque sculpture blends with the incipient humanism of †Gothic. They date from c. 1150 to 1160. The transept sculpture is early 13th century. Its stylistic sources were partly Laon and partly Sens, but the scale was infinitely more elaborate than anything previously attempted and Chartres became the model for other High Gothic portals in France, of *Paris, *Amiens and *Reims. The Cathedral also contains the only virtually complete set of stained-glass windows to have survived from the 12th and 13th centuries. It is the only place in the world where the effects which early stained glass were intended to produce can still be appreciated.

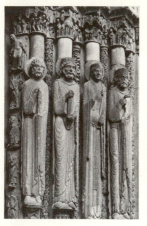 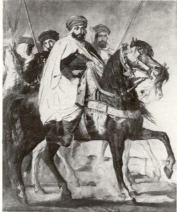

Left: CHARTRES CATHEDRAL Jamb Figures from the Royal Portal. c. 1160
Right: THEODORE CHASSERIAU *The Caliph of Constantine with his bodyguard.* 1845. Versailles

CHASE, William Merritt (1849–1916)

b. Franklin, Indiana d. New York. Painter who studied at National Academy of Design, in Munich (1872–8), taught at *Art Students' League (1878–96, 1907–12), founded New York School of Art and travelled extensively in Europe. Influenced by *Whistler and *Velasquez, his work displays virtuoso brushwork, spontaneity and cheery, tasteful superficiality. A lesser *Sargent, he is known for his elegant portraits, his interiors of artists' studios and his still-lifes.

CHASSERIAU, Théodore (1819–56)

b. Ste Barbe de Samana, South America d. Paris. French painter who synthesised teachings of *Ingres, whose studio he entered at twelve, with the colour and exoticism of *Delacroix in Biblical, Shakespearean and North African scenes (visited Algeria in 1846). He painted large mural decorations in Parisian churches (St Merri, 1843; St Roch, 1854; St Phillipe-du-Roule, 1854) and for the staircase of the former Finance Office (1844–8).

CHAULUKYA DYNASTY (AD 974–1238)

The Chaulukya dynasty, also known as the Solanki, based at Kathiawar, Gujarat, was one of many Rajput clans which set up small kingdoms in the wake of the collapsed *Gurjara-Pratihara empire (c. AD 1000). The religion which they most lavishly patronised as *Jainism, and in particular the Shvetambara ('white-clothed') sect which rose to special prominence under King Kumarapala in the 12th century. The magnificent and intricate Jain and Hindu temples of the Chaulukyas distinguish this dynasty from others of the region in the development of Indian sculpture. Their early Hindu temples, the *Shiva temple at Somnath and the *Surya temple at Modhera in Gujarat, are both in a derelict state; the brown sandstone temple of the sun god at Modhera is richly and delicately carved on every surface excepting only the very base of the pediment and the curious corrugated, sloping roof-projections over the entrance and, in miniature, over the niches

housing images of the gods. Decorative motifs include rows of elephants, horses and fabulous beasts, amorous couples, celestial nymphs and musicians. This relief work is cut very deep into the stone, and from close quarters has a softness of contour, produced by abrasion, which foreshadows the gentle intricacy of the Mount Abu temples. At Abu, in Rajasthan, Chaulukya art reached its highest point. The sculpture of these Jain temples has been described as 'decadent', yet it possesses grace and simplicity. The medium is white marble; structurally, the domes consist of superimposed concentric circles of masonry crossed by supporting brackets, from the centre of which is a pendent 'stalactite'. The circles consist, at the lower levels, of narrow mythological friezes, while the transverse brackets are carved in the forms of the goddesses of wisdom. The higher circles are in the form of open flowers surrounding, or emanating from, the central pendant.

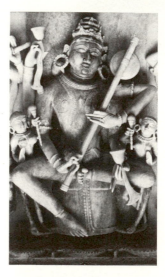

Left: CHAULUKYA DYNASTY *Sarasvati with musicians.* Jaina temple, Mount Abu. 11th century. White marble
Below: CHAULUKYA DYNASTY Domed ceiling with goddesses of wisdom. Vimala Shah Jaina temple, Mount Abu. 11th century. White marble
Bottom: WILLIAM MERRITT CHASE *Hide and Seek.* 1888. 27½×36 in (69·9×91·4 cm). Phillips Collection, Washington, D.C.

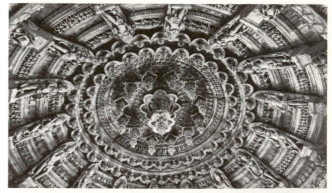

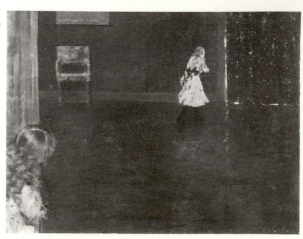

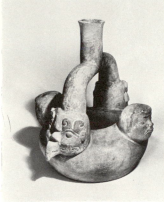

Left: JOSE CHAVEZ MORADO *Hidalgo, the Liberator.*
Altiondiga le Granaditas
Right: CHAVIN Grey pottery vessel decorated with human and anthropomorphic heads in relief. *c.* 900–200 BC. Cupisnique, Peru. h. 8⅞ in (22·8 cm). Royal Scottish Museum

CHAVEZ MORADO, José (1909–)

b. Guanajuato. Painter who studied at Chouinard Art Institute and Central School of Plastic Arts, Mexico; taught at Academy of San Carlos; was leader of Taller de Gráfica Popular (1938–41). While his murals are energetic but conventional political allegories, his easel-paintings show a more personal vivacity and grotesque black humour.

CHAVIN

The earliest major art style in North Peru (*c.* 900–200 BC), characterised by bird and feline motifs arranged in tightly packed curvilinear shapes. Chavín art consists of low-relief architectural decoration, notably at the site of Chavín de Huantar, small stone carvings, goldwork, textiles and a distinctive modelled grey pottery, the finest of which comes from Cupisnique in the Chicama Valley. The Chavín style was widespread, its influence being evident as far south as *Paracas.

CHE SCHOOL *see* CHIANG SUNG; TAI CHIN; WU WEI; MING DYNASTY PAINTING

CHEERE, Sir Henry (1703–81)

b. d. London. English sculptor (pupil of John *Nost) in marble, bronze, stone and lead. He executed many commissions for statues and commemorative busts at Oxford and a large number of monuments, including nine in Westminster Abbey. His chimneypiece designs have a †Rococo flavour.

CHEMEHUEVI *see* CALIFORNIA

CH'EN Hung-shou (1599–1652)

Chinese painter from Chu-chi, Chekiang. Orphaned early, Ch'en Hung-shou studied from rubbings of engraved versions of ancient masterpieces. His line thus often has a sharply defined quality; his figures, for which he is renowned, have an archaic appearance. Many of his designs were used by the engravers of woodblock book illustrations. But he was accomplished with landscapes also: that illustrated is one leaf from an album painted about 1647 by several artists for the Nanking scholar Chou Liang-kung (1612–72), who collected over fifty such albums by friends and contemporaries, and who wrote biographical notes on them in his *Tu hua lu* ('Record of Reading Paintings').

CH'ENG CHENG-KUEI *see* K'UN-TS'AN

CHENG Hsieh (1693–1765)

Chinese painter from Yangchow, Kiangsu. One of *Eight Eccentrics of Yangchow, he painted bamboo, chrysanthemums and orchids, often interweaving his highly individual calligraphy between the stems or on the face of a rock.

CHEN-LA

Chen-la was the successor state to Funan which occupied parts of present-day Cambodia (*c.* AD 600–*c.* 800). The sculpture includes a fine figure of Lakshmi from Koh Krieng in an erect, frontal pose, with deep folds under the ample breasts. The treatment is markedly different from that of another, triple-curved torso of a goddess in Indian style from Sambhor Prei Kuk. A later Lakshmi of the 9th century in which the drapery of the lower garment continues the sensuous unity of the figure as a whole, demonstrates a characteristic combination of sexual and divine power. Although belonging to Buddhism not Hinduism, the standing Buddha from Tuol Prah Theat is similarly presented as a majestic, almost sensually divine figure rather than as an ascetic who has renounced the world and its power. The Bodhisattva from Rach Gia probably symbolises the ruler as a Buddhist whose authority derives from his spiritual dependence upon the teachings of the Buddha. The horse-head form of *Vishnu, in an incarnation yet to come, demonstrates the skill of the Chen-la carver in combining an animal head with a human torso, while his mastery of monumental style and scale is clearly shown in the great Harihara from Prasat Andet.

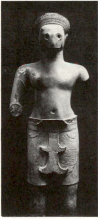
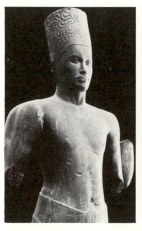
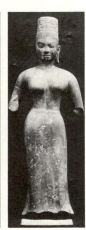

Above right: CHEN-LA *Lakshmi* from Koh Krieng. 7th century. Sandstone. h. 57⅛ in (145 cm). Musée Guimet, Paris
Above centre: CHEN-LA *Vishnu with horse's head. c.* 700. Sandstone. h. 76⅜ in (194 cm). National Museum, Phnom Penh
Above left: CHEN-LA *Standing Buddha* from Tuol Prah Theat. 7th–8th century. Sandstone. h. 15¾ in (40 cm). Musée Guimet, Paris

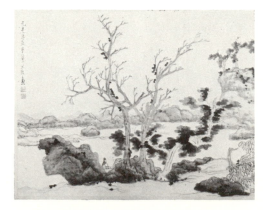

CH'EN HUNG-SHOU *Landscape.* Leaf 2 of an album of 8 leaves by six Nanking artists, painted *c.* 1647 for Chou Liang-kung. Ink and colours on paper. 9¾×12⅝ in (24·7×32·1 cm). BM, London

CHERMAYEFF, Serge Ivan (1900–)

b. The Caucasus, Russia. Painter and architect, educated in England and Germany (1910–17), who went to America (1940), became Director of Institute of Design, Chicago (1946–51), Professor of Architecture at Brooklyn College, then Yale University. His abstract paintings are highly intellectual structures, dependent on an artful interplay of colour.

CHEVALIER, Hippolyte-Guillaume-Sulpice see GAVARNI, Paul

CHEVREUL, Michel Eugène (1786–1889)

b. Angers. French chemist who studied in Paris. He was appointed Head of the Dye Laboratories at the Gobelins tapestry works (1824). There he carried out valuable investigations into colour theory and formulated his findings in his *De la loi du contraste simultané des couleurs* (1839). This became an important source of theory for *Seurat and *Pointillism.

CHEYENNE see PLAINS INDIAN ART

CHIANG Sung (active c. 1500)

Chinese painter from Nanking, Kiangsu. A professional artist of the *Chê School, he excelled in portraying the rivers and hills of his native area, using bold ink washes in ever-varying tones suggestive of mists and luxuriant vegetation.

CHIAROSCURO

An exaggerated use of extreme contrasts of light and shade in painting and drawing.

CHIAROSCURO *The Dice Players* by Georges de la Tour (and detail). c. 1649–51. Teesside Museums, Middlesbrough

CHIBCHA

Colombian culture (c. AD 1000–1550) characterised by distinctive plaques called *tunjos* cast in gold and tumbaga, a copper-gold alloy, in the form of flat figures with the details of features and ornament rendered in fine wire. Chibcha pottery forms, bowls, jars and effigy vessels, are generally monochrome and decorated with stamped and incised detail and applied clay strips.

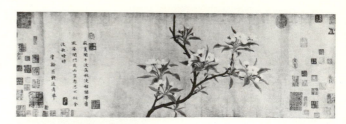

CH'IEN HSUAN *Branch of a blossoming pear tree*. Handscroll. Ink and colours on paper. Mrs John D. Riddell Collection

CH'IEN Hsüan (active late 13th century AD)

From Wu-hsing, Chekiang. Chinese painter, best known for his paintings of flowers and birds, in a continuation of the *Sung Academy style. Ch'ien also painted landscapes and figures, adopting a consciously archaic style in these subjects. *Chao Mêng-fu was his pupil.

CH'IEN Tu (1763–1844)

Chinese painter from Ch'ien-t'ang, Chekiang, who painted landscapes, flowers and other subjects in orthodox styles, and with considerable skill.

CHIKUDEN (Tanomura Chikuden) (1777–1835)

One of the most academic of the 'second-generation' Japanese *Nanga painters, attempting to be severely Chinese. His lesser works are perhaps his most successful.

EDUARDO CHILLIDA *Modulation of Space*. 1963. Metal. $21\frac{1}{4} \times 27\frac{1}{2} \times 15\frac{3}{4}$ in (54×69·9×40 cm). Tate

CHILLIDA, Eduardo (1924–)

b. San Sebastian, Spain. Sculptor who studied architecture in Madrid (1942–7). By nature intuitive, concentrated and conservative, Chillida developed slowly from stone figures to abstract iron (from 1950) and wood (from 1959). Becoming more involved with suggesting space than describing mass, his work retained a figure-like discreteness of form and homogeneity of material. Like *Brancusi he believes almost mystically in form and content emerging from his craftsman-like attention to materials.

CHIMU

A Peruvian people (c. AD 1000–1500) who built their immense capital Chan Chan in the Moche Valley. Chimu art includes carved wooden figures and staffs, gold and silver vessels, masks and ornaments, sometimes inlaid with shell and turquoise, and textiles. A characteristic feature is the mass-produced black pottery, usually mould-made stirrup-spout vessels with low-relief decoration or modelled in the form of figures, animals and fruit.

CHIN Nung (1681–after 1764)

Chinese painter from Hangchow, Chekiang, one of the *Eight Eccentrics of Yangchow. Painter of plum-blossom and a calligrapher renowned for his personal interpretation of the 'official' style with thick horizontals and thin verticals, as though executed with an edged pen instead of the brush.

Top: CHIN NUNG *Returning Home.* Album-leaf with poem by T'ao Ch'ien. Ink on paper. C. A. Drenowatz Collection, Zürich
Above left: CHINESE BRONZE FIGURINES *The Buddhas Prabhutaratna and Shakya-muni.* Dated AD 518. Gilt-bronze. h. 10⅝ in (27 cm). Musée Guimet, Paris
Above right: CHINESE CERAMIC FIGURINES Pottery figure of a Lokapala from the tomb of Lin T'ing-hsun. T'ang dynasty, early 8th century AD. h. 20⅝ in (52·4 cm). BM, London
Below left: CHIMU Hammered fifteen-carat gold beaker decorated with a raised design of warriors. *c.* AD 1000–1450. Lambayeque, Peru. h. 4¾ in (12 cm). Royal Scottish Museum
Below right: CHINESE BRONZE FIGURINES *Seated Buddha.* Northern Wei, dated AD 477. Gilt-bronze. h. 15¾ in (40 cm). MM, New York

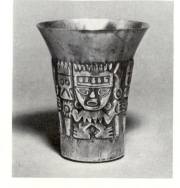 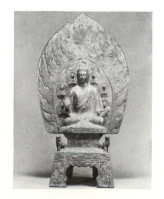

CHINESE BRONZE FIGURINES

In addition to fine Buddhist sculpture in stone, images were cast in bronze throughout the centuries that Buddhism was prevalent in China. Although the texts record the casting of immense bronze images most of the surviving examples are small. They were cast by the *cire perdue method. In style the bronze images reflect many of the sculptural trends seen in the great cave-temples at *Yün Kang, *Lung Men and *T'ien Lung Shan. However it was possible to produce finer detail in bronze than in stone which gave rise to important developments in the use of complicated silhouettes, openwork decoration and elaborate surface treatment. In the later centuries of the Ming (AD 1368–1644) and Ch'ing (AD 1644–1911) dynasties stone sculpture diminished in importance but many bronze images were cast for shrines and household altars.

CHINESE CALLIGRAPHY

The relationship between calligraphy and painting in China is an ancient one. In criticism the same critical terms, such as *Hsieh Ho's *ch'i* ('breath') and *yün* ('consonance'), could be applied to both. The Chinese brush was used for both, giving to Chinese painting its outstanding linear qualities. This is particularly evident in early works such as *Ku K'ai-chih's *Admonitions* handscroll. In this painting also, a section of text is written next to each scene, identifying it and dividing it from the next. The development of literati, or scholar painting in the *Sung and *Yüan periods strengthened the links between painting and calligraphy. In the 11th century, under the influence of such men as *Su Shih and his friends, painting joined poetry and calligraphy as one of the recognised means of expression available to the gentleman and scholar in his leisure-time. Henceforth less emphasis came to be placed on rendering natural form, and more on the expressive possibilities of brush and ink. The *Four Masters of the late Yüan period created individual brush and ink styles, developing forms which served as a basis for ever more calligraphic transformations in later centuries. From the *Ming dynasty onwards, it was common for the scholar-painter to adopt different styles of painting for different occasions, just as the calligrapher had long enjoyed a choice of styles to write in. Poems and inscriptions by the artists, written directly on the painting surface, became part of the work of art, and added to it the dimensions of both poetry and calligraphy.

CHINESE CERAMIC FIGURINES

There was in China a long tradition of sculpture in ceramics. The most important aspect was the modelling of buildings, figures, animals and utensils for burial in tombs. These tomb figures were usually modelled or moulded in pottery and brightly decorated with coloured lead glazes or with painting on the fired clay. A wide variety of elaborate models of buildings and groups of figures have been found dating from the Han dynasty (206 BC–AD 220). The shape and features of the figures are rather rudimentary but the grouping of the figures into troops of actors and musicians, farm-labourers or friends gambling is often lively and convincing. In the Six Dynasties period (AD 221–598) figures rather than models predominate, usually made in dark grey clay. The increasingly realistic representation of human figures in this period reached its climax in the first half of the 8th century, the beginning of the T'ang dynasty. Although made in repeatedly used moulds the best figures of the T'ang period have a liveliness of expression and stance, and accuracy in form which clearly suggests their close relationship to contemporary fine Buddhist sculptures in stone and clay in China and Japan. This same tradition of lead-glazed pottery figures continued in later centuries notably in the decoration of buildings in the form of tiles which often included figures and animals modelled in the round. Figures were also made in stoneware and porcelain in the later Ming and above all the Ch'ing (AD 1644–1911) dynasties. The two most important groups are figures decorated with yellow, green and black glaze on the biscuit, and fine models of birds and animals in porcelain with *famille rose* enamels. *See also* T'ANG DYNASTY SCULPTURE; NARA SCULPTURE

CHINESE FIGURE-PAINTING

Figure-painting is chiefly important in the early history of Chinese painting, until the end of the T'ang dynasty (618–906). *Narrative painting called for the portrayal of good and evil characteristics rather than the exploration of individual natures. The classical style of *Ku K'ai-chih was to be revived in *Li Kung-lin's outline figure-painting, while the brash energy of *Wu Tao-tzŭ was to be echoed in that of *Wu Wei and *Chang Lu, centuries later. Those qualities and aspirations which in the West found expression through the exploration of the human form, were in China lodged in landscape, in natural forms and in the brushwork itself of calligraphy and painting. Portrait painters, with the exception of early masters such as *Yen Li-pen, were generally anonymous: Ming and Ch'ing ancestor portraits in particular reveal little or nothing of their subjects' individual characteristics. Nevertheless, there are a number of exceptions: Sung portraits of monks, *Liang K'ai's portrait of Li Po, *Ch'en Hung-shou's archaic figures and self-portraits, and portraits and self-portraits of 17th- and 18th-century painters.

CHINESE FLOWER-AND-BIRD AND ANIMAL PAINTING

Natural forms have always figured prominently in Chinese art: striking portrayals of animals and birds are constantly found on the ancient bronze vessels of the Shang (1300–1027 BC) and Chou (1027–256 BC) periods, while many of the seemingly abstract patterns found on late Chou and Han dynasty painted lacquer, etc, are stylisations based on real or mythical animals. Plants and trees appear frequently in the art of the Han and Six Dynasties. The overall form is generally simplified, but individual leaves are magnified and are often recognisable as to species. Flowering plants and trees are a constant motif in paintings of the T'ang dynasty (618–906), while at court artists such as *Han Kan and Tai Sung were celebrated as specialist painters of horses or buffaloes. The nobility of their animal paintings was to be revived in the 14th century by *Chao Mêng-fu. Two anonymous paintings Deer in an Autumn Forest attributable to the 10th century (now in the Taiwan National Palace Museum) are sole survivors of their time of a genre that was to absorb the Emperor *Hui-tsung and his painting academy in the early 12th century, when birds and flowers were the subject of countless fans and album leaves. Such paintings were also popular at the Ming court when the academy was revived in the 15th century. From the 14th century onwards, plants and flowers were an important part of the repertory of the scholar-painters. Ink-bamboo could express scholarly and Confucian ideals (*Wên T'ung); Cheng Ssu-hsiao's ink-orchids, rootless, protested against Mongol rule on China's soil; *Chu Ta's broken stems and quizzical birds record his bitter resentment of the Manchu conquest in 1644. See also HSÜ Wei; YÜN Shou-p'ing

CHINESE LANDSCAPE PAINTING

Landscape forms, along with other motifs from nature, are to be found in the earliest surviving Chinese paintings, from the Han dynasty (206 BC–AD 220). At first, trees and hills served merely as the setting for narrative themes: *Ku K'ai-chih wrote How to Paint the Cloud Terrace Mountain as the setting for a portrait of a Taoist master, and his Admonitions handscroll contains a landscape interpretation of one of the morals illustrated; Buddhist narrative paintings at *Tunhuang almost all have landscape settings. Landscape became a painting genre in its own right in the course of the T'ang (618–906) and Five Dynasties (907–66), and monumental works were created in the latter period and in the Northern Sun (967–1126) by masters such as *Li Ch'êng, *Tung Yüan, *Fan K'uan, *Kuo Hsi and many others. The Southern Sung (1127–1279) saw a more lyrical, intimate approach to landscape, exemplified in the works of academic artists like *Ma Yüan. In the 14th century, landscape became a major theme of the scholar-painters, drawing inspiration not from the preceding Southern Sung, but from the giants of the Five Dynasties and Northern Sung. The expressive possibilities of landscape, in the various modes derived from this

'return to antiquity' led by *Chao Mêng-fu and the *Four Masters of the late Yüan, were to ensure its dominance in succeeding centuries (*Ming and *Ch'ing dynasty painting in China).

CHINESE MONUMENTAL TOMB SCULPTURE

From the Han dynasty (206 BC–AD 220) until the Ming period (AD 1368–1644) there was in China a tradition of placing sculptures, first of animals, and later of officials and tribute-bearers, in pairs lining the roads leading to important tombs. Such figures intended, naturally, to be imposing were therefore boldly if somewhat stiffly executed in large blocks of stone. The main stylistic development in the centuries from the Han to the T'ang period (2nd century BC to 10th century AD) was a growing attention to realistic representation of feature and form. In subsequent centuries differences in surface decoration rather than in fundamental treatment are evident.

CHINESE NARRATIVE PAINTING

The earliest paintings so far discovered in China, dating to the Western Han dynasty (1st and 2nd century BC), are principally narrative in character, illustrating either Confucian principles, or mythological and historical events as recent as those leading up to the establishment of the Han dynasty. The advent of Buddhism introduced further opportunities for narrative painting. Many series of *jatakas (stories of the previous lives of the Buddha) and of the life-story of the historical Buddha, are found in stone at *Yün-kang, and in wall-paintings and paintings on silk from *Tun-huang. Such narratives may be illustrated as a series of small separate scenes, or as a long strip with successive incidents in a landscape setting. Both forms can be paralleled in secular painting and bas-reliefs of the Han dynasty, and both survived in the Chinese handscroll format: examples are the Admonitions scroll by *Ku K'ai-chih, with single scenes separated by text passages, and the Ch'ing-ming scroll by *Chang Tsê-tuan, which is a continuous scene. Narrative painting was at its height in China in the T'ang dynasty (618–906). Later, the emphasis was on pure landscape painting, so that *Chang Tsê-tuan's handscroll is one of the last great examples of the genre. Spectacular handscrolls of court events were however executed by or under the direction of *Wang Hui, *Wang Yüan-ch'i and others for the K'ang-hsi and Ch'ien-lung emperors in the 17th and 18th centuries.

CHINESE PAINTING: INSCRIPTIONS AND SEALS

Inscriptions on early Chinese paintings, eg of the *Han and Six Dynasties, are generally in explanation of the subject, identifying the characters in a historical or moral narrative scene. In the Admonitions handscroll after *Ku K'ai-chih, a section of text precedes each illustration in a long sequence. Landscape paintings of the Five Dynasties and Northern *Sung often bear the signature of the painter, hidden in an obscure corner. With the growth of painting by scholars and literary men from the Sung on, inscriptions are more common and longer; in the *Yüan and thereafter, these often include, besides the painter's own inscription, poems or comments by his friends, written on the painting itself. Each inscription may be preceded or followed by a seal or seals, impressed in red ink, giving the names of the writer. Connoisseurs or later owners of a painting may also impress their seals on a painting. Colophons, often bearing on the history of the work as revealed in the style, subject or earlier inscriptions, may be added, especially on handscrolls, where they follow the painting on additional lengths of paper. Inscriptions, seals and colophons were, however, often forged, and can only be corroborative evidence of a painting's authenticity.

CHINESE PAINTING: METHODS AND FORMAT

The Chinese brush, used both for *calligraphy and for painting, has been the single most important factor in the whole history of Chinese painting, from the *Han dynasty and before, to the present. Mounted in a simple bamboo holder, its hairs are carefully graded, both as to length and as to resilience, so

that they come to a point when the brush is moistened. Thus both fine and broad lines can be produced with the same brush, by variation of pressure. Ink, made of pine soot, refined and solidified with glue into sticks or blocks, is ground with water on a suitable stone; the degree of dilution determines the shade, from palest grey to deepest black. Colours are mineral earths mixed with water. The majority of early paintings, up to the end of the *T'ang dynasty, were wall-paintings, applied to dry plaster in secular buildings, and with the introduction of Buddhism, in monasteries and cave-temples also. Paintings on silk and on paper, which had existed alongside wall-paintings, gained the ascendancy from the 10th century on. The principal formats used for these paintings were the hanging scroll, in vertical format, mounted with paper backing and silk borders so as to hang flat when unrolled; the handscroll, generally about a foot high and many feet in length, to be unrolled on a table so that a short section remains visible at any stage in the unrolling; fan-paintings in various shapes; and albums, generally of eight, ten or twelve leaves, often with facing pages for poems or colophons. Chinese scroll-paintings were seldom hung for any time, but were kept rolled up and protected by a box or outer covering, to be produced for the enjoyment of a few friends, and put away again. The hand-scroll and the album are intimate forms which have to be viewed at close quarters, and in sequence, introducing a time element not present in Western painting.

CHINESE SCULPTURE

The sculpture of China can be studied in the general essay at the beginning of this book and under the following headings: SHANG DYNASTY STONE SCULPTURE; CHOU DYNASTY BRONZE SCULPTURE; YUN KANG; LUNG MEN; MAI CHI SHAN; T'ANG DYNASTY SCULPTURE; T'IEN LUNG SHAN; WAN FO SSU; KUNG HSIEN; YIN HUA HSIEN; CH'U YANG; CHU YUNG KUAN; FEI LAI FENG; CHINESE CERAMIC FIGURINES; CHINESE MONUMENTAL TOMB SCULPTURE and CHINESE BRONZE FIGURINES.

CH'ING DYNASTY PAINTING

At the end of the Ming dynasty, *Tung Ch'i-ch'ang intensified the earlier contrast between the outlook of the professionals and that of the scholars in his interpretation of the history of Chinese painting. Early Ch'ing artists, particularly the *Four Wangs, followed his precepts to create orthodox styles. These artists, some of them high officials, were popular and successful. Others, monks or individualists like *Chu Ta, *Tao-chi and *K'un-ts'an, painted in mute protest against Manchu rule and in loyalty to the Ming. Their interpretations are highly personal, reflecting the intensity of their emotions and appearing far from ancient manners. Yet they share with the orthodox painters the creation of a new, more abstract vocabulary of brush and ink. The orthodox painters used systematic brush motifs to re-create various noble landscape styles of antiquity; Chu Ta and others stripped their subjects to essentials, which, if free of direct inspiration from antiquity, owed their power also to the expressive possibilities of brush and ink. The orthodox landscape styles were unfortunately open to uninspired imitations: only *Tai Hsi stands out in the later orthodox tradition. The 18th century was a time of vast growth for the imperial collections, and of highly disciplined artists at court (among them the Italian Jesuit Giuseppe Castiglione, famed for his pictures of horses). The *Eight Eccentrics of Yangchow painted for a new clientele of wealthy salt merchants. Meanwhile, however, Ch'ing scholarly interest in epigraphy encouraged calligraphers to experiment with archaic forms of script, and the works of the early Ch'ing individualists inspired late 19th-century and modern painters of importance: Jen I, Wu Ch'ang-shih and others.

CHING Hao (active late 9th and early 10th centuries)

Chinese artist from Ch'in-shui, Honan. Landscape painter and author of the *Pi-fa-chi* ('Notes on Brushwork'), a treatise on landscape painting.

CH'ING PERIOD SCULPTURE see CHINESE BRONZE FIGURINES; CHINESE CERAMIC FIGURINES

CHINNEN (Onishi Chinnen) (1792–1851)

Japanese artist, one of the most imaginative of the *Shijō painters in the central period (1830s). Best known for his printed books.

CHINOISERIE

European vogue which began in the 17th century but was most important from mid 18th century onwards, being particularly relevant to the decorative arts and architecture. The style was based on a combination of accurate information, coming from the East with travellers and traders, and Romantic ideas of the Orient. Sir William Chambers's pagoda at Kew was an early example of chinoiserie in garden architecture and landscape gardening was also increasingly influenced by the style. Eventually little distinction was drawn between Japanese and Chinese and, ironically, at the same period Chinese were taking to Occidental culture for the first time. It influenced painting through *Boucher and *Tiepolo and was an essential ingredient of the †Rococo.

CHIOS, Nea Moni, Greece

A monastery church built and decorated by the Byzantine Emperor Constantine IX Monomachos (1042–54). The damaged mosaic cycle is executed in a rigid, monumental style with heavy shadowing on the faces and unrealistic patterned lines to express drapery. The bright colours and provocative handling of gold promote an atmosphere of elegance and sophistication rather than monastic austerity.

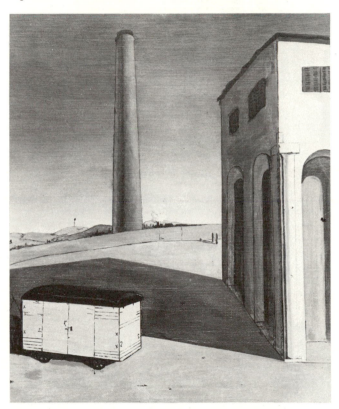

GIORGIO DE CHIRICO *The Anguish of Departure*. 1913–14. 33½×27½ in (85·1×69·9 cm). Albright-Knox Art Gallery, Buffalo, New York

CHIRICO, Giorgio de (1888–)

b. Volo, Greece. Italian painter who studied painting in Athens and later Munich where he discovered *Böcklin. The dream-like intensity of his paintings (1910–18) of arcades, towers, Italian squares, often empty except for statues, and later,

mannequins, eg *The Enigma of a Day* (1914), and *Grand Metaphysical Interior* (1917), strongly influenced the *Surrealists. A feeling of mystery is heightened by his use of contradictory perspective, and the juxtaposition of unlikely objects. After 1918 his work became more mechanical and lost much of its power.

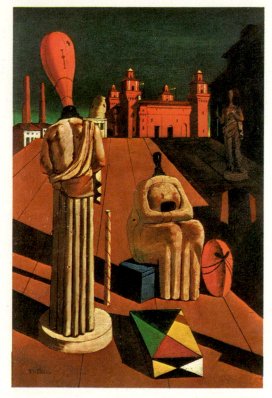

GIORGIO DE CHIRICO *The Disquieting Muses*. 1917. 38¼×26 in (97·2×68 cm). Mattioli Coll, Milan

CHIRIQUI

Late Pre-Columbian culture in Panama, notable for goldwork and a variety of pottery styles including a two-colour negative painted ware, and painted vessels decorated with alligator motifs in red and black on a cream ground.

CHISEL

A steel bar formed into a cutting tool by sharpening one end to a point or wedge. The tool can have a great variety of points or cutting-edges and is used principally by sculptors for carving or working stone, wood or metal.

CHITON

A light, sleeved tunic worn by women in ancient Greece; sometimes belted or waisted.

CH'IU Ying (active *c*. 1500)

Chinese painter from T'ai-ts'ang, Kiangsu. A professional painter of the highest calibre, reinterpreting academic themes from the *Sung, both in figure and in landscape painting. His paintings have attracted more imitations than those of any other artist: hundreds of 'blue and green' (*Li Ssŭ-hsün) landscapes and handscrolls showing the life of ladies at court bear his signature and seal, though executed much later in the *Ch'ing dynasty (1644–1911).

CHLUDOV PSALTER

One of a small group of †Byzantine manuscripts containing the Greek text of the Psalter together with a large cycle of marginal illustrations, which comment on the text in a propagandist anti-*iconoclast manner. The style is crude and simple yet fresh in design. The manuscript probably originates from the Patriarchal circle in Constantinople in the second half of the 9th century. (Historical Museum, Moscow.)

CHLUDOV PSALTER *The Destruction of the Icons*. State Historical Museum, Moscow

CHOCQUET, Victor (1840–99)

b. Lille. An early friend and patron of the †Impressionists (from 1874). He worked in the customs administration and with his limited resources acquired a significant group of works by *Delacroix, *Monet, *Manet, *Renoir, *Pissarro, *Cézanne and *Sisley. He became a staunch early defender of Cézanne who painted him several times.

CHODOWIECKI, Daniel (1726–1801)

b. Danzig d. Berlin. Polish-German painter who went to Berlin (1746). Starting as a miniaturist he turned to genre scenes of the German bourgeoisie. Their delicate realism contrasts with the †Rococo historical and allegorical scenes then in vogue and foreshadows 19th-century *Biedermeyer painting.

CHOKWE *see* BAJOKWE

CHOLA DYNASTY (AD 850–1267)

The Cholas had been a power in the Dravidian south of India even in *Mauryan times; but it was in the mid 9th century AD that a Chola chief took the Tanjore region and declared himself king. *Pallava lands were annexed, the neighbouring state of the Pandyas and the northern half of Ceylon were invaded and the two capitals, Madurai and Anuradhapura, taken. In the early 11th century they lost Ceylon, but the nucleus of the kingdom round Tanjore and Kanchi persisted until the 13th century when the *Hoysalas and Pandyas between them finally destroyed Chola power in the south.

The influence of the art style of the Pallavas, whom the Cholas superseded in the 9th century, is clearly visible in early Chola stone and bronze sculpture. The early Chola figures, however, are more elongate; the anatomy is less ponderous in the case of sculpture and more graceful of posture in the case of bronze figurines. The iconography also reflects Pallava influence; the trident, for example, which is an emblem of *Shiva in northern images, appears in early Chola images of the god

along with the specifically southern attributes of axe and deer. Early Chola sculpture is to be found on the temples of Kumbakonam, Kilayur and Shrinivasanallur. The classical phase of Chola art began in the 10th century and centred round the god Shiva. The great Shiva temple at Tanjavur (Tanjore) (built *c.* AD 1000), has a two-hundred-foot tower which abounds with superb sculptural work depicting the mythological episodes in which Shiva triumphs over the forces of darkness and bestows blessings upon his devotees. One such piece, a *Lingodbhava (Sanskrit: *linga-udbhava*, 'manifestation of the phallus') is now in the British Museum. The myth depicted treats of the manifestation of Shiva as core and axis of the universe, the active characters in the story being the two other main gods of Hinduism, *Vishnu and *Brahma. The icon illustrating this myth is a *linga* (phallic emblem) which is Shiva, as demonstrated by the anthropomorphic image of the god standing inside it with his lower right hand raised in the gesture of bestowing peace upon the worshipper. The stylistic representation of flame as seen on this icon is paralleled in Chola bronzes, particularly in the Shiva Nataraja images. The two gods over whom Shiva demonstrated his superiority are shown in relief on the face of the *linga*, Brahma at the top assuming the form of a goose (his cognisance) flying upwards, and Vishnu in his boar incarnation digging downwards, in the vain attempt to find an end of the fiery column. Besides the flames, two other stylistic peculiarities may be noted in this image. The sharp edge running down the centre of Shiva's legs below the knee and indicating the tibia is a feature not so emphasised elsewhere. Secondly, the earrings of the god present a new feature in that while on the proper left (the female side) he wears a large ring inserted into a slit in the lobe causing elongation, on the right (male) side is a pendent ornament in the shape of a *makara or sea-monster; this combination of ear-ornaments was employed also in Chola bronze figurines. The other great temple of this period, built some twenty-five years later (*c.* AD 1025) is at Gangaikondacholapuram near Kumbakonam. An interesting image from this temple portrays Shiva seated with *Parvati and winding a garland round the head of a devotee, thought to represent the Chola king Rajendra who built the temple. Parvati sits to the god's proper left, which is conventional in Hindu iconography; similarly, she is smaller than the deity himself. The Shiva-Parvati couple was a favourite theme of Chola artists, in stone and bronze. Particularly popular in the latter medium was an image-type known as Somaskanda Shiva, 'together with Uma [ie Parvati] and Skanda [ie *Karttikeya]'. The couple is depicted seated at opposite ends of a dais with the tiny figure of the infant Skanda between them (often missing from extant composite bronzes). In the example illustrated, the torso of Uma is turned towards her son, one hand holding her habitual emblem of blue lotus bud, the other open and turned outwards in the gesture of bestowing largesse upon the worshipper. Shiva himself sits facing the devotee, his two upper hands holding his attributes, the lower two quelling fear with the *abhaya gesture and inviting the worshipper to approach with the other. The eyes of both figures are closed in meditation. The excellent images of Shiva as *Nataraja. (Sanskrit: 'Lord of the dance') were developed by the Cholas from Pallava prototypes. The image consists of Shiva, four-armed, dancing within a circle of fire upon a prostrate dwarf. The two upper hands of the god carry, instead of the usual attributes, a small double-ended hand-drum (*damaru*) on the right, and on the left a ball of fire. Of the two lower hands, the right is raised in the gesture of reassurance and the left arm is swung across the body in the so-called 'elephant's trunk' gesture, parallel to the raised left leg. The right leg is planted firmly on the back of the dwarf. Indicative of the frenzy of the dance, the god's hair and sash fly outwards to touch the fire-circle. In the midst of this display of power and rhythm the god's face is serene and introspective, the eyes shut. The drum signifies creation; the ball of fire dissolution, the fate of all mortality; and Shiva crushes underfoot selfish desire, represented by the puny dwarf. Later Chola sculpture is to be found on the temple at Darasuram which is especially famous for its reliefs depicting the classical Indian dance. The lives of the *Shaiva saints, each with its own identificatory inscription,

are sculpted round the plinth. On the pediment of the hall are carved wheels and horses, thus representing the temple as the chariot (*ratha) of the god.

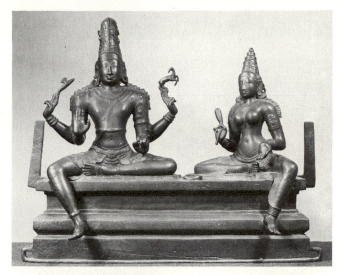

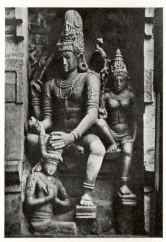

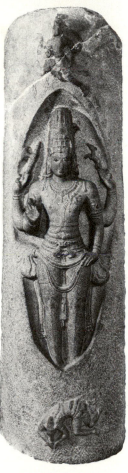

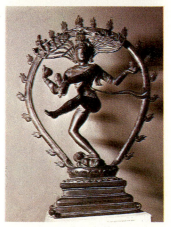

Top: CHOLA DYNASTY *Shiva and Parvati.* From Madras region. 10th century. Bronze. h. 18½ in (47 cm). V & A, London
Centre: CHOLA DYNASTY *Shiva with Parvati honouring a devotee.* Gangaikondacholeshvara temple, Gangaikondacholapuram. *c.* 1025
Above left: CHOLA DYNASTY *Shiva Nataraja.* From Madras region. 10th century. Bronze. h. 27 in (68·6 cm). V & A, London
Above right: CHOLA DYNASTY *Shiva Lingodbhava.* From Tanjavur. 10th century. Granite. h. 54 in (137 cm). BM, London

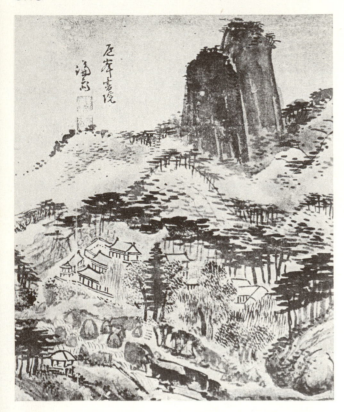

CHONG SON *The Confucian college of Tobong Sowon.* Ink on paper. P'yongyang Gallery of Art

CHONG Sŏn (Kyomjae) (1676–1759)

Korean painter and that country's master of landscape. Unlike many of his contemporaries, he avoided the Chinese manner to paint in a more immediate and realistic style. His technique is soft and his most famous subject-matter is misty valleys in mountains. *Yi In-sang, *Sim Sa-jŏng and others followed him on this independent course.

CHOSHUN (Miyagawa Choshun) (1683–1753)

Japanese artist who originally studied the *Tosa school of painting, but came later under the influence of *Moronobu and produced his own version of *Ukiyo-e. He never designed prints or illustrated books.

CHOU Ch'en (active c. 1500)

Chinese landscape painter from Soochow, Kiangsu, who worked in the manner of *Li T'ang. Both T'ang Yin and *Ch'iu Ying were his pupils, and their names are linked in Chinese writings as a group distinct from both the scholars of the Wu School (*Shên Chou, *Wên Cheng-ming) and the professionals and *Che School painters.

CHOU DYNASTY BRONZE SCULPTURE
(1028–221 BC)

Among the wealth of Chinese bronzes of the Chou period, vessels, weapons and chariot-fittings, sculptures of animals and figures are very rare. However from the very beginning and from the latter part of this long dynasty a few examples are known. The early pieces comprise some vessels cast in the shape of real or imaginary beasts and fittings in the shape of single or of groups of animals. The sculptures from the end of the Chou dynasty, although often intended as mounts of supports for vessels, appear more independent than the previous group. This tradition continued into the Han dynasty (206 BC–AD 220) until the use of bronze declined.

CHOU Fang (active second half 8th century)

From Ch'ang-an, Shensi. Praised in Chinese records as a painter of portraits, and of wall-paintings in Buddhist temples, none of which have survived, but known especially for his paintings in full colours of T'ang court ladies, engaged in courtly pastimes and magnificently dressed.

CHOU Liang-kung see CH'EN Hung-shou

CHOU Wên-chü (active 10th century)

Chinese painter from Chü-jung, Kiangsu. Court painter at the academy of Li Hou-chu (reigned 961–75). As a figure-painter, he ranked with Chang Hsüan and *Chou Fang of the *T'ang dynasty.

CHRETIEN, Félix (c. 1510–79)

b. d. Auxerre. French painter, who worked mainly for the Dinteville family, which also patronised *Holbein the Younger. This explains his emphasis on strong colour and accurate (and allegorical) portraiture.

CHRISMAS, Garrett see CHRISTMAS, Gerard

CHRISTI, Petrus see CHRISTUS

CHRISTMAS, Gerard (Garrett CHRISMAS)
(d. 1634)

b. ?Colchester d. London. English sculptor and architect. As architect, he was responsible for the design of the Aldersgate (made before 1625, destroyed 1761) which included an equestrian relief of James I, and for the façade of Northumberland House. Did much work on allegorical pieces for festivals and pageants.

CHRISTUS (CHRISTI, CRISTUS), Petrus (d. 1472)

b. Baerle d. Bruges. Early Netherlandish painter who worked in Bruges, probably a pupil of Jan van *Eyck. Historically his importance lies in bridging the gap between van Eyck and *Memling. An excellent craftsman and fine portrait painter, he was indebted to others for his compositional ideas. Influenced by van Eyck (1444, *Exeter Madonna*, Berlin) and Rogier van der *Weyden (1465, *Lamentation over Christ*, Brussels). His

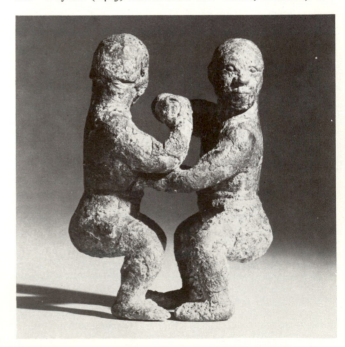

CHOU DYNASTY BRONZE SCULPTURE *Wrestlers.* 6th–3rd century BC. BM, London

dated portraits, eg *Edward Grymestone* (1446, NG, London) are finely and sensitively painted even if they lack the immediacy of van Eyck's.

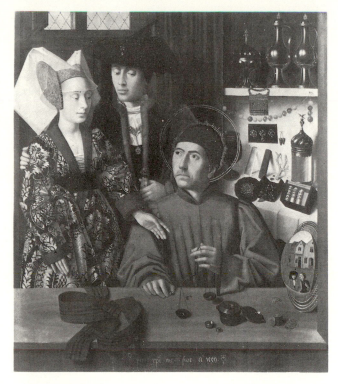

PETRUS CHRISTUS *St Eligius and the Lovers*. 1449. 39⅜×33⅞ in (100×85·9 cm). Robert Lehman Collection, New York

CHU-JAN (active *c.* 960–80)
From Chiang-ning, Kiangsu. Chü Jan was a monk and a follower of *Tung Yüan, painting landscapes in the softer character of the south, in contrast to the ruggedness of the north (*Fan K'uan). *Asking for the Tao in Autumn Mountains* clearly shows the 'earthen slopes topped with boulders' of his manner. The title itself is an embodiment of Chinese thinking which saw in landscape painting the expression of the Tao or constant principles of the universe, through formal conventions of brushwork.

CHU Ta (Pa-ta-shan-jen) (*c.* 1625–1705)
Chinese painter, a member of the *Ming imperial family who became dumb at the Manchu conquest (1644). Painted landscapes, flowers and birds, all in a highly individual style and often with poems or pictorial allusions sharply critical of Manchu rule and the society of his day. He was also a powerful calligrapher using a worn brush that gives his writing the same blunt character as the bent flower stems of his painting.

CHU Tê-jun (1294–1365)
Chinese painter from Sui-yang, Honan, who continued the landscape style of *Li Ch'êng and *Kuo Hsi. As a young man, he was recommended by *Chao Mêng-fu to a visiting Korean prince and his painting was probably influential in the early development of Korean landscape painting.

CHUMASH *see* CALIFORNIA

CHUPICUARO *see* WESTERN MEXICO

CHURCH, Frederick Edwin (1826–1900)
b. Hartford, Connecticut d. New York. Painter who studied and lived with *Cole at Catskill (1844–8), and travelled extensively: to South America (1853, 1857), Europe and Palestine (1868), Labrador and West Indies. His vast paintings of exotic landscapes frequently combined scientific observation with religious awe, but often lost vision in bombast.

Above: FREDERICK EDWIN CHURCH *The Heart of the Andes*. 1959. 66⅛×119¼ in (168×302·9 cm). MM, New York, Bequest of Mrs David Dows, 1909

Above left: CHU-JAN *Asking for the Tao in Autumn Mountains*. Hanging scroll. Ink on silk. 61½×30⅜ in (156·2×77·2 cm). National Palace Museum, Taiwan
Above right: CHUSONJI *Ichiji Kinrin*. Late Heian period. Wood. 34⅞ in (44 cm)

Left: CHU TA *Landscape*. Hanging scroll. Ink on satin. 24⅝×19¾ in (62·6×50 cm). BM, London

CHUSONJI, The
A Buddhist temple in Iwate Prefecture, Japan, dedicated to Amida. It houses the most securely dated group of wooden sculptures of the late *Heian period.

CH'U YANG, Sculptures from
Excavations at the site of Hsiu Te Ssŭ in Ch'ü Yang Hsien in Hopei province, China, have brought to light some 2200

pieces of Buddhist sculpture in white limestone, of which 247 are dated. This important group exemplifies the style of the region in the period AD 520–750. The earliest dated piece, a figure of the Buddha (AD 520) in heavy robes with sharply peaked folds is related to sculptures from Shantung province and thus perhaps to a school of sculpture which must have flourished to the south in the coastal region. Distinctive features of sculptures of the later 6th century among this group include two iconographic types less common elsewhere: the Meditating Bodhisattva seated with one ankle resting on the knee of the other leg; paired figures of Bodhisattvas or of the Buddha. Contrasting with the smooth figures are trees carefully pierced in delicate openwork which frame many of the images. This local sculptural style was particularly influential in Korea.

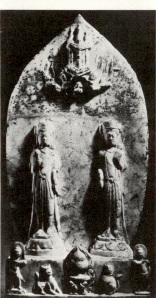
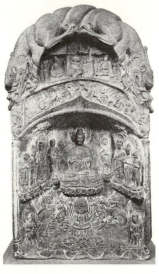
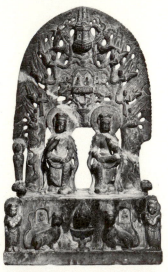

Above left: CH'U YANG Paired figures of the Bodhisattva Avalokiteshvara. Northern Ch'i dynasty, second half 6th century AD. Marble. Freer Gallery of Art, Washington, D.C.
Above right: The Buddha attended by Bodhisattvas and disciples. Dated AD 551. Limestone. h. 39 in (99·1 cm). University Museum, Philadelphia. (This Northern Ch'i piece should be compared with the two examples from Ch'u Yang in north-eastern China)
Left: CH'U YANG Paired figures of the Bodhisattva Avalokiteshvara. Stele excavated at Ch'u-yang-hsien. Northern Ch'i dynasty, dated AD 562. Stone. h. 21¼ in (54 cm)

CHU YUNG KUAN, Reliefs at the

A stone gate some fifty miles north-west of Peking. It was constructed in the reign of the Mongol Emperor Shun Ti (AD 1336–67). Originally built as a podium for Buddhist *stupas or reliquaries, it is rectangular in plan and has a central archway. It is decorated with lively carvings in low relief. The interest of the Mongols in the *Tibetan or lamaist form of Buddhism inspired the incorporation of deities celebrated in that pantheon. These exotic figures were combined with more typically Chinese motifs such as the vivid leaping figures of the four guardian kings.

CIBBER, Caius Gabriel (1630–1700)

b. Flensburg d. London. Anglo-Danish sculptor. Visited Rome and came to England before the Restoration. He produced the relief on the monument erected in memory of the Great Fire of London and worked at Chatsworth, St Paul's and Hampton Court. Mainly influenced by Italian *Mannerist and †Baroque sculpture, his later work reflects contemporary Dutch trends.

CIBORIUM

*Baldacchino. The same name is also given to a receptacle for the Eucharist, shaped like a cup, with an arched cover.

CIGNANI, Carlo (1628–1719)

b. Bologna d. Forlì. Italian painter, trained by *Albani. Executed fresco cycles for the Farnese family in Leghorn, Rome and Parma. He settled at Forlì (after 1686), decorating a chapel in the Cathedral. Estimated to have trained sixty-four pupils.

CIMA DA CONEGLIANO, Giovanni Battista (c. 1460–1518)

b. Conegliano. Venetian painter successively influenced by *Antonello da Messina, Giovanni *Bellini and *Giorgione. He was preoccupied by the need to unify figures, landscapes and architecture through the action of mellow, diffuse light on rich colour harmony. Changes in style evident in comparison of *Baptism of Christ* (1494, Venice) and his *Doubting Thomas* (1504, NG, London).

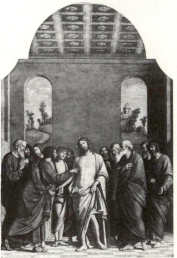

Left: CHU YUNG KUAN Guardian King and attendants, from the Chu Yung Kuan gate, Wall of China. Yuan dynasty. 14th century
Right: CIMA DA CONEGLIANO *Doubting Thomas.* 1504. 115¾×78⅛ in (294×199·5 cm). NG, London

CIMABUE (Cenni di PEPI) (late 13th century)

Florentine painter mentioned in Rome (1272) and in Pisa (1301–2), who developed the Florentine tradition of *Coppo di Marcovaldo. His new solidity, leading to *Giotto's *Ognissanti Madonna* (Uffizi), can be seen in his *Sta Trinità Madonna* (1280s, Uffizi). His angels stand on the ground unlike *Duccio's hovering angels in the *Rucellai Madonna* (c. 1285, Uffizi). His range is apparent in the mural-paintings he executed with imperfect technique in S. Francesco in Assisi (c. 1280) which includes a dramatic Crucifixion and paintings of cities in the Evangelist portraits.

CIPRIANI, Giovanni Battista (1727–85)

b. Florence d. London. Italian artist, who came to England (1755). Active as a restorer (of *Verrio at Windsor, and *Rubens at Whitehall) he designed everything from bookplates to mythological paintings in a highly decorative manner. He also practised *stipple-engraving.

CIRCLE see CONSTRUCTIVISM

CIRE PERDUE (LOST WAX)

A method of metal-casting from a wax model used since antiquity. The model is coated with refractory substance such as *terracotta and then fired. The clay bakes hard and the wax is melted out, leaving a hollow mould into which the hot metal can be poured. The mould is broken off the casting and destroyed, but any number of wax models can be made from an original mould. Used increasingly today as an industrial process.

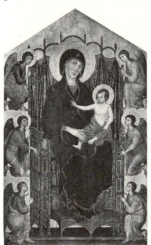

Left: CIMABUE *Maestà* from Sta Trinità, Florence. *c.* 1280. 151⅝×87⅛ in (385×223 cm). Uffizi
Right: PIETER CLAESZ *Still-life.* 1636. Boymans-van Beuningen Museum, Rotterdam

Below: CIMABUE (attr) *Madonna and Child Enthroned with Angels and St Francis. c.* 1280. Fresco. S. Francesco, Assisi

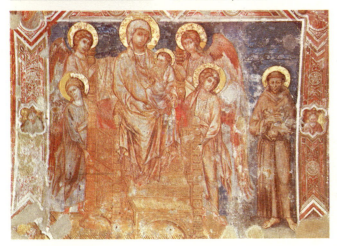

CIULINOVI, Giorgio see SCHIAVONE, Giorgio

CIURLIONIS, Mikolajus (1875–1911)

b. Orany, Wilno d. Heilanstalt Cervony Dvor, nr Warsaw. Lithuanian painter and composer, attended the Conservatory, then Art School in Warsaw, lived in Wilno, but towards the end of his life worked in St Petersburg. About the same time as *Kandinsky's, his *Symbolist compositions tended towards abstraction. The *World of Art' exhibition (1912) devoted a section to his work.

CIVITALI, Matteo (1436–1501)

b. d. Lucca. Italian sculptor and architect, friend and probably pupil of Antonio *Rossellino. He worked chiefly in Lucca Cathedral, the tomb of Piero da Noceto being his first important commission. Influenced, almost inevitably, by Florentine sculpture, Civitali was an unoriginal but tasteful artist.

CLAESZ, Pieter (1597/8–1661)

b. Burgsteinfurt d. Haarlem. Dutch still-life painter who worked mainly in Haarlem and popularised the breakfast piece. With Willem *Heda, his contribution to Dutch still-life

painting lies in his ability to animate the simple, everyday objects in his pictures – a crumpled cloth, a hunk of bread – through tonal painting in subdued colours and a skilful disposition of those objects in space. His informal compositions are imbued with atmosphere.

CLARKE, Geoffrey (1924–)

b. Derbyshire. English sculptor who studied at Lancaster and the Royal College of Art (1948–52). Received many commissions for public buildings, eg the Flying Cross and the High Altar Cross at Coventry Cathedral. Uses principally metal castings of abstract forms exploiting various degrees of surface finish.

CLARKE, Lygia (1920–)

b. Belohorizonte. Brazilian *Kinetic sculptress who studied under *Léger, Dobrinsky and Szenes in Paris (1950). Her work consists of abstract reliefs, articulated sculpture and environmental projects which invite spectator participation. Her pieces relate to *Constructivism in manipulation of time and space.

CLAUDE *Hagar and the Angel.* 20¾×17¼ in (52×44 cm). NG, London

CLAUDE (Claude GELLEE, Claude LORRAINE, LE LORRAIN) (1600–82)

b. Chamagne, Lorraine d. Rome. French ideal landscapist whose influence was widespread in 18th-century England;

trained as a pastry-cook, he travelled to Rome (c. 1613), becoming the pupil, then assistant, of Agostino *Tassi. Between 1619 and 1624 he spent two years in Naples, settling in Rome for life (1626/7). Beginning as a decorative fresco painter, by the mid 1630s he was famous as a landscapist. His style evolved gradually, starting with Northern-influenced, often small, paintings. In the 1630s he developed a new use of light both in seaport subjects and pastoral landscapes. His *Harbour Scene* (1634, Hermitage) contains the first representation of a visible sun to illuminate the whole picture. The 1640s saw his most classical phase, influenced by *Domenichino, subjects being drawn from mythology or the Bible; *Marriage of Isaac and Rebecca* (NG, London). In the early 1660s his last style emerges, mysterious and solemn. Silvery tones predominate, the subjects set the mood, as in his most famous single picture *The Enchanted Castle* (1662, Loyd Coll., Wantage). Claude's drawings are remarkable, and were clearly cherished by him. The *Liber Veritatis* (BM, London) contains 195 drawings recording his compositions as a safeguard against forgery. His nature drawings, executed spontaneously in chalk or pen and wash, supplied visual material for his paintings.

CLAUDE *The Tiber above Rome*. Wash drawing. 7½×10½ in (19·1×26 cm). BM, London

CLAUDE GLASS

A convex mirror in black glass used for viewing a landscape in a reduced, intensified image and as an aid to painting. Said to have been used by, or to produce an effect similar to the work of *Claude.

CLAUSEN, Sir George (1852–1944)

b. London d. Newbury. English painter, worked in Paris under *Bouguereau, but was given direction by *Bastien-Lepage's *plein-air painting. His first such work, one of many studies of the rural labourer at work in a landscape, was exhibited in 1886. His work is characterised by small, vibrant touches of paint.

CLAVE, Pelegrín (1810–80)

b. Catalonia d. ?Spain. Painter who was Director of Mexican Academy of San Carlos (c. 1845–68). Academic himself, influenced by French†Neo-classicism and German†Romanticism and opposed to native Mexican art and ideas, Clavé imposed the rules and customs of sophisticated European art on Mexico for twenty years.

CLEAVAGE

The accidental separation of a painting from its *support, or into its constituent layers.

CLEEF, Joos van *see* CLEVE

CLERCK, Hendrick de (c. 1570–1630)

d. Brussels. Flemish painter whose successful career was due to the great demand for altarpieces in Brussels to replace those destroyed in 1576. He was at his best in small-scale panels with mythological and Biblical themes, using unnaturally bright colours.

CLEEVE (CLEEF), Joos van (MASTER OF THE DEATH OF THE VIRGIN) (d. 1540)

b. ?Cleves d. Antwerp. Flemish painter of portraits and religious subjects. Master at Antwerp (1511) – registered as Joos van der Beke, probably his real name – he ran a large workshop. In demand as a portraitist he was at the court of François I (c. 1530) where he painted the King and Queen Eleanor several times. In England he painted Henry VIII (1536). His earliest dated religious works are two panels, *Adam* and *Eve* (1507, Louvre) showing a debt to *David. His later work reflects the influence of *Leonardo, eg *Madonna and Child* (Fitzwilliam, Cambridge). Although no innovator, and although owing much to *Memling and David, Joos developed an easy form of *Mannerism, his often restless figures in exaggerated poses being set in wide and pleasant landscapes. Two pictures of the death of the Virgin (1515, Cologne and Munich) show considerable skill in rendering effects of interior light.

JOOS VAN CLEEVE *Death of the Virgin*. 1515. 52×60⅝ in (132×154 cm). AP, Munich

CLIMACUS, ST JOHN, Illustrations of

The text of the *Ladder of Paradise* was written by St John Climacus, Abbot at Mount Sinai (d. c. 650). The theme is moral perfection, to be achieved in thirty 'rungs'. The book was first illustrated in Byzantium in the 11th century, as part of an ascetic movement which encouraged the monastic life.

CLODION, Claude-Michel (1738–1814)

b. Nancy d. Paris. French sculptor. In Rome (1762–71), his specialisation thereafter in erotic table pieces was abruptly ended by the Revolution. After 1806, however, he worked on two large commissions, including the *Arc de Triomphe du Carrousel*.

CLOISONNE

An *enamelling technique. Raised fences of metal ribbon are soldered to a plane surface, and the little enclosures are filled with coloured enamels and fired.

JEAN CLOUET *François I. c.* 1527. 37¾×29 in (95×73 cm). Louvre

Top left: CLAUDE-MICHEL CLODION *Cupid and Psyche*. Terracotta. h. 23⅛ in (58·7 cm). V & A, London
Top right: ST JOHN CLIMACUS *Ladder of Paradise*. 1082. 10½×8 in (27×20 cm). Princeton University Library
Above: CLOISONNE Pectoral from the tomb of Tutankhamun. Late 18th dynasty. Gold, lapis lazuli, turquoise, cornelian and glass. Egyptian Museum, Cairo
Below: FRANCOIS CLOUET *Lady in her Bath* (?Diane de Poitiers). *c.* 1550. 36¼×32 in (92·1×81·3 cm). NG, Washington, Samuel H. Cress Collection, 1961

CLOUET, François (before 1510–d. 1572)

b. ?Netherlands d. France. The son of Jean *Clouet whose nickname, 'Janet' he often used, he succeeded his father as Court Painter in France. His earliest signed work *Pierre Quthe* (1562) is so strongly reminiscent of Florentine *Mannerist portraits (*Bronzino, *Salviati) as to suggest a stay in Italy. His *Charles IX* (KH, Vienna) shows the influence of *Cranach and *Seisenegger. The elaborate patterning of the costume, slightly unstable stance, exquisite grace and emphasis on linear rather than plastic forms, give it a sense of aloofness. Many of his meticulous portrait drawings survive.

CLOUET, Jean ('Janet') (d. 1540/1)

Possibly the son of Jean Clouet, Court Painter to the Duke of Burgundy, he is documented from 1516 as working for the French court. His contemporary reputation was very high – laudatory poems of 1509 and 1539 compare him to *Bellini, *Perréal, *Perugino and even *Michelangelo. His portraits are in the older Flemish tradition, keenly observed, well modelled, solid and rather static. His drawings are outstanding; he used little outline but modelled with delicate strokes and a *Leonardesque use of light and shade.

CLOVIO, Giulio (1498–1578)

b. Croatia d. Rome. Manuscript illuminator and portrait miniaturist. In Rome at an early age he studied briefly under Giulio *Romano and executed designs for medals and seals for Cardinal Grimani (1516/19). He was widely admired by patrons and artists in his lifetime.

CLUNY ABBEY

The third abbey church (started *c.* 1088) contained some outstanding early †Romanesque sculpture and wall-paintings. The set of historiated capitals round the apse have survived together with fragments of the carved *tympanum over the

west door. The date is controversial; some believe the capitals to have been made before a papal consecration in 1096, others put them at about 1120. The wall-painting in the vault of the apse is known from drawings and descriptions. The paintings at *Berzé-la-Ville were probably by the same workshop.

COADE STONE

An artificial stone patented in the 19th century and used for sculpture and architectural cladding.

COAST SALISH *see* NORTHWEST COAST, AMERICAN INDIAN ART OF THE

COBRA

*Expressionist group of Scandinavian and Netherlandish painters formed in Paris (1948–50) including *Appel, *Corneille, *Jorn, *Atlan, *Alechinsky and Constant. Superficially related to American *Action Painting, they attempt to express inner states directly, their large-scale gesturing with thick paint creating suggestions of a folklorish imagery. (CO= Copenhagen, BR = Brussels, A = Amsterdam.)

COCK, Pieter *see* COECKE VAN AELST

COCLE

Pre-Columbian culture in Panama (believed to date from *c.* AD 500–1000). Major site at Sitio Conte has produced remarkable pottery painted with scrolls and highly stylised animal motifs in black, brown, purple and red, and distinctive gold ornaments sometimes inlaid with precious stones.

CODDE, Pieter (1599–1678)

b. d. Amsterdam. Dutch painter best known for his genre scenes of soldiers and civilians relaxing. He also painted portraits. His ability to adapt his style caused him to be chosen to complete an unfinished group portrait by Frans *Hals.

COECKE VAN AELST (COCK), Pieter (1502–50)

b. Aelst (Alost) d. Brussels. Flemish painter, designer of tapestries and stained glass, book-illustrator, decorator, possibly a pupil in Brussels of Bernard van *Orley. He travelled widely and his well-known drawings of Turkish life were subsequently engraved and published. His *Last Supper* exists in at least forty replicas. Coecke was a mediocre artist, but an important artistic figure in his day, running a large workshop, translating *Serlio into Dutch and reputedly the teacher of Pieter *Bruegel the Elder.

COELLO, Alonso Sanchez (1531/2–1588)

b. Benifayo, Valencia d. Madrid. The most important Spanish portrait painter before *Velasquez. In Portugal as a child, he was sent by John III to Flanders to study under Anthonis *Mor. Later he became Court Painter to Philip II. He was the ideal interpreter of the strict and formal etiquette of the Spanish court, paying meticulous attention to fine detail.

COELLO, Claudio (1642–93)

b. d. Madrid. Of Portuguese origin, he studied *Titian, *Rubens and *Van Dyck in the Spanish royal collection, becoming Court Painter (1684). His masterpiece, a highly illusionistic altar-painting containing about fifty portraits, is *Charles II adoring the Host* (1685–90, Escorial).

COHEN, Bernard (1933–)

b. London. English painter who, in his mature work, slowly covers the surface with a continuous and meandering line which appears to emit its own florescence. The development of the picture is traced through major and minor variations until the entire area is overlayed in a complex fugal composition. He owes some debt to *Pollock's random distribution, but his improvisation is more formal, more decorative and less varied.

HAROLD COHEN *Secrets*. 1964. 98×118 in (248·9×299·7 cm). Peter Stuyvesant Foundation Collection

COHEN, Harold (1928–)

b. London. English painter influenced by *Abstract Expressionism before going to New York (1959), where he underwent a period of reappraisal, reducing his art to its essentials. The work of this period has a strong horizontality, consisting of areas of colour and bare canvas. Returning to London (1961) he developed a wider vocabulary of basic marks which he contrasts variously.

COLDSTREAM, Sir William (1908–)

b. Belford, Northumberland. English painter chiefly of portraits, but also of landscape and still-life. Studied at the Slade School of Art (1926–9) and founder of the *Euston Road School. His early work registered conflict between working from nature and abstraction. This he resolved in a conscious return to traditional realistic values, achieving stylistic austerity by muted paint-handling and colouring.

Opposite page top: ALONSO COELLO *The Infanta Isabella, daughter of Philip II.* 1579. Prado
Opposite page left: BERNARD COHEN *One, Two, Three.* 1962. 40×50 in (101·6×127 cm). Department of the Environment, London
Above: WILLIAM COLDSTREAM *Reclining Nude.* 1953–4. 34¾×53½ in (88·3×135·9 cm). Arts Council of Great Britain
Above near right: COLLAGE *Breakfast* by Juan Gris. 1914. Papier collé, pencil and oil on canvas. MOMA, New York, Lillie P. Bliss Bequest
Above far right: CHARLES ALLSTON COLLINS *The Convent Garden.* 1853. Drawing. 13×7¾ in (33×19·7 cm). Tate
Right: THOMAS COLE *The Oxbow.* 1846. 51½×76 in (130·8×193 cm). MM, New York, Gift of Mrs Russell Sage, 1908

COLE, Thomas (1801–48)

b. Lancashire, England d. Nr Catskill, New York. Painter who settled in Ohio (1819), working as engraver (1820–2), portraitist (1822); lived in New York (from about 1823), in Catskill (from 1836); visited England, France and Italy (1829–32, 1841–2), being deeply influenced by *Claude and Italian ruins. The leader of the *Hudson River School, he imbued landscapes with the grandeur of nature undefiled; with age, morality overcame reality in allegorical visions.

COLEMAN, Glenn O. (1887–1932)

b. Springfield, Ohio d. Long Beach, New York. Painter and lithographer who studied under *Chase at New York School of Art, then under *Henri at the Henri School and exhibited at *Armory Show. His realistic pictures of Greenwich Village characters appeared in the radical journal, *The Masses.*

COLIMA see WESTERN MEXICO

COLLA, Ettore (1889–1969)

b. Parma, Italy. Sculptor who assisted *Despiau, *Laurens and *Brancusi in Paris (1923), settling in Rome (1939). He produced generally free-standing abstract and vertical works in iron, using found objects – the waste of urban technology. He described his sculptures as 'rust as history'.

COLLAGE

Picture-making by gluing scraps of paper, cloth, sand or any other suitable materials on to the picture surface. *See also* PAPIER COLLE

COLLANTES, Francisco (1599–1656)

b. d. Madrid. Spanish painter, pupil of Vincencio *Carducho. He executed decorative paintings for churches, with large figures influenced by *Ribera. His landscapes are more imaginative, with dramatic light effects, cubic architecture rising from violent scenery and panoramic views.

COLLINS, Charles Allston (1828–73)

b. Hampstead d. London. Son of the landscape painter William Collins. He was influenced by the *Pre-Raphaelite style of *Millais, in, for example, *Convent Thoughts* (1850), praised for its naturalism by *Ruskin. Millais tried unsuccessfully to elect him to the Pre-Raphaelite Brotherhood. He later gave up painting and published several novels.

COLLINS, William (1788–1847)

b. d. London. English painter, whose earliest works are views near Millbank (1801). He specialised successfully in sentimental genre scenes with children and pets in a landscape or seaside setting, but pure landscapes in oil or watercolour dominate his later work.

COLLINSON, James (1825–81)

b. Mansfield d. London. A characteristic example of an English painter applying *Pre-Raphaelite techniques to a conventional genre formula derived from *Wilkie. First exhibited (1847) and a founder-member of the Pre-Raphaelite Brotherhood (1848). Three years later he left the group to train as a priest.

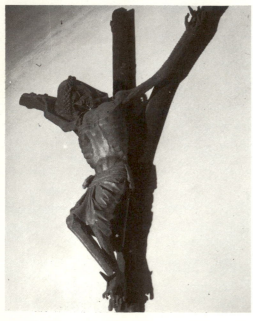

Top: JAMES COLLINSON *The Renunciation of Queen Elizabeth of Hungary*. 1850. Pen and ink. 12×17¾ in (30·5×45·1 cm). Birmingham
Above: COLOGNE, St Maria im Kapitol The *Pestkreuz*. c. 1330. Wood. Over life-size

COLOGNE CATHEDRAL

Cologne Cathedral (started 1248) was partly a copy of *Amiens, partly intended to serve as a sanctuary for the Shrine of the Three Kings by *Nicholas of Verdun. The treasury of the cathedral contains several other figured shrines and in the north choir aisle is the famous *Gero Crucifix. Round the choir are statues of the Twelve Apostles, dating from the early 14th century, also the Milan Madonna of the same period.

COLOGNE, St Maria im Kapitol, Pestkreuz

This particularly gruesome interpretation of Christ on the Cross (dated c. 1330) owed its inspiration to a bout of plague. It represents one of the polarities to which German late †Gothic art tended – the exaggeration of pathos to the limits of caricature. There is a direct descent from this to the paintings of *Grünewald.

COLOMBE, Jean (documented until 1493/4)

d. Bourges. French miniaturist, probably brother of Michel *Colombe; worked mainly in Bourges. In 1484 he was commissioned by Charles I of Savoy to complete the unfinished *Très Riches Heures du duc de Berry*. Stylistically indebted to the *Limbourgs and Jehan *Fouquet, his densely packed canvases have bright colours and richly decorated †Gothic settings.

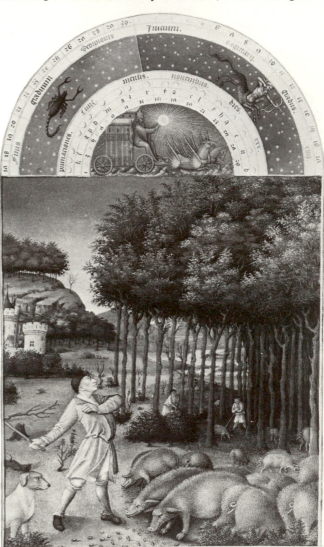

JEAN COLOMBE 'November' from the *Très Riches Heures du duc de Berry*. 1484. 11½×8¼ in (29×21 cm). Chantilly

COLOMBE, Michel (c. 1430–c. 1515)

b. ?Bourges d. Tours. Last of the traditional French †Gothic sculptors, he is frequently mentioned in documents as working for leading French families between Bourges and Tours. His two documented works are the tomb of François II of Brittany and Marguerite de Foix (1502–7, Nantes Cathedral) and a relief, *St George and the Dragon* (1508–9, Louvre).

COLOMBIERE, LA (Perigordian)

†Palaeolithic site at Ain, France. The small cave has engraved

river pebbles, much overdrawn. A rhinoceros and reindeer appear to be stuck with feathered arrows.

COLOMBIERE, LA Incised pebble with representation of a deer pierced by arrows and simplified line-drawing of same

COLOSSUS OF RHODES

A bronze statue of the sun god Helios erected out of the spoils left by Demetrios Poliorketes who had unsuccessfully besieged the city at the end of the 4th century BC. The work of Chares of Lindos, a pupil of *Lysippos, it was one of the Seven Wonders of the ancient world. It took twelve years to make and stood seventy cubits high. It was placed near (not over) the harbour entrance, and collapsed in an earthquake (224 BC).

COLOUR

White light contains all colour wavelengths which, when passed through a prism can be separated into all the component colours of the spectrum. In the *colour circle* (see illustration over-page) the colours of the spectrum are arranged as continuous segments of a circle. The *primary colours* of the spectrum are red, yellow and blue. All other colours can be made from varying combinations of any two or all three of the primary colours. *Secondary colours* are made from pairs of primary colours eg green(blue + yellow), orange(red + yellow), purple(red + blue). The colour circle has its own *tonal values*, pure yellow is the lightest colour, red is half-tone and pure ultramarine is the darkest of the three. *Complementary colours* are those which occur as natural opposites within the colour circle, eg red/green, blue/orange, yellow/violet. Artists often describe colour and colour effects in terms of music, speaking of colour harmony and discord and of 'high' and 'low' key (light and dark). *Colour harmony* is the use of colours in their natural tonal order in the colour circle or spectrum eg blue/blue violet. *Colour discord* is the use of colour against their natural order, eg pale blue/dark yellow. *Cool colours* are those with a bluish cast; *warm colours* have a reddish-orange cast. *Receding colours* are those which produce an effect of depth. An obvious example is the use of blue-grey-violet tones to give distance in a landscape painting. (However red-browns too, and even bright red have been used to give depth to shadows in a still-life and a portrait painting.) *See also* COLOUR THEORY; EARTH COLOURS; HUE; LAKE; OPACITY; REFRACTION; TONE

COLOUR THEORY

Colour description was attempted by *Leonardo da Vinci in his note-books; *Goethe also developed a colour theory based on the difference between transmitted and reflected light, but most colour theories are based on the optical spectrum first analysed by Isaac Newton. In the 19th century and after, various attempts were made to assign scales of numerical values to colour and tonal mixtures. These are of particular value to designers and architects for colour specification rather than to painters, but ranges of colours come on to the paint market based on two classifications in particular; those of Ostwald and of Munsell.

COLQUHOUN, Robert (1914–62)

b. Kilmarnock, Ayrshire d. London. Painter who studied at Glasgow School of Art (1933–8), in Europe (1938–9) and settled in London (1941) with a group of painters and writers. He used *Cubist angularity to characterise traditional narrative figure compositions with a certain awkward originality.

COLVILLE, (David) Alexander (1920–)

b. Toronto. Canadian painter who studied at Mount Allison University, where he taught (1946–63); was Official War Artist in Mediterranean and northern Europe. Often called a *Magic Realist, Colville uses painstaking craftsmanship, infinite, precise detail and unusual viewpoints to conjure up images characterised by quiet, enigmatic, often solitary ambiguity.

COMANCHE see PLAINS INDIAN ART

COMBARELLES (mostly Middle Magdalenian)

†Palaeolithic site near Les Eyzies, Dordogne, France. The deep cave has engravings of horse, bison, reindeer, lion and (?)saiga antelope.

COMFORT, Charles Fraser (1900–)

b. Edinburgh. Painter who went to Winnipeg (1912); studied at Winnipeg Art School and *Art Students' League; settled in Toronto (1925); was Official War Artist in Italy and northern Europe (1943–6); taught in Ontario and Toronto. Influenced by *Social Realism and the *Group of Seven, Comfort's paintings achieve breadth without excitement.

COMMEDIA DELL'ARTE

Sometimes called 'Commedia Italiana'. Title given to professional groups of itinerant actors who flourished in Italy (and later spread elsewhere) from the mid 16th until the beginning of the 19th century. The first professional groups of actors since antiquity, their repertoire was wide, but they were famed particularly for comedies in which the actors improvised with acrobatics, mime and dance.

CONCA, Sebastiano (1680–1764)

b. Gaeta d. Naples. Italian painter, trained by *Solimena. In Rome (1706) Clement XI commissioned him to work in S. Clemente. He painted in Central Italy, Sicily and Naples; internationally famous for his rapid execution and fertility of imagination.

CONCEPTUAL ART

Conceptual Art, including the recent work of Carl André, Sol Lewitt, Dan Flavin, Robert *Morris, etc, posits the idea or system as more important than, or replacing, the work itself.

183

Colour circle

JOHN CONSTABLE *Hampstead — Evening*. 1822. Oil on paper. $6\frac{1}{2} \times 11\frac{3}{4}$ in (16·5×29·8 cm). V & A, London

JOHN CONSTABLE *The Hay Wain*. Exhibited 1821. $51\frac{1}{4} \times 73$ in (130·5×185·5 cm). NG, London

It originates in *Duchamp's fundamental questioning of the definition of art as existing in material objects. Conceptual Art has value not as timeless masterpiece but only as it is experienced in its art-historical, historical, social and political contexts. Its purpose is didactic rather than aesthetic.

CONCRETE

A mixture of *cement, sand and pebbles. Sets into an artificial stone.

CONCRETE ART *see* ART CONCRET

CONDER, Charles (1868–1909)

b. London d. Virginia Water. English painter, returned to Europe from Australia (1890) where he had exhibited with avant-garde groups. Settled in France where an exhibition of his work (1891) was admired by *Degas and *Pissarro. His paintings, stylistically relating to *Watteau, *Whistler and *Beardsley, treated decorative groups of beautiful figures with luxurious accessories.

CONDIVI, Ascanio (c. 1525–74)

b. Ripatransone d. Merocchia. Italian painter and sculptor, a pupil and friend of *Michelangelo. He published a biography of the master (1553), partly written at his dictation which was the source of most subsequent studies of Michelangelo.

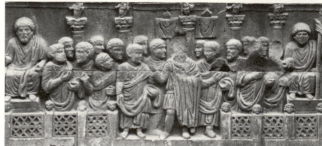

CONSTANTINE, Arch of. Detail from frieze showing the Emperor addressing the people from the rostrum of the Roman Forum

CONINXLOO, Gillis van, III (1544–1607)

b. Antwerp d. Amsterdam. Flemish landscape painter who combined traditional elements from Pieter *Bruegel (eg progressive use of brown, green and blue) with naturalistic treatment of foliage. His compositions are fanciful, delighting in tunnel-like vistas through forests. He influenced *Elsheimer.

CONQUES, Ste Foy

This Benedictine abbey church in Central France possesses the largest of the †Romanesque *tympana. Dating from about 1124, it represents Christ in the centre of a Last Judgement and is divided into compartments by copious inscriptions. Much of the original colouring is still visible. The sculpture stresses redemption and is less alarming than *Moissac.

CONSTABLE, John (1776–1837)

b. East Bergholt, Suffolk d. London. English landscape painter, widely popular today. He went to London (c. 1795) but was largely self-taught and developed very slowly. He became a probationer (1799) and a student (1800), at the *Royal Academy Schools, and began to exhibit (1802). His early works are partly based on *Gainsborough, but he gradually evolved a highly personal style of great immediacy and directness, rich and vibrant in colour and brushwork (but also grand in composition) in passionate response to the beauty of the English countryside, his deep love of which is also revealed in his writings. His most famous painting, *The Hay Wain* (NG, London), was exhibited in 1821. He became ARA (1819) and RA (1829), but was not widely appreciated in England during his lifetime, and was more influential in France, both on the *Barbizon School, and on †Romantic artists such as *Delacroix, who particularly admired Constable's fresh colour and breadth of handling. His oil sketches from nature have particular

vividness and charm. His practice of making full-size sketches for his exhibition pictures is evidence of his thoroughness.

CONSTANTINE, Arch of (completed AD 316)

A *triumphal arch set up near the Colosseum in Rome by the Senate in honour of Constantine's victory over Maxentius in AD 312. The arch has a large central opening flanked by two smaller ones and is excellently proportioned. Some of the reliefs, including those showing Constantine's victories over Maxentius, are Constantinian, but the majority of the reliefs were removed from earlier buildings.

CONSTANTINOPLE see ISTANBUL

CONSTRUCTIVISM

A problematic term in the historical range of its application, first coined by *Tatlin in Moscow in relation to his hanging geometric reliefs of 1913 – the year that *Rodchenko was working on non-objective drawings constructed with compasses, while *Malevich was independently developing his *Suprematist theory insisting on the necessity of abstraction. After the Revolution a split occurred among those professing 'constructivist' ideas: Rodchenko, Tatlin, and later El *Lissitzky, held that art must be useful rather than purely aesthetic and should employ industrial materials and engineering techniques, whereas Naum *Gabo, supported by his brother Antoine *Pevsner, argued in his Realist Manifesto (1920) that art, using engineering techniques and space as a sculptural element should retain its aesthetic bias. The fortunes of Constructivism *inside* Russia declined after 1922 with Gabo's departure for Paris: Lenin favoured *Social Realism. The movement became European; in 1922 a Constructivist congress was held in Düsseldorf, and a Constructivist-*Dada congress in Weimar. After 1923 it diffused into an international style which had absorbed the elements of *De Stijl; the *Bauhaus taught its ideals. Gabo maintained his theory of Constructivist art as the spiritual source for future architecture, and his predilection for glass and plastics; in England he edited, with Ben *Nicholson and Sir Leslie Martin the magazine *Circle* (from 1937) as a vehicle for these ideas.

CONTE, Jacopino del (1510–98)

b. Florence d. Rome. Italian painter who studied under Andrea del *Sarto. Worked in Rome (from 1538). His *Mannerist frescoes for S. Giovanni Decollato, Rome, combine Florentine clarity of line with *Michelangelesque treatment of volume. He achieved modest fame by his portraits of the popes from Paul III to Clement VII, also of Michelangelo.

CONTRAPPOSTO

Pose in which one part of the body is twisted to face in the opposite direction to another – for example the torso twisting away from the axis of the legs. The term is applied both to sculpted figures and to individual figures in a painting.

CONTUCCI, Andrea see SANSOVINO

CONVERSATION-PIECE

Small-scale portrait group usually depicting members of a family in their home setting – either domestic interiors or parks. Common in Dutch 17th-century painting, the type became popular in 18th-century English portraiture, eg *Hogarth, *Devis and *Gainsborough.

COOK ISLANDS

An island group in central *Polynesia, Stylised representations of gods were carved as figures or on staffs with a head on top and a series of human figures below. Adzes and paddles, originally cult objects but later manufactured for sale to Europeans, were decorated with repetitive geometric ornament derived from the human form.

COOPER, Samuel (1609–72)

b. d. London. English portrait miniaturist, gaining an international reputation by the 1640s. The diaries of Aubrey,

Left: SAMUEL COOPER Oliver Cromwell. c. 1657. 3½×2½ in (8·9×6·4 cm). Duke of Buccleuch Collection

Below: SAMUEL COOPER Unknown Lady. 2 11/16×2¼ in (6·7×5·4 cm). Fitzwilliam

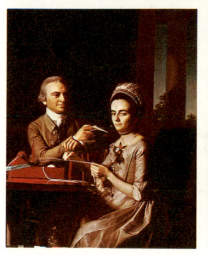

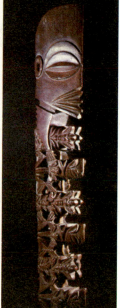

Above left: JOHN SINGLETON COPLEY Mr and Mrs Thomas Mifflin. 1773. 61½×48 in (156×121·9 cm). Historical Society of Pennsylvania, Philadelphia
Left: CONVERSATION-PIECE Queen Charlotte with her two eldest sons by Johann Zoffany. 1766/7. 44¼×50⅞ in (112·4×129·2 cm). Buckingham Palace
Right: COOK ISLANDS The deity, Te Rongo. Wood. h. 27½ in (69·9 cm). BM, London

Evelyn and Pepys all mention him and he was often called *'Van Dyck in little'. He contrived a more painterly style than his predecessors, such as *Hilliard, and a greater sense of shading. His best works include *Oliver Cromwell* (c. 1657, Duke of Buccleuch) and *Charles II* (Wallace).

COPLEY, Dr Alfred L. see ALCOPLEY

COPLEY, John Singleton (1738–1815)

b. Boston d. London. American painter, first trained by artist stepfather, he began painting in Boston (1753), went to Philadelphia and New York (1771–2), to Europe (1774) and

settled in London (1775). America's leading portraitist for twenty years, he had the Yankee obsession with visual fact, depicting the particular character and physiognomy of each sitter with palpable clarity in firmly composed settings. In Europe, influenced by *West and *Reynolds, he assumed an overall painterliness, subordinating loved details to harmonious wholes; taking up history-painting, he dared to paint contemporary history. He thus sacrificed uniqueness for membership of the fashionable school, greatness for the *Grand Manner.

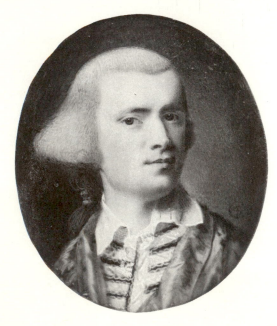

JOHN SINGLETON COPLEY *Self-portrait. c.* 1765. Miniature on ivory. 1⅜×1⅛ in (4·4×2·9 cm). Boston

COPPER

Non-ferrous, soft, easily worked metal used in sculpture and coining or medal-making, as a support for painting or enamel, but mainly for *engraving upon.

COPPO DI MARCOVALDO (active 1260–76)

Florentine painter of the same generation as the *Sienese *Guido da Siena. He signed a *Madonna and Child* (1261) painted for Sta Maria dei Servi in Siena. The angular features for the two main faces were overpainted in the style of *Duccio but have been rediscovered in X-ray photographs. The gold-patterned drapery and the new sense of volume are taken up in *Cimabue's *Sta Trinità Madonna* of some twenty years later.

COPTIC ART

The word 'Copt' derives from the same root as 'Egypt' and is used to describe a member of the Egyptian Monophysite church, which gradually became estranged from Orthodox Byzantine Christianity from 451 onwards. Coptic art is thus the Christian art of Egypt, flowering even after its conquest by Muslim forces in the 640s, although the term is often used to describe textiles produced there up to the 7th century, which do not have specifically Christian themes. Typical of Coptic art is the crude yet lively figural and non-figural sculpture found in many sites in Egypt, and a simple yet powerful painting style, eg the apse from Bāwīt in Cairo and *The Bāwīt Icon* in the Louvre, of Christ and St Menas.

COQUES, Gonzales (1614–84)

b. d. Antwerp. Flemish painter, notable for his small-scale group and individual portraits, a genre then fashionable in Holland. Coques's compositions owe much to *Van Dyck, but his work is nevertheless distinctive. His early warm palette

gave way to cooler colours and his works are meticulously executed.

CORDELIAGHI, Andrea *see* PREVITALI

CORDOBA, The Great Mosque

Begun by the Umayyad Caliph Abd al-Rahman I (785–6) and extended (833 or 848) by Abd al-Rahman II. Between 961 and 965 al-Hakam II further extended the mosque and decorated it with *mosaics. It is now a Christian cathedral.

CORDOBA, Pedro da (active 2nd half 15th century)

?b. d. Cordoba. Spanish painter known from a single dated and authenticated work, the *Annunciation* altarpiece (completed 1475) in Cordoba Cathedral for Canon Diego Sanchez de Castro. This shows strong Flemish influence combined with an Andalusian love of rich decoration and attention to detail.

CORINTH, Lovis (1858–1925)

b. Tapiau, East Prussia d. Berlin. German painter, at first a conventional landscape artist, he later studied under *Bouguereau and *Lepage (1884–7). Returning to Germany he evolved his own style, using the liberal paint application of the *Impressionists. His work is unresolved between a painterly surface tension and illusionistic space. He was, however, a precursor of *Expressionism.

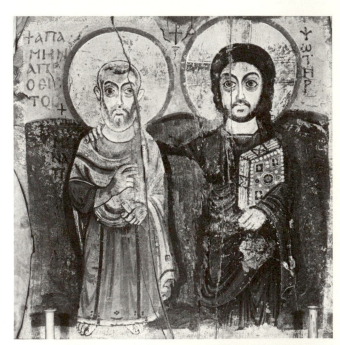

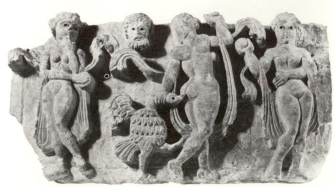

Top: COPTIC ART *The Bāwīt Icon.* 7th–8th century. Louvre
Above: COPTIC ART Relief of Leda and the Swan. Ashmolean

LOVIS CORINTH *Self-portrait with Skeleton*. 1896. Stadtlische Galerie, Munich

CORINTHIAN POTTERY

Corinth was the chief centre of Greek *Orientalising art. Corinthian pottery falls into two periods, the first, termed 'Proto-Corinthian' (725–625 BC), began with the introduction of free, sweeping Orientalising patterns. Gradually the *black-figure technique was evolved and vases were filled with a host of mythological creatures on a field sprinkled with dot rosettes. By the end of the period the animals are less carefully drawn, and become bigger so that they fill a larger area faster. The second period (625–550 BC), termed 'Corinthian', witnessed the decline of Corinthian pottery. The animals become bigger and distorted to fill the field and much of the background is filled with solid incised rosettes. By the beginning of the 6th century Corinthian pottery was losing ground to *Attic to such an extent that about 570 BC Corinthian potters took to reddening the ground of their pots to imitate the redder Attic clay, but it could no longer compete with Athenian black-figure.

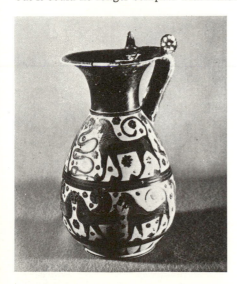

CORINTHIAN POTTERY Jug. *c*. 600 BC. h. 12 in. (30·5 cm). BM, London

CORNEILLE (Cornelius van BEVERLOO) (1922–)

b. Liège. Dutch painter and co-founder with *Appel and Constant of the Dutch Reflex group (1947–8) and of the *Cobra group (1948–51). He attempted to release subconscious images unguided by the intellect, in reaction to the geometric art of Paris.

CORNEILLE DE LYON (active 1533/4–1574)

b. The Hague d. ?Lyon. Naturalised French portrait painter working mainly in Lyon. Although no documented work survives, frequent contemporary references testify to his fame in his lifetime. Court Painter to Henry II and Charles IX he produced small-scale portraits of the royal family. Works ascribed to him are usually dark-clothed figures modelled in thin glazes in the manner of Joos van *Cleve, with great sensitivity and keen observation in treatment of faces.

 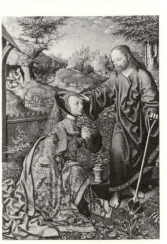

Left: CORNEILLE DE LYON *The Earl of Hertford* (?). 8¼×5⅜ in (21×14 cm). Wallace
Right: JACOB CORNELISZ VAN OOSTSANEN *Christ as Gardener*. 1507. 21½×15¼ in (54·5×38·8 cm). Staatliche Gemäldegalerie, Kassel

CORNELISZ (KUNST), Cornelis (1493–1544)

?b. d. Leiden. Netherlandish painter who continued the style of Lucas van *Leyden. The son of Cornelis *Engelbrechtsz and brother of Lucas Cornelisz (called 'Kock'); the family collaborated. A group of paintings, now usually ascribed to him, are *Mannerist in style, the landscapes recalling those of *Patenier. Best known are various versions of the life of St Anthony.

CORNELISZ VAN HAARLEM, Cornelis (1562–1638)

b. d. Haarlem. Dutch history and portrait painter. As the former he worked in a *Mannerist style influenced by *Spranger, producing heavy multi-figured mythological scenes with poses pedantically derived from the *Antique. His group portraits of guilds and militia companies are stiffly conventional.

CORNELISZ VAN OOSTSANEN, Jacob (Cornelisz van AMSTERDAM) (c. 1470–1533)

b. d. Amsterdam. Painter, engraver and designer of stained glass and embroidery, strongly influenced by South German engraving, especially *Dürer. His later style reflects that of his pupil Jan van *Scorel. His work has considerable charm and a strong feeling for linear pattern (eg *Christ as Gardener*, 1507, Kassel).

CORNELIUS, Peter von (1783–1867)

b. Düsseldorf d. Berlin. After associating in Rome with the *Nazarene group, he led the Munich School which attempted to revive monumental fresco painting, designing and executing most of the Ludwigskirche decoration (Munich). He was influential in England.

CORONATION GOSPEL OF THE HOLY ROMAN EMPIRE (c. 800)

This Gospel Book was probably executed in the Palace School at Aachen. The Evangelist portraits seem to be a living link

with antique author portraits. They are individualised, set in the open air and executed in an illusionistic manner. A stylisation of this survival or revival of classical techniques lies behind Reims manuscripts like the *Utrecht Psalter (Schatzkammer, Vienna).

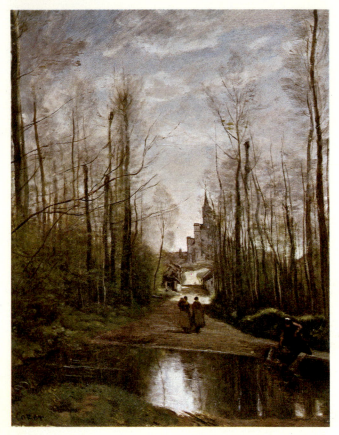

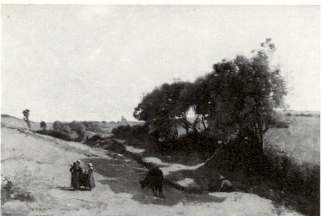

Top: JEAN-BAPTISTE COROT *The Church at Marissel.* 1866. 21¾×17 in (55×43 cm). Louvre
Above: JEAN-BAPTISTE COROT *The Dell.* 13¾×21¼ in (34·9×54 cm). Louvre

COROT, Jean-Baptiste Camille (1796–1875)

b. d. Paris. French landscape painter, who worked as a draper till 1822. He painted en *plein-air, chiefly round Fontainebleau, and travelled to Rome (1825). Here he produced a beautifully luminous series of topographical views. His art went through a decided Dutch phase in the early 1830s, but it was the Italian light and the †Romantic landscape of *Claude that Corot chiefly absorbed. His landscapes reject perspective devices and flatten space into simple, more luminous colour

areas. Associated with the *Barbizon School, his interests developed increasingly towards 'poetic landscape'; he preferred to paint at twilight, and of the Barbizon School he was the least 'realistic'. He painted decorative panels in his friends' houses, and frescoes for the Church of Ville d'Avray (1855). In old age he painted extremely fine figure studies of women, eg *Femme à la perle* (1870) and was the revered 'père Corot' of the Parisian artistic community.

CORREGGIO (ALLEGRI), Antonio (1489/94–1534)

b. d. Correggio. Emilian painter whose work was widely influential, albeit after his lifetime. From *Mantegna and *Michelangelo (he may have visited Rome about 1520) he learnt how to devise effects of *sotto in sù foreshortening and from *Leonardo a delicate *sfumato modelling. These influences fused, resulting in solutions of striking originality especially in his masterpieces, the frescoes at Parma in the domes of S. Giovanni Evangelista (1520–3) and the Cathedral (c. 1525–30). Here, for the first time, he relied on the concentric shape of the cupola to provide the basis for circles of ascending saints upon clouds who are eventually dissolved at the summit in a haze of golden glory; this illusionistic conception was of prime importance for †Baroque decorators. His early frescoes in the Camera di S. Paolo (1518, Parma) and his later easel-paintings like the *Antiope* (Louvre) and the *Jupiter and Io* (KH, Vienna) show his response to the stimulus of learned classical circles in Parma and especially the famous collection of antique cameos. In these, and his sacred works, the silken softness of his flesh painting (known as *morbidezza) is notable and is often sensitively set off by glowing coloured stuffs. The ecstatic mood of his late religious pictures is redolent of the uneasy spiritual climate of the time.

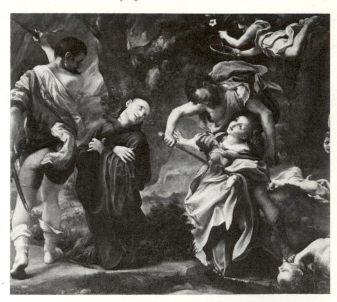

ANTONIO CORREGGIO *The Martyrdom of St Flacidus and St Flavia.* 1524–6. 63×72⅞ in (160×185 cm). Gall Naz, Parma

CORTESE see COURTOIS

CORTONA, Pietro Berrettini da (1596–1669)

b. Cortona d. Rome. Italian painter and architect. One of the creators of Roman High †Baroque. His first patrons were the Sacchetti family, but he was taken up by the family of the new pope (Urban VIII), the Barberini (1624). For them he painted the frescoes in Sta Bibiena (1624–6) and his greatest work, the ceiling in the Palazzo Barberini (1633–9). The work is a culmination of the illusionistic trends already developed by *Guercino and *Lanfranco. Although a painted architectural framework divides the ceiling into five compartments, dozens of figures, seen *sotto in sù, sweep triumphantly across the sky. Its subject, an allegory of Divine Providence, has a com-

plicated programme alluding to the power of the Barberini. Cortona commenced other works at the same time, including a series of frescoes in the Pitti Palace, Florence, and later painted the dome and ceilings of the Chiesa Nuova, Rome, and the ceiling of the gallery in the Palazzo Pamphili. His powerful figure style was in some ways a parallel to *Bernini's in sculpture.

CORVUS, Joannes (active c. 1512–c. 1544)

b. ?Flanders d. ?England. Bruges painter generally identified with Jehan Raf who painted a map of England for François I and with John Raven, naturalised English (1544). Two portraits attributed to him are *Bishop Fox* (Corpus Christi, Oxford) and *Mary Tudor* (c. 1530, NPG, London).

COSIMO, Agnolo di *see* **BRONZINO**

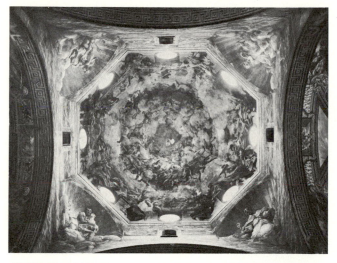

ANTONIO CORREGGIO *Assumption of the Virgin* and detail. 1526–30. Dome fresco. Parma Cathedral

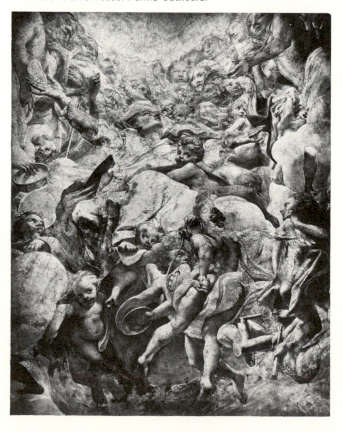

COSMAS INDICOPLEUSTES, Christian Topography of

The earliest manuscript (9th century) of the Topography, a Christian world scheme and cosmogony which had been written in the mid 6th century by the Alexandrian merchant, Cosmas. The illustrations, full of symbolism, are in style comparable to the †Byzantine manuscript of the Homilies of St *Gregory Nazianzus in Paris. (Vatican, gr. 699.)

COSMATI WORK

This name applied to Italian decorative inlay work, derives from one of the families of Roman craftsmen who practised it. Fragments of antique marbles and coloured stones were re-used to form geometric patterns on church floors, façades and cloisters. Similar decorations on tombs, altars, thrones and candlesticks were made in gilded and brightly coloured glass.

COSMATI WORK Tabernacle. Sta Sabina, Rome

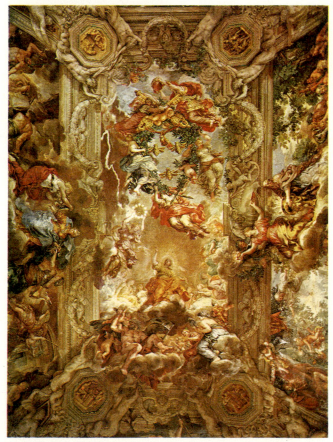

PIETRO CORTONA *Allegory of Divine Providence*. 1633–9. Fresco. Palazzo Barberini, Rome

COSSA, Francesco del (c. 1435–77)

b. Ferrara d. Bologna. Ferrarese painter (active from 1456). Influenced by *Piero della Francesca, *Castagno, *Mantegna, *Pisanello and *Tura. The fresco series of the Months (finished in 1470) in the Palazzo di Schifanoia shows the triumph of a god matched by the activity of the month, affording a glimpse into the court life of the d'Este family. Went to Bologna where he was prolific and popular.

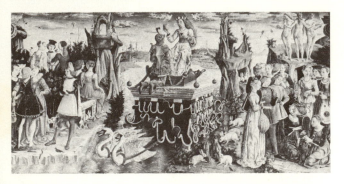

FRANCESCO DEL COSSA *The Triumph of Venus*. Detail from fresco of the Month of April. 1467–70. Palazzo Schifanoia, Ferrara

COSTA, Lorenzo (c. 1460–1535)

b. Ferrara d. Mantua. Ferrarese painter who studied with *Tura who influenced an early *St Sebastian* (Dresden). Worked with *Francia at the Bentivoglio court in Bologna (1483). Appointed Court Painter at Mantua (1506) where he executed two allegories for Isabella d'Este.

COTAN, Juan Sánchez *see* SANCHEZ COTAN

COTES, Francis (1725–70)

b. d. London. English portrait painter (*Knapton's pupil) he made his reputation working in pastels. For his oil portraits he adopted the painterly style of *Reynolds. His best work is perhaps *Paul *Sandby* (1760/1, Tate).

JOHN COTMAN *Greta Bridge*. 1805. Watercolour. 10×14¼ in (25·4×36 cm). BM, London

COTMAN, John Sell (1782–1842)

b. Norwich d. London. English landscape painter in oil and watercolour. He first worked in London, exhibiting at the *Royal Academy (1800–6). He returned to Norwich where, with John *Crome, he became the leading artist of the *Norwich School. His sure feeling for composition led him to exploit contrasts of silhouetted flat areas of colour that give his paintings an almost abstract quality. He visited Normandy

(1817, 1820) and became Professor of Drawing at King's College, London (1834). His sons, Miles Edmund and Joseph John, were also painters.

COTTON GENESIS

The earliest illustrated †Byzantine manuscript of the Septuagint (5th or 6th century), only charred fragments of which remain after a fire (1731). It seems to have possessed a very full cycle of illustrations. This may be the book copied by the mosaicists of St Mark's, *Venice in the late 13th century. (BM, London.)

COUBINE, Orthon (1883–1938)

b. Boskowitze, Czechoslovakia. Painter who studied in Prague and Antwerp, travelling in Italy and France (1903–5). He settled in Haute Provence, whose landscape became the major subject of his painting. Working independently of contemporary movements, Coubine abandoned *Fauvism in favour of an anti-modernist classical naturalism. He exhibited at the Salon des Indépendants, Paris (1919–25).

GUSTAVE COURBET *Cliffs at Etretat*. 1870. 51¼×63⅞ in (130×162 cm). Louvre

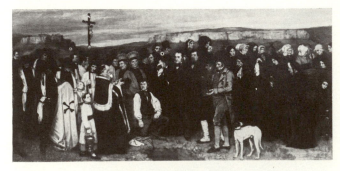

GUSTAVE COURBET *Burial at Ornans*. 1850. 123⅔×261⅞ in (314×665 cm). Louvre

COURBET, Jean-Désiré Gustave (1819–77)

b. Ornans d. Vevey, Switzerland. French painter, arrived in Paris (1840), benefited more from studying Venetian and Dutch painting in the Louvre than from official tuition. He began to make a reputation at the end of the 1840s, a time when he was mixing with *Baudelaire, *Champfleury and *Prud'hon, with *After Dinner at Ornans* exhibited at the Salon of 1849. This was the first of a series of large canvases depicting scenes from the everyday life of the peasant, rather than classical myth or Romantic effulgence, painted broadly, often with the

palette-knife, in sombre tones, eg *Burial at Ornans* (1850), *The Stone-Breakers* (1850). In the 1850s his name was associated with revolutionary political activity, and in his paintings he was accused of deliberately cultivating the ugly and the vulgar. After the major statement of the decade *The Artist's Studio* (1855), political references in his work diminished as he turned to the pictorial considerations of portraits and landscapes. After political disgrace and exile (1871) he painted a series of voluptuous nudes and many still-lifes and landscapes.

COURTOIS (CORTESE), Jacques (1621–75)
Guillaume (1628–79)

Brothers, both b. Franche-Comté d. Rome, and both known as 'Il Borgognone'. Jacques, a battle painter, drew on experience as a soldier acquired on the journey to Rome. He first painted histories, but, partly inspired by Giulio *Romano, turned to painterly cavalry charges, also etching battle scenes. Guillaume, a *history painter, worked in St John Lateran and other Roman churches. Pupil of *Cortona, he afterwards adopted *Maratta's style, although his strong relief and azure backgrounds derive from early *Guercino.

COUSIN, Jean the Elder (active 1526–60)
the Younger (c. 1522–c. 1594)

The Elder, b. Sens d. Paris, was a French painter and designer of tapestries and stained glass. An early work *Eva Prima Pandora* (c. 1538, Louvre) shows the influence of the School of *Fontainebleau, especially *Rosso, though the setting is *Leonardesque. In Paris he was successful as a tapestry-designer; two of his stained-glass windows are in Sens Cathedral. His son, b. Sens d. Paris, was a prolific artist though little of his work survives. His drawings (*Livre de Fortune*, 1568) show Rosso's influence. His major surviving painting *The Last Judgement* (Louvre) recalls *Bronzino and the Florentine *Mannerists.

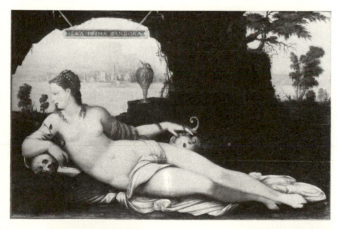

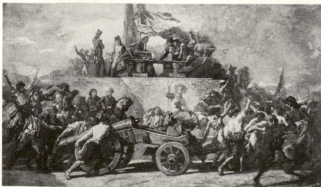

Top: JEAN COUSIN THE ELDER *Eva Prima Pandora. c.* 1538.
38⅛×59⅛ in (97·5×150 cm). Louvre
Above: THOMAS COUTURE *Enrolment of Volunteers of 1792.*
23×40 in (58·4×101·6 cm). Springfield Museum of Fine Arts

COUTURE, Thomas (1815–79)

b. Senlis d. Villiers-le-Bel. French painter, studied under Baron *Gros and briefly under *Delaroche. Sought to establish a middle ground between the Academy and the avant-garde, a course which found public and critical ratification in the successful showing of *The Romans in their Decadence* (1847), a classical subject with contemporary political overtones, which, in its painting, preserved something of the spontaneity and immediacy of handling which characterised his oil studies. He was encouraged to open his own studio. Pupils included *Puvis de Chavannes, *Manet, William Morris *Hunt, *Feuerbach and *Leighton, to whom he taught a system of fluent technical expression which retained the freshness of the first touch, with the very minimum of retouching. His pictorial range embraced portraits, landscapes, satirical and allegorical genre and religious subjects for the decoration of the Church of St Eustache, Paris, the only one of three public commissions that he completed.

COVERT, John (1882–1960)

b. Pittsburgh, Pennsylvania. Painter who lived in Europe, primarily Paris (1909–14). Influenced by *Picabia, *Duchamp's *Dadaism, and *Cubism, Covert produced interesting collages, including his 'string paintings', and experimental abstractions. By 1920, he rejected his experiments and abandoned art.

COX, David (1783–1869)

b. d. Nr Birmingham. English landscape painter. He learnt watercolour painting from John *Varley (1804) then travelled widely in England, sketching in watercolours. After 1839 he painted in oils. His son, David, was a pupil and imitator.

COX, Kenyon (1856–1919)

b. Warren, Ohio d. New York. Painter of murals, portraits and figures, who studied under *Carolus-Duran and *Gérôme in Paris. At first drawing New York's low life, his work degenerated into sentimentalised pseudo-classicism.

COXCIE (COXYEN), Michiel van (1499–1592)

d. Malines. Flemish Romanist painter famous in his day as the 'Flemish *Raphael'. In Rome (from 1531) he met *Vasari and was one of the first Flemish painters to decorate Italian churches. Returning to Malines (1539) he became Court Painter to Philip II. His work is rather cold and strongly Italianate.

COXYEN, Michiel van *see* COXCIE

COYPEL Family

Parisian family active in the 17th and 18th centuries. Most important members were Antoine (1661–1722) and his son, Charles-Antoine (1694–1752), both of whom had distinguished academic careers. Antoine painted *history; his more prolific son etched, illustrated books and painted *bambochades, though best known for his portraits.

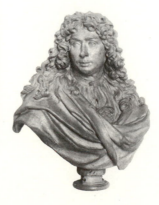

ANTOINE COYSEVOX *Charles Le Brun.* 1676. Terracotta. h. 26 in (66 cm). Wallace

COYSEVOX, Antoine (1640–1720)

b. Lyon d. Paris. French sculptor, he was working at Versailles by 1679 and evolved a manner more †Baroque than his senior *Girardon, eg the large oval relief *France Triumphant* (Salon de la Guerre, Versailles). He executed many formal portraits of Louis XIV but it is in his later more intimate busts like *Robert de Cotte* (Ste Geneviève, Paris) that he achieved greater lightness and movement.

COZAD, Robert Henry *see* HENRI, Robert

COZENS, Alexander (1717–86)

b. Russia d. London. English landscape draughtsman and teacher of drawing. He advocated a system of composition through the scanning of random 'blots', publishing this idea and various other systems. His own compositions derived from blots heralded †Romanticism.

ALEXANDER COZENS *Study of a Tree*. Pen and sepia ink. 6⅜×7¾ in (16·2×19·7 cm). Whitworth Art Gallery

COZENS, John Robert (1752–97)

b. d. London. English watercolour landscapist and son of Alexander *Cozens. He travelled in Italy and Switzerland (1776, 1783), first with Richard Payne Knight then with William Beckford. Using a colour scheme restricted to blue-grey and greenish grey, he achieved remarkable atmospheric effects in his picturesque and imaginative landscapes that are not merely topographical. His works belonging to Dr Monro, who cared for him in mental illness from 1793, were copied at Monro's request by *Turner, *Girtin and others.

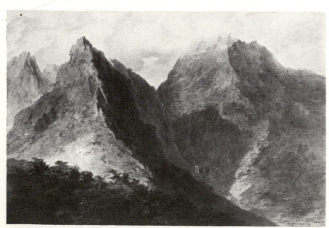

JOHN COZENS *View in the Island of Elba*. 1780. 14½×21⅛ in (36·8×53·7 cm). V & A, London

CRACKING (OF AN OIL PAINTING)

Can result from physical damage to a *canvas or *panel, or by water penetrating to the *ground and dissolving the *size. But it is also the result of faulty technique, usually in the mixture of *varnish with paint during painting, or by varnishing a picture before it is thoroughly dry. Drying *oils, such as linseed, dry by polymerisation. They take up oxygen either from the air or from oxygen-rich pigments, and make a mosaic of large flat molecules. They actually expand as they dry, and dry very slowly. The process continues long after the surface is dry to the touch. Varnishes on the other hand dry quickly and by evaporation. As they lose their volatile solvents they shrink. Consequently a thin, brittle, dry skin of varnish will crack up and be pulled into islands as the paint underneath it continues to expand. If the varnish is merely on the surface it can be removed and the picture revarnished, but if the varnish is in the paint itself then there is no cure. *Bitumen and non-drying oils will produce the same effect if mixed with drying oils.

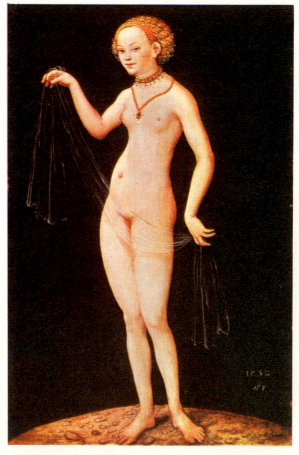

LUCAS CRANACH THE ELDER *Venus*. 1532. 25⅝×18⅛ in (65×46 cm). Frankfurt

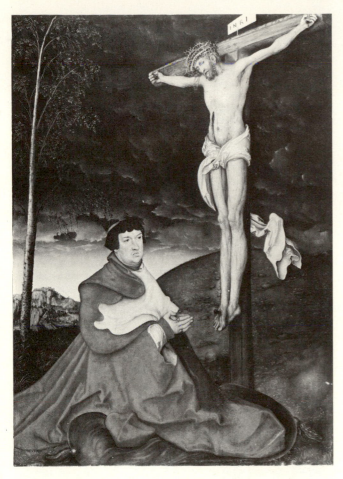

LUCAS CRANACH THE ELDER *Albrecht of Brandenburg kneeling at the Cross.* 62¼×44⅛ in (158×112 cm). AP, Munich

WALTER CRANE *The Anemones* from 'Flora's Feast'. Published 1889. 9¾×7 in (24·8×17·8 cm).

CRANACH, Lucas the Elder (1472–1553)

b. Cronach d. Weimar. Leading painter and graphic artist in Protestant Germany. A pupil of his father, Hans Maler, he is first documented (1502) working for university circles in Vienna. Work before 1505 shows a knowledge of *Dürer and the older German tradition, and includes woodcuts and panel-paintings, eg *Johannes Cuspinian and Wife* (1502). His religious paintings, eg *Rest on Flight into Egypt* (Berlin) show deep tenderness of feeling. The landscapes are in the style of the *Danube School. He was appointed Court Painter to Frederick the Wise, Elector of Saxony (1505) and he continued to serve successive Electors until his death. His style changed to suite the more sophisticated tastes of court circles, showing a highly original adaptation of Italian art. His erotic female nudes and piquant mythological scenes are exquisitely painted in a highly finished enamel-like technique. Enormously popular, he employed a large workshop which included his two sons, Hans (d. 1537) and Lucas *Cranach the Younger. Friendly with Luther, they were godfathers to each other's children; Cranach painted the reformer many times and illustrated his writings. Throughout his life he remained an excellent portrait painter and his late self-portrait (1551) shows him in full command of his powers.

CRANACH, Lucas the Younger (1515–68)

b. Wittenberg d. Weimar. German painter, the son of Lucas *Cranach the Elder, who trained in his father's workshop. His mature style, especially in portraits (eg *Unknown Man*, KH, Vienna) is harder in outline, flatter in design and more in the style of international *Mannerism than the warmer, more personal works of his father.

CRANE, Walter (1845–1915)

b. Liverpool d. Horsham. English painter, designer and illustrator, apprenticed to Linton the engraver, he first established his reputation with the *Toy Books* he designed for children. These show, with their bold areas of pure colour, an early (from *c.* 1865 onwards) influence of Japanese art. As a painter, one of many brought to public attention by the *Grosvenor Gallery exhibitions (from 1877). He was active in the *Arts and Crafts movement (1880s). He worked in many areas of design, from commercial posters to interior decoration, his profound knowledge of European art never overwhelming a firm sense of structure.

CRAQUELURE

The cracking of the surface of a painting. *Also* the fine crazing upon a ceramic surface.

CRAWFORD, Ralston (1906–)

b. St Catherines, Ontario. Painter who moved to United States (1910), has travelled throughout the world, and taught all over America. His earlier paintings were austere *Precisionist simplifications of industrial architecture; later becoming increasingly abstract, they retain the chaste geometric formal vocabulary, eliminating all reference to real life.

CRAWFORD, Thomas (?1813–57)

b. New York d. London. Sculptor, first apprenticed to Frazee and Launitz in New York, settled in Rome (1835) where he studied under *Thorwaldsen. Powerful naturalism, always evident in his portraits, gradually overcame chaste †Neoclassicism in his major works, many being publicly commissioned monuments.

CRAXTON, John (1922–)

b. London. English painter, mainly of people in landscapes. After a phase under the influence of *Picasso and early *Miró, he came increasingly to paint with linear clarity and fresh colour the light and people of modern Greece.

CRAYON

Pigments bound by wax, glue or gum into a solid mass that can be extruded or moulded into sticks for drawing.

CREDI, Lorenzo di (c. 1458–1537)

b. d. Florence. Italian painter, the son of a goldsmith, he trained in *Verrocchio's workshop (1480–8), eventually supervising all painting commissions. The latter's influence was modified by that of his fellow assistants, *Leonardo and *Pollaiuolo. Disquieted by the sermons of Savonarola, he burnt almost all his paintings of profane subjects (1497), though a self-portrait (1488) survives.

LORENZO DI CREDI *Annunciation*. 34¾×28 in (88×71 cm). Uffizi

CRESPI, Daniele (c. 1598–1630)

b. Busto d. Milan. Milanese painter. An unusual exponent of Counter-Reformation piety, well known for his *St Charles Borromeo at Supper* (S. Maria della Passione, Milan) whose realism and sincerity of expression comes closer to that saint's spirit than any other †Baroque work.

CRESPI, Giovanni Battista see CERANO, IL

CRESPI (LO SPAGNUOLO), Giuseppe Maria (1665–1747)

b. d. Bologna. Sole genius of the Bolognese late †Baroque, he revolted against the academic tradition, adopting a strong *chiaroscuro and experimenting with glazes. His spontaneous and sincere art – eg *Confession* (Turin) – influenced Venetian artists, especially *Piazzetta.

CRETAN ART see MINOAN ART

CRIPPA, Roberto (1921–)

b. Milan. Painter who studied at the Brera Academy. With *Fontana, a prominent member of the Italian *Spatialists. His early abstracts, based on loops, changed (after 1948) to collages – often of isolated heads, or social themes – using wood, cork and newsprint.

CRISTUS, Petrus see CHRISTUS

CRIVELLI, Carlo (active c. 1457–1493/1500)

b. Venice. Venetian painter who may have studied in the *Vivarini workshop. Early influences include *Mantegna and *Squarcione's followers. He left Venice (1457) and worked mainly in the Marches. Among his best paintings are *Coronation of the Virgin* (1493, Brera) and *Annunciation* (1486, NG, London). His early work is characterised by an ascetic †Gothic quality but later on he becomes decorative and rather superficial. The bitter anguish of his Passion scenes is almost insupportable because of the morbid ugliness of his angular, knobbly forms which became typical of the style of the Marches.

CARLO CRIVELLI *Coronation of the Virgin*. 1493. 88⅝×100⅜ in (225×255 cm). Brera

CROME, John ('Old Crome') (1768–1821)

b. d. Norwich. English landscape painter, with *Cotman, the leading member of the *Norwich School, living mostly in Norfolk. Self-taught, he was mainly influenced by *Wilson and by the landscapists of 17th-century Holland. Painting mainly in oils, applied in thick coats, his accurate observation of tone enabled him to fill his pictures with air and sometimes sunshine. He went to Paris (1814) to see the works of art looted by Napoleon. He also produced many fine etchings. His son, John Burnay Crome, imitated his style closely.

CROPSEY, Jasper Francis (1823–1900)

b. Rossville, New York d. Hastings-on-Hudson, New York. Painter, first an architect, then studied at National Academy of Design, travelling in Europe (1847–50, 1857–63). Associated with the *Hudson River School, he drew sensitively, but his autumn landscape paintings had the substance and colour of sugar candy.

entered prominently into the formation of both *Fauvism and *Cubism. Severe arthritis sometimes immobilised him, and limited his travels to annual trips to Paris, and two visits to Italy (1903, 1908).

CROSS-HATCHING

Shading in drawing or engraving by parallel lines which are crossed by others.

CROSS RIVER MONOLITHS

Some three hundred basalt monoliths, known as *akwanshi*, have been recorded in the *Ekoi-speaking area round Ikom on the Cross River, southern Nigeria. The monoliths are usually grouped in large circles on the now-deserted sites of former villages. They are said to represent dead chiefs and may have been carved over several hundred years up to about 1900.

CROSS RIVER MONOLITHS
Figure of a male ancestor.
19th century or earlier. Basalt.
h. about 36 in (90 cm).
Nigerian Museum, Lagos

CRUIKSHANK, George (1792–1878)

b. ?London d. London. English political caricaturist, best known for illustrations to children's books, eg *Grimms' Fairy Tales* (1824), *Oliver Twist* (1837–9). In later life he produced visual propaganda for the Temperance movement, eg the series *The Bottle* (1847) and a painting, *The Worship of Bacchus* (1862).

Top and above right: CARLO CRIVELLI *Annunciation* and detail. 1486. 81½×57¾ in (207×146 cm). NG, London
Above left: JOHN CROME *A Windmill near Norwich. c.* 1816. 43¾×36 in (11·1×91·4 cm). Tate

CROSS, Henri-Edmond (1856–1910)

b. Douai d. Lavandou. Born Delacroix, he changed his name to its English equivalent. After studies in Lille, he settled in Paris (1881) and exhibited at the official Salon. A founder-member of the Salon des Indépendants (1884) he was acquainted with the *Pointillists but did not share their style until after *Seurat's death (1891). He moved to the South of France, where together with *Signac, he developed the later Neo-Impressionist style of large mosaic-like brushstrokes that

GEORGE CRUIKSHANK *Oliver claimed by his affectionate friends*, from *Oliver Twist* by Charles Dickens. 1838. 7×4¾ in (17·8×12·1 cm). V & A, London

CRUSADER ART

The Crusader states imported Western artists, some of whom became so profoundly affected by †Byzantine art as to produce a new composite style, best known from Jerusalem (12th century) and Acre (13th century). Latin mosaics, which at first sight appear Byzantine, survive in the Holy Sepulchre and at Bethlehem; the key manuscript is the British Museum Psalter of Queen Melisende (1131–43), signed by Basilius, a Latin painter disguised by a Byzantine veneer. Some icons on *Mount Sinai and manuscripts produced in 13th-century Acre develop the Crusader synthesis of Western iconography veiled in Byzantine style, or Byzantine iconography in Western style. Crusader sculpture is a franker transplant of French and Italian workshop traditions to the Levant.

CRUZ, Diego de la (active 1489–99)

Spanish sculptor, a citizen of Burgos, where mainly active. Collaborated with *Gil de Siloe on the High Altar of the Charterhouse of Miraflores near Burgos, a high point of Spanish late †Gothic art (1496/9).

CSAKY, Joseph (1888–1971)

b. Szeged d. Paris. Hungarian sculptor who studied in Budapest (1904–5). Already influenced by *Rodin, he moved to Paris (1908). He adopted *Cubist geometric simplifications of form (from 1911). At first a stone-carver, his later bronze work is more naturalistic, though retaining a Cubist compactness.

CUBISM

A style and a movement, Cubism was initially the invention of *Picasso and *Braque. Anticipated by Picasso's *Les Demoiselles d'Avignon* (1907) and Braque's *Grand Nue* (1908), the style came to fruition between 1909 and 1912. By 1910 Picasso and Braque's ideas had been taken up by artists possessed of a more missionary determination – *Gleizes, *Metzinger, *Léger, *Le Fauconnier and *Delaunay – who organised the first Cubist *succès de scandale*, the 'Salle 41' at the 1911 Salon des Indépendants in Paris. Works by these artists, by Picasso, Braque and *Gris were shown in London, Amsterdam, Munich, Berlin, Prague and Moscow (1912–14), infecting many avant-garde campaigns so that from often utterly un-Cubist metamorphoses came conclusions of major importance – the abstraction of *Mondrian and *Malevich, the mature *Futurism of *Boccioni, the *Expressionism of *Marc and *Macke. The ideas underlying Cubism were most influentially expounded by Gleizes and Metzinger (*Du Cubisme*, 1912) and *Apollinaire (*Les Peintres Cubistes*, 1913). The artist's conception of a subject was held to be more essentially real than its appearance; therefore the subject could be both geometrised (idealised) and constructed from aspects seen at different times and from different viewpoints. Further, the painting or sculpture was held to be as real as its subject – a thing in its own right, and in painting surfaces were flattened to emphasise this fact by reinforcing the flatness of the picture plane. Yet this emphasis on the work as such only led to abstraction outside Cubist circles, for the first Cubists aimed to exploit with wit and intelligence the tension between pictorial form and subject-matter, promoting effects of paradox. They introduced actual fragments of the subject – letters, papers (*papier collé) and material (*collage) to this end, and although after 1912 their means of depicting things became increasingly 'synthetic', they always remained at root concerned with the relationship between art and reality. *See also* ANALYTICAL AND SYNTHETIC CUBISM

CUBIST REALISM *see* PRECISIONISM

CUBO-FUTURISM

Term invented by *Malevich to describe his work of 1911–13, which combined elements of *Cubism and *Futurism with Russian primitivism. Following the example of *Gontcharova and *Larionov, Malevich borrowed freely from Russian peasant embroideries and *lubki* (wood-engravings) in his paintings (1910–11). During 1911–12 his increasingly geometrised figures anticipated *Léger's 'tubist' paintings. *The Knife-Grinder* (1912) represents the culmination of Malevich's Cubo-Futurist period: it combines Futurist treatment of rapid mechanical movement with a superficially Cubist treatment of space, while retaining the vivid colouring of Russian folk-art.

CUEVAS, José Luis (1933–)

b. Mexico City. Self-taught artist who taught at Philadelphia Museum School (1957); has illustrated several books. Influenced by *Goya, Cuevas draws his themes from the dregs of society, emphasising its sickness and cruelty through *Expressionist, grotesque, distorted images rendered in thin washes of colour and powerful, yet often delicate, draughtsmanship.

CULMBACH, Hans Süss von *see* KULMBACH

CUPISNIQUE *see* CHAVIN

CURATELLA MANES, Pablo (1891–1962)

b. d. ?Argentina. Sculptor who worked as diplomat. First influenced by *Lipchitz and *Cubism, his work developed in two directions: energetic figurative work and abstractions of interlocking geometric forms.

CURE, Cornelius *see* CURE, William

CURE, William (active 1606–d. 1632)

Netherlandish sculptor and mason, active in London, where he collaborated with Cornelius Cure on the tomb of Mary Queen of Scots (1606/7, Westminster Abbey). Employed later on the Banqueting House, Whitehall.

CURRIER AND IVES

American firm of lithographers, headed by Nathaniel Currier (1813–88) and James Merritt Ives (1824–95). Currier, b. Roxbury, Massachusetts d. New York, served apprenticeship with Pendletons in Boston, Philadelphia and New York (1828–33), formed own business in New York (1835) and retired (1880). Ives, b. New York d. Rye, New York, was a printmaker in New York until 1852, when he became Currier's book-keeper, later partner and business manager (1857). Their lithographs of portraits, landscapes, sporting and genre scenes, occasionally charming, often crude, provide a remarkably comprehensive record of 19th-century America, a cross-section of average American thought at that time. Like popular journalists, they exploited every appeal to sentiment, nostalgia and national pride.

CURRIER, Nathaniel *see* CURRIER AND IVES

CURRY, John Steuart (1897–1946)

b. Dunavant, Kansas d. Madison, Wisconsin. Painter who studied in Kansas City, at Chicago Art Institute, *Art Students' League, and Russian Academy in Paris, painted *WPA murals, and lived in New York. A Regionalist of *American Scene painting, Curry saw his beloved Kansas in melodramatic terms, distinguished more by sincerity and vigour than finesse.

CURTEA DES ARGES

This town became the capital of Wallachia and seat of the Metropolitan of Wallachia (now southern Roumania) in the 14th century. The domed Church of St Nicholas has some wall-paintings dating from its foundation in the third quarter of the 14th century. Some scenes copy the *Istanbul Kariye Camii mosaics, but in a dry, academic style similar to Decani in *Serbia and unlike the progressive art of *Ivanovo.

CUYP, Aelbert (1620–91)

b. d. Dordrecht. Dutch painter. His whole life was spent in Dordrecht where he received his artistic training from his

father, a portrait painter. His early works follow the tonal mode of van *Goyen, but his main influence came from those Dutch landscapists who brought *Claude's style back to Holland from Rome. His idyllic landscapes, suffused with a golden light are a combination of Dutch fields with herds of cattle, rivers, and canals and foreign mountain ranges. His marriage (1658) brought him considerable wealth and he painted little in the latter part of his life.

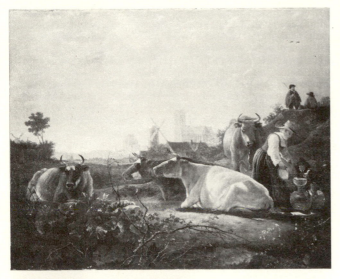

Above: AELBERT CUYP *Distant View of Dordrecht.* 62×77½ in (157·5×197 cm). NG, London

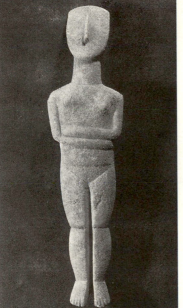

Left: CYCLADIC IDOL 3rd millennium BC. Marble. h. 19¼ in (49 cm). BM, London

CYCLADIC ART

The art of the twenty-four islands of the Greek archipelago. Its main centres were Naxos, Paros, Delos and Melos. Situated geographically between the areas of the *Helladic and *Minoan civilisations, and possessing a plentiful supply of white *marble, the islands were famed for their statuary from as early as the Bronze Age, and by the 7th century BC they formed a great sculptural centre. To this period belong the *Colossus of Naxos,* a statue sixteen feet high of Apollo dedicated at Delos (*c.* 600 BC) and, also from Naxos, an Ionic column forty feet high surmounted by a sphinx and dedicated at Delphi (*c.* 570/560 BC). By the end of the 6th century Parian marble was preferred for sculptures, especially at Athens. Many sculptors of Cycladic origin worked in Greece and Asia Minor throughout the 5th and 4th centuries.

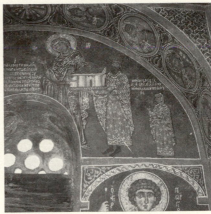

Left: CYPRUS Church of Panagia tou Arakou, Lagoudera. *The Prophet Jonah.* 12th century
Right: CYPRUS Church of the Virgin, Asinou. Donor presenting the church to the Virgin. 12th century

CYPRUS, Medieval art in

The Christian art of Cyprus, seen in the context of †Byzantine art, is represented mainly by survivals from two periods. From the earlier (6th and 7th centuries) come the mosaics of the Virgin in the apses of churches at Lythrankomi and Kiti. From the 7th century onwards Cyprus suffered much from Muslim raiding and Byzantine counter-attacks and it is not until the 12th century that we have extensive evidence again of large-scale artistic production. The frescoes in the churches at Asinou (1105 and later), Perachorio (1160–80), St Neophytos (1180s and later) and Lagoudera (1192) exhibit styles linked closely with that of contemporary Constantinople, though some were executed by local artists. Cyprus was conquered by the Crusaders (1191) and never again became part of the Byzantine Empire, although an Orthodox, post-Byzantine tradition of painting continued on the island.

D

DADA

Dada was an international movement which originated in Zürich (1916) in the Cabaret Voltaire. The name spread quickly to other groups of artists and poets with similar ideas, in Cologne, Berlin, Paris and New York. Not a movement in the sense of having a fixed theory, or positive programme, Dada was rather a 'state of mind' (*Breton), a 'revolt of the unbelievers against the misbelievers' (*Arp). Aiming at the destruction of bourgeois values in art and society, Dada involved a complex irony for its members, many of whom continued to explore new artistic techniques, while aggressively attacking existing aesthetic beliefs, and these were later to flower into *Surrealism and *Constructivism. Born of disgust at the rationalism, and nationalism, responsible for World War I, Dada explored irrationality and chance, and used violent means to alienate its audiences, insulting manifestos, performances and exhibitions (eg *Duchamp's attempt to exhibit a urinal in New York). Dada took its most overtly political form in Berlin; it ended in Paris (1922).

DADD, Richard (1819–87)

b. Chatham. d. Broodmoor. English painter, mainly of 'faerie'. His most celebrated works of obsessive detail and grotesque aspect were done after his confinement to an asylum (1844). There, he amplified studies made in the Middle East, and

juxtaposed images copied from available illustrated magazines, eg *The Fairy Feller's Master Stroke* (1855–64).

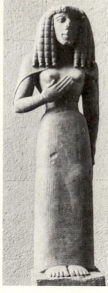

Left: RICHARD DADD *The Fairy Feller's Master-Stroke. c.* 1855–64. 21¼×15½ in (54×39·4 cm). Tate
Right: DAEDALIC STYLE *Kore of Auxerre. c.* 640 BC. Limestone. h. 25½ in (65 cm). Louvre

DADDI, Bernardo (*c.* 1290–1349/51)

Italian painter active in Florence, a pupil and close associate of *Giotto. He adopted and developed the *Sienese taste for very decorative, elaborately tooled panels with complex frames. A large workshop produced many small portable panels, usually for private devotional use. The main image was often flanked by wings containing several narrative scenes.

DAEDALIC STYLE

An *Archaic sculptural style (660–620 BC) which succeeded *Geometric. The individuality of Geometric sculpture is replaced by a more rigidly mathematical and intellectual approach. Characteristics of the style are a somewhat triangular head, a low forehead, a straight fringe and a flat top to the head.

DAGNAN-BOUVERET, Pascal Adolphe Jean (1852–1929)

b. Paris d. Quincey. French painter, first exhibited at the Salon of 1875, later changing from mythological subjects to passive and contemplative aspects of peasant life, studied in Brittany and influenced by *Bastien-Lepage, but with a painting style that can be related to that of *Meissonier.

DAGUERRE, Louis Jacques Mandé (1787–1851)

b. Cormeilles-en-Parisis d. Bry-sur-Marne. French pioneer photographer. Apprenticed to Degotti, Chief Designer at the Paris Opéra. He then painted panoramas and opened his own diorama in Paris and London (1822–3). He began photographic experiments (*c.* 1824) and made a partnership agreement with Niepce (1829). His great discovery, the *Daguerreotype, was publicised (1839) and was purchased by the French government and patented in Britain.

DAGUERREOTYPE

An early photographic process invented by Louis *Daguerre and published in 1839. By this process the negative impression was received upon a silver surface made sensitive to the action of light by iodine. It was then developed by mercury vapour.

DAHL, Johann Christian Clausen (1788–1857)

b. Bergen d. Dresden. Norwegian landscape painter influenced by Old Dutch Masters, particularly *Everdingen, and new trends in Rome. A friend of Caspar David *Friedrich, he settled in Dresden (1818) joined the Academy and travelled in Italy (1820–1).

DAHL, Michael (1656/9–1749)

Swedish portraitist, settled in London (1689). His *Petworth Beauties* compare favourably with the corresponding series by *Kneller, whose only serious rival he was. His softer style and colour contrast with the more heroic style of Kneller.

DAKAKARI see NIGERIA, NORTHERN

DAKOTA (SIOUX) see PLAINS INDIAN ART

DALEM, Cornelis van (documented until 1565)

?b. d. Antwerp. Flemish landscape painter said by Karel van *Mander to have painted for his own pleasure. Other artists painted the figures in his compositions. Most have great rocks with overhanging trees. His *Farmstead* (1564, Munich) is more naturalistic, foreshadowing artists of the turn of the century.

DALI, Salvador (1904–)

b. Figueras. Spanish painter who attended Madrid Academy of Fine Arts. Influenced by *Meissonier and de *Chirico, he joined *Surrealism (1929) and became its most notorious member. The detailed realism of his style is a vehicle for his hallucinatory imagery and his almost anecdotal explorations into abnormal psychological states. His 'paranoiac-critical

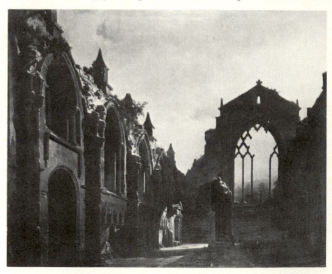

Above: LOUIS DAGUERRE *Ruins of Holyrood Chapel.* 1822. 82×100 in (208·3×254 cm). Walker Art Gallery

Left: DAGUERROTYPE

method' inspired poetry, objects, critical writings, and *gestes*, as well as the double-imagery of paintings such as *The Invisible Man* (1929–33). Dali made two Surrealist films with Buñuel, *Le Chien Andalou* (1929), and *L'Age d'Or* (1930).

Top: SALVADOR DALI *Premonition of Civil War.* 1936. $43\frac{1}{4} \times 33\frac{1}{8}$ in (110×83 cm). Philadelphia Museum of Art, Louise and Walter Arensberg Collection
Above: SALVADOR DALI *Agnostic Symbol.* 1932. $21\frac{3}{8} \times 25\frac{5}{8}$ in (54·8×65·1 cm). Philadelphia Museum of Art, Arensberg Collection

DALMATA, Giovanni (Giovanni da TRAU)
(*c.* 1440–after 1509)

b. Traù. Italian sculptor and pupil of Giorgio da Sebenico. A minor but influential artist who was active over a wide area collaborating with *Mino da Fiesole in Rome and visiting Hungary (1481–90).

DALMAU, Luis (documented 1428–*c.* 1460)

b. ?Valencia d. Barcelona. Spanish artist, Court Painter to Alfonso V (by 1428). A visit to Flanders (1431) was a major factor in his art which was purely Flemish in style, indebted above all to van *Eyck (eg *Councillors of Barcelona,* 1443).

DALOU, Aimé-Jules (1838–1902)

b. d. Paris. French sculptor, pupil of *Carpeaux and Duret, Dalou began to exhibit at the Salon of 1867. He fled to England during the 1870–1 political events, returning after the 1879 Amnesty. A promoter of the 1890 Salon of Dissidents opened at the Champ-de-Mars by the Société Nationale des Beaux-Arts, he is responsible for the imposing *Triumph of the Republic* (1889–99) in the Place de la Nation, Paris.

DALWOOD, Hubert (1924–)

b. Bristol. English sculptor who attended Bath Art Academy (1946–9) and Leeds University (1955–8). His primeval forms cooled into geometric shapes (mid 1960s), although elements of primitivism such as mass and scored surface have remained.

DAMASCUS, The Great Mosque (705–15)

Built by the Umayyad Caliph al-Walid I upon the site of a Christian church, itself built within the enclosures of a pagan temple, the Mosque of al-Walid is said to have been built with the aid of Greek workmen, as well as Syrians and Egyptians, and was lavishly decorated both inside and out with *mosaics.

DAMASCUS Detail of mosaic decoration in the Umayyad Mosque. 705–715

DAMMAR RESIN

Natural *resin gathered from trees in the Far East. When used as a *varnish it discolours less than other resin varnishes. It also has less tendency to *bloom.

DAMOPHON (active 2nd century BC)

Messenian sculptor who repaired *Pheidias's *Zeus* at Olympia. He also made statues of gods and goddesses for Messene, Aigon in Achaea, Megalopolis and Lycosura in Arcadia. His style is academic and much influenced by the sculpture of the 5th and 4th centuries.

DAMP FOLD STYLE

Term applied to a particular style of depicting drapery in England (13th–15th century) both in carving and painting, in which the material appears to cling to the body – as if it were damp – and the folds are shallow and linear.

DANBY, Francis (1793–1861)

b. Nr Wexford d. Edmouth. Irish landscape painter who settled in Bristol (by 1820) and in London (1825). His early work is full of poetical feeling and exquisite figures; he later painted in a heroic †Romantic style echoing John *Martin. Quarrelling with the Royal Academy (1829), he lived by the Lake of Geneva (till 1840). He probably went to Norway (1841), and returning to England, settled at Exmouth (*c.* 1847).

DANDRIDGE, Bartholomew (1691–after 1754)

b. London. English portrait painter; he apparently made small models for his group portraits and conversation-pieces, to study the light effects, and posed his figures carefully in a †Rococo manner, eg *The Price Family* (MM, New York). His single portraits are more conventional.

DANIELE DA VOLTERRA (Daniele RICCIARELLI) (1509–66)

b. Volterra d. Rome. Italian *Mannerist painter and sculptor, influenced in early life by *Sodoma. Active in Rome (after 1536) he became the friend and most gifted follower of *Michelangelo. An early fresco is in the Palazzo Massimi. He was in charge of the decoration of the Orsini Chapel (after 1541) where he painted his most admired work, the *Deposition* (1541). Influenced by *Rosso's painting in Volterra, it reflects Michelangelo's interest in anatomy combined with Daniele's own sense of the decorative. He produced five paintings (c. 1555–6) based on sketches supplied by Michelangelo, and late in life he executed a bronze bust of him.

DAN-NGERE

A diverse group of tribes in Liberia, Guinea and western Ivory Coast including the Dan, Ngere, Kpelle (or Gerze), Toma (or Loma), Kran, Grebo, Bassa, Kru Bete, etc, which all share a more or less common art style. Their masks exhibit two extremes, one naturalistic and restrained, the other grotesque and aggressive. The Dan favour the former, the Ngere the latter, while other tribes seem to accommodate both extremes at once. Some Toma masks, however, are distinctive for the way in which they reduce the human face to a flat plane over-shadowed by a heavy forehead. The wooden figures of these tribes, mostly portraits of pretty girls (though some represent chiefs and elders, carved as substitutes for them when away from home or sick) are homogeneous in style, all tending towards the Dan mode, ie naturalistic rather than grotesque. Some of the Dan-Ngere tribes also cast miniature brass figures by the *cire perdue method as ornaments for the houses of chiefs and elders. The Poro men's society is common to most of these tribes and also to the *Mende of Sierra Leone.

DANSE MACABRE

Dance of death. A widespread theme in the 14th and 15th centuries seeming to indicate a growing enjoyment of life and consequent reluctance to leave it and perhaps also connected with the Black Death (1348–9). There is a famous example in the Abbey of La Chaise-Dieu in France where dancing corpses compel unwilling representatives of all classes to follow them.

DANTI, Vincenzo (1530–76)

b. Perugia d. Florence. Italian sculptor, architect, poet and theoretician. He published a treatise on proportion (1567) and was Professor at the Perugia Academy. After casting his statue of Julius III (1555) he was employed by Cosimo I in Florence where the *Decollation of St John* (Baptistery, Florence) reveals the influence of *Michelangelo and *Sansovino whose *Baptism of Christ* he completed.

DANUBE SCHOOL

Not a school in the usual sense, the term denotes a style of painting practised by artists concentrated in the Danube area (Regensburg, Passau, Krems, Vienna) during the first thirty years of the 16th century. The best known are the *Altdorfer brothers and Wolfgang *Huber, but many other artists contributed to the style. The landscapes were based mainly on the picturesque scenery of Austria which the artists infused with a romantic poetic mood. In addition to pure landscape they also used similar landscape settings for figure subjects; religious, mythological or portraits. Forerunners were Jörg *Breu, Rueland *Frueauf the Younger and *Cranach the Elder. The Danube School is of importance as introducing pure landscape painting as a new form of art.

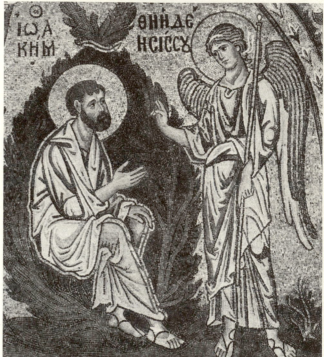

Top: DANUBE SCHOOL, Albrecht Altdorfer. *Sarmingstein on the Danube.* 1511. $5\frac{7}{8} \times 8\frac{1}{8}$ in (14·8×20·8 cm). NG, Budapest
Above: DAPHNI, Church of the Koimesis of the Virgin *The Angel appearing to Joachim.* 11th century
Left: DAPHNI, Church of the Kolmesis of the Virgin. *Christ Pantocrator.* 11th century

DAPHNI, Church of the Koimesis of the Virgin

The main church of a monastery near Athens, was built and decorated towards the end of the 11th century. By comparison with *Hosios Loukas, the style of the mosaic cycle is conspicuously softer, more elegant and naturalistic. This development into naturalism is not the influence of the nearby Parthenon sculptures, but is part of a movement in Byzantium, seen also at *Chios, Nea Moni, where the artists aim to please rather than edify. In this context, the powerful *Pantocrator in the cupola can be attributed to a workshop with a more 'old-fashioned' manner.

JACQUES DARET *Adoration of the Magi.* 22½×20½ in (57×52 cm). Staatliche Museum, Berlin

DARET, Jacques (c. 1404–after 1468)

?b. d. Tournai. Netherlandish painter active in Tournai and documented as an apprentice of Robert *Campin (1427). A signed altarpiece painted for the Abbey of St Vaast, Arras (now Thyssen-Bornemisza Coll., Lugano and Petit Palais, Paris) shows his debt to the *Master of Flémalle and provides an important reason for identifying that painter with Campin. Daret painted rather stiff, over-life-size figures set in attractive miniature-like landscapes, all the while attempting a very realistic style.

DASBURG, Andrew (1887–)

b. Paris. Painter who studied at *Art Students' League with *Cox and *Henri, later teaching there (1919–21), worked in Europe (1907–10), and exhibited at *Armory Show (1913). Influenced by *MacDonald-Wright's Synchromism, Dasburg painted colourful *Cubist abstractions; by 1920, he returned to representational painting, retaining the vigorous structure grasped in studying *Cézanne.

CHARLES DAUBIGNY *Landscape on the Oise.* 1822. 35½×71¾ in (90×182 cm). B-A, Bordeaux

DAUBIGNY, Charles François (1817–78)

b. d. Paris. French artist trained by his artist father. He worked first as a picture-restorer and graphic artist and published some fine etchings (1850–1). He had briefly studied under *Delaroche but abandoned the academic approach and in-

spired by the *Barbizon painters took up painting from nature, travelling the French rivers in his own floating studio-boat. He established himself at Auvers (1860) which later became a painters' haunt. He was in London with *Monet (1870–1), and his later works reflect †Impressionist influences, while he had himself, like *Boudin, influenced the Impressionists' approach and subject-matter.

Above: HONORE DAUMIER *Don Quixote reading.* c. 1865. 13¼×10¼ in (33·6×26 cm). NG, Victoria, Melbourne

Left: HONORE DAUMIER *My Dear Colleague.* Crayon, pen and wash. 11⅛×5⅝ in (28×21·8 cm). NG, Victoria

DAUMIER, Honoré (1808–79)

b. Marseille d. Valmondois. French painter, sculptor and lithographer, moved to Paris where eventually he worked for Philippon's weekly paper *La Caricature* and was imprisoned for six months for his satirical attacks on the monarchy. He turned from political to social comment and became a regular contributor to *Charivari* when *La Caricature* was suppressed (1835), but resumed his political commentary after the 1848 Revolution. Though chiefly known for his lithographs (eg *Le Ventre Législatif* and *Rue Transnonain le 15 avril 1834*), he produced a considerable number of paintings, watercolours, drawings and sculptural works of scenes in the Courts of Justice, everyday life and religious themes (eg *Christ with His Disciples*, 1850). His later works, like the *Don Quixote* series, were freer in execution, less sculptural in effect, but still very

monumental, lively and flowing in drawing. Towards the end of his life he gradually became blind and received financial assistance from *Corot.

DAVENT (THIRY), Leonard (d. c. 1550)

b. ?Deventer d. Antwerp. Flemish painter and engraver, better known as the latter. Active at *Fontainebleau (1536–42), first under *Rosso, then assisted *Primaticcio whose work he engraved. His style is, as one would expect, very Italianate, full of decorative fancy and, at times, erotic.

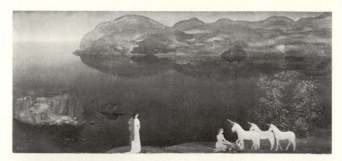

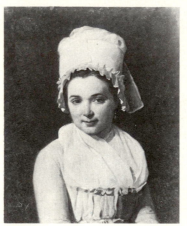

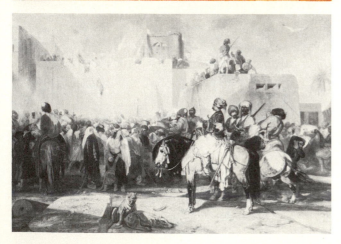

Top: GERARD DAVID Virgin Enthroned with Female Saints. 1509. 47¼×89⅞ in (120×213 cm). B-A, Rouen
Centre: JACQUES-LOUIS DAVID The Oath of the Horatii. 1785. 129⅞×168⅛ in (329×429 cm). Louvre
Above: ALEXANDRE DECAMPS The Punishment of the Hooks. 1839. 35⅞×53¾ in (91×137 cm). Wallace

Top: ARTHUR BOWEN DAVIES Unicorns. 1906. 18¼×40¼ in (46·4×102·2 cm). MM, New York, Lillie P. Bliss Bequest
Second row: ALAN DAVIE The Birth of Venus. 1955. 63×96 in (160×243·8 cm). Tate

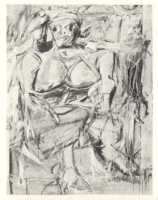

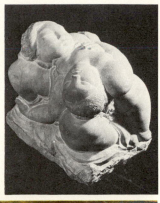

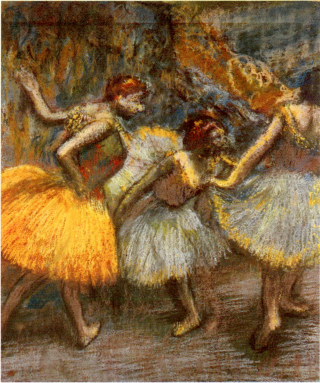

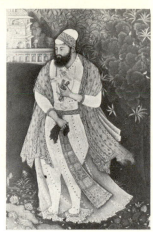

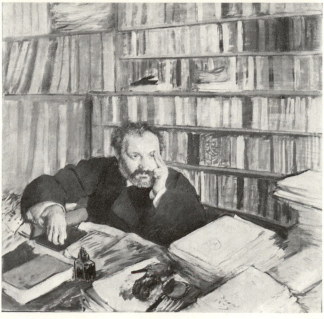

Opposite page 3rd row left: JACQUES-LOUIS DAVID *Catherine Tallard.* 1799. 25¼×21¼ in (64×54 cm). Louvre
Opposite page 3rd row right: DECCAN PAINTING: EARLY INDIAN Fresco of Flying Figures from Cave 32 at Elura. *c.* 850
Left: THOMAS DAVIES *A View on the River La Puce.* 1789. 13¼×20¼ in (33·7×51·4 cm). NG, Canada
Top: STUART DAVIS *Owh! in San Paō.* 1951. 52¼×41¾ in (132·7×106 cm). Whitney Museum of American Art, New York
Above left: DECCAN PAINTING: MUSLIM *Lady with a Myna Bird.* Golkonda School. *c.* 1630. Chester Beatty Coll, Dublin
Above right: DECCAN PAINTING: MUSLIM *Portrait of Ibrahim Adil Shah II.* Bijapur School. *c.* 1615. 6¾×4 in (17×10 cm). BM, London
Top centre: WILLEM DE KOONING *Woman I.* 1950–2. 75⅞×58 in (192·7×147·3 cm). MOMA, New York
Extreme top right: JOSE DE CREEFT *Group of Women.* 1936. Limestone. h. 13 in (33 cm). Norton Gallery, Florida
Right centre: EDGAR DEGAS *Dancers. c.* 1899. Pastel. 37¼×31¾ in (94·6×80·6 cm). MOMA, New York
Right: EDOUARD DEGAS *Portrait of Duranty.* 1879. Mixed media. 39¾×39¼ in (101×100·4 cm). Glasgow

DAVID, Gerard (c. 1460–1533)

b. Oudewater, nr Gouda d. Bruges. Early Netherlandish painter working in Bruges apart from a visit to Geneva (1511) and a period in Antwerp (from 1515). He painted in the older Flemish style of Rogier van der *Weyden and Hugo van der *Goes, and was much indebted to *Memling whose position he inherited as leader of the Bruges School. Despite his traditionalism, he was familiar with Italian art and learned something from *Mantegna, *Pintoricchio and even *Piero della Francesca, expressed in the solid dignity of his figure groups. His only fully documented painting is *Virgin and Child with Saints* (1509, Rouen) and around this a large body of work has been established, including portraits. His Dutch origins explain his finely observed landscape settings.

DAVID, Jacques-Louis (1748–1825)

b. Paris d. Brussels. French painter who developed a radically new and monumental style in response to the late 18th-century revival of interest in classical antiquity. A pupil of *Vien, David's early works show a rather slow change from a †Rococo manner to one of austere simplicity and power, notable in *The Oath of the Horatii* (1785, Louvre). During the Revolution and Napoleonic period he received the chief official commissions, including *The Death of Marat* (Brussels) and *The Coronation of Napoleon* (1805–7, Louvre). Forced to treat contemporary themes and deeply involved with the historical events he portrayed, David introduced a new painterly brilliance into his work, although the formal clarity characteristic of his †Neoclassical compositions remains. At this time he also painted portraits which are remarkably clear and alive. Regicide and supporter of Napoleon, upon the return of the monarchy (1815), David exiled himself to Brussels where he painted amorous scenes from mythology, and portraits with a new realistic note. David's importance for the history of art resides not only in his stylistic and to a lesser extent compositional innovations, but also in his role as teacher of many of the prominent artists of the period, notably *Gros and *Ingres.

DAVIE, Alan (1920–)

b. Grangemouth, Scotland. Primarily a painter, he studied at Edinburgh Art College (1939–40) exhibiting at the Royal Scottish Academy (until 1942). Whether painting, writing poetry or playing music, Davie seeks to create on impulse, without preconception. In this sense he is a true *Surrealist.

DAVIES, Arthur Bowen (1862–1928)

b. Utica, New York d. Florence. Painter who studied at Chicago Art Institute and *Art Students' League; member of The *Eight, he was a major organiser of the *Armory Show, where he exhibited. Later producing *Cubist and abstract work, he is remembered for earlier poetic idylls of nymphs in twilight landscapes of fantasy.

DAVIES, Thomas (c. 1737–1812)

b. ?Nr Woolwich d. Blackheath. Painter who probably studied with Massiot; as soldier, spent considerable time in North America, Gibraltar and Jamaica (from 1757). Most impressive of Canadian topographical painters (often compared with *Rousseau), Davies shows intense sensitivity to individual textures, achieving unity and impact through a precise, linear style and beautiful composition.

DAVIS, Stuart (1894–1964)

b. Philadelphia d. New York. Painter whose parents were commercial artists associated with The *Eight, Davis studied with *Henri in New York, did cartoons, exhibited at *Armory Show (1913), worked in Paris (1928–30), taught at *Art Students' League (1931–2), painted for *WPA, and was Executive Secretary of Anti-Fascist Artists' Congress. Influenced by *Cubism, *Futurism, *Fauvism and *Léger, most of which he first saw at the Armory, Davis transformed these tendencies with the counterpoint, syncopation and joyous improvisation he found in Negro jazz, creating a distinctly American image:

brilliantly coloured everyday objects, symbols and words, flattened, stylised and intertwined in dynamic, witty, rhythmic patterns.

DAYES, Edward (1763–1804)

d. London. English artist who began as a miniaturist and mezzotinter, but became very interested in watercolours. He painted classical and Biblical scenes, and portraits, but his most interesting work was landscape and views of architecture, drawn in Indian ink and tinted.

DECAMPS, Alexandre Gabriel (1803–60)

b. Paris d. Fontainebleau. French history, landscape, animal and genre painter. He travelled in Europe and the Levant, and produced his most original creations in his Oriental themes characterised by powerful colouring and brilliant lighting effects. History painting remained his ambition but his attempts in the 1830s and 1840s were not successful.

DECCAN PAINTING, EARLY INDIAN (from c. AD 600)

This painting consists of various fragments in different styles in several places in the Deccan. The earliest are in Badami Cave III, executed under the Early Western *Chalukyas in the 6th century. The *fresco secco technique is used throughout. The hall marks are soft contours and delicate modelling. Fragments occur also at Elura (AD 750–950), where there are Hindu, Buddhist and *Jain paintings. A new style emerges here, influenced by South *Indian painting; the central figures are majestic and dominant, richly decorated and ornamental. The colours used are few.

DECCAN PAINTING: MUSLIM

In the Deccan (the Indian south-central plateau) there were developed schools of Muslim painting contemporary with the early Mughals *Akbar and *Jahangir, but independent of influences from the northern courts. The earlier influences were from *Malwa painting and from *Vijayanagara, and there was some direct contact with Persia; some Mughal influences start to appear only after 1590. Popular themes were the *Ragamala (*Indian Painting: General), court ladies and portraits. Deccan artists showed a fondness for high horizons, patterned and flowered grounds and exotic foliage; they used a bold palette, and affected tall slender figures, the men with jewelled girdles and the women with long stiff veils; scarves were used as fans (rather than the yak tail familiar in Mughal painting). The three centres, Ahmadnagar, Bijapur and Golkonda, were closely connected; the Golkonda tradition persisted under the first Nizams of Hyderabad.

DE CREEFT, José (1884–)

b. Guadalajara, Spain. Sculptor who was apprenticed to 'imagier' and foundry, Barcelona, and to sculptor Querol, Madrid (1900); studied at Académie Julian (1905) and worked in carving-shop (c. 1909), Paris; settled in America (1928); taught at *Art Students' League. Pioneering direct carving, De Creeft reveals Oriental influence in rounded, sweeping, bold figures.

DEESIS

The Greek means 'prayer'; Byzantine artists represented this literally with the petitioner holding out an inscribed scroll to Christ, the Virgin, or any saint. However, the scheme where Christ is seen between the Virgin and St John the Baptist is now often termed the Deesis: this formula represents the intercession of these saints for mankind, an abbreviated Last Judgement.

DEGAS (Hilaire Germain Edgar de GAS) (1834–1917)

b. d. Paris. From a wealthy banking family that made him financially independent, Degas began in law, but entered the Ecole des Beaux-Arts under Lamothe, a pupil of *Ingres whom Degas also knew and admired. On his return from Italy, he painted portraits and historical subjects, but by the late 1860s,

probably influenced by his friend *Manet, changed to contemporary subject-matter. He ceased to exhibit at the Salon in 1870, and took an active part in the †Impressionist exhibitions from their first show (1874). The racecourse and women dancing, working, bathing, dressing provided the principal themes for his investigations of light, colour and form. His unusual viewpoints, asymmetrical compositions, dramatic foreshortenings and emphasis on contours, were influenced by an interest in photography and Japanese prints. The progressive failure of his eyesight towards the end of his life turned him to a broader, freer style in pastels and to sculptural works of dancers and figures in movement.

DEHN, Adolf (1895–1968)

b. Waterville, Minnesota d. New York. Painter who studied in Minneapolis (1914) and with Boardman *Robinson in New York; visited Europe, particularly Paris (c. 1921–8) and Haiti (1946); worked for *WPA; lived in New York. Dehn used his broad, energetic technique both to satirise hypocrisy and pretentiousness and to evoke the Midwestern and Southwestern landscape.

DE KOONING, Willem (1904–)

b. Rotterdam. Painter who studied at Rotterdam Academy of Fine Arts (1916), went to America (1926), had close relationship with *Gorky (1927–48), did commercial art and murals (late 1920s, early 1930s), worked for *WPA (1935), and taught at Black Mountain College and Yale University. De Kooning's painting evolved through *Expressionism, *Cubism, and *Surrealism to *Abstract Expressionism. Extremely influential, his work is characterised by paradox: refined painterliness, inventive colour and composition, crossed with turbulence, accident and slashing vulgarity.

DELACROIX, Eugène (1798–1863)

b. Charenton-Saint-Maurice, nr Paris d. Paris. Friend of Chopin and George Sand, he was the greatest exponent of French †Romantic painting, often deriving inspiration from English literary sources (Shakespeare, Scott, Byron) or from medieval and †Renaissance history. He studied under *Guérin at the Ecole des Beaux-Arts, admired *Géricault, and already revealed the powerful influence of *Rubens in the *Barque of Dante* shown at the Salon of 1822 (Louvre). *The Massacre of Chios* (1824, Louvre) inspired by the Greek revolt against the Turks, aroused controversy manifesting as it did Delacroix's love of exoticism, his use of brilliant colour, his free handling and consequent rejection of French classical values. He visited England (1825) – he was already an admirer of *Constable – and travelled in North Africa (1832) which supplied him with subjects for the rest of his life. After his return his style was sufficiently accepted for him to be awarded many official commissions, among them the decoration of the libraries of the Palais Bourbon and Luxembourg and the ceiling of the Salon d'Apollon in the Louvre; but his real achievement lay in smaller, highly animated, colourful scenes – animal-hunts, etc. His journal is an outstanding record of an artist's life and work.

DE LA FOSSE, Charles (1636–1716)

b. d. Paris. French history-painter. A pupil of *Lebrun, and friend and supporter of de *Piles, he was a prominent decorative painter in France and England. Under Lebrun he worked at Versailles on the Salon de Diane and Salon d'Apollon and painted the dome of the Invalides (1692) for Jules Hardouin-Mansart. His work shows more individuality than most of his French contemporaries, heralding the lighter touch of the †Rococo.

DELAROCHE, Paul (Hippolyte) (1797–1856)

b. d. Paris. French painter of history, portraits, religious subjects, he studied under *Gros, and was admired by *Géricault at his Salon of 1822 début with *Christ Descending from the Cross*. *Delacroix, however, disapproved of his academic interpretation of †Romanticism. In preparation for the Church of the Madeleine decoration, he went to Italy (1834) where he

married *Vernet's daughter. He discontinued this commission when he found part of it entrusted to another artist. He exhibited regularly until his *Ste Cécile* (1837) received adverse criticism and he renounced official painting. His most ambitious work was the hemicycle of classical figures in the Ecole des Beaux-Arts (1837–9).

DELAUNAY, Robert (1885–1941)

b. Paris d. Montpellier. French painter who trained as a scenery-designer (1902–3). Married Sonia Terk *Delaunay (1910). Exhibited with *Cubists (1911), and *Blaue Reiter (1912). Influenced by *Cézanne, then by *Analytical Cubism. His destructive use of light in *Tour Eiffel* (1910) influenced *Boccioni. The *Fenêtres* series (early 1912) marks the beginning of his 'constructive' period, which *Apollinaire called 'Orphic'. Delaunay's reinterpretation of *Chevreul's 'simultaneous colour contrasts' soon led to a completely abstract art based on the dynamic properties of pure prismatic colour. His *Disques Simultanées* and *Formes Circulaires* (1913) were perhaps the first completely abstract paintings by a French artist. Delaunay then abandoned abstraction until 1930.

DELAUNAY, Sonia Terk (1885–)

b. Ukraine. Painter who studied in St Petersburg, Karlsruhe and Paris. Settled in Paris and married Wilhelm Uhde (1909). Married Robert *Delaunay (1910). Influenced by *Van Gogh, *Gauguin and *Chevreul, she shared Robert Delaunay's fascination with colour. She successfully developed his theories of *simultanéisme* in her own painting (eg *Prismes Electriques*, 1914) and also in theatre design and applied art.

DE LISLE PSALTER (before 1339)

The later section of this English Psalter contains a full-page series of unusual symbolical pictures, and scenes from the lives of Christ and the Virgin. In the first of two styles, graceful, elongated figures, modelled by delicate tinting, inhabit elaborate †Gothic frameworks, with richly patterned backgrounds. The illuminations of the second style have much bolder modelling in colour and show the influence of Jean *Pucelle, and ultimately Italy.

DELL, Peter the Elder (1501–52)

b. d. Würzburg. German woodcarver, much influenced by his master, *Riemenschneider. His *Virgin and Child with St Anne* (Hörstein) shows his sharply linear and sophisticated style. He executed mainly small woodcarvings, some bronzes and powerful portrait-reliefs.

DELLO, Niccolò delli (c. 1404–1470/71)

b. Florence d. Valencia. Florentine painter and a close friend of *Uccello. He fled with his father, who was accused of treason, to Siena (1424), and was in Venice (1427). He seems to have become well known, and twice went to Spain. His work at Sta Maria Novella may have been done under Uccello's guidance.

DELPHIC CHARIOTEER

A life-size bronze figure which belonged to a chariot group erected at Delphi. It was donated (470 BC) by Polyzalos, Tyrant of Gela in Sicily. It is a fine example of *Severe Style sculpture with the *chiton hiding the lower part of the body in tubular folds, and the finely modelled head slightly turned to the right. (Delphi Museum.)

DELVAUX, Paul (1897–)

b. Antheit. Belgian painter who studied at the Brussels Academy (1920–4). First influenced by the Belgian *Expressionists, his journey to Italy and France (1932) introduced him to de *Chirico's *Pittura Metafisica and *Surrealism. An initial aversion to *Magritte gave way to participation in international Surrealist exhibitions (1938, 1940). His typical apparatus of passively statuesque women and *Palladian architecture juxtaposed with urban brickwork offers an atmosphere of contemplative eroticism.

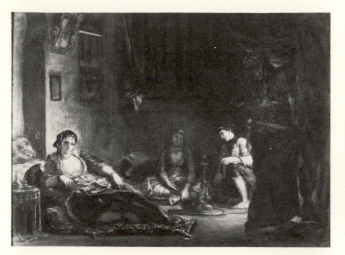

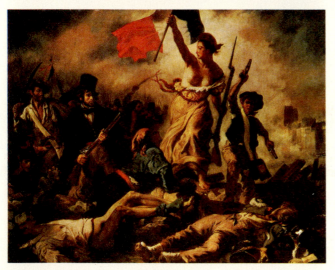

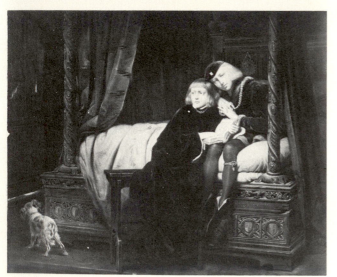

Top: EUGENE DELACROIX *Algerian Women in their Quarters.*
1849. 33×43¾ in (83·8×11·1 cm). Musée Fabre, Montpellier
Centre: EUGENE DELACROIX *Liberty Leading the People.* 1830.
102½×128 in (260·4×325·1 cm). Louvre
Above: PAUL DELAROCHE *The Princes in the Tower.* 1831.
17¼×20⅜ in (44×52 cm). Wallace
Top right: ROBERT DELAUNAY *The Window.* 1912. 18×14¾ in
(45·7×37·5 cm). Tate

Centre above: SONIA
DELAUNAY *Triptyque.* 1963.
39¼×78¾ in (99·7×200 cm).
Tate
Left: DE LISLE
PSALTER *Ascension.* Before
1339. 13¾×9 in (35×23 cm).
BM, London
Opposite page top left:
PAUL DELVAUX *The Iron
Age.* 1951. 59⅞×94½ in
(152×240 cm). Museum
Voor Schoone Kunsten,
Ostend
Opposite page top centre:
ROBYN DENNY *Garden.*
1966–7. 96×78 in
(243·8×198·1 cm). Tate

Opposite page top right: DELPHIC CHARIOTEER
c. 470 BC. Bronze. h. 71 in (1·8 m). Delphi Museum
Opposite page centre: DEMOTTE SHAH-NAMA *The Bier of
Iskandar.* Mongol School. Mid-14th century. Freer Gallery of Art,
Washington
Right: CHARLES DEMUTH *My Egypt.* 1927. 35¾×30 in
(90·8×76·2 cm). Whitney Museum of American Art, New York

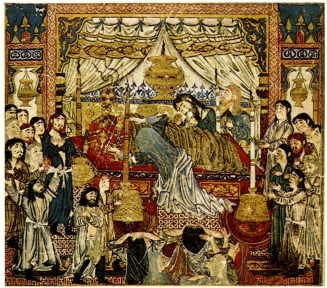

DEMETER OF KNIDOS (c. 350 BC)

A seated statue of Demeter mourning the loss of her daughter Persephone. It is attributed by some to *Leochares. (BM, London.)

DEMOTTE SHAH-NAMA (mid 14th century)

This dispersed Islamic manuscript of the *Mongol School is named after its former owner and generally dated 1320–75, having perhaps been produced for the *Jalairid Sultan Uways (1356–74). Probably originally consisting of 120 miniatures, the surviving 58 are the works of several artists in distinct styles. Considered to be the apogee of the Mongol School under the Il-Khanids, the miniatures are held generally in a rectangular frame across the whole page with pyramidic compositions of the *Mesopotamian School, often with a figure in the extreme foreground. Simple perspective is attempted, but more attention is given to echoing and linking colours and shapes. The figures can be classed as pathetic and heroic/elegant, being elongated with small heads with expressive faces. A wide range of colours is used together with more sombre tones. †Chinese Sung and Yüan idioms are found in tree, ground and figure treatment. *See also* MONGOL PAINTING

DEMUTH, Charles (1883–1935)

b. d. Lancaster, Pennsylvania. Painter who studied at Pennsylvania Academy under Anschutz and *Henri; lived in Paris (1907, 1912–14). Influenced by *Hartley and *Duchamp, he Americanised *Cubism, *Futurism and *Dadaism in *Precisionist paintings of industrial subjects. Except for looser flower studies, his mature works are elegantly cool, geometric stylisations. He invented a type called the 'poster portrait'.

DENIS, Maurice (1870–1943)

b. Grandville d. Paris. Painter who studied at the Académie Julian and was a co-founder of the *Nabis (1888). Denis attempted to revive religious art, founding the Ateliers d'Art Sacré (1919). An insignificant painter, Denis in theory anticipated abstract art, publishing his *Definition of Neo-Traditionalism* (1890) which begins 'A picture, before being a war horse, a nude woman, or some anecdote, is essentially a flat surface covered by colours arranged in a certain order.'

DENNY, Robyn (1930–)

b. Abinger, Surrey. English painter who studied in Paris (1950), St Martin's School of Art (1951–4) and the Royal College of Art (1954–7). He became influenced by the paintings of the *Abstract Expressionist group (c. 1959), especially *Rothko, painting *hard-edged geometric shapes on large canvases. His rich, closely toned colour relationships are deceptively ambiguous.

ANDRE DERAIN *Landscape in Provence*. 1906. Private Collection, Paris

DERAIN, André (1880–1954)

b. Chatou d. Garches. French painter, trained in Paris at the Académies Carrière and Julian. He met *Matisse (1905), spending the summer painting with him at Collioure, where they produced, under the influence of *Signac and *Cross, work shown at the *Fauve Salon d'Automne. While his painting at this time is similar to that of Matisse, his handling of colour and paint is somewhat less sensitive. He soon withdrew into isolation from Paris society, becoming more interested in *Cézanne, and turned for a period to *Cubism, restricting his palette and formalising his drawing. Later, in deep mental perplexity, his work falls into disarray under a variety of influences from ballet to the *quattrocento.

Left: ANDRE DERAIN *Window at Vers*. 1912. $51\frac{1}{2} \times 35\frac{1}{4}$ in (130·8×89·5 cm). MOMA, New York, Abby Aldrich Rockefeller Fund, purchased in memory of Mrs Cornelius J. Sullivan
Right: DESIDERIO DA SETTIGNANO Angel from the Altar of the Sacrament. 1458–61. Marble. S. Lorenzo, Florence

DERUET, Claude (1588–1660)

b. d. Nancy. French painter, who reflects in subject-matter the influence of his fellow Lorrainer, *Callot. He decorated the Carmelite Church and the Ducal Castle at Nancy. His portraits are in a stiff, late *Mannerist style quite out of touch with contemporary developments.

DESIDERIO DA SETTIGNANO (c. 1429–64)

b. d. Settignano, nr Florence. Italian sculptor in low relief, influenced by *Donatella. A major work is the Sta Croce tomb

monument of Carlo Marsuppini (d. 1453) in Florence. He did the *tabernacle in S. Lorenzo, Florence (1461). Desiderio also produced marble busts of women and children. His evident interest in youthful subjects is appropriately matched by a lyrical graceful style.

DESIDERIO, Monsù

A pseudonym covering at least three artists, the major figure being NOME, François b. Metz (?1593) and in Naples by 1610, painting *Mannerist architectural fantasies perhaps derived from Florentine stage design. BARRA, Didier, his fellow-countryman, painted topographical scenes.

DESIGN

Italian: *disegno*. The total composition of a finished work, or the plan for it.

DESIGNERS' COLOURS

Fine *poster paint or *gouache in metal tubes.

DESNOYER, François (1894–1972)

b. Montauban d. Sète. Painter who studied at the Ecole des Arts Décoratifs (1913, 1919–23). Desnoyer's popular scenes of cheerful activity combine broad strokes of bright colour with a traditional spatial structure in a style reminiscent of *Fauvism in its *Cézannesque phase (1906–9).

DESPIAU, Charles (1874–1946)

b. Mont-de-Marson d. Paris. French sculptor who studied at the Ecole des Beaux-Arts and assisted *Rodin (1907–14). He achieves subtle psychological definition in his portraits with minimum manipulation of form. The classical calm of his work is reminiscent of *Maillol rather than Rodin.

DESPORTES, François (1661–1743)

b. Champaigneulles d. Paris. French painter of animal still-lifes and hunting scenes, becoming official painter to Louis XIV and Louis XV. Previously worked as a portraitist in Poland. A precursor of the English watercolourists, he painted *plein-air sketches in oil on paper.

FRANCOIS DESPORTES *Dog with Flowers and Dead Game*. $51\frac{1}{4} \times 64\frac{1}{4}$ in (131×164 cm). Wallace

DE STIJL

Movement founded in Holland (1917) by painters *Van Doesburg, *Mondrian, *Van der Leck, *Huszar, architects Oud, Wils, Van t'Hoff, the sculptor *Vantongerloo, the poet Kok and joined by architects Rietveld (1918) and Van Esteren (1922). Mondrian was the creative spirit, Van Doesburg the

leader and propagandist of the movement, organising the *De Stijl* magazine (1917–31), lecturing in Germany, Italy, Belgium (1920) and at the *Bauhaus (1921–3). *Lissitzky above all encouraged Van Doesburg to turn towards notions of space/time in architecture, and this, coupled with his introduction of the dynamic diagonal in painting caused Mondrian's resignation (1925). Like *Constructivism and *Dadaism, De Stijl's enthusiasm for the new had as its ultimate aim harmony in life. Believing that discord is caused by nature's unequal balance between opposites – universal/individual, male/female, etc, they argued that only an abstract *Neo-Plastic art and eventually an 'abstract', man-controlled life could achieve perfect harmony. Their style, based on a dynamic balance between basic opposing elements – vertical/horizontal, etc, originating in painting had its fullest and most influential expression in architecture.

DETAILLE, Jean-Baptiste-Edouard (1848–1912)

b. d. Paris. French painter of history and battle scenes, entered *Meissonier's studio at seventeen, and exhibited *Un coin de l'atelier de Meissonier* in the Salon of 1867. An indefatigable traveller, he returned to Paris to learn of the declaration of war with Germany. Military life was depicted with intensity and detail in his Panthéon and Hôtel de Ville decorations in Paris.

DEUTSCH, Nikolaus Manuel (1484–1530)

b. d. Berne. German painter, probably pupil of a stained-glass worker and of Hans *Burgkmair in Augsburg. After travelling abroad he settled in Berne (1509) and played an active part in the Reformation, both in politics and in writing satires. His early painting shows medieval, then classical elements. In the main, it has both high drama and unnatural *Mannerist colouring (eg *Beheading of St John the Baptist*, 1515–20, Basle). His frenzied, grotesque treatment of figures and lush landscapes, show an affinity with early *Cranach and *Grünewald, as in the *Life of St Anthony* panels (1520, Berne).

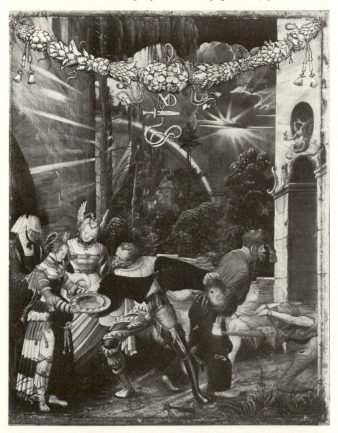

NIKOLAUS MANUEL DEUTSCH *Beheading of St John the Baptist*. 1515–20. 12¾×10¼ in (32·5×20 cm). Kunstmuseum, Basle

DEVERELL, Walter Howell (1827–54)

b. Charlottesville, USA d. Chelsea. A close associate of the *Pre-Raphaelite Brotherhood but never a member. Came to England (1829) and was appointed Assistant Master at the Government School of Design (1848). In his short working life, he showed considerable thematic innovation, eg *The Pet* (1852/3), which prefigures later Pre-Raphaelite non-narrative studies of female beauty.

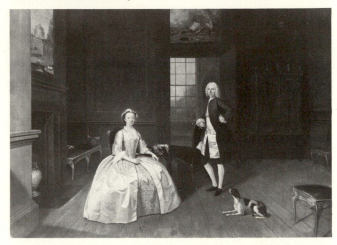

ARTHUR DEVIS *Mr and Mrs William Atherton*. 1740. 36¼×50 in (149·9×127 cm). Tate

DEVIS Family

English painters. Arthur (1711–87) b. d. Preston, specialised in small portraits and *conversation-pieces set in a secure middle-class world – of particular interest to the social historian. Eclipsed by *Zoffany in the 1760s, he experimented with glass-painting. Anthony (1729–1816) was a minor landscapist.

DEWING, Thomas Wilmer (1851–1938)

b. Boston d. New York. Painter who studied in Munich, under Boulanger and Lefebvre in Paris (1876–9) and taught at *Art Students' League (1881–8). His academically †Impressionist paintings of women in landscapes and interiors grew increasingly disembodied, leaving little but atmosphere.

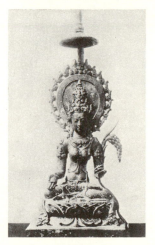

DEWI SHRI Bronze statue of the rice goddess. Central Java. *c*. 9th century. h. 8⅞ in (20·5 cm). Resink Collection

DEWI SHRI, Java (*c*. 9th century AD)

Shri, like Lakshmi, is a wife of *Vishnu, but in Indonesia she also assumed an independent existence as a goddess of fertility, especially of the rice harvest. A bronze sculpture from central Java shows her with the left hand holding a head of rice, while the right is in the gesture of giving. (In the island of Bali she is so far separated from her vaishnavite role that she is considered as a wife of *Shiva.)

DE WINT, Peter (1784–1849)

b. Stone, Staffordshire d. London, of Dutch-American origin. Landscape painter, particularly in the flat Lincolnshire countryside, whose peaceful atmosphere he conveyed on broad canvases. Visited Normandy (1828). Beginning in oils, he is chiefly known as a watercolourist using broad, simple washes.

DEXAMENOS (active 450/425 BC)

Greek *gem engraver who signed several gems including one featuring a flying heron, and another with a profile bearded head.

DEXILEOS STELE

A tombstone from near the Dipylon Gate at Athens dedicated to Dexileos who died in 394 BC in the Corinthian War. It shows a young mounted warrior with his right arm raised to strike down his foe, who lies on the ground looking helplessly up at him.

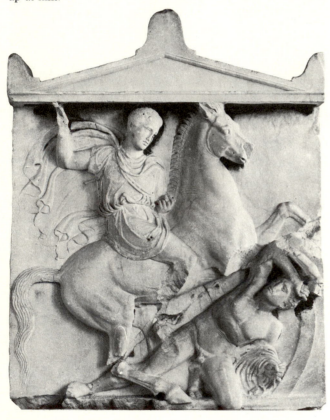

DEXILEOS STELE *c.* 394 BC. h. 5 ft 8 in (1·72 m). Kerameikos Museum, Athens

DEYROLLE, Jean (1911–)

b. Nogent-sur-Marne. French self-taught painter, influenced by *Sérusier and *Braque, but launched from *Cubism into abstraction by *Domela. Deyrolle composes free, angular structures in shaded tones both discreet and subtle.

DHARMA-CHAKRA

Sanskrit: literally 'law-wheel'; spoked wheel symbolising continuity of the Buddha's teaching.

DIADOUMENOS see POLYKLEITOS

DIAGUITA

Refers to two different cultures appearing in Chile and Argentina (*c.* AD 1000–1450). Argentine Diaguita includes *Santa María and *Belén pottery styles and follows on from *Aguada.

Chilean Diaguita is characterised by bowls and bridge-handled jars with wide spouts and modelled heads, painted with delicate geometric designs and stylised faces in red, white and black.

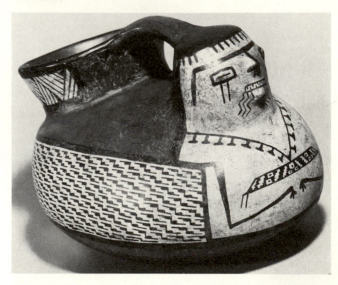

DIAGUITA Pottery jug with a modelled head. Painted red, white and black. *c.* AD 1000–1450, Coquimbo, Chile. $6\frac{1}{8} \times 8$ in (15·5×20·3 cm). Royal Scottish Museum

DIAPER GROUNDS

Decorative pattern composed of a small, repeated unit such as a lozenge or square, used as a background to an initial or a figurative illustration in a medieval manuscript.

DIAZ DE LA PENA, Narcisse Virgile (1808–76)

b. Bordeaux d. Menton. The son of Spanish refugees. While working at a porcelain factory he met *Dupré and for a time he studied under Souchon. In his early works he followed the Romantic and Oriental themes of *Delacroix while his firm impasto owed much to *Decamps. He first exhibited in the 1830s when he also began to paint at Fontainebleau with Théodore Rousseau who considerably influenced his landscapes. These he enlivened with mythological nudes – Leda, Diana, Venus, etc – reminiscent of *Prud'hon and *Correggio. His finest works are forest interiors penetrated by sunlight, painted round *Barbizon. His strong individual technique influenced *Monticelli and the young †Impressionists.

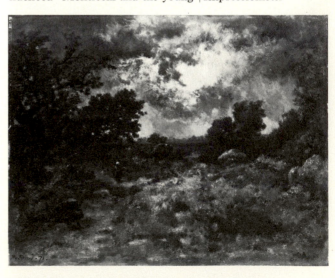

NARCISSE DIAZ DE LA PENA *Storm in the Forest of Fontainebleau.* 1871. $17\frac{1}{8} \times 21\frac{3}{4}$ in (43·5×55·2 cm). Fitzwilliam

DIAZ YEPES, Eduardo (1910–)

Uruguayan sculptor who has experimented with both abstract and figurative work in many schools, including *Cubism and *Expressionism, being most influential in Uruguay in symbolic works based on natural forms.

DICKINSON, Edwin (1891–)

b. Seneca Falls, New York. Painter who studied with *Chase at *Art Students' League (1910), lived in Provincetown (1920–37), and travels abroad frequently, especially to France. Unclassifiable, Dickinson's characteristic paintings are weird, haunted fantasies: strange juxtapositions of exquisitely rendered, twisted figures, objects and whirling draperies weave through *chiaroscuro and inexplicable mists.

EDWIN DICKINSON
Composition with Still-life.
1933–7. 97×77¾ in
(246·4×197·5 cm). MOMA,
New York, Gift of Mr and Mrs
Ansley W. Sawyer

DICKINSON, Preston (1891–1930)

b. New York d. Spain. Painter who studied at *Art Students' League and lived in Paris at beginning of century. Influenced by *Cézanne, *Cubism and *Futurism, he became one of the *Precisionist 'Immaculates', reducing complex urban scenes to exquisitely severe geometric patterns.

DIDEROT, Denis (1713–84)

b. Langres, Champagne d. Paris. Editor of the *Grande Encyclopédie*, and important 18th-century French art critic, writing sophisticated accounts of Salons for private circulation. His aesthetic system was traditional – beauty derived from rules and great art conveying great ideas and emotions – but his response was personal.

DIEBENKORN, Richard (1922–)

b. Portland, Oregon. Painter who studied at various California art schools, including California School of Fine Arts, where he later taught; now teaches at California College of Arts and Crafts, Berkeley. Influenced by *Still and *Rothko, he was a leader of California *Abstract Expressionism, then led the movement back to figurative painting. Diebenkorn uses his broad brushwork and intense colour paradoxically to evoke awkward, solitary, introspective figures, expressing a California mood of desolation in paradise.

DIGAMBARA see SHVETAMBARA

DILLER, Burgoyne (1906–65)

b. d. New York. Painter who studied at Michigan State College, *Art Students' League and with Hans *Hofmann, and taught industrial design. First an *Expressionist, Diller developed logically through *Cézanne's influence and *Cubism to *Neo-Plasticism, becoming *Mondrian's first American disciple (1934); thereafter, he painted personal variations on Mondrian's theme.

DILUENT

Fluid used to dissolve, thin or dilute *oils, *resins and other painters' materia.

DINE, Jim (James) (1935–)

b. Cincinnati, Ohio. Painter/sculptor who studied at University of Cincinnati, Ohio University and Boston Museum School; taught at Oberlin, Yale, Cornell and Royal College of Art, London. Influenced by *Oldenburg, *Johns and *Rauschenberg, Dine's assemblages combine everyday objects with painting and drawing, akin to *Pop Art, but warmer, wittier and more erotic.

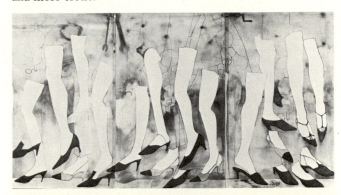

Top: JIM DINE *Walking Dream with a Four Foot Clamp.* 1965. 60×108×1⅛ in (152·4×274·3×2·9 cm). Tate
Above: RICHARD DIEBENKORN *Woman with Newspaper.* Collection: the Artist

DINOS PAINTER (active late 5th century BC)

Athenian vase painter working during the period when the Pheidian tradition was coming to an end. His painting is full of restless lines, hooks and flourishes. His forms are rounder and there is a great feeling of movement in his work.

DIONISY (c. 1440–c. 1508)

The best Russian painter in Moscow in the second half of the 15th century, famous for icons and frescoes, eg his last and

well-preserved wall-paintings in the Ferapontov Monastery in North Russia (1500–2). His work is distinctive for elegant, elongated figures in bright colours. He was possibly influenced by late *quattrocento artists like *Botticelli, though he continued the tradition of *Rublev.

DIONISY *The Unprofitable Servant*. Fresco in the Church of the Birth of the Virgin, Ferapontov Monastery. 1500–2

DIONYSIOS OF FOURNA

An Athonite artist of the 17th century, who wrote the *Painters' Guide*, a handbook on painting techniques and iconography, purportedly reflecting the methods of Panselinos, a late †Byzantine painter who also worked on Athos. Dionysios drew on older sources and traditions, so that his methods and scheme probably do partially reflect Byzantine practices.

DIOSKORIDES (late 1st century BC–early 1st century AD)

Greek *gem-engraver of the Augustan period whose signature appears on several gems. *Pliny says of him: 'He engraved that perfect likeness of the god Augustus which later emperors have used as their seal.'

DIPYLON VASES (9th–8th century BC)

A number of large *Geometric vases were found in the cemetery near the Dipylon Gate at Athens. For a long time the term 'Dipylon' was used to denote all Geometric pottery, but it was later restricted to *Attic Geometric pottery. The term has now passed out of use, although it is still sometimes applied to the big Attic Geometric kraters with high stems and scenes of human figures.

DISKOBOLOS *see* MYRON

DISTEMPER

Water-based paints employing *glue as a *binder and chalk as a filler used by house-painters. Technically should be generic term for all water-based colours, eg *poster paint, but this is extreme specialist usage.

DIVISIONISM *see* POINTILLISM

DIX, Otto (1891–1969)

b. Untermhaus, Thuringia d. Hemmenhofen. German painter who studied in Dresden (1909–14), teaching there. Moved to Düsseldorf and studied there (1922–5). Travelled extensively in Europe, returning to Dresden to teach (1925–33) until

Nazi repression. Dix's painting is closely associated with the *Neue Sachlichkeit of post-1918 Germany. Often reflecting strong social and political convictions, his photographic realism demonstrates both a horror and a fascination for scenes of violence, poverty and death.

Left: OTTO DIX *Dr Mayer Herman*. 1926. $59\frac{1}{8} \times 39\frac{3}{8}$ in (150×100 cm). MOMA, New York, Gift of Philip C. Johnson

Below: DJAGO Relief from plinth of the temple, illustrating an episode from the Parthayajna. 13th century. h. $29\frac{1}{2}$ in (75 cm)

DJAGO, Java

Although this Buddhist temple was apparently conceived about AD 1280, there is reason to believe that in its present form it is about sixty years earlier. There are a number of statues of Mahāyānist deities which show late *Pala influence: these contrast very markedly in style with the reliefs which include moralistic themes of redemption, and a substantial number of episodes from the *Mahabharata* (an Indian epic translated into Javanese in the 10th century AD which tells the story of the war between the Pandavas and the Koravas). In manner the narrative technique is reminiscent of the *wayang beber, the scroll type of story-telling. A very fine *kala* head, perhaps from a gateway, is in the enclosure.

DJAWI *see* MADJAPAHIT PERIOD

DOAN (Yamada Doan) (d. 1571)

A high-ranking Japanese nobleman who painted in ink in the *Muromachi Suiboku style.

DOBELL, Sir William (1899–)

b. Newcastle. Australian painter who studied under Julian Ashton and at the Slade School of Art under *Tonks, returning to Australia (1939). Considered the nominal leader of modern art in Australia, he was probably not advanced in terms of contemporary art trends elsewhere. His portraits combine a sharp cynicism with keen observation, expressionistically exaggerating physical features.

DOBSON, Frank (1886–1963)

b. d. London. English sculptor of figure subjects; also a decorative painter. At first he was greeted as the only native-born sculptor of the artistic avant-garde in England. But maintaining a heavy, bloated naturalism, this role was subsequently taken over by Henry *Moore.

DOBSON, William (1610–46)

b. d. London. First important English painter on the scale of life, executing many portraits of Royalists and royal children during the Civil War. His style is more vigorous, down-to-earth and Venetian than *Van Dyck's.

DOCENO, IL see GHERARDI

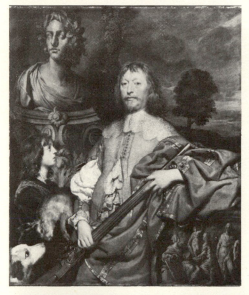

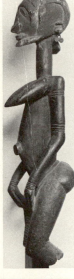

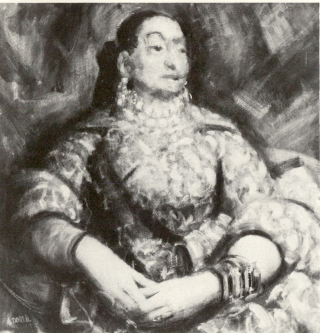

Top left: WILLIAM DOBSON *Endymion Porter.* c. 1643–5. 59×50 in (149·9×127 cm). Tate
Top right: DOGON *Figure of a woman.* 19th century. Wood. h. 23½ in (60 cm). Collection M. Charles Ratton, Paris
Above: WILLIAM DOBELL *Helena Rubinstein.* 1960. 39½×39½ in (100·3×100·3 cm). NG, Adelaide

DOGON

A tribe inhabiting the Bandiagara escarpment area of Mali. Because of the inaccessibility of their environment, the Dogon were thought to have escaped the pressures of Islam unlike most other peoples of the western Sudan. Nevertheless, the increasing abstraction in style of Dogon sculpture, seen especially in their masks (some of which bear an uncanny re-

semblance to the architectural forms of mosques at Jenne and Mopti) may reflect †Islamic influence. As among other peoples of the western Sudan, the smiths are the professional sculptors of the Dogon working in wrought iron and cast brass as well as carving masks, figures, doors, house-posts and other objects of wood. Certain wooden figures found in caves high up in the Bandiagara escarpment are attributed, by the Dogon, to the Tellem, the mythical predecessors of the Dogon in this area, but as they form a stylistic continuum with later Dogon sculpture they can probably best be regarded as the earliest Dogon work. Some of the supposed Tellem pieces have been dated by radio carbon to the 13th century AD, but as Dogon smiths are known to prefer working in old wood (apparently there is a plentiful supply) rather than new, it is difficult to place any reliance on such dates which only tell us the date of the death of the tree and not when its wood was carved. There is no other evidence to prove that any Dogon (or Tellem) piece is earlier than AD 1800.

DOIDALSAS (active 3rd century BC)

Sculptor from Bithynia. He is said to have made a statue of Aphrodite washing herself. This has been recognised in the crouching Aphrodite which appears on coins and in several marble copies.

DOLCI, Carlo (1616–86)

b. d. Florence. Regarded by contemporaries as the greatest living Florentine artist, Dolci's precocious early portrait style is best seen in his *Ainolfo de' Bardi* (Pitti). His later, morbidly religious paintings, borrowing widely from Italian and Northern sources, are the direct result of a deepening melancholia and a vow to paint only sacred subjects.

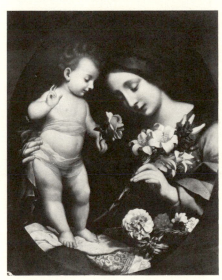

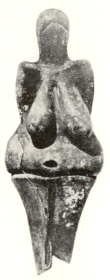

Left: CARLO DOLCI *Virgin and Child.* 30½×24½ in (77×62 cm). NG, London
Right: DOLNI-VISTONICE Clay figurine of 'Mother Goddess'

DOLNI-VISTONICE (Eastern Gravettian c. 27,000–23,000 BC)

†Palaeolithic site in Moravia. Finds include female figurines in ivory, some highly stylised, and an ivory female head. A small oven in the dwelling-pit is associated with baked clay animal heads.

DOMELA-NIEUWENHUIS, Cesar (1900–)

b. Amsterdam. Dutch painter and relief-maker, the youngest member of *De Stijl movement. A friend of *Mondrian, he joined in 1924 and was active in the group for two years painting strong *Neo-Plastic works. Later began making reliefs, at first *Constructivist, but later becoming superficially decorative.

DOMENICHINO (Domenico ZAMPIERI) (1581–1641)

b. Bologna d. Naples. Italian painter, taught in Bologna by *Calvaert, then by the *Carracci. He went to Rome (1602) remaining there except for short intervals until 1631. With the death of Annibale Carracci he became with *Reni the most important painter in Rome in the 1610s. The decoration of the S. Cecilia Chapel (1612–14, S. Luigi dei Francesi) and the *Communion of St Jerome* (1614, Vatican) exemplify his classic style based on *Raphael and Annibale's late manner. Though supported by *Agucchi's artistic theory, and by Pope Gregory XV his work became unfashionable in the 1620s; despite a modification towards †Baroque, he was overtaken by *Lanfranco. He went to Naples (1631). He was an important landscapist following Annibale's style; he anticipates *Poussin, even *Claude.

Left: DOMENICHINO
Last Communion of St Jerome. 1614. 157½×100¾ in (419×256 cm). Vatican

Below: DOMENICO VENEZIANO *Madonna and Child with SS Francis, John the Baptist, Nicholas and Lucy* (the St Lucy altarpiece). *c.* 1440. Tempera. 82⅜×89⅞ in (209×213 cm). Uffizi

DOMENICO VENEZIANO (*c.* 1400–61)

Italian painter who worked in Venice and Umbria before arriving in Florence (1438/9) where he collaborated with *Piero della Francesca on a series of lost frescoes in S. Egidio; he also assisted Fra *Angelico. Domenico is noted for his cool, delicate colour and mastery of space, qualities which make the signed *St Lucy Altarpiece* one of the most important examples of early *sacra conversazione groups.

DOMITIUS AHENOBARBUS, Altar of

The name given to two sets of sculptured reliefs, one in Munich and the other in the Louvre. The Munich part, in a *Hellenistic style, shows a procession of marine deities following Thetis and Achilles; the Louvre part shows a *Suevotaurilia* (sacrifice of a bull), a sheep and a swine in a characteristically Roman style. According to some it is a very early official monument (115/70 BC) and according to others it dates to the Second Triumvirate (40/30 BC).

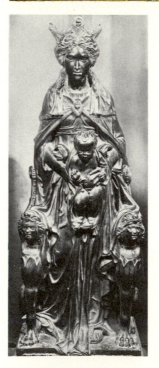

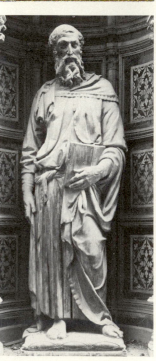

Top: DONATELLO *The Annunciation* (the Cavalcanti altarpiece). *c.* 1463–40. Limestone. h. 165 in (419 cm). Sta Croce, Florence
Left: DONATELLO *Virgin and Child*. Cast 1448. Bronze. h. 62⅝ in (159 cm). S. Antonio, Padua
Right: DONATELLO *St Mark*. 1411–13. Marble. h. 93 in (236 cm). Or S. Michele, Florence

DONATELLO (Donato di NICCOLO) (c. 1386–1466)

b. d. Florence. The greatest Florentine sculptor of the Early
†Renaissance and also its most widely influential artist. Trained
by *Ghiberti, his earliest works show †Gothic characteristics,
eg *David* (1408/9, Bargello, Florence). In the years 1411–16 he
discovered the secret of fusing physical vigour with an inner
authority in the figures of St Mark and St George (Or San
Michele, Florence) and the relief on the socle of the latter was
the first attempt to combine the effects of linear and aerial
perspective. Between 1415 and 1436 he was intermittently
engaged in carving the Prophets for the Campanile and was
also carrying out statuettes and reliefs for the Siena Baptistery
font, including the Dance of Salome, which is instinct with a
terrible catalytic power. A sojourn in Rome (1430–3) inter-
rupted these activities and was followed by a Florentine
decade in which he created his most overtly classical works,
the *Cantoria* (1433–8), *Annunciation* (Sta Croce) and the cele-
brated bronze *David* (Bargello, Florence), the first free-
standing nude statue of the Renaissance. The ensuing Paduan
period (1443–53) was also notable for its innovations, the
bronze equestrian *Gattamelata* and the design of the High
Altar of the Santo in which he grouped the figures to form a
*sacra conversazione, while in the low reliefs of the *Miracles
of St Anthony* he reached a new dramatic intensity which
deepened into tragedy in the last Florentine works, eg
Resurrection (pulpit, S. Lorenzo).

DONG-SON, Thanh Hoa, North Vietnam

Type site for a bronze-using culture, the bronze usually
having a high tin content up to 25 per cent, which is generally
associated with Indonesian-speaking peoples. The most
famous of its products are bronze kettle-drums, probably cast
in negative stone moulds, some fragments of which have been
found in Bali. The objects have been found from South China
to the islands of Indonesia, and seem to date from *c.* 3rd
century BC to 4th century AD, though late forms of the drums,
generally used for rain-making ceremonies persisted among
South-East Asian hill tribes until the present. (The culture
had demonstrable links with finds from Shih Chai Shan in
Yunnan.) Other objects include pediform axes, bronze vessels
and figurines, and one remarkable lamp-holder of a kneeling
figure from Lach Truong. The largest of the drums with a
diameter of sixty-four inches is that from Pedjeng in Bali.
Many contain scenes arranged in concentric bands round a
central star whose points are interfilled with faces. Processions
of animals, birds, fishes are also found, and there are boats with
plumed warriors depicted on the drum bodies.

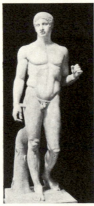

DONI, Paolo see UCCELLO

DONNER, Georg Raphael (1693–1741)

b. Essling d. Vienna. Foremost Austrian †Baroque sculptor, he
worked at Salzburg, Pressburg (Bratislava) and Vienna, chiefly
in lead. His early exuberance, influenced by *Michelangelo,
developed into a more concentrated, linear art, eg *St Martin
and the Beggar* (Pressburg Cathedral).

DORAZIO, Piero (1927–)

b. Rome. Painter who studied architecture and has worked in
Europe and America as exhibition organiser, critic, teacher and
painter. Dorazio's deliberate experiments in the optical effects
of colour, using interweaving colour bands belong to the
tradition of European geometric abstraction.

DORE, Gustave (1833–83)

b. Strasbourg d. Paris. French illustrator, arrived in Paris
(1847) and worked as a caricaturist for Philippon's *Journal
pour Rire*. Between 1847 and 1853 he produced over a thousand
designs for French and English magazines. His first successful
commission to illustrate a book was that for an edition of
Rabelais (1854). The Crimean War provided him with sub-
jects for reportage and for paintings exhibited at the Salon.
During the 1860s he established a huge reputation with his
illustrations to Dante's *Inferno* (1861), Cervantes' *Don Quixote*
(1863) and the Bible (1866). His sense of the Sublime, in scale
and group composition, which allies him to the earlier genera-
tion of John *Martin and Francis *Danby, is best seen in his
illustrations to Coleridge's *Ancient Mariner* (1876) and
Jerrold's *London* (1872). Each commission necessitated
elaborate research. In late years he took up painting again, on
colossal canvases, exhibited at his own gallery in London.

Above left: GUSTAVE DORE *Don Quixote and Sancho Panza
entertained by Basil and Quiteria.* After 1862. 36¼×28¾ in
(92·1×73 cm). MM, New York, Gift of Mrs William A. McFadden
and Mrs Giles Whiting, 1928
Above right: DOSSO DOSSI *Portrait of a Warrior.* 33½×27⅝ in
(85×70 cm). Uffizi
Near left: DORYPHOROS OF POLYKLEITOS Roman copy of
5th-century Greek original. National Museum, Naples
Far left: DONG-SON Type 1 bronze situla from Thanh Hoa.
Musée Guimet, Paris

DORSET see ESKIMO ART

DORYPHOROS OF POLYKLEITOS (450–440 BC)

A statue of a nude male holding a lance. *Polykleitos's most
famous work, it had more influence on Greek sculpture than
any other statue. It embodies the 'canon', a measured inter-
relation of the parts of the body. Beginning with the *Kritian
Boy, an attempt was made to move away from the stiff stance
of the *Archaic *kouros and distribute the weight of the body
unevenly over the two legs. This reached its climax in the
Doryphoros where the weight of the body is exactly poised on
one leg. There is a Roman copy in Naples.

DOSSI, Dosso (Giovanni LUTERI) (c. 1490–1542)

b. d. Ferrara. One of the last painters of the Ferrarese School.
His early work is influenced by *Giorgione and *Titian, show-
ing a soft poetic treatment but summary draughtsmanship.
From 1520 he developed a more exotic style producing bizarre
landscapes peopled with richly dressed figures.

GERRIT DOU *The Young Mother*. 1658 29×21$\frac{7}{8}$ in
(73·5×55·5 cm). Mauritshuis, The Hague

DOU, Gerrit (1613–75)

b. d. Leiden. Dutch genre painter working in Leiden. His
highly finished 'microscopic' art made him one of Holland's
most successful artists, and the motifs he developed were
widely popularised. Before †Impressionism, his paintings
were more highly valued than those of *Rembrandt, his
teacher.

DOUGHTY, Thomas (1793–1856)

b. Philadelphia d. New York. Self-taught painter and litho-
grapher who moved to Boston (1832), travelled to Europe
(1837–8, 1845–6), living primarily in New York after 1838. A
founder of the *Hudson River School, he excelled in evoking
the placid poetry of rural landscapes under subtle light.

DOURIS (active 500/470 BC)

Athenian *red-figure cup painter. He was much influenced by
the Panaitios Painter although his figures had a quieter, more
statuesque quality. He took a great deal of trouble over details
such as eyes and drapery.

DOVA, Gianni (1925–)

b. Rome. Italian painter who works in Milan in an *Auto-
matist 'informal' style, suggesting analogies with organic life.
He influenced *Baj and Dangelo who founded Nuclear Art
(1950), but belongs to the rival *Spatialist movement founded
by *Fontana. *See also* BAJ

Top: GIANNI DOVA *Explosion*. 1953. 31$\frac{3}{8}$×27$\frac{5}{8}$ in
(79·7×70·2 cm). Tate
Above: JOHN DOWNMAN *Francis Charles Seymour-Conway*.
1781. 8$\frac{1}{4}$×6$\frac{1}{2}$ in (21×16 cm). Wallace
Left: THOMAS DOUGHTY *In the Catskills*. Addison Gallery of
American Art, Phillips Academy, Andover

DOVE, Arthur G. (1880–1946)

b. Canadaigua, New York d. Long Island, New York. Painter who lived in Paris (1907) and belonged to *Stieglitz group in New York. Influenced by *Cézanne and *Fauvism, he pioneered American abstract art, attempting to embody his responses to the essential characteristics of nature in abstract shapes painted in intense colour.

DOWNMAN, John (c. 1750–1824)

English painter, working in London and Cambridge, whose major work consisted of small society portraits – frequently oval – in pencil and charcoal, lightly tinted with watercolour. He also painted (less successfully) life-size oil portraits and small-scale histories.

DOYEN, Gabriel-François (1726–1806)

b. Paris d. St Petersburg. French †Neo-classical painter. He executed work for many Paris churches, and became Academy Professor (1776). He accepted an invitation from Empress Catherine II (1789), and decorated palaces for her and Paul I, including several ceilings at the Hermitage.

DOYLE, Richard (1824–83)

b. d. London. English illustrator, specialising in subjects from 'faerie'. After 1851, when he left the staff of *Punch*, he illustrated many books, the most successful being Allingham's *In Fairyland* (1871) for Edmund Evans. His depiction of social customs for the *Cornhill* magazine in the 1860s shows his inherent love of the grotesque, here influenced by a *Pre-Raphaelite graphic style.

DRAWING

Building an image on a surface by a series of marks; pencil on paper, chalk on stone. Usually describes the use of dry media on the flat ground, but there are two important exceptions. *Watercolour-paintings are referred to as drawings; and dry *pastel drawings are referred to as paintings.

DRIER see SICCATIVE

DROESHOUT, Martin (1601–after 1650)

Engraver to London booksellers. Chiefly known for his portrait of Shakespeare prefixed to the First Folio (1623). He also portrayed John Donne, illustrated Captain John Smith's *True Travels* (1630) and executed the title-page of Crooke's *Microcosmographia* (1631).

DROST, William (active 1650s)

Seventeenth-century Dutch painter and engraver whose career is still very obscure. He was probably in touch with *Rembrandt in the 1650s, as his *Bathsheba* (Louvre) is certainly inspired by Rembrandt's painting. Stylistically close to *Bol.

DROUAIS Family
Hubert (1699–1767)
François Hubert (1727–75)

Hubert, b. La Roque d. Paris, was a French portraitist, often in miniature, influenced by Jean-Baptiste *Van Loo and *Nattier (*Joseph Christophe*, Louvre). The fashionable portraits painted by his son François, b. d. Paris, were in the manner of *Boucher and enjoyed greater fame, rivalling those of Nattier. François painted the royal family and many prominent members of the aristocracy.

DRYING OIL see OIL

DRYPOINT see ENGRAVING

DRYSDALE, Sir George Russell (1912–)

b. Bognor Regis, England. Settled permanently in Australia (1926). His artistic training began at the George Bell School (1935); he subsequently travelled to England and France to study the work of the moderns. He is best known for his brilliantly coloured, near-*Surrealist paintings of the Australian outback and its inhabitants, particularly those depicting solitary aborigine figures in vast and desolate landscapes.

Top: RUSSELL DRYSDALE *The War Memorial.* 1949. 26×40 in (66×101·6 cm). Tate
Above: MARTIN DROESHOUT *William Shakespeare.* Engraving. 7⅝×6¾ in (19·4×16·4 cm). NPG, London

DUALA

A tribe living in the creeks and mangrove swamps around the port of Duala in Cameroun. They have developed a form of openwork sculpture for the embellishment of ceremonial canoes.

DU BOIS, Guy Pène (1884–1958)

b. Brooklyn, New York d. Boston. Painter and critic who studied with *Chase and *Henri, and at the Académie Colarossi, Paris; exhibited at *Armory Show (1913); worked in France (1924–30); taught at *Art Students' League (1920–4, 1930–2, 1935–6). Du Bois painted New York's night-world denizens, gradually simplifying them into cold, tight, mannequin-like hardness.

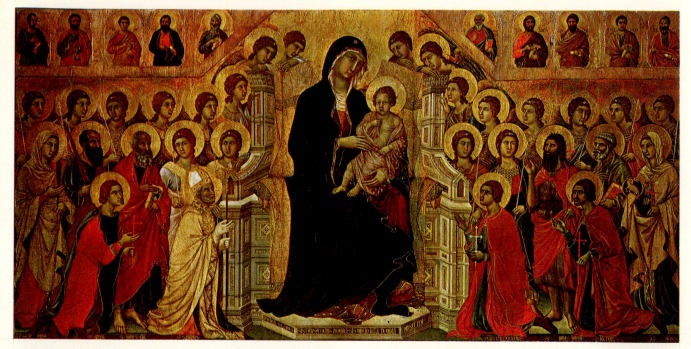

Middle above: JEAN DUBUFFET *Nimble Free Hand*. 1964.
59×79 in (149·9×200·7 cm). Tate
Above: CHARLES DUFRESNE *The Spahi*. 1919. Gouache.
15½×19⅞ in (39·4×50·5 cm). Tate

Top: DUCCIO DI BUONINSEGNA *Maestà*. 1308–11.
161¾×107½ in (411×273 cm). Museo dell'Opera del Duomo, Siena
Centre left: JEAN DUBUFFET *Man with a Hod*. 1955–6.
40¼×19⅞ in (102·2×50·5 cm). Tate

Top left: RAOUL DUFY *Posters at Trouville.* 1906. 25⅝ × 34⅝ in (65·1 × 87·8 cm). Musée National d'Art Moderne, Paris
Top right: GASPARD DUGHET *Abraham and Isaac Approaching the Place of Sacrifice.* 60 × 76¾ in (152·5 × 195 cm). NG, London
Above left: RAOUL DUFY *The Regatta.* 1910. 21¼ × 25⅜ in (54 × 64·5 cm). Musée du Petit Palais, Paris
Above right: JULES DUPRE *Crossing the Bridge.* 1838. 19½ × 25½ in (50 × 65 cm). Wallace
Near right: MARCEL DUCHAMP *The Bride Stripped bare by her Batchelors, even . . . (The Large Glass).* 1915—23. Oil and lead wire on glass. 109¼ × 69 in (277·5 × 175·5 cm). Philadelphia Museum of Art, Arensberg Collection
Opposite page middle right: DUCCIO DI BUONINSEGNA *Entry into Jerusalem.* Panel from the *Maestà.* 1308—11. 40¼ × 22⅛ in (102 × 56 cm). Museo dell'Opera del Duomo, Siena
Opposite page left: RAYMOND DUCHAMP-VILLON *Le Grand Cheval.* 1914. Plaster. 39⅜ × 43⅜ × 43⅜ in (100 × 110 × 110 cm). Musée National d'Art Moderne, Paris

Right: MARCEL DUCHAMP *Nude Descending a Staircase No. 2.* 1912. 58 × 35 in (147·3 × 88·9 cm). Philadelphia Museum of Art, Arensberg Collection

DUBREUIL, Toussaint (1561–1602)

French painter of the Second School of *Fontainebleau. Most of his works have been destroyed, but his *Sacrifice* (Louvre) and designs for tapestries of the *History of Diana* show a light, restrained style, midway between *Mannerism and classicism.

DUBROEUCQ, Jacques (c. 1505–84)

b. d. Mons. Flemish sculptor who, after staying in Rome (1530/5), settled in Mons, executing many tombs, altarpieces and roodscreens. Though his reliefs have linear movement, his statues, such as *Fortitude* (c. 1548, Mons) are gently classical and Italianate in feeling. Master of Giovanni da *Bologna.

DUBUFFET, Jean (1901–)

b. Le Havre. Painter who abandoned the Académie Julian (1918) resuming painting as an amateur (1942). Inspired by *Art Brut, Dubuffet follows the *Surrealists in rejecting the aesthetic and moral values of Western civilisation. He combines partial automatism with the use of intractable materials to encourage the irrational and accidental. Unlike many Surrealists, Dubuffet does not work from principle but from 'ardent celebration' of the unsimple tragi-comic life around us. Neither a naïve nor an uncontrolled expressionist his ironic, affectionate humour shows a civilised detachment.

DUCCIO, Agostino di see AGOSTINO DI DUCCIO

DUCCIO DI BUONINSEGNA (d. before 1318)

The leading *Sienese painter of his generation. His artistic progress was characterised by a move away from the †Byzantine tradition as practised by *Guido da Siena towards a †Gothic style under French influence, which presumably reached Italy in the form of manuscripts and ivories. But his use of colour, and his interest in landscape, anecdotal detail and 'stage setting' was personal, and his success with the large polyptych form created a new fashion. So also did his predilection for unusually elaborate frames. His standards of craftsmanship were exceptionally high. His long and successful career culminated in the commission for the *Maestà*, the High Altarpiece for Siena Cathedral (completed 1311). It is painted on both sides, with the Virgin and Child on one side surrounded by the Heavenly Court and on the other twenty-six scenes from the Passion of Christ, ten of the early life of Christ and many other panels. This unprecedented work established the reputation of Siena as the centre of Italian panel-painting up to the Black Death. Duccio's influence on 14th-century painting in Siena was immense (eg *Simone Martini and the *Lorenzetti), but it can also be detected in France (eg *Pucelle).

DUCHAMP, Gaston see VILLON, Jacques

DUCHAMP, Marcel (1887–1968)

b. Blainville d. New York. French painter and theorist who attended the Académie Julian, Paris (1904–5). Under the influence of his brothers Raymond *Duchamp-Villon and Jacques *Villon, he became a *Cubist painter. In 1913 he painted an ironic study of a machine, *Chocolate Grinder 1*, and produced his first Readymade (commercial mass-produced objects chosen by the artist). He now virtually abandoned conventional oil painting and initiated a series of intellectual and visual experiments culminating in the glass-painting, *The Bride stripped bare by her Bachelors, even* (1915–23), and its accompanying box of notes. After 1923 he outwardly ceased artistic activity, the logical outcome of his search for an anti-retinal art, for idea-painting. However, for many years he worked in secret on a mysterious room, to be seen through a peep-hole, which has now been assembled in Philadelphia. Although he remained detached from movements, Duchamp was associated with *Dada and *Surrealism.

DUCHAMP-VILLON, Raymond (1876–1918)

b. Damville d. Cannes. Brother of Marcel *Duchamp and Jacques *Villon, sculptor and architect who began in the tradition of *Rodin and turned to a simplistic *Cubism (1911). While developing parallel ideas to *Archipenko, *Matisse and *Boccioni, his major work, the *Great Horse* surpassed them. By wedding traditional to modern themes – dynamism, the machine – he kept close to the ideas of Villon and his friends.

DUCK, Jacob (1600–after 1660)

b. ?Utrecht d. ?The Hague. Dutch genre painter and etcher who entered the Utrecht Guild as apprentice (1621) and worked mostly in Utrecht (up to 1646). After 1656 he moved to The Hague, continuing to paint multi-figure military scenes with great delicacy of touch.

DUFRESNE, Charles (1876–1938)

b. Millemont d. La Seyne. French painter and designer who studied briefly at the Ecole des Beaux-Arts, Paris, where he won a scholarship for two years in Algiers (1910). He painted large imaginative compositions influenced by *Delacroix which reinstated subject-matter.

DUFRESNOY, Charles Alphonse (1611–68)

b. Paris d. Villiers-le-Bel. French *history-painter who worked in Rome, for French patrons (1633–53) and afterwards in Paris. His theoretical treatise *De Arte Graphica* (in Latin verse), published posthumously (1668), was translated into modern languages and became a widely used academic rule book for the following hundred years.

DUFY, Raoul (1877–1953)

b. Le Havre d. Forcalquier. French painter who studied at the Ecole des Beaux-Arts (1900). He was converted to *Fauvism (1905) on seeing *Matisse's painting *Luxe, Calme et Volupté*. After a brief Fauve period he began to develop a formula which never altered. He painted light-hearted scenes of recreation, applying large areas of bright colour with superimposed flowing outlines. His decorative and idiosyncratic work made him a popular but uninfluential artist.

DUGHET (POUSSIN), Gaspard (1615–75)

b. d. Rome. Brother-in-law and pupil of Nicolas *Poussin, he successfully synthesised the landscape painting styles of Poussin and *Claude. His life and work form a coherent, but chronologically uncertain picture. He had houses at the two favourite sketching areas near Rome, and received an important fresco commission in S. Martino ai Monti (1647). His style is less rigid than Poussin's (though his later style was influenced by Poussin's increasing geometrisation) but without the sense of infinite distance in Claude. Historically very significant, he was admired by English landscape painters (*Wilson) and influenced the landscape garden.

DUJARDIN, Karel (1622–78)

b. Amsterdam d. Venice. Highly versatile Dutch painter and etcher who studied under *Berchem. He is best known for his cabinet-size Italianate pastoral landscapes suffused with a clear yellow light. He was in Italy (c. 1642–62, 1674–8).

DUMONSTIER (DUMOUTIER) Family
Geoffroy du Monstier (?1537)
 Chardin (?1550)
 Cosme (alive 1602)
 Estienne (1520–1603)
 Pierre I (1565–1656)
 Daniel (1574–1646)
 Pierre II
 Estienne Jeune (1604–alive 1655)
 Nicolas (1612–67)

Works are difficult to attribute to precise members of this family of French artists, much reputed in their time. Daniel is today best known, since he dated his works (mainly pastel portraits, now in the Louvre). Geoffroy's etchings in the style of *Rosso are still collected. Other than three portrait drawings attributed to Pierre II, little remains.

DUMOUCHEL, Albert (1916–)

b. Valleyfield, Quebec. Canadian printmaker and painter who studied in Montreal and Paris; taught at Collège de Valleyfield, Ecole des Arts Graphiques and Ecole des Beaux-Arts in Montreal. Inspired by *Borduas, Dumouchel combines playful, almost child-like drawing with sophisticated graphic techniques, his technical mastery more impressive than his essentially decorative images.

DUMOUTIER see **DUMONSTIER**

DUNOYER DE SEGONZAC, André (1884–)

b. Boussy-Saint-Antoine. Painter, engraver and illustrator. Trained by *Laurens, Desvallière and Guérin, he started to work alone from 1906 developing an intuitive method of achieving balance and harmony in landscapes and nudes which remained his theme. He avoided theory and associated with *La Fresnaye, *Boussingault, *Marchand and Luc-Albert *Moreau.

DUPRE, Jules (1811–89)

b. Nantes d. Isle Adam. French artist of the *Barbizon School. While working at a Paris porcelain factory he met *Diaz. In the 1830s he was influenced by *Constable whose works he saw in England. He worked with *Rousseau, *Troyon and *Daubigny, and his early landscapes, painted from nature, remained his best and most influential works.

DUQUESNOY, François ('Il Fiammingo') (1597–1643)

b. Brussels d. Livorno. Flemish sculptor. In Rome (1618–43) he soon became important in the classical circle there and was a friend of *Poussin. His major works include *St Andrew* (1628–40, St Peter's, Rome) and *Sta Susanna* (1629–33, S. Maria di Loreto, Rome), which *Bellori held was a perfect synthesis of nature and the *Antique. He was famous for his small bronzes and *putti which were widely influential.

DURA-EUROPOS

Dura-Europos, on the Euphrates was the 'Pompeii' of the Syrian desert. Founded by one of Alexander's generals, a Roman garrison was besieged there by the Sassanian army soon after AD 256. The town was captured and then abandoned. Excavations have revealed many well-preserved buildings including a synagogue covered with fresco-paintings demonstrating the existence of a well-developed Jewish pictorial art and iconography at that time, and a 3rd-century church in a converted house containing frescoes important as witnesses of †Early Christian iconography.

DURAN, Charles Emile Auguste see
CAROLUS-DURAN

DURAND, Asher Brown (1796–1886)

b. Maplewood, New Jersey d. South Orange, New Jersey. Painter, first an engraver (1812–36), soon thereafter becoming member of *Hudson River School, studying in Europe (1840–1). His landscapes, often painted outdoors, are fresh and precise, with a solid realism and poetic depth won by painstaking study and imaginative penetration.

DURAND-RUEL, Paul (1831–1922)

French art-dealer also active in Holland, Belgium and England, who specialised initially in landscapes of the *Barbizon School. He was organising exhibitions when he met *Pissarro and *Monet (1870). From this date he sought to advance the †Impressionist cause, and made small but regular payments which allowed many artists to continue to paint.

DURANTY, Edmond (1833–80)

b. d. Paris. French novelist and art critic. He edited *Réalisme* (1856), a magazine in which he advocated modern life themes with an element of social awareness. He was a friend of *Courbet and later joined the circle round *Manet and *Zola. He wrote an early critique of †Impressionism, *La Nouvelle Peinture* (1876).

DURER, Albrecht (1471–1528)

b. d. Nuremberg. German painter, printmaker and draughtsman, the son of a goldsmith, and pupil of Michael *Wolgemut, painter and woodcutter. Early influences were *Schongauer and the *Master of the Housebook. He travelled in the Upper Rhineland and perhaps the Netherlands (1490–4). More influential were his Italian journeys. One, to North Italy, made after his marriage (1494) stimulated his growing interest in *quattrocento art (especially that of *Mantegna whose engravings he copied), and made him aspire to the status of creator rather than artisan (*Self-portrait*, 1498, Prado). It also encouraged, in addition to a taste for antique themes, his interest in the world about him, as a series of landscape watercolours, freely handled and evocative, show (eg *House by the Pond*, BM, London). The second visit, to Venice (1505–6), stimulated him to formulate a system of human proportion and intellectualised his approach to his work. He emulated the Venetian handling of colour in his *Feast of the Rose Gardens* (Prague). In his journey to the Netherlands (1520–1), he was, however, more influential than influenced. In his woodcut series the *Apocalypse* (1498), Dürer added to the classical artistic language of the Italian quattrocento a grandiose, dramatic turbulence, symptomatic of the Reformation. His command of proportion, chiaroscuro and technical refinement grew, and his *Large Passion* (1500–11), his *Engraved Passion* (1507–13) (copper), among other series, and individual works, all share these elements. This rich 'language' culminated in the famous engravings *Knight, Death and the Devil* (1513), *St Jerome in his study* (1514), *Melancolia* (1514), where classical and †Gothic combine in deeply symbolic prints. His paintings share the same preoccupations. Their scope varies from portraits (*Jakob Muffel*, 1526, Berlin), which assert his interest in detail as greatly as his love of Italian harmony, to religious works, as esoteric in their iconography as they are original in their composition (eg *Adoration of the Trinity*, 1511, KH, Vienna). Dürer's own attitude to his art, his belief that rules of procedure must never be allowed to override spontaneity, is expressed in his treatises and in his remarkably full diaries. In his lifetime he enjoyed the patronage of Emperor Maximilian and Charles V, and the friendship of the leading intellectuals of his day, including Willibald Pirckheimer.

DURET, Théodore (1831–1927)

b. Saintes d. Paris. French politician and critic who, in his critical articles, defended the work of *Pissarro, *Degas and particularly *Manet. His contacts with the painters of the movement, as friend and patron, resulted in a history of †Impressionism (1906). He also wrote monographs on Manet (1902) and *Whistler (1888) both of whom painted his portrait.

DURGA

Hindu goddess, aspect of *Pārvatī; represents the ferocity necessary to destroy evil.

DURHAM CATHEDRAL

Although chiefly famous as a piece of †Romanesque architecture, Durham Cathedral contains fragments of a superb 12th-century screen, whose style links it to the *Bury and *Lambeth Bibles. In the Galilee Chapel at the west end are wall-paintings of SS Oswald and Cuthbert (c. 1170).

DURRIE, George Henry (1820–63)

b. d. New Haven, Connecticut. Painter, pupil of Jocelyn, lived in Connecticut and New Jersey (1840–2), settled in New Haven, visiting other Northeastern states professionally. First a portraitist, he is remembered for small, simple rural winter scenes, rendered with firm clarity in low-keyed colour, made famous by *Currier and Ives.

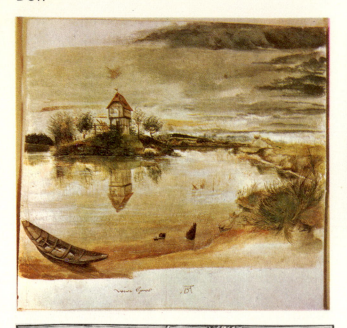

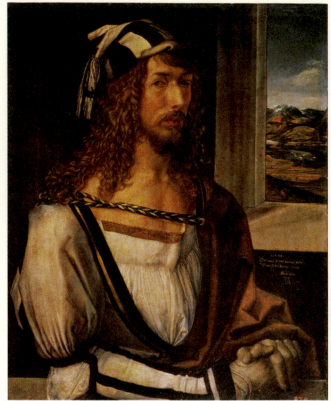

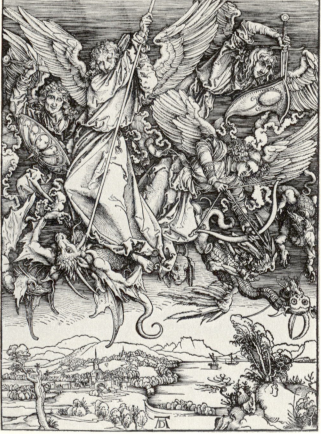

Top left: ALBRECHT DURER *A Weierhaus. c.* 1495–50.
Watercolour. $8\frac{3}{8} \times 8\frac{7}{8}$ in (21·3×22·5 cm). BM, London
Top right: ALBRECHT DURER *Self-portrait.* 1498. $20\frac{1}{2} \times 16\frac{1}{8}$ in
(52×41 cm). Prado
Above: ALBRECHT DURER *St Michael and the Dragon* from the
Apocalypse series. 1498. Woodcut. $15\frac{1}{2} \times 11\frac{1}{8}$ in (39×28 cm).
BM, London
Right, centre: ASHER BROWN DURAND *White Mountain
Scenery.* 1859. 36×45 in (91·4×114·3 cm). New York Historical
Society
Bottom right: FRANCOIS DUQUESNOY *St Andrew.* 1628–40.
Marble. St Peter's, Rome

Top: GEORGE HENRY DURRIE *Winter Landscape: Gathering Wood.* 1859. 28×34¼ in (71·1×87 cm). Boston, Karolik Collection
Above: WILLEM DUYSTER *Soldiers fighting over Booty in a Barn.* 11¾×22½ in (37·6×57 cm). NG, London
Right: DURHAM CATHEDRAL Carved stone screen. 12th century

Opposite page bottom left: BOOK OF DURROW Folio 84 recto showing eagle. MS. A.4.5. Second half 12th century. Trinity College Library, Dublin

DURROW, Book of (2nd half of 7th century)

A Gospel Book of Northumbrian (some say Irish) origin. Its purely decorative pages and the Evangelist symbols show very close parallels to *Anglo-Saxon jewellery (eg *Sutton Hoo hoard). Many other sources including *Coptic models have been suggested for the intricate decoration which is further developed in the *Lindisfarne Gospel. (Trinity College, Dublin.)

DUSART, Cornelis (1660–1704)

b. d. Haarlem. Dutch genre painter. Late pupil of Adriaen van *Ostade, he finished many of his dead master's canvases, and followed Ostade's bold coloration. His work was, however, more satirical and coarse, moving towards caricature. He also engraved and mezzotinted peasant scenes.

DUSSELDORF SCHOOL

The name attached to a group of artists working in Düsseldorf about the mid 19th century and who specialised in a rather academic type of realistic genre painting. The Belgian history painters Gallait and de Bièfre introduced a naturalistic style which conflicted openly with the heroic epics of *Cornelius. Bendemann (1811–89) and Leutze (1810–68) painted modern history subjects in a similar vein and close also to *Delaroche. Both had many pupils who continued the type. In history and genre anecdotal and illustrative concerns took precedence over matters of form. Village scenes and petit-bourgeois life were dominant themes, with moralising or humorous overtones.

DUTCH MORDANT

A weakened *acid solution used for etching. *See also* ENGRAVING

DUVENECK, Frank (1848–1919)

b. Covington, Kentucky d. Cincinnati, Ohio. Painter who studied under von Diez in Munich (from 1870), taught in Florence and Venice (1878–88) and at *Art Students' League (1898–9). This influential American proponent of Munich concepts captured the essence of unidealised subjects with broad, sensuous painterliness and masterfully sculptural form.

DUVET, Jean (1485–after 1561)

b. Langres. French engraver and goldsmith, active Dijon and ?Geneva. Despite his obvious contact with Italian High †Renaissance and *Mannerist art, his engravings of the *Unicorn* series (1540s) and *Apocalypse* series (c. 1560) show a mystic, †Gothic quality in which realistic space and scale are ignored.

DUYCKINCK Family
 Evert 1st (1621–1702)
 Gerret (1660–1710)
 Gerardus 1st (1695–1742)
 Evert 3rd (1677–1727)
 Gerardus 2nd (1723–97)

*Limners and glaziers, they were major portraitists of Dutch Colonial families in New York (then New Amsterdam), attempting to model form in 17th-century Dutch tradition, but limited by awkward factualness.

DUYSTER, Willem Corneliz (1599–1635)

b. d. Amsterdam. Dutch genre painter of small guard-room and similar scenes; pupil of Pieter *Codde, he specialised in sensitively rendered cloth textures. His portraits are remarkable for their naturalism and psychological intensity.

DVARA-PALA

Sanskrit: literally 'door-guardian'; sentinel statues symbolically protecting Indian temple entrances.

DYCE, William (1806–64)

b. Aberdeen d. Streatham. Scottish history-painter who studied at the Academies of Edinburgh and London. He made three early trips to Italy and his religious subjects and highly finished style owed much to the German *Nazarenes at Rome. He became head of the government Schools of Design and during the 1840s painted frescoes in the Houses of Parliament, All Saints', Margaret Street and at Osborne.

DYCK, VAN *see* **VAN DYCK**

DYING GAUL *see* **PERGAMENE SCHOOL**

E

EADWINE PSALTER (c. 1150)

This *Psalter is the second of three copies made at Canterbury of the illustrations in the famous †Carolingian *Utrecht Psalter. The light, impressionistic line and movement of the original are here replaced by the harder, clearer lines of †Romanesque. The Psalter contains a portrait of Eadwine, the scribe, shown with blue hair and flattering inscription and also a uniquely informative map of the waterworks of the monastery. (Trinity College, Cambridge, MS R 17 1.)

EAKINS, Thomas (1844–1916)

b. d. Philadelphia. Painter who studied anatomy at Jefferson Medical College and art at Pennsylvania Academy (1861), with *Gérôme at Ecole des Beaux-Arts (1866); visited Spain (1869); taught at Pennsylvania Academy (from 1876), becoming Director (1882); collaborated with *Muybridge in photographing figure in motion (1884). An influential teacher, Eakins pioneered direct painting from the nude despite violent controversy. Inspired by *Velasquez and *Ribera, he became America's foremost Naturalist; his unidealised individuals, at work or play are modelled with sculptural solidity in sombre, luminous colours. Eakins's uncompromising eye probed human beings – flesh, muscle, blood and bone, intellect and soul – and made him arguably America's greatest portraitist and painter.

EARL, Ralph (1751–1801)

b. Leicester, Massachusetts d. Bolton, Connecticut. Painter, who went to England (1778), studied under *West and returned to America (1785). Best known for his New England portraits (from 1786), despite West's teaching he retained native simplicity and puritanical austerity in architecturally structured paintings.

EARTH COLOURS

*Pigments occurring naturally in earths and clays, usually oxides of common metals; iron, copper. The colours include yellow and red ochres, umbers and terre verte.

EASEL

An adjustable stand upon which a *canvas or *panel is held while it is being painted.

EASEL

EASEL-PAINTING

A portable painting on a movable *support.

EASTER ISLAND

Most eastward of all the *Polynesian islands. Famous for the colossal stone statues which littered the slopes of Rano-Raraku, an extinct volcano. Wood figures were carved of men with stooped posture and emaciated physique. Other figures represent lizards and bird-headed men. The blades of elegant dance-paddles are conventionalised representations of the human face. Seated figures made from painted bark-cloth have been described variously as tattooing models and protective images.

EASTERN GRAVETTIAN

The eastern European counterpart to the late glacial art in France, broadly contemporary with *Perigordian, *Aurignacian, *Solutrian and *Magdalenian. It has certain technical affinities with Late Perigordian.

EASTERN UNITED STATES AND CANADA, ART OF

The most remarkable art forms from this immense region were produced by early pre-European cultures. A cult of the dead, marked by large earthworks, and burial-mounds containing a variety of grave goods, was an important feature of the Woodland Tradition or Period. The first significant art style appears with the Adena culture in the Ohio Valley (c. 1000 BC) and is characterised by carved stone ornaments and tubular pipes. The Adena stage was followed by the important *Hopewell culture which had widespread influence until its decline (c. AD 700). At about this time the complex Mississippian tradition was beginning to develop. Characterised by temples and other buildings standing upon platform mounds, the major Mississippian arts included carved stone pipes, shell ornaments and a range of pottery styles, one of the better known being the incised and polished black wares of the Caddo region. The Temple Mound cultures of the Mississippian tradition appear to have reached their peak shortly before European contact, and by about AD 1700 they had disappeared. An extraordinary group of art works belonging to this pre-European period (although not part of the Mississippian tradition), is the cache of wooden sculptures discovered at Key Marco off the Florida Coast. The finest pieces are small naturalistic carvings of animals and animal heads, some of which show traces of paint. Best known among the arts of the historic post-European period in this area are probably the 'False-Face' Society masks of the *Iroquois tribes.

EASTERN WEI SCULPTURE see T'IEN LUNG SHAN

Left: EASTER ISLAND Ancestor figure. Wood. h. 14½ in (37 cm). Museum für Völkekunde, Munich
Right: EASTERN UNITED STATES AND CANADA, ART OF Key Marco carved wooden figure of a puma. Pre-European period, Florida. h. 6 in (15 cm). U.S. National Museum, Washington D.C.

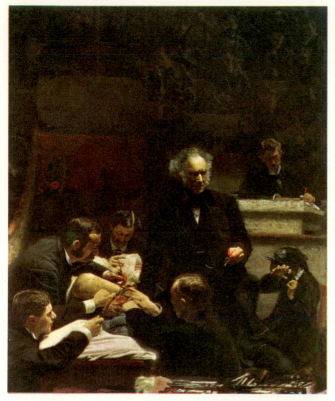

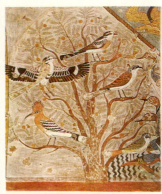

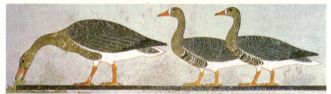

Below: AUGUSTUS EGG *Beatrice knighting Esmond.* 1857. 33½×45½ in (85·1×115·8 cm). Tate

Top left: THOMAS EAKINS *The Gross Clinic.* 1875. 96×78 in (243·8×198·1 cm). Jefferson Medical College, Philadelphia
Left: CHARLES LOCK EASTLAKE *The Champion.* 1824. 48½×68¾ in (123·2×174·6 cm). Birmingham
Top centre: CHRISTOFFER ECKERSBURG *Berthold Thorwaldsen.* 1815. Royal Academy, Copenhagen.
Top right: EGYPTIAN PAINTING *Birds in an acacia tree.* Tomb of Khnemhotpe at Beni Hasan. 12th dynasty. Painting on limestone. h. 22 in (56 cm).
Middle above: EGYPTIAN PAINTING *Banquet Scene with Musicians.* Tomb of Nebamun, Thebes. Mid-18th dynasty. Painting on plaster. h. (of musicians) 10 in (25·5 cm). BM, London
Above: EGYPTIAN PAINTING *Geese in a marsh.* Tomb of Itet at Meidum. 4th dynasty. Painting on plaster. h. (of geese) 8 in (20 cm). Egyptian Museum, Cairo

EASTLAKE, Sir Charles Lock (1793–1865)
b. Plymouth d. Pisa. English painter who studied at the Royal Academy. Travelled to Italy and Greece and painted subjects of Italian life and scenery when he lived in Rome (1820s). His reputation later was based on his knowledge of art history and techniques. He was Keeper of the National Gallery (1842–7) and Director (from 1855). He was knighted (1850) and elected President of the Royal Academy.

EASTMAN, Seth (1808–75)
b. Brunswick, Maine d. Washington, D.C. Painter graduated at Military Academy, West Point (1831), teaching drawing there (1833–40), later studying Indians in West, going to Texas (1848–9, 1855–6). During their lifetimes, Eastman was the

popular portrayer of Indians while *Catlin was neglected. Though showing documentary thoroughness, Eastman's work is artistically inferior to Catlin's.

EBBO GOSPELS (possibly before 823)

Made for Archbishop Ebbo of Reims. It illustrates a transitional style between the painterly, illusionistic style of the New Palace School of †Carolingian artists (*Aachen Cathedral Treasury Gospels) and the linear version of the same style found in the *Utrecht Psalter. (Bibliothèque Municipale, Epernay.)

ECHAURREN see MATTA

ECHTERNACH GOSPELS (probably early 8th century)

A Gospel Book either written in Northumbria and taken to the Anglo-Saxon monastery at Echternach (nr Trier) by the founder, St Willibrord, or written in a Northumbrian scriptorium at Echternach. An example of the channels through which Insular influence reached the Continent. The paintings of the Evangelist symbols show intensity and movement. St Matthew's drapery is even more abstract than in the *Lichfield Gospels, St Mark's lion is particularly vivid and the lettering of its inscription as in other Insular manuscripts conforms to the general spirit of pattern. (Bib. Nat., Paris.)

ECKERSBERG, Christoffer-Wilhelm (1783–1853)

b. Sundeved d. Copenhagen. The most important 19th-century Danish artist. He studied under *Abilgaard, with two years spent in *David's studio in Paris. He was in Rome (1813–16). His debt to French †Neo-classicism with its cool colours and precise contours is revealed in his portraits. He also painted religious and historical subjects, genre and still-life, seascapes and landscapes. He taught at the Academy in Copenhagen and became its Director. His works strongly influenced Danish art in the period 1830–50.

ECOUIS, Collegiate Church

The Collegiate Church of Augustinian Canons near Rouen was founded by Enguerrand de Marigny (1310). It is distinguished by the best surviving early 14th-century stone sculpture in France. The subjects are all religious, but the style is aristocratic rather than emotional (compare the contemporary work of Giovanni *Pisano).

EDO

The proper name for the people of the *Benin kingdom by which they know themselves. The word 'Bini', used by the people, and 'Benin', their capital, are both transliterations of *Ubini* a name of uncertain origin and meaning. North-west of the Edo (or Bini) are the Ishan and Afenmai or northern Edo (formerly called *Kukuruku*, a term of abuse!), a group of very small tribes, some no more than a village or two in size. South of the Edo are the Urhobo and Isoko. These peoples speak related languages and are thus referred to as the 'Edo-speaking peoples'. The sculpture of this area is diverse in form and owes little to the art of the Benin court. The Edo and Ishan place wooden rams' heads on their ancestral altars (just as bronze heads are placed on the royal altars). The Edo also have *ekpo* masks (nothing to do with *Ibibio *ekpo* masks) which appear in order to purge the community of disease and witchcraft. The Ishan carve massive wooden house-posts. The northern Edo peoples carve a variety of masks the most spectacular of which are five-foot-high structures used in age-grade ceremonies. The Urhobo carve, among other things, wooden protective spirits called *ivbri* in the form of an elephant surmounted by a human figure. This form is also found among the western *Ijo (where it is called *ejiri*).

EDWARDS, Edward (1738–1806)

b. d. London. English painter and engraver, who started by copying Old Masters for publication, and worked on all kinds of material from Shakespearean scenes, to dog portraits and views of Rome. He wrote a continuation to Horace Walpole's *Anecdotes of Painting* (published posthumously, 1808).

EECKHOUT, Gerbrandt van den (1621–74)

b. d. Amsterdam. Dutch painter who studied with *Rembrandt (c. 1640) and continued his master's style faithfully in his religious paintings. His genre scenes however show affinities with *Terborch and *Vermeer.

EFFORT MODERNE

Founded by the dealer, Léonce Rosenberg, L'Effort Moderne was a gallery which also arranged debates and published pamphlets (active 1915–27). It presented the work of *Picasso, *Braque, *Gris, *Léger, *Mondrian, *Severini, *Lipchitz, *Servranckx and others. Its high point was when it promoted a more rational *Cubism (1917–21), the prologue to *Purism. It published the *Bulletin de L'Effort Moderne* (1924–8).

EGG, Augustus Leopold (1816–63)

b. London d. Algiers. English painter, first exhibited in 1838, and subsequently, within the Royal Academy a supporter of the *Pre-Raphaelites who inspired him to discard a history-painting style influenced by *Delaroche, in favour of the more sensuous surface, eg *The Travelling Companions* (c. 1862), and the significant modern subject, eg *Past and Present* (1858).

EGGELING, Viking (1880–1925)

b. Lund, Sweden d. Berlin. Abstract painter who studied in Switzerland and Paris (from 1908) and associated with Zürich *Dada (1918–19). His system of linear orchestrations was based on musical counterpoint. With *Richter he experimented with the time factor in visual art, making scroll-paintings (from 1919) and abstract films (from 1920).

EGG TEMPERA see TEMPERA

EGYPTIAN PAINTING

Apart from designs and crude drawings on predynastic pottery, the earliest paintings from Egypt, likewise of predynastic date, are fragments of simple patterning upon gesso, leather and other materials, and parts of two compositions with human figures and boats, one on the wall of a tomb, the other on linen. Panels in imitation of coloured matting occur in several 1st dynasty mastabas, but the oldest representational paintings in characteristic Egyptian style are from the early Old Kingdom. There are the pictures of furniture in the tomb of *Hesyrē, and the 4th dynasty mural incorporating the *Meidūm geese. Painting did not become usual until the 6th dynasty, when it gradually superseded relief in private tombs, doubtless for economic reasons – and from this period too there are indications of easel work. The rectangular wooden coffins of the 1st intermediate period and the Middle Kingdom were commonly ornamented in painting, some quite elaborately, and there are outstanding murals of varied interest in several 12th dynasty tombs of provincial noblemen, notably those at *Beni Hasan. The great age of Egyptian painting was the New Kingdom, when it was the usual method of decoration in *Theban tombs, largely because the rock was unsuitable for relief. Some of the finest examples are in tomb-chapels of courtiers of the late 18th dynasty, their execution revealing developed awareness of the medium and its possibilities. This is accentuated in the *Amarna period, when painting achieved a certain independence. Work was frequently done freehand, without preliminary sketches – even in an impressionistic manner, and a plastic feeling of depth was gained by skilful and delicate brushwork, with variation in density and an intelligent grading of colour. During the later New Kingdom, painting was also employed extensively in illuminating papyri, such as the *Book of the Dead, in sketching on *ostraca, and as cheap ornamentation on mummy-cases, furniture and the like – though from the 20th dynasty there is a steady decline in quality. Little is known of the art thereafter, until, under Hellenistic influence, it was revived in an un-Egyptian form, the *mummy-portraits of Roman times being of some importance. Egyptian painting was never fresco, as frequently stated, but essentially a distemper or gouache, with water or dilute gum as the vehicle. Except for carbon black, the prin-

cipal pigments (red, yellow, blue, green, white, black) were either natural minerals, finely ground, or preparations of mineral origin. They were applied with brushes of reed or fibrous wood, bruised to form bristles, or, for large surfaces, with stumpy brushes of grass or fibre. Varnish was added occasionally in 18th dynasty tombs and, more often, on wooden objects. The Egyptian painter tended to work conventionally in simple colours, though the 'primaries' varied considerably, and intermediate shades were obtainable by overlaying or mixing. In the New Kingdom particularly, the use of more subtle tints was not uncommon, and, as in the tomb of *Nofretiri, there were experiments in conveying transparency and (rarely) with shading. Where painting was purely decorative, the harmonising of form and colour was often very successful.

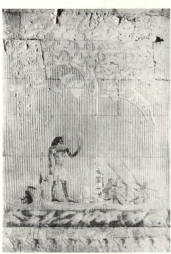

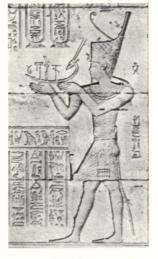

Top: EGYPTIAN RELIEFS Relief of Senwosret I. 12th dynasty. Limestone carved in low relief. h. (of pillar) 8 ft 4⅞ in (2·56 m). Temple of Karnak, Thebes
Above left: EGYPTIAN RELIEFS *Marsh scene.* Tomb of Thy, Saqqara. 5th dynasty. Painted relief on limestone. h. (of principal figure) about 15 in (40 cm).
Above right: EGYPTIAN RELIEFS Trajan making an offering to the goddess, Hathor. Roman period. Yellow sandstone. Temple of Hathor, Dendera

EGYPTIAN RELIEF

The earliest incised figures and crudely carved reliefs occur on predynastic knife-handles, combs and similar objects, of wood, bone and ivory, as well as on ordinary slate palettes, the characteristic Egyptian style of representation appearing first on the large ceremonial palettes and mace-heads of the period of *Narmer and the unification of Egypt. By the beginning of the Old Kingdom, the technique of handling low relief was fully accomplished, as seen in the wooden panels from the 3rd dynasty mastaba of *Hesyrē, and the lively quality of the scenes in many tombs of the 4th and 5th dynasties, for example that of *Thy at *Saqqāra, is in some respects unsurpassed later. The tradition of carefully modelled low relief continued during the Middle Kingdom, but sunk relief (*relief en creux*) was employed increasingly, not only for walls, but on stelae and stone sarcophagi – perhaps because it would weather better and be more easily seen in a strong light. Both types of relief were commonly used during the 18th and 19th dynasties, and, while on the whole there is a decline in standard, some few examples in tombs of the later 18th dynasty, such as that of *Ramose, are of outstanding excellence. The best *Amarna reliefs are also notably competent, with experiments in the use of differing planes and three-dimensional detail, and of transition from sunk to low relief. The elegant low reliefs of *Sety I at *Abydos and elsewhere show the same polished craftsmanship, and this is apparent too in the delicate plaster modelling in the tomb of Queen *Nofretiri. From the time of *Ramesses II, and during the later New Kingdom, temple reliefs became coarser, owing in part to the quality of the sandstone, and figures were deeply sunk and coated thickly with plaster, in which the details were executed. In the Late Period there was a conscious return to earlier models, though with a growing tendency to mould the forms more roundly, and this is further developed in Greco-Roman work, where figures have greater plasticity and substance. Egyptian relief of either form was never conceived as three-dimensional, and seems indeed to have been regarded as little more than a reinforced method of drawing – apparent anomalies, such as full frontal figures in high relief, being treated as statues attached to a dorsal slab. The unity of relief and other forms of two-dimensional representation, especially painting, is evident from the technique of execution. In either case, the ground was simply prepared to afford a smooth surface, and on this the composition was sketched in detail, following drafted guide-lines. For a relief, the sculptor merely cut round the outlines and then carved the flat shapes, while the painter, whether working independently or colouring a relief (usually over a wash of plaster), first brushed in the background and then painted the separate items, which were finally outlined.

EGYPTIAN STATUARY

Crude figurines of clay, bone and ivory occur from earliest times, the end of the predynastic era showing a marked improvement technically, and in the use of materials such as wood, stone and faience. No clear development can be traced during the protodynastic period, though there is a greater variety among the small pieces known, and evidence too that larger figures were fashioned. The oldest statues that are unmistakably Egyptian belong to the 2nd dynasty (when a royal image in metal is also mentioned), and the dynastic style as such was formalised during the 3rd and early 4th dynasties – the first colossi apparently dating from the same period. The sculpture of the Old Kingdom, mainly produced under royal patronage, was of a high standard, though the increasing use of wood in the 6th dynasty may indicate economic restrictions. From the Middle Kingdom, however, work for provincial officials was often less competent, with a tendency towards simplified forms like the figure swathed in a mantle or the block statue. The latter, in which the subject may be reduced to no more than a contoured block, became common in the New Kingdom, when similar compact types were also favoured – and these persisted later. The best features of 18th dynasty sculpture, its delicacy (as in the work of *Thutmose III) and its feeling for detail, were consciously imitated in the 3rd

intermediate period (eg the statue of *Karmem), and older models were copied under the 25th dynasty, and in the Saite renaissance. From about this time there was also a growing concern for texture and surface treatment, and an awareness of formal composition – even to the extent of subordinating the subject. Smoothness and polish were set against ornamental detail, precisely carved, and preference was shown for darker stone, especially under the 30th dynasty, as with the *Nectanebo lions. 'Egyptian' sculpture was still produced in the Greco-Roman period, with Roman emperors put in pharaonic garb, but the forms were somewhat exaggerated and rounded, and details of dress and adornment were frequently *Hellenistic. The method of executing a statue amounted effectively to working together the profile and frontal aspects of the intended sculpture. Sketches were made on at least two sides of a cuboid block, which was then reduced systematically by jarring and pecking off layers of stone all round, so that the statue had form throughout, but was modelled in detail only during the final stages (eg the unfinished figures of *Menkaurē). Hard rocks were worked mainly by pounding and chipping with stone mauls and picks, though sometimes cut with metal saws and drills fed with abrasive sand, while for carving softer stones both chisels and adzes were used, their blades of copper (or, later, bronze). In the Old Kingdom, all statuary was painted, usually overall (as *Rahotpe and Nofret), but from the Middle Kingdom onwards the harder stones might be coloured only in part, or not at all – and the surface was generally left untouched during the later dynasties. Stone statues betray the cubic form of the parent block, and figures mostly face straight ahead, though occasionally glancing downwards. The profile attitude may indeed vary, but frontally the median plane bisecting the body is always rigid and vertical, with shoulders and hips at right angles to it, and no deflection sideways. With rare exceptions, men stand with the left foot forward, while women's feet are together or barely spaced, and the legs are normally solid between and attached to a dorsal pillar. Seated, kneeling and squatting figures dispense with the pillar, but the lower limbs are similarly consolidated – and arms are almost invariably in unbroken contact with the body. Wooden and metal statues follow the same conventions, but in that the limbs were more often made separately they are less restricted in treatment. Only where figures are incidental, as in tomb models (eg *Meketrē) or when serving to hold cosmetics, may the whole body be made more flexible. Men are usually shown in their prime, virile, alert and confident, though sometimes more fleshily prosperous like the *'Sheikh el-Beled', while women retain the firm breasts, slim hips and graceful curves of youth. The body above the waist is as a rule more carefully worked than the lower limbs, with even greater attention paid to the head, which may be enlivened by the insertion of inlaid eyes (eg *Rahotpe and the *'scribe accroupi'. Often the features are strikingly real, as in royal sculpture of the 12th dynasty (*Senwosret III), the most convincing portraits dating from the Late Period, among them the priestly *'green head'. But portraiture was in a sense irrelevant, since identity was established primarily by inscribing the name, and the portrait bust as such was never developed, because it was not an entity – heads such as that of *Nefertiti having been studio models.

EGYPTIAN STATUARY

Top left: Isis protecting Osiris. 26th dynasty. Green schist. h. 32 in (81 cm). BM, London

Top right: Hawk. 30th dynasty. Black basalt. h. 18¾ in (47·5 cm). Louvre

Middle left: Statue of a standard-bearer usurped by Sheshonq. Late 18th dynasty, usurped in the 22nd dynasty. Green breccia with white streaks. h. 19 in (48 cm). Egyptian Museum, Cairo

Middle right: Statue of Khertyhotpe, the Steward. Late 12th dynasty. Quartzite. h. 29½ in (75 cm). Staatliche Museen zu Berlin

Bottom left: Wooden figure of a servant girl holding an ointment jar. Mid-18th dynasty. h. 5⅛ in (13 cm). Gulbenkian Museum, Durham

Bottom right: Statue of Ankhaper. 3rd dynasty. Granite. h. 31⅛ in (79 cm). Rijksmuseum, Leiden

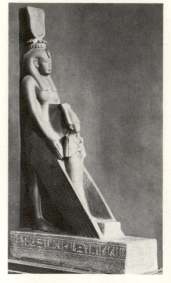

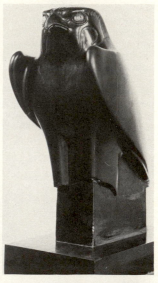

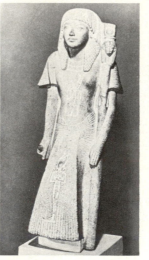

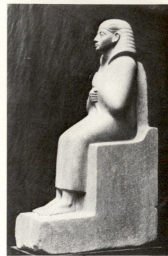

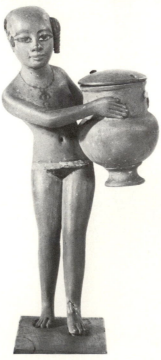

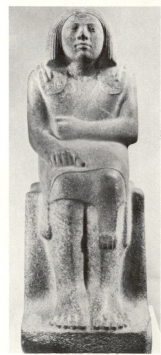

EIGHT, THE

Group of painters comprising *Henri, *Luks, *Shinn, *Sloan, *Glackens, *Prendergast, *Lawson and *Davies, who exhibited together at the Macbeth Gallery, New York (1908), the exhibition then travelling to other cities. Stylistically heterogeneous, the first five were realists of the *Ash Can School, the latter three painting in †Romantic or †Impressionist styles. The group formed when the National Academy of Design rejected work by Luks, Glackens and Shinn (1907), and Henri withdrew his work in protest. Their independent show created a revolution on two fronts: first, the Ash Can School's subject-matter raised a storm of protest and infused American art with new life; second, the formation of a group of artists, united only by their individuality, exhibiting together, broke the National Academy's stranglehold on exhibitions, setting the precedent for independent mixed modern exhibitions in America, including the *Armory Show (1913).

EIGHT ECCENTRICS OF YANGCHOW

A group of painters who worked in the 18th century for the wealthy merchants of Yangchow, each with a distinctive and unorthodox style both in calligraphy and in painting. The list varies: *Chin Nung, *Huang Shen, *Cheng Hsieh, *Lo P'ing, *Kao Fêng-han, *Li Shan.

EILSHEMIUS, Louis Michel (1864–1941)

b. Nr Newark, New Jersey d. New York. Painter who studied at *Art Students' League (1884–6), with *Bouguereau at the Académie Julian, Paris, in Geneva and Dresden; travelled in Europe, Africa and South Seas (1888–early 1900s); stopped painting (1921). His enchanted female nudes in mysterious landscapes blend poetic primitivism with visionary art.

EISHI (Chobunsai Eishi) (1756–1829)

Japanese painter, member of a Samurai family. After a *Kanō School training, when he became painter to the Shōgun, he

Top: LOUIS EILSHEMIUS Figures in Landscape. 1906. 22½×25¾ in (57·2×65·4 cm). Whitney Museum of American Art, New York
Above: EITOKU Six-fold screen with lion dogs. 2nd half of 16th century. Colour on gold leaf. 7 ft 4½×15 ft 1 in (224×458 cm). Imperial Collection, Tokyo

changed to the *Ukiyo-e style and produced delicate prints at first somewhat in the manner of *Kiyonaga and later in the manner of *Utamaro.

EITOKU (Kano Kuninobu) (1543–90)

Japanese painter, the pupil and grandson of *Motonobu. Early recognised as a painter of genius, he was patronised successively by the Konoe family, by Nobunaga and Hideyoshi. His use of avowedly decorative colour – painting on a background of gold-leaf – was uniquely successful and the technique was used by almost all succeeding schools of painters. Few of his works survive.

EKOI

A group of tribes, also known as Ejagham, in the middle Cross River area of south-east Nigeria. The *Cross River monoliths are found on the sites of old Ekoi villages around Ikom. The Ekoi are best known for their wooden masks and headdresses which are covered with animal skin stretched over the wood, and most of which are made for age-sets within the Ekpe society.

ELAM

A region of south-western Iran. From the third until the middle of the first millennium BC, it was an important kingdom with its centre at *Susa. Geographically it is and was an extension of the Mesopotamian plain and did produce fine works of art within the *Mesopotamian tradition such as the life-size bronze statue of Queen *Napirasu.

ELEMA see PAPUA, GULF OF

ELEMENTARISM see DE STIJL

ELEPHANTA see RASHTRAKUTA DYNASTY

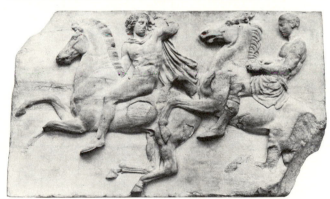

Above: ELGIN MARBLES Horsemen from the west frieze of the Parthenon. Marble. h. 3 ft 3 in (1 m). BM, London
Left: ELGIN MARBLES Reclining figure of a river-god from the east pediment of the Parthenon. 440–932 BC. 1. 5 ft 3½ in (1·61 m). BM, London

ELGIN MARBLES (447–432 BC)

The sculptures from the Parthenon brought from Greece by Lord Elgin between 1801 and 1811. They include almost half the frieze which ran above the inner row of columns, and fourteen of the ninety-two metopes above the outer row of columns. In addition there are seventeen figures from the two pediments. The frieze shows a Panathenaic procession with chariots, horses, and men and women bringing sacrificial offerings and victims. The metopes, from the south side of the building, show battles between lapiths and centaurs. The

subject of the east pediment is the birth of Athena, and of the west pediment the contest of Athena and Poseidon. They were designed by *Pheidias.

ELIASZ (PICKENOY), Nicolaes (1590/1–1654/6)

?b. d. Amsterdam. Dutch portrait painter who was sought after for official group portraits on account of his straightforward and restrained treatment, in direct contrast to the work of his Amsterdam contemporary *Rembrandt.

ELLIOTT, Charles Loring (1812–68)

b. Scipio, New York d. Albany, New York. Painter who studied in New York under *Quidor (c. 1829), under *Trumbull (c. 1834), and painted portraits in central New York State (1830–40). His numerous portraits of Manhattan notables (from 1840) are painterly, perceptively drawn and skin-deep.

ELSHEIMER, Adam (1578–1610)

b. Frankfurt d. Rome. German painter and engraver, in Rome by 1600; a founder of 17th-century ideal landscape. Melancholy introversion (described by *Rubens) may explain the minute scale of his work. Trained in the Frankenthal School, his figure style was influenced by *Tintoretto at Venice, and the new Roman naturalism. His originality lay in the sensitive melancholy and poetic grace of his figures, his interpretation of decorative detail, and his 'searchlight' technique – picking out areas round a number of light sources. His *Flight into Egypt* (Louvre) is the first realistic portrayal of a nocturnal landscape, with full moon and stars.

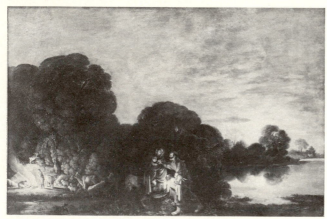

ADAM ELSHEIMER *Flight into Egypt*. 1609. 12¼×16¾ in (31·1×42·5 cm). Louvre

ELURA *see* RASHTRAKUTA DYNASTY

ELY CATHEDRAL

The largest of the three †Romanesque doors of the Cathedral, the so-called 'Prior's Door', includes some of the most important 12th-century English figure-sculpture. The carved *tympanum is itself a French idea, and so perhaps is its subject – Christ in Majesty with attendant angels. But the style, as in many other English instances, seems to owe much to *Anglo-Saxon *manuscript illuminations.

EMULSION

A mixture, not a solution of oil and water. The oil is broken down into tiny droplets which are suspended evenly throughout the water. The mixture can be thickened by the addition of oil, or thinned by the addition of water. The emulsion can be natural, as in milk, or synthetic, as in the suspension of oil or fat like polymer plastics droplets in water.

ENAMEL

Glass and pigment fused together by heat into a hard bright coating upon metal or clear glass. Also misleadingly used to describe fast-drying glossy paints with varnish added. *See also* LIMOGES

ENAMELS, Byzantine

The art of *enamelling either by the *champlevé or *cloisonné method, probably had a continuous tradition from Greek and Roman times into the Byzantine era. Examples of early Byzantine enamels are rare, possibly owing to destruction during *Iconoclasm, and the majority surviving (9th–12th centuries) include many splendid examples of *reliquaries, crowns and *icons – eg the *Pala d'Oro in Venice and the Reliquary of the True Cross (964–5) now at Limburg-an-der-Lahn.

ENCAUSTIC

A technique of painting with *pigments bound in wax. The paint is afterwards melted lightly into the *ground.

ENDOIOS (active 560 BC)

Athenian sculptor said to have made a statue of Athena dedicated in 564 BC. An inscription in the Ionian dialect bearing his name has been found on the Acropolis at Athens.

ENGELBRECHTSZ, Cornelius (1468–1533)

b. Leiden. Netherlandish painter active in Leiden (1499–1522). He may have been a pupil of Colin de Coter and his early style, seen in the *Marienpoel Altarpiece* (1508, Leiden) has sculptural figures and clear colours. His compositions gradually became more crowded and complex, yet ornamental and skilled in detail (*Crucifixion Altarpiece*, 1520, Leiden). The elongated figure proportions (*Constantine and St Helena*, c. 1515/20, Munich) are typically *Mannerist, but he also produced an individual sense of drama and agitation. He had a large workshop and was the master of Lucas van *Leyden.

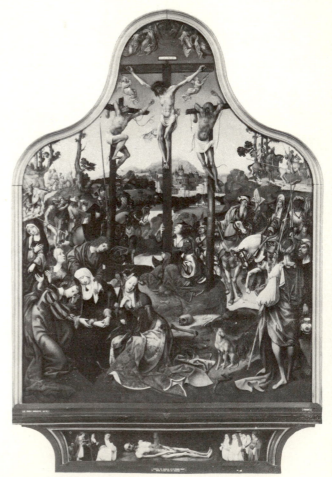

CORNELIUS ENGELBRECHTSZ *Crucifixion*. 78½×57½ (198·5×146 cm). Lakenhal Museum, Leiden

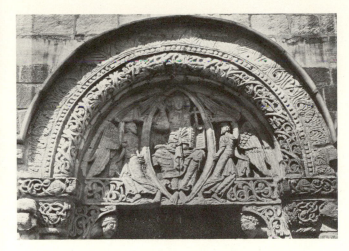

Top: ELY CATHEDRAL *Christ in Majesty* from the Prior's Door. 12th century
Above: ENCAUSTIC

Above and left:
(ENGRAVING): LINE ENGRAVING Pierre Drevet's engraving (1724) of Cardinal Dubois after the portrait by Rigaud (1723) and detail. Plate size 1 ft 7⅛ in×1 ft 2 in (48·5×35·7 cm). V & A, London

ENGRAVING

The production of prints from a surface into which the design has been incised.

Line-engraving The ink is held in a V-shaped grooved line cut into a metal plate. The plate is polished so that ink tends to roll off the surface.

Dry-point The line is more lightly scratched into the surface. The *burr of the groove holds the ink and produces a subtle variety of line and texture, but the burr soon wears down during the printing process and only a limited number of prints can be taken.

Etching The plate is covered with acid-resisting wax or varnish, and the drawing is lightly scratched through this film. The plate is immersed in a corrosive *acid which bites the line into the plate. This process may be repeated many times during the preparation of a single plate. Etching may be combined with dry-point.

Soft ground An etching process. The plate is covered with a tallow mixture. When a sheet of paper is laid on the plate and then drawn on with a pencil, the ground will stick to the impressed line and pull away from the plate when the paper is pulled off. The plate is then etched. The line produced is of a chalky, grainy texture.

Mezzotint The plate is pitted all over by a *rocking tool that leaves raised *burrs. These are carefully scraped away to lighten the plate. The process is capable of producing finely graded and blended shading, and was invented to reproduce the blending of tone in painting.

Aquatint The etching ground is made porous by the addition of grains of soluble material – resin or sugar. The acid eats tiny dots into the plate which are printed from. The size of the dots is controlled by *stopping-out or revarnishing the plate during the process of preparation. This technique is employed when the engraver wishes to imitate a wash drawing.

Stipple-engraving Tiny dots are cut into the surface of the plate by special multiple tools.

Printing The plates are inked, then the surface is wiped clean leaving ink in the burr, lines or dots. The paper is damped and placed on the plate in an *etcher's press. Great pressure is applied in printing.

Top and above: (ENGRAVING): DRY POINT *The Image seen by Nebuchadnezzar* engraved by Rembrandt, signed and dated 1634 (and detail). One of four illustrations from the Spanish Book. 11⅛×6¼ in (28×16 cm). BM, London

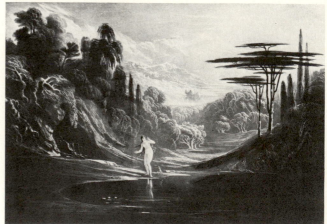

Top and above: (ENGRAVING) ETCHING *Tyzac Whiteley & Co* (and detail) by James McNeill Whistler. 1st state, 1859. $5\frac{7}{8}\times8\frac{3}{4}$ in (14·9×22·3 cm). V & A, London

Top and above: (ENGRAVING) MEZZOTINT *Eve at the Fountain* by John Martin (and detail). 1825. $7\frac{3}{4}\times10\frac{1}{2}$ in (19·7×26·7 cm). V & A, London

Left and below: (ENGRAVING) SOFT GROUND *Interior of a Ruined Church* (and detail). Imitated from an original study by John Sell Cotman. One of Louis Francia's 'Studies of Landscapes'. 1810. $12\frac{1}{2}\times9\frac{7}{8}$ (31×25 cm).

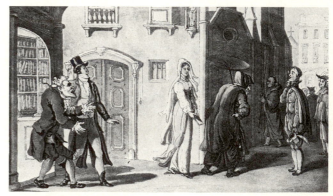

Above and left: (ENGRAVING) AQUATINT *At Avignon: First sight of Clara* by Thomas Rowlandson (and detail). An illustration from his *Journal of Sentimental Travels in the Southern Provinces of France*. 1817. $5\frac{1}{2}\times8\frac{5}{8}$ in (14×22 cm). V & A, London

Above and left:
(ENGRAVING) STIPPLE
ENGRAVING *Old Chairs to
Mend* (and detail). Painted
by Wheatley, engraved by
Vendramini. One of series
published by Colnaghi,
1793–7. $16\frac{1}{2} \times 13$ in
$(42 \times 33$ cm). V & A, London

ENICHI-BO-JONIN (first half 13th century)

Japanese artist who painted the portrait of his teacher Myōe,
still housed at Kozan-ji, the Kegon sect temple where he was a
monk. Although in a Chinese style, this has a distinctively
Japanese treatment of the landscape background.

Above: JACOB EPSTEIN
Joseph Conrad. 1924.
Bronze. Life-size.
Birmingham
Left: ENICHI-BO-JONIN
Portrait of Myōe. 1st half
13th century. Hanging
scroll. Ink and colour on
paper. $57\frac{1}{2} \times 23$ in $(146 \times 58$
cm). Kozan-ji, Kyoto
Right: JAMES ENSOR *Old
Woman with Masks.* 1889.
$21\frac{1}{4} \times 18\frac{1}{2}$ in $(54 \times 47$ cm).
B-A, Gent

ENNION (active 1st century AD)

Probably a native of Sidon, he signed a large number of fine
figured glasses found in Italy, Cyprus and the Crimea. The
glasses, cups or amphorae are beautifully balanced and are
decorated with exquisite scroll or floral motifs.

ENSOR, James (1860–1949)

b. d. Ostend. Belgian painter, half-English in origin. Studied
in Brussels (1877–80). Returned to Ostend where he remained.
Lived in solitude all his life. He became a member of the
French-Belgian *Post-Impressionist group *Les Vingt (1883).
Using oil and crayon, he worked in bright, expressive colours,
dealing with subjects of an obsessive and often disturbing
nature – masked figures, skeletons, etc. His paintings often
feature subjects suggested by his father's antique shop,
Ostend's fish market or by his deeply rooted personal concept
of Christianity, eg *Christ entering Brussels* (1888). He has been
considered as a precursor both of *Expressionism and of
*Surrealism. He was knighted by the Belgian king (1929).

EPIKTETOS (active 520/500 BC)

Athenian cup painter, one of the earliest to use *red-figure
although he sometimes used *black-figure on the same cup. He
was a master of outline and adapted his figures perfectly to fit
the inside of a cup. He often set one or two figures between a
pair of *apotropaic eyes on the outside rim.

EPIPHANIUS OF EVESHAM (1570–after 1633)

b. Evesham. English sculptor apprenticed in London. Worked
in Paris (1601–14), although no work is recorded there. In
England, his tombs (eg that of Lord Teynham, Lynsted, Kent)
have a dignity and quiet charm lacking in the mainly mass-
produced work of the period.

EPSTEIN, Sir Jacob (1880–1959)

b. New York d. London. Monumental and portrait sculptor.
Began studying in America, continued in Paris at the Ecole des
Beaux-Arts and the Académie Julian (1902–5), then settled in
London. Temporarily drawn into the international abstraction
movement, his work was schematic, hard-edged and anti-
humanistic, the *Rock Drill* (1913) representing the roman-
ticisation of machinery. Subsequently Epstein saw abstraction

as a cul-de-sac, though still admitting its disciplinary benefit. In his later work as a modeller, his return to tradition was complete, but in his monumental work there survived a continuing degree of distortion.

ERGOTIMOS see FRANCOIS VASE

ERHART, Gregor (c. 1465–1540)

b. Ulm d. Augsburg. Son of the sculptor, Michel Erhart (active 1469–1522), he moved to Augsburg (1491). His equestrian portrait of Emperor Maximilian (c. 1500–9), was left unfinished, the horse only being cast in bronze. It is fully monumental and impressive in its control of a life-size statue. His handling of detailed carving and psychological expression is shown in the *Virgin of the Misericord* (c. 1510, Frauenstein).

Above: GREGOR AND MICHAEL ERHART Detail of the Birth of Christ from the High Altar. 1494. Painted wood. Klosterkirche, Blaubeuren

Left: GREGOR AND MICHAEL ERHART High Altar of the Adoration of the Magi. 1494. Painted Wood. Klosterkirche, Blaubeuren

ERNST, Jimmy (1920–)

b. Brühl, Germany. Painter, son of *Surrealist Max *Ernst; studied at European craft schools; went to America (1938); taught at Pratt Institute and Brooklyn College. Influenced by *Cubism and *Futurism, Ernst's painting was always Surrealist. Formalising and abstracting Surrealism, Ernst evolved his intricate, cool, web-like structures, laced with stained-glass warmth.

ERNST, Max (1891–)

b. Brühl, nr Cologne. German painter who with *Arp and Baargeld activated *Dada in Cologne (1919–20). He started making collages in which the juxtaposition of strange objects, sometimes taken from old engravings, turns a poetic into an effective visual device; these prefigure his later *Surrealist

'collage-novels', eg *La Femme 100 Têtes* (1929). A series of paintings (1921–4), eg *The Elephant Celebes* (1921), strongly influenced by de *Chirico, forge a link between Dada and Surrealism. The painter who was perhaps closest to the Surrealist poets, Ernst invented *frottage* (1925), a technique of rubbing textured surfaces with pencil and seeing, then developing, images in them – a technique which he claimed was equivalent to automatic writing. Paintings like *La Ville Entière* combine such automatic techniques with dream imagery to create an hallucinatory intensity. Ernst was also influenced by primitive art, particularly in the sculptures he began in the 1930s.

Above: MAX ERNST *Woman, Old Man and Flower*. 1923–4. 38×51¼ in (96·5×130·2 cm). MOMA, New York
Top: MAX ERNST *The Great Forest*. 1927. 44⅞×57½ in (114·5×146·5 cm). Kunstmuseum, Basle

ERRARD, Charles (1606–89)

b. Nantes d. Rome. French painter, engraver and architect. He engraved the plates for Chambray's *Parallel of Architecture*, decorated the Louvre and Tuileries palaces, and designed the Church of the Assumption, Paris. He was Director of the French Academy in Rome (1666–83).

ESCOBAR see MARISOL

ESIE

A small village in the north of the *Yoruba area of Nigeria near which is a group of some eight hundred soapstone figures. Although broadly speaking they are within the range of sculptural style found in southern Nigeria their origin is a complete mystery. The local people regard them as the original inhabitants of the area turned to stone.

ESKIMO ART

The Eskimo inhabit the Arctic Coasts of Greenland and North America. The beginnings of their cultural tradition have been traced to about 1000 BC and the earliest art style of importance, *Okvik, appears about 300 BC. The Okvik tradition was followed by Old Bering Sea, *Ipiutak, Birnik and Punuk cultures, each of which was distinguished by a characteristic art style, although they were all confined to small objects carved in walrus ivory and often engraved with distinctive linear designs. Birnik was succeeded by the Thule tradition which evolved in Alaska (c. AD 1000) and spread gradually eastwards finally absorbing the Dorset culture established in the area of Hudson Bay, Labrador, Baffinland and Greenland. On the Pacific Coast of southern Alaska the Aleut culture developed outside the mainstream of Eskimo tradition. Partly owing to environmental differences Aleut art included some unusual features such as woodcarving and painting. In historic times elaborate ceremonial dance-masks in painted wood have been produced in the Aleutian area, and on the Kuskokwim River, Alaska. The essential features of early Eskimo art persisted into the historic period, and carved and engraved ivory implements and figurines continued to be produced. Typical decoration consisted of incised narrative scenes of hunting and fishing blackened with soot. Today, the work of Eskimo artists has become something of an industry and new techniques have been introduced, but the modern stone sculptures and graphic art still retain a traditional quality.

Top left: ESIE Figure of a man. Age uncertain, but presumably pre-19th century. Soapstone. h. about 24 in (60 cm). Esie Museum, Nigeria
Top right: ESKIMO ART Carved wooden face supporting wooden hoops decorated with various symbols. Painted white, blue, black and red. Aleutian Islands, Nunivak. h. 23 in (58·4 cm). Royal Scottish Museum
Above: ESKIMO ART Bow drill of walrus ivory, incised with hunting scenes blackened with soot. Leather thong for operating with drill. Alaska. 1. 15⅜ in (39·1 cm). Royal Scottish Museum

ESQUIVEL, Antonio María (1806–57)

b. Seville d. Madrid. Spanish painter, trained in Seville who, after a military career, settled in Madrid where he became a member of the Academy of S. Fernando. Known chiefly for his †Romantic portraits and history-paintings in the manner of *Murillo. He was also a distinguished professor of anatomy.

ESSEN, Golden Madonna (late 10th century)

This statue of the Madonna and Child is one of the earliest examples in the round of this subject known in European sculpture. It was made before 1000 for the royal nunnery at Essen and is now in Essen Minster. The technique of overlaying the wooden core with gold leaf and using enamels for the eyes is reminiscent of the slightly earlier statue of Ste Foy at *Conques.

ESTEVE, Maurice (1904–)

b. Culan. French painter who attended the Académie Colarossi, Paris (1924), studied the works of the Primitives, *Fouquet and *Uccello, and became deeply influenced by *Cézanne and later *Léger. From a synthesis of *Cubist form and *Fauve colour he became, after 1950, exclusively involved in purely abstract colour and shape relationships.

Top: MAURICE ESTEVE *Composition 166.* 1957. 19⅞×25⅛ in (50·5×63·8 cm). Tate.
Above: JOSE MARIA ESTRADA *The Agony.* 1852

ESTRADA, José María (active 1830–62)

b. d. Guadalajara. Mexican painter who studied with Don José María Uriarte. His portraits of the Jalisco bourgeoisie are reminiscent of those of the Colonial *limners in their delight in intricate, delicate line and pattern and their calm evocation of the sitter's character.

ETCHING *see* ENGRAVING

ETCHING-PRESS

A machine for printing paper from the engraved plate.

ETRUSCAN ART

The Etruscans occupied an area north of Rome extending as far as the Arno. The major sites are Clusium, Perugia, Volterra and Fiesole in the north; Vulci and Tarquinia in central Etruria; and Caere and Veii in the south. Although highly developed and individual, Etruscan art seems to have been constantly influenced by Greek. Etruscan sculpture of the 7th and 6th centuries BC is related to *Daedalic, and the terracotta sculptures of the 6th century seem to be influenced by Ionian

sculpture. The finest sculptures of the period were produced at Veii where a famous statue of *Apollo was found. Veiian sculptors, such as *Vulca of Veii, were commissioned by the Kings to work in Rome. Bronze sculptures were produced in the 6th and 5th centuries BC, such as the *Capitoline Wolf – if it really belongs to this period. The Etruscans also excelled in painting and the discovery of over sixty painted tombs at Tarquinia and twenty at Clusium has added much to our knowledge of the Etruscans and their art. The earliest paintings are *Orientalising and are related to *Corinthian vase painting. The subjects include mythological scenes and funeral games. In the 5th century Etruscan painting fell under *Attic influence; later, shadows and three-dimensional devices were introduced. Some late tombs at Vulci reflect *Hellenistic trends in chiaroscuro and perspective. By the 1st century BC all national characteristics had been obliterated by the Roman conquerors and the existence of the Etruscan people can only be inferred from an occasional work like the *Arringatore.

ETTY, William (1787–1849)

b. d. York. English painter active in London. One of the few English specialists in the female nude, he drew and painted in the life class at the *Royal Academy for many years. His lush, often elaborately composed paintings are influenced by *Titian and *Rubens.

EUPHRANOR OF CORINTH (active 364 BC)

Greek painter and sculptor interested in proportion and colour. Like those of *Lysippos his figures are slighter than before. He painted heroic subjects such as cavalry battles, a Theseus, and the feigned madness of Odysseus. He also painted Philip and Alexander of Macedon.

EUPHRONIOS (active 515/500 BC)

Athenian *red-figure vase painter. He tried to incorporate new ideas about anatomy into his work. Although he was much concerned with details such as eyelashes, muscles, folds of material and even fingernails, he never forgot the figure as a whole.

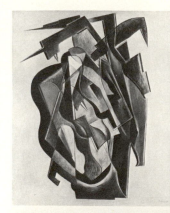
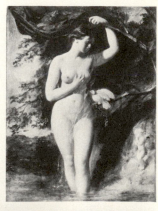
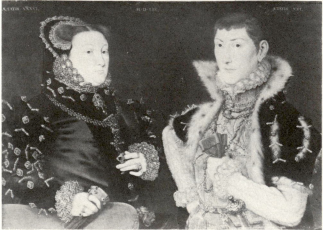
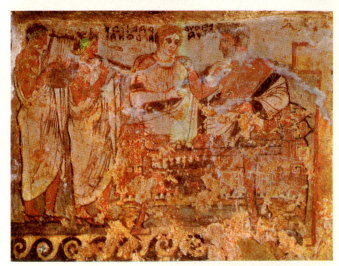
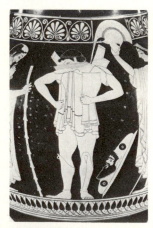

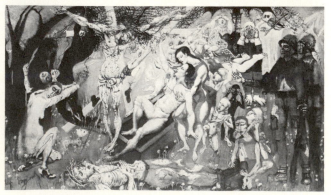

Top left: MERLYN EVANS *The Conquest of Time*. 1934. 40×32⅛ in (101×81·6 cm). Tate
Top right: WILLIAM ETTY *The Fairy of the Fountain*. 1845. 27⅛×20 in (68·9×50·8 cm). Tate
Second row: HANS EWORTH *Frances Brandon, Duchess of Suffolk, and Adrian Stokes*. 1559. 19¾×27¾ in (50·2×70·5 cm). Col. J. C. Wynne Finch Collection
Third row left: EUTHYMIDES Amphora from Vulci showing Hector arming. Late 6th century BC. Antikensammlungen, Munich
Third row centre: ETRUSCAN ART Fresco in the tomb of Hunting and Fishing, Tarquinia. 520–510 BC.
Third row right: ETRUSCAN ART Tomb of the Shields, Tarquinia. The Banquet of Velthur-Nelcha. 3rd century BC.
Left: PHILIP EVERGOOD *The New Lazarus*. 1927–54. 48×83¼ in (121·9×211·5 cm). Whitney Museum of American Art, New York

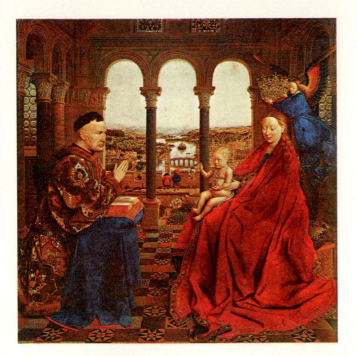

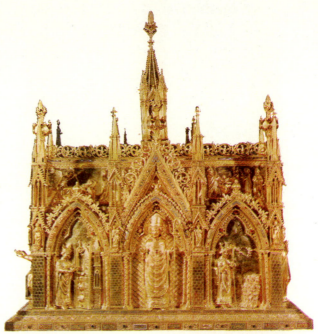

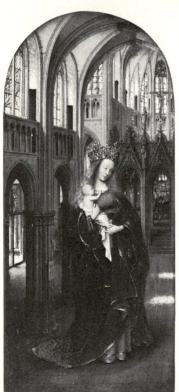

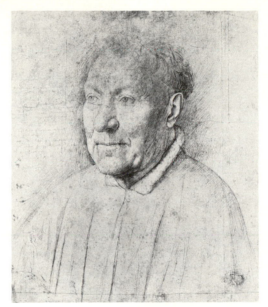

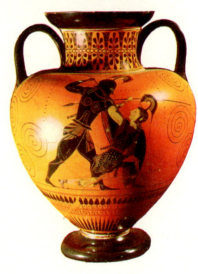

Top left: JAN VAN EYCK *Madonna with Chancellor Rolin.*
c. 1435. 26×24½ in (66×62 cm). Louvre
Top right: EVEREUX Shrine of St Taurin. 1240–53. Silver and
gilded copper with enamel plaques. h. 28 in (70 cm)
Middle row left: JAN VAN EYCK *Madonna in a Church.* 1425.
12⅝×5½ in (32×14 cm). Staatliche Museum, Berlin-Dahlem
Middle row centre: JAN VAN EYCK *Cardinal Albergati.* 1431.
Silverpoint drawing. 8¼×7⅛ in (21·2×18 cm). Kupferstich
Kabinett, Dresden
Middle row right: EXEKIAS Achilles slaying Penthesilea. h. 16¼ in
(41 cm). BM, London
Right: ALLART VAN EVERDINGEN *Rocky Landscape.*
17⅝×23¾ in (44·8×60·3 cm). NG, London

EUSTON ROAD SCHOOL

Founded (1937–8) by Sir William *Coldstream, Claude Rogers, Graham *Bell and Victor *Pasmore in Euston Road, London. It taught a direct unprejudiced approach in painting to the objective world.

EUTHYKRATES (active late 4th century BC)

Sculptor from Sikyon, the son of *Lysippos. According to *Pliny he followed the composition and proportions of his father's work, but lacked his grace. His sculptures include a Herakles at Delphi and a group showing Alexander the Great hunting.

EUTHYMIDES (active 510 BC)

Athenian *red-figure vase painter and a rival of *Euphronios. His most famous work, the *Rape of Korone*, shows three revellers in violently foreshortened positions. However, despite his boast that this vase was better than Euphronios could have done, his work in general falls short of his rival's, and his figures are rather heavy.

EUTYCHIDES (active late 4th century BC)

Greek sculptor from Sikyon and pupil of *Lysippos. His most notable work was a statue of Fortune made for the city of Antioch. She is shown seated on a rock with the River Orontes at her feet. There are several bronze copies and the figure also appears on Syrian coins of Tigranes.

EVANS, Merlyn (1910–)

b. Cardiff. Welsh painter who studied at Glasgow Art School (1927–30) travelling in Europe on a scholarship (1930), then attending the Royal College of Art (1931–3). His early style used *Cubist form to evoke *Surreal situations, moving to flat geometric painting by the 1960s which, nevertheless, has a strongly symbolic content.

EVENEPOEL, Henri Jacques Edouard (1872–99)

b. Nice d. Paris. Belgian painter trained in Brussels; he became a pupil of Gustave *Moreau (1892), at whose studio he met *Matisse and *Rouault. Associated with portraits of children, influenced by *Toulouse-Lautrec and *Steinlen. He also painted Parisian scenes in the manner of *Degas but with a strong element of caricature.

EVERDINGEN, Allart van (1621–75)

b. Alkmaar d. Amsterdam. Dutch painter and etcher who worked under *Savery and *Molyn painting landscapes and seascapes. He travelled to Sweden and depicted the grandeur of the northern mountain landscape, influencing many of his Dutch contemporaries including *Ruisdael.

EVERGOOD, Philip (1901–)

b. New York. Painter who studied with *Tonks at the Slade School of Art, *Luks at *Art Students' League (1923) and *Lhote at Académie Julian (1924); travelled on the Continent (1919–21), and to Spain (1931); painted controversial murals for *WPA. Influenced by Tonks's draughtsmanship and El *Greco's flowing drama, Evergood's allegories, often satirical, affirm triumphant humanity.

EVREUX, Shrine of St Taurin (c. 1250)

This opulent metalwork shrine reflects in its figures and scenes the gentler †Gothic style of the Joseph Master at *Reims. Its church-like form with pinnacles and crockets shows the new interaction between small-scale church furniture and an architecture which has become more delicate and decorative.

EWORTH (EWOUTS), Hans (active 1540–73)

Painter, probably trained in Antwerp, active in England. Worked for Mary I and from 1572 for Elizabeth. His style, modelled on Jan van *Scorel and influenced by *Holbein and *Clouet, is delicate and precise, observing character, as in

Frances Brandon, Duchess of Suffolk, and Adrian Stokes (1559), Wynne Finch Collection).

EWOUTS, Hans see EWORTH

EXEKIAS (active 550/520 BC)

Athenian *black-figure vase painter. His works include Ajax and Achilles playing draughts and Achilles slaying Penthesilea. In these paintings he achieves all the pathos and feeling it is possible to evoke in so limiting a medium as black-figure. He was the last of the great black-figure painters and undoubtedly the best.

EXPRESSIONISM

The art and life of *Van Gogh make him the archetypal modern Expressionist. Prepared to work on a knife-edge between banality and suicide, the Expressionist is the opposite of cool; his choice and interpretation of subject and his technique declare his commitment. Associated with the Northern and †Gothic rather than the Southern and †Renaissance, Expressionist movements include die *Brücke, der *Blaue Reiter, Mexican *Social Realism, the *Kitchen Sink and *Ash Can Schools, the *Cobra group and the dubiously titled *Abstract Expressionists. More typically one thinks of individuals such as *Munch, *Ensor, *Rouault, *Beckmann, *Kokoschka, *Soutine, *Bacon and *Pollock.

EXETER, Alexandra (1884–1949)

b. Kiev. Russian painter who before World War I was in frequent contact with Paris, where she assimilated the ideas of both *Cubism and *Futurism, transmitting them to Russia. Influenced by the revolutionary attitude of *Tatlin (1921), she abandoned easel-painting to devote herself to theatre design.

EYCK, Hubert van (d. 1426)

b. Maaseyck *or* Maastricht d. Ghent. Flemish painter. No certain works survive though there are tentative attributions. He may have been a book-illustrator. Apart from slight documentary evidence, the main source is the inscription on the *Ghent Altarpiece* which states that it was begun by Hubert, the most famous painter of his day and completed by his brother Jan in 1432 at the instigation of Jodocus Vydt. Opinions on Hubert's share differ widely and some scholars regard the inscription as a later addition and doubt the very existence of Hubert.

EYCK, Jan van (c. 1390–1441)

b. Maaseyck *or* Maastricht d. Bruges. The leading painter of the early Netherlandish School, he is first documented at The Hague (1422) in the service of John of Bavaria. From 1426, Court Painter to Philip the Good, Duke of Burgundy, who held him in high esteem and sent him on confidential missions – two to Portugal – and was godfather to one of his children. After Jan's death the Duke granted a pension to his widow, Margaret. Jan settled at Bruges (1431) and became founder of the Bruges School. Originally trained as a book-illuminator (several miniatures in the now lost Turin Hours are ascribed to him and his workshop and, more doubtfully, to Hubert), Jan's secure paintings, some signed and dated and with his motto *als ick kan*, begin with the *Ghent Altarpiece* (1432) for which only the monochrome panels and donor portraits on the outside and the Adam and Eve inside are undisputed. His main theme was the Madonna and Child, alone, eg the early *Ince Madonna* (1433, Melbourne) or the late *Madonna at the Fountain* (1439, Antwerp); or with saints and donors, eg the *Van der Paele Altarpiece* (1436, Bruges); or with donor only, eg *Madonna with Chancellor Rollin* (?1437, Louvre). As a portrait painter he broke new ground with his double marriage portrait of the Arnolfini (1434, NG, London) which for the first time sets full-length figures standing freely in space in an interior. Stylistically all his work shows a positive response to the physical world, minutest details of landscape or interior are lovingly recorded and integrated into an overall unity. Light and shade create natural space, though he never employs

mathematical perspective. These qualities are also apparent in his few surviving drawings. Technically, his recipes for oil painting – though he did not invent the medium – produced colours that have retained their richness and luminosity down to the present day.

FABRIANO, Gentile di Niccolò di Giovanni *see* GENTILE DA FABRIANO

FABRIANO, Gilio da

Italian writer on art, chiefly remembered as the author of a diatribe against *Michelangelo's *Last Judgement* (1564), which together with *Aretino's, persuaded Pope Paul IV to have drapery painted on the nudes.

FABRITIUS, Carel (1622–54)
Barent (1624–73)

Brothers, Carel b. Nr Amsterdam d. Delft and Barent b. d. Nr Amsterdam. Carel was *Rembrandt's pupil (*c.* 1642–3), and his work is the bridge to *Vermeer, whose master he probably was. The delicacy of his works, the placing of dark figures against a light background and mosaic-like colour application are the basis of this. Many of his paintings perished with their creator in a powder explosion. Barent was probably also Rembrandt's pupil and he remained a Rembrandt imitator all his life.

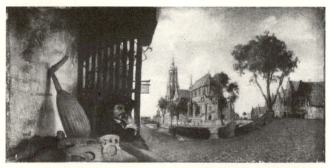

Top: CAREL FABRITIUS *A View in Delft, with a Musical Instrument Seller's Stall.* 1652. $6\frac{1}{16} \times 12\frac{7}{16}$ in (15·5×31·6 cm). NG, London
Above left: CAREL FABRITIUS *The Goldfinch.* 1654. $13\frac{1}{4} \times 9$ in (33·5×22·8 cm). Mauritshuis, The Hague

FABRO, Luciano (1936–)

b. Turin. Italian sculptor whose works, made of various materials such as draped cloth, do not invite aesthetic judgement. Since 1965 he has taken part in exhibitions of Arte Povera, *Conceptual Art, Land art, etc. He works in Milan.

FAITHORNE, William (1616–91)

b. d. London. English engraver and printseller. He learnt pastel drawing from *Nanteuil in Paris, and was the first English engraver to bear comparison with continental masters. Particularly active as a portraitist (1650–75), he engraved religious subjects and published an engraving handbook (1662).

FALCA, Pietro *see* LONGHI

FALCONE, Aniello (1607–56)

b. d. Naples. Italian painter who worked primarily in Naples, specialising in complex and violent battle-pieces. He is particularly remembered as a teacher of Salvator *Rosa.

FALCONET, Etienne-Maurice (1716–91)

b. d. Paris. French sculptor who studied under Jean-Baptiste *Le Moyne and who produced †Rococo statues and figurines for the French aristocracy, which contrast with his forceful and realistic equestrian portrait of Peter the Great (Leningrad), a commission secured with the help of *Diderot.

Above: ETIENNE-MAURICE FALCONET *Milo of Croton.* 1754. Louvre
Below left: FAN K'UAN *Travellers among Streams and Mountains.* Hanging scroll. Ink and colours on silk. $81\frac{1}{4} \times 40\frac{3}{4}$ in (206·3×103·3 cm). National Palace Museum, Taiwan

FAN K'uan (active early 11th century AD)

From Hua-yüan Shensi. Landscape painter whose *Travellers Among Streams and Mountains* is the archetype of Northern *Sung landscape painting and of the rugged northern scenery of China. Monumental in contrast of scale, with tiny figures overshadowed by great trees and the towering peak, this is also one of the finest examples of a Chinese 'high distance' landscape. *See also* CHINESE LANDSCAPE PAINTING

FANG Ts'ung-i (active *c.* 1340–80)

Chinese painter from Kuei-ch'i, Kiangsu, who produced landscapes in the style of *Mi Fu and *Kao K'o-kung.

FANCY PICTURE *see* GAINSBOROUGH

FANG (PANGWE)

A group of tribes on both sides of the border between Gabon and Cameroun, including the Yaunde, Bulu and Ngumba in Cameroun and the Fang proper in Gabon. Their wooden heads and figures are placed upon boxes made of bark (*bieri*) in which

the bones of an ancestor are kept, and are rubbed with oil daily which gives them a deep rich patination. Fang masks, however, are usually long-faced and white.

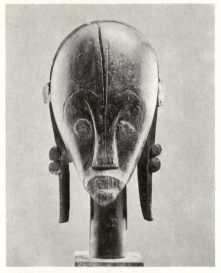

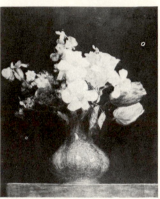

Above left: FANG Head from an ancestral reliquary. Wood. h. 12½ in (32 cm). Museum of Primitive Art, New York
Above right: FANG Figure for an ancestral reliquary. Wood. Collection Mr K. J. Hewitt, London

Left: IGNACE HENRI FANTIN-LATOUR *Flowers.* 1862. 17⅜×14⅝ in (44×37 cm). Louvre

FANTIN-LATOUR, Ignace Henri Jean Théodore (1836–1904)

b. Grenoble d. Buré. Studied first with his father Théodore, later in *Courbet's studio. His figure subjects, portraits and flower still-lifes are painted in the Salon tradition although he was friendly with *Manet and his circle. He appreciated the *Pre-Raphaelites and Wagner, an interest reflected in some of his lithographs.

FARINGTON, Joseph (1747–1821)

b. Leigh d. Moorshedabad, East Indies. English landscape painter and draughtsman and pupil of Richard *Wilson. His immensely detailed diary (1793–1821) is a major source-book for the period.

FATIMID PAINTING

There is as yet no true picture of what Fatimid style in painting might have been like, as only a small number of paper fragments have survived which can be ascribed to the Fatimid dynasty in Egypt (969–1171). The style of the paintings on these fragments seems to be a blend of local Egyptian older styles as well as being related to *Mesopotamian schools of painting. The paintings on the wooden ceiling of the Cappella Palatina, Palermo, believed for a long time to be an outstanding example of Fatimid painting, are now thought to have been painted by a group of craftsmen of different nationalities and eclectic works not representative of what must have been the style of the Fatimid court in Cairo, although they share with it some elements and some of its subject-matter. Fragments of stucco painting from a bath-house in Cairo again suggest links with Mesopotamian fresco painting. Contemporary Egyptian pottery is virtually the only basis for establishing iconographical precedents.

FATTORI, Giovanni (1825–1908)

b. Leghorn d. Florence. Italian painter and etcher who studied with Baldini in Leghorn and was in Florence (1847). One of the *Macchiaioli. He was Professor at the Florence Academy (1869), in Rome (1873) and Paris (1875). A painter of military subjects, peasant life and landscapes. His freshly seen depictions of down-to-earth reality are painted crisply in a high key.

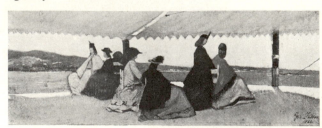

GIOVANNI FATTORI *La Rotonda dei Bagni Palmieri.* 1866. 4¾×13⅞ in (12×35 cm). Galleria d'Arte Moderna, Florence

FATTORI, IL *see* PENNI

FAUTRIER, Jean (1898–1964)

b. d. Paris. French painter who studied at the Royal Academy (1913) before returning to France (1917). He produced sombre *Expressionist works before inventing an original technique in 1943. Building up a central corrugated form with paper and plaster he covered it with lyrical colour and light lines.

FAUVISM

The term 'cages aux fauves' was first used by the critic Vauxcelles to describe a room in the 1905 Salon d'Automne in which *Matisse, *Derain, *Puy, Valtat, *Manguin, *Marquet, *Rouault, *Vlaminck and *Freisz had exhibited. Although having no group aesthetic, the 'wild beasts' had evolved a style in which colour became the most significant vehicle for expressing the effects of nature. From †Impressionism and *Van Gogh they assimilated the fragmentation of the image into a surface of brushmarks, and from *Cézanne the chromatic structuring of forms. Matisse had worked with *Signac and *Cross (1904) and had utilised their *Divisionist technique at Collioure, with Derain (1905). The Fauves painted boldly, heightening observed sensations and producing a two-dimensional picture surface, eg Matisse's *Portrait with a Green Line* (1905). Their painting as a clearly recognisable style lasted only a few years, but long enough to be an important formative influence in German *Expressionism.

FAZIO, Bartolommeo (d. 1457)

Italian writer on art, pupil of *Guarino of Verona (1420–6). He went to Naples (1444) and became historian and secretary to Alfonso V. His principal works are *De viris illustribus* (1456) and *De differentia verborum latinorum.* The former points an analogy between painting and writing, since both involve *dispositio* and *inventio*; his brief lives include his theories on painting. Fazio's comments on Flemish painting are especially illuminating since he valued works for their intrinsic merit, and wrote of paintings he had actually seen.

FEDERIGHI, Antonio (d. 1490)

Italian sculptor, pupil of Jacopo della *Quercia. His marble seat in the Loggia di S. Paolo, Siena (1464) shows a tentative attempt at classical style and imagery, further developed in the Chapel of S. Giovanni font in the Cathedral (after 1482).

FEDOTOV, Pawel Andrejewitsch (1815–52)

b. Moscow d. St. Petersburg. Russian painter and poet, with

army background and limited artistic training. Seventeenth-century Dutch paintings in the Hermitage and English engravings after *Wilkie and *Hogarth inspired him to express his disenchantment with life with critical realism in the satirical spirit of Gogol. He died shortly after a nervous breakdown.

FEI LAI FENG, Sculptures at

A Buddhist cave-temple near Hangchow in Chekiang province, China. The most important sculptures date from the Sung (AD 960–1279) and the Yüan (AD 1280–1368) periods. The Sung sculptures continued the *T'ang tradition with solid almost fleshy figures firmly articulated and enlivened with somewhat extraneous floating scarves and jewellery. But in the Yüan dynasty when China was ruled by the Mongols the Tibetan form of Buddhism which they favoured brought new elements into this style. Buddhist deities with many arms or multiple heads from the greatly enlarged Mahāyānist pantheon were carved at Fei Lai Fêng, while a new vigour in the stance of these deities enlivened the traditional style.

FEININGER, Lyonel (1871–1956)

b. d. New York. Painter who studied in Hamburg and Berlin (1887–92). He was already an established cartoonist when he took up painting (1907). Visited Paris (from 1892). *Nabi influence preceded that of the second-phase *Cubists (from 1911). He exhibited with der *Blaue Reiter (1913) and taught at the *Bauhaus (1919–32). Returned to America (1937). In Feininger's work the congested surface structure of Cubism becomes a transparent screen separating us from still, spacious cityscapes, their atmosphere emphasised by Manhattan-like elongated proportions.

LYONEL FEININGER *Grutze Tower, Treptow*. 1928. 40×32 in (101·6×81·3 cm). Hessian State Museum, Darmstadt

FELAERT, Dirk Jacobsz *see* VELLERT

FELIBIEN DES AVAUX, André (1619–95)

b. Chartres d. Paris. French architect, biographer and theorist whose acquaintance with *Poussin in Rome occasioned a remarkable biography of that painter, inserted in a comprehensive set of biographies, which influenced the formation of academic taste in France.

FENEON, Louis Félix Jules Alexandre (1861–1944)

b. Paris d. Vallée-aux-Loups. French art critic who from the 1880s, when he sensed the impasse reached by †Impressionism, advocated the scientific system of *Seurat, *Signac and *Pissarro. He first expounded his theories in *Les Impressionistes en 1886* and in subsequent articles in many magazines, eg *Le Chat Noir* and *La Revue Indépendante*.

FENTON, Roger (1819–69)

A pioneer news photographer best known for his Crimean War photographs (1855). He founded the Photographic Society (1853), the earliest of its kind. He had studied under *Delaroche in Paris and made consciously artistic still-life photographic compositions and figure subjects. He resumed his legal career (1862).

FERENCZY, Károly (Charles) (1862–1917)

b. Vienna d. Budapest. Hungarian portrait and figure painter, he studied in Naples, Munich and later in Paris at the Académie Julian with *Bouguereau and *Robert-Fleury. After several years in Munich he settled in Nagybánya (1896) and became a leader of the naturalist open-air painting in the artist colony there.

FERNANDEZ, Alejo (c. 1470–1543)

Painter from Germany and the Netherlands. The major artist in Seville of his day, he arrived there from Cordoba (1508). The main altar at Seville Cathedral (1508–10) with its elongated figures and floating veils shows his contact with Antwerp *Mannerism, and there is much emphasis on space-creating architectural settings in his work.

FERNANDEZ (HERNANDEZ), Gregorio (c. 1576–1636)

b. ?Sarrià bei Lugo, Galicia d. Valladolid. Spanish sculptor who worked in Valladolid (after c. 1605). He continued the tradition of polychrome sculpture, preferring naturalistic colouring. His work is remarkable for its realistic expressiveness and drama.

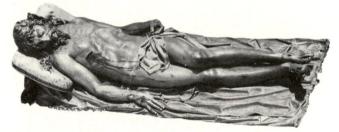

GREGORIO FERNANDEZ *The Dead Christ*. 1605. Capuchinos del Pardo, Madrid

FERNANDES, Vasco (Grao VASCO) (c. 1475–before 1542)

Leading Portuguese painter, mainly active in Viseu. He worked in Lisbon at the studio of Jorge Afonso (1513–15), as altarpieces such as the one in Lamego Cathedral (1506–11) show. This work reflects his almost Flemish care with space and texture, and the *Pentecost* (1535, Sta Cruz, Coimbra) his *Mannerist style, distorted figures and dramatic colour. The engravings of Lucas van *Leyden also influenced him.

FERNANDEZ DE NAVARRETE, Juan (EL MUDO) (c. 1526–79)

b. Logroño d. Toledo. Spanish painter who came to be influenced by Italian painting through works in the Escorial, before his visit to Italy. His emulation of *Titian (eg *Holy Family*, Bucharest) brought him important commissions from Philip II.

FERRATA, Ercole (1610–86)

b. Pelsotto d. Rome. Italian sculptor who worked in Naples before settling in Rome where he frequently assisted *Bernini. Although he was much influenced by this sculptor, he never fully absorbed Bernini's dynamic style but tended towards a classicism of *Algardian derivation.

FERRI, Ciro (1634–69)

b. d. Rome. Italian painter, pupil of Pietro da *Cortona, whose style he followed faithfully although with little originality. He did much large-scale work in fresco, including that of finishing his master's decorations in the Pitti Palace, Florence, where he remained from 1659 to 1665.

FETE CHAMPETRE

French: 'outdoor feast'. Open-air scenes of gentlemen and ladies amusing themselves eating, dancing, listening to music

in a fine parkland setting. Specifically a French 18th-century subject – *Watteau, *Lancret and *Pater were the principal exponents of the *genre.

FETE GALANTE

French: 'courtship party'. Similar to *fêtes champêtres and a speciality of the same artists – the emphasis being on courtship and amatory attentions.

FETTI, Domenico (1589–1623)

b. Rome d. Venice. Italian painter influenced by *Rubens while working for the court of Mantua, whose work has a novel breadth and nervousness of brushstroke and an attention to picturesque detail, particularly apparent in his small, late depictions of the Parables.

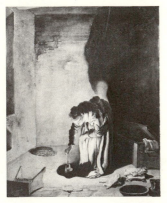 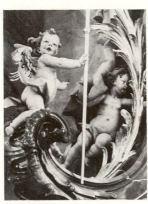

Top left: DOMENICO FETTI *Parable of the Lost Piece of Silver.* 21¾×17⅜ in (55×44 cm). Dresden
Top right: JOHANN MICHAEL FEUCHTMAYER *Putti. c.* 1760. Stucco, Abbey Church, Ottobeuren
Above: FEUCHTMAYR FAMILY General view of the stucco and painted decoration at Ottobeuren Parish Church, Bavaria. *c.* 1760

FEUCHTMAYER Family

A prolific 17th- and 18th-century Bavarian family of sculptors and stuccoists, the most important members being Joseph Anton (1696–1770) and Johann Michael II (1709–72). Joseph Anton (b. Linz d. Mimmenhausen) developed an original interpretation of the *grotesque in sculpture, almost caricaturing his historical statues. Responsible for decorating the pilgrimage church at Birnau, he produced there in his highly finished *Putto Licking Honey* a masterpiece of †Rococo vitality and humour. Johann Michael II (b. Wessobrun d. Augsburg) executed two light and graceful masterpieces of Rococo plasterwork: the staircase and adjoining rooms of the episcopal palace at Bruchsal, and the decoration of the Church of Vierzehnheiligen (both built by Neumann).

FEUERBACH, Anselm (1829–80)

b. Speyer d. Venice. German painter, trained in Düsseldorf, Munich and Antwerp, before studying in Paris with *Couture who inspired in him a veneration of the Venetian masters that was to mark his early work. More importantly, Couture encouraged a broad handling of paint and spontaneity of touch. Feuerbach went to Italy (1855), where he was to spend most of his working life, evoking in his pictures the harmonic formal qualities he associated with antique art. For his series of subjects of Greek myths, and studies of statuesque female beauty, he refined a palette largely made up of muted greens and greys.

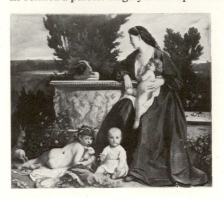

ANSELM FEUERBACH *Family Portrait.* 1866. 53¾×62¾ in (136·4×159·5 cm). Schackgalerie, Munich

FIAMMINGO, IL *see* DUQUESNOY

FIBREGLASS

Very finely extruded glass filament. Can be used for reinforcing and filling synthetic resin moulds and *castings in sculpture. Also has been used as a reinforcing filler in *concrete sculpture.

FIEDLER, Conrad (1841–95)

German philosopher who had studied law. In Rome he met and supported the artist von *Marées and in the 1870s they were joined in Florence by von *Hildebrand. Fiedler developed his theory of pure form and the creative process through contact with them. He published *On Judging Works of Visual Art* (1876).

FIELDING, Anthony Vandyke Copley (1787–1855)

b. East Sowerby d. Worthing. His father and four brothers were also artists. A pupil of John *Varley he quickly achieved success as a watercolourist and popularity as a teacher. His facility led to inevitable repetition and mannerisms, but his best work – British landscapes and marines – is of high quality. He won a medal at the Paris Salon of 1824.

FIENE, Ernest (1894–1965)

b. Eberfeld, Germany d. Paris. Painter who went to America (1912), studied at National Academy of Design and *Art Students' League, and taught in New York. Gradually abstracting his early realism, Fiene painted Manhattan cityscapes with vigour, knowledge and love.

FIERRO, Pancho (1803–79)

b. d. Peru. One of the major Peruvian artists of the 19th century. His loose, free watercolours are largely caustic satires of an ossified aristocracy.

FIGARI, Pedro (1861–1938)

b. d. Montevideo. Painter who worked as lawyer, official and writer; painted full-time (c. 1921–38). Influenced by †Impressionism and *Intimisme, particularly *Vuillard. Figari's paintings of Uruguay's life and landscape are characterised by odd perspectives, semi-flattened space and form, painterly brushwork and subtly vibrating colour.

FIGUEIREDO, Cristavao de (active c. 1508–40)

Portuguese painter, who was Examiner of Paintings (1515). Active primarily in Coimbra, but collaborated with *Lopes elsewhere. His tragic mood made him the best Passion painter of his day.

FIJI ISLANDS

Although it has a *Melanesian population the art style of this island group is *Polynesian. This is most obvious in rare wood and ivory figures which may have served to decorate their temples. Fine decoration was carved on to the surfaces of clubs, cannibal-forks, etc.

FILA, Emil (1882–1953)

b. Chropyne, Moravia d. Prague. Czechoslovakia's most consistent adherent to *Cubism. His early work displays the influence of *Munch and *Expressionism. In 1911 he became committed to *Picasso's work and Cubism until the mid 1930s when a pre-Cubist Expressionist element re-entered his work.

FILARETE (Antonio AVERLINO) (c. 1400–?1469)

b. Florence d. Rome. Florentine sculptor and architect. Two of his major works are extant: the bronze doors for Old St Peter's (c. 1433–45) and the Ospedale Maggiore, Milan (1456). Its practical and original design delighted *Vasari who, however, thought Filarete's *Treatise on Architecture* (c. 1464) was probably the most ridiculous book ever produced.

FILDES, Sir Luke (1843–1927)

b. Liverpool d. London. English painter who first made an impact as illustrator to the *Graphic* magazine, his sympathetic studies of social problems later worked up as paintings for exhibition, eg *Applicants for admission to a Casualty Ward* (1874). His later paintings of Venetian women were stigmatised as *Aesthetic. From the 1890s he concentrated on portraiture.

FILIPEPI, Sandro see BOTTICELLI

FINI, Leonor (1918–)

b. Buenos Aires, of Latin, Slav and German family. With a highly proficient technique, she renders a morbid sensuality in the obsessive and recurrent imagery with which she illustrates the literary ideas of her disturbing vision. Although she exhibited with the *Surrealists, her work is closer in approach to that of *Doré.

FINI, Tommaso di Cristoforo see MASOLINO

FINK, Don (1923–)

b. Duluth, Minnesota. Painter who studied at Walker Art Institute, Minneapolis and *Art Students' League, and lived in Paris (1953–4, from 1955). A follower of the abstract calligraphic movement led by *Pollock and *Tobey, Fink weaves black lines over low-keyed grounds.

Below left: PEDRO FIGARI *Federal Ladies*. 27⅝×19¾ in (70×50 cm). Srta Emma Figari Collection

FINSON, Ludovicus (Louis FINSONIUS) (c. 1580–1617)

b. Bruges d. Amsterdam. Flemish painter who visited Naples (1612) where he studied *Caravaggio. Active mainly in Provence, especially at Aix. He introduced the new Italian realism to the area.

FINSONIUS, Louis see FINSON, Ludovicus

FISHER, Alvan (1792–1863)

b. Needham, Massachusetts d. Dedham, Massachusetts. Painter who worked in various States (1817–25), studied in Europe (1825) and settled in Boston. Primarily a portraitist, in 1815 he began painting quiet landscapes and farm scenes; agreeable but undistinguished, they are historically important as seeds of American romantic realism.

FITZGERALD, Lionel Lemoine (1890–1956)

b. d. Winnipeg. Canadian painter who studied in Winnipeg and at *Art Students' League (c. 1921); did commercial art; taught at Winnipeg School of Art (1924–49); was member of *Group of Seven (1932–3). His delicate precision and distanced, odd-angled vision invests his landscapes and still-lifes with a subtle, intimate mood.

FIXATIVE

Very weak *varnish solution used to bind soft powdery drawings in *charcoal, chalk or *pastel to their *grounds.

FLANAGAN, Barry (1941–)

b. Prestatyn, Wales. British sculptor and film-maker, influenced by Philip *King. His work has consisted of arrangements of sacks of polystyrene granules, lengths of rope, mounds of sand, etc, often deliberately lacking a focal point. He exhibited in *Six at the Hayward* (1969) and *The New Art* (1972, Hayward Gallery).

FLANDES, Juan de see JUAN DE FLANDES

FLANDRIN, Hippolyte-Jean (1809–64)

b. Lyon d. Rome. French painter, pupil of *Ingres, he went to Italy on a Rome Prize where he came into contact with works of *Raphael and the German *Nazarenes. Their influence is evident in his church murals of the 1840s and 1850s in Paris (St Severin, St Germain-des-Près, St Vincent-de-Paul) and in the provinces (St Paul at Nîmes, St Martin-d'Ainay at Lyon). He was also known for portraiture, eg *Mme Vinet* (Louvre).

FLANNAGAN, John Bernard (1895–1942)

b. Fargo, North Dakota d. New York. Sculptor who studied painting at Minneapolis Institute of Arts (1914) and in New

Below centre: BARRY FLANAGAN *Aaing i gui aa*. 1965. 72×36×36 in (182·9×91·4×91·4 cm). Tate
Below right: LUKE FILDES *The Doctor*. Exhibited 1891. 65½×95¼ in (166·4×241·9 cm). Tate

York (1922); worked in Ireland (1930, 1932); was helped by *Davies and Zigrosser. Pioneering *Brancusi's direct-carving aesthetic in America, Flannagan summoned simplified animals from barely altered fieldstones, combining mysticism with wit.

Left: JOHN B. FLANNAGAN *Monkey and Young.* 1932. 16×11×12 in (40·6×27·9×30·5 cm). Addison Gallery of American Art, Phillips Academy, Andover
Right: JOHN FLAXMAN *Monument to Agnes Cromwell.* Marble. Chichester Cathedral

FLAXMAN, John (1755–1826)

b. York d. London. English sculptor and talented linear draughtsman. Introduced to classical antiquity through the 'blue-stocking' circle, his interest in medieval art – the other component of his style – was stimulated by his friendship with *Blake. He executed commemorative sculpture groups, eg *Lord Nelson* (1808–18, St Paul's) and statues, but was more at ease with small-scale monuments and busts. Here he showed continuous originality, unfortunately swamped by vast numbers of 19th-century travesties. His finest work was in outline drawings illustrating classical texts; his *Odyssey*, *Iliad* and *Aeschylus* gained him a European reputation. His *Hesiod* illustrations were engraved by Blake.

FLICKE, Gerlach (active c. 1545–d. 1558)

b. Osnabrück d. England. Flemish painter in England (from c. 1545). His meticulously detailed and dull style is shown in the unimaginative treatment of drapery in his *Unknown Nobleman* (1547, Edinburgh).

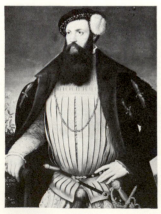

Left: GERLACH FLICKE *?William, 13th Lord Grey de Wilton.* 1547. 41¼×31¼ in (104·8×79·4 cm). NG, Edinburgh
Right: GOVAERT FLINCK *A Young Negro Archer.* 26⅝×20⅜ in (67×52 cm). Wallace

FLINCK, Govaert (1615–60)

b. Cleves d. Amsterdam. Dutch painter who settled in Amsterdam (1632) and studied under *Rembrandt for about three years. His early works are much influenced by his master, but he later turned to a more elegant and commercially successful style which secured him major commissions.

FLINT, Sir William Russell (1884–1969)

b. Edinburgh d. London. British painter, illustrator and etcher who was President of the Royal Society of Painters in Water Colours (1936–56). A prolific artist, Flint specialised in mildly erotic peasant scenes and watercolour landscapes.

FLORIS, Cornelis *see* FLORIS DE VRIENDT Family

FLORIS, Frans *see* FLORIS DE VRIENDT Family

FLORIS DE VRIENDT Family
Cornelis (1514–75)
Frans (1516–70)

Early Netherlandish family of artists working Antwerp, the important members of which were the brothers Cornelis and Frans. Each went to Italy, Cornelis in 1538, Frans after 1541, and subsequently led the Roman style in the Netherlands. By his Italianate engraved ornamental designs (1548–57), Cornelis (master of Antwerp, 1559) prompted a far-reaching and lasting taste for the *grotesque in architecture and sculpture. His own achievements in these fields were, however, more restrained, and his *Tabernacle* (1550–2, Zoutleeuw) shows his subjugation of the figure to general decorative effect. Frans took elements from the *Mannerist and Venetian painters under influence from his master Lambert *Lombard. His *Fall of the Angels* (1554, Antwerp) has *Michelangelesque nudes, and with a neglect of spatial clarity, he achieves instead a dynamic vigour. Side by side with such works he painted others, monumental and simple, like *St Luke* (1566, Antwerp); also portraits. These have spatial clarity, pale thin tints and vigorous brushstrokes. They were as influential as his more fashionable Romanist works. His workshop, and that of his brother, was for many years the artistic focus of Antwerp.

FLOTNER, Peter (c. 1490–1546)

b. ?Thurgau, Switzerland d. Nuremberg. Swiss-German sculptor and engraver active in Nuremberg (from 1522), having visited Italy (c. 1520). His early work is vigorous: the *Bronze Horse* (1520/30, Stuttgart) lacks, however, any classicistic bent. After his second Italian visit (c. 1530), his style takes on the flowing elegance of his *Apollo Fountain* (1532, Nuremberg).

FOAMED PLASTICS

Lightweight honeycombed form of plastic that can be used for moulding and *casting in sculpture.

FOGGINI, Giovanni Battista (1652–1737)

b. d. Florence. Italian sculptor who studied with *Ferrata and developed a *Berninesque style apparent in his numerous works in Florence, but whose fluid compositions generally lack the unity and clarity of Bernini.

FOHR, Karl Philipp (1795–1818)

b. Heidelberg d. Rome. German landscape artist who painted two remarkable mountain landscapes in Rome, before drowning himself in the Tiber, aged twenty-three; also noted for his landscape drawings in bold wash, and his portrait drawings (influenced by *Dürer).

FON

A tribe in southern Dahomey, related to the Ewe in Togo, which in the 17th century established the powerful kingdom of Dahomey lasting until French colonisation at the end of the

19th century. Fon art includes wooden protective figures (*bochio*), the appliqué textiles and bas-reliefs which adorned the royal palace at Abomey and the two large figures of Gun, god of iron and war, one of iron and the other of sheet-brass.

FONT DE GAUME

†Palaeolithic site near Les Eyzies, Dordogne, France. The very famous painted cave has representations of rhinoceros, horse, bison, reindeer and mammoth. Some of the simple flat wash paintings with twisted perspective are probably late *Perigordian. The greater part and the best are *Magdalenian with fine bichrome work and great accuracy of drawing.

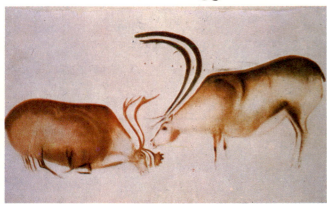

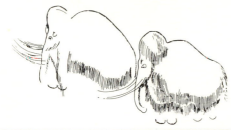

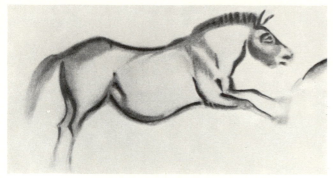

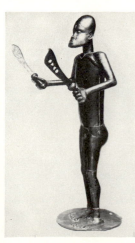

Top: FONT DE GAUME Copy by the Abbé Breuil of a cave painting of a horse on a stalactite formation at Font de Gaume
Centre: FONT DE GAUME Line drawing of mammoths based on rock engravings
Above: FONT DE GAUME Reconstruction by the Abbé Breuil of the cave painting of confronted male and female deer.
Left: FON *Gun*, the god of war. 19th century. Riveted sheet brass. h. 40 in (102 cm). Collection M. Charles Ratton, Paris

FONTAINEBLEAU, School of

A group of painters brought together because of the desire of François I to glorify the French Crown in the manner of the Italian humanist princes. Between 1528 and 1558, Italian *Mannerist artists were summoned to decorate the Château of Fontainebleau and other royal palaces. In 1531 and 1532 respectively, *Rosso and *Primaticcio began the decoration of the Galerie François I. Rosso died in 1540, and in 1552 Niccolò dell' *Abbate joined Primaticcio. The painters added a particularly French quality of sensuality and voluptuousness to the mannered elegance of the Italian style. In decorative schemes, they invented the combination of stucco ornament and painting. Their highly contrived mythologies and idyllic landscapes were painted with no real distinction, but their influence in France, and abroad, on interior decoration, was immense. The designs were spread by engravings. Henri IV revived the School at the end of the century, following the Wars of Religion. *Dubreuil and *Fréminet were the principal artists, but though their aspirations were similar to those of the First School, their inventive talents fell far below.

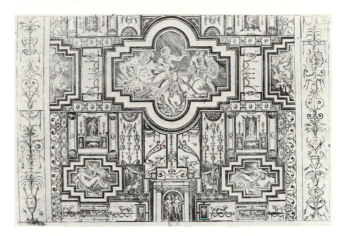

SCHOOL OF FONTAINEBLEAU Ceiling of the Galerie d'Ulysse engraved by Du Cerceau. *c.* 1550. Bib Nat, Paris

FONTANA, Annibale (?1540–87)

b. d. Milan. Milanese sculptor, apparently trained in Rome, he was originally a gem-engraver. Recorded in Palermo (1570), but he worked chiefly in Milan, where he executed the marble sculptures on Sta Maria presso S. Celso, and also created bronzes. Influenced by *Leoni, Fontana has an eloquence which foreshadows *Bernini.

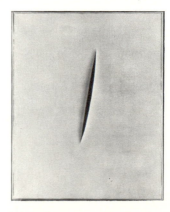

Left: LUCIO FONTANA *Spatial Concept Pause.* 1960. $36\frac{5}{8} \times 29\frac{1}{8}$ in (93×74 cm). Tate

FONTANA, Lucio (1899–1968)

b. Santa Fè, Argentina of Italian parents d. Milan. Sculptor and painter who studied at the Brera Academy (1927). In Paris (1934) a member of the *Abstraction-Création group. Spent the war years in Argentina where he issued his White Manifesto (1946), the first document of *Spatialist theory, calling

for co-operation with scientists in the creation of new concepts and materials. Returned to Milan (1947). Founded Spazialismo, the ideas of which combined 'concrete' art with the provocative procedures of *Dada. Concerned more with the concept of a work of art than its realisation, Fontana (by 1951) slashed canvas, clay or metal attempting to make a positive element of vacuity.

FONTEVRAULT, Abbey tombs

This abbey near the Loire was generously endowed by the Plantagenets during the heyday of the Angevin empire. It was used as a family burial-place and four recumbent tomb effigies (c. 1254) of Henry II, Eleanor of Aquitaine and Richard I (in stone) and Isabella of Angoulême (in wood) survive. Life-size tomb effigies become increasingly numerous about 1250; other important examples are in *St Denis and *Westminster Abbey.

FOPPA, Vincenzo (1427/30–1515/16)

b. d. Brescia. Milanese painter possibly taught by *Squarcione and influenced by the *Bellinis and *Mantegna in his use of perspective. Patronised by the Duke of Milan, he worked mainly in Pavia, returning to Brescia in his old age. The leading local painter until the arrival of *Leonardo, his characteristic style is apparent in fresco cycles for the Carmine, Brescia, and S. Eustorgio, Milan.

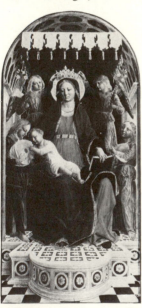

Left: VINCENZO FOPPA *Madonna and Child with Angels.* 141¾×115 in (360×292 cm). Brera

Below: JEAN-LOUIS FORAIN *Tribunal Scene.* 21⅜×25⅞ in (54·5×65 cm). Louvre

FORAIN, Jean-Louis (1852–1931)

b. Reims d. Paris. Primarily, like *Daumier, a satirist, Forain collaborated on principal illustrated French journals and in the foundation of *Psst*, a publication provoked by his opposition to the Dreyfus verdict. A recognised painter in oils, he exhibited with the †Impressionists and the Salon, but these works lacked the liberty of expression of his drawings.

FORMALDEHYDE

Hardening additive to natural *glues and *emulsions.

FORMENT, Damian (c. 1475–1540)

Valencian sculptor who perhaps trained in Florence, but active in Valencia (from 1500); in Saragossa (1509). Specialised in large altars, mainly in alabaster. His best altarpiece (1520–34, Huesca Cathedral) is an early *Mannerist work, with elongated figures and a genuine though not always successful attempt to use lighting effects to project his figures.

MARIANO FORTUNY-Y-CARBO *La Vicaria.* 1870. 23⅝×37 in (60×94 cm). Museum of Modern Art, Barcelona

FORTUNY-Y-CARBO, Mariano José María Bernardo (1838–74)

b. Reus d. Rome. Spanish painter. Although trained in Barcelona, with experience as a war artist in Morocco, most of his working life was spent in Italy, which he had first visited in 1858. He established a huge reputation in Europe as a painter of historical and genre scenes, which in composition and brushwork relate to the work of *Meissonier, whom he met in Paris (1866). From 1869, after a short stay in Spain, his style broadened under the influence of *Goya, becoming more rich and vigorous in tonal contrasts and paint textures.

FORTY-EIGHT BUDDHIST IMAGES, The

A group of more than fifty small Japanese gilt-bronze images ranging in date from the *Asuka to early *Nara periods. Formerly preserved in the *Hōryūji they were presented to the Imperial Household and are now in the Tokyo National Museum. In the figures of the Asuka period the Korean style with large heads and heavy robes has been developed, exaggerating these features in an abrupt and rhythmically accentuated manner. By contrast the later pieces are more gently balanced and show a greater concern with details of anatomy, a style which the Nara sculptors adopted from Sui and *T'ang dynasty sculpture in China.

FOSCHI, Piero Francesco (1502–67)

b. d. Florence. Italian painter, taught by Andrea del *Sarto, he developed a simple smooth style more influenced by *Pontormo whom he assisted at Careggi in 1536 than his teacher. During the 1540s he painted three altarpieces for Sto Spirito, Florence, which are imbued with *Mannerist piety. He was a founder-member of the Accademia del Disegno set up in 1563 to oversee the standards of artistic education in Florence.

FOSSANO, Ambrogio da *see* **BERGOGNONE**

FOSSE, Charles de la *see* **DE LA FOSSE**

FOUCQUET, Jehan *see* **FOUQUET**

FOUQUET (FOUCQUET), Jehan (?1420–?1480)

b. d. Tours. Major French painter of the 15th century, who may have received early training in Paris. Was in Rome some time between 1443 and 1447. On his return to Tours (1448) he worked for Charles VII and then Louis XI. Both aspects of his painting, panel and miniature, demonstrate the influence of the Italian †Renaissance, eg *Etienne Chevalier with St Stephen* (Berlin). However, later miniatures show a movement away from such monumental simplicity towards scenes full of narrative and movement.

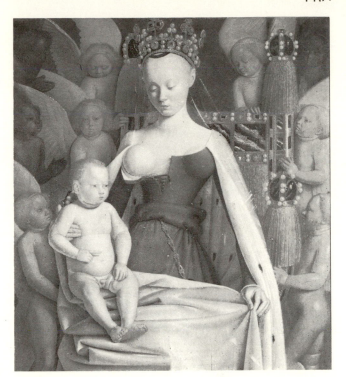

JEHAN FOUQUET *Virgin and Child. c.* 1450. 36½×33½ in (93×85 cm). Koninklijk Museum voor Schone Kunsten, Antwerp

FOUJITA, Tsugouharu (1886–1968)

b. Tokyo d. France. Painter and engraver who settled in Paris (1913) and attended the Ecole des Beaux-Arts. He developed an academic brand of primitivism, its characteristic elements being delicacy and sensuousness of colour combined with a well-defined simplicity of form.

FOUR MASTERS OF THE LATE YUAN

The hermit-painters of the 14th century who developed brush styles for the 'writing' of Chinese landscape. *See also* HUANG KUNG-WANG; NI TSAN; WANG MENG; WU CHEN; *and* YUAN PAINTING

FOURNEAU DU DIABLE (c. 18,000 BC)

*Solutrian rock shelter in the Dordogne, France, with engravings and reliefs on limestone slabs.

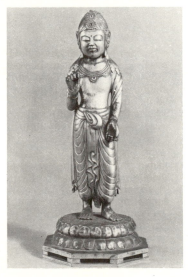

Top: JEHAN FOUQUET *The Coronation of King Louis VI.* Detail from the 'Grandes Chroniques de France'. Bib Nat, Paris
Above left: FORTY-EIGHT BUDDHIST IMAGES The Bodhisattva Kannon. Dated AD 651. Bronze. h. 9⅛ in (23·2 cm). Tokyo National Museum
Above right: FORTY-EIGHT BUDDHIST IMAGES Bodhisattva. Nara period, late 7th century. Gilt bronze. h. 17¼ in (43·9 cm). Tokyo National Museum
Right: JEAN-HONORE FRAGONARD *Baigneuses.* 25¼×31½ in (64·1×80 cm). Louvre

FRAGONARD, Jean-Honoré (1732–1806)

b. Grasse d. Paris. French painter who studied briefly with *Chardin and *Boucher and for several years with Carle *Van

Loo. In Rome (1756–61) he was influenced by the work of his contemporary *Tiepolo. He developed a landscape style related to that of his companion Hubert *Robert. He returned to Paris (1761) where he painted easel-paintings and larger decorative works for aristocratic patrons. His work is usually light-hearted in subject-matter, but always delightful and often witty. With the advent of †Neo-classicism and of the Revolution he lost favour and died a forgotten artist.

Top left: JEAN-HONORE FRAGONARD *The Swing.* 1768 or 1769. 32⅝×26 in (83×66 cm). Wallace
Top right and above: FRANCESCO DI GIORGIO Unidentified classical scene, formerly known as *the Allegory of Discord*, and detail. Cast 1475. 19½×26½ in (49·5×67·3 cm). V & A, London

FRANCAVILLA, Pierre *see* FRANQUEVILLE

FRANCES, NICOLAS *see* NICOLAS FRANCES

FRANCESCO DI GIORGIO (MARTINI)
(1439–1501/2)

b. d. Siena. Italian sculptor, painter and architect. Influenced by *Donatello, *Vecchietta and *Neroccio whose studio he shared. He was employed (c. 1475–85) at Urbino by Federigo and Guidobaldo da Montefeltro. This cultivated ambiance had a decisive effect upon his imagination; his works became more classical in style and learned in theme, eg *Allegory of Discord* (V & A, London). A wide-ranging curiosity made him keep a note-book, illustrated with skilful drawings of diving gear, etc, inspiring *Leonardo da Vinci whom he met in Milan (1490) to do the same. Pale colour, graceful charm and spatial fantasy prevail in his painting while the more purely †Renaissance aspects of his style appear in the sculpture and architecture.

FRANCHEVILLE, Pierre *see* FRANQUEVILLE

FRANCIA, Francesco Raibolini (c. 1450–1517)

b. d. Bologna. Bolognese goldsmith and painter, whose works derive from *Perugino. A partner of Lorenzo *Costa (1483–1507). Once highly thought of, he was praised by *Raphael. Marcantonio *Raimondi was his apprentice. His paintings influenced the *Nazarenes.

FRANCIABIGIO (Francesco di Cristofano BIGI)
(?1482–1525)

b. d. Florence. Italian painter and pupil of *Piero di Cosimo; he inherited some of Cosimo's melancholy, but aspired with minor success to the classical grace of *Raphael and *Leonardo. He assisted Andrea del *Sarto in the Annunziata cloister and in the Chiostro dello Scalzo (c. 1518, *Last Supper*), and executed the *Triumph of Cicero* at Poggio a Caiano.

Left: FRANCIABIGIO *Knight of Rhodes.* 23¾×18 in (60×45 cm). NG, London

Below: SAM FRANCIS *Around the Blues.* 1957 and 1962. 108×192 in (274·3×493·6 cm). Tate

FRANCIS, Sam (1923–)

b. S. Mateo, California. Painter who studied at University of California and California School of Fine Arts (1945); has lived in Paris since 1950, travelling to Far East and Mexico. His best-known abstract paintings are meditative, Orientally influenced compositions of brilliantly coloured, organically shaped stains; later work is more turbulent.

FRANCKEN Family

Dynasty of Flemish painters working mainly in Antwerp and Paris founded by Nicolaes Herenthals Francken (?1520–96). Most important are his three sons, all pupils of Frans *Floris, and one grandson, Hieronymous I (1540–1610) who worked at Fontainebleau and later became Painter to the King. Frans I (1542–1616) was a classicist and follower of de *Vos. Ambrosius I (1544–1618) also worked at Fontainebleau but later made a successful public career in Antwerp. Of the sons of Frans I, the best is Frans II (1581–1642) who painted religious and historical scenes, but exerted most influence through his genre and still-life interior pictures. His son, Frans III (1607–67) painted religious subjects and church interiors and was influenced by *Rubens. His nephew, Constantyn (1661–1717), the last of the line, spent fifteen years in Paris and Versailles, and painted battle scenes and portraits.

FRANCOIS VASE (c. 570 BC)

A volute *krater made by Ergotimos and painted by Kleitias. It is twenty-seven inches high and covered with rows of small figures painted in the *black-figure style and almost all identified by inscriptions. The principal subjects include the lives of Peleus and Achilles, the exploits of Theseus, the return of Hephaistos. Other subjects include wild animals and the battle of the pygmies and cranes. (Archaeological Museum, Florence.)

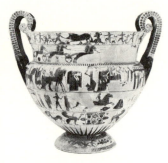

Above: FRANCOIS VASE h. 26 in (66 cm). Archaeological Museum, Florence

Left: HELEN FRANCKEN-THALER *Blue Territory.* 1955. 113×58 in (287×147·3 cm). Whitney Museum of American Art, New York

FRANKENTHALER, Helen (1928–)

b. New York. *Abstract Expressionist painter who studied at Dalton School with *Tamayo, at Bennington College and *Art Students' League. Influenced primarily by *Pollock, Frankenthaler adopted his freedom and spatial openness, inventing her own influential technique of staining into canvas; lately she has intensified her pale colours and solidified her forms.

FRANKISH ART *see essay* MIGRATION PERIOD ART

FRANQUEVILLE (FRANCAVILLA; FRANCHEVILLE), Pierre (?1548–1615)

b. Cambrai d. Paris. French painter, sculptor and architect who trained in drawing in Paris, as a sculptor at Innsbruck and then worked under Giovanni da *Bologna in Florence. Produced much sculpture throughout Italy. Recalled to France (1601) by Henri IV, he carved the slave figures for Bologna's equestrian statue of that king, commissioned by Marie de' Medici for the Pont-Neuf, Paris, and was active at Fontaine-bleau and elsewhere.

FREAKE MASTER *see* GIBBS

FREDENTHAL, David (1914–58)

b. Detroit, Michigan d. Rome. Painter who studied with Boardman *Robinson, painted murals for New York World's Fair (1939–40), and was influential artist-correspondent during World War II. His paintings are characterised by the compassionate realism associated with descendants of the *Ash Can School.

FREIBERG, SAXONY, Golden Gate

The so-called 'Golden Gate' of the †Romanesque church was reset in the south wall of its late †Gothic successor. Dated about 1230, it combines French ideas about portal design in the *tympanum and column figures, with German drapery styles and ultimately Italian ornament. It is a characteristic monument of the transition in Germany from Romanesque to Gothic.

FREIBURG-IM-BREISGAU CATHEDRAL

The west porch contains an elaborate programme of figure sculptures, ultimately based on *Reims in France, dated about 1260. While far inferior to the earlier German †Gothic sculpture at *Strasbourg, *Bamberg and *Naumburg the marionette-like figures at Freiburg are perhaps important as one of the sources for the 14th-century *schnitzältare. The interior of the church contains a particularly fine group, the *Three Marys at the Tomb of Christ* (c. 1340).

FREMINET, Martin (1567–1619)

b. d. Paris. French painter, one of the chief masters of the Second School of *Fontainebleau. Went to Rome (c. 1592) where he studied *Michelangelo and *Parmigianino. Recalled to Paris (c. 1602) by Henri IV for whom he decorated the ceiling of the Chapel of the Trinity at Fontainebleau with Passion scenes from the Old Testament. His style is entirely Florentine in origin.

FRANKEN FAMILY, Frans Floris II, *Interior with Couple Dancing.* KH, Vienna

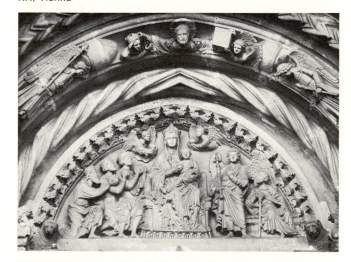

FREIBURG, Saxony. The Golden Gate. Second quarter 13th century. Now reset in the Cathedral

FRENCH, Daniel Chester (1850–1931)

b. Exeter, New Hampshire d. Nr Stockbridge, Massachusetts. Sculptor who studied with *Rimmer in Boston, *Ball in Rome (1876) and lived in New York (from 1887). The Establishment showered him with public commissions; his work sometimes

attained sturdy naturalism, more often combining academic facility with a certain lack of commitment.

DANIEL CHESTER FRENCH
Minute Man. 1874. Concord, Massachusetts

FRENCH ACADEMY *see* ACADEMIE ROYALE (DE PEINTURE ET DE SCULPTURE)

FRESCO

Fresco buono is true fresco. The artist paints into fresh wet plaster using pigment mixed with lime water as a *medium. The surface of the plaster sets hard in a thin transparent film locking the colour into the plaster. The technique is difficult; the painter must be quick and sure, the medium allowing no alteration. *Fresco secco* is dry fresco. The paint is applied to dry plaster, usually as a form of *distemper. Such paintings flake and deteriorate quickly and should not be compared or confused with true fresco.

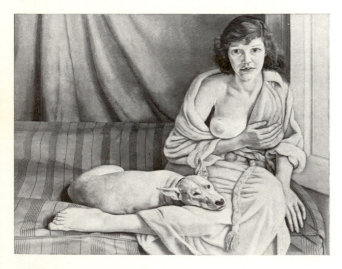

LUCIEN FREUD *Girl with White Dog*. 1950–1. 30×40 in (76·2×101·6 cm). Tate

FREUD, Lucien (1922–)

b. Berlin. His works of the 1950s present the figure with so concentrated a realism as to create shock. During the 1960s he adopted a larger format and more lucid technique. His colour is applied in carefully placed *taches*, but the overall effect is an uneasy conflict between the subject and the physical aspect of paint.

FREUNDLICH, Otto (1878–1943)

b. Stolp d. Concentration camp, Poland. Sculptor and painter who studied art history in Berlin and Munich before becoming an artist (1905). He worked mainly in Paris (from 1908) contributing to *Abstraction-Création. Influenced by *Jugendstil towards a decorative abstraction in his early painting, the abstract symbolism of his sculptures has a stronger formal quality.

FRIEDRICH, Caspar David (1774–1840)

b. Griefswald d. Dresden. German landscape painter and draughtsman who studied for a few years at the Copenhagen Academy before settling permanently in Dresden (1798). His early works are careful topographical studies, but he soon infused his landscapes with allegorical and symbolical content, reflecting on man's fate and on the presence of God in nature. His works are both powerful and lyrical, mixing observed elements from nature in a highly personal and stylised manner. From 1816 he taught at the Dresden Academy, but from 1820 his mental and physical health declined.

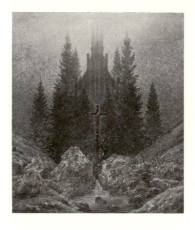

CASPAR FRIEDRICH *The Cross and the Cathedral in the Mountains*. c. 1811. 17¾×15 in (45×38 cm). Kunstmuseum, Düsseldorf

FRIESEKE, Frederick Carl (1874–1939)

b. Owosso, Michigan d. Mesnil-sur-Blangy, France. Painter who studied at Chicago Art Institute, *Art Students' League, and in Paris at Académie Julian and *Whistler School, with Constant and *Laurens. His landscapes and interiors are mildly †Impressionist, cheerful in mood, exploring the effects of flowing, dappling light.

FRIESZ, Emile Othon (1879–1949)

b. Le Havre d. Paris. French painter whose first and most successful paintings are *Fauvist. With impasto he breaks up the image into a composition of rhythmic gestures, using a palette of strong colour derived from †Impressionism. In 1907 he abandoned colour in favour of more clearly defined form, later falling under the influence of the Baroque. His painting degenerated into insensitive *chiaroscuro with a poor handling of paint.

OTHON FRIESZ *Fernand Fleuret*. 1907. 76×60 in (193×152·4 cm). Musée Nationale d'Art Moderne, Paris

FRINK, Elizabeth (1930–)

b. Thurlow. Sculptress who studied at Guildford and Chelsea Schools of Art. Her subjects – *Warrior Bird, Winged Figure, Falling Man* – and her style with its angular forms in contrasts of rough and smooth bronze finish, typified British sculpture in the 1950s. Her later large heads are more austere, and more complete, in form and expression.

Top: ELIZABETH FRINK *Horse and Rider.* 1970. Bronze. h. 19¾ in (50·2 cm). Waddington Galleries, London
Above: WILLIAM POWELL FRITH *The Railway Station.* 1862. Royal Holloway College, Egham

FRITH, William Powell (1819–1909)

b. Ripon d. London. English painter, trained in London, exhibited in 1838 the first of many subjects from popular literature. In 1851, he turned to paintings of modern life, eg *Ramsgate Sands* (1854). Despite his abuse of the group, his later handling of paint, eg *Derby Day* (1858) was influenced by the *Pre-Raphaelites.

FROMENT, Nicolas (active 1450–90)

b. Uzès d. Avignon. French painter working in the South of France, mainly for Réné of Anjou. Although the narrative scenes of his triptych *The Rising of Lazarus* (1461, Uffizi) have angular forms almost amounting to caricature, a number of heads demonstrate penetrating individualisation. The *Virgin of the Burning Bush* (1476, Aix-en-Provence) shows his art considerably mellowed, still possessing, however, his sense of characterisation.

FROMENTIN, Eugène Samuel Auguste (1820–76)

b. La Rochelle d. St Maurice. French artist and writer. He studied law, and then art under Cabat. Drawn to the Oriental works of Marilhat and *Decamps he went repeatedly to North Africa and painted the Arab life there. He is best remembered for his essays on 17th-century Northern artists, published as *Les Maîtres d'autrefois.*

FRONTE NUOVO DELLE ARTI

A short-lived group of Italian abstract painters and sculptors who exhibited at the Galleria della Spiga, Milan (1947). Chief members were Vedova, *Santamaso, Corpora, *Guttuso and Pizzinato; the last two returned to realism as the more 'committed' form of art.

FROST, Terry (1915–)

b. Leamington Spa. English painter who studied at Camberwell School of Art (1947–50). He has developed a style in which the primary concern is with abstract surface relationships derived from nature, the textured, freely executed planes and forms of which induce and govern colour.

Left: TERRY FROST *June, Red and Black.* 1965. Acrylic. 96×72 in (243·8×182·9 cm). Tate

Below: NICOLAS FROMENT *The Virgin of the Burning Bush.* 1476. Central panel of the Burning Bush Triptych. 161×120 in (410×305 cm). Aix-en-Provence Cathedral

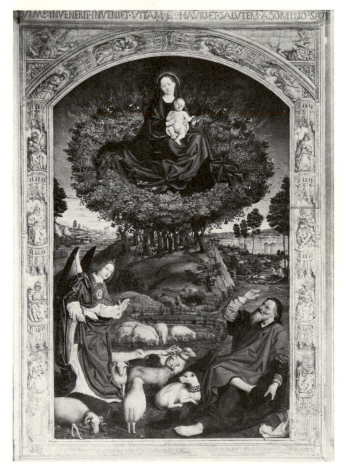

FROTTAGE

French: 'rubbing'. The introduction of textures into drawings by taking rubbings off a chosen surface.

FRUEAUF, Rueland the Elder (c. 1440/5–1507)

d. Passau. German painter, a citizen of Salzburg, where recorded (after 1470). Is identified with the painter who signed *R.F.* on an altarpiece dated 1490 and 1491 (now KH, Vienna). Later, worked in Passau on wall-paintings and panels in the Town Hall. His works have a monumental flavour, the expansive contours producing a calm, deliberate grace.

FRUEAUF, Rueland the Younger (c. 1465/70–1545)

German painter, perhaps the son of Rueland *Frueauf the Elder. His most important works are panels of the *St Leopold Altar* (Klosterneuburg). His emphasis on deep landscapes and towering mountains is novel and his treatment of them, brightly coloured with a sense of swelling, almost animate personality, shows him to be one of the founders of the *Danube School.

Left: RUELAND FRUEAUF THE YOUNGER *Departure to Hunt of Markgraf Leopold III and his wife Agnes*. 1505. 30×15¾ in (76·2×39·1 cm). Stiftes Museum, Klosterneuberg
Right: ROGER FRY *The Zoo*. 1911. 53×43½ in (134·5×109·2 cm). Tate

FRY, Roger (1866–1934)

b. d. London. Painter and critic of art. Studied painting in London, Paris, Italy, then in London again under *Sickert. While interested in Old Masters and Primitive art, his importance lay in introducing modern art to England with the *Post-Impressionist exhibitions of 1910 and 1912. He also directed the *Omega Workshops (1913–19). His criticism expressed a concern for order (*Vision and Design*, 1920); his paintings reflect this in their balance between colour and design. He never accepted the aesthetic validity of non-representational art.

FUHR, Xaver (1898–)

b. Mannheim. Self-taught German painter whose pedestrian realism was part of a 1930s reaction against *Expressionism. Although opposed to abstraction, direct views of places gave way to imaginary compositions in which real objects seem stranded in an abstract linear framework.

FUHRICH, Joseph von (1800–76)

b. Kratzau, Bohemia d. Vienna. Austrian artist who studied in Prague and Vienna. He went to Rome (1827) and there abandoned his classical style in the completion of frescoes begun by *Overbeck, whose style he adopted. These were in the Villa Massimo and the subjects were from Tasso's *Jerusalem Delivered*. In the 1850s he painted Biblical frescoes in Vienna where he taught historical composition.

FULLER, George (1822–84)

b. Deerfield, Massachusetts d. Brookline, Massachusetts. Painter, first a portraitist, studying and working in Boston (1842–7), in New York, Philadelphia and Southern cities (1847–59), going to Europe (1860), then ceasing painting until 1875. He painted autumnal visions of solitary, enchanted girls in Venetian-inspired colour and sensuous form.

GEORGE FULLER *Arethusa*. Boston, Gift by Contribution

FULLER, Isaac (c. 1606–72)

d. London. English painter who probably studied in France with Perrier and who was mainly occupied with decorative paintings at Oxford and London. His portraits are remarkable for their excited brushwork and heavy impasto.

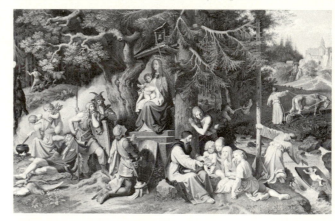

JOSEPH VON FUHRICH *Christianity brought to Germany*. 1864. 63⅜×101 in (161·5×256·5 cm). Schackgalerie, Munich

FRANCESCO FURINI *Poetry*. c. 1633. 16¼×13½ in (41·3×34·3 cm). NG, Edinburgh

FURINI, Francesco (1604–49)

b. d. Florence. Deriving his style partly from *Reni during a Roman visit, Furini returned to Florence (1623) and developed an exotic type of painting of voluptuous nudes in semi-darkness. He painted only one large fresco in the Pitti Palace, and later became a priest.

G

HENRY FUSELI *Titania, Bottom and the Fairies*. 1793. Executed for Boydell's Shakespeare Gallery. $66\frac{1}{2} \times 53\frac{1}{8}$ in ($168\cdot9 \times 134\cdot9$ cm). Kunsthaus, Zürich

FUSELI, Henry (Johann Heinrich FUSSLI)
(1741–1825)

b. Zürich d. London. Painter and draughtsman who began as an intellectual in Switzerland and Germany, then moved to London (1765), chiefly because of his enthusiasm for the works of Shakespeare. He was in Rome (1770–8) where he was influenced by the *Antique and *Michelangelo. Although †Neo-classicism played some part in his formation, his thirst was for the horrific and the sublime, which characterise his paintings and drawings done in England on themes from Shakespeare, Milton, Dante, etc. RA (1790), he was Professor of Painting (1799–1805) and Keeper of the *Royal Academy (1804–25).

FUSSLI, Johann Heinrich *see* FUSELI

FUTURISM

An Italian movement initiated by the poet *Marinetti's First Futurist Manifesto (1909). Futurism expanded (1910) to include the Milanese painters *Boccioni, *Carrà, *Russolo, the Rome-based *Balla and the Paris-based *Severini. Demanding an unthinking response to the sheer force of modern experience, obsessed particularly by the sensations of speed, conflict and change, the Futurist painters moved during 1911 from an early dependence on the direct visual excitement of *Neo-Impressionism to a distinctly independent version of Parisian *Cubism. Between 1912 and 1914 their development as individuals created great variety, ranging from Boccioni's attempts to convey dynamic movement in sculpture to Severini's attempts to evoke disconnected ideas by means of near-abstract forms in painting. Their Technical Manifesto (1910) and their exhibition, which in 1912 visited Germany, Holland and England, besides Paris, ensured an international importance for the movement, finally releasing Cubists like *Léger and *Gleizes from the studio-bound confines of early Cubism and giving a new mechanistic verve to the work of artists as far afield as *Malevich and *Marc.

FYT, Jan (1611–61)

b. d. Antwerp. Flemish painter who studied under *Snyders and who produced primarily still-lifes and hunting pieces in a decorative style influenced by *Rubens. His work is notable for its sensitively ordered multiplicity of carefully observed objects.

NAUM GABO *Spiral Theme*. 1941. Perspex. $5\frac{1}{2} \times 9\frac{5}{8} \times 9\frac{5}{8}$ in ($14 \times 24\cdot4 \times 24\cdot4$ cm). Tate

GABO, Naum (Nanum PEVSNER) (1890–)

b. Briansk, Russia. Sculptor who studied engineering in Munich (1910–14), visited Paris (1913–14), became a sculptor in Norway (1914–17) and worked in Russia (1917–22) – publishing with Antoine *Pevsner the *Realist Manifesto (1920), Berlin (1922–32), Paris (1932–3), London (1933–46) and America (from 1946). Following *Boccioni's example, his heads (1914–17) made of intersecting planes, use line rather than mass to express structure. Using materials like transparent plastic, his seemingly immaterial constructions are increasingly spatial. Unlike *Tatlin he is firmly pro-art. His work is a metaphor for a physicist's image of the world as an always balanced field of forces.

GABRIEL, Paul Joseph Constantin (1828–1903)

b. Amsterdam d. Scheveningen. Dutch artist who studied at Amsterdam and with *Koekkoek at Cleve. He was influenced in his landscapes by *Mauve. He worked in Gelderland and North Holland and lived in Brussels (1860–84). He became a master of the almost empty landscape and a leading artist of the *Hague School.

GABRIELENO *see* CALIFORNIA

GADDI, Agnolo (active c. 1369–96)

Florentine artist whose panel-painting style owes much to his father, Taddeo *Gaddi. His major fresco cycle, the *Legend of the Cross* (Sta Croce), represents the transition between late *Giotto School and *International Gothic. Here a dream-like quality results from the crowded compositions with confusing mixtures of scale and action, the fragile architecture and the delicate, decorative palette. He was *Lorenzo Monaco's master.

GADDI, Taddeo (active c. 1313–66)

A pupil of *Giotto who remained in his Florentine workshop for twenty-four years. His anecdotal version of his master's fresco style appears in the Baroncelli Chapel, Sta Croce. Here he experimented with light, using a supernatural yellow glow from the angel to illuminate the night scene in the *Annunciation to the Shepherds*. He painted many panels of the Virgin and Child and in Sta Croce the first illusionistic representation of the Last Supper in a refectory.

GAILDE, Jean (Giovanni GUALDO) (d. 1519)

Sculptor and architect active in Troyes. Perhaps from Italy. Named Master of Works of Ste Madeleine (1495) where he made his masterpiece, the rich and delicate roodscreen (1508–17). His style is basically late †Gothic but with more modern Italian influence.

GAINSBOROUGH, Thomas (1727–88)

b. Sudbury, Suffolk d. London. English portraitist and landscape painter, identified with all that is most elegant in English 18th-century society. He went to London (1740), probably studying under *Gravelot, and was influenced by *Hayman, especially in his group portraits in landscape settings. Seventeenth-century Dutch landscape paintings, which he copied and restored for dealers, also influenced him from an early date. Landscape painting was always his first love, and he painted landscapes throughout his career, but his output consists mainly of portraits because they were more financially rewarding, and his move to Bath (1759) – having previously moved from London to Sudbury, and thence to Ipswich – was probably to find more sitters. At Bath *Van Dyck's influence introduced more elegance and refinement into his style: eg the *Blue Boy* (Huntington Museum, San Marino, California). He became a founder-member of the *Royal Academy (1768) and moved to London (1774), becoming *Reynolds's chief rival. Gainsborough was less profound than Reynolds, but more spontaneous, with a greater facility for likenesses and a superbly fresh technique (he never employed a drapery man). In his last years he developed a new genre, consisting of beggar children in landscapes – the 'fancy picture'.

GALERIUS, Arch of (AD 297–311)

A four-sided *triumphal arch built at Salonika by Galerius to celebrate his Persian victories. Only two piers survive and these are decorated with four narrow bands of sculpture. The work of eastern Greek craftsmen, the sculptures fall into two distinct stylistic groups: stiff and symmetrical, and highly animated and lively, particularly in the battle scenes.

GALGARIO, Fra *see* GHISLANDI

GALLEGOS, Fernando (c. 1440–after 1507)
Francisco (active 1500)

Spanish painters working in Salamanca much influenced by Netherlandish work. Possibly brothers; Fernando, the teacher of Francisco, was a follower of Jorge *Ingles.

GANDHARA SCULPTURE (early 1st century–c. AD 250)

In addition to the Greek influence pervading the region of Gandhara (around the confluence of the Indus and Kabul rivers) from the days of the autonomous satrapies left behind after Alexander's retreat from the Indus, the Gandharan style was influenced by Roman trends – a result of the trading and political ties established by Kujula, first of the dynastic *Kushanas, with the Eastern Roman Empire. The religious theme of Gandharan art is mainly Buddhist, and the interpretation of iconographical formulations from India on formerly Greek-ruled soil in terms of Roman style results in a uniquely incongruous sculptural type. Carved in stone from local quarries is a tall figure swathed in a toga with a youthful Apollo-like face crowned with wavy hair piled in a kind of chignon to escape the Indian convention that the Buddha display, beneath the stubble of the ascetic's shaven skull, an abnormally large cranial bump (Sanskrit: *ushnisha) while the circle of hair between the brows (Sanskrit: *urna) and the elongated ear-lobes of a Shakyan tribal prince add the final touches of incongruity. Local variations from this 'classical' type are numerous, as the Kafir-Kot head from the Punjab illustrates. The heavily lidded eyes have a curious downward slant, and there is a distinct touch of humour in the line of the lower lids and the proud curves of the eyebrows and lips. It is above all the carefully draped folds of the toga (replacing the

monk's patchwork robe) which make the Gandhara Buddha, standing, seated or lying on his deathbed, instantly recognisable. When stucco work supplemented stone-sculpting at some time in the 3rd century, the same pattern persisted. Images of the *Bodhisattvas, permitting more scope for artistry in personal adornment and characterisation, are often superbly rich pieces, the Shahbaz-Gahri statue being an almost perfect example. The combination of Indian concepts with Greco-Roman style makes it difficult to decide by which cultural criterion to judge these works. It is best, perhaps, to leave them as the enigmatic products of a 'no-man's-land between East and West'. In their original state, painted and picked out in gold-leaf and set in the niches of a *stupa or *vihara, they unified, through the medium of a common religion, the bewildering cross-currents of artistry which flowed through this area into a coherent school which even dictated stylistic trends back into the Western world and handed on certain elements which contributed to the classical art forms of India. There is insufficient evidence to determine the pattern of evolution in the Gandhara style, which is remarkably coherent.

GANESHA (GANA+ISHA)

Literally 'lord of the host'. Hindu elephant-headed deity; relatively late addition to the pantheon as a son of *Shiva, leader of the god's host of goblins. He is the god of auspicious beginnings, and remover of obstacles to success.

GANGA DYNASTY (AD 490–900; 900–14)

The imperial Gangas of Orissa, whose dynasty endured for some five centuries, are famed for their superb temples at Konarak and Bhuvaneshvara. The earliest Hindu structure of the Gangas is the 8th-century Mukhalingeshvara at Mukhalingam. Relief sculptures of gods and goddesses are set in niches in the outer walls of the entrance-hall to the main temple, all of them infused with vigour and solidity and carved, one feels, with an affection that makes of each deity an individual personality. These images capture better than most the spirit of popular Hindu mythology contained in the Sanskrit anthologies. The doorways of this temple are covered with a profusion of intricately carved floral decoration which has no rival in complexity and chiaroscuro effect. The precision of detail in the images, particularly the incised strands of hair and cross-hatching on inner surfaces, similarly imparts a richness of texture to the individual sculptures. The Vaital Deul is a Bhuvaneshvara temple (of unusual type, with barrel-vaulted roof) belonging to the same century as the Mukhalingeshvara. It was built by the Bhauma kings, and has sculpture very similar in spirit and style to the early Ganga statuary at Mukhalingam. Bhuvaneshvara is also the site of the 12th-century Lingaraja which typifies the classical Orissan temple style; only the later parts of it, however, such as the 'dancing-hall', were built by the Gangas, the original shrine and assembly hall being the work of the Kesari dynasty according to the temple records. In terms of sheer size – the assembly hall alone is 128 feet high – as well as in the perfection of sculptural integration with architectural form, it is the sun temple (*Surya-deul) at Konarak which represents the height of Imperial Ganga sculpture. The great hall is designed to represent the chariot (*ratha) of the sun, with twenty-four intricately carved wheels almost ten feet in diameter round the pediment and seven horses carved on the sides of the approach stairway. A sense of lightness is lent to the massive bulk of the hall by areas of perforated chess-board pattern. The original *shikara* (tower over the sanctum) has collapsed. The numerous sexual postures of the *Kamasutra*, and more besides, are energetically detailed in panels round the base. Higher up this monument the sculpture is more restrained: greenstone images of Surya the sun god appear in niches, highly polished and exquisitely proportioned, the virtually nude body richly ornamented and – a peculiarity of northern Surya images inherited from the *Kushana costume – wearing knee-length boots. Yet higher, on the upper terraces, one is confronted by life-sized sculptures in the round of celestial nymphs playing musical instruments. Their solidity, no doubt partly dictated by the distance from

which they are meant to be seen by the worshipper on the ground, in no way detracts from the ethereal effect.

GANGAIKONDACHOLAPURAM *see* CHOLA DYNASTY

GANKU (Kishi Ganku) (1756–1838)

Founder of the *Kishi version of the *Shijō School, this Japanese artist was particularly famous for his paintings of tigers (he owned a tiger skin). His technique depended on a subtle use of ink wash as well as line and colour, reflecting an interest in the *Kanō School.

GARBO (CARLI), Raffaellino del (1466–c. 1527)

b. d Florence. Italian painter; according to *Vasari, assistant of Filippino *Lippi also influenced by *Perugino. He continued to work in the *quattrocento manner well on into the cinquecento. He is remembered largely because Andrea del *Sarto trained under him (c. 1505); so later did *Bronzino.

GARGALLO, Pablo (1881–1934)

b. Mailla, Aragon d. Reus. Spanish sculptor, friend of *Picasso, who studied in Barcelona and visited Paris (from 1906). Influenced first by *Maillol's massive figures, his characteristic style translates solid forms into curved planes and ligaments of metal; armatures whose elegant silhouettes catch a figure's pose and type rather than expressing its structure.

GARGARINO (Eastern Gravettian, late glacial)

†Palaeolithic site in the Don Valley, Russia, which has yielded female figurines in ivory.

GARGAS (Perigordian and Aurignacian)

Important †Palaeolithic site in the Hautes-Pyrénées, France, with engraved Perigordian limestone plaques, similar to those on the walls. There are 150 stencilled hands in black or red, usually the left hand, with some fingers apparently missing. The hands constitute the sole paintings in the cave.

GAROFALO (Benvenuto TISI) (c. 1481–1559)

b. Ferrara. A prolific but provincial painter of sacred themes whose long career reflects the influence of *Costa and *Mantegna and, later, that of *Raphael and Dosso *Dossi. He never approached any of these in inventiveness or skill.

GASSER, Erasmus *see* GRASSER

GATCH, Lee (1902–68)

b. Nr Baltimore d. Lambertville, New Jersey. Painter who studied at Maryland Institute, with *Sloan and *Kroll, New York, and *Lhote and *Kisling, France (1924). Influenced by *Cubism, *Intimisme and *Klee, Gatch's work evolved from charming, geometric landscapes to abstract combinations of collage and paint, composed of flat shapes in subtle tonalities.

GAUDIER-BRZESKA, Henri (1891–1915)

b. Saint-Jean-de-Braye d. Neuville-Saint-Vaast. French sculptor who studied English in Bristol (1907–9) and after a period in Germany (1909) and Paris (1909–11), returned to England and became a prominent *Vorticist. He was killed in action (1915). Gaudier-Brzeska drew upon *Cubism, primitive sculpture and *Brancusi to produce savage energetic figures of great promise.

GAUGUIN, Paul (Eugène Henri) (1848–1903)

b. Paris d. Atuana, Marquesas. The son of a journalist with a mother of Peruvian extraction. He spent some years as a small child in Lima. Later, in the merchant service, he sailed to South America. He worked in a Paris stockbroker's office (1870s–1883). He also began to paint, sculpt and to purchase †Impressionist pictures. Having met the Impressionists he showed with them in their last four group exhibitions and painted in the company of *Pissarro, *Cézanne and *Guillaumin. He visited Panama (1887) and Martinique and he developed his mature style at *Pont Aven (1888–9) (*Synthetism). His first trip to Tahiti was in 1891 and he returned in 1895, moving to the Marquesas in 1901. With his removal from Western life he continued his interests in primitive faith and folk-art and produced his most symbolic works, including the allegory of human life *Where do we come from? What are we? Where are we going?*

GAULLI (BACICCIA), Giovanni Battista (1639–1709)

b. Genoa d. Rome. Italian painter who was early influenced by the work of *Rubens and *Strozzi in Genoa and settled in Rome (1657), initially largely as a portrait painter. Close contacts with *Bernini in Rome and the study of *Correggio on his trip to Parma (1669) led to the formation of the style that brought to Roman †Baroque fresco decoration a new dynamism in the illusionistic treatment of vast areas with perfect compositional and tonal unity. This is best seen in his frescoed nave ceiling of the Gesù in Rome.

GAURICUS, Pomponius (d. 1530)

Italian writer on art. His *De scultura*, written in Padua, dates from 1503/4. Gauricus was a champion of the antique style in sculpture. He criticised *Verrocchio's ideas of anatomy, admired *Riccio's work and praised Tullio *Lombardo for his understanding of classical learning, which he considered essential in a sculptor.

GAUTIER, Théophile (1811–72)

b. Tarbes d. Paris. French novelist and art critic, who advanced the theory of 'Art for Art's Sake' in, among other writings, the preface to his novel *Mademoiselle de Maupin* (1835). He believed that art was under no moral or social obligation, but obeyed its own laws of beauty and harmony. Particularly influential in the *Rossetti circle in the 1860s.

GAVARNI, Paul (Hippolyte-Guillaume-Sulpice CHEVALIER) (1804–66)

b. d. Paris. French draughtsman, watercolourist and lithographer, studied engraving with Adam (1824), and became known as Gavarni when in the Salon of 1829 he exhibited a watercolour, the *Cirque de Gavarni*. After several newspapers, he joined *Charivari* where he portrayed the carefree frivolous side of Parisian petit-bourgeois and artistic society. Although themes overlap, he lacked *Daumier's depth of vision. His stays in England (1847, 1849–51), when he exhibited at the Royal Academy, resulted in a celebrated series *Garvarni in London*, which marked the change from his early carefree mood to concern for social distress, and stylistically, to greater linear emphasis (eg *Le propos de Thomas Vireloque* series, 1852).

GEAR, William (1915–)

b. Methil. Scottish painter who trained at Edinburgh (1932–7) and in Paris under *Léger (1937). His work expresses an interrelationship between black structural armature and patches of bright colour, polarised between crisper and looser handling.

GEELVINK BAY

The art styles of north-west *New Guinea, concentrated upon Geelvink Bay and the Ajau islands, received influences from eastern Indonesia: complex scroll-work is characteristic of both areas. Korwar figures were used to communicate with the ancestors: larger types supported skulls or contained them in their hollowed-out heads; smaller versions were personal amulets. The Korwar style was also used in decorating canoe prows, sago pounders and the pubic shields of young girls. Masks from the Geelvink Bay area are very rare.

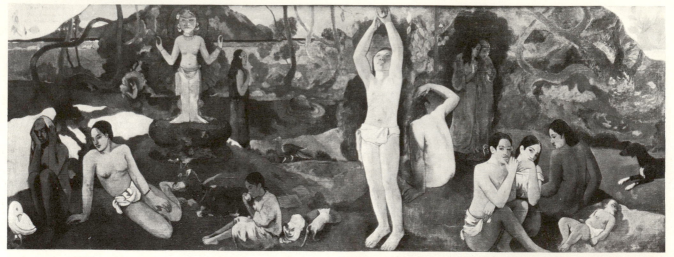

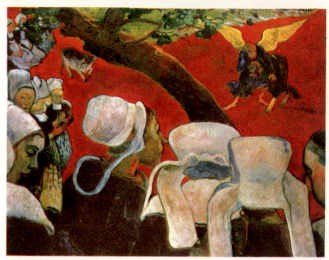

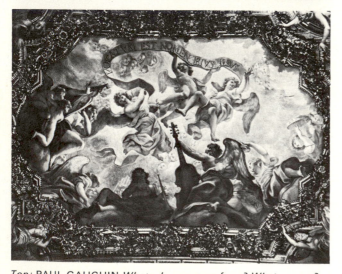

Top: PAUL GAUGUIN *Where do we come from? What are we? Where are we going?* 1897. 54¾×147½ in (139·1×374·6 cm). Boston, Arthur Gordon Tompkins Residuary Fund
Middle: THOMAS GAINSBOROUGH *Cornard Wood.* 1748. 48×61 in (121·9×154·9 cm). NG, London
Above: GIOVANNI BATTISTA GAULLI *The Adoration of the Name of Jesus.* 1674–9. Ceiling fresco. Church of the Gesù Rome
Middle right: PAUL GAUGUIN *The Vision after the Sermon.* 1888. 28¾×36¼ in (73×92·1 cm). NG, Edinburgh

Left: THOMAS GAINSBOROUGH *Mary, Countess Howe.* 1760. 96×60 in (244×152·4 cm). Iveagh Bequest, Kenwood
Right: GANDHARA STYLE *Bodhisattva.* From Shahbaz-Gahri. *c.* 2nd century. Schist. h. 47 in (120 cm). Musée Guimet, Paris

 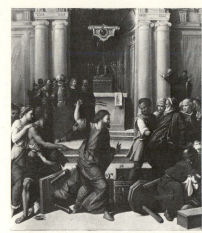

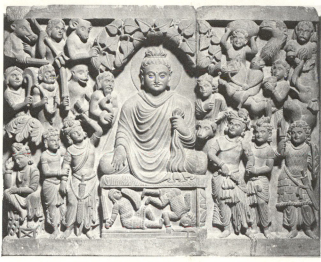 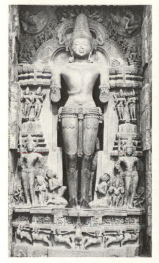

Top left: GANDHARA STYLE Head of Buddha. From Hadda, Afganistan. *c.* 5th century. h. 11 in (29 cm). V & A, London
Top right: GANDHARA STYLE Head of Buddha. From Kafir Kote. 2nd–3rd century. Schist. h. 8 in (20·3 cm). BM, London
Middle: GANDHARA STYLE *Enlightenment of the Buddha. c.* 2nd century. Schist. Freer Gallery of Art, Washington
Above left: GANKU *Deer.* Early 19th century. Ink and colour on silk. Fenollosa-Weld Collection, Boston
Above right: GANGA DYNASTY Erotic tableaux on pediment of Surya temple, Konarak. 13th century

Top left: GAROFALO *Christ driving Merchants from the Temple.* 18¼×14¼ in (46·3×36·8 cm). NG, Edinburgh
Top right: HENRI GAUDIER-BRZESKA *Red Stone Dancer. c.* 1913. 17×9×9 in (43·2×22·9×22·9 cm). Tate
Middle left: GANGA DYNASTY *Surya.* Surya temple, Konarak. 13th century
Middle right: GANGA DYNASTY (Early Period) *Ganesha.* Mukhalingeshvara temple, Mukhalingam. 8th century.
Above: GANGA DYNASTY *Hermaphrodite Shiva Nataraja.* Parashurameshvara temple, Bhuvaneshvara. 7th–8th century

GEERTGEN TOT SINT JANS (1455/65–1485/95)

b. Leiden d. Haarlem. The name means 'Little Gerard of the Brethren of St John' (Haarlem). Netherlandish painter and possibly pupil of *Ouwater. There are no contemporary mentions of his name and his œuvre is based round a *Lamentation* (KH, Vienna) mentioned by van *Mander. He may have visited Bruges (1475/6) and had contact with Hugo van der *Goes. His charming, doll-like figures, occasionally verging on geometric abstraction, perform as if in a naïve, static play, within wide landscape settings.

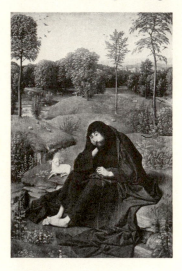

GEERTGEN TOT SINT JANS
St John the Baptist in the Wilderness. $16\frac{1}{2} \times 11$ in (42×28 cm). Staatliche Museum, Berlin-Dahlem

GEIAMI (1431–85)

Japanese painter, the son of *Nōami.

GEIGER, Ruprecht (1908–)

b. Munich. German painter, trained as an architect in Munich, who took up painting after the war. Although Geiger's austere, geometric forms are entirely abstract, the gradations of colour contrive to give his paintings an atmosphere and space reminiscent of *Feininger.

GELATINE

An animal *glue, which when dry becomes hard, yet flexible.

GELDER, Aert de (1645–1727)

b. d. Dordrecht. Dutch painter who studied with van *Hoogstraten and with *Rembrandt in Amsterdam (c. 1661). He remained a faithful follower of Rembrandt while working in Dordrecht, although his colours become paler in his later work.

GELEE see CLAUDE

GEMMA AUGUSTEA (late 1st century BC–early 1st century AD)

A particularly fine cameo of sardonyx decorated with two figured zones. In the upper and more important zone sit Augustus and Roma enthroned; on the right Earth places a crown on Augustus's head, and on the left Tiberius is shown stepping out of his chariot. The gem has been attributed to *Dioskorides. (KH, Vienna.)

GEMS

A word used to describe semi-precious stones with engraved designs. In Greece in the 6th and 5th centuries BC they were mainly of the scarab or scaraboid type. The designs were incised in the *intaglio technique and thus they could be used as seals. During the 4th century BC scenes of everyday life and portraits appeared on gems. A gem-engraver of the period, *Pyrgoteles, is known to be the only man Alexander the Great would allow to carve his features on a gem. In *Hellenistic times perforated ringstones became common. In Augustan times the cameo, a Hellenistic invention whereby the design was carved in relief (the opposite to intaglio), became popular. *See also* GEMMA AUGUSTEA

GENRE

French: 'type'. Painting which depicts everyday life as opposed to specialised or idealised aspects. Although genre was accepted as subject-matter even in classical times (*still-life), it was in 17th-century Dutch painting that it became of real importance and it permeated wherever that school was an influence. In the 19th century the movement towards realism and naturalistic representation brought genre to the fore and it has continued to be important in the 20th century.

GENT, Joos van see WASSENHOVE

GENTILE DA FABRIANO (Gentile di Niccolò di Giovanni di MASSIO) (c. 1370–1427)

b. Fabriano d. Rome. One of the most gifted Italian exponents of the *International Gothic style. Employed in Lombardy, Umbria, Venice, Florence, etc, working in fresco and *tempera. Gentile's charming descriptive scenes appealed to the taste of humanist patrons such as Pope Martin V and Palla Strozzi, who commissioned his masterpiece the *Adoration of the Magi* (1423, Uffizi).

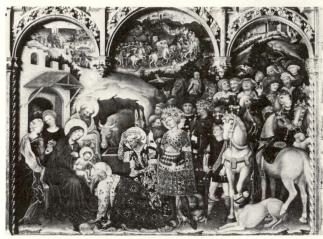

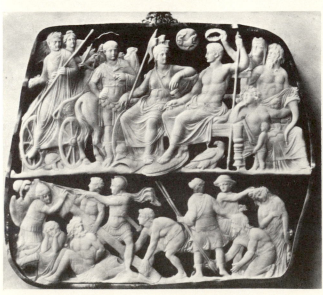

Top: GENTILE DA FABRIANO *Adoration of the Magi.* 1423. $111\frac{1}{8} \times 128\frac{1}{8}$ in (282×300 cm). Uffizi
Above: GEMMA AUGUSTEA Sardonyx cameo. h. $7\frac{3}{4}$ in (18.7 cm). KH, Vienna

GENTILESCHI (LOMI), Artemisia (c. 1597–after 1651)

b. Rome d. ?Naples. Italian painter, daughter of Orazio *Gentileschi, visiting Florence (1621–4), and settling in Naples (from c. 1630), leaving (1638/9) to visit her father in England. Her work is in a *Caravaggesque style noted for its brutal subject-matter but subtle colours and dramatic elegance.

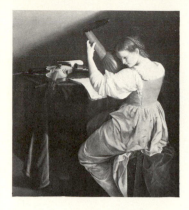

ORAZIO GENTILESCHI The Lute Player. $56\frac{1}{2} \times 50\frac{5}{8}$ in (143·5 × 128·8 cm). NG, Washington, Ailsa Mellon Bruce Fund 1962

GENTILESCHI, Orazio (1563–1639)

b. Pisa d. London. Italian painter who worked in Rome where he came into contact with *Caravaggio and was influenced by that artist's early works. His smooth modelling, cool colours and attention to detail are due in part to his Tuscan sensibility. He travelled to Paris by way of Genoa and Turin and worked for the French royal family in the mid 1620s. He accepted an invitation to paint at the court of Charles I (1626) and moved to London where he spent the rest of his life.

GEOMETRIC ART (c. 900–700 BC)

During this period of Greek art the main art form was pottery, although a few terracotta and small bronzes were produced. The pottery was of a very fine quality and was covered entirely in a network of very fine patterns. At first these were completely abstract, eg the meander, chequer, triangle, herringbone and swastika. Later, birds and animals were introduced and highly angular, silhouette figures. The head is a blob, the upper part of the body a triangle and the arms and legs thin sticks. Eventually the figures are given rudimentary features. The scenes are usually funerary or land- and sea-battles.

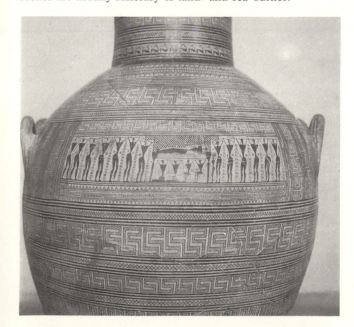

GEOMETRIC ART Detail of vase from Dipylon cemetery. 8th century BC. h. 5 ft 1 in (1·55 m). National Museum, Athens

GEORGIAN ART see CAUCASIAN ART

GERARD, Baron François-Pascal (1770–1837)

b. Rome d. Paris. French painter, and the pupil and assistant of *David to whom he remained closest in style, though his classicism is considerably gentler. He painted history, but excelled in portraiture, eg Mme Bonaparte (1799) and Mme Récamier (1805). Negotiating political changes very successfully, he was appointed Principal Painter to the King (1814), and subsequently ennobled, but mass production lowered the quality of his later works.

Above left: FRANCOIS-PASCAL GERARD Madame Récamier. After 1805. $88\frac{5}{8} \times 58\frac{1}{4}$ in (225 × 148 cm). Musée Carnavalet, Paris
Above right: NICOLAUS GERHAERTS VAN LEYDEN Self-portrait. c. 1467. Sandstone. Musée de l'œuvre Notre Dame, Strasbourg

Right: NICOLAUS GERHAERTS VAN LEYDEN Tomb of Archbishop Jacob von Sierck. 1462. Bischöfliches Museum, Trier

GERHAERTS VAN LEYDEN, Nicolaus (active 1462–d. 1473)

b. ?Leiden d. Vienna. The outstanding and most influential Netherlandish sculptor of the second half of the 15th century, working in Trier, Strasbourg, Passau and Wiener Neustadt. The deep cutting, increased volume and realism of the tomb of Archbishop Jacob von Sierk (1462, Trier) is in complete contrast to anything immediately before him and encourages parallels with Claus *Sluter. The self-portrait (?) (c. 1467, Strasbourg) and Christ on the Cross (1467, Baden-Baden) show his ability to convey inner feeling through the perfectly controlled rendition of naturalistic detail, enhanced by sharp contrast of light and shade. Invited to Vienna by Emperor Frederick III (1463) he did not go until a second summons (1467). Here he executed the lid of the tomb of Frederick III, a work that combines austere design with subtly animated surfaces. His style is highly personal, dynamic, giving amazing expressive power to his sculpture.

GERICAULT, Jean Louis André Théodore (1791–1824)

b. Rouen d. Paris. French painter whose highly personal works proved crucial for nascent †Romanticism. In Paris he studied

under Carle Vernet and Pierre-Narcisse *Guérin, and frequently made copies of Old Masters. His interest in horses is manifest in his monumental early paintings of cavalry officers. He was in Italy (1816–18) where he was influenced by *Michelangelo, †Baroque art and the excitement of Roman life. In Paris on his return his masterpiece, *The Raft of the Medusa* (Louvre), was not given the official praise he expected. This aggravated his frequently depressive mental health with noticeable effect on his art. In England (1820–2) he turned to subjects of a lighter nature. He died following an accident (1824). His grand and original paintings are suffused with a pervasive disquieting quality, but the actual use of paint is always brilliant and exciting.

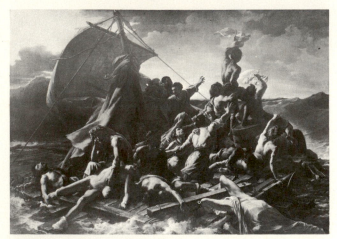

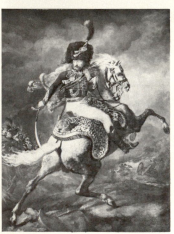

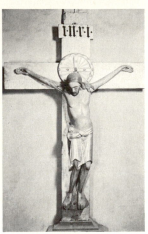

Top: JEAN-LOUIS GERICAULT *The Raft of the Medusa.* 1819. 193×283 in (489×718 cm). Louvre
Above left: JEAN-LOUIS GERICAULT *An Officer of the Imperial Guard Charging.* 115×76¾ in (292×194 cm). *Louvre*
Above right: GERO CRUCIFIX 970–976. h. 74 in (188 cm). Cologne Cathedral

GERINES, Jacques de (d. 1463/4)

Sculptor in bronze, active in Brussels. His effigy of Isabella of Bourbon with its intricate drapery, is a masterpiece of late †Gothic bronze sculpture.

GERO CRUCIFIX

This crucifix in *Cologne Cathedral was made for Gero, Archbishop of Cologne between 970 and 976. It is the oldest surviving example in the round of a statue of the Crucified Christ known to Western art. Made of oak, it is virtually life-size. The formal arrangement of this dead Christ was already familiar in †Byzantine manuscripts and ivories. Its influence on later German sculpture in the Rhineland, especially in bronze, was profound.

GEROME, Jean Léon (1824–1904)

b. Vesoul d. Paris. French painter and sculptor, a pupil of *Delaroche. First exhibited at the Salon of 1847, *The Cockfight,* paralleling Delaroche's emphasis on archaeological accuracy, but here applied to an antique setting. He was more closely associated with paintings of the East, and of Biblical history. He favoured large, long canvases, with carefully painted vistas of arid desert, stalked by wild animals. These were interspersed with scenically effective history-paintings, eg *The Death of Caesar* (1867). In later life he turned more and more to sculpture.

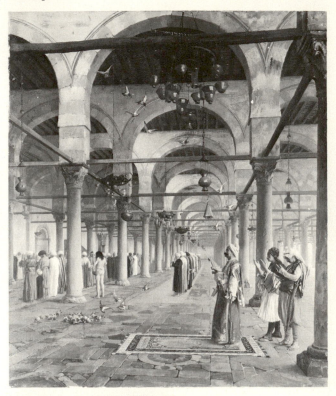

Above: JEAN GEROME *Prayer in the Mosque.* After 1867. 35×29½ in (88·9×74·9 cm). MM, New York, Bequest of Catherine Lorillard Wolfe, 1887

Left: MARK GERTLER *Jewish Family.* 1912. 26×20 in (66×50·8 cm). Tate

GERTLER, Mark (1891–1939)

b. d. London. English painter who trained at the Regent Street Polytechnic and the Slade School of Art (1907–12) and was a member of the *London group. After early Jewish subjects and a brief period of *Post-Impressionist influence, he painted realistic nudes and still-lifes with decorative effect.

GESSHO (Cho Gessho) (1772–1832)

Japanese artist from Nagoya who worked in the *Nanga/ *Shijō style, notable for his superb sketches, especially those in *Zoku Koya Bunko* (1798).

GESSNER, Salomon (1730–85)

b. d. Zürich. Swiss poet and landscape painter, he engraved illustrations for his own poetical works and for editions of Shakespeare and Samuel Butler. He painted ideal landscapes in *gouache and watercolours, full of temples, grottoes and waterfalls, and mythological figures.

GESSO

White chalky pigment bound in a water and glue medium, used as a *ground on wood and other supports in painting and *gilding.

GHASSUL (4th millennium BC)

Chalcolithic mud-brick houses at Teleilat Ghassal in East Jordan were decorated with murals on the mud plaster. One such mural shows a curiously futuristic combination of strange human forms and geometric doodles. Another painting is a colourful representation of a game-bird.

Above: GHASSUL Wall-painting. Chalcolithic. Mud-brick house. Teleilat Ghassul I

Left: LORENZO GHIBERTI *Annunciation* from the first Baptistery Doors. 1403–24. Bronze parcel-gilt. $20\frac{1}{8} \times 17\frac{3}{4}$ in (52×45 cm). Baptistery, Florence

GHAZNAWID PAINTING (999–1186)

The earliest significant phase of Muslim art in India was initiated by Sultan Mahmud, the capital of whose empire was at Ghazni in Afghanistan. Only very little Ghaznawid painting survives at Lashkari Bazar in Afghanistan, where there is the remains of a composition which once included at least forty-four figures. In these, Turkish-Buddhist elements from Uighur and Turkmen sources have been identified. Ghaznawid painting also shows elements comparable to those found in *Samanid painting. Literary evidence also gives further information, recording the production of erotic paintings for Masud I, and also the presence of a collection of Manichean illustrations in the Ghaznawid treasury, suggesting a further source of Ghaznawid painting.

GHEERAERTS, Marcus the Elder
(1516/21–before 1604)

b. Bruges. Flemish decorative and possibly portrait painter, who produced paintings for Bruges churches before fleeing to London (1568) to escape the Alvan persecution. He illustrated Aesop's *Fables* (1567). None of his portraits are known today.

GHEERAERTS, Marcus the Younger
(active c. 1561–d. 1636)

b. Bruges d. London. Leading Flemish portraitist, son of *Marcus the Elder who worked mainly in England. Much influenced by the Antwerp School, especially *Pourbus, his portraits characterise the sitters in a tender affectionate way, and show great attention to the materials and jewellery. He painted Elizabeth I (1592, Welbeck Abbey) and became Court Painter to James I.

GHENT, Joos van see WASSENHOVE

GHERARDI, Cristofano ('Il Doceno') (1508–56)

b. Borgo S. Sepolcro d. Florence. Italian *Mannerist painter, a pupil of Raffaellino da Colle and *Rosso. A friend and gifted assistant to *Vasari. His sensuous depiction of fruit, vegetables, flowers, birds and animals was ingenious.

GHEYN, de, Family

Dutch artists. Jacques (Jacob) I (1532–82) was primarily a glass and miniature painter. His son, Jacques II (1565–1629, b. Antwerp d. The Hague) was the most important member. A pupil of *Goltzius, he was a brilliant draughtsman, using an *engraving technique of dots and hatching to produce an expressive effect only surpassed by *Rembrandt. He moved to the northern Netherlands (1585), and visited London (1622) with his son Jacques III (1596–1644, b. Leiden d. Utrecht).

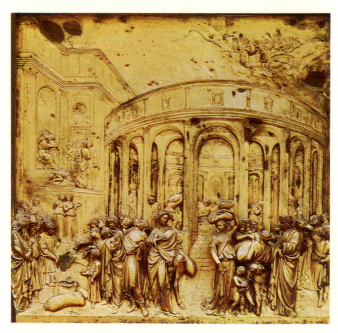

LORENZO GHIBERTI *Story of Joseph* from the Gates of Paradise. 1425–52. Gilt bronze. $31\frac{1}{8} \times 31\frac{1}{8}$ (79×79 cm). Baptistery, Florence

GHIBERTI, Lorenzo (1378–1455)

b. d. Florence. Florentine painter, sculptor and author of the first artist's autobiography, *Commentarii* (c. 1450), in which he tells us the judges were unanimous in awarding him the commission for the Baptistery doors (1401). These occupied him for many years (1403–24) and necessitated the maintenance of a vast workshop employing *Donatello, *Michelozzo, *Uccello, etc. Simultaneously he created three life-size bronze statues of saints for Or San Michele (1414–27) and two delicately wrought reliefs for the Siena Cathedral font (1417–27). All these works reveal that he was nurtured in the *International Gothic style and may have been influenced initially by the mysterious German, Master Gusmin, whom he praised so enthusiastically. Later he mastered perspective, introduced classical motifs into his reliefs and took casts of heads in Rome to adorn the frame of his doors. Why he figured in the dedication of *Alberti's

Della Pittura is clear from the Porta del Paradiso (commissioned 1425, executed 1429–52). The change from *quatrefoil to rectangular panels allowed much greater expressive freedom reflected in the diverse conception of the reliefs ranging from the lyrical *Creation* and the intricate *Storming of Jericho* to the austere classicism of the *Jacob and Esau* panel.

GHIRLANDAIO (BIGORDI) Family
Domenico (1449–94)
Davide (1452–1525)
Benedetto (1458–97)
Ridolfo (1483–1561)

One of the most notable families of painters in Florence at the turn of the 16th century. Domenico, brother of Davide and Benedetto and father of Ridolfo was certainly the most famous, although he was almost exclusively a frescoist. His major fresco cycles are those in Florence. He painted the *Scenes from the Life of St Francis* in the Sassetti Chapel, Sta Trinità (1482–5) and *Scenes from the Life of St John the Baptist and the Virgin* for the choir of Sta Maria Novella (1486–90). His most important Roman work was *Christ Calling the First Apostles* for the Sistine Chapel (1481–2) into which he introduced portraits of Florentines living in Rome. Indeed it was his talent for depicting the life of the wealthy middle class in his apparently religious subjects that made him so popular. His closely observed detail can be explained partly by his interest in Flemish art. Altarpieces such as his *Madonna in Glory* (Munich) show his work at its best. Davide and Benedetto helped him run his large studio, whose finest product was *Michelangelo. Ridolfo was a portrait painter influenced by his friend *Raphael and by Sebastiano del *Piombo.

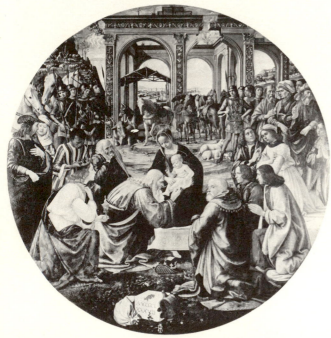

DOMENICO GHIRLANDAIO *Adoration of the Magi*. 1487. Diameter 67⅞ in (171 cm). Uffizi

GHISLANDI (Fra GALGARIO), Vittore (1655–1743)
b. d. Bergamo. Italian painter whose naturalistic and penetrating portraits of priests and professional men make him a prominent figure of early 18th-century North Italian realism.

GIACOMETTI, Alberto (1901–66)
b. Borgonovo, Ticino d. Chur. Swiss sculptor and painter, the son of an †Impressionist landscape painter. Worked in *Bourdelle's studio in Paris (1922–5), and lived in Paris (1927–66). He was an important member of the *Surrealist group (1931–4), expelled as reactionary. Afterwards moved to a personal style using elongated figures, standing or walking, grouped or singly, to explore problems of space, density and movement. His paintings and drawings, portraits or figure studies are complex linear compositions of extraordinary penetration. His sculpture varies in scale from minute to over lifesize.

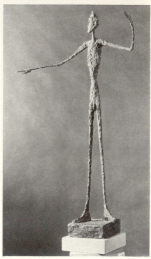

Top: ALBERTO GIACOMETTI *Pointe a l'œil*. 1931. Plaster and metal. 4¾×23⅜×11⅞ in (12×59×30 cm). Kunsthaus, Zurich
Left: GRINLING GIBBONS Lime wood carving from Carved Room, Petworth House. 1692
Right: ALBERTO GIACOMETTI *Man Pointing*. 1947. Bronze. 69½×35½×24½ in (176·5×90·2×62·2 cm). Tate

GIAMBOLOGNA *see* BOLOGNA, Giovanni da

GIAMBONO, Michele (Michele di Taddeo BONO) (active 1420–62)
Venetian painter whose style is close to the *International Gothic of *Gentile da Fabriano. In Venice 1409–14, where there are signed works. He may also have been influenced by Jacobello da Fiore.

GIBBONS, Grinling (1648–1721)
b. Rotterdam d. London. Sculptor who came to England (before 1668) and was soon patronised by Charles II. He executed large marble tombs and bronze statues, but his fame rests on his exquisite, highly realistic decorations in carved wood of flowers and fruit, *putti and small animals in which field he was unsurpassed.

GIBBS (FREAKE MASTER) (active 1670–80)
Active New England. Portraitist best known for paintings of John and Elizabeth Freake; portraits of the Gibbs children are also attributed to him. He represents the *limners' tradition at its best, in his rich sense of linear pattern, lovingly rendered textures and sonorous colours.

GIBSON, John (1790–1866)

b. Gyffin, nr Conway d. Rome. English sculptor, apprenticed to a Liverpool mason (1804), went to Rome to work under *Canova and *Thorwaldsen (1817), and became internationally known. His principal innovation was the use of tinted marble. He revisited England to work for Queen Victoria (1844, 1850). A member since 1834, he left his fortune to the Royal Academy.

GILBERT, Sir Alfred (1854–1934)

b. d. London. English sculptor, painter and watercolourist, he studied at South Kensington Art School, then with Sir J. E. Boehm at the Royal Academy. In Paris he entered the studio of Cavelier at the Ecole des Beaux-Arts, and then left for Rome (1878). After his début with *Kiss of Victory*, and the naturalistic bronze head, *Capri Fisherman* (1882), he exhibited regularly at the Royal Academy. He completed the Shaftesbury memorial fountain, *Eros* for Piccadilly Circus in 1893. For a time he lived in Bruges. He was associate (1887), later member (1892) of the Royal Academy, honorary member of the Royal Institute of Painters in Water Colour, member of the Royal Society of British Artists and of the Society of British Sculptors.

GIL DE CASTRO, José ('El Mulato Gil') (1779–1832)

b. Lima. Painter who worked in Chile (1814–22). Known as the painter of the Chilean fight for independence, Gil de Castro painted its heroes in a †Neo-classical style severe to the point of stiffness, transforming them into overpolished, stony masks.

GIL DE SILOE (active c. 1486–c. 1505)

Sculptor, active in Burgos, although possibly of Orléans origin. The monument to John II and Isabel of Portugal (1489–93, Burgos) and the wall monument there to Juan de Padilla (c. 1500–5) are his main works in stone, but he also worked in wood. His style is highly decorative with an emphasis on minute detail which gives his ensembles a flamboyant effect. He was much influenced by Lower Rhenish work.

GILDING

The application of gold leaf to a prepared surface as part of a picture, or on a picture-frame, or on sculpture. Usually the surface is made slightly sticky with the application of a special *size. The *ground is usually polished and tinted red, and the applied gold *burnished with an agate tool.

GILL, Eric (1882–1940)

b. Brighton d. High Wycombe. English sculptor and typographer who studied at the Central School of Arts and Crafts (1899–1903). Following the tradition of William *Morris, he regarded himself as a worker and craftsman. Became a Dominican tertiary. His stone sculpture and reliefs are influenced by †Gothic sculpture and Indian hieratic art.

GILLES, Werner (1894–1961)

b. Rheydt d. Essen. German painter who studied with *Feininger at the *Bauhaus (1918–24) and in France and Italy. He painted abstracted landscapes using delicately coloured interweaving shapes with a lyrical intention. Classical mythology and poetry were also sources of inspiration, prompting anaemic derivations from *Klee and *Picasso.

GILLOT, Claude (1673–1722)

b. Langres d. Paris. French painter who excelled in decorative *arabesque designs in a style related to that of *Audran. He frequently depicted subjects taken from the *commedia dell' arte, an interest which influenced his illustrious pupil *Watteau.

GILLRAY, James (1757–1815)

b. d. London. Largely self-trained English caricaturist whose contemporary notoriety was the result of the wit and clarity of his personal political and social commentary. He became insane (1811).

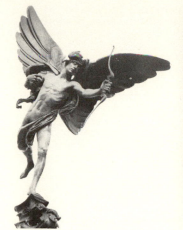
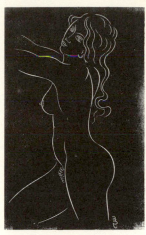

Left: SIR ALFRED GILBERT *Eros* from the Shaftesbury Memorial Fountain. 1893. Bronze and aluminium. Piccadilly Circus, London
Right: ERIC GILL *Female Nude*. 1937. Woodcut. 9⅛×5⅝ in (23·2×14·3 cm). V & A, London

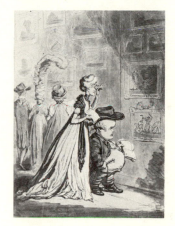
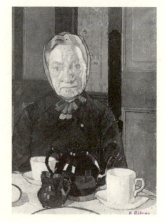

Left: JAMES GILLRAY *A Peep at Christies* (or Tally-ho and his Nimeney-pimeney taking the Morning Lounge). 1796. 14¼×10¼ in (36×26 cm). BM, London
Right: HAROLD GILMAN *Mrs Mounter at Breakfast. c.* 1917. 24×16 in (61×40·6 cm). Tate

GILMAN, Harold (1876–1919)

b. Rode, Somerset d. London. English painter who studied at the Slade School of Art (1897–1901). Associated with *Sickert and *Gore; a founder of the *Camden Town group and first President of the *London group. After early sombre works indebted to *Velasquez, his final brilliant canvases reflect *Post-Impressionist influence (1910–19).

GILPIN, Sawrey (1733–1807)

b. Carlisle d. London. English painter, brother of William *Gilpin, who studied with Samuel *Scott and concentrated on the depiction of horses for wealthy patrons. He also used horses as the subject of *history paintings.

GILPIN, Rev William (1724–1804)

b. Cumberland d. Hampshire. English amateur draughtsman and writer; his three essays on *Picturesque theory (1792) define the elements constituting the Picturesque as a mode of beauty. His *Picturesque Tours* (issued from 1782) influenced attitudes towards natural and composed scenery, both in landscape and painting.

GINNER, Charles (1878–1952)

b. Cannes d. London. A founder-member of the *Camden Town group and of the *London group. A painter mainly of

architectural subjects and landscapes, he blended the art of *Van Gogh with traditional English qualities of subtle tone, light and atmosphere.

GIORDANO, Luca (1632–1705)

b. d. Naples. The pupil of his father Antonio, and probably *Ribera, influenced also by *Cortona and Venetian painting, he was perhaps the first virtuoso in the 18th-century sense, painting in any style he desired, and at great speed ('Luca Fa Presto'). He worked in Florence (1682–3) and his influence became strong in Venice. He was summoned to Spain by Charles II (1692) and worked in the Escorial and at Madrid and Toledo (until 1702).

GIORGIONE (1476/8–1510)

b. Castelfranco d. Venice. Venetian painter and founder of the High †Renaissance in Venice. Trained by Giovanni *Bellini. Essentially an innovator, he is noted for the creation of a gentle bucolic idyll saturated with the spirit of Virgil's poetry and *Gli Asolani* by Pietro Bembo whom Giorgione may have met at Caterina Cornaro's court. The most evocative of his mood landscapes is the *Tempestà* (c. 1505, Accademia, Venice) which seems to have been a free imaginative creation and not an illustration of any literary source since X-rays prove that the soldier replaced another woman bathing in the stream; it is mentioned by Michiel. Giorgione's colours are sensitively harmonised, his forms ideal, their contours softened by a blurred *chiaroscuro which may have been inspired by *Leonardo. His composition is carefully balanced and frontal as in the *Castelfranco Altarpiece*. Handsome, musical and, as *Vasari tells us, much sought after at parties he created a type of poetic youth, and the mysterious *Portrait of a Young Man* (Berlin) became the prototype for Venetian renderings of their scions for the next decade. His only fresco on the Fondaco dei Tedeschi (1508) has perished and many of his works were completed by Sebastiano del *Piombo and *Titian, including the *Sleeping Venus* (Dresden), in which he invented the motif of the recumbent female nude.

Top left: LUCA GIORDANO Detail of Fortitude from the ceiling of the Grand Gallery, the Medici-Riccardi Palace, Florence. 1682–3
Bottom left: GIORGIONE *Madonna and Child with SS Francis and Liberale.* 78$\frac{3}{4}$×60 in (200×152 cm). S. Liberale, Castelfranco
Above: GIORGIONE *La Tempestà. c.* 1505. 32$\frac{1}{4}$×28$\frac{3}{4}$ in (82×73 cm). Accademia, Venice

GIOTTO (c. 1266–1337)

Active Tuscany, Rome, Naples d. Florence. Giotto's role as the father of Italian †Renaissance painting is often acknowledged, but his ties with contemporary Italian painting and with Northern †Gothic developments should not be forgotten. His debts to Pietro *Cavallini's experiments in light and modelling and interest in Early Christian cycles, and to Nicola and Giovanni *Pisano's narrative styles and use of the *Antique, are considerable. The nature of Giotto's contribution to the frescoes at S. Francesco, *Assisi, is controversial, but the introduction of the new Roman method of narrative

cycle painting into Tuscany, even if it did not involve Giotto directly, had important consequences and no surviving work is documented. The Arena, Bardi and Peruzzi Chapels show his growing mastery of lighting, perspective and fusion of compositional form with dramatic content. Their complex iconographical programmes reflect Northern Gothic practice, while panels such as the *Ognissanti Madonna* and *Baroncelli Altarpiece* show awareness of Northern sculpture, illumination and decorative motifs. Giotto established several new types of altarpiece design which his followers developed and which were still influential at the end of the century. He also designed a mosaic, the *Navicella*, for Old St Peter's, Rome, was Capomaestro of the Cathedral in Florence and became a successful businessman. The intellectual rather than visual appeal of Giotto's work was acknowledged in his own day, but his achievement in extending the representational, dramatic and doctrinal qualities of fresco and panel painting were not fully appreciated by other painters until *Masaccio's time. *See also* PADUA, Arena Chapel

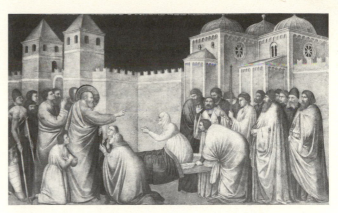

GIOTTO *Raising of Drusiana. c.* 1320. Tempera. 110¼×176 in (280×450 cm). Peruzzi Chapel, Sta Croce, Florence

The influences of *Mantegna and *Bellini are apparent in their work. It is possible that Giovanni was a German.

GIOVANNI DA MILANO (active 1350–69)

This Lombard painter became a Florentine citizen (1366) and adapted his Northern style and exquisite use of colour to the current Florentine panel-painting formulae. In his frescoes of the life of the Virgin (Rinuccini Chapel, Sta Croce), dignified, elegant figures, repetitive facial types and generally simple settings contribute to the restrained serene atmosphere.

GIOVANNI DA UDINE (Giovanni NANNI) (1487–1564)

b. Udine d. Rome. Italian painter, architect and stuccoist. One of *Raphael's principal assistants, he specialised in reviving antique processes for the decorations in the Vatican loggie which were based on classical ornament. He thus formed part of the chain of artists and archaeologists who were to influence 18th-century decorators in their use of *grotesque designs.

GIOVANNI, Giovanni da San (Giovanni MANNOZZI) (1592–1636)

b. d. Florence. Italian decorative painter, pupil of Matteo Rosselli. After Rome (1623/4–27) he decorated the Sala degli Argenti (Pitti).

GIOVANNI D'ALEMAGNA (d. 1450)

Venetian painter, known through his collaboration with his brother-in-law Antonio *Vivarini. Apparently the dominant partner, they produced together a *Coronation of the Virgin.*

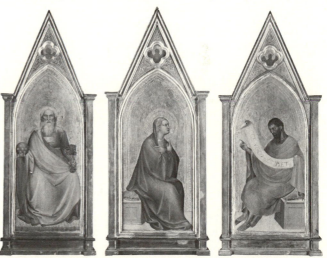

Left: GIOTTO *Madonna in Glory with Saints and Angels* (Ognissanti Madonna). *c.* 1310–15. Tempera. 128×80⅜ in (325×204 cm). Uffizi
Above: GIOVANNI DA MILANO Three Pinnacles from an altarpiece depicting God the Father, the Virgin and Isaiah. 25¼×10 in (64×25.5 cm), 22¾×10 in (57.5×25.5 cm), 22¾×10 in (57.7×25.5 cm). NG, London

GIOVANNI DI PAOLO (active 1403–1482/3)

b. Siena. Italian painter and illuminator, influenced by *Gentile da Fabriano and *Sassetta. Scenes from the life of St John the Baptist (Chicago, London, Oxford) show his discriminating colour sense, nervous expressive figures, sharply

observed fields and jagged unreal mountains which typify the contradictions of his vision, at once sophisticated and naïve.

GIOVANNI DI PAOLO *St John the Baptist Retiring to the Desert.* 12¼×15¼ in (31×38·5 cm). NG, London

GIRARDON, François (1628–1725)

b. Troyes d. Paris. French sculptor who collaborated with *Lebrun in the decorative enterprises commissioned by Louis XIV at Versailles. His work is the classical counterpart to academic painting of the late 17th century and reflects his interest in *Hellenistic sculpture. His most famous works are the sculpture group *Apollo Tended by the Nymphs* at Versailles and his monument to Richelieu (Sorbonne Church).

GIRODET DE ROUCY-TRIOSON, Anne-Louis (1767–1824)

b. Montargis d. Paris. French painter and book-illustrator. He trained under *David, and won the Rome Prize (1789). His style and technique were based on David, but his choice of subject-matter and his emotional treatment of it (exemplified by his *Entombment of Atala,* 1808, Louvre), were distinctly †Romantic, and he was highly acclaimed by the young Romantics of his day. He inherited a fortune (1812) and abandoned painting to write (very bad) poems on aesthetics. The books he illustrated included those of Racine and Virgil.

ANNE-LOUIS GIRODET DE ROUCY-TRIOSON *The Entombment of Atala.* 1808. 82¾×105⅛ in (210×267 cm). Louvre

GIROLAMO DAI LIBRI (1474–1555)

b. Verona. Painter and miniaturist, trained by his father Francesco. Early influences on him of *Mantegna and *Montagna were supplanted by those of *Luini, *Raphael and

*Savoldo. His *Madonna and Child with St Anne* (c. 1518, NG, London) reveals Veronese belief in the Immaculate Conception as a protection from plague and tempest.

GIRTIN, Thomas (1775–1802)

b. d. London. English watercolourist and etcher. He made *soft-ground etchings in Paris (1801–2), and exhibited a vast panorama of London in oils – the *Eidometropolis* (1802, lost). His most important work is in watercolour, which medium he revolutionised. He instituted a change from the 18th-century tradition of tinted washes over line-drawing, employing instead strong colours applied in broad washes. In addition he displayed a great gift for bold composition and the suggestion of mood. His style up to about 1798 is closely related to *Turner's (who influenced whom is difficult to establish), and his last works influenced *Constable and *Cotman.

Above: THOMAS GIRTIN *The White House, Chelsea.* 1800. Watercolour. 11¾×20¼ in (29·5×51·4 cm). Tate
Top: THOMAS GIRTIN *Kirkstall Abbey at Evening.* Watercolour. 12×20⅛ in (30·5×51·1 cm). V & A, London

GISLEBERTUS (active 1120s and 1130s)

French †Romanesque sculptor who worked principally on the Cathedral of St Lazaire in Autun. His work there includes a series of capitals, a female nude (Eve) and a *tympanum with the Last Judgement where Christ dominates the other figures and the devils are particularly vicious. The style which belongs to the Burgundian School of *Cluny and *Vézelay combines vivid characterisation with minutely observed treatment of drapery. Gislebertus's signature, very prominently placed on the tympanum, is one of many contemporary artists' signatures.

GIUSTI, Giovanni *see* JUSTE, Jean

GIZA

The modern location of part of the ancient necropolis of *Memphis, most famous as the site of the great pyramid of the 4th dynasty king Khufwi (Cheops), and of the *sphinx.

Around the three pyramids of Gīza are the mastaba tombs of contemporary courtiers, some with fine decoration in relief. *See also* MENKAURE

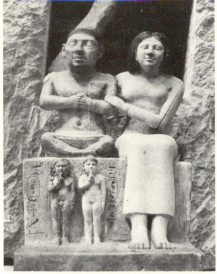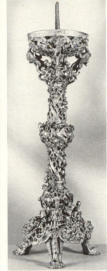

Left: GIZA Statuette of the dwarf Seneb and his family, found in his tomb at Giza. Late 5th–6th century. Painted limestone. h. 13 in (33 cm). Egyptian Museum, Cairo
Right: GLOUCESTER CANDLESTICK 1104–13. Bell metal. h. 23 in (58 cm). V & A, London

GLACKENS, William James (1870–1938)

b. Philadelphia d. New York. Painter/illustrator, who studied at Pennsylvania Academy, in Paris (1895), at *Art Students' League (later lecturing there); exhibited with The *Eight and at *Armory Show. Influenced first by *Henri, later by *Manet and *Renoir, his spontaneous, realistic paintings of urban life moved from dark sonorities to bright *Impressionist simplicity.

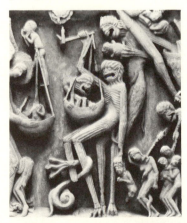

Left: GISLEBERTUS *The Weighing of the Souls.* Detail from West Tympanum. 2nd quarter of the 12th century. Autun Cathedral

Below: GISLEBERTUS *Eve* from St Lazare, Autun. *c.* 1120–30. $27\frac{1}{2} \times 51\frac{1}{2}$ in (69·9×130·8 cm). Now Musée Rolin, Autun

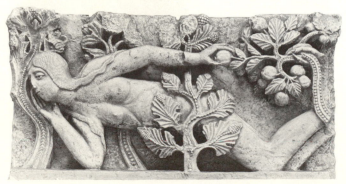

GLARNER, Fritz (1899–1972)

b. Zürich d. Locarno. Painter who studied in Naples (1914–20) and worked mainly in Paris before emigrating to America (1936). A member of the American Abstract Artists group, he helped spread European geometric abstraction, but remained aloof from later developments. Although a close disciple of *Mondrian, Glarner's wedges of colour are closer to *Hofmann than Mondrian.

GLAZE

A transparent thin layer of colour applied over *underpainting.

GLEIZES, Albert (1881–1953)

b. Paris d. Avignon. French painter who attended the Salon de la Société Nationale (1901), exhibiting with *Duchamp, *Léger, *Picabia and *Metzinger in the Salon d'Automne. With Metzinger he published *Du Cubisme* (1912), founded a crafts centre (1927) and became famous following a highly successful exhibition in Paris (1937). An †Impressionist in his student years, Gleizes became one of *Cubism's chief exponents. His late canvases (1950–2) incorporate a *Futurist rhythm into their flat forms.

ALBERT GLEIZES *The Bathers.* 1912. $41\frac{1}{4} \times 67$ in (104·8×170·2 cm). Musée d'Art Moderne de la Ville de Paris

GLEYRE, Marc Gabriel Charles (1808–74)

b. Chevilly, Vaud d. Paris. Swiss history and genre painter, moved to Lyon at eight, and encouraged to study painting, entered Hersent's studio in Paris. His studies terminated in a stay in Italy (1828–34) followed by travels in the Orient. He established himself in Paris (1838). His decoration of the staircase at the Château de Dampierre was destroyed after two years' work on *Ingres's advice, but his *Soir ou les illusions perdues* (1843) was well received. Like *Couture, he became an important teacher when entrusted with *Delaroche's studio during his twenty-seven-year absence in Italy.

GLOUCESTER CANDLESTICK (*c.* 1110)

One of the finest examples of †Romanesque metalwork, the candlestick was given by Peter, Abbot of Gloucester to his monastery. Made of gilded bell-metal, it possesses Romanesque ornament of little men, animals, monsters and foliage with inscriptions and the symbols of the Evangelists. The type has its origins in †Ottonian Germany, though the ornament is now thought to be closely related to Canterbury manuscripts. (V & A, London.)

GLUE

Animal colloid used as a *binder in a water solution.

GNATHIA VASES

A type of pottery found at Gnathia, an ancient city of Apulia. The style was current throughout the 4th and 3rd centuries BC. The surface of the pottery is covered with black glaze with small figured scenes painted on it. Sometimes vases are *strigilated or have high ornate handles in imitation of metal vases.

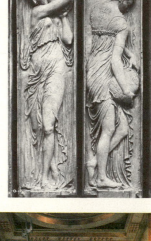

Top left: HUGO VAN DER GOES *Adoration of the Shepherds.*
c. 1475. Central panel of the Portinari Altarpiece. Uffizi
Top centre: NUNO GONCALVES Retable of St Vincent,
Archbishop panel. Museu National d'Arte Antiga, Lisbon
Top right: GOSHUN *Landscape.* Late 18th/early 19th century.
Ink and colours on paper. Hillier Coll, Redhill
Middle left: HUGO VAN DER GOES *Death of the Virgin.*
59×48 in (141×122 cm). B-A, Bruges
Middle centre: HENDRIK GOLTZIUS *Head of a Man.* 1600.
16¾×12¾ in (42·5×32·4 cm). BM, London

Middle right: JEAN GOUJON Nymph personifying a river of
France. 1547–9. Panels from the Fontaine des Innocents
76×28 in (193×71 cm). Louvre
Bottom left: FRANCISCO GOITIA *Tata Jesucristo.* 33⅝×42⅛ in
(85·5×107 cm). Instituto Nacional de Bellas Artes, Mexico City
Bottom centre: NATALYA GONTCHAROVA *Cats.* ?1910.
33½×33¼ in (85·1×85·1 cm). Solomon R. Guggenheim Museum,
New York
Bottom right: JAN GOSSAERT *Neptune and Amphitrite. c.* 1516.
74×84¾ in (188×124 cm). Staatliche Museum, Berlin-Dahlem

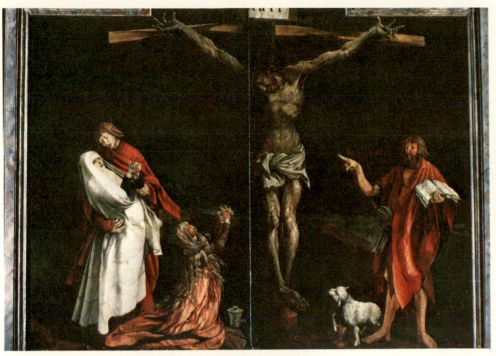

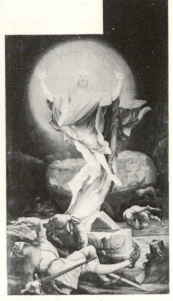

MATHIS GOTHARDT-
NEITHARDT. *Crucifixion*
(*top left*) and *Resurrection*
(*top right*) from the Isenheim
Altarpiece. 1515. h. (of
panels) 8 ft 10 in (269 cm).
Musée d'Unterlinden,
Colmar
Centre left: GOUACHE
The Castle Mountain of S.
by Paul Klee.
Dated 1930. 14×18⅜ in
(36·8×46·7 cm). Tate
Centre: GOUGES
Above: SPENCER GORE
Mornington Crescent. 1911.
25×30 in (63·5×76·2 cm).
Tate
Far left: ARSHILE GORKY
Plumage Landscape 1947.
38×51 in (96·5×129·5 cm).
Norton Simon, Inc. Museum
of Art, Los Angeles
Left: JULIO GONZALEZ
The Large Maternity. 1930–3.
Metal. 51×15×6½ in
(129·5×38·1×16·5 cm).
Tate

GOA GADJAH *see* BALI, ART OF

GODEFROY DE CLAIRE (active 1130–50)

*Mosan metalworker from Huy on the Meuse to whom a number of works have been attributed. Among them is the *Stavelot Triptych* (Morgan Library, New York), a very luxurious example of Mosan art, made of silver and copper-gilt with *champlevé scenes in enamel and set with precious stones. If the attribution is correct, he practised in the style of *Rainer of Huy and must have been influential outside the Meuse area.

GODESCALC GOSPELS

Made (*c.* 781) by a scribe called Godescalc for use in the Palace Chapel, this is one of the earliest dated †Carolingian manuscripts and makes a complete break with Merovingian traditions. This involved going back to †Early Christian sources, and the range of these sources determined the variety of styles found in Carolingian illuminated manuscripts. *See also* AACHEN CATHEDRAL TREASURY GOSPELS

GOEMAI *see* NIGERIA, NORTHERN

GOENEUTTE, Norbert (1854–94)

b. Paris d. Auvers-sur-Oise. Pupil of Pils at the Ecole des Beaux-Arts, he sought to translate in all its reality Parisian life. He figured at the Salon of 1876 with humorous Parisian scenes, and was an organiser of the Painters-Engravers' Exhibitions. His work shows the influence, but lacks the intensity, of *Raffaelli.

GOERG, Edouard (1893–1968)

b. Sydney, Australia, of French parents d. Fayence. Studied at the Académie Ranson (1912). A painter of the *School of Paris whose early *Expressionist works were harsh and satirical. Later work displays an increasing sentimentality. Goerg painted in rich tones laying on thick pigments.

GOES, Hugo van der (active 1467–d. 1482)

b. ?Ghent. The most important painter in the Netherlands in the second half of the 15th century. Possibly a pupil of Joos van *Wassenhove, he became a master in Ghent (1467) and was regularly active there until 1478. He was involved in decorating Bruges for the marriage celebrations of Charles the Bold and Margaret of York (1468). Having become Dean of the Ghent Painters' Guild (1474) he entered the Monastery of the Rode Klooster, near Brussels (?1478), where, however, he continued to paint and receive visits from men of importance including the future Emperor, Maximilian. Here too, he was subject to fits of depression, and, in 1481, an acute attack of suicidal mania. He went to Cologne (*c.* 1481) and died on the return journey. Attributions are based on the large *Portinari Altarpiece* (Uffizi) which *Vasari mentions. His composition is direct, often stark (eg *Death of the Virgin*, Bruges), his gesture and characterisation profound, and he worked happily on a large scale. His work had far-reaching influence both in the North and in Italy.

GOETHE, Johann Wolfgang von (1749–1832)

b. Frankfurt d. Weimar. German poet, playwright, novelist and statesman whose numerous writings and ideas on art were crucial for the development of the German †Romantic movement. In his first publication *Von Deutscher Baukunst* he expressed an enthusiasm for primitive †Gothic as opposed to the prevailing †Neo-classical values. After visiting Italy (1787) he became a supporter of the classical idea, and propounded the view that the inner laws of nature had never been more effectively achieved than by the art of antiquity. He wrote a book on colour theory in which he claimed to refute Newton. He studied painting throughout his life, but his influence on art history rests in his criticism.

GOETZENBERGER, Jacob (1800–66)

b. Heidelberg d. Darmstadt. German painter who studied in Düsseldorf under *Cornelius and in Munich. In the 1820s he painted frescoes in the hall of Bonn University and in the Chapel at Nierstein, etc. He came to England after the events of 1848 and painted portraits, and also frescoes at Bridgewater and Northumberland House.

GOITIA, Francisco (1884–1960)

b. Zacatecas d. ?Xochimilco. Painter who studied at Bellas Artes School (*c.* 1898–1903), with Gali, Barcelona (*c.* 1904–8), in Italy (*c.* 1908–12); was war artist in Revolution (1912–17); did archaeology in Teotihuacán (1918–25) and Oaxaca (1925). First painter of the Revolution, Goitia then turned to painting emotive pictures of Mexico's timeless suffering and sorrow.

GOLDEN HOUSE OF NERO

The great pleasure palace built by Nero after the fire of AD 64. This vast series of structures, which covered a large area of Rome round where the Colosseum now stands, was entirely demolished by Nero's successors except for one wing on the Esquiline Hill which was incorporated into the foundations of Trajan's Baths. The Golden House contains some fine painting in the Fourth *Pompeian style and was said to have been decorated by *Amulius. In one room was found the *Laocoön group.

GOLDENES ROSSEL *see* ALTOTTING

GOLTZIUS, Hendrik (1558–1617)

b. Mühlbrecht d. Haarlem. Dutch engraver, draughtsman and painter. He began engraving at Haarlem (1582), and founded an academy (1583). Despite his crippled right hand, his technique was unsurpassed. He travelled in Italy (1590–1), and his subsequent classicising engravings after *Dürer influenced *Rubens's early style. His landscape drawings (*c.* 1600) and his early portrait-engravings were very naturalistic, but his paintings (all executed after 1600) did not keep pace stylistically.

GONCALVES, Nuño (active 1450–71)

Most important Portuguese painter of the 15th century. Appointed Court Painter in Lisbon (1458). Influenced by the Netherlandish masters, but the austere simplicity of his figures and portraits derives from indigenous woodcarving. The crowded two-dimensionality of his *St Vincent* panels (Lisbon) recalls tapestry design.

GONCOURT Brothers

Edmond (1822–96) and Jules (1830–70) de Goncourt began their writings in the 1850s. Their realist novels achieved a lasting reputation, but they also wrote pioneering articles on 18th-century French art (collected edition 1875). They advocated the type of modern subjects depicted by *Degas – laundresses and dancers. Edmond later wrote on *Utamaro (1891) and *Hokusai (1896)

GONTCHAROVA, Natalya (1881–1962)

b. Ladyzhino d. Paris. Russian painter and theatre designer who studied in Moscow (1898). Her icon-style paintings are part of a revived interest in folk-art which fused (1906) with influences from Paris. Her decorative frieze-like peasant scenes influenced *Malevich. *Cubist influence resulted in *Rayonism, developed by herself and *Larionov (1912–13), in which reality is abstracted into lines of force. She designed for the theatre (from 1913), moving to Paris where she worked with Diaghilev (1914).

GONZALEZ, Bartolomé (1564–1627)

b. Valladolid d. Madrid. Spanish painter. He produced ninety-one royal family portraits (1608–21) – mainly for export to other Habsburg members – in a linear, late *Mannerist style, pretty and rather stereotyped. Court Painter (1617–27), his late religious painting is more progressive.

GONZALES, José see **GRIS, Juan**

GONZALEZ, Julio (1876–1942)
b. Barcelona d. Arceuil, France. Spanish sculptor, who went to Paris (1900) and worked almost exclusively as a painter until 1926 when he devoted himself wholly to sculpture, working chiefly in metals. He showed *Picasso the principal techniques of metalwork (1930–1), and together they developed an open, linear style, denying the traditional properties of mass, where the expressiveness of iron was powerfully exploited – a crucial stimulus for later figures like David *Smith.

GOPE BOARDS see **PAPUA, GULF OF**

GO-PURA
Sanskrit: literally 'cow-pen'; came to mean a gateway with enclosures; applied to massive, temple-like gateways in the wall surrounding South Indian temple complexes.

GORE, Spencer (1878–1914)
b. Epsom d. Richmond. English painter who studied at the Slade School of Art (1896–9) and was associated with *Sickert, *Gilman and *Ginner. Founder-member and first President of the *Camden Town group. A painter of landscapes, music-hall scenes and interiors with figures. After †Impressionist work characterised by soft brilliance of colour, he was influenced by *Cézanne, but this new conceptual approach did not impair his sense of tonal value.

GOREME VALLEY CHURCHES see **CAPPADOCIAN ROCK-CUT CHURCHES**

GORGON PAINTER (active c. 590 BC)
Athenian *black-figure vase painter, working a few years later than the *Nessos Painter. He is called after a very elaborate dinos in the Louvre showing Perseus fleeing from the Gorgon. He is the last *Attic painter to be interested in the Animal Style.

GORKY, Arshile (1904–48)
b. Khorkom Vari Haiyotz, Armenia d. Sherman, Connecticut. Painter who went to America (1920), to New York (1925), where three art academies expelled him. First influenced by *Picasso and *Léger, later by *Surrealists, particularly *Miró, and close relationships with *De Kooning and *Davis, Gorky's work moved from highly coloured *Cubism to a refined, intensely personal Abstract Surrealism, characterised by organic forms, lashing lines and explosive colour, with undercurrents of wit and fantasy – spontaneous inventions which influenced *Abstract Expressionism.

GOSHUN (Matsumura Gekkei) (1752–1811)
Celebrated Japanese painter, first a pupil of *Buson, later influenced by *Okyo. His style was a softer and less realistic version of that of Okyo, and he founded the *Shijō School.

GOSSAERT, Jan (MABUSE) (active 1503–d. 1532)
Netherlandish painter. Up to 1515 his signatures are some form of Jennin Gossart: from 1516 (after which there are many dated works) he signs Joannes Malbodius, the surname referring to Maubeuge in Hainault, whence his family came. First mentioned as a master of Antwerp (1503): there in 1505 and 1507. He made an Italian journey (c. 1508/9), which influenced him in introducing classical subjects and nude figures into his crowded compositions. His works were important in the spread of these elements throughout the Netherlands.

GOTHARDT-NEITHARDT, Mathis (GRUNEWALD) (c. 1470/80–1528)
b. ?Würzburg d. Halle. German painter and architectural engineer. In Nuremberg (c. 1503). At Aschaffenburg (1505), he was commissioned to paint and inscribe the epitaph of Johann Reitzmann (now Aschaffenburg Church); contracted to restore a bridge in Bingen (1510); elected Painter and Overseer of Works to Uriel von Gemmingen, Archbishop of Mainz (1511); in Isenheim (1513–15); returned to Aschaffenburg (1516) in the service of the powerful and learned Cardinal Albrecht von Brandenburg; in Frankfurt (1526); in Halle from 1527. Several works and a number of drawings exist, but all are overshadowed by his masterwork, the so-called *Isenheim Altar* (now Musée d'Unterlinden, Colmar) painted about 1513–15 (part of it bears the date 1515), for the High Altar of St Anthony's Monastery at Isenheim. It was originally located in the Hospital Chapel. The first view of the now-dismembered Altar (the week-day view), showing a Crucifixion with the Virgin, St John the Evangelist, St John the Baptist and the Magdalen, flanked by fixed wings with St Sebastian and St Anthony displays saints qualified to help the sick (especially sufferers from the plague). The scarred body of the Crucified Christ is clearly related to the symptoms of some skin disease. The Sunday view of the Altar shows scenes related to the Birth and Resurrection of Christ, while the third view (for feast-days) has two wings showing St Anthony which flank the vigorous sculptural centrepiece made earlier by Niclas Hagnower of Strasbourg. The paintings throughout are influenced by the mysticism of the *Revelations of St Bridget*, their style in gentle scenes being curiously non-physical, emotional rather than descriptive, the colours almost totally unnatural. In the *Crucifixion*, this predilection for the expressive at the expense of the realistic takes the form, not only of distortion of colour but of physique – hands and feet are knotted and attenuated. The Altar is one of the supreme achievements of Northern art, one of the most deeply emotional works of all time, the earliest example of Expressionism.

GOTTLIEB, Adolph (1903–)
b. New York. Painter who studied at *Art Students' League with *Henri and *Sloan (1919–21), at Académie de la Grande Chaumière, Paris (1921), painted for *WPA (1930s) and lived in Arizona desert (1937). Influenced by *Matisse and *Rothko, Gottlieb simplified, enlarged and loosened his 'pictographs' – compartmentalised primitive symbols – adopting Rothko's brand of *Abstract Expressionism.

GOTZ, Karl Otto (1914–)
b. Aachen. German painter who lives in Düsseldorf. He made his first abstract painting (1933); experimented with abstract film-making (1936) and joined the *Cobra group (1948). Has taught at Düsseldorf Art Academy since 1959. His paintings convey a gestural strength as well as a chromatic power obtained by the use of clashing colours.

GOUACHE
Watercolour made opaque by the addition of dense white pigment.

GOUDT, Count Hendrik (1585–1648)
b. d. Utrecht. Dutch draughtsman and etcher, executing seven plates after *Elsheimer, whose patron he was in Rome. These were the basis of Elsheimer's posthumous European reputation, particularly the *Tobias and the Angel* (1609), etched in a soft, rounded style.

GOUGE
A woodcarving tool with a chisel-like blade which is curved in cross section. It will cut rounded grooves or flutes.

GOUJON, Jean (d. 1564/8)
French sculptor and architect. First mentioned as the author of organ-loft columns (1540) in St Maclou, Rouen. His pure classical design suggests first-hand knowledge of Italian work. He went to Paris (1544) where he executed the roodscreen of St Germain l'Auxerrois (panels now Louvre) and the *Fontaine des Innocents* (1547–9). He may have spent his last years as an exile in Bologna.

GOWER, George (1540–96)

Most important English portrait painter in 1570s and 1580s. Appointed Serjeant-Painter to Elizabeth I (1581), and he collaborated with *Hilliard whose influence made his style more exaggeratedly brilliant.

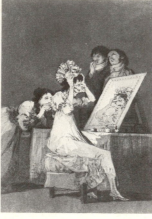

Left: GEORGE GOWER *Sir Thomas Kytson.* 1573. 20¾×15¾ in (52·7×40 cm). Tate
Right: FRANCISCO GOYA *Till Death.* Caprichos etching No 55. 7½×5¼ in (19·25×13·5 cm). BM, London

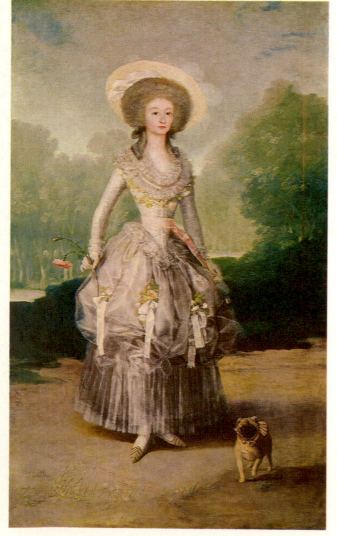

GOYA, Francisco (1746–1828)

b. Fuendetodos, Saragossa d. Bordeaux. Spanish painter and etcher, apprenticed at fourteen in Saragossa. Visiting Italy (1771) he won second prize in a competition at the Academy of Parma. After returning to Spain he painted religious frescoes in Saragossa but was summoned to Madrid (1774) to produce †Rococo designs for the royal tapestry works which occupied much of his time during the 1780s. He became deaf (1792) after a serious illness during which he began his etched series, *Los Caprichos*, which heralded a new, anti-Rococo level in Goya's art. He continued his career as Court Artist and portrait painter, owing much to *Velasquez, but also pursued a vein of genre painting coupled with further fantastic or satirical inventions. He recorded the invasion of Spain by Napoleon's army in 1808 in a series of etchings, *The Disasters of War* (1810–13) and in two paintings, *2nd May 1808* and *3rd May 1808* (1814, Prado) in which he exposed the horror and universality of violence. The witchcraft paintings with which he decorated his house (1819) further explored human savagery. He left Spain during a period of repression (1824). He was one of the most acute portrait painters of all time.

GOYEN, Jan van (1596–1656)

b. Leiden d. The Hague. Dutch landscape painter. After a year in France, he worked in Haarlem under Esaias van de *Velde, and settled in The Hague (1634), although he travelled extensively in Holland and Flanders. After about 1630 Esaias's influence becomes less marked and van Goyen's work more simplified and atmospheric, usually with a low horizon, almost monochrome colouring and broad handling of paint producing in his best work an effect of great majesty. His output was vast, and he had many pupils and imitators.

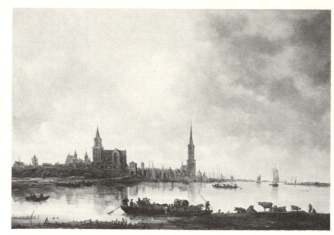

Above: JAN VAN GOYEN *A View of Emmerich Across the Rhine.* 1645. 26×37½ in (66×95·4 cm). Cleveland Museum of Art
Left: FRANCISCO GOYA *The Marquesa de Pontejos.* 1787. 82¾×50½ in (210×128 cm). NG, Washington, Mellon Coll

GOZZOLI (di LESE), Benozzo (c. 1421–97)

b. Florence d. Pistoia. Italian painter active in Tuscany and round Rome. He assisted *Ghiberti on the Florence Baptistery doors (1444); in Rome and Orvieto with Fra *Angelico (1447–9) whose influence is evident in Benozzo's Montefalco work (1450–2). His later style reflects the revival of *International Gothic elements in mid-century Florentine art, above all in the Medici Chapel frescoes, commissioned by Piero de' Medici who figures among the retinue of the Magi in a scene replete with elaborate landscape detail and ornamental use of gold.

GRAEVENITZ, Gerhard von (1934–)

b. Mark Brandenburg, Germany. *Kinetic artist; co-founder of the *Nouvelle Tendance group (1962). His objects involve reflecting elements, or are motorised at random with simple revolving parts, creating a network of movement.

GRAF, Urs (c. 1485–1527/8)

b. Solothurn d. Basle. Swiss engraver, designer of woodcuts, goldsmith and mercenary soldier active mainly in Basle. As a soldier, in Rome (1511) and later Dijon and northern Italy. He illustrated soldiering activities and Alpine landscapes, made effective by his sweeping, impetuous *Mannerist line.

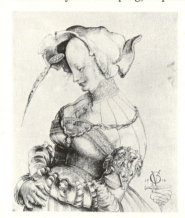

Left: URS GRAF *Girl in her Finery.* 1518. Pen and ink. $9\frac{7}{8} \times 8\frac{1}{8}$ in (25·2×20·8 cm). Kupferstichkabinett, Kunstmuseum, Basle

Below: BENOZZO GOZZOLI *The Procession of the Magi.* 1459. Fresco. Chapel of the Palazzo Medici-Riccardi, Florence
Bottom: GERHARD VON GRAEVENITZ Kinetic object with 145 white stripes on black. 1967. $39\frac{3}{8} \times 39\frac{3}{8}$ in (100×100 cm). Galerie Denise René, Paris

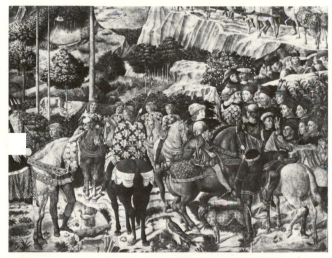

GRAFFITO

Italian: 'scratching'. Coats of colour are successively applied to a surface, and then scratched back into, revealing the colours underneath. Usually carried out in *plaster on *stucco.

GRAND MANNER

Term used in connection with mid-18th-century British portraiture. It was *Reynolds who introduced the idea of the Grand Manner in English painting and it is the ideal to which his *Discourses* are committed. It refers to the influence of the *Antique and the great Italian †Renaissance masters on artists visiting Italy, leading to the embellishment of the style and elevation of the school as a result. Such ambitious concepts were bound to fail more often than they succeeded – with Reynolds it frequently led to pomposity and overstatement, but a more sensitive artist such as Allan *Ramsay often combined the elements to best effect.

GRANDVILLE (Jean Ignace Isidore GERARD) (1803–47)

b. Nancy d. Vanves. French illustrator who came to Paris (1823). Associated with caricature and satire, using an armoury of the *grotesque, transposing man, beast and inanimate object with a sense of fantasy that influenced English illustrators such as *Tenniel and *Doyle, and, in bizarre juxtapositions of strange objects, the *Surrealist movement.

GRANT, Duncan (1885–)

b. Rothiemurchus, Inverness. Painter and decorative artist who studied at Westminster (1902–5) and the Slade Schools of Art. In Paris (1906–9); met *Matisse (1910). An associate of Roger *Fry, Vanessa and Clive *Bell; worked at *Omega Workshops. After some years under *Post-Impressionist influence when it typified a civilised *Fauvism, his work became restrained and formal though without loss of bright colouring.

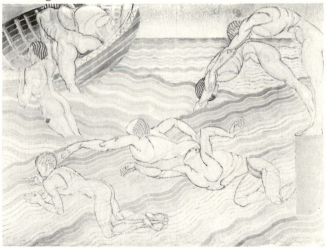

DUNCAN GRANT *Bathing.* 1911. $90 \times 120\frac{1}{2}$ in (228·6×306·1 cm). Tate

GRANT, Sir Francis (1810–78)

b. Kilgraston d. Melton Mowbray. Scottish painter whose first exhibits in the 1830s were of hunting-meets, but he soon became the fashionable portrait painter of the day, painting many society figures and celebrities. He was elected President of the Royal Academy (1866), not primarily for his artistic powers (*Maclise and *Landseer had declined prior offers).

GRAPHITE

A smooth, slippery form of carbon. It is mixed with china-clay and extruded to form the black 'lead' of 'lead' pencils.

GRASSER (GASSER), Erasmus (c. 1450–1518)

b. Schmidmühlen, Oberplatz d. ?Munich. German sculptor and architect of the late †Gothic style. His best works are of about 1480, and include an *Entombment* (c. 1490–2, Freising Cathedral). His style is energetic, the animated, grotesque

dancers on the façade of the Munich Frauenkirche (1502) being good examples.

GRAVELOT, Hubert (1699–1773)

b. d. Paris. French engraver, draughtsman and book-illustrator. He worked in Paris and London, forming an important link between the French School (especially the followers of *Watteau) and the British. He influenced *Gainsborough.

GRAVER see BURIN

GRAVES, Morris (1910–)

b. Fox Valley, Oregon. Painter who worked for *WPA (1936–9), travelled in Orient (1928–30, 1956) and lived in Ireland (1956–62). Deeply influenced by *Tobey and Oriental religion, Graves used Tobey's 'white writing' to weave shining skeins round his solitary birds, ambiguous mystical symbols of survival in chaos; later work grew abstract.

GRAY, Henry Peters (1819–77)

b. d. New York. Painter who travelled and studied in Europe (1840–2, 1845–6, 1871–5), lived in New York (1846–71) and was President of National Academy of Design (1869–71). Obsessed with discovering the Venetian colourists' secrets, in portraits he sometimes achieved their golden glow, never their poetry.

GREAVES, Walter (1846–1930)

b. d. London. The bold style of his early works, eg *Hammersmith Bridge on Boat Race Day* (c. 1862), changed radically under the influence of *Whistler, whom he met in 1863. Emphasis on detail gave way to a unity of impression painted with a Whistlerian palette, although his subject-matter, Thames-side scenes, did not change.

GREBO see DAN-NGERE

GRECO, EL (Domenikos THEOTOKOPOULOS) (1541–1614)

b. Crete d. Toledo. Cretan painter, later in Spain famous for his individual expressive religious subjects in a quasi-*Mannerist style. Arriving in Venice (1560s), and in Rome (1570), he is mentioned as a former pupil of *Titian, but he absorbed many styles, notably that of *Tintoretto, and soon revealed his originality (*Purification of the Temple*, Minneapolis). Greco's freedom from conventional styles increased after reaching Toledo (before 1577). He received major commissions (altarpieces for S. Domingo el Antiguo) but Philip II rejected the commissioned *Martyrdom of St Maurice* (Minneapolis) and Greco experienced other hostile criticism on account of his originality. He created new methods of illustrating standard themes, depending on those abstracted forms and elongated figures that became for him such effective instruments of spiritual expression. His *Burial of Count Orgaz* (1586, S. Tomé, Toledo) shows a maturer style but in the later paintings Greco's dramatic manner reaches its climax (*Laocoön*, NG, Washington). Here the emotional faces and fevered handling of flesh is exaggerated and the range of colours stresses the strident violets and cold bluish and silvery-grey tones. Greco excelled also in portraiture (*Cardinal Guevara*, c. 1601, MM, New York) and his exceptional *View of Toledo* (MM, New York) anticipates later pure landscape painting.

GRECO, Emilio (1913–)

b. Catania. Sicilian sculptor who worked for a marble-mason then studied in Palermo. Influenced by *Marini, Greco's figures of young women have a mannered grace reminiscent of *Modigliani. Their elongated balloon-like limbs are incised with the patterns of hair or hands – an elegant combination of smooth surface and sharp line paralleled by the combination of hatching and line in his drawings.

GREEN HEAD

Egyptian head of a priest (now in Berlin), perhaps the best known of the many realistic portraits of the later dynasties. The earliest date from the Persian period (c. 500 BC), but the present example would seem to belong to the close of the Ptolemaic age, ie sometime about the middle of the 1st century BC.

GREEN, Valentine (1739–1813)

b. Nr Evesham d. London. English engraver who began by illustrating the *Survey of Worcester* (1764). Coming to London he taught himself mezzotinting and became a very successful portraitist. War cut short his attempt to publish the ducal painting collection at Düsseldorf (1789).

GREENAWAY, Kate (1846–1901)

b. Hoxton d. London. English illustrator, trained in London. She produced drawings for illustrated magazines, for Valentines and Christmas cards, until she met Edmund Evans with whom she worked (from 1877), depicting happy children at play in rustic surroundings and with decorative accessories later affected by the *Aesthetic movement.

GREENE, Balcomb (1904–)

b. Niagara Falls, New York. Painter who studied psychology in Vienna, and was first Chairman of American Abstract Artists (1936). Influenced by *Cézanne, Greene first painted austere geometric abstractions; in his compassionately objective mature paintings, light shatters and dissolves monumental figures, unifying figure and environment, yet giving solid integrity to each.

GREENE, Stephen (1918–)

b. New York. Painter who studied at *Art Students' League (1936–7), and at State University of Iowa with Philip *Guston. An *Expressionist, Greene frequently painted religious and *Surrealist allegories; gradually abstracting his content and loosening his technique, he retained a firmly structured composition under his ambiguous symbolism.

GREENOUGH, Horatio (1805–52)

b. Boston, Massachusetts d. Somerville, Massachusetts. Sculptor/critic who lived in Italy (1824–6, 1829–51), studying under Bartolini, informally with *Thorwaldsen. Despite its pedantically detailed †Neo-classicism, his sculpture approached monumental power; his prophetic criticism propounded the principal doctrine of organic and democratic art: 'Form follows function.'

GREENWOOD, John (1727–92)

b. Boston, Massachusetts d. Margate, England. Painter and engraver who went to Surinam (1752), to Holland (1758) where he studied mezzotint engraving, and to London (1763) permanently establishing himself as portraitist there. His portraits are stiffly factual, but his genre paintings, probably America's earliest, are robust, earthy satires.

GREGORY OF NAZIANZUS, Homilies of

One of the finest surviving †Byzantine manuscripts. It is datable to 880–3 and was produced for the Emperor Basil I. Its cycle of illustrations served as frontispieces to each of the homilies, and consisted of symbolic and interpretative scenes derived from diverse sources. The figures are thick-set and well modelled; compare for style the Christian Topography of *Cosmas Indicopleustes. (Bib. Nat., Paris, gr. 510.)

GREUZE, Jean-Baptiste (1725–1805)

b. Tournus d. Paris. French painter who came to Paris (1755). He began by painting Dutch-style genre pieces and achieved success with *L'Accordée du Village* (1761) which was praised by *Diderot who advocated a return to morality in art. Greuze's career suffered a setback with the universal condemnation of his *Severus and Caracalla* (1769) in imitation of *Poussin. His

later paintings applied this style to middle-class moral subjects with which he gained a world-wide reputation. In his last years, when his style was out of fashion, he painted sentimental and erotic pictures of young girls. His most attractive work is in his portraits.

GRIEN, Hans Baldung see **BALDUNG GRIEN**

GRILO, Sarah (1920–)
b. Buenos Aires. Self-taught painter who lived in Madrid and Paris (1948–50); visited Europe and the United States (1957–8); has lived in New York (from 1962). She has painted both antiseptic geometric abstractions influenced by the *Bauhaus and *Abstract Expressionist canvases in which dripped and scribbled brushwork is combined with collage and printing.

GRIMALDI, Giovanni Francesco ('Il Bolognese') (1606–80)
b. Bologna d. Rome. Italian landscape painter. He developed a style in the *Carracci manner, and through his great popularity helped to disseminate that manner. He also painted frescoes in Roman palaces (Quirinale and Villa Doria Pamphili).

GRIMM, Samuel Hieronymous (1733–94)
b. Burgdorf d. London. Swiss painter, who illustrated books in Berne (1760–4). Coming to England (1765), he painted landscape, architectural views and genre scenes. His best work was topographical illustration, eg for the Society of Antiquaries' *Vetusta Monumenta*.

GRIMMER, Jacob (c. 1525–90)
　　　　Abel (after 1570–before 1619)
Flemish painters, father and son, both b. d. Antwerp. They painted bright landscapes, often populated with frolicking peasants in the manner of *Bril and *Bruegel the Elder, though lacking the psychological undertones of those masters. Paintings of this type influenced *Streeter and *Siberechts in their early introduction of landscape painting into Britain. Jacob was praised in his day by *Vasari and van *Mander.

GRIMSHAW, John Atkinson (1836–93)
b. Leeds. A prolific English landscape painter with no formal training. His work was preoccupied with the poetics of rural or urban street scenes, usually seen by moonlight, varied by harbour views. Impeccably painted with little sense of the manipulation of pigment, an effect gained by working upon photographically enlarged images of his sketches.

GRIS, Juan (José GONZALES) (1887–1927)
b. Madrid d. Paris. Painter who studied at the School of Applied Art, Madrid (1902–4) and arrived in Paris (1906). He abandoned his decorative *Jugendstil manner to come seriously under the influence of *Picasso (by 1911), immediately settling into his classical and unimpassioned style. His earliest *Cubist paintings were virtual monochromes. Like *Braque and Picasso he was making *collages (by 1911); in Gris's pictures materials like newsprint and mirrors represent their actual functions. The flat coloured architecture of his work (1916–19) is constructed from formal elements which are the result of a prolonged evolution: the object emerges as an emblem inscribed within the framework of the composition. Gris believed that a 'pure' (abstract) architecture of forms could be projected into what he saw by his painting, thus idealising reality. Retaining this approach, he moved to a looser, more sensual style (after 1921).

GRISAILLE
French *gris*: 'grey'. A monochromatic oil painting. Sometimes used as an *underpainting; sometimes in its own right as an illusionistic substitute for sculpture and architectural decoration.

GROMAIRE, Marcel (1892–1971)
b. Noyelle-sur-Sambre d. Paris. Influenced by the Analytic *Cubism of *Braque and others, Gromaire was a *School of Paris painter who, having initially studied law, painted simple and monumental figures which display a clear articulation of planes and subdued colour.

GROPPER, William (1897–)
b. New York. Painter and illustrator who studied with *Henri and *Bellows, began painting (1921). His best work is black and white: horrifyingly realistic images of urban squalor and macabre symbolic satires, embodying radical social and political convictions, drawn in acid with crisp forcefulness.

GROS, Baron Jean-Antoine (1771–1835)
b. d. Paris. French painter, and pupil of *David. While in Italy, he was introduced to Napoleon, and, present at the Battle of Arcola, found his vocation as illustrator of the Napoleonic saga. He helped select looted works of art bound for France, and between 1799 and 1808 painted a magnificent series of battle pieces and *Napoleon's Visit to the Jaffa Pesthouse*. Although the mood of his paintings was †Romantic, his treatment of the figure naturalistic and his colour boldly experimental, he remained tied to †Neo-classical form. His inspiration waned once Napoleon was replaced by the Bourbons, and after this only his Panthéon dome (1811–24) was successful.

GROSS, Chaim (1904–)
b. Austria-Hungary. Sculptor who went to America (1921), studied at *Art Students' League, Educational Alliance, and Beaux Arts Institute; taught at Brooklyn Museum School (from 1942). One of the first Americans of the direct-carving revival, Gross frequently stacked his stocky, simplified acrobats and athletes in spiral columns, rendered with muscular force.

GROSVENOR GALLERY (1877–90)
The first English attempt to counteract the influence of the Royal Academy on an important scale, opened by Sir Coutts Lindsay in Bond Street, London. Showed *Alma-Tadema, *Crane, *Legros, *Leighton, *Millais, *Poynter, *Tissot, *Watts, *Whistler, and especially *Burne-Jones, who made it the symbol of the English *Aesthetic movement, celebrated by W. S. Gilbert in *Patience* (1881) for the 'Greenery-yallery, Grosvenor Gallery, foot-in-the-grave young man'.

GROSZ, George (1893–1959)
b. d. Berlin. German painter and caricaturist who studied in Dresden (1909–12) and Berlin (1912–16). Associated with Berlin *Dada (after 1918). In the early 1920s participated in publication of a few satirical reviews in Berlin. Travelled much in Europe, publishing satirical portfolios. First journey to America (1931). Moved to New York (1933). Lost German nationality (1938). Taught in Columbia University (1941–2). Returned to Berlin (1959). Capable of exquisite draughtsmanship, he turned his delicate skill to the most violent satirical ends, his mockery directed above all against bourgeois values and morals. *See also* NEUE SACHLICHKEIT

GROTESQUE
Fanciful decoration in paint or *stucco, consisting of medallions, foliage, sphinxes, etc, similar to *arabesque. Much used for interior decoration of domestic buildings by the Romans, eg the Golden House of Nero, which was excavated in the late 15th century when the rooms, being underground, were called 'grottoes'; hence the name. Revived by *Raphael and also much used in the 18th century.

GROUND
The dense layer of priming on which a painting is actually carried out.
　Non-absorbent grounds are generally used for oil paintings on *canvas or *panel. In this case white pigment is mixed with oil.

Absorbent grounds are used for *tempera painting. Here the chalk is mixed with *glue and water to make *gesso. The surface being porous sucks the fluid from the painting medium.

A half-chalk ground is a cross between an oil and a gesso ground. More flexible than gesso it is also more absorbent than an oil ground. It is made by emulsifying *linseed-oil with glue and adding half chalk and half mineral white pigment.

Top left: ERASMUS GRASSER *Morris Dancer. c.* 1480. Painted wood. h. 25⅝ in (65 cm). Munich Town Hall
Top right: MORRIS GRAVES *Bird Singing in the Moonlight.* 1938–9. Gouache 26¾ × 30⅛ in (67·9 × 77·5 cm). MOMA, New York
Above left: EMILIO GRECO *Head of a Girl.* 1954. Drawing. 19⅝ × 14 in (49·8 × 35·6 cm). Tate
Above right: 'GREEN HEAD' Head of a priest. Late Ptolemaic period, 1st century BC. Schist. h. 8½ in (21·5 cm). Agyptisches Museum, Berlin-Charlottenburg

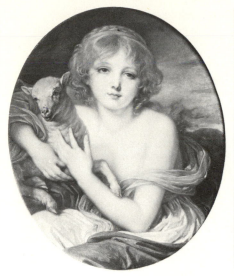

OPPOSITE PAGE
Top: JEAN-BAPTISTE GREUZE *The Village Betrothal.* 1761.
36×46½ in (91×118 cm). Louvre
Centre: JOHN ATKINSON GRIMSHAW *Liverpoool Docks.*
?1885. 24×36 in (61×91·4 cm). Lady Abdy Coll
Left: EL GRECO *Burial of Count Orgaz.* 1586. 189×141¾ in
(480×360 cm). S. Tomé, Toledo
Middle left: EL GRECO *Cardinal Don Fernando Niño de Guevara.*
c. 1601. 67¼×42½ in (170·8×108 cm). MM, New York
Far left: GRISAILLE *St Barbara* by Jan van Eyck. Dated 1437.
12¾×7¼ in (34·2×18·6 cm). Musées Royaux, Brussels

THIS PAGE
Top left: JEAN-BAPTISTE GREUZE *Innocence.* 24⅞×20⅜ in
(63×52 cm). Wallace
Top centre: CHAIM GROSS *Mother and Child at Play.* 1927.
Wood. h. 56¾ in (144·1 cm). Newark Museum, New Jersey
Top right: JUAN GRIS *La Place Ravignan.* 1915. 45⅞×35⅛ in
(116×89·2 cm). Philadelphia Museum of Art, Arensberg Coll
Above: WILLIAM GROPPER *Farmer's Revolt.* 1933. Brush
drawing. 16×19 in (40·6×48·3 cm). Whitney Museum of
American Art, New York
Centre right: JUAN GRIS *Le Canigou.* 1921. 25½×39½ in
(64·8×100·3 cm). Albright-Knox Art Gallery, Buffalo, New York
Right: GEORGE GROSZ *Night Café.* 1916. Indian Ink. 12⅞×8½ in
(32·9×21·4 cm). Staatsgalerie, Stuttgart
Far right: JEAN-ANTOINE GROS *Bonaparte at the Battle of
Arcola.* 1796. 28¾×23¼ in (73×59 cm). Louvre

GROUPE DE RECHERCHES D'ART VISUEL

Paris movement of *Kinetic artists (founded 1958, foundered 1969). It included the Argentinian, Julio *Le Parc, Sobrino, Morellet, Garcia-Rossi, Stein and Yvaral. They worked with light in unstable structures, using acceleration, repetition, brusque movement and interruption. The 1961 manifesto *Propositions of the Movement* explained their aims: a new visual situation between the object and the eye of the spectator, the artist's significance and intervention being minimal. They pioneered a co-operative programme of research to these ends, which were publicly demonstrated by their *Journée dans la Rue* (1966).

GROUP OF SEVEN

The artists involved, James Edward Hervey *MacDonald, *Harris, *Lismer, *Varley, *Jackson, Carmichael and Johnston, took this name for their first group exhibition in Toronto (1920), though others, such as *Thomson (d. 1917) and Holgate, *FitzGerald and other younger painters belong in this context, since the Group lasted until 1933. The name has become synonymous with a movement which began about 1910 and maintains its influence today. Encouraged by expansionist optimism, Canadian painters created the first, and only purely Canadian, art movement. Having assimilated the influences of †Impressionism, *Fauvism and Scandinavian art, they painted the Canadian landscape with vigour and simplicity. Although first shocked, the public was won over to modern art by nationalist pride and admiration of the painters' pioneering spirit.

GRUBER, Francis (1912–48)

b. Nancy d. Paris. Painter who studied under *Dufresne, Waroquier and *Friesz at the Académie Scandinave (1929). He was not an innovator and painted stiffly stylised, *Expressionist subjects influenced by *Bosch, *Bruegel and *Surrealism. He associated with André *Marchand, *Tal Coat, Tailleux and *Giacometti.

GRUNER, Wilhelm Heinrich Ludwig (1801–82)

b. d. Dresden. German engraver, best known as adviser on matters of art to Prince Albert, Queen Victoria's Consort. In this capacity he bought works of art in the Prince's name, and was highly influential in increasing a general knowledge of German art in England before 1860.

GRUNEWALD see GOTHARDT-NEITHARDT

GUALDO, Giovanni see GAILDE, Jean

GUARDI, Gianantonio (1699–1760)
Francesco (1712–93)

Venetian painters, sons of the painter Domenico Guardi. Gianantonio b. Vienna d. Venice. Francesco b. d. Venice. They worked together on historical and religious paintings in a †Rococo style. The forms are insubstantial and the brushwork reminiscent of *Magnasco although the colour is softer and the total effect less sombre. Gianantonio was probably the dominant partner. A few years before his brother's death Francesco began painting views of Venice although he had already painted *caprices. His earliest attempts are in the style of *Canaletto but probably because he lacked the earlier artist's precise knowledge of perspective he developed a more personal style in which form is dissolved into flickering light in a manner anticipating †Impressionism. Although not as famous in his lifetime, he is now as highly regarded as Canaletto.

GUARIENTO DI ARPO (3rd quarter 14th century)

Paduan painter who did ceiling panels and mural decorations in Padua and to whom is attributed the *Coronation of the Virgin* (probably 1365–7) in the Doge's Palace, Venice, which is a large and very damaged wall-painting of figures set in an elaborate architecture of throne and seats. His debt to *Giotto can be explained by the proximity of the Arena Chapel in *Padua.

GUARINO OF VERONA (1374–1460)

Italian writer on art, who established a humanist school at Ferrara (1429); pupils included *Fazio. He was instrumental in the revival of classical learning in Italy. His art criticism is based on a thorough knowledge of very few works, considering each one's unique qualities rather than looking for formal values.

GUAYASAMIN CALERO, Oswaldo (1919–)

b. Quito, Ecuador. Painter who studied in Quito. Influenced by *Picasso and *Orozco, Guayasamín uses Picasso's formal abstractions combined with indigenous earth colours to render his native themes of social protest – shrieking, anguished, controversial pictures.

GUDEA

A ruler of Lagash in southern Mesopotamia (c. 2250 BC) who has left many statues of himself characteristic of the Neo-Sumerian style of the later 3rd millennium. He is depicted as the servant of the city god, praying or awaiting the divine command. Although the pose resembles that of Early Dynastic statues, the head is an obvious portrait, the musculature of his body and the folds of his robe are more realistically shown, revealing the influence of the intervening *Agade school of sculpture.

Top left: OSWALDO GUAYASAMIN *The Cry.* 1951. 37½×27½ in (95·3×69·9 cm). Luis Angel Arango Library, Bogota
Top right: GUDEA OF LAGASH Neo-Sumerian period. *c.* 2130 BC. Diorite. h. 24 in (61 cm). Louvre
Above: FRANCESCO GUARDI *View of Venice with Sta Maria della Salute and the Dogana. c.* 1780. 14×21⅞ in (36×56 cm). Wallace

GUERCINO (Francesco BARBIERI) (1591–1666)

b. Cento d. Bologna. Italian painter. A follower of Ludovico *Carracci, he was perhaps influenced indirectly by *Caravaggio, and his early work is in a very individual manner, grand in form and dramatic in lighting. He went to Rome (1621) and there painted his most famous work, the *Aurora*, on a ceiling of the Villa Ludovisi. The prevailing classicism in Rome led him to modify his own style in that direction, a trend which became more accentuated (and his work tamer) with his return to Cento (1623), and his move to Bologna, where he became the leading painter. Apart from the *Aurora*, he was chiefly a painter of altarpieces.

GUERCINO *The Incredulity of St Thomas*. 45½×56⅛ in (115·6×142·5 cm). NG, London

GUERIN, Baron Pierre-Narcisse (1774–1833)

b. Paris d. Rome. French painter and *lithographer. He perpetuated the †Neo-classical tradition of *David, painting subjects from Roman history and French classical drama, but is primarily remembered as the teacher of *Géricault and *Delacroix.

GUERRERO *see* WESTERN MEXICO

GUERRERO GALVAN, Jesús (1910–)

b. Jalisco. Painter who studied at School of Plastic Arts, Texas, with Vizcarra (1922) and Zuno (1924); has taught in several Mexican schools. Influenced by *Castellanos, *Picasso's classicism and German New Objectivity, Guerrero Galván's paintings, particularly of children, transform Mexican Indians into calm, classical figures, living in a lyrical, visionary dream.

JESUS GUERRERO GALVAN *Children*. 1939. 53¾×43¼ in (136×109 cm). MOMA, New York, Inter-American Fund

GUERRERO, Xavier (1896–)

b. Coahuila. Self-taught painter who was co-founder of El Machete (1924) and League of Revolutionary Writers and Artists (1930s); travelled in eastern Europe and Asia (1930s). A leader in Mexican muralism and inventive technical experimenter, Guerrero first painted *Rivera-influenced, firmly composed, symbolic, socially conscious murals, then calmer, personal paintings.

GUETAR

Pre-Columbian culture in Costa Rica. Guetar art includes pottery, gold ornaments and stone carvings. Characteristic are stone *metates* or maize-grinders carved in the form of jaguars.

GUETAR Stone for grinding maize, carved in the form of a jaguar. Costa Rica. 6×14 in (15·2×35·5 cm). Royal Scottish Museum

GUGLIELMI, O. Louis (1906–56)

b. Cairo, Egypt d. Amagansett, New York. Painter who went to America (1914), and studied at National Academy of Design (1920–5). Guglielmi painted urban scenes, first with socially conscious realism, then with the disturbing *Surrealist symbolism of *Magic Realism, and later in a severely simplified, abstract *Precisionism.

GUGLIELMO *see* WILIGELMO

GUIDA DA SIENA (? active *c.* 1260–*c.* 1290)

Once regarded as the founder of Sienese painting, more recent opinion is inclined to doubt Guido's dates and personality. Apparently belonging to the generation before *Duccio, works associated with him are influenced by the †Byzantine tradition and by *Coppo di Marcovaldo. He may have introduced a more informal pose into the depiction of the Virgin and Child and have established the enlarged, divided type of panel painting with cusped mouldings separating half-length figures of the Virgin and Saints.

GUILDS

Throughout medieval Europe, urban craftsmen were divided into as many groups as there were professions, variously known as guild (England), arte/compagnia (Italy), Innung/Zunfte (Germany), etc. Guilds provided economic protection and social benefits for members, excluding non-guild members from practising their trade in the town. They regulated workshop practice, but by rigorously enforcing uniformity, all possibility of innovation or ingenuity was denied. The richest guilds were those dealing in international commerce: wool, silk, etc. In each workshop the master owned the raw materials and sold the finished product; he trained the apprentices (a painter's apprenticeship lasting six to ten years). Journeymen who had finished their training but had no workshop of their own, were hired by the week by masters. To qualify as a master, a journeyman presented a masterpiece and paid a fee to his guild. Painters and sculptors did not always have independent guilds. In Florence, painters belonged to the *Medici e Speziali* (physicians), sculptors to the Fabbricanti (builders). The

foundation of independent *academies broke the power of Italian guilds over artists, but in northern Europe their influence lasted longer.

GUILLAUMIN, Jean-Baptiste Armand (1841–1927)

b. Paris. The least well known of the French †Impressionists. He met and was influenced by *Cézanne while working at the Académie Suisse. He worked with Cézanne and *Pissarro at Pontoise (1872). Financial independence came to him only in 1891, but by then his works had lost their early sense of construction.

Above: JEAN-BAPTISTE GUILLAUMIN
Paris, Quai de Bercy: Snow.
$19\frac{7}{8} \times 24\frac{1}{8}$ in (50·5×61·2 cm).
Louvre

Above right: IGNAZ GUNTHER *Virgin of the Annunciation* and detail. 1674. Carved and painted wood. h. 63 in (160 cm). Weyarn, Bavaria

Left: GULER SCHOOL *The Meeting of Eyes. c.* 1810. 6×8 in (15×20·3 cm). Raja D. D. Chand Coll

GULER SCHOOL (from c. 1740)

Guler state in the *Panjab Hills produced a style of painting often described as pre-*Kangra since it anticipates many of the developments of that school. Govardhan Chand, a late 18th-century ruler, was the chief patron of its painting. The style bears two strands of influence, *Mughal and *Basohli. From the former come the individuality of the faces and the suave and fluid line, and also the vivid naturalism. From Basohli come the schematic backgrounds, flat red planes and strong colours. These two blended with the native art to form an original and individual style characterised by a tendency to elongate figures, the use of warm tones and the depiction of skirts with a series of horizontal stripes. Gold and silver were used lavishly, notably on the large miniatures (3 × 2 feet) of the *Ramayana.*

GUM

A sap which naturally exudes from certain trees. Unlike *resins they are water soluble and can therefore be used as adhesives and *binders. Resins are soluble in alcohol and *turpentine, gums are not.

GUM ARABIC

A *gum from tropical trees used as a *binder in *watercolours.

GUNTHER, Ignaz (1725–75)

b. Altmannstein d. Munich. Bavarian †Rococo sculptor, the pupil of *Straub in Munich (1743–50) and at the Vienna Academy (1753), whence he returned to Munich the following year. His most important work was ecclesiastical, particularly the making of free-standing figures for the elaborate frames of altarpieces, although he also produced small religious sculptures for private houses. He often employed colour and his figures combine balletic grace with religious intensity.

GUNTHER, Kurt

b. Gera. German painter whose savage portraits of contemporary life at first employed *Dada techniques in a combination of painting and photomontage. Advocating a nationalist, racist basis for culture, his style became reactionary and his content fascist.

GUPTA CONTEMPORARY MINOR DYNASTIES AND THE POST-GUPTA EMPIRE

Round the centre of the Gupta Empire were growing new political divisions and within them new art styles. The *Vakatakas* were related, during the reign of Chandragupta II, with the imperial family through a marriage alliance. They inherited the artistic traditions of the *Satavahanas whose main centre had been at Amaravati. Sculptures in the late Ajānta caves and the earlier caves at Elura are products of their dynasty. The Ajānta sculpture is stylistically similar to that of Amaravati but with the elaboration of ornament characteristic of Gupta art. The river goddesses Ganga and Yamuna are carved at the top of the door-jambs as in classical Gupta architecture. Below them as guardian figures to the shrines are found anthropomorphised serpent (Sanskrit: *Naga*) images flanked by their serpent-consorts and female attendants. These reptilian deities are recognised as such only by the enormous corona of seven cobra-hoods behind their heads, the spirit of the deadly serpent-guardian being expressed in human terms as a crowned and bejewelled prince without need of weapons. The hieratic nature of this art in no way impedes the portrayal of individual personalities in the sculpture, particularly in the attendant and female figures. The *Maitrakas*, originally feudatory to the Guptas, became independent when the hold of the Guptas was weakened by the Hun invasions in the north-west. Ruling from Valabhi in modern Gujarat, the Maitrakas sponsored a school of sculpture which, while clearly linked with northern prototypes, quickly developed its own individuality, and much well-structured precise decorative work is to be found on their temples. Individual sculptures of *Vishnu, *Ganesha and other gods found at Shamalaji and Roda are among the finest of any period. The *Vishnukundins*, centred round Vijayawada in modern Andhra, were related by marriage with the Vakatakas. Their sculptures in the Undavalli

and Mogalrajapuram caves represent a transitional phase between the northern Gupta style and the new southern style of the *Pallavas. The *Licchavis*, a tribal confederacy to the north of Magadha, preceded and survived the Gupta Empire. At the break-up of the Empire, or even earlier, it was no great journey for craftsmen from Magadha to reach the relative freedom of Licchavi territory. Sculptures bearing Licchavi inscriptions found in *Nepal display the unmistakable stylistic and iconographical hallmarks of Gupta art, while standing out, perhaps more than any other peripheral school, as a strongly independent local variation. The last vestiges of Gupta imperialism perished with the death of King Harsha who had ruled the war-torn remnants of the Gupta Empire (c. 606–47). It is interesting to note a more pacific and integrated – though noticeably 'post-classical' – style appearing in sculptures produced within his empire. After Harsha, the territories that he had commanded from Kanauj were long disputed by three dynasties: the *Palas of Bengal from the east, the *Rashtrakutas of the Deccan from the south, and the *Gurjara-Pratiharas from their adjacent lands in Gujarat and Saurashtra to the south-west.

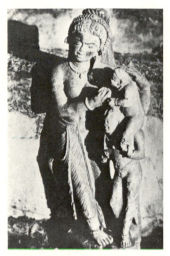

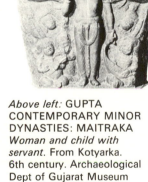

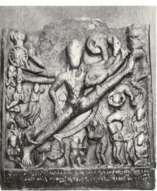

Above left: GUPTA CONTEMPORARY MINOR DYNASTIES: MAITRAKA *Woman and child with servant*. From Kotyarka. 6th century. Archaeological Dept of Gujarat Museum

Above right: GUPTA CONTEMPORARY MINOR DYNASTIES: VAKATAKA *Shiva with six emanatory forms*. From Parel. 5th century. Prince of Wales Museum, Bombay

Above: GUPTA CONTEMPORARY MINOR DYNASTIES: LICCHAVI *The three cosmic strides of Vishnu*. From Kathmandu. Dated by inscription AD 467. Nepal Museum, Kathmandu

GUPTA DYNASTY (AD 320–540)

As the power of the *Kushanas declined, so all of North India became fragmented into small warring kingdoms. In Magadha (c. AD 320) one Chandragupta belonging to an obscure family with no aristocratic clan-affiliation, rose to prominence through marriage with a princess of the powerful Licchavi tribe. The conquests of his son Samudragupta along with those of Chandragupta II extended the kingdom into an empire stretching south into the northern Deccan, east into Bengal and Assam, and west into the late Saka territories ruled from Ujjain. Chandragupta II thus effectively controlled the entire north, and the country enjoyed peace and economic stability

for the first time in centuries. Until the emergence of the Gupta Empire, the Brahmans had never been attached so closely to monarchs of such ascendancy; their position had been basically a defensive, self-preservatory one, as guardians of ancient tradition in the face of heresies. Now, with Buddhism already somewhat on the decline in India there was a re-emergence of Hinduism

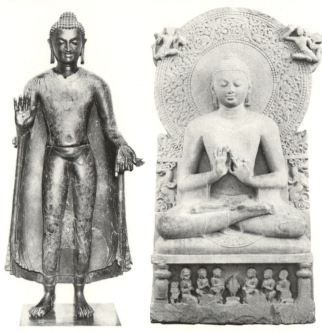

Left: GUPTA DYNASTY *Buddha*. From Sultanganj. 5th–6th century. Copper. h. 88½ in (225 cm). Birmingham
Right: GUPTA DYNASTY *Buddha initiating the Buddhist doctrine*. From Sarnath. 5th century. Sandstone. h. 62 in (157 cm). Sarnath Museum

The Gupta age was one of great idealism; the divine order was brought down to earth and expressed in concrete terms. The scene of this Golden Age was the northern plain beneath the sacred Himalaya ranges, fertilised by the great rivers Yamuna (Jumna) and Ganga (Ganges), which were personified as goddesses in Gupta statuary to adorn the doorways of the free-standing temples. The sculptures of the gods of Hinduism, either in the round or in high relief, are crystallisations of the iconographic formulae that were in the process of development under the *Kushanas. In fact the symbolism is worked into the compositions with such fluency that one must suppose a great familiarity with a fixed vocabulary of symbols to have existed in the minds of the priests and sculptors by the time the Gupta Empire was established. The standing Buddha-images produced in or around Mathura, are depicted swathed in a robe which is folded in looped ridges clearly deriving from *Gandharan models, but with a lightness that scarcely veils the torso. The face retains Gandharan elements in the nose and brow, but the hair is treated in the fashion developed at Amaravati under the *Satavahanas, in tight curls, and the *ushnisha is a pronounced feature. At Sarnath to the east the robe is smooth with only a few faint lines incised about the shoulders to indicate drapery. The edges of the cloak are deeply cut into the stone and their vertical parallel folds define the outline of the image. In both schools the scalloped edge of the nimbus, developed in *Kushana sculpture, remains, but the halo surface, enlarged to a diameter half the height of the figure, is engraved with concentric bands of floral decoration, perhaps to compensate for the absence of body adornment. The Vishnu images are richly bejewelled and enhanced by intricate crowns which recall in their contrast with the nearly naked torso the *yaksha statues of the *Mauryan period. The nimbus proved a useful surface on which to reinterpret the stock of symbols which the Gupta image-maker inherited. Thus the *Vishnu-image, for

example, in the Mathura region, was provided with a halo upon which were carved two extra heads, those of the god's incarnations as the mythical boar and lion. This innovation led on to a further development in which the entire surface of the halo was covered with minor figures in low relief in order to express the god's nature as all-creator. Many narrative reliefs, belonging to both Buddhist and Hindu faiths, survive. The Buddhist examples depict in panels the main events in the life of the Buddha, commencing either with his birth from the side of Maya, depicted as a young woman clinging to the branches of a tree, or with Maya's dream in which she conceived the future Buddha. Several episodes may be represented in a single panel, the figures of the Buddha overlapping physically although there may be a span of time between the actions which they perform. The last scene, at the top, inevitably is the death scene, showing the Buddha lying on his side about to enter *Nirvāna. Of the bronzes surviving from the Gupta period, the largest and one of the most refined is the colossal image of the standing Buddha from Sultanganj. It corresponds to the stone image type of the Sarnath School in the lightness of the anatomy and the slight movement represented by a subtle flexion of the body at the knees and waist. The Gupta coins, too, especially the gold ones, are exceptionally fine and may be classified as works of art.

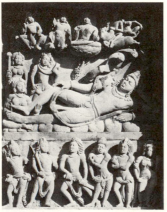
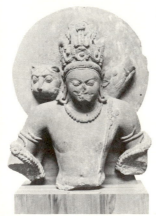

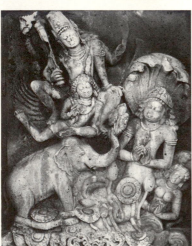
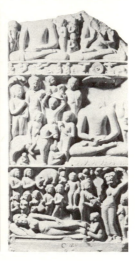

Top left: GUPTA DYNASTY Birth of Brahma upon a lotus issuing from the side of Vishnu sleeping upon the serpent of eternity. Dashavatara temple, Deogarh. 5th century
Top right: GUPTA DYNASTY Vishnu with boar and lion heads. 5th–6th century. Sandstone. h. 25½ in (65 cm). Boston
Above left: GUPTA DYNASTY Vishnu astride Garuda liberating an elephant from the coils of a naga. Dashavatara temple, Deogarh. 5th century
Above right: GUPTA DYNASTY Birth, enlightenment and teaching of the Buddha. From Sarnath. 5th century. Sandstone. National Museum, New Delhi

GURJARA-PRATIHARA DYNASTY (AD 800–1019)

The Pratiharas, as they came to be known, were probably Central Asian in origin, a people originally calling themselves 'Gurjaras' who had entered India with the Huns and settled in Rajasthan, where they were confronted in the 8th century by the Muslim expansion in Sind. The Gurjara-Pratiharas consolidated, successfully kept back the outsiders, and penetrated eastward to capture and rule from Kanauj, the old capital of Harsha. The Pratihara sculptural style centred on Kanauj represents a renaissance of *Gupta classical forms with a greater sophistication of composition. In the iconographical sense, artists under the Pratiharas evolved classical forms which were in a merely formative stage during the Gupta period. An example is the Kanauj Vishvarupa (Sanskrit: 'Universal-form') aspect of *Vishnu, which imposes a general framework in the form of a tree upon the image with its enlarged nimbus crowded with minor deities. The iconography is precise and the whole piece displays a controlled harmony and balance of proportion, perhaps as far as Hindu image-making could go in terms of multiplicity of forms to portray the universe in a single icon.

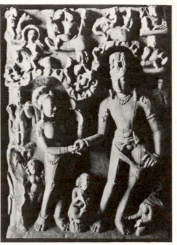
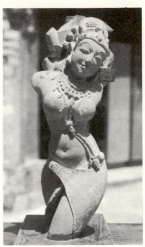

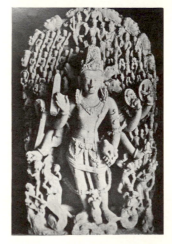

Above left: GURJARA-PRATIHARA DYNASTY Marriage of Shiva and Parvati. From Kanauj. 9th century
Above right: GURJARA-PRATIHARA DYNASTY Tree nymph. From Gyaraspur. 9th–10th century. Sandstone. h. 19½ in (49·5 cm). Archaeological Museum, Gwalior
Left: GURJARA-PRATIHARA DYNASTY Vishnu Vishvarupa. From Kanauj. c. 9th century. Private Collection, Kanauj

GURO

A tribe in Ivory Coast best known for their elegant zamle masks representing antelope heads.

GURUNSI

A tribe in the south of Upper Volta carving wooden figures and tall rectangular flat do masks decorated with brightly painted geometric patterns generally similar to Bwaba (*Bobo) masks. South of the Gurunsi, related tribes around the Ivory Coast-Ghana border, such as the Nafana, carve flat, geometrically patterned shield-shaped masks with horns.

GUSTON, Philip (1913–)

b. Montreal, Canada. Painter who went to United States (1919), studied at Otis Art Institute, painted *WPA murals, and taught at State University of Iowa (1941–5). Guston converted from *Social Realism to *Abstract Expressionism; his Action Paintings, first intimate, delicate and atmospherically Impressionistic, have grown larger, murkier and more aggressive.

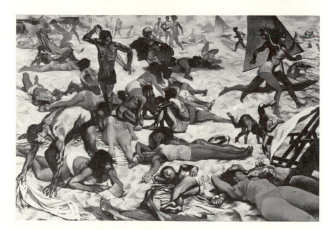

GUTFREUND, Oto (1889–1927)

b. Drůr Králové nad Labem, Bohemia. Czech sculptor who studied in Prague and Paris and became Professor of Structural Plastics at the Prague School of Industrial Design (1926). Gutfreund worked as a *Cubist sculptor at a time when only *Picasso and *Archipenko did; later (1916–19) he passed through a *Constructivist phase under *Boccioni's influence, then turned to a more monumental and abstract style. His last works, before he was drowned, were naturalistic representations of lovers.

GUTTUSO, Renato (1912–)

b. Bagheria, Sicily. Italian painter and illustrator who produces polemical paintings of *Social Realism, dramatically expressed in harsh colour and simplified form though they have become less violent in recent years. Guttuso is influential among young Italian figurative painters.

GUY, Francis (1760–1820)

b. Lorton, England d. Brooklyn, New York. Self-taught painter who moved to Brooklyn (1795), to Philadelphia (c. 1797), to Baltimore (1798–1817), then back to Brooklyn. Although he specialised in orthodox views of Maryland country estates, he is remembered for Brooklyn winter scenes, wealthy in details organised in vivacious patterns.

GUYS, Constantin Ernest Adolphe Hyacinthe (1802–92)

b. Flessinque d. Paris. A draughtsman, self-taught in the technique of ink and watercolours, Guys chronicled the wars and society of Europe in the 19th century. He travelled extensively, and with Lord Byron took part in the Greek war of liberation (1824); during the Crimean War (1854) he was war artist for the *Illustrated London News*. Inspired by drawings of *Callot, *Rembrandt and *Goya, he was a witty anonymous observer who *Baudelaire described as 'the painter of modern life'. His rapid sketches with washes of flat colour convey the essence of his subjects, prostitutes, soldiers, musicians and sailors, in the context of their environment.

Top left: PHILIP GUSTON *The Room.* 1954–5. 71⅞×60 in (182·5×152 cm). Los Angeles County Museum of Art
Top right: OTO GUTFREUND *Cubist Bust.* 1912–13. Bronze. 23¾×23×17½ in (60·6×58·4×44·5 cm). Tate
Centre: ROBERT GWATHMEY *The Painting of a Smile.* 40×60 in (101·6×152·4 cm). Nebraska Art Association, Gift of Mr and Mrs Thomas Woods, Sr
Bottom: RENATO GUTTUSO *The Beach.* 1955. 118½×178 in (301×452·1 cm). Galleria Nazionale d'Arte Moderna, Rome
Right: GYOKUDO *Forbidden to the Vulgar.* Edo period, 1745–1820. Ink on paper. 53×20⅛ in (134×51·4 cm). Cleveland Museum, Mr and Mrs William H. Marlatt Fund

GWATHMEY, Robert (1903–)

b. Richmond, Virginia. Painter who studied at Southern colleges and Pennsylvania Academy, went to Europe (1925, 1928, 1929), and taught at several Northern colleges. Remembering his destitute Virginia boyhood, Gwathmey used intricate patterns of dark line and richly coloured flat shapes to make compassionate, searing statements about the destruction of segregation.

GYOKUDO (Kawai Gyokudo) (1873–1957)

Japanese artist who studied the *Shijō and *Kanō styles, but developed a Western-influenced variation of his own. Became Professor at Tokyo University of Arts.

GYOKUDO (Uragami Gyokudo) (1745–1820)

A *Nanga painter whose scratchy and eccentric style became one of the high points of the school. He was a famous *koto* (Japanese: harp) player and calligrapher.

GYPSUM

A form of calcium sulphate. Can be used as an inert white filler in *gesso. *Alabaster is a crystalline gypsum.

H

HAAN, Meyer Isaac de (1852–95)

b. d. Amsterdam. Dutch artist who, at the suggestion of *Pissarro, met *Gauguin in Paris early in 1889. The two became close friends and de Haan, although he had been an academic painter, became a follower of *Synthetism, and helped Gauguin financially. They worked together at *Pont-Aven and Le Pouldu (1889).

HACKAERT, Jan (1629–99)

b. d. Amsterdam. Dutch landscape painter who travelled in Switzerland and Italy (1653–8). Sensitive to the light of both Umbria and Holland, his *Lake Trasimene* (Rijksmuseum) is a rare 17th-century example of the application of Dutch realistic principles to the Italian countryside.

HACKERT, Jacob Philipp (1737–1807)

b. Prenzlau d. Florence. German landscape painter influenced by *Claude. After executing architectural and landscape decoration in Sweden, and visiting France, he worked predominantly in Naples, becoming official painter to King Ferdinand. Also worked in *gouache and engraved landscapes of France and Sweden.

HADJU, Etienne (1907–)

b. Turda, Roumania. Sculptor who moved to Paris (1927) and studied with *Bourdelle. Hadju's 'Têtes', as much concerned with the qualities of marble as with the forms of a head, are a decorative and sensual contribution to the tradition of *Brancusi and *Arp.

HADRA VASES

A type of pottery produced in Alexandria between the 4th and 2nd centuries BC. The vase type is the hydria (water-jar). The decoration is of two kinds: a series of stylised motifs with sometimes a figured zone in dark brown paint on the natural clay, or coloured decoration on a white background similar to contemporary wall-painting.

HAES, Carlos de (1829–98)

b. Brussels d. Madrid. Spanish artist who worked mostly in Spain where he was taught by Juan Cruz; he also studied landscape painting with Quineaux in Brussels. He taught landscape painting in Madrid and was elected a member of the Academy of S. Fernando. He also made etchings from his landscape studies.

HAGNOWER, Niclas *see* GOTHARDT-NIETHARDT

HAGUE SCHOOL

A Dutch group of the 1870s and 1880s whose interests corresponded, especially in the relation between observation and adaptation from nature, to the French *Barbizon and early †Impressionist Schools. The light effects, hazy atmosphere and melancholy mood of the founder, Joseph *Israels's work continued to develop in the paintings of the leading artists *Mesdag, *Mauve, and the *Weissenbruchs and the *Maris brothers.

HAIDA

Occupying the Queen Charlotte Islands and part of Prince of Wales Island, Alaska, the Haida were arguably the most talented artists of all the *Northwest Coast tribes. Besides being superlative woodcarvers, during the historic period the Haida also began using argillite, a form of slate, to make pipe-bowls, cups, dishes and model totem-poles for sale to Europeans.

Top: JAN HACKAERT *Avenue in a Wood.* $24\frac{3}{4} \times 20\frac{1}{2}$ in (63×52 cm). Wallace
Above: HAIDA Cedarwood rattle carved in the form of a raven supporting a shaman and a frog. Painted in red, green and black, and inlaid with haliotis shell. Early 19th century. Northwest Coast of America. l. $12\frac{3}{4}$ in (32.4 cm). Royal Scottish Museum

Above left: HALAF Polychrome plate from Arpachiyah, Iraq Museum, Baghdad
Above right: HAKUIN *Portrait of Daruma.* Edo period, 18th century. Hanging scroll. Sumi on paper. $45\frac{3}{4} \times 21\frac{3}{8}$ in (116×54.3 cm). Seattle Art Museum, Eugene Fuller Memorial Coll

HAKUIN (1685–1768)

Japanese Zen priest and painter of *Zenga in many styles, with great verve and originality.

HALAF

This culture spread over the northern plain of Mesopotamia and parts of eastern Anatolia about 5000 BC. Its principal art was the decoration of handmade pottery with finely executed geometric and curvilinear motifs in dark paint on a cream slip. In the latest stage the patterns were polychrome in red, black and white paint.

HALEBID see HOYSALA DYNASTY

HALF-CHALK GROUND see GROUND

HALPERT, Samuel (1884–1930)

b. Russia d. Detroit, Michigan. Painter who studied at National Academy of Design in New York (1899–1902), in Paris at Ecole des Beaux-Arts (1902–3), in Spain, Portugal, England and France (1903–11), then returned to New York. His paintings reflect the influence of *Cézanne's structure and *Fauvist colour.

HALS, Dirk (1591–1656)

b. d. Haarlem. Dutch genre and portrait painter and younger brother of Frans *Hals. Although influenced by his brother's impressionistic brushwork, his early work is close to that of *Buytewech. His lively group scenes gave way in the 1630s to calmer interiors (eg *Woman Tearing Up a Letter*, Mainz) which set a pattern which *Vermeer and the Delft School were to develop still further. He is thus one of the earliest practitioners of the *conversation-piece.

DIRK HALS *Woman Tearing up a Letter*. 1631. 17⅞ × 22⅛ in (45·5 × 56 cm). Mittelrheinisches Landesmuseum, Mainz

HALS, Frans (1580/6–1666)

b. ?Antwerp d. Haarlem. Dutch painter. A pupil of Karel van *Mander he became one of the greatest of Dutch portraitists, second only to *Rembrandt. He was able to catch a fleeting expression imparting immediacy to the sitter, an impression heightened by his virtuoso painterly technique. He gained his reputation painting the Civic Guards of Haarlem (militia groups formed by gentlemen to defend Holland against the Spanish). His vigorous brushwork, which imbues atmosphere and enlivens the picture surface, helped him to solve the problem of giving all sitters equal emphasis without destroying the unity of the composition. He spent most of his life in Haarlem and despite a constant stream of commissions from the Regent class he was often in debt. He received fewer commissions after 1650. He painted group portraits of the Regents and Regentesses of the Almshouse of Haarlem (1664).

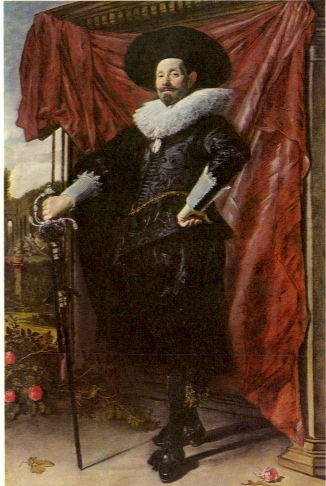

Top: FRANS HALS *Regentesses of the Almshouses at Haarlem.* 1664. 170½ × 249½ in (433·1 × 633·7 cm). Frans Hals Museum, Haarlem
Above: FRANS HALS *Willem van Heythuyzen. c.* 1625. 80¾ × 53¼ in (205 × 135 cm). Vaduz, Liechtenstein Coll

HAMBEI (Yoshida Hambei) (active c. 1664–90)

An early Japanese illustrator of books in the Kyōto version of the *Ukiyo-e style. Most famous for his illustrations to the novels of Saikaku.

HAMEN, Juan van der (1596–1631)

b. d. Madrid. Son and pupil of a Flemish painter. Painted flowers and fruit, but is best known for his *bodegones, in which a still-life is set against a kitchen background, where he

combines atmospheric realism and a feeling for different textures, frequently scattering objects over a geometric composition of planes and ledges.

HAMILTON, Gavin (1723–98)

b. Lanarkshire d. Rome. Scottish *history painter. Trained in Rome in the 1740s, and settling there permanently in 1754, he became a well-known member of the †Neo-classical circle of *Mengs and *Winckelmann. A pioneer Neo-classical painter, he was important for both French and English art.

HAMILTON, Richard (1922–)

b. London. British painter who studied at the Royal Academy Schools, the Slade School of Art and as an engineering draughtsman (1940). He belonged to the Institute of Contemporary Arts Independent group (1952–6) whose exhibition 'This is Tomorrow' – particularly Hamilton's contribution – heralded *Pop Art. Like *Duchamp, Hamilton questions our assumptions about art and reality. The ideas, not the style, unify his work; any source or technique may be used. An ambiguous result is ironically produced by the most deliberate process.

HAMMERSHØI, Vilhelm (1864–1916)

b. d. Copenhagen. Danish painter, student of *Krøyer and the Copenhagen Academy, he was a leader of the Scandinavian School. His *Girl Sewing* (1887) is a sensitive, rather melancholy, but monumentally effective example of his work. He received a bronze medal in Paris (1889), and a silver at the 1900 Universal Exposition (1900).

HAMMURAPI, Stele of

The relief at the head of the stele on which Hammurapi of Babylon (c. 1750 BC) inscribed his Law Code shows the King saluting an enthroned deity who is identified by the rays emerging from his shoulders as Shamash, the sun-god and dispenser of justice. The god's horned headdress is for the first time shown in profile, but the awkward presentation of the bodies in near-frontal view and the heads in profile is characteristic of a problem that Mesopotamian sculptors never fully resolved. The treatment of drapery recalls *Agade and Neo-Sumerian technique. The whole scene is typically Mesopotamian.

HAMZA-NAMA

Popular tales of a folk-hero, Hamza (confused with the Prophet's uncle) commanded to be illustrated by Humāyun for his son *Akbar (commencing 1555). Many Indian artists were instructed in painting for the *Mughal taste by two Persian masters (Khwaja Abdus Samad and *Mir Sayyid Ali). Paintings were large (about 70 × 55 centimetres) and done on cloth; trees and rocks are heavily outlined; the motifs and foliage are gradually Indianised and naturalism increases; the delicate details of faces, embroidery patterns and arabesques were probably by the Persians. There were fourteen hundred folios, of which perhaps a tenth remain; the collection is dispersed (mostly V & A, London, and Vienna).

HAN AND SIX DYNASTIES PAINTING IN CHINA

Both wall-paintings and paintings on silk have been discovered in recent years in Han tombs of the 2nd and 1st centuries BC, while Han tombs and funerary shrines dating to the 1st and 2nd centuries AD, decorated with engraved stone slabs, reflect the painted decoration on the walls of Han buildings and palaces long since vanished. From the ensuing period of the Six Dynasties (220–589) paintings and calligraphy have been transmitted, in the original or in copies, through collections to our time. In the years of Communist rule in China, this heritage has been considerably increased though archaeological excavations, such as that of the 5th-century tomb at Teng-hsien, Honan province, with numerous large bricks stamped with figural designs, or that at Nanking where similar bricks make up a large composition on two walls showing a famous group of Eastern Chin (317–420) Taoists

and literary friends. With the achievements of *Wang Hsi-chih, the Six Dynasties saw the invention of the principal modern Chinese scripts; in painting, it is necessary to mention both *Ku K'ai-chih as a figure-painter, and *Hsieh Ho as the author, following developments in the criticism of poetry and calligraphy, of the famous 'Six Laws' which are of fundamental importance in the development of painting in China.

HAN DYNASTY SCULPTURE see CHINESE CERAMIC FIGURINES; CHINESE MONUMENTAL TOMB SCULPTURE

HAND STENCILS: AUSTRALIAN see AUSTRALIAN ABORIGINAL ART

HANIWA

Red pottery models and figures known as *haniwa* were placed on the slopes of the great tomb-mounds constructed in Japan between the 3rd and 6th century AD. The earliest examples were simple cylinders of clay which surrounded the edge of the tomb like a palisade. The first models were of houses. The necessities of life, particularly arms and armour, followed, and finally in this line of development came animals and human beings. A preponderance of figures of warriors and models of military equipment illustrates the overriding preoccupation of the period with war. The cylindrical origins of the *haniwa* are evident in the way the figures were built up of several tubular sections making for a rigid motionless effect. There was little attempt to capture subtlety of form, movement or expression.

HAN Kan (active mid 8th century)

From Ch'ang-an, Shensi. A younger contemporary of *Wang Wei, Han Kan was the most famous of a long line of Chinese painters of horses, going back to the 4th century. Summoned to court to paint the imperial horses, he is said to have painted the flesh but not the bones of his subjects. *White Steed Brightening the Night* is the finest of surviving attributions.

HANNEMAN, Adriaen (1601–71)

b. d. The Hague. Dutch portrait painter, friend of Cornelius *Johnson, he worked in England, with little success (1623–37). Returning to The Hague, he painted for the court and administration, influenced stylistically by *Van Dyck. He also painted genre scenes.

HARAPPA see INDUS VALLEY CIVILISATION

HARBAVILLE TRIPTYCH

Perhaps the finest and most delicately carved of †Byzantine *ivories of the 10th century, probably designed for private devotion. The central panel depicts the *Deesis with standing saints, and on the two side panels more standing saints. The Garden of Eden appears on the reverse. (Louvre.)

HARDBOARD

A synthetic board made from wood fibre bonded by glue, moulded and rolled under pressure. One side is shiny, the other has a canvas-like texture printed on it from a wire screen. Much used as a painting *support.

HARD EDGE

A style of painting, usually abstract, in which areas of colour are clearly defined and set in contrast to one another by a use of sharp outlines. The movement started in the United States in the mid 1950s and is associated among others with the work of Ellsworth *Kelly and Frank *Stella.

HARDING, Chester (1792–1866)

b. Conway, Massachusetts d. Boston. Painter, first backwoods itinerant portraitist (1817–21), painted Congressmen in Washington, D.C. (1821), studied with Stuart in Boston (1822), worked in Great Britain (1823–6, 1846), otherwise largely round Boston. The élite delighted in his acutely per-

ceived portraits, sensuously painted but vigorously honest, symbolic of Jacksonian democracy.

HARNETT, William Michael (1848–92)

b. Ireland d. New York. Painter, first an engraver, came to Philadelphia (1849), studied at several American art schools (1867–76), went to Europe (1880–6, 1889), studying in Munich, settled in New York. His *trompe l'œil story-telling still-lifes, influenced by Dutch painting, are brilliantly designed, luminous intensifications of mysterious reality.

HARPIGNIES, Henri Joseph (1819–1916)

b. Valenciennes d. Saint-Privé. French landscape painter and watercolourist who studied art at a late age with Achard. After a trip to Italy, he exhibited *Vue de Capri* at the Salon of 1853 and in London with the New Water-Colour Society. His interests in light and weather conditions reflect his study of the landscape artists of the 1830s, principally of *Corot.

HARRIS, Lawren Stewart (1885–1970)

b. Brantford. Painter who studied in Germany (1905–7); travelled in Europe; settled in Toronto (1910); was founder-member of *Group of Seven (1920); taught at Dartmouth College (1934–40); resident, Vancouver (from 1942). From *Fauvist and Scandinavian influences, Harris gradually reduced his landscapes to essential shapes and harsh contrasts, and eventually pure abstraction.

HART, 'Pop' (George Overbury) (1868–1933)

b. Cairo, Illinois d. New York. Painter and printmaker, largely self-taught, who studied briefly at Chicago Art Institute and Académie Julian, Paris, and travelled throughout the world, from Iceland to the South Seas. Hart often mixed media experimentally to express his boisterously unconventional personality in genre scenes drawn from his travels.

HARTIGAN, Grace (1922–)

b. Newark, New Jersey. Painter who studied in Newark, lived in California, and went to New York (1949). Influenced by *De Kooning, Hartigan has occasionally applied *Abstract Expressionist techniques to urban subjects; characteristically, she embodies her worship of American vulgarity in big, brash Action Paintings, broadly brushed and brilliantly coloured.

HARTLEY, Marsden (1877–1943)

b. Lewiston, Maine d. Ellsworth, Maine. Painter who studied at *Chase School and *Art Students' League, travelled in Europe, exhibited with der *Blaue Reiter (1913), at *Armory Show (1913), and with *Stieglitz. Rejecting his *Expressionism and abstractions, Hartly followed *Cézanne and *Ryder, grasping essential forms and moods of the harsh, solitary Maine landscape. Though sharing a common subject-matter with Winslow *Homer, his approach was nevertheless different.

HARTUNG, Hans (1904–)

b. Leipzig. Painter, engraver and sculptor who started to paint abstractly (1922) and later attended the Academies of Leipzig, Dresden and Munich (1924–8). He combined his knowledge of *Kandinsky's work (from 1925) with an inherent interest in German *Expressionism to produce spontaneous graphic images of psychic impulses. One of the most influential *School of Paris painters, his simple abstractions correspond to the *Art Informel* of *Soulages, *Wols and *Fautrier and to *Abstract Expressionism.

HARTUNG, Karl (1908–)

b. Hamburg. Sculptor who studied in Hamburg before going to Paris (1929–32). Hartung emerged after the war as one of the most popular and accomplished German sculptors. Influenced by *Arp and *Brancusi, Hartung's abstracted biomorphic forms have a traditional solidity, completeness and respect for materials.

HARUNOBU (Suzuki Harunobu) (c. 1725–70)

Japanese printmaker who achieved fame as a designer of calendar prints. He was the first to use the polychrome 'brocade' print (1765), and is sometimes credited with its invention. He specialised in small-scale prints of young girls who have an ethereal and fragile beauty. He is regarded as one of the greatest masters, and surely the best loved of all the *Ukiyo-e artists.

HARUSHIGE see KOKAN

HASANLU

An important site in north-western Iran. The city was destroyed in about 800 BC. Among the many finds were a gold bowl decorated with repoussé reliefs, a silver bowl and numerous ivory objects: these have interesting parallels with Hurrian art of northern Mesopotamia.

HASEGAWA SCHOOL see MOMOYAMA PERIOD; TOHAKU

HASSAM, Childe (1859–1935)

b. Boston d. Easthampton, Massachusetts. Painter, lithographer and illustrator who studied in Boston, Munich and Paris at Académie Julian. An academic †Impressionist, Hassam painted cityscapes and interiors with cheerful animation, occasionally subsumed by saccharine prettiness.

HATCHING

Shading by drawing with parallel lines.

HATSHEPSUT

Egyptian queen of the 18th dynasty, known principally on account of her mortuary temple at Deir el-Bahari (*Thebes), with reliefs depicting an expedition sent to the land of Punt.

HATTUSAS

A site in central *Anatolia near the modern village of Boghaz-köy. Occupied from the 3rd millennium, Hattusas achieved its greatest importance as the capital of the *Hittite Empire, from which period date impressive architectural remains and a massive enclosing wall. Pairs of large-scale, semi-engaged, stone sphinxes and lions guarded two of its gates, and the lintel of a third – the so-called 'Royal Gate' – bore a larger-than-life relief of a male figure. Once identified as a king, it has since been recognised as a deity, probably Teshub, the great Hittite storm god. Skilfully executed, the modelling is strong and the relief exceptionally high: the face is almost three-quarters free of its background. *See also* YAZILIKAYA

HAUSMANN, Raoul (1886–1971)

b. Vienna d. France. Sculptor, painter and poet, an inventor of photomontage – Hausmann's works were subsidiary to his *Dadaist life-style. His aggressiveness and savage humour made him rival Huelsenbeck as chief organiser, publisher, propagandist and provocator of Berlin Dada (1918–22). He made Dadaist tours of Germany and Czechoslovakia and contributed to the Dada International Fair (1920).

HAWAIIAN ISLANDS

The art of Hawaii is the most purely sculptural in *Polynesia. It served a hierarchical society with kings and a priest-temple cult. Large wood representations of war gods stood before temple-platforms within sacred enclosures. Wickerwork images of these same ferocious gods, covered with bright red and yellow feathers, were carried into battle by priests. Chiefs wore feather cloaks and crested helmets. Other symbols of rank were necklaces of human hair carrying ivory hook-shaped pendants. Food-bowls, game-boards and drums were supported by figures in contorted positions.

HAYDEN, Henri (1883–)

b. Warsaw d. Paris. Painter who settled in Paris (1907) after studying at the Ecole des Beaux-Arts in Warsaw. He associated with *Picasso and *Gris during World War I and pro-

duced original Synthetic *Cubist paintings culminating in the *Three Musicians* (1920) which predates Picasso's version. Abandoning Cubism, he arrived in 1949 at a glowing *Matissian style.

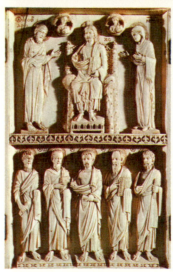

Top left: GAVIN HAMILTON *Priam Redeems the Dead Body of Hector.* 25×39 in (63·5×99·1 cm). Tate
Centre left: HAN DYNASTY PAINTING Legend of the Nine Suns, detail of hanging painting in ink and colours on silk, from No 1 Han tomb at Ma-wang-tui, Ch'ang-sha, Hunan province. Height of detail about $25\frac{5}{8}$ in (65 cm).
Centre right: HANIWA Pottery figure of a warrior. h. $44\frac{7}{8}$ in (114 cm). Tokyo National Museum
Above: RICHARD HAMILTON *Interior II.* 1964. Oil, collage, cellulose and metal. 48×64 in (121·9×162·6 cm). Tate
Top centre: HAWAIIAN ISLANDS War god, Kukailimoku. Basketry and feathers, mother-of-pearl eyes, human hair, dog teeth. h. $33\frac{1}{2}$ in (85 cm). Museum für Völkerkunde, Berlin-Dahlem

Top right: HAWAIIAN ISLANDS War god, Kukailmoku. Early 19th century. Wood. h. 6 ft 9 in (2·05 m). BM, London
Centre left: HARBAVILLE TRIPTYCH Deesis with Standing Saints. 10th century. Ivory. $9\frac{1}{2}$×$5\frac{1}{2}$ in (24×14 cm). Louvre
Centre right: WILLIAM HARNETT *Old Models.* 1892. $54\frac{1}{10}$×28 in (137·5×71·1 cm). Boston, Charles Henry Hayden Fund
Above: HAN KAN *The Night-Shining White Steed.* c. 750. Handscroll. Mrs John D. Riddell Coll

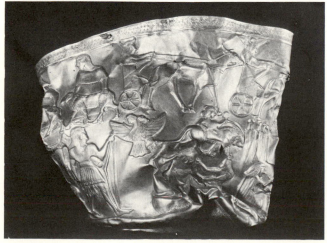

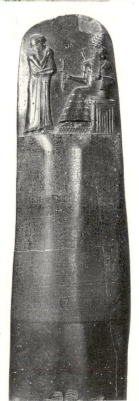

Top left: HANS HARTUNG *Tableau.*
1951. 38×57½ in (96·5×146 cm).
Kunstmuseum, Basle
Top right: LAWREN HARRIS *Return
from Church.* 1919. 40×48 in
(101·4×121·9 cm). NG, Canada
Second row right: MARSDEN
HARTLEY *Smelt Brook Falls.* 1937.
28×22 in (71·1×55·8 cm). St Louis
Art Museum, Eliza McMillan Fund
Second row right: HENRI HARPIGNES
Les Oliviers à Menton. 1907.
39¼×32½ in (100×81 cm). NG, London
Third row left: HATTUSAS Jamb figure
of a god protector on the Royal Gate.
h. 78¾ in (200 cm). Archaeological
Museum, Ankara
Third row right: CHILDE HASSAM
Union Square in Spring. 1896.
21½×21 in (54·6×53·5 cm). Smith
College Museum, Northampton, Mass
Left: HASANLU Gold cup. *c.* 900 BC.
Archaeological Museum, Teheran
Above left: HAMZA-NAMA *The
Sending of an Emissary* 1555–65.
18½×23¼ in (47×59 cm) Museum of
Asian Art, Vienna
Above right: HARUNOBU *Evening Bell
of the Clock. c.* 1760. Colour print.
Chuban, 11¼×8½ in (28×21 cm). Art
Institute of Chicago, Buckingham Coll
Right: HAMMURAPI, Stele of. Basalt.
88⅝ in (225 cm). Louvre

HAYDON, Benjamin Robert (1786–1846)

b. Plymouth d. London. English painter. A mediocre and over-ambitious history painter, his tragi-comical life, suicide and passionate advocacy of the nobility of art have nevertheless made him famous. Most of his creative ability went into the writing of his journals.

HAYEZ, Francesco (1791–1881)

b. Venice d. Milan. Italian *history and portrait painter. Influenced at first by *Canova and *Ingres in Rome, but after 1820 turned away from †Neo-classicism and was hailed as leader of the †Romantic School. His portraits of notable contemporaries include Cavour.

HAYMAN, Francis (1708–76)

b. Exeter d. London. Versatile English artist, President of Society of Artists (1766–8) and Librarian of *Royal Academy (1771). Combining French and English traditions, he executed decorations for Vauxhall Gardens (mainly in the 1740s), *conversation pieces, portraits and *history paintings. He probably taught *Gainsborough.

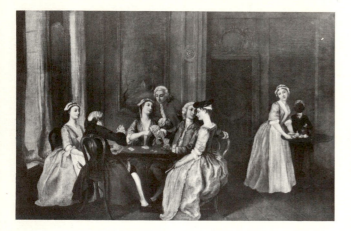

FRANCIS HAYMAN *Playing at Quadrille*. 54×80 in (137·2×203·2 cm). Birmingham

HAYTER, Sir George (1792–1871)

b. d. London. Son of a miniature painter, he spent some years in Rome and was elected to many Italian academies. In the 1820s he painted history and scriptural subjects and portraits of nobility and royalty. He received court posts from Queen Victoria and painted her coronation and marriage. He was knighted (1842).

STANLEY HAYTER *Defeat*. 1938. Engraving. BM, London

HAYTER, Stanley William (1901–)

b. London. Graduated as a scientist, then took up painting and printmaking. Settled in Paris (1936), and became closely associated with the *Surrealists. Founded Atelier 17 (1933).

Moved to New York (1940–50), then back to Paris. Hayter revolutionised the art of engraving with his use of Surrealist automatic techniques, and his wide experimentation with colour and texture.

HEADE, Martin Johnson (1819–1904)

b. Lumberville, Pennsylvania d. St Augustine, Florida. Painter, naturalist and poet who studied with *Hicks, and in Europe (c. 1837–40); worked in Eastern and Midwestern states (1840–60); visited Latin America often; settled in St Augustine (1885). Heade is best known for his bird- and flower-paintings, characterised by glowing luminosity and exquisite detail.

HEARTFIELD, John (Helmut HERZFELDE) (1891–1968)

b. d. Berlin. Graphic artist who studied in Munich (1907–10) and Berlin (1912–14). *Dadaism, reaching Berlin in 1918, naturally attracted the Communist Heartfield. Dada protest, using all the instruments of satire, bluff, irony and finally violence, focused his energies. An inventor and brilliant exponent of photomontage, Hartfield's posters, book designs, etc have a directly propagandist intention alien to Dadaist individualism. Through his brother Wieland's publishing house Malik-Verlag, and later from England (1938–50), he attacked fascism and returning to East Germany (1950), was honoured for it.

Left: JOHN HEARTFIELD *A Voice out of the squalor.* 1936. Photomontage
Top right: JAN DE HEEM *Still-Life with a Lobster.* $31\frac{1}{4}$×$40\frac{7}{8}$ in (79×104 cm). Wallace
Near right: WILLEM HEDA *Still-life.* 1648. Hermitage
Far right: ERICH HECKEL *In the Madhouse.* 1914. $27\frac{3}{4}$×$31\frac{3}{4}$ in (70·5×80·5 cm). Mönchen Gladbach Museum

HEATH, Adrian (1920–)

b. Burma, of British parents. Painter who studied at the Slade School of Art (1942–5), Heath was among the earliest defenders of abstract art in England. He began exhibiting geometric abstractions in 1949. Later works are more painterly with the addition of curvilinear elements.

HECKEL, Erich (1883–1970)

b. Döbeln, Saxony d. Radolfzell. German painter, self-taught while studying architecture. With *Kirchner and *Schmidt-Rottluff he founded die *Brücke group (1905). Abandoned architecture for painting (1905). His art, characteristic of *Expressionism, reveals self-doubt and a sense of man's isolation in an isolated world. Less violent in feeling than his fellow members, Heckel's work nevertheless has a frenzied quality through the use of pure colours in dramatic juxtaposition. His later works, by contrast, became more subdued. He was declared 'degenerate' by the Nazis.

HEDA, Willem Claesz (1594–1680/2)

b. d. Haarlem. Dutch still-life painter, together with *Pieter Claesz the most important exponent of the *ontbijt* or breakfast-piece. Heda's pictures, however, are notably more aristocratic in choice of subject – he painted oysters as opposed to Claesz's herrings, dishes of silver rather than pewter – and more sensitive in execution.

HEEM, Jan Davidsz de (1606–84)

b. Utrecht d. Antwerp. Dutch still-life painter, the most brilliant member of a large family of artists. He worked in Utrecht, Leiden and Antwerp, specialising in very elaborate and rich flower- and fruit-paintings.

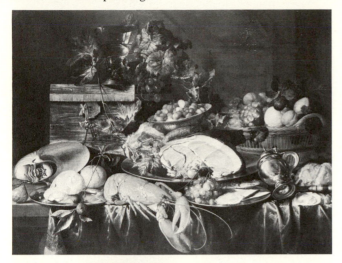

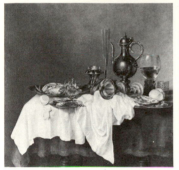

HEEMSKERCK (VEEN), Maerten van (1498–1574)

b. Heemskerck d. Haarlem. Netherlandish *Mannerist painter who had worked in Haarlem (1527–8) with *Scorel before visiting Rome (1532–6). Thenceforth resident in Haarlem. His earliest surviving work is already mature: *Family Portrait* (c. 1530, Kassel) shows the influence of Scorel in the Italianate monumentality and free handling. Even before he visited Rome, Heemskerck painted with full knowledge of *Mannerist ideas, eg *St Luke Painting the Virgin* (c. 1532, Haarlem). In Rome he sketched antique art and these drawings provide important documentary evidence of the state of ancient Roman monuments at that time. He also studied contemporary art and was more influenced by post-†Renaissance painters, eg *Pontormo, than by the more classic style, eg *Michelangelo.

Later his style became gentler, with a subsequent emphasis on pathos. His *Self-Portrait* (1553, Fitzwilliam) succeeds by a more apt use of Mannerist asymmetry and disparity of scale.

HEGESO, Stele of (c. 400 BC)

A fine Athenian grave relief showing a dead woman holding a casket containing a necklace brought as an offering by a young girl. The sculpture is in medium relief and the modelling of the drapery is very fine. (Kerameikos, Athens.)

HEIAN AND KAMAKURA HANDSCROLLS

Japanese scroll-paintings are read like a book from right to left. They may be all painting, or paintings divided by text, and the main characters will reappear in each scene. In the 10th century Japanese texts and stories were used for the first time, and with

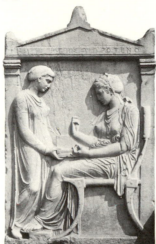

Left: HEGESO, Stele of. Marble. h. 4 ft 11 in (1·49 m). National Museum, Athens

Below: MAERTEN VAN HEEMSKERCK *St Luke Painting the Virgin.* c. 1532. 66⅛×92½ in (168×235 cm). Frans Hals Museum, Haarlem
Bottom: HEIAN AND KAMAKURA HANDSCROLLS *The Burning of the Sanjo Palace.* 13th century. h. 16¼ in (41 cm). Fenollosa-Weld Coll, Boston

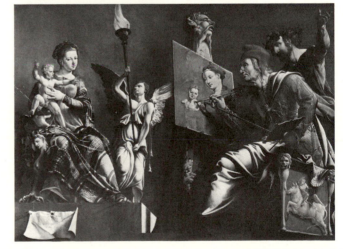

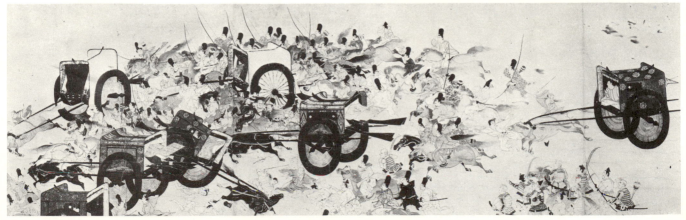

this comes the rise of two distinct and purely Japanese styles, the *Yamato-e and the vigorous genre-painting of the Heian and Kamakura period handscrolls. The latter appear in different forms. There are stories of miracles and the lives of great Buddhist figures, such as the *Shigisan-engi* which is partly humorous, or the biography of Hsüang-chuang which is poetic and beautiful, and there are rhetorical Buddhist scrolls such as the Hell scrolls. There are secular stories such as the *Heiji monogatari*, and caricatures and satires such as the *Choju-giga*. It is from these styles that the less Chinese aspects of Japanese art descend.

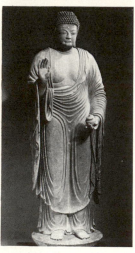
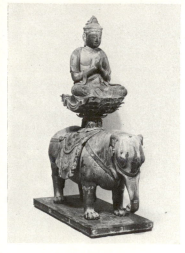

Top: HEIAN AND KAMAKURA HANDSCROLLS *Hsüanchuang makes a pilgrimage to the sacred site of Jetavara.* 13th century. h. 15⅞ in (40·3 cm). (Section 1 of 5th screen). Fujita Art Museum, Osaka
Above left: HEIAN SCULPTURE Yakushi Nyorai. Heian period, last quarter 9th century AD. Wood. h. 66 in (167·7 cm). Gankōji, Nara
Above right: HEIAN SCULPTURE Fugen Bosatsu. Late Heian period. h. 21¾ in (55 cm). Okura Cultural Foundation, Tokyo

HEIAN SCULPTURE (AD 784–1185)

A ponderous style of Japanese wooden sculpture which had developed from the wooden sculpture of the *Tōshōdaiji flourished in the early Heian period. The Yakushi Nyorai in the Gankōji illustrates the broad masses of shoulders, neck, chest and thighs separated by sinuous drapery folds characteristic of this group. Mannered emphasis on drapery with an insistent repetition of pairs of higher chiselled ridges separated by lower ridges is found on some of these sculptures particularly the images in the *Murōji. A few concessions to naturalistic detail and ornament lingering from the *Nara styles are seen in some images of minor deities of the *Shingon sect. The later Heian period saw a return to a more gentle, serene style epitomised in the work of *Jōchō. Examples of the

fine perhaps over-delicate style, fostered by the use of the *yosegi technique then prevalent is the Fugen Bosatsu in Okura Museum, Tokyo.

HEILIGER, Bernhard (1915–)

b. Stettin, then Germany. Sculptor who worked with *Maillol in Paris. At a point when German artists were effectively isolated from contemporary developments, Heiliger continued to base his work on modern French sculpture. In the 1950s, as the quasi-official representative of the avant-garde, he produced several civic commissions. These were mostly hanging or vertical constructions in bronze or aluminium which attempted to represent flight or speed. Heiliger became Professor of Sculpture at the Berlin Academy (1949).

HEITIKI see NEW ZEALAND

HELD, AI (1928–)

b. New York. Painter who studied at *Art Students' League, and in Paris at Académie de la Grande Chaumière with *Zadkine (c. 1949–52). From political *Social Realism, Held moved towards *hard-edge abstractions, combining the influences of *Pollock and *Mondrian in boldly coloured huge canvases, composed first of letters, then geometric shapes.

HELION, Jean (1904–)

b. Couterne. Painter who studied engineering and architecture and was introduced to *Cubism by *Torrès-Garcia and to *De Stijl by *Mondrian (1926), combining both styles until he met *Van Doesburg and contributed to *Art Concret (1930). He was a member of the *Abstraction-Création group producing powerful abstract paintings of modelled machine-like forms rhythmically arranged on grounds suggesting depth. He was in America (1937–9) and later reverted to representational painting bordering on *Surrealism.

JEAN HELION *Ile de France.* 1955. 57¼ × 78¾ in (145·4 × 200 cm). Tate

HELLADIC ART

A name applied to art on the Greek mainland from the Stone Age until the beginnings of the *Mycenaean civilisation. At first development was slower than that of *Minoan art, because there was less contact with Egypt, but fresh impetus was given to Helladic art by invaders (c. 1900 BC), perhaps from Anatolia, who produced the fine *Minyan pottery. By 1550/1500 BC Minoan influence was very strong as can be seen by the famous *Vaphio Cups found in Laconia. As Minoan power declined (by 1400 BC), *Mycenaean culture became dominant.

HELLENISTIC ART

The period following the death of Alexander the Great (323 BC) up to the 1st century BC when his empire was finally

taken over by the Romans, is known as the 'Hellenistic period'. After Alexander's death, his empire was split up and three main artistic centres emerged, *Rhodes, *Alexandria and *Pergamon. The period is marked by an increasing interest in human moods and emotions and sympathy for the individual. The art of realistic portraiture is developed. Genre subjects, allegory and landscape are all popular themes. The attempt to capture the emotional climax of a great event results in a violent and Baroque style of sculpture which, especially at *Pergamon, declines into empty theatricality by the 2nd century BC. Classical influence never died during the period and there is a continual return to earlier types. This produces an extremely varied series of styles compared with the steady progression of the classical period.

BARTHOLOMEUS VAN DER HELST *Family Group*. 1654. 67¼×78⅛ in (171×198 cm). Wallace

HELST, Bartholomeus van der (1613–70)

b. Haarlem d. Amsterdam. Dutch portrait painter. His talent was unexceptional, but his smooth †Baroque style was very popular and influential, and painters such as *Bol and *Flinck abandoned their master *Rembrandt's manner for his.

HEMESSEN, Jan Sanders van (c. 1500–after 1563)

b. Hemiksem d. Haarlem. Netherlandish painter, a pupil of Hendrick van Cleve in Antwerp (1519). Dated works 1531–60. His figures are monumental and vigorously three-dimensional. Various of the Deadly Sins often comprise his subject-matter.

HEMESSEN, Katharina de (1527/8–after ?1566)

Antwerp painter, the daughter of Jan van *Hemessen. Probably went to Spain (1556) with Mary of Hungary. Most of her signed pictures are small female portraits, the sitters having a pensive quality closer to the work of Hans *Holbein the Younger than that of her father.

HENNER, Jean-Jacques (1829–1905)

b. Bernwiller d. Paris. French artist who studied at Altkirch and Strasbourg and then at Paris with Drolling and Picot. He painted portraits in Alsace and then spent seven years in Rome. *Correggio was a strong influence on his treatment of chiaroscuro. His limited theme became the figure in an idealised landscape setting.

HENRI, Robert (Robert Henry COZAD) (1865–1929)

b. Cincinnati, Ohio d. New York. Painter who studied at Pennsylvania Academy (1886–8), at Académie Julian and Ecole des Beaux-Arts, Paris (1888–91), in France, Spain and Italy; taught at *Chase School, Henri School and *Art Students' League (1916–28); exhibited with The *Eight (1908) and *Armory Show (1913). As leader of The *Eight, Henri influenced American Realists enormously. His broadly brushed, solidly built portraits and urban scenes radiate his

ebullient love of life and the individual. He was perhaps most important as a teacher between 1890 and 1913, the Henri 'School' being more of a gathering-place for dissidents from the Pennsylvania Academy.

ROBERT HENRI *Mary*. Addison Gallery of American Art, Phillips Academy, Andover

HENRY, Edward Lamson (1841–1919)

b. Charleston, South Carolina d. Ellenville, New York. Painter who studied at Pennsylvania Academy, and with *Gleyre and *Courbet in Paris, and lived in Europe (1860–3, 1871, 1875, 1881). His dry, detailed, fussy paintings of American history won great popularity; his landscapes and genre scenes are slightly fresher.

HEPWORTH, Barbara (1903–)

b. Wakefield. British sculptress who studied at Leeds Art School with Henry *Moore (1920) and the Royal College of Art (1921). Influenced by *Brancusi, Barbara Hepworth produced smooth-surfaced abstract pieces, carving directly in stone or wood, exploring a limited range of primary forms (1933–4). She achieves greater complexity in her later works utilising string, colour and pierced forms and, since 1958, she has also worked with plaster, casting in bronze. Inspiration for her calm, icon-like sculptures come from man, nature and her close relationship with her material.

Above: BARBARA HEPWORTH *Pelagos*. 1946. Wood, colour and strings. 14½×15¼×13 in (36·8×38·9×33 cm). Tate
Left: HERAT SCHOOL *Firdusi and the Three Poets*. Royal Asiatic Society, London

HERAT SCHOOL (TIMURID SCHOOL) (1425–33; 1468–1507)

The Herat School represents the peak of refinement in Persian painting. Sultan Baysunqur assembled at his court some of the leading artists of his day, who produced in a remarkably short space of time work of the highest quality. The composition of the paintings observes the traditional formulae; use of diagonal or circular forms, a concentration of detail to the left. Elongated figures with over-large heads dominate the scenes, with frail-looking horses. A Chinese influence is apparent but highly stylised in cloud, flame, rock and tree treatment with the

popular mythical animals and birds. After the confused years of the mid-century, a more linear style developed, but with the increased use of a stronger palette including gold. By the end of the century the accent is on decorative motifs in elaborate compositions; small rocks, twisted flowering trees, polygonal pavilions with tile-work and railings in the background and ducks on ponds in the foreground frequent the miniatures. This was to be continued in the later Persian schools and also to influence the 16th-century Ottoman calligraphic drawings and *Mughal painting.

HERBIN, Auguste (1882–1960)

b. Quiévy d. Paris. Attended the Ecole des Beaux-Arts in Lille (1898). Developed through †Impressionist and *Cubist styles. From an interest in works by *Giotto, Fra *Angelico and *Piero della Francesca, his painting progressed (after 1938) towards an investigation of the relationships between flat, hard-edged colour and simple geometric shapes.

HERDER, Johann Gottfried von (1744–1803)

b. East Prussia d. Weimar. German philosopher, and initiator of the Romantic literary movement, *Sturm und Drang*. His impact on †Romantic painters was equally powerful; his aesthetic doctrines included the idea that art should possess a moral content and express the beautiful and the good.

HERING, Loy (c. 1484–c. 1555)

b. Kaufbeuren, Swabia. German sculptor who settled in Eichstätt (1513) after an apprenticeship in Augsburg and a probable visit to Italy. Italian inspiration helped him achieve a grand monumentality in his stone sculpture. His later small-scale works, although †Renaissance in form, show influence of *Baldung and *Dürer in content.

HERKOMER, Sir Hubert von (1849–1914)

b. Waal, Bavaria d. Budleigh Salterton. Settled in England (1857), studied at the South Kensington Schools, and then drew subjects of social concern for the *Graphic* and other illustrated magazines. Practised all the arts, his activities in print-making, the theatre, the cinema, in painting and carving, centred on a colony he founded in Bushey, Hertfordshire.

Left: HUBERT VON HERKOMER *On Strike*. 1891. 89¾×49¾ in (228×126·4 cm). Royal Academy, London
Right: FRIEDRICH HERLIN *Female Donors in the Stalls*. 1462. Städtisches Museum, Nordlingen

HERLIN, Friedrich (active c. 1459–c. 1499)

b. ?Rothenburg d. ?Nördlingen. German painter whose first dated work, an altarpiece in Nördlingen (1459), depends on the circle of Rogier van der *Weyden. His painting generally is a less-developed version of the Netherlandish style, his

gaucheness in terms of spatial description and psychological expression lending a naïve quality to his art.

HERM

Pillar surmounted by a human head, especially a bearded Hermes; the genitals are usually carved on the pillar. The short herm form was much used in Roman times for portrait heads.

HERNANDEZ, Gregorio see FERNANDEZ

HERON, Patrick (1920–)

b. Leeds. English painter who studied at the Slade School of Art (1937–9). In addition to painting, Heron wrote *The Changing Forms of Art* (1955). He was converted to non-figurative art under the influence of American abstractionists like *Rothko (1956). He describes the subject of his work as 'colour and the space that colour generates'.

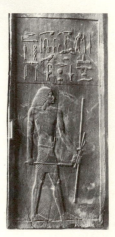

Above left: PATRICK HERON *Purple Shape in Blue*. 1964. 51¾×47½ in (131·4×120·7 cm). Tate
Above right: HESYRE Panel from the mastaba of Hesyre at Saqqara. 3rd dynasty. Wood carved in low relief. h. 3 ft 9¼ in (1·15 m). Egyptian Museum, Cairo
Left: FRANCISCO HERRERA *St Basil Dictating his Rule*. 1639. 98½×76⅞ in (250×195 cm). Louvre

HERRERA, Francisco (c. 1590–1656)

b. Seville d. Madrid. Spanish painter, working in Seville (c. 1610–40) where he decorated the Episcopal Palace, and thereafter in Madrid. Of violent disposition, but technically brilliant, he painted with liquid brushstrokes in a powerfully expressive style. Contemporaries admired his kitchen-pieces.

HERZFELDE, Helmut see HEARTFIELD, John

HESDIN see JACQUEMART DE HESDIN

HESSELIUS, Gustavus (1682–1755)

b. Sweden d. Philadelphia. Painter who went to America (1711) and settled in Philadelphia. Primarily a portraitist, Hesselius also did history-paintings. His work developed from †Baroque formula towards American Realism, occasionally dull, at best perceptive. He is chiefly known today as the first American artist to have painted scenes drawn from classical poetry (eg *Bacchus and Ariadne*, Detroit).

HESSELIUS, John (1728–78)

b.d. Philadelphia. Portrait painter, son of Gustavus Hesselius; first worked in Philadelphia, then settled in Maryland. Influenced by *Wollaston, Hesselius abandoned his †Baroque style for the †Rococo manner; his work shows a firm grasp of form, some psychological insight, and a disagreeable, but popular, slickness.

HESYRE

Egyptian courtier of the 3rd dynasty, whose tomb at *Saqqāra contained a remarkable series of wooden panels with figures of the deceased and *hieroglyphs carved in fine low relief. The walls bore painted representations of various objects, the earliest known that are wholly Egyptian in style and convention.

HEYDEN, Jan van der (1637–1712)

b. Gorkum d. Amsterdam. Dutch painter of still-lifes, landscapes and (most importantly) townscapes, which he was the first artist in Amsterdam to paint. He was also a scientist, and published descriptions of his inventions illustrated with his own engravings.

HICKS, Edward (1780–1849)

b. d. Bucks County, Pennsylvania. A coach- and sign-painter and Quaker preacher, Hicks became the best-known primitive painter in 19th-century America. He painted over one hundred versions of *The Peaceable Kingdom*, in which his precise craftsmanship, delightful flat patterns and stylised, naïve imagery literally embody his profound Quaker beliefs.

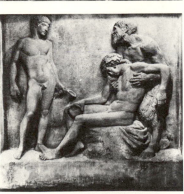

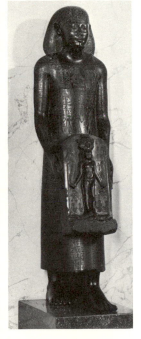

Top left: EDWARD HICKS *The Peaceable Kingdom.* 17½×23⅝ in (44·5×60 cm). Brooklyn Museum, New York, Dick S. Ramsay Fund
Above left: ADOLF VON HILDEBRAND *Dionysos.* 1888. Terracotta relief. 57½×56¾ in (146×143 cm). Wolfgang Braunfels Coll
Above right: HIEROGLYPHS Magical statue of Petemios. 30th dynasty – early Ptolemaic. Black basalt. h. 26¾ in (68 cm). Louvre

HIEROGLYPHS

One of the earliest functions of representational art was to re-create events, and Egyptian hieroglyphs were essentially an extension of visual narrative. On palettes and other pieces of early dynastic date it is sometimes difficult to distinguish the 'written' elements, and even when fully developed the system of writing retained its pictorial character, the signs being neatly grouped without irregular gaps, and often beautifully detailed. In two-dimensional representation, descriptive 'labels' and short inscriptions were always treated as integral to the composition, just as a name was considered essential to any statue. The phonetic values of individual hieroglyphs were derived from original logograms depicting the object named, and the pictures were then adapted to other words or syllables of the same sound, that could not be represented otherwise – perhaps at first in the writing of proper names – with purely pictorial ideograms retained as 'determinatives' to assist the meaning. In later times, many signs acquired additional values and were used cryptically, which led to their being misunderstood by classical authors, who believed they were esoteric symbols without phonetic significance. This view, epitomised in the treatise of Horapollo, was universally held in the Renaissance, and greatly influenced the overall attitude to things Egyptian until the discovery of the Rosetta Stone. *See also* MENSA ISIACA; NARMER PALETTE

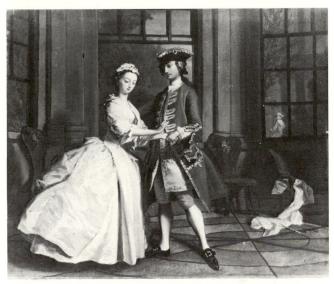

JOSEPH HIGHMORE *Pamela and Mr B in the Summer-house.* 1745. 24¾×29¾ in (62·9×75·6 cm). Fitzwilliam

HIGGINS, Eugene (1874–1958)

b. Kansas City, Missouri d. New York. Painter who studied in St Louis and in Paris (1894–1904) with *Laurens, Constant and *Gérôme, and exhibited at *Armory Show (1913). Influenced by *Millet, his genre paintings of the poor and downtrodden are imbued with compassion, strength and dignity.

HIGHLANDS, NEW GUINEA

Art in this area of *New Guinea has been limited to self-decoration and carving of abstract patterns on shields and other objects. Stone-carvings have been found which predate European contact.

HIGHLIGHT

Relatively the lightest part of the tonal range in a picture or print. The shine on the surface of sculpture.

HIGHMORE, Joseph (1692–1780)

b. London d. Canterbury. English portrait painter, influenced by contemporary French art. Interested, like *Hogarth, in genre and historical scenes, he painted twelve illustrations to Richardson's novel *Pamela* by 1745, and presented a *history painting to the Foundling Hospital (1746).

HILDEBRAND, Adolf von (1847–1921)

b. Marburg d. Munich. German sculptor who studied at Nuremberg and Munich. For more than twenty years he remained in Italy where he met Hans von *Marées and Conrad

*Fiedler. The latter's aesthetic theories he adapted to sculpture in his own book *The Problem of Form* (1893). Fiedler formulated his own ideas in contact with Marées and Hildebrand, who was concerned with volume and dignity in his portrait busts, full-length figures and works for architecture. His finest public monuments were the *Wittelsbach Fountain* at Munich and the bronze equestrian statue of Bismarck at Bremen.

HILDESHEIM, Abbey of St Michael

Bishop Bernward (d. 1022) founded and built the famous Abbey of St Michael which he embellished with a number of metal fittings, notably some bronze doors, two bronze columns modelled in Roman antiquities and a pair of candlesticks. The workshop in which these were made was the first in northern Europe to produce metalwork on a large scale and it exercised considerable influence on the subsequent evolution of medieval sculpture.

HILL, Anthony (1930–)

b. London. English artist influenced by *De Stijl and *Constructivism. His art is pure abstraction, rationally concerned, like that of Kenneth and Mary *Martin, with the problems of interrelationships within structures. He has worked towards this 'concrete' reality through painting in the *Op-Art manner, through relief constructions and a significant contribution in writing.

HILL, Carl Frederik (1849–1911)

b. d. Lund. Swedish painter trained at the Stockholm Academy (from 1871). Worked in Paris mainly on landscapes (1873–81). Many of these were drawn in chalk, and have a tonal range similar to *Corot's, while reflecting his own mental instability in a proto-*Expressionist handling.

HILL, David Octavius (1802–70)

b. Perth d. Edinburgh. Scottish artist and photographer. He studied and exhibited in Edinburgh. In the 1830s he contributed landscape illustrations to editions of Scott and Burns. He teamed with Robert Adamson (1843–7) to produce calotype portraits of the highest quality, and for which he is now best known. He also made landscape photographs.

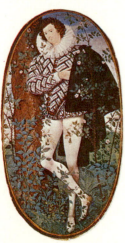
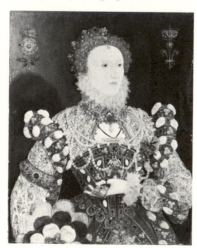

Left: NICHOLAS HILLIARD *Young Man amid Roses. c.* 1590. 5¼×2¾ in (13.5×7 cm). V & A, London
Right: ATTR. NICHOLAS HILLIARD *Queen Elizabeth I. c.* 1575. 30¼×23½ in (76.8×59.9 cm). Walker Art Gallery

HILLIARD, Nicholas (1547–1619)

b. Exeter d. London. English painter principally of miniatures. Became *Limner to Queen Elizabeth (c. 1570). Later served James I. Unlike contemporary 'official' portraits his miniatures were painted as intimate mementoes of individuals, often laced with amatory symbolism, intended to be cherished as jewels. His portraits, unlike those by his rival *Oliver, are

conceived in terms of line rather than shadow, as postulated in his *Treatise on the Art of Limning* (c. 1601). This also tells that the aim of his art was to capture the fleeting 'witty smilings' of his aristocratic sitters. Hilliard's later work, eg *Sir Anthony Mildmay* (c. 1605), is less successful, due to the introduction of compositional devices from large-scale painting. He modelled his miniature technique on that of *Holbein the Younger.

HILTON, Roger (1921–)

b. London. English painter who studied at the Slade School of Art (1929–31) and in Paris (1931–9). Reducing his traditional language to relatively few defined shapes, earth colours and textures, in the 1950s he championed a self-sufficient abstraction. In effect he remained close to the landscape abstractions of St Ives, where he worked (1957). His recent work achieves a *Matisse-like adjustment of flat surface and figurative image.

ROGER HILTON *September 1961*. 1961. 35×42 in (88.9×106.7 cm). Tate

HINAYANA

Sanskrit: literally 'Low Way'. A term invented by the adherents of the *Mahāyāna school of Buddhism to designate *Theravāda, the Doctrine of the Elders, which was the earliest institutionalised religion derived from the teachings of the *Buddha. Its scriptures were written, in the Pali language, some four hundred years after the death of the Buddha. It is today a living religion in Sri Lanka, Burma, Thailand, Cambodia and Laos.

HIROSHIGE (Ando Hiroshige) (1797–1858)

Japanese printmaker, originally a pupil of *Toyohiro. Following the success of *Hokusai, he came to specialise in landscape. He produced *The Famous Views of Edo* (1831) and in 1833 began his great series *The Fifty-three Stations of Tokaido*, his popularity becoming even greater than that of the ageing Hokusai.

HIROSHIGE *White Rain.* Early 19th century. Woodblock colour print. Oban, approx 10×14 in (25.4×35.6 cm). Ashmolean

HIRSCH, Joseph (1910–)

b. Philadelphia. Painter who studied at Philadelphia Museum, with *Luks at *Art Students' League, in France (1949); travelled extensively abroad (1935–6); worked for *WPA; was World War II artist-correspondent; taught at Art Students' League. His Urban Realism, first bitingly satirical, has become

more objective and painterly, monumentalising the humblest subject.

HIRSCH, Stefan (1899–1964)

b. Nuremberg, Germany d. New York. Painter and print-maker who studied at University of Zürich, went to United States (1919), and studied there. His earlier *Precisionist paintings of industrial architecture and cityscapes were austerely geometric; later he loosened his technique and painted figures and landscapes, retaining his refined structure.

HISTORY PAINTING

In 18th-century academic theory, painting was divided according to subject-matter, history painting being accorded first place. Subjects were chosen from mythology and classical antiquity and later from the Bible, but it was not until the late 18th century that it came to include general historical subjects or even contemporary events. Although the term has a general application to European art, it was with the British artists James *Barry and Gavin *Hamilton, and the deluded Benjamin *Haydon, that history painting became distinct. In the 19th century the trend toward historicism became increasingly marked, with heavy moral and sentimental overtones, provoking strong reactions.

HITCHENS, Ivon (1893–)

b. London. English painter who studied at the Royal Academy Schools and since 1940 has painted in Sussex. From a family of painters, Hitchens belongs to the English landscape tradition. His contribution to the 'Objective Abstractions' exhibition (1934) already showed him transforming landscape into broad flat areas of subtly related colours.

IVON HITCHENS *A Boat and Foliage in five Channels*. 1970. 24×64 in (61×162·6 cm). Waddington Galleries, London

HITTITE ART

Although contemporary texts describe free-standing cult statues, Hittite art survives almost entirely in relief sculpture, examples of which have been found in widely separated parts of *Anatolia. Executed during the Empire Period (c. 1500–1200 BC), these reliefs seem almost exclusively religious (although a lighter vein appears at *Alaca) and show a preponderance of kings and deities presented according to certain conventions of pose and costume. The frontal torso of Hittite male figures with head and limbs in profile is a pre-Greek treatment general in the Near East; Hittite goddesses, however, are presented in full profile. At *Hattusas, the capital, and at *Yazilikaya, the sculpture is further distinguished by vigorous modelling and by the extreme height of the relief. Motifs ultimately from *Egypt and *Mesopotamia occur frequently in Hittite art. Hurrian influence on Hittite culture was particularly strong, but its effects on the art are problematical. However, despite its obscure origins and undoubted foreign influence, the style of Hittite art is original and recognisable among the contemporary styles of other regions.

HOARE, William (c. 1707–99)

b. Eye, Suffolk d. Bath. English painter. In Italy (1728–37), he settled in Bath (1738), where he was the leading portraitist until *Gainsborough's arrival (1759). Particularly noted for his pastel portraits, he also painted for Bath churches and the General Hospital.

HOBBEMA, Meindert (1638–1709)

b. d. Amsterdam. Dutch landscape painter. His style is based on that of his friend and master, *Ruisdael, and although he may lack Ruisdael's depth of feeling and range of subject-matter, his work has great freshness and clarity. Favourite subjects were water-mills, which he painted again and again and trees round a pool. His most famous work however is *The Avenue, Middelharnis* (NG, London). *See* PERSPECTIVE

MEINDERT HOBBEMA *A Woody Landscape with a Cottage on the Right*. c. 1665. 39⅛×51⅜ in (99·5×130·5 cm). NG, London

HOCH, Hannah (1889–)

b. Gotha. Painter who studied and still lives in Berlin. As *Hausmann's and later *Schwitters's girl-friend she took part in *Dadaism (from 1918). Surrounded by mementoes of Dada, she continues to make photomontages and collages, but her intention is whimsically personal rather than political.

HOCKNEY, David (1937–)

b. Bradford. English painter who studied at Bradford (1953–7) and the Royal College of Art (1959–62). Influenced by *Kitaj, Hockney helped launch British *Pop Art at the 'Young Contemporaries' exhibition (1961). A well-known artistic personality, his wit and humanity inform all his work. Originally influenced by *Dubuffet, his line-etchings typify the purity of his later style. An acute observer even while working from poetry and imagination, his visits to California (from 1963) inspired an increasingly straightforward realism, though always allied to a cool awareness of the artificiality of his medium.

DAVID HOCKNEY *Mr and Mrs Clark and Percy*. 1970–1. Acrylic. 84×120 in (213·4×304·3 cm). Tate

HODGES, William (1744–97)

b. London d. Brixham, Devon. English painter and engraver of picturesque scenery, stylistically dependent on *Wilson. He was Cook's official painter (1772–5) in the South Pacific, bringing back a remarkable series of exotic landscapes executed there, and worked in India (1780–4).

HODGKINS, Frances (1869–1947)

b. Dunedin, New Zealand d. Dorset. Painter who studied in Dunedin and travelled widely in Europe and Britain (from 1901). Freeing herself gradually from *School of Paris mannerisms, most dominant in the 1930s, her later landscapes combine subtle, muted colours with a free, calligraphic technique.

HODLER, Ferdinand (1853–1918)

b. Bern d. Geneva. Swiss painter, a pupil of Barthélemy Menn. His early work, mainly portraits, reveals an admiration for *Holbein. The whole character of his art and life changed after something of a religious crisis (1880), and in the 1890s he was one of the many Swiss artists to exhibit with the *Rosicrucians in Paris. He spent all of the year 1890 at work on *Night*, the first work to amplify his theories of parallelism, to intensify the effect of the allegorical content by symmetrical repetitions of similar forms. When painting landscapes, he chose appropriately symmetrical and balanced views.

FERDINAND HODLER *The Battle at Näfels*. 1896–7. Tempera. 19½×37½ in (49.5×95 cm). Kunstmuseum, Basle

HOFER, Karl (1878–1955)

b. Karlsruhe. German painter who studied in Stuttgart, Zürich and Rome. Exhibited with Neue Kunstlervereinigung ('New Association of Artists') (1909). Member of Prussian Academy (1923). Hofer rejected *Expressionism in favour of a structural calm and objectivity derived from *Cézanne and the classicism of Hans von *Marées. *See also* KANDINSKY

HOFMANN, Hans (1880–1966)

b. Weissenburg, Bavaria d. New York. Painter and influential teacher who studied in Munich (1904–7), worked in Paris (1907–14), led own school in Munich (1915–32) and New York (from 1934); went to America (1932). Hofmann's style evolved through *Expressionism, *Cubism and *Fauvism to *Abstract Expressionism, using concentrated colour to construct vibrating spatial effects.

HOGARTH, William (1697–1764)

b. d. London. English satirical painter and engraver who commented mordantly on contemporary life. He studied painting under *Thornhill, whose daughter he married. He made his name with a *Scene from the Beggar's Opera* (1728), although at this time he relied on portraiture and *conversation pieces for a living. He painted a moralising series *The Harlot's Progress* (1731, lost), following this with other series such as *The Rake's Progress* and *Marriage à la Mode*, filled with highly charged characterisation and detail. Fervently patriotic, he aimed to found a national school of comic painting, using modern subjects in contrast to the Italian *history painting popular with collectors, although he produced occasional history-pictures himself. He took over the St Martin's Lane Academy (1734) which became a centre for life drawing from the model and he published a theoretical treatise *The Analysis of Beauty* (1753).

HOGUE, Alexandre (1898–)

b. Memphis, Missouri. Painter who grew up in Texas and studied at Minneapolis Institute of Arts. Hogue's terse, realistic paintings of the devastated Texas dustbowl reveal its eroded skeleton, paradoxically giving its horror more impact with his straightforward accuracy.

HOHOKAM

A Pre-European desert culture from Arizona with a long history in the *Southwest Area, although it was most active about AD 1200–1400. Hohokam art includes pottery vessels and figurines painted red on buff, carved stone and shell ornaments, stone paint-palettes, and mortars and vessels ornamented in relief with stylised animals, birds and human figures.

HOITSU (Sakai Hoitsu) (1761–1828)

Japanese painter who studied under various schools. but became an admirer of the works of *Kōrin, publishing *Kōrin hyakuza* ('One hundred Masterworks of Kōrin') and started a revival of the *Rimpa style.

HOKUSAI (Katsushika Hokusai) (1760–1849)

Japanese printmaker who trained as a woodblock engraver before becoming a pupil of *Shunshō. Abandoning Shunshō's style (1795) he experimented in almost every style, *Kanō, Chinese, even Western, when he studied under Shiba *Kōkan. His most famous published works are the *Manga*, 'random sketches' of very uneven quality and his great *Thirty-six Views of Fuji* in which he initiated the *Ukiyo-e style of landscape painting that was so successfully exploited by *Hiroshige. He was a most inventive and prolific draughtsman and print-designer.

HOLBEIN, Hans the Elder (c. 1460/5–1524)

b. Augsburg d. Isenheim. German painter, father of *Holbein the Younger. Early travel to the Netherlands resulted in compositional dependence upon Rogier van der *Weyden. He collaborated with Michel Erhart on the *Weingarten Altarpiece* (1493, now Augsburg Cathedral). In Ulm (1499), at Frankfurt (1500–1), but otherwise in Augsburg (1494–1515) where he had a large workshop. Then active at Isenheim and around Basle and Lucerne. His style represents the opposite to *Dürer's calligraphic draughtsman's manner. He had throughout a pictorial emphasis on light and shade, exemplified in many drawings of everyday scenes.

HOLBEIN, Hans the Younger (1497/8–1543)

b. Augsburg d. London. The last great German painter of the 16th century. Even in his early work, two distinct stylistic modes are evident: one, the dramatic use of lighting and composition to impart the fundamentals of a religious narrative (eg *The Dead Christ*, 1521), and the other, a dispassionate and less dramatic portrait style, which primarily gives objective renderings of specific facial features, rather than psychological 'reports' (eg diptych portraits of Jacob Meyer and his wife, 1516). He began his career in Basle, where he went with his brother Ambrosius (1514/15). He was in North Italy (1517–19), and his work of the early 1520s (eg *The Last Supper*, c. 1520–5) shows direct influence of this visit, as did the (now lost) murals he painted for Basle houses, which employed †Renaissance and antique decorative motifs. He went to France (1524) – where he is thought to have learned his technique of drawing in chalk – to the Netherlands (1526) and on to England, where his main work was the (now lost) group portrait of Sir Thomas More and his family. Being quite straightforwardly a portrait of a family with no religious or anecdotal

undertones this work was a forerunner of the 17th-century Dutch group portraits, although it was, in its turn, influenced by *Mantegna's frescoes in Mantua. He went back to Basle (1528), but because of the growing antagonism to art and artists, engendered by the Reformation, and the consequent drop in commissions, he abandoned his wife and family and left for England (1532). Two early paintings of this last period are the portrait of George Giesze (1532) and *The Ambassadors* (1533), both *Mannerist in their richness of colour, texture and symbolism. In 1536 he became Court Painter to Henry VIII, his duties ranging from the design of triumphs to jewellery. His paintings of this period were more lavish in colour and texture with even less emphasis on psychological insight. Only one major work appears in this period, the portrait of Christina of Denmark (1538), who stands serene and dignified above the other ostentatious works of this time.

HOLLANDER, Jan de see AMSTEL

HOLLAR, Wenceslaus (Wenzel) (1607–77)

b. Prague d. London. Bohemian engraver, he was trained by Merian in Frankfurt, but after meeting the Earl of Arundel. came to England, where his most important works, which form an invaluable topographical record of 17th-century English towns, especially London, were produced.

HOLY THORN, Reliquary of

The reliquary was made for a fragment of the Crown of Thorns in the Ste Chapelle, *Paris and was given to the Duc d'Orléans between 1389 and 1407. An elaborate composition of metalwork, enamels and jewellery, it is one of the few surviving examples of a kind of religious art patronised by only the most socially elevated patrons and found only in their private chapels. (Waddesdon Bequest, BM, London.)

HOLTZMAN, Harry (1912–)

b. New York. Painter who studied at *Art Students' League (1928–33); met *Mondrian in Paris (1934); helped found American Abstract Artists; largely abandoned painting to study semantics and teach (c. 1940); published *Transformation* (from 1950). Although Holtzman painted competent *Neo-Plasticist abstractions before 1940, his major contribution was his extensive help to Mondrian.

HOLZEL, Adolf (1835–1934)

b. Olmutz, Austria. Painter who studied at the Vienna Academy and at Munich, and taught at Stuttgart (from 1906). He initially worked in an impressionistic style, later turning to what was in effect abstract impressionism, producing graphic 'ornaments' – strong, convoluted forms in black and white. His coloured compositions, based on interlocking circles and spirals, also explored surface density. Hölzel's work as a teacher was important, several of his pupils moving on to the *Bauhaus.

HOMER, Winslow (1836–1910)

b. Boston d. Scarboro, Maine. Painter and illustrator who first trained as printmaker, then studied briefly at National Academy of Design (1859); depicted Civil War on commission from *Harper's Weekly* (1861); lived in New York (1859–80s) working extensively as a designer of wood-engravings for *Harper's* and other popular journals, visited France (1866–7), England (1881–2); thereafter lived in Maine, visiting Canada, Adirondacks, Caribbean and Florida. Homer first painted genre scenes; later, in Maine, he shifted the emphasis in his pictures from human figures to the elements of landscape and sea. A solitary realist, Homer selected his motif with an unerring eye for design, then used watercolours with luminous freshness and absolute objectivity to record light and shadow playing on form, unconsciously capturing the scene's essential poetic drama.

HONDECOETER, Melchior (1636–95)

b. Utrecht d. Amsterdam. Dutch painter and engraver, the pupil of his father, Gisbert, and his uncle Jan *Weenix. He specialised in still-lifes and often exotic paintings of birds. He had many imitators.

HONDIUS, Abraham (1625/30–1691/5)

b. Rotterdam d. London. Dutch painter of hunting scenes and violent conflicts between animals. He also painted classical and religious scenes, employing †Baroque movement and lighting. He went to Amsterdam (1659) and worked in London (from 1666).

HONORE, MAITRE (active late 13th–early 14th century)

Parisian illuminator who worked for the court, known from documentary references during the reign of Philip the Fair (1285–1314). He is stated to have painted a breviary for the king, probably the Breviary of Philippe le Bel (Bib. Nat., Paris, Lat. 1023). This and other works attributed to him show a delicacy and elegance of design, decorated gold and *diaper grounds and drapery modelled in a way suggesting Italian influence.

HONTHORST, Gerrit van (1590–1656)

b. d. Utrecht. Dutch *history and portrait painter who studied under *Bloemaert. In Rome (1610/12–1620) he painted artificially lit scenes influenced by *Caravaggio. After returning to Utrecht he used a lighter tonality and achieved a more decorative mood. He visited London (1628) and worked at Hampton Court (1628). He lived at The Hague (from 1637) and his later work is mainly conventional portraiture. He was an important link between Italian Caravaggism and Dutch painting.

HOOCH (HOOGH), Pieter de (1629–after 1684)

b. Rotterdam d. Amsterdam. Dutch painter. He was a pupil of Nicolaes *Berchem, presumably at Haarlem, but he spent the greater part of his career at Delft, where he was a contemporary of *Vermeer. His works are less exquisite than Vermeer's, but he approaches him in quality more consistently than any other Dutch genre painter, rendering space, atmosphere and the fall of light in his interior scenes with a beautiful clarity and precision.

HOOGH, Pieter de see HOOCH

HOOGSTRATEN, Samuel van (1627–78)

b. d. Dordrecht. Dutch painter and etcher, noted for trompel'œil *illusionism (one of his peep-show boxes is in the National Gallery, London). He was also an art theorist and wrote one of the few contemporary appraisals of *Rembrandt.

HOPEWELL

A Pre-European Indian culture active in the Ohio-Illinois region between about 300 BC and AD 700. Elaborate burial complexes have produced a variety of grave goods including distinctive incised pottery, and copper and mica cut-out figures and motifs. The most important Hopewell works of art are carved stone platform pipes, often surmounted by naturalistic bird and animal figures. *See also* EASTERN UNITED STATES AND CANADA, ART OF

HOPPER, Edward (1882–1967)

b. Nyack, New York d. New York. Painter, printmaker and illustrator who visited Paris between 1906 and 1910, studied with *Henri, Kenneth *Miller and *Chase, and exhibited at *Armory Show (1913). Under Henri's influence, Hopper discarded his early †Impressionism for a more acute Realism. Often associated with *American Scene painting, Hopper belongs more to the American Realist tradition that flowered with *Copley. In his urban and New England scenes, Hopper uses light of unnatural clarity and deep shadow to reveal the terse structure of form in space, and to evoke an American mood of urban loneliness, silence and arid isolation, even where no figures are present.

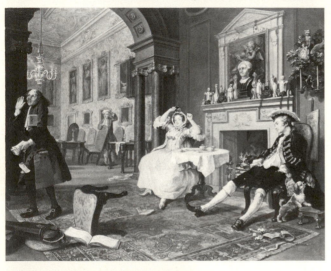
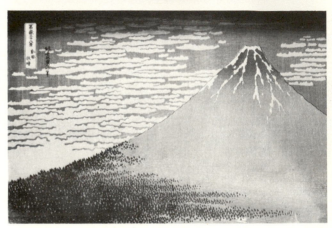

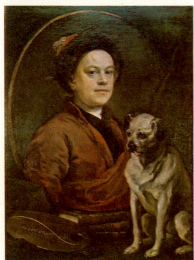
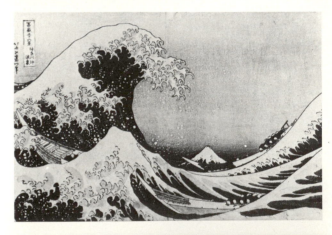

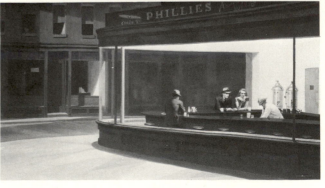

Top left: KARL HOFER *The Black Room.* 1943. 58¾×43⅜ in (149×110 cm). NG, Berlin
Top right: HANS HOFMANN *Smaragd Red and Germinating Yellow.* 1959. Cleveland Museum of Art
Centre: WILLIAM HOGARTH *Marriage à la Mode: Shortly after the Marriage.* 1744. 27½×35¾ in (70×91 cm). NG, London
Above: WILLIAM HOGARTH. *The Painter and his Pug.* 1745. 35½×27½ in (90·2×69·9 cm). Tate
Right hand column top left: HOLBEIN THE ELDER *Fountain of Life.* ?1519. Museu Nacional de Arte Antiga, Lisbon
Right hand column top right: RELIQUARY OF THE HOLY THORN. *c.* 1389–1407. Gold, precious metal and pearls. BM, London

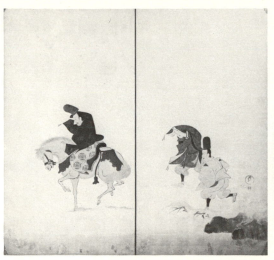

Left second row: HOKUSAI *Red Fuji*. Early 19th century. Woodblock colour print. Oban, approx 10×14 in (25·4×35·6 cm). BM, London

Left third row: HOKUSAI *The Great Wave*. Early 19th century. Woodblock colour print. Approx 10×14 in (25·4×35·6 cm). BM, London

Left: EDWARD HOPPER *Nighthawks*. 1942. 30×60 in (76·2×152·4 cm). Art Institute of Chicago

Top left: HOITSU *The Sano River Crossing*. Two-fold screen. Colour on gold leaf. 4 ft 11⅛×5 ft 1 in (150×154 cm). Joe D. Price Coll, Oklahoma

Above centre: WINSLOW HOMER *West Point, Prout's Neck*. 1900. 30×48⅛ in. (76·4×122·2 cm). Sterling and Francine Clark Art Institute, Williamstown

Above: GERRIT VAN HONTHORST *Supper Party*. 1620. 55⅛×82¾ in (140×210 cm). Uffizi

HANS HOLBEIN THE YOUNGER *Top centre:* Madonna of Burgomaster Meyer. *c.* 1525. 56×40 in (142·5×101·8 cm). Hessisches Landesmuseum, Darmstadt. *Top right:* The Artist's Family. 1528. 32×26 in (76·5×66 cm). Kunstmuseum, Basle. *Above centre:* The Ambassadors. 1533. 81½×82½ in (207×209·5 cm). NG, London

Above left: PIETER DE HOOCH *An Interior c.* 1658. 29×25 7/16 in (73·7×64·6 cm). NG, London

Above right: HOPEWELL Carved steatite pipe. *c.* 300 BC–AD 700, Ohio. l. 3⅝ in (9·2 cm). BM, London

HOPPNER, John (1758–1810)

b. d. London. English portrait painter, stylistically dependent on *Reynolds, and *Lawrence (whose rival he was). Portrait Painter to the Prince of Wales (from 1789), and fashionable in the Prince's circle, his best work is at St James's Palace, London.

HORAPOLLO see HIEROGLYPHS

HORYUJI, THE

Many temples were built in the region round the capital, Nara, during the regency of Prince Shōtoku (592–622). One of these, the Hōryūji, has survived and contains some of the earliest examples of Buddhist art in Japan. The temples were lavishly decorated inside with paintings on wood and plaster, and with embroideries, some of which still survive. The *Tamamushi shrine is decorated with painted panels illustrating a Buddhist story. Most important are the paintings on dry plaster in the sanctuary, the Kondō. Although the temple was burned down (670), the sanctuary was rebuilt by the end of the century and the whole complex rebuilt before 711. The murals, severely damaged by fire (1949), consisted of the Four Paradise scenes according to Chinese convention. Above the paintings are flying *apsarases, fortunately undamaged. The paintings are done in a firm outline of red paint and the colours in mineral pigments. Most of the important stages of Japanese sculpture are also represented. From the *Asuka period there are the Shaka Nyorai triad and the Yakushi Nyorai, both works by the earliest known sculptor, *Tori; also Shaka and Monju, the Yumedono Kannon and the four guardian kings. From the early *Nara period attempts at a more realistic type of sculpture can be seen in the Yumetagae Kannon and the triad of the *Tachibana shrine. From the late Nara period vivid clay figures include the temple guardians, Teishakuten, Bonten and figures decorating the lower storey of the five-storey pagoda, while in the contrasting medium of *kanshitsu are figures of Gyōshin, Sōzu, Amida and Miroku and of the Yakushi triad. Wood is the characteristic medium of the *Heian period and works include the guardians of the four directions and two figures of Prince Shōtoku. A clay figure of Dōsen Risshi illustrates the development of *Japanese portrait sculpture. Belonging to the main school of the *Kamakura period, the *Kaikei School, is the Amida by Kōshō.

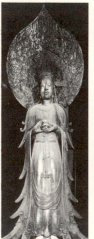
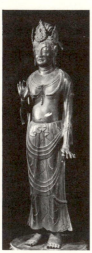

Left: HORYUJI Yumedono Kannon. Asuka period, first half 7th century AD. Wood. h. 6 ft 5⅝ in (197 cm).
Centre: HORYUJI Yumetagae Kannon. Early Nara period, second half 7th century AD. Bronze. h. 34¼ in (87 cm)
Right: HORYUJI The Tamamushi Shrine. Mid-7th century. Detail of painting on the pedestal illustrating the legend of the starving tiger. Oil-bound paint on wood, w. 14 in (35·6 cm).

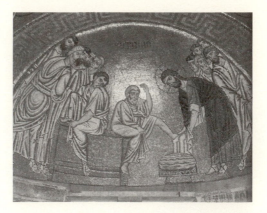

HOSIOS LOUKAS *The Washing of the Feet*. 11th century

HOSIOS LOUKAS, Monastery of

The main church of this Greek monastery was built by 1011 to receive the body of St Luke Stiriotes. Its decorative scheme consists of frescoes in the crypt and a magnificent mosaic cycle in the church above. The style of the mosaics is simple, severe, even abstract, very different from the more naturalistic style of *Daphni and much closer to the style of Haghia Sophia, *Kiev.

HOSKINS, John (1595–1664)

d. London. English miniaturist, who was in much demand at the court of Charles I, and portrayed the king and his wife (Rijksmuseum). Charles I granted him £200 a year for life, as his *Limner. He was the uncle and teacher of Samuel *Cooper.

HOUBRAKEN, Arnold (1660–1719)

b. Dordrecht d. Amsterdam. Dutch painter, but much more important as an art historian. His dictionary of Dutch painters and paintings (*De Groote Schouburgh de Nederlantsche Konstschilders en Schilderessen*, 1718) is the most important source on 17th-century Netherlandish artists.

HOUCKGEEST, Gerrit (1600–61)

b. The Hague d. Bergen-op-Zoom. Dutch painter, specialising in church interiors, sometimes as the background for historical scenes like the *Judgement of Solomon*, and fantastic architecture. After 1638 his paintings were characterised by a light palette, and an impressive sense of space and sunlight.

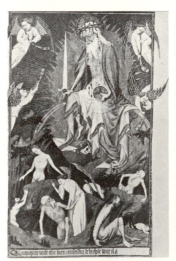

Left: BOOKS OF HOURS, the Master of the Rohan Book of Hours. *The Last Judgement*. c. 1425. Page 11½×8⅛ in (29×20·8 cm). Bib Nat, Paris
Right: JEAN-ANTOINE HOUDON *Voltaire*. 1781. Life-size. Théâtre-Français, Paris

HOUDON, Jean-Antoine (1741–1828)

b. Versailles d. Paris. French sculptor. He was a pupil of *Le Moyne and *Pigalle, and won the Rome Prize (1761). He stayed in Rome (1764–8), winning renown with *St Bruno* (Sta Maria degli Angeli). Returning to Paris, he became a full Academician with his *Morpheus* (1771, Louvre). He enjoyed great success (although he was almost imprisoned at the Revolution), and retired in 1814, becoming senile in 1823. His greatest works are his brilliantly vivid portraits, and he was so renowned for them that he even went to America (1785) to execute a statue of George Washington (Richmond, Virginia).

HOURS, Books of

From the late 13th century onwards, these manuscripts superseded the *Psalter as the private prayer-book of the laity. Their contents, arranged according to the eight canonical hours of the day, include a calendar, the Hours of the Virgin, Penitential Psalms and a Litany of Saints. Secular patronage encouraged the increase of elaborate whole-page scenes, interspersed among text pages decorated with numerous *grotesques. The most splendid Books of Hours were produced in late medieval France and Italy.

HOVENDEN, Thomas (1840–95)

b. County Cork, Ireland d. Plymouth Meeting, Pennsylvania. Painter who studied at Cork School of Design, at National Academy of Design, New York (1863), in Paris with *Cabanel (1874–80); settled in Philadelphia and taught at Pennsylvania Academy. Hovenden's popular genre and figure paintings had more quantity than quality in their size and exact detail.

HOWARD, Charles (1899–)

b. Montclair, New Jersey. Abstract/*Surrealist painter who trained in the Bouché and Guertler decorating shop in New York (1926–31), then lived in England (1933–40) where he was associated with the Surrealist group in London (1936–8). He has done several major murals.

HOYLAND, John (1934–)

b. Sheffield. English painter who studied in Sheffield and at the Royal Academy Schools. He travelled to New York (1964), meeting several of the *Abstract Expressionist group. Hoyland's large canvases, where slabs of pigment are placed against amorphous colour-grounds to create oppositions of edge and density, show an intelligent exploration of the uncertain depths behind the picture plane.

JOHN HOYLAND *Green, with Two Reds and Violet*. 1966. Acrylic. 72×120 in (182·9×304·3 cm). Arts Council of Great Britain

HOYSALA DYNASTY (AD 1110–1327)

Early in the 12th century, Vishnuvardhana, leader of the Hoysalas who were feudatories of the *Chalukyas of Kalyani, consolidated a kingdom at Dorasamudra (modern Halebid in Mysore). From this small beginning his successors expanded to take the southern Deccan from the Chalukyas by the end of the century. In the 13th century, Hoysala and Pandya assaults destroyed the *Cholas. The Yadavas in the northern Deccan remained the principal threat to the Hoysala realm, until in the 14th century the Muslim Sultanate in Delhi asserted control over the country and the old Hindu empires were dissolved. The heavily ornate temples of the Hoysalas, innovatory in design and unique in sculptural style, remain to the present day, notably at Halebid, Belur and Somnathpur in Mysore. The impression of horizontality in Hoysala temples – the wall-surfaces closely striated with registers of deeply carved sculpture and crowned by squat towers – is echoed in the individual sculptures. The anthropomorphic figures lack the heroic proportion and articulation found in *Chola work, appearing compressed and even distinctly plump by comparison: an impression augmented by the heavy layers of ornamentation. The extraordinary richness of the carving was in fact straightforward artistic exploitation of the medium, a greenish-grey chloritic schist which is extremely tractable immediately after quarrying, setting to brittle hardness on prolonged exposure to the air. The silicate content, moreover, endows the profuse ornamentation with a glitter which perhaps adds to the distaste with which Hoysala work is viewed by certain critics. While it is true that the all-important symbolic attributes of the gods are elaborated almost to the point of unrecognisability in some cases, iconographical dictates are nevertheless scrupulously obeyed and the ritual symbolism required to charge the temple with supernatural power is found to be as precise under the Hoysalas as it was under earlier dynasties. The 'horizontal staircase' treatment of outer wall-surfaces developed in *Chandella architecture at Khajuraho is more pronounced in Hoysala structures, the plan of each shrine being the shape of a many-pointed star, a salient feature of the classical temples at Belur, Halebid and Somnathpur. The lower narrow friezes below the main niches reserved for images of the gods may number as many as six, each frieze devoted to a particular theme such as rows of elephants, lions, *makaras (aquatic monsters) and geese, in addition to troops of cavalry, heroes of legend, the godlings of popular mythology. The *mithuna (amorous couple) – discussed under the *Chalukyas – are prominent in the main registers, observing the Chalukyan propriety of deportment, shaded by the foliage of a tree. An image of great dynamism displaying all the typical Hoysala features is that of the terrible goddess *Mahishamardini, destroyer of the buffalo-demon, now in the Victoria and Albert Museum. The jewelled collar and necklace, epaulette tassels and magnificent crown with flying plumes are matched by the many-stranded girdle and the loops and cords of the goddess's skirt. The goddess, created by all the gods to combat the power-

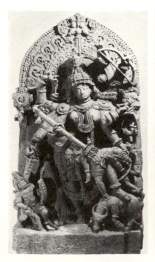 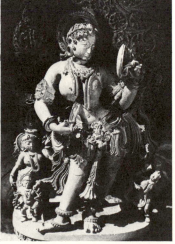

Left: HOYSALA DYNASTY *Mahishamardini*. From Mysore. 13th century. Chloritic schist. h. 56 in (142 cm).
Right: HOYSALA DYNASTY *Dancer with mirror*. Chennakeshvara temple, Belur. 12th century

ful demon, bears the attributes of both *Vishnu (the disk in the second proper right hand) and *Shiva (the trident in the lowest right hand). The buffalo-demon is represented both theriomorphically as a water-buffalo with the typical crescent horns and anthropomorphically as a warrior springing from inside the animal to be impaled on the trident. The violence of battle leaves the goddess herself completely unmoved: her expression is serene, with her eyes gazing beyond the immediate conflict of good and evil. The ornamentation above the image in the form of an arch is typical of Hoysala decorative motifs: a *kirtimukha (Sanskrit: 'face of glory') emits an elaborate ramification of foliage which terminates at each side with a *makara* figure which stands upon the capital of the two pillars flanking the tableau. The same gateway-frame and style of dress characterise an image of *Surya, the god of the sun. The head is backed by a circular nimbus with radiating lines incised at the perimeter. His hands carry the usual attributes of lotuses, flowers of the sun. On either side, his two archers drive away the darkness with their arrows. The chariot in which the sun god traverses the sky is represented merely by two small flower-like wheels beside his feet. The figure of a dancer from the Belur temple illustrates the rhythm and grace which the Hoysala artist was fully competent to convey. She exemplifies the spirit of controlled exuberance and ornate decorousness which characterises this art.

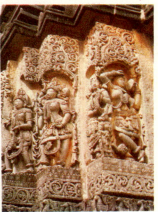

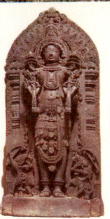

Left: HOYSALA DYNASTY *Nymphs and lovers.* Exterior of Hoysaleshvara temple, Halebid. 12th century
Below left: HOYSALA DYNASTY *Surya.* From Mysore. 13th century. Chloritic schist. h. 59 in (150 cm). V & A, London
Below right: HSIA KUEI *Landscape.* No. 4 of an album of Sung and Yüan masters. Ink and light colour on silk. $9\frac{3}{8} \times 9\frac{7}{8}$ in (23·9×25·1 cm). Boston

HSIA Kuei (active *c.* 1190–1225)

From Ch'ien-t'ang, Chekiang. Painter at the Imperial Academy. His name is linked in Chinese art history with that of *Ma Yüan, and his landscape style is related to that of *Li T'ang. His album leaf in fan shape (Boston) is typical of Southern *Sung landscapes in the evocation of atmospheric effects and in its limited scale (contrast *Fan K'uan).

HSIANG SHENG-MO *see* HSIANG YÜAN-PIEN

HSIANG Yüan-pien (1525–90)

Chinese connoisseur from Chia-hsing, Chekiang, with an extremely rich collection of paintings. He also painted, as did his grandson, Hsiang Sheng-mo (1597–1658), an eclectic painter with a meticulous manner.

HSIAO Chao (active *c.* 1130–60)

Chinese painter from Hu-tse, Shansi, a pupil of *Li T'ang and painter at the Southern *Sung Academy. He is recorded as being a past master of the brush, painting in a style similar to that of *Li T'ang, but richer in his use of ink.

HSIAO Yün-ts'ung (1596–1673)

Chinese landscape painter from Wu-hu, Anhui, influenced by his greater contemporary *Hung-jen. Many of his works were reproduced in woodblock-prints, to which his clear-cut rock forms lent themselves readily.

HSIAO YUN-TS'UNG *Landscape.* Detail of handscroll. Ink and colours on paper. Entire scroll $9\frac{1}{8} \times 88\frac{1}{4}$ in (23×224 cm). BM, London

HSIEH Ho (active *c.* AD 500)

Author of the *Ku hua p'in lu* ('Old Record of the Classification of Painters'), containing the famous Six Laws of Painting. Five of these refer to practical matters such as the use of the brush, likeness, colouring, composition and copying. The first law, 'breath-resonance life-motion', or 'animation through spirit consonance' (to give two of the many English translations) is a quality only attainable through innate understanding and loftiness of the painter's conception.

HSU Hsi (active 1st half 10th century)

Chinese painter from Nanking who specialised in flowers, birds and similar subjects, studied from nature rather than executed in traditional styles. Though he was not a member of the Imperial Academy, Hsü's works were highly prized at court; the catalogue of Emperor *Hui Tsung's collection in the early 12th century lists 259 paintings by him.

HSÜ TAO-NING *Fishing in a Mountain Stream.* Detail of handscroll. Ink on silk. Entire scroll 19×82½ in (48×210 cm). Gallery of Art, Kansas City

HSU Tao-ning (active 11th century)

Chinese painter from Ho-chien, Hopei. 'A skilful landscape painter, who made a study of *Li Ch'êng. Early in his career he set great store by meticulous precision; but as an old man he cared only for simplicity and swiftness of drawing. With peaks that rose abrupt and sheer, and forest trees that were strong

and unyielding, he created a special school and form of his own' (*Kuo Jo-hsü, *Experiences in Painting*, translated by A. C. Soper). *Fishing in a Mountain River* is a good example of his work.

HSU Wei (1521–93)

From Shan-yin, Chekiang. Chinese poet of distinction, calligrapher (especially of 'running' and 'grass' styles), and painter, Hsü Wei was extremely free in his use of the brush, as seen in the detail from the handscroll *Four Seasons* (Stockholm).

HSÜ WEI *Four Seasons*. Detail of handscroll. Ink on paper. Museum of Far Eastern Antiquities, Stockholm

HUA YIN HSIEN *see* YIN HUA HSIEN

HUANG Ch'üan (c. 900–65)

Chinese painter from Ch'eng-tu, Szechwan. An official of high rank, he painted animals, flowers and birds, as well as figures, landscapes and dragons. His style, without the use of ink outline, was contrasted with that of *Hsü Hsi, as was his social position, Hsü being an unconventional scholar living in retirement.

HUANG Kung-wang (1269–1354)

Chinese painter from Ch'ang-shu, Kiangsu, one of the *Four Masters of Late Yüan. *Dwelling in the Fuch'un Mountains* (completed in 1350) clearly shows the character of Huang's brush and ink landscape style, in which he used relatively few motifs and simple brushstrokes. In this way, a landscape could be 'written out', rather than painted. Huang's manner was to serve as an inspiration to many painters of later centuries, especially *Shên Chou and *Wang Shih-min.

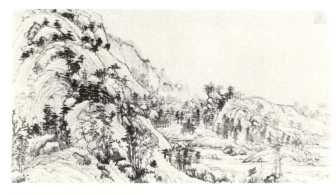

HUANG KUNG-WANG Dwelling in the Fu-ch'un Mountains. Detail of handscroll, dated 1350. Ink on paper. Entire scroll 12⅞×251 in (33×636·9 cm). National Palace Museum, Taiwan

HUANG Shen (1687–after 1768)

Chinese painter from Fukien who worked in Yangchow. One of the *Eight Eccentrics of that city. His calligraphy, written with a worn brush, is often difficult to read; his figures are humorous but sympathetically drawn; his landscapes feature a playful line that echoes the fluidity of his calligraphy.

HUANG T'ing-chien (1045–1105)

From Nan-ch'ang, Kiangsi. One of the foremost Chinese calligraphers of his day, Huang T'ing-chien was a friend of *Su Shih and a scholar who emphasised the importance of study and travel to complement the natural talents and innate understanding of an artist. His own calligraphy is gaunt and plain, but of great power. *Shên Chou was an able exponent of his style.

HUASTEC

One of the few cultures whose art continued to develop during the Mexican Post-Classic Period (c. AD 900–1519), its chief features being large limestone sculptures and a characteristic pottery painted in black on cream.

HUA Yen (1682–1765)

Chinese painter from Lin-ting, Fukien who worked in Hangchow and Yangchow. A skilled painter of landscapes, figures and flowers, poet and calligrapher.

HUBER, Wolfgang (c. 1485–1553)

b. ?Feldkirch d. Passau. Austrian painter, draughtsman, woodcut-artist and architect. After *Altdorfer the most important painter of the *Danube School. Commissioned (1515) to produce *St Anne Altarpiece* for the church at Feldkirch. In the service of the Prince Bishop at Passau (1528). His landscape drawings which show a deep response to nature, were influential in the development of this genre.

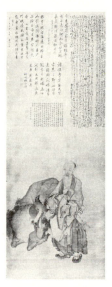
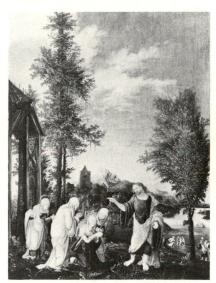

Left: HUANG SHEN *Ning Ch'i with his ox*. Ink and colours on silk. BM, London
Right: WOLFGANG HUBER *Lamentation*. 1521. Stadtpfarrkirche, Feldkirche

HUDSON RIVER SCHOOL

The first native American school of landscape painting (active c. 1825–70) divides into two generations. The first, led by *Cole, then including *Durand, *Kensett, *Doughty and *Casilear, painted the Hudson River Valley and surrounding New England. The second, including *Church and *Bierstadt, moved westward and to more exotic regions. Their work was characterised by painstaking detail and panoramic composition, moving gradually from sombre colour and *Claudian formula to more realistic compositions and luminous colour. Called 'Romantic Realists', they were united by love of the American wilderness, nature in her many moods and forms untainted by man; from this, interacting with contemporary literature, they drew moral messages, often bombastic in later years.

HUDSON, Thomas (1701–79)

b. Devon d. Twickenham, nr London. Prolific English portrait painter. He was the son-in-law of Jonathan *Richardson, under whom he studied, and whose capable but comparatively unoriginal style he emulated. His fame, however, lies in the fact that he was *Reynolds's master, and he retired as soon as his pupil's popularity increased.

HUE

The intensity of a *local colour.

HUERTA, Juan de la (active 1st half 15th century–
d. c. 1462)

b. Daroca, Aragon. Spanish sculptor of funerary monuments who worked in the Dijon and Besançon areas of France continuing the tradition of Dijon sculpture. A follower of *Sluter, whose influence is evident in his figures, monumentally conceived and clothed in voluminous and deeply undercut draperies.

HUET, Paul (1803–69)

b. d. Paris. French artist who studied with *Guérin and *Gros. He was the most significant of those landscape painters who felt the influence of English painting in the 1820s, of *Bonington, *Turner and especially *Constable. He developed a vigorous sketching style in oils and watercolours and, outside the artists of the *Barbizon School, was the chief link between English *Romantic landscape and later French developments.

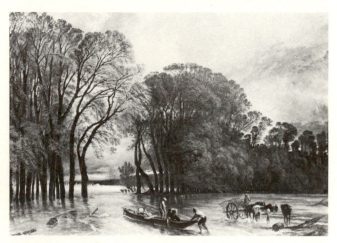

PAUL HUET *The Flood at St Cloud*. 1855. 80⅜×118⅜ in (204×304 cm). Louvre

Left: ARTHUR HUGHES *April Love*. 1856. 35×19½ in (88·9×49·5 cm). Tate
Right: VICTOR HUGO *The Eddystone Lighthouse*. 1866. Pen and ink. 35⅛×18½ in (89×47 cm). Maison de Victor Hugo, Paris

HUGHES, Arthur (1830–1915)

b. London d. Kew. English painter converted to *Pre-Raphaelitism (1850), having studied at the Royal Academy Schools. Millais had the most influence on his sensitive studies of figures in landscape, eg *April Love* (1856). His work deterio-

rated in the 1860s but a sinuosity of line cultivated in his book-illustrations prefigures *Art Nouveau.

HUGHET, Jaime (before 1414–1492)

b. ?Valls, Tarragona d. Barcelona. Spanish painter whose art, after a brief display of Flemish influence, turns in the 1450s to a *Sienese-inspired decorative linearity, use of bright local colour and emphasis on surface richness.

HUGO, Victor Marie (1802–85)

b. Besançon d. Paris. French poet, novelist and amateur artist. He worked with pen and ink or brush producing monochrome landscape sketches with fantastically composed buildings, vaguely based on those seen on his European trips. He favoured dramatic, surreal lighting effects and unusual media – coffee grounds and cigar ash. He has been called 'The Gothic *Piranesi'.

HUI TSUNG *see* **CHAO CHI**

HUMBOLT BAY *see* **LAKE SENTANI**

HUMPHREY, Ozias (1742–1810)

b. Honiton d. London. English portrait painter, who began as a successful miniaturist, but turned to oil portraits after a riding accident affected his eyes (1772). He visited Italy (1773–7) and India (1785–8). He then turned to crayon portraits, holding a royal patent from 1792.

HUNDERTWASSER, Fritz (1928–)

b. Vienna. Painter who studied in Vienna and works in Paris and Venice. Inspired by the decorative and primitive qualities of *Klimt, *Schiele and *Klee, Hundertwasser's dense mazes of colour lack completely their elegance and wit. A maze-like, claustrophobic atmosphere characterises his images.

HUNER-NAME *Military campaign of Sultan Süleyman* attributed to Osman. Topkapi Sarayi Library, Istanbul

HUNER-NAME

The 'Book of Accomplishments' was written in Persian by the Ottoman historian Luqman b. Huseyn al-'Ashuri, in the second half of the 16th century. It describes events in the reign of Sultan Süleyman (1520–66), and is illustrated with miniatures which are attributed to the *Turkish painter, *Osman.

HUNG-JEN (17th century)

From Hsieh-hsien, Anhui. Like many other Chinese born under the *Ming he became a priest at the fall of the dynasty (1644). His paintings are constructed with the bare essentials of landscape; outlines, with few other modelling or texture strokes. They show the landscape of Huang-shan, with tall cliffs, leafless trees and angular pines.

HUNT, William Henry (1790–1864)

b. d. London. English painter who studied with John *Varley and at the Royal Academy Schools. His early oil landscapes, some of them painted with *Linnell, were superseded by his brightly coloured, minutely stippled watercolour studies of flowers, fruit, birds' nests and rustic figures. He was a prolific exhibitor at the Water Colour Society.

HUNT, William Holman (1827–1910)

b. d. London. English painter, a founder-member of the *Pre-Raphaelite Brotherhood. Throughout his life he, more than any other, consistently followed the principle of truth to nature, applied to the significant modern subject. This is a feature of his early illustrations to Shakespearean texts, his modern subjects, eg *The Awakening Conscience* (1854), and his paintings of religious history, eg *The Finding of the Saviour in the Temple* (1854–60), which was scrupulously researched for archaeological accuracy on several journeys made to Palestine. His work relies on the delicate balance between visual truth and symbolism, often achieved with audacious simplicity of composition.

Left: WILLIAM HOLMAN HUNT *The Lady of Shallot*. 1886. 74×57 in (183×144·8 cm). Wadsworth Atheneum, Hartford, Ella Gallup Sumner and Mary Catlin Sumner Coll
Right: WILLIAM MORRIS HUNT *Self-Portrait*. 11×8¾ in (27·9×22·2 cm). Boston, Gift of Wm. P. Babcock

HUNT, William Morris (1824–79)

b. Brattleboro, Vermont d. Isles of Shoals, New Hampshire. Painter who studied in Düsseldorf, and in Paris with *Couture; returned to America (1856), settling in Boston (1862). Influenced by Couture's broad painterliness, *Millet's humanity and the *Barbizon handling of light, Hunt painted portraits and genre scenes with solid, yet visionary, monumentality. His home was one of the leading intellectual salons of Boston.

HUON GULF

A style area of north-east *New Guinea comprising the coastal area of Huon Gulf and off-shore islands. Tami island is the source of the most highly regarded sculpture, including ancestor figures, finely carved head-rests, food-bowls and masks of bark-cloth and wood. Long-distance trading contacts and style relationships with *Astrolabe Bay and *New Britain.

HURD, Peter (1904–)

b. Roswell, New Mexico. Painter, illustrator and printmaker who studied with the illustrator Newell Convers *Wyeth. Hurd's meticulous, exacting realism has largely been devoted to paintings of the American West and portraits. His portrait of President Johnson created a furore; its wiry line and scrupulous, unflattering detail drew angry comment from the President.

HUSZAR, Vilmos (1884–)

b. Hungary. Painter and designer who settled in Holland (1905).

A friend of *Van Doesburg, he became a co-founder of the *De Stijl group (1917). His work as a writer, interior decorator, stained-glass worker and theatre designer attempted to embody De Stijl principles.

HUYSMANS, Joris Karl (1848–1907)

b. d. Paris. French novelist and critic. His reviews of Paris art exhibitions (1879–81) were published as *L'Art Moderne* (1883). His novel *A Rebours* ('Against the Grain') appeared in 1884. The search for the exquisite and bizarre of its hero Des Esseintes parallels and reflects the art of the *Symbolists *Moreau and *Redon, whom he knew.

HUYSUM, Jan van (1682–1749)

b. d. Amsterdam. Dutch flower painter. His rich colourful compositions, sometimes with a light background (his innovation) earned him an international reputation in his lifetime as one of the greatest of flower painters.

HYPPOLITE, Hector (1894–1948)

b. d. St. Marc. Painter and Voodoo priest, first apprenticed to house- and furniture-painters. The most influential Haitian primitive painter, Hyppolite uses delicate draughtsmanship, loose brushwork, original colours and child-like forms to create a world largely concerned with Voodoo rites and spirits, imbued with a strange psychological power and presence.

Left: HECTOR HYPPOLITE *Le Dieu Puissant*. c. 1945–8. Oil on cardboard. 37⅛×25⅞ in (94·3×65·7 cm). Le Centre d'Art, Port-au-Prince
Right: JAN VAN HUYSUM *Flowers in a Vase*. 1726. 31½×23¾ in (80×60 cm). Wallace

I

IATMUL *see* SEPIK RIVER

IBBETSON, Julius Caesar (1759–1817)

b. Churwell Bank d. Masham. English painter apprenticed to a ship-painter in Hull before coming to London (1777). His early works are close in theme and style to his friend George *Morland's landscapes with rustic figures. He painted also landscapes and coast scenes. He published *An Accidence or Gamut of Painting* (1803), a technical treatise on media and colours.

IBIBIO

A people in south-east Nigeria organised in numerous small autonomous village groups, like the Ibo, without centralised political authority and little sense of 'tribal' identity. Most of their wood sculpture, which includes *ekpo* society masks,

puppets and dolls, is carved by the Anang (no relation of the Anyang, one of the *Ekoi peoples) or western Ibibio round Ikot Ekpene. The Anang also paint pictures of people and animals on the walls of shrines to the dead. Each village has its *ekpo* cult home and the society provides magical and religious protection to the village as well as being the main avenue of achieving political power. The word *ekpo* refers to the spirits of the dead which cult members impersonate wearing black wooden masks at ceremonies (from which non-members and women are excluded) after the harvest of yams. During these ceremonies the wooden stakes representing the ancestors are renewed. One of the southern Ibibio tribes, the Oron opposite Calabar at the mouth of the Cross River, carve wooden figures, *ekpu* (perhaps a dialect variation of *ekpo*), which commemorate deceased family heads and which were kept in a common shrine in each village as a permanent genealogical record. Some of these figures are thought to be up to two hundred years old. The Oron do not carve wooden masks.

Above left: IBIBIO Figure of an ancestor of the Oron sub-tribe. Early 19th century. h. 42 in (107 cm). Nigerian Museum, Lagos
Above right: IBO Figures of painted mud in an *Mbari* house built in honour of the earth goddess. Owerri area, Nigeria
Left: IBO Altar stand excavated at Igbo-Ukwu with the figure of a woman. 9th century AD. Bronze. h. 12 in (30 cm). Nigerian Museum, Lagos

IBN-BAWWAB (d. 1022)

Islamic calligrapher, famous for perfecting the styles of writing introduced by *Ibn-Muqla. He lived mainly in Baghdad, starting his career as a house-decorator, then became a book-illuminator before taking up calligraphy. For some time he was in charge of the library of the Buwayhid ruler, Baha al-Dawla in Shiraz. Of the early calligraphers of note, he is the only one from whom we have an autographed dated manuscript (Chester Beatty Library, MS K.16).

IBN-MUQLA (885–939)

A famous Islamic calligrapher of the Abbasid period, important in that he first laid down the rules of writing Arabic which formed the basis of Islamic calligraphy. He invented the process of establishing the proportions of the stroke. He is said to have invented The Six Styles (*Aqlam Sitta*): Muhaqqiq, Reyhan, Thulth, *Naskhi, Riqa and Tawqi. That he developed Naskhi out of *Kufic is no longer accepted.

IBO

A multitude of autonomous small groups of villages in eastern Nigeria, united in speaking related dialects and in sharing many features of culture and social organisation, but without any form or sense of political unity in pre-colonial times. There is no single art style and one can but list a few of the more important forms. Among the north-western Ibo, heavy black masks, either of basketry covered with gum and animal horns or of wood with horns all of one piece, which portray masculine strength, contrast with the well-known white-faced 'maiden spirit' masks which, together with their black costumes brightly decorated with coloured appliqué, portray the ideals of feminine beauty. The north-west Ibo also have *ikenga*, a horned object of wood often in human form, the shrine to the strength of a man's right arm. Round Owerri, in the south, they build *mbari* houses, monuments to the earth goddess, Ala, which are peopled with innumerable brightly painted figures. Terracotta tableaux, furniture for shrines to the yam goddess Ifijioku have been found among Ibo west of the Niger River. Round Bende in the east they carve magnificent figures carried as headdresses in *ogbom* masquerades, and also huge wooden posts for men's club-houses. There is no brass-casting among the Ibo although discoveries at Igbo-Ukwu, a village south-east of Onitsha suggest this may not always have been so. In 1939 an extraordinary group of ornamental bronze vessels were accidentally dug up by a local farmer. Subsequent excavations between 1959 and 1964 revealed two groups of ritual objects cast in bronze and the burial-chamber for a man of considerable importance seated upon a stool dressed in full regalia. The style of Igbo-Ukwu bronze-castings looks north-east along the Benue Valley, if anywhere, and certainly not west towards *Ife and *Benin. The Igbo-Ukwu discoveries have been dated by radiocarbon to about the 9th century AD, which makes them the earliest known examples of bronze-casting in sub-Sahara Africa.

ICON

From the Greek *eikon* meaning 'portrait'. Generally applied to portable representations of sacred subjects, either religious scenes or figures in *Byzantine and Orthodox art. According to St Basil 'an icon's worth derives from the original which it portrays', but in Byzantium from the 7th century onwards, except during *Iconoclasm, many icons were themselves the objects of a veneration and worship similar to that given to the relics of saints. Icons could be made in various media: in miniature mosaic-work, in enamel or carved in stone, but most common were the icons painted on wooden panels. Their style could reflect current developments in monumental painting and may indeed often have been produced during slack periods by the artists who decorated churches.

ICONOCLAST ART

Iconoclasm, the policy for the destruction and abolition of figurative religious images, was maintained by Byzantine emperors between 787 and 813. Iconoclasm was partly an assertion of imperial power in the face of such threats as the expansion of Islam. The art which replaced the images was one consisting of plant motifs, rinceaux, birds and plain crosses. Figural decoration was acceptable as long as the subject was secular. One of the few surviving examples of iconoclast art is the plain cross in the couch of the apse of St Eirene, Istanbul.

ICONOSTASIS

The screen dividing sanctuary and nave in a Byzantine church. The simplest Early Christian forms seem to have been low walls pierced by gates for various liturgical entrances and exits. Later examples were surmounted by columns supporting beams from which could be hung curtains to hide the activity in the sanctuary from view at various points during the liturgy. Icons were certainly to be found hanging on the screens by the late 11th century, but they probably did not become true iconostases, ie totally covered by icons, until the 14th century.

IDOMA *see* NIGERIA, NORTHERN

IFE

A town in Nigeria where Oduduwa, ancestor of all the kings of the *Yoruba, climbed down from heaven to create the world. The German ethnologist Leo Frobenius discovered (1910) a bronze head, several terracotta heads and the fragments of a threequarters-life-size royal figure seated on a stool which were brought into the royal palace at Ife for safe-keeping from a sacred grave west of the town. Seventeen bronze heads and the upper half of a bronze figure were accidentally dug up behind the royal palace in an area formerly within the palace (1938–39). A number of terracotta heads and fragments, a bronze figure, a pair of figures arm in arm also in bronze and other small bronzes were discovered at a site in the north-east of Ife (1957). These discoveries are but a small selection of the sculptures, mostly in terracotta found at Ife either as cult objects in shrines and sacred groves or by accident when digging foundations and so on. One further discovery should be mentioned; the seated bronze figure from Tada village on the Middle Niger, clearly an Ife work although the other bronzes of Tada belong to the *Lower Niger bronze industry. The art of Ife is remarkable for its naturalism, yet sculptures of the full figure follow typical 'African proportion' with the head amounting to a quarter the length of the figure. Moreover the treatment of the torso and limbs is remarkably similar to the terracottas of the *Nok Culture, and it may be significant that Nok and Ife are the only two cultures in Africa with the ability to fire such large terracotta sculptures. The terracotta heads and figures were almost certainly among the furniture of shrines and sacred groves in ancient Ife. The bronze heads may have been mounted on wooden pillars and dressed for use in funerary rites as effigies of deceased kings and chiefs. Radiocarbon dates put the culture of ancient Ife somewhere about the 10th–11th centuries AD.

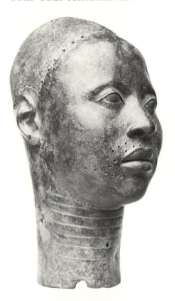
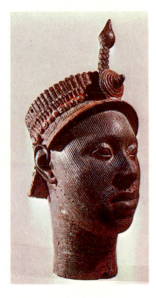

Left: IFE Head of a man. *c.* 11th century AD. Bronze. h. 14¾ in (36 cm). Ife Museum, Nigeria
Right: IFE Head probably of a king. *c.* 11th century. Bronze. h. 14¼ in (36 cm). BM, London

IGALA *see* NIGERIA, NORTHERN

IGBO-UKWU *see* IBO

IJO

A group of tribes inhabiting the creeks and mangrove swamps of the Niger delta. Their sculpture is characterised by a severe reduction to basic rectangular forms. They have many different masks for the water spirits which control fishing conditions upon which their livelihood depends. These masks are not intended to have a visual impact on those watching the per-

formance as they are worn on top of the head facing upwards often obscured by the costume. The masks serve to fix the presence of the spirit in the masquerader himself. Other wood sculptures include the *ejiri* protective spirits of the western Ijo (related to the *Urohobo *ivbri*) and the *duen fobara*, the ancestral screens of the Kalabari Ijo on the eastern side of the Niger delta.

ILLUSIONISM

Giving a painted subject the appearance of reality by means of technique, either mechanical (foreshortened *perspective) or through virtuoso painting (a veil across the picture, a fly on a canvas). Also called *trompe l'œil* (French: 'to deceive the eye'). The Italian *quadratura refers more specifically to the illusionistic painting of architecture. Much used by the Romans (at Pompeii and elsewhere) it was revived during the †Renaissance, an early example of trick perspective being *Mantegna's *Camera degli Sposi*, Mantua. The technique reached its peak in the †Baroque era in Italy when plasterwork was used to bridge the gap between spectator and work of art. Virtuoso painting of small objects is mentioned by *Pliny and was employed by Northern artists as well as Italian in the 15th century.

IMPASTO

Thickly applied paint.

IMPRIMATURA

A wash of thin, diluted colour to tone down a white *ground preparatory to painting.

INCA

The empire of the Incas dominated Peru and parts of Ecuador, Bolivia and Chile between AD 1476 and 1534. Inca art owes much to its predecessors and only a few forms can be regarded as typical. In addition to textiles and carved stone dishes, maceheads and figures, the most characteristic objects are carved and painted wooden goblets called *keros*, gold and silver figures of llamas and men and women, and painted pottery vessels of aryballos form with pointed bases.

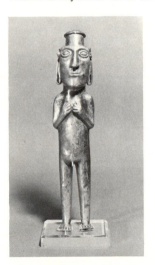

Left: INCA Silver figure of a standing man. *c.* AD 1476–1534, Peru. h. 8⅞ in (22·5 cm). Royal Scottish Museum
Right: JOHN INCHBOLD *In Early Spring.* Ashmolean

INCHBOLD, John William (1830–88)

b. d. Leeds. Studied with Louis Haghe and after his first exhibits (1849) he turned to a *Pre-Raphaelite approach to nature uniting laborious detail with atmosphere and poetic effects. This is more evident in his later, more broadly treated works. He painted fine mountainous landscapes and *The Moorland* (1855) won *Ruskin's praise.

INDIAN INK

A mixture of lampblack and watered *gum that is waterproof when dry.

INDIAN PAINTING: GENERAL

There are no remains of Indian painting before the 2nd century AD, except for a few prehistoric cave- and rock-drawings; a complete and uninterrupted history starts only in the 16th century. The first phase includes large-scale religious wall-paintings: *Ajānta, *Bagh and other western caves, mostly Buddhist; and the more southern schools, discussed under *Deccan Painting: Early Indian, *Indian Painting, South and *Vijayanagara painting. Otherwise we are concerned almost exclusively with small-scale works, manuscript-illustration and album-painting. As a second phase we consider such works before the advent of the Mughals: the 11th- and 12th-century *Pala Buddhist palm-leaf manuscripts of eastern India; the western manuscripts, mostly *Jain, although secular subjects are also known, of the 11th-16th centuries; the *Malwa paintings which exhibit not only Jain tradition but also the emergence of a distinct style at the Muslim court at Mandu in the late 15th century; and the scattered evidence of northern schools before the mid 16th century, here treated for convenience as Pre-Mughal, which in their later stages often merge into the provincial Mughal styles. The third phase deals with *Mughal painting, whose period of excellence is 1550–1650: at first imported Persian artists trained indigenous craftsmen in the royal atelier to produce the illustrations to the tales known as the *Hamsa-nama; the new style is firmly established under *Akbar (1556–1605), under whose direction some European influence (especially in chiaroscuro and perspective) appears. For convenience the story-books, histories and translations of the Hindu classics are considered separately. Under *Jahangir (1605–27), the greatest connoisseur of painting, story-book illustrations continue, although album-pieces were more important: biographical court scenes, portraits, natural history studies in which *Mansur is pre-eminent, and the 'new iconography' of *Abu'l Hasan and Bichittar; this period also sees the development of the bourgeois and provincial *Mughal schools. The high period starts its decline under *Shahjahan (1628–57). The three schools of *Deccan Painting (Ahmadnagar, Bijapur, Golkonda) are independent of the contemporary Mughal schools. Painting of the Northern Hindu kingdoms, which owes much to Mughal inspiration, forms the fourth phase. It falls under two main divisions, the *Rajasthan schools and the *Panjab Hills schools. Here the themes illustrated are commonly Hindu legends and illustrations of common themes of literary convention (stories of the *Ramayana*, of the loves of Radha and Krishna, of the *Ragamala* – personifications of the musical modes and their evocations – of the six seasons, depictions of the heroes and heroines of the Indian *ars poetica* which is commonly also an *ars erotica*). Under the Rajasthan schools we consider the styles of *Mewar, *Bundi, *Malwa, *Bikaner, *Kota, *Kishangargh, *Jaipur and *Jodhpur; in the Panjab Hills styles are included those of *Basohli, *Guler, *Kangra, Garhwal, *Bilaspur and Nurpur. A slightly different position, more directly dependent on Mughal inspiration, is that of the Sikh School. A late eastern school, of tantric inspiration, is that of *Kalighat. In wall-paintings, the technique is essentially *tempera; true *fresco work, however, is known as Tanjore and Vijayanagara, and the cut plaster designs of late mosques and palaces may also be fresco-painted. Early pigments were mostly mineral, suspended in a gum, the palette limited to five or six colours; in paintings of divinities the colour scheme was conventional, following that prescribed for the decoration of sculptured images. Outlines are often drawn in lampblack or red ochre, sometimes both. Early manuscripts were on palmyra leaf; paper appears sporadically after the 12th century, not regularly until the Mughal period. Here the technique is that of *gouache. The brilliance of Mughal painting is enhanced by new pigments (ultramarine, kermes, and the Indian yellow *peori* from the urine of stalled cattle), and by burnishing with an agate. Detail is effected by fine brushstrokes; stippling does

not appear until the 18th century. In Mughal ateliers the artist was at first subordinate to the calligrapher, who controlled the spaces where painting might appear. A repertoire of common designs (including even court portraits) was maintained on pierced parchment tracings through which charcoal could be pounced; whole paintings were copied by such tracings.

INDIAN PAINTING, SOUTH (from c. AD 700)

The painting of the Pallavas survives in fragments in temples at Kanchipuram, Panamalai and a Jain cave at Sittanavasal. The *fresco secco technique is used, with few colours, mainly red and yellow. There is little modelling. The style is very close to that of *Pallava sculpture. The *Cholas (AD 850–1250) used true fresco at the Tanjore temple. More colours were used including lapis blue, though the fondness for strong yellows and reds predominates. The outlines are clear, drawn in red. The female figures are very attractive with deeply curved hips and thighs. The sharp angles of the limbs of some figures give the effect of vigour and movement. Compositions are two-dimensional, with little attempt at modelling.

INDIAN SCULPTURE: GENERAL

The sculpture of the Indian sub-continent can be studied in the general essay at the beginning of this book and under the following headings: *Prehistoric Sculpture* under *INDUS VALLEY CIVILISATION; *Sculpture of the post-Buddhist empires* under *MAURYA DYNASTY, *SHUNGA AND KANVA DYNASTIES, *SATAVAHANA DYNASTY; *Sculpture of the early and classical Hindu empires* under *GANDHARA SCULPTURE, *KUSHANA DYNASTY, *GUPTA DYNASTY, *GUPTA CONTEMPORARY MINOR DYNASTIES AND THE POST-GUPTA EMPIRE, *CHALUKYA DYNASTY; *Sculpture of the medieval Hindu dynasties of the North and Deccan* under *RASHTRAKUTA DYNASTY, *KASHMIR, *GURJARA-PRATIHARA DYNASTY, *PALA DYNASTY, *CHAULUKYA DYNASTY, *CHANDELLA DYNASTY, *GANGA DYNASTY; *Sculpture of the medieval Hindu dynasties in the South* under *PALLAVA DYNASTY, *CHOLA DYNASTY, *HOYSALA DYNASTY, *VIJAYANAGARA EMPIRE.

ROBERT INDIANA *The Demuth American Dream No 5*. 1963. 144×144 in (365·7×365·7 cm). Art Gallery of Ontario

INDIANA, Robert (1928–)

b. New Castle, Indiana. Painter who studied at John Herron Art Institute (1945–6), Munson-Williams-Proctor Institute (1947–8), Chicago Art Institute (1949–53) and Edinburgh College of Art; lives in New York. Indiana's blue, red and green *Pop parodies of American road signs comment harshly, if obviously, on the Midwestern social wasteland.

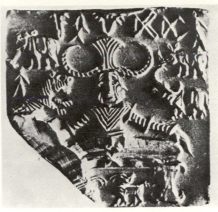

Left: INDUS VALLEY CIVILISATION Bust of a (?)priest. From Mohenjodaro. *c.* 2000 BC. Limestone. h. 6¾ in (17 cm). Museum of Central Asiatic Antiquities, New Delhi
Right: INDUS VALLEY CIVILISATION Seal impression showing a seated horned figure, animals and, at the top, a line of script. From Harappa. *c.* 2000 BC. Steatite. 1⅜×1⅜ in (3·5×3·5 cm). Museum of Central Asiatic Antiquities, New Delhi

INDIVIDUALISTS *see* **CHU TA; K'UN-TS'AN; KUNG HSIEN; MEI CH'ING; CH'ING DYNASTY PAINTING**

INDONESIA, ART OF

The art styles of those hoe-farming peoples of Indonesia whose way of life preceded and survived successive influences from Hinduism, Buddhism and Islam show formal similarities to the sculpture of *Oceania. They also share a concern with honouring the ancestors and the recently dead. Thus the wood figures of Nias Island are revered as containing the souls of the dead and sacrifices are made to them. They are carved with high-peaked headdresses and distended ear-lobes. On Babar, Tanimbar and Leti islands in the South Moluccas ancestor figures with eyes of shell inlay squat on pedestals with arms crossed and resting on their knees. Representations of the dead are carved in the Philippines, too, either as free-standing figures or ornamenting the handles of spoons, etc. Perhaps the most brilliant sculptures are those of the Batak peoples of Sumatra. The Batak house, with saddle-shaped roof, is covered with carved and painted decoration. Figures designed to ward off evil spirits are fixed to the exteriors. But greatest virtuosity is displayed by the intricate compositions of human and animal figures which embellish the 'magic staffs' carried by priests during rituals and the buffalo-horn amulet-containers. Wood masks, with human features naturalistically portrayed, were worn at dances for those who died without leaving male descendants. The Dyak of Borneo carve posts to contain the souls of the dead. Their large hexagonal wooden shields are painted with demoniac figures and scroll patterns.

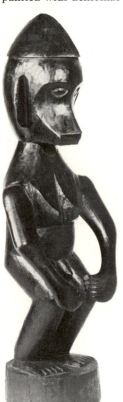
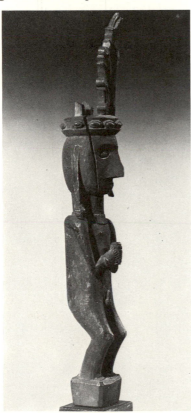

Left: INDONESIA, ART OF Philippine Island bisexual figure. Wood, painted black. h. 24¾ in (62·9 cm). Ethnographical Museum, Budapest
Right: INDONESIA, ART OF Nias Island ancestor figure. Wood. h. 11 in (28 cm). Museum für Völkerkunde, Munich

INDRA

Hindu god, little changed from his *Vedic identity as storm god and apotheosis of the concept of *kshatra*, the rule of the warrior caste; attribute is the thunderbolt (*vajra*). Cognisance is the elephant, Airavata.

INDUS VALLEY CIVILISATION *(c.* 2500–1500 BC)

Before 2500 BC there existed to the north-west of India a web of localised agricultural village communities which had settled in the Baluchistan region from about the end of the 4th millennium BC. These fragmented, but related, miniature cultures may be broadly distinguished by their pottery, which was mainly red in the north and buff-coloured in the southern areas. Religion, in common with that of early Mediterranean and Middle Eastern agricultural communities, appears to have centred round the propitiation of fertility goddesses and phallic symbols. It is from this general background that there emerged on the Indus (*c.* 2500 BC) an urban culture with planned cities, a pictographic script, artists who could engrave exquisitely fine seals or execute free-standing sculptures with equal accomplishment. With its two main cities on the Ravi and the Indus – Harappa in the north and Mohenjo-daro in the south – this culture extended from the Makran round the coast to Saurashtra, north along the rivers as far as Lahore and east beyond Delhi. The Indus Valley Civilisation, as it is justly termed, endured for a thousand years before the arrival of the Vedic Aryans. Despite the large number of finds and the intensive study devoted to it, the Indus Valley Civilisation remains an enigma. The two great cities were without precedent among the surrounding Chalcolithic cultures, and the culture is unique in so many aspects as to preclude its establishment by the sudden arrival of migrants from the other urban centres in Mesopotamia. The evidence points to a spontaneous, indigenous burst of creativity which contained within it, however, a determined conservatism which was to preserve the civilisation, little changed, for a thousand years. The artistic products of the culture are in many ways as enigmatic as its genesis: the pictographic script, which is unique, has never been satisfactorily deciphered, and a coherent understanding of the religious system has not been arrived at, making interpretation of the art hazardous. The pottery was wheel-turned and fired in kilns. Designs included the unique intersecting circle pattern, circles with radiating lines, chessboard panels and overlapping 'fish-scale' designs. Men, animals, birds and fish also figured as decorative motifs. Terracotta figurines were produced on a large scale, the workmanship being fairly crude. It is significant that of the anthropomorphic figures, the females, largely fertility deities bedecked with tall headdresses, necklaces and garlands, far outnumber the representations of men. Clay-modelled animals such as the humped bull, elephant, rhinoceros and monkey were also made and are presumed to be children's toys. Sculpture was practised on a small scale, but with finesse. Limestone busts and statuettes six to eighteen inches high have been recovered, the eyes often inlaid with stone or shell. The two

much-published limestone torsos from Harappa stand a mere four inches in height, one which is decidedly male offering comparison with the later *yaksha statuary in its solid rotundity, the other which has been identified as both male and female by various writers, represents a dancing figure. Bronze-casting was carried out (by the *cire perdue technique) and has left us a portrait of a nude girl standing in a relaxed posture with one hand on her hip. One arm is completely covered with bangles and her coiffure is evidently styled with some care. It is in the seals, and to a lesser degree in the pottery designs, that we may find most of intellectual interest. The seals were incised with precise and complicated scenes, often accompanied by a line of the baffling script. Many of the scenes represented must imply a considerable body of current mythology, some of it not unconnected with Mesopotamian legend. On minute scrutiny, one may find connections between the art of the Indus Valley Civilisation and that of the Middle East; or one may see in it prototypes of later Indian art forms, thus working it into a continuous sub-continental tradition, religious and artistic. But the fact remains that the *Vedic Aryans had no history of civilisation when they entered India over the ruins of Harappa and Mohenjo-daro, and it took them a very long time to create on Indian soil an urban culture of comparable self-assurance. It is perhaps most satisfying to regard the Indus Valley Civilisation in isolation, as a unique, unaggressive and conservative culture that lived out its millennium and expired quietly before the great invasions began.

Above left: INDUS VALLEY CIVILISATION Torso of a dancing figure. From Harappa. *c.* 2000 BC. Limestone. h. 4 in (10 cm). Museum of Central Asiatic Antiquities, New Delhi
Above right: INDUS VALLEY CIVILISATION Male torso. From Harappa. *c.* 2000 BC. Limestone. h. 3½ in (9 cm). Museum of Central Asiatic Antiquities, New Delhi
Left: INGEBORG PSALTER *Pentecost. c.* 1220. Illumination on vellum. 8½×6 in (21·7×15 cm). Chantilly

INGEBORG PSALTER (1st quarter 13th century)

This luxury manuscript belonged to the Danish princess, Ingeborg, wife of King Philip Augustus II of France. It established there the English practice of prefacing the Psalter text with a cycle of scenes from the Old and New Testaments. The style and iconography of the Ingeborg cycle seem to belong to north-eastern France, with strong †Byzantine and *Mosan influences. The use of the *muldenfaltenstil treatment of drapery connects the illustrations with sculpture at *Chartres,

*Reims and *Strasbourg and with the drawings of *Villard de Honnecourt.

INGLES, Jorg (active 1455)

Painter, perhaps of English origin, who painted, for the Marquis of Santillana, *Retable of the Virgin* (1455). Representative of the Hispano-Flemish style in Castile, he gradually sacrificed naturalism to decoration and exaggerated action.

INGRES, Jean Auguste Dominique (1780–1867)

b. Montauban d. Paris. French *history-painter and portraitist, one of the leaders of †Neo-classicism; he entered *David's studio (1796) after some initial training at the Toulouse Academy. Very early he criticised David's work for not being sufficiently classical. He won the Rome Prize (1801), but was not sent to Rome until 1807 on account of the Napoleonic Wars. Even in his early career he produced masterly portraits notable for their linear lyricism and cool formal precision. He remained in Rome until 1820, treating a wide range of subjects and drawing numerous pencil portraits, the latter occupation being his main source of income. He stayed in Florence (1820–4) working on a major religious commission which became his ideological statement at the Salon of 1824: *The Vow of Louis XIII* (Montauban Cathedral). This painting with its obvious dependence on *Raphael secured for the artist the leadership of the classical opposition to the flowering †Romantic movement. He remained in Paris from 1824 until his return to Rome in 1834, as Director of the French Academy. After his return to Paris (1842) he continued to paint grander and more sumptuous portraits and elaborated his depictions of the female nude. An obsession with rules and motifs runs through his impressive production. He was a prolific draughtsman, and taught that correct drawing was the foundation of all good art.

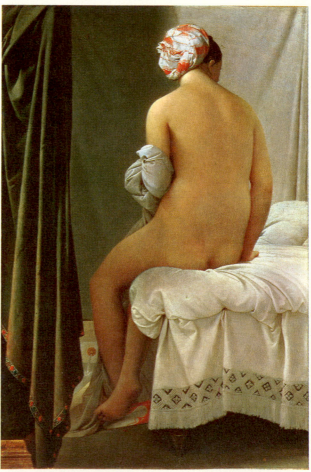

JEAN AUGUSTE INGRES *La Baigneuse de Valpincon.* 1808. 56¾×38¼ in (144·1×97·2 cm). Louvre

INNES, James Dickson (1887–1914)

b. Llanelly, Carmarthenshire d. Swanley, Kent. Studied at the Slade School of Art, London (1905–7), an associate of Augustus *John. Painter of mountain landscapes and of some figure subjects. After a phase of *Steer influence, his colour sense was aroused by a visit to France, and he returned to paint Welsh scenes with similar colour values.

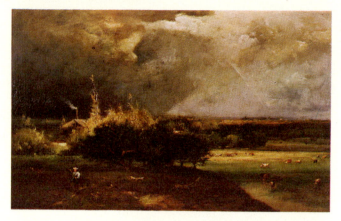

GEORGE INNESS *The Coming Storm. c.* 1880. Addison Gallery of American Art, Phillips Academy, Andover

INNESS, George (1825–94)

b. Nr Newburgh, New York d. Bridge of Allan, Scotland. Painter who visited Europe (1850, 1854); lived in France and Italy (1870–4). Influenced aesthetically by *Constable, *Titian and the *Barbizon School, and spiritually by Swedenborg, Inness's landscapes are distinguished by glowing colour and atmosphere. His work falls into two periods: first, analytic, based on direct study from nature; second (from 1878), poetic visions synthesised in the studio. Seeing both palpable and intangible realities, Inness became a major American landscapist.

INTAGLIO

In which a line or design is cut into a surface.

INTERNATIONAL GOTHIC

The name given by some to a stylistic tendency discernible in most European schools (c. 1400) towards courtly elegance and naturalistic detail. Frequently quoted examples are the *Wilton Diptych, the illuminations of the *Limbourg brothers and in Italy *Stefano da Verona's *Madonna of the Rose Garden* or *Gentile da Fabriano's *Adoration.* The elegance seems to derive from Siena via Avignon and the naturalism from late 13th-century sculpture and illumination. Elements of the style survive in *Gozzoli and even in *Leonardo da Vinci's *Virgin of the Rocks.*

INTIMISME

Term applied in particular to *Bonnard's and *Vuillard's intimate scenes of domestic life revealed in an equally intimate structure of closely-knit colour touches. Intimisme is a particular use of †Impressionist everyday subjects, and of Impressionist technique of colour strokes corresponding to individual visual sensations of the subject. In general an intimate theme and atmosphere characterise much 20th-century French painting, eg *Matisse and *Braque.

INTONACO

The final layer of plaster upon which *fresco is carried out.

IPIUTAK

A remarkable early *Eskimo site near Point Hope, Alaska, which has produced a variety of unusual and richly decorated works of art in carved walrus ivory including masks, small figures of animals and birds, and curious linked and swivel-shaped forms, in addition to engraved harpoon-heads and other tools and weapons.

IPOUSTEGUY, Jean-Robert (1920–)

b. Dun-sur-Meuse, France. Painter who turned to sculpture (1954). Influenced by *Picasso, *Brancusi and primitive masks, Ipousteguy's best early works are semi-abstract, geometric forms characterised by an organic roughness. In the 1960s he returned to figurative sculpture (eg *La Femme au Bain,* 1966). He models mainly in clay and plaster, arriving at a ripeness of form so full that his figures split open, their potency appearing in the end destructive.

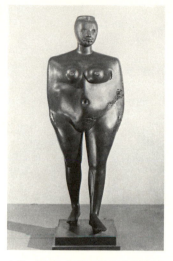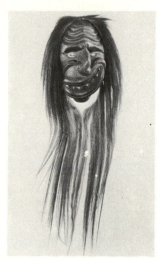

Left: JEAN-ROBERT IPOSTEGUY *Earth.* 1962. Bronze. 73×27×20 in (185·4×68·6×50·8 cm). Tate
Right: IROQUOIS 'False-Face' society mask. 19th century, Canada. Carved poplar wood, painted and decorated with teeth, hair and brass. h. 12½ in (31 cm). Royal Ontario Museum, Toronto

IRANIAN ART

'The predominance of the decorative interest may be accounted the outstanding and almost unfailing characteristic of Iranian art from prehistoric to modern times.' This was the judgement of a great scholar of Iranian art. There is, however, very little continuity in other respects between the various styles from Iran, not only because Iran was peripheral to the centre of development in *Mesopotamia but also because of the very fragmentary nature of the preserved evidence: in one period pottery has survived as the main artistic medium, in another stone bas-reliefs, in a third metalwork. The early painted pottery of Tepe Siyalk, Tell-i Bakun and *Susa is admirably suited to the limitations of the potter's art and its stylised, almost geometric, designs give a fine ornamental effect. The art of *Elam, however, has its main links with the art of Mesopotamia. During the second millennium BC the first Iranian tribes were moving on to the Iranian plateau from the steppe country farther north. The first artistic effect of these semi-nomadic tribes is seen in the *Luristan bronzes with their concentration on stylised animal designs. The use of animal motifs is also present in *Achaemenian art but many other styles from other countries have been borrowed to create the Achaemenian style. Here, as with the Luristan bronzes the predominant effect is decorative rather than narrative. *Parthian and *Sassanian art despite their connections with the *Greco-Roman world are essentially iconic and are not subservient to architecture or function as the earlier styles were. Their textiles and carved stucco, however, like Islamic tile-work and carpets were decorative.

IROQUOIS

A group of Indian tribes inhabiting the north-eastern part of the United States. Pre-European art forms included a distinctive pottery style and carved bone combs, but the Iroquois are

better known for a more recent and continuing tradition of grotesque ceremonial masks associated with the 'False Face' secret societies. The masks are carved out of the living tree and decorated with horsehair to represent spirits which are believed to cure illness. *See also* EASTERN UNITED STATES AND CANADA, ART OF

ISABEY, Eugène Gabriel (1804–86)

b. d. Paris. The son of a miniature-painter, Isabey began with †Romantic genre subjects, but after a visit to Algiers as marine painter to the French Navy (1830), he concentrated on marine and beach scenes, often with a bourgeois emphasis that prefigures *Boudin. A noted watercolourist.

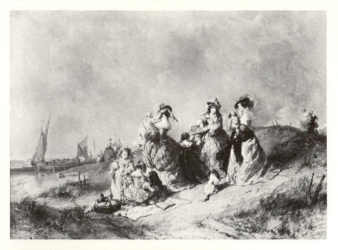

Top: EUGENE ISABEY *Promenade by the sea.* 1846. 20×27 in (51×69 cm). Wallace
Above: ADRIAEN ISENBRANDT *The Magdalen.* 15¾×12¼ in (40×31 cm). NG, London

ISENBRANDT (YSENBRANDT), Adriaen
(active 1510–d. 1551)

d. Bruges. Flemish painter, perhaps pupil of Gerard *David. Master in Bruges (1510). Attributions, of which there are many, depend on *The Seven Sorrows of the Virgin* (Notre-Dame, Bruges). Two dated pictures exist, one a male portrait (1515), the other an altarpiece (1518). The ascribed works are influenced by David and have connections with *Benson and the *Master of the Female Half-Lengths, producing a soft style of subdued colours and emotions.

ISENMANN, Caspar (d. 1472)

d. Colmar. German painter active in Colmar (from 1433). His *Passion Altarpiece* for St Martin's (surviving parts Colmar Museum) show the influence of Konrad *Witz's stark mime and an interest in rendering dramatic landscapes.

Top left: CASPAR ISENMANN *Resurrection.* 1462–5. 42½×28¾ in (108×73 cm). Musée d'Unterlinden, Colmar
Top right: ISLAMIC BOOKBINDING Copy of Jal al-din Rumi's *Mathnawi.* Herat. 1483. Leather. 10¼×7 in (26×17·6 cm). Museum of Turkish and Islamic Art, Istanbul
Above: ISLAMIC LACQUER PAINTING. Style of Sultan Muhammad. Persian c. 1540. BM, London

ISFAHAN SCHOOL

Under the Safavid Sultan Shah Abbas I (1587–1629) the Persian capital was moved to Isfahan (1598) where for nearly two hundred years it became the centre of eastern Islamic culture. *Sadiki Beg became head of the court scriptorium bringing the *Qazvin drawing style to Isfahan. His successor as leading artist there was *Riza Abbasi whose work became the model for all subsequent 17th-century painting. At the beginning of the century there was a revival in Isfahan of the *Herat style, perhaps to be explained by the presence in Shah Abbas's library of such manuscripts as the Gulistan *Shah nama* (1430). Some of these Neo-Timurid manuscripts were as brilliant in technique as the originals.

ISLAMIC BOOKBINDING

In the Islamic world, bookbinding is classed with painting as one of the fine arts. It was a flourishing art produced by highly skilled craftsmen throughout the Middle East using basically the same techniques and materials. Most of these techniques appear to derive ultimately from Coptic and Manichean prototypes. The international character of Islamic bookbinding, which has little regional variation, makes it difficult to ascribe pre-13th-century bindings to any specific country. Until the 10th century, when paper became readily available in the Middle East to make pasteboards, bookbindings were made of wooden boards covered with tooled leather. Early Islamic bookbindings had a horizontal format in which the decoration is often set in a rectangular panel; yet there are already signs of the evolution of a central medallion, which was to become one of the most popular designs in bindings from the 13th century onwards, set in the middle of a vertical panel. The embossed decoration which probably came into wider use in the 11th century uses a leather covering over an underlying design made of stiffened cord. Gold tooling first appears in Almohad (1130–1269) bookbinding. By the 16th century the technique was known and imitated in Europe. Special care was lavished on the bindings designed to protect Qur'ans (Korans) because of their association with the Holy word. Of these, the works commissioned by the Mamluk sultans of Egypt (13th–15th century) – sometime very large in size – include some of the finest examples of book production in the Islamic world. Mostly in leather, sometimes with a silk background for the cut-out decoration, they are stamped in blind and gold tooling with pierced or painted decoration on both sides and also on the triangular flap which is a peculiarity common to all Islamic bookbindings. The magnificent bookbindings of 15th- and 16th-century Persia show Chinese influence in their decorative motifs. Persian binders achieved a special polychrome leather relief by cutting the decoration through layers of coloured leathers, though by the 16th century paper was being substituted for the cut-out leather and with time the decoration became more mechanised and repetitive. Hunting and garden scenes were favourite subjects in 16th- and 17th-century bindings, not only in Persia but also in Turkey and Mughal India. Another style, using a medallion theme, has parallels with contemporary carpet designs, a reminder that ever since the 10th century the two crafts had been somewhat related.

ISLAMIC CALLIGRAPHY

Islamic calligraphy is based on the Arabic script, used throughout the Islamic world. After the Muslim conquest of different countries this script was adapted to many different languages, and borrowing by non-Semites invariably resulted in the development of letters which expressed sounds not existing in Arabic. It is generally accepted that the Arabic script derived from the Nabatean script at the end of the 4th century or during the 5th century AD. From an early stage there were two main styles, an angular and a cursive. Several types developed from the angular, the most common being the so-called *Kufic. By the 8th century, writing had become one of the major arts of Islam. The great calligraphers who formulated and defined the rules of calligraphy were: *Ibn-Muqla (10th century), *Ibn-Bawwab (11th century) and *Yaqut Mustasemi (13th century). Sources indicate the variety of script in the early period but none are extant. After the 13th century we find that the number of scripts is limited for the most part to *Nashki, Thulth, Riqa, Muhaqqiq, Reyhan, and Tawqi, each one being popular in a certain country. In the 14th century *Ta'liq script developed in Iran, and it led to the *Nasta'liq script. The last type of script which was introduced was *Shikasta Nasta'liq (broken) in the 17th century. There were, however, other decorative scripts such as Tughra, Gulzar, Tavous, and Larza.

ISLAMIC LACQUER PAINTING

By the end of the 15th century, Persian craftsmen had learnt the technique of lacquer painting from the Chinese. As a cheaper alternative to leather *bookbinding, paperwaste boards were covered with a foundation of chalk and then with layers of lacquer used as a ground for painting; this in turn was covered with a final layer carrying the decoration in liquid gold, silver and mother-of-pearl dust. This technique was used from the 16th century onwards throughout the Islamic world not only for bookbindings but also on objects of everyday use such as boxes, mirrors and doors. It was particularly well done in *Qajar times in Persia, in the 18th and 19th centuries.

ISLAMIC RELIGIOUS PAINTING

In the Islamic lands, miniatures with a religious content were first merely illustrations of romantic or historical stories based on the Qur'an (Koran) with no doctrinal or educational function, in such works as *Shah-nama, *Jami al-Tawarikh and *Khamsa. Later in Iran, Turkey and perhaps Mamluk Syria a mystical quality was acquired with the influence of Sufism. Specific religious iconography was therefore slow to evolve; nimbi were first used indiscriminately to set the face in relief or to signify the importance of the figure within the scene illustrated. The flame halo later was reserved for Muhammad, his Companions and Ali, until it symbolised the figure of the Prophet (17th–18th century). Through the 14th–15th century the Prophet was frequently depicted unveiled as in the Jami al-Tawarikh and the Freer Shah-nama. But then there was an increasing tendency to cover the face with a veil and finally the entire body, as in the British Museum Nizami (1539–43).

ISLAMIC SCULPTURE see UMAYYAD SCULPTURE

ISRAELS, Joseph (1824–1911)

b. Groningen d. The Hague. Dutch painter trained in Amsterdam under *Kruseman and in Paris with *Delaroche and *Vernet, and also influenced by Picot. Back in Holland he gave up history works for genre subjects of peasant life, and the fishing life at Iandvoort. His works achieved notable success in Paris and exerted considerable influence in Holland on the members of The *Hague School. He specialised in subtle, low-keyed, almost monochromatic works. His subjects are similar to *Millet's, and like him he managed to avoid sentimentality.

JOSEPH ISRAELS *Maternal Joy.* 41¾×50⅞ in (106×129 cm). Rijksmuseum

ISTANBUL, Fethiye Camii

Formerly the Church of the Theotokos Pammakaristos – 'the most blessed Mother of God', substantially rebuilt in 1292, with a parecclesion added at the south end early in the 14th century. It contains frescoes from a Virgin cycle, and in the parecclesion, mosaics of high quality, close in style to those of the *Istanbul Kariye Camii.

Above: ISTANBUL, Great Palace Mosaics. Children riding a camel (detail)

Left: ISTANBUL, Great Palace Mosaics. Head of Neptune (detail)

ISTANBUL, Great Palace Mosaics

Probably laid in the 6th century, the mosaic floor on the site of the Imperial Palace represents mythological scenes and scenes from country life, with birds and animals, highly reminiscent of classical mosaics. Set against a white background worked in a shell pattern, the figures are realistically modelled by means of *tesserae of various tones.

ISTANBUL, Haghia Sophia

The Church of the Divine Wisdom, originally founded by Constantine, rebuilt and completed by Justinian (537), with subsequent repairs and alterations. The original Justinianic decoration was non-figurative, consisting of coloured marbles and mosaics with plain crosses; later emperors added figurative mosaics, notably the 9th-century Virgin and Child with archangels in the apse. Among the other mosaics added were imperial portrait-panels, the 9th/10th-century prophets and saints in the *tympana under the dome, and the late 13th-century *Deesis panel. The sheer scale and virtuosity of all these stress the veneration in which Haghia Sophia was held by the Byzantines throughout the period of the Empire.

ISTANBUL, Kalenderhane Camii

A moderate-sized church near the Aqueduct of Valens, converted into a mosque, with decorations from throughout the †Byzantine period. A mosaic panel of the Presentation of Christ to Simeon dates from before *Iconoclasm, and is the only festival icon of this period so far discovered in the capital. Fragments of a St Francis fresco cycle is mid 13th century and must have been executed by *Crusader artists during the Latin occupation.

ISTANBUL, Kariye Camii

Formerly the Church of Christ the Chora, the present building dates from three phases of construction in the 11th, 12th and 14th centuries. The extensive surviving decoration was mostly executed between 1315 and 1320/1 and was donated by Theodore Metochites, a leading Byzantine statesman and savant. The narthex contains a Christ cycle, the exonarthex a Virgin cycle, both in mosaic, and the parecclesion, designed as a mortuary chapel contains a fresco cycle on the themes of Resurrection and Judgement. In the conch of the apse of the parecclesion is represented the Anastasis – the 'descent into Limbo' – a composition full of energetic movement, yet remaining two-dimensional. This decoration is the major surviving example of late †Byzantine art.

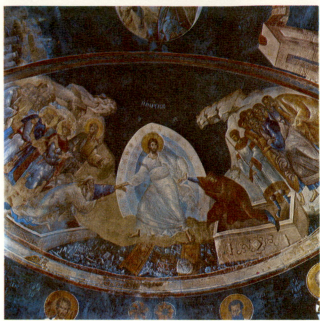

ISTANBUL, Kariye Camii. Wall-painting in the apse of the parecclesion: *The Resurrection. c.* 1305

ISTANBUL, St John of Stoudios

The main church of an important monastery in Constantinople founded by the Patrician Stoudios (AD 463), now, after damage by fire and earthquake, an open shell. It contains an extensive mosaic pavement probably dating from a restoration of the church by Michael VIII Palaeologos (second half of the 13th century).

ISTANBUL, SS Sergius and Bacchus

A centrally planned church, built by Justinian and Theodora, finished probably by 536, as part of a monastery near the Hormisdas Palace. The original decoration probably included mosaics; intricately carved capitals and the entablature survive from the 6th century.

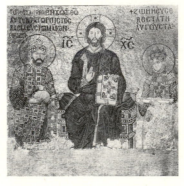

ISTANBUL, Haghia Sophia. *The Emperor Constantine II and the Empress Zoe making presentations to Christ.* 1030

ISTURITZ

Site in the Basses-Pyrénées, France, the sequence being *Aurignacian, *Solutrean and *Magdalenian. A number of decorated objects associated with the Magdalenian include an engraving of a hare and a bird. Engravings of animals are executed with the background cut away as with a cameo. There are small animals carved in stone and a lion's head in amber.

ISTURITZ Rock carving in sunk relief of the head and foreparts of a reindeer

ITCHO (Hanabusa Itcho) (1652–1724)

Japanese painter, originally a pupil of *Yasunobu, who broke away from the *Kanō tradition to develop his own individual genre style. He was banished for twelve years (1698). He was a friend of the haiku poet, Bashō.

ITTEN, Johannes (1888–)

b. Sudern-Lindern, Switzerland. He met Gropius and joined the *Bauhaus as a teacher (1919). Although he meant to encourage individuality, he tended to dogmatise, which led to his departure (1923). He painted under the influence of *Kandinsky, also producing works consisting of colours arranged in a grid to illustrate his own complex colour theories.

IUTI see BAK

IVANOV, Alexander Andreyevitch (1806–58)

b. d. St Petersburg. The most considerable Russian religious painter of the 19th century, Ivanov entered the Academy at the age of twelve and had early successes with classical history-pictures. He spent most of his life (1827–58) abroad, chiefly in Rome, where he was close to the *Nazarenes, and turned to religious themes. Plans to visit the Holy Land (1835) failed, but Ivanov became more and more attached to the idea of historical accuracy, notably after his reading of David Strauss's *Life of Jesus*, which led him to conceive an epic decorative picture of Biblical history. He brought this work back to Russia with him and it was acquired by the state. He visited Paris, Germany and London (1858). His great religious subjects have generally been forgotten, but his sketches, especially of landscape have some freshness as well as a sharpness of vision.

IVANOVO

A valley in northern Bulgaria honeycombed with rock-cut monasteries of which one, known as the 'Crkvata', was painted under Tsar Ivan Alexander (1331–71) with murals. The life of Christ is painted in a cycle of small panels across ceiling and walls; the story is acted out by anatomically distorted figures set in ornate architecture, a new manner in 14th-century †Byzantine art.

IVERNY, Jacques (active 1411–30)

b. ?Avignon. Eclectic French court painter, active in Provence and Piedmont. His style varied between that of his Italianate

Madonna and Child (1420/5) and his prettified *Nine Heroines of Antiquity* (1420/30), a typical product of the late *International Gothic style.

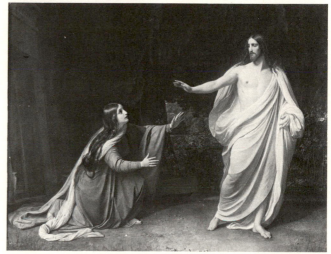

Left: JACQUES IVERNY Detail from a fresco showing two heroines of Antiquity. *c.* 1425. Castello della Manta, Piedmont
Below: ALEXANDER IVANOV *Noli me Tangere.* 1835. Hermitage, Leningrad

IVES, James Merritt see CURRIER AND IVES

IVORIES, Byzantine

Ivory-carving as an independent art form seems to have flourished during the Byzantine Empire in two periods, from the 4th to the 6th century and again from the 10th to the 11th century. Examples of objects from the early period are the splendid diptychs in various museums and *Maximian's Throne. From the second period survive ivories of a religious character such as the *Harbaville Triptych, and for secular use, the *Veroli Casket. Several workshops may be distinguished among the surviving pieces by tracing characteristic styles. Production seems to have dwindled from the 11th century on, perhaps due to changes in fashion, or to a shortage of ivory.

IVORIES, Gothic

In the second half of the 13th and during the 14th centuries there was a great increase in private chapels needing small-scale furnishings in luxurious taste. The largely French ivory industry developed for this purpose. The objects tend to be elegant, and by the 14th century mass-produced. There are a few free-standing figures, eg at *Villeneuve-lès-Avignon, but the bulk were painted reliefs, diptychs and triptychs of the Passion or the Virgin and mirror-cases and caskets with chivalrous scenes for secular use. Although not exclusively French, †Gothic ivories were in general vehicles of the French taste, influential throughout Europe.

IVORY

Bone or tusk, used for carving, also as a *support for miniature-paintings.

J

JABA (HAM) *see* NIGERIA, NORTHERN

JACKSON, Alexander Young (1882–)

b. Montreal. Canadian painter who studied with *Brymner, at Chicago Art Institute (1906–7) and Académie Julian; visited Europe (1904, 1907–9, 1911–13); was founder-member of *Group of Seven (1920); travelled extensively through Canada. From early *Fauvist-influenced *Expressionism, Jackson gradually reduced his landscapes to a few broad strokes and basic shapes.

ALEXANDER JACKSON *Terre Sauvage* (Mount Ararat). 1913. 50×60 in (127×152·4 cm). NG, Canada

JACOBSEN, Robert (1912–)

b. Copenhagen. Danish sculptor whose early works in wood and stone were inspired by German *Expressionism and Viking art. A tendency towards abstraction (1941) was accelerated by his move to Paris (1947). His constructions, though made of entirely abstract metal parts, like *González's, strongly suggest figures.

JACQUEMART DE HESDIN (d. *c.* 1411)

Illuminator to the Duc de Berry, with whom he took service (before 1384). His atelier produced the four lesser Books of *Hours listed in the Duke's inventory of 1402, the fifth and greatest being the *Très Riches Heures* of the *Limbourg brothers, who succeeded him in the Duke's establishment. The one book definitely associated with him is the *Très Belles Heures*, now in Brussels. From this it emerges that, while no outstanding personality, Jacquemart clearly played an important part in the series of experiments by which Franco-Flemish painting (*c.* 1400) prepared the way for 15th-century Flemish realism.

JAHANGIR (1605–27)

This Mughal emperor was India's greatest connoisseur of painting. His first atelier was established while he was still a prince; he collected choice Persian paintings, and brought some Persian artists into his service (eg *Aqa Riza, and his son *Abu'l-Hasan). The earliest productions of Jahangir's atelier continue the manuscript illustration traditions of his father *Akbar, especially in the fables, eg the *Anwar-i Suhayli* (BM, London), and the histories, especially the Chester Beatty

Akbar-nama (BM, London); but now the colours are more refined and the composition less symmetrically formal. Contemplating a similar history for his own reign, he travelled with selected court artists, but no full 'Jahangir-nama' was ever produced; studies for this (coronation, court scenes, State visits, hunts) were eventually collected in albums (*Muraqqas), together with Persian miniatures, studies of nature – especially birds – and idealised scenes of the life of a 'young prince'. There was excellent portraiture by many artists; later portraits of Jahangir himself borrow the nimbus from European painting. In his later years his dreams were interpreted, as a 'new iconography', especially by *Abu'l-Hasan and Bichittar. Most of his artists' names are known; the finest nature artist was *Mansur.

Above left: JAHANGIR *Jahangir visiting his father's tomb at Sikandra in 1619.* ?painted by Manohar. 11×7½ in (28×19 cm). Chester Beatty Coll, Dublin
Above right: JAHANGIR *Coronation of Jahangir* from the Leningrad Album, fol. 22r. 1605–6. 15×9 in (38×23 cm). Hermitage

Left: JACQUEMART DE HESDIN *The Madonna enthroned* from the 'Tres Belles Heures du duc de Berry'. *c.* 1402. Bibliothèque Royale, Brussels

JAINA

Sanskrit: literally 'pertaining to the Jina'; Jina ('Victor') being the religious title accorded to Mahavira, founder of the Jaina religion. Hence Jain-ism. *See also* SHVETAMBARA

JAIN PAINTING (12th–16th centuries)

The Jain school of miniature-painting, centred in Gujarat in western India was the result of patronage by wealthy Jain merchants. Its history is a long one and sees several developments. It is a predominantly religious art; scenes of Mahavira's life are used to illustrate a text, written on palm leaves and later on paper. The line is strong and the colours bright and deep with red as the predominant background. A rich effect is achieved by use of gold and ultramarine. Naturalism is rejected, with no attempt at modelling. Figures are strangely angular and the further eye of a face in profile projects beyond the cheek. Later the figures become less angular, and the subject-matter begins to include secular material. The school is important for its

great influence on Hindu painting. *See also* MUGHAL PAINTING, PRE-

JAIN PAINTING *Balamitra and his Wife. c.* 1400. Prince of Wales Museum, Bombay

JAIPUR SCHOOL (from c. 1720)

Jaipur, a Rajput state centred round the city of the same name in western India, produced a school of painting which marks a great development in Hindu art. Its rulers maintained friendly relations with the Mughals, which is reflected in the strong *Mughal artistic influence. Later, under Pratap Singh (1779–1803) a genuine Jaipur-Rajput style emerged. The artists were highly skilled and produced miniatures of a larger size than most other schools in *Rajasthan. They excelled in painting beautiful women with oval faces, and the use of gold is a characteristic of the school.

JAKUCHU (Ito Jakuchu) (1716–1800)

Japanese painter, who was probably trained originally by a *Kanō master. He excelled in two totally contrasting techniques, that of highly finished, detailed coloured paintings and abbreviated stylised, rather eccentric ink-drawings. He also published a number of printed books in the so-called 'stone-print' style (ie a white reserve on a black ground).

JAKUCHO *Fowls and Hydrangeas.* Late 18th century. Ink and colour on silk. 55×33½ in (139×85 cm). Joe D. Price Coll, Okla

JALAIRID SCHOOL

The dynasty held Iraq and western Persia (1340–1411) with the capital in Baghdad, capturing Tabriz (1359); but the exact limits of the school of painting are disputed. Several innovations enter at this point; no longer a single-plane concept, the paintings have a high horizon. The palette is rich with many tones being adopted later by the *Timurid School; gold or rich blue is used for the sky. The landscape is purely decorative, minutely detailed with stylised symmetrically arranged plants and coral-type rocks. The compositions are generally larger, with smaller figures than the *Demotte *Shah-nama* and

adapting the Chinese idioms. The school is characterised by the work of Abd al-Hayy taken by Timur to Samarqand, and Junayd as seen in the *Khwaju Kirmani* (1396, BM, London) and the Istanbul *Anthology* (1398); it strongly influenced the Timurid style.

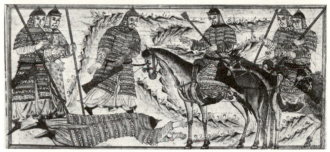

Top left: JALAIRID PAINTING Page from *Kwaju Kirmani* illustrated by Junayd, 1396. BM, London
Top right: WENZEL JAMNITZER *Spring.* Before 1578. Bronze. h. 28 in (71 cm). KH, Vienna
Above: JAMI' AL-TAWARIKH Page from an early illustrated copy, dated 1314. Royal Asiatic Society, London

JALISCO *see* WESTERN MEXICO

JAMI' AL-TAWARIKH (completed in 1310)

A 'Complete Collection of Histories' written by Rashid al-Din (1247-1318), Grand Vizier to the first Mongol ruler at Tabriz, Ghazan Khan. Several early 14th-century illustrated copies survive, most famous being the Edinburgh manuscript (1306) and that of the Royal Asiatic Society (dated 1314). Both are characterised by a linear quality, the soft colour being applied thinly. The framed miniatures in the treatment of landscape, animal forms and costume details indicate a strong Chinese flavour, but an independent *Mongol style is emerging.

JAMNITZER Family

Engravers and goldsmiths originating from Vienna. Wenzel (1505–85) accompanied by his brother Albrecht (d. 1590), set up as a Master in Nuremberg (1534). Wenzel's work typifies the grace of *Mannerist distortion and exaggeration of natural forms desired by his courtly patrons. He produced numerous small figures and ornamental pieces which prompt a comparison with *Cellini. His engraved work includes mathematical puzzles and a treatise on perspective. Cristoph (1563–1618) continued in the family manner.

JANCO, Marcel (1895–)

b. Bucharest. Roumanian painter who went to Zürich (1915), becoming involved with *Dada. He made posters and created

grotesque masks for Cabaret Voltaire entertainments. His abstract wood and plaster reliefs reflect his early architectural training. He left Switzerland after the war, finally settling in Israel.

JANSENS, Cornelius see **JOHNSON**

JANSSENS, Abraham (1575–1632)

b. d. Antwerp. Flemish painter of portraits, religious and allegorical subjects. A pupil of Snellink, he probably visited Italy twice, and his style is a mixture of *Rubensian and Italian (particularly *Caravaggesque) elements.

JANSSENS, Pieter (c. 1640–before 1700)

Dutch painter. Little is known of him, but his style is connected with de *Hooch's, and he possibly knew *Hoogstraten. The figures in his interiors almost always have their backs turned towards the spectator.

JAPANESE BUDDHIST PAINTING

Buddhism was introduced into Japan from Korea in the mid 6th century and became the court religion under the Regent, Prince Shōtoku (592–622). It brought about a complete change in Japanese art. Painting and sculpture of Buddhist subjects flourished. Until the end of the *Nara period (794) a Chinese style predominated, so much so that it cannot be convincingly argued that *Asuka and Nara period works are Japanese as opposed to Chinese. Renewed contacts with China in the *Heian period resulted in the introduction of new Buddhist sects – the Shingon and the Tendai. The Shingon held that an image of a deity was itself a deity, which led to the formulation of somewhat rigid modes of representation and the need for painters to be monks, not lay artists. The Tendai sect held that all creatures are equal before the Buddha, encouraging paintings of nature. With the rise of the Pure Land sect scenes of paradise became an important theme. By the beginning of the 11th century a real Japanese style is becoming apparent. The *Death of Buddha* (dated 1086) is purely Japanese. The esoteric Shingon sect produced representations of God's anger as a warning to evildoers; these appear both in sculpture and painting, where the Fudō-myōō is often seen ringed in flame. By the end of the 11th century, the great vigour of Buddhist art gives way to a more gentle and delicate depiction of more kindly disposed deities – an aristocratic art. During the subsequent *Kamakura period (1181–1392) religious art was more or less at a standstill, in spite of the introduction of the Zen (*Ch'an) sect, which was to become a powerful influence in the *Muromachi period and later.

JAPANESE EARLY PORTRAITURE

Portraiture in Japan descends from the Buddhist tradition of posthumous portraits of patriarchs, such as the 11th-century portrait of the 7th-century Jiondaishi, which is in *T'ang style. But in the 12th century, Fujiwara *Takanobu painted portraits that shocked the court because of their realism. These portraits are rather formal in design but the faces are softly rendered. The cross-legged position was also portrayed in sculpture. The Zen (*Ch'an) sect attaches great importance to portraiture of patriarchs, and after the 13th century these become more common, and are more true to life, often being painted by a disciple of the patriarch, eg the portrait of Musō Soseki by Mutō Shūi.

JAPANESE BUDDHIST PAINTING *Left: Death of the Buddha*. Dated 1086. Hanging scroll. Colour on silk. $105\frac{1}{4} \times 106\frac{3}{4}$ in (269×273 cm). Kongobu-ji, Wakayama. *Above: The Bodhisattva Fugen*. Heian period, 12th century. Ink, gold, colour and silver on silk. $61\frac{1}{4} \times 32\frac{3}{4}$ in (155×83·2 cm). Freer Gallery, Washington. *Right: Kokuzo-basatsu*. 12th century. Painting on silk. $51\frac{7}{8} \times 33\frac{1}{8}$ in (131×84 cm). Tokyo National Museum.

JAPANESE PAINTING: MATERIALS, FORMAT, CONVENTIONS

Ultimately deriving from Chinese sources, Japanese painting uses most of the formats and conventions of Chinese art. The main surfaces for painting are the hanging scroll, the handscroll and the album, and, for decorative effect, pairs of folding screens and sets of sliding doors. The hanging scroll is usually hung singly, and, after the end of the 15th century, in a specially constructed alcove, the *tokonoma*. The handscroll is designed to be read from right to left and consists either of pictures alternating with passages of text, or a continuous picture, often telling a story, in which the main character(s) may appear again and again. Screens for decoration appear in great houses in the *Heian and onward and become more common in the *Muromachi and the *Momoyama periods. In the latter period they become more showy, often being painted on a background of gold leaf. Screens are usually twofold or sixfold and were always used in pairs. Sliding doors were painted in the same manner as screens, but in some cases the decoration overflows the doors and carries over on to the remainder of the wall, eg the *Pine Trees* in Nijo Castle by Kano *Tannyu. Paintings may be on silk or on paper of various types and of different absorbencies: for the more detailed or formal paintings, sized paper or silk are the rule. Ink and mineral or vegetable colours are applied with a thick but pointed brush, which enables the artist to produce a strong and continuous line of varying intensity and thickness. Chiaroscuro is never used. With the adoption of Chinese canons of art, the conventions of painting were also copied. Perspective is vertical: that is, the lower down the picture, the nearer an object or place is to the viewer. In the *Heian period, the *Yamato-e handscrolls sometimes took an oblique vertical view down into a building that had the roof 'removed'. Cloud bands often invade the picture space, sometimes almost meaninglessly, but often providing an important decorative element: they may also be used to divide scenes of a screen up into separate areas. These cloud bands become particularly important during and after the *Momoyama period when part of the background was gold. There is little or no interest in the human figure – even in the erotica of the *Ukiyo-e school, nudes are rare and never sensuous, but the clothes are treated with great attention and the stance of the figures may be graceful or suggestive. Realistic drawing is confined to a few schools (eg the *Maruyama) or a few individual artists (eg *Shiko): the Japanese painter is more interested in depicting the spirit of the object than the reality. Cartoon-like drawing is common – from the *Choju Giga* (*Heian and Kamakura hand-scrolls) to the sketches of *Hokusai and of the *Nanga artists.

JAPANESE PORCELAIN FIGURES

Models of animals and human beings were made at the kilns at Arita in Japan, from the 17th century AD. A favourite subject was leaping carp. Figures of courtesans modelled in finest porcelain and decorated with Kakiemon enamels, were made at the end of the 17th century and became very popular in Europe. The figures with Imari-type enamels are slightly later in date.

JAPANESE PORTRAIT SCULPTURE

Portraits of venerated priests and patriarchs are an important aspect of Japanese Buddhist and Shintō sculpture. The interest of the *Nara period in realistic sculpture produced some of the earliest portraits, for example the *kanshitsu figure of Ganjin in the *Tōshōdaiji. In the early *Heian period portrait sculptures were made of the priest Rōben in the *Tōdaiji and of Shintō deities. It is with the revival of Nara styles in the *Kamakura period, particularly in works of the *Kaikei School, that portrait sculpture became widely popular. The *Patriarch Mujaku* by Unkei at the *Kōfukuji is one of the most successful sculptures of this type. This figure is not so much a portrait of an individual personality as an interpretation of the emotions and features which are attributes of his achievement. The portrait of Uesugi Shigefusa is the only portrait of a lay person surviving from the Kamakura period.

JAPANESE PRE-BUDDHIST PAINTING

Before the advent of Buddhism into Japan, painting was confined to the walls of chamber tombs, and to pottery. The earliest painted tombs are those of the Tumulus period (*c.* 5th century AD), though painted pottery is known from the Middle Yayoi (1st century BC). The paintings on the tombs are naïve in concept and crude in execution, and portray either abstract patterns with a few recognisable features used almost as patterns – horses, arrows – or clear depictions of those things necessary to the dead man to convey him to the next world – a horse, a boat, a flying dragon.

JAPANESE PRE-BUDDHIST PAINTING

JAPANESE PRINTED BOOKS see UKIYO-E; NANGA SCHOOL; SHIJO SCHOOL

JAPANESE PRINTS see UKIYO-E; MEIJI PERIOD (1868–1912) AND LATER

JAPANESE SCREENS see MOMOYAMA PERIOD; KANO SCHOOL; TOSA SCHOOL; RIMPA SCHOOL

JAPANESE SCULPTURE

The sculpture of Japan can be studied in the general essay at the beginning of this book and under the following headings: JOMON FIGURINES; HANIWA; ASUKA SCULPTURE; TORI SCHOOL; NARA SCULPTURE; HEIAN SCULPTURE; KANSHITSU SCULPTURE; SHINGON SCULPTURE; SHINTO SCULPTURE; JAPANESE PORTRAIT SCULPTURE; KAIKEI SCHOOL; JOCHO SCHOOL; YOSEGI SCULPTURE; JAPANESE STONE SCULPTURE; JODO SCULPTURE and JAPANESE PORCELAIN FIGURES. Reference to further entries is made within the above passages.

JAPANESE STONE SCULPTURE

Stone sculpture is very rare in Japan. However at Usuki on the island of Kyushu there is stone suitable for carving. Here a number of Buddhist reliefs were carved in the rock face in the late *Heian period. They often represent Amida, a Buddha who was especially popular at this period. This sculpture completely lacks the delicacy and softness characteristic of contemporary wooden sculpture.

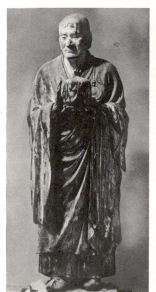 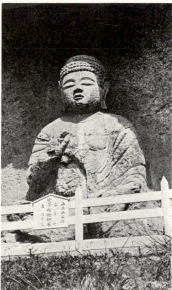

Left: JAPANESE PORTRAIT SCULPTURE The Patriarch, Mujaku by Unkei. Kamakura period, dated AD 1208. Wood. h. 76⅜ in (194 cm). Kōfukuji, Nara
Right: JAPANESE STONE SCULPTURE Buddha triad. Heian period, 12th century AD. Stone. h. 9 ft 4¼ in (2·85 m). Usuki Oita

'JAPANESE STYLE' see MEIJI PERIOD (1868–1912) AND LATER

JAPANESE WESTERN STYLES

When the Portuguese introduced Christianity (and firearms) to Japan in the 16th century, a fashion was created for copying Western paintings and prints. These were usually of Christian or genre scenes, but subjects included noblemen on horses and copies of maps. In the 18th and 19th centuries, many *Ukiyo-e and even *Nanga artists experimented with Western techniques, perspective and styles (notably Shiba *Kokan), and there grew up in Yokohama a school of woodblock-print artists who specialised in depicting the Foreign Barbarians with their outlandish dresses and customs. In the *Meiji period, a new vogue for things Western swept Japan, and Western styles of painting were taken seriously as art forms instead of being treated as curiosities.

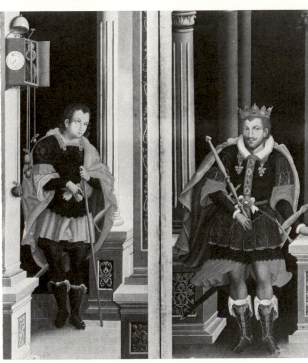

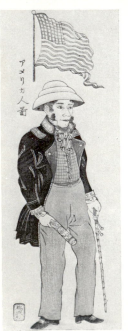

Above: JAPANESE WESTERN STYLES. *European King and a courtier.* Kano School, 17th century. Ink colour and gold on paper. Each panel 4 ft 2 in× 1 ft 9⅞ in (127×55·6 cm). Fenollosa-Weld Coll, Boston
Right: ALEXEI VON JAWLENSKY *Olga – Girl with a Feathered Hat.* 1912. 21½×19 in (54·6×48·3 cm). Pasadena Art Museum

Left: JAPANESE WESTERN STYLES American Yokohama woodblock colour print. 19th century. 16½×6 in (41·8× 15·2 cm). Ashmolean

JARVIS, Charles see JERVAS

JARVIS, John Wesley (1780–1840)

b. England d. New York. Painter, first an engraver, who painted portraits and miniatures with Joseph Wood (1802–10), made several working trips south, and painted full-length portraits of the War of 1812 heroes for New York (1813). His portraits, as uneven as his eccentric personality, were sometimes sensitively drawn and perceptive, often repellently coarse.

JATA-KA

Sanskrit: literally 'relating to the birth'; corpus of Pali literature describing previous incarnations of the Buddha.

JAWLENSKY, Alexei von (1864–1941)

b. Kuslovo d. Wiesbaden. Painter who left Russia (1896), met *Kandinsky in Munich and formed a lasting friendship. Influenced by *Fauvism and in particular by *Rouault, he painted with bold colour and dark outlines. He retained a constant allegiance to figuration, refusing to join der *Blaue Reiter, but under the influence of *Delaunay, he produced a series of repeated motifs which come close to abstraction. In later years he was preoccupied with paintings derived from the image of a head.

JEANNERET, Charles-Edouard see LE CORBUSIER

JEMDET NASR see MESOPOTAMIA, ART OF

JENKINS, Paul (1923–)

b. Kansas City, Missouri. *Abstract Expressionist painter who studied at Kansas City Art Institute and *Art Students' League; travelled in Spain, Sicily and France, settling in Paris (1953). By dripping paint on canvas and kneading it, Jenkins creates luminous, organic, liquid veils of colour, the epitome of accident and chic.

JENNYS, William (J. WILLIAM) (active c. 1795–1810)

Active New England and New York. Portrait painter whose work is characterised by confident, firm draughtsmanship, low-keyed colours and penetrating insight.

JERICHO Plastered skull. 7th millennium BC. Amman Museum, Jordan

JERICHO (c. 7000–6000 BC)

A group of nine plaster skulls were discovered during excavations at the Neolithic city of Jericho. The application of clay modelled over the facial area of the skulls gives them a remarkably lifelike appearance. They may represent portraits of some worshipped ancestors. The eyes are of shell.

JERUSALEM, Dome of the Rock

The Dome of the Rock in Jerusalem was built by the *Umayyad Caliph Abd al-Malik (691). It is an octagonal building decorated with mosaics, standing above a rock thought to have been a part of Solomon's temple. The decoration was extensively altered at a later date. See also MOSAICS, Islamic

JERVAS (JARVIS), Charles (c. 1675–1739)

d. London. Irish portrait painter. After several years in Italy, he settled in London (1709), married a rich widow and became famous overnight. He succeeded *Kneller as George I's Court Painter (1723), and portrayed many prominent writers and scientists – for whom he kept open house.

JESSE WINDOW

The theme of the ancestry of Christ expressed in the literal interpretation of the prophecy of Isaiah ('And there shall come forth a rod out of the stem of Jesse . . .') with the Virgin and Christ at the top of a family tree springing from the loins of Jesse and ancestors in the branches – became widespread in the 12th century and was popular until the end of the Middle Ages. In France, notable examples in stained glass are at *St Denis, *Chartres and the Ste Chapelle, *Paris. In England there is a 12th-century fragment in York Cathedral and fine late 14th-century examples in two of William of Wykeham's foundations, Winchester College and New College, Oxford. An extension of the Jesse window can be seen in Dorchester (Oxfordshire) where the tracery is carved in the form of a Jesse tree.

JESUITS see SOCIETY OF JESUS

JEWETT, William (1795–1874)

b. East Haddam, Connecticut d. Bayonne, New Jersey. Portrait painter who studied in New York with Samuel Lovett *Waldo (1812–18), and painted portraits in partnership with him (1818–54). Occasionally painting landscape and genre as well as portraits, Jewett is conventionally skilful, lacking ambition and penetration.

JIHEI (attr.). The Insistent Lover. 1625–94. Colour print. 10¾×16 in (27·3×40·6 cm). Art Institute of Chicago, Buckingham Coll

JIHEI (Sugimura Jihei) (active 1681–97)

Japanese painter, one of the earliest *Ukiyo-e artists, and particularly famous for his erotica. He made book illustrations in a manner similar to that of *Moronobu, but they are more relaxed and sensual in feeling.

JOANNES, Juan de see MASIP, Vincente Juan

JOCHO SCHOOL

A Japanese school of sculpture led by Jōchō (active AD 1022–57). Jōchō was responsible for a reformulation of the seated Buddha image in the late *Heian period. The only surviving example of his work is the figure of Amida in the Hōōdō of the Byōdoin, a temple founded in AD 1051. The image is firmly executed contrasting with the more facile treatment of many images of this period. It was Jōchō who systematised the use of *yosegi, or the joined wood technique, a technique which enabled him to give delicacy of detail and expression to his sculpture.

JŌCHŌ SCHOOL Amida Buddha by Jōchō. Heian period, AD 1053. Wood. h. 9 ft 8½ in (295 cm). Hōōdō of the Byōdoin, Kyōto

JODE, Pieter de, the Elder (1570–1634)
the Younger (1606–after 1674)

Both b. Antwerp, the Elder d. Antwerp, the Younger d. England. Flemish engravers, they were father and son, master and pupil, and both engraved numerous plates after important Flemish masters.

JODHPUR SCHOOL

This Rajput state in western India was one of the most prolific, and under the direct influence of the *Mughal School produced many miniatures depicting favourite subjects such as women in all moods, and portraits. The portrayal of human faces and figures is an improvement over earlier schools and the colours used, though bright and almost gaudy, blend and harmonise well. Silver was used to represent water, a Mughal device. About 1750, a highly stylised kind of equestrian portrait in profile of the ruler developed. The background of these was most frequently pale green.

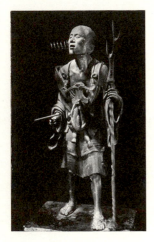
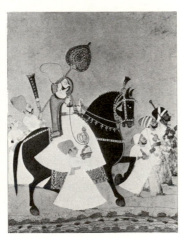

Left: JODO SCULPTURE The itinerant priest, Kūya by Kōshō. Kamakura period, 13th century AD. Wood. h. 46½ in (118 cm). Rokuharamitsuji, Kyōto
Right: JODHPUR PAINTING *Raja Ram Singh of Jodhpur* c. 1750. 11⅞×9⅝ in (30×24·5 cm). V & A, London

JODO SCULPTURE

The Jōdo sect of Buddhism was introduced into Japan from China and gained popularity towards the end of the *Heian period through the efforts of the priest Hōnen (AD 1133–1212). Entry into paradise was guaranteed for those who recited the name of Amida. The sect had some influence on the *Jōchō School but it is in the *Kamakura period that it was most important becoming part of a widespread popularising movement in Buddhism. The qualities of realism and directness prevalent in *Kamakura sculpture were exploited by the Jōdo sect in such images as the figure of the itinerant priest Kūya by Kōshō in the Rokuharamitsuji. Small figures of Amida issuing from the mouth of the priest are a concrete representation of the faith of this sect in the efficacy of the name of Amida.

JOEST, Jan (von KALKAR) (c. 1455/60–1519)

b. Wesel, Lower Rhine d. Haarlem. Netherlandish painter, the nephew of Derick *Baegert. He painted altar wings for St Nicholas, Kalkar (1505–9) and was in Haarlem from 1509. His works show an interest in coarse characters and dramatic lighting effects.

JOHAN, Pedro (Pedro de VALLFOGONA)
(1398–after 1458)

b. ?Barcelona d. ?Saragossa. Catalonian sculptor, trained in the †Gothic tradition, who came into contact with early 15th-century Italian styles. His alabaster reliefs for the high altar of Tarragona Cathedral (1425–36) are, in their compact design of short figure types, close to *Ghiberti.

JOHN, Augustus (1878–1961)

b. Tenby, Wales d. Fordingbridge, Hampshire. Painter of portraits, figure compositions, landscapes and flowers; also draughtsman, etcher and lithographer. Studied at the Slade School of Art (1894–8). Essentially a draughtsman, his paintings have the strong contours and forms which belong to drawing, but this meant he was never really successful on a large scale. His natural facility made him a rapidly successful portrait painter. His later work became progressively looser in handling. Brother of Gwen *John.

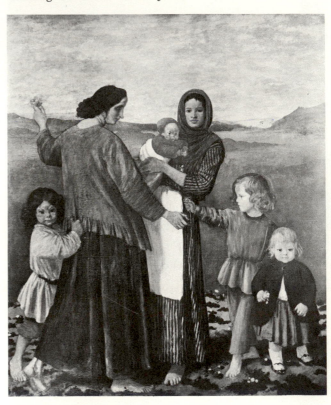

Above: AUGUSTUS JOHN *Decorative Group.* 79½× 68¼ in (201·9×165·7 cm). Municipal Gallery of Modern Art, Dublin
Left: GWEN JOHN *Woman holding Flower.* 17×11¼ in (43·2×28·6 cm). Birmingham

Right: EASTMAN JOHNSON *Not at home.* c. 1870/80. 26½×22¼ in (67·3×56·5 cm). Brooklyn Museum, New York

JOHN, Gwen (1876–1939)

b. Haverfordwest, Pembrokeshire d. Dieppe. Painter chiefly of portraits and single-figure studies of women and children. Studied at the Slade School of Art (1894–7) and under *Whistler; lived in France (from 1898). Sister of Augustus *John. Her work exhibits qualities of austerity, reticence and control, maintaining tonal balance with little variation in subject-matter.

JASPER JOHNS *Flag*. 1954. Encaustic, collage, canvas. 42×60 in. (106·7×152·4 cm). Philip Johnson Coll, New York

JOHNS, Jasper (1930–)

b. Augusta, Georgia. Painter who studied in South Carolina and New York; moved to New York (1952); associated with *Rauschenberg. By applying the lush, painterly, *Abstract Expressionist technique to banal motifs, eg flags and targets, often incorporating real objects, Johns became an influential catalyst in developing *Pop Art's philosophy and imagery.

JOHNSON (JANSENS), Cornelius (1593–1661)

b. London d. Utrecht. Anglo-Dutch portrait painter. Probably a pupil of Marcus Gheeraerts, he worked for James I and Charles I, but left England during the Civil War (1643). He was influenced by *Mytens and *Van Dyck.

JOHNSON, (Jonathan) Eastman (1824–1906)

b. Lowell, Maine d. New York. Portrait and *genre painter who studied with *Leutze in Düsseldorf (1849–51) and *Couture in Paris; studied *Rembrandt and *Vermeer in The Hague; settled in New York (1858), travelling in Europe and America. His work is distinguished by painterly breadth, architectonic composition, warm tones and discerning, sympathetic realism.

JOHNSTON, David Claypoole (1799–1865)

b. Philadelphia d. Dorchester, Massachusetts. Printmaker, illustrator and genre painter who studied engraving in Philadelphia (1815), made caricatures of Philadelphia notables (1819), moved to Boston (1826), and published *Scraps* annually (from 1830). Called the 'American *Cruikshank', Johnston used his animated line to draw blood in caricatures. Later, less individually barbed satires were popular.

JOHNSTON, Henrietta (d. 1729)

b. ?England d. Charleston, South Carolina. Portraitist active in Charleston (1705–29), and in New York (1725). Probably the first American woman artist, she introduced pastel portraiture to America in charming, elegant, little works.

JOMON FIGURINES

Small pottery figures were made in Japan during the second half of the Jōmon period (3000–250 BC). They appear in many instances to have been symbols of fertility. Their elaborate incised and appliqué ornament, resembling tattoo markings, has a decorative rather than representational effect.

Left: JOMON FIGURINE from Saitama. h. 8 in (20·4 cm). Tokyo National Museum
Right: JOMON FIGURINE from Gumma. h. 12 in (31 cm). Private Coll, Japan
Below: ALLEN JONES *Man Woman*. 1963. 84½×74½ in (214·6×188·6 cm). Tate

JONES, Allen (1937–)

b. Southampton. Painter who studied at Hornsey School of Art (1958–9), the Royal College of Art (1959–61) and visited America (1964–5, 1966). Jones helped launch British *Pop Art

at the 'Young Contemporaries' exhibition (1961). His nostalgia, stemming from *Hamilton, for American popular culture of the 1940s, is an exotic rather than popular taste in the British context. In Jones's work an engaging naïveté and painterliness preceded an intentional banality of sexy image and commercial technique.

DAVID JONES *Guenivière*. 1940. 24½×19½ in (62·2×48·3 cm). Tate

JONES, David (1895–)
b. Brockley, Kent. Studied at Camberwell and Westminster Schools of Art. A painter and draughtsman of landscape, still-life, portraits, animals, literary and imaginative subjects, portrayed with delicate handling and colouring. Also an engraver, poet, writer and calligraphist.

JONES, Joe (Joseph John) (1909–63)
b. St. Louis, Missouri d. Morristown, New Jersey. Self-taught painter who first painted realistic, socially conscious works. Later associated with the Regionalists of *American Scene painting, he evoked the Midwest with energetic breadth, more successful in easel-paintings than in murals. His late landscapes are more subdued and intimate.

JONES, Thomas (1743–1805)
b. d. Radnorshire. Welsh landscape painter. A pupil of Richard *Wilson, he painted classical landscapes and, more importantly, oil sketches from nature in Wales and Italy, which he visited 1776–1782/3.

JOHAN JONGKIND *Street Scene – Demolition*. 1868. 13½×16¾ in (34·3×42·5 cm). Glasgow

JONGKIND, Johan Barthold (1819–91)
b. Latrop d. Côte-Saint-André. Dutch artist who studied at The Hague under *Schelfhout and then in Paris under *Isabey in the 1840s. He was again in Holland (1855–60) greatly in debt and only came back to France through the help of his French artist friends, including *Corot and *Rousseau. Although he got to know the †Impressionists, and influenced the young *Monet, he did not adopt outdoor painting. Two of his main themes, moonlight scenes and Dutch winter landscapes, had their origins in 17th-century Dutch art. His vigorous watercolours form an important part of his œuvre.

JOOS VAN GENT *see* **WASSENHOVE, Joos van**

JORDAENS, Jacob (Jacques) (1593–1678)
b. d. Antwerp. Flemish painter of portraits, still-lifes, genre, mythological and religious subjects, etcher and designer of tapestries. He was the pupil and son-in-law of Adam van Noort, and also worked as an assistant to *Rubens. Jordaens was head of the Antwerp Guild and had a large workshop (by 1621). After the death of Rubens and *Van Dyck, he received several important commissions, and helped decorate the Huis ten Bosch, the royal hunting-lodge, near The Hague. He became a Calvinist (1655), and his extrovert style (which derives many elements from Rubens, but is generally coarser and employs thicker impasto and stronger *chiaroscuro) became more sober.

JACOB JORDAENS *The Bean-King*. *c*. 1642. 14½×21½ in (37×54 cm). Koninklijk Museum voor Schone Kunsten, Antwerp

JORN, Asger (1914–)
b. Vejrum. Danish painter who studied with *Léger and worked for *Le Corbusier in Paris (1936–7). Was greatly impressed by *Klee and *Miró. After anti-Nazi wartime activities, he joined the *Cobra group (1948–51). Settled in Paris (1953). His painting is anti-rational, aimed at the spontaneous revelation of hidden urges. Sympathetic in general terms to political protest, his mutilated human images and aggressive manipulation of colour and pigment have during the 1960s increasingly implied social criticism.

JOSEPHSON, Ernst (1851–1906)
b. d. Stockholm. Swedish painter of genre and realistic portraiture, often with a great amount of detail. He studied in Stockholm, travelled in Europe and stayed for a time in Paris. In the late 1880s he went mad but continued to paint figures, in a distorted manner.

JOSETSU (Taiko Josetsu) (early 15th century)
Japanese painter famous for his *Catching a Catfish a Gourd* which uses a backward landscape of Southern Sung inspiration. He was a monk at Shōkoku-ji, Kyōto.

JOSHUA ROTULUS
Originally a long parchment roll on which was executed, in

wash-drawings, a continuous frieze concerned with the victories of Joshua. Naturalistic in style it is comparable with the *Paris Psalter and is therefore seen in the context of a 10th-century renaissance of a classical style in Byzantium. Its triumphal character seems to link it with the series of Byzantine victories in war in the second half of the 10th century. (Vatican.)

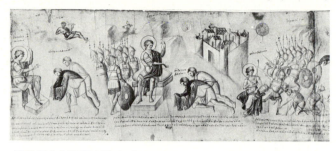

JOSHUA ROTULUS *Joshua receiving emissaries*. 10th century. Vatican

JOUVENET, Jean (1644–1711)

b. Rouen d. Paris. French *history and religious painter. He went to Paris (1661) and (strongly influenced by *Lebrun) worked on large decorative schemes at Versailles and Marly. After Lebrun's death (1690) he developed a more dramatic †Baroque style.

JUAN DE FLANDES (active 1496–c. 1519)

Flemish painter at the court of Isabella of Castile (1496–1504), his most important commissions were the Salamanca retable (1505) and the high altar retable at Palencia (1509, now Prado). These works justify the supposition that he was trained in the Netherlands, for they show clarity of composition and spatial elements influenced by Hugo van der *Goes.

JUAN DE JUNI (c. 1506–77)

b. ?Joigny, Champagne d. Valladolid. Sculptor of French extraction, who probably trained in Italy. First recorded at León (c. 1533). He settled in Valladolid (1541). In turn he practised High †Renaissance style (1530s), *Mannerism (1538, St Jerome) and an emotional humanistic Proto-†Baroque (1540, St Matthew).

JUAREZ, José (c. 1615–c. 1667)

Mexican painter of huge altarpieces. His stylistic dependence on *Zurbarán suggests that he studied in Seville (c. 1635–40). His classically balanced compositions, frequently with an architectural framework, also display a characteristic Sevillian interest in naturalistic still-life.

JOSETSU *Catching a Catfish in a Gourd*. Early 15th century. Ink and slight colour on silk. 40×30 in (101×76 cm). Taizo-in, Kyōto

JUDD, Donald (1928–)

b. Excelsior Springs, Missouri. Sculptor who studied at *Art Students' League (1947–53), Columbia University: BS (1949–53) and Fine Arts Department (1958–61); lives in New York. From painting influenced by *Rothko and *Newman, Judd turned to *Minimal sculpture, making large, awkward, subtly lit 'primary structures' of repeated geometric shapes, manufactured from industrial materials.

DONALD JUDD *Untitled*. 1965. Painted iron and aluminium. 33×141×30 in (83·8×358·1×76·2 cm). Philip Johnson Coll, New York

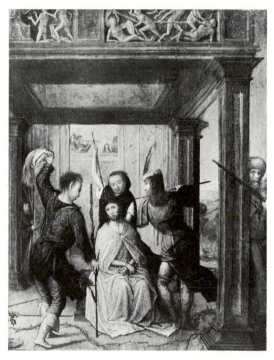

JUAN DE FLANDES *Christ Crowned with Thorns*. c. 1498. 8½×6⅜ in (21·6×16·2 cm). Art Institute of Detroit

JUEL, Jens (1745–1802)

b. Gamborg Figen d. Copenhagen. Danish Court Painter (from 1780), after studying in Rome and Paris; Director of Academy. Best known for his small-scale portraits, frequently oval, he also executed group portraits in landscape, flower and fruit compositions, and landscapes.

JUGENDSTIL see ART NOUVEAU

JUKUN see NIGERIA, NORTHERN

JULES, Mervin (1912–)

b. Baltimore, Maryland. Painter and printmaker who studied at Maryland Institute of Fine and Applied Arts and with *Benton at *Art Students' League; taught at Smith College (c. 1949–69). His earlier satirical social protests had some *Expressionist power; more recent woodcuts of flowers, children and political martyrs show more technique than conviction.

JUNIUS BASSUS, Sarcophagus of

A three-sided sarcophagus made in Rome (*c.* 359) for the Prefect of the City, Junius Bassus. The scenes in two registers are carved in a deep-cut and naturalistic style; their message is the triumph of Christ and his Church after initial suffering.

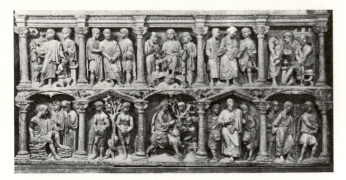

SARCOPHAGUS OF JUNIUS BASSUS *c.* 359. Vatican

JUSTE, Jean (Giovanni GIUSTI) (1485–1549)

b. Florence d. Tours. Most important member of Italian family of sculptors. Settled in Tours (*c.* 1504/5). Collaborated with brother Antonio on the tomb of Louis XII (St Denis), bringing a free-standing, spatial form of monument to France.

JUSTUS OF GHENT *see* WASSENHOVE, Joos van

K

KAHLO, Frida (1910–54)

b. d. Coyoacán. Painter who taught at Esmeralda School and on Cultural Mission in Coyoacán. Her firmly ordered *Surrealist paintings, often of Mexican themes, are filled with complex references to her husband *Rivera and the constant pain of her lifelong illness.

KAHNWEILER, Daniel-Henry (1884–)

b. Mannheim, Germany. Art dealer who came to Paris (1902), opening his first gallery at 28 rue Vignon (1907). Here he showed *Braque (1908), working with *Gris, *Picasso and *Léger (by 1912/14). He published *Der Weg zum Kubismus* (1920). The Occupation drove him into hiding; his Galerie Simon was liquidated, later reopening as the Galerie Louise Leiris. Kahnweiler, the first publisher of *Apollinaire, Jacob, etc, believed in 'teamwork' with his artists; he was particularly close to Juan *Gris, publishing a monograph on him (1943).

KAI Ch'i (1774–1829)

Chinese painter who lived in Sung-chiang, Kiangsu. He produced figure paintings in a refined style, based on the works of great masters of the past.

KAIGETSUDO (Ando Kaigetsudo) (traditionally 1671–1743)

Japanese artist, the first of a line of painters of the *Ukiyo-e School who specialised in statuesque, full-length portraits of courtesans. This original theme appears both in paintings and in the few prints produced by the group.

KAIKEI SCHOOL

A Japanese school of sculptors of the early *Kamakura period whose main aim was to reproduce the powerful style of the *Nara period. This movement was led by Unkei, son of Kōkei, a sculptor who traced his descent from the sculptor *Jōchō. Kaikei took over the direction of the studio from Kōkei working both alone and in collaboration with Unkei. The sons

of Unkei, Tankei, Kōun, Kōben and Kōshō continued the tradition. Jōkei, to whom the *Shō Kannon* (1226) in the Kuramadera and the *Yuima Koji* in the *Kōfukuji are reliably attributed, belonged to the group. Two figures of guardians at the great gate of the *Tōdaiji by Unkei and Kaikei (1203) illustrate the effective use of a realistic style. As with most Kamakura sculpture the impact of the images is more worldly and physical than the austere emotional realism of their Nara counterparts.

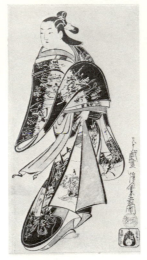
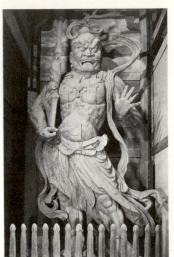

Left: KAIGETSUDO Standing Figure of Oiran. *c.* 1715. Print. 21¾×11½ in (55·2×29·2 cm). Art Institute of Chicago, Buckingham Coll
Right: KAKEI SCHOOL Guardian figure by Unkei and Kaikei. Kamakura period, AD 1203. Wood. h. 26 ft 3 in (8·05 m). Tōdaiji, Nara

KAKUYU *see* TOBA-SOJO

KALAMIS (active 1st half 5th century BC)

Greek sculptor, perhaps from Boeotia, who was famous for his statues of horses. He also made a statue of Zeus Ammon for the poet, Pindar, a Hermes for the city of Tanagra, a colossal statue of Apollo for Apollonia Pontika, and a statue of Apollo Alexikakos which stood in the Kerameikos at Athens.

KALF, Willem (1619–93)

b. d. Amsterdam. Dutch genre and still-life painter. He worked in Rotterdam, Paris and Amsterdam. His luxurious still-lifes, showing great sensitivity to light and texture, suggest the influence of *Vermeer.

KALIGHAT PAINTING

Kalighat painting is a survival of an older, native tradition from eastern India. The school is so called because it is associated with the cult of the terrible goddess, Kali. She is frequently depicted as a black hag with fangs and a red, lolling tongue, adorned with skull-necklaces. The usual size of the paintings is roughly 18 × 12 inches. Bright watercolours are used with touches of gold and silver. Many represent Hindu deities, but some are secular and somewhat fanciful: men beating their wives, Europeans with umbrellas and so forth. Because they are sold so cheaply, the pictures are made in great numbers and the technique has become increasingly simplified, resulting in a rather abrupt style.

KALILA WA DIMNA

A collection of fables, originating in India, but translated into Arabic and Persian. Its two main characters are the jackals, Kalila and Dimna. A favourite subject for illustration, the work survives in many copies, Arab, Persian and Mughal. The Bibliothèque Nationale manuscript (1200–20) is probably

Syrian with its simple compositions on a single plane, framed only by the stylised trees and unnaturalistic tall plant life. Of a later date, the Gulistan copy (dated c. 1430) at Herat with its thirty-nine miniatures is judged a superb example. *See also* BIDPAI

KALINGA *see* SATAVAHANA DYNASTY

KALKAR, Jan von *see* JOEST

KALLIMACHOS OF ATHENS
(active 2nd half 5th century BC)

Greek sculptor reputed to have invented the Corinthian capital, and to have been the first to use the running-drill. His works include a golden lamp for the Erechthion and a seated statue of Hera for a temple at Plataea. He is said to have spoiled his work by over-elaboration.

KALPA-VRIKSHA

Sanskrit: literally 'attainment-tree'; in Hindu mythology the tree which grants the desires of the supplicant.

KAMAKURA PERIOD *see* HEIAN AND KAMAKURA HANDSCROLLS

WILLEM KALF *Still-life with Nautilus Cup*. c. 1660. Thyssen-Bornemiza Coll, Lugano

KAMAKURA SCULPTURE (AD 1185–1392)

A period of political stability and renewed contact with China contributed to a revival of sculpture in the early Kamakura period in Japan. The delicate realism in the Dainichi Nyorai by Kōkei and Unkei in the Enjōji is in part the result of the influence of Sung China. However, the Chinese contribution is confined to minor elements, to realistic touches in the drapery folds, to strings of jewellery and hints of human expression. The main proportions and power of the figure were adopted from sculpture of the *Nara period. This conscious reinterpretation of the Nara styles, which was one of the main features of the *Kaikei School, replaced the awe-inspiring emotional intensity of the original sculptures with a more intimate

quality. An increasingly worldly approach was characteristic of the period which saw a growing interest in portrait sculpture and in images of deities associated with personal salvation, such as the Amida images of the *Jōdo sect. *See also* JAPANESE PORTRAIT SCULPTURE

KAMAKURA SCULPTURE Dainichi Nyorai by Kōkei and Unkei. AD 1176. Wood. h. 40 in (101 cm). Enjōji, Nara

KAMARES WARE

A type of *Minoan pottery (2000/1700 BC) called after the sacred cave on Mount Ida where it was first found. It was a dark-surfaced pottery with designs in red and white often with sophisticated spiral motifs. It is largely confined to Knossos, Phaistos and the Kamares area.

KANACHOS (active 500/450 BC)

Greek sculptor mentioned by Quintilian and Cicero as producing stiffer and more rigid statues than *Kalamis.

KANAUJ *see* GURJARA-PRATIHARA DYNASTY

KANDINSKY, Wassily (1866–1944)

b. Moscow d. Neuilly-sur-Seine. Painter, theorist and teacher who abandoned law to study painting in Munich (1896–1900). He travelled in Europe and North Africa (1903–8). In Munich (1908–14) he exhibited with the anti-*Secessionists organisation Neue Kunstlervereinigung, then organised der *Blaue Reiter (1911), published *Concerning the Spiritual in Art* and painted what have been called the earliest abstract pictures (1912). He lived in Moscow (1914–22), taught at the *Bauhaus (1922–33) and moved to Neuilly (1933–44). At first divided between imaginary compositions influenced by *Jugendstil and nature studies; perception, memory and imagination combine in increasingly free, rich paintings (from 1908). Kandinsky felt both intuitively and intellectually that subject-matter could be suppressed to increase the impact of colour and form. His developing abstraction was for him a developing spirituality paralleled in the other arts and confirmed by his theosophical studies, although the residue of romantic subjects usually remained visible in his work. *Constructivist influence (1917–22) made his style more austerely geometric

and more deliberately considered. His last paintings perhaps achieve his ambition of combining the sincerity of 'improvisations' with the deliberateness and wholeness of 'compositions'.

Top: WASSILY KANDINSKY *Yellow Accompaniment.* 1924. 39¼×38⅜ in (99·7×97·5 cm). Solomon R. Guggenheim Museum, New York
Above: WASSILY KANDINSKY *Improvisation 'Klamm'.* 1914. 43¾×43¾ in (111·1×111·1 cm). Stadtisches Galerie im Lenbachhaus, Munich, Gabriele Münter Foundation

KANE, John (1860–1934)

b. Scotland d. Pittsburgh, Pennsylvania. Painter who went to America; lived in Pittsburgh; worked as coal-miner, carpenter and house-painter. Kane's primitive paintings of landscapes, genre scenes and Pittsburgh past and present are composed of subtly coloured, exact details woven into charming patterns, carrying the conviction of child-like love and vision.

KANE, Paul (1810–71)

b. County Cork d. Toronto. Painter who went to Canada (*c.* 1819); painted portraits in North America (1830–6); worked in Europe (1841–5); went on Hudson's Bay Company expedition to West (1846–8). Kane's paintings of the Western landscape and Indians are Canadian in subject but European in style; at their best dramatically composed.

KANG Hǔi-an (1419–65)

Korean painter, calligrapher and poet. A member of an aristocratic family he passed the Government examination (1441) and was attached to the Chiphyonjon, the scholars' academy. He visited China many times and was influenced by painters of the Southern Sung. *Sage in Meditation* is one of his most famous works.

KANGRA SCHOOL

Kangra painting has a long history and the name has been used somewhat generally. The 'high' Kangra School flourished in the state of the same name in the western Himalayas under the patronage of Sansar Chand (1775–1823). This attracted some artists from the *Guler School who represented the *Mughal strand of that art. The several sets of paintings of the Krishna cycle painted by them have, therefore, much Guler influence. The chief characteristics of the Kangra style are its delicacy and refinement, its aura of romance and idealism. The women are particularly graceful and are frequently depicted in gliding motion. The angularity of the architecture in the paintings is a splendid foil for the softly rounded figures. The landscapes have a warm luxuriance, and nature is used symbolically to parallel and enhance the emotions of the characters in the paintings.

KANGRA SCHOOL *Lady on a Swing c.* 1810. 8½×5½ in (21×14 cm) V & A, London

KANO SCHOOL

The greatest of the hereditary schools of Japanese painters, the Kanō was founded in the *Muromachi period (1392–1573) by Kanō *Masanobu. At first painting in the *Chê Chinese manner, as imported to Japan by *Sesshū, the style changed to a more decorative one under Kanō *Motonobu, Masanobu's son, the first really great Kanō painter, and to an avowedly decorative purpose under Kanō *Eitoku. Eitoku was patronised by Nobunaga, the first military dictator of the *Momoyama period, and his bold masses of colour on the gold background of screens and sliding doors perfectly suited the taste of the time. This decorative bent became the hallmark not only of the Momoyama period, but of the succeeding generations of the Kanō School. Eitoku's adopted son *Sanraku developed the style still further, under the patronage of Hideyoshi, but after the generation of Kanō *Tannyu and his brothers *Naonobu and Tsunenobu, there was a tendency in the school towards a degeneration into Academic or merely decorative set-pieces. Most Kanō artists, being trained in the Chinese manner, were excellent ink painters as well, and because the Kanō style became adopted as the classical style, many artists of other schools had their original training under a Kanō teacher. An offshoot to the later Kanō was a style of genre painting, centred in Kyōtō, that became one of the formative influences on *Ukiyo-e, and is also interesting in its own right.

Left: KANO SCHOOL The dog chase. Part of a screen (detail). Ink and colour on gold leaf. Harari Coll, London
Right: KANSHITSU SCULPTURE Eleven-headed Kannon. Nara period, second half 8th century AD. Gilded lacquer. h. 6 ft 10⅜ in (2·09 m). Shōriuji, Nara

KANSHITSU SCULPTURE

From the 7th century much use was made of lacquer in Japan to make up the surface of wooden sculptures. During the 8th and 9th centuries various methods were used to reduce the wooden core and leave a space in the centre. This is known as 'Mokushin Kanshitsu'. For a short time (c. AD 730) figures were produced which consisted, when completed, of an unsupported shell of lacquered cloth. This is Dasshin Kanshitsu. Eight layers or more of cloth were placed over clay models and stuck with liquid lacquer. The clay was then removed by way of a panel cut in the sculpture. The sensitivity of the treatment of the texture of hair, skin and draperies of Dasshin Kanshitsu sculptures, notably those in the *Kōfukuji are in part a product of this technique.

KANT, Immanuel (1724–1804)

b. d. Königsberg. German philosopher whose ideas on aesthetics formed a philosophic background to many concepts about art fostered by the †Romantic movement, eg 'originality' and 'genius'. He asserted that judgements about beauty were entirely subjective, and hence dismissed the idea (inherent in academicism) that theoretical rules could be compiled for the creation of beautiful objects. However, he argued that stimulation of sense-perceptions by a work of art did not vary from individual to individual, and that consequently art had universal validity.

KANTOR, Morris (1896–)

b. Russia. Painter who went to America (1911); studied (1916–18) and taught (from 1936) at *Art Students' League. First influenced by *Seurat and *Cubism, Kantor combined his knowledge of structure and composition with a latent romanticism to create moving *Surrealist images whose mood shifts ambiguously between dream and nightmare.

MORRIS KANTOR Haunted House. 1930. 37⅛×33¼ in (94·3×84·5 cm). Art Institute of Chicago

KANYOSAI (1719–74)

Japanese artist who studied in Nagasaki and did much to spread the influence of *Shen Nan-p'in with such books as Kanyōsai Gafu (1768).

KAO Ch'i-p'ei (c. 1672–c. 1734)

Manchu painter from Liao-yang, Manchuria. Primarily known as a finger-painter, both of landscapes and figures.

KAO FENG-HAN Rocks and bamboo in snow. Fan painting dated 1722. Ink and colours on paper. Width 21¾ in (55 cm). BM, London

KAO Fêng-han (1683–after 1747)

Chinese painter from Chiao-chou, Shantung. One of the *Eight Eccentrics of Yangchow. His early paintings, such as the fan from a series in the British Museum, show a freedom and individuality that is typical of the Yangchow painters. Later he lost the use of his right arm and painted with his left.

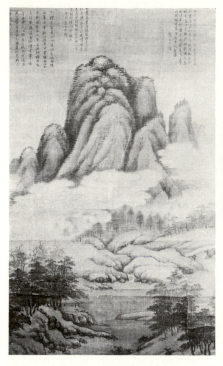

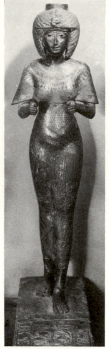

Left: KAO K'O-KUNG *Verdant Peaks above Clouds.* Dated 1309. Ink and colours on silk. 71¾×42⅜ in (182·3×106·7 cm). National Palace Museum, Taiwan
Right: KARMEM, Statuette of. 22nd dynasty. Bronze inlaid with gold, silver, electrum and copper. h. 23 in (58·9 cm). Louvre

KAO K'o-kung (1248–1310)

From Ta-t'ung, Shansi. Kao K'o-kung's family had come from Turkestan; he himself had a classical Chinese education and a brilliant official career. In painting he followed *Mi Fu and *Tung Yüan. *Verdant Peaks above the Clouds,* ascribed to Kao in an inscription of 1309, shows both his brush technique in the *Tung Yüan-*Chü-jan tradition and a clarity of structure that is characteristic of *Yüan dynasty landscape.

KAO TSUNG *see* MA HO-CHIH; CHAO PO-CHU

KARAWARI RIVER *see* SEPIK RIVER

KARLE *see* SATAVAHANA DYNASTY

KARFIOL, Bernard (1886–1952)

b. Budapest d. Irvington-on-Hudson, New York. Painter who moved to Brooklyn, studied at National Academy of Design (*c.* 1900) and with *Laurens at Académie Julian (1901); travelled in Europe (1901–6); exhibited at Salon d'Automne (1904) and *Armory Show (1913). Karfiol's best-known works are sonorously coloured, simplified, sensuous nudes, painted with ardent humanity.

KARMEM (Karomama)

Egyptian princess of the 22nd dynasty, attached to the cult of Amūn at *Karnak, whose bronze statue (now in the Louvre) is one of the finest surviving examples of pharaonic metalwork. The figure is inlaid with gold, silver, electrum and copper, and was originally gilded on the flesh surfaces; the now-empty hands held sistrum rattles.

KARNAK

The site of the massive remains of the greatest of Egypt's temples. The earliest monuments are of the Middle Kingdom, but most of what now survives dates from the 18th and 19th dynasties, with extensive additions down to the Greco-

Roman period. The principal precinct is that of Amon-Rē, adjoining which are others of Mut and Mont, inaugurated by *Amenhotpe III. A cache of statues was discovered at Karnak (1905) including those of many kings and officials of the New Kingdom.

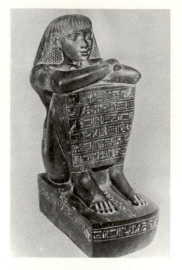

KARNAK Block statue of Hor, son of Ankhkhons. 25th dynasty. Schist. h. 19½ in (49·5 cm). Egyptian Museum, Cairo

KARTTIKEYA

Also known as 'Skanda', Hindu god of war who rides the peacock; son of *Shiva.

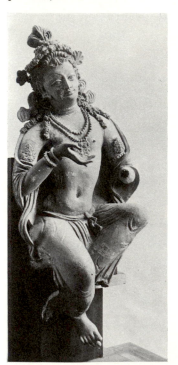

Left: KASHMIR *Bodhisattva* in late-Gandhara style. From Fondukistan. 7th century. Terracotta. h. 28⅜ in (72 cm). Musée Guimet, Paris

Right: KASHMIR *Head of a girl.* From Ushkur. *c.* 8th century. Stucco. h. approx. 6 in (15 cm). Central Museum, Lahore

KASHMIR

Kashmir formed a part of the *Mauryan Empire and of the *Kushana kingdom when it was a stronghold of Buddhism and culturally part of the *Gandhara region. In later centuries, as an independent power, it was to play an important part in the politics of the north, invading the post-*Gupta territories as far eastward as Bengal and taking Kanauj during the reign of its greatest ruler, Lalitaditya of the Karkota dynasty. Under the Karkotas, in the 8th century AD, a unique Kashmiri-Hindu style was developed out of the Post-Gupta art of the plains. Lalitaditya built both Buddhist and Hindu shrines in the mid 8th century, eg the Buddhist establishments at Parihasapura.

The Hindu temples at Martanda and Avantipura date from the 9th century. Multi-headed *Vishnu images have been found among the sculpture at the Martanda sun temple, a feature from which one of the most striking developments in Kashmiri iconography derives. This is the creation of figurines of Vishnu with three heads, at least two of which were found at Avantipura. The image is a variation of a late Gupta type in which the central head of the god was flanked by those of two of his incarnations, the lion and the boar. The significance of the side-heads has evidently been changed in the Kashmiri image, as they are both those of a lion. The images of this type preserve a form of the *Kushana crown with its circular crest which is set upon each of the three heads. In certain of these images, at the back of the three heads, invisible to the worshipper, is carved an uncrowned demoniacal mask. Several extant Kashmiri sculptures illustrate in their iconography the transitional phase from the Gandhara style to Hindu imagery. Such pieces retain the Romano-Buddhist drape and train of the garments and the wavy treatment of the hair, while acquiring the multiple arms, emblems and attributes of Hinduism. A 7th-century image of the *Bodhisattva Avalokiteshvara from Fondukistan illustrates this trend as it was manifested even farther to the west: both the elaboration of ornament and the articulation of posture and facial expression are elements which came from Eastern sources. A late (12th-century) temple at Pandrenthan near Shrinagar is the only Kashmiri temple remaining virtually intact from the days of independence. The ceiling here is ornamented with relief work representing etherial spirits in the Gupta manner. Ladakh, on the frontier with Tibet, came under Karkota rule and the art of the region often shows direct *Tibetan influence.

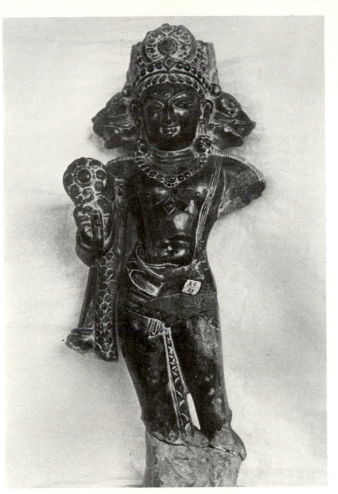

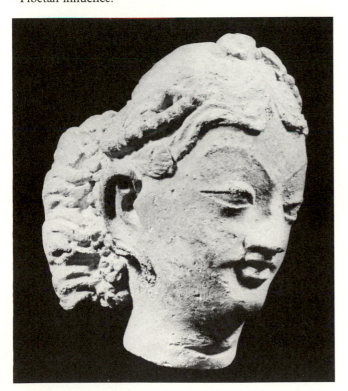

Above: KASHMIR Tricephalous *Vishnu* (with demon mask at rear). From Avantipura. 9th century. Marble. h. approx. 36 in (91·4 cm). Sri Pratap Singh Museum, Srinagar

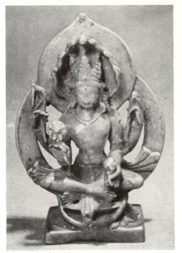

Left: KASHMIR-territories *Balarama aspect of Vishnu.* Swat valley, Ladakh. 8th century. Bronze with silver and copper inlay

KASSITE DYNASTY *see* MESOPOTAMIA, ART OF; AQAR QUF

KAUFFMAN, Angelica (1741–1807)

b. Coire, Grisons d. Rome. Swiss painter. She was in London (1766–81) and became a founder-member of the *Royal Academy. She worked in a †Neo-classical style, but still with †Rococo flavouring, producing elegant sentimental scenes from classical mythology and some fine portraits. Her work was often engraved and the compositions adapted for decorative art objects. In later life she settled in Rome.

KAULBACH, Wilhelm von (1805–74)

b. Arolsen d. Munich. German artist who studied in Düsseldorf and Munich with *Cornelius. In Munich he painted frescoes and made illustrations to *Goethe, Wieland and other German authors. These established his reputation. He painted large historical works (1830s) and decorations in the Berlin Museum (1847). He became Director of the Munich Academy.

KAZAN (Watanabe Kazan) (1793–1841)

A *Nanga painter who also produced Western-style portraits. He has been greatly overpraised as a painter on account of his fame as a Japanese patriot.

KEENE, Charles (1823–91)

b. d. London. English painter and etcher, one of the finest draughtsmen to work for illustrated magazines. His drawings, primarily of comic social situations, had a freedom of touch and a sophistication of modelling that was admired by *Sickert, *Degas, *Bracquemond and *Whistler. Worked for *Punch* (from 1851).

KEIBUN (Matsumura Keibun) (1779–1843)

Japanese painter, a younger brother and pupil of *Goshun and a leading member of the *Shijō School.

KELLS, Book of (c. 800)

The last of the great Hiberno-Saxon manuscripts, also the most elaborate in its decoration and the most stylised in its conception of the human figure. A date of about 800 has been deduced from its Canon Tables which imply a knowledge of †Carolingian manuscripts. It is unfinished. The sumptuous part was done at Iona and the remainder at Kells. (Trinity College, Dublin.)

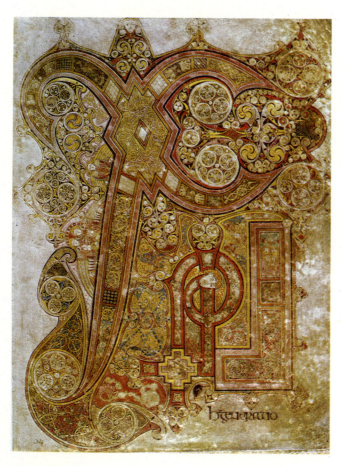

Above: BOOK OF KELLS Title Page. *c.* 800. Trinity College Library, Dublin
Right: ELLSWORTH KELLY *Blue, Green, Yellow, Orange, Red.* 1966. Acrylic. 5 panels each 60×48 in (152·4×121·9 cm). Solomon R. Guggenheim Museum, New York

KELLY, Ellsworth (1923–)

b. Newburgh, New York. Painter and sculptor who studied at Boston Museum School (1945–8) and lived in Paris (1948–54). Influenced by *Arp, *Braque and *Matisse, Kelly's work evolved through *Constructivism to hard-edge, vividly coloured, flat geometric abstractions, frequently comprising several canvases of one colour; his *Minimal sculptures are similarly conceived.

KEMENY, Zoltan (1907–65)

b. Banica, Roumania d. Zürich. Painter and sculptor who studied architecture in Budapest (1924–7), and painting (1927–30). Worked as a designer in Paris (1930–40), resuming painting in Zürich (1942). Worked on reliefs and collages using materials ranging from metal scrap to dried vegetable roots (from 1946). Kemeny was introduced to *Art Brut by *Dubuffet. His images combine structures borrowed with some poetic licence from the organic and inorganic microcosmos to create a deeply absorbing and original world of form.

Above: ZOLTAN KEMENY *Temps sur Temps.* 1962. Iron. 41¾×28⅜ in (106×72 cm). Galerie Maeght, Paris

KENSETT, John Frederick (1816–72)

b. Cheshire, Connecticut d. New York. Painter who first studied engraving, travelled in Europe (1840–8) with *Durand and *Casilear, and settled in New York, travelling frequently through countryside. A landscapist of the *Hudson River School, Kensett used delicate draughtsmanship and luminous, muted colour to evoke the quiet moods of half-lit tranquil spaces.

KENT, Rockwell (1882–)

b. Tarrytown, New York. Painter, illustrator and writer who studied with *Chase, *Thayer and *Henri, and travelled widely throughout the world. Influenced by *Blake and Henri, Kent developed a vigorous, simplified realism in his landscapes, seascapes and figures, most effective in the tautly dramatic black and white drawings for his books.

KENZAN (Ogata Kenzan) (1663–1743)

Japanese potter, a younger brother of *Kōrin, who also painted in *Rimpa style. Kōrin sometimes painted on pots by Kenzan.

KEPES, Gyorgy (1906–)

b. Selyp, Hungary. Painter and writer who worked at *Bauhaus, Berlin (1931–4), went to America (1937), taught light and colour, Institute of Design, Chicago (1937–43) and visual design, Massachusetts Institute of Technology (from 1946). His paintings combine science and poetry in romantic abstract landscapes, discerning the structural continuum of macrocosmic and microcosmic.

KEPHISODOTOS

1. Greek sculptor (active 400/370 BC), a relative (perhaps the father) of *Praxiteles. He made a bronze statue of Peace carrying the infant Wealth which was set up on the Areopagos at Athens. The figure has more solidity than the over-delicate figures of his day, although it has a 'sweet' expression.
2. The son of *Praxiteles (active late 4th century BC). He sculpted portraits of Menander, Lycurgos and others and carried the Praxitelean tradition into the 3rd century BC.

KERSTING, Georg Friedrich (1785–1847)

b. Güstrow d. Meissen. Danish portrait and genre painter. After fighting in the later campaigns against Napoleon, he worked in Warsaw. Made Director of the Meissen porcelain factory, he designed battle scenes for a service presented to Wellington.

KESSLEROCH (late Magdalenian)

†Palaeolithic site in Switzerland with a horse engraved on antler.

KETEL, Cornelis (1548–1616)

b. Gouda d. Amsterdam. Netherlandish portrait painter. In England (1573–81). Pioneer of full-length group and single portraits in Holland.

KETTLE, Tilly (1735–86)

b. Exeter d. Aleppo, Syria. English portraitist, influenced by *Reynolds and *Cotes, who worked in India (1769–76) on portraits of native rulers. Unsuccessful on his return to London, despite his ability (eg *Warren Hastings*, NPG, London), he moved to Dublin (1783) and died while returning to India.

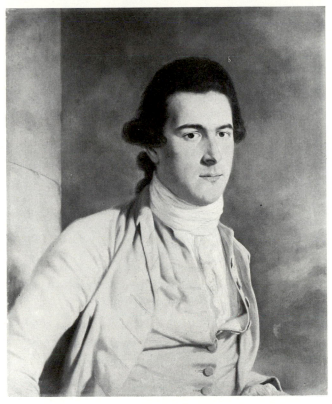

Above: TILLY KETTLE *Young Man in a Fawn Coat. c.* 1772–3. 30×24¾ in (76·2×62·9 cm). Tate
Left: JOHN FREDERICK KENSETT *White Mountain Scenery.* 1859. 45×36 in (114·3×91·4 cm). The New York Historical Society

KEY, Willem (c. 1515–68)
 Adrien Thomasz (active 1558–after 1589)

Surname of two Netherlandish painters, known principally for their portraits. Willem, b. Breda d. Antwerp, was a pupil of Lambert *Lombard, and developed away from †Gothic traditions. His nephew, Adrien Thomasz was active in Antwerp where he became master (1568). His portraits are more Italianate, being close to those of *Mor.

KEY MARCO *see* **EASTERN UNITED STATES AND CANADA**

KEYSER, Thomas de (1596/7–1667)

b. d. Amsterdam. Dutch portrait painter and architect, son of the sculptor and architect Hendrik de Keyser. He painted numerous group portraits, but his smaller works are usually more attractive. He influenced the young *Rembrandt.

KHAEMHET *see* **RAMOSE**

KHAJURAHO *see* **CHANDELLA DYNASTY**

KHAMSA

(Arabic: 'five'.) A collection of five works. That of the Persian poet Nizami (1140–1203) consists of the Makhzan al-Asrar ('Treasury of Mysteries'), Khusrau and Shirin, Layla and Majnun, the Haft Paikar ('Seven Portraits') and lastly the Iskandar-nama (the 'Book of Alexander'). The work therefore afforded dramatic, romantic and war-like content for illustra-

tion, becoming very popular in 15th-century Persia, either in the original form or imitations (eg the Khamsa of Nawai, 1458, John Ryland Library). Other Khamsas were similarly selected to carry illustrations.

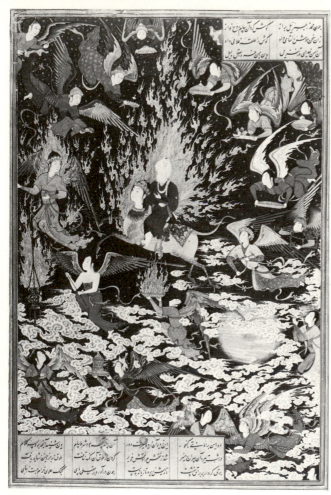

KHAMSA OF NIZAMI *Miraj Muhammad* Copy made in Tabriz 1539–43 perhaps by Sultan Muhammad. 14½×10 in (36·8×25·4 cm). BM, London

KHERUEF *see* RAMOSE

KHIRBAT AL-MAFJAR (743–744)

An Umayyad palace west of the River Jordan. The building consisted of two storeys and a bath-house lavishly decorated with *mosaics, stucco and marble. *See also* MOSAICS, Islamic

KHMER ART

The word Khmer means 'Cambodian'. The art is usually divided into the following periods: pre-Angkorian (*Chen-la), *Angkorian (AD 800–1431), and Cambodian. The art associated with Chen-la shows affinities with that of *Champa and must have derived in part from the earlier Funan period. The Angkor period is conventionally subdivided stylistically into Kulen-Preah Ko-Bakheng (9th century), Koh Ker-Banteay Srei-Kleang-Baphuon (10th-11th centuries), Angkor Wat (first half 12th century) and Bayon (13th century). With the fall of Angkor (1431), classical Khmer art served as a basis for subsequent craftsmen, but the creative phase was over. Almost without exception, the themes of Khmer art were Indian; the repertory of iconography was very small and the main evolution was the emergence of the single figure with little regard for internal structure; slender, upright, graceful. High cheekbones, deeply arched eyebrows and soft smiling lips are the hallmarks of the Khmer face in statuary.

KHNEMHOTPE *see* BENI HASAN

KHORSABAD

This city was constructed and briefly occupied by Sargon II (d. 705 BC) as the capital of the Late Assyrian Empire in succession to *Nimrud. In addition to a great range of gypsum reliefs that adorned the royal palace, it has produced the most completely restorable example of Assyrian wall-painting from the palace of one of the royal officials. The principal panel, in black, red and white on a blue ground, shows the King attended by his chief minister in front of the god Ashur, who extends to him the ring and staff of power (*Mari). The panel is surrounded, and the wall below decorated, with registers of geometric ornament alternating with formalised bulls and winged genii, and edged by a frieze of lotus blossom, all typical Assyrian motifs.

KIENHOLZ, Edward (1927–)

b. Fairfield, Washington. Sculptor who studied at several Western colleges; moved to Los Angeles (1953); opened avant-garde galleries (1956, 1958). Kienholz moved from painting to painted wooden reliefs to *Pop Art assemblages of junk, allied with *Surrealism and *Dada. His sordid images

Above: EDWARD KIENHOLZ *The State Hospital.* 1964–6. Mixed media tableau. 96×144×120 in (243·8×365·7×304·8 cm). Dwan Gallery, New York
Left: KHIRBAT AL-MAFJAR Carved and moulded plaster ceiling from the entrance to the bath hall

and environments reproduce society's chaos, decadence and putrefaction.

KIEV, Haghia Sophia

The cathedral was founded by the Grand Prince Yaroslav (1037). Its decoration, begun in mosaic (central dome and main apse, 1043–6), was completed for the main part in fresco by the 1060s. The mosaics, in a heavy two-dimensional style, comparable with *Hosios Loukas, were executed by a *Byzantine workshop. The frescoes, haphazard in plan and style and including portraits of Yaroslav and his family, were perhaps done by a Byzantine-Kievan team.

KIEV, St Michael

Founded by the Grand Prince Michael Svjatopolk (1108) and demolished in the 1930s, only fragments of the mosaic decoration (finished by 1111–12) survive. This could have been done by a team of Byzantines sent in 1080 to decorate the Pechersky Lavra. The style is softer and more elegant than that of Haghia Sophia, *Kiev.

KIITSU (Suzuki Kiitsu) (1796–1858)

Japanese pupil of *Hōitsu, who adhered to the *Rimpa tradition.

KIM Chong-hūi (Ch'usa, Wandang) (1786–1856)

Korean calligrapher and archaeologist who was educated in China and worked for the civil service. The most famous calligrapher of his day, he also wrote a treatise on orchids which he excelled in painting. His dramatic thick-thin brushstrokes were much admired.

KIM Dōk-sīn (1745–1822)

Korean painter of the Yi period who specialised in genre scenes. Using ink and colour washes he produced albums describing everyday life.

KIM Hong-do (T'anwōn) (b. 1760)

Korean painter who was equally proficient as a genre painter and in landscape, flower and animal studies. His brushstrokes are light and fluent. Although prolific, he was not prosperous in his lifetime.

KIM Myong-kuk (Yondam) (1623–49)

Korean painter, well known for his Zen paintings, for figures and landscape. He accompanied an official envoy to Japan (1636) where his work was much admired. His style is monumental with an original bold touch.

KIM Tu-ryang (1698–1794)

Korean painter, best known for his landscape paintings in the Chinese manner. He used ink drawings with colour washes and often introduced figures into his landscapes. Like *Chong Son he painted cycles of the seasons with harvesting scenes, etc.

KINETIC ART

Kinetic art originates in earlier *Constructivist and *Dadaist experiments. It has involved an inventive range of media and techniques, including sound, light, water, magnets (*Takis, *Nouvelle Tendance); machinery (*Tinguely, *Schöffer); mechanical power to produce infinite variation (von *Graevenitz). Movement may be unpredictable or self-directing, as *Calder's mobiles and *Soto's vibrating rods. The upthrust of Kineticism in the 1950s and 1960s coincided with an enthusiasm for technology (as the *Groupe de Recherches d'Art Visuel), and an emphasis on the role of the spectator.

KING, Charles Bird (1785–1862)

b. Newport, Rhode Island d. Washington, D.C. Painter who studied in New York, and with *West in London (1805–12); settled in Washington (1816). Although he became known for his sympathetic, painterly portraits of Indian chiefs, King has sparked contemporary interest with his witty, narrative trompe l'œil still-lifes.

KING, Philip (1934–)

b. Tunis, moved to England (1945). Student at Cambridge and at St Martin's School of Art where *Caro taught. Worked as Henry *Moore's assistant (1958–9). He now lives in London. King works mostly in plastic materials, like resin reinforced with glass fibre. He makes calm, self-enfolding shapes which he intends to be more metaphysical than three-dimensional in effect. Colour is often used as an important sculptural dimension.

KIOWA see PLAINS INDIAN ART

KIRCHNER, Ernest Ludwig (1880–1938)

b. Aschaffenburg d. Davos. German painter who studied architecture in Dresden (1901–5). A founder of the *Expressionist *Brücke group (1905–13), after a breakdown (1915), he worked in isolation in Davos (1917–38). He committed suicide. His bold handling of colour and form stem from *Fauvism, but his passionate call for 'freedom of life and action' is closer to

Above: KIM MYONG-KUK *The Priest, Li T'ie-kuai with a bat.* Ink on paper with slight colour. 9⅞ × 13⅜ in (25 × 34 cm). P'yongyang Gallery of Art

Above right: PHILIP KING *And the Birds began to Sing.* 1964. Sheet metal. 71 × 71 × 71 in (180·3 × 180·3 × 180·3 cm). Tate

*Dadaism. Moving from pastoral celebration to acid, jagged city scenes, his paintings parallel his despair. Painting kept him going. He experimented with abstraction (from 1926) then returned to landscape.

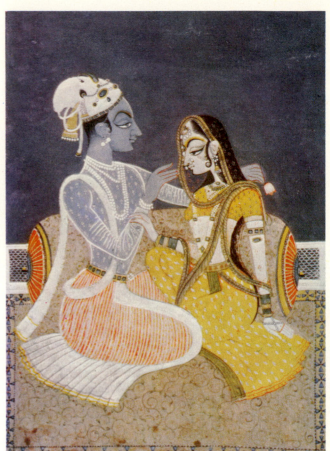

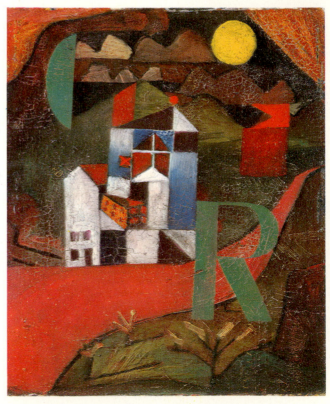

Top left: ERNST KIRCHNER *Self-portrait with Model.* 1907. 59×39¾ in (150·4×100 cm). Kunsthalle, Hamburg
Above left: PAUL KLEE *The Golden Fish.* 1925. Oil and Watercolour. 19⅛×27 in (48·5×68·5 cm). Kunsthalle, Hamburg
Top right: KISHANGARGH SCHOOL *Krishna and Radha on a terrace at night.* c. 1760. 12¾×9¼ in (32·5×23·5 cm). V & A, London

Above: PAUL KLEE *Villa R.* 1919. Tempera and oil 10½×8¾ in (26·7×22·3 cm). Kunstmuseum, Basle

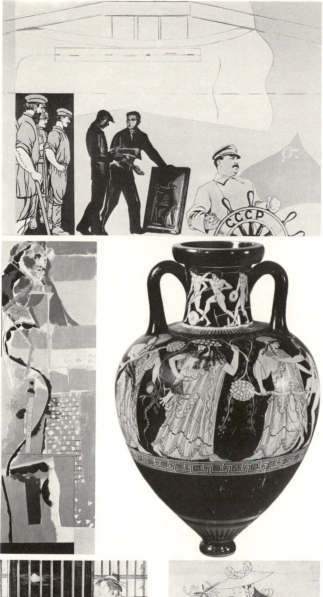

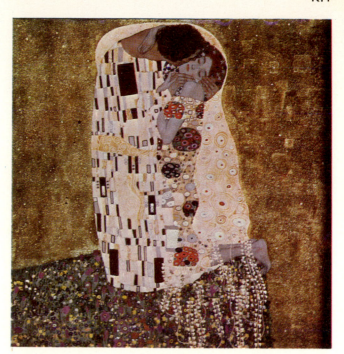

Above: GUSTAVE KLIMT *The Kiss.* 1908 or 1911. 71×71 in (180×180 cm). Osterreichische Galerie, Vienna
Left: KLEOPHRADES PAINTER Dionysiac revel on an amphora from Vulci. Antikensammlungen, Munich

KIRTI-MUKHA

Sanskrit: literally 'glory-face'; an Indian architectural and sculptural motif in the form of a demoniacal mask, the purpose of which it is difficult to define. Architecturally, in that the temple is in itself a memorial glorifying its builder, the mask spewing forth pearls, flowers and other symbols of plenty may epitomise his renown; ritually, it may represent the spiritual power of the temple or image which it adorns.

KISHANGARH SCHOOL (18th–19th century)

Kishangarh, a small state in the centre of *Rajasthan, produced a very distinctive style of miniature-painting. Most of the paintings were inspired by one ruler's (Savant Singh, 1748–57) love for his mistress. An excellent artist, Nihil Chand, skilled in *Mughal technique, portrayed his master and mistress as Radha and Krishna and invented a distinctive style. The human figures are comparatively small, but elegant and aristocratic. The characteristic face is elongated with a receding forehead, arched eyebrows, long eyes, a sharp nose and pointed chin. Green and gold were used lavishly, and landscapes were panoramic.

KISHI SCHOOL *see* MARUYAMA SCHOOL

KISLING, Moise (1891–1953)

b. Cracow d. Sanary. Polish painter who studied at the Cracow Academy; arrived in Paris in 1910. A painter of the *School of Paris, he produced sharply defined portraits and nudes in brilliant colour attempting to emulate *Modigliani.

KISSI

A tribe in north-east Sierra Leone and the neighbouring area of Guinea which carved ancestral figures in soapstone called *pomdo* (plural *pomtan*). They are still carved in a decadent style for tourists. The Kissi have never practised woodcarving, however. *See also* NOMOLI

KITAJ, R. B. (1932–)

b. Ohio. Painter who studied at the Vienna Academy (1951), the Ruskin School, Oxford and the Royal College of Art,

Top: R. B. KITAJ *Things to come.* 1965/70. Screenprint. 25×35 in (63·5×89 cm). Marlborough Fine Art, London
Middle left: R. B. KITAJ *Hugh Lane.* 1972. 96×30 in (244×76 cm). Marlborough Fine Art, London
Above left: KIYONAGA *A Night of the Ninth Month. c.* 1785. Woodblock colour print (part of a diptych). Oban, about 14×10 in (25·4×35·6 cm). Boston Museum, Bigelow Coll
Above right: KIYONOBU *Sawamura Kodenji as a woman dancing. c.* 1696. Colour print. 18½×12½ in (46×31·5 cm). Art Institute of Chicago, Buckingham Coll

London (1958–61). Although older and American, Kitaj was influential among future *Pop artists at the College. A thoroughly educated artist, he suggests meaning through a complexity of allusions. Technically accomplished, he juxtaposes ideas and images with surprising abruptness, their identity transformed by association or transmutation. His narrative content increasingly finds expression in graphic work.

KITAMURA, Shikai (1871–1927)

b. Nagano, Japan. He studied in France for a year (1893) and is known for his sculpture in a Western classical style. Characteristic works are *Spring and Autumn* and *Eve*.

KITCAT CLUB

A dining-club founded towards the end of the 17th century, whose members included some of the greatest intellects of the time, drawn from many circles including politics, literature and the arts. The name Kitcat was taken from the delicious mutton-pies that Christopher Cat served at his tavern near Temple Bar where the Club first met. Sir Godfrey *Kneller painted portraits of forty-two members of the Club (*c.* 1702–17, NPG, London) which are distinctive for the size of canvas used. All but one of the paintings measure 36×28 inches, and the word now designates any portrait or canvas of that size.

KITCHEN SINK see SOCIAL REALISM

KIYONAGA (Torii Kiyonaga) (1752–1815)

Japanese painter who revolutionised the *Torii branch of the *Ukiyo-e School by striving for a statuesque realism in place of the exaggerations of his predecessors. He achieved a detached sophistication that in turn led to the personalised versions of *Sharaku and *Utamaro. The leading Ukiyo-e artist of the 1780s.

KIYONOBU (Torii Kiyonobu) (1664–1729)

Japanese painter, the founder of the Torii school of actor-printmakers. His style, founded on a bombastic version of *Moronobu's Kabuki style dominated *Ukiyo-e for almost the first half of the 18th century.

KLAPHECK, Konrad (1935–)

b. Düsseldorf. German painter who studied at Düsseldorf Academy (1954–8). He paints isolated mechanical objects presented almost as personalities – a sewing-machine is entitled *Intellectual Woman*. Whereas American *Pop Art derives its style largely from popular culture, Klapheck's style relates more to *Purism, recalling *Léger's similarly ambiguous still-lifes of the 1920s.

KLEE, Paul (1879–1940)

b. Münchenbuchsee d. Muralto-Lugano. Swiss painter, also accomplished musician and highly articulate writer. Studied under *Stuck in Munich. Exhibited with der *Blaue Reiter group. At first found colour difficult: much early work is in black and white. Visited Tunisia (1914), after which colour, together with line, became the strongest features of his art. Taught at the *Bauhaus (1921–31), then at Düsseldorf (1931–33). His teaching, much of which is preserved in writing, has proved at least as influential as his painting. Unlike some more rationalist Bauhaus colleagues, Klee stressed the importance of the unconscious, was sympathetic to German Romantic philosophy and evoked the worlds of fairy-tale and children's fantasy. Like some *Surrealists, he experimented with automatism. His work was a synthesis of abstract and representational elements, and also conceived as a temporal process, all of which was of especial interest to American artists in the 1940s, who, however – partly because of its reproduction on film screens – greatly increased its scale. Klee's art is very delicate and sensitive, often somewhat tentative and often humorous. Highly original and varied, its particular quality is a feeling of magic.

KLEIN, Yves (1928–62)

A *Dada-inspired founder-member of *Nouveau Réalisme (1961), Klein's total activity was concerned with art. Concerned with the nature of artistic experience rather than making objects, his activities have included exhibiting an empty, white gallery (1958), and the sale of 'zones of immaterial pictorial sensitivity'.

KLEITIAS see FRANCOIS VASE

KLEOPHRADES PAINTER (active 500/480 BC)

Athenian *red-figure vase painter, the pupil of *Euthymides. His work, with its strong assured lines, is later than the period of experimentation of Euthymides and *Euphronios. He chose big vases like *kraters to develop large-scale dramatic compositions and grand figures.

KLIMT, Gustav (1862–1918)

b. d. Vienna. Austrian painter who studied in Vienna. From a wide variety of sources he developed a highly refined ornamental figure style in works for the theatre, paintings, posters and decorative allegorical friezes. Faces and hands, painted naturalistically, merge in a scheme of almost total abstraction. A founder-member of the Vienna *Secession, he became the most important representative of *Jugendstil. He made significant decorative works at Vienna University and at the Palais Stoclet in Brussels. He had considerable influence on *Schiele and *Kokoschka.

KLINE, Franz (1910–62)

b. Wilkes-Barre, Pennsylvania d. New York. *Abstract Expressionist painter who studied at Boston University (1931–5) and Heatherley's Art School, London (1937–8); moved to New York (1938). Kline's early works were *Cubist and *Expressionist; under *De Kooning's influence, he developed his characteristic huge Action Paintings of slashing black and white calligraphy.

FRANZ KLINE *Meryon*. 1960. $92\frac{7}{8} \times 77$ in ($235 \cdot 9 \times 195 \cdot 6$ cm). Tate

KLINGER, Max (1857–1920)

b. Leipzig d. Nuremberg. German painter, sculptor and printmaker, exhibited (from 1878) scenes of myth and history with supernatural elements, the narrative amplified by panels in the frame. His humour ranged from the whimsical to the macabre, tinged with eroticism and blasphemy.

KNAPTON, George (1698–1778)

b. d. London. English portrait painter. A founder-member of the Dilettanti Society set up (1732) for the study of antiquities

and the arts, he became its official painter (1736). From about 1737 he worked mainly in pastel and painted little after 1763.

KNATHS, Karl (1891–)

b. Eau Claire, Wisconsin. Painter who studied at Chicago Art Institute, moved to Provincetown (1919), and travels regularly to New York, then Washington to teach at Phillips Memorial Art School. Influenced by *Cubism, Knaths uses flattened, geometric forms and refined line within subtly structured space – painterly devices frequently obliterating recognisable images.

KNEALE, Bryan (1930–)

b. Douglas, Isle of Man. Attended Douglas School of Art and Royal Academy Schools. Worked as a painter until 1959 when he began to make plaster reliefs; the following year he produced his first works in steel. Uses welded sheet and tubed metal in simple geometric configurations.

KNELLER, Sir Godfrey (Gottfried KNILLER) (1646/9–1723)

b. Lübeck d. London. British portrait painter who dominated the field between the death of *Lely and the emergence of *Hogarth. Trained under *Bol and possibly *Rembrandt, he settled in England (1674) and achieved immense success, becoming Principal Painter and gaining a baronetcy. His style brought a new kind of sober grandeur to British portraiture. A feeling for paint, an understanding of *Baroque classicism, a definite tendency towards naturalism are the three elements which are present in his best work. His output was vast, and although he painted some exceptionally fine portraits, much of his work is rather slick and mechanical being the product of a mass-production system with specialist assistants working in a highly efficient studio.

GODFREY KNELLER *John Dryden*. c. 1698. 38×26 in (95×65 cm). Trinity College, Cambridge

KNIGHT, Dame Laura (1877–1970)

b. Nottingham. English artist, book-illustrator and engraver who first exhibited at the Royal Academy in 1903. A straightforward figurative artist owing much to *Degas, she is known for her scenes of circus and theatrical life, which are remarkable for their linear vitality.

KNILLER, Gottfried see KNELLER

KNOWLES, Justin (1935–)

b. Exeter. English sculptor with no formal art training, who worked in industry (until 1965). Knowles's simple volumes and constructions of sheet-steel are visually fractured by being painted in areas of bright, even colours, resulting in an integration of two-dimensional appearances with three-dimensional form.

K'O Chiu-ssŭ (1290–1343)

From T'ai-chou, Chekiang. An admirer of *Su Shih, K'o Chiu-ssŭ was a prominent connoisseur as well as calligrapher and painter. He followed *Wên T'ung in painting bamboo, admired in China for its gentlemanly qualities and preferred in the *Yüan to the peonies and hibiscus of the *Sung.

KOCH, Joseph Anton (1768–1839)

b. Tyrol d. Rome. Austrian landscape painter who crossed the Alps on foot and settled in Rome (1795), travelling in Italy, and working in Vienna (1812–15). His influential Italianate landscape style combined a †Romantic approach with a strong †Neo-classical strain derived from *Poussin.

KOEKKOEK, Barend Cornelis (1803–62)

b. Middelburg d. Kleef. Dutch landscape painter, pupil of his father Jan Hermann, then the Amsterdam Academy; he travelled in Belgium and frequently in the Rhineland. His work is in the national tradition of landscapes and derives from *Ruisdael and the Italianate painters. He exhibited in Paris and was a member of the St Petersburg and Rotterdam Academies.

KOERNER, Henry (1915–)

b. Vienna. Painter who studied at Vienna Academy and moved to America (1938). Influenced by *Expressionism and *Surrealism, Koerner used the *Magic Realist style and imagery in his frequently satirical allegories. His later works are looser in technique, simpler in subject and more commercial.

KOETSU (Honnami Koetsu) (1558–1637)

A professional sword-appraiser, Kōetsu was a famous Japanese calligrapher who on occasion collaborated with *Sōtatsu and is regarded as an influence on Sōtatsu's work.

KOETSU Section of Koetsu/Sotatsu scroll. Rimpa School, 17th century. Scroll with 11 sheets of poems. 430¾×13 in (9·942 m× 33 cm). Freer Gallery of Art, Washington

KOFUKUJI, The

A temple in Nara Prefecture, Japan. A head of Yakushi Nyorai, all that remains of a massive sculpture cast in 685, was found buried in the precincts of this temple. Fine examples of *kanshitsu sculpture, made for the temple (AD 734), include a

group of the Hosts of the Eight Divisions, and a group of disciples; lively figures of the Guardians of the Four Directions date from the early *Heian period and to the later Heian period belong a remarkable set of the Twelve Guardians of Yakushi carved in wood in low relief. Of the *Kaikei School are figures of the patriarchs Mujaku and Seshin by Unkei, and the patriarch Genpin by Kaikei, a standing figure of Bonten, Yuima Koji, and a Kongōrikishi ascribed to Jōkei, a Fukuken-saku Kannon by Kōkei, and a demon lantern-bearer by Kōben.

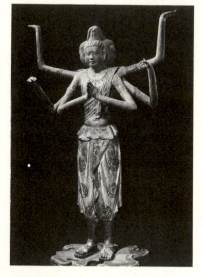

KOFUKUJI Ashūra. Nara period, AD 734. Lacquer (kanshitsu). h. 60¼ in (1·53 m).

KOKAN (Shiba Kokan) (1738 or 1747–1818)

Japanese painter, a self-confessed forger of the work of *Harunobu. He also designed prints in the style of Harunobu which he signed 'Harushige'. Kōkan also experimented with Western techniques and styles. He was the first Japanese to learn how to make copper engravings.

OSKAR KOKOSCHKA View of the Thames. c. 1926. 35⅜×51¼ in (89·9×130·2 cm). Albright-Knox Art Gallery, Buffalo, New York

KOKOSCHKA, Oskar (1886–)

b. Pochlarn. Austrian painter who studied in Vienna (1905–9), influenced by *Klimt and the *Jugendstil illustrators. He visited Berlin and became an illustrator for Der *Sturm (1910). He produced his drama The Burning Thornbush and two lithographic series, Bach Cantata and The Fettered Columbus (1912). Serious wounds in World War I precipitated a nervous crisis. He taught at the Dresden Academy (1917–24); spent the next seven years travelling widely; returned to Vienna (1931), but moved to Prague (1934–8), because of the Nazis; in England (1937–48), then moved to Switzerland. One of the leading *Expressionists, he was, however, in no way a pictorial innovator, remaining intuitively true to the fluxing effects of natural light. The violent and erotic qualities of his early art caused him to be denounced as a 'degenerate' artist. Among his finest work is his remarkable early series of portraits and the deeply disturbed Biblical and symbolical works (painted after 1918). The more relaxed landscapes of his middle period retain considerable emotive verve.

KOLBE, Georg (1877–1947)

b. Waldheim, Germany d. Berlin. A figurative sculptor, influenced by *Rodin, Kolbe's most successful works are his early figures (c. 1912–1920s) which although complicated in pose, achieve a sinuous and harmonious effect. His more grandiose public projects of the 1930s are less felicitous, although they achieved considerable recognition.

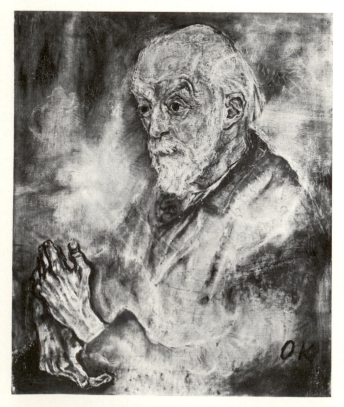

OSKAR KOKOSCHKA Dr August Forel. 1910. 27⅝×22⅞ in (70×58 cm). Kunsthalle, Mannheim

GEORG KOLBE Walter Lestikow. 1908. Bronze. h. 17¾ in (45 cm). NG, Berlin

KATHE KOLLWITZ *Visit to a Children's Hospital.* 1926. 10⅞×13 in (27·5×33 cm). Marlborough Fine Art, London

KOLLWITZ, Käthe (1867–1945)

b. Königsberg d. Moritzburg. Graphic artist and sculptress who studied in Berlin, Munich and Paris. Became first woman member of the Prussian Academy (1919). A passionate Socialist and feminist, Kollwitz made poverty and social injustice the lifelong theme of her work. Her early graphic style was influenced by Max *Klinger and *Van Gogh. Stimulated by *Barlach's example, she achieved an *Expressionist intensity in her later woodcut cycles (*Death*, 1934–5) and sculpture.

KONARAK *see* GANGA DYNASTY

KONENKOV, Sergei Timofeiewitsch (b. 1874)

Russian sculptor, visited Italy while a Moscow Art School student. His early work was technically mature, but stylistically archaic. His portraits of musicians, eg *Paganini*, and later *Bach* (1910) began to show rhythm and spirit. A trip to Greece and Egypt (1912) marked his return to archaic forms. He became a resident of New York (1923).

KONGO *see* BAKONGO

KONINCK, Philips de (1619–88)

b. d Amsterdam. Dutch painter. He was the pupil of his brother Jacob in Rotterdam, and may previously have studied under *Rembrandt. He painted unexceptional portraits and genre scenes, but he ranks among the greatest of Dutch landscape painters. He was influenced by Rembrandt and Hercules *Seghers, and in his best work (frequently scenes of flat country in which the sky occupies half or more of the picture space) he displays a comparable grandeur. He was a prolific draughtsman, and his drawings are sometimes confused with Rembrandt's.

KOPMAN, Benjamin D. (1887–1965)

b. Vitebsk, Russia d. Teaneck, New Jersey. Painter, printmaker and sculptor who was largely self-taught. Influenced by European *Expressionism, Kopman's paintings of figures, landscapes and imaginative visions are executed in an emotionally charged style.

KORE

A standing, draped female statue of the *Archaic period. A large number were found in Athens. The statues had been thrown down by the Persians in their invasion (480 BC) and they had later been incorporated into the platform of the Acropolis. In the first half of the 6th century BC they wore the *Attic *peplos, a garment which produced sculpturally the broad surfaces and simple folds of drapery, seen in the so-called 'Peplos Kore' from the Acropolis. In the second half of the century, Ionian dress became more common and the korai wore a thin garment with buttoned sleeves with a multiplicity of small folds. The lighter garment and cloak over it gave greater scope in the rendering of drapery and showed more of the human form beneath. One of the finest korai is signed by *Antenor and dates to about 530 BC.

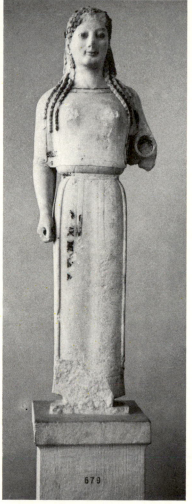

KORE The Peplos Kore No 679. Marble with traces of colour. h. 4 ft (1·21 m). Acropolis Museum, Athens

Below: PHILIPS DE KONINCK *An Extensive Landscape with a Road by a Ruin.* 1655 NG, London

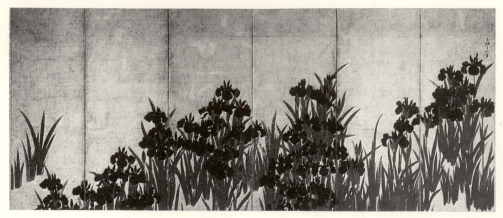

Above: KORIN Iris screen. Six-fold screen.
Late 17th/early 18th century. Ink and colours on gold leaf.
4 ft 11¾ in × 11 ft 9¾ in (151 × 360 cm).
Nezu Art Museum, Tokyo

Right: LEON KOSSOFF *Man in a Wheel-chair.* 1959–62.
84 × 48½ in (213·4 × 123·2 cm). Tate

KORIN (Ogata Kōrin) (1658–1716)

Japanese painter, greatly influenced by *Sōtatsu (whose work he sometimes copied) and *Kōetsu. Kōrin is the exemplar of the *Rimpa School. By profession a designer of kimono, he was rich enough to indulge his taste for extravagance (thereby earning punishment under the sumptuary laws). He became bankrupt (c. 1700) and turned to painting, having moved from Kyōto to Edo. His work is justly famous for its superb decorative effects.

KORO *see* NIGERIA, NORTHERN

KORWAR STYLE *see* GEELVINK BAY

KORYUSAI (Isoda Koryusai) (2nd half 18th century)

Japanese painter, who although a Samurai, made prints in the style of *Harunobu. He is most famous for his pillar-prints and his prints of birds and flowers. He was the first to use the *oban* size (10 × 14 inches), later to become the standard size for prints.

KOSSOF, Leon (1926–)

b. London. English painter influenced by *Abstract Expressionism. He uses oil paint in a thick and agitated application to describe forms which consequently have fluidity and physical presence. His images are taken from industrial London.

KOSTIENKI I (Eastern Gravettian c. 12,000 BC)

†Palaeolithic site on the River Don, Russia. Finds include female figurines, small animal heads and geometric decoration on bone tools.

KOTA SCHOOL (from c. 1770)

The small kingdom of Kota in the *Rajasthan province of western India became an independent school of painting in the late 18th century under the patronage of Ummed Singh (1771–1819). Most of the miniatures depict hunting scenes as the ruler was obsessed by the sport. The style is vigorous and the colours strong without being garish. The landscapes are far more detailed than in other schools and reflect the countryside and atmosphere of Kota faithfully, with its hilly jungle on a moonlit night. The animals, both those being hunted and those in the background are beautifully realistic.

KOUROS

A type of male statue representing a god or an athletic victor. He is shown naked, his left leg advanced, his arms stretched by his side and looking straight ahead. The pose was derived from *Egyptian statue types, but greatly refined throughout the *Archaic period as more anatomical knowledge was incorporated. During this period the kouros and its female equivalent, the *kore, remained the main Greek sculptural types.

KRAFT Adam (active c. 1490–1509)

German sculptor active in Nuremberg. Worked mainly in sandstone. His most important work is the very tall, highly decorated tabernacle in St Lorenz, Nuremberg, which is supported by three kneeling figures – portraits of the sculptor and two assistants. Both in relief and in the round, his psychological depth and skill in rendering the more sombre emotions makes him the introspective counterpart of his fellow townsman Veit *Stoss.

KRAMER, Harry (1925–)

b. Lingen. English sculptor initially trained as a dancer, which has affected the mood of his works, the first of which was a series of figures for a mechanical theatre (1955). Influenced by

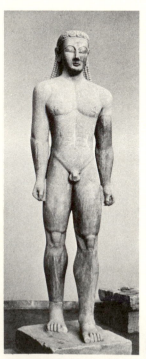

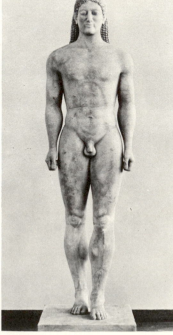

Left: KOUROS from Sunion c. 600 BC. h. 10 ft (3·05 m). National Museum, Athens
Right: KOUROS from Anavyssos Marble. c. 520 BC. h. 6 ft 4 in (1·94 m). National Museum Athens

*Tinguely, he now makes delicate and playful wire constructions in the basic shapes of sphere, column or pyramid, using small electric motors and sometimes bells in a wide variety of movements within the filigree structure.

KRASNER, Lee

b. Brooklyn. Painter who studied at Cooper Union (1927–9), National Academy of Design (1929–32), City College of New York (1933) and with Hans *Hofmann (1938–40); did mural for *WPA (1938–42); married *Pollock (1945); visited Europe (1956). Krasner's mature work, a structured *Abstract Expressionism, is composed of large, leaf-like forms, growing increasingly agitated and intricate.

KRATER

Large bowl used in ancient Greece for mixing water and wine.

KRESILAS (active 440 BC)

One of the four sculptors who competed to make an Amazon for the temple of Artemis at Ephesos (c. 440 BC). His Amazon rests her left elbow on a pillar and is wounded near the breast. He also sculpted a famous head of Perikles, of which there is a copy in the British Museum.

ADAM KRAFT Self-portrait from the Tabernacle. 1493–6. Stone. S. Lorenz, Nuremberg

KRICKE, Norbert (1922–)

b. Düsseldorf. German sculptor who studied at the Berlin Academy. A pilot during the war, his sculptures resemble three-dimensional drawings – lines of force thrusting into the surrounding space. The more predictable, centralised structures of his early work gave way to clusters of rods – straight or curving back on themselves – which have the appearance of being blown by a fitful wind.

KRIEGHOFF, Cornelius (1815–72)

b. Amsterdam d. Chicago. He studied painting in Düsseldorf, went to the United States (1837) and settled in Montreal after marrying a Canadian (1840). His popularity stems from his Canadian subject-matter of pioneer days and his meticulous technique. Winter Landscape, Laval is an example of his narrative of Quebec life.

KRIMMEL, John Louis (1787–1821)

b. Württemberg, Germany d. Philadelphia. Painter who went to America (1810) and settled in Philadelphia. Krimmel made several portraits, but is remembered for his good-natured, sometimes mildly satirical, genre paintings.

KRITIAN BOY (c. 480 BC)

An early Greek classical statue attributed to Kritios. The parts of its body are more closely integrated than the earlier *kouros type. The weight of the body is on the left leg and the other is freed and bent slightly forward. The left hip is slightly raised and the head is turned a little towards the free leg. (Acropolis Museum, Athens.)

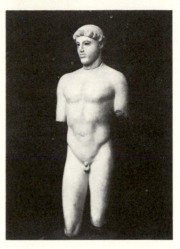

KRITIAN BOY Marble. h. 2 ft 9 in (84 cm). Acropolis Museum, Athens

KRITIOS see KRITIAN BOY; TYRANNICIDE GROUP

KROLL, Leon (1884–)

b. New York. Painter who studied at National Academy of Design, *Art Students' League and with *Laurens in Paris; exhibited at *Armory Show (1913). Influenced by *Henri and *Bellows, Kroll painted urban scenes and landscapes with vigour and brevity. His later idealised figures are imposing in their elegance and solid sense of form.

KRØYER, Peter Severin (1851–1909)

b. Stavanger d. Skagen. Genre, seascape, portrait and landscape painter, watercolourist, engraver and sculptor. After studies at the Copenhagen Academy and with *Bonnat in Paris (c. 1880), he initiated a period of so-called 'realism' in Danish art. He was a leader in open-air painting and studies of light effects in his country; his work won prizes in Paris, Berlin and Munich.

KRUSEMAN, Cornelis (1797–1857)

b. Amsterdam d. Lisse. Dutch history, genre, portrait painter and engraver, a student of Hodges and Daiwaille, Kruseman worked in Italy, then settled in Lisse, near Haarlem. He was a member of the Amsterdam Academy and received a gold medal at the Brussels exhibition (1851).

KUAN-HSIU (832–912)

From Chin-hua, Chekiang. Ch'an (Japanese: Zen) Buddhist painter and monk, famous for his sets of paintings of the sixteen Lohan (divines who have attained a level of enlightenment only inferior to that of the Buddha and Bodhisattvas). Surviving examples associated with his name show his style to have been bizarre, his figures grotesque, with exaggerated modelling in rough ink brushstrokes.

KUAN T'ung (active early 10th century)

From Ch'ang-an, Shensi. Northern Chinese landscape master, with a considerable fame, but of whom no original works survive.

KUBIN, Alfred (1877–1960)

b. Leitmeritz, Bohemia d. Zwickledt-am-Inn. Austrian graphic artist and book-illustrator who studied in Munich (1898). Kubin's strange personality, expressed in writing (eg his novel *The Other Side*, 1909) as well as through grotesque, mysterious drawings, fascinated his *Blaue Reiter friends. His literary imagery is formed from a multiplication of scribbling and hatched lines.

Above: ALFRED KUBIN *Frogs*. 1914. Pen and watercolour. 74⅞×67 in (190×170 cm). Albertina
Left: BOHUMIL KUBISTA *The Hanged Man*. 1915. 19¾×12 in (50×30·5 cm). Location unknown

Right: WALT KUHN *The Blue Clown*. 1931. 30×25 in (76·2×63·5 cm). Whitney Museum of American Art, New York

KUBISTA, Bohumil (1884–1918)

b. Bohemia. Czech artist influenced by *Analytical Cubism, in particular that of *Lhote and *Fresnaye. Detached from the Czech group of avant-garde artists, he rejected expressive colour in favour of the more controlled disciplines of *Cubism. His forms are bolder and less fragmented than those of the Parisian painters.

KUFIC

An angular variety of the Arabic script which received its name from the town of Kufa; it was, however in use before the foundation of the town. Extensively used in the first five cen-turies of Islam for all purposes. Can be generally classified into five groups: simple, foliated, floriated, plaited and rectangular. Replaced by *Naskhi except as an ornamental script in the 11th century. A special form of this script, *Maghribi, was used in North Africa and Spain.

KUFIC Various styles of the script used in the first six centuries of Islam

KUHN, Justus Engelhardt (d. 1717)

b. ?Germany d. Annapolis, Maryland. Painter who settled in Annapolis (before 1708) and worked there until death. Essentially a *limner, Kühn painted portraits of children in muted colour and exquisite detail, composed with a fine feeling for pattern, and usually characterised by backgrounds of elaborate formal architecture and gardens.

KUHN, Walt (1880–1949)

b. d. New York. Painter who studied in Europe, particularly Paris (*c.* 1900–5); was important organiser of *Armory Show (1913), where he exhibited; taught at *Art Students' League (1926–8). Kuhn is noted for his paintings of clowns and acrobats, their forms sculptured in dynamic patterns, their physical and psychological presence insistent and intense.

KU K'AI-CHIH *Admonitions of the Court Instructress*. Detail of handscroll. Ink and colours on silk. Entire scroll 9¾×137½ in (24·8×349·2 cm). BM, London

KU K'ai-chih *(c. 344–c. 406)*

From Wu-hsi, Kiangsu. Major Chinese figure-painter of the Eastern Chin period (317–420). His work is known through versions of three subjects, the *Admonitions of the Instructress to the Court Ladies*, the *Fairy of the Lo River*, and *Biographies of Virtuous Women*. All are handscrolls. A reflection of his flowing drapery line can also be seen in stamped brick reliefs of the Six Dynasties period (220–589). Ku also wrote the earliest description of the method of composing a landscape painting: *How to Paint the Cloud Terrace Mountain*, a Taoist subject.

KUKURUKU *see* EDO

KULMBACH (CULMBACH), Hans Süss von *(c. 1482–1521)*

b. Kulmbach d. Nuremberg. German painter and designer of woodcuts. With *Schäuffelein the best and closest follower of *Dürer, but his individual sense of colour and calm interval shows Venetian influence. In Cracow 1510/11, 1514–16.

KUNG Hsien *(1617/18–1689)*

b. K'un-shan, Kiangsu. Chinese painter active in Nanking. A Ming loyalist who bitterly resented the Manchu domination of China (1644), Kung Hsien created a highly personal style, sombre but always monumental landscapes without a single human figure, based on textural effects of dark and light using massed repeated strokes.

KUNG HSIEN Landscape. One of a set of ten album leaves mounted as scrolls. Ink and colour on paper. 9½×17⅝ in (24×45 cm). Nelson Gallery, Kansas City

KUNG HSIEN, Cave-temples at

Buddhist cave-temples in Honan province, China. Carved in the early 6th century AD, the site comprises five caves, three colossal figures on the cliff face and a large number of minor niches. The caves are all square in plan and all, except Cave 5, have a central shaft. The groups of Buddhist images arranged symmetrically round the caves are fine characteristic examples of the sculpture of the second half of the Northern Wei dynasty. The carving of the images at this site is smooth and solid by comparison with the dynamic linear effect of contemporary work at *Lung Mên. Attractive features are the ceilings imitating coffered wood with bold designs of flowers and flying beings, and the small figures of dwarfs and monsters supporting the thrones of the images. *See also* YUN KANG

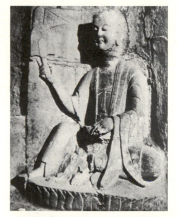

Left: KUNG HSIEN Vimalakirti. Cave 1, east wall. First half of 6th century AD

Below: KUNG HSIEN Relief from Cave 5 showing a flying apsaras. First half of 6th century AD
Bottom: KUNIYOSHI *The Last Stand of the Soga Brothers*. Early 19th century. Triptych woodblock colour print, each panel approx 14×10 in (25·4×35·6 cm). Ashmolean

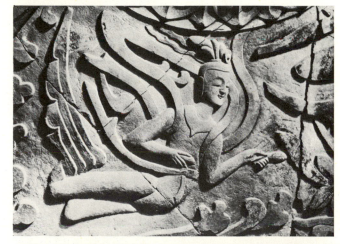

KUNINOBU *see* EITOKU

KUNISADA (Utagawa Kunisada) *(1786–1864)*

Japanese artist, who as Toyokuni III was a prolific designer of actor and historical prints. He was rather overshadowed by his fellow pupil, *Kuniyoshi.

KUNIYOSHI (Utagawa Kuniyoshi) *(1797–1861)*

Japanese painter, a pupil of *Toyokuni. He specialised in historical and mythological scenes, often of warriors in battle. His landscapes were excellent, usually containing some

historical or dramatic reference. He is regarded by some as the last great printmaker in the *Ukiyo-e tradition.

KUNIYOSHI, Yasuo (1893–1953)

b. Okayama d. New York. Painter who went to America (1906), and settled in New York (1910); studied at several art schools, including *Art Students' League with Kenneth *Miller (1916–20); visited France (late 1920s); worked for *WPA; taught at Art Students' League (1933–53). His figure-paintings are unpretentious, but subtle in line and colour.

KUNST, Cornelis *see* CORNELISZ

K'UN-TS'AN (active 2nd half 17th century)

Chinese painter from Wu-ling, Honan. In his thirties when the Manchu dynasty was established (1644), he remained all his life loyal to the Ming. He became a Buddhist monk, intensely solitary in character. His landscapes, executed with a dry brush and reddish tones, are detailed and often autobiographical. *Winter Landscape*, originally from a set of four leaves showing the seasons, was painted (1666) for his intimate friend Ch'eng Cheng-k'uei, who was also a painter.

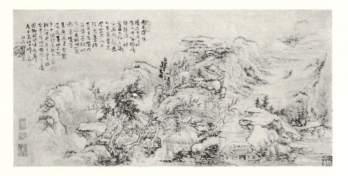

Top: KUN-TS'AN *Winter Landscape*. Dated 1666. Album leaf mounted as a handscroll. Ink and colour on paper. $12\frac{3}{8} \times 25\frac{1}{2}$ in ($31 \cdot 4 \times 64 \cdot 9$ cm). BM, London

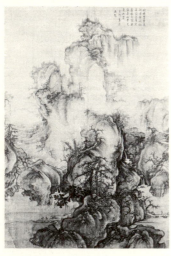

Left: KUO HSI *Early Spring*. Dated 1072. Ink and light colours on silk. $62\frac{1}{4} \times 42\frac{5}{8}$ in ($158 \cdot 3 \times 103 \cdot 1$ cm). National Palace Museum, Taiwan
Right: KURODA KIYOTERU *Lakeside*. 1897. Oil on canvas. $27\frac{1}{4} \times 33\frac{1}{2}$ in (69×85 cm). Museum of Modern Art, Tokyo

KUO Hsi (c. 1020–c. 1100)

From Wen-hsien, Honan. Chinese landscape painter in the tradition of *Li Ch'eng. His *Early Spring* (1072) is a monumental landscape, more intricate in composition and in atmospheric effects than those of earlier Northern *Sung masters. Kuo Hsi's treatise *Lin ch'üan kao chih* is the best source of Sung concepts of landscape painting. *See also* CHINESE LANDSCAPE PAINTING

KUO Jo-hsü (active 11th century)

Author of the *T'u-hua chien-wen chih* (translated by A. C. Soper, *Kuo Jo-hsü's Experiences in Painting*, Washington, 1951). Like *Chang Yen-yüan's *Li-tai ming-hua chi*, this work contains discussions of painting, anecdotes and biographies of Chinese painters, carried down to the year 1074.

KUPKA, Frantisek (1871–1957)

b. Opocno, Czechoslavakia d. Puteaux, France. Czech painter who studied in Prague and Vienna, moved to Paris (1895), contributed to the *Cubist 'Section d'Or' exhibition (1912) and to *Abstraction-Création (from 1931). Kupka's painting, in contact with Cubism and with *Post-Impressionist theories of abstract expression parallel to music, slipped from symbolism into abstraction (1911). Like *Kandinsky he was inspired by the need to give mysticism a scientific basis and he conceived his rhythmic colour structures as a 'quest for the absolute'.

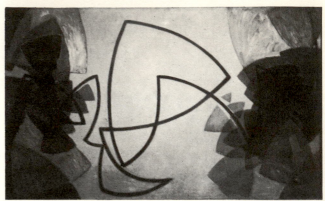

Above: FRANTISEK KUPKA *Solo of Black Line*. 1912–13. $27\frac{5}{8} \times 45\frac{1}{2}$ in (70×115 cm). NG, Prague

KUPPER, C. E. M. *see* VAN DOESBURG, Theo

KURODA KIYOTERU (1866–1924)

Baron Kuroda went to Paris as a young man to study law, but took up painting instead. He painted in oils in the Western (French) style and was the first Japanese to paint a realistic nude. Later he became a member of parliament and first Professor of Tokyo University of Arts.

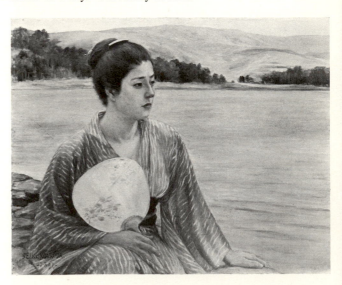

KURUMBA

A small tribe around Aribinda in the north of Upper Volta best known for their graceful antelope headdresses. They also call themselves Tellem, the name given by the *Dogon to the earliest inhabitants of the Bandiagara escarpment. The Kurumba also extend into the *Mossi kingdom of Yatenga where they call themselves Nioniosse (ie 'not-Mossi') and what is generally regarded as the Mossi style in sculpture is in fact usually the work of Kurumba smiths.

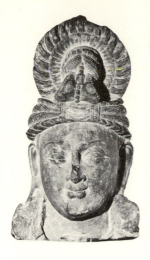
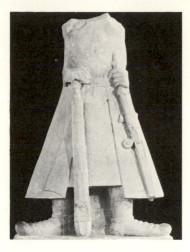

Left: KUSHANA DYNASTY *Head of a (?) Bodhisattva. c.* 2nd century. National Museum, New Delhi
Right: KUSHANA DYNASTY *Statue of king Kanishka.* From Mathura. *c.* 2nd century. Red sandstone. h. 64 in (163 cm). Archaeological Museum, Mathura

KUSHANA DYNASTY (early 1st century–*c.* AD 250)

The struggle between the Iranian Pahlavas and the Yüeh-chih who stemmed from an area in western China was settled in the high north-west by the end of the pre-Christian era. In the 1st century AD, the Kushana tribe of the victorious Yüeh-chih descended into India, ultimately establishing a sphere of control from Afghanistan across the Indus and the Panjab, through Taxila and Mathura as far as Banaras. The heartland remained in the far north-west with two capitals at Peshawar and Begram, while the axis of artistic creativity lay between the *Gandhara region on the upper Indus in the north and the area round Mathura on the River Yamuna to the south. Under Kushana rule, the Mathura area became the most significant centre of sculpture for the north. Images produced there were exported along the Ganges to Banaras and north to the other main centre, Gandhara. The Mathuran artists were conscious of the inheritance of Bharhut and Sanchi (*Shunga and Kanva dynasties), which they incorporated and exploited to the full, while evolving new forms in response to the demands of new cults and different rulers. The vexed question as to whether the anthropomorphic Buddha-image originated with the sculptors of Mathura or Gandhara has never been finally settled. Factors such as the essential *yogin* nature of the Buddha, in legend as in sculpture, which is alien to Western thought; the distinctly Indian character of the body-adornments of the early images; and the social pressures which must have been felt among the Buddhist community of the time for a focus of devotion more satisfying than the cold abstraction of mere symbolism, weight the argument for a Mathuran origin most convincingly. Early *Jain iconography was also established at Mathura. Among the most intricate of Jain products are the votive stone tablets, which are engraved with both anthropomorphic images of the Jain saints and beautiful arrangements of the earlier symbolism. Remains indicate that both Jain and Buddhist *stupas, almost identical in form, were built in the Mathura area under the Kushanas. Much of the human relief work on the railing uprights and many of the free-standing statues represent the Kushanas themselves in their traditional costume of conical cap, long heavy coat, trousers and boots. The evolution of the Brahmanical pantheon developed rapidly under the Kushanas, from statues of local folk-heroes such as Vasudeva and Sankarshana before their assimilation to Vishnu, to complex multi-headed images of *Brahma, *Vishnu, *Indra and the *linga (phallic emblem) of *Shiva. Shiva also appears in anthropomorphic form with his consort *Parvati, and his sons *Karttikeya and the elephant-headed *Ganesha. The ferocious aspect of the goddess also

develops: *Durga as *Mahishamardini, slayer of the buffalo-demon, and Simhavahini, armed like a warrior and riding a lion, establishes her cult. The advances made in representation of the anthropomorphic figure, whether in Buddhist, Jain or Hindu art, are enormous, the plasticity and aesthetic balance of line and form leaving the cumbrous *yaksha statuary and charming Buddhist relief work far behind. Stylistic elegance and iconographic complexity anticipate the perfection of *Gupta art. From this time onward, with the powerful impetus of Mathura behind it, Indian art is truly liberated from Western influences.

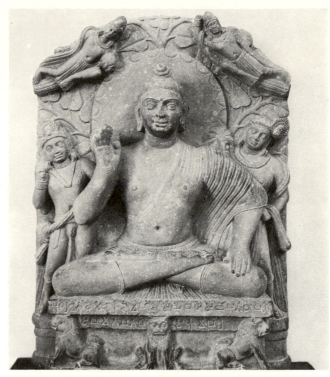

Above: KUSHANA DYNASTY *Buddha seated under the tree of enlightenment, attended by gods and spirits.* From Katra. 2nd century. Red sandstone. h. 27¼ in (69 cm). Archaeological Museum, Mathura

Left: KUSHANA DYNASTY *Linga with four faces of Shiva.* From Mathura. *c.* 2nd century. Sandstone. National Museum, New Delhi

KUSNETSOV, Pavel (1878–)

b. Saratov, Russia. Pupil of *Borissov-Mussatov (1895–9), who inspired the *Blue Rose group of which Kusnetsov was a characteristic exponent. Early influences included Russian landscape artists and the *Barbizon School; his work then went through a mystical and essentially joyful phase, only later becoming more monumental and primitive.

KUYU

A tribe living between the Sangha and upper Ogowe rivers in Congo-Brazzaville. Their most common sculpture is a wooden head which the dancer, hidden by a long white robe, holds above his own head. There is also an important group of figures in a style which flourished some fifty years ago.

KWAKIUTL

Indian tribe inhabiting the Skeena River and Queen Charlotte Sound area of British Columbia. The Kwakiutl made some of the most elaborate carved and painted masks produced on the *Northwest Coast. Some masks consisted of several parts and could be ingeniously manipulated by means of strings so that one face would split open to reveal another beneath.

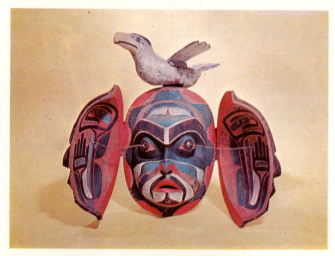

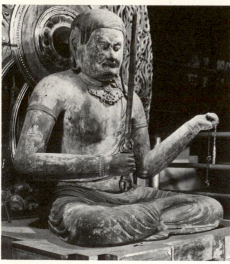

Top: KWAKIUTL Mechanical 'revelation' mask representing three faces and a bird figure. Kwakiutl, British Columbia. Painted wood. Museum of the American Indian, NY
Above: KYOOGOKOKUJI Fudō Myōo. Heian period, 9th century AD. Wood. h. 5 ft 8⅛ in (1·73 m)

KYLIX

A shallow drinking-cup with two handles and a comparatively high foot, used in ancient Greece for drinking wine. The broad surfaces provided generous areas for painted decoration. The work of some of the finest Greek vase painters from the 6th to the early 5th century appears on these vessels.

KYODEN *see* MASANOBU (Kitao)

KYOOGOKOKUJI, The

A temple in Kujomachi, Kyōto, Japan, also known as 'the Tōji'. It contains one of the main examples of a set of early *Shingon images dating from the 9th century comprising a Dainichi Nyorai, four of the five transcendental Buddhas, the five Light Kings or Myōō, five transcendental Bodhisattvas, four guardian kings and figures of Bonten and Teishakuten. Other *Heian sculptures include a Jizō, a seated figure of Hachiman and a Monju Bosatsu.

L

LABASTIDE (Magdalenian)

†Palaeolithic site in the Hautes-Pyrénées, France. Small chamois heads carved in flat bone with the neck of each perforated suggests they are part of a necklace.

LABATUT (Perigordian *c.* 25,000–19,000 BC)

†Palaeolithic site in the Dordogne, France. On a small limestone block, deer are painted in red ochre. This is an early example of painting in chattel art.

LACASSE, Joseph (1894–)

b. Tournai. Belgian painter, originally a labourer (1905–12), who studied at night-school (1909–12), at Tournai (1912–14) and at the Brussels Royal Academy (1919–20). A talented imitator of *Cubist and *Orphist styles (1910–15), Lacasse has fluctuated between working-class subjects and abstraction.

LACHAISE, Gaston (1882–1935)

b. Paris d. New York. Sculptor who studied with *Monet and at Ecole des Beaux-Arts; worked for Lalique; worked in Kitson's studio, Boston (1906–12); and for *Manship in New York (1912–21); shared studio with *Nakian (1920–3); exhibited at *Armory Show (1913); was associated with *Stieglitz. Lachaise's shining bronze earth goddesses, proudly voluptuous in their rhythmic, sensual forms, are monuments to the dignity of the flesh; they mark the first appearance of unabashed sexuality in American sculpture.

LADAKH *see* KASHMIR

LAER, Pieter van *see* BAMBOCCIO, IL

LA FARGE, John (1835–1910)

b. New York d. Providence, Rhode Island. Painter who studied with William Morris *Hunt in Boston and *Couture in Paris (1856); went to Orient and South Seas (1886). The leading contemporary muralist, influenced by Hunt's admiration of *Barbizon artists, La Farge at his best painted profound visions of the past in richly resonant Venetian colour.

LA FOSSE, Charles de *see* DE LA FOSSE

LA FRESNAYE, Roger de (1885–1925)

b. Le Mans d. Grasse. French painter who studied at Académies Julian and Ranson. He was a member of the outer circle of *Cubist painters (from 1911) whose exhibition, 'Section d'Or' (1912), made a great impact. La Fresnaye's paintings are only superficially Cubist. A basic perspective composition is overlaid by coloured angular planes, often more decorative than structural. After 1917 he increasingly succumbed to the Neo-classical trend initiated by *Picasso.

LAGASH, Stele of the Vultures

This stele depicts on the reverse the victory of Eannatum of Lagash over the neighbouring city of Umma, and on the obverse the god of Lagash, Ningirsu, holding the prisoners in a net. The lower register shows the king in his chariot leading the army to battle; in the upper register, he is dismounted and in action at the head of the phalanx. The arrangement in ascending registers is characteristic of Early Dynastic narrative sculpture.

LAGUERRE, Louis (1663–1721)

b. Versailles d. London. French decorative painter. He worked under *Lebrun before coming to England (1683/4), working with *Verrio, and won great success with his work at country-houses such as Burghley and Blenheim.

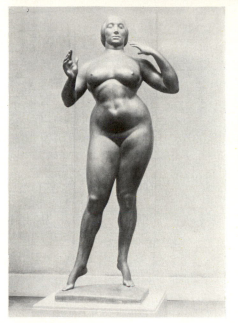

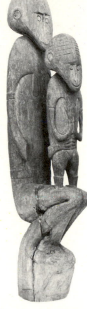

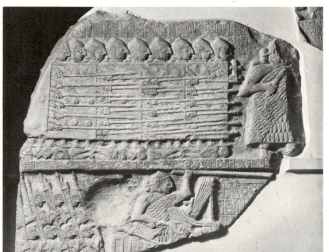

LA HYRE, Laurent de (1606–56)

b. d. Paris. French painter. He painted a variety of subjects, being influenced first by the Second School of *Fontainebleau, then by *Poussin. His landscapes are his best and most personal work.

LAIB, Conrad (active mid 15th century)

Painter from Eislingen, active in Austria, whose signature occurs on an altarpiece for the Cathedral of Graz (dated 1457), and round this an œuvre has been built up. Like Hans *Multscher and his slightly older contemporary Konrad *Witz, Laib came under the influence of Flemish art, notably the *Master of Flémalle and Rogier van der *Weyden. He must have contributed to the reaction against the *Soft Style prevalent in Germany during the early 15th century.

LAIRESSE, Gérard de (1640–1711)

b. Liège d. Amsterdam, where he settled (1665). Flemish painter, who decorated the Stadtholder's various residences and the Court of Justice. Going blind (1690), he wrote two popular treatises on art (published 1701, 1707).

LAKE

A combination of intense pigment or dye and an inert base.

LAKE SENTANI

The Lake, a few miles inland from Humboldt Bay on the north-west coast of *New Guinea, produced a characteristic style of sculpture and relief decoration. The interiors of chiefs' houses were decorated with carved centre-posts and free-standing sculpture. Some figures were relatively naturalistic; the theme of mother and child occurs frequently. Ceremonial equipment and utilitarian objects were profusely decorated with incised curves and meanders. Finely painted bark-cloth was worn by women on festive occasions.

LAKSHMI

Hindu goddess of good fortune, also known as Shri, the incarnation of the glory which comes of success; consort of *Vishnu.

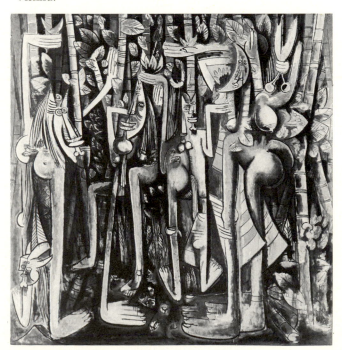

Top: LABASTIDE Chamois heads of carved and engraved bone
Middle left: GASTON LACHAISE *Standing Woman.* 1912–27. Bronze. h. 70 in (177·8 cm). Whitney Museum of American Art, New York
Middle right: LAKE SENTANI Mother and Child. Wood. h. 36¼ in (92 cm). Museum für Volkerkunde, Basle
Above: LAGASH Stele of the Vultures. *c.* 2400 BC. Limestone. h. 71 in (180 cm). Louvre
Right: WILFREDO LAM *The Jungle.* 1943. 7 ft 10¼ in×7 ft 6½ in (293×229 cm). MOMA, New York, Inter-American Fund

LAM, Wilfredo (1902–)

b. Sagua la Grande, Cuba. Painter who studied in Havana and Spain; lived in Spain (1925–38) and Paris (1938–41). A

*Surrealist influenced by *Picasso and *Breton, Lam draws on primitive mythology to create a mysterious, dark jungle characterised by jagged forms, and inhabited by magical images, evoking a deep psychological disturbance.

LA MADELAINE

†Palaeolithic site in the Dordogne, France. There are rich deposits of middle and late Magdalenian with carved and engraved bone and antler tools. The later levels show a decrease in naturalism, becoming rather stiff. Such sites are invaluable for a comparison of cave and chattel art.

LA MADELEINE (Magdalenian c. 15,000–12,000 BC)

†Palaeolithic site in the Tarn, France. Two reclining female figures are lightly engraved on the cave wall, also a horse.

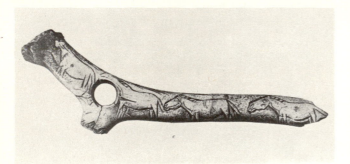

Above: LA MADELAINE
Engravings of horses on bone

Left: LA MARCHE Simplified drawing from a rock engraving of a clothed human figure wielding a club

Below: LAN YING *River Landscape*. Dated 1624. Detail of handscroll. Ink and colour on gold-flecked paper. Entire scroll 10½ in×21 ft (26·7×640·5 cm). Seattle Art Museum

LA MARCHE (middle Magdalenian)

†Palaeolithic site in Vienne, France, with engravings of human figures indicating clothing, including hats.

LAMBERT, George (1700–65)

b. Kent d. London. English landscape painter. A pupil of *Wootton, he was influenced by Gaspard *Dughet, whose style of classical landscape he applied to the English countryside. He also produced two precociously realistic topographical views (1733, Tate) and worked as a scene-designer.

LAMBETH BIBLE

This Bible, probably from Canterbury, dates from the middle of the 12th century. The *'damp-fold' style is here conventionalised into a metallic pattern. The figures are livelier and more naïve than those of the dignified *Bury Bible. (Lambeth Palace and Maidstone Museum.)

EUGENE LOUIS LAMI *A Supper with the Regent*. 1854. 15⅛×26 in (36×66 cm). Wallace

LAMI, Eugène Louis (1800–90)

b. d. Paris. Student of *Gros and *Vernet, Lami was a French painter, watercolourist (a founder of the French Watercolour Society), illustrator, but foremost a lithographer. His collections document French society of the time of the Restoration and Louis-Philippe: *Uniformes des Armées Françaises de 1791 à 1814*; *Voitures*; *Voyage à Londres, par Eugène Lami et Henri Monnier, 1829–30*; *Bal de la Duchesse de Berry*, an album of twenty-two costumes, are examples.

LA MOUTHE (Perigordian/Aurignacian and middle and late Magdalenian)

†Palaeolithic site near Les Eyzies, Dordogne, France, with paintings and engravings, many superimposed.

LAN Ying (1585–after 1660)

From Ch'ien-t'ang, Chekiang. In Chinese accounts, Lan Ying is traditionally the last master of the *Chê School. In actual fact, though a professional, his work is based on the styles of the scholar-painters, as in the handscroll at Seattle which follows the manner of the *Four Masters of the Late Yüan period.

LANCRET, Nicolas (1690–1743)

b. d. Paris. French painter of *fêtes galantes. He was greatly influenced by *Watteau (both were pupils of *Gillot), and, like *Pater, he painted mainly in a style close to Watteau's, but without his subtlety or profundity.

NICOLAS LANCRET *Mademoiselle Camargo Dancing. c.* 1731. 17×21¾ in (43×55 cm). Wallace

LANDAU, Jacob (1917–)

b. Philadelphia. Printmaker and painter who studied at Philadelphia College of Art, New School for Social Research and Académie de la Grande Chaumière; taught at Philadelphia Museum School (1953–8) and Pratt Institute (from 1964). Landau's prints, combining bold contrasts with intricate line, forcefully delineate the emotional and physical animation of the figure.

LANDI, Bartolommeo di Benedetto de' *see* NEROCCIO

LANDSEER, Sir Edwin (1802–73)

b. d. London. The son of an engraver. He studied at the Royal Academy Schools, and made careful anatomical drawings. His moral-humorous animal subjects soon met with popular and academic success. On his constant visits to the Scottish Highlands he made landscape studies and pictures of stags. He was knighted (1850). A favourite painter of Queen Victoria and her frequent guest, he made a large fortune from the sale of en-

EDWIN LANDSEER *The Old Shepherd's Chief Mourner.* 1837. 18×24 in (45·7×61 cm). V & A, London

gravings from his works. The *Pre-Raphaelites condemned his sentimental exhibition pictures, while his very spirited oil-sketches, which link him with contemporary French art, remained little known.

LANDUMA *see* BAGA

LANE, Fitz Hugh (Nathaniel Rogers) (1804–65)

b. d. Gloucester, Massachusetts. Painter and printmaker who studied lithography with Pendleton in Boston (c. 1832), but was otherwise self-taught; lived in Gloucester (1849–65), often visiting Maine and Puerto Rico. Although he later sacrificed subtlety to drama, Lane's best landscapes evoke a world of intensified reality, precisely detailed and brilliantly lit.

LANFRANCO, Giovanni (1582–1647)

b. Parma d. Rome. Italian painter, a pupil of *Agostino, then of Annibale *Carracci, with whom he worked in the Farnese Gallery. His style is derived partly from his study of *Correggio's dome paintings in his native Parma, and the style this synthesis produced, dynamic and theatrical, is one of the foundations of mature †Baroque painting. His most revolutionary work is the *Assumption* in the dome of S. Andrea della Valle, Rome (1621–5), in which Correggio's illusionism is carried to extreme lengths. This and similar works in Rome and Naples (c. 1640, S. Gennaro Chapel) were enormously influential.

LANIER, Nicholas (1588–1665)

b. d. London. Anglo-French painter and collector. A musician in the royal household, he painted scenery for masques. He was also an agent of Charles I, and acquired for him *Mantegna's *Triumph of Caesar* (Hampton Court).

PETER LANYON *Thermal.* 1960. 72×60 in (182·9×152·4 cm). Tate

LANYON, Peter (1918–64)

b. St Ives. English painter, influenced by *Gabo and Ben *Nicholson, whose major preoccupation was landscape and the meeting of the elements. He made preparatory constructions to investigate the play of spatial volumes and took up gliding to experience the sensation of movement (1959). His painting combines the resonance and intricacy of experiments in nature with bold gesture and varied handling of paint.

LAOCOON GROUP

A 1st-century BC sculptural group of the *Rhodian School showing Laocoön, the priest of Apollo, and his two small sons being devoured by a pair of serpents. The work is rich in

pathos and, in the true *Hellenistic manner, chooses a dramatic psychological moment to emphasise the tragedy of the situation. (Vatican.)

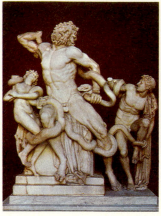

Above left: LAOCOON GROUP White marble. h. 8 ft (2·42 m). Vatican
Above right: NICOLAS DE LARGILLIERE *La Belle Strasbourgeoise.* 1703. Strasbourg

LAPICQUE, Charles (1898–)

b. Epinal. French painter who trained as an engineer and continued to research into colour theory and optics. His recent work depicts fantastic lions and tigers. He uses brilliant colouring and an easy line, recalling *Matisse, in an anecdotal and humorous vein.

LA PILETA

Site near Rhonda, Spain, with the best small group of painted caves in southern Andalusia. Many of the paintings are Neolithic or later, but there are outline paintings of a horse and ox in a style similar to the *Perigordian of northern Spain.

LA PORTEL

†Palaeolithic site in Ariège, France, with *Perigordian/ *Aurignacian painting in outline and flat-wash and *Magdalenian horses in black outline.

LAPRADE, Pierre (1875–1931)

b. Narbonne. French painter who briefly attended the Ecole des Beaux-Arts, Paris, and exhibited at the Salon des Indépendants (1901). He illustrated, among others, Flaubert and Valéry. His †Impressionist work, often depicting harlequins, women, parks and flowers, recalls *Fragonard.

LARGILLIERE, Nicolas de (1656–1746)

b. d. Paris. French painter. He spent his youth in Antwerp, and worked under *Lely in England. He was once famous as an historical painter, but is now remembered primarily as *Rigaud's chief rival in portraiture.

LARIONOV, Mikhail (1881–1964)

b. Tiraspol d. Fontenay-aux-Roses. Russian painter and stage-designer who studied in Moscow (1898), where he met *Gontcharova. Participated in *'World of Art' exhibition (1906) and that organised by Diaghilev in Paris. Left Russia with Gontcharova to join Diaghilev (1914); continued to design for the Ballets Russes for a number of years. His early work was in a *Symbolist/†Impressionist vein; he produced his first *Rayonist works (1911), publishing the movement's Manifesto (1913). A powerful, if unstable, personality Larionov was one of the prime movers of the Russian *Futurist movement, who continued to promote a national school of a different kind through his work for Diaghilev.

LARSSON, Carl Glof (1853–1919)

b. Stockholm d. Sundborn. Swedish painter who studied in Stockholm. He later held a teaching post at Göteborg where he painted a large decorative work. He worked on six frescoes in the Stockholm Museum (1890s) and was influenced by the decorative style of *Mucha, Chéret and Japanese prints.

LASANSKY, Mauricio (1914–)

b. Buenos Aires. Printmaker who studied in Buenos Aires; directed Free Fine Arts School, Argentina (from 1936); studied Metropolitan Museum's prints and worked with *Hayter (1943–4); taught at State University of Iowa (from 1945). Powerfully influential in American printmaking, Lasansky creates his symbolic figures through a rich technique, bold yet delicate.

LASCAUX

†Palaeolithic site in the Dordogne, France, near Montignac. Discovered in 1940, and now one of the best-known French caves. Noted for the frieze of horses, oxen and red deer. Down a twenty-foot-deep shaft is a bison apparently being attacked by a small human being, while a rhinoceros is walking away from the scene. Usually dated *Perigordian, some of the paintings may be *Magdalenian, since twisted perspective is common. There are also a few rather poor engravings.

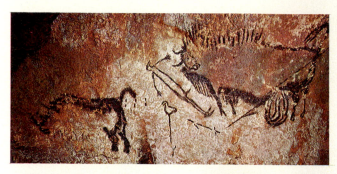

Top: LASCAUX Cave painting of man attacked by a bison. h. 55 in (140 cm)
Above left: MIKHAIL LARIONOV *Glasses.* 1909. 41×38¼ in (104·1×97·2 cm). Solomon R. Guggenheim Museum, New York
Above right: MAURICIO LASANSKY *España.* 1956. 31¾×20¾ in (80·6×52·7 cm). Collection: the Artist

LASSAW, Ibram (1913–)

b. Alexandria, Egypt. Sculptor who went to New York (1921), studied at Beaux Arts Institute and was co-founder of American Abstract Artists. Influenced by *Brancusi and *Constructivism, then by *Abstract Expressionism and Zen Buddhism, Lassaw evolved richly textured and coloured metallic mazes, intertwining form and space in a complex continuum.

Above: IBRAM LASSAW *Galactic Cluster Number 1*. 1958. Bronze and silver. h. 33 in (83·8 cm). Newark Museum, New Jersey
Right: GEORGES DE LA TOUR *St Peter Denying Christ*. 1650. 47½×63 in (12·7×160 cm). B-A, Nantes

LASTMAN, Pieter (1583–1633)

b. d. Amsterdam. Dutch *history painter and engraver. He visited Italy (1604–7), being influenced by *Caravaggio and *Elsheimer. He was the master of *Lievens and *Rembrandt, and probably inspired the latter in the field of history painting. His own works show a naïve exuberance with forms derived from the latest Flemish †Baroque models and from Italian paintings of the early 17th century.

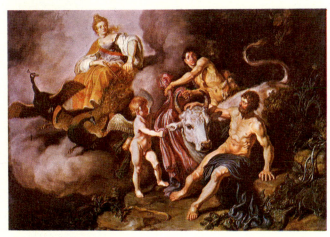

PIETER LASTMAN *Juno Discovering Jupiter with Io*. 1618. 21⅜×30⅝ in (54·3×77·8 cm). NG, London

LATHAM, John (1921–)

b. Zambesia, Rhodesia. Sculptor who came to England (1928); studied at Chelsea School of Art (1946–57). He has made sculpture-paintings called 'skoobs' – books cut, torn and charred – recalling *Duchamps's *Unhappy Readymade*, a geometry book exposed to the weather. Recent works include constructions with suitcases and roller-blinds.

LA TOUR, Georges de (1593–1652)

b. Vic-sur-Seille d. Lunéville. Painter; the most original of the French followers of *Caravaggio, he became immensely popular among the bourgeois circles in Lunéville and with members of the French administration at Nancy. His indebtedness to the Utrecht *Caravaggisti (*Terbrugghen and *Honthorst) rather than the Italians, is apparent in the naturalistic detail of his early *St Jerome* (Stockholm), his consistent use of an unguarded candle as a light source, and the warm brown tonality of his mature works like the *Christ in the Carpenter's*

Shop (Louvre). La Tour, however, is at his most distinctive in his very late paintings (eg *St Sebastian*, Berlin), where a geometric elimination of detail produces a unique kind of classicism.

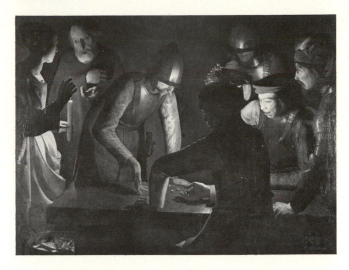

LA TOUR, Maurice Quentin de (1704–88)

b. d. Saint-Quentin, northern France. French pastel portraitist. He studied under Jean Spoede in Paris, went to London (1723) and returned to Paris (1727) when he took up pastel, encouraged by the success of Rosalba *Carriera, although his own work has more vivid characterisation and less †Rococo *brio*. He made an extended trip to Holland (1766), returning to his birthplace (1784), where he devoted the rest of his life to politics.

Above left: MAURICE DE LA TOUR *Self-portrait*. c. 1750–60. 25¼×21 in (64×53 cm). Musée de Picardie, Amiens
Above right: FRANCESCO LAURANA *Isabella of Aragon*. Polychrome marble. h. 17⅜ in (44 cm). KH, Vienna

LAUGERIE BASSE (middle to late Magdalenian)

†Palaeolithic site in the Dordogne, France, with engravings on bone and limestone.

LAUGERIE HAUTE

†Palaeolithic site in the Dordogne, France, adjoining *Laugerie Basse. The sequence is *Perigordian/Aurignacian, *Solutrean and nearly all the stages of *Magdalenian. There are engravings in bone and limestone and a fine head of a musk-ox.

LAURANA, Francesco (c. 1430–1502)

b. Dalmatia d. France. Venetian sculptor and architect, active Italy, Sicily and France. Worked in Naples on the Triumphal Arch of the Castel Nuovo. In France he made medals for René I of Anjou. His sensitivity as a portraitist is evinced in the bust of Isabella of Aragon (KH, Vienna) where the clear, elegant forms are judiciously heightened with colour.

LAURENCIN, Marie (1885–1956)

b. d. Paris. Painter and lithographer, a friend of both *Apollinaire and *Picasso taking an active part in the discussions which gave rise to *Cubism. Employing light decorative colours to achieve an atmosphere of serenity, she painted compositions of slender beautiful girls in idyllic surroundings. Her own work permanently disregarded Cubism and remained essentially lyrical.

LAURENS, Henri (1885–1954)

b. d. Paris. French sculptor who trained as an ornamental stone-carver. By 1915 he had become one of the principal *Cubist sculptors. He produced a series of reliefs in terracotta and stone (1919) indebted to *Lipchitz, but acknowledging also a debt to African Negro sculpture. Small, free-standing sculptures (1926–30) were superseded by his great marine themes: sea, sirens, nudes. Laurens moved from Cubism to achieve roundness and fullness. A lifelong friend of *Braque, he sought for calm and stability in his work.

LAUSSEL (late Perigordian c. 25,000–19,000 BC)

†Palaeolithic site in the Dordogne, France, famous for a limestone relief of a female holding a bison horn, the hair being indicated, but no face. Three other figures, two female and one male are carved in the same technique.

LA VENTA see OLMEC

LAVERY, Sir John (1856–1941)

b. Belfast d. Kilkenny. Portrait painter trained in Glasgow and London; in Paris with *Bouguereau (1881), where his style broadened, but more under the influence of *Bastien-Lepage. This culminated in The Tennis Party (1885). He settled in London (1895), his painting style more fluid and facile for his many portrait commissions.

LAWRENCE, Jacob (1917–)

b. Atlantic City, New Jersey. Painter who moved to New York (1930), studied at Harlem WPA Workshop and American Artists School; worked for WPA; painted in Nigeria (1964). Lawrence's flat patterns of searing colour universalise topical problems, especially those of the Negro, creating compassionate portrayals of human pain and persecution.

LAWRENCE, Sir Thomas (1769–1830)

b. Bristol d. London. Perhaps the last great English portrait painter, he succeeded *Reynolds as Painter in Ordinary to the King (1792). He subsequently established a European reputation, was knighted (1815) and made President of the *Royal Academy (1820). His few literary/historical compositions – like Satan Addressing the Legions – were resounding failures, but the flamboyant sparkle of his best portraits revealed a new awareness of the expressive qualities of paint which endeared him to *Delacroix, and was most fully elaborated in the series of Allied leaders painted (after 1815) for the Waterloo Chamber at Windsor.

Above left: MARIE LAURENCIN *Two Girls.* 1915. 13×18⅛ in (33×46 cm). Tate

Right: THOMAS LAWRENCE *The Archduke Charles.* 1818. 106¼×69¼ in (270×176 cm). Windsor
Far left: HENRI LAURENS *Seated Woman.* 1922. Stone. 20⅞×13×11½ in (53×33×29 cm). NG, Berlin
Left: LAUSSEL, Venus of. Rock relief carving. h. 18 in (46 cm). Musée d'Aquitaine, Bordeaux

LAWSON, Ernest (1873–1939)

b. San Francisco d. Miami Beach, Florida. Painter who studied with *Weir and *Twachtman at *Art Students' League; lived several years in France; exhibited with The *Eight (1908) and at *Armory Show (1913). Particularly known for his winter scenes, Lawson kept his grasp of solid form while using an essentially †Impressionist technique.

LAY FIGURE

A jointed manikin used as a drawing model by the artist.

LAYLA WA MAJNUN

One of the most famous love-stories of the Islamic world, a counterpart to the European Romeo and Juliet. Originally Arabic, the tragic story is usually incorporated into larger literary works (eg *Khamsa of Nizami). Artists took full advantage of the dramatic content of the ill-fated love, the exile and madness of Majnun in the desert among the animals, always favourite subjects for painting.

LEAD PENCIL see GRAPHITE

LEAR, Edward (1812–88)

b. Holloway d. San Remo. Best known as a comic writer. From zoological drawings of birds he turned to landscape, and went to Rome (1837), later publishing lithographs from his sketches. On his widespread travels in Greece, Albania, Sicily, Corsica, Palestine, Syria and Egypt, etc, he made many topographical sketches, lightly inked-over and washed with clear transparent watercolour.

LEBOURG, Albert Charles (1849–1928)

b. Montfort-sur-Risle d. Rouen. French landscape painter trained in Rouen and Paris. Exhibited (1879, 1880), with the

†Impressionists from whom he derived his sensitive brushwork and his palette. Also painted in Algeria where he taught (1872–6), and in Normandy and Holland.

LE BROCQUY, Louis (1916–)

b. Dublin. British painter whose realist and sub-*Cubist scenes of significant human life (1939–55) preceded a style depending for effect on the juxtaposition of fluid paint washes (space) and an isolated textured area (figure).

LEBRUN, Charles (1619–90)

b. d. Paris. French painter and Louis XIV's grand impresario for the Arts. He was a pupil of *Vouet and after a spell in Rome (1642–5), played a leading role in French decorative painting. Lebrun's fame, however, resides principally in his directorship of the Gobelins factory, the Manufacture Royale des Meubles de la Couronne, started by Colbert (1662) which produced not only tapestries but all forms of decorative art including furniture and metalwork. He was also the first Director of the *Académie Royale de Peinture et de Sculpture, both directorships dating from 1663. As Director of the Académie and an admirer of *Poussin, he formulated a rigidly classical art theory which determined the course of French academic practice for generations. His own painting, paradoxically, was often more †Baroque than classical.

LEBRUN, Rico (Federico) (1900–64)

b. Naples d. Malibu, California. Painter who went to America (1924); he lived in New York (1925–38) and California (1938–64); studied mural-painting, Italy (1930s); worked for *WPA; was influential teacher, particularly in California. Lebrun's superb, baroque draughtsmanship and profound compassion for tormented humanity are epitomised in his monumental *Crucifixion* and *Concentration Camp* series.

LE CLERC, Jean (1587/8–1633)

b. d. Nancy. French painter and engraver. Like his friend *Callot, he was active in Italy as well as France, painting in the Doge's Palace, and engraving works after *Saraceni, his Italian master.

LE CORBUSIER (Charles-Edouard JEANNERET) (1887–1968)

b. La Chaux-de-Fonds, Switzerland d. South of France. Architect who worked as a painter and sculptor. In Paris (from 1918) Corbusier, with *Ozenfant, developed *Purism and edited *L'Esprit Nouveau* (1920–5). His later painting became freer in subject and style. A great architect, Corbusier considered the 'intense, pitiless battle, without witnesses' of painting to be the basis of his work.

Above: RICO LEBRUN *The Crucifixion* (Triptych). 1950. 192×312 in (487·6× 792·4 cm). Syracuse University, New York
Left: LE CORBUSIER *Still-life.* 1922. 57⅝×35¼ in (146·5×89·5 cm). Kunstmuseum, Basle

Below left: LAYLA WA MAJNUN *Life at Camp.* From Mir Sayyid Ali's *Khamsa.* Tabriz, c. 1540. 10⅞×7½ in (27·7×19·1 cm) Fogg Art Museum, Cambridge, Mass
Below right: CHARLES LEBRUN *Entry of Alexander the Great into Babylon.* 1660–8. 177×256 in (450×701 cm). Louvre

LEE, Doris Emrick (1905–)

b. Aledo, Illinois. Painter and printmaker who studied at Kansas City Art Institute, with *Lhote in Paris, and with *Blanch and *Lawson. Lee is best known for her genre scenes of small-town America, painted in a would-be primitive, child-like style, not entirely convincing in an artistically sophisticated adult.

LEECH, John (1817–64)

b. d. London. An English comic illustrator with no formal training, Leech worked for *Punch* (1841–64) producing over three thousand cartoons. He illustrated a book by Surtees (1853) and was henceforth associated with depictions of hunting life. He successfully exhibited paintings after his own drawings (from 1862).

LE FAUCONNIER, Henri (1881–1946)

b. Hesdin. French painter who attended the Atelier Laurens and Académie Julian (1901). An ex-*Fauve turned *Cubist, he showed with *Metzinger and *Gleizes as a group at the Salon des Indépendants (1911). Le Fauconnier's Cubism always retained Fauve elements; his style moved back towards the figurative (after 1913).

LEGA see BALEGA

LEGA, Silvestro (1826–95)

b. Modigliana, Romagna d. Florence. Italian painter, a member of the *Macchiaioli. Later founder of the School of Pergentina which sought to bring greater flexibility and poetry to Macchiaioli doctrine. Chiefly known for domestic subjects which relate to the †Impressionists, especially *Degas.

LEGER, Fernand (1881–1955)

b. Argentan d. Grif-sur-Yvette. French painter and ceramicist, of Norman peasant origins, who cultivated a directness antagonistic to taste throughout his career. He evolved a solid, weighty *Cubism (after 1909) whose formal strength was allied (1913–14) to an aggressive range of colour. He aimed at a violence of pictorial content which could convey the energy of a *Futurist machine image (by 1914). World War I rooted his art more firmly in the experience of modern life, showing him the power of mechanised violence in action. The persuasive certainty of *Purism and of *Picasso's Neo-classicism convinced him that things modern were precise and ordered as well as superhuman in their energy, and a mechanised classicism emerged (1920). *Surrealism was the cause of its demise (1927), but Léger's adaptation of the Surrealist practice of incongruously confronting objects with one another was stripped

FERNAND LEGER *Elément Mécanique*. 1924. 38¼×51¼ in (97×130 cm). Kunsthaus, Zürich

of its psychological implications for purely formal effect. He lived in New York (1940-6), and on his return to France (1946) he worked increasingly on a public scale, developing popular themes (eg *Parade du Cirque*) which fused post-Cubist sense of form with a *Social Realist representational clarity.

FERNAND LEGER *Composition with Two Parrots*. 1935–9. 157½×11⅞ in (400×30 cm). Musée National d'Art Moderne, Paris

LEGROS, Alphonse (1837–1911)

b. Dijon d. Watford. Went to Paris (1853) to study under Le Coq de Boisbaudron. He settled in England (1863), but continued to paint French subjects, usually of a sombre disposition, and in low-keyed colour harmonies. Particularly influential as a teacher and etcher at the Slade School of Art, London (from 1877).

LEGROS, Pierre II (1666–1719)

b. Paris d. Rome. High †Baroque French sculptor, who worked in Rome, on the great *Altar of St Ignatius* (Gesù). He sculpted the ultra-realistic polychrome memorial to the Blessed Stanislas Kostka (S. Andrea al Quirinale) and designed a chapel in S. Giacomo degli Incurabili.

LEHMBRUCK, Wilhelm (1880–1919)

b. Meiderich d. Berlin. German sculptor, graphic artist, painter and poet who studied in Düsseldorf but received his significant influences in Paris, where he lived (1910–14). He had developed his characteristic style by 1910 which, influenced by *Maillol rather than *Brancusi or *Modigliani, is exemplified by an unprovocative stretching of natural proportions. This emphasises the inward-looking melancholy of his figures. He was deeply depressed by the war and committed suicide (1919) when his work was beginning to be appreciated.

LEIBL, Wilhelm Maria Hubertus (1844–1900)

b. Cologne d. Würzburg. German painter, studied under *Piloty and Ramberg at the Munich Academy. His early work was influenced by *Courbet whom he met in 1868, and who advised him to go to Paris (1869/70). The serenity and stillness of Leibl's work distinguishes it from that of Courbet. Leibl favoured small groups of peasants seated usually in interiors and in muted light, never disturbed by violent action or extreme emotion. These scenes were realised in two painting manners, a *Holbeinesque focus of detail or a broad, impasted brushstroke.

LEIGHTON, Sir Frederic (1830–96)

b. Scarborough d. London. English painter and sculptor, whose early work in Frankfurt (1846–52) showed the influence of 'faerie' painters rather than the *Grand Manner of his masters *Veit, Steinle and Passavant. After working in Rome for three years, chiefly on subjects from art history, Leighton learnt a fluency of painting from *Couture in Paris that was to benefit him in future fresco commissions. He had already developed a decorative, non-didactic style (by 1860) that came to be applied increasingly to classical subject-matter. This he regarded as a convenient vehicle for abstract form and colour. He was President of the Royal Academy (1878–96).

SIR FREDERIC LEIGHTON *Music Lesson*. 1877. 36½×37½ in (92·7×95·3 cm). Guildhall, London

LEINBERGER, Hans (c. 1480/5–c. 1531/5)

German sculptor from Bavaria. First mentioned at Landshut (1511) where active 1513–30. His life-size devotional figures display proto-*Baroque features in the combination of corporeality, expanding energy and extraverted emotion.

LEKYTHOS

Small Greek flask used for oil or perfume. It has a single handle and a flaring spout. Used particularly by *black-figure painters of the mid 6th century BC for decorative scenes.

LELY, Sir Peter (1618–80)

b. Soest, Westphalia d. London. Portrait painter who trained under Pieter de Grebber at Haarlem but established his reputation in England (1641/3 onwards), where he painted portraits of Charles I and Cromwell before his appointment as Court Painter at the Restoration. Though indebted to *Van Dyck, he evolved a fashionably voluptuous style which was formally inventive if psychologically vapid. His collection of Old Masters was famous, and his numerous pupils included Greenhill and *Largillière.

LE MANS CATHEDRAL

The nave south door is richly decorated with a sculptured *tympanum showing the Apocalyptic vision of St John and column figures in the jambs (c. 1150); it could have been copied from the central portal of the west front at *Chartres; alternatively it could be the model for Chartres. The south aisle of the nave contains two 12th-century stained-glass windows, perhaps the best among the few that have survived. Removed from the cathedral and now in the Musée des Beaux-Arts is the enamelled copper slab from the tomb of

Above: LE MANS CATHEDRAL. Plaque from the tomb of Geoffrey Plantagenet. Late 12th century. Champlevé enamel. 24¾×13 in (63×33 cm). Musée Tessé, Le Mans
Far left: WILHELM LEIBL *The Hunter's Return*. 1893. 28¾×33⅝ in (73×85·5 cm). Wallraf-Richartz Museum
Left: PETER LELY *Comtesse de Gramont*. c. 1665. 50×40 in (127×101·6 cm). Hampton Court Palace

Geoffrey Plantagenet (d. 1151), the only surviving example of an unusually ambitious variety of *Limoges enamelwork. Such slabs anticipate the sculptural effigies which became popular in the 13th century, and in another respect they were the forerunners of monumental brasses.

LEMIEUX, Jean-Paul (1904–)

b. Quebec. Canadian painter who studied at Ecole des Beaux-Arts, Montreal, and Académies Colarossi and de la Grande Chaumière, Paris; taught in Montreal (1935–6) and at Ecole des Beaux-Arts, Quebec (from 1937). Lemieux's mature works are starkly simplified compositions of figures in vast landscapes, their sharp contrasts and evocative spaces creating obsessive ambiguities.

Left: JEAN-PAUL LEMIEUX *The Visit.* 1967. 67×42 in (170·2×106·7 cm). NG, Canada
Right: LEMNIAN ATHENA Roman copy of Greek original. Museo Civico Archeologico, Bologna

LEMNIAN ATHENA (c. 440 BC)

A sculpture by *Pheidias said to have been signed by him which survives only in copies. From coins and copies it appears that the original was of bronze and showed the goddess standing with a helmet in one hand and a lance in the other. It was regarded as one of the most beautiful statues of antiquity.

LE MOINE, François see LE MOYNE

LE MOYNE (LE MOINE), François (1688–1737)

b. d. Paris. French decorative painter. He perpetuated the tradition of *Lebrun, and painted extensively at Versailles, notably the Salle d'Hercule which was greatly admired. He was appointed official painter to Louis XV (1736), but committed suicide shortly afterwards. *Boucher was among his pupils.

LE MOYNE, Jean-Baptiste (1704–78)

b. d. Paris. French sculptor. He was official sculptor to Louis XV, and executed equestrian statues of him for Bordeaux, Rennes and the Ecole Militaire. He is remembered primarily, however, for his portraits and as the teacher of *Falconet, *Houdon and *Pigalle.

LE NAIN Family
Antoine (c. 1588–1648)
Louis (c. 1593–1648)
Mathieu (c. 1607–77)

Three brothers, b. Laon, who established their reputation in Paris (1629/30 onwards). The problem of attribution between the three is a vexed one, since few of their extant paintings are individually signed. They are chiefly memorable for a group of paintings attributed to Louis, which depict an unidealised peasant life in almost classical compositions done in a narrow range of colours. Louis's fully integrated canvases differ as much from Dutch prototypes as they do from the rather naïvely grouped diminutive figures of Antoine, or Mathieu's distinctly Dutch groups like the *Corps de Garde.* Most of the few religious pictures have been ascribed to Mathieu.

LENBACH, Franz Seraph von (1836–1904)

b. Schrobenhausen d. Munich. German painter, trained in Munich. After a brief flirtation with Naturalism, he became firmly established as a portraitist of the eminent in Munich. His brushwork, influenced by *Titian and *Velasquez, fails to enliven rather stilted poses often derived from photographs.

LEOCHARES (active c. 350 BC)

One of the four sculptors of the *Mausoleum at Halicarnassus. He is said by *Pliny to have sculpted the west side. His only attributed works are the seated statue, *Demeter of Knidos, in the British Museum, and a head of Alexander the Great in Athens.

LOUIS LE NAIN *Peasant Family.* 44½×62⅝ in (113×159 cm). Louvre

LOUIS LE NAIN *The Farm Wagon.* 1641. 22×28½ in (56×73 cm). Louvre

LEON, S. Isidoro (begun 1054)

This Spanish †Romanesque church contains the Panteón de los Reyes ('Pantheon of the Kings of León') which is decorated with wall-paintings. They possess a lighter palette than *Tahull, suggesting a knowledge of western French examples.

LEONARDO DA VINCI (1452–1519)

b. Vinci d. Cloux. Florentine painter, sculptor and writer whose wide-ranging culture and scientific pursuits (including the invention of a flying machine, the dissection of the uterus to show the embryo within, and he almost discovered the circulation of the blood) has led to him being regarded as the most celebrated example of the †Renaissance ideal of the Universal Man. Trained by *Verrocchio, his first important Florentine work was the unfinished *Adoration of the Magi* (1481, Uffizi).

In this and the two versions of the *Virgin of the Rocks* (1483–1506, Louvre and NG, London) many of his most characteristic motifs appear: harsh rocks, rearing horses, a pointing finger, beautiful youths and cadaverous old men. Above all, his famous *sfumato modelling (a soft, smoky shading fused with a pale filter of light playing across the forms) at once unifies the design and evokes a mood of tantalising ambiguity. He was employed at the Milanese court (c. 1482–99) by Ludovico Sforza for whom he painted the *Last Supper* (1497, Sta Maria delle Grazie, Milan), often described as the first painting of the High Renaissance, and was also engaged upon the ill-fated project of the bronze monument of the Duke's father, in which he tried to solve the problem of balancing a huge rearing horse. From this time forward Leonardo began to compile his famous notebooks which eventually contained drawings of military machines, rock formation, studies of water, animals, plants, buildings and anatomy, as well as notes for a treatise on painting. The French invaded Milan (1499) and Leonardo returned to Florence, via Mantua and Venice. Such was his reputation that not only was the *Cartoon of the Virgin and the Child with St Anne* (NG, London) rapturously received (1501), but the Florentines were prepared to overlook his defection to their enemy Cesare Borgia (1502), inviting him to paint the *Battle of Anghiari* in the Council Hall. Unhappily his love of technical experimentation proved disastrous and it was unfinished; the best idea of its composition exists in a copy by *Rubens. Most famous and influential of all his works of this period was the *Mona Lisa* (c. 1503, Louvre). He was in Milan (1508–13) and visited Rome (1514–

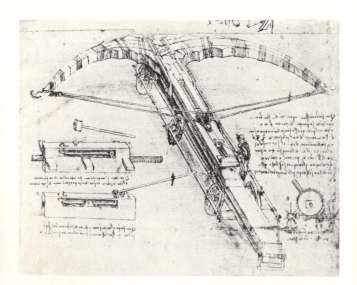

LEONARDO DA VINCI *Ginevra di Benci. c.* 1480. 15⅛×14½ in (38·4×36·8 cm). NG, Washington

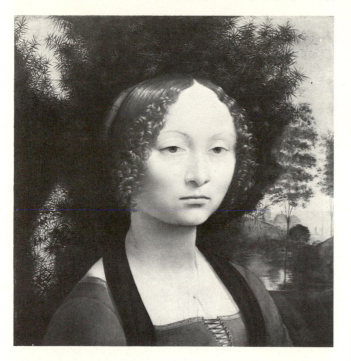

LEONARDO DA VINCI Drawing of a giant cross-bow from the Codex Altanticus, folio 314 recto b. Ambrosian Library, Milan

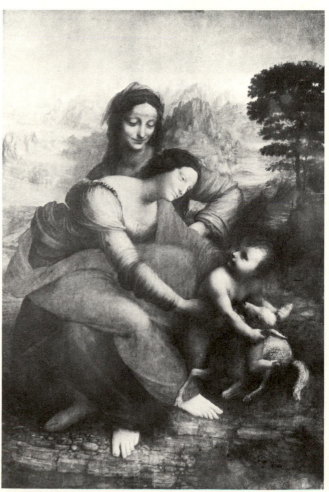

LEONARDO DA VINCI *Virgin and Child with St Anne. c.* 1500–7. 67⅛×50⅞ in (170×129 cm). Louvre

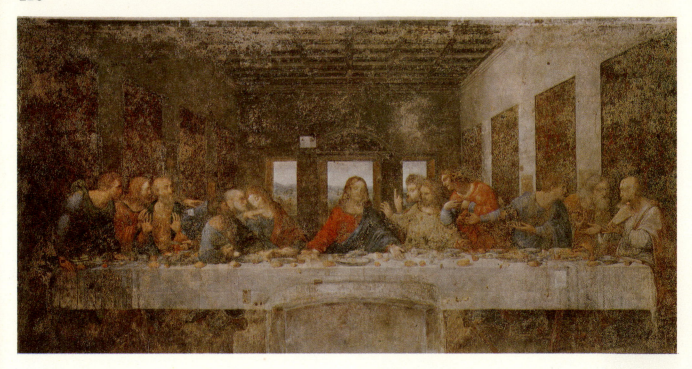

16). Shortly afterwards he settled in France, enjoying the unbounded admiration of François I. But his last works reveal a strange dejection and are largely devoted to scenes of cataclysmic destruction.

LEONI, Leone (1509–90)

b. Arezzo d. Milan. Italian sculptor. Trained as a goldsmith, he later became a monumental sculptor, active in Italy, also Brussels and Augsburg. He executed portrait medallions of patrons, humanists and artists, eg *Andrea Doria*. He was coin-engraver to the Papal Mint (1538–40). As Court Artist to Charles V he sculpted *Charles V Triumphant over Discord* with removable armour, and he made twenty-seven statues for the high altar of the Escorial. The Milan Senate gave him a grand house for which he carved six huge *Bearded Captives*.

LEONI, Pompeo (1533–1608)

b. Milan d. Madrid. Italian sculptor and medallist, the son of Leone *Leoni by whom he was trained and whom he assisted. In 1582 he accompanied the twenty-seven statues carved by his father to the Escorial, where he completed them. Appointed to the service of the Regent, Juana of Austria, he settled in Madrid. He produced the tomb figures for the monuments of Charles V and Philip II (1598, Escorial). His lavish use of gems and the intricate detailing reflects the influence of Spanish taste.

LE PARC, Julio (1928–)

b. Argentina. Attended the Buenos Aires Art School. Travelled and worked in Europe. Has disavowed the gallery system and is in favour of multiples. His work aims at altering physical awareness and equilibrium by the distortion of visual information. To accomplish this he uses lights, reflective surfaces, distorting mirrors, lenses, patterned glass, etc. He has manufactured hand-mirrors and spectacles, using curved reflective surfaces to distort perception.

LEPICIE, Michel-Nicolas-Bernard (1735–84)

b. d. Paris. French painter. After early failures as a *history painter, he concentrated on genre scenes in a style deriving elements from *Greuze and *Chardin and produced works which have much charm.

Above: LEONARDO DA VINCI *Last Supper*. 1495–8. Tempera wall painting. 173×339 in (439×859 cm). Convent of Sta Maria delle Grazie, Milan
Below left: POMPEO LEONI Detail of tomb figure from the Tomb of Charles V. Escorial
Below right: JULIO LE PARC *Continuel-Mobile, Continuel-Lumière*. 1963. Relief. 63×63×9 in (160×160×22·9 cm). Tate
Bottom: STANISLAS LEPINE *Caen Harbour*. 28½×36 in (72·3×91·5 cm). Louvre

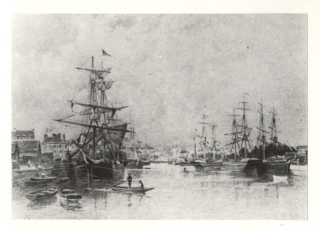

LEPINE, Stanislas Victor Edouard (1835–92)

b. Caen d. Paris. French landscape painter, student of *Corot, and friend of *Boudin, *Jongkind and the †Impressionists. He specialised in views of Paris, especially the Seine, in a style derived from Corot and Impressionism. He began to exhibit at the Salon of 1859. The patronage of Count Doria allowed him to work free of material concerns.

LE PORTEL

†Palaeolithic site in Ariège, France, with a *Perigordian/*Aurignacian painting in outline and flat wash and *Magdalenian horses in black outline.

LE PRINCE, Jean-Baptiste (1734–81)

b. Metz d. Saint-Denis-du-Port. French painter and copper-engraver. He was very versatile and prolific, executing *history and genre paintings, portraits and landscapes. His style included elements from his master *Boucher and from the Dutch School.

LEPTIS MAGNA, Arch of Septimius Severus

A four-sided *triumphal arch erected, probably hastily, for a visit by the Emperor to his birthplace in AD 203. The main sculptures adorn the *attic and show triumphal processions, a scene of sacrifice, and Septimius Severus with his sons.

LE ROC DE SER (Solutrean c. 18,000 BC)

†Palaeolithic site in Charente, France, with limestone blocks carved in relief with bison, horse and a human figure.

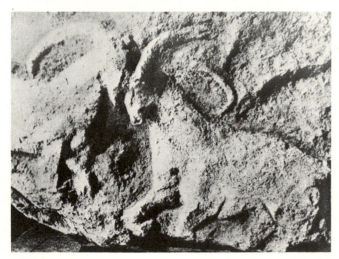

LE ROUX, Roland (d. 1527)

b. d. Rouen. French sculptor and architect. Master of the Rouen Cathedral Works (1508). Rebuilt the spire. Designed and executed with assistants the tomb of the Amboise Cardinals (1515), a highly detailed, flamboyant niche-tomb, but with more modern kneeling effigies of the deceased.

LESE, Benozzo di see GOZZOLI

LESLIE, Charles Robert (1794–1859)

b. d. London. American artist trained at the Royal Academy Schools and befriended by fellow Americans *West and *Allston. After painting a few portraits and historical works he developed his own lines of humorous subjects taken from, eg Cervantes, Molière and Sterne. He published a memoir of John *Constable (1843) and was Professor of Painting at the Royal Academy Schools (1847–52).

LESPUGUE (Perigordian)

†Palaeolithic site in Haute-Garonne, France. An ivory female figurine with accentuated breasts and buttocks was found there.

Opposite column: LE ROC DE SERS Rock relief carving of ibexes fighting
Above left: CHARLES ROBERT LESLIE *Uncle Toby and the Widow Wadman.* 1842. 33×23 in (83·8×58·4 cm). Tate
Above right: EUSTACHE LE SUEUR *Death of St Bruno.* 76×51¼ in (193×130 cm). Louvre

LESSING, Gotthold Ephraim (1729–81)

b. Kamenz, Saxony d. Brunswick. German scholar and critic. In his essay *Laokoon* (1776), he attacked the notion, most recently pronounced by *Winckelmann, that the visual arts pursue the same ends as literature though by different means. Lessing argued that the purpose of art was the creation of ideal beauty, not the illustration of a literary idea.

LESSING, Karl Friedrich (1808–80)

b. Breslau d. Karlsruhe. German painter, a student of Schadow and Dähling at Berlin. He moved to Düsseldorf (1826), and began a long career as a history painter by decorating the Gartensaal of Heltdorf Castle. Also celebrated as a painter of the heroic landscape. His work is often hard in feeling, and far removed from the fresh oil studies he made direct from nature as a student.

LE SUEUR, Eustache (1616–55)

b. d. Paris. French religious painter. He was influenced by *Vouet (his master), profoundly by *Poussin, and later by *Raphael. His best work is the series of paintings representing the life of St Bruno (Louvre). Greatly admired in his lifetime and during the 18th century, his reputation almost equalled that of Poussin.

LE SUEUR, Hubert (c. 1595–c. 1650)

b. Paris d. London. French sculptor. He was trained in France, and came to England (c. 1625) where he was patronised by the Crown. His most famous work is the equestrian statue of Charles I at Charing Cross, London.

LES VINGT

An exhibiting society in Brussels formed by twenty Belgian artists, among them *Ensor and *Rysselberghe, in 1884, shortly before the Salon des Indépendants, and lasted for ten years. They deliberately avoided formulating any common aesthetic programme, confining themselves to the practical aim to exhibit yearly and to invite the collaboration of the same number of guests, partly from abroad, who would be representative of new vital tendencies. There was no president, its secretary, the lawyer Octave Maus, edited *L'Art Moderne* to spread its views. Among guests were *Rodin (1884), *Monet (1886), *Seurat (1887), *Gauguin (1889), *Cézanne and *Van Gogh (1890), reflecting major artistic currents alongside Belgian tendencies.

LE TAVERNIER, Jean I (active 1454–c. 1477)

b. Oudenarde. Netherlandish miniaturist, member of the Tournai Guild (1434). Notably active in the service of Philip the Good. Much influenced by Rogier van der *Weyden, he achieves elegant, movemented figures, but lacks perspectival control. Sometimes confused with Jean Le Tavernier II, a less important miniaturist from Bruges (d. 1480) who may have been his pupil in Tournai.

LETI see INDONESIA, ART OF

LEU, Hans the Younger (c. 1490–1531)

b. Zürich d. Gubel. Swiss painter, son of Hans the Elder and follower of *Dürer and *Baldung at Freiburg. Back in Zürich 1514. Financially ruined by the Reformation, he died fighting at the Gubel. His style is often seen as being connected with the *Danube School for his landscapes have a similar sense of unreality.

LEUTZE, Emmanuel Gottlieb (1816–68)

b. Württemberg, Germany d. Washington, D.C. Painter who studied with *Lessing in Düsseldorf (1841); visited Munich, Venice and Rome (1842); painted in Düsseldorf (1845–63); settled in America (1863). Leutze is remembered for his American historical paintings, characterised by grandiose poses, mindless multiplication of diligently painted details and totally unconvincing bombastic sentimentality.

LEVI, Julian (1900–)

b. New York. Painter who studied with *Charles at Pennsylvania Academy; worked in Europe, largely France and Italy (c. 1919–24); worked for *WPA (1936–8); taught at *Art Students' League. Influenced by *Cubism and *Post-Impressionism, Levi's characteristic seascapes are romantic and subdued in colour; lately, they have become more abstract, simplified and symbolic.

LEVINE, Jack (1915–)

b. Boston. Painter who studied at Boston Museum School and with Ross at Harvard University (1929); worked for *WPA (1930s); settled in New York (c. 1945); visited Europe (1947). Influenced by *Rembrandt, *Daumier and European *Expressionism, Levine's satires of corruption and hypocrisy gain power from their paradoxically delectable painterliness and jewel-like colour.

LEVITAN, Isaac Illyitch (1860–1900)

b. Kibarty by Wirballan d. Moscow. Significant in development of Russian landscape painting. Levitan was a Moscow College student, later teacher, under Savrassov and *Polenov. The latter introduced him to the *Abramtsevo colony as theatrical designer in the 1880s. After his Paris trip (1889), the influence of *Corot, *Daubigny and *Dupré appeared in his melancholic Volga landscapes. He contributed to the first *'World of Art' exhibition (1898).

LEVNI (18th century)

Ottoman painter from Edirne, best known for his illustrations for the *Sur-name ('Book of Festivals', c. 1720–5). He also painted individual miniatures, usually depicting elegant ladies, carried out in a very personal style and with a taste for realistic detail. See also TURKISH PAINTING

LEVY, Rudolph (1875–1943)

b. Stettin, Germany. Painter who studied at Karlsruhe and Munich. He met *Matisse in Paris (1909) and with *Moll and *Purrman formed the 'German Matisse School'. Levi worked in a delicate style using *Fauve-like colouring. He settled in Italy (1937); he was deported by the SS and disappeared (1943).

LEWIS, John Frederick (1805–76)

b. London d. Walton-on-Thames. The son of an engraver, he achieved early success with animal subjects. A stay in Spain (1832–4) produced bold watercolours, rich in colour, which won him acclaim. He was in Italy (1837–50), and then Greece, Egypt and Asia Minor. His Eastern harem themes in a minutely detailed style were highly praised by *Ruskin.

LEWIS, Percy Wyndham (1882–1957)

b. On a yacht off Nova Scotia, Canada d. London. English painter who, after studying at the Slade School of Art (c. 1900) travelled in Europe, returned to London (1909), eventually channelling his vast energies into being the leading spirit of *Vorticism. Trench warfare tempered his abstraction; his art became increasingly figurative and less prolific as he concentrated on writing novels and pamphlets, often violently satirising contemporary taste. His painting has an uncompromising external vision.

LEYDEN, Lucas van (?1494–1533)

b. d. Leiden. Netherlandish painter and engraver, pupil of his father, Hugo, and Cornelius *Engelbrechtsz. He met *Dürer in Antwerp (1521) and may have entered the guild there (1522). His engravings and woodcuts are heavily influenced by Dürer, but display a sensitive line and true originality, eg The Small Passion series (1521). His paintings, characterised by fluid brushwork, are problematic owing to lack of knowledge about the Leiden School, but his mature works evince Romanist influence, eg The Last Judgement (c. 1526, Leiden). He is said to have travelled with *Gossaert (1527). Tradition described him as something of an epicurean.

LEYSTER, Judith (1606–60)

b. Haarlem d. Heemstede. Dutch portrait, still-life, animal and genre painter. One of Frans *Hals's most successful pupils, she did not however achieve quite his spontaneity. Greatly esteemed by her contemporaries, she married *Molenaer (1636) and began to paint small-scale genre scenes similar to those of her husband.

LHERMITTE, Léon Augustin (1844–1925)

b. Mont-Saint-Père d. Paris. French landscape painter and engraver, the first work he exhibited at the Salon of 1864, Bords de Marne près d'Alfort won recognition, and he continued to be acclaimed with the Legion of Honour and membership at the Institute (1905). He painted rural scenes in the manner of *Millet and adopted the *Impressionist peinture claire without their chromatic research.

LHOTE, André (1885–1962)

b. Bordeaux d. Paris. French painter who studied in Bordeaux; moved to Paris (1910). Founded an art school (1922) and wrote several important books on art theory. Rigidly based on theory, his work represents a continuing attempt to give *Cubism a solid academic foundation.

LI Chao-tao (active c. 670–730)

Son and follower of *Li Ssŭ-hsün.

LI Ch'êng (919–67)

From Ying-ch'iu, Shantung. One of the great Chinese landscape painters of the Northern *Sung dynasty, Li Ch'êng was a scholar whose grasp of nature was said to be such that he could forget the actual landscape that inspired him to paint. His tradition was carried on by *Kuo Hsi, but no actual works survive by Li himself. Even by the late 11th century *Mi Fu maintained that he had seen only three genuine paintings by him.

LI Kung-lin (c. 1049–1106)

Chinese painter from Shu-ch'eng, Anhui. The chief figure-painter of the *Sung dynasty, he revived the styles of *Ku K'ai-chih and of the Six Dynasties, creating a figure style of classic dignity. His pai-miao (white drawing) or outline technique found numerous followers in later centuries.

LI Kung-nien (active early 12th century)

Only one painting by him survives: a fine landscape in Princeton, showing a softening of the awesome Northern *Sung landscapes towards the more accessible landscapes of the Southern Sung. His contemporary *Li T'ang occupies a similar position in the history of Chinese painting.

LI Liu-fang (1575–1629)

From Hsieh-hsien, Anhui. Chinese scholar-painter of flowers and landscapes in *Tung Ch'i-ch'ang's circle.

LI Shan (active 1st half 18th century)

Chinese painter from Yangchow, Kiangsu. One of the *Eight Eccentrics of Yangchow, he painted flowers and birds in a free manner. Like others of the group, Li was criticised for the wildness of his brushwork.

LI Ssŭ-hsün (651–716)

Li Ssŭ-hsün and his son Li Chao-tao, both Chinese court painters and members of the imperial *T'ang family, were especially known for their paintings of landscape. Li Ssŭ-hsün is traditionally held to be the ancestor of the 'Northern School', and to have painted in a detailed 'blue and green' style. Surviving works attributed to them convey the appearance of T'ang compositions, with narrow soaring peaks closely spaced and affording a view of deep valleys and wider open spaces behind; but they are not a reliable guide to the appearance of Li's or his son's brushwork.

LI T'ang (c. 1050–after 1130)

Chinese painter from Ho-yang, Honan, whose work can be seen as transitional between the awesomely remote landscapes of Northern *Sung and the more personal scenery of Southern Sung. *Autumn Landscape*, one of a pair of paintings surviving probably from an original set of four seasons, demonstrates this in the larger scale of the human figure when compared to *Fan K'uan. The rocks in the foreground are modelled with slanting strokes, known as 'axe-cut strokes', drawn with the brush held at an angle.

LIANG K'ai (active early 13th century)

From Tung-p'ing, Shantung. Chinese painter of figures and landscapes: his works, like those of the Ch'an monk *Mu-ch.i, now survive chiefly in Japan, where they were brought by Japanese Zen monks. *Portrait of the T'ang poet Li Po* characterises the poet in a few consummate strokes; *Sakyamuni descending from the mountain* conveys the emotional intensity of the Buddha's renunciation in the archaic, frozen folds of his robe and the wintry landscape round him.

LIANG PERIOD SCULPTURE see **WAN FO SSU**

LICCHAVIS see **GUPTA CONTEMPORARY MINOR DYNASTIES**

LICHFIELD GOSPELS (early 8th century)

This Gospel Book, also known as St Chad's Gospels, was made in Northumbria, Mercia or possibly Wales. Some of the decoration is close to the *Lindisfarne Gospel but the two surviving Evangelist portraits show a much greater dissolution of form into abstract pattern especially in the drapery. (Lichfield Cathedral Library.)

LICHTENSTEIN, Roy (1923–)

b. New York. *Pop artist who studied with *Marsh at *Art Students' League and made *Abstract Expressionist paintings (until 1960). Lichtenstein's subjects drawn from popular culture, such as comic strips, are blown up and rendered mechanically; conversely, great paintings are rendered as comic strips, banalising the monumental and monumentalising the banal.

LICINIO, Bernardino (c. 1489–before 1565)

b. ?Poscante d. ?Venice. Italian painter, employed mainly as a portraitist. His early style was influenced by Giovanni *Bellini. Later he produced some works in the fashionable Venetian style, drawing for inspiration on *Giorgione, *Titian and *Palma Vecchio.

LIE, Jonas (1880–1940)

b. Moss, Norway d. New York. Painter who first lived in Paris; settled in America (1893); studied at National Academy of Design and *Art Students' League; exhibited at *Armory Show (1913). Lie's landscapes and seascapes, including paintings of the Panama Canal during construction, are distinguished by buoyant, often sparkling, colour.

LIEB, Michael see **MUNKACSY, Mihaly**

LIEBERMANN, Max (1847–1935)

b. d. Berlin. Principal German †Impressionist genre, landscape, and portrait painter, left philosophical studies at Berlin University to study painting with Thumann and the Belgian painter Pauwels. Eventually better known outside Germany, he settled in Paris where he became acquainted with *Munkacsy. Trips to Holland furnished him with subjects like the *Canning Factory* (exhibited 1873). He visited *Barbizon (1874) where *Millet's subjects of simple peasants at their daily activities especially interested him. He returned to Germany (1878) and continued to paint genre until the 1890s when he began to work more in the Impressionist manner. When the Berlin *Secession was founded (1899) he became its president.

LIEVENS, Jan (1607–74)

b. d. Amsterdam. Dutch painter, etcher and wood-engraver, whose early work is often indistinguishable from that of his close friend *Rembrandt. Both young men studied under *Lastman and worked together in Leiden (c. 1625–31). Lievens painted portraits, landscapes and allegorical and *history pictures. He enjoyed a successful career, though he later turned to a rather weak imitation of Flemish models.

LIGORIO, Pirro (c. 1500–83)

b. Naples d. Ferrara. Italian architect, painter, archaeologist and engineer. Studied painting in Rome. He was principally occupied as an architect (from 1549), combining the virtues of charm and imagination in the little Casino in the Vatican Gardens and the dramatically scenic waterfalls of the Villa d'Este, Tivoli. His passion for antiquity culminated in the publication of the *Book of Antiquities of Rome* (1553), a work of inestimable value today as a source of knowledge of what was visible at the time.

LIJN, Liliane (1939–)

b. New York. American *Kinetic artist who came to Europe (1955), studying in Paris (1958–64) and developing her intricate 'Poem Machines' (1964). Using industrial processes her delicate constructions describe the mutual exchanges operative within a time-light-space-movement continuum.

LIM, Kim (1936–)

b. Singapore. Sculptress who came to England (1954). Studied at St Martin's and Slade Schools of Art. She has recently produced identical or multiple forms which are placed on the ground and have infinite pattern possibilities. These units have a loose geometric basis and are uniform in colour.

LIMBOURG BROTHERS
Pol (Paul)
Hannequin (Jean)
Hermant (Hermann)

Flemish family of miniature-painters and illuminators from Nimwegen (active c. 1399–c. 1416). On their way home from

Paris after their apprenticeship to a goldsmith, they were thrown into prison in Brussels. Their uncle, Jean *Malouel, prompted his patron the Duke of Burgundy to bail them out and take them into his service. After the Duke's death, they probably worked for his son, John the Fearless. Next heard of in Bourges, it is recorded that a local girl was kidnapped by the Duc de Berry on behalf of Pol, who had become his *valet de chambre*. Brother of the King of France and the Duke of Burgundy, the Duc de Berry was the Limbourgs' most important patron. For him they executed their masterpiece, the *Très Riches Heures* (Chantilly). This exquisitely elegant and refined Book of *Hours reflects their goldsmiths' training and a possible visit to Italy. The Hours are preceded by a pictorial calendar in which the months are illustrated with courtly pleasures and appropriate labours. These scenes are among the earliest examples of genre painting with the châteaux and domains of the Duke depicted in minute detail and brilliant colour, showing a selective naturalism which anticipates the van *Eycks.

Above: JACK LEVINE *Gangster Funeral.* 1952–3. 63×72 in (160×182·9 cm). Whitney Museum of American Art, New York

Left: LIMBOURG BROTHERS *May* from the Très Riches Heures of the duc de Berry. *c.* 1415. 11½×8¼ in (29×21 cm). Chantilly
Right: LI T'ANG *Autumn Landscape.* Hanging scroll. Ink on paper. 26⅞×17⅓ in (68·5×43·6 cm). Kōtō-in, Kyoto
Below left: JOHN FREDERICK LEWIS *The Harem.* 35×44 in (88·9× 111·8 cm). Birmingham
Below: LI KUNG-LIN *The Classic of Filial Piety.* Detail of handscroll. Ink on silk. Entire scroll 8¼–8¾×186¼ in (21–22×473 cm). Art Museum, Princeton

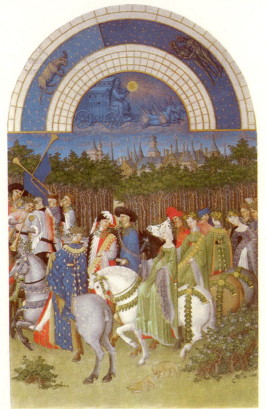

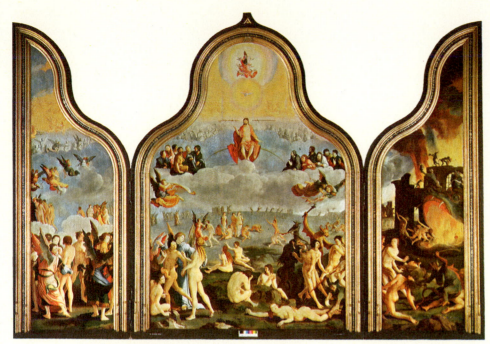

Left: LUCAS VAN LEYDEN
The Last Judgement. c. 1526.
$104\frac{3}{4} \times 30\frac{1}{8}$, $106 \times 72\frac{3}{4}$,
$104\frac{3}{4} \times 30\frac{1}{8}$ in ($265 \times 76 \cdot 5$,
$269 \cdot 5 \times 184 \cdot 8$, $265 \times 76 \cdot 5$
cm). Lakenhal Museum,
Leiden
Below left: LUCAS VAN
LEYDEN *Original Sin.*
1505—8. Engraving. $4\frac{5}{8} \times 3\frac{1}{2}$ in
($11 \cdot 7 \times 8 \cdot 8$ cm). BM, London
Below: PERCY WYNDHAM
LEWIS *Edith Sitwell.*
1923—33. 34×44 in ($86 \cdot 4 \times$
$111 \cdot 8$ cm). Tate
Bottom left: ROY
LICHTENSTEIN *Whaam!*
1963. Acrylic. 68×160 in
($172 \cdot 7 \times 406 \cdot 4$ cm). Tate
Bottom right: JAN LIEVENS
Self-portrait. c. 1644.
$37\frac{7}{8} \times 30\frac{5}{16}$ in ($96 \cdot 2 \times 77$ cm).
NG, London

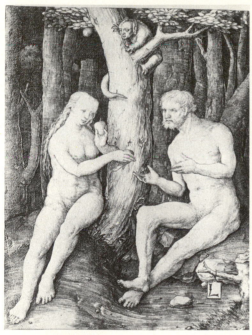

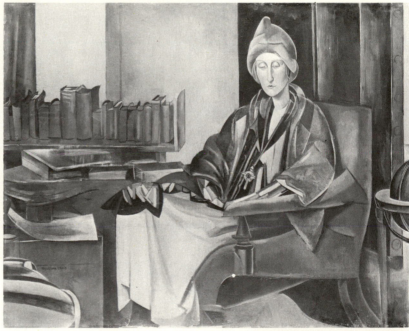

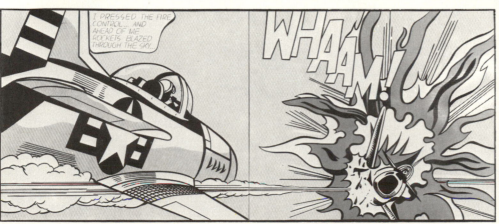

LIMEUIL (late Magdalenian)

†Palaeolithic site in the Dordogne, France, with a large number of engraved limestone plaques of horse, ibex, reindeer and a bear, some with superimposed drawing.

LIMNER

From the French: *luminer*, the word was used in the Middle Ages to describe a manuscript illuminator. By the 16th century it came to describe specifically a painter of portrait miniatures, though it was also used more loosely of painters in general. Now obsolete.

LIMNERS, The

In America, the limners were the usually anonymous and itinerant portraitists of the mid 17th century, their work varying from the severity of Puritan New England to the more elegant grace of the lower East Coast. They shared a love of rhythmic, linear, flat pattern, colour and texture, and a basic devotion to truth and reality which often penetrated character deeply.

Above left: THE LIMNERS, Gerrit Duyckinck. *Mrs Gerrit Duyckinck*. New York Historical Society
Above right: LINCOLN CATHEDRAL, The Angel Choir. Music-making angel. 1255–80

LIMOGES ENAMELS, Medieval

During the 12th, 13th and 14th centuries the Limoges region in western France was a major centre for the production and export of metal liturgical objects. The technique employed combined engraved surfaces, high relief and *champlevé enamelling (surface cavities filled with brilliantly coloured enamels). Dense surface patterning, a heavy figure style and a limited repertoire of basic forms, executed with efficiency rather than excellence, characterise most Limoges products.

LINCOLN CATHEDRAL, Angel Choir (1255–80)

An extension to Lincoln Cathedral Choir, built to house the shrine of St Hugh. Its sculpture style, architectural decoration and portal design draw on English tradition, on the French importations at Westminster Abbey and on the angel sculptures at *Reims. The carving of a choir of music-making angels, which decorates the gallery, is an innovation. These angels and the choir's elaborate *Judgement* portal are among the finest surviving examples of English medieval sculpture.

LINDISFARNE GOSPEL

Written by Eadfrith, Bishop of Lindisfarne (between 689 and 721) and presumably illuminated in Northumbria, this is one of the masterpieces of Hiberno-Saxon art. It is an extraordinary conflation of decorative elements drawn from many sources – not all of them Celtic – and a figure art which is unmistakably Mediterranean in origin. *See also* DURROW *and* KELLS, Books of

LINGA

The phallus, symbol of *Shiva; the usual focus of devotion in temples of Shiva.

LINGELBACH, Johannes (1622–74)

b. Frankfurt d. Amsterdam. Dutch painter and etcher. He painted *bambocciate and Italianate landscapes, and is notable because he often painted the figures in the landscapes of other artists, especially *Hobbema and *Wynants.

LINGODBHAVA (LINGA+UDBHAVA)

Sanskrit: literally *'linga-manifestation'; mythological episode in which *Shiva revealed himself as an endless pillar of fire.

LINNELL, John (1792–1882)

b. London d. Redhill. English †Romantic landscape painter, pupil of *West and *Varley, friend of *Blake and (for a time) also of his son-in-law Samuel *Palmer. His portraits include *Robert Peel*, *Malthus* and *Carlyle*; he also engraved Bible illustrations.

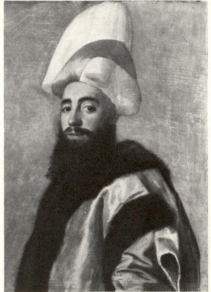
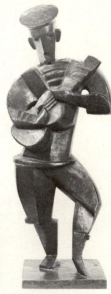

Top: JOHN LINNELL *Contemplation*. 1864–5. 28¼×39¼ in (71·8×99·7 cm). Tate
Above left: JEAN ETIENNE LIOTARD *A Grand Vizir*. Pastel. 24½×18¾ in (62×47·5 cm). NG, London
Above right: JACQUES LIPCHITZ *Sailor with a Guitar*. 1914. Bronze. 30×12 in (76·2×30·5 cm). Albright-Knox Art Gallery, Buffalo, New York

LINOCUT *see* BLOCK-PRINTING

LINSEED OIL

Drying oil pressed from the seeds of the flax plant. The most common of the painter's oils.

LIOTARD, Jean Etienne (1702–90)

b. d. Geneva. Swiss pastel painter and engraver. He worked in Paris, Holland and England, and became famous for his portraits of fashionable sitters wearing Eastern costume. (He himself had visited the Near East and wore Eastern dress.)

LIPCHITZ, Jacques (1891–)

b. Druskieniki, Lithuania. Sculptor who studied at the Ecole des Beaux-Arts and the Académie Julian (1909–10) and gradually combined an interest in exotic and primitive art with an awareness of the *Cubism of *Picasso and *Archipenko, producing important Cubist sculptures (1915–20) carved directly in stone. He was associated with *L'Esprit Nouveau* (1922) with *Le Corbusier and *Ozenfant, attempting to unite art with architecture. By using *cire perdue casts he broke away from Cubism (1925–7) and produced a transparent linear style, important for Picasso and *González. Although always an inventor of forms, his imagery from the 1930s became freer, more menacing and more profound. *See also* PURISM

LIPPI, Filippino (c. 1457–1504)

b. Prato d. Florence. The precociously talented son of Fra Filippo *Lippi whose frescoes at Spoleto he completed. He was closely associated with *Botticelli (early 1470s) whose influence is still apparent in the *Apparition of the Virgin to St Bernard* (1486, Badia, Florence). Went to Rome (1488) and decorated the Caraffa Chapel, Sta Maria sopra Minerva. He made an intense study of antique remains which bore fruit in his most sophisticated work, the frescoes in the Strozzi Chapel, Sta Maria Novella, Florence (1502). The bold classical architecture, restless figures and restrained colour typify the transition from Early to High †Renaissance.

LIPPI, Fra Filippo (c. 1406–69)

b. Florence d. Spoleto. Painter and Carmelite friar whose earliest work *The Relaxation of the Carmelite Rule* (c. 1432, Forte di Belvedere, Florence) shows *Masaccio's influence. By 1440 his style had radically changed and become exemplified by crowded scenes enriched with flowers, ornate jewels, diaphanous veils, Roman candelabra, all combined within an ambitiously planned space, eg *Coronation of the Virgin* (1441–4, Uffizi). His sensuous colour and brushwork was well adapted to the depiction of Nativity scenes and paintings of the Virgin and Child in which the former nun Lucrezia Buti, whom he abducted and married, is sometimes the model. He also produced fresco cycles at Padua (1434), Prato (from 1452) and Spoleto (1467–9).

Top: FRA FILIPPO LIPPI *Coronation of the Virgin*. 1441–4. Tempera. 78¾×113 in (200×287 cm). Uffizi
Above left: ARTHUR LISMER *Rain in the North Country*. 1924. 28½×34½ in (72·4×87·6 cm). NG, Canada
Above right: RICHARD LIPPOLD *Variation Within a Sphere, No 10: The Sun*. 1953–6. Gold filled wire. MM, New York
Left: FILIPPINO LIPPI. *Detail from the life of St Philip*. c. 1487–1502. Fresco. Strozzi Chapel, Sta Maria Novella, Florence

LIPPOLD, Richard (1915–)

b. Milwaukee. Sculptor, son of engineer; studied at Chicago Art Institute; did industrial design; taught in Milwaukee and at University of Michigan (1940s); has had several commissions for architectural decorations. Deeply influenced by *Gabo and *Constructivism, Lippold fabricates glittering, radiant wire constructions, often suspended in darkness, delicately interlacing space and line.

LISMER, Arthur (1885–1969)

b. Sheffield, England. Painter who studied in Sheffield (1898–1905) and Antwerp (1906–7); emigrated to Toronto (1911); taught in Ontario (1915–16, 1920–7), Halifax (1916–19), Montreal (from 1946); was Educational Supervisor of Toronto

Art Gallery (1920–36); was original member of *Group of Seven (1920). A highly important teacher, Lismer painted powerful, broad landscapes, capturing their essentials with simple force.

LISS (LYS), Johann (1595–1629/30)

b. Holstein d. Venice. German painter who trained in the Netherlands, possibly under *Goltzius. Visited Rome before settling in Venice, where his spirited style shows not only *Rubensian influence but also that of the Venetian colourists. His work became very popular in Venice, perhaps because of the current lack of native talent there.

LISSITZKY, Lazar El (1890–1941)

b. Smolensk d. Moscow. Russian painter and graphic designer who studied engineering in Darmstadt. Participated in 'Knave of Diamonds' and *'World of Art' exhibitions in Moscow. Met *Malevich (1919) and began work on the book designs for Mayakovsky's poetry (1923). Member of the ABC group of *Constructivist architects and for the last twenty years of his life an important Soviet architect. His early work was in a *Cubo-Futurist manner, but he produced his Story of Two Squares (1919), based on *Suprematist principles. One of the leading Suprematists and Constructivists, Lissitzky was also largely responsible for disseminating their ideas in the West.

LITHOGRAPHY

A printing process. The design is drawn on to a porous surface with greasy ink or chalk. The surface is thoroughly wetted; the design resists wetting. Printing ink is rolled over the surface. This is resisted by the water, but 'takes' on the design. The water is dried off, the paper applied, and a print taken in a press. The process reproduces the texture of pen and chalk drawing. It was invented in the late 18th century. See also TRANSFER PAPER

LIVIA, House of (late 1st century BC)

A house on the Palatine Hill in Rome, thought to have been the residence of the Emperor Augustus. Its four main rooms are decorated in the Second Style of *Pompeian painting with illusionistic columns, swags and landscapes full of small figures and mythological scenes.

LO P'ing (1733–99)

Chinese painter from Hsieh-hsien, Anhui. Pupil of *Chin Nung and, like him, one of the *Eight Eccentrics of Yangchow, Lo P'ing painted ghosts, strange figures and Buddhist subjects as well as ink plum blossom, orchids and bamboo.

LOBI

A tribe on the border of Upper Volta and northern Ghana carving figures and heads in hardwood usually in a style of extreme simplicity. Indeed, their ancestral shrines often contain figures which are virtually unshaped pieces of wood.

LOCAL COLOUR

The basic colour of an object, regardless of any apparent change caused by ephemeral effects of light and shade and proximity to other local colour.

LOCATELLI, Andrea (1595–1641)

b. Rome. Italian painter. A pupil of Paulo Arnesi, he painted ideal landscapes with Biblical, mythological or genre scenes, and architectural views. He was chiefly influenced by Gaspard *Dughet and *Grimaldi.

LOCHHEAD, Kenneth Campbell (1926–)

b. Ottawa. Canadian painter who studied at Queen's University and Pennsylvania Academy; visited Europe (1948–9); was Director of Art School, Regina College (1950–64); teaches in Manitoba. Influenced by *Newman, *Noland and Clement Greenberg, Lochhead moved from his ambiguously powerful figurative *Surrealism to painting rectilinear abstractions of dominant colour fields with subordinate colour variations.

LOCHNER, Stephan (active 1442–d. 1451)

b. ?Meersburg, Lake Constance d. Cologne where first recorded in 1442 when paid for decorations made to celebrate the visit of Emperor Frederick III. Became a councillor of the painters' guild (1447). His large triptych Adoration of the Kings (Cologne Cathedral), painted for the Town Hall, is the basis for attributions. There is a Presentation (dated 1447, Darmstadt). The style is influenced by the soft femininity of *International Gothic. In his hands almost all characters become child-like in form and innocent in expression, painted in rich, jewel-like colours.

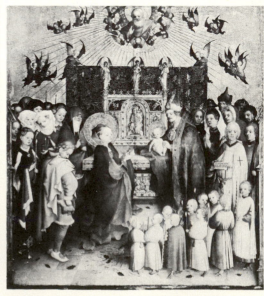

Left and above: LITHOGRAPHY Duel by Francisco Goya (and detail). c. 1819. $9\frac{7}{8} \times 9\frac{1}{2}$ in (25×24 cm). BM, London

Above: STEPHAN LOCHNER Presentation in the Temple. 1447. $54\frac{3}{4} \times 49\frac{5}{8}$ in (139·1×126 cm). Hessisches Landesmuseum, Darmstadt

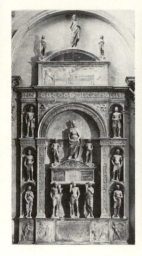

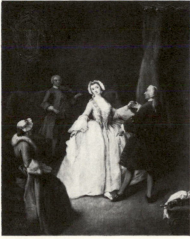

Above left: PIETRO LOMBARDO Tomb of the Doge Pietro Mocenigo. 1476. Marble. SS Giovanni e Paolo, Venice
Above right: PIETRO LONGHI *The Dancing Master*. 1745. 23⅝×19¼ in (60×48 cm). Accademia, Venice

LOGGAN, David (c. 1635–92)

b. Danzig d. London. Scottish etcher, who worked in Amsterdam before coming to England (c. 1658). He portrayed Oliver Cromwell and many Restoration figures, but is chiefly known for his two books of engravings, *Oxonia Illustrata* (1675) and *Cantabrigia Illustrata* (c. 1690). He was Oxford University's official engraver.

LOMAZZO, Giovanni Paolo (1538–1600)

b. Milan. Italian writer on art. Up to the age of thirty-three, when he became blind, he was a painter, pupil of Gaudenzio Ferrari; his few surviving paintings include a self-portrait (Brera). He wrote two important treatises on art theory: the *Trattato dell' Arte della Pittura* (1584) and the *Idea del Tempio della Pittura* (1590), the former widely influential, although a philosophical analysis of painting rather than an artist's handbook. Ideal beauty, he maintained, was in the artist's mind not in nature, and the finest qualities in painting were movement and light.

LOMBARD, Lambert (c. 1506–66)

b. d. Liège. Netherlandish painter and architect, said to have studied under *Gossaert and Aert de Beer. Visited Italy (1537/8). His knowledge of contemporary and antique art in Italy made him the centre of artistic discussion and he is more important as an intellectual and source of inspiration than as a practising artist. His own figure studies, dignified but lifeless, are almost all quotations from antique statues.

LOMBARDO Family
 Pietro (c. 1435–1515)
 Tullio (c. 1455–1532)
 Antonio (c. 1458–?1516)

Italian sculptors and architects. Tullio and Antonio were Pietro's sons and all three were unrivalled among Venetian sculptors of their time. Pietro's early work (eg Roselli Monument, 1467, Padua) shows some Florentine influence; his mature style, while craftsman-like, has originality and Northern vigour (eg Pietro Mocenigo Monument, 1481, SS Giovanni e Paolo, Venice). His sons participated in many monuments designed by Pietro; increasingly, he only supervised and left the execution to them (eg Onigo Monument, 1490, S. Niccolò, Treviso). His work as both sculptor and architect is probably seen at its best in Sta Maria dei Miracoli, Venice (1481–9). His elder son Tullio, together with Antonio, worked in Pietro's studio from at least 1475. Tullio's classical style is characterised sometimes by a tedious rigidity (eg *Coronation of the Virgin*,

S. Giovanni Cristostomo, Venice), sometimes by a manly vigour (eg the warrior on the Vendramin Monument, SS Giovanni e Paolo, Venice), occasionally by a tender lyricism (*Bacchus and Ariadne*, KH, Vienna). The younger son, Antonio, collaborated in many of Pietro's monuments and possibly in the Sta Maria dei Miracoli reliefs; but his serene, grave, classical style is at its best in the Zen Chapel, St Mark's, Venice and at S. Antonio, Padua. From 1506 he worked in Ferrara, mainly on interior decoration.

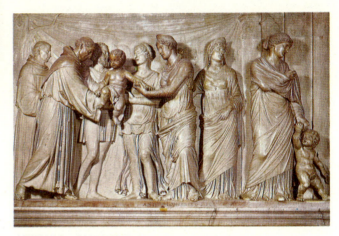

ANTONIO LOMBARDO *The Miracle of the New-born Child*. 1505. Marble relief. S. Antonio, Padua

LOMI, Artemisia *see* GENTILESCHI

LONDON GROUP

Formed (1913) in the ferment after *Fry's *Post-Impressionist exhibitions (1910, 1912), initially having no single stylistic basis; members of both the *Camden Town group and the *Vorticists belonged. This diversity of outlook did not last long and the adherence of *Fry, Vanessa *Bell and *Grant temporarily defined its direction. The practical function of the Group was to provide exhibition facilities for chosen artists.

LONGHI (FALCA), Pietro (1702–88)

b. d. Venice. Prolific Italian painter who studied under *Crespi in Bologna, but from 1734 remained in Venice. He executed some frescoes, but is primarily remembered for his elegant genre scenes recording Venetian amusements and fashionable life.

LOPES, Gregorio (?1490–c. 1550)

Important Portuguese painter working in Lisbon, who was Court Painter to Manuel and John III. His style was largely based on northern European masters and contains *Mannerist influences.

LOPEZ-Y-PORTANA, Vicente (1772–1850)

b. Valencia d. Madrid. Spanish painter, studied in Valencia and Madrid. His reputation as a portraitist was such that he returned to Madrid as Court Painter (1814). In his portraits he emphasised tangible form, but maintained, particularly in his portraits of elderly people, a real sense of psychological penetration.

LORENZETTI, Ambrogio (active c. 1319–c. 1348)
 Pietro (active c. 1320–c. 1348)

These two Sienese brothers, under considerable Florentine influence, represent the progressive development of the achievements of *Giotto and *Duccio. Both experimented with the depiction of space and the relationship of the frame to pictorial space, eg Pietro's *Birth of the Virgin* and Ambrogio's *Presentation* (both 1342). There is a greater pathos and solidity

in Pietro, as can be seen in his *Deposition* in Assisi. Ambrogio's innovations include a new tender portrayal of the Virgin and Child, a development of political iconography and the portrayal of contemporary town and country life in his civil commission, *Good and Bad Government* (1338–9).

Left: AMBROGIO LORENZETTI *Peace* from the fresco cycle of Good and Bad Government. 1338–9. Palazzo Pubblico, Siena
Right: LORSCH GOSPELS, the cover. Early 9th century. Ivory. 15×10½ in (38·1×26·7 cm). V & A, London
Far right: LORENZO LOTTO *The Annunciation*. Sta Maria Sopra Mercanti, Recanti
Below right: PHILIP DE LOUTHERBOURG *An Avalanche in the Alps*. 1803. 43¼×63 in (109·9×160 cm). Tate

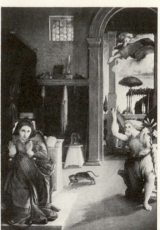

LORENZETTO (Lorenzo LOTTI) (1490–1541)

b. Florence. Italian sculptor, architect, restorer of antiques, fortunate enough to be favoured by *Raphael, who shared with *Vasari a faith in his ability difficult now to justify. With Raphael's recommendation, he received a commission for the Chigi Chapel sculptures (1519); later he carved the Virgin and Child for Raphael's tomb (1523).

LORENZO MONACO, Don (c. 1370–c. 1422)

b. Siena. Camaldolese monk at Sta Maria degli Angeli, Florence; painter and miniaturist. Monaco was a pupil of Agnolo *Gaddi, but his chilly religious feeling was developed from *Spinello Aretino. He was the foremost Florentine exponent of *International Gothic, eg *Adoration of the Magi* (Uffizi) and the impassioned drawing of the *Journey of the Magi* (Berlin).

LORENZO MONACO *Madonna and Child and Saints*. 1410. 109½×92½ in (277×235 cm). Palazzo Davanzati, Florence

LORRAIN, LE see CLAUDE

LORRAINE see CLAUDE

LORSCH GOSPELS (early 9th century)

A Gospel Book painted in the Palace School at Aachen for Charlemagne. The paintings use classical forms in a new non-naturalistic symbolism. The two ivory covers are now

divided between the Vatican and the Victoria and Albert Museum in London and are works of very high quality, showing late antique influence probably through †Byzantine ivories. (National Library, Bucharest.)

LOST WAX see CIRE PERDUE

LOTTI, Lorenzo see LORENZETTO

LOTTO, Lorenzo (c. 1480–1556)

b. Venice d. Loreto. Italian painter, active mainly near Venice. His early work was influenced by Giovanni *Bellini, but he later absorbed many styles and his religious work shows debts to *Dürer, *Raphael, *Leonardo and *Titian. He was capable of great intensity of religious feeling, eg the *Annunciation* (Recanti). He had close contacts with the Lutherans and executed a portrait of Martin Luther and his wife. As a portraitist, Lotto dwells on the psychological unrest of his sitters, and his compositions show many *Mannerist features, eg in *Portrait of a Man* (Accademia, Venice).

LOUIS, Morris (Morris Louis BERNSTEIN) (1912–62)

b. Baltimore d. Washington, D.C. Painter who studied at Maryland Institute of Fine and Applied Art (1929–33) and worked for *WPA (1930s). Louis's first abstractions were *Cubist; later adopting *Frankenthaler's *Abstract Expressionist staining technique, Louis made concentrated colour itself his subject, first in his fluid, amorphous 'veils', then reduced to parallel stripes.

LOUTHERBOURG, Philip James de (1740–1812)

b. Strasbourg d. London. Franco-German painter. His easel-paintings are usually melodramatic landscapes, but his best works were designs of stage-sets for Garrick, executed after he

settled in England (1771). He also invented a moving-picture peep-show – the Eidophusikon.

LOWER NIGER BRONZE INDUSTRY

The temporary label for a diverse group of bronzes of uncertain origin. Many were found at *Benin (1897) but for reasons of style are unlikely to have been cast there. Another group were discovered in the Nupe villages of Jebba and Tada on the middle Niger where they are said to have been left by Tsoede the founder of the Nupe kingdom. Others have turned up in villages in the Niger delta.

Left: LOWER NIGER BRONZE INDUSTRY Figures of a woman (left) and a bowman. Date uncertain (? 16th century). Bronze. h. 45½ in (115·5 cm), and 36 in (92 cm). The Chief of Jebba Island, Nigeria
Below: L. S. LOWRY *Industrial Landscape.* 1955. 45×60 in (114·3×152·4 cm). Tate
Bottom left: EUGENIO LUCAS Y PADILLA A sketch. 1868. 15¾×11¾ in (40×29 cm). New York Hispanic Society
Bottom right: LU CHIH *The Green Cliff.* Ink and colours on silk. 33⅝×11⅞ in (85·3×30·3 cm). Art Museum, Princeton

LOWRY, Laurence Stephen (1887–)
b. Rusholme, Manchester. English painter who studied at the Municipal College of Art, Manchester, and Salford School of Art. Lowry depicts, without satire or romance, humanity in industrial surroundings – typically as milling black ciphers. An independent worker, he had established his style by 1920. He sticks to his vision and his area.

LOZI see BAROTSE

LU Chih (1496–1576)
Chinese painter from Soochow, Kiangsu, whose landscapes show the development of *Ming dynasty wên-jên-hua (scholar-painting) to a point where the motifs are far removed from natural forms. The refinement of the brushwork and execution is all: it is an art chiefly aimed at the appreciation of like-minded artists and connoisseurs, such as Wên Chia (*Wên Cheng-ming).

LUBA see BALUBA

LUCAS VAN LEYDEN see LEYDEN, Lucas van

LUCAS Y PADILLA, Eugenio (1824–70)
b. Alcalá de Henares d. Madrid. Spanish artist who studied at the Madrid Academy and by copying Old Masters in the Prado. His varied subjects included portraits, still-lifes, genre and bull-fights closely following *Goya. In Paris (1850s) he met *Manet who became interested in Spanish painting. He travelled in Italy and North Africa and there painted Moroccan subjects.

LUCE, Maximilian (1858–1941)
b. d. Paris. French painter and anarchist who studied at the Académie Suisse and under *Carolus Duran. He joined the *Neo-Impressionists (1886) and exhibited at the Salon des Indépendants (1887–93). Temperamentally unsuited to *Divisionism, his work became closer to †Impressionism but he followed *Seurat in painting the industrial, proletarian scene.

LUCIANI, Sebastiano see PIOMBO

LUCIDEL, Nicolas see NEUFCHATEL

LUDIUS (late 1st century BC–early 1st century AD)
Roman wall-painter of the Augustan period, mentioned by *Pliny. He is said to have painted pictures with villas, harbours, gardens, woods, hills, pools, rivers, with figures of fishermen, hunters and women.

LUDOVISI THRONE (c. 460 BC)
A three-sided relief, probably part of an altar, made in southern Italy or Sicily. It is part of the Ludovisi Collection in the National Museum at Rome. The central panel shows Venus rising from the waves assisted by two females. Her form is modelled through the wet clothes which cling to her body. On

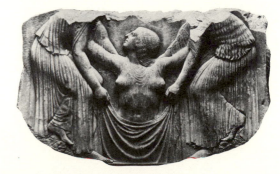

LUDOVISI THRONE Detail showing birth of Venus. Marble. w. 56 in (1·43m). National Museum, Rome

the left panel is a young, naked flute-girl sitting cross-legged, and on the right an old woman sitting fully clothed on a box – a contrast between youth and old age.

LUINI, Bernardino (c. 1481–1532)

Italian painter, active Milan, Lombardy and Lugano. Early influences are Venetian and later *Leonardo, especially in his repetition of the Madonna's smile, soft *chiaroscuro, full forms and serenity of mood.

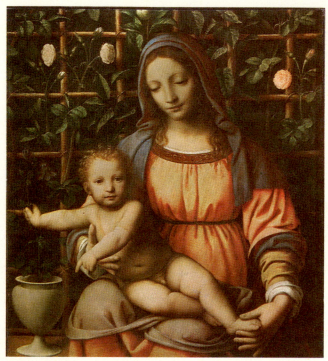

BERNARDINO LUINI *Madonna del Roseto.* 24⅞×27⅝ in (63×70 cm). Brera

LUKS, George Benjamin (1867–1933)

b. Williamsport, Pennsylvania d. New York. Painter who studied at Pennsylvania Academy, in Düsseldorf, Paris, London and Munich; exhibited with The *Eight (1908) and at *Armory Show (1913); taught at *Art Students' League (1920–4). Luks revealed *Hals's influence and his own ebullient vitality in urban genre scenes of the *Ash Can School.

LUNG MEN, Cave-temples at

Work started at the Buddhist cave-temple of Lung Mên in Honan province, China, after the capital of the Northern Wei state was moved to I oyang (AD 495). The three main caves of Northern Wei date are: the Ku Yang Tung which, dating from the end of the late 5th century, can be compared with the western caves at *Yün Kang; the Pin Yang Tung (AD 505–23), in which the groups of imposing images with heavy robes in the early 6th-century manner with overlapping folds, patterned hems and crossed scarves form a contrast with the elegant almost flat donor friezes originally from this cave; the Lien Hua Tung with a single graceful image of the Buddha. Images of the late 6th century of the Sui period, solid and columnar, austere and remote from the spectator are found in several caves, eg the southern Pin Yang Tung and the Yao Fang Tung. The sculptural developments of the *T'ang period with its increasing preoccupation with the accurate representation of the human body and of a wide range of character and emotion can be followed through the caves of the Ch'en Ch-i Ssǔ, the Feng Hsien Ssǔ and the Kang Ching Ssǔ.

LURÇAT, Jean (1892–1966)

b. Bruyère. French artist who studied at the Ecole des Beaux-Arts and the Académie Colarossi. Although active as a painter, lithographer, engraver and ceramic-designer, Lurçat is chiefly important as one of the originators of modern tapestry revival. His fundamentally *Cubist approach to figural scenes produces effects of fascinating decorative complexity.

LURISTAN BRONZES

These bronze objects were looted from graves and sanctuaries in Luristan, a district of western Iran. Although the term includes bronzes of many periods the most characteristic and finest Luristan bronzes were made between 1000 and 700 BC. Standards and pins decorated with stylised opposed animals and grotesque demoniac figures (so-called 'Gilgamesh figures') are typical but axes, plaques for belts and quivers, horse-harness, rings and disk-headed pins are also common.

LUTERI, Giovanni *see* DOSSI

LURISTAN BRONZES
Bronze ornament with
Gilgamesh figure. *c.* 900 BC.
h. 12 in (30 cm). Ashmolean

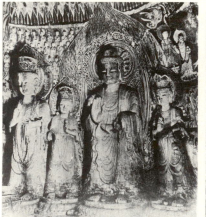

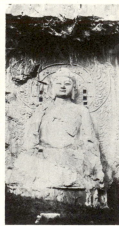

Top left: LUNG MEN The Buddha with attendant Bodhisattvas in the Pin-yang cave. Early 6th century AD
Top right: LUNG MEN Vairorana Buddha in the Feng-hsien-ssu recess. Inscription on pedestal gives date of construction as AD 672–5
Above: LUTTRELL PSALTER Detail of man chasing geese. 1335–40. BM, London

LUTTRELL PSALTER (before 1340)

Made for Geoffrey Luttrell, depicted in the manuscript with his wife and daughter-in-law. A late example of the East Anglian School of illumination, remarkable for profuse secular marginal decoration. The Psalter text is surrounded by coarse, vivid illustrations of contemporary sport, wild life, trade, home life, agriculture and fabulous beasts. These scenes parallel contemporary *misericord designs.

LYMAN, John Goodwin (1886–1967)

b. Biddeford, Maine d. West Indies. Painter who studied in Paris and London (1907), later with *Matisse; travelled and worked in Europe, North Africa and West Indies (1919–31); returned to Montreal (1931); taught at McGill University. A formative influence on modern Canadian painting, Lyman shows his French orientation in painterly, formalist canvases.

LYON, Corneille de see CORNEILLE DE LYON

LYS, Johann see LISS

LYSIPPOS (active 350–300 BC)

Greek sculptor from Sikyon and Court Sculptor to Alexander the Great. It is said of him that he represented men as they appeared to be, while others represented them as they were. His bodies are more lithe than previously and the head is smaller in relation to the body. His statues have an alert tense look. One of his most famous works is the *Apoxyomenos.

LYSISTRATOS OF SIKYON (active 2nd half 4th century BC)

Greek sculptor and brother of *Lysippos. He was interested in realistic portraiture and apparently took wax casts from living models. *Pliny says he was the first to take casts of statues.

M

MA Ho-chih (active 12th century)

Chinese painter from Ch'ien-t'ang, Chekiang. He executed a series of long handscrolls illustrating the ancient Book of Odes, in a lyrical style with graceful, flowing brushstrokes. The texts of the odes, accompanying each illustration, are attributed to Emperor Kao Tsung (reigned 1127–62). The example shown is one of ten 'Odes of Ch'en' in the handscroll at the British Museum.

MA Yüan (active late 12th–early 13th century)

Chinese painter from Ho-chung, Shansi. Known as 'One-corner Ma' from the composition of many of his paintings. These are often in a lyrical mood, with the landscape forms rendered in refined brushwork and ink-wash. In contrast to Northern *Sung landscapes, Ma Yüan's are small in scale, with larger figures, and greater use of atmospheric effects. He and *Hsia Kuei were both Academy members, and their names were linked in later centuries as the Ma-Hsia School.

MABUSE see GOSSAERT, Jan

MACCHIAIOLI

The Italian 'spotters', a movement in painting against academicism, developed throughout the 1860s and centred round the Caffè Michelangelo in Florence. Giovanni Costa's contact with the *Barbizon School and *Corot in Paris introduced the open form and new feeling for nature to *Fattori, the leading painter, Sernesi, *Abbati, D'Ancona and *Signorini, their theoretician. They aimed at simplification through reduction to clear contrasts of brightness and colour, and in their development towards †Impressionism, attempted the objective representation of the phenomena of light.

MACDONALD, James Edward Hervey (1873–1932)

b. Durham, England d. Toronto. Painter who went to Ontario (1887), where he studied (c. 1890); was graphic designer, Toronto (c. 1895–1911), London (1904–7); was founder-member of *Group of Seven (1920); taught at Ontario Art College (1921–32). From †Impressionist and Scandinavian influences, MacDonald reduced his mature landscapes to a few telling, stark shapes.

THE MACCHIAIOLI, Adriano Cecioni *Il Caffè Michelangiolo*. 1861. 21×32⅜ in (53·5×82 cm). Eugenio Gerli Collection, Milan

Above: JAMES MACDONALD *Spring Breezes, High Park*. 1912. 28×36 in (71·1×91·4 cm). NG, Canada
Left: MA HO-CHIH *The Odes of Ch'en*. Section of handscroll with calligraphy attributed to Emperor Kao Tsung. Ink and colours on silk. Entire scroll 10½×288 in (26·8×731·5 cm). BM, London

MACDONALD, James Wilson Alexander
(1824–1908)

b. Steubenville, Ohio d. Yonkers, New York. Sculptor who studied in St Louis and worked in New York (c. 1865–80). MacDonald made bronze portraits, equestrian sculptures and monuments, many commemorating the Civil War, popular because they combined factual realism with heroic sentiment.

MACDONALD, Jock (James Williamson Galloway)
(1897–1960)

b. Thurso, Scotland d. Toronto. Painter who studied at Edinburgh College of Art (until 1922); emigrated to Canada (1926); taught in Vancouver, Banff, Calgary and Ontario; was founder-member of Painter's Eleven (1953). MacDonald was a greatly influential teacher, kindling original ideas and propagating *Abstract Expressionism, which he practised forcefully and freely.

MACDONALD-WRIGHT, Stanton (1890–)

b. Charlottesville, Virginia. Painter who went to Paris (1907); studied at Ecole des Beaux-Arts, Académie Julian and Sorbonne; founded Synchromism with *Russell (1912); exhibited at *Armory Show (1913) and with *Stieglitz. MacDonald-Wright's abstract Synchromist paintings, based on complex colour theories, create pulsating rhythms of pure colour and geometric forms.

MCEWEN, Jean (1923–)

b. Montreal. Canadian self-taught painter who worked in Paris (1951–3) and Greece (1963); was President of Association des Artistes non-figuratifs de Montréal (1959). Influenced by *Borduas, and probably *Francis and *Rothko, McEwen's paintings are divided into hard-edge rectilinear zones, within which painterly brushwork gives an odd sense of depth.

MCFEE, Henry Lee (1886–1953)

b. St Louis, Missouri d. Altadena, California. Painter who studied in Pittsburgh, Woodstock and at *Art Students' League (1909); taught at Scripps College and Graduate School, Claremont, California (from 1942). Influenced by *Cubism and *Cézanne, McFee discarded his early †Impressionism; his still-life compositions are formally solid, if bland and derivative.

MACHUCA, Pedro (active 1517–d. 1550)

b. Toledo d. Granada. Spanish architect and painter trained in Italy. Returned to Spain with Jacopo Fiorentino (1520) and became, with *Berruguete, founder of the *Mannerist School. The palace at Granada which he designed for Charles V (1527–8) shows the influence of *Bramante's stern classicism.

MACIP, Vicente Juan see MASIP

MACIVER, Loren (1909–)

b. New York. Painter who studied briefly at *Art Students' League (1919); worked for *WPA (1936–9); visited Europe often (from 1948). MacIver's style varies constantly from figurative to near-abstract art, depending on her subject; in all her paintings she retains her luminous, subtle colour and lyrical vision.

MACK, Heinz (1931–)

b. Lollar. German artist who studied art in Düsseldorf (1950–3). He started developing his light theory which led to the making of mobile light sculptures where reflection plays a major part (late 1950s). He moved to New York and exhibited with the *Zero group. Using repetitive patterns and auxiliary motors to create his mobile effects, he works in a manner which is both Op and Kinetic.

HEINZ MACK Light Dynamo. 1963. Kinetic. $22\frac{1}{2} \times 22\frac{1}{2} \times 12\frac{1}{4}$ in ($57 \cdot 2 \times 57 \cdot 2 \times 31 \cdot 1$ cm). Tate

MACKE, August (1887–1914)

b. Meschede d. Champagne. German painter who studied in Düsseldorf (1904–6). Met *Marc (1909/10). Was involved with Marc and *Kandinsky in der *Blaue Reiter (1911–12). Met *Delaunay in Paris (1912). He travelled with *Klee and Moillet to Tunisia (1914), being killed in the war the same year. He moved from early flirtations with †Impressionism and *Cézanne, to a style whose prismatic colours and firm, geometric structure owes much to Delaunay, although unlike Delaunay, he endowed colour with an emotional rather than merely an optical force.

MACKINTOSH, Charles Rennie (1868–1928)

b. Glasgow d. London. Designer and architect based in Scotland who developed an anti-historicist style of design (from 1894) which nevertheless had its roots in a Japanese sense of

Far left: PEDRO MACHUCA Assumption of the Virgin. 1517. $65\frac{3}{4} \times 53\frac{1}{4}$ in (167×135 cm). Prado
Centre: AUGUST MACKE Strollers on a Bridge. Hessisches Landesmuseum, Darmstadt
Below: F. E. McWILLIAM Cain and Abel. 1952. Metal. $18\frac{1}{8} \times 15\frac{5}{8}$ in ($46 \times 39 \cdot 7$ cm). Tate

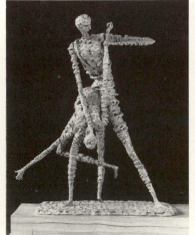

interval and in *Celtic linear patterns. Trained as an architect, he was commissioned to build an extension to the Glasgow School of Art (1898–1909) which had immense influence in Europe, as did his designs for furniture and decorations which could be seen reproduced in the *Studio* magazine (from 1897), or at the Vienna *Secession exhibition (1900). A boldness in handling space also characterises the interiors of the houses he designed round Glasgow.

MACLISE, Daniel (1806–70)

b. Cork d. London. Came to London (1827) and first exhibited in 1832, although he was known as a caricaturist for *Fraser's Magazine* from 1830. His subject paintings, of history and genre, suggest the strong influence of contemporary German painting, with their symmetrically disposed figures under almost theatrical conditions of light, realised with emphatic contours and rather harsh colours. It is surprising that as an aspiring mural-painter, he should have waited until 1859 before going to Germany. His virtuosity in composing scenes involving many figures made him a natural candidate for mural commissions, his most successful being the decoration of the Royal Gallery in the House of Lords (1857–65).

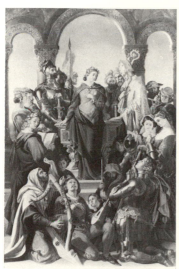 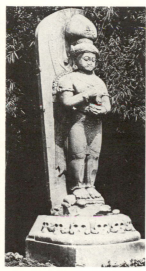

Above left: DANIEL MACLISE *The Spirit of Chivalry*. 1845. 49¼ × 35¼ in (125·1 × 89·5 cm). Sheffield City Art Gallery
Above right: MADJAPAHIT PERIOD Colossal statue of Bhairava

MACMONNIES, Frederick William (1863–1937)

b. Brooklyn, New York d. New York. Sculptor who studied with *Saint-Gaudens (1880), at *Art Students' League and with Falguière at Ecole des Beaux-Arts (c. 1884–7); lived in France until 1915. MacMonnies adopted the animated surfaces and personifying iconography of contemporary French sculptors; his vitality was skin deep, and eventually ossified.

MCWILLIAM, Frederick Edward (1909–)

b. Banbridge, Ireland. Sculptor who studied at the Slade School of Art and in Paris. His bronze sculptures express the dynamics of figures in various reclining states but with a severe angular simplification of form. The concern for surface qualities causes variations from high polishes to coarse, pitted textures. His recent works are highly polished, curvilinear and almost totally abstract.

MADAGASCAR

The large island off the south-eastern coast of Africa with a population and culture of diverse African and Asiatic origin. Their finest sculptures are wooden grave-posts from six to twelve feet high which combine often naturalistic figures and geometric ornament.

MADERNO, Stefano (1576–1636)

b. Bissone d. Rome. Italian sculptor. He was one of the leading sculptors in Rome before the emergence of *Bernini, after which he himself was influenced by the latter. His best work is the *Sta Cecilia* (Sta Cecilia in Trastevere).

MADJAPAHIT PERIOD, Indonesia

The last of the great pre-Islamic kingdoms of Indonesia had its capital near Trawulan at the head of the Brantas estuary, Java. Some fine examples of secular work in terracotta have been found in the vicinity. During this period (AD 1293–1478) temple carving in low relief continued, but there was a steady increase in a silhouette style which bears close resemblance to that of the *wayang puppets. It is, however, possible that the resemblance stems from later attempts to produce puppets which would not be so obviously human as to offend Islamic principles against human representations. Among the most striking examples of statuary is a colossal figure of Bhairava from central Sumatra which is believed to be a portrait-statue of King Adityavarman, a vassal of Madjapahit. The temple complex at Panataran, near Blitar, dates in part from this period as does the mountain shrine of Candi Sukuh with its remarkable reliefs from the *Sudamala*. It is possible that the Yeh Puloh carvings from Bedaulu, *Bali also belong to this period when the island came under East Javanese control.

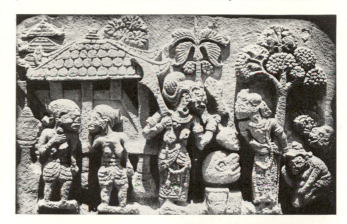

Above: MADJAPAHIT PERIOD Relief from the temple of Candi Sukuh representing an episode from the *Sudamala*. h. 37⅜ in (95 cm)
Right: FEDERICO MADRAZO-Y-KUNTZ *The Marquesa de Montelo*. 1855. Museum of Contemporary Art, Madrid

MADRAZO Family

The Spanish painter Federico Madrazo-y-Kuntz (1815–94), himself the son and pupil of the †Neo-classical artist Madrazo-y-Agudo, is best known for his portraits of fashionable society. His work shows the influence of *Ingres whom he met in Paris (c. 1837). Later works show a greater rigidity which may have been influenced by German art; he met *Overbeck in Rome (1840). His two sons, Raimondo (1841–1920), and Ricardo (1851–1917) Madrazo-y-Garreta, were both active as portrait and genre painters, the former studying under his brother-in-law *Fortuny, and the latter under Léon Cogniet in Paris.

MAES, Nicolaes (1632–93)

b. Dordrecht d. Amsterdam. Dutch genre and portrait painter. He was a pupil of *Rembrandt and his early work shows his influence. Later, however, he developed a much cooler, more elegant style which won him great success.

Above left: NICOLAES MAES *Woman at Prayer.* 1655. 52¾×44½ in (134×113 cm). Rijksmuseum
Above right: MAGDEBURG CATHEDRAL Detail from the Parable of the Wise and Foolish Virgins, from the Paradise Portal. c. 1245

MAESTA

Veneration of the Virgin increased rapidly in 13th-century Italy and new types of devotional images of Mary were therefore developed. The *maestà* (majesty), popular during the 13th and 14th centuries, shows the Virgin enthroned as the Queen of Heaven, surrounded by a court composed of saints and angels. This type, used among others by *Duccio, Simone *Martini and Ambrogio *Lorenzetti, is essentially large in scale, richly decorated and elegant.

MAFFEI, Francesco (c. 1600–60)

b. Vicenza d. Padua. Italian painter who revolted against the current academic style. Basing himself on the great Venetians and *Parmigianino, he evolved a very personal style, characterised by rapid, nervous brushwork and indefinite outlines. He was active all over North Italy painting altarpieces.

MAGDALENIAN (15,000–11,000 BC)

The period of †Palaeolithic art which produced the last works of cave art and saw the peak of chattel and cave art. *See also* LAUGERIE HAUTE; LAUGERIE BASSE; LIMEUIL; LA MADELEINE; ALTAMIRA

MAGDEBURG CATHEDRAL

Among the objects transferred to the †Gothic cathedral from the previous †Ottonian building are two bronze effigies of 12th-century bishops – survivals of the metalworking tradition of †Romanesque Germany. The Cathedral choir is surrounded by guardian saints and apostles (c. 1225–30), which were perhaps the first of their kind. From the same period dates the statue of St Maurice, the earliest convincing representation of a Negro in European art. The most notable sculpture is on the north transept portal – a set of Wise and Foolish Virgins, mid 13th century in date and closely dependent on *Bamberg. (In the market-place at Magdeburg is an equestrian statue of Otto II which closely resembles the *Bamberg Rider.*)

MAGHRIBI

Islamic script used in North Africa (except Egypt) which derived from *Kufic and has not changed much since its early period. It was taken to Spain and was called 'Andaluzi' or 'Qirtabi'. Other scripts derived from Maghribi were: Tunesi, Aljazayeri, Fasi and Sudani.

MAGIC REALISM

This movement, at its height in the 1930s, was *Surrealism Americanised. Influenced by Surrealism and *Precisionism, the Magic Realists painted with the sharp focus and heightened reality of the photograph. Their imagery was drawn from ordinary America, becoming effective through odd, dreamlike combinations and conjunctions. A major proponent of pure Magic Realism was *Blume; other artists, like *Albright, shared the imagery, but not the *Daliesque technique. Later painters, eg *Wyeth, have been called Magic Realists owing to their precise draughtsmanship, odd viewpoints and enigmatic vision.

MAGNASCO, Alessandro (1677–1749)

b. d. Genoa. Often referred to as 'Il Lissandrino' Magnasco spent most of his career working for private patrons in Milan. In both style and content his paintings epitomise the complicated transition from †Baroque to †Rococo. Though rooted in Genoese practice, his style of spasmodic flicks and his ambivalent approach to subject-matter at once recall Salvator *Rosa and anticipate *Guardi. His range included violent seascapes, genre scenes, visionary religious subjects and landscapes full of dark foreboding.

MAGNELLI, Alberto (1888–1971)

b. Florence d. Meudon-Bellevue. Italian self-taught painter who allied himself with *Cubist and Post-Cubist abstract developments (from 1910). He moved to Paris (1931), contributing to *Abstraction-Création. Magnelli developed gradually from Expressionist landscapes to a *Léger-like simplification; since 1936 his geometrical compositions have been totally abstract.

Top: ALESSANDRO MAGNASCO *The Monks' Refectory.* Museo Civico, Bassano
Above: MAGHRIBI SCRIPT Page from a Maghribi Qur'an. 13th–14th century

MAGRITTE, René (1898–1967)

b. Lessines d. Brussels. Belgian painter, radically influenced by de *Chirico after a *Cubist beginning. He lived in Paris and exhibited with the French *Surrealists (1927–30); remained a member of the Belgian Surrealist group all his life. Certain themes dominate Magritte's work, all related to an argumentative questioning about the nature of reality, eg the relationship between an object and its image in representation (*The Human Condition 1*, 1933), or levitation, a heavy object, like a stone, floating in the sky (*The Sense of Realities*, 1963). He paints in a dry descriptive manner, avoiding fussy details, but often with handsome colour; he often takes a symmetrical arrangement in a stage-like setting as his subject, straightforwardly relating unrelated objects and spaces within a single perspective, thus making of the extraordinary something which seems ordinary. Magritte's unspectacular technique emphasises the strangeness of his paintings.

Above: RENE MAGRITTE *The Man of the Sea*. 1926. 55⅛×43¼ in (140×110 cm). Musées Royaux, Brussels
Left: RENE MAGRITTE *The Menaced Assassin*. 1926. 59¼×77 in (150·5×195·6 cm). MOMA, New York, Kay Sage Tanguy Fund
Below: BENEDETTO DA MAIANO *Pietro Mellini*. Marble. Bargello

MAHABHARATA

Title of one of the Sanskrit Hindu epics; contains the *Bhagavad-Gita*.

MAHAVIRA

Sanskrit: literally 'Great Hero'. Title accorded to Vardhāmana (c. 540–c. 468 BC), founder of the *Jaina religion and a contemporary of the Buddha. He is referred to in Buddhist texts as one of the main opponents of early Buddhism. Like Gautama the Buddha, Vardhāmana the Jina was the son of a tribal chief; he belonged to the Jñātrika clan which was associated with the Licchavis (*Gupta Contemporary Minor Dynasties).

MAHAYANA

Sanskrit: literally 'Great Way'; developed Buddhism as distinct from the early *Hinayana School; incorporates the *Bodhisattva doctrine; has many cult ramifications. Practised in Tibet, China, Indonesia, Japan and Vietnam.

MAHISHAMARDINI

Literally 'she who crushes the buffalo'; Hindu goddess created by all the gods, each of them contributing a weapon or characteristic, to overcome the buffalo-demon who was too powerful for them to combat individually.

MAHLSTICK

A thin stick or wand, generally with a padded tip that can be rested against a painting in process. Held in the painter's free hand, he can use it as rest for his brush hand to steady the hand and wrist in fine work.

MAHONGWE *see* BAKOTA

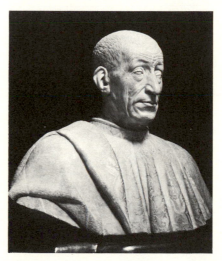

MAIANO, Benedetto da (1442–97)

Italian sculptor, active Florence, Loreto, Arezzo and Naples. His early work was influenced by Antonio *Rossellino and *Desiderio da Settignano. His pulpit in Sta Croce, Florence (1472/5) shows the same careful naturalism associated with *Ghirlandaio's paintings. He also produced some accomplished portrait busts. He was assisted by his brothers Giuliano, an architect and woodworker, and Giovanni.

MAI CHI SHAN, Cave-temple at

A Buddhist cave-temple in Kansu province in north-west China. The soft rock of this mound-shaped mountain though easily tunnelled into caves is not suitable for fine carving and

the sculptures here were therefore executed in stucco. A few free-standing stone sculptures were worked from stone transported from elsewhere. The use of stucco together with remoteness of Mai Chi Shan from the centre of Northern Wei rule allowed an individual sculptural style to evolve in the late 5th and early 6th centuries AD. The long elongated figures with softly modelled robes, typical of this site, can be seen in Caves 100 and 115. A particularly characteristic elaborate robe hanging in three sweeps over the feet of the seated figures is seen in Caves 127 and 133. Similar local variants can be followed through the late 6th century and succeeding *T'ang dynasty (AD 618–906).

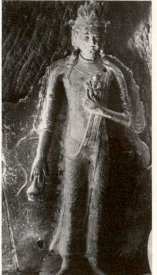
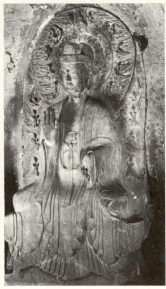

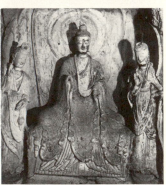

Above left: MAI CHI SHAN Bodhisattva in Cave 100. Last quarter of 5th century AD
Above: MAI CHI SHAN Seated Buddha in Cave 127. First half of 6th century AD
Left: MAI CHI SHAN Seated Buddha with attendant Bodhisattvas. Cave 133, niche 3. First half of 6th century AD

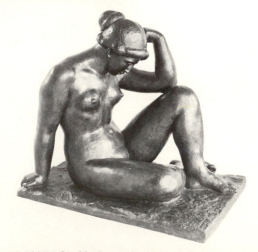

ARISTIDE MAILLOL *Mediterranée*. 1902–5. Bronze. h. 41¾×310¾ in (106×788 cm). Boymans van Beuningen Museum, Rotterdam

MAILLOL, Aristide (1861–1944)

b. d. Banyuls. French sculptor who originally studied painting at the Ecole des Beaux-Arts (1881). He started making tapestries under the influence of *Gauguin and the *Nabis (1890–1). Failing eyesight forced him to abandon tapestry for sculpture in wood and terracotta (1900). The rounded forms which appeared in his paintings were manifested in his sculpture and, having found a style, he varied it little during the rest of his career. He modelled heavy, simplified and serene female figures which stemmed from both Gauguin's work and *Renoir's late nudes. Maillol remarked that after *Rodin there should be a 'return to more stable and self-contained form'. His classical, generalised, smooth-surfaced figures demonstrated an alternative path to Rodin's *Expressionism.

MAINARDI (DI BARTOLA), Sebastiano (end 15th century–c. 1515)

b. S. Gimignano. Domenico *Ghirlandaio's brother-in-law, and his favourite pupil. Ghirlandaio's influence is clearly felt in his Baroncelli Chapel fresco *St Thomas receiving the Virgin's Girdle* (Sta Croce).

MAISTRE, Roy de (1894–)

b. Bowral, New South Wales d. London. Australian artist who studied both painting and music and evolved, after paintings influenced by *Cubism, a theory of colour related to music. His work is *painterly, and constructed as a correlative of arrested phrases taken from various pieces of music.

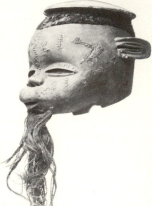

Above left: ROY DE MAISTRE *Vegetable Still-life*. 1956. 31×24 in (78·7×61 cm). Tate
Above right: MAKONDE Mask worn at initiation and other ceremonies. Wood. h. 8¼ in (21 cm). BM, London

MAITRAKAS *see* GUPTA CONTEMPORARY MINOR DYNASTIES

MAKARA

Sanskrit: aquatic monster sometimes identified with the crocodile; popular Hindu decorative motif both as personal and architectural adornment. Cognisance of river goddess, Ganga (Ganges).

MAKONDE

A group of tribes in southern Tanzania and northern Mozambique. They are perhaps the most accomplished carvers of East and South Africa. Their masks and figures can display a high degree of naturalism and of grotesque caricature.

MALANGGAN *see* NEW IRELAND

MALBONE, Edward Greene (1777–1807)

b. Newport, Rhode Island d. Savannah, Georgia. Painter who worked first in Boston, then in New York and Philadelphia, settling in Charleston (c. 1801); was close friend of *Allston, with whom he visited London (1801). America's outstanding

miniaturist, Malbone painted portraits in the *Neo-classical style with delicacy and precision.

MALEKULA see NEW HEBRIDES

MALERISCH see PAINTERLY

MALEVICH, Kasimir (1878–1935)

b. Kiev d. Leningrad. Russian painter who studied at Kiev, moved to Moscow and worked in an †Impressionist style influenced by *Borissov-Mussatov (1905). Developed figure compositions derived from *Cézanne. During his association with the group who showed at the 'Knave of Diamonds' exhibitions (1910–16), his painting became more abstract, revealing influences from the *Futurists and *Picasso's late *Cubist works. Founded *Suprematism (1915). His Suprematist works consist of clearly defined geometric forms, painted in black and white, or pure even colours, grouped to evoke an effect of dynamic movement in an infinite space. He announced that Suprematism was at an end (1919) and, retaining an essentially mystical view of the world, rejected the utilitarian aesthetic of *Constructivism. Wrote and lectured extensively on art and aesthetics and produced idealised architectural drawings and sculptures, but reverted, in his last years, to painting portraits of his family.

Right: JEAN MALOUEL or HENRI BELLECHOSE *The Martyrdom of St Denis.* 1416. 63⅞×82⅝ in (161×210 cm). Louvre
Below: KASIMIR MALEVICH *Suprematist Composition: Black Square and Red Square.* 1914–15. 28×18½ in (71·1×44·4 cm). MOMA, New York
Bottom left: KASIMIR MALEVICH *Suprematist Composition.* c. 1915. 23×19 in (58·4×48·3 cm). MOMA, New York
Bottom right: MALWA PAINTING *Preparation and Perfuming of Sherbat.* From the Mandu Nimat Nama, c. 1500–10. India Office Library, London

MALINKE see BAMBARA

MALMESBURY ABBEY, Wiltshire

The south porch to this former abbey church (dating c. 1160–70) is remarkable among English †Romanesque sculp-

tures for its expressiveness and elaborate iconography. The Christ in Majesty on the *tympanum of the inner arch is flanked by two lunettes with Apostles and angels on the side walls. The outer arch is of eight orders without capitals containing foliage and related scenes from the Old and New Testaments and Virtues and Vices. The designers drew heavily upon *Anglo-Saxon models for their ideas, but the arrangement and certain details owe something to western French examples.

MALOUEL, Jean (d. 1419)

Flemish painter, trained in Paris, he was employed by the Duc de Berry (by 1397). He seems to have been related to the *Limbourg brothers, and was also closely associated with Henri *Bellechose, who succeeded him as the Duke's painter (1415). No works by him have been identified for certain; but either he or Bellechose seems to have been responsible for a round *Pietà* (Louvre) and the *Martyrdom of St Denis.* His other activities included the painting of stone statues, eg *Sluter's figures for the Calvary at Champmol.

MAL'TA (c. 12,750 BC)

Site in Siberia in the Angara basin, west of Lake Baikal comprising a complex of dwellings and burials. Finds include female figurines in bone and two bone birds.

MALVASIA, Count Carlo Cesare

b. d. Bologna. Seventeenth-century Italian art historian. He published *Felsina Pittrice* (1678), biographies of Bolognese artists; and *Le Pitture di Bologna* (1686), a catalogue of ancient and modern pictures in Bologna.

MALWA PAINTING

The kingdom of Malwa in Central India acted as a meeting-point for several styles of painting which blended and resulted in an original style. In the 15th century painting continued in the *Jain tradition with similar subject-matter. After the Muslim conquest, Persian influences affected the style. The early 16th-century *Nimat-nama* ('Book of Delicacies') is a mixture of Persian (*Shiraz) and Indian styles; the former is seen in the softened contours, the dress of some figures and the decorative, symmetrical flowered background. The female figures are reminiscent of the *Vijayanagara style. A third strand emerges under the Pathans with paintings depicting the *Chaurapanchasika,* a love-poem, influenced greatly by the Jaunpur style. The last strand reflects the influence of Ahmadnagar (*Deccan painting: Muslim); the colours are softened and female figures are very elongated and slim. *See also* MUGHAL PAINTING, PRE-

MAMA see NIGERIA, NORTHERN

MAMALLAPURAM *see* **PALLAVA DYNASTY**

MAMBUNDA *see* **BAROTSE**

MAMLUK PAINTING (from mid 13th century)

Primarily based on the Baghdad and Mosul workshops, this abstract style of Islamic painting current in Egypt and Syria was also influenced by the developments in the *Persian Schools. Movement is arrested; emotions indicated in the same manner by the placing of hands, etc. No real attempt is made at distinct facial characterisation, the three-quarter profile being generally used with square jaws, thick short necks, small mouths and stylised eyes and nose forms. No modelling technique except on animal forms is apparent; drapery folds are represented unrealistically as ornamental designs. The formal, regal aspects of *Saljuq painting are incorporated with many inconographic details giving the works an abstract quality. The overall monochrome background colour is usually gold.

MAMLUK PAINTING
Frontispiece from a copy of Hariri's *Makamet*. 1334.
7⅝×6⅞ in (19·2×17·5 cm).
National Library, Vienna

MANABI *see* **MANTENO**

MANAIA MOTIF *see* **NEW ZEALAND**

MANDAGAPATTU *see* **PALLAVA DYNASTY**

MANDALA

Sanskrit: literally 'disk' or 'circle'; any bound group of entities. In the religious field, a diagrammatic representation of the cosmos or an aspect of it. The abstract design is a precisely structured means through which the mind may be focused upon a supramundane aspect of reality; the diagram is thus also termed *yantra* (Sanskrit: meaning 'that which grips' the concentration, or 'an instrument' to deeper understanding). The layout of a mandala is often compared to a lotus, its segments being termed petals and so forth. In appearance the diagram may be a purely abstract design of overlapping triangles within concentric circles mounted upon a four-doored plinth and inscribed with sacred syllables or formulae. The relationship between such drawings and architectural form belonging to all the major Eastern religions is clear in the plans of many temples, eg the great *stūpa of *Borobudur in Java, and in the structure of some sculptural myth-tableaux. Peopled mandalas containing the figures of *Buddha, *Bodhisattvas and other deities are found in much Eastern art, eg *Tibet and *Nepal.

MANDER, Karel van (1548–1606)

b. Courtrai d. Amsterdam. Religious and allegorical Dutch painter best known for his *Het Schilderboek* ('The Painter's Book', 1604) that is both biographical and didactic, and has earned him the name of the 'Dutch *Vasari'. He founded an academy in Haarlem with *Goltzius (1580s).

MANDIJN, Jan *see* **MANDYN**

MANDORLA

An almond-shaped frame for the figure of Christ, in a glow of heavenly light, signifying his divinity. Thought to stem from the Roman practice of placing a portrait bust with a circle representing a shield or medallion. First seen in †Early Christian art, the mandorla became less popular by the 15th century and was abandoned by †Renaissance painters.

MANDYN (MANDIJN), Jan (1502–c. 1560)

b. Haarlem d. Antwerp. Flemish painter, a follower of *Bosch in his use of small figures set in landscapes peopled with fantastic creatures. Attributions are based round the initialled *Temptation of St Anthony* (1547, Haarlem).

MANESSIER, Alfred (1911–)

b. Saint-Ouen. French painter and designer of cartoons for stained-glass windows and Aubusson and Gobelins tapestries. Notable chiefly for his new approach to religious subjects, his work stands on the border-line between the abstract and the figurative and depends for its impact on powerful colour and design.

MANET, Edouard (1832–83)

b. d. Paris. Pupil of *Couture (1850–6), but trained himself through the study of Old Masters and by foreign travel. The *Guitarist* (1861) was his first success at the Salon where he continued to seek acceptance throughout his life. The scandal of *Déjeuner sur l'herbe* at the Salon des Refusés (1863) continued with *Olympia*. Based on †Renaissance compositions, their intensity results from the strong contrasts of colours, the

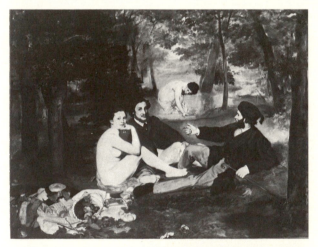

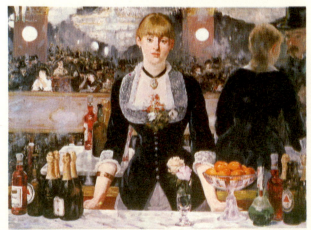

Top: EDOUARD MANET *Déjeuner sur l'herbe*. 1863. 84½×106¼ in (215×270 cm). Louvre
Above: EDOUARD MANET *Le Bar aux Folies-Bergères*. 1881. 37⅞×51¼ in (96×130 cm). Courtauld Institute Galleries

flattening of forms, and his use of black. He went to Spain (1865), whose 17th-century masters, *Velasquez, *Zurbarán and *Murillo, were already a strong influence both stylistically and in subject-matter, although from this time his interest changed to contemporary Parisian scenes. He frequented the Café Guerbois and met regularly the founders of †Impressionism: *Monet, *Cézanne, *Pissarro, *Renoir, *Sisley and *Morisot. A close friend of *Baudelaire until the poet's death in 1867, he was also supported by Zola, Mallarmé and others. After 1870 he painted *plein-air landscapes and adopted a more Impressionist technique and palette, but never exhibited with them. Suffering from illness, he found it easier to work in pastels on portrait studies towards the end of his life.

MANFREDI, Bartolommeo (1580–1620)

b. Ustiano, nr Mantua d. Rome. Italian painter who worked in the style of *Caravaggio. His pictures of such subjects as soldiers in guardrooms influenced many Northern artists, particularly members of the *Utrecht School. His works were very popular with collectors and were exported abroad, thus being a major source for the dissemination of the Caravaggesque style.

MANGAREVA see TUAMOTU ISLANDS

MANGBETU see AZANDE

MANGUIN, Henri-Charles (1874–1949)

b. Paris d. Saint-Tropez. French painter and pupil with *Matisse of Gustave *Moreau. First exhibited at the Salon des Indépendants (1902) and later at the Salon d'Automne. He painted nudes, Mediterranean landscapes and still-lifes using *Fauve colours, but was always structural in his interpretation of *Cézanne.

MANIERA see MANNERISM

Left: MANSUR Pied Crows. Freer Gallery of Art, Washington
Below left: ANDREA MANTEGNA The Triumph of Caesar (detail of the Trophy Bearers). c. 1490. 107×112 in (271×284 cm). Hampton Court Palace
Below right: ANDREA MANTEGNA Ludovico Gonzaga receiving the Messenger announcing the return of Federigo Gonzaga from exile (detail). 1472–4. Fresco. Camera degli sposi, Ducal Palace, Mantua

MANNERISM

A term coined in recent times, and based upon the Italian maniera, ie the manner of the artist's skill, to describe a stylistic change that occurred in Renaissance art from c. 1516. By the end of the 16th century it had spread throughout western Europe. Its modish, artful interpretations of classical devices were often fantastic. In Italy there was a deliberate flouting of the laws of classical art, elsewhere an ignorance of those laws led to a reckless grafting of Roman motifs on to an alien stock. See also essay THE ITALIAN RENAISSANCE

MANNOZZI, Giovanni see GIOVANNI DA SAN GIOVANNI

MANSHIP, Paul (1885–1966)

b. St Paul, Minnesota. Sculptor who studied in St Paul, at Pennsylvania Academy and with S. Borglum and Konti; worked in Rome (c. 1909–12), and from 1924 in Paris, Rome and New York. Essentially eclectic, Manship combined the subjects and style of archaic art with modern abstraction to create gracefully stylised, refined works.

MANSUETI, Giovanni (active 1485–d. 1526/7)

Venetian painter, influenced by *Cima and *Carpaccio. Of his life little is known except that he was lame, a friend of Lazzaro *Bastiani and a pupil of Giovanni *Bellini. A believer in the Miracle of the Cross, his painting (1474) of this subject is in the Accademia, Venice. His style is somewhat rigid.

MANSUR

Mughal miniaturist of the reign of *Jahangir (and previously an artist of the atelier of *Akbar) who specialised in sympathetic and finely detailed studies of birds, mammals, sometimes also flowers.

MANTEGAZZA, Cristoforo (d. 1482)
Antonio (d. 1495)

Cristoforo b. Milan. Italian sculptors, brothers. Cristoforo's first known commissions were for the Certosa at Pavia (1464–6); he was in Milan working for the Sforzas (1467). He returned with Antonio to Pavia to construct the Certosa façade. He continued working there until his death, as did Antonio until 1489. The brothers' styles can hardly be differentiated; both have a frenetic angularity.

MANTEGNA, Andrea (c. 1428–1506)

b. Padua d. Mantua. Paduan painter, adopted and trained by *Squarcione whose collection of antiquities stimulated his awareness of classical art; also influenced by *Donatello, *Castagno and, briefly, by his brother-in-law Giovanni

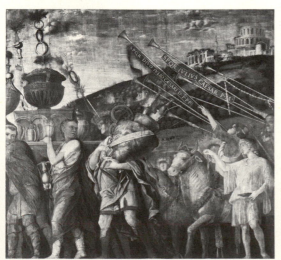

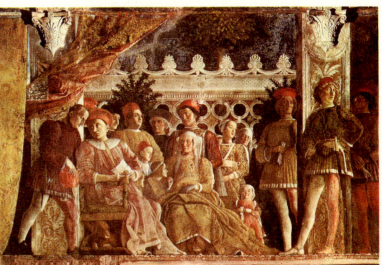

*Bellini. His precocity in the expressive use of perspective, the learned application of Roman motifs and sculptural realism of his forms visible in his first major work, the frescoes in the Eremitani Church (1448–56), instantly established a characteristically †Renaissance style in north-eastern Italy. The rest of his life was spent in elaborating these qualities: most notably in the S. Zeno altarpiece (1456–9, Verona) and in the works carried out for the Mantuan court, where he lived from 1459 and was revered by three generations of Gonzagas. The frescoes in the Camera degli Sposi (c. 1472–4) evince his abilities as both decorator and portraïtist. The ceiling contains a *trompe l'œil opening with heads looking down at us; a witty device and the first use of *sotto in sù in the Renaissance. The apogee of his spirited re-creations of the ancient world occurs in the *Triumph of Caesar* (Hampton Court), praised in 1492 as 'living and breathing images'.

MANTENO

A culture from the Manabi area of Ecuador (c. AD 500–1550), noted for stone sculpture, particularly slabs carved in low relief with birds, animals and human figures, monolithic U-shaped seats supported by the crouching figure of a man or a jaguar, and free-standing human and animal figures. Manteño art also includes monochrome pottery decorated with incised geometric and bird motifs, and gold and silver jewellery.

MANUEL DEUTSCH, Niklaus see DEUTSCH

MANUSCRIPTS, Byzantine

Fewer types of book were illustrated in Byzantium than in the medieval West. The medium was expensive and the main patrons were emperors and the higher civil servants and ecclesiastics. Manuscripts consequently demonstrate the most refined painting of Constantinople and the taste of the educated aristocracy; but some provincial monasteries must have had scriptoria. The main survivals are narrative books of the Bible, eg octateuchs and Gospels, and collections of sermons, which often had pictures for didactic purposes, and Psalters, lectionaries and menologia, whose pictures must have helped meditations on the readings for the Church year. Psalters usually featured the life of the author, David, as in the *Paris Psalter (Bib. Nat., gr. 139), but sometimes add ideas for private reflection, as in the *Chludov Psalter. A major period of production was after *Iconoclasm; the large, luxury books of the 9th and 10th centuries, eg the Paris Psalter, were constantly reused as models, especially in the 13th-century revival of art in Constantinople after the Latin occupation.

MANUSCRIPTS, Early Christian

The papyrus roll of antiquity was not a durable medium for painting, and the most likely books to receive illustration were scientific treatises needing explanatory diagrams. The revolution in book manufacture came when the parchment codex was invented (c. AD 100). Early Christian books took this form, but the earliest illustrated survival, the early 5th-century Quedlinburg Itala fragment, has rudimentary pictures with stock figure-types. The 6th- or 7th-century Purple Codices partly copy lost models, which indicate a period of variety and competence in illumination, and partly invent new formats, eg prophets pointing to New Testament scenes, as in the *Rossano Gospels. Early Christian manuscripts were copied and their schemes sometimes expanded by †Carolingian and †Byzantine illuminators.

MANUSCRIPTS, Medieval

Apart from Italy, where wall- and panel-painting flourished from the mid 13th century onwards, illustrations in manuscripts are the major surviving record of western medieval painting. Pages exclusively for illustrations, often relating to remaining large-scale works, prefaced Bibles, Psalters and other texts. During the earlier Middle Ages manuscripts were usually written in and for monasteries and cathedrals, kept in their libraries and copied frequently. From the mid 13th cen-

tury onwards, professional illuminators, working for noble and royal patrons, predominated. Books became private luxury objects of tiny scale, with elaborate decoration of text pages in capital letters, margins and line ends. Burnished gold, strong colours, luxuriant foliage and humorous *grotesques met the requirements of late medieval lay patronage.

MANZU, Giacomo (1908–)

Italian sculptor, the son of a sacristan, and the eleventh of twelve sons. He early showed exceptional talent, and was apprenticed to a woodcarver (1919–20), a gilder (1921) and a stucco worker. Thereafter he began to draw, paint and sculpt on his own, his first one-man show being held in Milan in 1932. Manzù's birthright to great Italian figure sculpture was reinforced by contact, through *Maillol, with the reinvigoration of this tradition begun by *Rodin. Somewhat isolated from modern movements, Manzù's figures of dancers and cardinals use a traditional language with confidence and originality.

MANZUOLI, Tommaso see MASO DA SAN FRIANO

MAORI ART see NEW ZEALAND

MAQAMAT AL-HARIRI

The *Assemblies* of al-Hariri was written by al-Hariri of Basra at the beginning of the 12th century, a narrative of some fifty adventures of the lovable rogue, Abu Zaid. Immensely popular, the story gave Islamic artists the opportunity to depict genre scenes. The most famous of the several surviving Maqamat manuscripts (Bib. Nat., 1237) is a realistic picture of 13th-century Arab life, illustrated by the Wasit artist, Yahya. Unframed, the paintings are elaborately composed on more than one plane, full of humorous detail but with stereotyped faces, expression being conveyed by head, hand and body positions. Constrastingly the Bodleian Library 14th-century copy produced in Egypt uses single-plane compositions with tall figures placed in narrow horizontal areas against ornamental and abstracted settings.

MAQUETTE

A sketch or model broadly defining the composition of a large-scale work. Particularly used to describe a sculptor's model, sometimes including a suggestion of the proposed site of the work.

MARAGHA MANUSCRIPT (1294–99)

Manafi al-Hayawan ('The Usefulness of Animals'). Consisting of ninety-four miniatures, the work of several artists, this is one of the earliest known manuscripts from Mongol Persia. It shows a transition from the earlier Baghdad and *Saljuq Schools, although continuing the single-plane composition, the palette and the unnaturalistic treatment of animal forms. Chinese *Sung and *Yüan influence is apparent both in the use of conventions and subject-matter. Delineating the painting area by a frame is an innovation and some miniatures illustrate Indian dress and ornaments obviously influenced by Buddhist Il-Khanids.

MARAJO ISLAND see MARAJOARA

MARAJOARA

Brazilian culture (c. AD 600–1300) centred on Marajó island in the Amazon estuary. Noted for painted burial-urns decorated with intricate excised and incised scroll designs in red, black and white, and triangular painted pottery pubic coverings, called *tangas*.

MARATTA (MARATTI) Carlo (c. 1625–1713)

b. The Marches d. Rome. Italian *history painter, the pupil of *Sacchi (1636–47). He had an international reputation stimulated by the praise of *Bellori for whom his art signified the triumph of classicism over †Baroque. Actually, Maratta's style was more a compromise between the clarity of Sacchi and

Baroque rhetoric, by which means he created a *Grand Manner. Although an accomplished rather than a great painter, his portraits are very penetrating. His Madonnas were much copied. He had a large studio and his late works are largely executed by his pupils who perpetuated his style after his death.

Below: MAQAMAT AL-HARIRI *Abu Zayid helping al-Harith to retrieve his Stolen Camel* 1337. $5\frac{1}{4} \times 6\frac{3}{4}$ in (13·5×17 cm). Bodleian Library, Oxford
Bottom: MARAGHA MANUSCRIPT *The Phoenix* by Abu Sa'id Ubaud Alla ibn Bakhtishu. *c.* 1294–9. $13\frac{1}{2} \times 9\frac{3}{4}$ in (33·5×24·5 cm). Pierpont Morgan Library, New York

Left: GIACOMO MANZU *Cardinal.* 1947–8. Bronze. $19\frac{3}{4} \times 11\frac{1}{2} \times 10\frac{3}{4}$ in (50·2×29·2×27·3 cm). Tate
Below: MARCUS AURELIUS, Equestrian Statue of. Piazza Campidoglio, Rome
Centre right: MARI Wall-painting from the Palace of Zirim-Lim. *c.* 2040–1870 BC. Paint on plaster. h. 5 ft 7 in (1·7 m). Louvre
Bottom right: MARINE STYLE Octopus vase. *c.* 1500 BC. h. $11\frac{1}{4}$ in (28 cm). Heraklion Museum, Crete

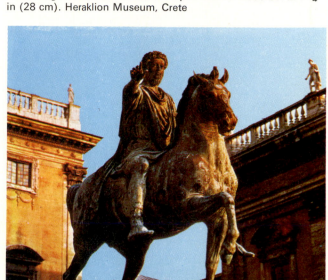

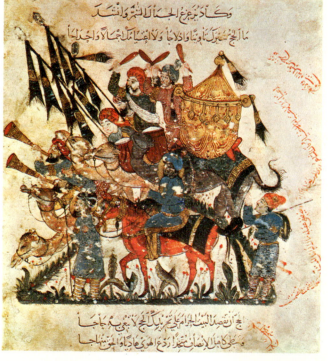

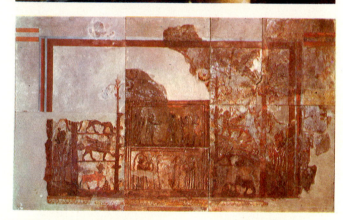

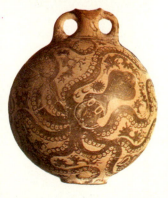

Left: JOHN MARIN *Maine Islands.* 1922. $16\frac{3}{4} \times 20$ in (42·5×50·8 cm). Phillips Collection, Washington D.C.

MARBLE

A hard, fine-grained crystalline limestone, very often figured and veined by coloured mineral deposits. Marble from the *Cyclades was used for early Greek sculptures of the 7th century BC. An early source was Naxos, but by the 5th century BC the hard, pure white, semi-transparent Parian marble was preferred, especially for sculpture. Another type popular during the 5th and 4th centuries BC was a fine, yellowish-white marble from Mount Pentelikos in Attica. In Roman times a variety of coloured marbles was used, especially for inlay work. Common types include: *cipollino*, a streaked greenish/grey marble from Karystos; a grey or blue/grey streaked marble from Mount Hymettos; dark red or dark green spotted marble from Chios; *rosso antico* or dark red marble from Laconia; and Numidian marble, yellow, sometimes with red veining. Italy's most famous marble, Carrara was used for many Renaissance sculptures. Other countries which possess marble suitable for carving are France (Languedoc, Griotte, Sarrancolin), Belgium (Rance, Belgian black), England (Sussex marble) and the United States (Vermont and Georgia white, Alabama cream, Tennessee pink and Rockingham Royal black).

MARC, Franz (1880–1916)

b. Ried d. Verdun. German painter, and founder-member of der *Blaue Reiter. After a late start, achieved an individual style (1911). Strongly influenced by *Delaunay and the *Futurists (1912–13). By fragmenting the normal appearance of things into a mass of dynamic shapes and expressive colours, Marc sought to suggest the unity of all things at a deeper, more spiritual level of reality. He believed animals to be the most potent symbols of cosmic unity, and is chiefly famous for his animal paintings. Killed in battle.

FRANZ MARC *The Fate of Animals*. 1913. 76¾×105½ in (195×263·5 cm). Kunstmuseum, Basle

MARCHAND, André (1905–)

b. Aix-en-Provence. French painter, book-illustrator and designer of stage-sets and tapestry cartoons, who studied in Paris. A widely travelled and successful artist, his early *Surrealist-flavoured paintings have moved closer to abstraction and are characterised by brilliant colour and a peculiar static quality.

MARCILLAT, Guglielmo di Pietro de (d. 1529)

b. Allier, nr Marcillat d. Arezzo. French painter and glass painter. Early in his career was involved in a murder and fled with his master, a glass painter called Claude, to Italy. Upon the latter's death, Marcillat finished the commissions for painted glass in the Vatican. He was later in demand at Cortona and Arezzo where he frescoed much of the vault of the cathedral in a rather *Michelangelesque style. Important in that he founded a school of glass painters who followed his monumental figure style and made it more overtly Italianate, although they seldom achieved his warm, gay tones and clarity of composition.

MARCKS, Gerhard (1889–)

b. Berlin. German sculptor who taught at the State School of Arts and Crafts, Berlin (1918), in contact with the *Bauhaus ceramic workshop (1919–24). After European travels, has lived in Germany since 1933, visiting the USA during the 1950s and Africa (1955). His serene and polished archaism is related to the figure sculpture of *Lehmbruck.

MARCOUSSIS, Louis (Lodwicz MARKOUS) (1878–1941)

b. Warsaw. Polish painter who attended the Cracow Academy and the Académie Julian, Paris. He began as a caricaturist and portrait painter. His early †Impressionistic style was abandoned after his introduction to *Picasso (1910), who continued to be a strong influence, declined, and he took to etching (1930s). A friend of *Apollinaire's, he illustrated *Alcools* (1933). Marcoussis produced a loose, non-analytic version of Cubism, often working in a flat, decorative, two-dimensional style.

MARCUS AURELIUS, Column of (AD 193)

Column erected in the Campus Martius in honour of Marcus Aurelius after his victorious German wars. It is similar to Trajan's Column, *Rome, although it is rather squatter and the sculptures are in much higher relief. The emphasis is more on individual figures than in Trajan's Column, and much attention is focused on the tragedy of war.

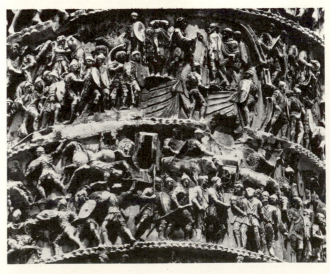

Top: LOUIS MARCOUSSIS *Still-life with a Jug*. 1925. Musée d'Art et d'Industrie St Étienne
Above: MARCUS AURELIUS, Column of. Detail of relief. Piazza Colonna, Rome

MARCUS AURELIUS, Equestrian Statue of
(AD 164/66)

Gilt-bronze equestrian statue of Marcus Aurelius (reigned AD 161–80) in the Capitoline Square, Rome. The Emperor is shown with his left hand raised, about to address the people. The left foot of his horse, also raised, originally rested on the head of a conquered warrior. Although the actual casting is not good the statue represents a rare survival of an Imperial bronze.

MAREES, Hans von (1837–87)

b. Elberfeld d. Rome. German portraitist and history-painter. Although trained in Berlin and Munich, like *Böcklin and *Feuerbach, he drew his inspiration from long residence in Italy, from his first visit (1864). He sought to capture the poetics of classical figures in a landscape, rarely giving narrative references, and seldom painted from nature. *See also* FIEDLER

Left: HANS VON MAREES *In the Loggia.* 1873. 29×24⅞ in (73·5×63 cm). Von der Heydt Museum, Wuppertal
Right: MARINO MARINI *Miracolo.* 1959–60. Bronze. 68½×96½×49¼ in (174×245×125 cm). Kunsthaus, Zürich
Below right: MARINUS VAN REYMERSWAELE *Two Tax Gatherers.* c. 1530. 36¼×29¼ in (92·5×74·5 cm). NG, London

MARI

The *Investiture of Zimri-Lim*, king of Mari on the Euphrates (c. 1770 BC), originally adorned the courtyard façade of the Palace throne room. It consists of a central panel divided into two registers. In the upper register the king is presented to a goddess, identified as Ishtar by the lion at her feet, who extends to him the ring and staff of power. Beneath, two deities holding flowing vases typify the fertility brought by the river, while on either side is a pair of stylised palm trees flanked by protective winged sphinxes, and an outer pair of naturalistic palms; attendant deities complete the composition. The combination of a typically Mesopotamian confrontation scene between king and deity with an extensive use of natural motifs has suggested Levantine influence, especially by comparison with the frescoes of the Palace at *Knossos. This is certainly the greatest example of Mesopotamian painting.

MARIETTE, Pierre-Jean (1694–1774)

b. d. Paris. French art historian, dealer and collector. He is most famous for his *Réflexions sur la manière de dessiner des principaux peintres* (1714), an early attempt at examining critically the graphic styles of individual artists.

MARIN, John (1870–1953)

b. Rutherford, New Jersey d. Cape Split, Maine. Painter who studied at Pennsylvania Academy and *Art Students' League; worked in Paris (1905–10); returned to New York (1910); exhibited at *Armory Show (1913) and with *Stieglitz. Cosmopolitan yet authentically American, Marin was a totally independent individual. A major watercolourist, he painted the Maine landscape and New York cityscape in a terse, explosive language of charged brushstrokes, potent colour and flashing spaces, recording not the subject but his immediate emotional response to it.

MARIND-ANIM *see* NEW GUINEA, SOUTH-WEST

MARINE STYLE

A style of vase painting current in Crete about 1500/1450 BC. Ornaments include stylised shells, starfish, seaweed and octopus with long tentacles and staring eyes. *See also* MINOAN ART

MARINETTI, Emilio Filippo Tommaso (1876–1944)

b. Alexandria. Italian poet and writer who achieved his first literary success with his book *La Conquête des Etoiles* (1902) and became editor of the magazine *Poesia* (1905). His enthusiasm for modern life, stimulated by French writers like Gustav Kahn and Paul Adam, led to the foundation of *Futurism, the first Manifesto of which he published in *Le Figaro* (February 1909). He subsequently became associated with *Boccioni, *Carrà, *Russolo, *Balla and *Severini, the group of artists who formed the nucleus of the movement, acting as central focus, sponsor and propagandist. His experiments with words freed from grammar and syntax affected those Futurist painters who used words in their work (eg Carrà and Severini).

MARINI, Marino (1901–)

b. Pistoia. Italian sculptor, painter and graphic artist who studied at the Florence Academy and has taught at the Brera Academy since 1940. Marini's subject-matter is limited; jugglers, dancers, nudes, portraits and his more widely known horsemen. He combines an impression of weight and balance with great tension created by the dynamic opposition of vertical and horizontal or diagonal masses.

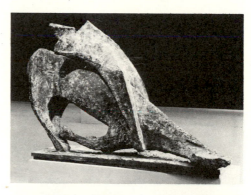

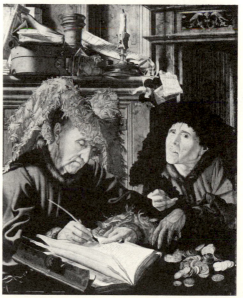

MARINUS VAN REYMERSWAELE (Marrinus Claesz van REYMERSWAELE, Marinus Claesz van ROYMERSWAELE) (c. 1497–after 1567)

b. Zeeland. Netherlandish *Mannerist painter, who was exiled for image-breaking (1567). He painted religious subjects, often St Jerome (earliest version 1521, Prado) and moralistic genre scenes (eg *Two Tax-Gatherers*, c. 1530, NG, London, possibly derived from a lost van *Eyck). The grotesque heads of his half-length figures show the influence of Quentin *Metsys, whose work he sometimes copied.

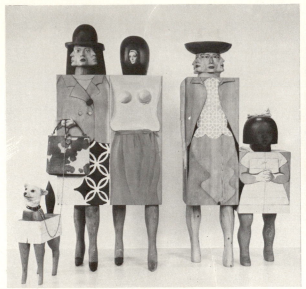

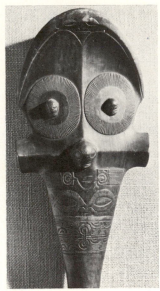

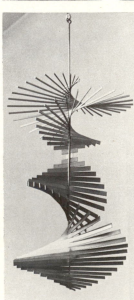

Top left: MARISOL *Women and Dog.* 1964. Mixed media. 72×82×16 in (182·9×208·3×40·6 cm). Whitney Museum of American Art, New York

Top centre: MARQUESAS ISLANDS Head of a club. Early 19th century. Wood. h. 54 in (137 cm). City of Liverpool Museums

Top right: REGINALD MARSH *Bowery and Pell Street – Looking North.* 1944. William Benton Coll, New York

Above left: SIMON MARMION *Soul of St Bertin being carried up to God* from the St Olmer Altarpiece. NG, London

Above centre: JOHN MARTIN *The Bard* 84×61 in (213·4×154·8 cm). Newcastle

Above right: SIMONE MARTINI *Annunciation.* 1333. 104⅛×120⅛ in (265×305 cm). Uffizi

Left: KENNETH MARTIN *Screw Mobile.* Sheldon Williams Coll, London

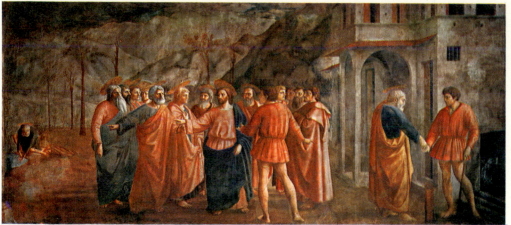

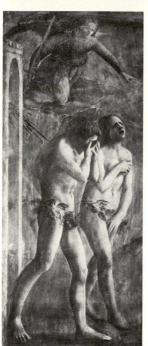

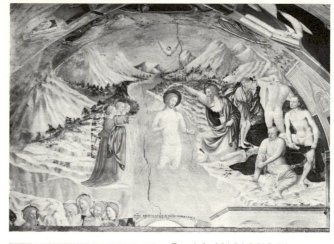

Top left: MASACCIO *The Tribute Money. c.* 1427. Fresco. Brancacci Chapel, Sta Maria del Carmine, Florence
Top right: BERNARDO MARTORELL *St George and the Dragon.* Before 1430. 56×38 in (142·2× 96·5 cm). Art Institute of Chicago
Above left: MASACCIO *Expulsion of Adam and Eve.* c. 1426. Fresco. 81×35 in (205×88 cm). Brancacci Chapel, Sta Maria del Carmine, Florence
Second row centre: MARY MARTIN *Compound Rhythms.* 1966. Painted wood and stainless steel. 42½×42½×42½ in (108× 108×108 cm). Peter Stuyvesant Foundation Coll
Above right: MASOLINO *Baptism of Christ.* 1435. Fresco from the Castiglione d'Olona, Como
Above centre: MAS D'AZIL Carved deer on the end of a spear thrower made of reindeer horn

Above: MASANOBU (Kanō) *Crane.* 16th century. Shinjuan
Right: MASANOBU (Okamura) *Oiran and Kamuro.* Hand-coloured sumi-e. 29⅛×10⅛ in (74·6×25·7 cm). Art Institute of Chicago, Buckingham Coll

Opposite page left: SIMONE MARTINI *St Louis of Toulouse crowning Robert of Anjou.* From the St Louis of Toulouse Altar. c. 1317. Gall Naz, Naples

MARIS Brothers

Three Dutch artists all born at The Hague (*Hague School). Jacob Henricus (1837–99) studied under van Hove and his Dutch landscapes and rustic scenes were influenced by *Corot and the *Barbizon School (1860s). Matthijs (1839–1917) was also in Paris (1860s) and then went to London where English art influenced his figure style. Willem (1844–1916) remained mostly in Holland. All three painted evocative, softly lit landscapes.

MARISOL (Marisol ESCOBAR) (1930–)

b. Paris. Sculptor who studied at Ecole des Beaux-Arts and Académie Julian, Paris, Hans *Hofmann School and *Art Students' League; settled in New York (1950); worked in Rome (1958–60). Her *Pop Art figures, assembled from wood, real objects, drawings and photographs, are charged with satirical wit, commenting ambiguously on American society.

MARKA see BAMBARA

MARKOUS, Lodwicz see MARCOUSSIS, Louis

MARLOW, William (1740–1813)

b. London d. Twickenham. English painter, who wandered through England and Wales (1762–5), then Italy and France (1765–8). He produced French and Italian views till he retired (c. 1785), paintings of country-houses (eg Castle Howard, 1772) and *capricci, notably *St Paul's Cathedral with a Venetian Canal* (Tate).

MARMION, Simon (d. 1489)

Miniaturist and painter who worked at Amiens (1449–54), then at Valenciennes (1458). A member of the Tournai Guild (1468). No strictly documented works survive, but attributions show a colourful style and even on panel a minute scale with many figures.

MAROUFLAGE

The process of sticking a canvas to a board or wall by means of an oil adhesive – usually white lead in *linseed oil.

MARQUESAS ISLANDS

The art style of this *Polynesian island group is characteristically one of surface adornment, although figures were produced of wood and stone, ranging in height from a few inches to many feet. Tattooing was more elaborate than in the rest of Polynesia, and a renowned warrior might be decorated from scalp to toes. The human figure (*tiki*) with conventional large; round eyes, broad nose with flaring nostrils, and wide oval mouth is a recurring theme in the decoration of war-clubs, paddles, bowls, stilt-steps, ivory fan-handles, ear ornaments, stone *poi*-pounders and shell plaques on woven headbands.

MARQUET, Pierre-Albert (1875–1947)

b. Bordeaux d. Paris. French painter who studied with *Matisse in the studio of *Moreau. Although he participated in the *Fauvist movement, he turned away from the use of pure colour towards a more linear, restrained style inspired by the Japonism of late *Monet.

MARSH, Reginald (1898–1954)

Painter who went to America as a child with his artist parents (1900); studied at *Art Students' League with *Sloan, *Luks and *Miller; visited Paris (1925, 1928) where he copied *Rubens at the Louvre. Marsh loved New York's common people, painting them with a gritty realism in the tradition of *Daumier and *Rowlandson. Later he developed a baroque complexity that exceeded his formal powers.

MARSHALL, Benjamin (1767–1835)

b. Leicestershire d. Newmarket. English sporting artist who from the late 1790s contributed illustrations and articles to the *Sporting Magazine*. He lived at Newmarket (from 1812) and there painted many of the period's famous horses, together with hunting scenes, horseraces and the occasional portrait.

MARTANDA see KASHMIR

MARTIN, Elias (1739–1818)

b. d. Stockholm. Swedish painter who worked in London (after 1768) on portraits, landscapes and topographical views (eg Westminster Bridge, Hanover Square). Returning finally to Sweden (1790), he became Court Painter, and published (with his brother) a series of views of Stockholm.

MARTIN, Fletcher (1904–)

b. Palisades, Colorado. Self-taught painter and printmaker whose realistic paintings, socially conscious in the 1930s, show a continuing stylistic inclination towards formalising and abstracting the subject.

MARTIN, Homer Dodge (1836–97)

b. Albany, New York d. St Paul, Minnesota. Landscape painter who lived in New York (1862–93), visiting England and France often; painted in Normandy and Brittany (c. 1881–6). Influenced by *Constable, then *Corot and †Impressionism, Martin abandoned his sombre *Hudson River romanticism for a delicately pensive, poetic, atmospheric Impressionism, unseen before in America.

MARTIN, John (1789–1854)

b. Haydon Bridge, Northumberland d. Douglas, Isle of Man. The most dramatically conscious of the English †Romantics, Martin's obsession with spatial infinity and satanic heroism gave him a European reputation which was hardly justified by the rather sickly surface of his canvases. Paintings like *The Celestial City and Rivers of Bliss* (1841) induced Heine to compare him with Berlioz in his striving for 'physical immensity'.

MARTIN, Kenneth (1905–)

b. Sheffield. English artist whose first abstract paintings date from the 1940s and, like his present work, are of the constructive type, making no allusion to nature. His interest in structure is expanded in his constructions (from 1951), which utilise materials more fully for their innate properties.

MARTIN, Mary (1907–71)

b. Folkestone, Kent. English painter and sculptress, who studied at Goldsmith's School of Art, London. Painted initially still-lifes and landscapes. First abstract paintings in 1950, after which she turned exclusively to spatial constructions. These are primarily reliefs of elementary, geometric forms, conceived with a serial discipline.

MARTINEZ DE HOYOS, Ricardo (1918–)

b. Mexico City. Self-taught painter who studied law at University of Mexico. His simplified, monumental figures with small, mask-like heads loom in powerful yet elegant arabesques, dark against a light ground in an eerie space; lately his mood and subject have changed, in more poetic landscapes.

MARTINI, Francesco di Giorgio see FRANCESCO DI GIORGIO

MARTINI (MEMMI), Simone (c. 1284–1344)

b. Siena d. Avignon. *Duccio's successor as the leading exponent of *Sienese painting, Simone made his début shortly after Duccio's death with a *Maestà for the Palazzo Pubblico at Siena (1315), which at once established his reputation. Famous in his own time as a colourist, Simone responded to the cultivated atmosphere of the Angevin court at Naples, and it may have been there that he acquired the quality of fastidious

elegance which emerged from time to time in his later work. He seems to have commanded a range of styles rather than to have undergone a stylistic evolution. For his less aristocratic patrons (eg at Pisa and Assisi) his work had many of the qualities of Duccio or his Florentine contemporaries. But the famous equestrian portrait of Guidoriccio da Foligno in the Palazzo Pubblico, Siena (1328) is unique in its combination of heraldic fantasy and spacious landscape – which provided the only model for Ambrogio *Lorenzetti's later landscapes in the same building. It is easy to see why Simone was called to Avignon to serve the Pope (1340); however his only fresco over the Cathedral door now survives only in the form of *sinopie.

MARTORELL, Bernardo (MASTER OF ST GEORGE)
(active 1427–c. 1453)

Most important Catalonian painter of his day, active in Barcelona. Contracts for retables in (1437, Púbol) and in Barcelona Cathedral (1445/52). His basically International Style of rhythmic contours and rich colour developed under Italian influence in naturalism and monumentality, with a concern for perspective.

MARUYAMA SCHOOL

The Japanese Maruyama School was begun by Maruyama *Okyo, and introduced a note of realism into a style derived from the *Kano. Okyo himself had studied under a Kano teacher, but had been much impressed by the realistic paintings of Watanabe *Shikō, some of which he copied. This realism was also tempered by some influence from the West through Nagasaki. Okyo had many pupils and the school was large and influential, but the most famous of his pupils were the ones who broke away from his influence and either started schools of their own (eg the *Shijō, started by *Goshun) or set up as independent painters, as did *Rosetsu and Mori *Sosen. The Kishi School, started by Kishi *Ganku, is one of the most important sub-schools that did not entirely break away (as did the *Shijō), but followed the realism on slightly different lines, using a softness of wash and line that is not usually thought to be typical of the *Maruyama.

MASACCIO (1401–?1428)

b. Panicale d. Rome. Florentine painter whose precocious genius made him the first truly †Renaissance painter. It is now known that he was not *Masolino's pupil, but he must have trained under a †Gothic artist, possibly *Bicci di Lorenzo. He was registered in the Guild (by 1423) and his early Virgin and Child with St Anne (Uffizi) is notable for its austere design. The Virgin and Child (NG, London) from the polyptych for the Carmine, Pisa (1426) shows the impact of his friendship with *Donatello and *Brunelleschi in the remarkable plasticity of the figures and the mastery of space and logical placing of cast shadows. He built up his forms through modulated light and shade rather than defining them by clear lines and this would seem to stem from a fusion of *International Gothic Soft Style and the free *chiaroscuro found in antique frescoes, though it is not known if he visited Rome before embarking on his major work, the frescoes in the Brancacci Chapel (Sta Maria del Carmine, Florence). There he evolved the first dramatically expressive nudes since antiquity (Expulsion). His groups are grave, employing economic but forceful gestures and display an entirely novel naturalism. In the Trinity (1425–8, Sta Maria Novella, Florence) he created for the first time (possibly with the help of Brunelleschi) the illusion of an architectural recess in the wall, while the Virgin's beckoning hand directly involves the spectator in a new way. He went to Rome where he died while engaged on frescoes in S. Clemente (1428).

MASANOBU (Kanō Masanobu) (1434–1530)

Japanese painter, the founder of the *Kano School. He worked for the Shōgun at Kyōto, and was the first lay painter (ie not a Zen monk) to work in the Chinese style. The early characteristics of the Kanō School are evident in his work (absence of

symbolism, firmness of line, etc) while lacking the later decorative element.

MASANOBU (Kitao Masanobu) (1761–1816)

Kyōden, usually known as Kitao Masanobu had been a pupil of *Shigemasa. He published a fine volume of double-sheet pictures of Japanese courtesans (1782–4). In the 1790s he stopped making prints to specialise in writing and in book illustration.

MASANOBU (Okumura Masanobu) (c. 1686–1764)

Japanese printmaker whose long life covers the span of *Ukiyo-e from the black and white line prints in the style of *Moronobu to the elaborate hand-coloured prints and green and red block-printed colours. In each genre he produced excellent work.

MAS D'AZIL (middle Magdalenian)

†Palaeolithic site in Ariège, France, which has yielded a beautiful deer carved out of reindeer horn on the end of a spear-thrower almost identical with one from Bedeilhac, over forty miles away.

MASIP (MACIP), Vicente Juan (Juan de JOANNES)
(c. 1500–79)

d. Bocairente. Spanish painter, a pupil of his father Vicente, but influenced mainly by contemporary Milanese and Florentine work, colouristically as well as compositionally. His work constitutes a happy union of the styles of Netherlandish and Italian *Mannerism.

MASO DA SAN FRIANO (Tommaso MANZUOLI)
(1532–71)

b. d. Florence. Florentine painter who worked under *Vasari in the Studiolo of Francesco I de' Medici. Although working within the context of *Mannerism, Maso tended to look back to the earlier 16th century and particularly to Andrea del *Sarto whose style was a major influence.

MASO DI BANCO (active 2nd half 14th century)

Florentine painter of the generation after *Giotto, to whom is attributed the decoration of the Bardi di Vernio Chapel in Sta Croce in Florence. His work there includes frescoes of the life of St Sylvester which show a clear and expressive spatial composition, stained glass and the painted scene of the resurrection of a dead Bardi placed above his tomb. The Chapel is an example of the private patronage of the newly enriched merchant class which can be seen on a larger scale in the Arena Chapel in *Padua.

MASOLINO (Tommaso di Cristofero FINI)
(c. 1383–1447)

b. Panicale d. Florence. Florentine painter. Earliest known work exhibits affinities with *Ghiberti and the *International Gothic. His style underwent a brief but startling transformation following his collaboration with *Masaccio in the Brancacci Chapel, in the Sta Maria del Carmine, Florence (c. 1426). He went to Hungary (1427). On his return his manner reverted to the earlier type, eg his frescoes in S. Clemente, Rome (1430) and in Castiglione d'Olona, near Como (1435).

MASON LIMNER (active 1670)

Active: Boston. Portrait painter whose name derives from the family he painted. His work shows the characteristic qualities of the American *limner: flat pattern, intricate line, relish for detail and simple charm.

MASSIM

A style area comprising the south-eastern tip of *New Guinea and the three archipelagos that lie off it; d'Entrecasteaux, Louisiades and Trobriand islands. Considerable homogeneity of style is maintained by an elaborate system of trade and ceremonial exchange (the Kula). Seated and squatting figures

were carved in the Trobriands, and smaller figures adorn the handles of lime spatulae. But the style is essentially ornamental: canoe-prow ornaments, dance-shields, betel-mortars, spatulae, etc are adorned with curvilinear incisions filled with lime. Conventionalised frigate birds and snake forms are utilised as decorative elements.

MASSIM Canoe prow. Wood. 15⅜ × 23¼ in (39 × 59 cm). Musée de l'Homme, Paris

MASSIO, Gentile di Niccolò di Giovanni di see GENTILE DA FABRIANO

MASSON, André (1896–)

b. Balagny, France. Painter who studied in Brussels and Paris, and joined the *Surrealist movement (1925) breaking from it in protest against *Breton's authoritarian leadership (1929). He worked in America and influenced the young *Abstract Expressionists (1941–6). Before 1925 Masson's work was *Cubist. Surrealism gave him a lasting concern with the psychological sources of art and he began working in a partly automatist manner; but even his most spontaneous work reveals in its balanced use of the whole surface a Cubist organisation.

ANDRE MASSON Le Jet au Sang. 1936. 49⅝ × 38⅝ in (126 × 98 cm). Musée National d'Art Moderne, Paris

MASSYS see METSYS

MASTER ALFONSO see BRU, Anye

MASTER BERTRAM see BERTRAM OF MINDEN

MASTER E. S. (MASTER OF 1466)
(active 1450–?1470s)

German engraver and goldsmith noted for his innovations in line-engraving. His subjects, which range from the large devotional Einsiedeln Madonna (1466) to the grotesque Fantastic Alphabet (c. 1464), are richly tonal in effect, being subtly *cross-hatched. His work was much copied.

MASTER FRANCKE

The leading Hamburg painter at the beginning of the 15th century. He seems to have been familiar with exponents of the *International Gothic style, and in Germany he stands somewhere between *Bertram of Minden and the Flemish-inspired realists of the mid 15th century. For the Hamburg merchants who traded with England he painted an altarpiece of St Thomas (from 1424) of which constituent panels survive. This must have been his most important work.

MASTER HONORE see HONORE MAITRE

MASTER H. W. (Hans WITTEN) (d. c. 1525)

b. Harz d. Saxony. German sculptor active in Upper Saxony. In Chemnitz, then Annaberg (1508–22). An early classical phase was followed by works of †Baroque emotion, eg his Pietà (1510/15, Goslar). The vigour and animation of his Tulip Pulpit (1510/15, Freiburg Cathedral) dealing with a folk-tale about the Prophet Daniel, is typically exuberant.

MASTER IAM OF ZWOLLE (?Jan van MIJNNESTEN) (d. 1504)

d. Zwolle. Engraver in London and Delft (active c. 1472). Also known as the 'Master of the Weaver's Shuttle' or the 'Master with the Scraper' from the little picture of a tool that often follows his monogram (which sometimes appears as 'I A'). The word 'Zwoll' also appears on his prints. His style is precise, yet softly modelled with tonal emphasis.

MASTER OF THE AIX ANNUNCIATION

The triptych of the Annunciation in the Church of St Mary Magdalene at Aix-en-Provence (completed 1445) is a focal point in several 15th-century styles – Flemish, Burgundian and Provençal. The identity of the artist is still unknown. Jean Chapus and Guillaume Dombet have been suggested. The original wings are in Brussels and Holland.

MASTER OF THE AMSTERDAM CABINET see MASTER OF THE HOUSEBOOK

Above left: MASTER E. S. Einsiedeln Madonna. 1466. Engraving. 8¼ × 4⅞ in (21 × 12·4 cm). BM, London
Above right: MASTER H. W. The Tulip Pulpit. Carved wood. Freiberg Cathedral

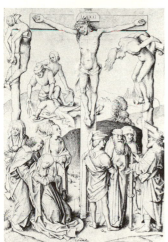

Top left: MASTER FRANCKE
Adoration of the Magi.
39×35⅛ in (99×89·3 cm).
Kunsthalle, Hamburg
Above: MASTER OF THE
HOUSEBOOK *St George
and the Dragon. c.* 1500–10.
Engraving. 4⅓×5½ in
(10·5×14 cm). BM, London
Middle left: MASTER OF
THE AIX ANNUNCIATION
The Annunciation. 1445.
61×69¼ in (154×175 cm).
St Mary Magdalene,
Aix-en-Provence
Bottom left: MASTER IAM
OF ZWOLLE *Crucifixion.*
Engraving. 14×9½ in (35·5×
24·5 cm). BM, London
Right: MASTER OF THE
LIFE OF THE VIRGIN
Presentation in the Temple.
32½×42 in (82×106 cm).
NG, London

MASTER OF THE DARMSTADT PASSION
(active 1435–50)

Painter active in the Middle Rhine area. Named from two large panels (*Crucifixion* and *Christ Carrying the Cross*) in Darmstadt. Unusually, influenced by Jan van *Eyck in his emphasis on brilliance of surface and luminous lighting effects.

MASTER OF THE DEATH OF THE VIRGIN *see* CLEVE, Joos van

MASTER OF THE DUKE OF BEDFORD *see* BEDFORD MASTER

MASTER OF THE FEMALE HALF-LENGTHS
(early 16th century)

Author (or rather production overseer) of a large group of works. He is named after a picture of a *Concert of Three Female Figures.* His studio was perhaps at Antwerp (close connections with *Patenier), though the style has relations with *Benson and *Isenbrandt (both at Bruges). His paintings (none dated) show rather insipid, elaborately clad young ladies, often engaged in music-making.

MASTER OF 1518 *see* ANTWERP MANNERISTS

MASTER OF FLEMALLE *see* CAMPIN, Robert

MASTER OF 1466 *see* MASTER E. S.

MASTER OF THE GROOTE ADORATION *see* ANTWERP MANNERISTS

MASTER OF THE HOLY KINSHIP (active 1480–1520)

German painter of the Cologne School who takes his name from the *Holy Kinship Altarpiece* (*c.* 1500, Cologne), which combines Flemish borrowings with a crowded and highly decorated composition.

MASTER OF THE HOUSEBOOK (MASTER OF THE AMSTERDAM CABINET) (late 15th century)

?German printmaker and painter. Named from drawings in a 'commonplace book' (*c.* 1475, Castle Wolfegg). His alternative name arises from the Amsterdam Print Room's large collection of his prints. As a draughtsman his style is extraordinarily free. Emphatically naturalistic as a painter and printmaker, he produced, as prints, highly original genre studies, often comic in nature. Used *dry-point, unusual before the 17th century, and is thought to have influenced *Dürer's early work. His paintings are more conventional.

MASTER OF THE IMHOFF ALTARPIECE
(early 15th century)

German painter from Franconia. His name-piece, the *Imhoff Altarpiece* (1418/22, St Lorenz, Nuremberg) has the somewhat archaic, soft, naturalistic style associated with Viennese art of the period.

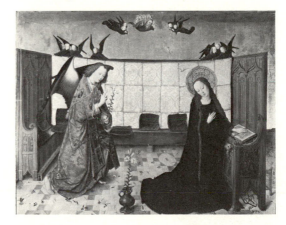

MASTER OF THE LETTERS OF ST GREGORY
(active *c.* 970–90)

Perhaps the most gifted of the †Ottonian manuscript-painters, he takes his name from a copy of the Pope's letters, commissioned by Archbishop Egbert of Trier (*c.* 985). Two full-page miniatures survive at Chantilly and Trier. These works show him to have been a delicate colourist with a grasp of spatial organisation unusual for his time. This implies that he had access to the †Early Christian sources, probably in Italy.

MASTER OF LIESBORN (active *c.* 1465)

German painter of the Westphalian School, strongly influenced by Flemish art. His major work, the High Altar of Liesborn Monastery (now Münster and London) gives him his name, and shows his delicate lyrical style. He had a large workshop.

MASTER OF THE LIFE OF MARY *see* MASTER OF THE LIFE OF THE VIRGIN

MASTER OF THE LIFE OF THE VIRGIN (active 2nd half 15th century)

Named from a series of eight panels (*c.* 1460/70, now mostly in Munich) which formed an altarpiece showing the life of the

Virgin in the Church of St Ursula, Cologne. Although active in Cologne, his elegant, slow and naturalistic figures suggest that he was trained in the Netherlands. Influenced by Rogier van der *Weyden or *Bouts.

MASTER OF MERODE see CAMPIN, Robert

MASTER OF MESSKIRCH (c. 1500–43)

b. Franconia d. Messkirch. German painter (active from c. 1530) influenced by *Dürer and Hans *Baldung. Named after his nine altarpieces for Messkirch Stadtkirche (now Munich, Donaueschingen and private collections), which show his brilliant use of radiant colour, his skill at landscape and his *Mannerist proportions.

Above left: MASTER OF NAUMBURG Ura, Wife of the Markgraf Ekkehard. After 1249. Painted stone. Life-size. Naumburg Cathedral
Above: MASTER OF MOULINS The Annunciation. 1498–9. Grisaille reverse of shutters of the Moulins Triptych. Moulins Cathedral
Left: MASTER OF MESSKIRCH St Benedict. c. 1540. $41\frac{3}{4} \times 29\frac{5}{8}$ in (106 × 75 cm). Staatsgalerie, Stuttgart

MASTER OF MOULINS (active c. 1480–c. 1500)

Franco-Flemish *International Gothic painter, whose early Nativity (c. 1480, Autun) borrows heavily from Hugo van der *Goes, though his highly individual figures are more elegantly expressed. The triptych (c. 1498, Moulins Cathedral), from which he is named, is more delicate although richly coloured. His plastic style is especially evident in the *grisaille angels. The precise and meticulous detail of The Meeting at the Golden Gate (NG, London), shows him to have been influenced by *Fouquet. He has been identified, unconvincingly, with Jean *Perréal, Jean *Provost and others.

MASTER OF NAUMBURG

Thirteenth-century German sculptor. Trained in France, eg at Noyon; active at Mainz (choirscreen, c. 1240), and Naumburg (choirscreen and figures). Document of 1249 refers to his work at Naumburg, but career probably extends into 1260s. Figures characterised by vehement animation, acute observation of detail and pathos. He forms the link between the formal idealism of French High Gothic, and the emotional extravagance of later †Gothic sculpture, eg Giovanni *Pisano, Claus *Sluter.

MASTER OF THE ST BARTHOLOMEW ALTARPIECE
(active late 15th–early 16th century)

Named from an altarpiece formerly in St Columba's, Cologne (now Munich). The two other altarpieces by the same hand exist at Cologne, probably commissioned before 1501. The whimsical style with exotically dressed, coquettish female saints is much influenced by Netherlandish work from the area of Utrecht, where he may have been trained. The leading Cologne painter of his time, he worked also as an illuminator of manuscripts.

MASTER OF ST GEORGE see MARTORELL, Bernardo

MASTER OF ST GILES (active c. 1500)

Of Netherlandish training, he was active in Paris. Named from two panels (NG, London) showing scenes from the life of St Giles.

MASTER OF ST ILDEFONSO (active late 15th century)

Named from a painting (now Louvre) from Valladolid (Spain) showing St Ildefonso receiving his chasuble from the Virgin. Crisp, sculptured draperies are characteristic of his *Campin-influenced style.

Top: MASTER OF ST SEVERIN Stigmatisation of St Francis. c. 1500. $51\frac{3}{8} \times 63\frac{3}{8}$ in (130·5 × 161 cm). Wallraf-Richartz Museum
Above left: MASTER OF THE ST BARTHOLOMEW ALTARPIECE Doubting Thomas. 1501. $56\frac{3}{8} \times 41\frac{3}{4}$ in (144·1 × 106 cm). Wallraf-Richartz Museum
Above right: MASTER OF ST GILES Mass of St Giles. $24\frac{1}{4} \times 18$ in (61·5 × 45·5 cm). NG, London

MASTER OF ST SEVERIN (active 1480–1510)

Painter from Cologne, whose works, such as the *Agony in the Garden* (Munich), suggest in their spatial clarity and depiction of light, a knowledge of the Dutch School and the style of *Geertgen.

MASTER OF THE ST URSULA LEGEND (active late 15th–early 16th century)

Named from a dispersed series of scenes from the life of St Ursula. Apparently active in Cologne, but his delicate characterisation of females suggests that he may have trained in the North Netherlands. The style is close to that of the *Master of St Severin.

MASTER OF ST VERONICA (active early 15th century)

Painter, active at Cologne, named from a *St Veronica with the Sudarium* (now Munich). Perhaps a pupil of Master William of Cologne, he represents the German interpretation of the precious *International Gothic style which later influenced *Lochner.

Above left: MASTER OF ST ILDEFONSO *The Investiture of St Ildefonso.* 1475–80. Louvre
Above: MASTER OF ST VERONICA *St Veronica.* c. 1400. 30¾×18⅞ in (78·1×47·9 cm). AP, Munich
Left: MASTER OF THE TUCHER ALTAR Detail of the Tucher Altarpiece. c. 1445. Frauenkirche, Nuremberg

MASTER OF THE STERZING WINGS (active 2nd half 15th century)

German painter named from a pair of altar wings showing scenes from the Passion and Life of the Virgin. The altarpiece was commissioned (1456) from Hans *Multscher (who executed the centrepiece) for the church in Sterzing (now Vipiteno, Italy). The style of the panels shows the influence of Rogier van der *Weyden with its lucid colour and graceful attenuation.

MASTER OF THE TUCHER ALTARPIECE (active mid 15th century)

German painter from Nuremberg whose figures, with features softly modelled in the manner of earlier Bohemian work, are clothed by draperies sculpturally conceived under the new style associated with the *Master of Flémalle. He was only reluctantly progressive, for his use of a frontal setting against a tooled gold ground in the *Tucher Altarpiece* (c. 1445, Frauenkirche, Nuremberg) is firmly traditional.

MASTER OF TREBON (MASTER OF WITTINGAU)

The Master of Trebon was the most outstanding exponent of the so-called *Soft Style in painting in Bohemia. His major work is the altarpiece from the church in Trebon (Wittingau) in southern Bohemia (now NG, Prague). He was active during the last two decades of the 14th century and his style predominated in Bohemian painting well into the 15th century.

MASTER OF THE VIRGO INTER VIRGINES (active c. 1470–1500)

Active in the northern Netherlands (?Delft) this painter is named after a painting of the *Madonna and Child with Four Female Saints* (Rijksmuseum), which provides the basis for all other attributions. His style may have been influenced by experience in designing woodcuts, an art which flourished in Delft, and by contemporary Flemish art. The high foreheads, elongated bodies, heavy draperies and contorted poses of his figures, give them a mannered appearance suggesting intense religious feeling.

MASTER OF WITTINGAU *see* MASTER OF TREBON

MASTER THEODORIC *see* THEODORIC OF PRAGUE

MASTIC VARNISH

Mastic *resin is a hardened sap obtained from a Mediterranean tree. It dissolves into a clear *varnish with alcohol, *turpentine and most aromatic solvents, but not in mineral white spirit. It has a tendency to *bloom and yellows with age.

MATABEI (Iwasa Matabei) (1578–1650)

Japanese painter traditionally held to be a pioneer of *Ukiyo-e, but without evidence.

MATSYS *see* METSYS

MATHIEU, Georges (1921–)

b. Boulogne. French painter who having previously studied law, began painting seriously in 1942. He has developed a highly personalised style of non-figurative painting, applying paint directly from the tube to a large area of flat contrasting colour; this technique generates a calligraphic style which hovers on the border-line between verve and elegance. Recently he has produced sculptures which are in effect three-dimensional translations of his paintings.

MATHURA *see* KUSHANA DYNASTY; GUPTA DYNASTY

GEORGES MATHIEU *Blue, Violet and Black.* 1959. Watercolour and Indian ink. 22×30 in (56·2×77·2 cm). Whitworth Art Gallery

MATISSE, Henri (1869–1954)

b. Le Cateau-Cambrésis d. Nice. Painter, sculptor and designer who abandoned law (1887–91) and studied at the Académie Julian and the Ecole des Beaux-Arts under *Moreau and Cormon. Matisse's thorough realist and †Impressionist studies developed through *Signac's *Pointillist influence (1904) into the bright colour and summary execution of *Fauvism (1905). For Matisse, more than his Fauve followers, colour has a structural function. Colour, line and composition became increasingly considered and simplified as he realised the necessity to consider equally his sensations of the subject and his sensations of the picture (1906–10); 'I must interpret nature and submit it to the spirit of the picture.' Moving between the near abstraction of *The Moroccans* (1916) and the detailed naturalism of *Interior at Nice* (1921), Mattise maintains in each work a tension between 'nature' and 'the spirit of the picture' originating in his profound understanding of *Cézanne and reaching a peak in paintings like *Pink Nude* (1935).

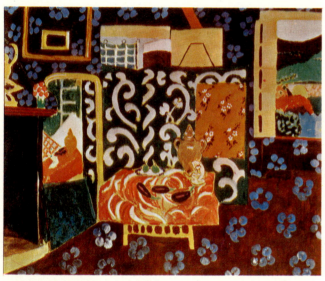

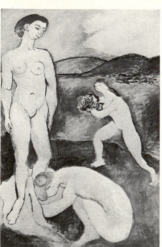

Above: HENRI MATISSE *Interior with Eggplants*. 1911. Tempera. 82¾ × 96⅛ in (210·2 × 244·8 cm). Musée de Peinture et Sculpture, Grenoble
Left: HENRI MATISSE *La Luxe*. 1907. 82¾ × 54⅝ in (210 × 138 cm). Musée National d'Art Moderne, Paris
Below: HENRI MATISSE *Reclining Nude*. c. 1929. Bronze. 11¾ × 19¾ × 6¾ in (29·5 × 50·2 × 17·1 cm). Tate

MATRIKAS

The (usually seven) Mothers, a tantric (*Tantra) development within Hinduism. In sculpture the group of seven is usually flanked by *Shiva and *Ganesha.

MATTA, Roberto Sebastian Antonio (Matta ECHAURREN) (1912–)

b. Santiago. Painter who studied architecture with *Le Corbusier, Paris (1934); went to America (c. 1940); lived in Mexico, Italy, England, Spain and now Paris. Matta eliminated recognisable objects from his mature *Surrealist abstractions, combining painterly geometric and organic shapes with frenetic line; his ambiguous space, automatism and egoism influenced *Abstract Expressionism.

Above: ROBERTO MATTA *Listen to Living*. 1941. 29½ × 37⅜ in (74·9 × 94·9 cm). MOMA, New York, Inter-American Fund
Left: MATTEO GIOVANETTI DI VITERBO Frescoed hunting scene from the study of Pope Clement VI in the Wardrobe Tower. c. 1343. Papal Palace, Avignon

MATTEO DI GIOVANNI (c. 1443–95)

b. Borgo S. Sepolcro d. Siena. Sienese painter, perhaps the pupil of *Vecchietta, later influenced by *Pollaiuolo. He painted Madonnas and altarpieces in a linear, lyrical style, eg his *Assumption of the Virgin* (1474, NG, London).

MATTEO GIOVANETTI DI VITERBO (c. 1300–1368/9)

b. Viterbo d. Rome. Italian painter who succeeded Simone *Martini as chief papal artist in *Avignon. He decorated chapels and halls in the Papal Palace in a weak, eclectic style, influenced by Simone and the *Lorenzetti brothers. His work may have helped to make French artists more aware of Italian developments.

MATTHEW PARIS (c. 1200–59)

Monk of St Albans of clearly defined personality, active as an illuminator, scribe, painter and historian. His line-drawings, sometimes tinted, are lively if not brilliant and revive in the

13th century a Pre-†Romanesque English tradition. His surviving illuminations include lives of saints, historical marginalia, heraldry and maps. His style was adopted by assistants.

MATTSON, Henry Elis (1887–)

b. Gothenburg, Sweden. Self-taught painter and printmaker who settled in New York, where he was helped by Whitney Studio Club. Mattson is best known for his introspective, yet passionate, seascapes, where rocks and water become characters in a vivid dream.

MAULBERTSCH (MAULPERTSCH), Franz Anton (1724–96)

b. Langenargen d. Vienna. Austrian painter and etcher. He was very prolific and painted many large frescoes of religious and historical subjects in a late †Baroque style, showing Venetian influence. His etchings were influenced by *Rembrandt.

MAURER, Alfred Henry (1868–1932)

b. d. New York. Painter who studied in New York with *Chase, in Paris (1897–1914); exhibited at *Armory Show (1913) and with *Stieglitz. Influenced by *Cubist form and space and *Fauvist colour, Maurer painted vibrantly coloured semi-abstract landscapes and still-lifes, finally evolving his own *Expressionism in tragic, obsessive images of women.

MAURYA DYNASTY (c. 320–184 BC)

Chandragupta Maurya overthrew the ruling house of Nanda in the dominant North Indian kingdom of Magadha (c. 324 BC). The Mauryas, being members of the cultivator and mercantile (vaishya) caste and not hereditary kshatriyas or warrior-rulers, were guided in their expansion by a political and economic theoretician named Kautalya, author of the first Indian treatise on imperial politics. Chandragupta brought under his control the Ganges basin, the Trans-Indus and the Indo-Greek satrapies of eastern Afghanistan. Early in the reign of his grandson, Ashoka (268–231 BC) virtually the whole sub-continent was under Mauryan rule. The 'official' art of Ashokan imperialism, being a curious amalgam of the traditional symbolism of royalty with the new imagery of Buddhism, has no room for anthropomorphic representation. The principal features of this school are the animal sculptures crowning the Emperor's edict-pillars which were erected throughout his domains to unify by symbol and inscription the various peoples under his rule. The capitals of the pillars

are bell-shaped; above them appear bands of floral or theriomorphic decoration, which in turn serve as the base for the animal at the top. The bull-capital of one such pillar (Rampurva) presents an exquisite contrast between the compact, rounded forms of the body of the animal and the delicate tracery of foliage in the flora beneath it. All parts bear a characteristic high polish. The four lions of the famous pillar-capital from Sarnath are of Persian stylistic origin, while beneath them are engraved four wheels, symbolising simultaneously the sovereign's universal dominion with the *dharmachakra of Buddhism, and four of the symbolic beasts of Indian mythology and royal power: the lion, elephant, bull and horse. Parallel with these developments there existed a school of massive sculpture representing anthropomorphic figures known as *yakshas or nature-spirits. The power of these images lies in the use of mass to communicate an impression of substantial presence never again achieved – or desired – in Indian sculpture. They are colossi, standing in some cases nearly nine feet high, 'primitive' in an historical sense only. The intricacy of dress and coiffure vies with the immobile solidity of the frame which they adorn as do the flowers at the feet of the Ashokan bull. At the secular level, individual portraiture is found in modelled terracotta heads from Sarnath and Pataliputra (modern Patna). Across the north, throughout this and succeeding periods, terracotta modelling of heavily ornamented female figures, presumed to be fertility goddesses and to be traced back to the time of the *Indus Valley culture, continued in an unbroken tradition.

MAUSOLEUM (c. 353 BC)

The tomb of Mausolus, satrap of Caria, built at Halicarnassus by his widow, Artemisia. It consisted of a colonnade of thirty-

Above: MAURYA DYNASTY *River goddess (?) with two fish.* Presumed from Mathura. 4th–3rd century BC. Moulded terracotta. h. 6 in (15·2 cm). Boston

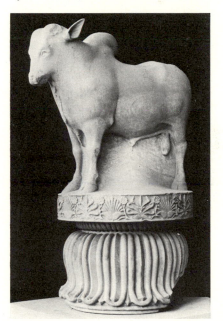

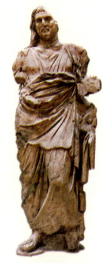

Above: MAURYA DYNASTY Bull capital. From Rampurva. 3rd century. Polished sandstone. h. 105 in (266 cm). National Museum, New Delhi
Above right: MAUSOLEUM Statue of Mausolus. Marble. h. 9 ft 4 in (3 m). BM, London
Left: MAURYA DYNASTY *Yaksha.* From Parkham. 4th–3rd century BC. Sandstone. h. 103½ in (262 cm). Archaeological Museum, Sarnath
Right: MAURYA DYNASTY Lion capital. From Sarnath. 3rd century. Polished sandstone. h. 84 in (213 cm). Archaeological Museum, Sarnath

six columns which rested on a tall rectangular base measuring 100 by 127 feet. Above rose a stepped pyramid supporting a chariot and horses, bringing its overall height to about 134 feet. Inside were colossal statues of Mausolus and his wife. The exterior was decorated with sculptures by *Skopas, *Bryaxis, *Timotheus and *Leochares.

MAUVE, Anton (1838–88)

b. Zaandam d. Arnhem. Dutch artist and the pupil of Van Os. He painted broad, empty, marshy landscapes, marines and forest interiors. In these he was influenced by *Millet, *Corot and *Daubigny and worked with grey, silvery tones and harmonious rather than positive colours. From the late 1870s he lived at Laren and was much admired by *Van Gogh.

MAY, Philip William (1864–1903)

b. Leeds d. London. In contrast to much of the stylistic verbosity of the English cartoon and caricature after 1880, Phil May, whose training had been experience with the Australian *Sydney Bulletin*, drew droll and cynical city street scenes in as few lines as possible, drawings fixed in ink from exploratory pencil studies.

MAYA

Maya civilisation, extending over southern Mexico, Guatamala and Honduras, achieved an outstanding level during the Classic Period (c. AD 300–900), when the brilliant art and architecture of the varied Maya centres were unparalleled in Middle America. Maya art includes painted and incised pottery, modelled figurines, stone sculpture, wall-paintings, feather-work and carved jade. Of these the most significant art forms are stone sculpture, particularly elaborate architectural decoration, stelae and altars, and wall-paintings, the most remarkable examples being at *Bonampak. In addition to their amazing artistic achievements, hieroglyphic inscriptions carved upon Maya altars and stelae have revealed a knowledge of mathematics and astronomy and the use of a complicated calendric system.

MAYNO, Juan Bautista (1578–1649)

b. Pastrana d. Madrid. Spanish painter. He was Philip IV's drawing master, and befriended *Velasquez, whose career he

advanced. His portraits are realistic in expression and texture, while his fanciful historical compositions reflect his study of El *Greco.

MAYOMBE see BAKONGO

MAXIMIAN, Throne of, Ravenna

An ivory chair made for Archbishop Maximian (545–53). It is a remarkable piece composed of a series of ivory plaques carved in different styles, the carvers having probably been trained somewhere in the Greek East. The plaques are framed by a border of intricate scrollwork. See also IVORIES, Byzantine

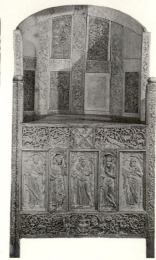

Above and right: MAXIMIAN, Throne of. c. 550. Ivory. 59×24 in (150×60·5 cm). Archiepiscopal Museum, Ravenna
Left: ANTON MAUVE *Het Moraes.* 23⅝×35½ in (60× 90 cm). Rijksmuseum
Below: GUIDO MAZZONI Lamentation group. 1492. Sta Anna dei Lombardo, Monte Oliveto, Naples

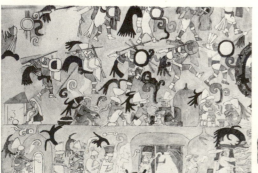

MAZEROLLES, Philippe de (c. 1420–79)

b. Mazerolles, Poitou d. Bruges. French goldsmith and miniaturist who worked in Paris and Bruges, where he became illuminator to Charles the Bold (1467). His illuminations are a marriage of courtly French figures, in the manner of *Fouquet, with a soft and delicately handled deep Flemish space. He made much use of decorative and fantastic costumes.

MAZO, Juan Bautista Martínez del (c. 1612–67)

b. Beteta, Cuenca d. Madrid. Spanish portrait, landscape and history painter, the pupil and son-in-law of *Velasquez, and Court Painter after his death. His works are often confused with Velasquez's – an indication of his often underrated skills.

MAZZOLA, Francesco see PARMIGIANINO, IL

Left: MAYA Corn God. Classic period, Copan, Honduras. Carved limestone. BM, London
Far left: MAYA Wall-painting from the Jaguar Temple, Chichen Itze, Yucatan, Mexico. Detail showing a battle scene. Average height of figures 10 in (25·4 cm). Peabody Museum, Harvard University

MAZZONI, Guido (active after 1473–d. 1518)

b. d. Modena. Italian sculptor, notable for his life-size groups in painted terracotta, eg the *Lamentation* group at Monte Oliveto, Naples; less histrionically powerful than *Niccolò dell'Arca's similar group in Bologna, it possesses nevertheless a dramatic peasant realism. Mazzoni worked mainly in France (1495–1515).

MEADOWS, Bernard (1915–)

b. Norwich. British sculptor who worked as an assistant to Henry *Moore (1936–40). Since 1960 he has been Professor of Sculpture at the Royal College of Art, London. Expressive interpretations of birds and crabs, utilising angular and contorted forms, characterised his work until recently when he started producing polished, rounded, abstract forms.

MECHAU, Frank (1904–46)

b. Wakeeney, Kansas d. Glenwood Springs, Colorado. Painter who studied in Denver, at Chicago Art Institute and in Paris (1929–32); worked for *WPA. Influenced by Oriental art and the Italian primitives, Mechau painted horses and Western subjects in abstract, formalised shapes, composed in refined patterns, very suitable for murals.

MECKENEM, Israel van (c. 1445–1503)

b. d. Bocholt. German printmaker and goldsmith. A copyist, particularly of *Master E.S., *Schongauer and *Dürer. His clear, if airless, style is characterised by crowded anecdotal compositions, light angular figures and sharp differentiation between light and shade. He was taught by his father and the Master E.S.

MEDIAS PAINTER (active 420/390 BC)

Athenian *red-figure vase painter who produced exquisite work with an unerring line. His figures often have wistful

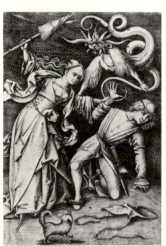

Left: ISRAEL VAN MECKENEM *The Jealous Wife* from 'Scenes of Daily Life'. 1495–1503. Engraving, NG, Washington, D.C., Rosenwald Collection
Below: MEDIAS PAINTER The rape of the Leucippids (detail). h. (of vase) 20½ in (52 cm). BM, London

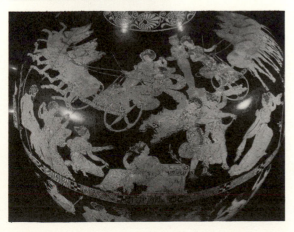

expressions, look up or down and are usually seen from a three-quarter view. His women wear soft, transparent draperies and hold objects without really grasping them. He superimposes flowers in clay and uses gold freely.

MEDIUM

The fluid used to bind the granules of pigment together in mixing paint. Generic types of painting are named after the respective medium, eg *oil, *tempera, *watercolour, *pastel.

MEDLEY, Robert (1905–)

b. London. English painter who studied at the Slade School of Art; a member of the *London group who later designed stage settings. Originally influenced by the Italian †Renaissance and the modern French school, Medley's paintings have become increasingly non-representational, achieving a rare balance between lucid control and expressive power.

MEGIDDO, Ivory Plaque from (c. 1350 BC)

A collection of ivory-carvings have been discovered at Megiddo in North Palestine, though they were carved in the Levant. One such plaque, probably originally used as a furniture fitting, shows a winged female sphinx. Egyptian influence in the representation is obvious as it is with the entire group.

MEGILP

When *mastic varnish is mixed with *linseed oil it is called megilp. It is a medium that is easy to blend and provides a rich gloss enhancing colour and giving it depth. It degenerates quickly however and is impossible to repair.

MEI Ch'ing (1623–97)

Chinese painter from Hsüan-ch'eng, Anhui. An individualist painter of the early *Ch'ing, he painted similar subjects to *Tao-chi, but in a much narrower range, chiefly pine trees and mountains in characteristic, often repetitive, brushwork.

MEIDNER, Ludwig (1884–1966)

b. Bernstaat. German *Expressionist painter and writer who studied in Breslau (1903–5) and Paris (1906–7). Moving to Berlin (1907) he exhibited at the *Stürm Gallery (from 1912). Lived in London (1939–53). Meidner's emotional approach to his subjects encouraged a trembling woolliness in execution. His later work is more realistic.

MEIDUM GEESE

Fragmentary detail from an Egyptian mural of the early 4th dynasty in the tomb of Itet at Meidūm, remarkable for the close observation and subtle colouring of the six geese. The scene, depicting a marsh, was painted on plaster in the ordinary way, but elsewhere in the tomb the figures were cut in the stone and filled with a solid mass of pigment – a unique experiment.

MEIJI PERIOD (1868–1912) AND LATER

The opening up of Japan to Western markets and influences, and the end of the prohibition of international travel for Japanese subjects, along with the collapse of the Shōgunate and the restoration of the Emperor to supreme power (1868) radically changed artistic fashion in Japan. Almost all the schools of painting were heavily diluted with Western ideas. There was an amalgamation of old styles into the so-called 'Japanese style', which is often manifest as a variation of *Shijō. Many painters used this style successfully, not only Kawai *Gyokudō, *Taikan and *Seihō, but also Hishida Shunsō, Shimomura Kanzan, Maida Seison and others. The *Nanga style persisted with Tanomura Chokunyu and was extended by Tomioka *Tessai, who clearly felt some influence from the West. *Ukiyo-e changed into a very Westernised version, poor in design and appalling in colour, only *Yoshitoshi succeeding in using the imported aniline dyes effectively. A

fashion for Western things became the rage, and oil painting was taken up by many artists, perhaps the most successful in assimilating the contemporary French style being Baron *Kuroda. In the 20th century there has been a swing back towards Japanese taste, and now the two courses run parallel in Japan Woodblock printing has continued, but not in *Ukiyo-e style. There are many artists using Japanese themes for prints (eg *Munakata, Saito Kiyoshi, Sekino Jun'ichiro), sometimes drifting into the semi-abstract (eg Mori Yoshitoshi), and others who are wholly abstract (eg Maki Haku, Kanō Mitsuo) or semi-representational in a Western way (eg Akiyama Iwao). Some artists use other materials, such as copper-plate (eg Hamaguchi Yozo), and most artists are at once influenced by and influence contemporary American printmaking.

MEISSEN CATHEDRAL

Several statues of founders, saints and the Virgin were prepared during the 13th century, most likely for a portal. They are now preserved in the choir. In style they are close to the works of the *Naumburg workshop, although they lack the pathos and depth of characterisation.

MEISSONIER, Jean Louis Ernest (1815–91)

b. Lyon d. Paris. Entered Cogniet's studio when young. The success of *La visite chez le bourgmestre* (1834) decided his father to send him to Rome. His detailed Salon paintings of the 1840s are in the Dutch genre tradition, but after an Italian trip (1859), he concentrated more on history painting. His *Rixe* (1855), bought by Napoleon III, earned him the medal of honour.

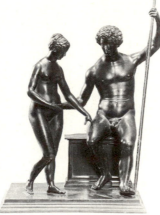

MEISTERMANN, Georg (1911–)

b. Solingen. German painter and stained-glass designer who studied in Düsseldorf (1929–33). A committed Catholic, Meistermann believes – like *Kandinsky – that the spiritual can only be expressed by the abstract. Whether geometric or biomorphic, his forms have a Synthetic *Cubist adherence to the picture surface.

MEIT, Conrad (d. c. 1544)

b. Worms d. Antwerp where *Dürer met him (1520–1) and admired his work. German sculptor and medallist. He served Frederick the Wise (before 1511), collaborating with the *Cranach workshop at Wittenberg. Working for Margaret of Austria as Court Sculptor (in Mecheln), he concentrated mainly on small figures and portraits, but also worked on the family tombs which are monumental and vigorous. He lived in Antwerp from 1534. Meit is the main figure of German †Renaissance sculpture, uniting Italian classic idealism with his native German realism. Most remarkable in his small free-standing nudes (eg *Mars and Venus*, Nuremberg) he also achieved great feeling in large works (*Pietà*, Besançon).

MEKETRE

Egyptian court official of the 11th dynasty, whose tomb equipment included the most elaborate funerary models as yet discovered. These represent his houses, his various boats, and the working establishments on his estates, among them a carpenter's shop and a group of women engaged in spinning and weaving.

MELANESIA, ART OF

The islands of Melanesia run along the northern coast of Australia and out into the Pacific; *New Guinea, *Admiralty Islands, *New Britain, *New Ireland, *Solomon Islands, *New Hebrides and *New Caledonia. Their black-skinned inhabitants were the most prolific artists in *Oceania. They were Stone Age farmers whose political groups were rarely larger than the village community. But their religious institutions stimulated a massive art production, and long-distance trading caused the dispersal of objects and ideas over wide areas. Elaborate ceremonials combined honouring the dead with the initiation of young men into secret societies. These rites were the occasions for making many carved and painted objects – masks, figures, drums, plaques, etc. In some areas huge men's club-houses were constructed to house the sacred equipment and act as a focus for ritual performances. Head-hunting and cannibalism were important everywhere and led to the construction of great canoes and houses for containing the trophies of war. Much Melanesian art was essentially theatrical. Masks are an important component of most styles. Sculpture was frequently brightly painted and decorated with feathers, tusks, teeth, shells and other organic materials. Where this is not so, eg in the Solomon Islands and the Massim area of New Guinea, a more subdued sculptural style is embellished with careful ornament of mother-of-pearl inlay and curvilinear incisions filled with lime.

Far left: JEAN-LOUIS MEISSONIER *Barricades, rue de la Mortellerie.* 1848. 11½ × 8¾ in (29×22 cm). Louvre
Left: CONRAD MEIT *Mars and Venus.* c. 1525. Bronze. h. 13½ in (34·3 cm). Germanisches Nationalmuseum, Nuremberg
Right: MEKETRE Fisherman drawing in a net from a boat. 11th dynasty. Wood painted over plaster. l. (of boat) 37⅜ in (95 cm). Egyptian Museum, Cairo

MELCARTH, Edward (1914–)

b. Louisville, Kentucky. Painter who studied with Zerbe and at Académie Ranson and Atelier 17 in Paris. A figurative painter, Melcarth is at his best in his exuberant, sweeping, dramatic renderings of city genre scenes.

MELCHERS, (Julius) Gari (1860–1932)

b. Detroit d. Fredericksburg, Virginia. Painter who studied in Düsseldorf (1877) and at Académie Julian, Paris; lived in Holland and Paris; was Court Painter to Grand Duke of Saxe-Weimar (1909–14); settled in Fredericksburg (1914). His early genre paintings of Dutch peasants are virile and sympathetic; later works degenerated into bloodless, pseudo-*Impressionist pseudo-classicism.

MELDOLLA, Andrea see SCHIAVONE, Andrea

MELENDEZ (MENENDEZ), Luis (1716–80)

b. Naples d. Madrid. Spanish painter. Court Painter to Charles III, he painted religious subjects and portraits, but his finest works are still-lifes which earned him the nickname 'the Spanish *Chardin'.

MELLAN, Claude (1598–1688)

b. Abbeville d. Paris. French etcher, particularly noted for his portraits. Technically brilliant, he abandoned cross-hatching while studying in Italy (1624) and achieved light and shade solely by varying parallel lines. Appointed Engraver of Royal Antiquities, he also etched the work of *Vouet and *Poussin.

MELOZZO DA FORLI (1438–94)

b. d. Forli. Italian painter, his first recorded work is a fresco, *Sixtus IV Nominating Platina as Vatican Library Prefect* (1477, Vatican). His early style was influenced by *Piero della Francesca. In the apse of SS Apostoli in Rome there are extant fragments and an *Ascension* which reveal an interest in foreshortening, suggesting a knowledge of *Mantegna's work. This allied to a subtle filter of light passing over the forms, anticipating the *sfumato of *Leonardo, contributes to the surprising theatricality of his *Angel Musicians* (Vatican).

MEMLINC, Hans see MEMLING

MEMLING (MEMLINC), Hans (c. 1440–94)

b. Seligenstadt-am-Main, nr Frankfurt d. Bruges. Flemish painter who settled in Bruges (by 1465), and became the major master of his time. His training was completed in Brussels where he was influenced by Rogier van der *Weyden. His work, although freely borrowing from Rogier's forms, is less dramatic. It is all things nice: harmonious, decorative, unified with a clear sense of space, and above all tasteful and marketable (Memling's workshop was the largest and most prolific in Bruges). He is at his best in religious groups such as the *Mystical Marriage of St Catherine* (Bruges) where his delicate feeling for tonal and figural balance can be displayed. His later works show some Italian influence in his use of swags and putti.

MEMMI see MARTINI, Simone

Left: LUIS MELENDEZ *Still-life.* 23⅝×31½ in (60×80 cm). Provincial Museum, Bonn
Right: HANS MEMLING *Martin van Nieuwenhove.* 1487. 17×13 in (44×33 cm). St Jans Hospital, Bruges
Far right: MEMNON COLOSSI of Amenhotpe III. Mid-18th dynasty. Thebes
Below: HANS MEMLING *The Donne Triptych.* c. 1485. Central panel 28×27¼ in (71×69 cm). NG, London
Below right: MELOZZO DA FORLI One of the Angel Musicians. Fresco. Vatican

MEMNON COLOSSI

The name often applied to the two quartzite statues of *Amenhotpe III that stood originally before his mortuary temple, now totally razed. In fact the northern colossus alone was originally so called, in consequence of its emitting a singing note with the coming of dawn – a fanciful image of Memnon greeting his mother Eos. This phenomenon was the result of damage sustained in an earthquake in 27 BC, and ceased when the statue was roughly repaired about AD 200.

MEMPHIS

The principal city of Egypt during the Old Kingdom, which retained its importance down to the Roman period. The extensive remains of Memphis were largely destroyed for the building of Arab Cairo, which also absorbed what was left of Heliopolis, and apart from the site of the temple of Ptah the chief monuments still surviving are the groups of pyramids and associated tombs at *Gīza, Abusīr, *Saqqāra and Dahshūr.

MENA, Pedro de (1628–88)

b. Granada d. Malaga. Spanish sculptor, combining great spiritual insight with the realism and grace of the Andalusian School. Executed forty choir-stalls for Malaga Cathedral (1658–62) and a brilliant *St Francis* in Toledo Cathedral. His workshop production was enormous.

MENCIO, Ansano di Pietro de' see SANO DI PIETRO

MENDE

The largest tribe in Sierra Leone grouped into nearly seventy independent chiefdoms with no centralised political authority. Two most important institutions of the Mende are the Poro society for men and the Sande for women, which control supernatural powers and the training of adolescents. The spirits of these societies appear in mask form and although the

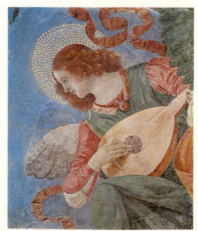

Poro spirits are never seen by non-members, the conical black masks of the Sande society are well known. The Mende also carve grotesque humorous *gonguli* masks which have little or no ritual significance. The neighbouring Vai tribe of western Liberia have a very similar art style although in language they are more closely related to the *Bambara. *See also* NOMOLI

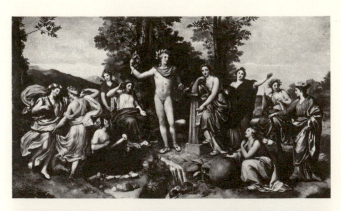

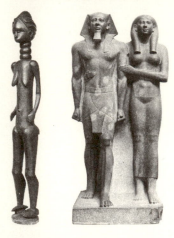

Far left: MENDE Figure of a woman. Late 19th century. Wood. h. 46½ in (118 cm). BM, London
Left: MENKAURE The King and Queen Khamerernebty. 4th dynasty. Schist with traces of painting. h. 56 in (142 cm). Boston
Top right: ANTON MENGS *Parnassus with Apollo and the Muses.* 1761. Villa Albani, Rome
Below right: ADOLPH MENZEL *Rolling Mill.* 1875. 62¼×100 in (158×254 cm). NG, Berlin

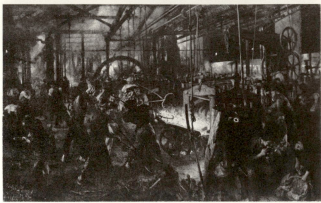

MENDEZ, Leopoldo (1903–)

b. Mexico City. Printmaker and painter who studied at Academy of San Carlos and Chimatistac 'open-air' school; was co-founder of Taller de Gráfica Popular and League of Revolutionary Writers and Artists. Influenced by *Posada and *Orozco, his *Expressionist prints, rendered in sharp contrasts, show a strong sense of social consciousness.

MENDUT, Central Java (9th century)

A small Buddhist temple immediately to the east of and connected with *Borobudur. The entrance staircase, unusually facing north-west, represents folk-tables, while the body of the building has narrative panels and figures of Bodhisattvas. The antechamber walls have panels showing Hariti and Atavaka. The cella contains three large figures, the Buddha Sakyamuni flanked by two Bodhisattvas, Avalokiteshvara and Vajrapani. There are four empty niches whose original occupants cannot be identified with certainty. There have been suggestions that the style is close to that of the western Indian caves.

MENENDEZ, Luis *see* MELENDEZ

MENGS, Anton Raffael (1728–79)

b. Aussig d. Rome. German painter, who worked in Italy and Spain. His father was Court Painter at Dresden, and brought him up to be a great artist. He was taken to Rome (1741) and became something of an infant prodigy painting portraits, mostly in pastel. He was appointed Court Painter in Spain (1761) and executed decorative cycles for the royal palaces. Portraits are his best works, but he is more important historically as one of the first and most influential protagonists (with his friend *Winckelmann) of †Neo-classicism. He wrote a treatise on painting and the most eloquent pictorial statement of his ideals is the *Parnassus* (1761, Villa Albani, Rome).

MENKAURE (Mycerinus)

Egyptian king of the 4th dynasty, the builder of the third pyramid of *Giza. The statuary found in his mortuary temple is of particular interest, including a group of the king and his consort, triads in which he is flanked by goddesses, and a number of seated figures in various states of completion.

MENNA *see* THEBAN TOMBS

MENSA ISIACA

The most famous 'Egyptian' monument of the Renaissance, regarded as the embodiment of pharaonic iconology. The bronze slab, inlaid with figures of deities, symbols and garbled *hieroglyphs, was found at Rome some time before 1520, and came perhaps from a shrine of Isis of the imperial period. The date of the piece is uncertain, but it was probably made in the middle of the 1st century AD, either in Rome or Alexandria. The decoration is in fact a pastiche of Egyptianising elements.

MENUS PLAISIRS

French: literally 'pocket-money'. In 18th-century France this term was used to designate the office of designer of costumes, ornaments, etc for the court.

MENZEL, Adolph (1815–1905)

b. Breslau d. Berlin. German artist trained in his father's lithographic workshop in Berlin. Early success came with illustrations to several works by Kugler on Frederick the Great (executed during the 1840s). In the next decade he produced a series of oils on the same themes. From the 1860s he took up modern life subjects – eg rolling-mills (1875). He travelled throughout Europe and achieved considerable academic success in later life. A prolific and powerful draughtsman, his fine pencil drawings gave way to broad, coloured chalk, pastel and gouache studies.

MERCIER, Philippe (1689/91–1760)

b. Berlin d. London. Huguenot portrait painter and engraver who studied in Berlin, Paris and probably, Hanover before settling in London (c. 1716) and becoming Principal Painter to Frederick, Prince of Wales (1729–36). Although technically clumsy, his unique blend of the styles of *Watteau and *Chardin made him influential. He probably originated the English *conversation piece.

MERERUKA *see* SAQQARA

MERIDA, Carlos (1893–)

b. Quezaltenango, Guatemala. Painter who studied and travelled in Europe (1910–14, 1927); emigrated to Mexico

Above: CARLOS MERIDA *Untitled.* 1964. Oil on paper. 23×31 in (27·9×80·0 cm). John and Barbara Duncan Coll

Right: HENDRIK MESDAG *Beach.* 45⅜×31½ in (115·5×80 cm). Rijksmuseum

CHARLES MERYON *Paris: La Morgue,* from the 'Eaux-Fortes·Sur Paris'. 1852. 9⅛×8³⁄₁₆ in (23·2×20·6 cm). V & A

(1919). Highly influential, particularly as a muralist, Mérida moved gradually from socially conscious figurative art to hard-edge abstraction, combining simplified primitive Mayan shapes with dominant brightly coloured geometric forms to create images floating in space.

MEROVINGIAN ART *see essay:* MIGRATION PERIOD ART

MERSON, Luc Olivier (1846–1920)

b. d. Paris French history painter, illustrator, student of Chassevent and Pils, Merson was a strong defender of classicism and academic theories at the Ecole des Beaux-Arts where he became Professor (1894). He began at the Salon of 1867 (*Leucothoe et Anaxandre*), received the 1869 Rome Prize, and first medal at the Salon of 1873 (*Vision, légende du XIV͏ᵉ siècle*). He also worked in the Panthéon and the Palais de Justice.

MERYON, Charles (1821–68)

b. Paris d. Saint-Maurice. Son of an English doctor and a French dancer. He went to Paris (1846) and copied many Old Master engravings under the instruction of the engraver Bléry. In the 1850s he made his *Eaux-fortes sur Paris*, picturesque Parisian views and his best work. They were praised by *Baudelaire.

MESDAG, Hendrik Willem (1831–1915)

b. Groningen d. The Hague. Dutch painter who studied with Roelofs and with *Alma-Tadema in Brussels. He became a master at rendering Dutch cloud-filled skies in the 17th-century tradition, and exhibited with success in Paris in the 1870s and 1880s. His own collection of modern paintings is in the Mesdag Museum in The Hague.

MESOPOTAMIA, ART OF

The character of Mesopotamian art has been determined throughout its history by two limiting factors, firstly by its heavily symbolic content and secondly (at any rate during the early periods) by the scarcity of locally available materials. In the south, where the civilisations of Sumer and later Babylon arose, wood, stone, all metals and even the ingredients of paint had to be imported. In the early prehistoric periods (*c.* 6000–4000 BC) painting was confined to the decoration of pottery, which became a highly skilled professional art in the *Halaf and *Samarra cultures (before 5000 BC). Sculpture was limited to alabaster and terracotta figurines, but some female heads from *Choga Mami, also of Samarra date, show a vigour and skill in modelling that entitles them to be regarded as works of art. The earliest known example of large-scale painting occurs some fifteen hundred years later at Tell 'Uqair, where the podium of a temple was decorated with polychrome representations of lions and leopards. At about the same time, the Jemdet Nasr period, we find relief carving used to depict cult scenes, as on the *Warka Vase, and the first large sculpture in the round, a female head in white calcite, also from Warka. This artistic tradition, particularly in narrative representation, was developed and formalised in the Sumerian city-states of the Early Dynastic period in the first half of the 3rd millennium BC, when the so-called 'Stele of the Vultures' shows, on the reverse, the triumph of a ruler of *Lagash over a neighbouring city, with the figure of his divine overlord dominating the obverse. The pictorial narrative of action in horizontal registers, in which spatial realism is largely ignored, recurs in Mesopotamian reliefs down to the Late Assyrian period. In Early Dynastic times a good example can be seen in the famous 'Standard' of *Ur of which the two sides present respectively the narrative of a campaign and the victory feast that followed. Contemporary sculpture in the round was stiffly geometric, with little attempt at individual portraiture although details such as hair style are faithfully observed. When the hegemony of Mesopotamia passed for the first time to a Semitic dynasty, founded by Sargon of *Agade (*c.* 2370 BC), a notable though not immediate change took place. Under Sargon's successors both narrative relief and sculpture in the round were liberated from some technical conventions while retaining their formal character. On the Stele of Naram-Sin, depicting a mountain campaign, the register arrangement was abandoned in favour of a more realistic, though still stylised representation of a tree-clad mountain, dominated by the superhuman figure of the king. A near-life-size head in copper, possibly of Sargon himself but more probably one of his successors, is a forceful portrait of great technical virtuosity. Other works also show a more realistic convention, particularly in the treatment of details such as musculature and the folds of clothing. The Agade tradition influenced sculptors of the succeeding Neo-Sumerian period, from which we possess many statues of a ruler of Lagash, *Gudea. Others represent Semitic rulers of *Mari on the Euphrates, and here the Agade inheritance is even more apparent. Many of these works were executed in the hardest stones, such as diorite, but the *cire perdue casting of copper continued, and in the early 2nd millennium temple façades were often guarded by protective genii and beasts in terracotta. From this time date two of the most famous Mesopotamian works of art, the Stele of *Hammurapi (*c.* 1750 BC), on which his laws were inscribed, and the painted Investiture of Zimri-lim, which adorned the throne-room façade in the palace at *Mari. The relief that surmounts Hammurapi's stele and the Mari painting show the ruler before a deity in the Mesopotamian manner, but the Mari composition also includes subsidiary scenes, with natural and formalised palm trees, real and mythical animals. This part-decorative, part-symbolic element employing motifs drawn

directly or indirectly from nature has been compared with the Minoan frescoes, and both may draw on Levantine traditions; Mari lay on the Euphrates route that linked Babylonia with the Levant. The rest of the 2nd millennium was a period of development in Mesopotamian craftsmanship, but few major works have survived. Control of the northern plain by the Mitanni, an Indo-Aryan dynasty, reinforced the Levantine contacts that we have observed at Mari, and a new style of painted pottery appeared, Nuzi ware, whose finer examples combine floral and geometric motifs with great delicacy. In the south the Kassites ruled Babylonia, adding to the Mesopotamian tradition a new naturalism in the modelling of terracotta (the *Aqar Quf lioness) and, in wall-painting, motifs such as the procession of courtiers in the throne room at their capital, Aqar Quf, which foreshadow Late Assyrian palace decoration. The invention of glass and the greatly increased use of glazing on terracotta and faience added a new element to the production of smaller works of art, and seal-cutting, an age-old craft, arguably reached its zenith in the Middle Assyrian cylinders of the 13th century BC. The last and perhaps the greatest phase of monumental sculpture and painting came under the patronage of the Late Assyrian Empire (9th–7th centuries BC), in the palaces at the successive capitals of *Nimrud, *Khorsabad and *Nineveh. True to tradition, reliefs and paintings depict the king as high priest of the god Ashur, the conqueror who overcomes Ashur's enemies and receives their tribute, and the hunter who protects his people from the inimical forces of nature represented by real or mythical animals. The wealthy Assyrian court supported many other craftsmen, notably the *Phoenician and Syrian ivory-carvers whose products have been found in thousands at Nimrud. But it was the decoration of the palaces, and particularly the sculptures, that expressed the Mesopotamian image of kingship in its ultimate form, and provided the model that was copied in the next two centuries by the *Achaemenid rulers of Persia.

MESOPOTAMIAN PAINTING : ISLAMIC

From the 12th century onwards, first in Mosul and then in Baghdad, earlier Syro-Hellenistic elements and Saljuq iconographic details developed into a distinctly independent school showing its full maturity in the Istanbul manuscript Rusail Ikhwan as-Safa (dated 1287) with its unique colour range limited to browns, blue and black with gold outlining. From the few examples surviving, there is a general close observation of detail, with an attempt at depth by angling the architectural setting. The composition is contained, usually symmetrical but without rigidity, and basically on one plane with superimposed figures giving added depth. Facial characterisation is attempted, verging on caricature, with red dots placed on cheeks, emotions being expressed by the positioning of the head, hands and body. Drapery folds are unrealistic forming decorative patterns. Trees and plants still tend to be stylised following the earlier conventions. The style succumbed to the dominant Iranian Schools fusing with provincial *Mamluk.

MESTROVICH, Ivan (1883–1962)

b. Vrpolje, Slavonia d. South Bend, Washington. Sculptor who was apprenticed to a mason in Split (1900), studied in Vienna (1900–04), moved to Paris (1904), and worked throughout Europe, settling in America (1947). Mestrovich never forgot his Yugoslavian peasant origins. He combined influences from Vienna *Secession, *Rodin and †Romanesque Dalmatia in sculptures full of patriotic sentiment.

METAL-SPRAYING

A method of spraying molten metal from a mechanical spray-gun. Low melting-point metals immediately harden on contact with the surface being sprayed and build up a solid metal coat. Used increasingly in mould-making, rarely for finished sculpture.

METHETHY see 'SHEIKH EL-BELED'

METSU (METZU), Gabriel (1629–67)

b. Leiden d. Amsterdam. Dutch painter, a pupil of *Dou. His early works were often allegorical or religious, but having settled in Amsterdam he began to work in the polished manner of the Leiden painters, producing portraits of the bourgeoisie and genre scenes, such as The Vegetable Market at Amsterdam (c. 1660–5, Louvre). He was influenced by *Rembrandt, but his style and choice of subject-matter are closer to de *Hooch and *Terborch. His paintings are highly finished and in his best work, eg The Sick Child (c. 1660, Rijksmuseum) he approaches *Vermeer in quality.

Top left: GABRIEL METSU The Sick Child. c. 1660 (33·2×27·2 cm). Rijksmuseum
Top right: QUENTIN METSYS Banker and his Wife. 1514. 28×27 in (71×68 cm). Louvre
Above: QUENTIN METSYS The Holy Kindred. Central panel of the St Anne Altarpiece. 1509. 34¾×33⅞ in (88·5×86 cm). Musées Royaux, Brussels

METSYS (MATSYS, MASSYS), Cornelius (c. 1510–after 1562)

b. d. Antwerp. Flemish painter and engraver, the second son and pupil of Quentin *Metsys. He was predominantly a landscapist, who, rather than painting bird's-eye 'world-scapes', as did *Patenier, attempted to show a piece of real countryside populated, rather than superimposed, with figures. He produced a large number of engravings on leather, mainly of an allegorical or moralising nature.

Above left: MEWAR PAINTING *Dipak Raga* by Nisradi. Chawand School, *c.* 1605. 6⅜×6⅛ in (17·1×15·6 cm). GK Kanoria Coll

Above right: JEAN METZINGER *Tea-time.* 1911. 29¾×27⅜ in (45·1×39·1 cm). Philadelphia Museum of Art, Arensberg Coll

METSYS (MATSYS, MASSYS), Jan (*c.* 1509–75)

b. d. Antwerp. Flemish painter, son and pupil of Quentin *Metsys. His careful delineation of symbolic detail recalls his father's style, but the slickness of his paint surfaces and the erotic treatment of his subject-matter, contrasts both with Quentin's work and that of contemporary Romanists.

METSYS, Quentin (Quinten MASSYS, MATSYS)

b. Louvain d. Antwerp. The leading painter of his time in Antwerp, two altarpieces are documented, one, the *St Anne Triptych* (centre panel, Brussels) is signed and dated 1509. Much influenced by *Leonardo's sfumato, he also shared Leonardo's interest in the grotesque (*Old Woman*, NG, London). His subject-matter was wide-ranging and included some vigorous portraits (eg *Erasmus*, 1517, Gall. Naz., Rome). The landscape backgrounds to some of his works may have been painted by *Patenier. He was highly influential.

METZINGER, Jean (1883–1956)

French painter, one of the original *Cubists, he exhibited at the Salon d'Automne with *Gleizes, *Léger, *Picabia and *Delaunay. With Gleizes he wrote *Du Cubisme,* a rationale of the movement. Influenced at first by *Picasso, his Cubism took on a personal, decorative brightness.

MEULEN, Adam Frans van der (1631/2–1690)

b. Brussels d. Paris. Flemish painter of battle scenes who studied under Snayers. He was summoned to the Gobelins factory by Louis XIV (1665) and designed a series of tapestries commemorating the heroic deeds of the king.

MEUNIER, Constantin Emile (1831–1905)

b. Etterbeck d. Ixelles. Belgian sculptor and painter, taught by the sculptor Fraiken and the painter Navez. His early paintings, influenced by de Groux, were religious and historical. He later took up realist subjects in a brighter palette – miners and workers – treated like *Millet's peasants in a heroic manner. His influence was considerable.

MEWAR PAINTING

The Mewar school of Indian painting has a long history representing a continuous tradition, but it can be divided into several phases. Udaipur, Chittaur and Chawand were the three centres of painting. The earliest examples, from the 16th century onwards show influence from the later *Jain school in its primitive vigour and use of primary colours – reds, yellows and blues. Symbolism rather than naturalism was the keynote. From the mid 17th century the life of Krishna was the main theme. Backgrounds were stylised and colours bold. The female type was similar to the *Bundi School but faces tended to be somewhat flat. Later there was influence from the *Mughal School, though the style remained essentially Indian.

There was an abundance of equestrian portraits (a Mughal taste) and game-shooting scenes.

MEXICO, PRE-COLUMBIAN ART OF *see* AZTEC; HUASTEC; MIXTEC; OLMEC; TEOTIHUACAN; TLATILCO; TOLTEC; VERA CRUZ; WESTERN MEXICO; ZAPOTEC

MEZZOTINT *see* ENGRAVING

MI Fu (1051–1107)

Chinese painter from Hsiang-yang, Hupeh, the most prominent connoisseur of his day. His *Hua-shih* ('History of Painting') and a companion work on calligraphy show him as a man of independent judgement and high critical standards. In painting, Mi Fu was famous for his wet-ink 'cloud-dot' technique. More survives of his calligraphy than of his painting.

MI Yu-jen (1086–1165)

Son and follower of *Mi Fu.

MICHEL, Georges (1763–1843)

b. d. Paris. French landscape painter, whose late *plein-air works are precursors of the *Barbizon School. Dutch landscapes (of which he was a restorer) strongly influenced his naturalistic style. He considered it unnecessary to travel great distances to find subject-matter for his paintings and most of them depict the plain of St Denis and the windmills of Montmartre.

MICHELANGELO BUONARROTI (1475–1564)

b. Caprese d. Rome. Florentine painter, sculptor, architect and poet who is acclaimed as the greatest master of the †Renaissance and probably of all time. His long career spans a period of more than seventy years during which momentous crises shook Christendom and materially affected his art. After a brief apprenticeship with *Ghirlandaio (1488) he entered the select coterie of artists under the protection of Lorenzo de' Medici and the supervision of *Bertoldo di Giovanni whose use of *contrapposto had a prolonged influence. In Rome (1496–1501) he created the *Bacchus* (Bargello) and the *Pietà* (St

MICHELANGELO The Libyan Sibyl. 1511–12. Detail from the Sistine Chapel ceiling. Fresco. Vatican

Peter's) in which he deployed great technical finesse for profoundly contrasted expressive ends, but they are still essentially Early Renaissance in style. Returning to Florence the *David* (1501–4) proclaims the heroic forms and spirit of the High Renaissance which is extended yet further in the *Battle of Cascina* (1504–5) (destroyed). This frieze of nudes in startled activity, was enormously influential even though abandoned incomplete when he was summoned to Rome by Julius II to work on the ill-fated tomb that was to harass him for forty years. After quarrelling with the Pope their reconciliation resulted in the Sistine Chapel ceiling (1508–12) on which his latent talents as a painter and decorator were given full rein. It was a crucial work too for its *sotto in sù, *trompe l'œil architectural framework, and especially for the portents enshrined in the contrasts afforded by the idealism of the *Creation of Adam* and the *Manneristic disquiet of the *Crucifixion of Hamaan* or the melancholy withdrawal of the *Ancestors of Christ*. He was deeply influenced by classical statuary which is not so much echoed in his work as assimilated into an expanded language of bodily expression and visible in the antitheses of the lithe grace of the *Victory*, the shrivelled *Evening* and the ponderously vital *Day* (1520–34, Medici Chapel, Florence). Disgusted by Medici tyranny, he left Florence for Rome (1534). The gloomy insecurity and spiritual fears pervading the city after the Sack (1527) are reflected in the *Last Judgement* (1535–41, Sistine Chapel) which brought the aged Pope Paul III to his knees when it was unveiled. The massive bodies betray Michelangelo's dissatisfaction with conventional notions of ideal form and reflect too his growing spiritual austerity fostered by his friendship with the ardent Catholic reformers Vittoria Colonna, Cardinal Pole and Ignatius Loyola. Much of his time was now taken up with architecture, but his drawings and his last sculpture the *Rondanini Pietà* (Castello Sforzesco, Milan) disclose that he turned his attention to †Gothic sculpture as part of a process of paring away all superfluities in a search for an irreducible spiritual essence.

Above: MICHELANGELO *Male Torso.* 1532–4. Red chalk. 9¾×7⅞ in (24·7×20·1 cm). BM, London
Below: MICHELANGELO *Last Judgement.* 1535–41. Fresco. h. 48 ft (14·64 m). Sistine Chapel, Vatican
Bottom: MICHELANGELO The Medici Chapel, S. Lorenzo, Florence. 1520–34

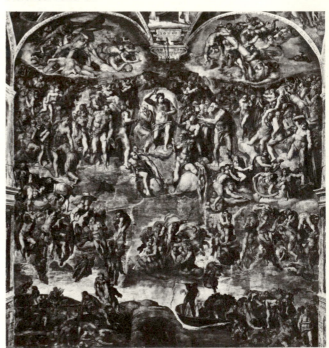

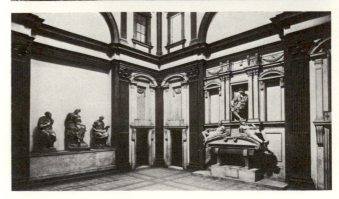

MICHELANGELO *Pietà.* 1498–9. Marble. h. 69 in (175 cm). St Peter's, Rome

MICHELINO DA BESOZZO (active 1388–1450)

Milanese painter, much admired in his lifetime. His *Mystic Marriage of St Catherine* (Siena) is typical of his *International Gothic style, using bright colours with fanciful detail. He also produced frescoes and possibly manuscript illuminations.

MICHELOZZO, Michelozzi (1396–1472)

b. d. Florence. Italian sculptor and architect whose name is linked with the major initiators of the †Renaissance. From *Ghiberti he received his training, assisting him on both sets of Baptistery doors, and a close but ill-starred friendship arose with *Donatello whose studio he shared (1425–33). His absorption of the ethos of Early Renaissance classicism is best demonstrated in the Aragazzi Monument (1437–8), the first humanist tomb. Its severe restraint reminds us that Cosimo de' Medici preferred his simpler design for a palace, remarking 'envy is a plant one should never water'.

MICHIEL, Marcantonio (d. 1552)

Italian writer on art, a Venetian connoisseur and collector (he owned a *Giorgione). He intended to write a history of art, but possibly to avoid competition with *Vasari, this was left in note form, and the *Notizie d'opere del disegno* remained unpublished until 1800. Michiel's discerning judgements were generally made at first hand.

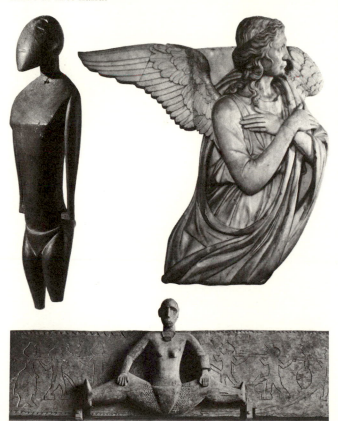

Top left: MICRONESIA, ART OF Caroline Island figure. Wood. h. 13⅞ in (35 cm). Musée de l'Homme, Paris
Top right: MICHELOZZI MICHELOZZO *Adoring Angel* from the Aragazzi Monument. 1438. Marble. 38¼×38¼ in (97·2×97·2 cm). V & A, London
Above: MICRONESIA, ART OF Palau Island carved gable from a men's house. 19th century. Museum für Völkerkunde, Hamburg

MICRONESIA, ART OF

These coral atolls, spread over a large area of the northern Pacific, received peoples and cultural influences from *Indonesia, *Polynesia and *Melanesia. Their barren nature has been used to explain the scarcity of painting and sculpture compared with the rest of *Oceania. Only in the Caroline and Palau islands were figures carved in wood and stone. The figures from Nukuoro resemble western Polynesian sculpture in their reduction of the human form to a combination of smooth geometric masses. Mortlock Island produced wood masks painted white and black to adorn the gable-ends of houses. Human figures were carved on Yap and the beams of men's houses carved and painted with naturalistic motifs. Truk Island canoes were adorned with prow ornaments carved as highly conventionalised birds. In the Palau Islands men's club-houses were decorated with carved and painted beams and posts. On the gable-end a large plank was carved in high relief with a female figure holding her legs apart to expose the genitalia. The head of the figure was made separately and affixed, and the plank was incised with realistically rendered mythological scenes. Beautiful bowls, some carved in the forms of birds, were varnished and inlaid with mother-of-pearl.

MIDDLEDITCH, Edward (1923–)

b. Chelmsford. English painter who has evolved a highly personalised imagery derived from nature and is commonly associated with the *Social Realist School.

Above: EDWARD MIDDLEDITCH *Sheffield Weir II.* 1954. 36×59¼ in (91·4×150·5 cm). Tate
Right: MICHIEL VAN MIEREVELT *Portrait of a Woman.* 1618. 24½×19⅞ in (61·6×50·5 cm). NG, London

MIEL, Jan *see* BAMBOCCIO, IL

MIEREVELD, Michiel Janszoon van (1567–1641)

b. d. Delft. Prolific Dutch painter who gave up *history painting to devote himself to portraits and became Court Painter to the Princes of Orange. His portraits have an aristocratic air but are plain and stiff in composition representing a stage before the introduction of *Van Dyckian influence.

MIERIS, Frans van, the Elder (1635–81)

b. d. Leiden. Dutch genre and portrait painter of high reputation whose luxurious handling of colour was especially suited to the depiction of jewellery and silks. He was Gerrit *Dou's favourite pupil.

MIGNARD, Pierre I (1612–95)

b. Troyes d. Paris. French painter, *Lebrun's rival and successor as First Painter to the King. He studied under *Vouet and established his reputation in Rome (1636–57), but his classicism was unoriginal and inflexible. His best works are his allegorical portraits.

MIJNNESTEN, Jan van see MASTER IAM OF ZWOLLE

MIKON (active 475/450 BC)

Athenian painter famed for his great battle scenes which may have influenced the *Penthesilea Painter. The ancient proverb 'easier than Butes' is said to have been first used about his painting of Butes as a helmet and an eye, the rest of the figure being hidden behind a rock.

MILAN, S. Ambrogio

Adjoining the †Romanesque Basilica of S. Ambrogio is the small church of S. Vittore in Ciel d'Oro, which has mosaics of St Victor in the dome. These are 5th-century works and show the close connections between Milan and Ravenna.

MILAN, S. Lorenzo

Built in the late 4th century near the imperial palace, it was a central-planned church with a portico. The octagonal Chapel of Saint' Aquilino on the south side (originally the baptistery) has mosaic apses with a youthful Christ seated among Apostles and an Ascension of Elijah, a didactic programme probably inspired by St Ambrose.

MILLAIS, Sir John Everett (1829–96)

b. Southampton d. London. English painter. The most naturally gifted painter among the original members of the *Pre-Raphaelite Brotherhood. With a miniaturist's technique, he was a consistent practitioner of the doctrines of truth to nature (1848–c. 1856). Millais, however, did not have the fertility of invention of *Rossetti, nor the compositional ease of *Hunt. He adopted an increasingly free painting style, concentrating on decorative groupings of form and harmonies of colour (from 1857). After 1870 he cultivated the popular subject, and painted more portraits, which showed his admiration for *Velasquez, *Gainsborough and *Reynolds. His later work, which went to support his ambitions in the landed gentry, varies in quality. He was made President of the Royal Academy (1896).

MILLARES, Manolo (1926–)

b. Las Palmas. Painter and promoter of modern art in Spain, he moved to Madrid (1955). Influenced by *Surrealism (1948), he began his Pictografías Canarias (1952). His style is close to *Tapiés. His pictures are made of burlap stretched taut, gashed or clenched in lumps and spattered with red, white and black paint. Inevitably they have associations with violence as well as with landscape.

MILLER, Alfred Jacob (1810–74)

b. d. Baltimore. Painter who studied with *Sully (1831–2) and in Europe (1833–4); went to Rocky Mountains and New Orleans (1837); visited Scotland (1840–2); settled in Baltimore (1842). Miller's watercolour sketches of Indians and the Western frontier are terse and rugged; later polished enlargements and popular portraits lost this pioneering freshness. His work parallels that of *Catlin and *Eastman, though he is less well known.

MILLER, Kenneth Hayes (1876–1952)

b. Kenwood, New York d. New York. Painter who studied with *Chase and *Cox at *Art Students' League, and with *Henri; exhibited at *Armory Show (1913); taught at Art Students' League (1911–31, 1933–6, 1944–52). An influential teacher, Miller painted realistic urban genre scenes with solidly modelled form, rigorous craftsmanship and intellectual coolness.

Far left: PIERRE MIGNARD *The Marquise de Seignelay and Two of her Children.* 1691. 76½×61 in (194·5×155 cm). NG, London
Left: JOHN EVERETT MILLAIS *The Woodman's Daughter.* 1851. 35×25½ in (88·9×64·8 cm). Guildhall Art Gallery, London
Right: KENNETH HAYES MILLER *The Shopper.* 1928. 41×33 in (104·1×83·8 cm). Whitney Museum of American Art, New York

MILLET, Jean-François (Francisque) (1642–79)

b. Antwerp d. Paris. Flemish landscape painter who spent the last twenty years of his life in Paris. His style derives from that of *Poussin and, more especially, Gaspard *Dughet, but sometimes reveals marked originality (eg *The Storm*, NG, London).

MILLET, Jean-François (1814–75)

b. Gruchy d. Barbizon. French painter who, after early lessons in Cherbourg, studied in Paris under *Delaroche. He first exhibited in 1840 and during the next decade painted portraits, and oils and pastels close to *Diaz in style and subject. He was at this period a significant painter of the female nude. By the late 1840s he had met all the *Barbizon painters and settled at Barbizon (1849), taking up landscape painting for the first time. He had begun to turn to contemporary subjects, such as *The Winnower* (1848), and *The Sower* (Salon, 1850–1). Other subjects were fishermen's families, wanderers, city-dwellers at work and peasants. He gave them a grandeur of form and composition which reflected his study of *Poussin and *Michelangelo. Although they were interpreted in the same way

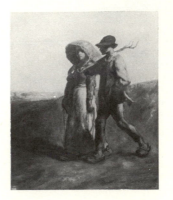

Left: JEAN FRANÇOIS MILLET *Going to Work.* c. 1850. 21⅞× 18⅛ in (55·6×46 cm). Glasgow
Above: JOHN EVERETT MILLAIS *The Sower.* Drawing. 5¾×8¾ in (14·6×21·2 cm). Ashmolean

as *Courbet's *Stonebreakers*, etc, his subjects do not have the special social significance of the latter's works. His figures impressed *Pissarro and *Van Gogh.

MILLMAN, Edward (1907–64)
b. Chicago d. Woodstock, New York. Painter who studied at Chicago Art Institute; lived in Mexico (1934–5); worked for *WPA (1935–41); painted a mural with *Siporin (1939–41); taught frequently. Millman's early realistic work was influenced by *Rivera; using landscape as his departure-point, he abandoned society for jagged, baroque, luxuriantly coloured *Abstract Expressionism.

MILLS, Clark (1815–83)
b. Nr Syracuse, New York d. Washington, D.C. Self-taught sculptor who lived in Charleston (1830s–50s) and Washington (1850s); invented new method of taking life masks, probably based on that developed by Isaac Browere (1790–1834), under *Houdon in Paris, and pioneered American bronze-casting. A leader of indigenous Yankee naturalism, Mills showed more technical ingenuity than artistic sensitivity, at best exhibiting a crude vigour in equestrian sculptures.

MILNE, David Brown (1882–1953)
b. Nr Paisley, Ontario d. Toronto. Canadian painter who studied at *Art Students' League; resident, New York (c. 1904–15), New England (1915–28) and Canada (from 1928); exhibited at *Armory Show (1913). Inspired by *Fauvism, Milne developed an intensely personal style in landscapes and still-lifes – singing patches of colour and loose line played against white space.

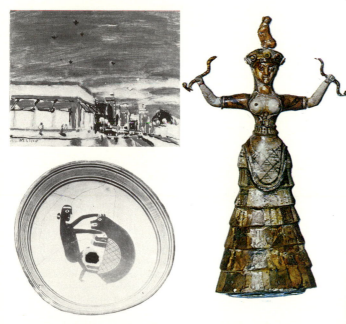

Top: DAVID MILNE *Stars over Bay Street.* 1942. 16×20 in (40·6×50·8 cm). NG, Canada, Gift from the Douglas M. Duncan Coll
Above left: MIMBRES Pottery bowl painted with a man and a bear. c. AD 1000–1600, Arizona and New Mexico. Peabody Museum, Harvard University
Above right: MINOAN ART Snake Goddess. c. 1600 BC. Faience. h. 17½ in (29·5 cm). Heraklion Museum, Crete

MIMBRES
North American Indian culture from Arizona and New Mexico in the *Southwest Area. A late phase of the Mongollon cultural tradition appearing about AD 1000 and declining at the start of the historic period. Famous for pottery, particularly shallow bowls painted with distinctive stylised animal, insect and human motifs in black on white.

MIMKA see **NEW GUINEA, SOUTH-WEST**

MINCHO (Kitsuzan Minchō) (1352–1431)
One of the earliest of the Japanese monochrome painters of the *Muromachi period, he was a monk at Tōfuku-ji, Kyōto.

MING DYNASTY PAINTING
Painters who, like *Wang Fu, followed the styles of the *Four Masters of late Yüan found little favour in the early Ming. At court the academic painters, liable to criticism on points of interpretation (as for instance *Tai Chin, said to have been dismissed for painting a fisherman's coat of the red colour reserved for officials) revived the styles of the Southern Sung, and the Hsüan-te emperor emulated Hui-tsung (*Chao Chi) in the painting of birds and flowers. Other professional artists, collectively known as the *'Che School', produced a brasher version of ink landscape styles. In the 15th century, however, the styles of the Yüan masters were taken up by literary men from Wu (Soochow), scholars and calligraphers of whom *Shen Chou was the earliest and leading master. The subsequent history of painting in the Ming, certain independent masters like *Ch'iu Ying and *Hsü Wei apart, is that of the dwindling importance of the professional and court group and the progressive acceptance of the scholars' styles. The latter, however, were weakened by copying and the appearance of various schools. None of these was to be of lasting importance until the theories of *Tung Ch'i-ch'ang brought ancient values and new life back to Chinese painting.

MING DYNASTY SCULPTURE see CHINESE BRONZE FIGURINES; CHINESE CERAMIC FIGURINES

MINIMAL ART
Movement during the 1960s involving *Judd, *Stella, Robert *Morris, Tony Smith, etc. Reacting against the *Abstract Expressionist cult of personal meaning, they denied that the subject is other than the form, or that the form is other than the material substance. Their large basic structures attempt to deny illusion, allusion, metaphor and symbol in favour of an overwhelming physical reality.

MINOAN ART
The art of the great civilisation which flourished in Crete (2500–1100 BC). Between 2500 and 2000 BC the inhabitants organised themselves into a civilised society with kings as their rulers. The first great palaces were built at Knossos, Phaistos and Mallia and rich polychrome pottery of the *Kamares type was produced (2000–1700 BC). The first palaces were destroyed (c. 1700 BC) and new, better planned palaces were built whose

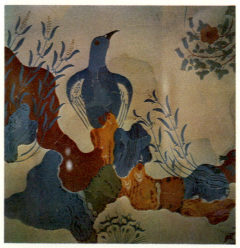

MINOAN ART Wall-painting from the House of the Frescoes, Knossos, Crete

walls were decorated with superb paintings. Favourite subjects were women, dancers, priests, bull-fights and marine scenes, including a whole repertory of dolphins, octopuses and other sea creatures. This *Marine style is also reflected in contemporary pottery, although in the Knossos region the more formal *Palace style was in vogue. The palaces were destroyed and never rebuilt c. 1400 BC. After that artistic standards declined and Minoan art became fused with *Mycenaean art.

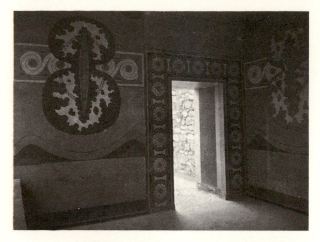

Above: MINOAN ART
Interior: verandah of the Royal Guard, Palace of Knossos, Crete
Left: MINO DA FIESOLE *Madonna and Child.* Marble. diameter 35½ in (90 cm). Bargello
Above right: JOAN MIRO *Triptych.* 1937. 54½×69¾ in (137·8×177·2 cm). Madame Marie Cuttoli Coll, Paris
Below right: JOAN MIRO *The Harlequin's Carnival.* 1924–5. 26×36⅝ in (66×93 cm). Albright-Knox Art Gallery, Buffalo, New York

MINO DA FIESOLE (1429–84)

d. Florence. Italian sculptor who began as a stonemason, then apparently trained under *Desiderio da Settignano. His portrait busts grow in characterisation from the stiffly Roman *Piero de' Medici* (1453) to the *Neroni* (1464). His principal monuments were the *Giugni* and *Count Ugo of Tuscany* (1469–81). He used the formula and manner of Desiderio but with elegance rather than vitality.

MINTON, John (1917–57)

b. Nr Cambridge d. London. English painter who studied in London and Paris; collaborated with Michael *Ayrton on the décor for Gielgud's *Macbeth* (1942). He painted imaginative scenes of the many countries he visited and also produced book-illustrations and portraits.

MINYAN POTTERY

A type of *Helladic pottery first found at Orchomenos in Boeotia, the legendary home of the Minyai, but made all over Greece. It was introduced by invaders, perhaps from Anatolia (c. 1900 BC). In shape the pottery is derived from metalwork and its yellow or grey colour is perhaps intended to imitate gold and silver.

MIR ALI HERAVI (d. 1544)

Calligrapher to Husein Bayqara (1470–1506) in Herat. Well known as 'Katib al-Sultani' the 'Calligrapher of the King'.

Later he went to Bukhara (1534) and worked in the Uzbek court. He wrote a treatise on calligraphy *Mi dad al-Khytut.* Before Mir Imad, he was the master of *Nasta'liq and produced remarkably beautiful script.

MIRKO, Basaldella (1910–)

b. Udine. Italian sculptor who worked under Arturo Martini in the 1930s. Mirko's post-war work is characterised by his enthusiasm for the primordial and by its technical sophistication. Inspired most directly by †Pre-Columbian civilisation, his sculpture can also be seen as heir to the *Futurist tradition.

MIRO, Joan (1893–)

b. Montroig, Catalonia. Painter who attended the School of Fine Arts, Barcelona and the Academy Gálí. He arrived in Paris (1919) where he met *Picasso and took an active part in the *Surrealist movement. By 1928, and his *Dutch Interiors* series, Miró had begun to establish his iconography of furled, round and hooked forms; always concerned with poetry, he gave his profusion of symbols a decipherable meaning, often combining benign with threatening forms. Later this obvious narrative element dissolves into a freer, more rounded and automatic use of form. Miró turned to graphic art on a large scale in the 1950s; his liking for brilliant primary colours persists through the body of his work. He manages to achieve an impression of freshness and spontaneity often literary in kind; in this, as in his concern with the form as sign, he is closer to medieval art than were any of his contemporaries.

MIR SAYYID ALI (mid 16th century)

*Safavid painter who, after working in the Tabriz court, travelled to India with the returning Emperor Humayun playing an important role in the establishment of the *Mughal School. The British Museum Khamsa Nizami (1539–43) shows his realism both in content and the individuality of his figures. *See also* HAMZA-NAMA

MISERICORD

The projection under a choir-stall seat, named from the Latin word meaning 'compassion'. When the chorister stands, and the seat is flapped up, the misericord provides a ledge for the chorister to rest on. Misericords are often carved with foliate patterns or humorous secular scenes. Most surviving examples are English and date from the 13th century onwards.

MISSISSIPPI CULTURES see EASTERN UNITED STATES AND CANADA

MITANNI see MESOPOTAMIA, ART OF

MITCHELL, Joan (1926–)

b. Chicago. *Abstract Expressionist painter who studied at Smith College (1942–4), Chicago Art Institute (1944–7) and Columbia University (1960s); visited Europe (c. 1947–9); moved to New York (1960). Influenced by *De Kooning, Mitchell moved from *Cubist-cum-†Impressionist abstractions to her mature style: Action Painting with a vengeance, violently brushed, dripped and spattered.

MITHUNA

Sanskrit: literally 'pair'; term used for amorous-couple motif on Indian temples.

MITSUNAGA (Tokiwa Mitsunaga)
 (active 1158–79)

Japanese painter, a member of the Painting Commission of the Emperor Goshirakawa. Some famous early handscrolls, the *Ban-dainagon*, are somewhat tenuously ascribed to him.

MITSUNOBU (Tosa Mitsunobu) (d. 1522)

Japanese painter, perhaps the most distinguished of the *Tosa School. Some famous handscrolls were formerly attributed to him.

MITSUOKI (Tosa Mitsuoki) (1617–91)

Official head of the Japanese Imperial Academy, as were his descendants, and perhaps the last of the *Tosa School to show any great talent.

MIXED METHOD

The combination of two or more media in one work – eg ink, *pastel and *watercolour, or *oil paint on top of *tempera, or vice versa.

Left: MITSUOKI *Quail*. 17th century. Ink and colours on silk
Right: MODELLING Wax model for sculpture by Michelangelo.
V & A London

MIXTEC

The Mixtec appear to have taken over *Zapotec centres in Oaxaca during the post-Classic Period (c. AD 900–1519), and an important centre of Mixtec culture at Puebla had considerable influence upon the *Aztecs at this time. The Mixtec were superlative craftsmen, particularly skilled in metalworking, mosaic and manuscript-painting. They also made fine pottery and carved in stone and bone.

MIYAMOTO MUSASHI see NITEN

MOBILE

Sculpture built of separate elements that can move, being articulated by balanced pivots and links.

MOCHI, Francesco (1580–1654)

b. Montevanti d. Rome. A Florentine sculptor who spent much of his career in Rome and Piacenza. His *Annunciation* at Orvieto (1603–8) is one of the seminal pieces of †Baroque sculpture.

Left: FRANCESCO MOCHI *Virgin Annunciate*. 1603–8. Marble. Museo dell'Opera del Duomo, Orvieto
Above: MOCHICA 'Portrait' vessel in the form of a man's head, painted red, white and brown. Peru. h. $8\frac{1}{2}$ in (21·6 cm). Royal Scottish Museum

MOCHICA

Peruvian civilisation, named after the temple site of Moche in the Chicama Valley, which was widespread in northern and central regions (c. AD 200–700). The Mochica produced textiles, carvings in wood, stone and bone, and gold and silver ornaments inlaid with shell and turquoise. Their most outstanding artistic achievements are in ceramics which have a unique pictorial quality, particularly the mould-made stirrup-spout vessels representing naturalistic forms of animals, plants and figures, portrait heads and a range of scenes from everyday life. The detail is modelled, or painted in red on cream.

MODELLING

The process of making sculpture by building up the form with pliable materials, adding to it and manipulating it.

MODELLING STAND

A tall stool-like stand enabling the sculptor to work on a small or bust-sized model at a convenient height. Sometimes the top revolves.

MODELLING TOOLS

A range of specially shaped trowels and spatulas for *modelling in clay and wax, with miniature rakes and scrapers for removing excess material.

MODELLO

Modelled sketch for large sculpture.

MODENA CATHEDRAL *see* **WILIGELMO**

MODERN STYLE *see* **ART NOUVEAU**

MODERSOHN-BECKER, Paula (1876–1907)

b. Dresden. German painter who visited Paris twice before exhibiting her most important works in Bremen. Contact with *Van Gogh, *Cézanne and *Gauguin greatly affected the work of this individual *Expressionist, so that her portrait, peasant and landscape subjects achieve an unusual synthesis between French and German elements.

MODHERA *see* CHAULUKYA DYNASTY

MODIGLIANI, Amedeo (1884–1920)

b. Leghorn d. Paris. Italian painter, whose first teacher was the Italian †Impressionist Micheli. Four years later he attended the art schools of Florence then Venice, arriving in Paris (1906) where he especially admired the work of *Toulouse-Lautrec, *Matisse and *Bonnard. Modigliani drew and painted mostly portraits. Artist friends and voluptuous mistresses were alike described in single continuous lines, fluid curves elongating limbs and features, the figures sharing a dignified, withdrawn pathos. He died aged thirty-six from tuberculosis hastened by self-neglect.

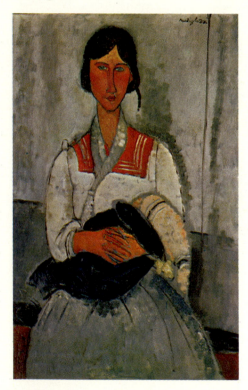

MOGOLLON *see* MIMBRES

MOHENJO-DARO *see* INDUS VALLEY CIVILISATION

MOHOLY-NAGY, Laszlo (1895–1946)

b. Bacsbarsod d. Chicago. Hungarian painter, designer, sculptor and important teacher and writer who became involved with *Constructivism (1920s) and taught at the Weimar *Bauhaus. Moved to Holland (1934), London (1935) and Chicago (1937) where he became Director of the New Bauhaus. His interest in the dynamic effects of light led to important experiments with photography and influential sculptural constructions (eg *Light-Space Modulator*, 1921–30). In Chicago he was involved with industrial design and made a number of plexi-glass sculptures in which he explored the light-refracting possibilities of the material with a rare degree of refinement.

MOIREE

Illusionist pattern of light and shade caused by interference of contours.

MOISSAC, St Pierre, Languedoc

The giant †Romanesque *tympanum (c. 1115–30) represents the Apocalyptic vision of Christ combining the visionary quality of Spanish manuscript commentaries with the drapery style of *Cluny. The lobed jambs derive from Moorish architecture. The disposition of the sculpture and the style were influential. The cloister (c. 1100) has reliefs of Apostles and a magnificent series of capitals. In some of these can be seen the influence of †Early Christian sculpture.

Above: MOISSAC, ST PIERRE *Three Elders.* Detail of tympanum. *c.* 1115–30
Left: AMEDEO MODIGLIANI *Gypsy Woman with Baby.* 1918. 45×28¾ in (114·3×73 cm). NG, Washington DC, Chester Dale Coll

Right: LASZLO MOHOLY-NAGY *Light Space Modulator.* 1930. Metal and plastic. 59½×27½×27½ in (151×69·9×69·9 cm). Busch-Reisinger Museum, Harvard University

MOKUBEI (Aoki Mokubei) (1767–1833)

One of the most distinguished and eclectic of the Japanese studio potters, who also painted in a bold and highly coloured version of the *Nanga style and is considered one of the greatest exponents of the style.

MOLA, Pier Francesco (1612–66)

b. Coldre d. Rome. Roman High †Baroque painter and President of the Academy of St Luke. His quasi-romantic style of warm brown tonalities, which owed something to *Guercino and the Venetians, involved a partial rejection of his classical training under *Albani.

MOLDAVIA

Monasteries with large churches painted with frescoed exteriors were built in the hills of present-day Roumania by the Princes of northern Moldavia (16th–early 17th century). The first church of the series, St George at Suceava (1514–22), still has some fragments of exterior paintings; but better preserved are the frescoes of Moldovitsa (?1532), Humor (1535), Voronets (1547) and the latest of the series Sucevitsa (1601). Some earlier Byzantine churches did have exterior decoration, but the scheme of painting one cycle on the outside of the church to convey Christian teaching to the laity (eg the Last Judgement) and another cycle on the inside for the aristocracy and monks is best represented in Moldavia.

MOLENAER, Jan Miensz (c. 1610–68)

?b. ?d. Haarlem. Dutch genre painter and engraver who spent part of his career in Amsterdam. Like his wife, Judith *Leyster, he was a disciple of Frans *Hals, but stylistically his paintings often bear more resemblance to those of Frans's brother, Dirk. The quality of his work declined after his marriage, when he took to painting peasant scenes in the manner of *Ostade.

MOLINARI, Guido (1933–)

b. Montreal. Canadian painter and sculptor who studied in

Montreal at Ecole des Beaux-Arts and Museum of Fine Arts; was member of Association des Artistes non-figuratifs de Montréal. Molinari's mature hard-edge abstractions are serial arrangements of parallel, equal stripes, their vibrating colour contrasts allying them with *Op Art.

MOLL, Oskar (1875–1947)

b. Silesia. Painter who formed part of the 'German *Matisse Group' in Paris, with *Levy and *Purrman (1907). He became Director of the Breslau Academy (1918), to which he brought *Muche. His work, condemned by the Nazis as 'degenerate', developed away from Matisse towards *Cubism.

MOLYN, Pieter de (1595–1661)

b. London d. Haarlem, whose guild he joined (1616). Dutch painter influenced by Esaias van de *Velde's naturalistic landscapes, he painted predominantly dune scenery, tonally unified without the traditional division into planes. He later specialised in finished chalk drawings.

MOMOYAMA PERIOD

In the rich and colourful days of the Momoyama period (1573–1614), with successive military dictators anxious to display not only their taste (via the tea-masters) but also their grandeur, the *Kanō School under *Eitoku had taken on a new decorative bent. In the main this was manifest in gorgeously coloured and boldly grouped paintings, often on screens or sliding doors, on a background of squares of gold leaf. This style was quickly adopted by other schools who set up in rivalry to the Kanō, often being themselves derived from the Kanō. The best of these schools was started by Hasegawa *Tōhaku, one of the greatest of Japanese painters, whose style is somehow more delicate than the Kanō. Another school was that of Kaiho *Yushō, who tried to regain the Chinese influence so much corrupted by the Kanō. Unkoku *Tōgan painted in ink in what he claimed was the spiritual descent of the style of *Sesshū, but the school did not attract many followers.

MOMPER, Joos de, II (1564–1634/5)

b. d. Antwerp. Flemish mountain landscape painter and engraver who studied under his father, Bartholomeus; probably travelled in Italy, and became Court Painter at Brussels. The figures in his landscapes were frequently by other artists.

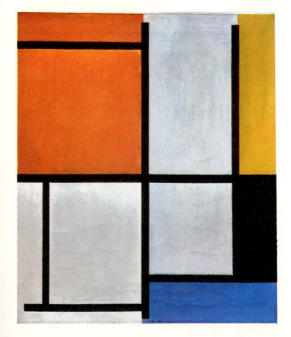

PIET MONDRIAN *Composition*. 1921. 19⅝×16⅜ in (49·5×41·5 cm). Kunstmuseum, Basle

MONAMY, Peter (?1670/89–1749)

b. Jersey d. London. An English marine painter who was possibly a pupil, and certainly a disciple, of Willem van de *Velde the Younger.

MONDRIAN, Piet (Pieter MONDRIAAN) (1872–1944)

b. Amersfoort d. New York. Dutch painter who studied at Amsterdam Academy of Fine Arts (from 1892). At Domberg (1908–11), Mondrian's art began to reflect modern tendencies, especially *Post-Impressionist and *Fauve. In Paris (1911–14), Mondrian's development was accelerated and concentrated in contact with *Cubism which he abstracted to the extreme simplicity of the '+ and −' paintings (1914–17). In Holland (1914–19), confirmed by the philosopher Schoenmaekers in his mystical search for pictorial symbols for 'universal' as opposed to 'particular' reality, he moved to complete abstraction (1917). *De Stijl provided a focus and platform for his theory and practice of abstraction or *Neo-Plasticism (1917–25). In Paris (1919–38), London (1938–40) and New York (1940–4), limiting himself to the most abstract 'universal' means – straight lines and primary colours – he created a grid which, itself defining the rectangles, prevents their separation as 'objects' in space. An increasingly acute and dynamic balance culminates in the all-over vibrancy of *Broadway Boogie-Woogie* and *Victory Boogie-Woogie* (1944).

MONE, Jean (c. 1480–c. 1550)

b. Metz d. Malines. French sculptor, trained in France, Italy and Spain, who became Court Sculptor to Charles V. Principally active in Malines (after 1524/5). His chief works are alabaster tombs and altarpieces, which employ Italian †Renaissance architectural elements and were the first works of their kind to appear in the North.

MONET, Claude Oscar (1840–1926)

b. Paris d. Giverny. Initiated into *plein-air painting by *Boudin during his youth in Le Havre, he studied in Paris at

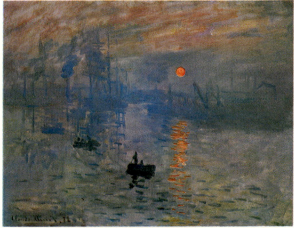

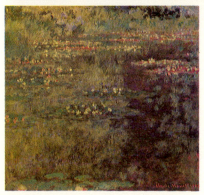

Above: CLAUDE MONET *Impression: Effet du Matin.* 1872. 19⅝×25½ in (50×65 cm). Musée Marmottan, Paris *Left:* CLAUDE MONET *Water-lilies.* 1904. 35½×36¼ in (90×92 cm). Louvre

the Académie Suisse (from 1859), where he met *Pissarro. After military service in Algeria he returned to Le Havre and was influenced by *Jongkind. He met *Renoir, *Sisley and *Bazille at *Gleyre's studio, Paris, and they began to paint outdoors together (1862). He studied the works of *Turner in England with Pissarro during the Franco-Prussian War (1870). He contributed *Impression-Sunrise*, which earned for the whole group the name †Impressionists, to a new exhibiting society he helped to organise (1874). His work came to represent the fullest expression of their principles, and he took part in four more Impressionist exhibitions. Monet began to paint series of *Poplars, Haystacks, Rouen Cathedral*, under various conditions and times of day (from 1890). Most famous of all are the *Water-lilies*, painted in his elaborate garden at Giverny, and completed in 1923 to decorate the Orangerie in Paris.

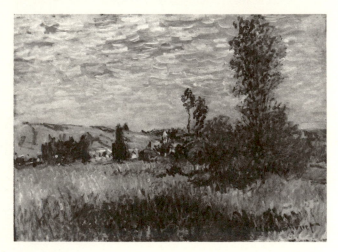

CLAUDE MONET *Vetheuil. c.* 1880. 23½×31½ in (59·7×80 cm). Glasgow

MONGOL PAINTING (late 13th–early 15th century)

Influenced by elements of †Byzantine classicism seen in the Baghdad School as well as native Iranian traditions and Chinese style, the early period is characterised by the Manafi al-Hayawan, the *Jami al Tawarikh and the *Demotte Shah-nama. The fusion of these traditions resulted in a more animated composition, with a richer palette at the same time retaining subtle colour tones. A more linear character emerges with the use of a high horizon, filling the designated area with formalised landscape as an arena for the dramatic action which occupied the centre or lower half of the illustration. The works of this period strongly influenced the styles of later Iran, spreading into *Mamluk Egypt and Syria in decorative ideas, forms and conventions.

MONNUS

Roman mosaicist who signed a big floor mosaic now in the museum at Trier. The mosaic is divided into octagons and squares, each of which contains representations of poets and writers such as Menander, Virgil and Aratos. It dates from the 3rd century AD.

MONOCHROME

In one colour, without colour. *Grisaille is a special form of monochromatic painting.

MONOPRINT *see* MONOTYPE

MONOTYPE

Single print made by printing from paint or printer's ink applied to a flat surface – say, glass sheet. Only one print can be taken, after which the surface has to be re-inked, repainted and redrawn.

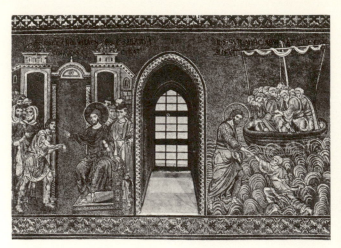

MONREALE CATHEDRAL Nave mosaics showing (*left*) Christ healing the man with a withered hand and (*right*) saving St Peter from the tempest. 1180–90

MONREALE CATHEDRAL, Sicily

This cathedral, to the south of Palermo, was founded by the Norman King of Sicily, William II. The vast *mosaic scheme of decoration was probably completed in the 1180s. The mosaics must have been executed by a †Byzantine workshop newly brought to Sicily, since they exhibit the late 12th-century 'agitated' style of the Greek East at its best. The cloister is a particularly florid example of Sicilian †Roman-esque, amalgamating various styles. There is †Islamic influence in the patterns of inlaid stone in alternating pairs of columns and the pointed arches. The carved corner columns and the rich series of double capitals are indebted to classical models.

MONSTRANCE

This liturgical vessel, introduced in the 14th century with the Corpus Christi processions, is a container for the display of the Host. Monstrances with a filigree of elaborate architectural details could be up to seven feet tall. In a smaller, more popular form, golden rays surround and emphasise the Sacrament.

MONTAGE

Combined images in a design; usually, superimposed photographic images.

MONTAGNA, Bartolommeo (c. 1450–1523)

b. Nr Brescia d. Vicenza. Italian painter active in north-east Italy. Early influences derive from Padua and later from Venice, especially the *Vivarini, *Antonello da Messina and Giovanni *Bellini. His style is relatively monumental, his forms solid.

MONTANES, Juan Martínez (1568–1649)

b. Alcalá La Real d. Seville. Spanish painter, architect, but above all, sculptor, whose painted wooden statues earned him the epithet of 'the god of wood'. A master of †Baroque realism, his work is now mostly in Seville.

MONTESPAN (Magdalenian)

†Palaeolithic site in Haute-Garonne, France. The cave contains some Magdalenian engravings on the walls and a beautiful horse drawn with a finger on the clay surface of a wall. The most famous objects are the clay models, one free-standing, the other leaning against the wall. The first is a crouching (?)bear, the body covered with holes as if jabbed with a spear. In the neck is a deep hole and at the feet was found the skull of a young bear apparently fixed to the neck. The back is very smooth, and was perhaps covered by a skin. The second model is assumed to be a lion, but only the fore-quarters and part of the head remain. It too is pierced with holes, particularly in the chest. The finger-drawings on the walls also indicate holes. This has given rise to a suggestion of sympathetic hunting magic.

MONTICELLI, Adolphe Joseph Thomas (1824–86)

b. d. Marseille. Artist of Italian extraction. After studying at Marseille he continued under *Delaroche in Paris but was more influenced by copying in the Louvre and by the works of *Delacroix and *Diaz. He spent much time in Marseille painting a variety of subjects, including flower-pieces and his own type of *fêtes galantes inspired by *Watteau. He worked rapidly in a technique of vigorous impasto and brilliant colour which had an important influence on *Cézanne and *Van Gogh.

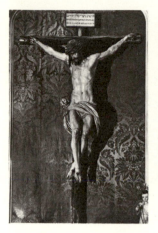 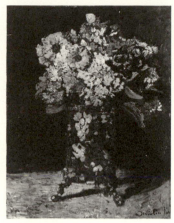

MONTOL see NIGERIA, NORTHERN

MONTORSOLI, Giovanni Angelo (?1507–63)

b. Montorsoli d. Florence. Sculptor who joined the Servite Order of the Annunziata. He assisted *Michelangelo in the Medici Chapel, where later he carved the St Cosmas (1532). For Clement VII he restored the *Laocoön and other antiquities. Profoundly influenced by Michelangelo, he is seen at his most vigorous in the Orion Fountain, Messina.

MOON, Jeremy (1934–)

b. Altrincham. English artist who started painting professionally in 1962. He has experimented with shaped canvases and with the use of two opposing systems within one work. His pictures are minimal in colour, and he rejects form and painterliness in favour of a rational structure and neutralised surface.

MOORE, Henry (1898–)

b. Castleford, Yorkshire. English sculptor in stone, wood and bronze; draughtsman. Studied at Leeds School of Art and Royal College of Art, London (1919–24). His early work combined naturalism with a certain primitivism. About 1930 wider experimentation began, his subject-matter ranging from characteristic Reclining Female and Mother and Child motifs to abstractions recalling natural organic forms; even the figurative work tended to abstraction. During World War II sculpture was difficult to practise owing to shortages of essential materials. Having previously executed much graphic work on sculptural ideas, Moore turned more exclusively to drawing, representing people sheltering underground or miners at work. This increased element of representationalism affected his sculpted work for a time. Since the war Moore has practised more clay modelling and casting, continuing to produce characteristic reclining figures but also locking pieces and fragmented compositions of emphatic formal impact, tempering his deep-rooted traditionalism with abstraction.

MOR, Sir Anthonis (Antonio MORO)
(1517/20–1576/7)

b. Utrecht d. Antwerp. Flemish portrait painter, a pupil of *Scorel, who achieved an international reputation. He joined the Antwerp Guild (1547) and became Court Painter at Brussels (1549). He was then widely patronised at the courts of

Europe, between which he travelled until at least the early 1570s. He was in London to paint the betrothal portraits of Mary Tudor and Philip II (1554). His court portraits show little development, mostly following a set formula of pose, derived from *Titian and Moroni, who also inspired the calm and sometimes introverted dignity of his sitters. His feeling for detail of physiognomy and costume, however, is typically Northern.

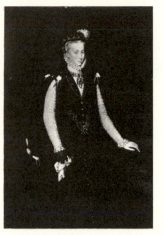 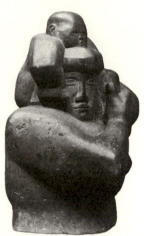

Opposite column left: JUAN MONTANES Christ of Compassion. Seville Cathedral
Opposite column right: ADOLPHE MONTICELLI A Vase of Flowers. Stedelijk, Amsterdam
Above left: ANTHONIS MOR Anne of Austria, Queen of Spain. 63¾×43¼ in (161×110 cm). KH, Vienna
Above right: HENRY MOORE Mother and Child. 1924–5. Hornton stone. 22½ in (57·2 cm). City of Manchester Art Gallery
Below: HENRY MOORE Recumbent Figure. 1938. Hornton Stone. 35×52¼×29 in (88·9×130·2×73·7 cm). Tate
Bottom: HENRY MOORE Three Forms. Los Angeles County Museum

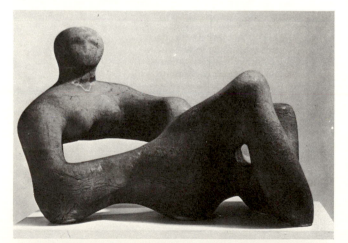

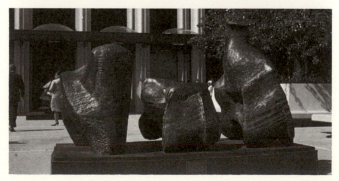

MORALES, Luis de (c. 1520/5–1586)

?b. d. Badajoz. Spanish *Mannerist painter of religious subjects whose misty facial and drapery modelling shows the influence of *Leonardo, perhaps transmitted to him through the Dutch painter Sturmio. Leonardo's influence is also noticeable in his composition and landscape backgrounds. Morales injects into his work a sharp spirituality later epitomised by El *Greco.

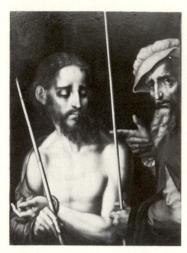

Left: LUIS DE MORALES *Ecce Homo.* 29⅝×22½ in (75×57 cm). Hispanic Society of America, New York
Below: GIORGIO MORANDI *Still-life.* 1959. 14×20 in (35·6×50·8 cm). Birmingham

MORAN, Thomas (1837–1926)

b. Bolton, England. d. Santa Barbara, California. Painter and printmaker who went to Maryland (1844); studied in Philadelphia (mid 1850s), in England (1862); visited Europe often; went on government expedition to West (1871); lived in California (1916–26). Influenced by *Turner, Moran produced vividly coloured, brilliantly lit sketches of the West.

MORANDI, Giorgio (1890–1964)

b. Bologna d. Grizzana. Italian painter whose early influence was *Cézanne. His painting shows a deep meditative assimilation of the genre objects of his studio, motifs which he paints repeatedly in differing groups, working always in isolation. Influenced by the *Metaphysical School (1918), he produced unobserved images in pale colours with the simple solidity of *Giotto. Returning to observation (c. 1920) he painted both still-life groups and landscapes, applying the paint more freely and employing the controlled light of *Piero della Francesca.

MORANDINI, Francesco *see* POPPI

MORAZZONE (Pier Francesco MAZZUCHELLI) (1571–1626)

b. Morazzone d. Piacenza. Milanese fresco- and *history-painter who studied in Rome (c. 1592–8) and Venice, and decorated many of the pilgrimage churches in Lombardy. He died while working on the dome of Piacenza Cathedral.

MORBIDEZZA

Italian: 'softness', 'delicacy'. Sometimes used to describe the softened contours and merging tones of *Correggio's style.

MORDANT

Corrosive *acid solution used in etching. *See also* ENGRAVING

MOREAU, Gustave (1826–98)

b. d. Paris. French painter, a student of Picot. Showed an early love of richly handled paint under *Delacroix's influence. His early work also shows an admiration for *Chassériau. His first mature statement was *Oedipus and the Sphinx* (1864), the first of a series of historical and mythical figures or legendary beasts, realised with an almost lapidary quality of paint, with the pig-ment itself often in relief. Subsequent work showed his fascination with elaborate detail and grandiose architectural constructions. His subjects full of cabbalistic imagery, reflect a general interest in the occult. A sympathetic teacher, his pupils include *Rouault, *Matisse and *Evenepoel.

Above: LOUIS GABRIEL MOREAU *Chez Naubet.* Engraving. 4⅜×6⅝ in (11×16·7 cm). BM, London
Left: GUSTAVE MOREAU *Jupiter and Semelé.* 1896. 83⅞×46½ in (213×118 cm). Musée Gustave Moreau, Paris

MOREAU, Jean Michel ('Le Jeune') (1741–1814)

b. d. Paris. French artist, younger brother of Louis-Gabriel *Moreau, who began by painting theatre decorations in St Petersburg. Returning to France, his delicate engraving and eye for detail, and costume, secured him the post of draughtsman of the king's *menus plaisirs. He also illustrated many literary classics.

MOREAU, Louis Gabriel (L'Aîné) (1740–1806)

b. d. Paris. French landscape painter, elder brother of Jean Michel *Moreau, of the Ile-de-France, whose freshness of vision seems to anticipate *Corot. His etchings rank among the most skilful of the period.

MOREELSE, Paulus (1571–1638)

b. d. Utrecht. Dutch painter and architect. His portraits resemble those of his master *Miereveld, while his mythological paintings developed from late *Mannerist formulae, through Utrecht *Caravaggism to a style influenced by *Rubens. He built St Catherine's Gate, Utrecht (1621–5) in an early †Baroque style.

MOREL, Jacques (active 1st half 15th century–d. 1459)

b. ?Lyon d. Angers. French sculptor, the most capable of all the followers of *Sluter. Worked in Lyon until 1423. His tomb of Charles I shows the deceased's acceptance of death with rare lack of sentiment, while his tomb of Agnes Sorel represents a move away from decoration to an uncluttered serious realism.

MORETTO DA BRESCIA (Alessandro BONVICINO) (1498–1554)

b. Brescia. Italian painter of altarpieces and religious subjects, a few interesting portraits are also known. He had a flourishing workshop and influenced the young *Veronese.

MORGNER, Wilhelm (1891–1917)

b. Soest, killed in action. Painter who studied in Worpswede (from 1908) and associated with der *Blaue Reiter (from 1912). He developed from a romantic naturalism to a *Nolde-like *Expressionism. His often religious subjects found a more mystical, abstract expression through *Kandinsky's example.

MORIKAGE (Kusumi Morikage) (active c. 1700)

Japanese painter, a pupil of *Tannyū, from whose studio he is traditionally supposed to have been dismissed. He was interested in genre scenes rather than decorative *Kanō-style painting. He is alleged to have designed the decoration for Kutani porcelain.

MORINOBU see TANNYU

MORLAND, George (1763–1804)

b. d. London. English painter of an idealised country life who trained under his father, Henry Robert, and worked mainly in Leicestershire, the Isle of Wight and the Home Counties. He specialised in stable interiors, ale-house doors and pigs.

MORISOT, Berthe (1841–95)

b. Bourges d. Paris. Instructed by Guichard, then *Corot (1860–6), she began to exhibit at the Salon of 1864, but after her introduction to *Manet (1868), whose younger brother she married (1874), she joined the †Impressionists. Her preoccupation with light in open-air and interior scenes of the serene life about her was controlled by a new attention to drawing from about 1889.

Left: MORETTO DA BRESCIA An Angel. 59½×20½ in (151×52 cm). NG, London
Above: JAMES WILSON MORRICE Ice Bridge over the St Lawrence. c. 1907. 23½×31½ in (59·7×80 cm). Montreal Museum of Fine Arts
Below: GEORGE MORLAND The Ale House Door. 1792. 24¾×30½ in (62·9×77·5 cm). NG, Scotland

MORO, Antonio see MOR, Sir Anthonis

MORONE, Domenico (c. 1442–after 1517)
Francesco (1471–1529)

The best-known painting by Domenico, b. d. Verona, is a long perspective townscape with figures, the Bonaccolsi Expelled by the Gonzagas (1494, Mantua), recalling Giovanni *Bellini and *Carpaccio. His son Francesco, also b. d. Verona, trained under his father and painted religious frescoes for the churches of Verona, eg Samson and Delilah. His work combines a knowledge of *Mantegna's firmness of form with the lyrical atmosphere of *Giorgione. Father and son worked together on the frescoes for the Convent of S. Bernardino (c. 1503). They founded a school in Verona.

MORONOBU (Hishikawa Moronobu) (d. 1694)

Japanese printmaker among the first great names in *Ukiyo-e, who has been called the consolidator of the style. A prolific illustrator of books, he also made large prints. He is especially notable for the vigorous outline delineation of his boldly placed groups of figures.

MORONOBU Three Ladies looking at Pictures. Dated 1683. Woodblock print (no colour). 8⅞×13 in (21·9×33 cm). Art Institute of Chicago, Buckingham Coll

MORRICE, James Wilson (1865–1924)

b. Montreal d. Tunis. Canadian painter who studied at Académie Julian and with *Harpignies in Paris; lived there (from c. 1890), travelling widely and returning often to Canada; painted in North Africa with *Matisse and *Marquet. Deeply influenced by *Whistler, Morrice painted with delicacy, low-keyed colour and formal pattern sense, later revered by modern Canadians.

MORRIS, George L. K. (1905–)

b. New York. Painter and critic who studied at Yale University School of Fine Arts and with *Léger and *Ozenfant in Paris (1930); made world tour (1933); was founder-member of American Abstract Artists. Influenced by *Arp, Morris plays with spatial ambiguities in his all too often mechanical geometric abstractions.

MORRIS, Kyle Randolph (1918–)

b. Des Moines, Iowa. Painter who studied at Chicago Art Institute and Northwestern University (c. 1935–40), and Cranbrook Academy (1946–7); taught at Stephens College (1940–1), Universities of Texas (1941–6), Minnesota (1947–51) and California (1952–4), and Cooper Union (1958). Morris's controlled *Abstract Expressionist paintings move rhythmically in dynamic stabs, slabs and slashing arcs.

MORRIS, Robert (1931–)

b. Kansas City, Missouri. Sculptor who studied at Kansas City Art Institute (1948–50), California School of Fine Arts (1951), Reed College (1954–5), and art history, Hunter

College (1961–2); abandoned painting for sculpture in New York (1960). Morris's basic geometric forms manufactured from industrial materials are *Minimal in everything but size.

MORRIS, William (1834–96)

b. Walthamstow d. Hammersmith. English artist. As a student at Oxford University, he was interested in Gothic architectural form and its †Romantic connotations, an interest briefly continued as an apprentice to the architect Street (1856). Not content with the design of contemporary houses and furnishings, he was rich enough to have a house built for him by Philip Webb, and to concern himself with its decoration. This reforming zeal crystallised in the formation of Morris, Marshall, Faulkner and Co, his own company, which employed *Rossetti, Madox *Brown and *Burne-Jones to design furniture, tapestries, stained glass and decorations. In the 1870s experiments in dyeing led him to examine the production of textiles and carpet-weaving. Similarly dissatisfied with the current resources of printing, he founded the Kelmscott Press (1890). The technical and stylistic advances he sought, he always hoped would accompany a reform of society.

Above: ROBERT MORRIS Untitled. 1966. Reinforced Fibreglass, polyester resin. 36×48×90 in (91·4× 121·9×228·6 cm). Whitney Museum of American Art, New York
Right: WILLIAM MORRIS Design for Daisy Wallpaper. 1862. Wood-block on paper. 27×21 in (68·5×53·5 cm). V & A, London

MORSE, Samuel F. B. (1791–1872)

b. Charlestown, Massachusetts d. New York. Painter and sculptor who studied with *Allston (1810), and *West in London (c. 1811–15); settled in New York (1823); with the *Grand Manner, Morse is at his best in elegant, painterly portraits, characterised by rich colour, solid form and psychological penetration. Discouraged by lack of success as a painter, he turned to scientific invention after 1832 and invented the telegraph and the Morse code.

MORTIMER, John Hamilton (1741–79)

b. Eastbourne d. London. English painter and etcher who studied under *Hudson, Pine and *Reynolds. His portraits are charming but he is chiefly important as a pioneer of English *history painting, choosing bizarre subjects from antiquity, English history and Shakespeare. He was a devotee of Salvator *Rosa.

MORTLOCK ISLANDS *see* MICRONESIA, ART OF

MOSAIC

Picture- or pattern-making by setting very small pieces of coloured material (*tesserae) in cement. In ancient times natural coloured stones and marbles, and glazed pottery tesserae were used, but after the invention of coloured glass in the Middle East, glass tesserae, including gold and silver foil sandwiched in glass layers were introduced. The tesserae were broken up into more or less uniformly small regular cubes. The

*cement into which they were embedded was an oil emulsion cement of a sticky nature which remained workable for a longer period than usual. The irregularity of surface is one of the pleasing qualities of glass mosaic.

MOSAICS, Byzantine

This technique of veneering architectural surfaces, especially curved vaults, with a *mosaic of glass, marble, terracotta or even precious stones became in the Middle Ages virtually a monopoly of Byzantine artists. They developed the medium to become much more than pictures executed in stone, creating a sparkling surface of saints and Christian scenes against blue, silver or gold backgrounds. The high point of this development was between the 9th and 12th centuries, eg *Hosios Loukas and *Daphni. After this the medium, obviously an expensive one, faltered. Late Byzantine miniature mosaics and the rare monumental commissions like the *Istanbul Kariye Camii, have the appearance of paintings. Byzantine mosaicists were employed outside the Empire, eg in Russia, Sicily, Venice and in the Islamic Empire and these decorations show what the lost mosaics of Constantinople were like.

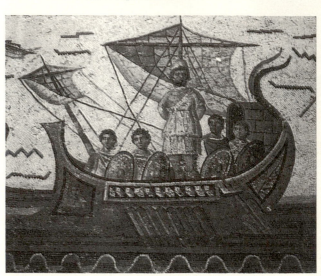

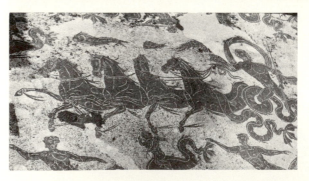

Top: MOSAIC Ulysses tied to the mast of his ship; from Dougga. 3rd century AD. Bardo Museum, Tunis
Above: MOSAIC Neptune in his chariot, from the Battles of Neptune, Ostia. Late 2nd century AD

MOSAICS, Classical

The earliest floor mosaics are the pebble floors found in Greece from the 6th to 4th centuries BC. Those found at Olynthos (destroyed 348 BC) have elaborate figured designs in white on a black background. Mosaics of cut stone cubes (*tesserae) appear in the late 3rd and early 2nd century BC, and a large number were found at Delos. The technique of using very tiny tesserae, *opus vermiculatum*, gave *Hellenistic mosaicists the chance to indulge their passion for copying paintings, as can be seen in the famous *Alexander Mosaic from Pompeii. Most

Pompeian mosaics, however, were of the black and white type, a kind in which Rome and Ostia also specialised. More polychrome mosaics began to appear in Rome in the 2nd century AD, but widespread use of polychrome mosaics was confined to other parts of the Empire, notably Antioch and North Africa. An unusually rich series of polychrome mosaics of the North African type have been found in a 4th-century Roman villa at *Piazza Armerina in Sicily.

MOSAICS, Islamic

The most important examples of mosaic decoration in Islam are found in the Dome of the Rock in *Jerusalem (691), the Great Mosque of *Damascus (705–15) and the Great Mosque of the Umayyad Caliphs of *Cordoba in Spain (961–5). There is also a mosaic pavement in the Palace of *Khirbat al-Mafjar in the Jordan valley (743–4) which is predominantly geometric in its motifs, with a scene of lions and deer round a tree in a *Sassanian tradition. The three main examples of mosaic in Jerusalem, Damascus and Cordoba are all reported to be associated with †Byzantine assistance, either freely given or forcibly extracted from the emperor. In Syria the tradition of mosaic decoration was strong under the Byzantines, and it was natural that it should have continued under the Umayyad Caliphate (661–750), a dynasty with its capital in Syria at Damascus, as well as under their descendants in Spain. Byzantine motifs appear in the mosaics in Jerusalem in the Dome of the Rock, which consist of floral motifs and crowns decorating the interior of the building. Influence from Persia can also be identified. The exterior of the building was also once covered with mosaic, a Byzantine practice, but this has now disappeared. The courtyard of the Great Mosque at Damascus bears traces of mosaic which once decorated the whole of the mosque. The scenes are mainly of landscape scattered with palatial buildings, subjects which appear in Byzantine mosaics in Palestine, *Thessalonika, *Constantinople, *Ravenna and *Rome, but at Damascus figures are entirely absent. The mosaics at Cordoba are in a quite different tradition, using only floral motifs and *Kufic script to decorate the *mihrab*, the domes and the vaulting arches above the *mihrab*. Red, green, blue and white flowers decorate a gold ground. The motifs are related, it would seem, to the stucco panels of the Palace of Madinah al-Zahra (936) near Cordoba, rather than to any Byzantine tradition.

MOSAN ART

Twelfth-century metalwork style named after the River Meuse and based on the Imperial diocese of Liège. It avoided the distortions of the true †Romanesque of *Moissac or *Autun and produced works under direct antique and †Byzantine influence of a remarkable plasticity to be seen early in the font of *Rainer of Huy and the Stavelot Bible (BM, London, Add. 28106–7) and in the works of *Nicholas of Verdun (c. 1200) whose work seems to herald that of the Master of the Antique Figures in *Reims and the more general classicism of about 1200. The primary art of the Meuse was metalwork and it was here that Suger of *St Denis looked for goldsmiths.

MOSCHOPHOROS (575/550 BC)

Statue of a man carrying a calf on his shoulders, found on the Acropolis, Athens (now Acropolis Museum). It bears a dedication by (Rhom)bos. The man's body is firm and compact with the very heavy shoulders typical of *Archaic sculpture.

MOSCOW, Medieval art in

In the 12th century a settlement beside the River Moskva subordinate to the princes of Suzdalia, the town became the political and ecclesiastical capital of Russia in the 14th century. In 1448 the Russian Church became independent of Byzantium. The buildings in the Kremlin represent the beginnings of a distinct Russian art. The 14th-century paintings had been produced by immigrant Byzantines, eg *Theophanes the Greek, but by the 15th century *Rublev and *Dionisy had modified Byzantine traditions partly under Western influence.

Such Muscovite painters show an interest in showing figures in repose, planned compositions and the decorative effects of colour. This composite art received a further injection from Italian models in the 17th century, eg the frescoes of Trinity Church in Nikitniki (1652–3). This form of art ceased to develop with the policy of complete Westernisation under Peter the Great when St Petersburg superseded Moscow at the beginning of the 18th century.

MOSER, Lucas (active 1431)

German painter known from the inscription on a polyptych (dated 1431) in the parish church of Tiefenbronn (nr Pforzheim). The altarpiece shows scenes from the life of the Magdalen. Moser's style is rigorously realistic both in detail and in his observation of poses. His dun colour sacrifices some of the more obvious glamour of the *International Gothic style, but preserves its feline grace in his female saints.

Top left: LUCAS MOSER *Magdalen Altarpiece*. 1431. 118×94 in (299·7×238·3 cm). Tiefenbronn Parish Church
Top right: MOSCHOPHOROS Marble. h. 66 in (1·65 m). Acropolis Museum, Athens
Above: GRANDMA MOSES *Sugaring Off*. 1938. $18\frac{1}{4}$×$24\frac{1}{4}$ in (46·4×61·6 cm). Mr and Mrs Albert D. Lasker Coll, New York

MOSES, 'Grandma' (Anna Mary Robertson) (1860–1961)

b. Greenwich, New York d. Eagle Bridge, New York. Painter who spent all her life on farms, living in Virginia (1887–1907) and Eagle Bridge (from 1907). An authentic primitive, Moses learned painting by copying *Currier and Ives prints. Drawing on memories of rural life, she painted child-like, charming genre scenes and landscapes.

MOSSI

A people of the western Sudan originating, according to their traditions, with the union of a Mandingo hunter and the daughter of a Dagomba chief (a tribe now in northern Ghana) in the 11th-13th centuries. Their sons and grandsons founded the four Mossi kingdoms which dominate much of Upper Volta. These kingdoms inevitably incorporated many different peoples including the *Kurumba whose smiths are largely responsible for what is known as 'Mossi sculpture'. Their work includes wooden house-posts, figures carried in funeral processions and oval-faced masks surmounted by horns and either a human figure or a tall geometric superstructure.

MOSTAERT, Jan (c. 1475–c. 1555/6)

b. d. Haarlem. Netherlandish painter active from 1498 in Haarlem, whose early influence was *Geertgen. Dean of the Haarlem Guild (c. 1507–43) and Court Painter to Margaret of Austria (c. 1507–21). His portraits were fashionable in their use of sensitive outline and warm-toned colour, often with populated landscape backgrounds.

Left: JAN MOSTAERT
Portrait of a young man.
c. 1520. 38×29$\frac{1}{16}$ in (96·5× 74 cm). Walker Art Gallery
Right: MOSSI Mask surmounted by the figure of a woman. Wood. h. 42$\frac{1}{2}$ in (108 cm). Princess Gourielli, Paris
Far right: MOTONOBU
Pheasants and Paeonies. 16th century. Ink and colours on paper. Daisen-in, Daitokuji, Kyoto

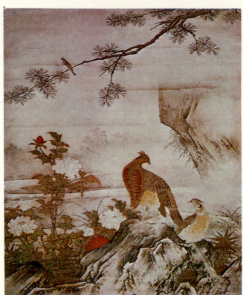

ROBERT MOTHERWELL *Pancho Villa, Dead and Alive.* 1943. Gouache and oil with collage on canvas. 28×35$\frac{1}{8}$ in (71·1×89·2 cm). MOMA, New York

MOTHE BORGLUM *see* BORGLUM, Gutzon

MOTHERWELL, Robert (1915–)

b. Aberdeen, Washington. Painter who studied at Otis Art Institute, California School of Fine Arts and several universities; moved to New York (1939); travels and teaches extensively. Influenced by *Surrealism, Motherwell is *Abstract Expressionism's intellectual; his refined collages and huge

canvases of abstract shapes show conflict between sensuality and cosmopolitan erudition.

MOTONOBU (Kanō Motonobu) (1476–1559)

Japanese painter, son of *Masanobu, who set the *Kanō School on a firm basis both financially and artistically. He introduced the decorative element into the Chinese-based style, possibly on account of his marriage to the daughter of Tosa *Mitsunobu, and set up a large studio to cope with the immense demand for his decorative works.

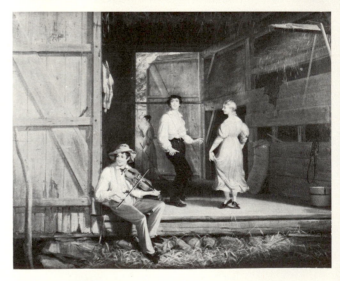

MOUCHERON, Frederick de (1633–86)

b. Emden d. Amsterdam. Dutch painter of decorative Italianate landscapes, like his teacher Jan *Asselyn. He worked in Amsterdam (from 1659), after three years in Paris and Rome. Specialist artists frequently painted his figures, a service he reciprocated.

MOUNT, William Sydney (1807–68)

b. d. Long Island, New York. Painter, first apprenticed as sign-writer (1824); studied at National Academy of Design (1826); worked in New York (1829–36); lived on Long Island (from 1837). Mount is remembered for his good-natured genre paintings, in which the firm clarity of his draughtsmanship establishes a monumental psychological and compositional unity.

MOUNT ATHOS

This Greek peninsula was already populated by hermits when the first monastery, the 'Laura', was founded (963) by St Athanasius with imperial support. Monastic foundations rapidly multiplied and have continued up to the present, rigorously excluding female visitors from the 'Holy Mountain'. Most of the wall-paintings belong to the 15th century or later, but some frescoes and mosaics from the Byzantine period survive, eg in Vatopedi, Chilandari, the 'Laura', and in the Protaton Church at Karyes, the village which acts as administrative centre for the twenty or so extant communities. Among icons, manuscripts and other objects are many major works donated from Constantinople, Thessaloniki, the Balkans and elsewhere. Athonite monks produced paintings and manuscripts, as well as wooden crosses for sale as souvenirs to pilgrims.

MOUNT SINAI

The fortified Monastery of St Catherine under Mount Sinai was built by the Emperor Justinian in the 6th century as part of his border policy to house both monks and soldiers as a garrison. He also erected the Church of the Theotokos which contains in the apse a well-preserved 6th-century mosaic of the Transfiguration of Christ. The monastery today owns a large and important collection of icons and manuscripts, some of which will have been produced in the monastery, but most must represent donations from various sources from all periods of its history.

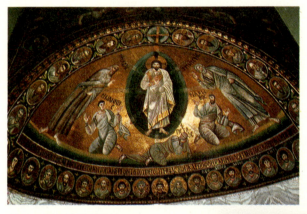

Above: MOUNT SINAI,
Monastery of St Catherine
The Transfiguration. c. 540
Left: WILLIAM SIDNEY MOUNT
Dancing on the Barn Floor. 1831.
25×30 in (63·5×76·2 cm).
Suffolk Museum at Stony Brook,
Long Island
Right: ALFONS MUCHA
La Dame aux Camelias. 1898.
Lithograph Poster. 82×30½ in
(208·3×77·5 cm). V & A, London

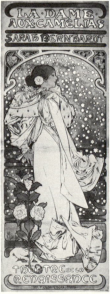

MUCHA, Alfons Maria (1860–1939)

b. Ivančice, Moravia d. Prague. The leading Czech *Art Nouveau designer, decorator and illustrator, trained in Vienna, the Munich Academy (1883) and Paris (from 1887), where he

became especially close to Sarah Bernhardt. Trips to the United States (from 1903) led to the great series of twenty paintings, *The Slav Epic* for C. B. Crane (1909–30). He settled in Bohemia (1910) and designed, among other things, postage stamps and bank-notes.

MUCHE, Georg (1895–)

b. Querfurt, Germany. Etcher and textile-designer who studied in Berlin and Munich (1912–15). He taught graphics at the Weimar and Dessau *Bauhaus (1920–7) and weaving at *Itten's School in Berlin (1927–31). Muche produced lithographs and *Klee-like etchings but by 1922 had abandoned pure abstraction for mobile natural forms and figure-painting.

MU-CH'I (active mid 13th century)

Chinese painter from Szechwan. A Ch'an monk, his works survive almost only in Japan, where they were brought by Japanese Zen Buddhist monks, sent to China to study in Ch'an monasteries. His landscapes display his use of ink-wash to suggest mist and atmospheric effects; in the triptych *Crane, Kuan-yin* and *Gibbons*, ink-washes subtly suggest the different textures of fur and feather.

MUDO, EL *see* FERNANDEZ DE NAVARRETE, Juan

MUDRA

Sanskrit: literally 'imprint'; ritual hand-gesture, which occurs in Asian dance, drama and religious sculpture; commonest Indian forms include *A-bhaya*, literally 'non-fear', gesture of reassurance; *Vara-da*, literally 'boon-giving', gesture of largesse; *Gaja-hasta*, literally 'elephant-trunk', formal sweep of the arm in classical Indian dance.

MUGHAL PAINTING: GENERAL

This subject is considered in greater detail under *Akbar; *Jahangir; *Shahjahan; *Mughal Painting, Late; *Mughal Painting, Provincial. These remarks relate to all its phases. Mughal painting is essentially secular (although mosque buildings might have their cut-plaster designs enhanced by geometric fresco-painting; and this painting might be paralleled by similar work in mosaic faience, mostly geometric under *Akbar, arabesque under *Jahangir, floral and calligraphic under *Shahjahan); it reflects the Mughals' attachment to the open air, especially the hunt and camp life. The palette is rich and varied, brushstrokes are delicate (stippling finds little place before Late Mughal painting); the viewpoint is regularly high, to show both exterior and interior of buildings, and the perspective may depend on different vanishing-points at different levels of the picture. The Persian side of its ancestry is shown in the *Herat-style tiled floors and walls, cypress trees laced by creeping flowering plants, and especially the persistent red rail-fences; features of the *Shiraz style sometimes appear in the landscape. Under *Akbar the paintings are often by more than one artist. The work of master artists was copied by tracings which were then pricked along the essential lines and used for copying by pouncing charcoal through; this was employed not only to train young artists but also by the masters to copy their own details; old tracings might be used in later reigns to copy portraits of earlier rulers. With the development of the *muraqqas under Jahangir, paintings of different sizes are accommodated in uniform album pages by elaboration of the *hashiya* (border); here the designs have affinities with those of bookbinding and those of architectural panels and dadoes. The influence of European artists appears first under Akbar through the Jesuit missions, later through James VI's ambassador Sir Thomas Roe, a connoisseur who was befriended by Jahangir. The Mughal styles had a profound effect on later Hindu painting of the *Rajasthan and *Panjab Hills schools.

MUGHAL PAINTING, LATE

The decline noticed under *Shahjahan continued under Aurangzeb (1658–1707) who through pietistic zeal discouraged

court artists and portraiture; some portraiture, however, continued, and campaigns continued to be illustrated (of sombre tints, with green and brown uniforms dominating the scene). Later emperors were less puritanical, but the dominant themes were rather romantic, elegant or melancholy: idealised harem or religious scenes, vast panoramas, night effects. Figures became more formalised, compositions more symmetrically disposed and the perspective more faulty; colours and modelling were somewhat over-emphasised, and dress and other ornament became over-rich.

MUGHAL PAINTING, PRE-

Evidence has been produced in recent years of flourishing schools of North Indian painting before the deliberate injection of Persianised styles which characterise the *Hamza-nama* and the productions of *Akbar's atelier; but there are signs of a less obtrusive Persian influence in the styles of some of the provincial Muslim courts. After 1450 the Persian classics began to be illustrated in some Indian provinces, with Persian features of composition and modelling mixed with the familiar western Indian *Jain conventions: the protruding eye is less used, but the figures are still stiff, the colours strong and female figures show a characteristic projecting head-garment. Such treatment appears first in the *Khamsa* of Amir Khusrau, of the late 15th century and ascribed to Delhi or Jaunpur; in the latter place the rule was Muslim, although it was a centre of *Jain painting, as shown by the *Kalpasutra* (1465), important for the evolution of later North Indian styles. Other works in this style include the Bharat Kala Bhavan's *Shah-nama*, a *Sikandar-nama* of Nizami, and the Tübingen *Hamza-nama*. By the end of the 15th century the Bharat Kala Bhavan *Laur-Chanda* manuscript, from Jaunpur, shows some departure from the earlier Jain tradition and the influence of the Turkoman style of *Shiraz. The Persian influence is even stronger in the India Office Library *Nimat-nama*, a sumptuous royal cookery book from Mandu in *Malwa, where Persian and Indian figures appear side by side in scenes of lush vegetation in an Indianised Shiraz style. Closer to the *Laur-Chanda* miniatures are those of the Agra *Aranyaka-parvan* (1516), and the extensive *Chaurapanchasika* of the Mehta Collection, Ahmedabad, of the middle of the 16th century. Another *Laur-Chanda*, in the John Rylands Library, carries this school further. Similar paintings are now coming to light from other North Indian centres, and presumably from these came the Indian artists trained in the Mughal style of the *Hamza-nama* of 1555. These Pre-Mughal schools were superseded by the productions of *Akbar's atelier, although the *Laur-Chanda* and *Chaurapanchasika* conventions survive in the Cleveland *Tuti-nama* and persist into the Provincial *Mughal styles.

MUGHAL PAINTING, PROVINCIAL

While the paintings in the ateliers of the court nobles followed the fashions of the imperial courts of *Akbar, *Jahangir or *Shahjahan, away from the courts a distinct style developed where the execution was cruder, and Hindu themes were frequently illustrated. The palette was more restricted and artists tended to use large areas of flat colour; planes of composition were simplified, and characters were often framed by parts of buildings. A horizontal format, rare in court painting, was preferred. The *Ragamala* theme (*Indian Painting: General) was popular, as were Hindi poems, such as the *Rasikapriya* illustrated in the Freer Gallery manuscript.

MUGGERIDGE, Edward James *see* MUYBRIDGE, Eadweard

MUKHALINGAM *see* GANGA DYNASTY

MULDENFALTENSTIL

German term describing a convention for representing drapery, current at the beginning of the 13th century. It originated in the trough-like folds and soft, clinging drapery employed by *Nicholas of Verdun. This *Mosan metalwork style was adopted by sculptors at *Chartres and *Reims. A drawn version of the style, indicating the troughs by loop-ended lines, occurs in the *Ingeborg Psalter, the drawings of *Villard de Honnecourt and parts of the *Bible Moralisée.

MULLER, Otto (1874–1930)

b. Liebau d. Breslau. German painter who studied in Dresden and Munich (1894–9), moved to Berlin (1908) and joined die *Brücke (1910) introducing his distemper technique. Inspired by *Jugendstil idealism, he painted pallid, melancholy nudes in landscapes, becoming gradually more sombre and static.

MULLER, William James (1812–45)

b. d. Bristol. English painter who studied in the late 1820s with Pyne and during the 1830s was strongly influenced by *Cotman and *Constable. Painted foreign subjects from a European tour (1834–5), and then Egyptian subjects from a tour to Athens, Alexandria and Cairo (1838–9). He was in Lycia (1841). Constable influenced his vigorous oil sketches.

MULREADY, William (1786–1836)

b. Ennis d. London. An Irish painter of genre scenes and conversation-pieces, he settled in London and was influenced by *Wilkie and the Dutch. His mature works from the late 1830s onwards (eg *The Sonnet*, 1839, V & A, London) are †Romantic in feeling and, in their light colouring, anticipate *Pre-Raphaelitism.

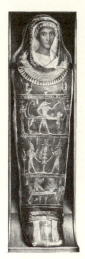

Left: WILLIAM MULREADY *Crossing the Ford*. c. 1842. $23\frac{7}{8} \times 19\frac{3}{4}$ in (60·5×45·1 cm). Tate
Right: MUMMY PORTRAITS Mummy of Artemidorus (with portrait). Roman period, 2nd century AD. Encaustic on wood, the case of stucco, painted and gilded. Life size. BM, London

MULTSCHER, Hans (c. 1400–67)

Sculptor and painter who lived and worked mostly in Ulm. Multscher's sculptural style must have been formed under the influence of Netherlandish art seen perhaps in Tournai or Dijon. He has thus been acclaimed the founder of monumental realism in the art of 15th-century Swabia. His most ambitious surviving work is the centrepiece (now dispersed) for an altarpiece at Sterzing, Vipiteno parish church in the Tyrol (erected in 1459), most remarkable for the physical projection into space of the lateral SS George and Florian. The (painted) wings (Multscher Museum, Sterzing) are by a hand different from that apparent in Multscher's known paintings (Berlin). *See also* MASTER OF THE STERZING WINGS

MUMMY PORTRAITS

The full-face portraits on mummies of Roman date, the majority from the Faiyūm, are quite un-Egyptian in inspira-

tion. They were executed in tempera, or, more often, in wax (the so-called *encaustic technique), sometimes on the actual wrappings, but mostly on wooden panels bound into them. The panel was normally about 43 × 23 centimetres and 2–8 millimetres thick, trimmed round at the top – though some were originally larger, and were probably not intended expressly for mummies, since one has been found framed. The ground was prepared with a coating of gypsum or whiting, on which the subject was outlined in black, or more rarely in red, with facial details indicated. The background, commonly grey, was brushed on thinly with liquid wax, and the hair and clothing were applied similarly. The flesh tones, which never reveal free brushmarks, were treated differently. The wax was laid on in a thicker, creamier state, with characteristic ridges suggesting that it was brushed continuously until it congealed, or that a rounded implement was used – perhaps the butt end of a brush, or one with fibres stiffened through use. Outlines were finally softened by scratching with a hard point, but there is no evidence that a spatula or a palette-knife was employed at any stage.

MUMUYE see NIGERIA, NORTHERN

MUNAKATA, Shikō (1903–)

A leading figure in contemporary Japanese woodblock-printing whose themes are based on early Buddhist prints.

MUNCH, Edvard (1863–1944)

b. Loeten, Norway d. Ekely. Painter and printmaker who studied in Oslo (1881–4). He worked in Paris and Germany (from 1889). His Berlin exhibition (1892) provoked violent controversy. Epitomising international *Symbolism he became the hero of the younger *Expressionists. After a breakdown (1908–9) he returned to Norway. Munch's early realism already possessed a heightened emotional content, eg *The Sick Child* (1885). In Paris (1889–90) contact with *Van Gogh, *Gauguin and *Toulouse-Lautrec confirmed this direction and added new formal means. The flat emphatic shapes of *Art Nouveau are used to express an intensely personal yet universal vision of the psychic realities of life, achieving his most powerful

Left: MUNATAKA *Tea Ceremony.* Contemporary. Woodblock colour print. 15¾ × 14½ in (40 × 36·8 cm). Ashmolean
Right: ALFRED MUNNINGS *Epsom Downs – City and Suburban Day.* 1919. 31¼ × 50½ in (79·4 × 128·3 cm). Tate
Below: EDVARD MUNCH *The Dance of Life.* 1899–1900. 49¾ × 75 in (125·5 × 190·5 cm). NG, Oslo

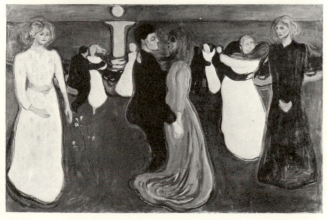

expression in the controlled economy of woodcuts (from 1896). After his breakdown, he painted realist scenes or milder repetitions of early themes.

MUNICH SCHOOL (2nd half of the 19th century)

Under the patronage of Ludwig I of Bavaria, an attempt to restore the dignity of German art by the foundation of a school of monumental painting in emulation of the mural achievements of the Italian †Renaissance. Its two principal painters were Peter *Cornelius, who decorated the Pinakothek and the Ludwigskirche, much influenced by *Michelangelo and *Signorelli, and Wilhelm von *Kaulbach, whose painting style was not so grandiose. The example of generous state patronage, the grandeur of scale and concept, and an apparent ability to create durable surfaces, drew aspiring mural-painters from England, Belgium and France.

MUNKACSY, Mihaly (Michael LIEB) (1844–1900)

b. Munkacs, Hungary d. Endenich, nr Bonn. He had an unfortunate childhood, little artistic training, but achieved European fame painting Hungarian peasant genres, still-lifes, figural compositions, portraits and *Barbizon-style landscapes. After stays in Vienna, Munich and Düsseldorf, he spent twenty-five years in Paris where his *Condemned Cell* won the gold medal at the World Exhibition (1870).

MUNNINGS, Sir Alfred (1878–1959)

b. Mendham d. Dedham. Painter who studied in Norwich. Elected Associate of the Royal Academy (1919), member (1925), President (1944–9). Munnings's immense popularity derives from his choice of the horse as favourite subject. He combines accurate observation with an elegant fluency.

MUNTER, Gabriele (1877–1962)

b. Berlin d. Munich. German painter who lived with *Kandinsky (1904–14) and participated in the founding of der *Blaue Reiter (1911). She moved to Murnau (1908) where, working with Kandinsky, she developed a *Fauvist style characterised by heavy outlines and non-naturalistic colour. A greater calmness distinguishes her work from Kandinsky's.

MURAL-PAINTING

Painting on a wall. May be painted direct on to the plaster, as in *fresco or *encaustic, or may be on a very large *canvas or *panel mounted on the wall's surface.

MURAQQAS

Islamic albums containing individual miniatures and specimens of the art of calligraphy. Particularly popular at the Ottoman and Mughal courts in the 17th and 18th centuries. *See also* TURKISH PAINTING; LEVNI; JAHANGIR

MURILLO, Bartolomé Esteban

b. d. Seville. Spanish painter. His earliest works date from 1640 and are influenced by *Zurbarán and *Ribera. He was the most successful painter in Seville (from 1645). His mature

style employs soft modelling and colours. His treatment of sacred themes (he is noted for his paintings of the Immaculate Conception) emphasise gentility and intimacy rather than spiritual intensity. He is consequently often judged sentimental, but his art reflects popular piety. He was also a gifted landscape painter in a Flemish idiom. His paintings of street urchins were popular with 18th- and early 19th-century collectors.

MURILLO, Gerardo see ATL, Dr

MUROJI, The

A Buddhist temple in Nara Prefecture, Japan. The most important sculptures of the early *Heian period are housed in this temple. They include a standing Shaka Nyorai, a seated Shaka Nyorai and figures of divine warriors.

Above: BARTOLOME MURILLO *The Immaculate Conception. c.* 1665. 67¾×112¼ in (172×285 cm). Louvre
Left: BARTOLOME MURILLO *Peasant Boys.* 63¼×41¼ in (160·7×104·8 cm). Dulwich College Picture Gallery
Below left: MUROJI Shaka Nyorai. Heian period, mid-9th century AD. Wood. h. 5 ft 4⅝ in (164 cm).
Below right: MUROJI Shaka Nyorai. Heian period, mid-9th century AD. Wood. h. 7 ft 10⅛ in (2·39 m)

MUROMACHI (1400–1573) SUIBOKU SCHOOL

The introduction of Zen Buddhism into Japan in the late 12th century had a profound effect on Japanese painting of the period, and stimulated interest in Chinese art. The *suiboku* or ink-wash technique of painting landscapes was taken from Chinese painters, notably *Mu ch'i, and first used in Japan by Zen monks who were almost professional painters. Among the earliest were *Minchō, and *Josetsu, whose *Catching a catfish in a gourd* uses landscape merely as a backcloth, but the landscape is in Chinese *Sung style. *Shūbun, said to be a pupil of Josetsu, visited Korea (1423–4), and consolidated the style in Japan, using the 'one-corner' convention of *Hsia Kuei and *Ma Yüan. It was *Sesshū, however, who having visited China (1467–9) and having become a member of the *Chê school, first made the style a Japanese one. Where Shūbun was essentially a painter of Chinese landscapes in Chinese style, Sesshū applied the technique in a personal style that was the forerunner of ink painting of later schools, particularly the *Kanō. Sōtan, a pupil of Shūbun, was among the better known monk-painters of Kyōto, while *Sesson, living in the north of Japan developed his own bold variation of Sesshū's style. During the Muromachi period, ink painting was virtually only practised by Zen monks, mostly living in temples round Kyōto. Among Sesshū's more notable contemporaries were two exceptions to this rule, Kanō *Masanobu, founder of the professional *Kanō School, who was a layman, and *Nōami, whose family became the *Ami School and who were Amida Buddhists.

MUYBRIDGE, Eadweard James (Edward James MUGGERIDGE) (1830–1904)

b. d. Kingston-on-Thames, England. Photographer who went to America (early 1850s); photographed animals and humans in motion with financial and technical assistance of Stanford, California (1872, 1877–8), and University of Pennsylvania (1884–7); lectured in America and Europe (1878–84). Muybridge completely changed most preconceptions about motion, influencing both anatomists and artists.

MYCENAEAN ART

The art which centred round Mycenae and Tiryns (1400/1100 BC). It supplanted *Helladic and *Minoan art although in many ways it is influenced by the latter. The best-known products of Mycenaean art are the gold and silver vessels, the bronze swords inlaid with precious metals and the gold funeral masks found in the tombs at Mycenae. The Mycenaeans were also very skilled potters as is seen by the stemmed goblets and 'stirrup jars' which were the most popular shapes. These were decorated with a repertoire of realistic, if somewhat stylised, patterns. The Lion Gate at Mycenae, with its large relief sculptures of two rampant lions with their paws resting on twin altars, showed that the Mycenaeans could also produce monumental sculpture.

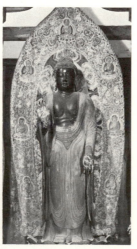

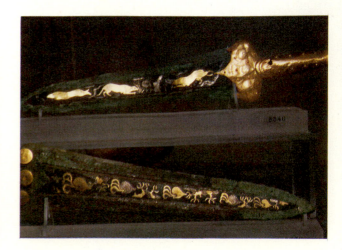

MYERS, Jerome (1867–1940)

b. Petersburg, Virginia d. New York. Painter who studied at Cooper Union, *Art Students' League and in France; helped organise *Armory Show (1913), where he exhibited. His urban genre scenes, painted in sombre glowing colours, show a relish for formal pattern and intimacy of feeling outside the mainstream of American urban realism.

MYRON (active 480/445 BC)

Greek sculptor who made a famous Diskobolos showing an athlete at the top of his swing. He lived during the period of experimentation in Greek sculpture and was interested in rendering the human body in a variety of positions. In the *Diskobolos* he succeeds in harmonising the frontal torso with the legs in profile.

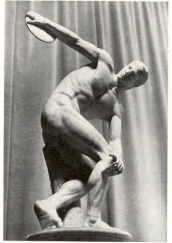
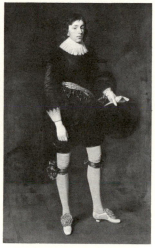

Left: MYRON *Discobolos* Roman copy of Greek bronze original. Life-size. National Museum, Rome
Right: DANIEL MYTENS *1st Duke of Hamilton as a Boy.* 1624. 79×49½ in (201·9×125·7 cm). Tate

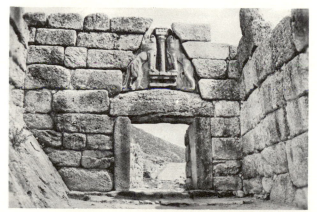
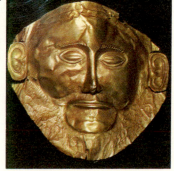

Above: MYCENAEAN ART The Lion Gate, Mycenae. 14th century BC
Left: MYCENAEAN ART Bronze dagger blades inlaid with gold, silver and niello. 16th century BC. National Museum, Athens
Right: MYCENAEAN ART Gold death mask of a Mycenaean king, the so-called 'Mask of Agamemnon'. National Museum, Athens

MYSTRA

A fortified hill-town near Sparta, originally founded by the Frankish Prince Guillaume de Villehardouin in 1249, from 1262 to 1460 it played an important strategic role in the diminishing Byzantine Empire. It was ruled by despots, often relations of the Byzantine emperors, under whom palaces and churches were built. The churches still contain much important fresco-work of the period. The most extensive cycles survive in the cathedral (St Demetrios), the Church of the Hodigitria (Aphendiko), St Sophia, the Pantanassa and the Peribleptos, whose frescoes (second half of the 14th century) are executed in brilliant colours and crammed with detail.

MYSTRA, Peribleptos church. Wall-painting of the Nativity. 14th century

MYTENS, Daniel, the Elder (c. 1590–before 1648)

b. Delft d. The Hague. Taught by ?*Miereveld, he spent much of his career in England (c. 1618–c. 1635). He was appointed Painter to Charles I (1625), and executed several rather stiff royal portraits before the arrival of *Van Dyck (1632).

N

NABIS

A group of painters active in Paris (from 1889). The group, mainly of students at the Académie Julian included *Sérusier, *Bonnard, *Denis, *Ranson, *Roussel, Ibels, Piot, *Verkade, *Vallotton, *Maillol and the Hungarian Joseph Rippl-Ronaï. Their stylistic and philosophical inspiration came from the theories of *Gauguin, *Bernard and the *Pont-Aven School, as relayed to them by Sérusier. Gauguin's works shown in 1889 at the Café Volpini were also influential. The common denominator of Nabi activity was an emphasis on the graphic arts, the multiple images of woodcut and lithograph, on decorative panels in the traditions of Japanese art, and on murals, rather than framed canvases for the Salon. Experiments in tempera and on absorbent cardboard sought to eliminate the glossy surface of oil paintings. An important area of work was painting sets and costumes for the theatre. Designs were also made for furniture, mosaics, tapestries and stained glass. After 1900 individual members tended to follow their own directions.

NADELMAN, Elie (1882–1946)

b. Warsaw d. New York. Sculptor who studied in Warsaw and Munich: lived in Paris (c. 1903–15); went to America (1915); exhibited at *Armory Show (1913) and with *Stieglitz.

Nadelman eliminated detail from his witty, elegant figures of high-society types and terracotta figurines, revealing graceful, spherical volumes and refined serpentine contours.

 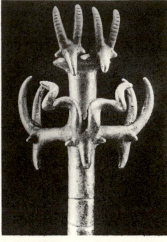

Left: ELIE NADELMAN *Man in the Open Air. c.* 1915. h. 54½ in (137·2 cm). MOMA, New York
Right: NAHAL MISHMAR Copper wand surmounted by a gazelle or goat's head and a ram's head. *c.* 3400 BC. Israel Museum, Jerusalem

NAGA

Sanskrit: literally 'serpent'. Indian mythological creature usually identified with the cobra and depicted in sculpture as a male or female anthropomorphic figure with seven cobra-hoods behind the head. The naga was regarded as a benevolent protective spirit, although the same motif also occurs as a dragon subdued by Krishna. The cobra-hoods also appear behind the heads of certain *Vishnu images.

NAHAL MISHMAR (*c.* 3400 BC)

Recent discoveries in the cave of Nahal Mishmar on the west side of the Dead Sea have brought to light a hoard of over four hundred copper objects: crowns, wands and sceptres. One of the wands is surmounted by a number of gazelle or goats' heads with a single ram's head, all stylistically portrayed. *See also* SYRO-PALESTINIAN ART

NAIRN, James (1859–1904)

b. Lenzie, nr Glasgow d. Wellington, New Zealand. A Scottish genre, portrait and landscape painter taught by Greenless and McGregor. He went to New Zealand where he became well known as an artist and teacher (1889).

NAKHT *see* THEBAN TOMBS

NAKIAN, Reuben (1897–)

b. College Point, New York. Sculptor who studied at *Art Students' League (1912) and with *Manship (1916–20); visited France and Italy (1931–2); worked for *WPA; was closely associated with *Lachaise, *Gorky and *Brook. Using classical mythological themes, Nakian moved from realism to richly textured *Abstract Expressionist bronzes and terracottas.

NALDINI, Battista (1537–91)

Florentine painter. Trained under *Pontormo (*c.* 1549–57), then after studying in Rome became *Vasari's assistant (*c.* 1562). His work was influenced by both masters, and through them, by Andrea del *Sarto. Eclectic and facile, Naldini evolved (eg *Gathering of Ambergris*, Palazzo Vecchio, Florence) a painterly *sfumato style more decorative than naturalistic.

NALU *see* BAGA

NAMAU *see* PAPUA, GULF OF

NANGA SCHOOL

The Japanese Nanga, or Southern style is also called *Bunjinga*, or 'scholar's painting', and is the equivalent and later offshoot of the Chinese Wên-jên-hua. The scholar-painters of 18th- and 19th-century Japan looked back to Chinese painting for their models, trying to avoid the corruption of Chinese styles then used by the degenerating *Kanō School. Whereas *Sesshū and the *Muromachi suiboku school had taken northern Chinese painting as their model, the *Nanga artists tried to look back to the Southern style, with its greater freedom and reliance on intuitive spontaneity. In fact they saw *Ch'ing paintings and print-books such as the *Mustard Seed Garden*. Several Chinese artists visited Japan at the beginning of the 18th century, notably Shen Nan p'in who visited Nagasaki (1731–3) and attracted many followers. The earliest Nanga artists (eg Gion Nankai) were rather stiff and formal painters, and it was *Taiga and *Buson who made Nanga into a great Japanese art form. Later in the 18th century Uragami *Gyokudō produced his brilliant unconventional landscapes, while the greatest names of the 19th century were the rather academic *Chikuden and the famous potter *Mokubei. Many Nanga artists were skilled at other styles, notably Tani *Bunchō who could paint in almost any style, even Western, and Yamamoto *Baiitsu and *Gesshō who were excellent *Shijō School artists. Watanabe *Kazan has been overpraised, but was a fine painter, sometimes of portraits, while the last really good painter who adhered closely to the school was Chokunyu. Tomioka *Tessai, one of the greatest names of all, was, like *Gyokudō, much more individual.

NANNI DI BANCO (*c.* 1387–1421)

Florentine sculptor, who by 1406/7 was working on the Cathedral with his father, Antonio (who had no experience in figure sculpture). He was commissioned to carve a Prophet for the Porta della Mandorla (1408) on which he subsequently executed the *Assumption* relief (1414), recalling Wölfflin's statement: 'The whole body becomes gesture....' Primarily an *International Gothic sculptor, he could be startlingly classical, as in the senatorial gravity of the *Quattro Coronati* (1413). His early death ended a potentially brilliant career.

 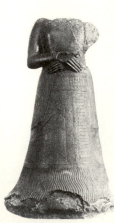

Left: NANNI DI BANCO *The Virgin of the Assumption* from the Porta della Mandorla. 1414–21. Marble. Duomo, Florence

NANNI, Giovanni *see* GIOVANNI DA UDINE

NANREI (Suzuki Nanrei) (1775–1844)

Japanese painter, one of the greatest of the *Shijō artists and perhaps representing the high point of the style. Best known for his album drawings.

NANTEUIL, Robert (1623–78)

b. Reims d. Paris. One of the most fashionable Parisian artists of the 1650s, famous for his engraved portraits. He was largely responsible for the inclusion of engraving among the liberal arts in the Edict of St Jean de luz (1660), and was also a poet.

NAONOBU (Kanō Naonobu) (1607–50)

A younger brother and collaborator of Kanō *Tannyū.

NAPIRASU, Statue of

The life-size bronze statue of the Elamite Queen Napirasu was found at *Susa and dates to the 13th century BC. The almost rectangular upper body and the tall bell-shaped skirt and the clasped hands with their long slender fingers give the figure an air of calm and elegance. *See also* ELAM

NAQSH-I RUSTAM

A sacred place in *Elamite, *Achaemenian and *Sassanian times. It is six kilometres from *Persepolis and was chosen by the Persian king, Darius (521–486 BC) and three of his successors as the site for their tombs. The cruciform façades are cut high in the cliff-face and show the king worshipping the sacred fire above a dais supported by thirty representatives of the subject-nations of the Persian Empire. The middle portion of the tombs shows the elevation of a Persian palace. Lower down on the same cliff are rock reliefs carved in the 3rd and 4th centuries AD by Sassanian kings depicting their triumphs. *See also* ACHAEMENIAN ART; SASSANIAN ART

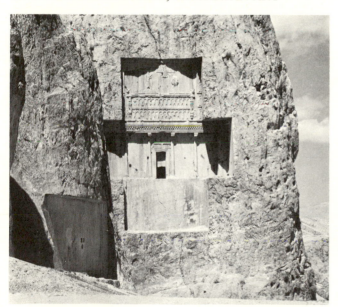

Above: NAQSH-I RUSTAM Tomb of Darius I. *c.* 486 BC
Left: NAPIRASU, Statue of. Mid-13th century BC. Bronze. h. 50¾ in (129 cm). Louvre

NARA SCULPTURE (AD 671–784)

The Japanese Buddhist sculpture of the first part of the Nara period sometimes known as the 'Hakuhō period' retained much of the formality of sculptures of the previous *Asuka period. However, with the growing influence of China there was an increasing interest in realistic representation of form and movement seen in its tentative beginnings in the later images among the *Forty-eight Buddhist images and in the triad of the Shrine of Lady *Tachibana. The full flowering of the influence of Chinese *T'ang dynasty sculpture with its emphasis on anatomical accuracy, the illusion of movement and solidity, and the delight in elaborate jewellery and flowing scarves is seen in the important bronzes in the *Yakushiji, probably cast at the beginning of the 8th century. Further developments of this realism can be traced in later Nara sculptures in the con-

trasting media of clay and dry lacquer or *kanshitsu. Clay sculptures, to be seen in the *Tōdaiji, are notable for boldness and force of the rendering of both the features and emotions of the deities in a style which recalls clay tomb figures of the T'ang period, while in the *kanshitsu* figures in the *Kōfukuji the serenity of the expression of the deities is matched by the delicate treatment of flesh and feature.

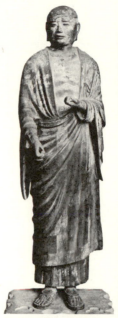

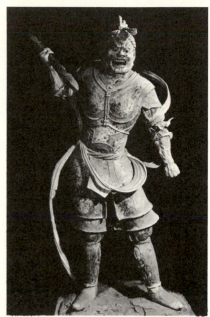

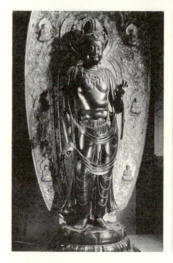

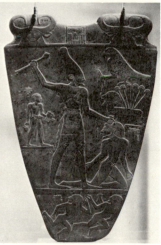

Top left: NARA SCULPTURE The Disciple, Furuna. AD 732. Lacquer (kanshitsu). h. 4 ft 10¾ in (1·49 m). Kōfukuji, Nara
Top right: NARA SCULPTURE Shikkongōjin (Thunderbolt-bearer). AD 733. Clay. h. 5 ft 8½ in (1·73 m). Tōdaiji, Nara
Above left: NARA SCULPTURE The Bodhisattva, Gekko. 8th century AD. Bronze. Yakushiji, Nara
Above right: 'NARMER' PALETTE King smiting an enemy. Reverse side. 1st dynasty. Schist. h. 26 in (66 cm). Egyptian Museum, Cairo

NARAMSIN, Stele of *see* AGADE

NARMER PALETTE

The most remarkable of a group of Egyptian monumental palettes of early dynastic date, and one of the first examples of fully conventional representation in relief. The king is shown triumphing over his enemies, and the various scenes are accompanied both by symbolic pictograms and by the earliest simple *hieroglyphs.

NARVAEZ, Francisco (1908–)

b. Venezuela. Sculptor who was head of School of Visual Arts, Venezuela (from 1935). The dominant figure in Venezuelan sculpture for several years, Narváez moved gradually away from the figure towards abstraction, carving pure, rhythmic forms in wood.

NASH, Paul (1889–1946)

b. London d. Boscombe, Hampshire. English landscape and imaginative painter. After early *Rossetti-inspired work and traditional English landscapes, in his World War I paintings Nash began to use the formal abstraction of *Nevinson. Formal preoccupation continued after the war under the influence of *Cézanne, though still fused with a traditional English sensibility, until about 1928 when under the impact of *Surrealism he reintroduced the element of imagination, achieving a composite style applicable equally to oil or watercolour work.

Above: PAUL NASH
Landscape from a Dream.
1936–8. 26¾×40 in (67·9×
101·6 cm). Tate
Below: NASHKI Script by
Yaqut Mustasemi in a 14th-
century Qur'an. Imperial
Library, Teheran
Right: NASTA'LIQ Script by
Mir'Ali Heravi. 16th century

NASHKI

The earliest known type of cursive Arabic script used simultaneously with *Kufic in the early period of Islam. Mostly used for texts in Arabic. Its use increased in the 10th century, eventually supplanting Kufic. The basic cursive script from which others (Riqa, *Ta'liq, *Nasta'liq) developed.

NASMYTH, Alexander (1758–1840)
Patrick (1787–1831)

Alexander, b. d. Edinburgh, was an Edinburgh portrait and landscape painter who studied in London under Allan *Ramsay. His landscapist son, Patrick, b. d. Edinburgh, was known as 'the English *Hobbema' and became a founder-member of the Society of British Artists (1824).

NAST, Thomas (1840–1902)

b. Landau, Bavaria d. Guayaquil, Ecuador. Painter and illustrator who went to New York (1846); studied at National Academy of Design; worked for several newspapers, primarily *Harper's Weekly* (1862–86). Nast's eloquently drawn, caustic cartoons destroyed the notorious Tweed Ring and created permanent symbolic American types, elevating the political cartoon to new, prophetic force.

NASTA'LIQ

A type of Arabic script developed in Persia in the 15th century which at once became very popular, and for most purposes replaced other scripts in Persia. An extremely cursive hand developed from *Nashki and *Ta'liq. Mir 'Ali Tabrizi first formulated its rules.

NATARAJA see SHIVA

NATOIRE, Charles Joseph (1700–77)

b. Nîmes d. Castel Gandolfo nr Rome. French †Rococo painter and engraver who studied under *Le Moyne and became Director of the French School in Rome (1751). His pictures resemble *Boucher's but are less spirited.

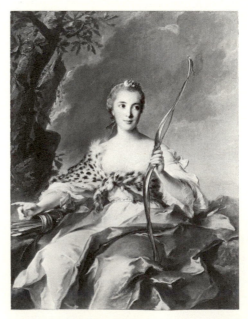

Above: JEAN-MARC NATTIER *Portrait of a Lady as Diana.*
1756. 54¾×41⅜ in (139·1×105·1 cm). MM, New York, Rogers
Fund 1903
Above right: NATUFIAN ART Carved bone sickle with a deer's
head from Mugharel-el-Kebarah. Plaster copy at Institute of
Archaeology, London
Left: ALEXANDER NASMYTH *Windings of the Forth.* c. 1827.
18×29 in (45·7×73·7 cm). NG, Edinburgh

NATTIER, Jean-Marc (1685–1766)

b. d. Paris. French painter and engraver who became the most successful portraitist at the court of Louis XV. His work was the epitome of †Rococo delicacy and informal elegance, qualities which were violently criticised by *Diderot and supporters of †Neo-classicism who reacted against the 'excesses' of his style.

NATUFIAN ART (c. 9000 BC)

In the caves of the Carmel Range at Mugharet Kebara finds have been made which include two bone sickle hafts, which date from the Mesolithic period, locally called 'Natufian'. They would have acted as a backing for a number of flint blades used in the harvesting of wild grain. On one of them an animal is depicted, possibly a gazelle.

NAUEN, Heinrich (1880–1941)

b. Krefeld d. Kalkar. German painter who studied in Düsseldorf, Munich and Stuttgart. Influenced by *Van Gogh then by *Matisse, his flat, outlined, elongated, pale figures have a melancholy *Jugendstil flavour closer to *Derain. His later work became more conventional.

NAUKYDES

The name of a Greek classical sculptor of the end of the 4th century BC, or perhaps two sculptors of the same name separated by some years. Attributed works include a famous statue of Hermes and a Diskobolos. There is also a statue base on the Acropolis signed by him.

NAUMBURG MASTER see MASTER OF NAUMBURG

NAVAJO see SOUTHWEST, AMERICAN ART OF THE

NAVARRETE, Juan Fernandez de see FERNANDEZ DE NAVARRETE

NAY, Ernst Wilhelm (1902–68)

b. Berlin d. Cologne. German painter who studied in Berlin (1925–8). Worked in Rome and Paris (1928–32). Exhibited in the São Paulo Biennale (1955). His emphasis is on colour as expressive of his vitality in painting. This led to the development of pictorial flora and fauna unrelated to existing phenomena, whoch gives his work a strong individual identity.

NAYARIT see WESTERN MEXICO

NAZARENES

A group of German and Austrian artists working in Rome founded as 'The Brotherhood of St Luke' by *Pforr and *Overbeck (1809). Later recruits were *Cornelius and *Schnorr von Carolsfeld. They reacted against the sophisticated *Mengsian classicism of the Vienna Academy and advocated a return to the moral purpose of medieval art. In practice this entailed a style of hard outline and clear colour derived from *Raphael and *Perugino. They worked together on fresco cycles for private houses, notably the Casino Massimo. In some ways they anticipated the English *Pre-Raphaelites.

NAZCA

The classic art of South Peru (c. AD 100–700), characterised by distinctive polychrome painted pottery. Open bowls, beakers and twin-spout with bridge-handle forms are typical. The wide range of colours includes red, black, white, orange, grey and violet, and some vessels are painted with as many as eight shades. Naturalistic designs of animals and birds occur, but the most common motifs are mythical cat-demons, half-man and half-beast.

NDENGESE

A tribe north of the *Bakuba in Zaire and, in their art style, heavily influenced by them. The sculptural strength of Ndengese royal figures frequently surpasses the somewhat flaccid Bakuba figures.

NEAGLE, John (1796–1865)

b. Boston d. Philadelphia. Painter who studied briefly with *Otis and visited *Stuart (1825); worked as itinerant portraitist (1818–20); settled in Philadelphia (1820); married *Sully's step-daughter (1826). Influenced by Stuart and Sully, Neagle's portraits vacillated between these styles, sometimes showing theatrical sentimentality and bravura painterliness, sometimes sharp formal and psychological perception.

NEBAMUN see THEBAN TOMBS

NECTANEBO LIONS

A pair of Egyptian lions of Nectanebo I of the 30th dynasty, taken to Rome, with other monuments, in the 1st century AD, as decoration for the Iseum Campense. Still visible in the 12th century, they were used as models by the *Cosmati, and later (having been moved from outside the Pantheon to the Acqua Felice) they figured in some of the earliest academic discussions of ancient Egyptian art. The pose, with head turned and forepaws crossed, is known from the 18th dynasty.

Left: NAZCA Pottery vessel painted with two cat-faced monsters in cream, brown, black, orange, red, grey and white. *c.* AD 100–700, Peru. h. 7½ in (19 cm). Royal Scottish Museum
Below: NECTANEBO LIONS 30th dynasty. Granite. l. 72⅞ in (1·85 m). Egyptian Museum, Vatican

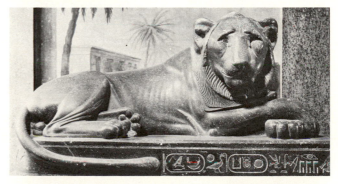

PIETER NEEFS I *Interior of Antwerp Cathedral*. 19¼×25⅜ in (49×64 cm). Wallace

NEEFS, Pieter I (c. 1578–1656/61)

b. d. Antwerp. Flemish painter of church interiors and architectural subjects, often incorporated in the works of other artists like Jan *Bruegel and *Teniers the Younger. His hand is almost indistinguishable from that of his son, Peter (1620–after 1675).

NEER, Aert van der (c. 1603–77)

?b. ?d. Amsterdam. Most gifted and consistent Dutch exponent of the moonlit landscape, which he developed from prototypes by *Elsheimer and *Rubens. He was not publicly successful, although *Cuyp painted the figures in many of his compositions.

Above: AERT VAN DER NEER *A Frozen River by a Town at Evening. c.* 1645. 10⅜×15⁵⁄₁₆ in (26·4×40·5 cm). NG, London

Left: NEFERTITI, Portrait bust of. Amarna period. Limestone and plaster, painted. h. 19½ in (48 cm). Agyptisches Museum, Berlin-Charlottenburg
Right: NEO-ATTICS Medici Vase. h. 5 ft 8 in. (1·73 m). Uffizi, Florence
Far right: NEO-HITTITE ART Relief of king Warpalawas and fertility god. 8th century BC

NEF

Metal container for incense. The long box, with hinged lid, used during the Middle Ages, resembled a boat, which probably symbolised the Church. From the †Renaissance onwards nefs sometimes assumed the form of detailed model ships.

NEFERTITI

Egyptian queen of the late 18th dynasty, the principal wife of *Akhenaten, whose portrait bust (now in Berlin) is surely the best-known piece of pharaonic sculpture. The 'bust' is not in itself a finished piece, but a sculptor's model for further portraits, such as the several quartzite heads of the queen discovered unfinished in workshops at el-Amarna and intended for composite statues. The unusual status of Nefertiti is emphasised by her being depicted on almost equal terms with her husband, and with kingly attributes.

NEGRETI, Jacopo see PALMA VECCHIO

NEGRI, Mario (1916–)

b. Tirano. Italian sculptor who studied architecture in Milan and became a sculptor (1946). Negri's figures or groups of figures are a highly abstracted variant on the humanist tradition revived by *Rodin. His elegantly interlocking forms, based on *Cubism, have a marked sense of movement.

NEO-ATTICS

A group of sculptors of the 1st century BC who signed themselves as 'Athenians' and copied classical works of the 5th and 4th centuries BC. Most of their works are sculptures and big relief vases in *marble. The movement probably started with the classical revival current in Athens in the 2nd century BC and was given impetus by the *Hellenistic courts. It reached Rome in the 1st century BC and culminated in Augustan classicism.

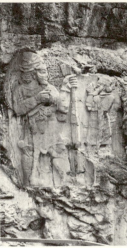

NEO-HITTITE ART

The art of a group of small Iron Age principalities of south-east *Anatolia and northern Syria, where *Hittite Empire traditions survived into the first millennium BC. The art of this area, which shows much intermingling of styles, is known chiefly from orthostat relief sculpture found at the sites of Malatya, Zincirli, Sakçagözü, Carchemish and Karatepe. Among complex influences, a traditional style – still mainly dependent on Hittite traditions – has been isolated, as well as styles showing *Assyrian and Aramean elements.

NEO-IMPRESSIONISM see POINTILLISM

NEO-PLASTICISM

*Mondrian's theory of art described in *Le Néo-Plasticisme* (1920) and many subsequent essays. Mondrian preferred the term 'Neo-Plastic' to 'abstract' because his work is not an abstraction from reality, but a purely pictorial or plastic metaphor for reality. 'The laws in art are the great hidden laws of nature which art establishes in its own fashion.' These laws, partly suggested by Schoenmaekers, are based on the dynamic balance of opposites in nature. The mutual interaction of pictorial elements could, Mondrian believed, convey this balance. Mondrian's theories seem to provide a complete system for painting. In fact, in contrast to other *De Stijl work, Mondrian's paintings are never diagrams of ideas, but evolve intuitively and gradually from his experience of painting, particularly *Cubism; sometimes following, sometimes preceding their written accompaniment. Of the artists who flirted with Neo-Plasticism the most faithful to Mondrian's word was Jean Gorin.

NEO-SUMERIAN SCULPTURE see GUDEA

NEPAL, ART OF

The Kingdom of Nepal occupies a fertile valley lying east–west between high mountains to the south and the higher main range of the Himalayas to the north. In this physically remote valley three religious and social cultures intermingle: first an animistic, shamanistic religion of spirits and demons upon whose constant appeasement men survived; then the Hindu pantheon of gods and goddesses, personifications of abstract philosophical speculation on time and creation and the smallness of man; and finally the reformed spiritual life of the Buddha, whose birthplace was Nepal. The spirits and demons are very real to mountain people; they could be felt and heard if not actually seen, and the results of their strength, their wrath and consequent destruction are always at hand. These demons are identified with the Hindu gods and goddesses, particularly with their more violent aspects in the creation, destruction and re-creation cycle of Hindu myth. The teachings of Buddha and his followers became distorted. Instead of using the spiritual and physical exercises recommended for the search for ultimate truth and at-one-ness with divine power, the magicians of Nepal and Tibet believed that yoga could be used to control that power or lesser manifestations of it for man's own ends. All this is the necessary key to the art of Nepal, which is entirely religious in origin. The Nepalese versions of the Indian pantheon are shown appearing in their various aspects and bearing their appropriate attributes. Their poses are those of the classical Indian dance, and their gestures (*mudra) are hieratical. These gestures are transferred with some modification to the peculiar demons of the north. These are guardians or enemies of the Buddha as well as of *Shiva and *Vishnu. Thus the terrible buffalo-demon Samvara appears coupling with his female escort Vajravatrati in the pose of Shiva as lord of the dance together with his shakti. Samvara is also transformed into a Buddhist guardian god. The magical *tantric art of Nepal and Tibet is the visual equivalent of the text or invocation, the *Mantra*. Tantric art can be a simple aid to meditation in a pure form, linked to a semi-hypnotic incantation, or an instructional anatomical or medical diagram, or an elaborate religious image, the use of which under certain conditions of concentration and posture will give the user power over demons. The main cultural centre of Nepal is concentrated in the Katmandu valley. Sculpture of a very high standard from the 5th century onwards (*Gupta Contemporary Minor Dynasties/Licchavis) can be found built into the walls of town and village houses, and freely accessible in temple precincts. There are excellent museums in Katmandu, Badgaon (Bhaktapur) and Lalitpur, and the holy city of Pasupatinath is a miniature Benares dedicated to Shiva. Nepalese artists and craftsmen were famous, and constantly exported work and even architectural styles to India, Tibet and China. The red-bricked buildings with carved wooden eaves and galleries and many-tiered pagodas originated in Nepal. A 9th-century Nepalese relief of the birth of Prince Siddhartha of the Shakyas, the historical Buddha (Lalitpur), follows closely the Buddhist texts. The Princess Maya, mother of the Buddha, is shown in a dancer's pose reminiscent of the *yakshi on the gates of the *stupa at Sanchi (*Satavahana Dynasty). The tree bears fruit and flowers at her touch. The Buddha raises his hand in blessing, prior to taking the first seven steps. Two benevolent spirits pour lotus-scented water out of the clouds. A 15th-century gilt-bronze (Katmandu) shows the Buddha in the classical pose of meditation, legs crossed with the soles of the feet turned up. He is seated on a lotus and surrounded by an aureole of fire. On his forehead is the *urna, or 'third eye'. A fine example of Nepalese painting is the 17th-century *Nrtyesvara* – Shiva as lord of the dance. He is shown

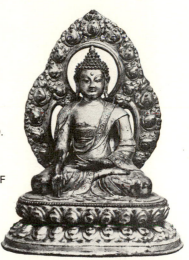

Right: NEPAL, ART OF
The Buddha Sakyamuni.
15th century. Gilt bronze.
h. 13⅝ in (34·5 cm).
Nepal Museum, Katmandu
Below left: NEPAL, ART OF
Birth of the Buddha.
9th century. Limestone.
h. 33¼ in (84 cm). Lalitpur
Below centre: NEPAL,
ART OF Vajravarahi. c. 1800.
Painted wood. h. 21 in
(53 cm). Philip Goldman
Coll, London
Below right: NEPAL, ART OF
Buffalo-headed Samvara.
19th century. Painting on
paper. 54¾ × 36⅝ in
(139 × 93 cm). National
Art Gallery, Bhaktapur

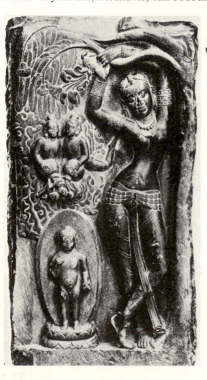

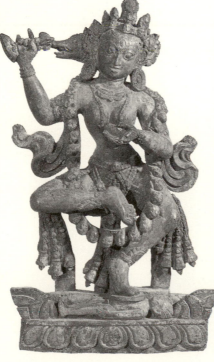

embracing his *shakti, *Durga. Each of his twenty arms bears an attribute. His four heads and headdresses combine to form the *linga. The centre panel has a border of tiny skulls and the elaborate girdle of the goddess is made of human bones. They dance upon a skull bowl full of blood which stands upon a lotus. Other gods and aspects are shown in panels round the icon. The buffalo-headed Samvara is represented in a 19th-century painting in Bhaktapur. Here the demon has sixteen feet, thirty-four arms and nine heads. The latter in three rows of three combine to form the linga. Each hand holds a different attri-bute. He dances against a background of flames on the bodies of human beings. The icon is bordered by other aspects of the demon in a classical dance pose. This demon has other human-headed aspects, but the buffalo-headed is the most terrible.

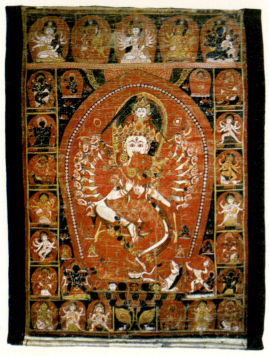

NEPAL, ART OF Shiva, Nrtyeshvara. 1659. Painting on cloth. $37\frac{1}{4} \times 25\frac{3}{8}$ in (94·5×64·5 cm). National Art Gallery, Bhattapur

NEREZI, St Panteleimon, Yugoslavia

Built (1164) by a member of the imperial Comnene family, this church was decorated with frescoes, presumably by a team of artists from Constantinople. The style is elegant and delicate with many touches of intimacy typical of the later 12th century.

NEROCCIO (Bartolommeo di Benedetto de' LANDI) (1447–1500)

b. d. Siena. Italian painter and sculptor, studied with *Verrocchio and collaborated with *Francesco di Giorgio (to 1475). His style, influenced by *Sassetta, is characterised by decora-tive curvilinear rhythms and subdued, clear, pastel colouring.

Above: NEROCCIO *St Bernard preaching in the Piazza del Campo.* From the fresco cycle of the Miracle of St Bernard. Palazzo Communale, Siena

NESIOTES *see* TYRANNICIDE GROUP

NESSOS PAINTER (active *c.* 615 BC)

An early *black-figure vase painter from Athens who painted an amphora four feet high round the neck of which is the scene of Herakles killing the centaur, Nessos. The painting is very spontaneous and accomplished, although the style is influ-enced by the *Corinthian style.

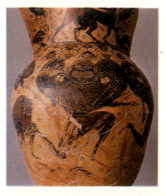

Above left: NESSOS PAINTER Detail of vase-painting showing a Gorgon in pursuit of Perseus. h. (of vase) 4 ft (1·22 m). National Museum, Athens
Above right: CASPAR NETSCHER *The Lace Maker.* 1664. $13\frac{1}{2} \times 11\frac{1}{8}$ in (34×28 cm). Wallace
Left: NEREZI, St Panteleimon. Wall-painting of the Deposition. *c.* 1164

NETSCHER, Caspar (1639–84)

b. Heidelberg d. The Hague. Dutch portrait and genre painter, taught by his father, Johan. He excelled in depicting opulent bourgeois interiors, and his small-scale polished por-traits, the subjects set against backgrounds of sculpture in the †Baroque manner, enjoyed considerable popularity in the Hague.

NEUE SACHLICHKEIT

German: 'new objectivity'. Term first used for a Mannheim exhibition (1925). Neue Sachlichkeit was part of an international realist backlash in the 1920s and 1930s. *Dix's and *Grosz's work was sharply critical of society, while *Beckmann's approached the urgency of dreams. The escapist melancholy of Kanoldt and *Schrimpf achieved wider currency.

NEUFCHATEL (NUTZSCHIDELL, LUCIDEL), Nicolas de (active 1561–7)

b. Nr Mons. Netherlandish painter, active in Nuremberg. Generally identified with Colyn van Nieucasteel (1527–90) who was a pupil of *Coecke van Aelst. His only certain work (although many portraits are attributed) shows the Nuremberg mathematician Johann Neudörffer with his son, absorbed in examining geometrical objects portrayed in meticulous detail.

Above left: NICOLAS DE NEUFCHATEL *Johann Neudorffer with his Son.* 1561. 39¾×36¼ in (101×92 cm). AP, Munich
Above right: NEW CALEDONIA Carved doorpost. Late 19th century. Wood. h. 5 ft 5½ in (166 cm). Museum für Völkerkunde, Munich
Below: LOUISE NEVELSON *Young Shadows.* 1959–60. Wood. 115×126×7¾ in (292·1×320×19·7 cm). Whitney Museum of American Art, New York

NEVELSON, Louise (1900–)

b. Kiev, Russia. Sculptor who went to America (1905); studied at *Art Students' League (1929–30) and with *Hofmann in Munich (1931–2); did archaeology, Mexico (1951–2). Influenced by *Constructivism and *Surrealism, Nevelson's mature works are wooden reliefs comprised of compartments containing abstract shapes, painted a single colour and making up entire walls.

NEVINSON, Christopher (1889–1946)

b. d. London. English painter who worked at the Slade School of Art (1908–12) and in Paris where he shared a studio with

*Modigliani. Associated with the *Futurists he applied their style to war subjects, but afterwards his work's quality declined.

Top left: CHRISTOPHER NEVINSON *Steam and Steel: Impression of Downtown New York.* 23½×17¾ in (59·9×41·1 cm). Birmingham
Top right: NEW BRITAIN Ancestor skull with clay modelling. 19th century. h. 11 in (28 cm). Museum für Völkerkunde, Munich
Above left: NEW BRITAIN Mask of the Baining people. 19th century. Barkcloth on light cane frame. h. 39½ in (100·3 cm). Museum für Völkerkunde, Hamburg
Above right: NEW ENGLISH ART CLUB Caricature of the New English Art Club Members by Max Beerbohm

NEW BRITAIN

The art of this *Melanesian island is forcefully represented by grotesque masks constructed of bark and fibres on basketry frames. Their surfaces are painted with bright greens, yellows and reds. Masks of the Baining people appeared as the climaxes of public festivals. Sulka masks seem to have been the property of secret societies. In the coastal areas of the Gazelle peninsula the front parts of skulls were over-modelled with resin and painted as masks.

NEW CALEDONIA

A *Melanesian island group whose art was manifested chiefly in the form of architectural sculpture. Huts were adorned with anthropomorphic roof-spires and door-jambs which were regarded as dwellings of protective ancestors. The faces carved on door-frames are repeated in large black masks bearing impressive coiffures of twisted fibre.

NEW ENGLISH ART CLUB

Founded (1886) in opposition to the *Royal Academy, by English artists who had studied in Paris. Exhibitors included *Sickert, *Steer, *Whistler, *Clausen, Crawhall and *Degas, *Monet and *Morisot. Taking *Bastien-Lepage as an ideal modern French artist, an English form of †Impressionism was developed – 'a clean solid mosaic of thick paint in a light key' –

(Sickert, 1910). Only Sickert developed as a painter of modern-life subjects and the essence of Impressionism remained largely unknown or ignored. Its rejection of *Post-Impressionism (1910–12) lost the New English its role as show-place for progressive tendencies. By the 1930s it was as conservative as the Royal Academy.

NEW GUINEA

This island is the largest in *Melanesia. Its native population divides into several races and many hundreds of tribal groups speaking distinct languages. Numerous art styles have been classified into a number of geographic/style areas: *Geelvink Bay, *Lake Sentani, *Astrolabe Bay, *Huon Gulf, South-west *New Guinea, *Torres Straits, *Papuan Gulf, *Highlands, *Massim and the *Sepik River.

Left: NEW GUINEA, South-west. Ancestor figure. Carved wood. h. 29¾ in (75·5 cm). Museum für Völkekunde, Basle
Right: NEW HEBRIDES Ancestor skull with modelling from Gaua Island. Late 19th century. h. 11¾ in (30 cm). Museum für Völkekunde, Munich

NEW GUINEA, SOUTH-WEST

The Asmat people inhabited swamp-land between the rivers Kampong and Eilanden. Figures were carved whenever a new ceremonial house was constructed. Commemorative poles (*bis*) were raised for rituals involving placation of those recently killed in war or by magic. Many designs carved on shields, canoe-prows, drums, etc were symbols relating to themes of head-hunting and cannibalism, eg hornbill and mantis motives. The Mimika were formerly the object of Asmat raids. The masks and figures of both groups are related stylistically. The Marind-anim, another head-hunting people, construct costumes from feathers, cordage and wood plaques for use at mourning ceremonies.

NEW HEBRIDES

The indigenous cultures of this *Melanesian island group were devastated soon after contact with Europeans. The finest art comes from the islands of Ambrym and Malekula, and is related to practices of a graded association in which men acquired rank by accumulating wealth in the form of pigs. Figures carved from tree-fern trunks were provided by the candidate at his grade ceremony and placed in front of the men's house. Tall slit-gongs with one or more carved faces and masks were also used. All objects were painted in earth pigments. Life-size commemorative figures, with the dead man's skull over-modelled in clay and painted, were stored in men's houses. Pole-axes for killing pigs might be carved with human figures.

NEW IRELAND

This *Melanesian island group produced polychrome wood sculptures on a scale equalled in Oceania only by the *Sepik region of New Guinea. Most of the carvings were for use in the

cyclical ceremonies known as *malanggan*: festivals which combined honouring the recently dead with the initiation of young men. Carvings were owned by individual families whose elders would instruct professional carvers in the required attributes of their *malanggans*. Carved and painted motifs included ancestor figures, birds, fish, snakes and mythological symbols which could be combined, as in the openwork friezes, in a confusing potage. In central New Ireland monumental hermaphroditic ancestor figures (*uli*) were created which resemble the *malanggan* art of the north. In the south-eastern part of the island, chalk figures were carved at a death and placed in a special house.

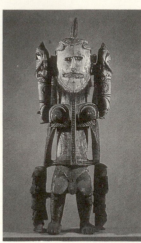

Left: NEW IRELAND Ancestor memorial board. 19th century. Wood. h. 43 in (109 cm). City of Liverpool Museums
Right: NEW IRELAND Uli figure. Early 20th century. Wood. h. 5 ft 7 in (170 cm). Museum für Völkekunde, Munich

NEW ZEALAND

The art of the Polynesian Maori, like that from the *Marquesas islands, is essentially two-dimensional: wood was carved about its surface with great skill and virtuosity, but not sculpted. Substantial meeting-houses were decorated with wall-panels and ridge-pole supports carved with representations of the ancestors. Free-standing figures are very rare and characterised by plain surfaces. Pegs, with a head carved at the top, were stuck into the ground to act as the temporary abode of spirits while rites were enacted. The finest Maori works are the panels of openwork and relief carving which adorned canoes and the doorways of meeting-houses. The canoe-prow and stern ornaments are compositions of openwork spirals, the one horizontal, the other vertical, with the addition on the front of the prow of a figure, arms thrown back, head and body thrusting forward. Lintel ornaments are dominated by a central figure, with symmetrically opposed compositions on

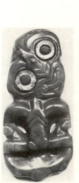

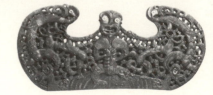

Left: NEW ZEALAND Heitiki pendants. Late 18th–early 19th century. Jade with shell inlay. h. (of largest) 5 in (12·7 cm). City of Liverpool Museums
Below: NEW ZEALAND Lintel ornament. Early 19th century. Wood with shell inlay. h. 13 in (33 cm). City of Liverpool Museums

each side and a profusion of detail. One prevalent motif resembling a bird or bird-headed man has been identified as the Manaia, a supernatural spirit, or, more plausibly, as a depiction of the human face in profile. Smaller objects providing open surfaces for the artist were covered with incised curvilinear and figurative decoration: chiefs' feather-boxes, feeding-funnels for those persons undergoing tattoo, canoe-bailers, bird-snares, flutes, fish-hooks and weapons. Jade was greatly coveted by the Maoris. Most familiar are pendent ornaments (*heitiki*) with ancestral significance. These grotesque little figures were handed down as heirlooms within chiefly families.

NEWMAN, Barnett (1905–70)

b. New York. Painter who studied at *Art Students' League, College of City of New York and Cornell University; taught widely; organised exhibitions of Pre-Columbian and Indian art. Newman moved from *Surrealism to the absolute purity of huge canvases of vibrating colour fields divided by bands running parallel to the edges.

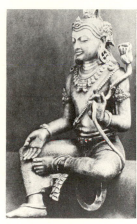

Left: BARNETT NEWMAN *Adam.* 1951–2. 95⅝×79⅞ in (242·9×202·9 cm). Tate
Right: NGAMPLAK SEMONGAN Manjushri. Early 10th century. Silver. h. 11⅛ in (28 cm). Djakarta Museum

NEWSOME, Victor (1935–)

b. Leeds. English artist who studied painting at Leeds (1953–5); began working in three dimensions (1960). His imagery is dualistic, usually referring to the female nude although only in an abstract, metaphorical sense. His works are executed in brightly coloured plastics and aluminium, usually of hinged and interlocking pieces.

NGAMPLAK SEMONGAN, Semarang, Java
(*c.* 10th century AD)

The statue of the Bodhisattva Manjushri from Ngamplak Semongan is one of the very rare Indonesian statues in precious metal to have survived. The figure is of 92% silver and weighs 8·25 kilograms. The Bodhisattva is shown in royal attire, seated in the position of royal ease. He is characterised as a youth, with the blue lotus in his left hand supporting a palm-leaf bush, the right being in the gesture of giving. The book represents transcendental wisdom. The style is *Pala.

NGERE *see* DAN-NGERE

NI Tsan (1301–74)

Chinese painter from Wu-hsi, Kiangsu. Of the *Four Masters of late Yüan, Ni Tsan was the only one of independent means. Fastidious by nature, in painting he was most sparing of his ink, so that only the essential touches of a rather dry brush are needed to 'write his ideas' in such a work as the *Jung-hsi Studio*. This theme, of sparse trees and a pavilion, became immensely popular, while his brush manner served as inspiration for

*Shên Chou and later generations of scholar-painters, particularly the *Orthodox School of early *Ch'ing.

NIAS *see* INDONESIA, ART OF

NIAUX (middle to late Magdalenian)

One of the richest of the French painted caves (Ariège). The paintings, all in black, represent bison and horse with a few reindeer and ibex. Executed almost entirely in outline, the manes and body hair are indicated on the horse and bison. There is also a fine bison and a fish drawn with the finger in clay.

NICAEA, Church of the Koimesis

Totally destroyed in 1922, the church in modern Iznik, Turkey, had been founded by a certain Hyakinthos towards the end of the 8th century. The mosaic decoration (of which photographs exist) represented several stages, due to the removal of images during *Iconoclasm and their subsequent restoration. The bema mosaics were probably done soon after 843, those in the narthex c. 1065–7.

NICCOLO, Donato di *see* DONATELLO

NICCOLO DELL' ARCA (Niccolò da BARI) (1435–94)

b. ?Bari. Italian sculptor active in Bologna. His work there includes the *Arca di S. Domenico* in S. Domenico Maggiore and the *Pietà* in Sta Maria della Vita. He portrays the mourners in a state of tragic frenzy achieved with the use of zigzagging planes, activated drapery and melodramatic gesture.

NICHOLAS OF VERDUN

*Mosan metalworker, active at the end of the 12th century. His pulpit, now an altar, at Klosterneuburg in Austria (1181) and the Shrine of the Three Kings in *Cologne Cathedral (c. 1200) are representatives of a classicising style that is neither †Romanesque nor †Gothic. It is seen again in the *Visitation* group at *Reims. *See also* RAINER OF HUY

NICHOLSON, Ben (1894–)

b. Denham. English painter who studied at the Slade School of Art (1910–11). During the late 1920s and especially the 1930s Nicholson, with *Hepworth and *Moore, made British art part of the modern movement. From London he moved to St Ives (1939) and then to Ticino (1958). After 1933 Nicholson's formal language relates to *Neo-Plasticism, eg the *White Reliefs* (from 1933), but for him abstraction and representation were not opposing principles. His father, William *Nicholson, taught him to select and condense perceptions, a lesson given

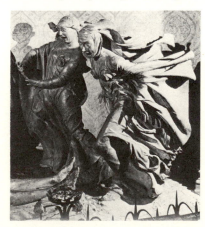

Left: NI TSAN *The Jung-hsi Studio.* Dated 1372. Hanging scroll. Ink on paper. 29¾×14 in (74·7×35·5 cm). National Palace Museum, Taiwan
Right: NICCOLO DELL'ARCA Mourners in a state of frenzy. S. Domenico Maggiore, Bologna

a modern slant by *Cubism. He is both a Constructivist with an almost sculptural respect for the material conditions imposed by his medium, and a perceptual artist translating from nature.

Top: BEN NICHOLSON *Tuscan Relief*. 1967. $58\frac{1}{8} \times 63\frac{1}{8}$ in ($147 \cdot 6 \times 160 \cdot 3$ cm). Tate
Above: BEN NICHOLSON *Au Chat Botté*. 1932. $36\frac{7}{8} \times 48\frac{3}{4}$ in ($93 \cdot 7 \times 123 \cdot 8$ cm). Manchester City Art Gallery

NICHOLSON, Sir William (1872–1949)

b. Newark d. Blewbury, Berkshire. English artist whose studies in Paris (1889–90) brought a more urbane and sophisticated note into English painting. In addition to portraits, he painted small landscapes and still-lifes of a fastidious refinement and disciplined simplicity. He also collaborated with his brother-in-law, James *Pryde, to produce posters under the pseudonym of the *Beggarstaff Brothers.

WILLIAM NICHOLSON *Silver*. 1938. $17\frac{1}{4} \times 22\frac{1}{2}$ in ($43 \cdot 8 \times 57 \cdot 2$ cm). Tate

NICOLAS FRANCES (*c.* 1400–d. 1468)

b. ?France d. León. Painter active in Spain; already living there by 1424. His main work was for the cathedral in León (completed 1434). It had eighteen large and two hundred small panels (now dismantled). His style bears traces of influence from various countries, thus confirming the contemporary aim for a soft, detailed *International Gothic style.

NIGERIA

In common with the rest of West Africa, the peoples of Nigeria occupy two types of habitat, the tropical forest in the south (the Guinea Coast), and the savanna in the north (the western Sudan). For the arts of southern Nigeria *see* BENIN, EDO, EKOI, IBIBIO, IBO, IJO and YORUBA. For prehistoric developments *see* CROSS RIVER MONOLITHS, ESIE, IBO (including Igbo-Ukwu), IFE, LOWER NIGER BRONZE INDUSTRY, NOK and SAO. For the arts of northern Nigeria *see* NIGERIA, NORTHERN.

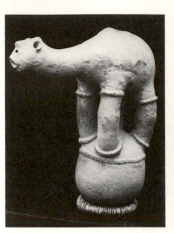

Left: NIGERIA, Northern. Figure of a woman with children. Afo tribe. Late 19th century. Wood. h. 27 in (68 cm). Horniman Museum, London
Right: NIGERIA, Northern. Figure of an animal from a grave near Zuru, Dakakari tribe. Terracotta. h. 22 in (55 cm). Nigerian Museum, Lagos

NIGERIA, NORTHERN

Most of the sculpture in northern Nigeria is concentrated along the Niger and Benue Valleys. The Nupe, a mainly Islamic people, live on both sides of the middle Niger, carving abstract geometric posts, and doors with representational though non-human forms. A few wooden masks have been discovered among them and, of course, the remarkable bronzes of Jebba and Tade villages (*Ife and *Lower Niger Bronze Industry). Farther along the Niger are the Dakakari whose women produce remarkable terracotta sculpture. East of the Niger-Benue confluence are the Igala and Idoma people with a great variety of sculpture much of which is common to the northern *Ibo. North of the confluence are the Afo, best known for their vigorous mother and child figures. Many small tribes of the eastern and southern escarpment of the Jos plateau produce interesting sculpture including the abstract headdresses of the Ham or Jaba, the antelope headdresses (also used as drinking-cups) of the Koro, Mama buffalo masks (the oldest of which make use of the natural shapes of roots rather than carved horns), and figures and animal masks of the Montol and Goemai. East of the Idoma are the Tiv, who carve heavy ancestor figures, and the Jukun who, north of the Benue, also carve ancestor figures but south of the river carve only masks for the ancestral cult. Beyond the Jukun are the Mumuye, best known for their elongated figures used in rites to cure disease, and the Chamba best known for their large buffalo masks and schematic figures. Finally to the north live the Verre who produce a remarkable array of cast bronzework. *See also* NOK and SAO and the LONGUDA at Waja, best known for their terracottas.

NIKE

In Greek mythology the goddess of victory, represented as a winged female figure, holding a palm branch and a garland. *See also* VICTORY OF SAMOTHRACE

NIKIAS (active 332 BC)

Athenian painter and pupil of Antidotos, who was a pupil of *Euphranor. He painted statues for *Praxiteles, and preferred large subjects such as cavalry and sea-battles. He was a master of light and shade.

NIMRUD

This city was founded as the capital of the late Assyrian Empire by Assurnasirpal II (884–859 BC). His palace there was ornamented with a vast series of gypsum reliefs, showing the king in his function as priest of Ashur, conqueror of Ashur's enemies and receiver of tribute. The panel which stood behind the royal throne shows the king, attended by protective genii, in front of the sacred tree and with his hand raised in salute to Ashur, who floats in his winged disk above. The immensely wealthy Assyrian court was for the next three centuries the great patron of artists from all parts of the Near East, and thousands of carved ivories, mostly executed by Levantine or Syrian craftsmen were found in the store-rooms of the imperial arsenal at Nimrud.

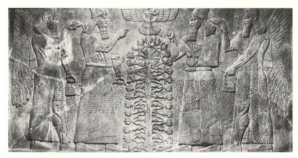

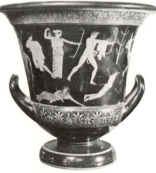

Above: NIMRUD Relief from the palace of Assurnasirpal showing the king as priest of Ashur. 884–859 BC. Gypsum. h. 7 ft 2 in (2·18 m). BM, London
Left: NIOBID PAINTER Apollo slaying the children of Niobe. Louvre
Right: NOFRETITI, Tomb of. 19th dynasty. Painting on modelled plaster. Figures about life-size. Thebes

NINEVEH

The last and most grandiose of the late Assyrian capitals, from 705 until its destruction in 612 BC. It contained the palaces of Sennacherib and Ashurbanipal, decorated with reliefs that illustrate all the aspects of Assyrian kingship (*Nimrud, *Khorsabad). The 7th-century style is more plastic and naturalistic, especially in the representation of animals, than the earlier sculptures, as can be seen in the scenes of Ashurbanipal hunting lions from his chariot. This was not mere royal sport, however, but a symbolic act performed by the king in his capacity as protector of Ashur's people against the forces of nature, and reproduces the age-old Mesopotamian theme of the struggle between hero and beast.

NIOBID PAINTER (active 480/450 BC)

Athenian *red-figure vase painter who tried to reproduce the grand wall-paintings of *Polygnotos and *Mikon on his vases. He chose to paint the moment of tension before or after a dramatic event, never the action itself. He ranges big assemblies of figures on several levels to give the impression of spatial depth.

NIRVANA

Sanskrit: literally 'blown out', 'extinguished'; that state of non-discursive, universal consciousness which transcends death and is the ultimate aim of the Buddhist; not strictly comparable to the Islamic, Hebraic or Aryan concepts of Heaven or the Land of the Fathers.

NITEN (Miyamoto Musashi) (1584–1645)

Japanese artist, a fine painter in monochrome ink. His work has a bold character that is often claimed to be associated with his skill as a swordsman, for which he was famous.

NOAMI (1397–1471)

Founder of the Japanese Ami group who used a softer style of Chinese painting as their model, and specialised in soft washes of monochrome ink. *See also* GEIAMI; SOAMI

NOFRET *see* RAHOTPE AND NOFRET

NOFRETIRI (Nefertari)

Egyptian queen of the 19th dynasty, the principal wife of *Ramesses II, whose tomb in the Valley of the Queens is famous for the quality of its decoration. The main figures are lightly modelled in plaster applied to the walls, and skilfully painted to give additional depth; flesh tints are shaded, and both the effect of transparency and the pleating of linen garments are indicated.

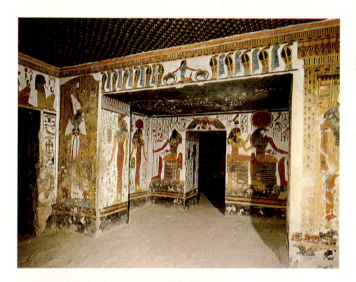

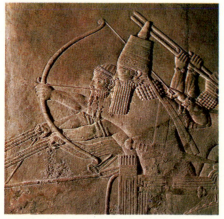

Left: NINEVEH Ashurbanipal hunting lions from his chariot. 668–626 BC. BM, London
Right: NITEN *Shrike on a Barren Tree*. Hanging scroll. Ink on paper. 49½ × 12½ in (125 × 31 cm). Tokyo National Museum

NOGUCHI, Isamu (1904–)

b. Los Angeles. Sculptor who lived in Japan (1906–17); was apprenticed to *Borglum (1922) and *Brancusi in Paris (1927–8); visited Orient (1930–1, 1952). Noguchi combines Oriental influences with those of Brancusi, *Constructivism and *Surrealism, creating elegant abstractions showing a profound respect for materials, purity of form and a continuing affinity with nature.

Left: ISAMU NOGUCHI *Capital.* 1939. Marble. 16×24×24 in (40·6×61×61 cm). MOMA, New York, Gift of Edward M. M. Warburg
Right: NOK Head discovered at Jemaa. *c.* 200 BC. Terracotta. h. 9 in (23 cm). Jos Museum, Nigeria

NOGUERA, Pedro de (1592–1655)

b. Barcelona d. Lima. Most notable Spanish sculptor to emigrate to Peru, he trained in Seville, arriving in Lima in 1619. His masterpieces are the *Baroque choirstalls in Lima Cathedral. There, movement, foreshortening and craftsmanship surpass almost all contemporary Spanish work.

NOK

A small village, the type site of a culture discovered throughout the central area of northern Nigeria. The Nok culture provides the earliest evidence of sculpture in sub-Saharan Africa (and also the earliest evidence of iron-working). Radiocarbon dates cover the period from about 900 BC to AD 200. A remarkable series of terracotta heads, figurines, fragments of larger figures (some may have been as much as three-quarters lifesize) and animals have been found. They probably represent but one stage in the development of a tradition in this part of West Africa which culminated in the terracotta and bronze sculptures of ancient *Ife.

NOLA, Giovanni da (Giovanni da MARIGLIANO) (c. 1488–1558)

b. Marigliano, nr Nola. Italian sculptor, established in Naples (by 1508), his early *Nativity* group in Sta Maria del Parto, was commissioned by the poet Sannazaro. Contact with Sannazaro's humanist circle gave Nola's work salutary classical stiffening, appropriately combined with some Spanish influence and an originality of arrangement in the Don Pedro da Toledo monument (S. Giacomo degli Spagnuoli).

NOLAN, Sydney (1917–)

b. Melbourne. Australian painter who changed from abstraction (1936–41) to figurative painting. Nolan travelled round Australia producing landscapes and paintings in series which were inspired by Australian legendary figures such as Ned Kelly. In 1951 he came to Europe and his work became broader and more fluent. Having previously worked in rippolin on board and paper he began using polyvinyl acetate, scraping down the paint to produce thin atmospheric transparencies. Further travels in the Far East, the South Seas and the United States were influential in his series entitled *Oceania* which includes *Paradise Garden* and *Snake and Shark*.

NOLAND, Kenneth (1924–)

b. Asheville, North Carolina. Abstract painter who studied at Black Mountain College and with *Zadkine in Paris; worked with *Louis in Washington, developing staining technique. Noland's differently shaped canvases, largely chevrons and circles, are covered with bands of saturated colour running parallel to the canvas edge, creating unusual spatial vibrations.

NOLDE, Emil (1867–1956)

b. Nolde, Schleswig d. Seebüll. German painter who studied in Flensburg and Karlsruhe (1884–9), then travelled between Berlin, Munich and Paris (1898–1906). *Post-Impressionism, particularly *Van Gogh, *Munch and *Ensor, provoked his development away from romantic naturalism. He briefly joined die *Brücke (1906–7). Full of passionate feeling for nature and for the primitive, he visited New Guinea (1913–14). Nolde's subjects are often intensely emotive, eg the religious series (1909–12), but he is the least illustrative and most abstract of the Brücke painters. Saturated colour, creating the movement and massiveness of his forms, is his real expressive force.

Above: EMIL NOLDE *Teacher and Girl.* 1916. 39⅜×28¾ in (100×73 cm). Kunstmuseum, Düsseldorf
Below: SYDNEY NOLAN *Ned Kelly.* Marlborough Fine Art, London

NOLLEKENS, Joseph (1737–1823)

b. d. London. English †Neo-classical sculptor who worked in Rome (1759–70) and became an RA (1772). His ability to capture a lifelike quality in his numerous busts of the famous and the aristocratic rapidly turned him into a millionaire. He made the bust of Dr Johnson in Westminster Abbey and also that of Pitt of which over fifty replicas were produced.

Left: NOMOLI Figure probably carved by the Sherbro tribe. 16th century. Soapstone. h. 14 in (36 cm). BM, London

Right: JOSEPH NOLLEKENS *William Pitt.* 1808. Marble. h. 28 in (71·1 cm). NPG, London

NOMOLI

Soapstone figures dug up by *Mende and Temne farmers in Sierra Leone. Whatever their original purpose they are now enshrined on the farms as 'rice gods' and if the harvest fails they are severely whipped. They may have been carved about the 16th century by the people of *Sherbro Island and the adjacent coastal area of south-west Sierra Leone. Before the Mende incursion three or four hundred years ago the Sherbro occupied a far more extensive area than at present. Two other forms of soapstone sculpture occur in Sierra Leone, the large *mahan yafe* heads found by the Kono tribe in the north which may be an earlier style of *nomoli*, and the *pomtan* figures of the *Kissi in the north-east.

NOOTKA see NORTHWEST COAST, AMERICAN INDIAN ART OF THE

NORTH AMERICAN INDIAN ART

See general essay and references under CALIFORNIA; EASTERN UNITED STATES AND CANADA; ESKIMO ART; NORTHWEST COAST; PLAINS INDIAN ART; SOUTHWEST

NORTHERN CH'I SCULPTURE see T'IEN LUNG SHAN

NORTHERN CHOU SCULPTURE see WAN FO SSU

NORTHERN WEI SCULPTURE see KUNG HSIEN; LUNG MEN; MAI CHI SHAN; YUN KANG

NORTHWEST COAST, AMERICAN INDIAN ART OF THE

The Northwest Coast Indian tribes occupied the Pacific Coast of North America between Alaska and Oregon. Their culture and art is remarkably homogeneous and differences between the objects produced by individual tribes are often slight. The unique Northwest Coast style consists of abstract decorative motifs derived from the characteristic features of individual animals. For instance, a bird may be distinguished by its beak, long and straight for a raven or short and curved for an eagle. The animals most frequently depicted are the beaver, bear, wolf, killer whale, frog, hawk, eagle and raven. The major art forms were carving and painting, and the commonest material was wood, particularly cedar and alder, although stone, horn and ivory were also used. The best-known Northwest Coast sculptures are totem-poles, which were most developed among the *Haida and Tsimshian. In addition to poles the Northwest Coast carvers produced masks, rattles, staffs and other equip-

ment for the dramatic performances staged by various secret societies during the winter festivities, and a range of domestic utensils including storage-boxes, cooking vessels, spoons and ladles. Painted designs were applied to basketry hats and leather dance costumes, and totem-poles, house fronts and many carved wooden objects were also enhanced with colour. Inlay, using bone, copper and iridescent pearl-shell was used, particularly on smaller items such as pipe-bowls and lip-plugs. A significant motive in the production of this immense variety of decorated articles was a unique social institution called a *potlatch*, a kind of feast at which a chief would demonstrate his wealth and superiority by lavish and conspicuous gift-giving. The finest sculpture was probably produced by the northern tribes, the *Tlingit, Tsimshian, *Kwakiutl and Haida, and the Bella Coola and Nootka were also notable artists. The tribes to the south produced less significant carving, although the Cowichan made abstract wooden masks, and the Coast Salish were accomplished weavers.

NORWICH SCHOOL

In 1803 the Norwich Society of Artists was founded. Its members, who were both professional and amateur, and mainly friends and pupils of John ('Old') *Crome, its founder and driving force, are known as the Norwich School. It became an exhibiting society in 1805 – the chief of its kind outside London. Two years later *Cotman joined, and the society flourished until about 1830. The painters were inspired by Dutch art as well as the beauties of the East Anglian countryside.

NOST (VAN OST), John (d. 1729)

d. London. Flemish sculptor, who came to England (before 1686) and became Artus *Quellin III's foreman. He executed vases, *putti and chimney-pieces in lead, stone and marble for royal palaces and great houses; also the magnificent †Baroque Queensberry monument (1711, Durisdeer, Dumfries).

NOTKE, Bernt

b. Lassan, Pomerania d. Lübeck. German sculptor and painter, whose work was important in the development of vivid, expressionistic sculpture in Germany. First mentioned in Lübeck (1467) as a painter, he was summoned to Scotland (1483). Here he executed the extravagant, intense *St George* (finished 1489), incorporating a portrait of the Swedish Regent's battle charger and armour, using real antlers for the dragon's horns.

Left: NORTHWEST COAST, AMERICAN INDIAN ART OF THE Tsimshian totem-pole. *c.* AD 1850, British Columbia, Lower Nass River. Red cedar carved with figures of ravens, ancestors and a fish. Royal Scottish Museum
Right: BERNT NOTKE *St George and the Dragon with the Princess of Libya.* 1489. 118×90 in (299·7×228·6 cm). Storkyrka, Stockholm

NOUVEAU REALISME

Group founded by Pierre Restany with *Arman, *Klein and *Raysse (1961). In theory New Realism 'registers the sociological reality without controversial intention' (Restany). It parallels many features of British and American *Pop Art.

NOUVELLE TENDANCE

A loosely knit group of *Kinetic artists who exhibited in Paris (Galerie Denise René) and London (Signals) during the late 1950s and 1960s. The nucleus was *Soto, Cruz-Diez and *Otero who had studied at the School of Fine Art at Caracas, Venezuela (1942–7). Soto worked with *Tinguely and *Klein in Paris (from 1950), showing at the Galerie Denise René (1956, 1957). Also prominent in this internationally composed group were *Takis, Burg, Martha *Boto and Assis; their work shared a common forum and a *Constructivist-inspired concern with the potential of light, form and motion.

NOVEMBERGRUPPE (1918–31)

Group founded in Berlin by the painters *Pechstein, Klein, Trappert, *Richter and Melzer. An exhibiting organisation, it aimed to keep art in contact with the social revolution in progress in Germany. The group never developed a particular aesthetic, and its political content was diminished by the departure of Pechstein (1920). Most leading German painters were associated with it, and with the collapse of the Workers' Council for Art (1921) it came to include several of the architects connected with the *Bauhaus, above all, Mies van der Rohe. The group first showed in Berlin (1919); its major exhibition was the 'Jubilaum Austellung', Berlin (1929).

NOVGOROD

A prosperous merchant city in North Russia from the 11th century until annexed by Moscow (1478). It lies on the River Volkhov, north of Lake Ilmen, and is being extensively excavated, giving information about the wooden dwellings of the medieval inhabitants and the masonry churches and monasteries of the princes and boyars. Byzantine painters including *Theophanes the Greek were attracted there and trained local workers to produce frescoes and *icons. The frescoes show great virtuosity and speed of execution, for they had to be painted in the course of a short suitable summer season. The production of many icons may correspondingly be due to the length of the winter and the supply of wood causing the relative cheapness of the medium, rather than to excessive piety.

NUBIAN ART

The northernmost of the three Nubian kingdoms, Nobadia, was officially converted to Monophysite Christianity (543), and Nubia remained Christian for about eight centuries. Extensive remains of Nubian Christian art do not however survive, the most important witness being the wall-paintings of Faras, the ecclesiastical capital of Nobadia (now split between the National Museum, Warsaw, and Egypt), which date from various stages between the 8th and 12th centuries. These seem to indicate relationships with different styles inside the Byzantine world and do not, as one might expect, exhibit total dependency on *Coptic art.

NUKUORO ISLANDS see MICRONESIA, ART OF

NUNEZ DEL PRADO, Marina (1910–)

b. Bolivia. Sculptor whose art developed from realistic figurative work to abstraction in her search for forms embodying the spirit of her native country. From sculptures based on popular music and dance she turned to emotional, socially conscious themes, finally developing symbolic abstractions of organic forms, influenced by the surrounding landscape.

NUPE see NIGERIA, NORTHERN

NUTZSCHIDELL, Nicolas see NEUFCHATEL

OBJET TROUVE

French: 'a found object'. The happy accident of discovering a natural object – a piece of wood, or stone – that is either suggestive of actual sculpture, or that provides a particular stimulus to the finder.

OBREGON, Alejandro (1920–)

b. Barcelona. Painter who emigrated to Colombia; studied at Boston School of Fine Arts (1937–41); was Director, Escuela de Bellas Artes (1948–9, 1959–60); visited France (1949). Called Romantic Expressionism, Obregón's semi-abstract work retains recognisable, powerful symbols, often a volcano or condor, in complex, painterly compositions of overlapping shapes and subtle colours.

OCHTERVELT, Jacob (c. 1635–1708/10)

b. ?Rotterdam d. ?Amsterdam. Dutch genre and portrait painter who was taught by *Berchem but has closer stylistic affinities with de *Hooch, *Metsu and *Terborch. He settled in Amsterdam (1674).

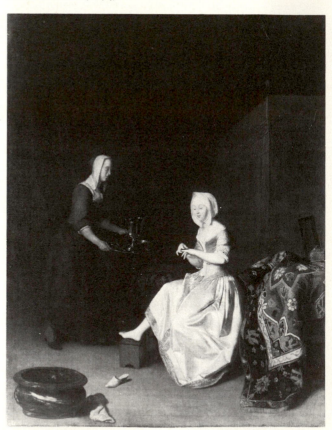

JACOB OCHTERVELT *A Young Lady Trimming her Finger-nails.* 29$\frac{3}{8}$×23$\frac{1}{4}$ in (74·6×59 cm). NG, London

ODERISI, Pietro (2nd half 13th century)

Probably Roman artist who was responsible for the influential tomb (1271–4) of the French pope, Clement IV in Viterbo, which combines traditional Roman *Cosmati work with French †Gothic forms new in Italy. He probably also worked on the *ciborium in S. Paolo Fuori Le Mura in Rome with *Arnolfo di Cambio. He is also identical with or related to one or both of Odoricus and 'Petrus Civis Romanus' who worked

(c. 1270) respectively on the pavement of the sanctuary and the base of Edward the Confessor's shrine in Westminster Abbey. Although fragmentary, both clearly belong to the Roman Cosmati tradition.

Above left: PIETRO ODERISI *Tomb of Pope Clement IV.* 1271–4. S. Francesco, Viterbo
Above right: JUAN O'GORMAN *History of the Tarascan Indian.* (detail) Biblioteca Gertrudis Bocanegra, Patzcuaro, Michoacan, Mexico
Right: OHRID, St Clement. The Annunciation icon. Late 13th century
Below: ODYSSEY LANDSCAPE Fresco. h. 4 ft 11 in (1·50 m). Vatican

ODYSSEY LANDSCAPES (1st century BC)

A series of Second Style *Pompeian paintings found in a house on the Esquiline Hill, Rome. The subject is the exploits of Odysseus. The figures are shown in landscape settings and the landscape is more prominent than hitherto. They are probably based on a *Hellenistic original.

OELZE, Richard (1900–)

b. Magdeburg. German painter who studied at the *Bauhaus (1921–6) and worked with the *Surrealists in Paris (1932), from whom he received his important influences. He paints with a smooth but sensitive proficiency producing compositions with irrational juxtapositions of figures and landscape.

OFFSET PRINTING

A two-stage lithographic process. A roller picks up the image off a *lithographic plate and prints it on to paper. Thus the artist can work straight on to the plate, 'the right way round'.

O'GORMAN, Juan (1905–)

b. Coyoacán. Painter who taught at Academy of San Carlos; was member of League of Revolutionary Writers and Artists. Deeply influenced by *Rivera, O'Gorman is one of the most extremely nationalist Mexican artists. His murals are crammed with Pre-Columbian symbols, legends, political and social allegories, drawn with exactitude and macabre fantasy.

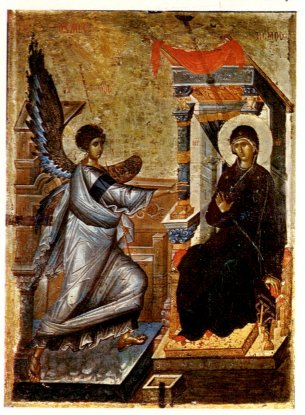

OHRID

This Macedonian lakeside town possesses several important Byzantine survivals, the most complete being the churches of Sta Sophia and St Clement. Sta Sophia has sanctuary frescoes of Byzantine work (c. 1040–5), designed to affirm the loyalty of the archbishop to Constantinople and the validity of Orthodox theology. St Clement, originally dedicated to the Virgin (1294/5), has the earliest frescoes by the painters Michael and Eutychius, but restoration has obscured their style. The icons, however, eg the Annunciation, do preserve the work of the late 13th century at its best.

OIL

The artist is usually referring to a 'drying oil'. By far the most commonly used is *linseed oil, others are poppy oil, oil of lavender and walnut oil. These oils dry naturally by oxidisation not by evaporation. (Olive oil never dries, but is sometimes added to proprietary paints to keep them soft in their tubes.)

OFFSET PRINTING

OIL PAINT

Pigment ground in a drying *oil. The oil molecules take up oxygen, either from the air or from the oxygen-rich *pigments and polymerise into large flat molecules that form a thick, leathery surface.

O'KEEFFE, Georgia (1887–)

b. Sun Prairie, Wisconsin. Painter who studied at Chicago Art Institute (1904–5) and *Art Students' League (1907–8); exhibited with *Stieglitz, whom she married (1924); has travelled and taught extensively; lives in New Mexico. A *Precisionist, O'Keeffe isolates images from nature, painting them with a visionary clarity, paradoxically evoking sensuous, mystical poetry.

Left: GEORGIA O'KEEFFE Black Iris. 1926. 36×30 in (91·4×76·2 cm). MM, New York, Alfred Stieglitz Coll
Right: OKVIK Carved and engraved walrus ivory head. c. 300 BC, Punuk Islands, Alaska. h. 3¼ in (8·3 cm). Nationalmuseet, Copenhagen

OKVIK

The first major *Eskimo art style, known from sites on St Lawrence Island and the Siberian side of the Bering Strait. Okvik art consists chiefly of carvings in walrus ivory, particularly human and animal figures, and engraved curvilinear designs on tools and weapons.

OKYO Pine Trees in Snow. Six-fold screen. Ink and colour on paper. 5 ft 1 in×11 ft 10½ in (154×361 cm). Mitsui Coll, Tokyo

OKYO (Maruyama Okyo) (1733–95)

Japanese painter, pupil of a *Kanō master, who started his own school, the *Maruyama. Apparently simple, yet realistic, his work had a great influence on his contemporaries and he had many followers. His own works became more stylised later in his lifetime.

OLD BERING SEA CULTURE see ESKIMO ART

OLDENBURG, Claes (1929–)

b. Stockholm. *Pop artist who went to America (1936); studied at Yale University (1946–50) and Chicago Art Institute (1953–4); moved to New York (1956); created 'Happenings' (1960). Oldenburg abandoned *Abstract Expressionist painting for Pop sculptures of mundane objects, like hamburgers, painted in an Abstract Expressionist manner, lately made of soft materials.

CLAES OLDENBURG Two Cheeseburgers, with Everything (Dual Hamburgers). 1962. Burlap soaked in plaster, painted with enamel. 7×14¾×8⅝ in (17·8×37·5×21·9 cm). MOMA, New York, Philip Johnson Fund

OLIVER, Isaac (?1551/56/65–1617)
Peter (1594–1647)

Isaac, b. Rouen d. London, was a miniaturist from Normandy who came to England as a child (1568) and became *Hilliard's pupil, and subsequently, rival. His son Peter, b. d. London, was if anything an even superior colourist to his father and was commissioned by Charles I to make replicas of the principal paintings in the royal collection.

Left: ISAAC OLIVER Self-portrait. NPG, London
Right: OLMEC Grey-green jade celt carved and incised with typical Olmec features. Pre-Classic period, Mexico. h. 12 in (30·5 cm). BM, London

OLIVIER, Ferdinand (1785–1841)

b. Dessau d. Munich. German landscape painter, influenced first by the *Nazarenes, then *Friedrich's Northern †Romanticism and (after 1825) by *Koch. He produced six lithographs of Salzburg scenery (1823–5), and became Professor of Art History at Munich (1838).

OLMEC

The earliest distinctive style in Mexico centred upon the ceremonial site of La Venta on the Gulf Coast, which was occupied

between 800 and 400 BC. Olmec art includes massive stone heads, carved altars and stelae, and jade figurines and plaques. Characteristic of the style are peculiar baby-faces with snarling jaguar features.

OLTOS (active 520/500 BC)

Athenian *red-figure cup painter who painted mythological scenes and athletes. His figures are thick-set and drawn with strong, firm lines and have some *Archaic features such as long, tapering feet and hands. He was interested in foreshortening and the suggestion of torsion in figures.

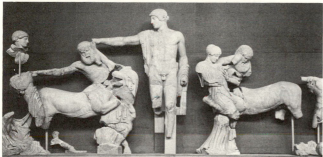

OLYMPIA, Temple of Zeus

The pediments contain sculptures of the early classical period (*c.* 457 BC). The east pediment shows the moment before the chariot-race of Pelops and Oenomaos, a scene without actual movement but full of tension and expectancy. The west pediment shows the battle of the lapiths and centaurs at the wedding-feast of Pirithous, and is full of vigorous action.

OMEGA WORKSHOP

Founded by Roger *Fry (1913), its purpose was to apply *Post-Impressionism and non-representationalism to applied art. The *Vorticist members broke away later (1913) and the Workshop only survived until 1919, the war preventing it having greater influence.

ONATAS (active 500/450 BC)

One of the main representatives of the Aeginetan school of sculpture which flourished on the island of Aegina. He sculpted mainly in bronze, and worked at Olympia, Delphi and Athens. A number of his works are mentioned by *Pausanias, but nothing is definitely attributed to him.

ONESIMOS (active 500/475 BC)

Athenian *red-figure vase painter whose drawing is refined and accomplished. In style he is related to the *Panaitios Painter.

OOSTSANEN, Cornelisz van see CORNELISZ VAN OOSTSANEN, Jacob

OPACITY (OF PAINT)

Opaque *pigments are those which are densest and reflect most light. Whites, some yellows and the lighter *earth colours are generally opaque. When opaque colours are tinted by the admission of stronger, transparent colours each reflecting granule of pigment is given a thin film coating of the added colour.

OPIE, John (1761–1807)

b. St Agnes, nr Truro d. London. An English self-taught artist of considerable ability and popularity whose *tenebrist renderings of peasant life were highly praised by *Reynolds. He worked in Norwich (from 1799) and became a Professor at the Royal Academy (1805), but his later work was disappointingly conventional.

Above: JOHN OPIE *The Peasant's Family.* 1783. 59×71 in (149·9×180·3 cm). Tate
Above left: OLTOS Aphrodite and Ares *c.* 515–510 BC. Tarquinia Museum
Left: OLYMPIA, Temple of Zeus. Central part of west pediment. Olympia Museum, Greece

OP ART

Op art, typified by *Vasarely, *Soto and Bridget *Riley, was to a certain extent a reaction against the romanticism implied in *Abstract Expressionism. It harks back to the experimental Purism of *Mondrian and *Malevich, and *Albers's sequence of squares. The eye of the spectator is used to activate the picture surface, which may rely on after-images; typical 'op' of the 1960s used hard-edged black/white patterns with *moiré dazzle effects, which, being easily reproducible, became commercially popular. Op art, like *Kinetic, relies on the prototype rather than the unique object.

OPTICAL GREYS

Tonal gradation achieved in painting by thinning out dense paint over a dry dark *underpainting. The white particles in the thinned-out paint reflect blue light as in spilt milk. By thinning out warm dense colour over a warm dark *ground, a cool, thin half-tone can be achieved. The result is very subtle and life-like in portraiture. The technique was combined with *sfumato. It formed the basis of *Goethe's colour theory, and was described physically by Tyndall in the 19th century. Sometimes described as 'Tyndall's effect'.

OPTICAL MIX see BROKEN COLOUR

OPUS VERMICULATUM see MOSAICS, CLASSICAL

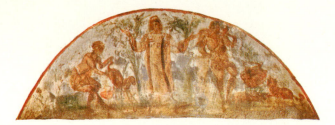

ORANS Painting in the Coemeterium Maius, Rome, showing a woman with her arms raised in supplication and prayer. Late 3rd century. Paint on plaster. 27×80 in (68×203 cm).

ORANS

Latin for 'praying', this term is used to describe a figure in †Early Christian or †Byzantine art depicted standing with arms raised in an attitude of prayer or supplication.

ORCAGNA see ANDREA DI CIONE

ORCHARDSON, Sir William Quiller (1835–1910)

b. Edinburgh d. London. One of the many distinguished Scottish artists who studied under Lauder at the Trustees' Academy, Edinburgh. Came to London (1862); began painting costume-pieces but later turned to modern subjects such as the breakdown of relationships in fashionable society. Frustration and melancholy are suggested by empty space and thin, spare painting.

WILLIAM ORCHARDSON *Marriage of Convenience*. 1883. 41¼×60¾ in (104·8×154·3 cm). Glasgow

ORDONEZ, Bartolomé (b. c. 1490)

b. Burgos d. Carrara. Spanish sculptor, perhaps trained in Florence under Andrea *Sansovino. Worked in Naples, then established himself in Barcelona. Important in the history of Spanish †Renaissance sculpture, his style shows the influence of *Michelangelo's reliefs. His effigies of Philip the Handsome and Joan the Mad (Royal Chapel, Granada) and the saints from the corners of the tombs show his grasp of anatomy, which he uses to achieve a unique religious expression.

ORIENTALISING (720–650 BC)

Term used to describe a period when Greek art was influenced by Oriental art through trading contacts and an influx of Oriental craftsmen to Greece. The new patterns which appear, largely on vases, include curvilinear designs in contrast to the rectilinear *Geometric ones. New subjects are monsters, sphinxes, griffins, gorgons, chimeras and lions. In general ornament is bigger and bolder and less diffused than in Geometric art, and outlining sometimes takes the place of silhouette. The chief artistic centre during the period was *Corinth.

ORIZZONTE see BLOEMEN

ORLEY, Bernard (Barent) van (active 1515–d. 1541)

Netherlandish painter, son of the painter Valentyn van Orley; already active for Margaret of Austria, Regent of the Netherlands (1515); at this time painted mainly court portraits. Elected Court Painter (1518); retained this title under Mary of Hungary (after 1530). Made many altarpieces as well as designs for tapestries and stained glass. His style (eg *Job Altarpiece*, 1521, Brussels) shows much Italianate influence, due either to a visit to Italy, or to his familiarity with prints and with *Raphael's cartoons, which were in Brussels c. 1515/19. His 'Romanist' style is very elaborate with intricate architectural decoration which often overcomes even the exaggeratedly plastic and flamboyantly movemented figures.

BERNARD VAN ORLEY *The Ruin of the Children of Job*. 1521. 69⅜×72½ in (176×184 cm). Musées Royaux, Brussels

ORON see IBIBIO

OROZCO, José Clemente (1883–1949)

b. Jalisco d. Mexico City. Painter, first a political caricaturist, who studied with *Posada and intermittently at Academy of San Carlos (1908–14); worked frequently in United States; visited Europe (1932). The greatest of the revolutionary Mexican muralists, Orozco turned German *Expressionism to his own purposes. Likewise, he saw in Mexico's history and

JOSE CLEMENTE OROZCO *Prometheus*. 1930. Frary Hall, Pomono College, Claremont, California

Revolution a universal lesson. Orozco's murals are dominated by his obsession with the glory of natural man and his oppression under the alleged civilisation of Christianity and capitalism; his recurrent symbols are Christ as revolutionary, the modern whore and all-consuming fire. His tormented figures and harsh contrasts embody a mood of despair and anguish.

OROZCO ROMERO, Carlos (1898–)

b. Guadalajara. Painter, first a caricaturist, who studied in Europe (1921–3); was co-director of Galería de Arte Moderna (from 1935); pioneered art education in Jalisco; taught at Esmeralda School. Influenced by *Surrealism and drawing on native themes, his witty paintings are characterised by delicate lines playing against simplified, often geometric, *Picassoesque shapes.

ORPEN, Sir William (1878–1931) ·

b. Stillorgan, Ireland d. London. Irish portrait and genre painter, associated with Augustus *John. A painter of facility in industry and execution, after early success in tonal treatment his work became uneven, using strength of colouring for effect.

ORPHISM

Term first used by Apollinaire (1912) about a new tendency deriving from *Cubism, but which made colour the principal pictorial element, and was also concerned with movement. The leading figure was Robert *Delaunay, this being the most important period in his career. The contemporary work of Sonia *Delaunay, *Kupka, *Picabia, *Duchamp and *Léger was related to Orphism.

ORRENTE, Pedro (1570/80–1644)

b. Albacete d. Valencia. Spanish painter, working in Valencia (until 1616), then mainly in Toledo (after 1617). He was influenced by *Bassano and he may have been to Venice. *Tenebrist elements in his style suggest that he had contact with *Ribera.

ORSI, Lelio (1511–87)

b. d. Novellara. Emilian *Mannerist painter and architect active in Novellara and Reggio. His secular façade paintings were influenced by *Correggio's illusionist devices. A visit to Rome (1555) profoundly changed his style which now became obsessed with *Michelangelo's Mannerism. Most of his surviving works are *cabinet pictures which, in spite of their size, are filled with energy.

ORTHODOX SCHOOL see TUNG CH'I-CHANG; WANG CHIEN; WANG HUI; WANG SHIH-MIN; WANG YUAN-CH'I; WU LI; YUN SHOU-P'ING

OSEBURG SHIP BURIAL (1st half 9th century)

Royal burial in Norway with a large number of carved wooden objects including the prow and stern of a Viking ship, a cart and various sledges. The carving seems to be the work of several artists over several years. It consists of intricate patterns, interlacing animal designs and some narrative scenes demonstrating the barbaric love of pattern also to be seen in a Christian context, for example in the *Lindisfarne Gospel.

OSEBURG SHIP BURIAL The Cart. 1st half 9th century. Universitets Oldsaksamling, Oslo

OSMAN (16th century)

Turkish painter who illustrated historical manuscripts for the Ottoman court, such as the *Hüner-name.

OSONA, Rodrigo de the Elder (active 1476–84)
the Younger (active 1502–13)

Spanish painters active in Valencia. The Elder b. ?Osona d. ?Vich was the most important Valencian painter of his time. It was he who introduced the influence of Hugo van der *Goes and *Geertgen to the area. The Younger is identified as a son of Roderigo the Elder by a signature on the *Adoration of Kings* (V & A, London) which provides a basis for attributions. He continued his father's style.

Above: RODRIGO DE OSONA THE ELDER *Crucifixion.* 1476. St Nicholas, Valencia
Right: ADRIAEN VAN OSTADE *A Peasant Courting an Elderly Woman.* 1653. $10\frac{3}{4} \times 8\frac{11}{16}$ in (27·3×22·1 cm). NG, London

OST, John van see NOST

OSTADE, Adriaen van (1610–84)

b. d. Haarlem. Dutch painter and etcher. He was very prolific, painting everything except marine subjects, but is most famous for his genre scenes. He was a pupil of Frans *Hals, but his style is much closer to *Brouwer's, his paintings usually depicting carousing or brawling peasants, although his subject-matter gradually became more 'respectable'. He was Jan *Steen's master.

OSTADE, Isaack van (1621–49)

b. d. Haarlem. Dutch painter, the pupil of his brother Adriaen van *Ostade. He specialised in open-air subjects, notably games on the ice.

OSTRACA

The name given to flakes of limestone and potsherds used by the ancient Egyptians for jotting down exercises, letters, odd notes, etc, and also for freehand sketching. The sketches, mainly of New Kingdom date, include trial drawings, copies of details from monuments, vignettes from nature and parodies of familiar subjects with animals acting as human beings (possibly illustrations of fables). Many are done in colour, the best with extraordinary sureness and freedom, though still retaining some of the standard conventions.

OTERO, Alejandro (1921–)

b. El Manteco, Venezuela. Painter who studied at Escuela de Artes Plásticas y Artes Aplicadas, Caracas (1939–43), where he taught (1943–5, 1954–9); lived in France (1945–52, from 1960). An influential proponent of *Op Art, Otero is best known for his 'colourhythms', consisting of parallel vertical elements, varying rhythmically in size and colour.

OTIS, Bass (1784–1861)

b. Bridgewater, Massachusetts d. Philadelphia. Painter and printmaker who first trained as coach-painter; worked in New York (1808–12); settled in Philadelphia (1812). A popular portraitist, Otis painted several celebrities with some charm and distinction. He is best known for executing the first lithograph in America (1818).

OTTOMAN PAINTING see TURKISH PAINTING

OUDRY, Jean-Baptiste (1686–1755)

b. Paris d. Beauvais. French painter of portraits, still-life and hunting scenes. He was Court Painter to Louis XV. He went to Beauvais as a tapestry designer (1726) and worked at the Swedish and Danish courts.

OUWATER, Albert van (active mid 15th century)

Very little is known about this Netherlandish painter whom van *Mander praises as a landscapist from Haarlem, saying that he was *Geertgen's master. Raising of Lazarus (Berlin) is generally accepted. Its emphasis on spatial amplitude and its dainty figures in tight groups show it to have stylistic connections with *Bouts and Geertgen.

OVERBECK, Fritz (1867–1956)

b. Bremen. Painter who studied at Düsseldorf and worked in Worpswede among a group of like-minded Naturlyrismus painters. Overbeck's vast unpeopled moorlands dramatised by solitary trees and towering clouds are expressive and symbolic without going beyond the limitations of naturalism. See also MORGNER

Above left: JEAN-BAPTISTE OUDRY Dog and Pheasants. 1748. 47×60⅝ in (119×154 cm). Wallace
Far Left: ALBERT VAN OUWATER Raising of Lazarus. 48⅛×36¼ in (122×92 cm). Staatliche Museum, Berlin-Dahlem
Left: JOHANN OVERBECK The Rose Miracle of Mary. 1829. Mural in the Portiuncula Chapel, Assisi

OVERBECK, Johann Friedrich (1789–1869)

b. Lübeck d. Rome. German painter and engraver. Studied at Vienna Academy (1806). Went to Rome (1809) where he was a founder of the *Nazarene group. He painted religious and allegorical subjects in an archaic style derived from *Perugino and *Raphael.

OVERPAINTING

May be purely obliterative and corrective, or made to produce a special effect as in *glazing or *scumbling.

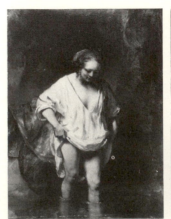
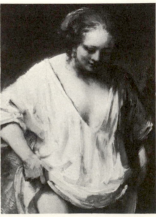

OVERPAINTING Woman Bathing (and detail) by Rembrandt. 1654. Oil on panel. 24×18¼ in (61×46 cm). NG, London

OXUS TREASURE

A hoard of precious metal objects found in Bactria and dating from the 4th century BC. It provides splendid evidence of the Achaemenian goldsmith's skill and of the uniformity of *Achaemenian art.

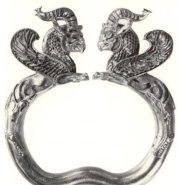

Left: OXUS TREASURE Gold armlet. 5th century BC. h. 5 in (12·3 cm). BM, London
Below: AMEDEE OZENFANT *Flask, Guitar, Glass and Bottle on the grey table.* 1920. 31⅞ × 39¾ in (81 × 101 cm). Kunstmuseum, Basle

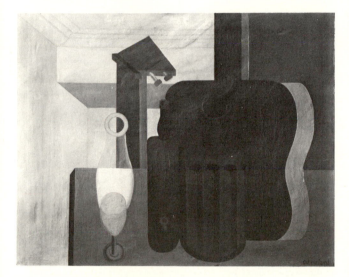

OXYACETYLENE WELDING

Joining metals by melting at their points of contact in a hot flame produced by burning acetylene in an oxygen stream. The gases are stored in cylinders under pressure. The equipment must be handled with care, but the technique is much used by sculptors in ferrous metals.

OZENFANT, Amédée (1886–1966)

b. d. Saint-Quentin. French painter who with *Le Corbusier developed *Purism and edited *L'Esprit Nouveau.* Important as a teacher and writer, Ozenfant moved to New York (1939). Purism rationalised *Cubism, thus destroying its spirit by reducing the subject to formalised emblems of mass-produced objects arranged in a logically harmonious composition.

P

PACH, Walter (1883–1960)

b. d. New York. Painter and critic who studied with *Chase and *Henri; lived largely in Paris (after 1906); was major organiser of *Armory Show (1913), where he exhibited. Pach's well-constructed figurative paintings, particularly portraits, show *Cézanne's influence. His critical writings were a powerful force in explaining modern art.

PACHECO, Francisco (1564–1654)

b. Sanlúcar de Barrameda d. Seville. Spanish religious painter, the masters of *Velasquez and Alonzo *Cano. He was censor of paintings for the Inquisition. His treatise *Arte de la Pintura* laid down iconographic requirements for religious painting.

PACHER, Michael (1435–98)

b. Nr Bruneck, where active d. Salzburg. German painter and sculptor, who was much influenced by *Multscher's sculpture at Sterzing, and by *Mantegna. His main works are altarpieces combining wood sculpture with panel-paintings. The latter show exciting, plunging townscapes and, later, a perspectival control unknown in the Tyrol at this date. This emotively coloured, plastic painting style balances perfectly with the polychrome sculpture which forms the central parts of his altarpieces. The *St Wolfgang Altar* (1471–81) is a major work.

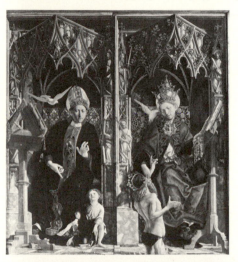

Top: MICHAEL PACHER *St Augustine and St Gregory.* 1482–3. 85⅛ × 77¼ in (216 × 196 cm). AP, Munich
Above: MICHAEL PACHER *Coronation of the Virgin.* 1471–81. Central panel of the St Wolfgang Altar. Polychrome wood. 153½ × 124½ in (390 × 316 cm). St Wolfgang

PADOVANINO, IL (Alessandro VAROTARI)
(1588–1648)

b. Padua d. Venice. Italian painter of religious and mytho-
logical subjects in a style derived from early *Titian and
*Domenichino which strongly influenced 17th-century Vene-
tian painting. He was in Rome c. 1616–20.

Above left: IL PADOVANINO *Cornelia and her Children.*
56×48 in (142×121 cm). NG, London
Above right: PALACE STYLE Storage jar painted with double
axes. h. 3 ft 3 in (1 m). Heraklion Museum, Crete
Right: PAINTING KNIFE
Below: PADUA, Arena Chapel. Giotto: *The Washing of the Feet.*
c. 1304–6. Fresco. 78¾×72⅞ in (c. 200×185 cm).

PADUA, Arena Chapel (1303–c. 1311)

Commissioned as a family chapel by the Paduan banker Enrico
Scrovegni, the building was begun in 1303 and decorated by
1311, and is the earliest securely documented work by *Giotto.
Consecutive scenes dealing with Joachim and Anna, the Virgin
and the life of Christ, form three registers encircling the walls.
The Last Judgement occupies a traditional position over the
west door and the choir contains a later cycle of the later life of
the Virgin. The tradition of narrative fresco cycles comes from
Rome, probably via *Assisi. Giotto introduces a new naturalism,
monumentality and clarity of narrative, employing gestures
and poses which increase the emotional content of the cycle
without disrupting compositional balance. The painting of the
whole cycle as if viewed from the centre of the chapel and lit
from the west window, shows Giotto's consciousness of
creating a tangible new world on the chapel walls.

PAGAN see BURMA, ART OF

PAGE, William (1811–85)

b. Albany, New York d. Tottenville, New York. Painter who
studied with *Morse (mid 1820s); worked largely in New York
and Boston (1829–49) and in Italy (1849–60); settled in Totten-
ville (1866). Unfashionable then, Page's romantic portraits
and history paintings, their sculptural form modelled with
sombre, sonorous, Venetian-influenced colour, achieve a pen-
sive monumentality.

PAINT

*Pigment colours bound in a drying *medium that will hold
the pigment in a thin film to the surface of application. *See also*
GOUACHE; OIL PAINT; TEMPERA; WATER-
COLOUR

PAINTERLY

German: *Malerisch.* A critics' term to describe the essence of
pure painting that creates its effect by the handling of the
medium, tone and colour, free from all linear restraints.

PAINTERS ELEVEN *see* ABSTRACT EXPRESSIONISM

PAINTING KNIFE

A special form of palette knife that is used for the application
of paint to a picture. The shape may vary from a long spatula
to a short trowel-like blade.

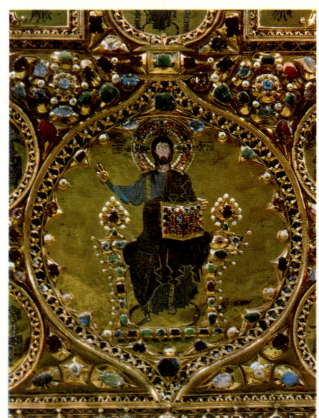

PALA D'ORO Detail from centre panel showing Christ as
Lawgiver. Enamel mounted in gold and silver, set with precious
stones. St Mark's, Venice

PAIONIOS (active c. 425 BC)

Greek sculptor from Mende in Thrace who sculpted a statue of Victory which was set on a column thirty feet high, at Olympia. The goddess, supported by the figure of an eagle beneath her feet, appears to be floating down because of the way the drapery is pressed against her body.

PAIR NON PAIR (Perigordian/Aurignacian)

†Palaeolithic site in the Gironde, France, with simple engravings of a horse, red deer, ox and mammoth.

PAJOU, Augustin (1730–1809)

b. d. Paris. French sculptor who studied under Jean-Baptiste *Le Moyne and at the French Academy in Rome (1752–6). In charge of the decoration of the Opéra at Versailles (1768), and made many busts of Louis XVI. He was appointed Curator of Antiquities at the Louvre (1777).

PALACE STYLE

A vase-painting style which flourished in the Knossos region (1700/1400 BC). It was a more regular and symmetrical type of decoration than the *Kamares style which preceded it, and often includes architectural motifs, rosettes, garlands, double-headed axes and papyri. See also MINOAN ART

PALA D'ORO

A glittering altarpiece fixed behind the High Altar of St Mark's, Venice. Many of the *enamel plaques were ordered from Byzantium in the 12th century, but more were brought as booty from the Sack of Constantinople (1204). Its present setting is a masterpiece of Venetian Gothic metalwork of the 14th century. The enamels form a large composition of Christ surrounded by Evangelists and venerated by angels and saints, together with scenes from the Gospels and the life of St Mark.

PALA DYNASTY SCULPTURE (AD 760–1142)

The Palas controlled extensive dominions in Bihar and Bengal. This area was at the time a stronghold of Buddhism which evolved the *Vajrayana sect with a complex pantheon. The Palas themselves patronised this religion as well as the flourishing Vaishnava cults, the great Buddhist monastery and university of Nalanda continuing under their auspices until their desecration in the Muslim invasions. The religious art of Bihar and Bengal under the Palas (8th–11th centuries) largely reflected tantric or *tantra-influenced ritualism which involved conjuration, magic and self-defilement in the sense of violation of traditional ritual taboos. Tantric religion is basically the worship and drawing out in the devotee of *Shakti, the female energy in the universe personified as the great goddess. One of the earliest Hindu Pala images incorporating this tantric element is the 8th-century, gold-plated figurine of the goddess as Chandi, photographed before its theft from a temple in modern Bangladesh. The elongated figure of the goddess, with three stylised flowers in her crown and leaves sprouting from her feet, stands on the back of a lion couchant upon a lotus-pedestal. The lion and the third eye in the centre of her forehead associate her with *Shiva, yet she holds the disk of *Vishnu. With her eight arms spread like branches, Chandi stands rigid in the *samabhanga upright posture, the inner energising force of nature, stimulating vegetal growth. Typical of Pala tantric sculpture in its evolved form is an image from Monghyr, Bengal, of the goddess Siddheshvari seated with a child upon her lap, with the delicate tapering face and the slender graceful figure. Many such *matrikas (mothers) were represented on temples throughout India, especially in groups of seven flanked by Shiva and his son *Ganesha. The *Shaiva connection with Shakti-worship was always pronounced, one of the names of Shiva's consort being Uma, which is simply another word for 'mother'. Images of Vishnu became stereotyped in the later centuries of Pala rule, but an early (8th-century) bronze has a lightness and simplicity to it which contrasts strikingly with later developments. The torana (gate-way) behind the deity is represented realistically as a separate element in the composition, without the subsidiary figures and foliate decoration which were to complicate the later stone reliefs of the same god. Round the nimbus, however, and even on the top of the mace in the deity's upper right hand, the floral motifs are already in evidence. An image of *Surya the sun god is typical of the ornate late Pala Hindu style. The embroidery on the god's vest has its parallels in *Chandella and *Ganga sculpture of similar date. The *Bodhisattva of the *Vajrayana ('thunderbolt vehicle') cult of Buddhism were derived more or less directly from the Hindu pantheon. The spread of *Mahayānist Buddhism north into Nepal also affected the style of these images in the Pala territories. The floral attributes of the early tantric Shakti images persist in the Bodhisattva images. The ubiquitous lotus in Vajrayanist iconography was to influence Hindu image styles to the extent of creating icons in which the attributes were placed on lotuses rather than being grasped in the hand as in the Siddheshvari image illustrated.

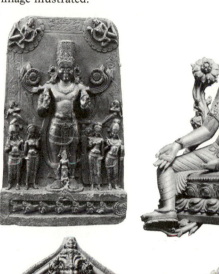

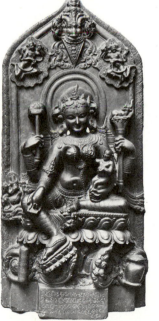

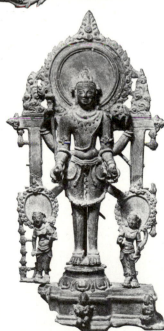

Top left: PALA DYNASTY *Surya.* From Bengal. 10th–11th century. Carboniferous shale. h. 56½ in (143 cm). V & A, London
Top right: PALA DYNASTY *Avalokiteshvara.* From Kurkihar. 11th–12th century. Gilt bronze. h. 9¼ in (23.5 cm). Patna Museum
Above left: PALA DYNASTY *Purneshvari.* From Monghyr. 11th–12th century. Carboniferous shale. h. 32 in (81.3 cm). V & A, London
Above right: PALA DYNASTY *Vishnu.* From Mahasthan. 8th century. Bronze. h. 13¼ in (33.7 cm). V & A, London

PALA DYNASTY PAINTING (11th–15th centuries)

Pala painting from eastern India consisted of miniatures illustrating a *tantric Buddhist text, executed on palm leaves. Two or three miniatures, each measuring not more than $2\frac{1}{2} \times 3$ inches were painted on each leaf, to break up the written text. These leaves were sewn together and bound in painted wooden covers. The forms were outlined in red or black and few colours were used – red, yellow, blue and green (used symbolically) and touches of white as highlights. The style has affinities with that of *Ajāntā – there is the same sinuous naturalism, delicacy and vigour of line, with additional characteristics of Pala art in the sharp noses and double-curved eyes.

PALAMEDESZ, Antonio (1601–73)

b. Delft d. Amsterdam. Dutch portrait and genre painter, the pupil of *Miereveld and Frans *Hals. He entered the Delft Guild (1621). He specialised in small-scale paintings of musical gatherings and genre scenes of soldiers.

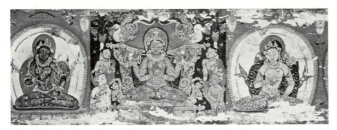

PALA PAINTING *Bodhisattva Prajnaparamita.* Back cover of a palm leaf manuscript. *c.* 1075–1100. $2\frac{5}{8} \times 7\frac{7}{8}$ in (6.7×20 cm). Bodleian Library, Oxford

PALAU ISLANDS *see* MICRONESIA, ART OF

PALERMO, Cappella Palatina

Built by the Norman kings of Sicily (1132–40), the complete church is a good example of the medieval royal chapel, where the court could afford the best artists from diverse cultural backgrounds to produce one grand synthesis. The early mosaics at the east end are characterised by flowing lines, subtle gradations of tone and elegant draperies, and were executed by Byzantine craftsmen. Those to the west are more awkward, and were probably produced by a local workshop under Byzantine supervision. The dome mosaics were added in 1143 and the whole cycle completed by 1189. The wooden ceiling is decorated with small painted panels depicting scenes of everyday and courtly life, mythical animals and symbolic representations of the ruler and his attendants. Long considered to be the

work of Muslim craftsmen in a style characteristic of *Fatimid Egypt, further analysis seems now to point to the work either of a local school of Sicilian craftsmen or to a composite group influenced by North African or Syrian traditions.

PALERMO, Cappella Palatina King Roger of Sicily. Detail from painted wooden ceiling. 1142

PALERMO, La Martorana, Sicily

A convent church built by George of Antioch, High Admiral of Roger II, King of Sicily, and decorated at some stage between 1143 and 1151. The mosaicists produced an abridged version of the Cappella Palatina, *Palermo decorative scheme. Their style was close to that of the east end of the Cappella and the apse of the Cathedral at *Cefalù.

PALESTINIAN BICHROME WARE (c. 1500 BC)

This painted pottery dating from the Late Bronze Age was common throughout *Syro-Palestine. Decorated with birds, fish or geometric designs the style was once thought to be an early manifestation of a Levantine vase-painting school, but the patterns are now attributed to the Hurrians, an intrusive people of the period in North Syria.

PALESTINE BICHROME WARE. Fragment of bichrome krater with bird motif. Institute of Archaeology, London

PALETTE KNIFE

A spatula-like blade used for mixing, manipulating and removing paint from the artist's palette. Also used for removing painting from a picture. Some forms of palette knife may be used for applying paint.

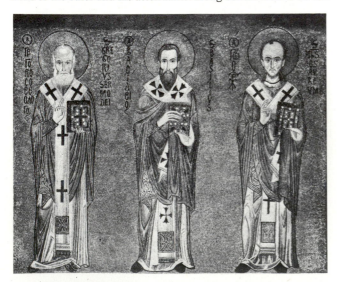

PALERMO, Cappella Palatina *The Three Fathers of the Church, SS Gregory, Basil and St John Chrysostom.* 12th century

PALLAVA DYNASTY (AD 300–888)

The Pallavas represent a Sanskritic culture in the south of India. Their expansion began, as early as the end of the *Satavahana dynasty (c. AD 236), in the area of the Krishna River. From here they spread southwards along the Coromandel coast, extending Sanskritic cultural forms into the Dravidian homeland, while gaining territories inland through royal marriages with the weakening Satavahanas. Their two capitals were established at Kanchi and at Mamallapuram (Sanskrit: Mahabalipuram) on the coast. It is for the Hindu sculpture produced at the height of their power (c. 7th century) that they are renowned in the history of Indian art. The Pallavas' earliest sculpture, though stylistically unique, is found on cave-façades, the cave-shrine form having been borrowed from the Satavahanas. Mandagapattu in the Tamil country (c. AD 610) is the site of the earliest identifiably Pallava cave. The plain, pillared entrance is protected by two powerfully rendered *dvara-pala (door-guardian) figures, each leaning on a mace, carved in relief at the ends of the veranda. The dvara-pala figures undergo considerable refinement as the cave-shrines develop, disposing of their warrior's maces and standing in more relaxed postures. Other features, eg the elaborate foliage designs flowing over the entrance, indicate increasing fluency in a technique which was to culminate in the classical 'paintings in stone' which are the highest achievements of the Pallava sculptor. At Mamallapuram, as well as the cave-temples on the hillside there are on the seashore seven monolithic temples called *rathas, each hewn from a single huge boulder. They represent the first Pallava attempts at free-standing architecture in stone, being imitations of various contemporary wooden temple types. The Shore Temple dates from about 700, half a century later than the rathas. It is in the cave-temples that we see in the sculptured reliefs the flowering of Pallava religious artistry. These reliefs had developed through the early 7th century from a panel carved behind the main image in the inner sanctum of the caves. Classicism in the Pallava School is marked by a complete mastery of medium – intractable granite, which leads the artists to carve shallowly – combined with the possession of a perfectly coherent code of symbolism and the ability freely to manipulate and integrate the elements of this symbology. The symbolism of the metaphysical struggle between order and chaos is dramatised in the tableau depicting *Mahishamardini. The goddess rides into battle mounted upon the lion, her cognisance, against the demon who is represented as a warrior of titanic proportions with the head of a buffalo. One of the most moving of Pallava works is the enormous cleft boulder covered with relief carving also at Mamallapuram, known as the Descent of the Ganges. In fact the imagination of this massive masterpiece was too broad to be limited to any precise legendary event; episodes from various myths to be traced in the Sanskrit scriptures are portrayed. The anonymous artist has simply exploited the possibilities of the rock as he found it, split down the middle. Genii of the rivers (Nagas) are carved in the cleft, down which water can flow over them into a pool at the base of the boulder. Beside this stream, undoubtedly representing the Ganges descending from heaven to earth, appear hosts of figures, divine and mortal: ascetics, gods, kings, temples and animals. Later Pallava sculpture is represented on the temples of the other capital city, Kanchi, such as the Kailasanatha, Vaikuntha Perumal and Muktesh-vara temples. Pallava bronzes are known from the early centuries of their expansion, such as the upper half of a figurine of the Bodhisattva Avalokiteshvara (7th century) which was found in the Krishna Valley. Later developments in *Vaishnava and *Shaiva images provided the basis of the famous *Chola Schools of bronze-casting. The exquisite bronze Nataraja figurines of Shiva originated with the Pallavas in the 8th and 9th centuries, the image itself having been first represented in the south on the rock-face above the façade of Cave-temple IV at the Post-Gupta *Vishnukundin site of Mogalarajapuram on the River Krishna early in the 7th century.

PALLAVA DYNASTY Descent of the Ganges (centre section). Mamallapuram. 7th century. Rock-cut. h. 28 ft (8·5 m)

Top: PALLAVA DYNASTY Mahishamardini. Mamallapuram. 7th century. Rock-cut. h. approx. 66 in (167 cm)
Above: PALLAVA DYNASTY The three cosmic strides of Vishnu. Mamallapuram. 7th century. Rock-cut. h. 68 in (172 cm)
Left: PALLAVA DYNASTY Avalokiteshvara. From the Krishna river delta. 7th century. Bronze. h. 6 in (15·2 cm). V & A, London

PALMA GIOVANE (Jacopo) (1544–1628)

b. d. Venice. Venetian painter, the great-nephew of *Palma Vecchio. Trained under his father Antonio, and copied *Titian's pictures. He was greatly influenced by *Tintoretto and *Veronese and extremely prolific, producing religious and allegorical works with a virtuoso skill.

PALMA VECCHIO (Jacopo NEGRETI) (c. 1480–1528)

b. Serinalta, nr Bergamo d. Venice. Italian painter active mainly in Venice. His earliest work derives from *Carpaccio. By 1512 he had absorbed the influence of *Giorgione and *Titian and had begun to produce his particular brand of *sacra conversazione. Into a broadly horizontal composition he introduces comely female saints in a landscape setting. His voluptuous blonde Venetians also feature in his portraits, eg *La Bella* (c. 1518).

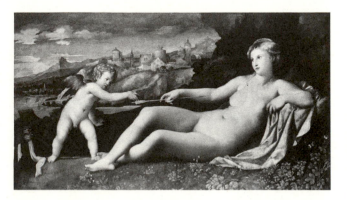

PALMA VECCHIO *Venus and Cupid*. 1523–4. 46½×82½ in (118·1×208·9 cm). Fitzwilliam

Left: ERASTUS DOW PALMER *White Captive*. 1859. Marble. h. 66 in (167·6 cm). MM, New York, Gift of Hamilton Fish 1894
Right: SAMUEL PALMER *In a Shoreham Garden*. Watercolour. 11 1/16×8¾ in (28·3×22·5 cm). V & A, London

PALMER, Erastus Dow (1817–1904)

b. Pompey, New York d. Albany, New York. Self-taught sculptor who moved to Albany (1846) and worked in Paris (c. 1873–7). A gifted leader of American Naturalism, opposing European †Neo-classicism, Palmer's capacity to find morality in nature and a distinctly Yankee formal vitality in American themes and figure types made him enormously popular.

PALMER, Samuel (1805–81)

b. Newington d. Redhill. English painter, the son of a bookseller, he was exhibiting landscapes in his mid-teens. He met *Varley and *Linnell and the latter introduced him to *Blake whose art and visionary character profoundly influenced him. He lived at Shoreham in Kent (1827–35) where, joined by *Calvert, *Richmond and others, he produced his astonishing series of 'visionary' landscapes in rich monochrome sepia and ink and in bright watercolours. This deeply felt inner vision left him during the 1830s, when he made a trip to Italy, and his later watercolours are often rather garish *Claudian pastorals. The vision, however, returned in his small but important output as an etcher (after 1850). With this new medium he recaptured the feeling of his early evocative Virgilian moonlit landscapes, the inspiration for which had stemmed originally from Blake's Virgil woodcuts. Palmer himself in his later years translated Virgil's *Eclogues* and illustrated them with his own etchings.

SAMUEL PALMER *The Bellman*. 1879. Etching. 7½×9⅞ in (19·1×25·1 cm). V & A, London

PAMPHILOS (active 4th century BC)

Greek painter of Amphipolis and pupil of Eupompos of Sikyon who was a contemporary of *Parrhasios. He taught *Apelles and his pupils paid him a talent for a course lasting twelve years. He regarded a knowledge of arithmetic and geometry as essential for a painter and had drawing introduced in Sikyon as a school subject.

PANAINOS (active mid 5th century BC)

Greek painter, a brother of *Pheidias. He is said to have produced a picture of the Battle of Marathon in which he painted the leaders on both sides as portraits.

PANAITIOS PAINTER (active 500/480 BC)

Athenian *red-figure cup painter whose drawing had great vitality and gusto, and whose line had a superbly vibrant quality. His figures are always seen in violent activity.

PANDRENTHAN *see* KASHMIR

PANEL

Thin sheet of wood, veneer, plywood or hardboard used as a *support for painting. Wood and veneer panels should be composite to avoid warping.

PANJAB HILL SCHOOLS: GENERAL

From the 17th to the 19th centuries the area of North Panjab and the western Himalayas was divided into numerous small kingdoms each with its own school of miniature-painting patronised by its rulers. The Mughals conquered the area for a time and it was a favourite place of refuge for unpopular or

unemployed Mughal artists. Most of the schools, therefore, have some influence from the *Mughal School. The history of painting in this region is extremely complex and highly controversial in some of its details. Arguments have raged over whether such schools as Nurpur and Garhwal exist in their own right or whether they were merely used as safe repositories for paintings of other schools in times of political crisis. Only the well-known schools are described here: *Basohli, *Guler, *Kangra and *Bilaspur.

PANNINI, Giovanni Paolo (1692–1765)

b. Piacenza d. Rome. Italian painter who studied at the stage-designers' school in Bologna and arrived in Rome (1615). He chiefly painted views of Roman ruins with figures, often showing the monuments in imaginary relationships.

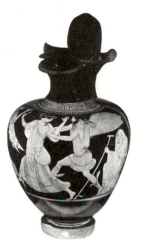

Left: PAN PAINTER *Boreas pursuing Oreithyia.* BM, London
Right: GIOVANNI PANNINI *Ruins with St Paul (?) preaching.* Prado

PAN PAINTER (active 470 BC)

Athenian *red-figure vase painter of the mannerist school. His drawing is brisk and lively and full of deliberate misproportions. He combines a dainty face with a thick neck; a thin waist with bulging thighs; muscular arms with tapering fingers.

PANTOCRATOR

Greek: 'Ruler for All'. Scholars use the generic term to describe the depiction of Christ in †Byzantine art, half-length holding an open or closed book and blessing with his right hand usually in the central dome of churches. *See also* HOSIOS LOUKAS

PANTOJA DE LA CRUZ, Juan (1553–1608)

b. Valladolid d. Madrid. Spanish portrait and religious painter, the Court Artist of Philip III whom he portrayed many times. The poses of his sitters were a source for *Velasquez.

PAOLO VENEZIANO (d. before 1362)

First important named Venetian painter. His paintings include the *Coronation of the Virgin* (Accademia, Venice), a subject popular with the Tuscan followers of *Giotto and a scene painted above the tomb of Doge Francesco Dandolo (d. 1339) (Chapter House, Frari, Venice). He combined †Byzantine and Tuscan elements in paintings with deep reds and blues and gold, which while decorative are less sophisticated than the best Tuscan work.

PAOLOZZI, Eduardo (1924–)

b. Leith. Sculptor who studied at Edinburgh and the Slade School of Art (1943–7). Of Italian extraction, Paolozzi evaded the British fine art tradition. In Paris (1947–9) this rejection found a positive focus in *Surrealism. *Dubuffet influenced him rather than *Moore. Drawing on mass-produced culture, his sculptures and graphics combine a self-assertive modernity with a deep nostalgia for 1940s America.

PAPER

Paper can be made from any cellulose fibre, but the best artists' papers are made from linen rags. The cellulose is boiled, shredded and beaten to a pulp, and then spread in a thin layer to dry.

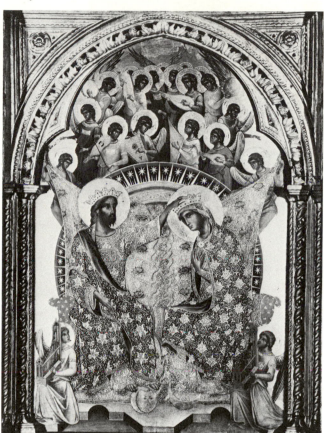

PAOLO VENEZIANO *Coronation of the Virgin.* First half of the 14th century. Tempera and gilding. 38⅝×24¾ in (98·1×62·9 cm). Accademia, Venice

EDUARDO PAOLOZZI *Crash.* 1964. Metal. Ulster Museum, Belfast

PAPIER COLLE

French: 'pasted paper'. A limited form of *collage. The picture is composed by pasting pieces of paper on to a ground, sometimes as part of a painting or drawing, sometimes in its own right.

PAPIER COLLE L'Escargot by Henri Matisse. 1953. Gouache on cut and pasted paper. 112¾×113 in (287×288 cm). Tate

PAPIER-MACHE

Pulped waste paper mixed with starch or gum to make a thick creamy paste which will set into a card-like hard thin shell. Used by sculptors for *maquettes, but picture-frames and even furniture have been made of reinforced papier-mâché.

PAPUA, GULF OF

The coastal area of south *New Guinea from the Fly River to Cape Possession contained a number of related art styles. Rounded forms are rare: figures and boards are carved with patterns in low relief and painted red, white and black. Large ceremonial houses were the foci of ritual activities requiring carved and painted objects. Elema villages on the eastern shore practised elaborate ceremonial cycles for which painted bark-cloth masks were made: the largest, up to twenty feet high, were ritually burned after use. Bull-roarers were the object of a special cult among the Namau. Ancestral boards (gope) with

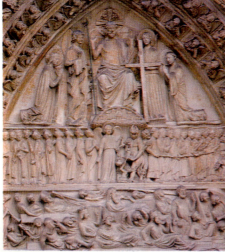

Left: PAPUA, Gulf of. Helmet mask from Orokolo Bay. Bamboo, barkcloth, reed, palm leaves. h. 51¾ in (131 cm). Museum of Primitive Art, New York
Right: PARIS, Cathedral of Notre Dame. The Last Judgement. Detail from the west portal. c. 1225–30.

protective functions were kept in the men's houses. Decorative carving is also found on shields, charms, and on the wide bark belts worn by men on ceremonial occasions.

PARACAS

The finest early Peruvian textiles come from graves in Paracas (700 BC–AD 100). The rich funerary garments are woven from llama wool and cotton and densely embroidered with stylised demons and animals in black, red and green. Other techniques such as brocade, gauze, tapestry, painting and double-cloth occur as well. Paracas pottery is also remarkable, and consists mainly of twin-spout and bridge-handled vessels decorated with incised feline faces and painted after firing.

PARCHMENT

Thin leather from the skin of lambs, calves or goats, used for writing upon. See also VELLUM

PAREJA, Juan de (1605/6–70)

b. Seville d. Madrid. Spanish painter of portraits and religious subjects. In 1623 he became *Velasquez's servant and was painted by his master. Pareja's earliest dated work is 1658. His style derives from *Valdés Leal and El *Greco.

PARET Y ALCAZAR, Luis (1746–99)

b. d. Madrid. Spanish painter and humanist, proficient in all media and painting every type of subject. Particularly notable for his painterly interiors and seaports, and his delight in the fantastic, he is often called the 'Spanish *Fragonard'.

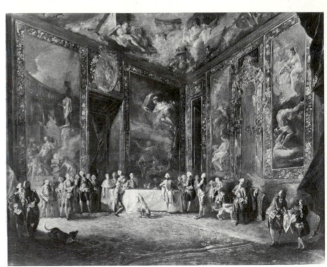

LUIS PARET Y ALCAZAR Charles III at Luncheon attended by his Court. 1768–72. 19½×25 in (49·5×63·5 cm). Prado

PARIHASAPURA see KASHMIR

PARIS, Cathedral of Notre-Dame

The earliest sculpture on the west front dates from soon after 1163. The greater part, however, belongs to the early 13th century. Much damaged during the Revolution enough remains to indicate the debt which Notre-Dame owed to Sens, but also that Paris was the source of an influential figure style which can be traced to *Amiens and *Reims. Later sculpture on the transept façades (1250–65) and north tower demonstrate the inventiveness of Parisian sculptors in the 13th century.

PARIS, Ste Chapelle

Built for St Louis (Louis IX) in the 1240s to house a shrine for the Crown of Thorns and other relics of the Passion which he acquired and housed at enormous cost. The Chapel is often thought of as a kind of *reliquary with its exterior gables and pinnacles and rich internal decoration, walls of glass with

numerous small scenes in medallions supported by slender stone supports, painting and sculpture – Apostles on the piers in heavy, angular robes and delicate *spandrel carvings of angels. The original effect must have been comparable to the shrine of St Taurin at *Evreux. Figures of the twelve Apostles were placed round the upper chapel during construction (1243–8) – not later as is sometimes claimed. Only six survive in the chapel – the others are in the Cluny Museum. Two main styles can be recognised – one close to the *Notre-Dame portals, the other to the Joseph Master at *Reims. The presence of both in the same building suggests that by the mid 13th century, Paris was the principal centre of stylistic innovation in France.

accomplished. It contains many motifs and figures in poses reminiscent of classical painting. Along with the *Joshua Rotulus it is used as evidence for a renaissance of a classical style in 10th-century Byzantium. The so-called 'renaissance' periods of later Byzantine art (eg 12th century and 13th century) sometimes depend directly on copying these two manuscripts. (Bib. Nat., Paris, gr. 139.)

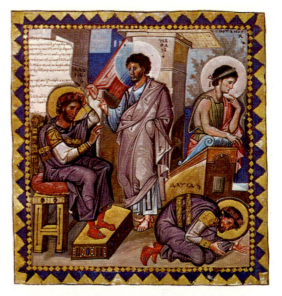

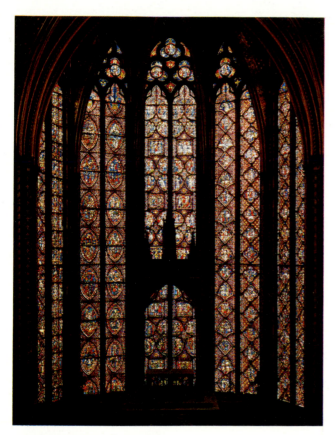

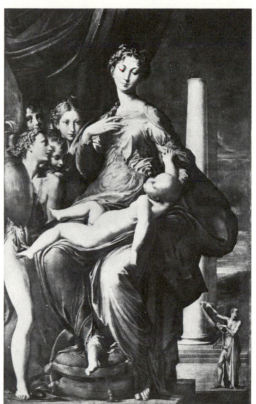

Above: PARIS Ste Chapelle. Stained glass at the East end of the Chapel.
Left: PARIS Ste Chapelle. Two of the Apostle figures.
Above right: PARIS PSALTER *The Penitence of David.* Bib Nat, Paris
Right: IL PARMIGIANINO *Madonna of the Long Neck.* 1534. 85×52 in (216×132 cm). Uffizi

PARIS, Jean de *see* **PERREAL, Jean**

PARIS PSALTER

A Byzantine luxury edition of the Psalter (probably mid 10th century). Its illustrations are a series of full-page scenes within frames. The style is very naturalistic, and the modelling very

PARMIGIANINO, IL (Francesco MAZZOLA)
(1503–40)

b. Parma d. Casalmaggiore. Italian painter and engraver, one of the creators of *Mannerism. Influenced by *Correggio and later by *Raphael and *Rosso. In Rome (1524–7). His precocious abilities earned him the nickname of 'un altro Raphael' in recognition of the graceful felicities of his draughtsmanship

and elegant classicism. He delighted in unusual spatial effects typified in the distorted mirror image in the *Self-Portrait* (KH, Vienna) and the exaggerated vistas in the *Madonna del Collo Lungho* (1534, Uffizi). Similarly his bodily proportions are marked by unnaturally small heads and the figure swelling out round the hips. This and the transparent drapery revealing the naked form beneath reflect his enthusiasm for *Hellenistic sculpture. While he was engaged upon the *Vision of St Jerome* (1527, NG, London) the troops sacking Rome entered his studio. The Sack was a traumatic experience and on his return to Parma he took up alchemy and became mentally unhinged and largely incapable of working. The church authorities lost all patience with him when he was working on the frescoes in Sta Maria della Steccata and threw him into prison. These unfinished frescoes are instinct with a sophisticated classicism but the angular poses reflect his own disquiet.

PARPALLO

†Palaeolithic site near Valencia, Spain. Late *Solutrean and early *Magdalenian deposits contain engraved and painted limestone plaques. The style appears to be common to both periods.

PARRHASIOS (active 425/400 BC)

Greek painter from Ephesos who was renowned for the subtlety of his outlining. According to *Pliny, his outlines 'expressed the contours of the figure', and 'implied the existence of the parts behind, thus displaying even what they concealed'.

PARROCEL, Charles (1688–1752)

b. d. Paris. French *history painter, famous for battle scenes. He served in the cavalry (1705/6) and studied in the French Academy in Rome (1712/21). He painted equestrian portraits of Louis XV and the king of Denmark.

PARTHENON

The name given since the 4th century BC to the Temple of Athena on the Acropolis, Athens. The temple, designed by Iktinos and Kallikrates and built 447–438 BC, is the most famous example of the Doric order and incorporates several refinements. Inside the temple stood a gold and ivory statue of Athena, the masterpiece of *Pheidias, who was also responsible for the pediments, metopes and friezes. *See also* ELGIN MARBLES

PARTHIAN ART

The Parthians ruled *Iran and *Mesopotamia (2nd century BC–AD 224). Parthian art is not well known and much of it is provincial Greco-Roman but some has a definite Parthian character especially some of the sculpture from Hatra, the figures on the coinage and the bronze statue from *Shami. Typically Parthian are the frontal composition (anticipating the art of Byzantium), the rigid attitudes and the lack of movement.

PARVATI

Literally 'she of the mountain'; consort of *Shiva; also figures as Uma, *Durga, etc.

PASARGADAE

The site chosen by Cyrus the first Achaemenid king for his royal city, some forty kilometres north of *Persepolis. Started (*c*. 545 BC) after his conquest of Lydia, many of the craftsmen that were employed in its building came from western Asia Minor. The palaces consist of columned halls with columned porticoes, built of contrasting black and white stone. The best-preserved relief is of a four-winged genius, carved in a *Phoenician style. The other less well-preserved reliefs seem to have been inspired by Assyrian originals. *See also* ACHAE-MENIAN ART

PASCALI, Pino (1935–68)

b. Bari d. Rome. Sculptor who studied at Bari, Naples and Rome. He produced abstract constructions which typically used canvas over wood, arranged as white forms on ribbed frames. He showed at the Venice Biennale of 1968, the year he died in an accident.

PASCIN, Jules (Julius PINCAS) (1885–1930)

b. Vidin, Bulgaria d. Paris. Painter who studied in Vienna and Munich, where he contributed satirical drawings to magazines (eg *Simplizissimus*, 1905–13). Settled in Paris (1905), successively influenced by *Toulouse-Lautrec, *Matisse and *Picasso. Exhibited *Armory Show (1913). He moved to America (1914); naturalised (1920). Characteristic of his work are vapid female nudes painted in watercolour or oil-wash.

PASEMAH, southern Sumatra

Convenient collective name for a number of megalithic sites whose principal artistic feature consists of large rocks carved in a strongly dynamic, agitated style. Represented are helmeted warriors (at Makelamau), groups of two or three figures, an elephant with a warrior and a bronze drum on each side (*Dong-Son), men riding buffaloes or elephants, two men struggling with a snake, another fighting an elephant, coupling tigers, etc. Although the carvings appear to be three-dimensional, the effect is achieved by high-relief carving on either side of the central axis of a rock. Similar scenes are also found on stone reliefs. A number of polychrome paintings in a closely linked style have been found on the inner walls of slab graves.

PASEMAH Megalithic stone group of man riding a buffalo

PASITELES (active mid 1st century BC)

Greek metalworker and sculptor from Neapolis (Naples). He wrote a long book about earlier works of art, and reproduced many of them. He fed the growing Roman taste for Greek art, and founded a school producing copies and adaptations of Greek originals.

PASMORE, Victor (1908–)

b. Chelsham, Surrey. English painter, who studied part-time in London. His early works of atmospherically treated figure studies and landscapes, resembled the work of *Sickert and *Whistler. Helped initiate the *Euston Road School of painting (1937). Abruptly abandoning *Pointillist-like landscapes, he developed abstract paintings and reliefs (*c*. 1951). Becoming progressively more elemental, they vary from geometric reliefs in wood and plastics to paintings which contrast and balance organic forms with hard, geometric lines.

PASSERI, Giovanni Battista (1610/16–1679)

b. d. Rome. Italian painter and writer on art. He painted frescoes in the Doria-Pamphili Palace (1661) and a portrait of *Domenichino. Of more importance is his scholarly compilation of deceased artists' biographies between *Baglione (d. 1644) and Salvator *Rosa (d. 1673), published first in 1772.

PASTEL COLOURS

A popular term to describe pale, light colours, tints with a large quantity of *body white added.

PASTELS

Powdered pigments bound by *gum arabic and compressed or extruded into sticks. The colours are as permanent as the quality of pigments used, and are applied directly to the surface of the drawing. They can be very smoothly blended, or applied in independent strokes, dots or hatches. Pastels are very crumbly and smudgy and the drawings have to be sprayed with *fixative for protection.

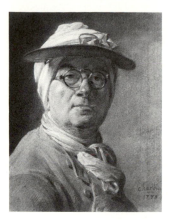
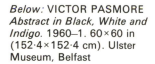

Left: PASTEL *Self-Portrait 'à l'abat-jour'* by Jean-Baptiste-Siméon Chardin. 1775. Louvre

Below: VICTOR PASMORE *Abstract in Black, White and Indigo.* 1960–1. 60×60 in (152·4×152·4 cm). Ulster Museum, Belfast

PASTERNAK, Leonid (1862–1945)

b. Odessa d. Oxford. Russian genre, portrait, landscape painter and etcher, studied at the Munich Academy with Heterich and Liezen-Mayer. He was Professor at the Moscow School of Fine Arts (from 1894), and an Academician (1905). He was a founder-member of the Union of Russian Artists. He moved to Berlin (1921). His friend Tolstoy was a subject for several paintings (eg *Tolstoy in his Family Circle*).

PASTI, Matteo de' (c. 1420–1467/8)

b. Verona d. ?Rimini. Italian medallist, sculptor and architect. First employed as an illuminator, Pasti then worked with almost unrivalled skill as a medallist, notably for Sigismondo Malatesta. He moved to Rimini (?1449), where he was responsible for the interior reconstruction of the Tempio Malatestiano, also possibly for the most fluent and sensitive of the reliefs.

Above: MATTEO DI PASTI. Bronze medallion, the obverse (*left*) bearing a portrait of Isotta degli Atti, wife of Sigismondo Malatesta. Dated (*right*) 1446. d. 2½ in (6·4 cm). V & A, London

PA-TA-SHAN-JEN *see* CHU Ta

PATCH, Thomas (1720–82)

b. Devonshire d. Florence. English artist who went to Rome, with *Reynolds (1749), and lived in Florence (after 1755). Predominantly an engraver after Italian masters, he engraved twenty-six plates of the Brancacci Chapel (1770). He also painted landscape and Florentine *vedute and caricatures of groups of English Grand Tourists.

PATEL, Pierre the Elder (1604/5–1676)
the Younger (c. 1635–95)

The Elder b. Picardie d. Paris; the Younger b. d. Paris. French landscapists, father and son. The Elder studied under *Vouet and was also influenced by *La Hyre and *Claude. The Younger imitated his father.

PATEN

The dish on which the species of bread is placed at the celebration of the Eucharist. Two especially fine examples, in silver and silver-gilt are the Riha and Stuma patens from Syria (6th century).

PATENIER (PATINIR, PATINIER), Joachim (active 1515–d. before 1524)

b. Dinant or Bouvines d. Antwerp. Netherlandish painter, master of Antwerp, where active (1515). Possibly, before this, a pupil of Gerard *David. His importance lies in his seminal position in the development of landscape painting; called a 'landscape artist' by *Dürer. His work, very popular in his own lifetime, consists almost exclusively of extensive craggy landscapes with tiny figures (perhaps by a different hand) acting out in miniature a religious, genre or mythological narrative.

JOACHIM PATENIER *Charon Crossing the Styx.* 25¼×40½ in (64×103 cm). Prado

JOACHIM PATENIER *Landscape with St Jerome*. 1515.
29×35¾ in (74×91 cm). Prado

PATER, Jean-Baptiste-Joseph (1695–1736)

b. Valenciennes d. Paris. French painter. He was *Watteau's
only pupil, and a close imitator of his style, painting mainly
*fêtes galantes. Like *Lancret he reproduced the outward
characteristics of Watteau's style, but lacked the latter's
subtlety and profundity.

PATER, Walter Horatio (1839–94)

b. London d. Oxford. English writer and critic, a spokesman
in England for the doctrine of 'Art for Art's Sake' from the
publication of his *Studies in the History of the †Renaissance*
(1873). Influenced by *Gautier, and buttressed by Swinburne
and Simeon Solomon the painter, he maintained in his life-
style and his criticism, that art transcended faith and morality.

JEAN-BAPTISTE PATER *Fête Galante*. 21×25⅜ in (53×64 cm).
Wallace

PATINA

Accumulation of surface dirt and discoloration with age. Par-
ticularly applied to the oxidation of bronze and copper.

PATINIER, Joachim *see* PATENIER

PATINIR, Joachim *see* PATENIER

PATTADAKAL *see* CHALUKYA DYNASTY

PAUL, Bruno (1874–)

b. Seifhennersdorf, Germany. Satirist and cartoonist who
worked in Munich; influenced by *Toulouse-Lautrec and
Félix *Vallotton. His boldly decorative woodcuts illustrated
the weeklies *Die Jugend* and *Simplizissimus* (from 1897). Paul
belongs to the strong German tradition of graphic *Expres-
sionism which includes the *Blaue Reiter group.

PAUSANIAS

Greek traveller and writer of the 2nd century AD who wrote a
book called the *Description of Greece* which is in the form of a
travelogue starting from Attica. He is particularly interested
in 5th- and 4th-century art, and is an important source of our
knowledge of the works of this period.

PEALE FAMILY

The extraordinary Peales were active for four generations in
invention, technology and scientific naturalism as well as art.
They founded the first American museums, art school, and the
Philadelphia School of Still-life Painting, as well as producing
some of the finest portrait, genre and history paintings of
their time. Owing largely to them, Philadelphia became a
centre of science and art.

PEALE, Charles Willson (1741–1827)

b. Charlestown, Maryland d. Philadelphia. Painter who
studied with *Copley, Boston (late 1760s) and *West, London
(*c.* 1766–7); founded Art Museum (1781–4), Museum of
Natural History (1786) and Art School (1795). Peale's †Neo-
classical portraits explore each sitter's character with solid
clarity, perception and warmth, equally characteristic of his
genre paintings and still-lifes.

Above: RAPHAELLE PEALE
Still Life with Cake. 9½×11½
in (24·1×29·2 cm). Brooklyn
Museum, New York

Left: CHARLES WILLSON
PEALE *Staircase Group*.
c. 1795. 89×39½ in
(226·1×100·3 cm).
Philadelphia Museum of Art,
George W. Elkins Coll

PEALE, James (1749–1831)

b. Chestertown, Maryland d. Philadelphia. Brother of Charles,
he is best known for his †Neo-classical miniatures and charm-
ing *conversation pieces. His most personal and influential
works are the Dutch-influenced still-lifes of his old age, loving
depictions of everyday poetry in glowing exactitude.

PEALE, James, Jr (1789–1876)

b. d. Philadelphia. Son of James, he painted landscapes and
still-lifes, but is best known for his watercolour seascapes.

PEALE, Maria (1787–1866)

b. d. Philadelphia. Daughter of James, she painted still-lifes.

PEALE, Margaretta Angelica (1795–1882)

b. d. Philadelphia. Daughter of James, she painted portraits, but was at her best in her still-lifes, which carried on her father's style, touched with her own modest elegance.

PEALE, Mary Jean (1826–1902)

b. New York d. Pottsville, Pennsylvania. Daughter of Rubens, she lived largely in Philadelphia, painting still-lifes and professional portraits.

PEALE, Raphaelle (1774–1825)

b. Annapolis, Maryland d. Philadelphia. Son of Charles, he directed Peale Museums in Philadelphia and Baltimore (1790s); was itinerant 'profile-cutter' (c. 1803–5). He is remembered for his still-lifes, which, like James's, show lucid design and love of the palpable; these characteristics, wittily applied, made *After The Bath* a superb *trompe l'œil painting.

PEALE, Rembrandt (1778–1860)

b. Bucks County, Pennsylvania d. Philadelphia. Son of Charles, he studied with *West, London (c. 1801–3); visited Europe (c. 1807–8, 1809–10, 1829–31); helped found Pennsylvania Academy. An uneven talent, famous for portraits of Washington and travelling mural, *Court of Death*, a melodramatic moral allegory, he was capable of creating powerful, painterly, acutely perceived portraits.

PEALE, Rubens (1784–1865)

b. Philadelphia d. ?Nr Schuylkill Haven, Pennsylvania. Son of Charles, he spent most of life managing Peale Museums in Philadelphia, Baltimore and New York. In retirement, he painted firm, scientifically orientated, clever still-lifes and animal paintings.

PEALE, Sarah Miriam (1800–85)

b. d. Philadelphia. Daughter of James, she worked in Baltimore (1831–45) and St Louis (c. 1845–77). She shared her sister Margaretta's gift for painting still-lifes, but achieved more distinction in her portraits, which include one of Lafayette.

PEALE, Titian Ramsay (1800–85)

b. d. Philadelphia. Son of Charles, he worked in Peale Museums; went with Long's Upper Mississippi expedition (c. 1818–21), Wilkes's Pacific expedition (c. 1838–42) and to Florida (1824). A distinguished artist and naturalist, he painted animals with cool, lucid refinement.

PEARCE (PIERCE), Edward (c. 1635–95)

d. London. English sculptor and architect. He may have been assistant to *Bushnell (1671). He worked on the Guildhall and

EDWARD PEARCE
Christopher Wren.
Ashmolean

his bust of Christopher Wren (Ashmolean) is the most accomplished English bust of the century. He was also employed by Wren as a stone-carver in London churches.

PEBBLE MOSAICS *see* MOSAICS, Classical

PECH MERLE (generally Perigordian; some possible Magdalenian)

†Palaeolithic site in Lot, France. One of the few caves containing hand-prints, others being *Gargas and *Castillo. There is also a large spotted horse and elongated mammoths, mostly in black.

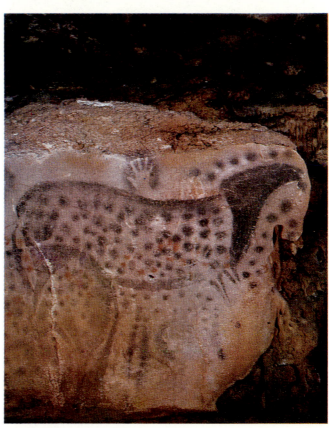

PECH MERLE Cave painting of horse and a human hand.
c. 20,000 BC

PECHSTEIN, Max (1881–1955)

b. Zwickau d. Berlin. German painter who studied in Dresden. Joined die *Brücke (1906). Travelled to Italy and Paris (1908). Founded New *Secession in Berlin (1910). Lived on South Pacific island (1914–15). Returned to Germany and organised the *Novembergruppe (1918), and 'Workers Council for Art' (1919). Pechstein's best works are those which retain his early vigour and spontaneity. After his contact with French *Fauvism (1908) his work became facile and decorative, although he was hailed by press and public as the leader of die Brücke.

PEETERS Family

Flemish family of painters. Bonaventura I (1614–52) b. Antwerp d. Hoboken, and Jan I (1624–80) b. d. Antwerp, were †Baroque marine painters. Their brother Gillis I (1612–53) b. d. Antwerp, was a Dutch-style landscape painter and father of Bonaventura II (1648–1702), b. d. Antwerp, another marine painter.

PEKARNA (Late Magdalenian)

†Palaeolithic site in Moravia, north-east of Brunn, with engravings of bison and horse in bone and antler.

PELEUS PAINTER (active *c.* 440 BC)

Athenian red-figure vase painter of the *Polygnotos group. He painted a famous amphora with Mousaios, Terpsichore and Melousa (now BM, London).

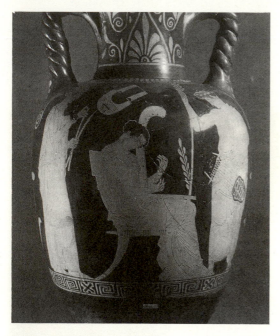

Above: PELEUS PAINTER The Muse, Terpsichore. h. (of vase) 23 in (58 cm). BM, London

Left: ALFRED PELLAN *Floraison. c.* 1945. 71×57½ in (180·3×146·1 cm). NG, Canada

PELLAN, Alfred (1906–)

b. Quebec. Canadian painter who studied at Ecole des Beaux-Arts, Quebec (1920–5) and at Paris academies; worked in Paris (1926–40, 1952–5); taught at Ecole des Beaux-Arts, Montreal (1943–52). Influenced by *Surrealism, Pellan was a catalytic influence in modern Canadian art's development as teacher and artist, creating decorative, complex, rhythmic abstractions.

PELLEGRINI, Giovanni Antonio (1675–1741)

b. d. Venice. Italian painter, pupil of Sebastiano *Ricci, whose light-hearted †Rococo style secured him international patronage. In England (1708–13, 1719) he competed unsuccessfully for the St Paul's Cathedral dome commission, but worked at Kimbolton and Castle Howard.

PELLEGRINO DA SAN DANIELE (Martino da UDINE) (1467–1547)

b. d. Udine. Italian painter, sculptor and stage-designer, active mainly in Udine. His early style is based on the *quattrocento but after 1520 he and his workshop adopted the style of *Pordenone. He developed the 16th-century perspective stage-set.

PEN

A writing and drawing instrument: the effective part of which is a split blade or nib, varying from a fine point to a chisel edge. Formerly made from reed, bamboo or the quill of a feather, latterly from steel.

PENANGGUNGAN

Mountain in eastern Java, the site of a great number of temples and shrines, the two best known being Belahan and Jalatunda. The former is traditionally the burial monument of King Erlannga (mid 11th century) who is portrayed as *Vishnu on Garuda, flanked by his two queens. The latter, which bears the date AD 977 has reliefs concerning the Pandavas. There are well over seventy other shrines on the mountain.

PENCIL

Formerly used to describe either a blunt drawing instrument of lead or silver, or a fine brush. Now refers nearly always to a stick of graphite or carbon in a wooden cylinder.

PENCZ, Georg (*c.* 1500–50)

b. Nuremberg d. Leipzig or Breslau. Painter, printmaker and designer of stained glass. Member of the Nuremberg Guild (1530). In Florence and Rome (1539). Appointed Court Painter to Duke Albrecht of Prussia, but died before he started work at the court. Initially influenced by *Dürer in whose workshop he was active. Subsequently he developed a genre of extroverted portraits, the sitters so dignified and grand as to be almost overblown. Essentially the portraits are *Mannerist; they owe their metallic textures and sharp outlines to the influence of Italy.

GEORG PENCZ *Man holding a Mirror.* 1544. Hessisches Landesmuseum, Darmstadt

PENDE *see* **BAPENDE**

PENE DU BOIS, Guy *see* **DU BOIS, Guy Pène**

PENNI, Giovanni Francesco (Il Fattori)
(c. 1488–c. 1528)
b. Florence d. Naples. Italian painter, the earliest of *Raphael's assistants in Rome. Later worked with Giulio *Romano, from whom he took over what remained of Raphael's workshop and its various unfulfilled commissions. He was a mechanical imitator of Raphael's style.

PENTHESILEA PAINTER (active 465/445 BC)
Athenian *red-figure vase painter. He painted large-scale battle scenes, probably inspired by those of *Mikon and *Polygnotos of Thasos, often crammed into a very small compass. Although many of his works are grandiose he paid great attention to detail and individual figures.

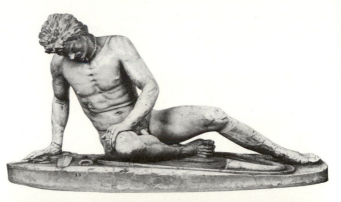

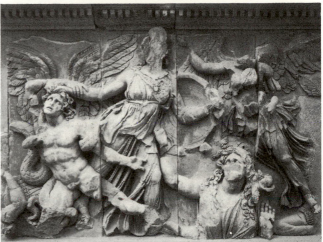

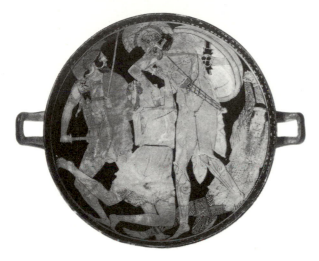

PENTHISILEA PAINTER The Death of Penthisilea. d. 18 in. (46 cm). Antikensammlungen, Munich

Top: PERGAMENE SCHOOL The Dying Gaul. Capitoline Museum, Rome
Above: PERGAMENE SCHOOL The Athena Group from the frieze of the Great Altar, Pergamon. Marble. h. 7 ft 6 in (2·28 m). Staatliche Museum, East Berlin

PENTIMENTO
The showing through in a painting of an alteration, *underpainting or underdrawing. All paint grows more transparent with time and this showing through is characteristic of the ageing process.

PEPLOS
A tunic worn by women in ancient Greece reaching to the ground. It was fastened at each shoulder by a pin or brooch and bound at the waist. Made of a rectangular piece of very heavy material, it hung in simple folds.

PEPLOS KORE *see* **KORE**

PEREDA, Antonio (1608–78)
b. Valladolid d. Madrid. Spanish painter, who executed two historical scenes for the Buen Retiro Palace (1634–5) before Olivarez's disfavour ruined his court career. He painted pictures of the Virgin rich in floral decoration, some notable still-lifes, and allegories of Vanity and Death which influenced *Valdés Leal.

PEREIRA, Irene Rice (1907–)
b. Boston. Painter who went to New York (c. 1916); studied at *Art Students' League (1927–31) and briefly with *Ozenfant (1931); visited Europe (1931); organised *Bauhaus-orientated *WPA Design Laboratory (1935). Experimenting with new media, she blends contemporary science, philosophy and poetry in profoundly luminous, organically textured, semi-geometric abstractions, evoking infinite space.

PERGAMENE SCHOOL
The wealthy kingdom of Pergamon in Asia Minor was a centre of *Hellenistic art. The early threat to the kingdom by the Gallic invasion (278 BC) resulted in sculptures like the Dying Gaul and the Gaul killing himself to avoid capture. The style is strongly realistic, but shows a certain sympathy for the proud, ruthless invader. This powerful realism declines into a shallower and more showy style, as for example in the Great Altar of Eumenes II at Pergamon (c. 150 BC).

PERGAMON ALTAR *see* **PERGAMENE SCHOOL**

PERIGORDIAN (c. 24,000 BC)
The earliest of the late glacial industries in France associated with *Homo sapiens*. No art has been found in the earliest stages. The middle stage and the *Aurignacian are roughly contemporary. The female figurines belong to this period and the Perigordian is similar in many ways to the *Eastern Gravettian.

PERLIN, Bernard (1918–)
b. Richmond, Virginia. Painter who studied at New York School of Design (1934–6) and *Art Students' League (1937–8, 1940); was World War II artist-correspondent; visited Europe frequently. From Social Realism influenced by *Shahn, Perlin has moved to lyrical paintings of crowded interiors, lonely individuals emerging and dissolving in glowing colour.

PERMEKE, Constant (1886–1952)
b. Antwerp d. Ostend. Belgian painter and sculptor who studied at Bruges and Ghent. He belonged to the second Laethem-Saint-Martin group (until 1910) with van der Berghe, Servaes and de *Smet. His early †Impressionist phase gave

way to realistic *Expressionism after the war when he sought to portray living situations in massive forms and gigantic figures. He began sculpture in 1936.

CONSTANT PERMEKE *The Betrothed*. 1923. $59\frac{1}{2} \times 51\frac{1}{4}$ in (151×130 cm). Musée d'Art Moderne, Brussels

PERMOSER, Balthasar (1651–1732)

b. Bavaria d. Dresden. German sculptor who went to Italy (1675) where he was influenced by *Bernini. He was called to Dresden by Johann Georg III to work on the Zwinger Palace (1689). His sculpture makes imaginative use of coloured marble.

PERREAL, Jean (Jean de PARIS) (c. 1455–d. 1530)

French painter, illuminator and architect active in Lyon (from 1483). Court Painter to Charles VIII, Louis XII and François I. In London to paint the portrait of Mary Tudor (1514). Sometimes erroneously identified with the *Master of Moulins. His portrait of Louis XII (Windsor) exemplifies his court style.

PERRONEAU, Jean-Baptiste (1715–85)

b. Paris d. Amsterdam. French portrait painter. He worked in oil and, more importantly, in pastel (although he was trained as an engraver), and was the chief rival of Maurice Quentin de *La Tour, who had more depth, but less charm, than Perroneau. He became a member of the Academy (1753) and subsequently journeyed extensively in Europe, even going as far as Russia.

PERSEPOLIS

Founded by Darius I (521–486 BC) as a royal ceremonial centre where the Persian New Year Festival was celebrated. Many features were borrowed from other lands: the cavetto moulding over the doors from Egypt, the columned hall from Media (and *Pasargadae), the bulls guarding the gateways and other motifs from Assyria, the stacking of the folds of the Persian gowns from Greece and so on; nevertheless the resulting synthesis has a definite character of its own. The numerous bas-reliefs decorating the podia and door-jambs are monotonously repetitive. An extremely limited number of subjects

is treated and the composition of each scene is unvarying. The figures march in rows and registers and the individuality of particular figures is lost in the overall decorative effect. Persepolis was destroyed by Alexander the Great (331 BC). *See also* ACHAEMENIAN ART

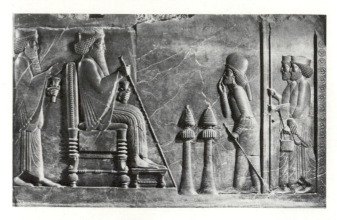

Top: PERSEPOLIS The Treasury relief. Darius receiving tribute. 521–486 BC
Above left: JEAN-BAPTISTE PERRONEAU *Girl with a Kitten*. 1745. $23\frac{1}{4} \times 19\frac{5}{8}$ in (59×50 cm). NG, London
Above right: PERSEPOLIS Detail of bull capital

PERSIAN PAINTING

A fusion of late classical elements from the West, and Chinese influences brought from the East by the *Mongols with the native Iranian tradition developed into a formal style employing stylised figures in abstract landscape with a high horizon complementing but not detracting from the fine calligraphy of the text. The palette with the almost luminous quality of colours and generous application of gold and silver heightened this two-dimensional quality. The illustrations were based on simple compositional patterns but contained a wealth of detail, best seen in the Timurid period at *Herat. Always elegant the human figure then took on a more graceful quality, with an accent on fine drawing. The adoption and adaptation of European techniques at the end of the 17th century was not very successful but the *Qajar style for all its faults retained the innate dignity and formality of the Persian painting tradition.

PERSPECTIVE

Greek: 'clear seeing'. A geometric convention for implying a three-dimensional space on a two-dimensional surface. It depends upon the understanding of the strict rules which govern the apparent diminution of size with distance by linear measurement.

PERU AND BOLIVIA, PRE-COLUMBIAN ART OF
see CHANCAY; CHAVIN; CHIMU; INCA; MOCHICA; NAZCA; PARACAS; TIAHUANACO

Left: PERUGINO *Delivery of the Keys to St Peter.* 1481. Sistine Chapel

Below: BALDASSARE PERUZZI The Sala delle Prospettive. *c.* 1515. Fresco. Villa Farnesina, Rome
Bottom: PESELLINO *St Jerome and the Lion.* 10¾×15¾ in (26·5×40 cm). NG, London

PERUGINO (Pietro VANUCCI) (*c.* 1445–1523)

b. Città della Pieve d. Perugia. Italian painter from Umbria who joined *Verrocchio's studio in Florence, where he learnt oil painting. His reputation sufficiently established, he was commissioned with *Rosselli, *Ghirlandaio and *Botticelli to paint frescoes in the Sistine Chapel (1481). *Pintoricchio assisted him, and the *Delivery of the Keys to St Peter* made his name. Perugino's best works, eg the *Crucifixion* in Sta Maria Maddalena de'Pazzi, Florence, have grace, assurance and well-articulated spatial relationships; too prolific, he later became repetitive. Chigi named him 'the best painter in Italy' (1500); other contemporaries criticised his excessive sweetness.

PERUZZI, Baldassare (1481–1536)

b. Accajano, nr Siena d. Rome. Italian painter and architect; together with *Bramante and *Raphael he was one of the foremost exponents of High †Renaissance classicism in the pontificate of Julius II. His close knowledge of antiquities is reflected in the learned and graceful frescoed allegories in the Villa Farnesina, while his research into antique theatre design produced the lively *trompe l'œil perspectives in the Sala delle Prospettive. A sensitive use of colour stems from his *Sienese origins.

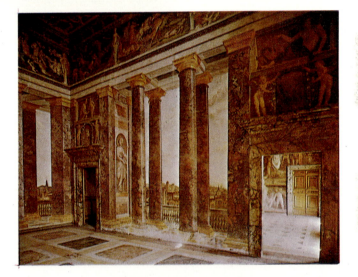

PERSPECTIVE *The Avenue; Middelharnis* by Meindert Hobbema. 1689. 40¾×55½ in (103×141 cm). NG, London

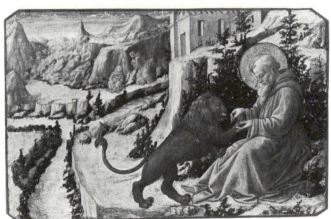

PESELLINO (Francesco di STEFANO) (*c.* 1422–57)

Italian painter whose only documented work is the *Trinity with Saints* (NG, London). Other attributions include the *predella of Filippo *Lippi's Sta Croce altarpiece, a predella *Beheading of John the Baptist,* *Stories of Griselda* (Bergamo) and *Triumphs of Petrarch* (Gardner, Boston).

PESNE, Antoine (c. 1683–1757)

b. Paris d. Berlin. French painter, the pupil of Charles *De La Fosse. He won the Rome Prize (1703). He was Court Painter to Frederick I in Berlin where he painted portraits and ceilings in a light †Rococo style (from 1710).

PETERDI, Gabor (1915–)

b. Budapest. Printmaker and painter who studied in Budapest, Rome and Paris; became American citizen (1944); taught at Brooklyn Museum Art School, and at Hunter College and Yale University (since 1952). Best known for his prints, Peterdi renders the intricacies of nature in fascinating complexity, stronger in technical mastery than in feeling. A very influential writer and teacher in the field of graphics.

PETERS, Rev Matthew William (1742–1814)

b. Isle of Wight d. Kent. English painter, who twice went to Italy, and copied *Rubens in Paris. He used rich colours and creamy impasto. His risqué ladies in undress were very popular as prints, as were his later (after Ordination in 1781) religious paintings.

PETERSFELS (late Magdalenian)

†Palaeolithic site in South Germany with naturalistic engravings on bone and antler and stylised figurines in jet.

PETERZANO, Simone (active 1573–90)

b. Bergamo d. Milan. Italian painter, the pupil of the ageing *Titian. His chief claim to fame was that he was *Caravaggio's master. Rare surviving works suggest that he was a typical late *Mannerist.

PETITOT, Jean (1607–91)

b. Geneva d. Vevey, Switzerland. French miniaturist, he worked in England for Charles I (c. 1636). He went to Blois (1644) and afterwards worked for Louis XIV. He returned to Geneva after Louis's withdrawal of rights from French Protestants (the Revocation of the Edict of Nantes, 1685).

PETO, John Frederick (1854–1907)

b. Philadelphia d. Island Heights, New Jersey. Painter who studied at Pennsylvania Academy (1878) and with *Harnett; lived in Island Heights (1889–1907). Despite Harnett's influence, Peto's still-lifes of everyday objects show more interest in painterly qualities than in *trompe l'œil realism; warm, muted harmonies of light and dark characterise them.

PETROV-VODKIN, Kuzma (1879–1939)

b. Province of Saratov. Russian painter, studied in Munich and Moscow, travelled to Africa (1905). Exhibited at second *Blue Rose exhibition (1909). Influenced by *Post-Impressionism, he later developed a brand of *Social Realism influential on Post-Revolutionary Russian painting.

PEVSNER, Antoine (1886–1962)

b. Orel, Russia d. Paris. Russian sculptor, the brother of Naum *Gabo. Studied in Kiev and St Petersburg. Visits to Paris (1911–14). Influenced by *Cubism. Moved to Moscow and associated with *Malevich and *Tatlin (1917). He signed the Realist Manifesto (1920), a credo of absolute *Constructivism which Gabo wrote. They renounced volume as a sculptural element, affirming that line and plane suffice to express the internal dynamics and rhythms of an object. His first sculptures attempted to express this concept (1922–3). His later works developed abstractly as linear descriptions of continuous planar articulations.

PEVSNER, Nanum see GABO, Naum

PFORR, Frans (1788–1812)

b. Frankfurt d. Albano, nr Rome. German painter, and one of the most original members of the *Nazarene group. He went to Italy (1810) with his associates in the 'Brotherhood of St Luke', and visited Naples (1811). His *history painting is deliberately 'primitive'; in his Rudolf of Habsburg and the Priest (Frankfurt), for example, the figures are silhouetted against a shallow ground, without perspective, and with minimum modelling in the draperies.

Left: FRANS PFORR Allegory of Friendship. 1808. Drawing. 15½×13⅜ in (24·2×18·7 cm). Frankfurt

Below: ANTOINE PEVSNER Monument Symbolizing the Liberation of the Spirit. 1955–6. Bronze. 56×52⅞× 15¾ in (142×133×40 cm). Musée National d'Art Moderne, Paris

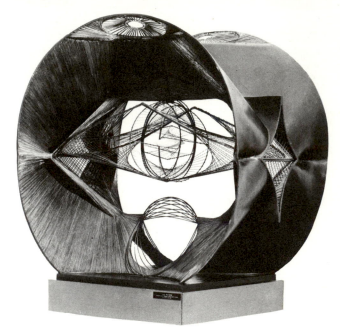

PHAIDIMOS (active c. 550 BC)

Greek sculptor who worked in Attica. His name appears on the bases of two funerary statues.

PHEIDIAS (active 460/430 BC)

Athenian sculptor renowned for his lofty and idealised statues of gods and goddesses. An early work, the *Lemnian Athena, was said to be a surpassingly beautiful statue, although he was better known for his cult statues in gold and ivory, such as his colossal statue of Athena for the *Parthenon. His seated statue of Zeus for the Temple at Olympia was considered his masterpiece. He probably also designed the metopes, frieze and pedimental figures for the Parthenon. See also ELGIN MARBLES

PHILIPPINES see INDONESIA, ART OF

PHILLIPS, Peter (1939–)

b. Birmingham. English *Pop artist, studied at the Royal College of Art, London (1959–62) with *Kitaj, *Hockney, *Caulfield, etc. Exhibited together at Whitechapel (1961).

Developing from *Blake, he uses city idioms. From severe, compartmented images he developed a freer style, although consistently bold in outline. Lives in Zürich.

PHILISTINE PAINTED POTTERY (c. 1150 BC)

This painted ware is considerably more sophisticated than the *Palestine Bichrome ware of some three hundred years earlier, and shows a more advanced composition. One such example is painted in black and red on a white background, the design enclosing a stylised water-bird, its neck bent backwards to preen its wing, thus balancing the picture. Though manufactured in Palestine, the design is well known to be from the Philistine homeland in the Aegean.

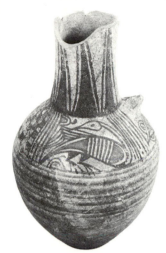

Left: PHILISTINE PAINTED POTTERY Pot with metopic decoration and a water bird. *c.* 1150 BC. Institute of Archaeology, London
Right: PHOENICIAN ART Ivory plaque from the North-West Palace at Nimrud, possibly represents the goddess Ashtart in the guise of the sacred harlot. BM, London

Below: PETER PHILLIPS *Random Illusion No 4.* 1968. Acrylic and tempera. 78⅜×133¾ in (199·1×339·7 cm). Tate

PHILOSTRATUS (active AD 190)

The author of two books called *Imagines* which discuss sixty-five real or imaginary paintings on mythological themes in a portico at Naples. They are an important source of our knowledge of *Hellenistic art.

PHILOXENOS OF ERETRIA (active late 4th century BC)

A famous painting of his is reproduced in the *Alexander Mosaic. It is a complex scene centred on the personal conflict between Alexander the Great and Darius of Persia. It is full of elaborate foreshortenings and perspective effects, such as the forest of spears in the background, which implies other troops, and the reflection of a soldier's face in a polished shield.

PHNOM DA, Funan

Hill site, probably associated with a capital of Funan in the early 6th century AD which has revealed a number of *vaishnavite statues, some of *Vishnu himself, others of Harihara, a combined form of Vishnu with *Shiva and Balarama a brother of Krishna. The features are markedly Indo-Chinese, not Indian. A horseshoe arch round the figures supports the arms and hands which hold the appropriate attributes. Although the backs of the statues are as carefully worked as the fronts,

the figures are not treated in the round, but as two addorsed planes. From the sensuous treatment of the figures, it has been deduced that *bhakti*, personal salvation by adoration of a specific god, was the basis for Funanese Hinduism.

PHOENICIAN ART

Phoenicia produced a great school of craftsmen, notably ivory-carvers, in the 8th and 7th centuries BC. Their style is characterised by the use of Egyptian motifs, often with coloured inlay and gold leaf, in the production of elaborately decorated furniture for the Late Assyrian court and for other rulers. *See also* ARSLAN TASH; MEGIDDO; NIMRUD

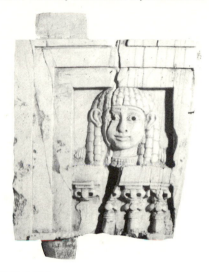

PHRYGIAN ART

The best-known remains of the Phrygian culture are the great rock shrines located in the hills to the south-east of modern Eskisehir, *Anatolia. The shrines are carved to resemble the decorated façades of buildings. Similar geometric patterns occur in the elaborate wooden furniture found in tombs near Gordion, the Phrygian capital, and as painted patterns on a range of imaginatively designed pottery. A pebble flooring, excavated at Gordion, is the earliest known *mosaic. Phrygian metalwork is well represented; bronze fibulae and vessels of local manufacture occur, as well as imported *Urartian cauldrons. It seems clear that Phrygia played a part in the transmission of Oriental ideas to Greece, but her precise role in the development of Greek art remains to be elucidated.

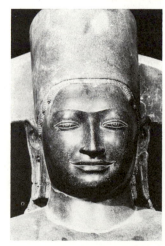
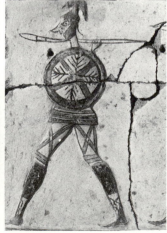

Left: PHNOM DA Head of Vishnu. Late 6th century. Sandstone. h. (of statue) 106⅝ in (270 cm). National Museum, Phnom Penh
Right: PHRYGIAN ART Glazed terracotta relief of a warrior, found at Pazarli. 8th century BC. Archaeological Museum, Ankara

PIAZZA ARMERINA, Villa of (c. mid 4th century AD)

A large and opulent Roman villa in Sicily. It contains an outstanding series of polychrome *mosaics whose total extent is little less than an acre. Subjects include hunting, chariotracing, the Slaughter of the Giants, Orpheus and ten bathing girls.

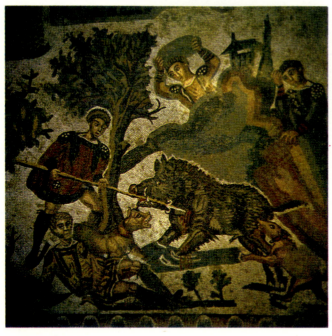

PIAZZA ARMERINA Mosaic of hunting scene from the Room of the Small Hunt

PIAZZETTA, Giambattista (1683–1754)

b. d. Venice. Venetian painter, the pupil of Giuseppe Maria *Crespi in Bologna (1703), he returned to Venice (1711) staying there all his life. His early paintings are in a *tenebrist style with red and brown colouring. Under the influence of *Strozzi he moved towards a lighter †Rococo style (after 1730). He was

appointed the first Director of the Venice Academy (1750). He was a notoriously slow worker and his later paintings are largely executed by pupils and become increasingly rhetorical. He is notable for his enigmatic genre subjects.

PICABIA, Francis (1878–1953)

b. d. Paris. French painter who was first successful as an †Impressionist painter, then as an *Orphic *Cubist (eg Procession, Seville, 1912). In New York, influenced by his close friend Marcel *Duchamp, he produced humorous paintings and drawings of machines (1915). He became an aggressive and nihilistic *Dadaist (cf his stuffed monkey called Portrait of Cézanne). He wrote Dada poetry and published the influential review 391 (1917–24). His painting lapsed into decoration after 1924.

FRANCIS PICABIA Child Carburetor. 1919. $49\frac{3}{4} \times 39\frac{7}{8}$ in (126·4×101·3 cm). Solomon R. Guggenheim Museum, New York

PICASSO, Pablo Ruiz y (1881–1973)

b. Malaga d. Mougins. Painter, sculptor, engraver, ceramist. For many the dominant figure of 20th-century art, Picasso combined an indomitable belief in the individual will with a total scorn for convention. In Barcelona and Paris (1901–4) he made a *Symbolist beginning with the 'blue paintings', attempting to convey by colour and figurative distortion the psychological depth of suffering. Settled in Paris, he moved from this, through a formal exploration of the nude, to a melodramatically anti-naturalist style announced by Le Demoiselles d'Avignon (1907). The aggressive dislocations of this style, rooted in African art, gave way to a cool investigation of the pictorial gains gathered from fusing different views of a subject into a single image and from flattening surfaces as angular facets. *Cézanne was his master here, *Braque his ally and *Cubism the result. With Braque (1912–14) he simplified the formal range of Cubism and at the same time complicated its relation to the subject by introducing fragments of reality – letters, material, wallpaper. Although his most revolutionary contribution had now been made, he continued (after 1914) to resist habit, his innovations still being influential. He developed a refreshed neo-classicism alongside his Cubism (1915–25), reviving apparently rejected representational values. From 1925 he entered new areas of suggestion, deep and disturbing enough to arouse *Surrealist interest and between 1929

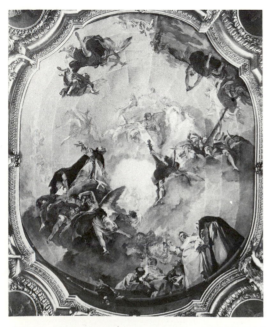

GIAMBATTISTA PIAZZETTA The Glory of St Dominic. Before 1727. Ceiling decoration in the Chapel of St Dominic, SS Giovanni e Paolo, Venice

and 1931, helped technically by *González, he made welded sculpture prophetic of the open mode developed later by David *Smith. These experiments led in painting to a marriage of expressive distortion and personal symbolism (with the bull-fight as a central theme) which culminated in *Guernica* (1937), Picasso's pictorial assault on Spanish Fascism. Less influential since 1946, Picasso remained in old age obstinately youthful, prodigiously productive and obsessed by his power to invent.

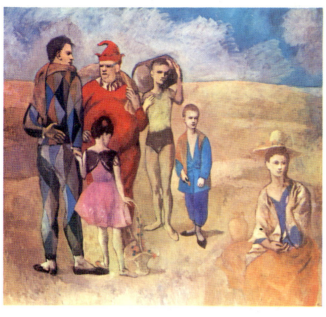

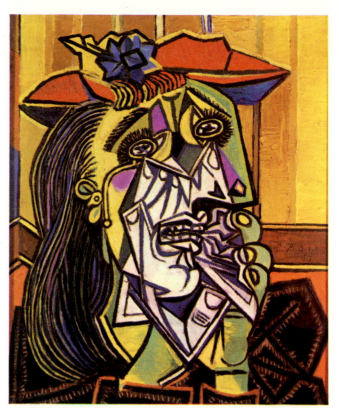

PABLO PICASSO
Above: Family of Saltimbanques. 1905. 40¼×86⅝ in (102×220 cm). NG, Washington
Above right: Weeping Woman. 1937. 25⅝×19¼ in (60×49 cm). Sir Roland Penrose Coll
Right: Two Women (La Muse). 1935. 52×66 in (132·1×167·6 cm). Musée National d'Art Moderne, Paris
Below: Seated Nude. 1909. 36¼×28¾ in (92·1×66·7 cm). Tate
Below right: Head. 1931. Wrought iron. h. 39½ in (100 cm). Coll: the Artist

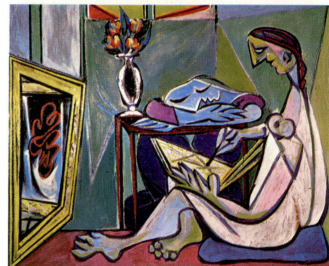

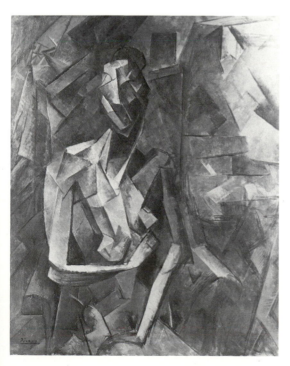

Above: PABLO PICASSO
Monster considering four children. 1933. Engraving

PICHE, Roland (1938–)

b. London. English sculptor who studied at Hornsey and the Royal College of Art, London. Assistant to Henry *Moore (1962–3). Piché uses steel resin, plastic and paint to produce forms analogous with the organic world; globoid, growing and decaying.

PICKENOY, Nicolas *see* ELIASZ

PICKENS, Alton (1917–)

b. Seattle, Washington. Painter who studied at Seattle Art Institute and Portland Museum Art School; visited Europe. Associated with *Magic Realism in the 1930s, Pickens paints genre scenes with a photographic exactitude, their apparently simple realism undermined by a brooding spirit of menace and tragedy which transforms them into social allegories.

PICKETT, Joseph (1848–1918)

b. d. New Hope, Pennsylvania. Self-taught painter who was a carpenter and shipbuilder. Pickett experimented with unusual materials to achieve strange textures in his primitive, child-like landscapes.

PICTURE PLANE

The plane of the surface of a picture. In *perspective theory the plane upon which the geometric perspective system is constructed.

PICTURESQUE, The

English Romantic aesthetic principle based on the search for pictorial qualities in landscape. Taking as models the work of *Claude, Gaspar *Poussin and Salvator *Rosa, it became a pedantic obsession at the turn of the 18th century and continued to govern taste through much of the 19th century. Payne Knight and Uvedale Price were the apostles of the movement, but the theories rested on Burke's *Sublime and Beautiful* (1757) and from then on beauty was approached in an analytical fashion. Capability Brown was *bête noire* to followers of the Picturesque as an improver of nature. The Alps and the Lake District were important as places where the landscape was unquestionably Picturesque. *Girtin and *Turner (early in his career) were considerably influenced in choice of subject-matter by these theories and English watercolourists continued to paint those parts of Europe conforming to these standards.

PIENE, Otto (1928–)

b. Laasphe, Westphalia. German *Kineticist who lives and works in Düsseldorf; founder-member of *Zero group (1958). Like Gerhard von *Graevenitz, he is concerned with light and ways of making it real and perceptible: he has designed a 'luminous ballet' (1954) and made 'fire pictures' using smoke.

PIERCE, Edward *see* PEARCE

PIERO DELLA FRANCESCA (c. 1419/21–1492)

b. d. Borgo S. Sepolcro. Umbrian painter, influenced by *Domenico Veneziano, Fra *Angelico, *Sassetta, *Castagno and *Alberti. Early examples of Piero's art (eg *Baptism*, NG, London and *Madonna della Misericordia*, Borgo S. Sepolcro) confirm that the main features of his style were rapidly defined. He employed muted colours, created a limpid atmosphere and intricate landscapes evoked by deft, free brushstrokes. Above all, a geometric simplification of shapes allied to a mathematical basis for his designs imparted a spiritual stillness to his scenes. This was augmented (from 1451) by a sophisticated presentation of architectural settings arising out of his contact with Alberti in Rimini. Differences in mood apparent in his masterpiece the *Legend of the True Cross* (begun 1452, Arezzo) may result from visits to Rome (1459) and Florence. He painted the *Resurrection* (c. 1460) for his birthplace of which he was a city councillor; he also entered the service of the Duke of Urbino and portrayed him and his wife. The late works, eg *Nativity* (NG, London) show Flemish influence and his treatise on perspective is redolent of his mathematical obsessions.

PIERO DI COSIMO (c. 1462–1521)

b. d. Florence. Florentine painter whose early influences were Filippino *Lippi and *Ghirlandaio. He may have worked with *Rosselli in the Sistine Chapel (1481). Piero's style is unique since it does not reflect the classical ideals of form typical of the †Renaissance. His subject-matter was unusual, reflecting an eccentric obsession with the primitive phase of human existence. He did numerous portraits – *Simonetta Vespucci*, *Giuliano da Sangallo*, *Francesco Giambetti*. His later style was influenced by *Leonardesque landscape and *Signorelli.

PIETA

As with the *maestà, the pietà developed from a growing veneration of the Virgin. The group of the sorrowing mother with her son lying across her knees, emphasises Mary's suffering and humanity. Growing out of the Deposition scene, the pietà occurs in an early 14th-century carving in Naumburg Cathedral and in the mid-15th-century *Avignon painting of the pietà. It was particularly popular with French and German sculptors in the later Middle Ages.

PIETRO, Lorenzo di *see* VECCHIETTA

PIGALLE, Jean-Baptiste (1714–85)

b. d. Paris. French sculptor who went to Rome (1736–9). He worked on tombs, secular allegory and portrait busts. His early style was †Baroque, but he developed a more classical manner (after 1760).

PIGMENT

The colouring matter in paint.

PIGNON, Edouard (1905–)

b. Males-les-Mines. French painter who began life as a miner and became a full-time painter (1943), associating with *Estève, Fougeron and Le Moal, painters influenced by Jacques *Villon and *Lhote. He exhibited paintings with Socialist themes at first influenced by *Matisse, later by *Picasso.

PILES, Roger de (1635–1709)

b. Clamency d. Paris. French art historian and theorist. Honorary member of the *French Academy (1699). He championed the art of *Rubens against the prevailing French taste for *Raphael and *Poussin. He has become notorious for his *balance des peintres* in the *Cours de Peintures par Principes* (1708), in which he awarded marks to past artists for composition, drawing, etc, but his criticism is generally more penetrating and informative than that.

PILLEMENT, Jean-Baptiste (1727–1808)

b. d. Lyon. French landscape, marine and genre painter influenced by Dutch painting, *Watteau and *Boucher. He worked in Spain and Portugal (1745–50). Engravings from his drawings were widely disseminated particularly in England and spread the taste for *chinoiserie.

PILON, Germain (c. 1535–90)

b. d. Paris. French sculptor, active for the French court in all sculptural materials. His most famous works are the tombs of François I and Henry II at the Abbey of St Denis. His large marble group, the *Three Graces* (now Louvre) supported a bronze urn which contained the heart of Henry II. With *Goujon, Pilon is the most important French sculptor of the †Renaissance, developing his graceful, elegant style under the influence of Italian *Mannerism of which he saw examples at *Fontainebleau, where he was frequently active.

PILOTY, Karl Theodor von (1826–86)

b. Munich d. Ambach. German painter trained in Munich (1840); became Director of the Academy there (1874). In contrast to the emphasis placed by *Cornelius on the creative process of preparing the cartoon for a wall-painting, and ensuing neglect of painterly values, Piloty introduced into the *Munich School and its decorated buildings more fluid brushwork and resonant colours.

PINCAS, Julius see **PASCIN, Jules**

PINO, Paolo (active 1534–65)

Venetian writer on art and (rather unsuccessful) painter, pupil of *Savoldo. His *Dialogo di Pittura* (1548, Venice) recommends to the painter eclecticism and a more painstaking technique than the best of his Venetian contemporaries used. Pino's painting style is colloquial; his approach was empirical and sensuous.

PINTORICCHIO (Bernardino di BETTO) (c. 1454–1513)

b. Perugia d. Siena. Active in Perugia (before 1481) where he was a member of the Painters' Guild. He assisted *Perugino in the Sistine Chapel in Rome (1481–4) where he also did frescoes in Sta Maria in Aracoeli and Sta Maria del Popolo. His career in Rome culminated in the frescoes in the Borgia Apartments of Pope Alexander VI (1490s). He decorated the Piccolomini Library in Siena Cathedral (1503–8) illustrating the colourful life of Aeneas Sylvius, later Pope Pius II. His decorative style is characterised by charming landscapes, lively colour harmonies heightened by gilding and classical architecture.

PIOMBO, Sebastiano del (Sebastiano LUCIANI) (c. 1485–1547)

b. Venice d. Rome. Italian painter who trained under Giovanni *Bellini but collaborated with *Giorgione. In Rome he is first recorded assisting *Raphael in the Villa Farnesina (1511). They quarrelled and henceforth his style reflects that of *Michelangelo with whom he remained a close friend, the latter sometimes providing him with drawings for his compositions. In his best works, eg *Raising of Lazarus* (1516, NG, London), he combines Venetian colour and lyricism with a Roman firmness of form.

PIPER, John (1903–)

b. Epsom. English painter and theatre and stained-glass designer who studied at the Royal College of Art and the Slade School of Art (1926–30). After visiting Paris (1933) he turned temporarily to abstraction but as a War Artist (1940–2) found his favourite motif of devastated architecture. Colour, texture and perspective heighten the dramatic effect of his romantic topographies which have wide appeal.

PIPPI, Giulio see **ROMANO**

PIPPIN, Horace (1888–1946)

b. d. West Chester, Pennsylvania. Self-taught primitive painter whose subject-matter ranged from Biblical and historical paintings to still-life and genre scenes drawn from childhood memories. All were superbly designed, characterised by vivid detail and intricate, imposing pattern, and endowed with the impressive dignity of profound emotional commitment.

PIRANESI, Giovanni Battista (1720–78)

b. Venice d. Rome. He settled in Rome (1740), after studying scenic design and architecture in Venice. He practised architecture only infrequently (S. Maria del Priorato, Rome, 1764–6), and concentrated on etching and engraving. His profoundly dramatic treatment of Roman architecture, as shown in his *vedute (1745–56), influenced succeeding generations' attitudes towards ancient Rome. While apparently altering scale, he retained archaeological accuracy. His *Carceri d'Invenzione* ('Imaginary Prisons') (1745, reworked 1760/1)

reveal his imagination at its most extravagant. During the 1760s Piranesi involved himself in polemics, arguing in opposition to *Winckelmann that ancient Roman was superior to ancient Greek architecture.

PISA, Isaia da (active 1447–64)

Italian sculptor, employed principally in Rome; he took over from *Filarete the Chiaves Monument in St John Lateran, and executed the Pope Eugenius IV Monument. He was the subject of a laudatory poem by Porcellio, who saw in Isaia's static Roman manner a rebirth of antique art.

PISAN SCHOOL CRUCIFIXES (late 12th–early 13th century)

One of the earliest types of Tuscan panel-painting. Scenes from the life of Christ appeared on the crucifix apron, flanking the body of Christ, and on the cross ends. Similar crucifixes were produced in Lucca, where the work of the *Berlinghieri family shows how †Byzantine influence soon modified this Tuscan formula.

PISANELLO (Antonio PISANO) (before 1395–c. 1455)

b. Pisa. Italian painter and medallist. His early style was influenced by the Venetians and *Gentile da Fabriano. He was employed at the Vatican and in all the major courts of northeastern Italy where humanist learning was gaining ground. This is reflected in the medals for Sigismondo Malatesta, Lionello d'Este and the Emperor John Paleologus (1438). Both in frescoes (eg *St George and the Princess of Trebizond*, Verona) and in panels (eg *Vision of St Eustace*, NG, London) he shows his refined technique and his wide curiosity about the minutiae of nature typical of the *International Gothic.

PISANO, Andrea (d. ?1348)

Italian goldsmith, sculptor and architect, all of whose work is associated with the Cathedral in Florence. He was responsible for the first pair of bronze doors (1330–6), a revival of a †Romanesque tradition, for the Florence Baptistery, later overshadowed by those of *Ghiberti. Scenes from the life of the Baptist and Virtues are skilfully adjusted to a framework of barbed *quatrefoils, a form deriving from †Gothic France. His standards of craftsmanship were high, but he was content to work in the fashionable French style of his time, mild in expression, mannered in gesture and drapery. Iconographically it was influenced by the mosaics in the Baptistery, and by *Giotto's murals in the Peruzzi Chapel. His finely cut cascades of drapery are reminiscent of *Duccio and small-scale French Gothic works. He was successor to Giotto as Capomaestro of the Cathedral, and is probably responsible for some of the sculptured reliefs on the Campanile.

PISANO, Antonio see **PISANELLO**

PISANO, Giunta (active 2nd quarter 13th century)

Pisan painter who evolved the crucifix type which was repeated for the rest of the century. Breaking with the *Berlinghieri type, he introduced, under renewed †Byzantine influence, a simplified and unified design, comprising a suffering Christ with curving body and schematised anatomy, against a patterned, unhistoriated background. Half-length figures of a blessing Christ and an emphatically sorrowing Virgin and St John, were placed on the cross ends.

PISANO, Nicola (c. 1220–before 1287)
 Giovanni (c. 1245–after 1314)

The Pisani were a family of Italian sculptors (active from about 1250 until 1314). Nicola came to Pisa from Apulia (before 1258). He was contracted to produce a pulpit for the Pisa Baptistery (1260) and a second pulpit for Siena Cathedral (1265). The stylistic differences between the two are considerable. At Pisa antique models can be recognised. At Siena these are less conspicuous and there is an element of †Gothic agitation. Nicola's classicism has often been claimed as a

proto-†Renaissance phenomenon, but it is perhaps better seen as a last vigorous manifestation of Italian †Romanesque interest in antiquity. The change in his style coincided with a general change of taste connected with the arrival in Naples of the Frenchman, Charles of Anjou. Nicola's last-known work was the fountain at Perugia (completed 1278), but in this many assistants co-operated, among them his son, Giovanni. Giovanni developed a much more personal style than his father. Gothic mannerisms, perhaps acquired from a knowledge of Rhenish and French cathedrals (eg *Strasbourg) were already present in his statues for the façade of Siena Cathedral (c. 1290), and they became more strident in his two pulpits for S. Andrea at Pistoia (1301) and Pisa Cathedral (1310). A similar intensification of emotional content can be recognised in his handling of traditional themes like the Virgin and Child, eg the Pisa Baptistery *Virgin* and the *Virgin* in the Arena Chapel, Padua, which though formally akin to French Gothic models, stand closer in spirit to the *Master of Naumburg.

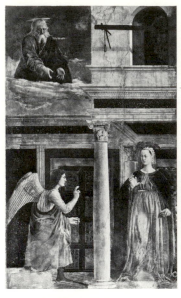

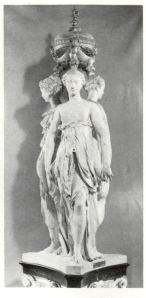

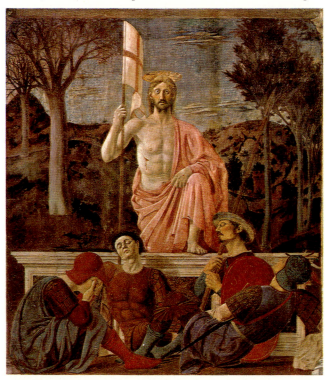

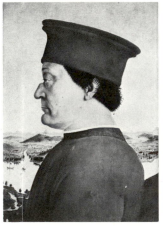

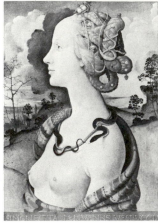

Left: PIERO DELLA FRANCESCA *Resurrection.* c. 1460. 114×100 in (289×254 cm). Palazzo Communale, S. Sepolcro
Top left: PIERO DELLA FRANCESCA *The Annunciation.* ?1455. Fresco. $129\frac{5}{8}$×76 in (329×193 cm). S. Francesco, Arezzo
Top right: GERMAIN PILON *The Three Graces.* 1560. Funerary monument for the heart of Henry II. h. 59 in (149·9 cm). Louvre
Above left: PIERO DELLA FRANCESCA *Federigo da Montefeltro, Duke of Urbino.* c. 1465. $18\frac{1}{2}$×13 in (47×33 cm). Uffizi
Above right: PIERO DI COSIMO *Simonetta Vespucci.* $22\frac{1}{4}$×$16\frac{1}{2}$ in (57·2×41·9 cm). Chantilly
Below: SEBASTIANO DEL PIOMBO *Death of Adonis.* c. 1512. $74\frac{1}{2}$×$116\frac{1}{8}$ in (189×295 cm). Uffizi

Above: KARL VON PILOTY *Seni and the corpse of Wallenstein.* 1855. $123\frac{1}{8}$×$143\frac{3}{4}$ in (365×372 cm). NP, Munich

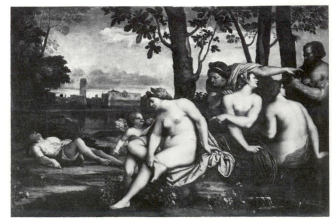

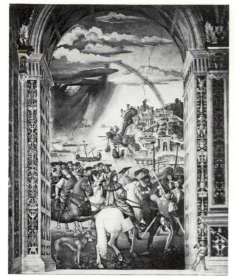

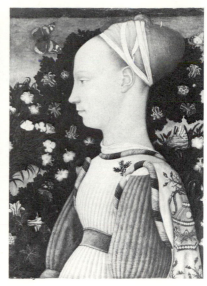

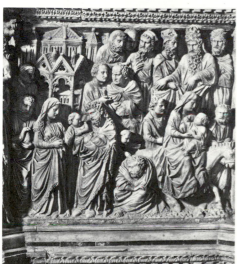

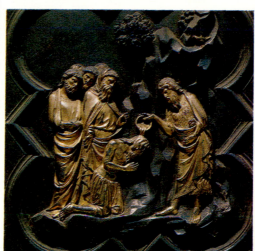

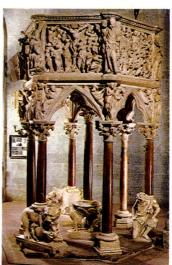

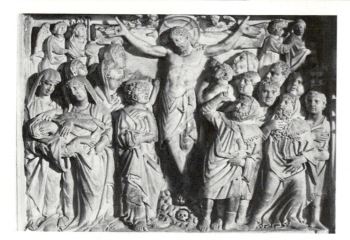

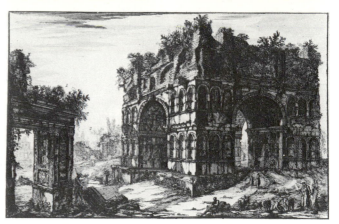

Top: PINTORICCHIO *Aeneas Piccolomini setting out for the Council of Basilea.* 1503–8. Piccolomini Library, Duomo Siena

Top centre: JOHN PIPER *St Mary le Port, Bristol.* 1940. 30×25 in (76·2×63·5 cm). Tate

Top right: PISANELLO *A Princess of the House of Este. c.* 1438. 17×11¾ in (43·2×29·5 cm). Louvre

Centre left: NICOLA PISANO *Presentation and Flight into Egypt.* 1265–8. h. 31⅞ in (81 cm). Relief from the pulpit, Duomo, Siena

Middle row centre: ANDREA PISANO *Baptism of Christ.* 1330–6. Bronze, parcel-gilt. 19¾×17 in (50×43 cm). Baptistery Doors, Florence

Middle row right: GIOVANNI PISANO *Pulpit.* Completed 1301. S. Andrea, Pistoia

Above left: NICOLA PISANO *Crucifixion.* 1206. h. 33½ in (85 cm). Relief from the pulpit, Baptistery, Pisa

Above right: GIOVANNI BATTISTA PIRANESI *Arch of Janus with the Arch of the Money Changers.* 1771. Etching. 18½×27⅞ in (47×70·8 cm). BM, London

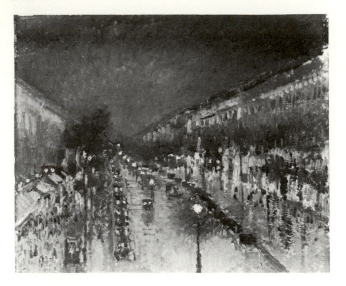

Above: CAMILLE PISSARRO *Paris: the Boulevard Montmartre at Night.* 21×25½ in (53·5×65 cm). NG, London

Below: CAMILLE PISSARRO *Lower Norwood, Londres: Effet du Neige.* 1870. 13⅞×18 in (34×35·7 cm). NG, London

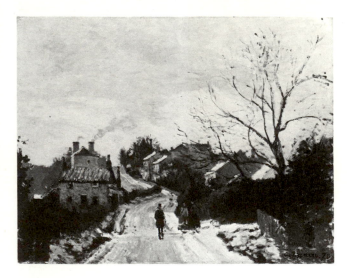

PISSARRO, Camille Jacob (1830–1903)

b. St Thomas, West Indies d. Paris. Enrolled at the Paris Ecole des Beaux-Arts (1855), he preferred the Académie Suisse where he met *Monet. The Salon of 1859 accepted a landscape, and he continued to contribute throughout the 1860s, but participated in the Salon des Refusés (1863). The Franco-Prussian War forced him to flee to London where he studied the works of *Turner and *Constable with Monet, and met *Durand-Ruel who became his patron and dealer. On his return, he participated in all aspects of the †Impressionist movement, including all the exhibitions, and directed *Cézanne and *Gauguin towards the group. His contact with *Seurat and *Signac led briefly to experiments with *Pointillism.

PISSARRO, Lucien (1863–1944)

b. Paris d. London. Son of Camille *Pissarro. Settled permanently in England (1890). Became active in engraving and book-illustration, following the tradition of William *Morris as an artist, craftsman and printer; he preserved, however, his †Impressionist style of painting, exerting a positive influence on young English artists.

PISTOLETTO, Michelagniolo (1933–)

b. Biella. Italian adherent of *Pop Art who has produced a series of painting-constructions using mirrors and impersonal figure images. The spectator is reflected in the mirror and becomes an integral part of the work, each forming it for himself differently.

PISTOXENOS PAINTER (active 475/450 BC)

Athenian *red-figure vase painter whose style is related to that of the *Penthesilea Painter. His best-known vase is a white-ground kylix showing Aphrodite riding a goose (BM, London).

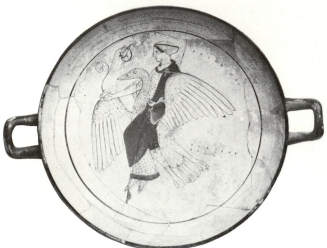

PISTOXENOS PAINTER White-ground cup from Camiros showing Aphrodite riding a goose. BM, London

PITLOO, Anton Sminck (1791–1837)

b. Arnhem d. Naples. Dutch artist who studied under van Amerom. He travelled to Paris, Rome and Naples and there became a teacher of landscape (1820s), painting the surrounding country in a clear manner reminiscent of English †Romantic landscape painting. His works and teaching led to the School of Posilippo, the forerunners of Italian †Impressionism.

PITOCCHETTO, IL *see* CERUTI

PITTONI, Giovanni Battista (1687–1767)

b. d. Venice. Venetian painter of religious and mythological subjects. Although he never left Italy he had an international clientele including the Swedish, Danish and German courts. He worked in a sentimentalised eclectic †Rococo style.

PITTURA METAFISICA

Terms invented by de *Chirico and *Carrà in Ferrara (1917), describing a style initiated by de Chirico (1913) and adopted by Carrà (1917) and *Morandi (1918) until about 1920. Their search for the metaphysical significance of ordinary objects by rediscovering them in extraordinary contexts inspired the *Surrealists. Rejecting *Futurist modernism, their static, clearly defined assemblages of images purposely recollect the *quattrocento; but the sense of a nightmarish crowding, achieved by distortions of perspective, owes much to the surface structure of Synthetic *Cubism.

PLACE, Francis (1647–1728)

b. d. Yorkshire. Remarkable English amateur. Taught etching by his friend *Hollar, he painted, mezzotinted and drew architectural views round York. Landscape was his major interest, in which he progressed from line-drawing to tonal wash. He also experimented with ceramics.

PLAINS INDIAN ART

The typical Plains tribes, the Dakota (Sioux), Blackfoot, Arapaho, Cheyenne, Kiowa and Comanche, occupied the grassland area of North America between the Rocky Mountains and the Mississippi River. The most important forms of Plains art were decorative, consisting of painted and quilled ornament applied to buffalo robes, ceremonial buckskin shirts, tipi covers, and other hide and skin objects. The differences between the individual articles made by the various tribes are so slight that Plains art may be regarded as a single style. The painted designs are both geometric and realistic, the latter being generally narratives recording significant events in the owner's life, especially successful battles and visionary experiences. The painting was usually done by the owner himself and so the standard of execution varies greatly. Horses, bison, and warriors in combat are the most common subjects. Porcupine-quill embroidery was done by the women. There are a great number of highly stylised animal patterns which vary according to tribe. After the early 19th century the use of quills gradually declined in favour of trade-beads, but the traditional designs persisted. Although it is often thought that sculpture is absent from Plains Indian art several examples are known, most notably catlinite pipe-bowls carved with representations of men and animals. Pipe sculpture seems to have been particularly developed among the Dakota (Sioux) in whose territories the catlinite sources were to be found. Simple carvings of animal and human heads also appear on wooden dance-wands, clubs and horn spoons, and incised geometric designs decorate bone tools and utensils and wooden dance-mirror frames.

PLAINS INDIAN ART Dakota (Sioux) pipebowl. Red catlinite carved in the form of a horseman. l. 9½ in (24·1 cm). Royal Scottish Museum

PLAMONDON, Antoine-Sébastien (1804–95)

b. Nr Quebec d. Neuville. Canadian painter who studied with *Guérin, Paris (1826–30); returned to Quebec (1830). Quebec's leading contemporary portraitist and religious painter, Plamondon was at his best in his portraits and still-lifes, influenced by †Neo-classicism, †Romanticism and native objectivity, showing penetration of character and a voluptuous delight in the tangible.

PLANTAGENET, Geoffrey, Tomb of see LE MANS

PLASTER OF PARIS

When calcium sulphate is roasted and dehydrated it becomes plaster of Paris. When mixed with water it will take up one and a half parts of water again, and will set on drying to a solid inert state. Can be used for making *gesso, and for *casting and carving in sculpture.

PLATE-MARK

The indentation left in the margin of a print from an *engraved plate after printing. See also ENGRAVING

PLEIN-AIR

French: 'open air'. Used to describe a painting executed out of doors. A 19th-century innovation, and basic precept of †Impressionism.

PLEYDENWURFF, Hans (c. 1420–72)

b. ?Bamberg d. Nuremberg. German painter, active in Nuremberg (from c. 1451). From Netherlandish influences he developed a style of intense pathos, subtlety of facial expression combining with brilliant, expressive use of strong colour and dramatic colour contrasts.

PLINY THE ELDER (AD 23/24–79)

d. AD 79, in the eruption of Vesuvius. Parts of his *Natural History* are a valuable source for the study of ancient art. The most useful books are xxxiv which deals with bronze statuary; xxxv which deals with painting; xxxvi which deals with stone and its use in building and sculpture; xxxvii which deals with *gems and precious stones.

POCHADE

A small sketch painting made in the open air, often for development into a full-scale picture.

Left: PLAINS INDIAN ART Dakota (Sioux) shirt. Early 19th century. Buckskin decorated with quillwork and human hair and painted with scenes of combat. l. 36 in (91·4 cm). Royal Scottish Museum

Centre and above: POCHADE *Weymouth Bay.* Oil sketch by John Constable (and detail) Oil on millboard. 8 × 9¾ in (20·3 × 24·8 cm). V & A, London

POELENBURGH, Cornelis van (c. 1586–1667)

b. d. Utrecht. Dutch landscapist, the pupil of *Bloemaert. He went to Rome (1617), returning to Utrecht (1625) where he continued to paint landscapes with ruins and classical figures influenced by *Elsheimer but with cooler tonality and more open space.

POINTILLISM

Known also as 'Divisionism' and 'Neo-Impressionism', a term coined by Félix *Fénéon (1886) to describe paintings by *Seurat, *Signac and *Pissarro, in which were placed regular touches of pure colour designed to mix optically and create the shimmering effect of coloured light. It was a reaction against the spontaneous technique of †Impressionism, spread widely in the late 1880s, and in Belgium became the dominant movement. It appealed to the*Symbolist writers Fénéon, Kahn, Verhaeren, etc who became its spokesmen. As well as landscapes and coastal views, subjects were drawn from modern life, the city and industrial suburbs. The classical preference for form and idealisation was revived with a totally new significance through the colour theories of *Delacroix and Ogden Rood, expressed in his *Modern Chromatics*. Later, *Signac and *Cross introduced a greater freedom and abstraction, and larger colour areas. This development greatly influenced the formative works of *Kandinsky, *Mondrian, *Matisse, *Delaunay, *Derain and the Italian *Futurists.

POINTING MACHINE

A machine used by the sculptor for measuring and for multiplying dimensions from a small model to a larger piece.

POITIERS, Notre-Dame-la-Grande

The west front of this collegiate church, dating from the second quarter of the 12th century is one of the masterpieces of a distinct western French school of †Romanesque sculpture. Here there is no *tympanum, and the whole façade is richly encrusted with deeply cut decorative sculpture. The effect must have been richer when paint and gilding were still visible. The reliefs in the *spandrels below the first string-course show scenes demonstrating the reconciliation of the Old and New Testaments.

POLACK, Hans (Johann) (d. 1519)

Painter of the German School, originally from Bohemia. Commission in Pipping, near Munich (1479). Town Painter of Munich (from 1488), where his main works are. Polack brought to Bavaria an intense, violent style quite new to the area. He was much influenced by *Breu's demonic characterisations.

POLENOV, Vassily (1844–1927)

b. St Petersburg d. Kalouga. Russian painter who studied at St Petersburg Academy and became Professor at the Moscow School of Art (1882). A member of the *Wanderer group, he later taught at *Abramtsevo. A *plein-air painter, he depicted the Russian countryside and corners of Moscow.

POLIAKOFF, Serge (1906–69)

b. Moscow d. Paris. Russian painter who studied in Paris and London (1930–7). Settled in Paris (1937), and met *Kandinsky, Otto *Freundlich and the *Delaunays. Poliakoff evolved a personal abstract style (1940s-50s), using the glowing colours and strange shapes of Russian icons to create subtly varied spatial relationships.

Above: SERGE POLIAKOFF *Abstract Composition.* 1954. 45⅝×35 in (115·9×88·9 cm). Tate
Left: POINTILLISM *Beach at Gravelines* by Georges Seurat. 1890. 6⅜×9¾ in (16×24·7 cm). Courtauld Institute Galleries

POLIDORO DA CARAVAGGIO (Polidoro CALDARA) (1500–43)

b. Caravaggio d. Messina. Italian painter, pupil and assistant to *Raphael, he was one of the Roman inventors of the *Mannerist style. His fame rests on the façade paintings which he executed in *grisaille in imitation of classical reliefs, renowned for their archaeological accuracy. After the Sack of Rome he moved south, eventually settling in Messina where he produced some dark brooding work in violent contradiction to his classicising phase. He was murdered.

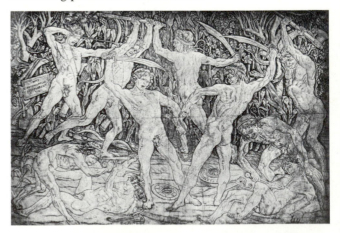

POLLAIUOLO BROTHERS *The Battle of the Nudes. c.* 1470. Engraving. Uffizi

POLLAIUOLO (DI JACOPO BENCI),
Antonio del (1431/2–98)
Piero del (1441–96)

Antonio, b. Florence d. Rome, was a Florentine goldsmith, sculptor, painter and engraver. He collaborated with *Verrocchio in the execution of the *Silver Altar* for the Cathedral and as a painter was influenced by *Castagno, under whom his brother Piero trained. The latter's role was largely that of an inferior collaborator; his dull *Virtues* series (Uffizi) was completed by *Botticelli when the brothers visited Rome (1469). Antonio, however, was a highly original artist noted for his

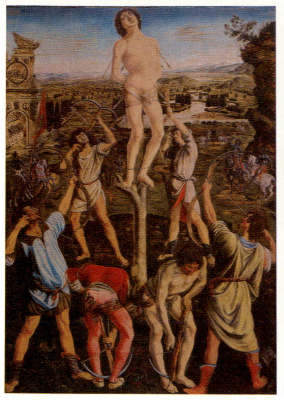

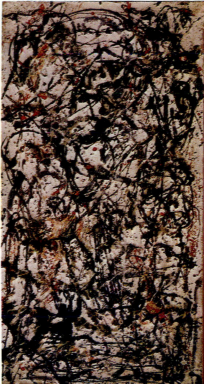

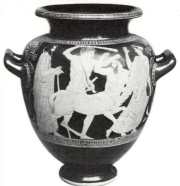

Above: POLLAIUOLO BROTHERS *The Martyrdom of St Sebastian.* 1475. 114¾×79¾ in (291·5×202·5 cm). NG, London

Centre: JACKSON POLLOCK *The Enchanted Forest.* 1947. 84×44½ in (219×113 cm). Guggenheim Foundation, Venice
Top right: JACKSON POLLOCK *Blue Poles* (detail). 1953. 83×192½ in (210·8×488·9 cm). Mr and Mrs Ben Heller Coll, NY
Right: POLYGNOTOS Herakles attacking the Centaur, Nessos. BM, London

panoramic landscapes, as a portraitist, and above all, for his mastery of the nude. The statuette *Hercules and Antaeus* (Bargello), the painting the *Martyrdom of St Sebastian* (1475, NG, London) and the engraving the *Battle of the Nude Men* reveal him as a pioneer in the study of anatomy, while the lesser known frescoes *Dancers* (Torre del Gallo, Arcentri) show the naked bodies reduced to sophisticated outline drawings suggesting an intimate study of antique ceramics. So great was his fame that Lorenzo de'Medici proclaimed that he was the 'principal master in the city . . . perhaps there never was one better'. His last work was the tomb of Pope Innocent VIII (1492–8, St Peter's, Rome) in which the vigorous figure of the pontiff anticipates *Bernini's †Baroque papal monuments.

POLLOCK, Jackson (Paul JACKSON POLLOCK) (1912–56)

b. Cody, Wyoming d. Easthampton, New York. Painter who studied in Los Angeles (1925) and with *Benton at *Art Students' League (1929–31); moved to New York (*c.* 1929); worked for *WPA (1938). From vigorous interpretations of the *American Scene, influenced first by Benton, then *Orozco and *Siqueiros, growing increasingly *Expressionist, Pollock moved to *Surrealism, influenced particularly by *Picasso and *Masson. Carrying automatism to absolute extremes, Pollock developed Action Painting: spreading huge canvases on the floor, Pollock moved round and through them, dripping, splashing and throwing household paints and foreign matter from sticks, knives and buckets, working completely unconsciously. The resulting rhythmic mazes, webs of colour woven by a delirious spider, made him the doyen of Action Painting and the leading name in *Abstract Expressionism.

POLONNARUVA *see* CEYLON

POLYGNOTOS (active 445/430 BC)

Athenian *red-figure vase painter and follower of the *Niobid Painter. His figures have rounded heads, woolly hair, sensitive, sad lips and deep-set eyes with distant lugubrious expressions. They are more earthly than those of the *Achilles Painter, but have the same air of *Pheidian abstraction.

POLYGNOTOS OF THASOS (active 475/450 BC)

Greek painter who twice painted the Sack of Troy, once in the Stoa Poikile (Painted Stoa) in the Agora at Athens and at Delphi. *Pliny says that he stressed the expression of emotion in the faces of his figures. *Pausanias says that his paintings were full of figures on different levels. He probably influenced the *Niobid Painter.

POLYKLEITOS (active 450/420 BC)

Greek sculptor famed for his bronze statues of athletes. It was said that *Pheidias was unsurpassed in making statues of gods, and Polykleitos in statues of men. His most famous works are the *Diadoumenos* (an athlete binding up his hair) and the *Doryphoros* (lance-carrier) which embodied the 'canon' of proportion. He also won the competition to make an Amazon for the Temple of Artemis at Ephesos.

POLYMER COLOURS

*Emulsion paints with a water base, the emulsifying *binder being a synthetic plastic.

POLYNESIA, ART OF

Polynesia is a division of the *Oceanian culture area including all the islands in a vast triangle of the Pacific Ocean with *Hawaii at its northern apex and *New Zealand and *Easter Island as the western and eastern corners. The islands were peopled from Asia by migrations which passed through *Melanesia and *Micronesia, reaching the eastern limits of their expansion about two thousand years ago. Contact with

Europeans, beginning at the end of the 18th century, quickly proved disastrous for the native societies and their arts. The concept of 'vital energy' with which African sculpture has been described as being imbued is more explicitly defined for Polynesian art. People and objects were believed capable of possessing power (*mana*) which could be communicated to others. Under control this power was beneficial, but in the wrong circumstances it became dangerous, or *tapu*. The creation of sculpture, whether a canoe ornament or a temple guardian, was to control *mana* for a social purpose. Wood, stone, ivory and bone were carved to represent gods, ancestors and minor spirits. Masks were not used by any Polynesian cultures. Figures ranged in size from the small *tiki* ornaments of New Zealand to the colossal stone images of Easter Island and the *Marquesas. In the *Fijian, *Tongan and *Tuamotu islands figures were characteristically aloof and impersonal, contrasting with the Cubist aggressiveness of Hawaiian islands war gods. Sculpture from the *Cook, *Austral and *Society islands was more stylised and the principal motif on carved ceremonial objects was the human form reduced to a series of geometric abstractions.

POMODORO, Arnaldo (1926–)
Giò (1930–)

Italian brothers, sculptors. Arnaldo, b. Morciano di Romagna, originally worked in close collaboration with Giò in the design and production of jewellery. Since 1955 he has concentrated on large, single forms, usually bronze, the surface planes of which are often encrusted or inset with deep abstract mouldings. Giò, b. Orciano di Pesaro, has since 1956 produced sculpture based on the theme of concave spaces. He also experiments with the effects of light on shape using highly polished metals.

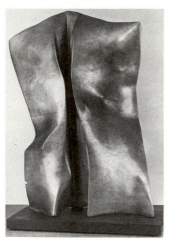

Above: LARRY POONS *Enforcer*. 1963. Liquitex and Fabric Spray. 80×80 in (203·2×203·2 cm). Mr and Mrs Robert C. Scull Coll

Above: GIO POMODORO *One*. 1959. Bronze. 114×82½×25 in (289·6×209·6×63·5 cm). Tate

POMPEIAN PAINTING

Wall-decoration at Pompeii has been divided into four chronological groupings. These groupings or 'styles' are also applied to wall-painting and wall-decoration elsewhere. In the 'First Style' which appeared during the 2nd century BC, walls are decorated with a painted 'incrustation', sometimes in relief, in imitation of marble inlay or veneer. In the 'Second Style' which begins about 50 BC not only are dados and cornices imitated in paint, but so also are colonnades behind which are illusionistic landscapes and buildings. Examples of this style are the Villa of the Mysteries, *Pompeii, the *Odyssey Landscapes, *Boscoreale Villa and the Villa of *Livia. In the 'Third Style' which appeared at the time of Augustus illusionism is replaced by a riot of delicate ornament, often of Egyptian origin. Sometimes the wall is divided into panels on to which small 'pictures' are painted. In the 'Fourth Style' which appears at the time of Nero, walls are often covered with fantastic architectural schemes in several tiers. Nero's *Golden House is painted in this way.

POMPEII, Villa of the Mysteries (70/50 BC)

A suburban villa a little outside the walls of Pompeii. The most important part of the villa is a room richly painted in the *Pompeian Second Style. The painting unfolds in episodic form the stages of initiation into a secret rite.

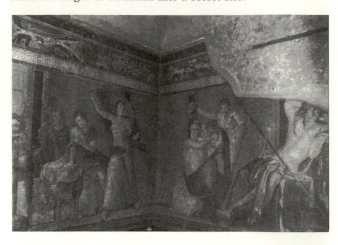

POMPEII, Villa of the Mysteries. Fresco showing initiation rites

PONT-AVEN SCHOOL

The name associated with a group of painters who were influenced in varying degrees by *Gauguin's *Synthetism developed at this village in Brittany in the company of *Bernard (1888). Gauguin first visited it in 1886 and spent four periods there up to 1894, during which his influence was felt by many artists, chiefly Bernard, Laval, *Sérusier, Schuffenecker, de *Haan, Séguin, *Verkade, and less significantly, by a small group of English artists – Bevan, O'Connor, Forbes-Robertson and Hartrick. Gauguin's *Vision after the Sermon* (1888) was his first picture to reveal fully the new Synthetist style, while a small landscape study painted by *Sérusier the same year under Gauguin's instructions, had a great influence on young painters in Paris who were later to form the *Nabis group – *Denis, *Vuillard, *Bonnard, Ranson and *Maillol. The landscape, life and religion of Brittany greatly inspired Gauguin and his followers.

PONTE, DA *see* BASSANO

PONTORMO (CARRUCCI), Jacopo (1494–1557)

b. Pontormo d. Florence. Italian painter, the master of *Bronzino. One of the first exponents of *Mannerism in Florence, his early work shows classical tendencies reflecting the influence of Fra *Bartolommeo and Andrea del *Sarto, whose pupil he was. His Mannerist works, one of the first of which was the *Madonna and Saints* (1518, S. Michele, Visdomini) are strongly reminiscent of *Michelangelo. Paintings such as the *Deposition* (c. 1526, Sta Felicità, Florence) show the same obsession with the human body. The spectator is drawn into the involvement of the intensely agitated figures. In portraits he sought to capture the inner spirit of the sitter (eg *Lady with a Lap Dog*). His diaries confirm the evidence in his works that he was an introspective melancholic.

POONS, Larry (1937–)

b. Tokyo. Painter who came to America (1938); studied in Boston at New England Conservatory of Music and Boston Museum School of Fine Arts; lives and works in New York. Poons combines *Mondrian's grids and *Pollock's all-over compositions in his *Op paintings, intensely coloured spaces vibrating with circles and ovals.

POOR, Henry Varnum (1888–1970)

b. Chapman, Kansas d. New York. Painter who studied in London at Slade School of Art, with *Sickert, and at Académie

Julian, Paris; taught at American Academy, Rome, Skowhegan School and Columbia University; worked for *WPA. First influenced by *Matisse, Poor painted solid, simplified landscapes, still-lifes and figures with strong, flowing, elegant brushwork.

POP ART

Generic term for type of art which arose independently in the United States and Great Britain in the late 1950s, taking as its basis familiar objects of modern life, eg wash-basins, hamburgers and soap-powder boxes, or forms of mass communication, eg advertisements, comics, television and popular films. The principal American representatives include *Warhol, *Lichtenstein, *Oldenburg, *Dine, Rosenquist, *Wesselmann, *Indiana and d'Archangelo. The principal British representatives include *Hamilton, *Paolozzi, Allen *Jones, Peter *Blake and Peter *Phillips. Pop Art arose partly as a reaction against the withdrawal from the real world implied by Abstract Expressionism. It scandalised many by its reintroduction of subject-matter, sometimes using art as a form of research, and its involvement with commercial art and 'kitsch'. Pop Artists have been fascinated by the glamour of advanced Western society, and especially by the ways in which images of things are transmitted. Neither wholly accepting nor wholly critical, their attitude is one of sophisticated playing.

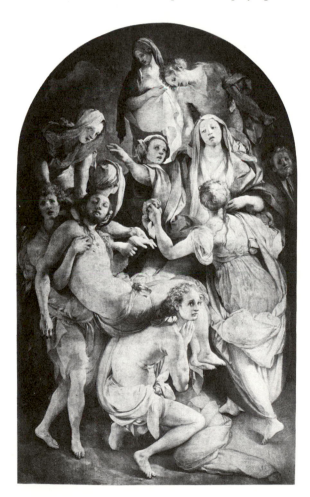

POPOVA, Liubov (1889–1924)

b. d. Moscow. Russian painter whose work shows *Cubist influence and characteristically includes the use of lettering as well as collage. She designed Revolutionary posters (after 1917) and, with the *Constructivists (1921), abandoned painting for 'production art'. Worked on theatre and textile designs in her last years.

POPPI (Francesco MORANDINI) (1544–c. 1584)

b. Poppi, nr Florence, he became a pupil of *Vasari, who himself singled out his Conception (S. Michelino, Florence) and his Visitation (S. Niccolo) as of special merit. His small-figured, delicate style is best seen in the Golden Age (NG, Edinburgh).

PORCELLIS, Jan (c. 1584–1632)

b. Ghent d. Nr Leiden. Flemish marine painter who moved to Holland (1605) working in many places. He changed the emphasis in marine painting from the descriptive portrayal of ships to a more atmospheric representation of sea and sky. *Rembrandt collected his work.

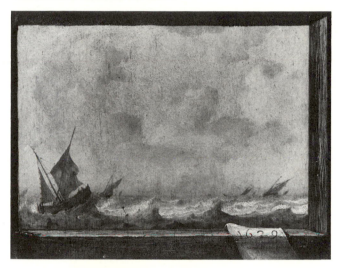

Left: JACOPO PONTORMO Deposition. 1526–8. $123\frac{1}{4} \times 75\frac{1}{2}$ in (313×192 cm). Sta Felicità, Florence
Above: JAN PORCELLIS Stormy Sea. 1629. $7\frac{1}{4} \times 9\frac{1}{2}$ in (18.5×24 cm). AP, Munich
Below: LIUBOV POPOVA Architectonic Composition. 1918. Leonard Hutton Galleries, New York

PORDENONE (SACCHI), Giovanni Antonio
(c. 1483/4–1539)

b. Pordenone d. Ferrara. Italian painter, trained locally, active in Venice, Lombardy and Emilia. Although his early work such as the *Madonna della Misericordia* was influenced by *Giorgione and the Venetians, many paintings show a knowledge of *Michelangelo and *Raphael. He exaggerated their styles in his turbulent and daring illusionistic compositions, eg his *Crucifixion* (Cremona). The set of organ-shutters which he painted with religious subjects for the Cathedral of Spilimbergo (1523–4) also show his sense of the dramatic. The *Annunciation* (1537, Murano) exemplifies the extreme *Mannerist style of his last works.

Far left: GIOVANNI PORDENONE *The Fall of St Paul.* Spilimbergo Cathedral
Above: CANDIDO PORTINARI *The Teaching of the Indians.* Detail from the mural in the Hall of Hispanic Foundation, Library of Congress, Washington DC
Left: JOSE GUADALUPE POSADA *Madero entering Mexico City.* Zinc engraving

POREC CATHEDRAL

The Cathedral of Porec (medieval Parenzo) on the northern shore of the Adriatic Sea in Yugoslavia has preserved much of its original decoration (c. 550), notably mosaics. Like the church on *Mount Sinai it demonstrates very well the aims of Justinianic art, but the artists probably came from *Ravenna rather than directly from the Greek East.

PORTA, della *see* BARTOLOMMEO

PORTA, Guglielmo della (?1500–77)

b. Porlezza d. Rome. Italian sculptor, architect and restorer of antique sculpture. In Genoa (1531) he worked in the studio of his uncle, Giacomo della Porta; by 1537 he was in Rome. He produced small bronzes based on classical examples in a style indebted to that of *Michelangelo.

PORTE CRAYON

A holder for chalk or crayon, enabling the crayon to be used with the freedom of a long pencil. The holder is often double-ended.

PORTINARI, Cândido (1903–62)

b. Brodósqui d. Rio de Janeiro. Painter who studied and taught at Escola de Belas Artes, Rio de Janeiro; visited Paris (1928). Portinari devoted himself to depicting the life and suffering of the Brazilian people in compassionate murals characterised by soft colours, a graceful overall pattern dominated by expressively drawn, sculptural figures.

POSADA, José Guadalupe (1851–1913)

b. Aguascalientes d. Mexico City. Printmaker who studied with Pedroza; went to Mexico City (1887); worked for Vanegas Arroyo. The first truly popular Mexican artist, Posada had enormous influence on later revolutionary Mexican artists. In his vigorous, lucid, often macabrely witty woodcuts, he satirised contemporary politics and society and enlivened old legends.

POST, Frans (1612–80)

b. Leiden d. Haarlem. Dutch landscape painter who executed 'primitive' views of Brazil while accompanying the Dutch West India Company's successful voyage of colonisation (1637–44). He thereafter worked exclusively on these themes, using a highly naturalistic style.

POSTER COLOURS

Water-based colours in a *gum *binder with dense *pigment added for opacity.

POST-IMPRESSIONISM

A term used loosely to denote French painting after the 1880s, notably the work of *Cézanne, *Gauguin and *Van Gogh. Used by Roger *Fry in the title of the Grafton Galleries exhibition of 1910–11 ('Manet and the Post-Impressionists') to imply what he and Clive *Bell understood as an essentially structural approach to painting.

POT, Hendrik Gerritsz (c. 1585–1657)

b. Haarlem d. Amsterdam. Dutch portrait and genre painter, probably a pupil (alongside Frans *Hals) of van *Mander. He travelled to England, and painted a portrait of Charles I (1631, versions Louvre and Buckingham Palace).

POTTER, Paulus (1625–54)

b. Enkhuisen d. Amsterdam. Dutch animal painter famous for his life-size *Bull* (1647, The Hague) although his smaller pictures integrate the animals into landscape better. Moved to The Hague (1649), and to Amsterdam (1652).

POUGNY, Jean (1894–1956)

b. Nr Leningrad d. Paris. Russian painter, associated with *Malevich and *Tatlin. His sympathies evolved through *Cubism, *Suprematism and *Constructivism (1912–20). Moved to Paris (1923). His work steadily became figurative (after 1925). His small interiors and beach scenes evoke a strong personal mood.

POUNCING

A method of transferring a drawing on to a painting *support, or on to an engraver's plate by pricking the outline of the drawing and dusting fine talc through the holes.

POURBUS, Frans the Elder (1545–81)
the Younger (1569–1622)

The Elder, b. Bruges d. Antwerp, was a Flemish religious and portrait painter in an Italian style, the pupil of Frans *Floris. His son, b. Antwerp d. Paris, was a typical international court portraitist of the early 17th century, working in Flanders, Italy and France.

POUSSIN, Gaspard see DUGHET

POUSSIN, Nicolas (1594–1665)

b. Les Andelys, Normandy d. Rome. Went to Paris (c. 1612), and to Rome (1624), becoming sufficiently well known to obtain a commission (1628) in St Peter's, *Martyrdom of St Erasmus* (Vatican). He fell seriously ill (1629), being looked after by Jacques Dughet, whose daughter he subsequently married. The early 1630s were experimental years during which he formed a style combining classical forms with rich, Venetian colouring. After 1634 he concentrated on the articulation of large Biblical and mythological compositions (using a minia-

Above: PAULUS POTTER *The Bull.*
1647. 92¾×133½ in (235·5×339 cm).
Mauritshuis, The Hague
Above right: NICOLAS POUSSIN
The Blind Orion Searching for the Rising Sun. 1658. 46⅞×72 in
(119·1×182·9 cm). MM, New York,
Fletcher Fund 1924
Right: NICOLAS POUSSIN *The Adoration of the Calf.* 60¾×84¼ in
(154×214 cm). NG, London

Below: FRANS POST *San Francisco, and Fort Maurice.* 1638. Louvre

ture stage with wax models) and the development of a wide range of individual expressions. He returned – under pressure – to Paris (1640), to work for the Crown, but finding his organisational role and the hostility of other artists uncongenial, he returned to Rome (1642). He maintained links, however, with a group of French bourgeois patrons who professed a Neo-Stoic philosophy, particularly with Chantelou and painted many 'Stoical' subjects from Roman history. For Chantelou he painted the *Seven Sacraments* series (1644–7, Earl of Ellesmere). His compositions became increasingly geometric, and his reconstructions of antiquity more painstaking. His last landscapes were philosophical statements, and his art became essentially cerebral. It offers a three-dimensional unity of vision uninterrupted by sensuous colour.

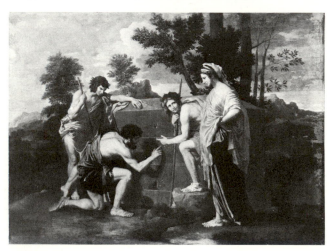

Above: NICOLAS POUSSIN *Et in Arcadia Ego.* 1638–9. 33½×47⅝ in (85×121 cm). Louvre
Below left: HIRAM POWERS *The Greek Slave.* 1847. Marble. h. 65½ in (166·4 cm). Newark Museum, New Jersey
Below right: EDWARD POYNTER *Paul and Apollos.* 1872. 24×24 in (61×61 cm). Tate

POWERS, Hiram (1805–78)

b. Nr Woodstock, Vermont d. Florence. Sculptor who was largely self-taught; worked in Washington (c. 1835–7); went to Florence (1837). His portraits show a penetrating naturalism, but his ideal *Greek Slave* became the most famous sculpture of its time by sterilising nudity with tepid pseudo-classicism, slick execution and piously antiseptic puritanical morality.

POYNTER, Sir Edward John (1836–1919)

b. Paris d. London. Trained in Paris, he settled in London (c. 1860), painting decorative designs for architects, before

specialising in archaeological reconstructions of Greek, Roman and Egyptian civilisations, eg illustrations to the *Dalziel Bible Gallery* (1864). The quality of his decorative paintings after 1870 barely survived the call made on his time as administrator for national institutions.

POZZO, Padre Andrea (1642–1709)

b. Trent d. Vienna. Trained in North Italy, he joined the *Jesuits as a lay-brother (1665) – 'Padre' was a courtesy title – but he was encouraged by the Society to continue his painting. He became a peripatetic, semi-official decorator to the Order, specialising in huge, many-figured, illusionistic ceilings. He painted the nave of S. Ignazio, Rome (1691–4). In 1703 he moved to Vienna, and worked in the Jesuit Church. His ceiling there influenced the growth of Austrian †Rococo. His *Perspectiva Pictorum* (1693–8) was translated into English and affected *Reynolds.

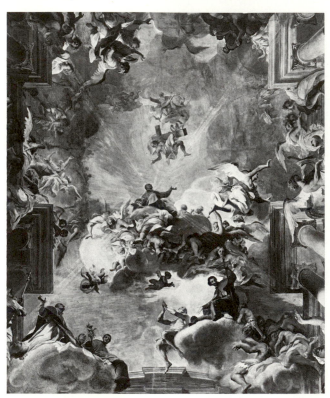

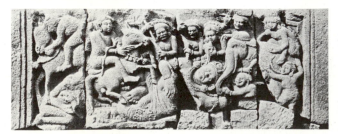

Top: ANDREA POZZO *Allegory of the Missionary Work of the Jesuits.* Ceiling fresco. S. Ignazio, Rome
Above: PRAMBANAN Relief from the balustrade of the temple of Brahma, representing an episode from the Ramayana. l. 6 ft 8¾ in (205 cm)

PRAMBANAN, Central Java (mid 9th–early 10th century)

A shaivite complex with three main temples, the central one dedicated to *Shiva and those to north and south to *Vishnu and *Brahma. Each is faced by a smaller building which is thought to have housed the deity's *vahana,* the bird or animal

on which the god rides. The whole *mandala consisted of some 232 shrines. The temples of Brahma and Shiva are decorated with reliefs from a version of the *Ramayana, that of Vishnu with stories of Krishna. A great variety of carved figures and panels adorn all the surfaces of the buildings. It is possible that the statues of the gods, only some of which have survived also portrayed the ruler and his principal ministers, as was certainly the case in later Javanese religious art.

PRAMPOLINI, Enrico (1894–1956)

b. Modena d. Rome. Italian painter who studied in Rome (1911) and joined the *Futurists (1912). Futurism led him to an abstract dynamism reminiscent of *Kandinsky. An isolated abstractionist in Italy, he lived in Paris (1925–37) contributing to *Abstraction-Création (from 1931).

PRASAT KRAVAN, Angkor, Cambodia

Dedicated to *Vishnu (AD 921), this temple shows a transitional style, the interior walls being decorated with divine figures in skilfully carved brickwork. It is perhaps the medium which gives the impression of a considerably lower degree of sensuality to the treatment of the figures. *Lakshmi is shown with attributes of both Vishnu and *Shiva.

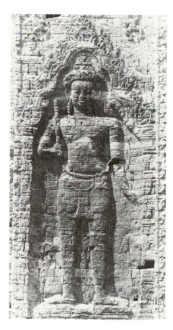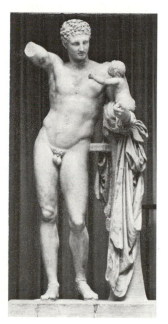

Left: PRASAT KRAVAN Vishnu emerging from the Ocean. 10th century. Carved brickwork
Right: PRAXITELES Hermes. Marble h. 7 ft (2·15 m). Olympia Museum, Greece

PRATT, Matthew (1734–1805)

b. d. Philadelphia. Painter who studied with uncle, *limner Claypole (1749–55) and with *West in London (1764–6); lived in England (1766–8); settled in Philadelphia (1768). Pratt achieved fame depicting West's studio in *The American Academy*, but West's teaching only debilitated Pratt's crisp draughtsmanship and endowed his portraits with glib flattery.

PRAXITELES (active c. 350 BC)

Athenian sculptor of the later *Attic School, he was famed for his statues in which he glorified the beauty of the human form and expressed emotion. Among his works are the *Aphrodite of Knidos, the *Apollo Sauroktonos* (Apollo the lizard-slayer) and the *Leaning Satyr*. A statue of Hermes at Olympia has been claimed to be an original work of his.

PRE-CAROLINGIAN ART see Essay: MIGRATION PERIOD ART

PRECISIONISM (CUBIST REALISM)

American movement of the 1920s–30s, whose major figures, also called the 'Immaculates', were *Demuth, *Sheeler, Preston *Dickinson, Ralston *Crawford and *O'Keeffe. Derived from *Cubism and *Purism, Precisionism sought the underlying structure of its subjects, using straight lines, flat planes and formalised geometric composition, creating abstract design without destroying the object's integrity. Related to, and often using, photography, Precisionist work is characterised by sharp focus, smooth surfaces and exact draughtsmanship. The subjects are largely urban and industrial – partly because such forms lent themselves to Precisionist geometric treatment, and partly because of the Precisionists' sense, reinforced by *Futurism and the *Ash Can School, that contemporary America lived in the age of the city and machine. Drawn from international movements, Precisionism lies in the American tradition of classical, realistic clarity.

PRE-COLUMBIAN ART see general essay and references under CENTRAL AMERICA ; MAYA ; MEXICO ; PERU AND BOLIVIA ; SOUTH AMERICA

PREDA, Giovanni Ambrogio see AMBROGIO DA PREDIS

PREDELLA

Italian. The narrow strip of painting or sculpted relief placed underneath the main panel, or panels, of a large altarpiece. Often composed of a series of small-scale scenes narrating the lives of the saints depicted above, although some predelle consist of one scene only.

PREDMOST (Eastern Gravettian c. 23,000 BC)

†Palaeolithic site in Moravia with a highly stylised female engraving on mammoth tusk, and a mammoth carved in ivory.

Top: PREDMOST Simplified line drawing of the geometric designs on an incised bone fragment
Above: MAURICE BRAZIL PRENDERGAST *The Promenade*. 1913. 30×34 in (76·2×86·4 cm). Whitney Museum of American Art, New York

PRENDERGAST, Maurice Brazil (1859–1924)

b. Boston d. New York. Painter who studied with Julian and *Laurens, Paris; worked in France (1880s); visited Venice (1898); went to New York (1914); exhibited with The *Eight

(1908) and at *Armory Show (1913). Influenced by French *Post-Impressionism, Prendergast turned his crowd scenes into exquisitely patterned, flat mosaics of joyous colour.

PRE-RAPHAELITE BROTHERHOOD

Formed (1848) by *Hunt, *Millais, *Rossetti, Thomas *Woolner the sculptor, *Collinson, Frederick *Stephens and William Michael Rossetti, to reform the prevailing carelessness of technique and frivolity of subject in the then English School. They advocated painting genuine ideas and 'a child-like reversion from existing schools to Nature herself'. In the paintings by the group this is realised by clear transparent colours achieved by the fresco technique of painting on a wet, white ground, by highly focused natural detail, and by angular or distorted forms influenced by Italian primitive art. After 1852 the group virtually disintegrated. This was caused by the friction of styles and opinions at variance, by the lack of a coherent statement of intent, by hostile critics and jealous rivals, and by the frustrations at the exhaustive preparations required in painting directly from nature. After 1856 Pre-Raphaelitism as a term applied to the more sensuous direction taken by Rossetti and his circle.

PRE-RAPHAELITE BROTHERHOOD *The Wedding of St George and Princess Sabra* by Dante Gabriel Rossetti. 1857. 14×14 in (35·6×35·6 cm). Tate

PRETI, Mattia (1613–99)

b. Taverna, Calabria d. Malta. Italian *history and religious painter who went to Rome (c. 1630) and to Naples (1656), where he worked in a full †Baroque style with strong tone contrasts, often making dramatic use of unusual viewpoints. He settled in Malta (1660), working there for the Order of St John.

PREVIATI, Gaetano (1852–1920)

b. Ferrara d. Lavagna, Liguria. Italian painter who studied in Ferrara and Florence before settling in Milan. The leader and theorist of the Italian *Pointillist movement (Divisionismo), his brushwork is nevertheless far more flexible and expressive than that of his French and Belgian counterparts.

PREVITALI (CORDELIAGHI), Andrea (c. ?1470–1528)

b. Bergamo. Italian painter who, like *Palma Vecchio, left Bergamo to train and work in Venice. After studying under Giovanni *Bellini, Previtali practised briefly in Venice before returning home (by 1512). His painting was influenced in turn by Bellini, by Lombardic art and by Lorenzo *Lotto.

PREVOST, Jan *see* PROVOST

PRIKKER, Johan Thorn (1868–1932)

b. The Hague d. Cologne. Dutch painter of the *Symbolist movement, and exhibited with *Les Vingt in Belgium. Often neglected in favour of *Toorop. In contrast to the latter's work, Prikker's designs are more abstracted, with more tranquil rhythms, with few esoteric overtones, and highly suitable for the many commissions he received for textiles, murals and stained glass.

Top: JOHAN THORN PRIKKER *The Smith*. 1894. Stedelijk Museum, Amsterdam
Above: ANDREA PREVITALI *Salvator Mundi*. 24¼×20¾ in (61·5×53 cm). NG, London

PRIMA PORTA, Statue of Augustus
(late 1st century BC)

A statue of the Emperor Augustus, found at the Villa of Livia at Prima Porta, near Rome. It shows the Emperor standing with his right hand raised preparatory to addressing the troops. He is bare-footed and wears a breastplate which shows a

bearded Oriental handing back the standards captured from Crassus at Carrhae in 53 BC when the Parthians defeated the Roman legions.

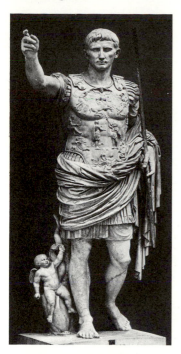

Left: PRIMA PORTA The Emperor Augustus. h. 6 ft 7⅛ in (2·01 m). Vatican

Below: FRANCESCO PRIMATICCIO Detail from the Chambre de la Duchesse d'Etampes. *c.* 1541–5. Paint and stucco. Château of Fontainebleau

PRIMATICCIO, Francesco (1504–70)

b. Bologna d. Paris. Italian sculptor, painter and architect who worked mainly in France for François I, establishing with *Rosso the School of *Fontainebleau. Assistant to Giulio *Romano on the decorative schemes for the Palazzo del Tè, he introduced this *Mannerist style to Fontainebleau, where he joined Rosso (1532). After Rosso's death he worked on the Galerie d'Ulysse, assisted by *Niccolò dell'Abbate.

PRIMING

The preparation of a *ground by which a *support is given a surface for painting upon. *Gesso priming is generally used for *panels, oil priming for *canvas.

PRINT

The product of printmaking; an etching, engraving, screen print or serigraph.

PROCACCINO, Ercole the Elder (1515–95)

Italian painter, who according to *Lomazzo trained under Prospero Fontana. He worked first in Bologna and later in Milan (from 1585/6). His œuvre (eg *Conversion of St Paul,* 1573, S. Giacomo Maggiore, Bologna) reveals him a somewhat pedestrian painter of the Bolognese *Mannerist style. His sons Camillo and Giulio Cesare achieved prominence among Milanese painters.

PROCKTOR, Patrick (1936–)

b. Dublin. Painter who studied at the Slade School of Art, London (1958–62). While retaining a figurative basis, his paintings, recently of transparent colours, investigate the surface quality of marks in relationship to the images they define, often contrasting the painterly gesture against the mechanically executed edge or the ruled line.

PRONOMOS PAINTER (active late 5th century BC)

Athenian *red-figure vase painter whose style is related to that of the *Dinos Painter. His most famous work is a volute *krater in Naples showing a satyr playing with a host of actors and dancers round a couch on which sit Dionysos and Ariadne. The scene is overloaded with figures and decoration. The vase is an early example of theatrical scenes influencing painting.

PROOF

Prints especially taken by the artist during the preparation of a plate or block in order to judge its state, and for the final approval of the print. The process is known as 'proving'.

PROVOST (PREVOST), Jan (c. ?1465–1529)

b. Mons d. Bruges. Netherlandish painter who married Simon *Marmion's widow. A master at Antwerp (1493), he settled in Bruges (1494). His *Last Judgement* (1524–6, Bruges) shows his characteristic light colour and graceful, charming types, sacrificing drama for elegance.

PRUD'HON, Pierre-Paul (1758–1823)

b. Cluny d. Paris. French portrait, religious and mythological painter. He studied in Dijon and worked in Paris, before going to Rome (1784). He painted little there, but his study of *Correggio and *Leonardo strongly affected his style after his return to Paris (1787). His sensuous and dream-like work is an important link between the elegance of the 18th century and the †Romanticism of the 19th. A favourite painter of both the Empresses Josephine and Marie-Louise, he remained in favour after the collapse of Napoleon mainly through support from Talleyrand.

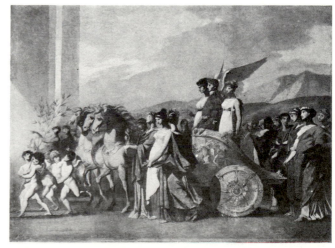

PIERRE-PAUL PRUD'HON *The Triumph of Bonaparte.* 1800. Study. 35½×69 in (90·2×175·3 cm). B-A, Lyons

PRYDE, James Ferrier (1866–1941)

b. Edinburgh d. London. Scottish painter and designer, trained Royal Scottish Academy and in Paris. Influenced by *Daumier and *Beardsley, he and his brother-in-law, William *Nicholson, under the pseudonym the *Beggarstaff Brothers, collaborated on designing posters (c. 1893–9). Pryde is best known for his architectural fantasies and interiors.

PSALTER

The medieval Psalter was the private prayer-book of the laity and essential knowledge for all clergy. In addition to the Old Testament Psalms it usually contained sections of the Liturgy. The *Utrecht Psalter and its derivatives had a literal illustration before every Psalm, but later Psalters restricted text decoration to the capital at the beginning of each section of Psalms. In the 13th century foliate or narrative capitals were replaced by a fixed French system illustrating the first line of various Psalms. Luxury manuscripts such as the *Westminster, *Ingeborg and *St Louis Psalters were preceded by illuminated calendars and Bible picture cycles.

PSKOV

The medieval town of Pskov shared in the prosperity of nearby *Novgorod and was, particularly in the 14th century, a minor artistic centre. Its painters and builders achieved employment in the late 14th-century development of the *Moscow Kremlin.

PTAHHOTPE see SAQQARA

PUCELLE, Jean (1st half 14th century)

Court illuminator of the generation after *Honoré whose modelled draperies and Parisian elegance he follows. There are documentary references to him (c. 1320) and he was head of the workshop which produced the *Belleville Breviary* (Bib. Nat., Paris, lat. 10488). His innovations included pictorial architecture derived from the school of *Giotto, *grisaille figures (found earlier in the Arena Chapel in *Padua) and the Parisian acceptance of marginal nonsenses already popular in northern France and England.

Left: PUEBLO Carved wooden figure representing a wargod. Pueblo period, Southwest area of North America. Staatliches Museum für Völkenkunde, Berlin

PUEBLO

Part of the Anasazi culture sequence in the *Southwest Area of North America. Characteristic Pueblo villages consisting of multi-storeyed apartment complexes began to appear about AD 700 and became fully developed between about AD 1000 and 1300. Pueblo art is particularly famous for pottery, the best known being the varied Anasazi forms painted with stylised plant and animal designs in black on white.

PUEYRREDON, Prilidiano (1823–70)

b. d. Buenos Aires. Painter who studied in Paris. His paintings, a chronicle of life on the pampas, evoking the atmosphere and subtle play of light and shadow of each particular place, give a sense of the vast space of the landscape.

PUGET, Pierre (1620–94)

b. d. Marseille. French sculptor. He worked in Italy, most importantly with Pietro da *Cortona on the decoration of the Pitti Palace, but met with little success in France because his †Baroque style was opposed to official taste. His two most famous works – *Milo of Crotona* and the relief *Alexander and Diogenes* (both Louvre) – mark him out, however, as the most important French Baroque sculptor.

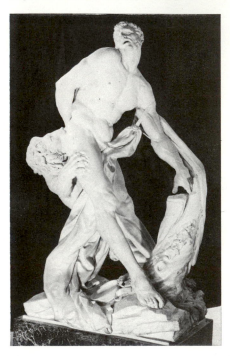

Right: PIERRE PUGET *Milo of Crotona*. 1671–83. Marble. h. 106½ in (270·5 cm). Louvre

PUGIN, Augustus Welby Northmore (1812–52)

b. London d. Ramsgate. English architect responsible for the design of chiefly Catholic churches. As a designer he collaborated with Charles Barry on the new Houses of Parliament, London, and as an organiser was responsible for the Medieval Court at the Great Exhibition (1851). A polemicist for the spiritual values inherent in a serious and antiquarian revival of †Gothic styles.

PURISM

A style and an aesthetic, the concepts of Purism were established by *Ozenfant and *Le Corbusier (1918), and were promoted by their review *L'Esprit Nouveau* (1920–5). Purism was based on the conviction that man, both intellectually and environmentally, needs order. In painting, therefore, it systematised *Cubism and in architecture it aspired to a marriage of functional and formal perfection in tune with the more geometrically ideal features of the industrial world.

PURNA-GHATA

Sanskrit: literally 'filled pot'; bowl of flowers, an Indian decorative temple motif signifying hospitality and plenty.

PURRMANN, Hans (1880–)

b. Speyer. German painter who studied in Karlsruhe and Munich (1898–1905). In Paris (1906–14) his German †Impressionism gave way to a mild imitation of *Matisse. He helped initiate the Matisse School (1907). Following Matisse south, his style has hardly changed.

PUTTO

Italian: 'small boy'. A small, naked boy child, sometimes winged. A term applied both to *amorini* (small cupids), and cherubim.

PUVIS DE CHAVANNES, Pierre (1824–98)

b. Lyon d. Paris. French painter, worked under Henri Scheffer, Delacroix and *Couture without finding direction. First exhibited 1850. His highly individual style of treating classical figures in a landscape emerged with *Concordia* (1861). Puvis's work, largely neglected until the advent of the *Symbolist movement in the 1880s, was dominated by the formal considerations of wall-painting, that the surface of the wall should not be pierced by illusionist devices. His paintings appear almost to be two-dimensional patterns in pale silvery hues, of figures in hieratic postures, often in frieze-like dispositions, eg decorations for the Panthéon (1874–9) and for the Sorbonne (1887).

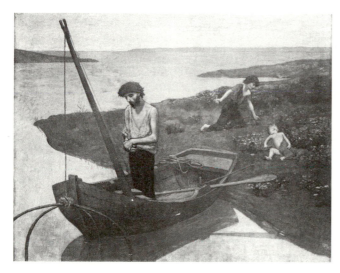

PIERRE PUVIS DE CHAVANNES *The Poor Fisherman*. 1881. 61 × 75½ in (155 × 192·5 cm). Louvre

PUY, Jean (1876–1959)

b. d. Roanne. French artist who abandoned architecture for painting which he studied at the Académie Julian with *Laurens and *Carrière. He was friendly with *Matisse, *Derain and *Braque (1900) and evolved from †Impressionism to *Fauvism with *Nabis tendencies.

PYE, William (1938–)

English sculptor who studied at Wimbledon and at the Royal College of Art, London. He held his first one-man show (1966). His sculpture has tried to capture fluid and sinuous movement in static form, often using chrome-reflecting surfaces in tubular constructions.

PYLE, Howard (1853–1911)

b. Wilmington, Delaware d. Florence. Illustrator and writer who studied in Philadelphia; settled in Wilmington (1879), taught at Drexel Institute (1894–1900), and at own school (from 1900). Pyle's extraordinary influence on American illustration established the Brandywine tradition. Rejecting Victorian prissiness, his simple, virile draughtsmanship and rich colour created a bold, joyous world.

PYNACKER, Adam (1622–73)

b. Nr Delft d. Amsterdam. Dutch landscape painter, influenced by *Jan Both, notable for his silvery light. He probably spent three years in Italy and afterwards worked in Delft, Schiedam and Amsterdam. Large rhubarb leaves frequently feature in his work.

PYNAS, Jacob (d. after 1648)
Jan (1583–1631)

Dutch painters (both b. Haarlem d. Amsterdam) who went to Rome (1605), where they were influenced by *Elsheimer. Jan went to Leiden (1610) and to Amsterdam (1613). In Holland he continued to paint Italian landscapes as well as figure paintings. *Rembrandt may have studied briefly with Jacob in Amsterdam (1624).

PYRGOTELES (active end 4th century BC)

A *gem-engraver, the only man, according to *Pliny, whom Alexander the Great would allow to carve his features on a gem. *Apelles had the same distinction in painting, and *Lysippos in sculpture.

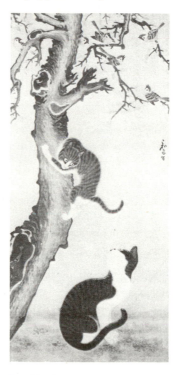

PYON SANG-BYOK *Cats and Sparrows*. Hanging scroll. Ink and colour on silk. 37⅛ × 16¾ in (94·3 × 42·5 cm). Duksoo Palace Museum

PYON Sang-byŏk (active early 18th century)

Korean painter best known for his studies of animals. In his work the landscape background is reduced to a mere formula but the cats, sparrows and chickens have distinct personality.

PYTHAGORAS OF SAMOS (active 5th century BC)

Greek sculptor who migrated to Rhegium (modern Reggio Calabria) and was a rival of *Myron and *Polykleitos in making statues of athletes. Sculpture lost much of its *Archaic stiffness because of the technical advances which he introduced. He was one of the first to convey physical expression in his work.

Q

QAJAR SCHOOL (late 18th–19th century)

Under the second Qajar ruler, Fath Ali Shah (1797–1834), a distinct Persian School emerged fusing European techniques of modelling and perspective with Islamic traditions. To a great extent, miniature-painting was replaced by large-scale

works, paintings and murals of battle or court scenes. With a 'primitive' quality, the style is static, ill-proportioned but with some dignity, unnatural and formal, seen at its best in the manuscript *Khaqan: Diwan* (1802, Windsor Royal Library).

Left: QAZVIN SCHOOL *Two lovers on an island of Terrestrial Bliss* from Jami's *Haft Awrang*. Freer Gallery of Art, Washington

Below: QASR AL-HAYR AL-GHARBI, Syria. Detail of wall-painting showing musicians

QASR AL-HAYR AL-GHARBI (723–7)

The Palace of Qasr al-Hayr al-Gharbi was built by the Umayyads and stands in the Syrian desert. It was extensively decorated with stucco and includes sculpture and paintings. *See also* UMAYYAD SCULPTURE; UMAYYAD PAINTING

QAZVIN SCHOOL (mid 16th–turn of 17th century)

Persian school of painting named after the town of Qazvin which became the capital city of Persia under the Safavid Shah Tahmasp (1524–76). Its existence as a separate school has been argued but it has a more dignified form than the work of the earlier *Tabriz School. The lines of the bodies, sinuous and graceful with long necks and round faces, are accentuated with firm and simple drawing as in the manuscript *Jami: Haft Awrang* (1556–65, Freer Collection), leading into an independent fine-art form seen in the work of later artists, eg *Sadiqi Beg.

QUADRATURA

*Illusionist architectural painting of walls and ceilings. In the 17th century painters who specialised in such work were called *Quadraturisti*; they sometimes collaborated with other artists on the decoration of large spaces.

QUADRO RIPORTATO

Italian: 'inserted picture'. A number of small-scale paintings set within an overall framework to decorate a vault or ceiling.

QUARTON, Enguerrand see CHARONTON

QUIMBAYA

Colombian culture (*c.* AD 100–1550) noted for skilful metal-work and a variety of pottery styles. Characteristic work in gold and *tumbaga* (a copper-gold alloy) are little figurines and graceful fluted vases. The major pottery forms are bowls, double vessels and stylised hollow figurines. Decoration includes negative painting, modelling, and chip-carved geometric designs.

QUSAYR AMRA

Qusayr Amra is a bath-house (*hammam*) built in the Jordanian desert by an Umayyad prince at some time after the year 711. Attached to the bath-house itself is an audience hall. Both are decorated with paintings. *See also* UMMAYAD PAINTING

QUATREFOIL

Pattern as of four leaves formed by the projecting points within †Gothic tracery.

QUATTROCENTO

Italian: literally 'four hundred', ie the 1400s. Sometimes loosely used to denote the period of the Early †Renaissance. *Cinquecento* = the 1500s; *seicento* = the 17th century, etc.

QUELLIN (QUELLINUS) Family
Artus I (1609–68)
Artus II (1625–1700)
Artus III (1653–86)

Flemish family of sculptors. Artus I, b. d. Antwerp, worked in Antwerp (from 1639), after studying in Rome where *Algardi deeply impressed him. He subsequently borrowed from *Rubens for his treatment of the nude, and worked on decorations for the Antwerp Town Hall (1650–63). Artus II, b. St Trond d. Antwerp, developed new †Baroque forms, eg *Bishop Copello 'rising' from his tomb* (1676, Antwerp Cathedral). His son Artus III, b. Antwerp d. London, assisted Grinling *Gibbons with marble sculpture.

Above: ARTUS QUELLIN II *Bishop Copello Rising from his Tomb.* 1676. Antwerp Cathedral.
Right: JOHN OUIDOR *The Money Diggers.* 1832. $16\frac{3}{4} \times 21\frac{1}{2}$ in (42·5×54·6 cm). Brooklyn Museum, New York

Left: QAJAR SCHOOL *Fath Ali Shah* by Mirza Baba. *Khaqan: Diwan* 1802. Royal Library, Windsor

QUELLINUS see QUELLIN

QUERCIA, Jacopo della (1374–1438)

b. Siena d. Bologna. Foremost Sienese Early †Renaissance sculptor, influenced by Dalle Massegne, the Burgundians and later by *Donatello. An unsuccessful competitor for the Florence Baptistery doors (1401), shortly afterwards he was in Lucca where he devised the tomb of Ilaria del Carretto (c. 1406) noted for the tender carving of the bridal effigy and the classical motif of garland-bearing *putti on the sarcophagus. The Fonte Gaia in Siena (1414–19) is still largely †Gothic, but contact with *Ghiberti and Donatello while he was working on the Siena Baptistery font (1417–31) transformed his style and in the Portal of S. Petronio, Bologna (1425–38), he invested the nude with heroic and dramatic qualities.

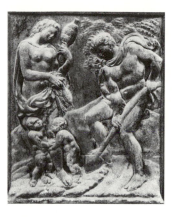

Left: JACOPO DELLA QUERCIA Creation of Adam from the central portal. 1425–38. Istrian stone. $32\frac{3}{8} \times 26\frac{7}{8}$ in (82×68 cm). S. Petronio, Bologna

Right: HENRY RAEBURN Sir John Sinclair. c. 1794. $93\frac{1}{2} \times 60\frac{1}{2}$ in (238×154 cm). NG, Scotland

QUESNEL Family

A family of French painters and draughtsmen. Pierre (d. 1574) was of Scottish descent and was active at Holyrood House, Edinburgh, in the service of the royal family. The most important of his three artist sons was François the Elder (1543–1619) who became Court Painter to Henri III and who produced †Mannerist portraits in the style associated with *Clouet.

QUIDOR, John (1801–81)

b. Tappan, New York d. Jersey City, New Jersey. Painter who studied with Inman and *Jarvis; lived in New York, painting signs, etc. Using Irving's tales as a springboard, Quidor jumped off into an unpopular, private world of romantic, grotesque fantasy, golden, sombre, glowing colours exploding in pyrotechnics of turbulent, whirling movement.

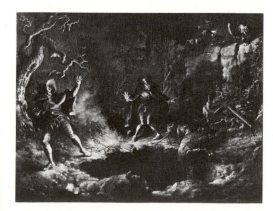

QUIRT, Walter (1902–)

b. Iron River, Michigan. Painter who studied at Layton School of Art, Milwaukee. Moving from early *Social Realism to more recent ambiguous abstractions, Quirt was most telling in his middle-period *Surrealism, in which acutely rendered shapes and compositions reminiscent of *Gorky evoke society's sickness and hypocrisy.

R

RABBULA GOSPELS

A Byzantine manuscript of the Gospels written in Syriac and finished in 586 by the scribe Rabbula. It contains several full-page illustrations and some canon-tables with marginal illustrations. These illuminated pages may have been done for an earlier book, to be reused by Rabbula. Along with the *Rossano Codex their style is vigorous and they are executed in bright colours. (Biblioteca Laurentiana, Florence.)

RAEBURN, Sir Henry (1756–1823)

b. d. Edinburgh. Scottish portraitist. He was apprenticed to a goldsmith, then worked as a miniaturist and appears to have taught himself oil painting. His bold, masculine style is certainly highly original – very direct (no drawings are known by him), although often merely insensitive. Without serious rivals in Scotland he achieved great popularity, being knighted (1822) and appointed King's *Limner for Scotland (1823).

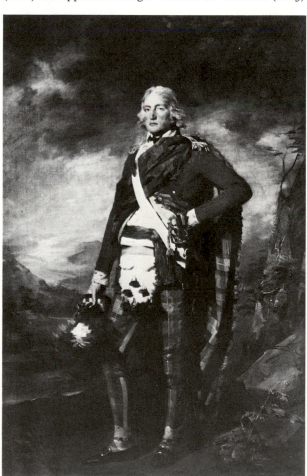

RAF, Jehan see CORVUS, Joannes

RAFFAELLI, Jean François (1850–1924)

b. d. Paris. Of Italian descent, began as an actor, entered *Gérôme's studio briefly, but became interested in †Impressionism, and was especially influenced by *Monet (eg Place du Parvis, Notre-Dame). At first he painted genre, then picturesque views of Paris. His one-man exhibition (1884) made his name. He painted portraits (eg Edmond de Goncourt, Clemenceau), but returned to genre and domestic scenes.

RAGGI, Antonio (1624–86)

b. Vico Morcote d. Rome. Italian sculptor, and *Bernini's chief assistant, his independent work is of very high quality. His late style was dependent on Bernini's late spiritual expressionism and is best seen, combined with *Gaulli's illusionist ceiling, in the Gesù, Rome.

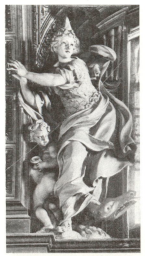

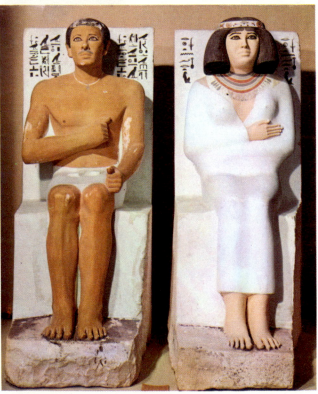

Top left: ANTONIO RAGGI Detail of the stucco decorations in the Church of Gesù, Rome. c. 1670–85
Top right: MARCANTONIO RAIMONDI *Descent from the Cross* after Raphael. $16\frac{1}{8}\times11\frac{1}{4}$ in (41×28·6 cm). V & A, London
Above: RAHOTPE AND NOFRET, Statues of. 4th dynasty. Painted limestone. h. $47\frac{1}{4}$ in (120 cm). Egyptian Museum, Cairo

RAHOTPE AND NOFRET

Egyptian prince and his lady of the 4th dynasty, whose matching funerary statues are chiefly remarkable for the preservation of the original colouring. The seated couple are stiffly conventional in pose, but the faces, especially that of the man, are enlivened by the insertion of inlaid eyes.

RAIMONDI, Marcantonio (c. 1480–c. 1534)

b. Argini, nr Bologna d. Bologna. Italian engraver. He went to Venice (1506) and copied *Dürer woodcuts there. He engraved *Raphael's work, including his paintings and the *Judgement of Paris* and *Dido* designs (from 1510); he also copied Giulio *Romano designs. His work was often reproduced on maiolica dishes and consequently had a widespread influence.

RAINER OF HUY (active early 12th century)

*Mosan metalworker who was commissioned to make a cast-bronze font for Notre-Dame-aux-Fonts in Liège (c. 1110). It is based on the 'molten sea' in the Temple of Solomon – hence the oxen round the base. The grasp of anatomy is astonishing. Rainer's classicism leads to that of the late 12th-century *Nicholas of Verdun and is in complete contrast to deliberate distortions usually associated with †Romanesque.

RAINER OF HUY Detail of Baptism from cast bronze font. 1107–1118. h. 25 in (64 cm). St Barthélemy, Liège

RAJASTHAN SCHOOLS: GENERAL

The Indian province of Rajasthan was divided into several states, each ruled by Rajputs, eg *Mewar, *Jaipur, *Jodhpur, *Bundi, *Malwa, *Bikaner, *Kota and *Kishangarh. These states came into being from about the 9th century onwards and continued after the advent of the Muslims either independently or as feudatories. Each state had its own school of painting which frequently had a strong folk-element and also influence of *Jain painting. After the Mughal invasion there was a good deal of *Mughal artistic influence and each of the schools reflects this to some extent. The most popular themes of painting were the *Ragamalas*, or depictions of Indian musical modes; scenes from Indian mythology, especially the Radha and Krishna legends; the seasons, and women in all moods; Mughal art introduced hunting and toilet scenes and portraits.

RAMAYANA

Sanskrit: title of one of the Sanskrit Hindu epics; hero Rāma is *avatara of *Vishnu.

RAMESSES II

Egyptian king of the 19th dynasty, whose name is famous today through his many surviving monuments (among them the temple of Abu Simbel). Though very extensive, the architectural work of his reign is mostly of rather poor quality, and this applies also to sculpture and other artistic production.

RAMOSE

Egyptian vizier of the late 18th dynasty (under *Amenhotpe III and into the reign of *Akhenaten) whose *Theban tomb has decoration both in the polished style of the earlier period and in the *Amarna manner. The carving of the reliefs – there

are also paintings – is of exceptional quality, the only comparable work in the Theban necropolis being in the contemporary tombs of Kheruef and Khaemhet.

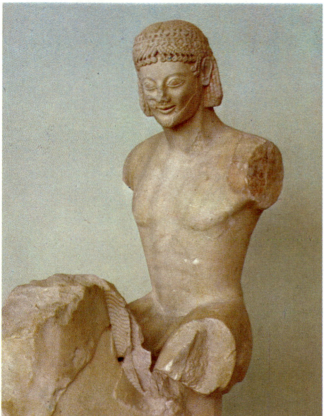

Top left: RAMESSES II, Colossal statue of. 19th dynasty. Granite with traces of pigment. h. 8 ft 10 in (2·70 m). BM, London
Top right: RAMOSE, tomb of. *Guests at a banquet.* Mid-18th dynasty. Limestone relief with black painting. h. 48½ in (122 cm). Thebes
Above: RAMPIN HORSEMAN Marble. h. 3 ft 7½ in (1·10 m). Acropolis Museum, Athens

RAMPIN HORSEMAN (575–550 BC)

Athenian sculpture, the head of which belonged to a Monsieur Rampin and is now in the Louvre; the body and part of a horse (with a cast of the head) is in Athens. For a long time the two were not recognised as belonging to the same sculpture becuase of the extremely elaborate hair and beard of the head, in contrast to the very simple body.

RAMPURVA *see* MAURYA DYNASTY

RAMSAY, Allan (1713–84)

b. Edinburgh d. Dover. Scottish portraitist, son of a poet, he first studied painting in Edinburgh and London, then in Italy (1736–8) – the first of four visits. He settled in London (1739), producing routine though often charming portraits and sometimes essaying the *Grand Manner in anticipation of *Reynolds. By the mid 1750s, however, Ramsay was producing graceful portraits, especially of women (his wife, *c.* 1755, NG, Scotland; *Lady Mary Coke*, 1762, Marquis of Bute), bearing a striking resemblance to French portraiture. These, together with his state portraits of George III and Queen Charlotte (*c.* 1762), constitute his importance for British painting.

RAMU DELTA *see* SEPIK RIVER

RAOUX, Jean (1677–1734)

b. Montpellier d. Paris. French painter who visited Rome and Venice, then London (1720–1) with his friend *Watteau. A lifelong protégé of Philippe de Vendôme, Grand Prior of France, he painted *fêtes galantes, allegorical pieces and female portraits in mythological guise.

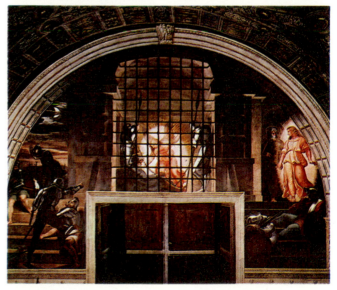

Top left: ALLAN RAMSAY *The Painter's Wife.* 1755. 29¼×24⅜ in (74·3×65·4 cm). NG, Scotland
Top right: JEAN RAOUX *Lady at her Mirror.* 32×26 in (81×66 cm). Wallace
Above: RAPHAEL *The Liberation of St Peter* from the Stanza d'Eliodoro. 1511–14. Vatican

RAPHAEL (Raffaello SANZIO) (1483–1520)

b. Urbino d. Rome. Umbrian painter and architect; for over three hundred years he was coupled with *Michelangelo as the greatest master of the †Renaissance. Initially influenced by his

master *Perugino from whom he inherited a sense of lucid space, idealised shape and harmonious colour, this was superseded on his arrival in Florence (1504) by an admiration for *Leonardo, reflected in his portraits and groups of the Virgin and Child with St John, eg *La Belle Jardinière* (1506, Louvre). In the *Entombment* (1507, Borghese) he made a not entirely successful bid to emulate Michelangelo's heroic style. He was in Rome (by 1509) employed by Pope Julius II to decorate his apartments in the Vatican. Also he was in close touch with his kinsman *Bramante and the architect *Peruzzi with whom he collaborated in the decoration of the Villa Farnesina (*Triumph of Galatea*, 1511); most important, they studied antique remains together. This transformed his art. He adopted a monumental scale, clothed his eloquent figures in ample, flowing drapery and the more sophisticated colour orchestration stemmed from his knowledge of antique frescoes and †Early Christian mosaics, while in the *Liberation of St Peter* the dramatic use of *chiaroscuro was a striking innovation. With the accession of Leo X the demands made upon his talents became exorbitant and the *Tapestry Cartoons* (1515–16, V & A, London) are the last series where his imagination, if not his hand, prevails. The final work, the *Transfiguration* (1517–20, Vatican) anticipates *Mannerism in its complexity.

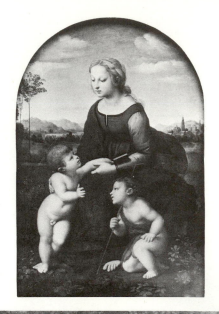

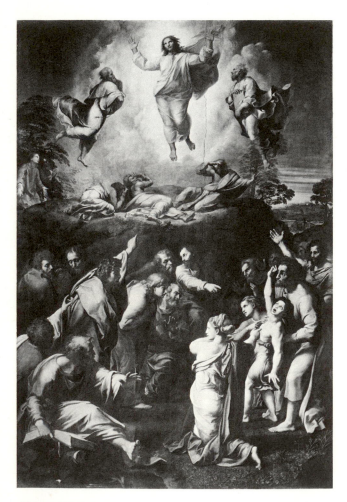

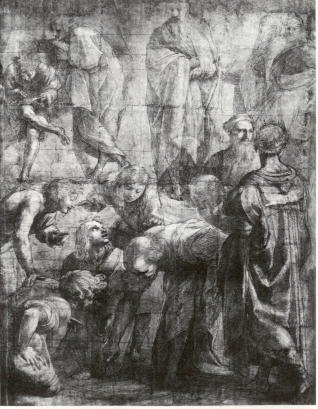

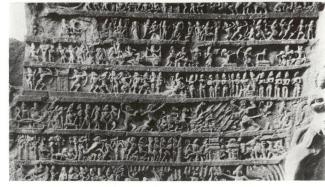

Above: RAPHAEL *Transfiguration*. 1517–20. 157½×109⅜ in (400×279 cm). Vatican
Top right: RAPHAEL *La Belle Jardinière*. 1506. 48×31 in (122×80 cm). Louvre
Centre right: RAPHAEL Detail from the cartoon for the school of Athens, showing Raphael and Bramante. *c.* 1509. Ambrosiana, Milan
Right: RASHTRAKUTA DYNASTY *Narrative relief illustrating the Ramayana: The War against Ravana.* Kailasa temple, Elura. 8th century. Rock-cut

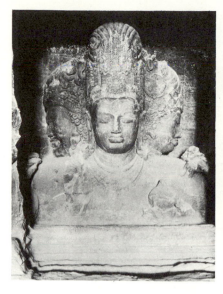
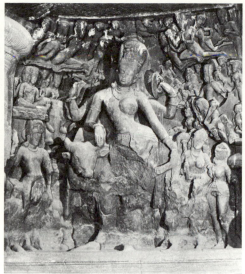
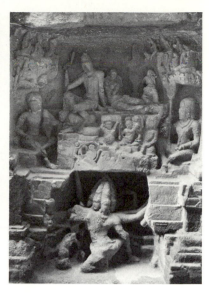

Left: RASHTRAKUTA DYNASTY *The three aspects of Shiva.* Cave-temple, Elephanta. 8th century. Rock-cut. h. 18 ft (5·49 m)
Centre: RASHTRAKUTA DYNASTY *Hermaphrodite Shiva (Ardhanarishvara) with Nandi and entourage of attendants, gods and spirits.* Cave-temple, Elephanta. 8th century. Rock-cut
Right: RASHTRAKUTA DYNASTY *Ravana shaking Mount Kailasa.* Kailasa temple, Elura. 8th century. Rock-cut

RASHTRAKUTA DYNASTY (AD 757–973)

In the middle of the 8th century Dantidurga Rashtrakuta, a feudatory of the Western *Chalukyas, asserted his claim to independence. His line established a firm rule from the Narmada River in the north to the valley of the Tungabhadra in the south. To the east, between the mouths of the Godavari and Krishna rivers, the eastern branch of the Chalukyas still survived. The Rashtrakutas, after defeats in North India fell back to their Deccan homeland south of the Narmada, but their days were numbered. By now the *Cholas ruled in Kanchi having replaced the *Pallavas, and they together with a new insurgent branch of the Chalukyas from Kalyani in the very heart of the Deccan crushed the Rashtrakutas. After more than two centuries, the Deccan came once more under Chalukyan rule. The Rashtrakutas inherited much from the architectural and sculptural styles of their defeated former masters, the *Chalukyas. At its best, their art transcends sectarian and even cultural differences. Elura, one of their capitals, saw the evolution of their sculpture in some eighteen Hindu shrines. The most magnificent of these is the Kailasa monolithic temple. A block of stone measuring more than one hundred feet square and nearly as tall was isolated from the living rock by scarping; from this was hewn a temple-tower the top of which is on a level with the rock-surface, while the worshipper may circumambulate the base some hundred feet below and pass through shrines inside on two levels. Narrative reliefs illustrating scenes from the two Sanskrit epics, *Ramayana and *Mahabharata, are carved on the temple wall in eight narrow horizontal registers one above the other. A relief panel depicts Ravana, the demon-king of the *Ramayana*, attempting to overthrow Kailasa, *Shiva's mountain home in the Himalayas. On the summit, the god's consort *Parvati is seen clutching at Shiva's arm while he, unconcerned, steadies the mountain by pressing down with his foot. Other reliefs reduce the anatomy of divine and semi-divine figures to mere slender embodiments of movement. Much of the temple was originally painted, inside and out, and considerable areas of this mural work still survive. The other principal Rashtrakuta monument is the main cave-temple on the island of Elephanta, the masterpiece of which is the three-headed Shiva image. Iconographically, the piece is a development of the phallic emblem (*linga) with attached face (*mukhalinga) or faces of the god. Here the *linga* is suggested by the emergent central head and shoulders of Shiva, particularly by the tall crown and piled braided hair. This rapt central face expresses the complete self-sustaining nature of the essence of divinity, while its two side-faces, the ferocious male and the passive female to the proper right and left respectively, represent the polarisation of divinity necessary to creation. The *dvara-palas (door-guardians) carved on the pillars before the shrine, are themselves far from alert, their eyes closed in meditation. The conception of such a work and its execution to such a degree of perfection with scarce regard for the usual iconographical conventions, make this sculpture one of the most profound, and simplest, statements of man on his understanding of the nature of the universe. Along with the Shiva Nataraja bronzes of the *Cholas and a few other Indian pieces, it is among the most celebrated works of art in the world.

RATGEB, Jörg (c. 1480–1526)

b. ?Schwäbisch Gmünd d. Pforzheim. German painter active at Heilbronn and Frankfurt, although perhaps trained in the Netherlands. His pictures are agitated and tense, full of passion, making him unusual in his geographical context. He was executed for his part in the Peasants' Revolt.

JORG RATGEB *Flagellation.* 1519. Panel from the Herrenberg Altar. $103\frac{1}{4} \times 56\frac{1}{8}$ in (262 × 142·5 cm). Staatsgalerie, Stuttgart

RATHA

Sanskrit: literally 'chariot'; in architectural terms, may refer to a literal attempt to make the god's temple resemble a chariot, as at Konarak; or more generally to any Hindu shrine as vehicle of the deity, as at Mamallapuram.

RATTNER, Abraham (1895–)

b. Poughkeepsie, New York. Painter who studied at Pennsylvania Academy, Corcoran School of Art and several French academies; lived in France (c. 1920–40); settled in New York (c. 1940). Influenced by *Cubism and *Fauvism, Rattner moved from emotive realism to *Expressionism, almost losing his subject in semi-geometric, slashing, rhythmic slabs of brilliant colour. Like *Rouault, he was influenced by stained-glass window designs.

RAUCH, Christian Daniel (1777–1857)

b. Arolsen d. Dresden. German sculptor, pupil of Valentin, Ruhl and Schadow. After the Berlin Academy (1802–3) he went to Rome (1804–11) where he was strongly influenced by *Thorwaldsen. On his return to Berlin, he became a member of the Academy of Fine Arts, and later of the French Institute. The smooth, pleasing, courtly elegance of his portraits and monuments were widely successful (eg the Frederick the Great monument in Berlin, 1839–52).

RAUSCHENBERG, Robert (1925–)

b. Port Arthur, Texas. Painter who studied at Kansas City Art Institute (1946–7), Académie Julian, Paris (1947), with *Albers at Black Mountain College (1948–9), at *Art Students' League and with *Motherwell, *Tworkov and *Kline. Influenced by *Schwitters and *Duchamp, Rauschenberg developed his assemblages, in which real objects of every conceivable description are combined with photographs, painted images and *Abstract Expressionist painting. The space moves from that of illusion to the real world, and the assemblages themselves are hybrids of art and life. Rauschenberg helped to break the dominance of Abstract Expressionism and was a catalyst in the development of *Pop Art.

ROBERT RAUSCHENBERG *Monogram*. 1959. Construction. 48×72×72 in (121·9×182·9×182·9 cm). Moderna Museet, Stockholm

RAVEN, John see CORVUS, Joannes

RAVENNA, Baptistery of the Arians

Built in the early 6th century by Theodoric, King of the Arian Ostrogoths, the mosaic in the dome was obviously inspired by the mosaic in the Baptistery of the Orthodox, *Ravenna. With the same theme of the Baptism of Christ, it is stylistically less subtle and lacks modelling and movement.

RAVENNA, Baptistery of the Orthodox

Erected in the first half of the 5th century, the mosaic in the dome and the stucco-work were put in by Bishop Neon (449–58). The mosaic represents the Baptism of Christ and a procession of the Apostles. It was probably executed by a Ravenna workshop.

RAVENNA, Mausoleum of Galla Placidia

Built as an oratory of St Lawrence in the mid 5th century by the Empress Galla Placidia, but used to house locally made sarcophagi, this small cross-shaped chapel has vaults covered in

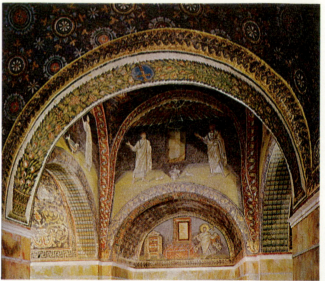

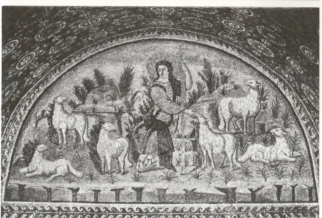

Top: RAVENNA, Mausoleum of Galla Placidia. General view
Above: RAVENNA, Mausoleum of Galla Placidia. *The Good Shepherd*. Lunette
Below left: RAVENNA, Baptistery of the Orthodox. *Baptism of Christ and procession of Saints*. Dome mosaic
Below right: RAVENNA, Baptistery of the Arians. *Baptism of Christ and procession of Saints*. Dome mosaic

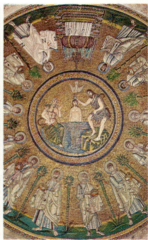

mosaic. The windows of alabaster and the walls revetted in marble demonstrate the original lighting and appearance of a 5th-century chapel. Unlike Sta Maria Maggiore, *Rome, the artists, probably also from Rome, managed to unify both decoration and architecture, for the predominant bright blue tesserae and the scaled figures harmoniously surround the spectator. The main scene of the martyrdom of St Lawrence has as a counterpart the more optimistic representation of the young Christ as the Good Shepherd.

RAVENNA, S. Apollinare in Classe

This basilica just outside Ravenna was consecrated by Archbishop Maximian (549). The mosaic decoration in the east end (6th–9th century) is dominated by the figure of St Apollinaris himself in the *Orans position witnessing the Transfiguration: the scene is an unusual and successful combination of symbolic (eg lambs for Apostles) and figurative elements. The mosaics are linear, and highly coloured; they are clear and conspicuous even from the entrance door into the nave.

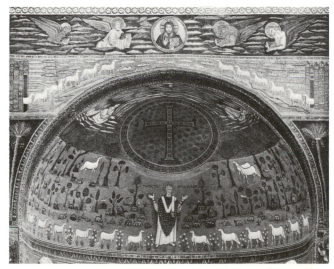

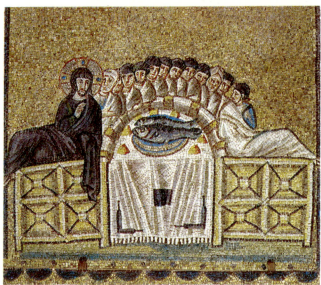

Top: RAVENNA, S. Apollinare in Classe. *The Transfiguration.* Apse mosaic
Above: RAVENNA, S. Apollinare Nuovo. *The Last Supper.* Early 6th century
Top right: RAVENNA, S. Apollinare Nuovo. *The Enthroned Christ receiving the Procession of Martyrs.* Nave mosaic
Bottom right: RAVENNA, S. Vitale. *The Emperor Justinian and his followers.* 546–548

RAVENNA, S. Apollinare Nuovo

Built under the Arian Ostrogoths (*c.* 500) and originally dedicated to Christ. Part of the mosaic decoration on the nave walls belongs to the Ostrogothic period. The austere but effective Gospel scenes seem intentionally to repeat the art of the Roman *catacombs; theologically embarrassing scenes, such as the Crucifixion, are omitted. The scheme was substantially altered by the conquering Byzantines later in the 6th century to include processions of Orthodox virgins and martyrs, in a repetitive yet sympathetic design which reiterates the imposition of Orthodoxy on Ravenna. This theological collision in the iconography is softened now by the overall similarity and high quality of the style.

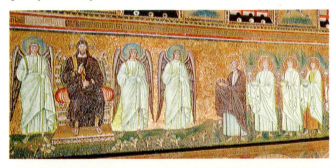

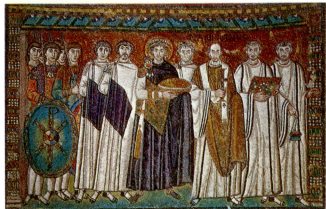

RAVENNA, S. Vitale

Begun about 530 and consecrated by Archbishop Maximian in 547, S. Vitale is centrally planned like SS Sergius and Bacchus, *Istanbul which may have inspired it. The interior is decorated with magnificent marbles and mosaics, notably those portraying Maximian with the Emperor Justinian and Theodora. Executed in a flat, hieratic style, the faces are nevertheless extremely portrait-like, for they record schematically the conspicuous and not always flattering features of the models.

RAVESTEYN, Jan Anthonisz van (*c.* 1570–1657)

b. d. The Hague. Dutch portraitist, associated with the Stadtholder's court and the leader of a group of minor artists, he was influenced by *Miereveld and produced numerous competently executed portraits and group pictures.

RAVILLIOUS, Eric (1903–42)

b. London. English watercolourist, draughtsman and muralpainter. Studied at the Royal College of Art. An official War Artist, Ravillious painted many scenes of the Norwegian naval campaign, stylistically reminiscent of Paul *Nash.

RAY, Man (1890–)

b. Philadelphia. Painter and photographer who studied at National Academy of Design (1908); founded New York *Dada movement with *Duchamp and *Picabia (1917); went to Paris (1921); worked in Hollywood (*c.* 1940–51); returned

to Paris. Ray moved from sensitive *Cubist paintings to Dada objects to weird *Surrealist images in experimental photographs, photograms and films.

RAYONISM

Abstract painting movement, started in Russia by *Larionov and *Gontcharova (1911–12). Influenced by *Futurism. By splintering the two-dimensional illusion of form with parallel and opposing lines of bright colour, they intended to evoke feelings of the fourth dimension. Though short-lived, the movement contributed to the emergence of pure abstraction.

RAYSKI, Louis Ferdinand von (1806–90)

b. Pegau, Saxony d. Dresden. German artist who studied art while a military cadet at the Dresden Academy and later became an officer. He travelled in Germany and to Paris. His sketches of battles and soldiers were influenced by *Vernet and *Géricault. In Dresden he painted battle scenes and landscapes but mainly portraits of noble patrons.

RAYSSE, Martial (1936–)

b. Golfe Juan. French artist who, after experimenting with painterly abstraction and *Surrealistic assemblage, found direction and fame as a founder-member of the *New Realists (1961). His billboard imagery and sprayed paint, stencil and neon technique possess a mechanical perfection which contrasts with the used, human appearance of *Arman's work. Nevertheless his images have an oddly personal seductive power. His recent work is more austere.

READ, Sir Herbert (1893–1968)

b. Muscoates, Yorkshire d. Stonegrave, Yorkshire. Critic and philosopher of art and literature; poet. After early literary involvement and museum and university activity in the arts, Read emerged in the 1930s as England's foremost apologist for modern art in such books as *Art Now* (1933). Showing a preference for theoretical rather than particular criticism, he was sometimes accused of lack of discrimination. His *Education Through Art* (1943) was another influential work.

RED-FIGURE STYLE

Greek vase-painting style (developed *c.* 525 BC) in which the figures were left in the reddish colour of the clay and the background painted in black glaze. It is said to have been invented by the *Andokides Painter who used both *black- and red-figure on the same vase. Minor details were painted rather than incised and the technique gave greater scope for perspective, shading and foreshortening than black-figure. *Euphronios and *Euthymides made early experiments with foreshortening and rendering of anatomy. The style achieved an early grandeur at the beginning of the 5th century BC with the *Berlin Painter and the *Kleophrades Painter. The cups of *Douris, the *Panaitios Painter and the *Brygos Painter are among the finest products of the style. A mannerist school flourished under the *Pan Painter (*c.* 470 BC). Vase-painting of the middle of the 5th century is characterised by the noble, idealised figures of the *Achilles Painter and *Polygnotos. The style declined into affectation towards the end of the 5th century as can be seen in the work of the *Medias Painter. *See also* DINOS PAINTER; EPIKTETOS; OLTOS; ONESIMOS; PELEUS PAINTER; PISTOXENOS PAINTER; PRONOMOS PAINTER

REDON, Odilon (1840–1916)

b. Bordeaux d. Paris. French artist and lithographer. He studied first in Bordeaux, and then briefly under *Gérôme in Paris. He learned more, however, from a study of *Rembrandt and *Goya in the Louvre, and from *Delacroix's colouring. His interest in lithography derived from *Bresdin and he later produced several series of visionary and imaginative lithographs – eg *A Edgar Poe* (1882), *Les Fleurs du Mal* (1890) and *L'Apocalypse* (1899). These were greatly admired by *Symbolist artists and writers. In his oils, pastels and charcoal drawings he translated classical subjects into dream-imagery forming a bridge between 19th-century †Romanticism and 20th-century *Surrealism.

ODILON REDON *The Cyclops.* c. 1900. $25\frac{1}{4} \times 20\frac{1}{8}$ in (64×51 cm). Kröller-Müller Museum

REDUCED PIGMENTS

*Pigments reduced or let down with inert filler substances for commercial purposes as in house-paints.

REFLECTED LIGHT

Light thrown back from a reflective surface. In *oil painting light passes through transparent and translucent layers of colour and should be reflected back by the white *ground beneath. This gives depth and intensity of colour that mere reflection from the coloured paint itself cannot give.

REFRACTION

The change of path that a light ray undergoes on passing through transmitting materials of different densities. The change of direction in light waves varies according to frequency, consequently white light is split into its component colours upon undergoing refraction. This has a marked effect in some colour pigments, particularly in the very transparent reds and blues.

REFREGIER, Anton (1905–)

b. Moscow. Painter and printmaker who settled in America; studied in Paris, in Munich with *Hofmann, and at Rhode Island School of Design; worked for *WPA. Refregier is best known for his murals, which varied from light-hearted, fantastic, floating figures to angular, powerful portrayals of grief and endurance in social allegories.

REFUS GLOBAL *see* ABSTRACT EXPRESSIONISM

REGNAULT, Guillaume (1450/5–1532/3)

b. Nantes. French sculptor active in Tours and Nantes. His documented work includes the marble statues of Louis de

Poncher and Robert Legendre (c. 1523, now Louvre). These show the influence of Michel *Colombe, whom Regnault assisted with the tomb of François II (Nantes Cathedral) and whose combination of †Renaissance form with †Gothic expressionism was imitated by Regnault.

REGNAULT, Henri Alexandre Georges (1843-71)

b. Paris d. Buzenval. French history and genre painter, pupil of Lamothe and *Cabanel, he received a Rome Prize (1866) with *Thetis remet à Achille les armes de Vulcain*. He left Rome (1868) for Spain where he studied works of *Goya and *Velasquez. His Moroccan works, eg *Salome*, show him best as a colourist. He joined the French army (1870) and was killed in combat.

REICHENAU

Monastery on Lake Constance, frequently used by the Imperial Chancellery during the Ottonian period. It has three churches and two have important wall-paintings: †Ottonian in Oberzell and †Romanesque in Niederzell. Reichenau is also associated with the principal schools of Ottonian manuscript-illumination, eg the Codex Egberti at Trier. The identification has been questioned, but Reichenau would have been an appropriate meeting-place for the two main contributory influences which determined the character of Ottonian minia-ture-painting: †Carolingian and Italian.

REICHLICH, Marx (active 1494-1508)

Austrian painter, documented as a citizen of Salzburg (1494) when he was probably admitted to the workshop of Michael *Pacher. The influence of Pacher's dramatic figurative and architectural style is seen in the altarpiece showing the life of the Virgin (signed and dated 1502, four exterior panels now AP, Munich). He became the most prominent artist in the area after Pacher's death, instrumental in diffusing this artist's influence, especially to the later *Danube School.

Left: MARX REICHLICH *Visitation*. 1502. 39½×32 in (100·5×81·2 cm). AP, Munich
Right: REIMS CATHEDRAL Detail of Joseph by the Joseph Master from the Central Portal. c. 1236-60

REIMS CATHEDRAL

After *Chartres, the most richly sculptured of French †Gothic cathedrals, and stylistically by far the most interesting. There are two main groups of figures. The first (dating from soon after 1211-33) is divided between the north transept and the west front. The second (belonging to the period 1236-60) occupies the remainder of the west front, inside as well as out. (The upper transept façades, the apse and the buttresses also have their quota of figures.) The earlier group owes something to *Chartres, but the principal source of inspiration was classical sculpture, either filtered through the medium of small-scale metalwork, eg *Nicholas of Verdun, or in the works of the Master of the Antique Figures, directly from classical models. The second workshop started from *Amiens and *Paris, but in the fully developed art of the Joseph Master was

soon galvanised into violent gestures and bold draperies that had no precedent. This later Reims style set the pattern for the subsequent evolution of much Gothic sculpture in Germany and Spain as well as France.

REIMS CATHEDRAL
Visitation on the West front.
c. 1220. h. 122 in (309 cm)

REINHARDT, Ad (Adolf J.) (1913-67)

b. Buffalo, New York d. New York. Painter who studied at Columbia College (c. 1931-5) and New York University (c. 1946-50); worked for *WPA; travelled in Asia (1958); taught at Brooklyn College (1947-67). Influenced by *Mondrian and *Rothko, Reinhardt gradually reduced colour and form to the barely perceptible in his abstract, cruciform 'black paintings'.

REINHART, Johann Christian (1761-1847)

b. Bavaria d. Rome. German landscape painter, whose early Dutch naturalism was combined, after he settled in Rome (1789), with the heroic style of *Koch. He painted eight Villa Massimi frescoes, and, for Ludwig I of Bavaria, four views of Rome in tempera.

REKHMIRE

Egyptian vizier of the 18th dynasty (under *Thutmose III), whose *Theban tomb has painted scenes of considerable interest, including representations of craftsmen at work and the bringing of gifts by foreigners. A notable detail is the unique depiction of a young servant-girl in a three-quarter back view.

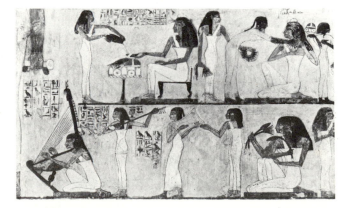

REKHMIRE, tomb of. Banquet preparations. Mid-18th dynasty. Painting on limestone. h. (of figure) 17½ in (44·5 cm). Thebes

RELIEF PAINTING see GRISAILLE

RELIEF SCULPTURE

Sculpture in varying degrees of solidity and roundness but remaining attached to and backed by a panel.

RELINING

Repairing an oil painting by mounting it, old canvas and all, upon a new support, usually canvas. Panels can be used for relining, but complications may ensue – blisters, warping and cracking.

RELIQUARY

Casket containing a sacred relic. The mortal remains of a saint or objects, such as the Crown of Thorns, of great religious importance, were placed in reliquaries on altars, in order to be venerated. From the 7th century onwards all churches were required to possess a relic. Diverse skills in metalwork led to increasingly elaborate reliquaries, so that a solid decorated box, probably based on sarcophagus design, was superseded by insubstantial structures in which the relics were set. Hand, foot and head reliquaries imitated, in wood and metal, the member from which the relic came.

RELIQUARY The Three Towers Reliquary. *c.* 1370. Silver gilt with enamel panels. h. 37 in (94 cm). Aachen Cathedral Treasury

REMARQUE PROOF

A proof bearing the marginal notes or sketches on an engraved plate, originally directions to the printer, later added for effect.

REMBRANDT, Harmensz van Rijn (1606–69)

b. Leiden d. Amsterdam. Painter, etcher and draughtsman and the greatest Dutch artist; in contrast to his specialist contemporaries, he treated all types of subject and his importance extended far beyond his own country and time. The son of a miller, he enrolled briefly at Leiden University (1620), then trained under *Swanenburgh, and, more importantly, *Lastman in Amsterdam (1624/5). After an early period in Leiden he settled in Amsterdam (1631/2), marrying the comparatively wealthy Saskia van Uylenburgh (1634; she d. 1642). From 1649 or earlier Rembrandt lived with Hendrickje Stoffels (d. 1663). They and Saskia's son Titus (1641–68) figure in his work, whose autobiographical flavour is further underlined by

his thirty-odd self-portraits. Successful in the 1630s he became bankrupt (1656) and died poor. Landmarks in his career include *The Anatomy Lesson of Dr Tulp* (1632, Mauritshuis, The Hague), *The Night Watch* (1642, Rijksmuseum) and *The Syndics* (1661, Rijksmuseum), all group portraits. His greatest contribution lay, however, in religious subjects in painting, drawing, and etching, for which he invented a new humanly tender, yet intensely spiritual style, conditioned by his Protestantism, and closely based on the Bible. A sense of the numinous also pervades his psychologically penetrating portraits. His painting style depends on increasingly free brushwork and mastery of light and shade, although colour blazes out in his late works. He was a vitally original etcher and a brilliant draughtsman, in which medium he allowed himself greater realism (cf his genre studies and landscapes) than in his paintings. Misunderstood and increasingly neglected in his lifetime, his fame grew in the 19th century and today he is perhaps the most widely admired of Old Master painters.

Top: REMBRANDT *View on the Bullewijk looking towards the Ouderkirk with a Rowing Boat.* Drawing. Devonshire Coll, Chatsworth
Above: REMBRANDT *The Painter in Old Age.* Mid 1660s. $33\frac{7}{8} \times 27\frac{3}{4}$ in (86×70·5 cm). NG, London

(1622), afterwards settling in Bologna. His most famous work is the *Aurora* (1613–14), Casino Rospigliosi, Rome) planned as a *quadro riportato, influenced by *Raphael and the *Antique, and demonstrating Reni's concern for ideal beauty and harmonious patterns. This concept of the perfect human body became almost an obsession with him (*Atalanta and Hippomenes*, c. 1625, Naples). In the 1630s Reni developed a new style, cool and silvery in tone, broad in handling. His reputation was such that he was held by his contemporaries to be a second Raphael.

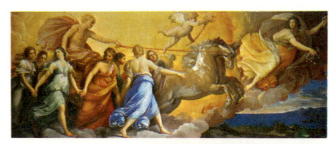

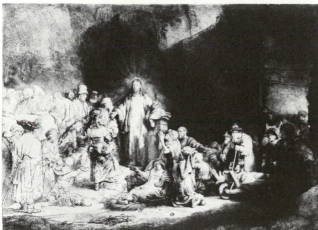

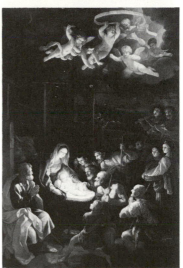

Above left: REMBRANDT *The Night Watch* (The Company of Captain Franz Banning Cocq). 1642. 141⅜ ×172½ in (359·1×438·1 cm) Rijksmuseum
Centre left: REMBRANDT *Christ Healing the Sick* (the Hundred Guilder Print). c. 1642–5. Etching. 11⅞×15½ in (28×39 cm). BM, London
Right: GUIDO RENI *The Adoration of the Shepherds*. c. 1640. 189×126 in (480× 321 cm). NG, London
Above: GUIDO RENI *Aurora*. 1613–14. Ceiling fresco in the Casino Rospigliosi, Rome

Above: FREDERIC REMINGTON *The Sentinel*. Remington Art Memorial Museum, Ogdensburg, New York

REMINGTON, Frederic (1861–1909)

b. Canton, New York d. Ridgefield, Connecticut. Illustrator, painter and sculptor who was cowboy in Montana (c. 1880–6); studied briefly at *Art Students' League and Yale University; settled in New Rochelle (c. 1886), travelling extensively abroad. Remington recorded the Old West in drawings, paintings and bronzes with vivid naturalism, absolute authenticity and dynamic energy.

RENI, Guido (1575–1642)

b. d. Bologna. Italian painter, pupil of the Fleming, *Calvaert (c. 1584–94), then influenced by the *Carracci. He alternated between Rome and Bologna (from c. 1600), visiting Naples

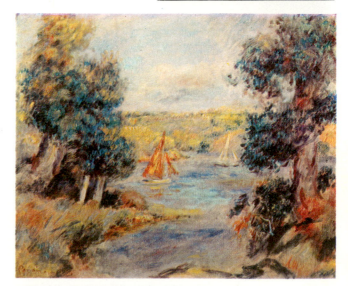

PIERRE AUGUSTE RENOIR *Sailing Boats at Cagnes*. c. 1895. 18×21½ in (46×55 cm). Private Coll, Geneva

RENOIR, Pierre Auguste (1841–1919)

b. Limoges d. Paris. He went to Paris to work in a porcelain factory, then entered *Gleyre's studio (1862) where he met

*Sisley, *Bazille, *Monet, and began to paint landscapes with them. He exhibited at the Salon (from 1864), and took part in the first †Impressionist exhibition (1874). He was influenced by *Diaz, *Courbet and *Delacroix, but adopted the Impressionist technique under the guidance of Monet (1872), and used it to paint figures in outdoor leisurely activities. Journeys (1881/2) to countries of intense sunlight (Algeria, Italy, South of France) and study of the works of *Ingres and *Raphael resulted in a lighter palette and more precise drawing. This was followed by a change to broader handling, and instead of contemporary scenes, to a concentration on portraits and female nudes. He settled in Cagnes (1906), where in spite of illness, continued to paint in a joyous lyrical style.

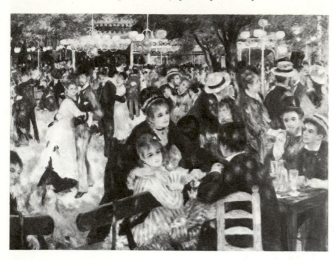

PIERRE AUGUSTE RENOIR *Le Moulin de la Galette*. 1876.
51½×69 in (130·5×175·6 cm). Louvre

REPIN, Ilya Efimovich (1844–1930)

b. Chuguyev, Ukraine d. Kuokkala, Finland. Russian narrative and portrait painter who studied at St Petersburg Academy (c. 1863). A member of the *Wanderer group and of the *Abramtsevo colony, he became Professor of History Painting at St Petersburg (1896). His realist paintings embodied social criticism and influenced the Socialist Realist movement.

REPLICA

A copy of an original work of art as exact as the craftsman can make it.

REPOUSSE

Embossing or hammering relief into sheet-metal. This technique may be combined with *enamelling.

REREDOS

An elaborately carved screen, or framed painting or group of paintings, behind a church altar. There were several in England, for example Winchester, but the most highly developed were in Spain.

RESIN

Natural resins are the exudations from certain trees which harden in the air. They will not dissolve in water, but may be dissolved in *oils, alcohol and *turpentine. Such solutions dry out by the evaporation of the solvent, leaving a thin film of resin behind. This is the basis of *varnish. The plastics industry has produced synthetic resins which behave more or less as do the natural resins, but the films tend to be more brittle.

RESNICK, Milton (1917–)

b. Bratslav, Russia. Painter who went to New York (1922); studied at Pratt Institute (1934–5), American Artists' School

(1935–7) and with *Hofmann (1948); worked for *WPA; lived in Paris (c. 1947). First influenced by *De Kooning, Resnick moved from his turbulent *Abstract Expressionism to more intimate paintings in feathery brushstrokes of perfumed colour.

RESTOUT, Jean (1692–1768)

b. Rouen d. Paris. French *history painter (pupil of his uncle *Jouvenet) who had a very successful academy career. Much in demand, he painted altarpieces for many Parisian churches, in a style formed on Jouvenet and *Le Sueur.

RETABLE

Painted or sculptured panel placed behind the altar in a church. Changes in the celebration of the Mass by which the priest no longer faced the congregation across the altar, encouraged the rapid growth of altarpieces, for example in Italy where *Cimabue's *Sta Trinità Madonna*, *Duccio's *Rucellai Madonna* and *Giotto's *Ognissanti Madonna* dwarf earlier Italian panels. In the 14th century altarpieces became more complex often consisting of many panels. The carved wooden retable became popular in the late Middle Ages with the German *schnitzaltare.

RETARDANT

A substance which slows up a chemical or physical process, eg an additive to slow the drying of paint, or to slow the hardening of plaster.

RETH, Alfred (1884–1966)

b. Budapest d. Paris. Painter who settled in Paris (1905). A typical *School of Paris painter, nurtured on *Cubism, Reth's abstract style of flat, interlocking shapes close to *Poliakoff, is differentiated by textural effects achieved by mixing sand and other substances with the paint.

RETHEL, Alfred (1816–59)

b. Aix-la-Chapelle d. Düsseldorf. German historical painter and illustrator, studied in Düsseldorf under Schadow, but found a more sympathetic environment in Frankfurt (1836–47). His major painting commission, half-completed at the time of his death, was the decorations in fresco for the Aachen Town Hall with scenes from the life of Charlemagne, painted with dramatic intensity and fertility of invention. His powers of draughtsmanship are best seen in his series of woodcuts *Another Dance of Death in the Year 1848* (1849), a conscious attempt to revive the tradition of *Dürer in response to the political turmoil of Europe.

REVERON, Armando (1889–1954)

b. d. Caracas. Painter who studied at Escuela de Artes Plásticas y Artes Aplicadas (1904) and in Madrid, Barcelona and Paris (c. 1913–21); lived in Macuto (1921–54). His attempt to capture the blinding light of the tropics led him through †Impressionism to the borders of *Abstract Expressionism in pale, almost white canvases.

REXACH, Juan II (active 1443/84)

Spanish painter of the Valencian School. He collaborated with the better known Jacomart *Baco, whose *Burjasot Retable* (commissioned 1441) he completed, and whose *Cati Retable* (1460) he worked on extensively. His own style, a weaker version of Jacomart's linear decorative one, is clarified by his only signed and dated work, the *Retable of St Ursula* from Cubells (1468, now Catalonian Museum, Barcelona).

REYMERSWAELE, Marrinus Claesz van *see* MARINUS VAN REYMERSWAELE

REYNOLDS, Sir Joshua (1732–92)

b. Plympton, Devon d. London. English painter, aesthetician and the man chiefly responsible for giving the English School

an established status. He was apprenticed to *Hudson in London (1740–3), then practised as a portrait painter before going to Italy (1749), where his studies of the masters of the *Grand Manner convinced him of their superiority and shaped his attitudes towards art. He returned to England, via France (1752) and achieved great fame and success, becoming the first President of the *Royal Academy (1768), then gaining a knighthood (1769), and the post of King's Principal Painter (1784). A journey to Holland and Flanders (1781) introduced more freedom into his style. He became blind (1789). His output (with much studio participation) was vast. Major works include: *Commodore Keppel* (1753, National Maritime Museum, Greenwich), *Georgiana Countess Spencer and her Daughter* (c. 1761, Earl Spencer), *The Three Graces* (1774, NG, London), *Mrs Siddons as the Tragic Muse* (1788, Huntington Museum, San Marino, California). His Grand Manner *history-paintings are usually unconvincing, and technical experimentation has damaged many works, but his best portraits clearly entitle him to a place among the greatest of British artists. His importance, however, extends beyond his paintings, for the example he set of a cultured gentleman raised the status of the artist in England, and his fifteen *Discourses* (delivered 1769–90) are the most sympathetic embodiment of 18th-century aesthetic principles.

RHODIAN SCHOOL

Rhodes was one of the chief centres of *Hellenistic sculpture. Among famous works attributed to the Rhodian school are the *Laocoön group, and the *Victory of Samothrace.

RHOIKOS (active 600–550 BC)

Greek architect and sculptor from Samos, credited along with *Theodoros with inventing bronze-casting. He was also the architect of the Temple of Hera at Samos.

RIBALTA, Francisco (1565–1628)

b. Solsona, Catalonia d. Valencia. Spanish painter who progressed from a *Mannerist style akin to that of *Navarrete to a clearer and more dynamic style after his move to Valencia (c. 1599). He was often commissioned to paint for monasteries producing works which are temperamentally Spanish in their subject-matter and mood, but †Baroque in their style and composition.

RIBERA, Jusepe (1591–1652)

b. Jativa, nr Valencia d. Naples. Spanish painter. Probably trained by *Ribalta in Spain, he settled in Naples (c. 1616), after studying in ?Parma and Rome. He was elected to the Academy of St Luke, Rome (1625). He was patronised by the Spanish Viceroys and court, who were attracted by his early *Caravaggesque style and treatment of religious subjects; many of his works found their way back to Spain. He combined dark and heavy realism with boldness of handling. In the 1640s he adopted a more classical style – probably in response to the pervasive Bolognese influence – including the *Communion of the Apostles* (1651, S. Martino, Naples).

RIBOT, Augustin Théodule (1823–91)

b. St Nicholas d'Attez d. Colombes. French artist, essentially self-taught, he was for a time a studio assistant to Glaize, and he also copied in the Louvre. He was influenced by the earthy tones and contrasted values of 17th-century Spanish paintings. He painted interiors and still-lifes, and, from the 1860s, religious subjects and French peasants.

RICCI (RIZI), Juan Andres (1600–81)
Francisco (1608–85)

Spanish painters, brothers. Juan, b. Madrid d. Monte Cassino, Italy, was a Benedictine scholar who, before settling in Italy, decorated the many Benedictine houses in Castile. Francisco, b. Madrid d. El Escorial, executed frescoes in Toledo Cathedral and royal palaces.

RICCI, Sebastiano (1659–1734)
Marco (1676–1730)

Sebastiano, b. Belluno d. Venice, was a Venetian decorative painter, pupil of Sebastiano Mazzoni, influenced by *Magnasco and *Veronese. With his nephew and pupil Marco, b. d. Belluno, he came to London (1712), where Sebastiano painted the apse of Chelsea Hospital Chapel. Both returned to Venice via Paris (1766). Marco painted numerous decorative landscapes and *capricci.

RICCIARELLI see DANIELE DA VOLTERRA

RICCIO (Andrea BRIOSCO) (c. 1470–1532)

b. Trento d. Padua. Italian sculptor. Trained under *Bellano; eventually surpassing him, he worked principally in Padua. According to *Gauricus, he began as a goldsmith, which may partly account for the technical excellence of his bronzes. Both statuettes and reliefs have vigour as well as an integrated classicism. He was one of the Paduan humanist circle, and sought (as in the Torre Monument, S. Fermo Maggiore, Verona) to reinterpret both contemporary and religious themes in antique terms. His masterpiece was the great Paschal Candlestick for S. Antonio, Padua, an intricate work of apparently limitless invention.

RICHARDS, Ceri (1903–71)

b. Dunvant, Wales d. London. Painter who studied at Swansea School of Art (1920–4) and the Royal College of Art, London. The influence of *Picasso and *Ernst figured principally in his early work. His later paintings, however, are characterised by abstract, freely painted forms, rich in colour and heavily textured, these are contrasted with a sharp, sometimes incised, outline. Vague evocations of romantic themes are allied to frankly decorative effects.

RICHARDSON, Jonathan (1665–1745)

b. d. London. Pupil of *Riley, and minor portraitist, he is most important for his writings, eg *Theory of Painting* (1715), an Italian guide-book (1722), using information provided by his son, and essays on connoisseurship.

RICHIER, Germaine (1904–59)

b. Arles d. Montpellier. French sculptress who studied at Montpellier, and moved to Paris (1925). Her skeletal bronzes occasionally resemble *Giacometti's, but her concerns are different. She is consistently preoccupied with the idea of atavistic instincts and regressive changes, as in the hybrid insect-women (1940s), the bat-men and tree-men. Her typical hooks, membranes, claws and angular animal projections give way to the vaster and more amorphous bird-men of the 1950s. She has also done ceramics, mosaics and prints.

RICHIER, Ligier (c. 1500–1566/7)

b. Lorraine. French sculptor, first generation of a family of sculptors. He went to Rome (1515) where he stayed for five or six years, and then returned to Lorraine. There he executed a sepulchre consisting of twelve large naturalistic figures (*St Pierre*, at St Michiel, 1550) and the tomb of René of Nassau, Prince of Orange. His works are neat and precise in technique and softly modelled, becoming progressively more Italianate.

RICHMOND, George (1809–96)

b. Brompton d. London. Son of a miniature-painter and trained at the Royal Academy Schools. Through Samuel *Palmer, who became a lifelong friend, he met *Blake and Edward *Calvert and painted poetic and religious subjects under their influence. This, however, was rather stylistic than deeply felt and from the 1830s he became a successful portrait painter.

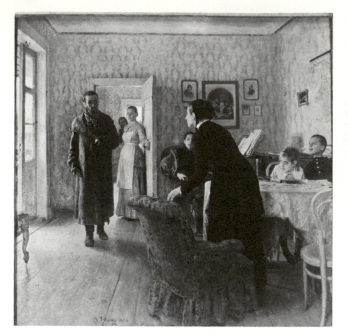

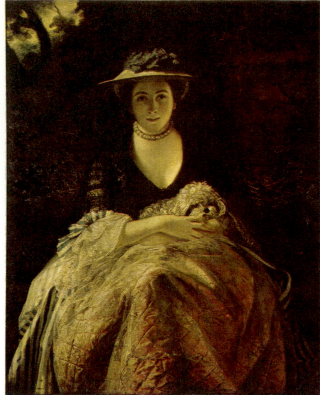

Top: ILYA REPIN *They did not expect him.* 1884. Tretyakov
Centre: REPOUSSE
Above: ALFRED RETHEL Scene from 'Another Dance of Death'.
1849. Woodcut. 8¾×12½ in (22·3×31·5 cm). V & A, London

Top: JOSHUA REYNOLDS *Nelly O'Brien.* 1763. 50¼×40 in
(127·6×101·6 cm). Wallace
Above: JOSHUA REYNOLDS *Lord Heathfield.* 1788. 56×44¾ in
(142×113·5 cm). NG, London

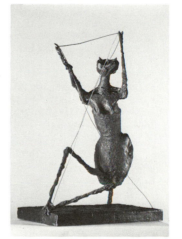

Above: GEORGE RICHMOND *Christ and the Woman of Samaria.* 1828. 16⅜×19⅝ in (41·5×49·8 cm). Tate

Top left: FRANCISCO RIBALTA *S. Bruno.* From the Portacoelli Retable. S. Carlos Museum, Valencia
Top centre: JUSEPE RIBERA *The Clubfoot.* 1652. 64⅝×36¼ in (164×92 cm). Louvre
Top right: CERI RICHARDS *La Cathédrale engloutie (profondément calme).* 1961. 60×60 in (152·5×152·5 cm). The British Council, London
Far left: SEBASTIANO RICCI *Bacchus and Ariadne. c.* 1728. 29⅞×24⅞ in (75·9×63·2 cm). NG, London
Near left: RICCIO *The Paschal Candlestick.* 1507–16. Bronze. h. 12 ft 11 in (392 cm). S. Antonio, Padua
Above left: GERMAINE RICHIER *The Ant.* 1953. Bronze. h. 38¼ in (97 cm). NP, Munich
Above right: ADRIAN LUDWIG RICHTER *Genevera.* Engraving. V & A, London

RICHMOND, Sir William Blake (1842–1921)

b. d. London. Son of George *Richmond, he studied at the Royal Academy Schools. He was in Italy (1860s) painting in fresco and tempera and practising sculpture. In England he exhibited portraits and painted history subjects from Greek mythology, and also frescoes. A notable late work was the internal mosaic decoration of St Paul's Cathedral.

RICHTER, Adrian Ludwig (1803–84)

b. d. Dresden. German artist taught by his landscape-engraver father. In Dresden he taught drawing at the Meissen porcelain

factory, studied in Rome with *Koch and later became a professor at the Dresden Academy, introducing a combination of genre and landscape. He became well known through his illustrations of German life, literature and scenery which were widely distributed in wood-engravings.

RICHTER, Hans (1888–)

b. Berlin. German painter who studied in Berlin and Weimar. He joined the Zürich *Dadaists (1917) and exhibited paintings of a purely geometric and abstract nature. By 1919 he was investigating the possibilities of movement on canvas and beginning to experiment with the real movement of geometric planes in film; he later extended this into the field of the documentary. He was appointed Director of the Institute of Film in the USA (1941).

RICKETTS, Charles (1866–1931).

b. Geneva d. London. English painter influenced by *Delacroix and Gustave *Moreau. Best known, with his lifelong companion Charles Shannon (1863–1937), for his work in the development of printing. Together they started the Vale Press (1896), influenced by *Morris's Kelmscott Press. Also a theatrical designer of great originality.

RICO-Y-ORTEGA, Martín (1833–1908)

b. Madrid d. Venice. Spanish painter, pupil of *Madrazo-y-Kuntz and Mario *Fortuny, but chiefly influenced by the paintings of the †Impressionists which he saw on several trips to Paris. Known for his charming, delicate landscapes and atmospheric views of the cities of Venice, Rome and Toledo.

RIDOLFI, Carlo (1594–1658)

b. Vicenza d. Venice. Italian biographer of Venetian painters, whose two-volume Le Maraviglie dell'arte was published in 1648, a riposte to *Vasari's Tuscany-biased work. His paintings (mainly religious), all over the Veneto, are *Mannerist with touches of *Veronese and *Tintoretto.

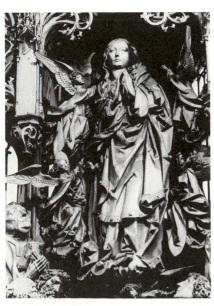
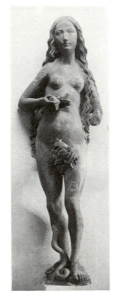

Left: TILL RIEMENSCHNEIDER Assumption. c. 1505–10. Detail of central panel of triptych. Linden wood. Hergottskirche, Creglingen
Right: TILL RIEMENSCHNEIDER Eve. 1493. White sandstone. h. 73 in (186·4 cm). Mainfrankisches Museum, Würzburg

RIEMENSCHNEIDER, Till (Tilman) (c. 1460–1531)

b. Osterode, Saxony d. Würzburg. German sculptor, active mainly in Würzburg. Best known for his wood-carvings but also worked in marble, limestone and alabaster. Admitted to Würzburg Guild as a journeyman (1483) and became a citizen by his marriage (1485). He was elected Councillor (1504) and Burgomaster (1520) but temporarily lost his position by sympathising with the Peasants' Revolt (1524). His earliest documented work, the Münnerstadt Altarpiece (1490/2, lindenwood, central statue of Magdalen now Bayerisches Nationalmuseum, Munich, rest in Berlin and Münnerstadt) shows a reliance on †Gothic qualities of lyrical outline and pattern. This linear beauty was used also to emphasise expressionism particularly of the tragic type, eg the Darmstadt Crucifixion. Riemenschneider's traditional Gothic and local sources (cf Hans *Multscher's linear style) are individualised by his increasingly powerful compositions. For example, the Creglingen Altarpiece (c. 1505/10, Herrgottskirche) is monumental and also clearly and structurally composed. This applies also to the reliefs and tombs, eg sarcophagi of Henry II and Kunigund (1499–1513, Bamberg Cathedral). This combination of native decorative characteristics with his innovations in a more planar style, emphasised by the use of the unadorned surface of the material, constitute Riemenschneider's great influence. His style is most recognisable and original in its use of a sharp, expressive drapery technique.

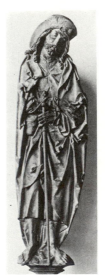
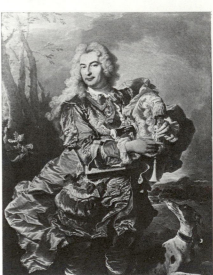

Left: TILL RIEMENSCHNEIDER The Holy Jacob. c. 1510. Kunstmuseum, Basle
Right: HYACINTHE RIGAUD Marquis Gaspard de Gueidan playing the Bagpipes. 1735. Musée Granet, Aix-en-Provence

RIGAUD, Hyacinthe (1659–1743)

b. Perpignan d. Paris. French portraitist. He arrived in Paris (1681), awarded the Rome Prize (1682), but remained in France as Court Painter, producing state portraits which admirably express the grandeur of the age. He had an active studio and a vast output; his unofficial works show *Rembrandt's influence.

RILEY, Bridget (1931–)

b. London. English painter who studied at Goldsmith's College and the Royal College of Art, London. Her early figurative work consisted mostly of drawings and was influenced by †Impressionism, particularly *Seurat. Visited Italy (1960) and influenced by the *Futurists, *Boccioni and *Balla. An exponent of *Op Art, she paints works which depend on the reaction to them of the optic nerve, inducing a kinesthetic response. Exploited in this way, physical sensations become almost indistinguishable from emotional reaction.

RILEY, John (1646–91)

b. d. London. Scarcely traceable before 1680, he was appointed joint Principal Painter with *Kneller to William and Mary (1688). He was important as the leading portraitist between *Lely and Kneller, and also as a teacher.

RIMMER, Dr William (1816–79)

b. Liverpool d. South Milford, Massachusetts. Painter and sculptor who settled in Boston (1826); was itinerant portraitist (c. 1840–5); studied medicine (1845–55); taught art in Boston (1864–6, 1870–9) and directed Cooper Union (1866–70). A brilliant anatomist, he created images of tormented, tragic figures in violent motion, prefiguring *Rodin, but unrecognised in Rimmer's time.

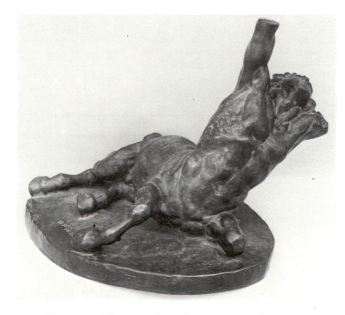

Top: WILLIAM RIMMER *The Dying Centaur.* c. 1871. Bronze. h. 21½ in (54·6 cm). MM, New York, Gift of Edward Holbrook 1906
Above: BRIDGET RILEY *Nineteen Greys.* 1968. Colour print. Each section 29¾×29½ in (75·6×74·9 cm). Tate

RIMPA SCHOOL

The Rimpa School was not formalised in the way most Japanese schools of painting were. It was more an association of artists, commencing with the friendship of *Kōetsu and *Sōtatsu. Neither men were professional painters but Sōtatsu is known to have repaired *Yamato-e handscrolls. He took themes, subjects and even pictorial images from this style and converted them to a uniquely decorative result that is, like *Yamato-e, entirely Japanese. The theme was adopted and extended by *Kōrin, a kimono-designer, in whom the style reaches its apotheosis. Kōrin's younger brother, the potter *Kenzan also painted in the style. It is unlikely that Kōrin ever had pupils as such, but followers include Fukae *Roshū, and, more distantly, Watanabe *Shikō. Many years after the death of Kōrin, Sakai *Hōitsu revived the style and published woodblock-prints of Kōrin's paintings. He in turn was followed by Suzuki *Kiitsu.

RINKE, Klaus (1939–)

b. Ruhr, Germany. A member of the Düsseldorf group of *Conceptual artists, he does not exhibit works of art but has tried to convert exhibition halls into events in themselves: in 1968–9 he had the Berne Kunsthalle surrounded with a water-bag, and a 'river' pumped through a Baden-Baden museum in hoses.

RIO NAPO

Culture in Ecuador (c. AD 600–1300) characterised by distinctive painted pottery bowls and effigy burial-urns decorated with complex excised and incised designs in red, black and white.

RIOPELLE, Jean-Paul (1923–)

b. Montreal. Canadian painter who exhibited with *Automatistes; visited Europe (c. 1945); emigrated to Paris (1947). Inspired by *Borduas, Riopelle became one of Canada's few internationally known painters. His *Action Paintings are characterised by slashing, thrusting lines executed with a palette-knife, creating a complex interaction of brilliant colour resembling intricate stained glass.

Above: JEAN-PAUL RIOPELLE *Knight Watch.* 1953. 38×76¾ in (96·5×194·9 cm). NG, Canada

Right: DIEGO RIVERA. *The Rain.* Ministry of Education, Mexico City

RIPPL-RONAI, Joseph *see* NABIS

RIVERA, Diego (1886–1957)

b. Guanajuato d. Mexico City. Painter who studied with *Velasco at Academy of San Carlos (1896); worked in Europe, primarily Paris (1907–21), and United States (1930–4). The most influential and dogmatic of the three founders of revolutionary Mexican muralism, Rivera absorbed many influences – *Posada, *Cubism, *Post-Impressionism, †Renaissance

frescoes; the major influences on him, however, were Communism and the Mexican Revolution. Consequently his murals constitute a chronicle of Mexican history from its beginnings through the present, emphasising the native's struggle against his oppressors. Crowded with details rendered with great clarity of draughtsmanship and solidity of form, they are decorative, realistic and didactic.

RIVERS, Larry (1923–)

b. Bronx, New York. Painter who studied with *Hofmann (1947–8), and lived in Europe (1950, c. 1961). A controversial individual, Rivers first showed *Bonnard's influence in his *Abstract Expressionism, then returned to the figure with a cruder realism, incorporating it in apparently random *Pop Art assemblages.

Above: LARRY RIVERS *Double Portrait of Birdie.* 1955. 70¾×82½ in (179·7×209·6 cm). Whitney Museum of American Art, New York
Right: LUCA DELLA ROBBIA *Resurrection.* 1442–5. Enamelled terracotta lunette relief. 78¾×102⅜ in (200×260 cm). Duomo, Florence

Left: RIZA ABBASI *Two Lovers.* Signed and dated 1630. 7⅛×4¾ in (18×12 cm). MM, New York (Francis M. Weld Fund)

RIZA ABBASI (d. 1635)

Although he and Aqa Riza were previously considered as two distinct artists, the latest research would indicate that Aqa Riza was the earlier name for this Persian artist, working at the Isfahan court. His earliest known works date from 1603 and 1610. In these he develops the firm *Qazvin drawing technique, with the line indicating depth and in colour work the traditional palette is employed. The attitude and poses of the human figures are more languid than graceful. This is accentuated in later works with the introduction of purple, brown and yellow shades into the colour repertoire which became the model for 17th-century *Isfahan court painting. The Aqa Riza of *Jahangir's court is to be distinguished from this *Safavid artist.

RIZI, Juan Andres *see* RICCI

RIZZIO, Antonio (active after 1465–d. 1499/1500)

b. Verona d. Foligno. Italian sculptor; first mentioned at the Certosa, Pavia, but worked chiefly in Venice. His Tròn monument, Sta Maria dei Frari (c. 1476) is a work of rather pedestrian classicism. But the influence of the *Bellinis and *Antonello da Messina may account for the surprising subtlety of the *Adam* and *Eve* statues for the Doge's Palace.

RIZZO, Antonio *see* BREGNO

ROBBIA, Luca della (1399/1400–1482)

b. d. Florence. Sculptor; trained under *Nanni di Banco, subsequently influenced by *Donatello, *Ghiberti and *Michelozzo. His earliest recorded work is the *cantoria for the Cathedral in Florence (1431–8) which is imbued with a decorous charm concealing the rigorous classical design of the marble reliefs. A delicately controlled naturalism is also a feature of his polychrome terracottas with their familiar white figures upon a blue ground, the details picked out in green and yellow. He frequently depicts the Virgin and Child, but more ambitious is the lunette relief the *Resurrection* (1442–5, Cathedral, Florence). Less happy in bronze, his door for the North Sacristy of the Cathedral, Florence (1446–69) is justly eclipsed by Ghiberti's and Donatello's examples. The tradition of the family workshop was carried on by his son Giovanni (1469–1529) and his nephew Andrea (1435–1525) who was also influenced by *Verrocchio. Their works, lavishly coloured and prettier, were popular.

ROBERT, Hubert (1733–1808)

b. d. Paris. French painter who remained round Rome up to 1765, apart from a trip to southern Italy with *Fragonard (1761). In Italy he developed a landscape style related to that of his friends *Piranesi and *Pannini. He returned to Paris (1765) where he continued to paint his highly evocative landscapes with ruins, a well-received novelty in France. He also applied his pleasing style to decorative and view painting.

ROBERT-FLEURY, Joseph Nicolas (1797–1890)

b. Cologne d. Paris. French painter and lithographer, pupil of *Vernet, *Girodet and *Gros, he exhibited at the Salon (1824–67). He was a member of the Institute (1850), and Director of the French School in Rome (1865). His Romantic history-paintings are painted with a knowledge of classicism.

ROBERTI, Ercole de' (c. 1453–96)

b. Ferrara. Italian painter influenced by *Tura, *Cossa and *Mantegna. In Cossa's workshop (1473–8); later in Bologna (S. Petronio) and Ravenna (Sta Maria in Porto). In Ferrara (from 1479), where he became Court Painter to the d'Este family (1486). His tense, nervous style is best shown in the *Ravenna Altarpiece* (1480/1, Brera).

ROBERTS, David (1796–1864)

b. Edinburgh d. London. Worked first in Scotland and then London as a scene-painter. He travelled in Spain (1830s) and produced lithographs from his sketches. Other successful series followed from his tours in the Holy Land, Syria and Italy. He exhibited continental and Eastern views and church interiors.

ROBERTS, (William) Goodridge (1904–)

b. Barbados. Painter who grew up in Canada; studied at Ecole des Beaux-Arts, Montreal, and *Art Students' League; taught extensively in Canada; was Official War Artist in England; painted in France (1953–5). Roberts's landscapes, still-lifes and figures are characterised by firmly structured composition and form, and quiet, *Cézannesque solidity.

Top: GOODRIDGE ROBERTS *Still Life*. 1947. 33¼×46⅛ in (84·5×117·2 cm). NG, Canada
Above: HUBERT ROBERT *The Pont du Gard*. 1787. 95¼×95¼ in (242×242 cm). Louvre

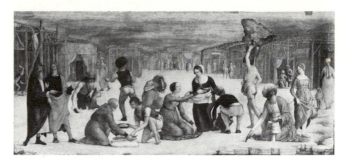

ERCOLE DE' ROBERTI *Israelites gathering Manna*. 11¾×25 in (29×63·5 cm). NG, London

ROBERTS, William (1895–)

b. London. English painter of figure compositions and portraits, trained as a commercial artist and at St Martin's and the Slade Schools of Art. Influenced by *Cubism, he worked briefly at *Omega Workshops. After early purer *Vorticist work he settled down to modified abstraction which he has since maintained, producing multi-figure compositions which allow him to make a certain social comment.

ROBINSON, Boardman (1876–1952)

b. Nova Scotia d. Stamford, Connecticut. Painter and illustrator who studied in Massachusetts and Paris; painted *WPA murals; exhibited at *Armory Show (1913); taught at *Art Students' League (1919–30) and Fountain Valley School (1930–47). Associated with *American Scene painting in his murals, Robinson achieved real greatness in his forceful, searing social satires.

ROBINSON, Theodore (1852–96)

b. Innsburg, Vermont d. New York. Painter who studied in Munich, with *Carolus-Duran and *Gérôme, Paris, with *Monet, Giverny (1888); exhibited posthumously at *Armory Show (1913). Influenced by the *Barbizon School and †Impressionism, Robinson's keenly observed landscapes moved from sombre tonalities to more brilliant, broken colour, broadly painted and strongly composed.

ROBUS, Hugo (1885–1964)

b. Cleveland, Ohio d. New City, New York. Sculptor who studied in Cleveland, in New York at National Academy of Design, in Paris at la Grande Chaumière and with Bourdelle (1912–14); abandoned painting for sculpture (1920). The graceful, rhythmic, abstract curves of Robus's polished bronze and marble figures are infused with charm and wit.

ROBUSTI, Jacopo *see* TINTORETTO

ROCK ART: AUSTRALIAN *see* AUSTRALIAN ABORIGINAL ART

ROCKER

Tool used to cover a plate with a ground texture as a basis for mezzotint *engraving.

RODCHENKO, Alexander (1891–1956)

b. St Petersburg d. Moscow. Russian artist/designer who studied at Kazan School of Art. Moved to Moscow (1914). Influenced by *Malevich and *Tatlin. Declared *Suprematism

and painting to be dead (1921). Co-founded *Constructivism, announcing that Soviet artists should be artists/designers/engineers. He carefully composed posters combining block letters and photomontage allowing little illusion of space and movement. They achieved an immediate impact and maximum readability. Until his death worked as designer, photographer, typographer, poster-designer and on some theatre and costume design.

ALEXANDER RODCHENKO Poster for the film 'Battleship Potemkin'. 1925

RODE, Herman

German painter, recorded in Lübeck (1485–1504) and whose only dated work is the altarpiece of the Guild of St Luke for the Church of St Catherine (1484, now Sankt-Annen Museum, Lübeck). Its style is close to that of painters like the *Master of Liesborn, in its clarity of colour and spatial arrangement, as well as its static charm.

RODERIGO DE OSONA see OSONA, Roderigo de

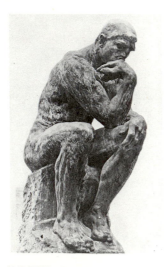

AUGUSTE RODIN *The Thinker*. 1880–1900. Bronze. 78×51×52¾ in (198·1×129·5×134 cm). Rodin Museum, Paris

RODIN, Auguste (1840–1917)

b. Paris d. Meudon. French sculptor who was given a religious education, and considered entering the priesthood. Turned down by the Ecole des Beaux-Arts he worked as ornamenter, moulder, chiseler in Carrière-Belleuse's studio in the National Sèvres Works (between 1864 and 1871). He was in Belgium (1871–8) where he became friendly with Constantin *Meunier. Rodin's first independent free-standing figure *Bronze Age* (1877), begun shortly after his visit to Italy (1875), was, like many of his works to follow, the subject of controversy and received recognition only in London (1884). His works reflect his interest in the relation of sculpture and architecture that

led him to study †Gothic; independent statues and groups demonstrate the numerous ideas provided by *Ghiberti's *Gates of Paradise*. Among his monumental works are the *Burghers of Calais* (1884–94), *Victor Hugo*, the *Gate of Hell*, the *Thinker*, the *Kiss*, and above all *Balzac*, refused by the committee that had commissioned it. Rodin finally received recognition at the Paris World Fair (1900) where a pavilion was devoted entirely to his work.

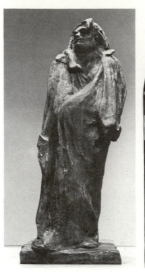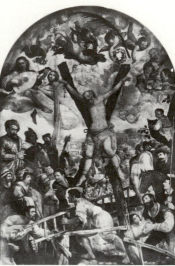

Left: AUGUSTE RODIN *Balzac*. 1897. Plaster Model. 118×47×47 in (299·7×119·4×119·4 cm). Rodin Museum, Paris
Right: JUAN DE ROELAS *The Martyrdom of St Andrew*. 1609. 204¾×136¼ in (520×346 cm). Seville Museum

RODRIGUEZ LOZANO, Manuel (1896–)

b. Mexico City. Painter who studied in Europe; taught at 'open-air' schools and Esmeralda School. Influenced by *Picasso's classicism and the 'Mexicanism' of artists like *Orozco, he creates a mystical world of subdued colour and brilliant light, in which mysterious figures symbolise the eternal human themes – birth, love and death.

ROELAS, Juan de (1558/60–1625)

b. ?Valladolid d. Seville, where he worked after 1603. The Spanish *Veronese, his painterly qualities, compositional skill and blending of realism and mysticism make him the finest Spanish figure-painter of his time. Outside Seville, however, he was virtually unknown.

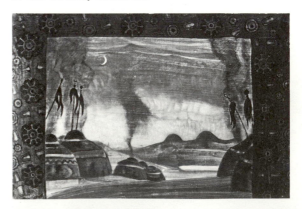

NIKOLAI ROERICH Design for a set for 'Prince Igor'. 1909. Tempera and gouache. 20×30 in (50×76 cm). V & A, London

ROERICH, Nikolai Konstantinovitch (1874–1947)

b. St Petersburg. An important contributor to the *World of Art magazine and among the most striking of Diaghilev's pre-

war designers, Roerich evoked remote Russian folk-art in scenes treated in broad areas of flat bright colour (eg Polovtsian camp in *Prince Igor*). He moved to the USA (1920) where as a Theosophist, conducted a Central Asian Expedition (1923–8), then lived and worked in northern India.

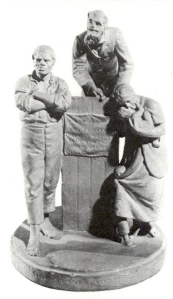

JOHN ROGERS *The Slave Auction*. 1859. Plaster. h. 13⅓ in (34·3 cm). New York Historical Society

ROGERS, John (1829–1904)

b. Salem, Massachusetts d. New Canaan, Connecticut. Sculptor who was draughtsman and mechanic (1848–57); studied briefly in Europe (1858); worked in New York (c. 1859–94). Rogers became famous for his mass-produced genre groups, characterised by lively naturalism, authentic detail, vitality of design and human warmth rising to passion in his Abolitionist subjects.

ROGIER VAN DER WEYDEN *see* WEYDEN, Rogier van der

ROHLFS, Christian (1849–1938)

b. Niendorf d. Hagen. German *Expressionist painter, the son of a peasant. Originally a painter in the late 19th-century landscape tradition, he developed slowly and in virtual isolation, though he did paint with *Nolde (1905–6). Influenced by *Monet, he used impasto to render light and to unite the image with the picture surface.

ROMANELLI, Giovanni Francesco (c. 1610–62)

b. d. Viterbo. Italian painter. He studied under *Domenichino and assisted *Cortona with the Barberini ceiling, Rome. He adapted the High *Baroque decorative style to French taste, working in Paris (1646–8, 1655–7) at the Palais Mazarin and the Louvre.

ROMANINO, Girolamo (1484/7–c. 1562)

b. d. Brescia. Italian painter, active in Brescia and northern Italy. With *Moretto and *Savoldo he was one of the three principal Veneto-Lombard artists of the 16th century. In his vigorous, dramatic paintings, he combines the descriptive realism of the Lombard tradition with Venetian colour.

ROMANO (PIPPI), Giulio (c. 1499–1546)

b. Rome d. Mantua. Italian painter and architect. A pupil of *Raphael from boyhood, he assisted him in the Vatican, inherited his workshop and completed unfinished commissions, including the *Transfiguration* (Vatican). He also took over the scheme for the Sala di Constantino, the first *Mannerist statement on a grand scale in Rome. The spatial effects and the differing figure scales in the crowded composition are Raphael's style exaggerated, and also show the influence of *Michelangelo. He entered the service of the Duke of Mantua (1524). In the

Palazzo del Tè, the frescoes are instinct with a sophisticated classicism resulting in exaggerated perspectives, proportions and titillating eroticism. The *Fall of the Giants* (1532–4) creates a feeling of catastrophic despair.

GIULIO ROMANO *Fall of the Giants*. 1532–4. Fresco. Sala dei Giganti, Palazzo del Tè, Mantua

ROMBOUTS, Theodor (1579–1637)

b. d. Antwerp. Flemish painter. He became a guild master (1601). He was in Italy (c. 1616–25) where his work became *Caravaggesque, a style he retained on his return until c. 1630 when he became heavily influenced by *Rubens, whom he believed he excelled.

ROME, Arch of Septimius Severus

A *triumphal arch dedicated to Septimius Severus and his sons, Caracalla and Geta, by the Senate (AD 203) to commemorate his victory over the Arabs and Parthians in Mesopotamia. It stands over the Sacred Way in the north-west corner of the Forum, Rome. It has a central arch flanked by two lesser ones. Over the side arches are panels with scenes from the campaign and on the *attic is an inscription.

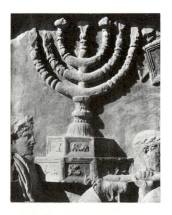

ROME, Arch of Titus. Relief from the arch passage showing the spoils of Jerusalem being carried away

ROME, Arch of Titus

*Triumphal arch erected at the top of the Sacred Way in Rome in honour of the Emperor Titus, after his death (AD 81). It has a single opening flanked by composite columns. On either side of the passageway are sculpted panels representing the triumph of Titus and Vespasian. In the vault is a relief representing the Apotheosis of Titus.

ROME, Column of Trajan (AD 114)

A column 126 feet high standing in Trajan's Forum, Rome, and in honour of Trajan's victories in Dacia. Round it runs a

spiral frieze in low relief showing in continuous narrative form Trajan's campaigns from the crossing of the River Danube (at the bottom) to his defeat of Decebalus (at the top). In style the sculpture is full of realistic detail.

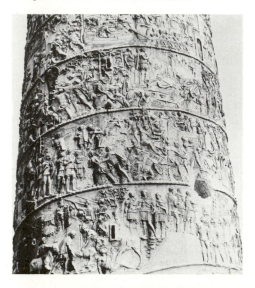

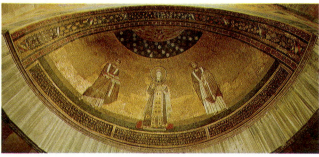

Top: ROME, Column of Trajan. Detail of reliefs from the Spiral frieze
Above: ROME, Sta Agnese Fuori le Mura. *St Agnes flanked by two Popes*. Apse mosaic

ROME, Sta Agnese Fuori Le Mura

The present basilica was built in the 7th century near the tomb of St Agnes who is portrayed in the apse mosaic (dated *c.* 625). Her portrait, tall, flat and unearthly, set against a plain gold background contrasts with the vivid portraits of the two popes to the left and right of her.

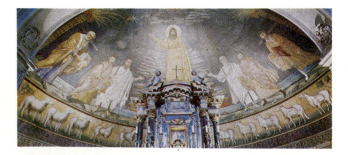

ROME, SS Cosmas and Damian. *Christ and the Apostles*. Apse mosaic

ROME, SS Cosmas and Damian

Occupying former imperial buildings, converted for use as a church in the early 6th century. Much rebuilt in the 17th century, it still contains mosaics in the apse (AD 526–30). More

naturalistic in style than the contemporary mosaics of S. Vitale, *Ravenna, the figures possess a solidity and power.

ROME, Sta Costanza (first half 4th century AD)

A circular mausoleum built by Constantine for his daughter Constantia. The barrel-vaults of the annular passage are decorated with a rich series of *vault mosaics divided into fifteen panels. Some panels are purely geometric in style, others contain rows of heads framed in medallions, and some have scenes of birds, fruit and Cupids gathering and pressing grapes. The subject-matter of the mosaics is entirely pagan.

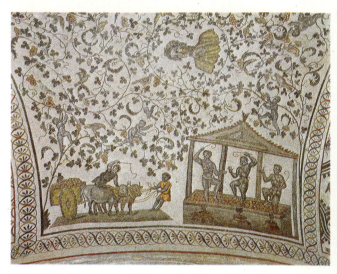

ROME, Sta Constanza. Vault mosaic with putti treading and gathering grapes

ROME, Sta Francesca Romana

Originally Sta Maria Nova, it was much rebuilt after the diaconate was moved there from the ruined Sta Maria Antiqua, *Rome in the late 9th century. In the sacristy is an intense cult icon of the Virgin (6th or 7th century) and the apse has 12th-century mosaics.

ROME, Sta Maria Antiqua

A Roman building in the Forum, converted for use as a church in the 6th century, the decoration consists of several superimposed layers of fresco, the most extensive of which belongs to the pontificate of John VII (705–7). Of very high quality, it represents an accomplished naturalistic style, perhaps executed by painters from Constantinople. The sequence of layers proves that medieval Roman art was far from being in a process of continuous decline.

ROME, Sta Maria Maggiore. *The Capture of Jericho.* Upper register of mosaic panel in the nave. Early 5th century

ROME, Sta Maria Maggiore

The present basilica was built in the 5th century but has under-

gone many subsequent restorations. It still contains much of its ambitious programme of mosaics (432–40) over the triumphal arch and on the nave walls, consisting of Old Testament scenes and a Virgin cycle in which the Virgin is interestingly portrayed as an empress. The chief problem for the mosaicists was to make the small panels visible from the ground – they tried to make realistic figures more conspicuous by setting them against an unreal carpet of gold.

ROME, St Peter's, Tomb of the Julii

A small tomb under the Basilica of St Peter's, Rome, built towards the end of the 2nd century by the pagan Julii family and redecorated in the 3rd or 4th centuries. On the ceiling surrounded by a luxuriant vine is represented a beardless, haloed male figure riding in a chariot – possibly to be identified as Christ as the Sun, since other more specifically Christian scenes were represented in the wall-mosaics.

ROMNEY, George (1734–1802)

b. Lancashire d. Kendal. English portraitist. Trained in the North, he settled in London (1762), studying in Italy (1773–5); his admiration of the *Antique made him aspire to the *Grand Manner for which he was ill-equipped. He is best known for his portraits of Emma Hamilton – probably his mistress for a while. Portraits such as *Lady Rodbard* (1768, Lever Gallery) demonstrate his elegant style.

ROOD-SCREEN

Screen placed across the east end of the nave, built to carry the rood, or crucifix. Often a gallery runs along the top of the screen. Usually made of wood, the screen can be intricately carved and painted.

ROOS, Jan (Giovanni ROSA) (1591–1638)

b. Antwerp d. Genoa. Prolific Flemish painter of landscapes, fruit and flowers, portraits and church interiors, whose speciality was animal painting. Pupil of Frans *Snyders, he was in Rome (1614–16), and thereafter worked in Genoa.

ROPS, Félicien Joseph Victor (1833–98)

b. Namur d. Essonnes, Seine-et-Oise. Belgian painter of genre subjects, figures and landscapes but best known as a print-maker. He studied in Namur and Brussels. After a short period in Paris he tried unsuccessfully to establish an engraving studio in Belgium. He finally settled in Paris (1874) but returned to Belgium for painting trips. Widely known for his prints and illustrations, the *Symbolist writers admired his sensual and demonic subjects, for example, *Les Diaboliques*, a series to a work by Aurevilly.

Left: ROME, Tomb of the Julii. Mosaic of Christ as Sun
Right: FELICIEN ROPS *Death at the Ball. c.* 1870. 59½×33½ in (151×85 cm). Kröller-Müller Museum

Below: GEORGE ROMNEY *Lady in a Brown Dress* (The Parson's Daughter). *c.* 1785. d. 25½ in (64·8 cm). Tate

ROSA, Giovanni *see* ROOS

ROSA, Salvator (1615–73)

b. Naples d. Rome. Neapolitan painter, poet and rebel against society, best known for his †Romantic battle-pieces, marines and landscapes. He himself considered these frivolous, aspiring to recognition as a figure-painter – the highest category in Academic theory. In Rome 1635–7, another stay was terminated by his satirical attack on *Bernini (1639). He worked in Florence (1640–9), the centre of a sophisticated literary circle. Contemporary Neapolitan interest in folklore and the Florentine taste for the bizarre led him to produce paintings of witches' sabbaths, partly inspired by *Bosch. Meanwhile, abandoning his naturalistic figure style for a classicising type, he adopted a Cynic philosophy based on the Greek critics of society,

Diogenes and Democritus. Returning to Rome (1649) as a philosophical and allegorical painter, he failed to develop an individual style, becoming eclectic in the 1660s. The 18th century admired his 'horrid' subjects.

SALVATOR ROSA *A River with Landscape with Apollo and the Sibyl*. Before 1661. 69×102¾ in (175×261 cm). Wallace

ROSALES MARTINEZ, Eduardo (1836–73)

b. d. Madrid. Spanish artist who studied in Madrid. He painted portraits, Arab subjects and themes from Spanish history, his chiaroscuro effects being influenced by earlier Spanish art. He was in Italy (late 1850s) and was subsequently elected Director of the Spanish Academy in Rome. He exhibited successfully in Paris.

ROSENBERG, Nicolaievich *see* BAKST, Léon

ROSETSU (Nagasawa Rosetsu) (1745–90)

Japanese painter, a rebel from the studio of *Okyo, whose realism he used as a basis for his eccentric and dashing personal style, which is one of great freedom.

ROSHU (Fukae Roshu) (1699–1755)

Japanese follower and possibly pupil of *Kōrin.

ROSICRUCIANS

A group of critics and artists round Sâr Peladan (1858–1918), notably *Huysmans, who constituted the Rose-Croix-Kabbalistique (1888). They held a series of Salons at *Durand-Ruel's (1892–7) 'to *ruin realism*, reform Latin taste and create a school of idealist art' (Sâr Peladan). Exhibitors included *Hodler, *Toorop, *Bourdelle and later *Bernard, *Denis, *Sérusier, *Vuillard and *Rouault.

ROSSANO CODEX

One of the earliest illustrated Byzantine Gospel manuscripts, probably dating from the 6th century. The text and illustrations appear on parchment sheets dyed purple. Bold and vigorous in execution, the illustrations are important early witnesses of iconography.

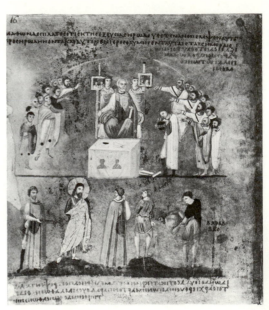

ROSSANO CODEX *Christ before Pilate*. 6th century. Purple parchment. 12×10½ in (30·7×26 cm). Cathedral Treasury, Rossano

ROSSELLI, Cosimo (1439–1507)

b. d. Florence. Italian painter, pupil of Neri di *Bicci and Benozzo *Gozzoli. Together with *Botticelli and *Ghirlandaio, he was commissioned (1481) to paint frescoes in the Sistine Chapel (*Last Supper*, *Sermon on the Mount*, *Moses Destroying the Tablets of the Law*). Influenced by Ghirlandaio, Cosimo's work has clarity but little life.

Left: ROSETSU *Bull and Puppy*. Six-fold screen. Ink on paper. Joe D. Price Coll, Oklahoma

Right: BERNARDO ROSSELLINO Tomb of Leonardo Bruni. 1444. Sta Croce, Florence

ROSSELLINO, Bernardo (1409–64) Antonio (1427–79)

Bernardo, b. Settignano d. Florence, was a sculptor and architect who collaborated with *Alberti. His sculptures were influenced by *Ghiberti and Luca della *Robbia and show a gentle restrained classicism, eg his *tabernacle (1449, S. Egidio, Florence). He executed the tomb of the learned Chancellor of Florence, Leonardo Bruni (1444, Sta Croce, Florence) whose design was the prototype for the humanist wall tomb. Antonio, b. d. Florence, was the younger brother of Bernardo, under whom he trained. Comparison of his early and late busts, *Chellini* (1456) and *Matteo Palmieri* (1478), demonstrates the range of his achievement and the †Renaissance admiration for Roman portraiture. His reliefs of the

Virgin and Child are akin to *Verrocchio's work; the tomb of the Cardinal of Portugal (1461, S. Miniato, Florence) echoes the theme evolved by Bernardo.

ROSSETTI, Dante Gabriel (1828–82)

b. London d. Birchington-on-Sea. English painter, a founder-member of the *Pre-Raphaelite Brotherhood in which he acted as a social catalyst and contributed to the High Church slant that caused public controversy. After the exhibition of *Ecce Ancilla Domini* (1850) he abandoned didactic Christian painting for the illustration by watercolour drawing of literary texts, eg Browning and Dante. His development towards decorative painting was assisted by the heraldic patterns of his Arthurian paintings (1856–8). Like many of his English contemporaries during the 1860s, he reduced narrative and historical elements in favour of decorative considerations, often applied to studies of female beauty. From the late 1860s until his death, he favoured a more reflective and less cadaverous female type which correspondingly allowed him more emphasis on sinuous linear rhythms that contributed to *Symbolist and *Art Nouveau painting. As a member of *Morris's decorative firm, he also designed stained glass, tiles and furniture.

Top: DANTE GABRIEL ROSSETTI *Borgia* (To Caper Nimbly). 1851. Watercolour. 9⅛×9¾ in (23·2×24·8 cm). Carlisle City Art Gallery
Above: DANTE GABRIEL ROSSETTI *Death of Lady Macbeth.* 1871. Pencil. 18¾×24½ in (47·6×62·2 cm). Carlisle City Art Gallery

ROSSI, Francesco *or* **Cecchino de'** *see* **SALVIATI**

ROSSO, Giovanni Battista (Rosso Fiorentino)
(1494–1540)

b. Florence d. Paris. Italian painter who worked in Florence, Rome and France. Influenced by Andrea del *Sarto and *Michelangelo, he was (together with his friend *Pontormo) one of the earliest *Mannerists. His first works show bold faceted sculptural forms and emotional intensity, eg *Deposition* (1521, Volterra). In Rome his classicism became more graceful. Shortly before his departure for France his paintings became strained and sinister, perhaps resulting from his morbid activities in graveyards and Satanic practices. At *Fontainebleau he introduced the Mannerist style to France.

Top: GIOVANNI BATTISTA ROSSO Detail from the Galerie François Iᵉʳ. *c.* 1533–40. Paint and stucco. Fontainebleau
Above left: MEDARDO ROSSO *Yvette Guilbert.* 1894. Bronze. Galleria Nazionale d'Arte Moderna, Rome
Above right: THEODORE ROSZAK *Sea Sentinel.* 1956. Steel brazed with bronze. h. 105 in (266·7 cm). Whitney Museum of American Art, New York

ROSSO, Medardo (1858–1928)

b. Turin d. Milan. First a painter, turned sculptor (1881). He modelled in wax the fleeting effects of light and materials in the spirit of †Impressionist painting. While in Paris (1884–5), where more esteemed than in Italy, he worked in *Dalou's studio and became acquainted with *Rodin, *Degas and the collector Rouard. He exhibited in most European centres.

ROSZAK, Theodore (1907–)

b. Poznan, Poland. Sculptor who went to Chicago (1909); studied in New York and Chicago; lived in Europe (1929–31); taught at Chicago Art Institute and *Moholy-Nagy's Design Laboratory (1938). Roszak abandoned painting and his cool *Bauhaus constructions to become the foremost *Abstract Expressionist sculptor, flaying metal into tortured, brutal images.

ROT, Dieter (1930–)

b. Hanover. Based in Reykjavik, he works throughout Europe as painter, graphic designer, film-maker, typographer, poet, etc. In the *Schwitters tradition, his fusions of the visual and verbal are fundamentally plastic rather than semantic. Has collaborated with *Hamilton.

ROTHENSTEIN, Michael (1908–)

b. London. English painter, relief-maker, lithographer and designer. After studying at Chelsea Polytechnic and Central School, London, he has specialised in graphic work, founding his own workshop (1954), and has done some decorative work.

ROTHENSTEIN, Sir William (1874–1945)

b. Horton d. Far Oakridge. English painter who studied at the Slade School of Art under *Legros (1888) followed by four years in Paris. Rothenstein was an innovator in art education and Principal of the Royal College of Art (1920–5). He also wrote extensively and painted portraits.

ROTHKO, Mark (1903–70)

b. Dvinsk, Russia d. New York. Painter who went to America (1913); studied at Yale University and with *Weber at *Art Students' League. Rothko's paintings evolved from figurative *Expressionism through *Surrealism to *Abstract Expressionism. His characteristically large canvases are composed of a few blurred rectangles, making their impact through resonant colour sonorities.

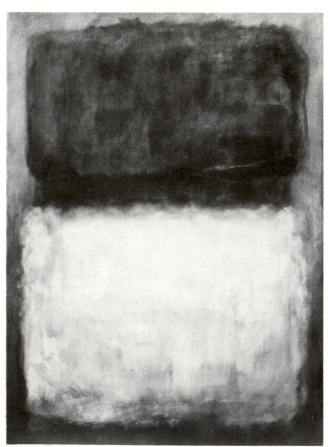

MARK ROTHKO *Green on Blue*. 1956. 89$\frac{7}{8}$×63$\frac{1}{2}$ in (228·3×161·3 cm). University of Arizona Museum of Art, Gallagher Memorial Coll

ROTTENHAMMER, Hans (1564–1625)

b. Munich d. Augsburg. German painter who collaborated in Rome (1590–6) with Jan *Bruegel; in Venice he was, like other northerners, strongly influenced by *Tintoretto. Settling in Augsburg (1606) he executed small-scale work and decorated the emperor's Munich residence.

ROTTMAYR, Johann Michael (1654–1730)

b. Laufen, Salzburg d. Vienna. Austrian *Baroque painter who succeeded in competing with the popular Italian ceiling decorators. In Venice (1675–88). His work, influenced by *Correggio and *Rubens, survives all over what was then Austria, eg at Melk, Wroclau and the Karlskirche (Vienna).

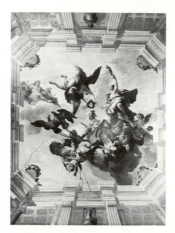

Left: JOHANN ROTTMAYR *Apotheosis of Helden.* Second Library, Liechtenstein Palace

Below: GEORGES ROUAULT *Girl.* 1906. Watercolour and pastel. 28×21$\frac{3}{4}$ in (71×55 cm). Musée d'Art Moderne de la Ville de Paris

ROUAULT, Georges (1871–1958)

b. d. Paris. French painter and printmaker who was apprenticed as a stained-glass designer (1885–90). He then studied under Gustave *Moreau, with *Matisse as a fellow pupil. Rouault's broad, rough technique classed him with the *Fauves, though the deeply moral intentions behind his paintings of clowns and prostitutes were alien to them. He exhibited in the famous Salon d'Automne of 1905, though his

work was not exhibited in the Fauvist collection. He turned to printmaking and illustration (1916–27) with the encouragement of his dealer, Vollard. He developed the almost relief-like use of layered impasto which is so characteristic of his major work (from 1927). His subject-matter became almost exclusively religious. At best his work has a density and luminosity often compared with medieval stained-glass. Emphatically inscribed forms throb with livid greens and yellows out of the surrounding blacks and reds.

Above: GEORGES ROUAULT *Christ mocked by soldiers.* c. 1932. 36¼×28⅜ in (92×72 cm). MOMA, New York
Left: LOUIS-FRANCOIS ROUBILIAC *Handel.* 1738. Marble. V & A, London

Top right: HENRI ROUSSEAU *Flowers.* 1910. 24×19½ in (61×49·5 cm). Tate
Right: HENRI ROUSSEAU *The Snake Charmer.* 1907. 65¾×74⅜ in (167×189 cm). Louvre

ROUBILIAC, Louis-François (?1705–62)

b. Lyon d. London. French sculptor who studied under Coustou and settled in England (before 1735). Shortly after his arrival he secured numerous commissions on account of the popularity of his statue of Handel (1737, V & A, London). His many portrait busts are notable for their informality and vivacity of expression. He also introduced drama to previously static tomb sculpture. In contrast to the sculpture of his contemporary *Rysbrack, his work is highly finished with close attention to detail.

ROUSSEAU, Henri Julien Félix (1844–1910)

b. Laval d. Paris. French painter who took up full-time painting when he retired from the French Civil Service (1893), although he had exhibited at the Salon des Indépendants (from 1886). He had had no formal training but had received advice from *Gérôme and Clément. His pictorial range was large, still-lifes, individual and group portraits, as well as subject pictures. As a landscapist he was one of the first to show industry impinging on the urban and rural environment, in the shape of factory chimneys and aeroplanes. His ambitions as a †Realist extended equally to the still-life, which he attempted to render exactly, even to the extent of taking accurate measurements. He is particularly associated with pictures of jungles, visions of exotic trees and flowers, men and beasts, rendered with a stylisation that hints at a knowledge of Japanese art and Indian painting. Towards the end of his life, he was taken up by the avant-garde through the agency of Alfred Jarry, and his work came to influence that of *Picasso, *Derain, *Vlaminck and *Delaunay.

THEODORE ROUSSEAU *Sortie de fôret de Fontainebleau: Soleil couchant.* 55½×77⅝ in (141×197 cm). Louvre

ROUSSEAU, Pierre Etienne Théodore (1812–67)

b. Paris d. Barbizon. French landscape painter and the leading member of the *Barbizon School. A cousin gave him his first art instruction, and his further study under Lethière was of little value to him as he early on adopted direct painting from nature. Studies made in the Auvergne mountains (1830) were praised by Ary *Scheffer, and he first exhibited in 1831. He became the most controversial exponent of landscape, comparable with *Delacroix as a figure-painter. He travelled widely in France seeking wild, remote sites in the Jura, the Auvergne and Fontainebleau regions (1830s). He worked in the Berry and Bordeaux areas (1840s), and exhibited again after a long gap (1849). He won widespread acclaim only during the next decade when he had settled, after repeated trips, at Barbizon working with *Millet, *Diaz, *Dupré, etc. He favoured dramatic lighting effects, especially sunsets, and an atmosphere of solitude and isolation.

ROUSSEL, Ker-Xavier (1867–1944)

b. Lorry-les-Metz d. L'Estang-la-Ville. At the Lycée Condorcet he met *Vuillard and *Denis and studied with them and *Bonnard at the Ecole des Beaux-Arts. Together they formed the *Nabis and Roussel exhibited with them and contributed important lithographs to *La Revue Blanche*. He painted mythological scenes (c. 1900), and, like Vuillard, large-scale decorative works, some of them for the theatre.

THOMAS ROWLANDSON *Entrance to the Spring Gardens.* 13¼×18⁹⁄₁₆ in (33·7×47 cm). V & A, London

ROWLANDSON, Thomas (1756–1827)

b. d. London. English comic draughtsman who studied briefly in Paris and at the Royal Academy. His first works are *history paintings and portraits but he soon turned to caricatures and illustrations for printed books. He comments on the whole of society around him with broad burlesque humour but highly accurate and witty. His masterful use of line and wash is appropriately exuberant.

ROYAL ACADEMY

Academies for purposes of instruction in art had existed in England from 1711 (that founded by *Kneller), but it was only in 1768 that the Royal Academy was founded, with George III's approval. Joshua *Reynolds became the first President, and delivered an important series of *Discourses* on painting. The Academy enhanced the status of 18th-century artists, and supported those in need; the annual exhibitions brought financial independence and freedom from government control or interference. At first a progressive institution, it was by far the most important artists' society in Britain until the late 19th century; thereafter it became increasingly reactionary, as much through weakness as through aesthetic exclusivity. It still exists, at Burlington House, Piccadilly.

ROYMERSWAELE, Marinus Claesz van *see* MARINUS VAN REYMERSWAELE

RUBBING *see* FROTTAGE

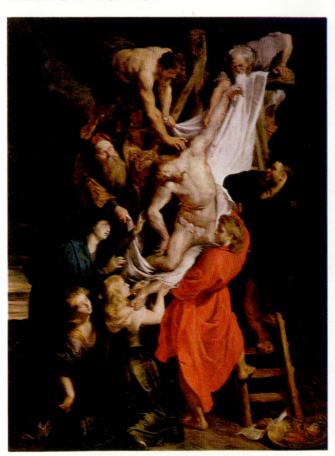

PETER PAUL RUBENS *Descent from the Cross.* 1611–14. 166×121 in (420×306 cm). Antwerp Cathedral

RUBENS, Sir Peter Paul (1577–1640)

b. Siegen, Westphalia d. Antwerp. Flemish painter, the son of a Calvinist exiled in Cologne, although he himself was a life-long Catholic, and the greatest master of the North European †Baroque. He went to Antwerp (1587). He trained under van *Veen and entered the Antwerp Guild (1598). His early paintings are in a typical Flemish *Mannerist style. He was in

Italy (1600–8), where he worked as Court Painter to the Duke of Mantua but contrived to visit every major city in the peninsula as far south as Rome. Although he painted outstanding portraits during his Italian period, he was anxious to rival the Italians in *history painting. He painted the principal altar of the Chiesa Nuova in Rome (1606). He completed *The Raising of the Cross* for Antwerp Cathedral in a vigorous †Baroque style, new to Flanders (1610). He had a large studio of assistants capable of enlarging his designs as well as specialist collaborators like *Snyders. This system enabled him to become the most prolific and versatile painter of his age. His linguistic skill made him an invaluable diplomat and during the 1620s he was occupied with negotiations in France, Spain and England. His paintings often have a political purpose, such as the *Marie de' Medici* cycle painted in Paris (1622–5), which shows his mastery of allegory. In his last years he devoted himself to more personal work, notably landscape and intimate portraits of his wife.

Top: PETER PAUL RUBENS *Château de Steen. c.* 1635. 54×92½ in (137×234 cm). NG, London
Above left: PETER PAUL RUBENS *Hélène Fourment with her children. c.* 1636. 44½×32¼ in (113×81·9 cm). Louvre
Above right: ANDREI RUBLEV Apostles from the *Last Judgement.* Fresco. 1408. Church of the Dormition, Vladimir

RUBLEV, Andrei (*c.* 1370–*c.* 1430)

Probably trained in Moscow in the 1390s by *Theophanes the Greek, whose late style he continues in frescoes at Zvenigorod (*c.* 1400), he began to develop his own personality in the *Last Judgement* frescoes in the Dormition Cathedral at Vladimir (completed 1408). He excelled at huge icons for the new Russian kind of high sanctuary screen, eg *Christ, St Paul, St Michael* (*c.* 1404, now Tretiakov Gallery). His masterpiece in this medium is the *Trinity* (also Tretiakov Gallery), painted for the Trinity Monastery at Zagorsk (1411 or 1422). He paints serene figures in cool, light tones in classically composed settings. He was a monk.

RUDE, François (1784–1855)

b. Dijon d. Paris. French sculptor who received a good academic training under Desvoge in Lyon and Cartellier in Paris, where he came (1807) with recommendations and a figure of Theseus (1806) as introductions to Vivant-Denon. He won the Rome Prize (1812), but did not have the usual stay in Italy. A supporter of Napoleon, he fled to Brussels (1814), and did not return to France until 1827. The work he is most famous for is the relief glorifying the Revolution, *The Departure of the Volunteers in 1792* (1835–6), which, because of its compelling impetus, came to be called *Marseillaise.* Another of his chief works is *The Awakening of Napoleon* (1845–7), a vision of Napoleon's immortality.

FRANCOIS RUDE *Departure of Volunteers.* 1836. Stone. h. 502 in (1280 cm). Arc de Triomphe de l'Etoile, Paris

RUELAS, Juan de (1558/60–1625)

b. Seville d. Olivares. Spanish painter of Flemish origin. He entered the priesthood in 1598, serving at Olivares (1603–6, 1621–5) and Seville (1606–20). An important figure in the introduction of Italian †Baroque art to Spain, he possibly visited Venice. Certainly his *Death of St Isidro* (1613/16) shows a reliance on the work of *Tintoretto and *Palma Vecchio in the treatment of anatomy and use of colour.

JACOB VAN RUISDAEL *The Windmill at Wijk Bij Duurstede. c.* 1670. 32¾×39¾ in (83×101 cm). Rijksmuseum

RUISDAEL, Jacob van (1628/9–1682)

b. d. Haarlem. The most powerful Dutch landscapist, Ruisdael introduced drama, colour and form into a tradition which had largely sacrificed these qualities to atmospheric purity. He began in Haarlem, then, after travelling to the German border territories, settled in Amsterdam (*c.* 1656). His early work recalls Cornelisz *Vroom or his uncle Salomon van *Ruysdael,

and his many waterfalls were probably inspired by Allart van *Everdingen or by his own travels. Throughout life Ruisdael stressed the fecundity of the countryside and the state of the weather, particularly bursts of sunlight in an overcast landscape. He portrayed the majesty of nature and his drawings and etchings reveal a very personal approach to naturalistic detail. His most famous works are *The Jewish Cemetery* (c. 1660, versions at Dresden and Detroit) and *Windmill at Wijk* (c. 1670, Rijksmuseum).

JACOB VAN RUISDAEL *Extensive Landscape with a Ruined Castle and a Village Church*. Late 1660s. 43×57½ in (109×146 cm). NG, London

RUNCIMAN, Alexander (1736–85)
John (1744–68)
Scots painters, brothers, early †Romantics. John, b. Edinburgh d. Naples, showed promise which was unfulfilled owing to his premature death. Alexander, b. d. Edinburgh, in Rome (1767–71), associated with *Barry and *Fuseli, decorated, Penicuik House near Edinburgh with scenes from Ossian (burnt 1900).

RUNGE, Philipp Otto (1777–1810)
b. Wolgast d. Hamburg. German painter. Trained in Copenhagen (1799–1801); active in Dresden as a leading †Romantic artist, he also worked on colour theory, which interested *Goethe. His ideas were reflected in a series of paintings entitled *The Times of Day*, the visionary quality of which represents a parallel with *Blake.

RUSCONI, Camillo (1658–1728)
b. Milan d. Rome. Italian sculptor, pupil of *Ferrata; his restrained manner recalls *Algardi, especially his tomb of Gregory XIII (begun 1719, St Peter's) and his *Four Apostles* for Borromini's tabernacle in St John Lateran (1706–18).

RUSH, William (1756–1833)
b. d. Philadelphia. Sculptor who was apprenticed to Cutbush (c. 1771); made figureheads for ships. An outstanding woodcarver, Rush combined the †Neo-classical allegorical vocabulary with native naturalism in figureheads, portraits and ideal sculptures. His use of nude models created scandal, but helped teach him to carve full-bodied forms with surging vitality and animated grace.

RUSINOL-Y-PRATS, Santiago (1861–1931)
b. Barcelona d. Aranjuez. Spanish painter trained in Barcelona, but he went to Paris (1887) where he studied under Gervex, *Carrière and *Puvis de Chavannes. His landscapes of the Catalan region show a quality of light and a handling of paint derived from the †Impressionists.

RUSKIN, John (1819–1900)
b. London d. Brantwood. A major influence on artistic taste in England and America after 1850 through his numerous published works, including *Modern Painters* (1843–60), *The Seven Lamps of Architecture* (1849), and *The Stones of Venice* (1851–3). These he illustrated from his own drawings and watercolours. He was influenced by Samuel Prout in his architectural style and by *Turner in his landscape vignettes and watercolours, in which he achieved considerable breadth and aerial effects. In his books he sought, through art, to find solutions for social problems. He became Slade Professor of Fine Art at Oxford University (1869).

Above: JOHN RUSKIN *The North-West Angle of the Façade of St Marks, Venice.* Watercolour. 37×24 in (94×61 cm). Tate

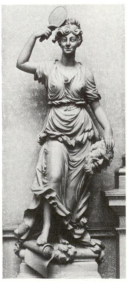

Left: WILLIAM RUSH *Comedy.* 1808. Pine. h. 114 in (289·6 cm). The Edwin Forrest Home, Philadelphia

RUSSELL, Charles Marion (1865–1926)

b. St Louis, Missouri d. Great Falls, Montana. Self-taught painter, sculptor and writer who settled in Montana (1880). His fame as a story-teller finds its visual equivalent in his vividly realistic paintings of Western life as he lived it; later, he turned to †Impressionism to evoke the Western landscape.

RUSSELL, John (1745–1806)

b. Guildford d. Hull. Fashionable English pastel portraitist who temporarily commanded prices as high as *Reynolds. He was an ardent Methodist who preached to his sitters. Appointed Prince of Wales's Crayon Painter (1785) and elected RA (1788). His popularity waned, save in Yorkshire.

RUSSELL, Morgan (1886–1953)

b. New York d. Broomall, Pennsylvania. Painter who studied with *Henri and *Matisse; went to Paris (1906); founded Synchromist movement with *MacDonald-Wright (1912); exhibited at *Armory Show (1913); lived in France (until 1946). Although he returned to representational painting (c. 1916), Russell is known for his 'synchromies', pure colour abstractions of geometric volumes.

RUSSOLO, Luigi (1885–1947)

b. Portogruaro d. Cerro di Laveno. Mainly self-taught Italian painter and musician, who became deeply involved in the *Futurist movement after meeting *Boccioni and *Carrà (1909), though his use of Futurist 'force-lines' is crude and limited. He applied Futurist ideas to music in his manifesto *The Art of Noises* (1913).

LUIGI RUSSOLO *Music*. 1911. 86⅝×55⅛ in (220×140 cm). Mr and Mrs Eric Estorick Coll, London

RUSTICI, Giovanni Francesco (1474–1554)

b. Florence d. Tours. Italian sculptor, perhaps trained in *Verrocchio's workshop. A dilettante artist, he worked in bronze and terracotta. His principal surviving work is the *St John the Baptist* bronze group (1506–11, Baptistery, Florence), much influenced by *Leonardo with whom he was then living.

RUTHWELL CROSS (c. 700)

This large stone cross in Dumfriesshire, Scotland, is of the Northumbrian School. The figures and inhabited scrolls show the same partial revival of classical standards that can be seen in the writing of Bede or in the Codex *Amiatinus, also products of the Northumbrian renaissance. The figures are simple and bold, as can be seen in the relief of Christ and Mary Magdalene. *See also* BEWCASTLE CROSS

RUYSCH, Rachel (1664–1750)

b. d. Amsterdam. Dutch woman painter of flowers and still-life, enjoying great popularity. Stylistically her work corresponds to †Rococo art when compared with earlier 17th-century flower painters; irregular grouping of bunches replace symmetrical composition, and the colours are much brighter.

RUYSDAEL, Salomon van (?1600/3–1670)

b. Naarden d. Haarlem. Dutch landscape painter, the uncle of Jacob van *Ruisdael. Like Jan van *Goyen he specialised in dune-land, river and estuary scenes, concentrating on tonal effects and evoking a lyrical, misty atmosphere. The more monumental pictures of his last years reflect the influence of his nephew. He also painted a few still-lifes.

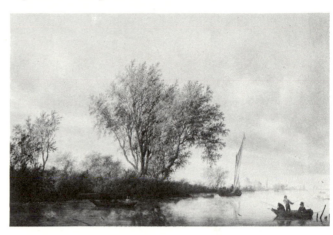

SALOMON VAN RUYSDAEL *River Landscape*. 1632. 25¼×36⅞ in (64×92·5 cm). Kunsthalle, Hamburg

RYCKAERT, David (1612–61)

b. d. Antwerp. Flemish painter of genre scenes. His early work, influenced by *Brouwer, represents peasant life, set in barn-like interiors. He developed more individual characterisation (c. 1640), and, doubtless with an eye on similar work by *Jordaens, later painted predominantly bourgeois festivities.

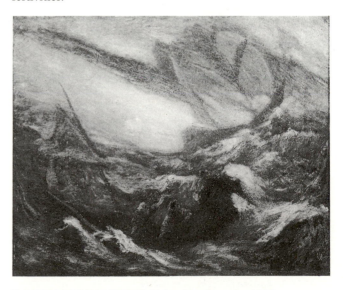

ALBERT PINKHAM RYDER *Flying Dutchman*. c. 1887. 13¾×16½ in (34·9×41·9 cm). Smithsonian Institution, Washington

RYDER, Albert Pinkham (1847–1917)

b. New Bedford, Massachusetts d. Elmhurst, Long Island. Painter who settled in New York (c. 1870); studied at National Academy of Design and with W. E. Marshall; visited London (1877) and Europe (1882); sailed Atlantic (1887, 1896). From naturalistic landscapes, Ryder turned inwards to mystical subjects. His imagination transformed Shakespeare, Chaucer,

the Bible, mythology, and the haunting sea into wholly personal, original poetry. With sensuously painted sombre colours permeated by unearthly light, Ryder shaped nature's essential forms and rhythms in a few superbly designed powerful masses. Deeply religious, dwelling in dreams, Ryder penetrated the reality of dream and spirit to become the greatest American visionary artist of his age.

RYSBRACK, Michael (1694–1770)

b. Antwerp d. London. Leading sculptor in England (1720–40), notable for busts, including *Sir Robert Walpole* and *Alexander Pope*, his monument to Sir Isaac Newton (1731, Westminster Abbey) and portrait busts in the classical manner. The Flemish †Baroque-classicist, *Duquesnoy, had the greatest influence on his art, and his style has a Roman gravity paralleling English *Palladian architecture. His statue of John Locke (1755, Christ Church, Oxford) is particularly fine.

RYSSELBERGHE, Théo van (1862–1926)

b. Ghent d. Saint-Clair, France. The principal Belgian Neo-Impressionist. He studied in Ghent and Brussels and was a founder of *Les Vingt (1884, from 1894 La Libre Esthétique), helping to introduce avant-garde French and English art to Belgium. He met *Seurat and *Signac (1886) and soon adopted a *Pointillist technique which he alone systematically applied to portraiture. He also painted landscapes and, during the 1890s, produced posters, book illustrations and applied art designs. After 1900 his touch broadened, contributing to the development of a *Fauvist style.

THEO VAN RYSSELBERGHE
Madame Charles Mans.
1890. Musées Royaux,
Brussels

S

SABOGAL, José (1888–1956)

b. Cajabamba d. Lima. Painter who studied in Europe (1909–12) and Buenos Aires (1912–18); was teacher (1920–33) and Director (1933–43) of School of Fine Arts, Lima; visited Mexico (1922). Influenced by Mexican artistic nationalism, he strove to create a similar indigenous movement in Peru, through his teaching and paintings of native subjects.

SACCHI, Andrea (1599–1661)

b. Nettuno d. Rome. Trained by *Albani in the *Raphaelesque and Bolognese traditions, Sacchi is the leading Italian exponent of the classical tradition of painting in 17th-century Rome. In St Luke's Academy he verbally challenged the †Baroque methods of Pietro da *Cortona, and his ceiling in the Palazzo Barberini (*Divine Wisdom*, 1629–33) contrasts strongly with Pietro's ceiling in the same building. Yet Sacchi produced some very freely painted portraits in a personal manner that were admired by *Bernini. *The Vision of St Romuald* (*c.* 1631, Vatican) is among his best altarpieces.

SACCHI, Giovanni Antonio *see* PORDENONE

SACCHI, Piero Francesco (1485–1528)

b. Pavia d. Genoa. Italian painter, who, according to *Lomazzo, worked in the Milan of Francesco Sforza. Considered the foremost Genoese painter of his time, he executed large altarpieces (eg *Crucifixion*, 1514, Berlin) influenced by *Leonardo and Giulio *Romano, which also display a Northern angularity and concern for landscape detail.

Above: PIERO FRANCESCO
SACCHI *Crucifixion.* 1514.
$72\frac{1}{8} \times 59\frac{1}{8}$ in (183×150 cm).
Gemäldegalerie, Berlin

Left: ANDREA SACCHI
The Vision of St Romuald.
c. 1638. 122×69 in
(310×175 cm). Vatican

SACH'ONWANG-SA TEMPLE

The Korean temple of Sach'onwang-sa, near Kyong-ju was founded during the early Silla period (AD 674). It was one of the largest Buddhist temples, though little remains of it now. Terracotta reliefs from the site show how Korean sculptors adopted Chinese Buddhist formulae while giving the figures a characteristic Korean liveliness.

SACRA CONVERSAZIONE

Italian: 'holy conversation'. The name given to an altarpiece in which the Virgin and Child are shown together with a group of saints in a unified setting. This was a mid-15th-century development which ultimately superseded the multipartite polyptych in which each saint was painted on a separate panel. An early example of the sacra conversazione is Domenico *Veneziano's *St Lucy Altarpiece* (Uffizi).

SADIQI BEG (?1540s–c. 1616)

Painter of Turkish origin who worked at the Persian court in *Isfahan. He studied under the artist Muzaffar Ali (d. 1576) and was appointed Director of the Royal Library by Shah Abbas. As with other artists of the age, he used the thickness of the pen to convey depth in his ink portrait drawings, emphasising the pupil of the eye, and the tapering fingers of his sitters.

Left: SADIQI BEG *Seated Man.* $6\frac{3}{4} \times 4\frac{1}{8}$ in (17·2×10·5 cm). Museum of Fine Arts, Boston

Near right: SAHARA Rock painting, one of several thousand at Tassili, southern Algeria
Far right: SAFAVID PAINTING Scene of rustic life signed by Muhammadi 1578. $10\frac{1}{4} \times 6\frac{1}{4}$ in (26×16 cm). Louvre
Below: PIETER SAENREDAM *The Interior of the Buurkerk at Utrecht.* 1644. $25\frac{5}{8} \times 19\frac{3}{4}$ in (60·1×50·1 cm). NG, London

SAENREDAM, Pieter (1597–1665)

b. Assendelft d. Haarlem. Dutch painter of architectural views. He studied in Haarlem under Frans de Grebber and was acquainted with the architect Jacob van Campen. Contact with the latter perhaps determined his choice of subject-matter. He broke with the fanciful tradition and specialised in faithful representations of specific buildings; hence his title, the 'first portraitist of architecture'. He had a subtle feeling for atmosphere and his paintings are a delicate honey colour.

SAFAVID PAINTING (16th–early 18th century)

With the unification of Iran under the Safavid rulers the provincial schools tended to die out. The metropolitan court style developed from the *Herat School, moving with the court from *Tabriz to *Qazvin then *Shiraz and *Isfahan. From *Bihzad and his pupils, the compositions were expanded with large-scale scenes of courtly elegance, considered the zenith of Persian painting though perhaps with a loss of vitality so marked in the Timurid works. The style then moved from book-illustration to genre scenes and, more particularly, album drawings with graceful youthful figures, old age being almost caricatured as in the works of Muhammadi of Herat in the 1570s. From this developed the languid, erotic Isfahan court style.

SAFTLEVEN, Herman (1609–85)

b. Rotterdam d. Utrecht. Dutch landscapist and etcher. Pupil of his father, and brother Cornelis. Travelled in northern Germany; he made topographical drawings, and paintings, at first forest scenes related to van *Goyen, then panoramic views.

SAHARA

More than thirty thousand examples of rock paintings and engravings have been discovered in the mountainous regions of the Sahara. More than half are in Tassili N'ajjer; other regions include Hoggar, Tibesti, the Fezzan, etc. A sequence of four periods can be recognised in the engravings. (i) The Bubalus Period characterised by *Bubalus antiquus* (a now extinct species of buffalo), elephant, rhinoceros, hippopotamus and other wild animals no longer found in the Sahara. This period reflects a hunting and gathering economy. (ii) The Cattle Period; *Bubalus* disappears though other wild animals continue and cattle begin to appear. (iii) The Horse Period; chariots and equestrian figures as well as sheep and dogs appear, cattle become rarer and wild animals disappear. (iv) The Camel Period, the latest and current phase (Tuareg tribesmen still engrave aeroplanes and other wonders of the 20th century) in which camels and the animals now found in the Sahara appear. The paintings follow a more complex but fundamentally similar sequence. The camel may have been introduced into the Sahara about 700 BC and was certainly known by Roman

times. The earliest date for human occupation of the Sahara is 5450 BC though there is no evidence that the art is that old. The desiccation of the Sahara is, of course, a relatively recent phenomenon. Apart from changing subject-matter reflecting changes in the population, there is also development in style away from earlier naturalism towards schematisation or simplification of form. This contrasts with *Bushman rock art which clearly develops towards greater naturalism, and which does not reflect any change in population (until the arrival of Europeans and Bantu).

SAIDAIJI, The

A Buddhist temple in Nara Prefecture, Japan. Among sculptures of the late *Heian period the four Buddhas of the Saidaiji show an unusually fresh interpretation of the traditional formula. The temple also includes an important *Kamakura image of Shaka Nyorai.

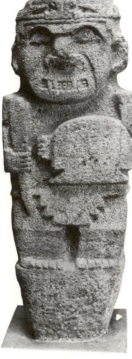

Left: SADAIJI Shaka Nyorai. Heian period, early 9th century AD. Wood. h. (of figure) 29⅝ in (75 cm)
Right: SAN AUGUSTIN Carved stone figure of a fanged warrior. Colombia. h. 47½ in (1·20 m). BM, London

ST ALBANS PSALTER *see* ALBANI PSALTER

SAN AGUSTIN

A highland site in Colombia, possibly originating about 500 BC, remarkable for a number of distinctive stone statues found in and around the temple structures. They consist of squat male figures bearing weapons and often with snarling fangs, and grotesque animals and birds.

ST CECILIA MASTER (active early 14th century)

Italian painter, active in Assisi, Florence and ?Rome, named after an altarpiece showing St Cecilia surrounded by eight scenes from her life. Stylistic comparison suggests that he also painted four scenes of the *St Francis* cycle in the Upper Church of S. Francesco, *Assisi. Both works show a pioneering interest in accurate architectural settings and classical details, combined with a use of rather shapeless figures, with carefully characterised faces.

ST CHAD GOSPELS *see* LICHFIELD GOSPELS

SANTA CRUZ ISLANDS *see* SOLOMON ISLANDS

ST DENIS ABBEY

A very rich artistic ensemble which suffered greatly during the French Revolution because of real and imaginary ties with the French monarchy. Its moment of glory was at its partial rebuilding (c. 1140) under Abbot Suger, who wrote an account of his role as patron and artistic impresario summoning artists from several countries who worked in many media. Influential innovations were achieved in the three-portal façade with column figures flanking the doors and in the stained glass with elaborate symbolism. St Denis and *Chartres represent the sudden awakening of both the art of the Ile-de-France and the Capetian monarchy. The monarchy from the time of St Louis (middle of 13th century) was also responsible for an interesting series of sculptured tombs in the Abbey. *See also* BEAUNEVEU, André

SAINT-GAUDENS, Augustus (1848–1907)

b. Dublin d. Cornish, New Hampshire. Sculptor who studied in New York (1861–7) and Paris (1867–9); worked in Italy (c. 1869–72), New York (c. 1873–98); taught at *Art Students' League (c. 1889–98). Influenced by the Florentine †Renaissance and contemporary French modelling, Saint-Gaudens brought a penetrating naturalism, monumental formal sense and personal iconography to imposing figures.

Left: AUGUSTUS SAINT-GAUDENS *Admiral David Farragut.* 1881. Art Commission of the City of New York

Below: ST GILLES DU GARD Detail from the porch of a centaur hunting a stag. c. 1160–70

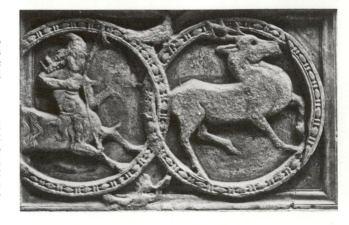

ST GILLES-DU-GARD, Provence

This 12th-century abbey was the result of one of the most successful attempts to promote a pilgrimage in the Middle Ages. The façade has three portals, organised on the model of the *scaena frons* of a Roman theatre. Local classical remains may have provided the inspiration for its sculptural decoration, but St Gilles is not typical of †Romanesque Provence, and like St Trophîme at *Arles, it may have owed its overt classicism to Tuscany. The date has been much disputed. There is a document of 1116, but most contemporary opinion is disposed to set this aside in favour of *c.* 1160–70.

ST LOUIS PSALTER (1254–70)

St Louis probably commissioned this manuscript after his return from the Crusades (1254). A picture-book containing many Old Testament scenes prefaces the text. Here a truly †Gothic style of illumination is introduced. Elaborate decorative borders and architectural framing reduce the picture field so that the style approaches miniaturist text decoration. Figures are elongated and sway gracefully. Glass-painting may have influenced the delicate pen drawing on the pale faces and the flat areas of blue and red. Attention to details of setting and gesture give some realism to the narrative.

SANTA MARIA

Argentine pottery style (*c.* AD 1000–1450), noted for funerary urns painted with distinctive geometric designs in black on yellow, and modelled with stylised faces in low relief.

SAINT-PHALLE, Niki de (1930–)

b. Neuilly-sur-Seine, France. Painter and sculptor who has moved between America and Europe, often exhibiting with Jean *Tinguely. Maker of 'Nanas' (enormous women), bathing belles and animals out of painted polyester. Her other cheerful ephemera include the recumbent giantess (1967, Moderna Museet, Stockholm). An entertainer.

ST SAVIN-SUR-GARTEMPE, Abbey Church

This †Romanesque church contains a rich series of paintings dating from about 1100 of the western French School. Lighter in colour and more naïve than *Berzé-la-Ville the best paintings are the *Apocalypse* in the narthex and the Old Testament scenes in the vault of the nave including lively representations of the Deluge and the Tower of Babel.

SALIMBENI, Ventura (1567/8–1613)

b. d. Siena. Italian painter and engraver. His youthful work as a decorator in Rome changed when he encountered the work of *Barocci. He was employed in Siena, Perugia, Pisa, Lucca and Genoa. His broad technique as an etcher influenced Northern engravers of the early 17th century, such as *Callot.

SALINCORNO *see* CAVALORI

SALJUQ SCHOOL *see* WARQA WA GULSHAH MANUSCRIPT

SALON

The French equivalent and precursor of the *Royal Academy exhibitions. It derived its name from the Salon d'Apollon in the Louvre where the 17th-century exhibitions of the Academy were held. It became a biennial feature in 1737 and annual after the Revolution, when it was opened to non-Academicians. In the 19th century the admissions system was so exclusive that the Salon des Refusés (1863) arose as a short-lived alternative.

SALMON, Robert W. (*c.* 1775–1842)

b. ?England d. ?Boston. Painter who worked in Liverpool (1806–12), Scotland (1812–21) and emigrated to Boston (*c.* 1828–41). A gifted marine painter, Salmon gave poetry and energy to his harbour and naval scenes with lucid draughtsmanship, formal clarity and sensitive rendering of light and atmosphere.

SALVI, Giovanni Battista *see* SASSOFERRATO, IL

SALVIATI (Francesco *or* Cecchino de' ROSSI) (1510–63)

b. Florence d. Rome. Italian *Mannerist painter, pupil of Andrea del *Sarto, he adopted the name of his patron, Cardinal Salviati. He worked mainly in Rome and Florence where he painted the *Camillus* cycle in the Palazzo Vecchio (1544–8). He was active at the French court (1554). His style echoes *Parmigianino's elegance.

SAMA-BHANGA

Sanskrit: literally 'even flexion'; in Indian sculpture a posture in which body and legs are held straight 'to attention'; the arms may be extended.

SAMANID PAINTING (874–999)

The Central Asian Samanids created flourishing cultured centres in their cities of Nishapur (Khurassan) and Afrasiyab (Samarkand). Hardly any of their painting survives, except for a few fragments of wall-painting found in eastern Persia at Nishapur. As might be expected a strong *Sassanian element appears in Samanid work, represented by a falconer riding a galloping horse, a typical Sassanian motif. However, Turkish elements appear in the fragments, reflecting the growing importance of Turks in Islam during this period. The Turkish element appears in certain technical details of riding equipment. Literary evidence exists of an interest among the Samanids in Chinese painting, but an evaluation of the significance of a Chinese influence is hard to make when so little of Samanid painting survives.

SAMARRA

This culture represents the earliest known settled communities in central Mesopotamia. They were notable craftsmen in alabaster, and many human figurines and vessels have been found at Tell al Sawwan on the Tigris. Terracotta female heads from Choga Mami, seventy miles east of Baghdad, show great delicacy of modelling, and their formalised features anticipate south Mesopotamian styles of a thousand years later. Pottery was handmade and decorated by professional potters with elaborate geometric patterns and sometimes animal motifs. A panel from a large bowl shows a group of ibexes and centipedes. The variations in size probably reflect a desire to fill the space rather than an attempt at perspective.

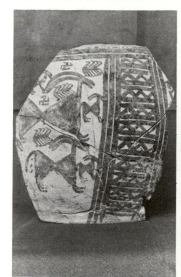 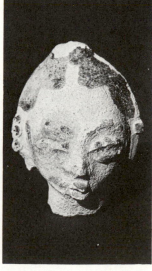

Left: SAMARRA Panel from a bowl showing ibexes and centipedes. Institute of Archaeology, London
Right: SAMARRA Terracotta head from Choga Mami. Institute of Archaeology, London

SAMOAN ISLANDS *see* TONGAN ISLANDS

SANCHEZ COELLO, Alonso *see* COELLO

SANCHEZ COTAN, Juan (1561–1637)

b. Orgaz d. Granada. Spanish painter. Before becoming lay teacher at the Paular Charterhouse (1603) he painted still-life, but thereafter specialised in Madonnas crowned with flowers. Transferred to Granada (1612) he painted a Crucifixion, apparently sufficiently illusionistic to deceive even birds.

JUAN SANCHEZ COTAN *Quince, Cabbage, Melon and Cucumber. c.* 1602. 25¾×32 in (65·5×81 cm). Fine Arts Gallery, San Diego

SANCHI *see* SATAVAHANA DYNASTY

SANDBY, Paul (1725/6–1809)
Thomas (1721–98)

Both b. Nottingham. English watercolourists employed as Ordnance Survey draughtsmen. Paul d. London, formed his style in the Highlands (1746–51). His finest works are large views of Windsor Castle. In these and other topographical watercolours he combined precision with compositional economy and feeling for atmosphere. He satisfied a taste nurtured on *Canaletto. Thomas d. Windsor, also painted, but is better known as designer of Virginia Water and the *Royal Academy's first Professor of Architecture.

PAUL SANDBY *View of Windsor Castle. c.* 1755. Pencil and gouache. 15½×38¼ in (39·5×97 cm). Windsor

SAND-CASTING

Process of *casting metal sculpture from a mould made of foundry sand.

SANDRART, Joachim von (1606–88)

b. Frankfurt d. Nuremberg. While prized as an artist in his day, he is better known as the author of *Der Teutsche Akademie* (1675), containing a collection of artists' biographies, many of whom he met in Italy (1629–35) and Holland.

SANDYS, Anthony Frederick Augustus (1829–1904)

b. Norwich d. London. English painter and illustrator. His fastidious drawing style brought a new integrity to wood-engraved illustration of the 1860s. His painting style and subject-matter reflect the influence of *Rossetti, with whom he lived briefly. His later works are mainly chalk portraits, somewhat in the style of George *Richmond.

Left: FREDERICK SANDYS *Rev. James Bulwer.* 1861. 29¾× 21¾ in (75·6×55·2 cm). NG, Canada, Gift of Mrs H. A. Bulwer *Right:* SANGUINE *Kneeling Youth* by Andrea del Sarto. 11×7⅞ in (27·9×20 cm). BM, London

SANGUINE

A red soft-textured chalk used for drawing.

SANO DI PIETRO (Ansano di Pietro de' MENCIO) (1406–81)

Prolific Sienese painter who was untouched by the Florentine innovations of *Masaccio and others. An attractive but conservative artist who was still working in the trecento style, his many portraits of S. Bernardino reflect the popularity of that Sienese mystic.

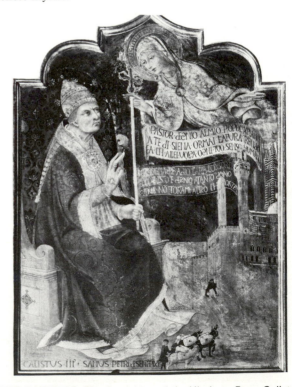

SANO DI PIETRO *The Apparition of the Virgin to Pope Calixtus VII.* Pinacoteca, Siena

SANRAKU *Plum and Pleasant*. c. 1630–35. Sliding doors. Paint on gold leaf. Each panel 72×10 in (182×25 cm). Myoshin-ji, Kyōto

SANRAKU (Kanō Sanraku) (1559–1635)

Japanese painter, the adopted son and natural successor to *Eitoku. He was patronised by Hideyoshi after Eitoku's death. In his work some of the bold grandeur associated with his master is lost in favour of more detail.

SANSETSU (Kanō Sansetsu) (1590–1651)

Japanese painter, the adopted son of *Sanraku, who collaborated with his father but is thought to have worked in a more muted style. He remained in Kyōto when the main *Kanō School moved to Edo (Tokyo) with the Tokugawa Shōgunate.

SANSOVINO (CONTUCCI), Andrea (c. 1467–1529)

b. d. Monte Sansovino. Italian architect and sculptor. Trained by *Pollaiuolo and *Bertoldo, his large-scale works show the influence of *Raphael and a knowledge of the *Antique, reflected in the triumphal arch motif used in the *Corbinelli Altar* (Sto Spirito). His best-known works, the monumental tombs of Girolamo della Rovere and Ascanio Sforza in Sta Maria del Popolo, Rome, decorated with pilasters, columns and figures of the Virtues set in niches set the style for 16th-century wall-tombs. He also carved narrative reliefs, eg the *Annunciation* (Sto Spirito) and those for the Holy House at Loreto.

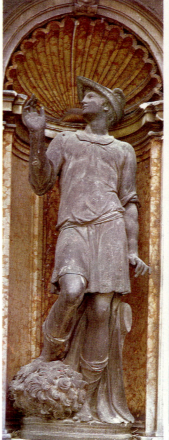
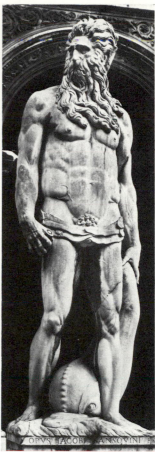

Left: JACOPO SANSOVINO *Hermes*. c. 1537–40. Bronze. h. 58½ in (149 cm). Loggietta di S. Marco, Venice
Right: JACOPO SANSOVINO *Neptune*. 1554–67. Marble. Doge's Palace, Venice

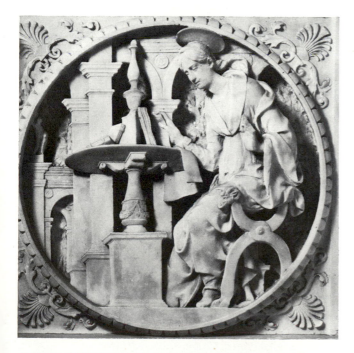

ANDREA SANSOVINO *Virgin Annunciate*. 1485–90. Marble roundel from the Corbinelli altar. S. Spirito, Florence

SANSOVINO (TATTI), Jacopo (1486–1570)

b. Florence d. Venice. Florentine sculptor, trained by Andrea *Sansovino whose name he adopted and with whom he worked in Rome (1505–6) – a vital experience since he was mainly occupied in restoring and copying antique statuary; also he met *Bramante there. He was again in Florence (1511–17) where he executed the *Bacchus* (National Museum, Florence) and was so exacting in his demands that his model went mad, posing naked upon a chimney-pot in the pouring rain. He went back to Rome (1518–27) and carved monuments and figures of saints. During the Sack he fled to Venice where remained to become the principal sculptor and architect in the city, enjoying, too, the friendship of *Titian and *Aretino. He also worked for the court at Mantua and contributed reliefs for the shrine of St Anthony in Padua, the latter displaying his classical idealism at its most refined. He occasionally worked in bronze and the concave door for the Sacristy of St Mark's, Venice (1546–53) reveals his aptitude in the medium. The next year he was commissioned to execute two statues over ten feet high of Neptune and Mars for the Scala dei Giganti, Doge's Palace; they were not finished until 1567 despite the terms in the contract insisting that they were to take 'not more than one year'. While Sansovino's art betrays an awareness of *Michelangelo's work and *Mannerism he remained a †Renaissance artist who was deeply inspired by antiquity.

SANTAREM

Site on the Tapajos River in Brazil (c. AD 1000–1500), remarkable for its flamboyant monochrome ceremonial pottery decorated with fantastic human, animal and bird forms.

SANTERRE, Jean-Baptiste (1651–1717)

b. Magny-en-Vexin d. Paris. French early †Rococo painter. Important in his own day as a portraitist of women (in allegorical poses), he painted *Ste Thérèse* for the Versailles Chapel (1709), which scandalised through its blatant eroticism. Much of his work foreshadows *Fragonard.

SANTIAGO DE COMPOSTELA CATHEDRAL

Santiago in north-western Spain was the goal of the great pilgrimage of St James, which did much to spread sculptural styles. The early 12th-century portal, the *Puerta de las Platerías* shows signs of rearrangement and parts are very close to the sculpture of *Toulouse. The *Portico de la Gloria* (1168–88) is a rich, precociously †Gothic ensemble.

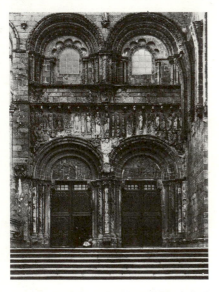

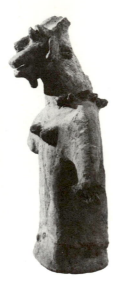

Left: SANTIAGO DE COMPOSTELA CATHEDRAL Puerta de las Platerías. 12th century
Right: SAO Figure either of a spirit or of a masked dancer excavated at Tago, Chad. ?15th century. Terracotta. h. 15 in (38 cm). Musée de l'Homme, Paris

SANTIAGO, Miguel de (c. 1625–1706)

Ecuadorian painter, working in Quito. Stylistically dependent on *Murillo, many of his compositions derive from Flemish prints. His landscapes were very advanced (eg those at Guápulo), and his painterly style, with progressively more evanescent atmosphere and draperies, was very influential.

SANTOMASO, Giuseppe (1907–)

b. Venice. Italian painter, influenced by *Braque and *Lurçat in the 1930s, who worked slowly towards abstract painting. A member of the *Fronte Nuova delle Arti (1946), he has developed an abstract hermeticism (since 1952).

SANTVOORT, Dirck van (1610/11–1680)

b. d. Amsterdam. Dutch portraitist, follower of de *Keyser, his style was old-fashioned compared with his contemporary *Rembrandt; he enjoyed popular fame; his works have an individual charm distinguishing them from others of the period.

SANZIO, Raffaello *see* RAPHAEL

SAO

A culture which flourished to the east and south of Lake Chad from at least the 10th century until the 16th when they were conquered and scattered by the Kanuri from west of Lake Chad. Sao remains include terracotta human and animal figures with some affinity to those of Northern Nigeria (*Nigeria,

Northern) in the recent past although they are nothing like the terracottas of the earlier *Nok culture.

SAQQARA

The site of part of the ancient necropolis of *Memphis, with monuments dating from every period of Egyptian history. The most notable are the step pyramid of the 3rd dynasty king Djoser, the very much later Serapeum, incorporating the burial vaults of the Apis bulls, and a number of mastaba tombs of the 5th and 6th dynasties, including those of *Thy, Ptahhotpe and Mereruka, whose low reliefs are of particular quality.

Right: SAQQARA Seated figure of Sekhemka. Late 5th dynasty. Painted limestone. h. 29½ in (75 cm). Northampton Museum

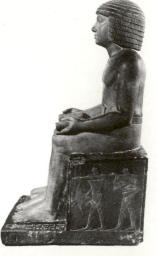

Below: CARLO SARACENI *St Cecilia and the Angel. c.* 1610. Palazzo Barberini, Rome

SARACENI, Carlo (1579–1620)

b. d. Venice. Italian painter, he arrived in Rome (c. 1598), becoming influenced by *Caravaggio and *Elsheimer, with whom he collaborated. Commissioned (1618) to paint a Death of the Virgin for Sta Maria della Scala replacing Caravaggio's rejected version, he returned to Venice (c. 1619).

SARCOPHAGI, Classical

Sarcophagi were not normally used by the Greeks although Greek craftsmen made them for the kings of Sidon. The *Alexander Sarcophagus is the best known as well as the latest in the Sidonian series. The *Etruscans produced many terracotta sarcophagi of high quality, but few were produced at Rome in the 1st centuries BC and AD when cremation was more common than inhumation. The *Caffarelli Sarcophagus dates to this period. A return to inhumation in the 2nd century AD led to the production of a large number of fine *marble sarcophagi at Rome, and these can be reckoned among the finest surviving examples of Roman sculpture.

SARCOPHAGI, Early Christian *The Sarcophagus of Adelphia.* 4th century. Syracuse, Sicily

SARCOPHAGI, Early Christian

Rich 3rd-century Christians continued the pagan practice of inhumation in figurative sarcophagi, even repeating the same motifs, eg the *Orans and Good Shepherd which had symbolised pagan virtues. They also translated the pagan mythology for the happy life after death into Christian scenes of salvation, eg the *Jonah* on a late 3rd-century sarcophagus (Sta Maria Antiqua). Under Constantine the production of Christian pieces increased; typical of his reign are frieze sarcophagi in the crude figure style of the Arch of *Constantine. These show files of figures in Old Testament salvation scenes or New Testament miracle scenes. In the second half of the 4th century before the industry declined, sarcophagi more complex in meaning and more refined in a classical style appear.

SARGENT, John Singer (1856–1925)

b. Florence d. London. Painter who worked in Paris (1874–84), studying with *Carolus-Duran (c. 1874–9); travelled in Italy and Spain (1879–80); settled in London (c. 1885), travelling frequently to New York and Boston. Influenced by *Hals and *Velasquez, Sargent first worked in dark, sonorous colours, later adopting the brighter †Impressionist palette. Primarily a fashionable portraitist, Sargent was unrivalled in capturing his subject in a personal setting, the spontaneity of the moment caught by his flashing, virtuoso painterliness and lightning-quick observation. His enthusiastic youthful works are his best; but his eye never penetrated the surface of life, and his detachment and sheer effortlessness soon palled. In his later years he produced, mainly for his own pleasure, some brilliant watercolours in which his technical facility is seen at its best advantage.

SARMATIAN ART *see* SCYTHIAN ART

SARNATH *see* MAURYA DYNASTY; GUPTA DYNASTY

SARRAZIN, Jacques (1588/92–1660)

b. Noyon d. Paris. The most important French sculptor of his age, he worked in Rome (1610–c. 1627) alongside the classicising, early †Baroque, Italian sculptors. He later sculpted statues for Paris churches, and for palaces (eg Louvre, Pavillon de l'Horloge) and made Henri de Bourbon's monument (Chantilly).

SARTO (AGNOLO), Andrea del (1486–1530)

b. d. Florence. The main Florentine representative of the High †Renaissance style in painting, parallel to that of *Raphael and *Michelangelo in Rome. In his painting lie the roots of *Mannerism, and his pupils such as *Rosso and *Pontormo are among its leading exponents. Like Raphael, Andrea was equally expert at working in oil or fresco. In the latter he made rapid progress, from the *S. Filippo Benizzi* frescoes in the forecourt of SS Annunziata, Florence (1509–10) to the *Birth of the Virgin* in the same setting (1514). A comparison of his *Madonna of the Harpies* (Uffizi), painted before his French visit (1518), with these frescoes reveals one of the first sources of Mannerism. His borrowings from *Dürer and his sharp areas of colour too are connected with Mannerism.

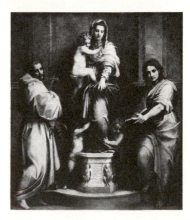

Top: ANDREA DEL SARTO *Nativity of the Virgin.* 1514. Fresco from the forecourt of SS Annunziata, Florence
Above left: JOHN SINGER SARGENT *Asher Wertheimer.* 1898. 58×38½ in (147·3×97·8 cm). Tate
Above right: ANDREA DEL SARTO *Madonna and Child enthroned with SS Francis and John the Evangelist* (Madonna of the Harpies). 1517. 81½×70½ in (207×178 cm). Uffizi

SARTORIUS Family

The Sartorius family of artists extended over four generations, with eight artists of that surname exhibiting English sporting subjects and pictures of racehorses and hunters. Francis Sartorius contributed to the *Sporting Magazine* in the 1790s, as did his son John Nott Sartorius, the most famous and widely patronised of the family, whose contributions extended to the late 1820s. Of the latter's two artist sons, one followed him as a sporting artist, and the other was a marine painter.

SASSANIAN ART

The Sassanids ruled Iran and Mesopotamia (AD 224–642) and were contemporaries, and at times rivals, of the Romans and Byzantines. The rock reliefs are especially well known, most of them come from the Fars, the homeland of the Sassanids, as at *Naqsh-i Rustam but they were also carved farther afield as at *Taq-i Bustan. They are mostly rather formal and stiff, but in the 5th century they become freer. The gilded silver vessels produced by the Sassanians are very fine; some are in a Greco-Roman tradition while others are more typically Sassanian. Sassanian art occupies an interesting middle position between Irano-Buddhist and Byzantine art.

Above: SASSANIAN ART Silver-gilt dish. 5th–6th century AD. Archaeological Museum, Teheran

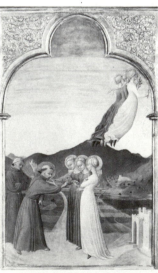

Left: SASSETTA *St Francis' Betrothal to My Lady Poverty.* 1444. 37½×22⅞ in (95×58 cm). Chantilly

SASSETTA, Stefano di Giovanni (c. 1400–50)

b. ?Cortona d. Siena. The leading *Sienese painter of the early 15th century. His style was formed on the late †Gothic local traditions and though he knew the sculptures of Jacopo della *Quercia, the font reliefs by *Ghiberti and *Donatello, and

may have seen *Masaccio's paintings, his response to the †Renaissance was limited. He never mastered perspective and was incapable of monumental severity and for all its tender humanity, the *Madonna of the Snows* (1432, Contini-Bonacossi Coll., Florence) has more in common with *International Gothic. As an expressive artist he had profound gifts; every detail adds to the mood of terror in *The Devils Scourging St Anthony* (1437, Yale). His spiritual intensity reached its apogee in his masterpiece, the *St Francis Altarpiece* painted for Borgo S. Sepolcro (1437–44, now dispersed). Possibly inspired by the preaching of S. Bernardino, the lively figures are instinct with the spirit of the legends from the *Fioretti*. The colour is sensitively deployed and the backgrounds reveal Sassetta's response to nature and the silvery Tuscan light. It was a formative influence upon *Piero della Francesca.

SASSOFERRATO, IL (Giovanni Battista SALVI)
(1609–85)

b. Sassoferrato d. Rome. Italian painter who learned the rudiments of his art from his father before going to Rome where he worked in the studio of *Domenichino. His intense study of *Raphael led to a style of such purity that *Pre-Raphaelite or *Nazarene painting comes to mind. This anachronistic style has caused him to be mistaken for a 16th-century follower of Raphael.

Left: IL SASSOFERRATO *The Mystic Marriage of St Catherine.* 91⅞×54⅜ in (233×138 cm). Wallace

Below left: SATAVAHANA DYNASTY *The Buddha, symbolised by trees and a stupa, worshipped by men and animals*: detail, east gateway of stupa, Sanchi. *c.* 1st century BC. Sandstone *Below right:* SATAVAHANA DYNASTY *Dancing couple.* Buddhist cave-shrine, Karle. *c.* 1st century AD. Rock-cut

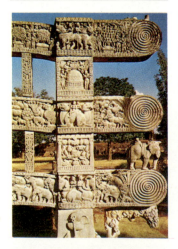

SATAVAHANA DYNASTY (c. 50 BC–AD 250)

Kharavela mustered forces in Kalinga (present Orissa) which was under *Shunga rule as an inheritance from the *Mauryan conquest by Ashoka, and regained autonomy for the region by defeating Pushyamitra Shunga in the field (c. 161 BC). The

Satavahanas, also known as Andhras, based at Amaravati and Pratisthana (Paithan) at opposite ends of the Godavari River which spans the Indian peninsula, had risen and extended their rule across the Deccan, raiding northward into the Shunga dominions. They were to retain effective control of the Deccan for more than three centuries. The caves excavated in Kalinga were intended for habitation by Jain monks and as official edict-shelters. The *vihara (monastery) caves of the Bhuvaneshvara region are known as the Ananta-, Rani- and Ganesha-gumphas, of which the latter two are double-storeyed. Elements in the formation of Hindu iconography include sculptures of *Surya, *Lakshmi and the sacred Tree of Plenty. Animals, especially elephants, are expertly portrayed in the friezes, which also depict non-sectarian narrative material. The main architectural effort in the Satavahana territories was also concentrated on the excavation of *viharas* and shrines from hillside rock-faces, the principal achievements here being Buddhist rather than Jain. One of the earliest and most interesting is that at Bhaja in the Poona area. Essentially it is an excavated hall with cells dug into the walls and fronted by a pillared veranda, typical of the many *viharas* of the period. Two scenes carved in bas-relief on the facing inner walls of the veranda are unique. One represents Surya the sun god riding across the sky in his chariot, and the other *Indra, lord of gods, on his elephant Airavata towering above an etherialised earthly landscape. Free-standing Buddhist shrines, often enclosing a sacred tree, are represented in reliefs of the period. A typical structure might consist of a square hall with pillars supporting one or two upper storeys with a curved 'elephant-back' (*gaja-prishtha*) or domed roof. The structure would be surrounded by a railing and the hall, with its unoccupied altar, reached by a flight of steps with a semicircular 'moonstone' at the base. It is clear, however, both from the reliefs and actual remains, that the shrine-building was of less importance to the Buddhism of the time than the *stupa. The cave-shrines – as distinct from the *viharas* – in fact contained, not an image, but a stupa as the focus of devotion. The most splendid example is at Karle. Anthropomorphic sculptures on the façade, in the massive archaic style, are evidently portraits, probably of donors; Buddha images were added at a later date. The existing stupa complexes, such as the one at *Sanchi, were extended under Satavahana rule. At Sanchi, four colossal gateways were erected at the cardinal points in the stone railing which surrounded the great stupa founded in *Maurya times. These gateways represent a transition, within a single generation of artists, from wood- and ivory-working to the sculpting of sandstone. On the uprights and triple architraves is represented the whole gamut of Buddhist history, fable, parable, *jataka*, symbolism and decorative motif. The horizontal surfaces were exploited to the full in the presentation of narrative scenes, front and back. It was during the 2nd century AD that Satavahana art reached its classical phase at Amaravati, a school which was to have a permanent influence upon the art styles of north and south. The full glory of the stupa is brought out in a superb relief on a slab over six feet square from Amaravati of the 2nd century. The dome, replete with parasols, garlands, banners and votive pillars, is seen as in an ecstatic vision surrounded by hosts of spiritual beings among whom, at last, appears the figure of the Buddha himself. The continuation of symbolic representation of the Buddha, however, produced superb sculpture. The female form in particular is used in such evocations in the Amaravati School. A carving of four women worshipping the footmarks of the Buddha provides the best example of this tendency. Although different in their ornaments, the four women might be one, seen in a time sequence typical of Indian sculpture. The female figure in such reliefs is almost nude, and the artistic possibilities of these poses are exploited to the full. It is characteristic of Indian art that the erotic undertones of the scene strengthen, rather than detract from the piety of emotion depicted. These four women of Amaravati epitomise the emotionalism of Buddhist religion at the time. When the Ikshvaku kings ruled after the Satavahanas, the same artistic traditions persisted in unimpeded development, although the centre moved from Amaravati to Nagarjunakonda. It is of par-

ticular interest here to note the influence of the art of Sri Lanka (*Ceylon) in the 'moonstones' – semicircular stone slabs – carved with multiple bands of animal motifs. *Jataka* narratives are continued in the art of Nagarjunakonda, and the beauty of the female form haunts all the sculpture in secular as well as religious themes.

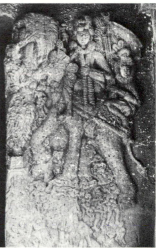

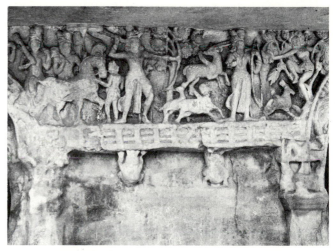

Top left: SATAVAHANA DYNASTY *Portrait of donor (?) and wife.* Buddhist cave-shrine, Karle. *c.* 1st century AD. Rock-cut
Top right: SATAVAHANA DYNASTY *Indra mounted upon the elephant Airavata.* Buddhist vihara, Bhaja. *c.* 1st century BC. Rock-cut
Above: SATAVAHANA DYNASTY *Prince hunting deer and encountering a tree-nymph.* Rani-gumpha, Khandagiri near Bhuvaneshvara. *c.* 100 BC. Rock-cut

SAVERY, Roelandt (1576–1639)

b. Courtrai d. Utrecht. Flemish landscapist. He went to Prague in the service of Rudolph II (1604). His drawings of the Alps were sources for later paintings. He worked in Vienna, then Utrecht (from 1619), painting animals and birds in landscapes.

SAVOLDO, Girolamo (1480/5–c. 1548)

b. Brescia d. Venice. Brescian painter active in Venice. With *Romanino and *Moretto he was one of the three most successful Veneto-Lombard painters. His work is characterised by a dramatic and skilful *chiaroscuro which anticipates *Caravaggio.

SAX, Marzal de, Andres (active 1393–1410)

Spanish painter, presumably originating in Saxony, who exerted a great influence upon Valencian painting. He

collaborated with local artists like Pedro Nicolai (1399/40), Gonzalo Perez (1404) and Gerardo Gener of Barcelona (1405). His own style, as in the *Doubting Thomas* panel (*c.* 1400, Valencia Cathedral), contrasts with the more delicate linear Valencian style, into which he injected a stronger Germanic plasticity. The *Retable of St George* (*c.* 1400/10, V & A, London) is the most important work attributed to him.

SCHAD, Christian (1894–)
b. Miesbach, Bavaria. Painter who studied at Munich. He moved to Zürich (1915), where he worked with *Arp, *Tzara, etc, producing woodcuts. He lived in Italy (1920–5), returning to Berlin (1928). As a member of the *Neue Sachlichkeit group (1929), he worked in a harshly realistic style.

SCHAFFNER, Martin (1478/9–1546/9)
b. d. Ulm. German painter, woodcut-maker and medallist, active in Ulm. He held a high position in the town, and is probably identifiable with the 'Stattmaler' recorded in 1518. His monogram is often a combination of letters 'MS' with 'ZU'. His style shows his dependence on *Dürer and *Schäufelein, eg the portrait of Hans Besserer I (AP, Munich).

SCHALKEN, Godfried (1643–1706)
b. d. Leiden. Dutch artist. Pupil of *Hoogstraten and *Dou, he painted candlelight scenes and portraits. He turned to *cabinet pictures (by 1675), often on classical themes, appealing to an educated élite.

SCHAUFELEIN, Hans Leonhard (c. 1480–1538/40)
b. Nuremberg d. Nördlingen. German painter and woodcut-designer, and pupil of *Dürer from *c.* 1503, at which date his woodcuts first appeared. His monogram is composed of the letters 'IS' and the shovel (echoing his name). He travelled to Italy (1505); was in Augsburg (1510–15) where he collaborated on woodcuts for Maximilian's Triumphal Procession. He became citizen of Nördlingen (1515). His earliest dated work is the *Crucifixion* (1508, Germanisches Nationalmuseum, Nuremberg). This shows (like his *Agony in the Garden*, 1516, Munich) his reliance on Dürer, natural since he contributed to workshop pictures like the *Ober St Veit Altarpiece* (1507, Diocesan Museum, Vienna). The woodcut designs are more independent of Dürer's influence.

Left: ARY SCHEFFER *SS Augustine and Monica*. 1854. 55¼×41¼ in (135×104·5 cm). NG, London
Right: HANS SCHAUFELEIN *Agony in the Garden*. 1516. 20×15½ in (51×39 cm). AP, Munich

SCHEFFER, Ary (1795–1858)
b. Dordrecht d. Argenteuil. Son of an artist of German extraction working as Court Painter at Amsterdam. He studied in Paris under *Guérin. He painted Biblical works and scenes from *Goethe, Byron, Dante, etc. Their poetry of sentiment and rather forced devotional fervour won him widespread acclaim, but as a colourist he was weak.

SCHEEMAKERS, Peter (1691–1781)
b. d. Antwerp. Flemish sculptor. After an early visit to London, he went with Delvaux to Rome (1728–32) and then settled in London (until 1771). He made the Shakespeare monument (1740, Westminster Abbey) and had a successful tomb-making practice.

SCHELFHOUT, Andreas (1787–1870)
b. d. The Hague. Dutch landscape painter and etcher, and the pupil of Breckenheimer. He became a popular artist, especially for his winter scenes. As for the majority of his contemporaries the roots of his naturalistic style lay in the 17th century.

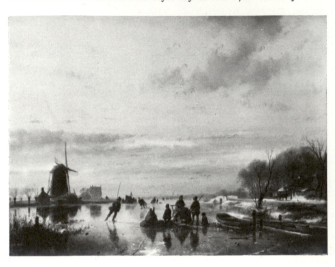

ANDREAS SCHELFHOUT *Winter in Holland*. 18¼×24¾ in (46×63 cm). Wallace

SCHIAVONE (MELDOLLA), Andrea (c. 1522–63)
b. Zara, Dalmatia d. Venice. Dalmatian painter and engraver who became associated with the Venetian School. Influenced by *Parmigianino, *Titian and *Tintoretto, he is best known for mythological and pastoral subjects. His paintings for the ceiling of St Mark's Library (1556–7) were completed by Tintoretto. He was an accomplished engraver.

SCHIAVONE (CIULINOVI), Giorgio (c. 1436–1504)
b. d. Sebenico. Dalmatian painter active in Padua. A pupil of *Squarcione (1456–9), he painted gentle altarpieces with crisp modelling and backgrounds of classical architecture. He later abandoned painting and became a merchant.

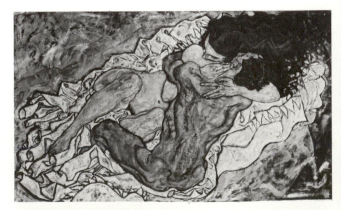

EGON SCHIELE *Embrace*. *c.* 1917. 39⅜×47⅜ in (100×120·2 cm). Österreichische Galerie, Vienna

SCHIELE, Egon (1890–1918)
b. Tulln d. Vienna. Austrian painter influenced by *Klimt and

the Vienna *Secession. His stark and angular nudes reject all decorative tendencies in their aggressive linearity and acid colour. He explores a state of mind whereby his suggestive and seemingly erotic figures become uncompromising expressions of violent agitation. Largely misunderstood in Austria, his recognition was in Germany, where he influenced *Expressionism.

SCHLEMMER, Oskar (1888–1943)

b. Stuttgart d. Baden Baden. German artist whose early work relates to *Cézanne and *Cubism, developing into a prime concern for structure with frequent use of a grid and geometry in paintings, and cement and wire reliefs. He joined the *Bauhaus (1921), where the simplified and almost mechanical figure becomes his central motif in complicated compositions which use perspectival organisation of space, but retain a basic two-dimensionality. His sculpture, theatre designs and choreography based on primary colours are equally important.

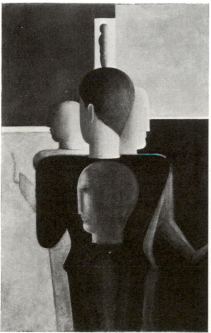

Left: OSKAR SCHLEMMER Concentric Group. 1925.
$38\frac{1}{4} \times 24\frac{1}{4}$ in (97·5×62 cm). Staatsgalerie, Stuttgart
Right: NICHOLAS SCHOFFER Cybernetic Tower. 1961. h.
170 ft (51·8 m). La Bouverie Park, Liège

SCHLUTER, Andreas (1660/4–1714)

b. Poland d. St Petersburg. Polish-German sculptor and architect. He settled in Berlin, after visiting Paris (1695) and Rome (1696). Italian †Baroque sculpture influenced his work, especially his statue of the Great Elector (completed 1708). He was involved in unsuccessful architectural schemes, and was invited to Russia (1714).

SCHMIDT-ROTTLUFF, Karl (1884–)

b. Rottluff. German painter who studied at Dresden and was a co-founder of die *Brücke (1905). Influenced by *Nolde, Schmidt-Rottluff was the least theoretical and most robust and directly realistic of the Brücke painters. His bold simplifications, inspired by *Van Gogh, derived a harsh angular solidity from Negro sculpture and *Cubism. After the last war his style became softer and more romantic.

SCHNITZALTAR

The carved altarpieces of 14th-century Germany, eg at Oberwesel, in which rows of figures were placed in separate frames,

developed during the next century into veritable theatrical tableaux, with many figures in relief or set in open *tabernacles as can be seen in the high altars of Michael *Pacher and Veit *Stoss.

SCHNORR VON CAROLSFELD, Julius (1794–1872)

b. Leipzig d. Dresden. German painter, working in Rome with the *Nazarenes (1818–25). Commissioned by Ludwig I of Bavaria he worked in the royal palace, Munich (1827–67), executing frescoes of mythological subjects, and supervising his pupils' *history cycles (executed in *encaustic wax).

SCHOFFER, Nicholas (1912–)

b. Kalocsa, Hungary. *Kinetic artist who studied at Budapest and settled in Paris (1936). His spatio-dynamic theories preceded the construction work of the 1950s, when he designed temperature-zone walls. His 'lumino-dynamic' spectacles in Paris and New York (1957), like his tower constructed at Liège (1961), combined flashing light-projections, movement and sound. Unlike *Tinguely, he combines his calculatedly random effects with technological respectability.

SCHOLZ, Werner (1898–)

b. Berlin. German painter who studied in Berlin (1914). Knew *Nolde (1930). Most of his pre-war work was destroyed in Berlin (1944). Since he has executed Biblical illustrations (1948–51), mythological paintings and notably, a triptych for Krupp, The World of Steel (1954). His art is emphatically *Expressionist, restless, dark colours being disturbed by uneven white illuminations.

SCHONFELDT, Johann Heinrich (1609–83)

b. Biberach d. Augsburg. German painter. After travelling in Italy (where he painted an altarpiece for the German church in Rome, S. Elisabetta de' Fornari) he painted religious and historical pieces all over southern Germany, including altarpieces for the cathedrals of Augsburg and Salzburg.

KARL SCHMIDT-ROTTLUFF Landscape in Lofthus. 1911.
$34\frac{1}{2} \times 37\frac{1}{2}$ in (87·6×95·3 cm). Kunsthalle, Hamburg

SCHONGAUER, Martin (1430 or 1445/50–1491)

b. Colmar d. Breisach. German painter and engraver. His only documented painting is the Madonna of the Rose Bower (1473, St Martin, Colmar) upon which attributions are based. All the engravings (about 115) are monogrammed 'MS', the letter 'M' altering its shape in later prints. Although primarily a painter,

the influence of metalwork is apparent in his preoccupation with engravings with metalwork designs and in the quality of his work in general – the clear decorative line, and jewel-like surface in paintings. He was one of the first painter-engravers and lent to printmaking the qualities of painting, eg the *Temptation of St Anthony* or the *Bearing of the Cross* shows a systematisation of hatching, and a tonal variety unprecedented in the work of craftsmen-engravers. The prints are close to painting also in their stylistic reliance on painters (especially Rogier van der *Weyden). These improvements, especially when developed by *Dürer, increased the status of engraving as an art form and as a vehicle for the spread of artistic styles.

Above: MARTIN SCHONGAUER *Madonna of the Rose Bower.* 1473. 79×44 in (201×112 cm). St Martin, Colmar

Left: MARTIN SCHONGAUER *Temptation of St Anthony.* c. 1480–90. Engraving. 13×10⅜ in (33×26 cm). BM, London

SCHOOL OF PARIS

The term is used in this book to mean no more than those painters who, without making important innovations, worked in Paris from 1914 onwards in a post-*Cubist style.

SCHRIMPF, Georg (1889–1938)

b. Munich d. Berlin. German self-taught painter who began as a Stürm Gallery *Expressionist (1915). In Schrimpf's case post-1918 German (*Neue Sachlichkeit) and Italian (Valori Plastici) movements towards a revived romantic classicism, inspired a genuine poetic primitivism. Solid, simple self-absorbed figures sleep or dream in bare interiors or in front of *quattrocento landscapes.

SCHUCHLIN, Hans (c. 1440–1505)

b. ?Ulm d. Ulm. German painter, who may have studied at Nuremberg under *Pleydenwurff, whose style is comparable. He became head of the Ulm Painters' Guild (1493). His *Tiefenbronn Altarpiece* (1469, Tiefenbronn Church) exemplifies both his reliance on Netherlandish composition and his characteristic flat simplification of forms and space.

SCHUMACHER, Emil (1915–)

b. Westphalia. German painter whose work (since 1953) is allied to the widespread development of informal abstract styles in Europe (eg *Tachisme). From his encrusted, cracked, blotched and stained surfaces, shadowy figures seem to emerge – a compromise between sculptural surface and painterly illusion. His 'tactile objects' – irregular reliefs of paper and wire – are a more straightforward solution.

SCHWIND, Moritz von (1804–71)

b. Vienna d. Munich. †Romantic, *Nazarene-influenced German artist, for whom the German Middle Ages provided subject-matter. He also worked in fresco (Karlsruhe), and illustrated works by *Goethe and Defoe's *Robinson Crusoe.* Visited England (1857).

KURT SCHWITTERS *Das Haarnabelbild* (The Hair-navel picture). 1920. Mixed media. 35¾×28½ in (91×72 cm). Lords Gallery, London

SCHWITTERS, Kurt (1887–1948)

b. Hanover d. Ambleside, England. German painter who began exhibiting under the aegis of German *Expressionism, but whose revolutionary and humorous attitude to art soon brought him into contact with *Dada. He remained independent from Dada, however, starting a one-man movement in Hanover called 'Merz'. He built 'merz' pictures from scraps of rubbish, bus-tickets, string, later leaves and grasses, and paint, creating harmonious, delicately coloured collages. He wrote poetry (eg *Anna Blume*, 1919), including phonetic poems (*Ursonata*, 1924/5), and published his bulletin *Merz* (1923–32).

SCOREL, Jan van (1495–1562)

b. Scorel, nr Alkmaar, d. Utrecht. Netherlandish painter, whose extensive travels in Holland, Germany and Italy are recorded by van *Mander. Probably worked with *Oostsanen in Amsterdam (1517/18) and *Gossaert in Utrecht (c. 1517). Was in Italy (by 1520). He returned to Utrecht (1525) where he trained Maerten van *Heemskerk and Anthonis *Mor, and was famous enough by 1550 to collaborate with Lancelot *Blondeel in restoring van *Eyck's *Ghent Altarpiece*. His style is close to that of Lucas van *Leyden in its panoramic compositions, contrasts of local colour and autonomous brushwork. Italian influence is more pronounced, eg *Death of Cleopatra* (1522, Rijksmuseum). Unlike the over-dramatic Romanism of the *Antwerp Mannerists, however, Scorel's increasing pre-occupation with characteristically Dutch atmospheric landscape (eg the *Magdalene*, 1529, Rijksmuseum) lends balance and clarity to his compositions. His portraits are notable with free, interesting brushwork.

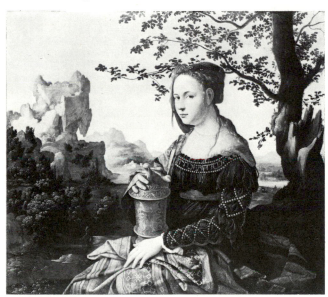

Top: JAN VAN SCOREL *Mary Magdalene*. 1529. 26⅜×30⅛ in (67×76·5 cm). Rijksmuseum
Above: SAMUEL SCOTT *The Thames at Battersea*. 20¼×37⅜ in (51·4×94·9 cm). Tate

SCOTT, Samuel (c. 1702–72)

b. London d. Bath. English marine and topographical artist. He began painting in the van de *Veldes' style, changing to townscapes, apparently in response to *Canaletto's arrival in England (1746). Scott's style is distinct from Canaletto's and less spacious.

SCOTT, Tim (1937–)

b. London. English sculptor who studied architecture at the Architectural Association and then sculpture under *Caro at St Martin's School of Art. Reacting strongly against the emotionally outspoken, incomplete feeling of 1950s sculpture, Scott's early work is solid, clear, one-coloured, opaque. His later work, formally more exciting and space-involving in its use of angular planes, rods, shiny or transparent surfaces, retains its cool self-sufficiency.

SCOTT, William (1913–)

b. Greenock. Painter who studied in Belfast (1928–31) and at the Royal Academy Schools (1931–5). In France and Italy (1937–9), his still-lifes achieve a tranquil decorative quality. One of the first British painters to respond to the scale and abstractness of American painting (1953), his arrangements of simple everyday objects against a flat ground, remain variations on the European still-life theme. He has *Morandi's single-mindedness without his intensity.

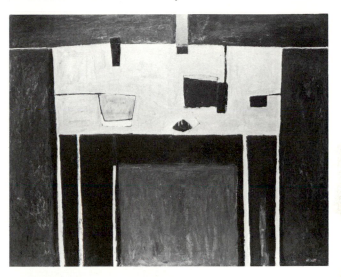

Above: WILLIAM SCOTT *Table Still-Life*. 1951. 56×72 in (142×183 cm). The British Council

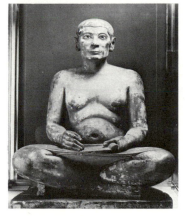

Left: 'SCRIBE ACCROUPI' Statue of a courtier as scribe. 5th dynasty. Painted limestone. h. 20⅞ in (53 cm). Louvre

SCRAPER

An *engraver's tool having a triangular blade with sharp edges and used for removing *burr from a plate.

SCRIBE ACCROUPI

Egyptian statue (now in the Louvre) of an official of the 5th dynasty in the role of a scribe, squatting cross-legged and about to write. Figures of this type were common during the later Old Kingdom, but no other example has such alert vitality.

SCROTES (STRETES, SCROTS), Guillim (d. 1544)

Flemish (or Dutch) portraitist, Court Painter to Mary of Hungary (1537) (pictures now dispersed). He went to England (1545) where he succeeded *Holbein as Court Painter to Henry VIII, and his forms are naturally close to Holbein's.

The full-length portrait of Edward VI (*c.* 1550, Hampton Court) is related to portraits of Henry VIII, while the distorted perspective bust portrait of Edward (1546, NPG, London) is also close to Holbein's *Ambassadors* (NG, London).

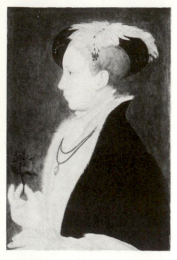

GUILLIM SCROTES
Edward VI. c. 1546.
18⅝×11 in (47·5×27·9 cm).
NPG, London

SCROTS, Guillim *see* **SCROTES**

SCUMBLING

To draw a fully loaded brush lightly over a previous layer of paint, allowing the latter to show through.

Left: SCYTHIAN ART Cast gold ornament in the form of a panther twisted into a circle. Originally filled with inlay. Hermitage Museum, Leningrad

Below: SCYTHIAN ART Chased gold stag from Kostromskaya in the Kuban. 7th–6th century BC. l. 12 in (30·5 cm). Hermitage Museum, Leningrad

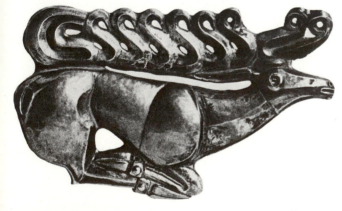

SCYTHIAN ART

The Scythians dominated the Eurasian steppe from the 8th century BC; the main body settling in southern Russia. Their art is known from objects found in mound-burials, notably magnificent gold pieces often set with precious stones and inlays. Weapons, horse-trappings, mirrors and a wide range of personal jewellery were covered with animal and some geometric decorations; the rare human figures are Greek or Greek-inspired. Real and fantastic animals are rendered with varying degrees of stylisation, usually in poses combining more than one view, but with vigour and balance. They are shown separately, in rows, or interlinked – in combat or with one beast emerging from the tail of another. The finest work comes from the Crimea, but closely related Siberian tombs have yielded

well-preserved carpets and leather, wood and appliqué-work goods. By the 2nd century BC southern Russia was controlled by the Sarmatians, who bought works of Scythian type from Greek craftsmen. Scythian motifs thus survived to influence the Goths, and hence affected †Migration Period, Scandinavian, *Celtic and *Anglo-Saxon art.

SEBASTIAN DE ALMONACID (active 1521)

Spanish sculptor active in Granada (1521), where he collaborated with Felipe *Vigarny on the High Altar of the Royal Chapel.

SECESSION

In Germany and Austria in the 1890s dissatisfaction on the part of young artists with the existing art institutions and their conservative teaching led to breakaway Secessionist groups being formed in Munich, Berlin and Vienna. The progressive artists involved were the originators of *Jugendstil and were the first to hold large exhibitions of modern French art outside Paris – the †Impressionists in Vienna (1902), and the *Post-Impressionists in Berlin (1903). The Secessions included architects, painters, sculptors and graphic artists and ran their own magazines, eg *Pan* (Berlin) and *Ver Sacrum* (Vienna). Special importance was attached to the applied arts and the Vienna Secession exhibition (1900) brought together the Glasgow School represented by Charles Rennie *Mackintosh and Margaret Macdonald; Henry van de Velde and the Paris *Maison Moderne*; and C. R. Ashbee's Guild of Handicraft from London. This led to the foundation of the Wiener Werkstätte (1903).

SECTION D'OR

French: 'Golden Section', or 'Golden Mean'. A proportional series used from time to time as an aid to composition in painting and architecture.

Left: PETER SEDGELEY
Colourcycle 3. 1970.
72½×72 in
(184·2×182·9 cm). Tate

SEDGELEY, Peter (1930–)

b. New York. Sculptor who studied at New York and Rutgers in *frottage. He changed to *Optical Art on seeing Bridget *Riley's paintings. He produces optical effects through the manipulation of colour and line on a framework of rectangles and circles.

SEGAL, George (1924–)

b. New York. Sculptor who studied at New York and Rutgers Universities; worked with Kaprow in creating first 'Happenings'; lives in New Jersey. Segal abandoned figurative painting for sculpture associated with *Pop Art. His genre scenes, comprised of plaster figures cast from life and real objects, virtually embody isolation and anonymity.

GEORGE SEGAL *Girl in Doorway*. 1965. Plaster, wood, glass, aluminium paint. 113×63½×18 in (287×161·3×45·7 cm). Whitney Museum of American Art, New York

SEGANTINI, Giovanni (1858–99)

b. Arco, Italy d. Pontresina. Italian painter, influenced by Grubicy de Dragon, who settled in the Swiss mountains. He used the Divisionist *Pointillist technique to paint shimmering landscapes of the Alps and peasant life.

SEGHERS, Daniel (1590–1661)

b. d. Antwerp. Flemish painter. Pupil of and collaborator with Jan *Bruegel, he became a Master (1611) and a *Jesuit (1614). He was in Rome (1625–7). He specialised in sophisticated flower-pieces, frequently garlands round a religious subject.

SEGHERS, Gerard (1591–1651)

b. d. Antwerp. Flemish artist, pupil of *Janssens, becoming a Guild Master (1608). He went to Rome and also worked for Philip III. He painted in a *Caravaggesque style (until c. 1628), then in a dry *Rubensian manner.

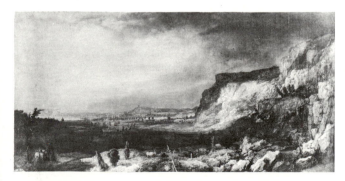

HERCULES SEGHERS *Landscape*. 1630–5. 21¾×39⅜ in (55×100 cm). Uffizi

SEGHERS, Hercules (1589/90–after 1633)

b. Haarlem d. ?The Hague. Dutch landscapist who broke away from the Flemish *Mannerist landscapists while retaining their interest in romantic effects. He was also the first artist to paint flat panoramas. His paintings, drawings and *etchings played an important part in the development of Dutch landscape painting, influencing *Rembrandt and Philips de *Koninck. His rare and mysterious etchings were hand-coloured, each impression often in a different tint.

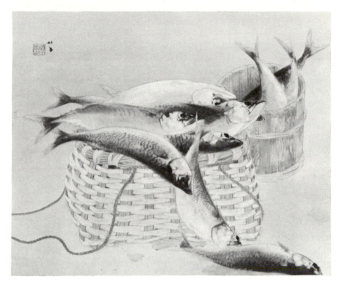

SEIHO *Mackerel*. Dated 1925. Colour on silk. 33¾×46 in (85×116 cm). Maeda Ikutokukai Inst, Tokyo

SEIHO (Takeuchi Seihō) (1864–1942)

Japanese painter who first studied as a *Shijō artist, but visited Europe (1900–1). His style is that of a Westernised Shijō artist.

SEISENEGGER, Jacob (1505–67)

d. Linz. Austrian painter, mainly of portraits, who was patronised considerably by the Habsburgs. At Augsburg he was made Court Painter to Ferdinand of Austria (1531), later Emperor, and then travelled widely – Bologna (1532), Vienna and Prague, Spain and the Netherlands. His portrait of Charles V (1532, KH, Vienna) is possibly the earliest Northern example of the full-length portrait and thus influential upon such artists as *Holbein and *Titian.

SELLAIO, Jacopo del (1442–93)

b. d. Florence. Italian painter, the son of a Florentine saddler and according to *Vasari pupil of Fra Filippo *Lippi. His altarpieces in Florence include *Annunciation* (1473, Sta Lucia dei Magnoli) and *Crucifixion with Saints* (c. 1490, S. Frediano); he also executed *cassone panels. An eclectic painter, his style owes much to *Botticelli and *Ghirlandaio.

SENGAI (1751–1837)

A distinguished Japanese Zen monk who became Abbot of Shofoku-ji at Hakata. He painted in both the humorous and serious styles of *Zenga.

SENNEDJEM see THEBAN TOMBS

SENNEFER see THEBAN TOMBS

SENUFO

A large tribe in northern Ivory Coast and neighbouring areas of Mali and Upper Volta. The central institution of their culture is the Lo society which, like the Poro of the *Mende and most *Dan-Ngere tribes, controls supernatural power and the training and initiation of adolescent males. Among the cult objects of the Lo are large wooden figures (*deble*), which are thumped on the ground in unison by Lo members at funerary and other rites. Also at funerary rites Lo chiefs appear at night wearing *degele* (wooden helmets each surmounted by a human figure). Another Lo cult object is the *porgaga* (a large wooden hornbill). Lo society members also appear at funerary and

other festivals wearing masks of which there are two main categories: *wabele* – grotesque helmet masks in the form of horned animals, which portray violent bush spirits; and *kpelie* – oval face masks (surrounded by geometric ornament) which portray dead persons during their funerary rites. Senufo metal-work includes small wrought-iron and cast-brass figures. The Diula, another tribe in northern Ivory Coast, have *kpelie* masks in cast brass.

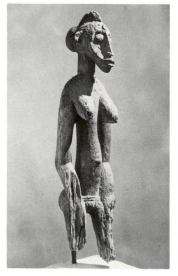

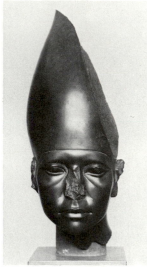

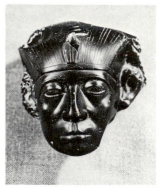

Above left: SENUFO Figure from a ceremonial pestle, Korhogo district, Ivory Coast. Wood. h. 37½ in (95 cm). Rietberg Museum, Zürich
Above right: SENWOSRET III, head of. 12th dynasty. Obsidian. h. 4¾ in (13 cm). Gulbenkian Foundation, Lisbon

Left: (SENWOSRET III) Head of Amenemhet III. 12th dynasty. Schist. h. 18½ in (46 cm). Ny Carlsberg Glypothek, Copenhagen

SENWOSRET III (Sesostris)

Egyptian king of the 12th dynasty, renowned for his military exploits. Among the royal sculptures of the period, those of Senwosret III and of his successor Amenemhet III are outstanding both in their execution and in their approach to individual portraiture. The characteristic features of the two kings are often reflected in an idealised form in private statuary.

SEPIA

Purple-brown ink made from the fluid secreted by cuttlefish. Used for pen and wash sketches.

SEPIK RIVER

In terms of quantity and sculptural virtuosity this is the richest of the art-producing areas of *New Guinea. It takes in the coast on both sides of the river-mouth, the areas bordering on both banks, and its tributaries. Throughout the area huge club-houses were built and adorned with carved house-posts, ancestor sculptures and painted bark façades and in which was stored equipment used in spectacular ceremonies of initiation into men's secret societies. A broad division can be drawn between styles of the Lower, Middle and Upper Sepik. Art from the last-named region is limited to relief carving on shields, house-boards and utensils; a typical style is that of the Telefolmin valley. Lower Sepik and Ramu delta styles are characterised by masks and figures of which the noses are

excessively long, reaching in some cases to a penis which continues the prolongation. Masks may be lavishly decorated with clay, shells, hair and feathers. Middle Sepik art is complicated by a profusion of tribal groups initiating and exchanging style elements. The Iatmul are the largest group in the area. Their men's houses were the greatest in New Guinea and all ceremonies involved the use of masks and figures in wood and basketry. Surrounding styles received influences from the Middle Sepik. The Washkuk practised a yam cult for which carvings were made by head-hunters to be shown to young initiates. The Abelam of the Maprik Hills produced polychrome figures, boards, bark hangings and basketry masks for their clan spirits. In carvings from the Upper Karawari River the human body is reduced to a series of hooks.

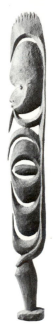

Left: SEPIK RIVER Karawari River hook figure. Recent date. Wood. h. 45 in (114 cm). City of Liverpool Museums
Centre: SEPIK RIVER Roof finial from Middle Sepik area. Recent date. Wood. h. 26 in (66 cm). City of Liverpool Museums
Right: SEPIK RIVER Face Mask from Lower Sepik area. Recent date. Wood, shell, tusks, fibre. h. 18 in (45·7 cm). City of Liverpool Museums

SEPTIMIUS SEVERUS, Arches of *see* LEPTIS MAGNA, ROME

SERBIAN ART

Like *Bulgaria, Serbia (now southern Yugoslavia) was in the Middle Ages an artistic centre within the Byzantine world. Major churches were painted by Byzantines, eg St Sophia at *Ohrid and St Panteleimon at *Nerezi, but the Serbian kings were the main patrons of art in the Balkans (1196–1459). In the first half of the 13th century, Serbia was the wealthiest East European state, and the frescoes of Studenica, Milesevo and Sopocani are the best representatives of the development of Byzantine art into the 'volume' style of the Palaeologan period which took place during the Latin occupation of Constantinople. While this new style is seen to develop on Serbian soil, it is the work of Byzantines and found independently at *Trebizond; it is not a national school. Local and immigrant artists continued to work in Serbia in the 14th-15th centuries.

SERIGRAPHY

Silk-screen printing. A stencil is made by stretching thin silk or muslin over a wooden frame and by making appropriate areas solid with paint, with cut-out paper or by a photographic process. The stencil is placed on the surface to be printed and printing-ink is forced through open areas of the screen by

means of a squeegee. Very fine detail and texture can be transferred by the photographic screen process.

SERIGRAPHY

SERODINE, Giovanni (1600–30)

b. Ascona d. Rome. Italian painter; arrived in Rome (c. 1615), and was attracted by *Caravaggio's work. His use of colour and handling of paint distinguishes him. His *St Peter in Prison* (1629, Rancate) shows an almost *Rembrandtesque impasto.

SEROV, Valentin Alexandrovich (1865–1911)

b. St Petersburg d. Moscow. Russian painter, a student of *Repin, who trained at *Abramtsevo. A member of the *World of Art movement, he became Professor at the Moscow School of Art. Known chiefly as a fashionable portraitist, but also as a landscape painter and theatre-designer.

SERPOTTA, Giacomo (1656–1732)

b. d. Palermo. Sicilian sculptor. Possibly trained in Rome, his work is highly decorative, reflecting the influence of theatre art; it can be seen in the Oratories of S. Zita (1687–1717), S. Lorenzo (1706–8) and S. Domenico (1720), all in Palermo, where the all-white figures and *putti suggest a vernacular version of *Duquesnoy's style.

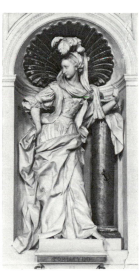

Top right: PAUL SERUSIER *Breton Women at Le Pouldu.* 1892. 23×27⅝ in (57×70 cm). Josefowitz Coll, Switzerland
Right: VICTOR SERVRANCKX *Opus 47.* 1923. Musées Royaux, Brussels

Left: GIACOMO SERPOTTA *Fortitude.* 1720. Oratorio di S. Domenico, Palermo

SERRA, Jaime (d. c. 1399)
Pedro (d. 1404/9)

Catalan painters active at the Aragonese court during the latter part of the 14th century. An altarpiece in the Saragossa Museum (1361) is definitely by Jaime and other polyptychs and altarpieces are ascribed to the brothers. Their work shows *Sienese influence which probably reached them via the papal court at *Avignon.

SERUSIER, Paul (1863–1927)

b. Paris d. Morlaix. French painter and theorist in close contact with *Gauguin and the School of *Pont-Aven (from 1888), whose *Synthetist theories he took back to other students in Paris at the Académie Julian. Became increasingly interested in mystic art. He met Jan *Verkade (1891) and became a Theosophist. As a member of the *Nabi group he collaborated on designs for the theatre. With Verkade's encouragement and that of Père Didier of the School of Religious Art at Beuron

Monastery, he produced a series of hieratic and mathematic paintings. In later life he retired to Brittany where he was interested in the pictorial forms of medieval *Celtic tapestry.

SERVRANCKX, Victor (1897–1965)

b. Dieghem. Painter who studied at the Brussels Academy (1912–17) and became the first Belgian abstractionist. He joined *L'Effort Moderne in Paris achieving international fame in the 1920s. He produced powerful abstractions based at first on the *Futurist machine aesthetic, progressing with a certain slickness towards *Purism and *Neo-Plasticism.

SESSHU *Landscape in Cursive style.* Hanging scroll. Ink on paper. Entire scroll 58¾×12⅞ in (149×32·7 cm). Tokyo National Museum

SESSHU (Tōyō Sesshū) (1420–1506)

Perhaps the greatest name in Japanese painting, he was an early pupil of *Shūbun. Already established as a painter, he visited China (1467–9) and won a considerable reputation there, virtually becoming a painter of the *Chê School. His landscapes

in ink have a power lacking in earlier Japanese work. He was famous for his *haboku* (splashed ink) cursive-style paintings.

SESSHU 'Ama-no-hashidate'. Early 16th century. Hanging scroll. Ink and colour on paper. 66½×35½ in (163×90·2 cm). Kyōto National Museum

SESSON (Shūkei Sesson) (*c.* 1504–*c.* 1587)

Japanese painter who worked in the broad monochrome manner of *Sesshū, but never studied directly under a great master as he lived all his life in the north of Japan.

SETY I (Sethos)

Egyptian king of the 19th dynasty, three of whose principal monuments – his *Abydos temple, his mortuary temple at Qurna (*Thebes), and his tomb in the *Valley of the Kings – are notable for the exceptional quality of their reliefs. The close similarity in the style and execution of the delicate low relief suggests that the work was carried out by the same craftsmen. Some details of painting, such as the treatment of linen drapery, are found again in the tomb of Queen *Nofretiri.

SEURAT, Georges Pierre (1859–91)

b. d. Paris. French artist and the pioneer and chief exponent of *Pointillism. He studied under Lehmann whose *Ingresque approach influenced his attitude to design. The †Impressionists' colour and technique he adopted in small oil sketches, but with greater method. In his short career of little over a decade he painted six large important figure compositions with modern-life subjects, and some smaller coast scenes. In their preparation he made many fine preliminary conté-crayon drawings, and oil studies, a method alien to the spontaneous approach of the Impressionists. In *La Grande Jatte* (1886) he fully developed Divisionism or Pointillism, in which pure colours are applied in small strokes side by side and intended to mix optically. In his later compositions, *Le Chahut* and *Le Cirque* Seurat sought to embody the aesthetic ideas of Charles Henry regarding the expressive value of colours and lines, and the colour theories of *Chevreul and Rood.

SEVERE STYLE

A style of Greek sculpture (*c.* 480–450 BC) which succeeded the *Archaic style. Poses became stiffer; the Archaic 'smile' was replaced by a more serious expression; forms were simplified; severe Doric clothes became more fashionable and there was an attempt to show the body underneath. There was also interest in showing movement and physical expression. *See also* AEGINA, TEMPLE OF APHAIA; DELPHIC CHARIOTEER; KRITIAN BOY; LUDOVISI THRONE; OLYMPIA, TEMPLE OF ZEUS; TYRANNICIDE GROUP

SEVERINI Gino (1883–1966)

b. Cortona d. Paris. Italian painter who, with *Boccioni studied under *Balla (1900). After several exhibitions in Italy he left for Paris (1906); signed *Marinetti's *Futurist Manifesto (1910). In his work Severini agitated the *Cubist form to suggest the dynamism of modern life, dislocated fragments of reality evolving in a jerky synthesis. His later mosaics, frescoes and paintings attained a more classical quietism influenced by his friend Juan *Gris.

SFUMATO

Italian word used to describe the subtle blending of formal outlines to produce the illusion of atmospheric thickening. The edges appear hazy and indefinite. By destroying the boundaries of forms the three-dimensional illusion can be enhanced under certain conditions of the use of subdued tone and colour.

SGRAFFITO *see* GRAFFITO

SHADBOLT, Jack Leonard (1909–)

b. Essex. Painter who grew up in Victoria, influenced by *Carr; studied with *Pasmore and *Coldstream (London), *Lhote (Paris), and at *Art Students' League; taught at Vancouver Art School. An influential teacher and versatile artist, Shadbolt has absorbed several influences, varying his work from grotesque *Surrealism to gay, *Klee-like whimsicality.

SHAHJAHAN (1628–58)

This *Mughal emperor is distinguished as the patron of magnificent building (Delhi Fort, additions to Agra and Lahore Forts, the Taj Mahal). He also continued to encourage in painting the high standards of his father, *Jahangir, especially in portraiture and in court scenes; but there were now more genre scenes, including studies of the common people, and groups of holy men and dervishes were popular. In his reign the technique of *siyah qalam* (Persian: 'black pen'), low-key line-drawing lightly gilded, was developed. Increasing stiffness and conventionalism led to a decline in the 1650s.

SHAHN, Ben (1898–1969)

b. Kaunas, Lithuania d. New York. Painter who emigrated to America (1906); was apprenticed to lithographer (1913); studied at National Academy of Design (1922); travelled in Europe and North Africa (1925, 1927–9); did murals for WPA; taught extensively. From the bitter satire of his Sacco-Vanzetti gouaches to his later, more mystical allegories, Shahn employed masterful draughtsmanship and a monumental sense of design to communicate deep compassion for the persecuted, lonely and oppressed, becoming the leader of America's socially committed artists.

SHAH-NAMA

The 'Book of Kings' originally written in 1009/10 by the famous poet Firdausi (Firdusi), it tells the history of Persia, both factual and mythical, relating the births and deaths, battles and loves of such heroes as Bahram Gur, Rustam and Zal. The most famous copy of this work is the *Demotte manuscript. Shah-nama illustrations represent the peak of achievement in Persian Islamic painting.

SHAIVA

Sanskrit: literally 'pertaining to *Shiva'.

SHAKTI

Literally 'power', 'energy'; the goddess who represents the growing, exuberant aspect of existence; central deity of tantric (*Tantra) religion.

SHAMI, Statue from

In the ruins of a Parthian temple at Shami in the mountains bordering ancient Elam a number of sculptures were found including a male figure in bronze, standing six feet four inches tall, probably dating to the 1st or 2nd century AD. The frontal pose and the firm rigidity of the statue are typical of *Parthian art.

SHANG DYNASTY STONE SCULPTURE

Small limestone sculptures have been excavated from tombs at Anyang in Honan province, China, capital of the Shang

dynasty (13th–11th century BC). Rather angular and block-shaped animals with cursory limbs and features following the shape of the original boulders form the main type. Their surface is often enhanced with linear designs derived from the decoration found on bronze vessels of the same period.

SHANNON, Charles *see* **RICKETTS, Charles**

SHARAKU (Tokushai Sharaku) (active 1794–5)

Japanese printmaker, one of the greatest mysteries of *Ukiyo-e. All his 160-odd prints were produced during a period of ten months, and almost nothing is known of the man. He specialised in Kabuki portraits and is particularly celebrated for his dramatic 'large heads'. His work was too satirical for contemporary taste, but he is now regarded as one of the greatest of the Ukiyo-e artists and the culminating point in actor-print designing.

SHEE, Sir Martin Archer (1769–1850)

b. Dublin d. Brighton. After studying art in Dublin he continued at the Royal Academy Schools in London. Although overshadowed by *Lawrence he acquired a high reputation as a portrait painter and became President of the Royal Academy after Lawrence's death. He published *Rhymes on Art* (1805) and *Elements of Art* (1809).

SHEELER, Charles R. Jr (1883–1965)

b. Philadelphia. Painter who studied with *Chase at Pennsylvania Academy; visited France and Italy (1909); exhibited at *Armory Show (1913); worked as photographer; lived in New York. Influenced by *Cézanne and *Cubism, Sheeler delineated the fundamental structure of barns and skyscrapers with *Precisionist clarity; this rational severity warmed in later landscapes.

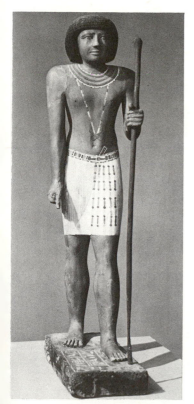

(SHEIKH EL-BELED) Statue of Methethy. Late 5th dynasty. Wood painted over plaster. h. 35 in (89 cm). Brooklyn Museum, NY

SHEIKH EL-BELED

Egyptian statue of an official of the 5th dynasty, so called by the workmen who found it because it resembled their village headman. It is one of the best examples of wooden sculpture from Egypt, though lacking its former finish of gesso and paint,

the effect of which may be judged from the later figure of Methethy.

SHEN Chou (1427–1509)

Chinese painter from Soochow, Kiangsu. From a distinguished family of scholars and officials, he chose to live in retirement instead of pursuing a career in government. He devoted his life to the arts, as had done the *Four hermit masters of late Yüan, whose painting styles he also followed, preferring in later life that of *Wu Chên. His calligraphy was modelled on that of *Huang T'ing-chien. Shên Chou was the leading master of the Wu (Soochow) school of scholar-painters in the *Ming; his principal follower was *Wên Cheng-ming.

SHEN Ch'üan (active *c.* 1725–80)

From Wu-hsing, Chekiang. Successful Chinese painter of animals, flowers and birds executed in a detailed and colourful manner. He was chiefly appreciated in Japan, where he spent three years (1731–3).

SHERBRO

The people of Sherbro Island and the adjacent coastal area of south-west Sierra Leone, but inhabiting a more extensive area before the arrival of the *Mende about the 16th century. They were almost certainly responsible for the soapstone *nomoli figures, and for most of the *Afro-Portuguese ivories. A 16th-century Portuguese travel writer praised the Sherbro Islanders for their skill in carving ivory salt-cellars, spoons and forks, etc. At the present day Sherbro sculpture is very similar to that of the Mende.

SHIH-T'AO *see* **TAO-CHI**

SHIELDS, Frederick James (1833–1911)

b. Hartlepool d. Wimbledon. English painter who first won fame as an illustrator to an edition of Defoe's *Journal of the Plague Year* (1862). Madox *Brown encouraged him in the direction of monumental painting. His most ambitious work was the Bayswater Road Chapel decorations (1889–1909) which show the influence of *Rossetti and *Watts.

SHIGEMASA (Kitao Shigemasa) (1739–1820)

Japanese printmaker most famous for his *Ukiyo-e prints of geisha, including a book published in collaboration with *Shunshō. His girls have a delicate solidity that seems intermediate between the fragile girls of *Harunobu and the robust women of *Kiyonaga.

SHIJO SCHOOL

The Shijō School was started by Matsumura *Goshun as an offshoot of the *Maruyama. *Okyo's realism was streamlined and softened to produce an almost formulated style that was immediately popular and continued for a long period. Followers include *Keibun, Goshun's brother, *Bumpō and *Baiitsu. Many artists produced printed books in the style, where the skill of the woodblock printing is unmatched, even perhaps in *Ukiyo-e: among these were *Gesshō and *Suiseki, and many were at their best in brief sketches, eg *Chinnen, *Nanrei. The style continued to have an influence and followers throughout the *Meiji period and later, an altered form of Shijō being the father of the so-called 'Japanese style' (*Meiji Period and Later). The style was also used for decorative effect in the minor arts, and particularly in lacquer by Shibata *Zeshin, and continues to leave a faint shadow on most Japanese decorative arts.

SHIKASTA NASTA'LIQ

The last stage in the development of Islamic calligraphy; was introduced in Iran about the 17th century. The letters are usually connected, so are the diacritical dots and vowel signs. It was first used for writing documents and letters and later for the writing of Persian literature.

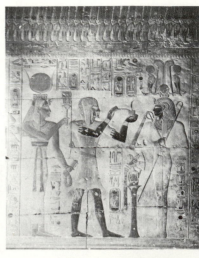

Above left: BEN SHAHN
The Passion of Sacco and Vanzetti. 1931–2. 84½×48 in (22·4×14 cm) Whitney Museum of American Art
Above: GEORGES SEURAT
Sunday Afternoon on the Island of La Grande Jatte. 1884–6. 81×120⅜ in (205·7×305·7 cm). Art Institute of Chicago, Helen Birch Bartlett Foundation
Far left: SHAH-NAMA
Bahram Gur slays a wolf. c. 1380. 16¼×11¾ in (14·3×29·8 cm). Fogg Art Museum, Cambridge, Mass
Near left: SHAHJAHAN
Shahjahan riding with his son, Dara Shikoh by Govardhan. 1630. 9×5½ in (23×14 cm). V & A, London

Top left: SESSON *Wind and Waves.* Ink on paper. 8¾×12¼ in (22×31·5 cm). Tokyo National Museum
Top centre: GEORGES SEURAT *Le Chahut.* 1890. 67½×55¼ in (171·5×140·5 cm). Kröller-Müller Museum
Top right: SETY I Relief from his temple at Abydos: the Goddess Isis and the Priest Jun-Mutef before Sethos-Osiris. 19th dynasty. Limestone carved in low relief and painted. About life-size

Right: GINO SEVERINI *Dynamic Hieroglyphic of the Bal Tabarin.* 1912. Oil on canvas with sequins. 63⅝×61½ in (162×156 cm). MOMA, New York

Top row left: GINO SEVERINI *Suburban Train Arriving at Paris.*
1915. $34\frac{7}{8} \times 45\frac{1}{2}$ in (86·6×115·8 cm). Tate
Top row right: CHARLES SHEELER *Midwest.* 1954. 18×32 in
(45·7×81·3 cm). Walker Art Center, Minneapolis
Above left: SHEN CHOU *Autumn Colours among Streams and
Mountains.* Detail of landscape in the style of Ni Tsan.
Handscroll. Ink on paper. Entire scroll $7\frac{3}{4}$ in×21 ft
(19·8 × 640·2 cm). Mr and Mrs Earle Morse Coll, New York
Above right: MARTIN ARCHER SHEE *The Infant Bacchus.*
Before 1824. $27\frac{3}{4} \times 35\frac{5}{8}$ in (70·5×90·5 cm). Tate

Left: SHANG DYNASTY
Stone buffalo. l. $7\frac{1}{2}$ in
(19·2 cm). BM, London
Below centre: SHARAKU
*Otani Oniji as Edohei the
Manservant.* Woodblock
print. Oban, approx 14×10 in
(35·6×25·4 cm). BM, London
Below: SHIKASTA
NASTA'LIQ Script by Abd
al Madjid Taleqani. 18th
century. Imperial Library,
Teheran

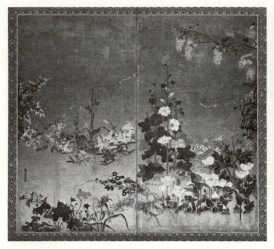

Left: SHIKO *Flowers, lilies, hollyhocks, poppies* etc., Signature and seal. Colour and gold on paper. Two-fold screen, overall $69\frac{3}{8} \times 75\frac{1}{4}$ in (1·72×1·87 m). Freer Gallery of Art, Washington
Centre: SHINGON SCULPTURE Bonten. Heian period, 9th century AD. Wood. h. 3 ft $5\frac{3}{4}$ in (1·06 m). Kyōōgokokuji, Kyōto

Right: SHINTO SCULPTURE Hachiman as a Buddhist priest by Kakei. Kamakura period, 1201 AD. Wood. h. $34\frac{1}{2}$ in (87 cm). Tōdaiji, Nara

SHIKO (Watanabe Shikō) (1683–1755)

Japanese painter who, after a training in the *Kanō style was much influenced by the work of *Kōrin. However his works often possess a realism that sets them apart from the *Rimpa and somewhat anticipate the *Maruyama and *Shijō Schools. *Okyo copied some of his work.

SHINGON SCULPTURE

The Shingon sect of Buddhism, transmitted from China to Japan, was first established there by Kōbō Daishi at the *Kyōōgokokuji (AD 823). This creed considered Dainichi Nyorai as the main Buddha of whose supreme being all other Buddhas, Bodhisattvas and spirits were manifestations. The sect had two important influences on the sculptural style of the *Heian period. Its large pantheon of spiritual beings, each denoted by symbols and attributes, greatly increased the iconographic repertory. However, this in its turn led to more concentration on the symbolic attributes of the deity with less concern for emotional force and realistic form than had been evident in the preceding *Nara period. Shingon sculptures such as the *Bonten* in the *Kyōōgokokuji thus came to have a rather mannered appearance.

SHINN, Everett (1876–1953)

b. Woodstown, New Jersey d. New York. Painter who studied at Pennsylvania Academy; worked in Paris and London; settled in New York (*c.* 1900); taught at *Art Students' League (1906–7); exhibited with The *Eight (1908). Influenced by *Henri and *Degas, Shinn painted the theatre, its gaudy light and gaiety, with affection and realism.

SHINTO SCULPTURE

In Shintōism, the native Japanese religion, deities were originally regarded as too mysterious to portray, and were usually denoted by paper symbols. However with the association of some Shintō shrines with Buddhist temples as in the *Yakushiji, Shintō images were created in the Buddhist tradition during the *Heian period. Many Shintō images can be compared with the portrait sculptures of Buddhist priests and patriarchs. Thus in the *Yakushiji are portraits of the god of war Hachiman shown as a priest, and an imaginary portrait of the Empress Jingō. These Heian figures are usually rather static and great play is made with the weighty robes which envelop the figure like a barrier between them and the world. Characteristic of the more realistic quality of the *Kamakura period is the figure of Hachiman in the *Tōdaiji. *See also* JAPANESE PORTRAIT SCULPTURE

SHIRAZ SCHOOL (early to mid 15th century; 16th century)

Painting in Shiraz falls into two periods; the first under the Timurids when the style is close to that of the *Herat School and a more isolated, independent style in *Safavid times. During the first phase certain local differences can be observed; there are fewer but larger figures than at Herat, elongated and expressionless, in compositions with a decorative, high horizon with little vegetation except rocks in unnatural colours and forms. The drawing is bold with a subdued palette of technically inferior pigments to those of Herat, as seen to perfection in the Bodleian *Shah-nama* (1420–30). Lapsing with the Turkoman invasions under Shah Ismail of the Safavid dynasty the style became simpler and more primitive, employing stronger colours, with the action depicted in the lower area of the painted illustration. At best Safavid Shiraz produced work which matched that of *Tabriz, but towards the end of the 16th century the painting became repetitive and merely decorative.

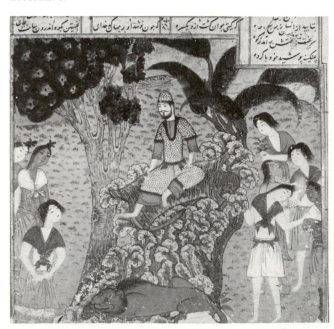

SHIRAZ SCHOOL *Guyumars, the First King.* From a Shah-nama copied for Ibrahim Sultan Shah Rukh. 1420–30. Bodleian Library, Oxford

SHIVA

Hindu god, derived from *vedic sources, in which as Rudra he is an object of fear; associated with the *linga of which he was later seen as the anthropomorphic manifestation; especially in South India is known as Nataraja (Sanskrit: 'lord of the dance'), Shiva being as cult deity (among other things) the supreme teacher of the arts, including the dance; also the destroyer who dissolves the universe at the end of its allotted span; with *Vishnu and the many forms of the goddess (*Shakti), is the most popular cult deity in Hinduism; as focus of cult devotion, may assume the functions of *Brahma and *Vishnu; cognisance is the bull Nandi; principal attributes in North India are the trident and cobra, in South India the axe and deer; consort *Parvati.

SHOHAKU (Soga Shōhaku) (1730–81)

Regarded as one of the eccentrics of Japanese painting. His early *Kano training formed the basis of his vigorous and personal use of ink, but many dubious works are attributed to him.

Top: SHOHAKU *Four Sages of Mount Shozan.* 18th century. Six-fold screen. Ink on paper. Each panel 5 ft 1⅜ in × 1 ft 11⅝ in (156 × 60 cm). Fenollosa-Weld Coll, Boston
Left: SHUBUN *Landscape.* Mid-15th century. Hanging scroll. Ink on paper. 35 × 13 in (89 × 33 cm) Seattle Art Museum, Eugene Fuller Memorial Coll
Right: SHUNEI *Nakamura Noshio II.* Mr and Mrs Richard Gale Coll, Minnesota

SHOKADO (Shōjō Shōkadō) (1584–1639)

Japanese painter-monk of great originality and verve. His ink-paintings are extremely bold and in a highly personal style.

SHOSO-IN

The Shoso-in was built to house the treasures of the Japanese Emperor Shomu, given to the Todaiji Temple by his widow (756). Many of the articles are still there and while a number may be the work either of Chinese or Japanese craftsmen, they were mostly made in Japan. The paintings are in the *T'ang style and include a screen painted with court ladies, on whose dresses were originally applied feathers. Other articles include musical instruments with leather panels painted with landscapes in oil and ink monochrome paintings on hemp cloth. These examples give one a good view of the early Chinese basis of Japanese art that was to flourish from the 10th century onwards.

SHRIRANGAM *see* VIJAYANAGARA SCULPTURE

SHUBUN (Tenshō Shūbun) (2nd half 15th century)

A monk at Shōkoku-ji, Kyōto, he was influenced by his fellow monk, *Josetsu. He made a trip to Korea (1423–4). No authentic work of his survives, but he is nevertheless considered one of the greatest of all Japanese painters, and a pioneer of the Ashikaga monochrome paintings of Southern Sung inspiration.

SHUNCHO (Katsukawa Shunchō) (active last quarter 18th century)

Japanese painter, at first a pupil of *Shunshō, he later followed *Kiyonaga.

SHUNEI (Katsukawa Shunei) (1762–1819)

Japanese painter, a pupil of *Shunshō, famous for actor prints and for his invention of the so-called 'large head' or bust portrait. His dramatic presentation anticipates that of *Sharaku and *Toyokuni.

SHUNGA AND KANVA DYNASTIES (c. 184 BC–AD 17)

The Emperor Brihadratha, last of the imperial line founded in India by Chandragupta, was assassinated (c. 184 BC) by Pushyamitra Shunga. The Shungas reinstated the *Vedic religious pomp of royalty, which entailed an eclipse of the Ashokan Buddhist ethic in favour of Brahmanic ritualism. After only three generations of military rule, the priest caste had grown sufficiently powerful to usurp the throne and the Kanva Brahmins murdered their Shunga king (28 BC). The reign of the priests, however, endured a mere forty-five years. Buddhism as a religion and motive force in the creative arts had by this time gathered momentum and the Shunga-Kanva period marks merely the beginning of the efflorescence of Buddhist art in India; but the gods of the post-Vedic priesthood are also seen emerging in the sculpture and beginning to develop an iconology of their own. These images, minor though they are in the Buddhist scheme, represent the birth of the Hindu pantheon. It is to the popularity of the heterodox sects, and especially to Buddhism, that the monumental art of the Shunga-Kanva period owes its sudden development. At this time the Buddha was represented only by symbols, but the characters of Buddhist parable, deities and spirits all figured prominently in the densely foliated reliefs which enclosed the sacred places of Buddhism. The Buddha himself not being tangibly represented, a hemispherical cairn or *stupa was erected instead, heaped up and bricked over, containing at its core a relic said to be part of the body of the Buddha or one of his disciples. The most famous remaining structure of the Shunga period is the massive stone railing, made in imitation of split-log prototypes, which enclosed a stupa at Bharhut. Carved on the uprights are life-sized figures of *yakshas and gods, all part of a codified folk-belief system. Scenes from the *Jatakas, stories of the Buddha's previous incarnations, similarly bear inscriptions so that the incidents portrayed can be traced to their literary sources in the Pali scriptures. Such compositions represent the presence of the Buddha by means of a tree (*bodhi-druma*, the tree of knowledge) and a parasol – traditional sign of royalty or great sanctity – beneath which stands a throne or altar, unoccupied, and sometimes the footprints of

the invisible Buddha. The tree was an object of veneration in its own right. Indwelling tree-spirits (*vrikshakas*) appear frequently in the art of this period, sometimes as an anthropomorphic figure – particularly the voluptuous sprites swinging from one of the branches – and sometimes portrayed merely as an arm emerging from a clump of trees. The apotheosis of the tree is represented by a stone *kalpavriksha* or tree of plenty, from Besnagar, which is of the height of a man; it is fenced off, as is the stupa, and beneath its branches lie the treasures of both land and ocean. The stone railing from Bodhgaya exhibits sculptures of more refinement than those at Bharhut, and may be assigned to the Kanva period.

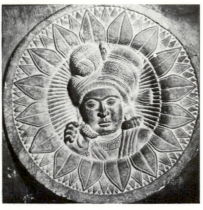
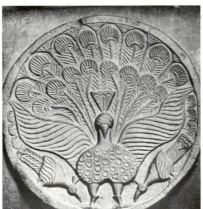

Above left: SHUNGA DYNASTY *Tree-goddess.* From Bharhut. 2nd century. Sandstone. h. 84½ in (214 cm). National Museum, New Delhi
Top right: SHUNGA DYNASTY *Royal Portrait* (?) From Bharut. 2nd century. Medallion on sandstone railing. d. approx. 24 in (61 cm). Indian Museum, Calcutta
Above right: SHUNGA DYNASTY *Peacock.* From Bharut. 2nd century. Medallion on sandstone railing. d. approx. 12 in (30·5 cm). Indian Museum, Calcutta

SHUNKO (Katsukawa Shunkō) (1743–1812)

Japanese painter, a faithful pupil of *Shunshō.

SHUNRO

The first art-name of *Hokusai.

SHUNSHO (Katsukawa Shunshō) (1726–92)

Japanese painter and printmaker, the first to inject *Harunobu's relaxed realism into Kabuki portraiture. He was celebrated in his lifetime both for actor prints and paintings. His style superseded the bombastic early Torii style (*Kiyonobu) in favour of a more real theatrical approach. He was very influential on subsequent *Ukiyo-e artists and had many famous pupils.

SHVETAMBARA (SHVETA+AMBARA)

Sanskrit: literally 'white-clothed'; name of one sect of *Jainas; the other, Dig-ambara, literally 'space-clothed', is an order the adherents of which go naked.

SIBERECHTS, Jan (1627–1700/3)

b. Antwerp d. London. Flemish landscapist; after an early stay in Rome, he became a master in Antwerp (1648/9), and settled in England (1672/4). Most of his landscapes are *Rubensian in manner. He also painted views of English country houses, including Longleat.

SICCATIVE

Substances added to *oil paint to speed up drying. They can cause the surface to dry more quickly than the underlayers, thus *cracking the surface. Also they may darken a picture very much with age.

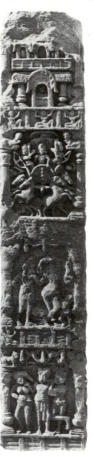

Left: SHUNGA-KANVA DYNASTY *Sandstone pillar from Bodhgaya. c.* 100 BC. h. (of each panel) approx. 12 in (30·5 cm).
Right: SHUNSHO *Actor.* Woodblock colour print. 12×5¾ in (30·5×14·5 cm). Ashmolean

SICKERT, Walter Richard (1860–1942)

b. Munich d. Bathampton, Somerset. English painter of figure compositions and urban scenes; etcher, writer and art critic. Studied at the Slade School of Art and under *Whistler; visited Paris (1883) meeting *Degas. His early work is sombre in colour and often cynical in treating music-hall scenes and sordid interiors. From about 1927 he relied increasingly upon photographs and Victorian engravings for pictorial themes, working in much brighter tones. A colourful personality, he influenced younger artists such as the *Camden Town group. At one stage he appeared as the champion of modernism when equivalent to †Impressionism; *Post-Impressionism rather left him behind.

SIDDHESHVARI

Sanskrit: literally 'lady of success'. A minor *tantric fertility goddess. An aspect of *Shakti, she is probably the consort of one of the Bhairavas who are ferocious aspects of *Shiva.

SIENESE PAINTING *Virgin and Child with Saints* possibly by Guido da Siena. 13th century. Pinacoteca, Siena

SIENESE PAINTING

In spite of the Florentine influence of *Coppo di Marcovaldo, *Cimabue and *Giotto, Siena, a political rival of Florence, remained artistically distinct. *Guido da Siena, *Duccio and Simone *Martini developed Sienese use of colour and linear arabesques. Simone both imported French †Gothic ideas into Italy and exported Sienese ideas to Europe through *Avignon. New subject-matter and subtleties of spatial construction were tackled by the *Lorenzetti. A new harshness, after the Black Death, can be seen in the work of Barna da Siena and *Bartolo di Fredi, but generally after the Lorenzetti, Sienese painters such as *Taddeo di Bartolo, *Sano di Pietro or *Sassetta draw on earlier Sienese achievements. The traditional contrast of the sculptural qualities of Florentine painting and the Sienese preference for colouristic and decorative effects is not without substance. Republican Siena is also comparatively rich in secular and civic painting.

SIGIRIYA *see* CEYLON

Top right: PAUL SIGNAC *Boats at St Tropez. c.* 1895. 7¾×11 in (19·7×27·9 cm). Courtauld Institute Galleries, London
Right: LUCA SIGNORELLI *Flagellation.* 35⅝×33⅛ in (60×84 cm). Brera

Left: WALTER SICKERT *The Old Bedford. c.* 1890. 50×30½ in (127×76·2 cm). NG, Canada, Gift of the Massey Coll 1946

SIGNAC, Paul (1863–1935)

b. d. Paris. French painter who had no formal art training but became a full-time artist (1882) basing his style on the †Impressionists, especially *Monet. He met *Seurat (1884) and by 1886, when he exhibited at the eighth and last Impressionist exhibition, he had adopted Seurat's *Pointillism. He was an important link between artists and the *Symbolist writers *Fénéon, Kahn, Alexis, etc who met together at his studio. He was also in close touch with the Belgian Neo-Impressionists. He shared Seurat's interests in the theoretical

ideas of Charles Henry and contributed diagrams to his books. Signac became the publicist of Neo-Impressionism and his book *D'Eugène Delacroix au Néo-Impressionisme* (1898–9) was the central theoretical document of the movement. His carefully constructed paintings are of marines and seaports and he produced vigorous watercolours. He worked frequently at his villa at Saint-Tropez (from 1892) which became an important rendezvous for *Cross, *Marquet, *Matisse, etc.

SIGNORELLI, Luca (c. 1441/50–1523)

b. d. Cortona. Umbrian painter, probably the pupil of *Piero della Francesca; influenced by *Pollaiuolo, *Botticelli and *Leonardo. Worked in Florence, Siena, Loreto and Perugia. His study of anatomy and antiquity resulted in a powerful representation of the nude both in violent action and repose, eg the *Triumph of Pan* (destroyed), the *Flagellation* (Brera) and above all his masterpiece the *Last Judgement* frescoes (1499–1502, Orvieto Cathedral) which reflect with deep emotional disquiet the fears of Hell, the coming of anti-Christ and the end of the world.

TELEMACO SIGNORINI *Settignano*. Galleria d'Arte Moderna, Florence

SIGNORINI, Telemaco (1835–1901)

b. d. Florence. Italian painter and engraver, a member of the *Macchiaioli. He travelled in France, England and Scotland. He painted the ghettoes of Florence, prison scenes and the streets of London and Edinburgh. His style is characterised by a naïve and bright colour.

SILANION (active 328 BC)

Greek sculptor of Athens whose sculpture of Plato, erected in the Academy by Mithridates the Persian, was the original from which many busts were taken.

SILVER POINT

Drawing with a silver point on specially prepared paper. The silver leaves a grey indelible line.

SILVESTRE, Israel (1621–91)

b. Nancy d. Paris. French etcher of a family of etchers and artists. His architectural records, in Rome and Florence as well as Paris, contain invaluable historical information, but his work is also intrinsically attractive. He was the Dauphin's drawing master.

SIMONE MARTINI *see* MARTINI

SIM Sa-jŏng (Hyŏnjae) (1706–70)

Korean landscape painter, the greatest pupil of *Chong Son. Famous are his *River Scene by Night* and *Rainy Landscape*. His autumn pictures with reddish-brown leaves and berries, and insects and birds judiciously placed within the composition were particularly popular.

SINGASARI, Java (13th century)

Capital of an East Javanese kingdom (AD 1222–92). Much very fine statuary has been found in the neighbourhood, some of the best pieces being removed to Leiden in the 19th century. A figure of the Buddhist goddess of transcendental wisdom, Prajnaparamita, is considered by some to be a portrait of Ken Dedes, wife of the dynasty's founder. A Chakra-chakra Bhairava confirms textual accounts of this being a *tantric centre; a *Ganesha and a magnificent statue of *Durga *Mahishamardini slaying the buffalo-demon are all in Leiden. Another style of portrait statue is to be seen in the *Shiva figure, believed to be from Candi Kidal which shows King

Anushapati in his posthumous form: the hand gesture is characteristic of such statues. The same temple has a fine relief of *Garuda bringing the sacred Amritan nectar to ransom his mother from the *Nagas. A holy-water vessel in bronze from Kediri is in the same manner. One of the memorial temples of the last king of Singasari, Kertanagara, appears to have been dedicated to a Shiva-Buddha cult: the reliefs, naturalistic in manner, have not been identified. They should be compared with the rather later panels from *Djago. A feature of the Singasari site is the existence of two giant guardian figures in stone which are almost four metres high.

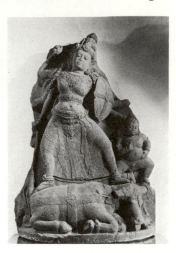

Left: SIM SA-JONG *Tiger.* Hanging scroll. Ink and colour on paper. $37\frac{7}{8} \times 21\frac{3}{4}$ in (96×55 cm). National Museum of Korea
Right: SINGASARI Durga Mahishamardini. 13th century. Volcanic stone. h. $61\frac{7}{8}$ in (157 cm). Rijksmuseum, Leiden

SINOPIA

An antique name for red oxide pigments, giving its name to the final transferred sketch on plaster for *fresco-painting.

SIN Saīm-dang (1512–59)

Korean painter, she is famous as the mother of the great Confucian thinker Yi Yulgok. She painted quiet scenes from nature with birds, fruit and insects as her subjects, executed with a fine attention to detail.

SIN SAIM-DANG Monkey and Dormouse. Private Coll, Korea

SIN YUN-BOK Genre Scene. One of an album of thirty leaves, with inscriptions and signatures. Ink and colour on paper. $11\frac{1}{8}\times13\frac{7}{8}$ in (28×35 cm). Hung-pil Coll, Korea

SIN Yun-bok (Hyewŏn) (1758–c. 1820)

Korean painter of genre scenes. With *Kim Hong-do he was the leading painter in this style which flourished during the later Yi period. His albums of elegant domestic life are particularly appreciated.

SIPHNIAN TREASURY (c. 525 BC)

A small building designed as a treasury at Delphi for the Siphnians. It is richly decorated with sculpture and the porch is supported by two *caryatids on high pedestals.

SIPORIN, Mitchell (1910–)

b. New York. Painter who studied at Chicago Art Institute; painted *WPA murals, including Missouri Post Office mural with *Millman (c. 1939–42); taught extensively, primarily at Brandeis University. Moving from *American Scene painting and social protest to satire and fantasy, Siporin plumbs the human condition in a style increasingly permeated by light.

DAVID ALFARO SIQUEIROS *Revolution against the Porfirian Dictatorship* (detail). National Arts Museum, Mexico City

SIQUEIROS, David Alfaro (1898–)

b. Chihuahua. Painter who went to Mexico City (1907); studied at Academy (1911); wrote Manifesto of Revolutionary Artists (1922); published *El Machete*; fought in Mexican Revolution; was military attaché in Europe (1919–22); founded Experimental Workshop, New York (1930s). The

most erratic and violently vocal of the three founders of Revolutionary Mexican muralism, Siqueiros has constantly experimented technically to bring art to the people, through outdoor murals, etc. Most of his murals and easel-paintings are imbued with intense Marxist ideology, though later work shows a more universal, undogmatic concern with humanity. All his work is characterised by monumental form, extreme contrasts and dramatic passion.

DAVID ALFARO SIQUEIROS Self-Portrait 1943. Pyroxylin on celotex. $36\times47\frac{1}{2}$ in (91×121 cm). Museum of Modern Art, Mexico City

SIRONI, Mario (1885–1961)

b. Sassari, Sardinia d. Milan. Italian painter who originally studied mathematics. A latecomer to *Futurism, joining as the group was weakening (1915). Worked with *Balla. Later joined Novecento group who were returning to a monumental figure style, and were strongly nationalistic during the period of Fascist government in Italy.

ALFRED SISLEY *Flood at Port Marly*. 1876. $23\frac{5}{8}\times31\frac{7}{8}$ in (60×81 cm). Louvre

SISLEY, Alfred (1839–99)

b. Paris d. Moret. French *Impressionist painter of English descent, Sisley painted mainly landscapes. He entered *Gleyre's studio (1862) at the Ecole des Beaux-Arts where he met *Bazille, *Renoir and *Monet, but was more influenced then by *Corot, *Courbet and *Daubigny. He left the following year to work in the open near *Barbizon and Fontainebleau. During the Franco-Prussian War he went to England where he became familiar with English landscape art. On his return,

forced to rely on painting, he lived in povery. He exhibited at the Salon des Refusés (1863) and at the first (1874) as well as some subsequent Impressionist exhibitions. The dealer *Durand-Ruel supported and organised exhibitions of his works.

SIX DYNASTIES SCULPTURE see CHINESE CERAMIC FIGURINES

SIZE

Glue made from animal skins boiled in water. Size liquifies with heat as well as by dilution. Used for making *gesso and for covering plaster for *gilding. Also to coat a canvas (back and front) before the *ground is applied. This is in order to fill the holes in the weaving not to attach the ground.

SKANDA see KARTTIKEYA

SKOPAS (active 350 BC)

Greek sculptor from Paros who was one of the four sculptors who worked on the *Mausoleum at Halicarnassus. His other works include the Temple of Athena at Tegea of which he was the architect, and for which he sculpted the pedimental figures. He was also said to have sculpted a group of sea-creatures, parts of which survive in copies. Features of his style are massive heads with thick brows overhanging deeply set eyes. Many of his figures have the 'sweet' expression of *Kephisodotos and wear drapery so thin that it seems almost transparent.

SLAKED LIME

Lime mixed with water produces calcium hydroxide – slaked lime. This should be of a colloidal putty-like substance for use in *fresco-painting. Much has been made of the necessity of maturing slaked lime. The writers of the past recommend twenty years as a suitable period.

SLEVOGT, Max (1868–1932)

b. Landshut d. Neukastel. German painter who studied in Munich (1885–9). Slevogt's lively style was a tardy and partial version of French †Impressionism. His interest in reality was never purely perceptual and his composition remained Old Masterly. In the context of German academicism his work was a stimulating force during the 1900s, though reactionary in the face of newer ideas.

Left: JOHN SLOAN *Three A.M.* 1909. 32×26 in (81·3×66 cm). Philadelphia Museum of Art
Right: CLAUS SLUTER *Isaiah* from the 'Well of Moses'. 1395–1403. Stone. Chartreuse of Champmol, Dijon

SLOAN, John (1871–1951)

b. Lock Haven, Pennsylvania d. New York. Painter and printmaker who studied at Pennsylvania Academy; moved to New York (1904); exhibited with The *Eight (1908) and at *Armory Show (1913); taught at *Art Students' League (1916–24, 1926–30, 1935–7). Sloan's unsentimentalised *Ash Can School urban genre scenes are firmly structured, broadly painted and frankly loving.

SLODTZ Family

Flemish family of sculptors. Sebastien (1655–1726) b. Antwerp d. Paris, sculpted statues for the Louvre, Invalides and Versailles Park. He had four sculptor sons. The most important, Michel-Ange (1705–64) b. d. Paris, worked in Rome (1728–46), making monumental sculpture. A fifth son, Dominique (1711–64) b. d. Paris, painted for the royal *menus plaisirs.

Left: CLAUS SLUTER *The Well of Moses.* 1395–1403. Polychromed and gilded stone. Figures h. *c.* 72 in (182·9 cm). Chartreuse of Champmol, Dijon
Right: CLAUS SLUTER *Virgin and Child.* 1391–7. Stone. From the portal of the Chartreuse of Champmol

SLUTER, Claus (d. 1405/6)

b. Haarlem d. Dijon. Netherlandish sculptor, active mainly in Dijon. Member of the Brussels stonecarvers' guild (*c.* 1379). He joined the workshop of Jean de Marville (1385), then employed on the tomb of Philip the Bold at Dijon. Marville died (1389) and Sluter became head of the workshop. His main work comprises some statues on the portal of the Chartreuse at Champmol (1391–7) and the *Moses Fountain* there (completed 1403). The former shows the kneeling figures of Philip the Bold and his wife presented to the Virgin and Child by their patron saints. The stone figures are separate, overhung by individual canopies, yet they are together in the composition which unifies vast spaces. The style is revolutionary and stands at the beginning of the †Renaissance in its emphasis upon dramatic gesture and deeply cut, three-dimensional forms. The strong character in the portrait heads of the donors is paralleled in its realistic aspirations by the attention to detail in the Prophets on the *Moses Fountain* (one even wore a pair of gold spectacles provided by a local craftsman). The figures were surmounted by a Calvary scene (now in fragments). Sluter invented a realist technique which was nevertheless highly expressive. His weepers from the tomb of Philip the Bold (Dijon Museum) exemplify his typical intensification of standard patterns.

SLUYTERS, Jean (1881–1957)

b. Bois-le-Duc d. Amsterdam. Painter who studied at the Amsterdam Academy. Until 1914 he was always stylistically up to date, his version of *Van Dongen's *Fauvism deeply influencing *Mondrian (1906). A brief *Cubist period (1913–14) gave way to *Expressionistic work with a Parisian flavour.

SMET, Gustave de (1877–1943)

b. Ghent d. Deurle-sur-Lys. Belgian *Expressionist painter. Trained at Ghent Academy, a member of the second Laethem-Saint-Martin group (1901–11). In Holland (1914–18) influenced by *Le Fauconnier and *Sluyters he turned to Expressionism, painting pastoral subjects in sombre colours. He later abandoned Expressionism for a freer, broader style.

SMIBERT, John (1688–1751)

b. Edinburgh d. Boston. Painter, first an artisan, who studied in Italy (1717–20); worked in London (1720–8); emigrated to America (c. 1728), working in Providence and Boston. His portraits developed from refined, harmonious Baroque stateliness to more forceful realism, delineating form and character with solidity and vitality, yet retaining their painterly eloquence. He influenced and personally encouraged *Copley in his early development.

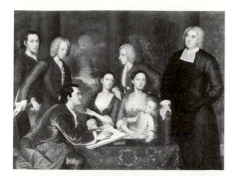

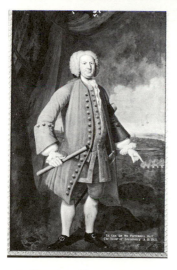

SMITH, David (1906–65)

b. Decatur, Indiana d. Nr Bennington, Vermont. Sculptor, son of engineer; worked as welder and riveter (c. 1926); studied at *Art Students' League (1927); visited Europe (1935); settled in studio called 'Terminal Iron Works', Bolton Landing, New York (1940). Influenced by *Picasso and *González, Smith abandoned painting for welded metal sculpture; *Cubism and *Surrealism too, were continuing influences on his abstractions. Gradually, Smith eliminated organic elements and found objects, reducing his structures to geometric, linear totems, monumental and shining.

SMITH, Jack (1928–)

b. Sheffield. English painter who studied in Sheffield and at St Martin's School of Art and the Royal College of Art, London (1944–53). At first a realist of the so-called *'Kitchen Sink School', he painted domestic subjects. Since 1956 he has become increasingly interested in representing light and its transformatory effects on shapes in the open air and under water. See also SOCIAL REALISM

SMITH, John Raphael (1752–1812)

b. Derby d. Worcester, 'Smith of Derby's' son. English mezzotinter, who worked after portraits by *Reynolds, *Gainsborough, *Romney, etc. He portrayed many friends direct, and used crayon and *stipple-engraving. A fast worker, he also experimented with miniatures and fresco.

SMITH, Sir Matthew (1879–1959)

b. Halifax, Yorkshire d. London. Painter of nudes, still-lifes and landscapes. Studied at Manchester School of Art and the Slade School of Art; mostly in France (1908–40), studying for a short time (1911) under *Matisse. A slow developer, his first main phase consisted of works representing an intellectual, constructive and draughtsman-like though sensitive way of seeing. From the mid 1920s he produced mostly still-lifes and nudes, characteristic works with bold and emphatic linear rhythms and sumptuous colouring.

Top left: JOHN SMIBERT *Bishop Berkeley and his Family.* 1729. 69½×93 in (176·5×236·2 cm). Yale University Art Gallery
Bottom far left: JOHN SMIBERT *Sir William Pepperrell.* Essex Institute, Salem
Bottom near left: DAVID SMITH *Cubi XIX.* 1964. Metal h. 113 in (287 cm). Tate
Right: MATTHEW SMITH *Nude, Fitzroy Street, No 1.* 1916. 34×30 in (86·4×76·2 cm). Tate

SMITH, Richard (1931–)

b. Letchworth. English painter influenced by *Stella, *Poons and *Morris. His allegiance is to self-contained statements of shape, colour and space. His handling of paint is economical and his colour both fragile and sensuous. The canvas is shaped and thus assumes a linear value whose clarity is contrasted with the loose paint-surface. Logically he progresses into three-dimensional work which projects a frontal surface, chromatically more saturated, into the spectator-space. His recent work includes multiples.

SNAYERS, Pieter (1592–after 1666)

b. Antwerp d. Brussels. Flemish painter of battle and hunting scenes and panoramas. He entered the Brussels painters' guild (1628) and was commissioned to commemorate important battles and events. The *Battle of Weissberg* (Brussels) shows his accuracy of historical detail, as do his topographically accurate panoramas. These, and his hunting and snow scenes, are early examples of this important type of 17th-century Netherlandish painting.

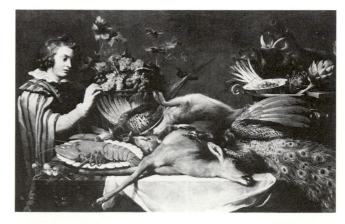

FRANS SNYDERS *Dead Game with Male Figure.* 50½×79 in (128×201 cm). Wallace

SNYDERS, Frans (1579–1657)

b. d. Antwerp. Flemish painter of animals, hunting scenes and still-life. His specialist talents were employed by *Rubens

with whom Snyders collaborated until Rubens's death (1640). Snyders started conventionally as a flower and fruit painter, but with Rubens's encouragement and influence, he developed a dynamic and exuberant style in which animals prance and glare with great vitality if some theatricality.

SOAMI (d. 1525)

Japanese painter, the son of *Geiami, famous for his landscape painting. The doors of the Daisen-in at Daitoku-ji are attributed to him.

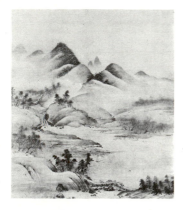 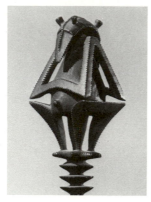

Left: SOAMI *Eight Views in the Region of the Hsiao-Hsiang Rivers.* Section from the original twenty panels. *c.* 1509. Ink on paper. 50⅝×44 in (128×111·8 cm). Cleveland
Right: SOCIETY ISLANDS Handle of a sacred fly-whisk. Wood, fibre, sennit. l. 32 in (85·4 cm). Museum of Primitive Art, New York

SOCIAL REALISM

Social Realism probably goes back to *Courbet and 19th-century literary sources (eg *Zola). Today it is concerned with the realistic depiction of everyday life, usually from a leftish viewpoint. Ben *Shahn and the *Ash Can School are American examples. The less politically committed work of *Bratby and Jack *Smith in the 1950s (Kitchen Sink School) are English examples. Social Realism in a general sense must be distinguished from Socialist Realism, which is the official Party art of the Soviet Union. This intends to glorify the state by idealising the worker and the family, and by celebrating impressive cultural and technological achievements for propaganda purposes.

SOCIETY ISLANDS

An island group in central *Polynesia. A few surviving wood figures may represent deities. Fly-whisk handles from Tahiti are elaborately carved in wood and whale ivory: motifs are combinations of elements abstracted from the human form.

SOCIETY OF JESUS

A religious order, whose members are known as Jesuits, founded by Ignatius Loyola (1540). Loyola's emphasis on self-awareness and missionary zeal eventually initiated a new departure in religious art which henceforth tried to convey the nature of religious experience to a wider and less sophisticated audience. While the Order did not 'invent' the †Baroque, and its artistic policy was austere at first, it later became identified with a florid style of art. Both *Bernini and *Rubens were associated with the Jesuits.

SODOMA, IL (Giovanni Antonio BAZZI) (1477–1549)

b. Vercelli d. Siena. A leading *Sienese painter, he was influenced by *Pintoricchio, *Signorelli and *Leonardo's *sfumato. After painting frescoes in Monte Oliveto, Siena, he began the ceiling of the Stanze della Segnatura in Rome for Julius II, but was supplanted by *Raphael. His work combines elegant forms with sharp emotional content.

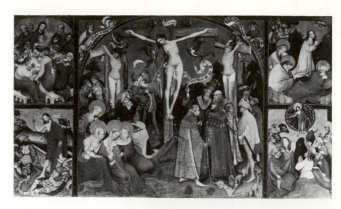

KONRAD VON SOEST The Niederwildungen Altarpiece: *Scenes from the Passion.* 1403–4. 62×62 in (157·5×157·5 cm). Niederwildungen Church, Bad Wildungen

SOEST (ZOUST), Gerard (c. 1600–81)

b. Holland d. London. Dutch painter in London (before 1650). He produced a number of society portraits similar to *Lely's but never so much in vogue. His later Restoration portraits are stiffer, but the individuality and personality of each sitter is immediately recognisable.

SOEST, Konrad (Conrad) von (active early 15th century)

German painter of the Westphalian School, known to have been working in Wildungen (1403). His major work is the *Niederwildungen Altarpiece* (Bad Wildungen), notable for its quality and size. The central panel is a Crucifixion, with surrounding and wing panels of Passion scenes and scenes from Christ's life. In spite of its scale, the graceful forms, high key and rich details are close to Parisian painting, possibly related to manuscript painting (cf Jacquemart de *Hesdin).

SOFFICI, Ardengo (1879–1964)

b. Rignano, Tuscany d. Forte dei Marmi. Italian painter and writer who with Papini and Prezzolini formed the Florentine movement which was initially critical of *Futurism (1907). The groups amalgamated (1913). His paintings were concerned with conveying the interpenetrating levels of experience. He wrote influential articles on French †Impressionism and Medardo *Rosso.

SOFT GROUND see ENGRAVING

SOFT STYLE

Name given to the German version of the *International Gothic style. It was in vogue at the end of the 14th and early 15th centuries. The name is partly explained by the contrast between the 'soft' style and the hard, angular style which succeeded it. It is found both in sculpture (eg the so-called 'Beautiful Madonnas') and in painting (eg Stefan *Lochner). Attempts have been made to extend the concept to contemporary architecture.

SOKKULAM

This Korean cave-sanctuary is placed high on a mountainside and was founded (AD 752) a year later than the nearby temple of Pulguk-sa. In the centre of the circular shrine is a massive seated figure of the Buddha, while the walls are covered with reliefs of Lo-hans and Bodhisattvas. The style of the figures is close to that of T'ang China.

SOLANKI see CHAULUKYA DYNASTY

SOLARI, Cristoforo (active 1489–d. 1527)

b. ?Angera d. Milan. Italian sculptor from Lombardy. He was commissioned (1497) to carve the tomb of Beatrice d'Este, of which the surviving parts are in the Certosa, Pavia. He also

executed sculptures for Milan Cathedral. His work is solid, sometimes over-ornate, but as a portrait sculptor he was capable of quite powerful characterisation.

SOLARIO, Andrea (c. 1460–1520)

b. Milan d. ?Pavia. Italian painter, a follower of *Leonardo. He probably trained first under his sculptor brother Cristoforo *Solari, with whom he visited Venice (1490). He worked chiefly in Milan, also in Normandy for the Count of Amboise. His *Madonna with a Green Cushion* (1507, Louvre) shows that he owed much to Venetian colouring.

SOLDER

A low melting-point alloy of lead and tin that will combine with the surface of non-ferrous metals to effect a join.

SOLIMENA, Francesco (L'ABATE CICCIO) (1657–1747)

b. Nr Avellino d. Naples. Chief Neapolitan late †Baroque painter. His early style, based on *Giordano and *Preti, is represented by the flickering multi-figured confusion of *Simon Magus* (S. Paolo Maggiore, Naples). Influenced by *Maratta his style became calmer and his figures weightier. His huge *Heliodorus Expelled* (Gesù Nuovo, Naples) marks an end to centrifugal composition and is a move towards †Neoclassicism. His Academy at Naples reinforced his international reputation.

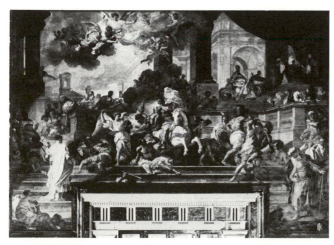

FRANCESCO SOLIMENA *Heliodorus expelled from the Temple of Solomon*. Church of the Gesù Nuovo, Naples

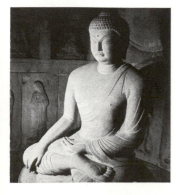

SOLOMON ISLANDS

This *Melanesian island group contains a diversity of art styles. Certain general features are identifiable, a preference for seated or squatting figures, sparse use of colours other than black and lavish employment of mother-of-pearl inlay. Large wood figures were carved in Bougainville and Buka islands for display during girls' puberty rites and at initiation ceremonies of young

men into the Upi age-grade organisation. In the central Solomons small squatting figures were lashed to the bows of the great head-hunting canoes. Skulls of chiefs were over-modelled with clay and inlaid with mother-of-pearl. Choiseul is known for openwork shell plaques carved with human figures. Other ceremonial objects include paddles carved with human figures in low relief from Bougainville, and bowls from San Cristoval Island in the form of frigate-birds. The small Santa Cruz group is renowned for the excellence of its shell breast-ornaments (*kap-kap*).

SOLUTREAN (18000 BC)

The third culture in the French †Palaeolithic sequence. No known cave art, but engravings on limestone plaques and carving in the round. *See also* LE ROC DE SER; FOURNEAU DU DIABLE

SOMER, Paul van (c. 1577–1622)

b. Antwerp d. London. Dutch portraitist who settled in London (1616) and painted *Queen Anne of Denmark* (1617, Windsor). Together with *Mytens and *Johnson, he held the field in portraiture before the arrival of *Van Dyck.

SOMNATH *see* CHAULUKYA DYNASTY

SOMNATHPUR *see* HOYSALA DYNASTY

SONDERBORG, Kurt R. H. (1923–)

German painter whose interest in nuclear research helped him to evolve his calligraphic and individual style. Working largely in black ink, his paintings evoke the speed of modern technology and dynamic experience, at the same time managing to convey the tranquillity of Chinese drawings.

SOPHILOS (active c. 570 BC)

*Attic *black-figure vase painter, the first whose name we know. Influenced by the *Corinthian style his manner is similar to that of the *Gorgon Painter, but more clumsy and laboured. His best-known work, the *Funeral Games of Patroclus*, shows a chariot-race with a bank of cheering spectators watching it.

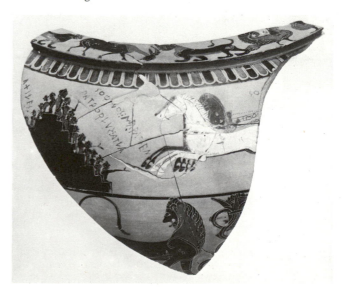

Above left: SOKKULAM Seated Buddha in the temple shrine. 8th century AD. Granite
Above centre: SOLOMON ISLANDS Canoe prow ornament. 19th century. Wood with shell inlay. h. 7½ in (19 cm). City of Liverpool Museums
Above right: SOPHILOS Detail of vase-painting showing a chariot race at the Funeral Games of Patroclus. Archaeological Museum, Athens

SOSEN (Mori Sosen) (1749–1821)

Japanese artist who specialised in painting animals, especially monkeys, in a variation of the style of *Okyo.

SOSETSU (mid 17th century)

Japanese painter, a pupil and follower of *Sōtatsu.

SO SHISEKI (1712–86)

One of the first Japanese to study under the Ch'ing painters living in Nagasaki who provided the basis of the *Nanga School.

Left: SOSEN *Monkey and Young* Early 19th century. Hanging scroll. Ink on paper. 37×13¾ in (94×34 cm). Impey Coll, Oxford
Above: SOSOS Mosaic from Hadrian's villa at Tivoli, probably a copy of a work by Sosos. 2nd century AD. h. 2 ft 9½ in (85 cm). Capitoline Museum, Rome
Below: SOTATSU *Scene from Genji Monogatari.* 17th century. Ink and colours on gold leaf. 57½×139½ in (151×357 cm). Seikado Foundation, Tokyo

SOSOS (active 2nd century BC)

Greek mosaicist from Pergamon, the only mosaicist mentioned by *Pliny. He made a famous mosaic of an 'unswept room' and another with doves perched on the handles of a vase filled with water. Both of these were much copied in antiquity.

SOTATSU (Nonomura Sōtatsu)
 (first half 17th century)

Japanese painter, a friend of *Kōetsu, and founder of the *Rimpa School. A great interest in *Yamato-e dominated his work (in fact he is known to have copied and repaired some Yamato-e scrolls). He was the first to infuse this entirely Japanese element into decorative painting. He was given the rank of Hokkyō – a Buddhist title open to laymen (1630). He was probably head of a fan shop called 'Tawaraya'.

SOTO, Jesús Rafael (1923–)

b. Ciudad Bolivar. Painter/sculptor who studied at Escuela de Artes Plásticas y Artes Aplicadas, Caracas (1942–7); was Director, Escuela de Bellas Artes, Maracaibo (1947–50); lives in Paris (since 1950). Influenced by *Constructivism, *Mondrian and *Calder, he invented a new *Op Art form, the 'Vibrations', geometric reliefs which seem to be *kinetic.

JESUS-RAPHAEL SOTO *Horizontal Movement.* 1963. Mixed relief. 24½×20¾×6½ in (62·2×52·7×16·5 cm). Tate

SOTTO IN SU

Italian: 'from below upwards'. Describes the effect of the use of an *illusionistic technique whereby, through the use of distorted *perspective, painted objects on walls or ceilings would appear to be foreshortened and suspended directly above the spectator. An early example is *Mantegna's Camera degli Sposi, Mantua.

SOUILLAC ABBEY CHURCH, Languedoc

The portal sculpture dates from about 1120. The decorative contortions of the Isaiah and the struggling pile of beasts representing evil forces on the *trumeau are to be seen in embryo on the trumeau at *Moissac. A sense of the supernatural is combined with very sensitive carving. Another relief shows Theophilus who sold his soul to the devil but was redeemed by the Virgin, a frequent theme in French medieval art.

PIERRE SOULAGES *Black, Brown and Grey.* 1957. 38×51¼ in (96·5×130 cm). NG, Berlin

SOULAGES, Pierre (1919–)

b. Rodez, of a peasant family. An early interest in standing stones and the †Romanesque Cathedral of *Conques has given his mature style, formed in Paris (after 1946), an architectural grandeur and stability. Over a ground of thin washes of colour he builds a structure of thick bars of dark paint which exert a physical presence. His paintings are balanced, gestural constructions behind which float areas of iridescent colour.

SOUTINE, Chaim (1893–1943)

b. Smilovitchi, Lithuania d. Paris. Painter who studied at Vilna (1910–13) then moved to Paris. In friendly contact with the

avant-garde, Soutine established his separate direction immediately. Like *Van Gogh (whom he disclaimed) Soutine essentially painted from nature. He admired *Rembrandt and *Courbet before the moderns. In Céret (1919–23) his *Expressionism reached an extreme point. Landscape is consumed into twitching, curling strokes of red and green. Later his painting became calmer and more conservative, expressing itself more through the physical and symbolic qualities of his subjects, eg the still-lifes with carcasses.

Above: SOUTHWELL MINSTER Capital from the Chapter House carved with grapes and vine leaves. 1290–5

Left: CHAIM SOUTINE *Page Boy at Maxim's*. 1927. 60⅜×26 in (153·4×66 cm). Albright-Knox Art Gallery, Buffalo, New York

SOUTH AMERICA, PRE-COLUMBIAN ART OF *see* AGUADA; ARAWAK; BELEN; CHIBCHA; DIAGUITA; MANTENO; MARAJOARA; QUIMBAYA; RIO NAPO; SAN AGUSTIN; SANTA MARIA; SANTAREM; TUNCAHUAN; VALENCIA

SOUTHWEST, AMERICAN ART OF THE

The Southwest area includes most of the present states of Arizona, New Mexico, Colorado and Utah. Three important art-producing cultures developed here during the Pre-European period. The Mogollon culture (beginning *c.* 300 BC) was characterised by several pottery styles, the most important being the distinctive black-on-white *Mimbres wares. *Hohokam art is also noted for painted pottery and stone-carvings, and certain features of this culture, such as ball-courts, appear to have been imported from Mexico. The Anasazi tradition (*c.* 100 BC) reached its peak during the *Pueblo stage (*c.* AD 1000–1300). In addition to their unique architecture the Pueblo peoples are noted for wall-paintings, usually found in their ceremonial chambers or *kivas*. In a few places the historic descendants of the Anasazi have succeeded in retaining much of their culture, and seasonal festivals are still held in the *kivas* of some Pueblo villages. The Hopi make carved wooden figures to represent the *kachinas* or spirits who are important in these ceremonies, and the Zuñi have a tradition of carving abstract wooden war gods, but sculpture is rare and modern Pueblo arts consist chiefly of pottery, textiles and silver jewellery produced for tourists. Other Southwest tribes such as the Navajo and Apache are latecomers to the area. Their nomadic hunting culture became modified by Pueblo influences and many groups adopted a sedentary agricultural life. Their art, especially the sand-paintings, blankets and jewellery of the Navajo, owes much to Pueblo culture.

SOUTMAN, Pieter Claesz (*c.* 1580–1657)

b. d. Haarlem. Dutch painter, pupil of *Rubens (1618), his figure-painting is similar to the more classical painting of Rubens (*Christ Appearing to his Disciples*, Ashmolean). He helped decorate Prince Frederick Henry's hunting-lodge, Huis ten Bosch, near The Hague (1640s).

SOUTHWELL MINSTER, Leaves of

The exquisitely detailed and naturalistic leaves of Southwell are carved on the capitals and doorways of the late 13th-century Chapter-House. Delicately sculpted in a fine limestone, by three or more hands, it is possible to recognise the foliage of the wild rose, hawthorn, vine, wild apple, hop and many more. The buttercup is the theme of the decoration of the double-arched doorway and these totally natural yet controlled leaves were probably executed by the Master Carver.

SOYER, Isaac (1907–)

b. Tambov, Russia. Painter and printmaker, younger brother of Moses and Raphael *Soyer; studied in New York at Cooper Union, National Academy of Design and Educational Alliance. Soyer had experienced the poverty of New York's lower East Side, and his modest, subdued paintings of its inhabitants reveal deep sympathy with them.

SOYER, Moses (1899–)

b. Tambov, Russia. Painter, twin brother of Raphael and brother of Isaac *Soyer; studied in New York; was engaged in anti-fascist political activity. Soyer's paintings of dancers, models and urban genre scenes are modelled with a sculptural knowledge of form, and a warm comprehension of the gestures that express the human condition in fleeting glimpses.

SOYER, Raphael (1899–)

b. Tambov, Russia. Painter and best known of the *Soyer brothers; studied at Cooper Union, National Academy of Design, and *Art Students' League with *Du Bois. Steeped in art's humanist tradition. Soyer paints urban *genre scenes with objectivity, compassion and quiet wit, disciplining draughtsmanship and light to shape the forms disclosing the innate nature of individuals.

SPADA, Leonello (1576–1622)

b. Bologna d. Parma. Italian painter who was nicknamed *'Caravaggio's ape', but was more connected with the *Carracci, especially Ludovico. His style became less Caravaggesque and more mellow under the influence of *Correggio when working in Parma for the Farnese. He painted mainly religious subjects.

SPAGNUOLO, LO *see* CRESPI

SPANDREL

The triangular area between the outer curve of an arch and the right angle formed by drawing a horizontal line from the apex and vertically through its springing.

SPATIALISTS, Italian

An Italian intellectual group, founded (1947) by Lucio *Fontana, its main exponent. The group included painters, critics and architects, and was supported by *Crippa and *Dova. It held an environmental exhibition at the Galleria della Naviglio, Milan (1949). Spatialism stressed the unimportance of the finished object, which served only as a demonstration of the concept of space.

SPEICHER, Eugene Edward (1883–1962)

b. Buffalo, New York. Painter who studied in Buffalo, New York with DuMond, *Chase and *Henri (1908), and Europe. Influenced by *Cézanne, Speicher achieved breadth, simplification and unity in the volumes and composition of his essentially realistic portraits and figure-paintings.

SPENCER, Gilbert (1892–)

b. Cookham. Influenced by his elder brother Stanley *Spencer, and by *Tonks, who taught him at the Slade School of Art. A

painter of landscapes, portraits, figure compositions and murals, the latter including *The Foundation legend of Balliol College* at Holywell Manor, Oxford (1933–6). RA (1959).

SPENCER, Miles (1893–1952)

b. Pawtucket, Rhode Island d. Sag Harbor, New York. Painter who studied in Rhode Island and with *Henri and *Bellows at *Art Students' League; worked in Europe (1921–2, 1928–9). A *Precisionist, Spencer painted industrial subjects and landscapes with a sharp clarity, first probing essential formal geometry, later growing more decorative than penetrating.

SPENCER, Sir Stanley (1891–1959)

b. d. Cookham. English painter who studied at the Slade School of Art and served in Macedonia during World War I, memories of which provided the theme for his murals in the Burghclere Chapel. Beginning from an almost naïve realism, he evolved a personal symbolism in which religious events, on occasion set in Cookham, are given often disturbing erotic undertones. He remained in isolation and his style is the complement of this, refusing to fit into any accepted historical category. Emphasis on content, and a dry, meticulous realism, find parallels perhaps most of all in the *Neue Sachlichkeit of *Beckmann.

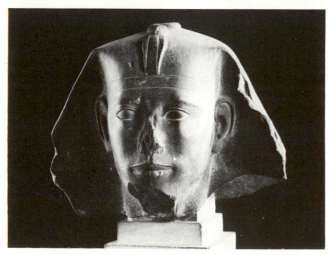

Top: STANLEY SPENCER *The Resurrection, Cookham.* 1923–7. 108×216 in (274·3×548·6 cm). Tate
Above: SPHINX Head of Redjedef. 4th dynasty. Quartzite. h. 11 in (27·9 cm). Louvre

SPHINX

The Egyptian sphinx has a lion's body and either a human head or, less commonly, that of a ram or hawk. Most human sphinxes are male, representing the king, but some are associated with queens. The great sphinx at *Gīza, symbolising the god Harmachis, has the features of the 4th dynasty king Rēkhaf/Khafrē (Chephren): it is hewn from the solid rock

and completed with masonry. Recumbent sphinxes were frequently used in architecture, notably flanking gateways and the approaches to temples.

SPINARIO

Bronze statue in the Palazzo dei Conservatori, Rome. A small boy is seated on a rock peering at the sole of his foot in which there is a thorn. The head is a 5th-century classical type, but the rest of the body and the pose suggest a *Hellenistic genre subject or a *Pasitelean composition.

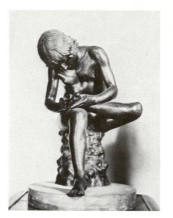

Left: SPINARIO Late Hellenistic genre sculpture. Bronze. h. (without plinth) 28¾ in (73 cm). Palazzo dei Conservatori, Rome
Near right: BARTHOLOMEUS SPRANGER *Allegory of Rudolph II.* 1592. 9⅛×6¾ in (23×17 cm). KH, Vienna
Far right: TONI STADLER *Dog.* 1950/51. Bronze. h. 39 in (99 cm). Wallraf-Richartz Museum
Below: SPINELLO ARETINO *St Michael and other angels.* 45¾×67 in (116×170 cm). NG, London

SPINELLO ARETINO (active 1373–d. 1410)

b. Arezzo. Italian painter who probably trained in Florence under Agnolo *Gaddi. His first dated work (1385) was a polyptych for Monte Oliveto (now dispersed) and he executed a number of fresco cycles in Tuscany. His series in the Sacristy of S. Miniato, Florence (completed 1387) show a return to *Giotto's narrative principles; the figures are powerfully conceived within a precisely defined space.

SPITZWEG, Carl (1808–85)

b. d. Munich. German artist who studied first as a chemist. This he gave up for art in which he educated himself by copying Old Masters at Munich. He travelled in Italy, France and England and got to know the works of caricaturists and humorous artists such as *Rowlandson and *Gavarni. His genre-pieces and landscapes show the influence of *Diaz and the *Barbizon painters. Usually small, they are full of picturesque detail and humorous content, without being caricatures. His generally bright colours are enhanced by a lively technique derived partly from *Delacroix. He illustrated a number of books.

SPRANGER, Bartholomeus (1546–1611)

b. Antwerp d. Prague. Flemish painter, first trained with Jan

*Mandyn in Haarlem (1557), then with Frans Mostaert and Cornelius van *Dalem. Then worked in Paris at the same time (c. 1565) as the *Fontainebleau painters *Primaticcio and Niccolò dell' *Abbate, and in Rome (c. 1567–75) with Taddeo *Zuccaro. He worked in Vienna (1575) for Maximilian II, and was based in Prague (from 1582) with Rudolph II. The influence of the Fontainebleau School, as well as that of *Parmigianino and *Correggio was seminal to this archetypal late *Mannerist. The flamboyant compositions, derived largely from Correggio, and dramatic polished colour contrasts and extravagant poses, depict mainly profane or even erotic scenes, eg *The Allegory of Rudolph II* (1592, KH, Vienna). Many compositions were engraved by *Goltzius.

SPRUCE, Everett Franklin (1908–)

b. Nr Conway, Arkansas. Painter who grew up in Ozark; was attendant in Dallas Art Museum; studied at Dallas Art Institute. Spruce's characteristic earlier Texas and Ozark landscapes were rendered with taut formal reductions and ominous, threatening spaces; his later style is more painterly and his subjects include figures and genre scenes.

SQUARCIONE, Francesco (1397–1468)

b. Padua. Italian painter who had a notable collection of antiquities, invaluable as a source of inspiration to his 130 pupils, including *Mantegna. His polyptych in Padua (1449–52) is marked by rather stiff, metallic drapery forms.

SRI LANKA see CEYLON

STABILE

A form of modern sculpture, usually a balanced assembly of sheet materials similar to a *mobile, but not articulated.

CARL SPITZWEG *The Poor Poet*. 1839. 14¼×17⅜ in (36×44 cm). NP, Munich

STADLER, Toni (1888–)

b. Munich. German sculptor who studied in Berlin and Munich then worked in Paris (1925–7). Stadler was stimulated by *Archaic sculpture but the seductive patina and flattened, decorative forms of his bronze figures are elegantly 20th century. A stylish charm relates his work to contemporary Italian sculpture (eg *Marini).

NICOLAS DE STAEL *Study at Le Ciotat*. 1952. 13×18 in (33×45·7 cm). Tate

STAEL, Nicolas de (1914–55)

b. St Petersburg d. Antibes. Painter who studied at the Ecole des Beaux-Arts, Brussels (1932–3) settling in Paris (1938). He progressed from linear, Expressionistic abstractions to large balanced shapes influenced by †Impressionism and Dutch landscape painting, after meeting *Braque (1945). Reacting against superficial abstractions, he attempted to reconcile abstract form and colour with a delight in visual experience. He returned to representational painting (1952) and after achieving a late recognition (1953), committed suicide.

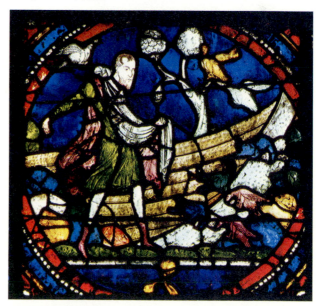

STAINED GLASS *The Parable of the Sower*. Panel from North Choir Aisle, Canterbury Cathedral. c. 1200

STAINED GLASS

Coloured sheet-glass set in a frame to produce a pattern or picture. The frame usually corresponds to the boundaries of coloured areas. Stained glass may be combined with glass-painting. The technique is particularly associated with the

church buildings of the Middle Ages. The stained-glass windows should be thought of as illuminated murals rather than as coloured fenestration. The framing within the window area is usually carried out in lead strip, although modern screens have been made with coloured glass set in concrete or fibreglass.

STAMOS, Theodoros (1922–)

b. New York. Painter, first a sculptor, who studied at American Artists' School; travelled in Western America, France, Sparta and Red Sea. Influenced by *Dove, *Surrealism and Oriental art, and inspired by Greece, Stamos increasingly abstracted organic forms, arriving at an atmospheric, calligraphic, luminously coloured, disciplined *Abstract Expressionism, echoing moody landscapes.

STAND OIL

A heavy viscous form of linseed *oil obtained by heating, and thereby speeding up the natural process of polymerisation. It produces a shiny, enamel-like effect in painting and yellows less than raw linseed oil. See also BOILED OIL; SUN-THICKENED OIL

STANKIEWICZ, Richard Peter (1922–)

b. Philadelphia. Sculptor who lived in Detroit (c. 1929–41); studied at Hans *Hofmann School (1948–9) and in Paris with *Léger (1950) and *Zadkine (1950–1); lectured extensively; teaches at State University of New York (since 1967). Ransacking junkyards for his materials, Stankiewicz reassembles scrap and discarded machine parts in abstract, often witty, constructions.

STANZIONE, Massimo (1585–1656)

b. Nr Naples d. Naples. Studied in Naples and Rome. A leading mid-17th-century Neapolitan painter of altarpieces (eg Virgin and Saints, S. Paolo Maggiore), influenced by *Caracciolo and *Ribera, he evolved a more elegant style than Ribera's and is often styled the 'Neapolitan Guido *Reni'.

MASSIMO STANZIONE Virgin with SS John the Evangelist and Andrew Corsini. S. Paolo Maggiore, Naples

STAVELOT TRIPTYCH see GODEFROY DE CLAIRE

STEEL ENGRAVING

Steel is coarser grained and harder to work than plates of copper or zinc for engraving, but it wears far less quickly and therefore is used for large editions of print such as book-illustrations. See also ENGRAVING

Above and left: STEEL ENGRAVING Newcastle upon Tyne (and detail). One of the series: 'River Scenes' painted by J. M. W. Turner, engraved by T. E. Lupton, published by Turner and Girtin 1823–27. V & A, London

Top right: PHILIP WILSON STEER The Bridge. c. 1887. $19\frac{1}{2} \times 25\frac{3}{4}$ in (48·3×65·4 cm). Tate

Bottom right: JAN STEEN Skittle Players Outside an Inn. c. 1660–3. $16\frac{3}{16} \times 10\frac{5}{8}$ in (33·5×27 cm). NG, London

STEEL FACING

Copperplate etchings and engravings can be given a thin steel coat by an electroplating process which enables larger editions of prints to be taken, but in the process something of the quality of the original copperplate is lost.

STEEN, Jan (1625–79)

b. d. Leiden. Although best known for his household or tavern scenes, Steen was one of the most versatile and prolific Dutch artists of the period, producing also portraits, historical and religious paintings. In Haarlem in the 1660s, he otherwise lived mainly in or near Leiden. Probably taught by *Van Goyen and Adriaen van *Ostade, he was widely influenced by and had some contact with theatrical groups that provided him with inspiration for numerous human types. He was as much able to gain atmospheric and elegiac effects as to depict a bawdy peasant environment, and included a wealth of detail in his pictures.

STEENWYCK, van, Family
Hendrik I (c. 1550–1603)
Hendrik II (c. 1580–1648)

Dutch painters of architectural interiors. Hendrik I, b. Steenwyck d. Frankfurt, painted church interiors, often by torchlight, and market scenes. He was very interested in the pictorial problems of rendering space. His son, Hendrik II, d. London, settled in England (by 1617) and worked for Charles I.

STEER, Philip Wilson (1860–1942)

b. Birkenhead d. London. Painter of landscapes and occasional portraits and figure studies; he studied at Gloucester School of Art (1878–81) and in Paris (1882–4). Influenced first by *Whistler and to some extent the French †Impressionists, he developed an original style which at the turn of the century became more conventional and closely linked to the tradition of *Gainsborough, *Constable and *Turner. Later in life he turned increasingly to watercolours (c. 1920–35); later still his eyesight began to deteriorate.

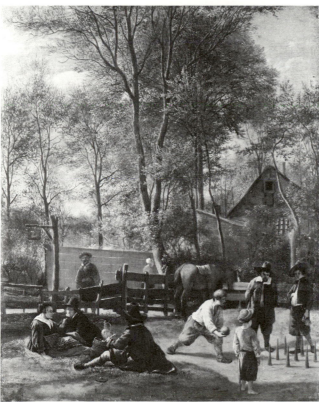

STEFANO DA VERONA (DA ZEVIO)
(active c. 1375–after 1438)

A practitioner of the *International Gothic style, he combined the decorative complexity and elegance of contemporary northern European manuscript illumination with a northern Italian panel-painting style. He specialised in scenes of the Virgin in the Hortus Conclusus, or Closed Garden symbolising virginity. Unusually for this date, several drawings survive.

STEFANO, Francesco di see PESELLINO

STEINLEN, Théophile (1859–1923)

b. Lausanne d. Paris. Graphic artist who studied in Lausanne and moved to Paris (1878). Steinlen's drawings of the seamy side of Parisian life achieved a wide circulation through his collaboration with Aristide Bruant and in left-wing magazines – particularly *Gil Blas*. Somewhat eclipsed by *Toulouse-Lautrec, his realism – more sentimental than satirical – impressed the young *Picasso.

STELLA, Frank (1936–)

b. Malden, Massachusetts. Painter who studied at Princeton University and lives in New York. First influenced by *Hofmann, Stella abandoned *Abstract Expressionism for *Minimal Art (1958). From severe stripes of black or metallic colours, Stella moved to brilliantly coloured, complex geometric shapes, creating spatial vibrations against shaped canvases.

STELLA, Joseph (1880–1946)

b. Muro Lucano, Italy d. New York. Painter who went to New York (c. 1902); studied in Italy and France (c. 1909–12); exhibited at *Armory Show (1913) and with *Stieglitz. Influenced by *Futurism, enthralled by New York, Stella is remembered for his Brooklyn Bridge paintings, heroic monuments to American energy in thrusting, fragmented planes.

STEPHENS, Frederic George (1828–1907)

b. London d. Hammersmith. An original member of the *Pre-Raphaelite Brotherhood who contributed little painting to the group, but who gave them critical support as a writer for the *Macmillan's Review* and the *London Review*. Most influential as art critic for the *Athenaeum* magazine (1861–1901).

STERNE, Maurice (1878–1957)

b. Libau, Russia d. Mount Kisco, New York. Painter and sculptor who went to America (c. 1890); studied with *Eakins at National Academy of Design (1894–9); worked in Europe, Greece, Egypt and Bali (c. 1904–14); taught at *Art Students' League (1919–22). Influenced by *Fauvism, *Cubism and *Cézanne, Sterne's firmly composed paintings realise each form's essential structure.

ALFRED STEVENS Design in Perspective for the Decoration of a Vaulted Corridor, c. 1860. Watercolour. 12⅝×18½ in (32×45·7 cm). Tate

STEVENS, Alfred (1817–75)

b. Blandford d. London. English artist, after an unusually thorough training in Italy (1835–42) which included working for *Thorwaldsen, he returned to England to become a master at the Somerset House School of Design, London. For the two years he worked there his versatility as a designer and his

powers of draughtsmanship were of great influence. There was no area of painted or sculptural decoration with which he was not familiar. A rare example of an English artist who systematically worked for manufacturers. He opened a studio to produce designs solely for industry (1856). His major sculptural achievement was the Wellington Monument (1856–75).

STEVENS, Alfred-Emile-Leopold-Victor (1823–1906)

b. Brussels d. Paris. Franco-Belgian painter, trained under Navez and at the Paris Ecole. Known chiefly for his fashionable portraits especially of women, painted in a range of subtle greys, but also the painter of sentimental genre and more socially conscious subject pictures early in his career. Hardly painted after 1900.

STIEGLITZ, Alfred (1864–1946)

b. Hoboken, New Jersey d. New York. Photographer who studied in New York (1879–81) and Germany (1881–90); settled in New York (1890); founded and ran Photo-Secession Gallery, 291 Fifth Avenue (1905–17), Intimate Gallery, Room 303 (1925–9), and An American Place (from 1930). Stieglitz battled for modern art both through his compassionate yet objective photographs, and by introducing European and American modern masters, particularly his special 'five' (*Marin, *Hartley, *Dove, *Demuth, *O'Keeffe), to America.

STILE LIBERTY see ART NOUVEAU

STILL, Clyfford (1904–)

b. Grandin, North Dakota. Painter who studied at Spokane University; taught at Washington State College (1933–41), California School of Fine Arts (1946–50), Hunter College and Brooklyn College. From *Surrealism, Still moved to his characteristic huge *Abstract Expressionist canvases, creating vast monochromatic areas of rich pigment seared by jagged flames of colour.

STILL-LIFE

Applied to a painting representing an arrangement of inanimate objects: fruit, dead animals, utensils, bottles, etc. The name is derived from the Dutch *still leven*, and first came into use in the 17th century.

STIMMER, Tobias (1539–84)

b. Schaffhausen d. Strasbourg. Swiss artist of varied production. Pupil of Hans Asper in Zürich, where he mainly executed book-illustrations. Also painted house façades (eg Haus zum Ritter, Schaffhausen, 1567/8). He went to Strasbourg (1570) where he painted the astronomical clock in the Cathedral of St John the Baptist (1571–4). Travelled widely working in several media, but particularly engraving, which suited his richly decorative style with its Italianate emphasis on forceful modelling.

STIPPLE

Shading by means of small dots. Usually refers to etching and *engraving, but also to drawing and even painting. A stipple brush is used to beat the paint on to a surface rather than stroke it on.

STOMER, Matthias (c. 1600–c. 1650)

b. Amersfoort d. ?Sicily. Dutch painter active in Utrecht (1620s), as a painter of *Caravaggesque works, reputedly a pupil of *Honthorst. Travelling to Italy, then Sicily (1630–50) he is distinguishable from other Utrecht *Caravaggists by his more leathery flesh and metallic colours.

STONE, Nicholas (1583–1647)

b. London d. Winchester. English tomb sculptor, well established in London (by 1622) and Master Mason to the Crown (1630). He evolved a naturalistic style (*Lady Carey*) that later became more classical (*Francis Holles*, 1622, Westminster Abbey) and introduced many innovations of design.

STOPPING-OUT VARNISH

A varnish which resists the etching *mordant. The artist paints it over those areas judged to be sufficiently etched while allowing further etching of other parts of the plate. *See also* ENGRAVING

STORY, William Wetmore (1819–95)

b. Salem, Massachusetts d. Vallombrosa, Italy. Sculptor who studied at Harvard University (graduated 1838) and in Italy (c. 1848–9); settled in Rome (1851). Story's portraits achieve some gravity, but he became famous for romantic, exotic subjects characterised by a proliferation of archaeologically precise props, elaborate narration and total insensitivity to sculptural form.

Above left and left: VEIT STOSS *Annunciation* and detail. 1518. Painted wood. S. Lorenz, Nuremberg
Above right: VEIT STOSS *Virgin and Child. c.* 1500. Wood. Germanisches Nationalmuseum, Nuremberg

STOSS, Veit (c. 1447–1533)

b. Herb, Neckar d. Nuremberg. Major German sculptor also painter and engraver. First documented when he gave up citizenship of Nuremberg (1477) and went to Cracow to work for Casimir IV. Returned to Nuremberg (1496) where mainly active thereafter apart from a stay at Münnerstadt (1503–5) whence he fled after a lawsuit. His first major sculptural work, the *Marienaltar* (1477–89, Church of the Virgin Mary, Cracow) is monumental. Like *Pacher's *St Wolfgang Altarpiece* it shows the influence of Nicolaus *Gerhaerts's unique style in the expressionistic surface of bold undercutting and *contrapposto forms, and in the individualised faces. After returning to Nuremberg, this activity of line and surface became restrained (perhaps due to *Dürer's influence) by the

dominating form of the figure, eg the *Annunciation* ('Englischer Grüss', 1517–18, St Lorenz, Nuremberg). The unpainted boxwood *Virgin and Child* (Germanisches Nationalmuseum, Nuremberg) from Stoss's house, illustrates the culmination of this unique and influential style in which complex internal lines are held within the simple, static outline.

STOTHARD, Thomas (1755–1834)

b. d. London. Prolific English painter, book-illustrator and designer, who had a successful Academy career and was befriended by *Flaxman. His *history painting included two important decorative commissions, and he also supplied designs for sculpture and jewellery.

Left: THOMAS STOTHARD *Cupids preparing for the Chase.* 18×13 in (45·7×33 cm). Tate
Right: STRASBOURG CATHEDRAL *The Synagogue from the South Portal.* After 1230. Musée de l'œuve Notre Dame, Strasbourg

STRASBOURG CATHEDRAL

The Cathedral possesses two important sets of figure sculpture. On the south transept façade there are twin portals, much damaged and restored, flanked with a pair of unusual carved figures. These date from about 1235 and have recognisable stylistic affinities with *Chartres, although the intense preoccupation with emotion and character is more German than French. On the west front (c. 1280–1300) there are three portals in a highly mannered †Gothic style, often verging on caricature. Both groups were probably known to Giovanni *Pisano.

JOHANN STRAUB Detail of sculptural decoration at the Residenz Theatre, Munich. 1751–3

STRAUB, Johann Baptiste (1704–84)

b. Wesensteig d. Munich. Bavarian sculptor who worked in Vienna (1728–34), and thereafter ran a large workshop in Munich. He sculpted statuary for the typical white and gold †Rococo altarpiece (eg at Ettal), but unlike his more gifted pupil Ignaz *Günther, he worked close to his model and used correspondingly realistic poses.

STREATER, Robert see STREETER

STREETER (STREATER), Robert (1624–79)

b. d. London. English painter, appointed Sergeant-Painter to Charles II (1663). He painted landscapes which prefigure the more sophisticated 'country-seat' views of the 18th century, but is best known for his allegorical and illusionistic ceiling in the Sheldonian Theatre, Oxford.

STRETCHER

The wooden frame on which a *canvas is stretched. The mortise and tenon corner joints are not fixed, but held tight by wedges. Thus the canvas can be tightened as necessary during and after the act of painting.

STRETES, Guillim see SCROTES

STRICKLAND, William (?1787–1854)

b. Philadelphia d. Nashville, Tennessee. Painter, printmaker and architect who studied architecture with Latrobe (1803–5); painted scenery in New York (c. 1805–9); visited Europe (1838); was Director of Pennsylvania Academy (1819–46). Strickland painted some portraits, but is best known for his disciplined, rather tight scenes of the War of 1812.

STRIGEL, Bernhard (1460/1–1528)

d. Memmingen. German history and portrait painter who is known to have been active in Memmingen by 1506. He then worked at Ulm with *Zeitblom and at Augsburg where, along with *Burgkmair, he painted for the Emperor Maximilian. The five frescoed murals of the cloisters of the Franciscan Church at Schwaz, near Innsbruck, are attributed to him. Numerous other works are on panel. *David with Goliath's Head* (AP, Munich), shows his typical flattened but lively figure style and composition. His portraits show great intimacy of psychological penetration.

STRIGILATED

Decorated with undulating horizontal flutings.

STROGANOV SCHOOL

The Stroganov family were major patrons of icons in Russia in the late 16th and 17th centuries. Painters developed a minute and refined style to suit their tastes, blending traditional compositions derived from icons of *Rublev and *Dionisy with motifs taken from Italian †Renaissance painting.

STROZZI, Bernardo ('Il Prete Genovese') (1581–1644)

b. Genoa d. Venice. Italian Capuchin monk painting in Genoa where he was influenced by *Van Dyck before moving to

Venice (1631). Successful and prolific, his works are sometimes domestic (*The Cook*, Palazzo Rosso) but more often religious in subject and †Baroque in conception.

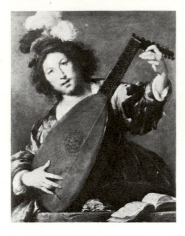

Left: BERNARDO STROZZI *The Lute Player.* 36¼×30 in (92×76 cm). KH, Vienna
Right: FRANZ VON STUCK *Sin.* 37½×23⅝ in (95×60 cm). NP, Munich

STUART, Gilbert (1755–1828)

b. Nr Narragansett, Rhode Island d. Boston. Painter who studied with C. Alexander in Newport (1770–2) and *West in London (1777–82); went to London (1775); worked in London (1782–7), Ireland (1787–92), New York (1792–4), Philadelphia (1794–1803), Washington (1803–5) and Boston (from 1805). Arguably the most famous, and certainly one of the most influential of American portraitists, Stuart painted eminent Americans as they wished to see themselves – dignified, self-possessed, and somewhat remote; most notably, the Stuart image of Washington remains dominant today. Stylistically, Stuart abandoned his early realism for a personal †Neo-classicism, characterised by disciplined draughtsmanship and luminous colour – delicate, fresh and painterly.

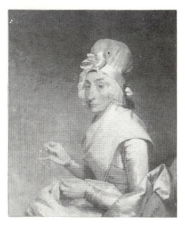

Left: GILBERT STUART *Mrs Richard Yates.* 1793–4. 30¼×25 in (76·8×63·5 cm). NG, Washington, Andrew Mellon Coll

Top right: GEORGE STUBBS *A Lady and Gentleman in a Carriage.* (Phaeton and Pair). 1787. 32½×40 in (82·5×101·5 cm). NG, London
Bottom right: GEORGE STUBBS *Horse Frightened by a Lion.* 40×50 in (101·6×127 cm). Walker Art Gallery

STUBBS, George (1724–1806)

b. Liverpool d. London. English painter, who was more than a competent 'sporting artist'. The basis of his art was the natural sciences rather than academic artistic method, and he would often draw from dissected animals. He published *The Anatomy of the Horse* (1766), containing his own etched illustrations. He thereafter became a successful painter of animal-pieces or riding scenes, charging high prices. His work has a quiet elegance (*Phaeton and Pair*, NG, London) that is sometimes †Romantic or dramatic (*Horse Frightened by a Lion*, Liverpool). There is always a remarkable feeling for form, but as an anatomist Stubbs's creative vision was somewhat pedantic.

STUCCO

Type of plaster composed of lime mixed with ground marble, glue, and sometimes reinforced with hair, used for the decoration of walls and ceilings. Being slow to dry, it can either be cast in moulds before application to the intended surface, or it can be modelled *in situ*. Usually it is then painted or gilded. Used by the Egyptians and during the *Hellenistic period, its use was revived in †Renaissance Italy, and reached its apogee in the †Baroque, †Rococo and †Neo-classical eras.

STUCK, Franz von (1863–1928)

b. Tettenweis d. Tetschen. German painter, sculptor and graphic artist who studied at the Munich Academy. He made illustrations for periodicals as well as posters and decorative cards. A pioneer of *Jugendstil, he was a founder-member of the Munich *Secession (1893). He taught at the Munich Academy (from 1895) and was influential as a teacher. From a painterly and subtle refinement he developed his decorative style and love of contrasts, a change which coincided with his adoption of sculpture. His subjects were idyllic and mythological, inspired by *Böcklin – eg *The Sphinx* and *Sin*, and the favourite theme of the *femme fatale*.

STUEMPFIG, Walter (1914–70)

b. Germantown, Pennsylvania. Painter who studied and taught at Pennsylvania Academy; travelled regularly to Europe (from 1933). A representational painter branded both as Neo-Romantic and *Magic Realist, Stuempfig was steeped in the whole history of art, classical and Romantic, echoing it in the subject and style of essentially introspective works.

STUMPING

An artist's stump is a rod of tightly rolled paper sharpened to a pencil-like point. It is used to obtain very smooth gradations of tone and colour in *pastel and chalk, or even soft pencil drawings, eliminating all trace of the direct touch.

STUPA

Hemispherical cairn containing sacred relics venerated in both the Buddhist and Jaina religions.

STURM, DER

Magazine (1910–32) and gallery (from 1912) founded by Herwarth Walden in Berlin. A focal point for German *Expressionism including *Kokoschka, die *Brücke and der *Blaue Reiter. Der Sturm also exhibited foreign art particularly *Futurism and *Orphism. After the war activity expanded – Sturm theatre, Sturm School – but no longer represented so unequivocally avant-garde thinking.

SU Shih (Su Tung-p'o) (1036–1101)

Chinese painter from Mei-shan, Szechwan. Scholar, painter, poet and official, he was a leading calligrapher of the *Sung. His paintings were closely linked with calligraphy in style and execution, with such subjects as rocks, old tree-trunks or bamboo in ink monochrome. Painting, for Su Shih and his friends (especially *Mi Fu, *Huang T'ing-chien and *Wên T'ung), was a form of expression for the scholar in his free time, as poetry and calligraphy were already; he led the way for the scholar-painters of later centuries.

SU Tung-p'o see SU Shih

SUARDI, Bartolommeo see BRAMANTINO

SUBLEYRAS, Pierre (1699–1749)

b. Provence d. Rome. French religious painter and Rome Prize-winner (1727), he remained in Italy throughout his life. A continuator of the Roman †Baroque style in a calmer and more delicate vein, he is known particularly for his *Mass of St Basil* altarpiece (several variants).

SUI PERIOD SCULPTURE see LUNG MEN

SUISEKI (Satō Suiseki) (active c. 1806–40)

Japanese painter, a pupil of *Goshun, whose *Shijō style is more than usually influenced by the *Nanga. Designed two outstanding books, *Suiseki Gafu* (1814) and a second series (1820).

SUKENOBU (Nishikawa Sukenobu) (1671–1751)

A prolific artist of the Kyōto-style *Ukiyo-e printed books and albums. His gentleness of style greatly influenced *Harunobu. He was also a designer of kimono patterns.

SUKHODAYA (Sukhotai), Thailand

The Buddha images of Sukhodaya derive from the *Hīnayāna Canon as conceived in Ceylon, but while they are conceived in the full round, the contours, remarkably sinuous, lack any sensuality, probably because of the absence of any clearly defined planes. From these images there developed the Ayuthia style and the more vigorous style of U Thong which perhaps retains elements of earlier pre-Thai cultures. In the late 18th and 19th centuries much interest in painting developed, but while the themes are edifying, the level of artistic achievement is uneven.

SULEYMAN-NAME Page illustrating a naval campaign by Matrakji Nasuh. Topkapi Sarayi, Istanbul

SULEYMAN-NAME (1543)

Ottoman manuscript in the Topkapi Saray Library, Istanbul. Illustrated by Matrakji Nasuh, an historian, calligrapher and painter at the Ottoman court during the reign of Sultan Süleyman the Magnificent (1520–66). The miniatures describe events in the Sultan's life and illustrate his foreign campaigns in a very precise and yet highly decorative manner. *See also* TURKISH PAINTING

SULLY, Thomas (1783–1872)

b. Horncastle, England d. Philadelphia. Painter who went to America (1792); studied with *Trumbull and *Jarvis, New York (1806), *Stuart, Boston (1807), and *West, London (1809); settled in Philadelphia (1810). Influenced by *Lawrence and *Romney, Sully's portraits are characterised by fluid, broad painterliness and †Romanticism, too often melting into sentimentality and prettiness.

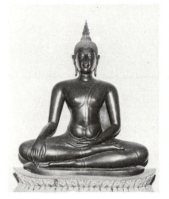 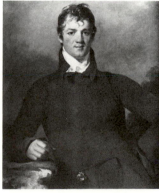

Left: SUKHODAYA Seated Buddha. 14th century. Bronze. h. 37 in (94 cm). National Museum, Bangkok
Right: THOMAS SULLY *John Myers.* 1814. 36 × 30 in (91·4 × 76·2 cm). Boston, Karolik Coll

SULTAN ALI MASHHADI (1437–1520)

b. Mashhad. Persian calligrapher who worked in Herat and was the calligrapher of the Timurid prince, Husayn Bayqara (1470–1506). He followed the style of Azhar and composed a poem on calligraphy called *Sirat al-Khatt* or *Sirat al-Sutur*. After the conquest of Herat by the Uzbeks, he went back to his native town, Mashhad. His works are to be seen in museums all over the world.

SUMATRA see INDONESIA, ART OF

SUMER see MESOPOTAMIA, ART OF; WARKA

SUN-THICKENED OIL

*Linseed oil refined and thickened by exposure to sunlight. It is shaken up with an equal quantity of water and left in a glass jar with a non-airtight closure. The time varies, but the process should last for several weeks. The oil bleaches to a very light colour and partly polymerises. The oil behaves rather like *stand oil, drying more quickly than raw linseed oil and with a gloss.

SUNG DYNASTY PAINTING

With the period of the Five Dynasties (907–59) and the Northern (960–1126) and Southern (1127–1279) Sung dynasties, original paintings survive in greater numbers than for the T'ang and earlier, though for many artists there are only the appraisals given by, for instance, *Kuo Jo-hsü. The Five Dynasties and the Northern Sung were the age of the great landscape masters: *Tung Yüan and *Chü-jan in the south, *Li Ch'eng, *Fan K'uan and *Hsü Tao-ning in the north. An imperial painting academy was established at the court of Li Hou-chu (reigned at Nanking 961–75). The academy flourished again under Emperor Hui-tsung *Chao Chi), especially in the genre of *flower and bird painting, but meanwhile the foundations for the rise of amateur painting were being laid in the theories of *Su Shih and his circle. Painting was to become, like calligraphy and poetry, an accepted leisure pursuit for the scholar; beginning with subjects like bamboo, this concept was extended to landscape painting in the *Yüan. Hui-tsung's almost exclusive concern with aesthetic pursuits led to the fall of the Northern Sung. Thereafter at Hangchow in the south the academy continued to flourish, with artists such as *Ma Yuan, *Hsia Kuei and *Ma Lin. Their landscapes were often more intimate than those of the early Sung. Scholars were often portrayed in self-conscious enjoyment of the scene. Elsewhere, Ch'an Buddhist painters, such as *Mu-ch'i and Liang K'ai, painted enigmatic landscapes and figure studies that found acceptance and following in Japan rather than in China, where under the succeeding *Yüan dynasty a revival of ancient styles was to determine the later course of painting.

SUNG DYNASTY SCULPTURE *see* FEI LAI FENG

SUPPORT

The panel, canvas or wall surface upon which a picture is painted.

SUPREMATISM

Painting movement invented by *Malevich as an absolutely pure, geometric abstract art. Launched by him (1915) with a black square on a white background. Attempting to 'liberate art from the ballast of the representational world', he reduced painting to its elemental components and so evoked an emotional response that relied purely on the painting, rather than on its associations with everyday reality. Suprematism heralded totally pure abstraction and paralleled similar developments made by *Mondrian and the *De Stijl movement in that it aspired towards an absolute. Its influence, through such artists as El *Lissitzky, *Moholy-Nagy and *Kandinsky, was felt across Europe especially at the *Bauhaus, even after Malevich announced its end (1919).

SURAWANA, Kediri, East Java

Probably built (c. 1400) as a burial-place for a royal relative. The reliefs include oblong panels, some erotic, and grotesque corner figures. Another course is carved with stories of Arjuna's penance and marriage, while the corners carry salvation stories. By this time temple decoration is much concerned with the possibility of personal salvation.

SURIKOV, Vassily Ivanovich (1848–1916)

b. Krasnoyarsk. Russian painter who studied at St Petersburg and was a member of the *Wanderer group. His narrative paintings reflect his interest in medieval Russian art together with a marked social criticism, as in his scenes of opposition to the established church and state in Russian history.

SURNAME (c. 1720–5)

The 'Book of Festival' written by the poet Vehbi to celebrate the circumcision of the sons of Sultan Ahmed III in 1720 and illustrated by the Ottoman painter *Levni. *See also* TURKISH PAINTING

SURREALISM

Movement founded by André *Breton in Paris (1924) which embraced the fields of painting, poetry, philosophy, psychology and politics. It grew out of Paris *Dada, inheriting 'the same rebellious attitude to art and life' (*Arp), but in place of Dada's anarchy, Surrealism was built round certain theoretical principles. The first Surrealist Manifesto (Breton, 1924) defined Surrealism as 'pure psychic automatism'. It proposed to investigate hitherto untapped regions of man's psyche, ie the unconscious, manifested through automatism and dreams. Freud had recently revealed the importance of dreams, but the Surrealists valued them also as poetic experiences. Surrealism claimed that automatic techniques enabled the mind to by-pass normal constraints of logic and produce verbal or visual images of unexpected brilliance, juxtaposing unrelated objects. It was a liberating influence for many of the painters who joined it, eg *Masson, *Miró, *Ernst, Man *Ray, *Magritte, *Tanguy, *Dali, although several received their initial impetus from the paintings of de *Chirico. Originally a literary movement, Surrealism never successfully reconciled its twin ambitions of revolution within human consciousness and in society: 'transform the world' of Marx, 'change life' of Rimbaud. It has nevertheless radically influenced† 20th-century art.

SURVAGE, Leopold (1879–1968)

b. Moscow d. Lyon. Painter who worked in Paris (from 1908). Influenced in turn by *Fauvism, *Cubism, *Picasso's Neo-classicism, *Léger, de *Chirico, *Magritte – Survage's style remained derivative. Only a kind of half-chic, half-crude mysteriousness of subject gives his work consistency.

SURYA

Hindu sun god, little changed from his origin in *Vedic poetic metaphor; is borne in a chariot drawn by a team of horses, accompanied by the two archers of the twilight; attributes are two lotus blossoms.

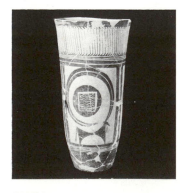

SUSA Susa A beaker. Beginning of 4th millennium BC. Archaeological Museum, Teheran

SUSA

A town in south-western Iran, the chief city of *Elam throughout antiquity. Prehistoric pottery from the site known as 'Susa A' dates from the fourth millennium BC. The elegant shapes of these pots and the stylisation of natural forms in their painted decoration, so well balanced and so well adapted to the circularly repeating nature of the medium, make them some of the finest examples of the potter's art in the world. In Susa many important works of art have been found not only of Elamite art such as the bronze statue of Queen *Napirasu but also looted from the temples of Mesopotamia such as the Stele of *Naram-Sin or the law-code of *Hammurapi. In the time of the Achaemenids, Susa was the administrative centre of the Persian Empire. The walls of the magnificent palace were decorated with brightly coloured glazed brick reliefs of

Persian archers, lions, sphinxes, griffins and so on very similar to those found at Babylon. *See also* ACHAEMENIAN ART

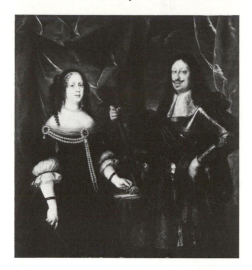

JUSTUS SUSTERMANS *Ferdinand II of Tuscany and Vittoria della Rovere.* 63½×58¼ in (161×148 cm). NG, London

SUSTERMANS (SUTTERMANS), Justus
(1597–1681)

b. Antwerp d. Florence. Flemish portraitist who travelled widely, settling at the courts of Florence (from 1620) and briefly visiting Vienna (1623–4). Immensely successful, he was a master of the international style developed by *Van Dyck (numerous Medici portraits, now in Florence).

GRAHAM SUTHERLAND *Head III.* 1953. 45×34¾ in (114·3×88·3 cm). Tate

SUTHERLAND, Graham (1903–)

b. London. English painter who trained as an etcher and engraver at Goldsmith's College of Art. Like *Picasso, *Kandinsky and *Miró, each of whom he greatly admires, Sutherland has developed a personal pictorial language primarily deriving from his intense observation of nature and first emerging in his near-abstract landscapes (from 1936). He was appointed Official War Artist (1941) and has since become interested in religious subjects, a notable commission being his design for the High Altar tapestry in Coventry Cathedral.

SUTTERMANS, Justus *see* SUSTERMANS

SUTTON HOO SHIP BURIAL (mid 7th century)

Richest of the pagan burials in Britain from the end of the pagan period. The objects found, which include Merovingian coins and †Byzantine silver, show that the East Anglian royal family was not entirely provincial. The discovery of East Anglian jewellery of exceptionally high quality of gold, garnets and millefiori glass led to a reappraisal of the *Anglo-Saxon element in Northumbrian manuscripts like the *Lindisfarne Gospel. (BM, London)

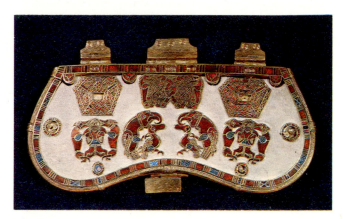

SUTTON HOO BURIAL *Purse-lid.* Before *c.* 655. Gold, garnets and mosaic glass. 7½×3 in (19×8 cm). BM, London

SUTTON, Philip (1928–)

b. London. English painter influenced by *Fauvism, he was at first a colourist, but the exploration of forms in light assumes increasing importance (from mid 1960s). He combines chromatic and linear expression in lyrical, though sometimes decorative, compositions of landscape, figures and flowers.

SWANENBURGH, Jacob Isaacsz van
(*c.* 1571–1638)

b. d. Leiden. Dutch painter who studied in Venice, and worked in Naples (*c.* 1605–17). He painted crowd scenes, views of towns and scenes of Hell. He was briefly *Rembrandt's first teacher (1621–3), but in no way influenced his pupil's style or subject-matter.

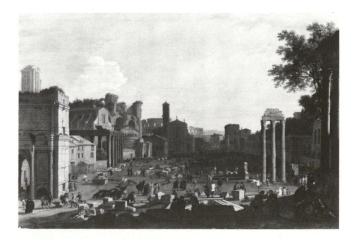

HERMAN VAN SWANEVELT
The Campo Vaccino. 17⅞×26⅜ in (45·4×67 cm). Fitzwilliam

SWANEVELT, Herman van (*c.* 1600–55)

b. Woerden, nr Utrecht d. Paris. Dutch landscape painter. In Rome (*c.* 1627–early 1640s) his earliest dated painting (1630) is very *Claude-like; indeed his development in certain respects preceded that of Claude. Swanevelt moved closer to *Poelenburgh in style. He executed decorations in Paris (1644,

Hotel Lambert), where he settled and helped to disseminate classical landscape. He also etched landscapes, which have an atmospheric, Claude-like feeling.

SWART VAN GRONINGEN, Jan (c. 1500–after 1553)
b. Groningen d. ?Antwerp. Netherlandish painter and woodcut maker who went to Gouda (c. 1522) where he was a pupil of Adrian Pietersz Crabeth I, and also travelled to Venice. He was mainly influenced by Lucas van *Leyden, to whom the *Adoration of the Magi* (Antwerp) was originally attributed. This indicates the reliance of Swart's style upon Lucas.

SWEERTS, Michiel (1624–c. 1664)
b. Brussels d. ?Goa. Flemish genre and portrait painter, at Rome (1646–56) painting similarly to the *Bamboccianti. He opened a school in Antwerp in 1656 (*Painter's Studio*, Rijksmuseum), and travelled to the Orient with some missionaries (1661). He was however found unsuitable and dismissed at Tabriz. He is distinguished by his subtle use of tone and by the charm of his subjects.

SYMBOLISM
An international art movement which developed in France and spread to the rest of the Continent. Embraced by writers and artists, whose common cause was a rejection of the restrictions which, they felt, were imposed upon them by objectivity. They chose instead a greater reality, one that lay in the imagination, in fantasy and magic. In the Symbolist Manifesto (1886), Jean Moréas wrote that the movement sought to clothe the Idea in a form perceptible to the senses. The movement was a natural culmination of the writings of Verlaine, *Huysmans and Mallarmé, and found pictorial inspiration in the work of *Puvis de Chavannes, *Moreau and *Redon. Favourite themes were death, sin, disease and a longing for the unattainable, realised in the shape of the *femme fatale* and the brute rapacious male. Often, musical imagery was used to invoke the intangible. Frequently, Symbolist thought was used to camouflage mediocrity of talent. By the early years of the 20th century the movement was defunct.

SYNCHROMISM see RUSSELL, Morgan; MACDONALD-WRIGHT, Stanton

SYNTHETISM
The term applied by Aurier (1891) to a *Post-Impressionist development in painting in which forms are reduced to essentials, and colours used in a non-naturalistic way, in flat decorative areas devoid of observed light and shadow and bounded by strong contours. It is associated with *Gauguin, *Bernard, *Sérusier, de *Haan, *Denis and the *Pont-Aven School. Inspiration came from stained glass, Japanese prints and Breton folk-art. Synthetism had a far-reaching influence on the *Nabis – *Bonnard, *Vuillard, etc – and later on the *Fauves.

SYRIAN ART, Medieval
The medieval art of the area stretching from ancient Antioch near the Mediterranean to the Upper Tigris is probably not usefully seen in terms of a unified tradition, but rather as the product of many different cultural strands and influences arriving in the region and intermingling. The result is such diverse objects as the pagan Syrian mosaics of Edessa, local Syrian architectural designs, the Hellenistic mosaics of Antioch, the *Rabbula Gospels and later Christian manuscripts showing stylistic influences from Byzantium and Islam.

SYRLIN, Jörg, the Elder (active c. 1458–82)
German sculptor, active mainly in Ulm where he controlled a large workshop which carried out all kinds of sculptural work. First recorded (1449) as a joiner, the son of a carpenter. The work he carried out, with many assistants, eg the elaborate choir-stalls of Ulm Cathedral, diverges from local tradition and emulates the bold carving and extraverted characterisation of Nicolaus *Gerhaerts van Leyden.

SYRO-PALESTINIAN ART
Art forms which may be said to be purely Syrian or Palestinian are not easily found. Economically and geographically, Syro-Palestine was always the poor relation of the ancient Near East, bridging as it does the two great civilisations of †Egypt and *Mesopotamia. The consequent lack of highly developed political and social structures common to these other areas has meant that an indigenous artistic spirit is difficult to trace. Economic and political weakness has further resulted in the country for ever being prey to these larger and more powerful states outside, alternating between the Nile dynasties and the empires of the Tigris-Euphrates valley. The former particularly has left its imprint upon both Syro-Palestinian culture, and its art. The attribution of an exclusively Levantine form to objects discovered in that area is frequently overshadowed by blatant foreign influence and rank imitation. Chronologically, Syro-Palestine follows the normal Near Eastern pattern, from the Neolithic farmers of the 8th millennium BC, through the urban expansion of the Bronze Ages of the 3rd and 2nd millennia, to the Iron Age beginning in 1200 BC. Writing appears only in this last phase, another limiting factor in the local cultural development. As with other areas of the world, it is difficult to speak of art in the Levantine Neolithic period aside from ritual objects. The term 'decoration' may well be wrongly applied to objects of an obviously tactile or religious significance. Mother-goddess figurines, for example, are questionable manifestations of an art form. However, from the proto-Neolithic of Palestine (*Natufian period) have been found a number of carved bone sickle-handles. They exhibit terminals of animalistic shapes, representing one of the earliest examples of the carver's art. With the following Neolithic period, steatopygous figurines appear, though crudely made. In contrast, a remarkable series of human skulls were found from the same period at *Jericho, the faces sensitively modelled in clay. Early ceramic of the time was frequently decorated also, but the designs are rectilinear and uninspired, perhaps as a copy of basketry. The late Neolithic (or Chalcolithic) period of the 4th millennium BC saw the beginnings of metalwork, and though rare, the objects are sometimes more than simply a technological achievement. The hoard of copper crowns and wands from the *Nahal Mishmar near the Dead Sea illustrates clearly a sophistication of manufacture and, more particularly, of elaborate decoration with fluted stems and moulded figures. The period further evidenced the art of wall-painting, as seen in the houses at Teleilat *Ghassul. The coming of the Bronze Age (3000 BC) heralds a new urban period with its consequent increase in styled household objects. It is to this time that can probably be ascribed the beginnings of *Canaanite civilisation, a culture stretching in its several facets from North Syria to the Sinai Desert. From this date, the Canaanites were the dominant native artistic force in Syro-Palestine, though always heavily influenced by surrounding nations. The use of the fast wheel which commenced about 2000 BC naturally led to freer ceramic types; but it was not until the middle of the 2nd millennium that real artistry is seen. From the many burials of the Middle Bronze Age have come wooden toilet-boxes intricately inlaid with carved bone strips. Carved scarab-beetle rings are also common, though plainly either Egyptian-made, or more frequently poor copies of the Egyptian original. The Late Bronze Age (1550–1200) is often first identified by the appearance of painted pottery, known as *Palestinian Bichrome Ware. This ware is found throughout the area and is typified by its decoration of birds, fish and geometric designs, all again thought to be foreign. In addition, the period renders examples of the metalsmith's and the carver's art. Gold-plate from Syria and carved ivories from Palestine indicate a degree of appreciation not previously evidenced, even though both forms are said to have been inspired elsewhere. Ceramic was further enhanced during the *Philistine period (c. 1200 BC) but once again an exotic art form is behind the decoration. The 1st millennium Iron Age saw the separation and the eventual disintegration of Syro-Palestine, first into the Phoenician and Aramean states of the north, and the Israelite kingdoms of the south, and eventually the complete

absorption of these areas into the great empires of Assyria, Babylon and Persia, and finally the Hellenistic and Roman empires. In the early part of the millennium (1000–600 BC) Canaanite art flourished, albeit with heavy foreign overtones. Highly ornamented ivory-carvings, similar to those of the Late Bronze Age, are used to enhance the furniture of royal palaces. The style seems to have been extremely popular with the kings of Assyria, since hundreds of the ivories turn up in the imperial capitals on the Tigris, brought there either by Canaanite craftsmen, or despoiled from the conquered territories of the Levantine coast. At the same time, Syro-Palestine seems to develop other forms of artistic expression in more tangible forms of architectural decoration. Many sites have provided examples of carved stone pillar capitals, their designs strongly reminiscent of the later Ionic capitals of the Aegean. Also, it would appear from Biblical records that such buildings as Solomon's Temple were highly decorated by artists working in metal, wood and stone. The inspiration of the objects described suggests Canaanite influence in the Israelite kingdom. With the coming of complete foreign domination, the imprint of other nations quickly overtakes the remnant culture of the area. The accession of Alexander the Great (333 BC) with his all-embracing Hellenistic dream meant the natural end of local art forms as the Greek civilisation began with all its facets to infuse both Syria and Palestine simultaneously.

T

TABERNACLE

Either a canopied stall or niche, or an ornamented recess or receptacle to contain the Holy Sacrament or relics.

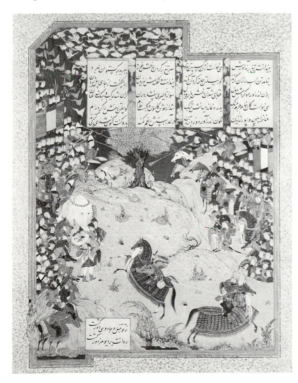

TABRIZ SCHOOL *Rustam defeating the Khakan of Cin* from a copy of Firdusi's Shah-nameh 1537. $18\frac{1}{2} \times 12\frac{1}{2}$ in (47×31·7 cm). Coll Arthur H. Houghton, Jr, New York

TABRIZ SCHOOL (early 16th century)

Tabriz, the capital of *Safavid Persia under Shah Ismail, was a flourishing cultural centre and its school of painting was famous and much admired. The greatest masters were *Mir Sayyid Ali, Sultan Muhammad and Mirak. Strongly dependent on the *Herat School, many of whose artists had moved from there to the new capital, the style continues to use a number of the earlier conventions, range of palette and brushwork, but with costume differences, particularly the Safavid turban baton. Later the individuality of *Bihzad's human figures is lost with the miniatures increasing in size. Tabriz excelled in genre painting. Everyday scenes are depicted with a keen observation of detail and the figures are realistic portraits rather than stylised types.

TACCA, Pietro (1577–1640)

b. Carrara d. Florence. Italian bronze sculptor, pupil of Giovanni da *Bologna whom he succeeded at the Medici court. His works include the *Four Slaves* beneath *Bandinelli's statue of Ferdinand I (Livorno) and the equestrian *Philip IV* (Madrid), modelled on a Spanish painting sent to Florence.

Above Left: TACHIBANA FUJIN NO ZUSHI Wooden shrine with bronze images of Amida and two Bodhisattvas. Nara period, early 8th century AD. h. (of Amida figure) $19\frac{1}{8}$ in (48·5 cm). Hōryūji, Nara
Above right: PIETRO TACCA *Philip IV*. Plaza Mayor, Madrid

TACCONI, Francesco di Giacomo (active 1458–1500)

b. Cremona. Italian painter. Together with his brother Filippo he worked on frescoes in his native Cremona and in Milan. Subsequently he was employed in Venice (organ-shutters, St Mark's). Much indebted to Giovanni *Bellini, he based his *Madonna* (1489, NG, London) on an example of that master's.

TACHIBANA FUJIN NO ZUSHI

This Japanese Buddhist shrine, containing a gilt-bronze triad of Amida, is said to have belonged to the Lady Tachibana in the 8th century AD. It represents a stage in the transition from the ordered formality of *Asuka sculpture to the growing realism of the *Nara period.

TACHISME

Term used in the early 1950s by the French critic Estienne to characterise contemporary methods of painting, whereby paint was applied to canvas in stains or blots (French: *tâches*). *Hartung had used this method already (1922), and it was taken up in America by Sam *Francis, Helen *Frankenthaler and others. Essentially a form of *Abstract Expressionism.

TADDEO DI BARTOLO (active 1386–d. 1422)

Sienese artist who painted the *Last Judgement* in the Collegiata of S. Gimignano and whose most interesting work is perhaps the series of Roman Republican heroes and civic Virtues painted in the antechamber of the Chapel of the Virgin in the

Above Left: TAI CHIN *Landscape.* Ink and light colour on silk. 72⅝×43⅛ in (184·5×109 cm). National Palace Museum, Taiwan
Above centre: TAIGA *Bamboo in Fine Weather After Rain.* Ink on paper. 64¼×71¾ in (163×182 cm). Cleveland
Above right: TAKANOBU *Taira-no-Shigemori.* Kamakura period. Colour on silk. 54×44 in (137×111 cm). Jingo-ji, Kyōto

Palazzo Pubblico, Siena. This was a survival of the tradition of civic commissions and secular painting in the Republic of Siena, eg Simone *Martini's *Guidoriccio* or Ambrogio *Lorenzetti's *Good and Bad Government.*

TAEUBER-ARP, Sophie (1889–1943)

b. Davos d. Zürich. Painter, sculptor of Polish descent. Active member of the Zürich *Dada group (1916–20). Made a set of puppets for *Le Roi Cerf* (1918), a Dadaist puppet-play. Married Jean *Arp (1921). Her work is marked by a concern with pure form and strong primary colours. In the late 1930s she produced polychrome wood reliefs.

TAHITI *see* SOCIETY ISLANDS

TAHULL, S. Clemente

The wall-paintings in this Pyrenean church are among the masterpieces of †Romanesque Catalan painting. The apse fresco (now removed to Barcelona) shows a Christ Pantocrator (c. 1123). The roots of the style are to be found in the rich colours and linear stylisation of Mozarabic art.

TAI Chin (1388–1462)

Chinese painter from Ch'ien-t'ang, Chekiang. One of the foremost painters of the *Ming dynasty, he was summoned to court under Emperor Hsüan Tsung (reigned 1426–35), but did not remain there long, returning to live in Chekiang. He is regarded as a follower of *Ma Yüan, but the sources of his style are varied, including Yüan painters such as *Wu Chên. His painting, and especially his use of ink washes, was followed by other painters from Chekiang, known collectively as the *Chê School.

TAIGA (Ike-no-Taiga) (1723–76)

One of the most distinguished of the Japanese *Nanga painters, with a definite style of his own which goes beyond the more conventional Nanga formula. Much influenced by Zen, and a fine calligrapher.

TAIKAN (Yokoyama Taikan) (1868–1958)

Painter in the so-called 'Japanese style', more properly a somewhat Westernised synthesis of the pre-*Meiji styles. Most famous for his ink paintings, now much forged and imitated.

TAKAMURA, Kōun (1852–1934)

b. Asakura in Yedo, Japan. He was commissioned to produce decorative sculpture for the imperial residences at the beginning of the Meiji period. Becoming famous he held several important academic and government positions. His sculpture is in a realistic Western style. Typical works are *A Japanese Bird* (1889) and *An Old Monkey* (1903).

TAKANOBU (Fujiwara Takanobu) (1142–1205)

Japanese painter, a nobleman who started a new theme in Japanese art, that of near-realistic portraiture. Three of these portraits still exist and are of his great contemporaries such as Yoritomo.

TAKANOBU (Kanō Takanobu) (1571–1618)

Son of *Eitoku and father of *Tannyū.

TAKIS, Vassilskis (1925–)

b. Athens. Self-taught Greek sculptor, who moved to Paris (1954) and produced his first experiments in *Kinetic sculpture. Takis constructs tall, slender rods, surmounted by electromagnets which mutually attract and repel each other, creating a sensitive, vibrating motion. Takis has made an original and exciting contribution to Kinetic art.

TAL COAT, Pierre Louis Corentin Jacob (1905–)

b. Clohars-Carnoët, Brittany, of a family of fishermen. From early landscape work he progressed to a series of violent paintings inspired by the Spanish Civil War. In the 1940s he began experimenting with the problems of light and of moving masses, his colour becoming softer.

TA'LIQ

A variety of the Arabic script that developed in Persia (c. 13th century), mostly used for literature in Persian. A cursive script with the tendency to slope downwards. Represents a style in the development from *Nashki into *Nasta'liq. Its exponent was Khwaja Taj Salmani Isfahani (?1418–91).

TAMAMUSHI ZUSHI

This small Buddhist painted shrine on a high base is in the *Hōryūji, Japan. An openwork metal edging originally inset with iridescent wings of beetle has given it its name. The paintings on the shrine of the *Asuka period are the earliest to survive in Japan.

TAMAYO, Rufino (1899–)

b. Oaxaca. Painter who studied at Academy of San Carlos (1917–21); taught at 'open-air' schools and Art Academy, Mexico City; moved to New York (1938); went to Europe

(1950). Influenced by *Braque, *Cubism, *Surrealism and *Expressionism, Tamayo rejected the thematic dogma of the Revolutionary Mexican muralists, seeking instead a more personal and universal expression of his country and time. His mature work is characterised by a jagged, angular distortion of forms painted dominantly in earth colours, the figures often merging with their background. These figures, at one with their world, yet uneasy in it, symbolise a 20th-century disturbance, sometimes rising to anguish.

Top: RUFINO TAMAYO *The Fountain*. 1951. 31¾ × 39½ in (81·6 × 101·5 cm). Museo de Bellas Artes, Caracas
Above: TA'LIQ Script from a copy of Firdusi's Shah Nameh. Shiraz, 1341
Above right: T'ANG DYNASTY PAINTING Buddha Preaching under the Bodhi tree, with Bodhisattvas, monks and a donor. Ink and colours on silk. From Tun-huang. 54¾ × 40 in (139 × 101·7 cm). BM, London
Above left: TAMAMUSHI ZUSHI Asuka period. Wood with bronze image. Hōryūji, Nara

TAMI ISLAND *see* **HUON GULF**

TANAGRA

Name referring to the hundreds of small terracotta statuettes found in tombs of the late 4th and 3rd centuries BC at Tanagra. They show men and women in attitudes of everyday life, and are exquisitely modelled and delightfully natural. It is thought that an influx of *Attic artists may account for their sudden occurrence.

T'ANG DYNASTY PAINTING

The major paintings of T'ang China were done on the walls of Buddhist temples and other buildings of the capital, Ch'ang-an, and other cities, as we know from *Chang Yen-yüan, writing (847) just after many of them had been destroyed in the Buddhist persecution (845). Archaeological excavations of imperial and other tombs near Sian (Ch'ang-an) in recent years have revealed many figure-paintings and even landscape motifs in a well-preserved state. Buddhist paintings from *Tun-huang and in the *Hōryūji at Nara, Japan further increase our knowledge of T'ang painting. Also in Nara, in the *Shōsōin repository, there survive numerous examples of decorative painting in the T'ang style on screens, furniture and musical instruments, the last including four lutes with fine landscape paintings on their leather plectrum guards. To these materials may be added copies and even surviving works of great masters such as *Wang Wei, *Yen Li-pen and *Han Kan, the evidence of written records for the marvellous brushwork of *Wu Tao-tzû, and the splendours of T'ang calligraphy in the works of men like Chu Sui-liang, Huai-su and Yen Chen-ch'ing, preserved in the original or through stone rubbings. All breathe the confidence and energy of a great age.

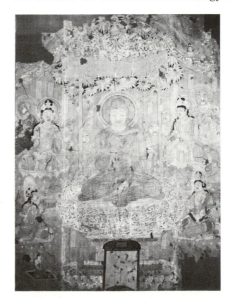

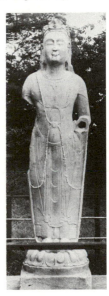

Above right: (T'ANG DYNASTY SCULPTURE) The Bodhisattva Kuan-yin. Sui dynasty, dated AD 585. White marble. h. 8 ft 5 in (2·56 m). The static, formal sculpture of the Sui period gradually gave way to a more realistic representation of form and movement during the T'ang period (see illustration over page)

T'ANG DYNASTY SCULPTURE

Three main stages can be observed in the evolution of a realistic style in Chinese Buddhist sculpture of the T'ang dynasty (AD 618–906). In the first period the block-like representation of form inherited from the late 6th century and the Sui dynasty was modified by an increasing roundness and a growing intimacy and humanity of interpretation. The main Buddha with attendants in the Feng Hsien Ssŭ at *Lung Mên (executed AD 672–5) is an example of sculpture in high relief in which the bold and solid representation of form is softened by the gentle sweep of the robes and by a serene expression. In the

second period fall the nine T'ang dynasty caves at *T'ien Lung Shan. Here the figures are rendered smooth and round barely attached to the wall of the cave with clearly articulated limbs. The third stage (late 8th and 9th centuries AD) saw the full development of realistic T'ang sculpture in which the figures were carefully modelled and were for the first time shown truly in the round. A pronounced degree of movement was suggested with the asymmetrical balance of the figures and the swing of jewels and drapery reinforcing this movement. *See also* **CHINESE CERAMIC FIGURINES; CHINESE MONUMENTAL TOMB SCULPTURE; TIEN LUNG SHAN; WAN FO SSU**

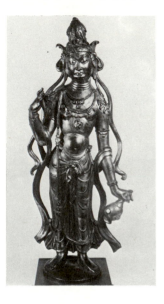

Left: T'ANG DYNASTY SCULPTURE The Bodhisattva, Kuan-yin. Gilt bronze. h. 13¾ in (34·8 cm). Fogg Art Museum, Cambridge, Mass. (Compare with example from the Sui dynasty on previous page.)

Below: YVES TANGUY *Indefinite Visibility.* 1942. 40×35 in (101·4×89·9 cm). Albright-Knox Art Gallery, Buffalo, New York

TANGUY, Yves (1900–55)

b. Paris d. Waterbury, Connecticut. Self-taught painter who joined original *Surrealists (1925), exhibiting with them (until 1938); emigrated to America (1939). Tanguy used a meticulous, polished, *Daliesque realism to render dreamlike, fantastic landscapes, in which unreal objects reminiscent of crumpled drapery and metal, strings and spheres, loom against vast, ominous skies.

T'ANG Yin (1470–1523)

From Su-chou, Kiangsu. The son of a merchant, T'ang Yin was befriended by *Wên Chen-ming's father, and so received the education of a Chinese scholar. He distinguished himself in the Imperial examinations, but a friend's implication of cheating denied him the first place. His disappointment is reflected in his paintings, yearning for seclusion from the cares of the world. A pupil of *Chou Ch'en, his brush style was more detailed than that of the scholar-amateurs, yet more restrained than the professional artists of the *Chê School and at court.

TANJORE *see* CHOLA DYNASTY

TANKA PAINTING *see* TIBET, ART OF

TANNYU (Kanō Tannyū) (MORINOBU) (1602–74)

Japanese painter, a grandson of *Eitoku, and leader of the Edo branch of the *Kanō School, who became official painters to the Tokugawa Shōgunate. A very prolific painter, he is perhaps best known for his interiors of Nijō Castle in Kyōto (built 1601–3 by Ieyasu). He is usually regarded as the last great painter of the Kanō School, which declined after his death into a stiff academicism.

TAANYU *Landscape.* 17th century. Six-fold screen. Ink on paper. BM, London

TANTRA

Sanskrit: literally 'loom'; technically, a set of texts said to have been dictated by *Shiva to *Parvati; hence Tantric and Tantricism, a deviant Hindu cult based on worship of the goddess as *Shakti.

TAO-CHI (Shih-t'ao) (1641–c. 1720)

Chinese painter from Kweilin, Kwangsi. A descendant of the *Ming imperial house, Tao-chi remained all his life loyal to the fallen dynasty. His paintings, often small album leaves and seldom dated, are of landscapes he visited, or flower subjects. He did not rely on earlier masters, believing instead in the creative power of the 'single brushstroke'. Both his painting and his theories have inspired painters down to the present day.

TAPIES, Antonio (1923–)

b. Barcelona. Spanish painter, largely self-taught, he was influenced by *Klee's articulation of rough canvas and the work of *Dubuffet and *Still. His paintings are entirely abstract, but have the feeling of elemental nature. Working intuitively and experimentally he uses fields of thick paint combined with grit and marks scratched into the surface. He is largely dependent, for the impact of his work, upon material and scale.

TAQ-I BUSTAN

A site where Sassanian monarchs carved rock reliefs (4th-6th

century AD). The carvings include the normal hieratic stiff investiture scenes, a magnificent figure of a knight on horseback in full armour in unusually high relief and a scene of a boar-hunt. The composition of this narrative scene is very effective and the details of the king's garments give us an idea of the splendid textiles of the period, many of which were exported to Europe. *See also* SASSANIAN ART

Top: TAQ-I BUSTAN Relief of a boar hunt. Sassanian, 4th–6th century AD
Above: TAO-CHI Landscape. Leaf from an album, 'Eight Views of the South'. Ink and colours on paper. 8×10⅞ in (20·3×27·5 cm). BM, London

Left: ANTONIO TAPIES Ochre Gris LXX. 1958. 102½×76 in (259·1×194·3 cm). Tate

TARA BROOCH (8th–9th century)

This fine brooch of bronze, silver, glass filigree, amber and enamel demonstrates the great richness and variety of Hiberno-Saxon ornament. Its interlace, animal heads, scrolls and chip-carving are closely related to the decorative pages of manuscripts, eg the Book of *Kells. The millefiori glass used on this and much other jewellery probably provided the source for the patterned Evangelist symbols of the Book of *Durrow. (National Museum, Dublin.)

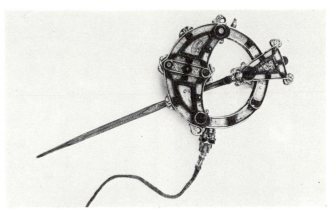

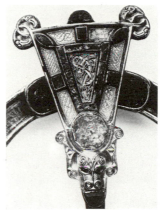

Above and left: TARA BROOCH and detail. Early 8th century. Cast silver, gold, glass and amber. National Museum, Dublin

TARBELL, Edmund Charles (1862–1938)

b. West Groton, Massachusetts d. New Castle, New Hampshire. Painter who studied at Boston Museum School and Académie Julian, Paris; taught at Boston Museum School (1889–1912); directed Corcoran Art School (1918–26). Tarbell composed his portraits and genre interiors harmoniously; his †Impressionism is charming, but academic, usually as genteel as his subjects.

TASSI (BUONAMICI), Agostino (c. 1580–1644)

b. d. Rome. Italian decorative painter, he was active in Rome (by 1610). Flamboyant and temperamental, he was involved in a lawsuit (1612), accused of raping Artemisia *Gentileschi. He specialised in *quadratura – most importantly for *Guercino's *Aurora* (1621–3, Casino Ludovisi) – and in landscape friezes. Tassi also painted small landscapes, coast and harbour scenes in oil (*The Ferry*, c. 1620–2, Private Collection, Rome) in the Northern tradition. Apparently arthritic, he stopped painting (mid 1630s). His work is uneven, but is significant in its own right as well as anticipating that of *Claude, who was his pupil.

TASSILI *see* SAHARA

TATLIN, Vladimir (1885–1953)

d. Moscow. Russian sculptor and designer, a leading figure in the *Constructivist movement. A pupil of *Larionov in Moscow, he visited Paris (1913), where he was strongly in-

fluenced by *Picasso's reliefs and a closer study of the Italian *Futurists. First constructions 1913–15, later works being hanging reliefs. He made his *Project for Monument to the 3rd International* (1919–20), intended to be twelve hundred feet high, a spiral outer shell on a steel core. He turned to industrial design (from 1920) being the artist who remained closest to Russian Revolutionary aims. He produced theatrical projects in 1930s and at this period came under strong official criticism.

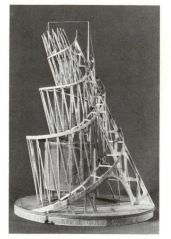 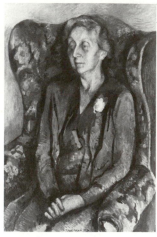

Left: VLADIMIR TATLIN Model of the *Monument to the Third International.* 1919–20. Wood, iron and glass. Remnants of maquette in Russian Museum, Leningrad
Right: PAVEL TCHELITCHEW *Mrs R. A. Glover.* 1930. 39¾ × 27 in (101 × 68·6 cm). Tate

TCHELITCHEW, Pavel (1898–1957)

b. Moscow d. Rome. Russian artist influenced by *Constructivism. In Kiev (1918–20); designed stage-sets in Berlin (1921–3); also *Ode* for *Diaghilev (1928). Settled in Paris (1923), a Neo-Romantic with Bérard, *Berman. Experimented with triple perspective, simultaneous images and metamorphosis (from 1930s). Settled in America (1934), his work increasing in complexity.

TEKE see BATEKE

TELEFOLMIN see SEPIK RIVER

TELLEM see DOGON

TEMPERA

A painting medium which is capable of being diluted with water, therefore the binding medium is an emulsion of some sort. Traditionally tempera was bound in an oil and water emulsion with egg-yolk as the emulsifying medium, but there are now synthetic emulsions available using polymer plastics. True tempera is generally painted on an absorbent *gesso *ground with a *panel as support.

TENEBRISM

Italian *tenebroso*: 'dark', 'obscure'. Low-toned 17th-century painting adopted by Neapolitan and Spanish followers of *Caravaggio.

TENIERS, David the Elder (1582–1649)
The Younger (1610–90)

Flemish painters, father and son. The Elder, b. d. Antwerp, apparently painted landscapes in the style of *Bril. The Younger, b. Antwerp d. Brussels, more famous, began by painting Biblical subjects and was influenced by Jan *Bruegel, but evolved his own genre scenes depicting peasants playing skittles, etc. The best of these date from before his move to Brussels (1651), when he was appointed Court Painter and

Picture Gallery Curator to the Archduke Leopold Willhelm. He there made invaluable painted records of the Archduke's collection (now in Vienna), both as ensembles and as individual copies, notably of the Venetian †Renaissance works, and compiled the catalogue.

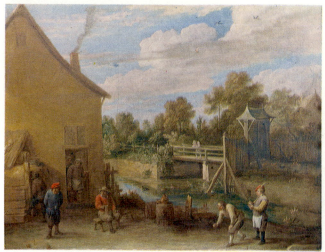

Top: DAVID TENIERS THE YOUNGER *Peasants Playing Bowls.* 47 × 75 in (119 × 190 cm). NG, London
Above: JOHN TENNIEL *The Mad Hatter's Tea Party.* Illustration from Lewis Carroll's 'Alice in Wonderland' first published 1865

Left and right: TEMPERA *Nativity* by Piero della Francesca (and detail) 49 × 48¼ in (129 × 123 cm). NG, London

TENNIEL, Sir John (1820–1914)

b. d. London. English illustrator. A promising career was thwarted by the loss of an eye, and he took to illustration as a cartoonist for *Punch* (from 1850). His hard-edged drawing style,

influenced by German graphics, brought distinction to a neglected medium. His illustrations to the *Alice* books for Dodgson and for *Lalla Rookh* reveal a liberated sense of fantasy.

TEOTIHUACAN

Probably the greatest city in ancient Mexico, with ceremonial pyramids and temples surrounded by extensive residential areas. Teotihuacan art features elaborate architectural decoration, colourful wall-paintings, carved stone masks and pottery ornamented with stucco. The city was active from about AD 200 to 600 when it was destroyed, but Teotihuacan stylistic influences persisted elsewhere after this date.

Left: TEOTIHUACAN Carved limestone mask. Classic Period, Mexico. h. 9⅞ in (25 cm). Dumbarton Oaks
Right: HENDRICK TERBRUGGHEN *Jacob Reproaching Laban for Giving him Leah in Place of Rachel.* 1627. 38⅜×45 in (97·5×114·3 cm). NG, London
Below: GERARD TERBORCH *Parental Admonition.* 27⅝×23⅝ in (70×60 cm). Staatliche Museum, Berlin-Dahlem

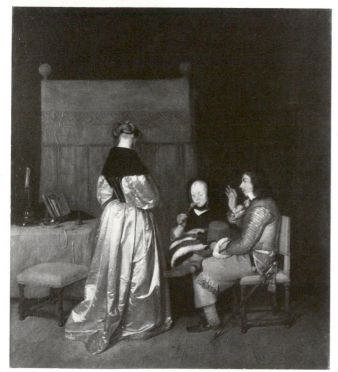

TERBORCH (BORCH, TER, TERBURG, TER BORCH), Gerard (1617–81)

b. Zwolle d. Deventer. Dutch painter of elegant interiors and small portraits. He travelled through Europe and Italy and had won international acclaim by his late twenties. His famous *Peace at Munster* (1648, NG, London) is unlike the majority of his pictures which are often on a more intimate social level and suggest more than their titles indicate (eg the so-called *Parental Admonition*, Berlin-Dahlem). His portraits are remarkable for their depth of expression, achieved with a limited palette, and for the exquisite rendering of dress materials, particularly the sheen of satin.

TERBRUGGHEN, Hendrick (c. 1588–1629)

b. Deventer d. Utrecht. Dutch painter, a leading member of the *Utrecht School. He probably spent ten years in Rome (1604–14), and work produced after his return shows the influence of *Caravaggio, though his style retained many Northern archaisms. His genre-pieces are perhaps closer to *Manfredi, and his paintings of the later 1620s with their clear, soft lighting, yellows, creamy whites and blues anticipate the pictorial treatment that members of the Delft School, such as *Vermeer, gave to their pictures.

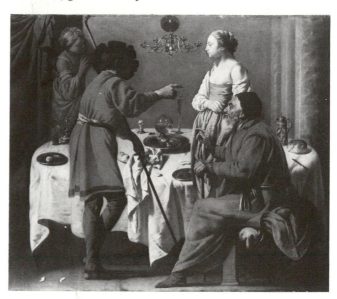

TERBURG, Gerard *see* TERBORCH

TERK, Sonia *see* DELAUNAY

TERRACOTTA

Italian 'baked earth'. A ceramic clay which is easy to handle and durable when fired. Usually tinted red by the presence of iron oxide, but may be white. Used for pottery, for sculpture and for architectural decoration.

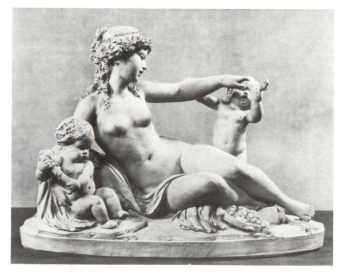

TERRACOTTA *Bacchante and Cupids* by Joseph Marin. Dated 1793. h. 7¾ in (19·7 cm). V & A, London

TESSAI (Tomioka Tessai) (1836–1924)

Probably the last of the great Japanese *Nanga artists. His greatest innovation was his use of thick masses of dark-coloured

pigments, almost in a Western oil-painting manner. His bold use of colour has led him to be compared with his contemporary, *Cézanne.

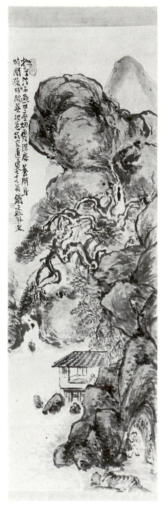

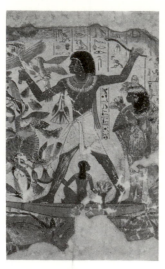

Above: THEBAN TOMBS Marsh scene from the tomb of Nebamūn. Mid-18th dynasty. Paint on plaster. Max. w. 38½ in (97.8 cm). BM, London

Left: TESSAI *Landscape.* Early 20th century. Hanging scroll. Ink and colours on paper. 57¼ in × 19⅛ in (145.3 × 48.5 cm). Impey Coll, Oxford

TESSERAE

The small pieces of stone, glass or ceramic of which a *mosaic is composed.

TESTA, Pietro (1611–50)

b. Lucca d. Rome. Italian painter and etcher. In Rome with *Domenichino (before 1630) and Pietro da *Cortona, he also worked for *Poussin's patron Cassiano dal Pozzo making antiquarian drawings. His work strangely blends the classical and †Romantic. His paintings are rare, his etchings often abstruse.

THACKERAY, William Makepeace (1811–63)

b. Calcutta d. Kensington. English novelist, critic and illustrator, author of *Vanity Fair.* Among his numerous sketches and illustrations are *Comic Tales and Sketches, The Irish Sketches, The Paris Sketches, The Book of Snobs, Vanity Fair.* As an art student in Paris in the 1830s he gives a vivid picture of Bohemian life.

THAYER, Abbott Henderson (1849–1921)

b. Boston d. Monadnock, New Hampshire. Painter who studied in Paris with *Gérôme and at Ecole des Beaux-Arts. Although Thayer's keen eye led him to evolve 'Thayer's Law' of protective coloration in animals and to paint forceful †Impressionist landscapes, he became known for depicting idealised American young ladies, simpering, soulful and insubstantial.

THEBAN TOMBS

Some of the finest Egyptian paintings were executed in the tomb-chapels of wealthy Theban officials of the New Kingdom, especially during the latter part of the 18th dynasty. Among the best known as scenes in the tombs of Userhet, Sennefer, Nakht and Menna, and the later Sennedjem (19th dynasty), while in the British Museum are paintings of quite outstanding quality from the now-destroyed tomb of one Nebamūn of the time of *Amenhotpe III. *See also* RAMOSE; REKHMIRE.

THEBES

The principal city of Egypt during the New Kingdom, the colossal remains of which include some of the greatest monuments of antiquity. On the right bank of the Nile are the temples of *Karnak, and that of Luxor, conceived by *Amenhotpe III, while on the left are the mortuary-temples of *Hatshepsut, *Sety I and *Ramesses II (the Ramesseum), the *Memnon colossi, the royal tombs in the *Valley of the Kings and the neighbouring Valley of the Queens, and, at the foot of the western hills, the many *Theban tombs of officials of the New Kingdom.

THEED, William the Younger (1804–91)

b. d. London. English sculptor, went to Rome (1826) where he studied under *Thorwaldsen, *Gibson and Wyatt, but returned to London (1844) when two designs were accepted for Osborne House by the Prince Consort. He received many commissions, chiefly for public statues, and exhibited at the Royal Academy (1824–85), British Institution (1852 and 1853) and *Prometheus* at the Great Exhibition (1851).

THEODORIC OF PRAGUE (documented 1348–late 1360s)

Master Theodoric was Court Painter to Charles IV, Holy Roman Emperor and King of Bohemia. His chief work was the decoration of the Chapel of the Holy Cross in the castle at Karlstein, near Prague. His figures of prophets, apostles and saints have an earthy quality oddly at variance with the accepted ideas of court art.

THEODOROS (active c. 550 BC)

Greek artist from Samos, credited with having invented the line, rule, lathe and lever and, with *Rhoikos, to have invented or introduced the art of modelling in clay and of casting images in bronze and iron. He is also said to have brought back from Egypt the *canon of proportion for the human figure.

THEOPHANES OF CRETE (active mid 16th century)

d. Herakleion, Crete. Possibly several inscriptions naming a Theophanes the Monk, Theophanes of Strelitzas and a Theophanes Bathas may refer to a single Theophanes the Cretan, who therefore may have worked at a church in the Meteora in Greece (1527) and on *Mount Athos (1535–58) on several commissions and who died at Herakleion, Crete (after 1559). An artist of the so-called 'Cretan School', this Theophanes was individualistic in his iconography which includes scattered Western elements, but his style was largely retrospective, reminiscent of the Palaeologan style (eg Kariye Camii, Istanbul).

THEOPHANES THE GREEK (active 1378–1405)

Trained in Constantinople, he worked there and in the Crimea before emigrating to Russia. His earliest surviving work is the wall-painting of the Church of the Transfiguration at *Novgorod (1378) in which expressive figures with staccato highlights are placed against muted tones. This rendering of faces of saints with bold energetic strokes was copied in Novgorod and by *Rublev. Theophanes moved to *Moscow where his virtuosity and originality were specifically noted in a letter by his contemporary, the writer Epifany. There he painted icons, manuscripts and frescoes – Epifany specially

records that he depicted the city of Moscow on the walls of two Kremlin churches. He is the only great personality in the history of Byzantine art.

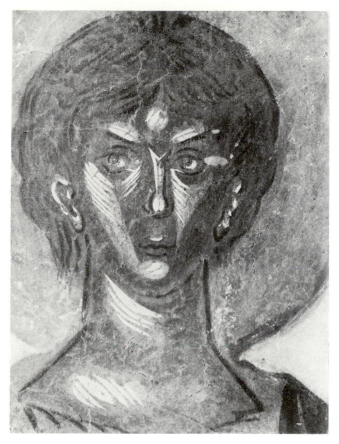

THEOPHANES THE GREEK Head of Abel. 1378. Church of the Transfiguration, Novgorod

THEOPHILUS

Considered by some to be identical with the German metal-worker Roger of Helmarshausen. His treatise, *De Diversis Artibus* (probably written in the first half of the 12th century), contains chapters on the preparation of materials for and the execution of paintings, glass vessels, stained glass, metalwork and enamels. The detailed descriptions of complex medieval techniques provide an invaluable source of information.

THEOTOKOPOULOS, Domenikos *see* GRECO, EL

THERAVADA

Pali: literally 'Doctrine of the Elders'. *See also* HINAYANA

THERMOPLASTIC

A synthetic plastic/polymer *resin formed and set by heat and pressure.

THESSALONIKI, Haghia Sophia

Founded at the end of the 8th century during *Iconoclasm, the original mosaic decoration in the apse appears to have been a plain cross. The present mosaics (late 9th century) are in a heavy unrealistic style, with broad dark lines expressing the folds of drapery in a stylised pattern. *See also* ICONOCLAST ART

THESSALONIKI, Holy Apostles

Built and decorated by the Patriarch Niphon of Constantinople (1312–15), the mosaics and frescoes are some of the best of the early Palaeologan style, showing elegance, dynamism and a fine sense of colour. They are comparable with the decoration of the Kariye Camii, *Istanbul.

THESSALONIKI, Rotunda of St George

Originally the imperial mausoleum of Galerius and converted to Christian use (*c.* AD 450). There are excellent mosaics of the 5th century, in several bands in its huge dome. Most impressive are the saints in the *Orans position portrayed in a very naturalistic style against a fantastic architectural background – a rendering of the Christian community in Paradise.

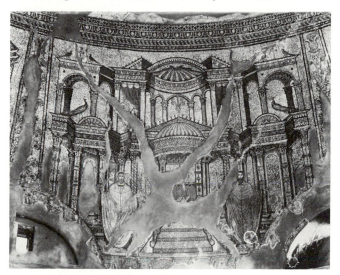

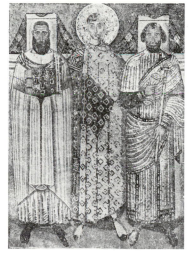

Above: THESSALONIKI. Rotunda of St George. Detail of dome mosaic showing Saints against a background of architecture. 5th century

Left: THESSALONIKI, St Demetrios *Saints with Donors*. 7th century

THESSALONIKI, St Demetrios

The church of the patron saint of Thessaloniki was probably built in the late 5th century and burnt down in 1917, but large portions of mosaic decoration still survive. These seem to be divisible into two phases, the first executed before a 7th-century fire, the second soon after it. The latter phase is an interesting series of ex-voto panels depicting the saint with various donors.

THESSALONIKI, St Nicholas Orphanos

A small basilica, probably built as the main church for a monastery in the first quarter of the 14th century. The recently restored fresco decoration exhibits a precious and gaudy rendering of the main scenes in the life of Christ, the Virgin and St Nicholas. They resemble the pages of an illuminated book or a set of portable icons.

THINNER *see* DILUENT

THIRY, Leonard *see* DAVENT

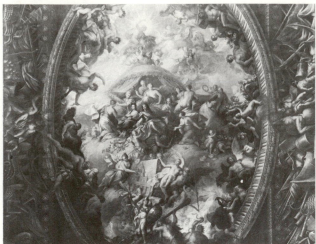
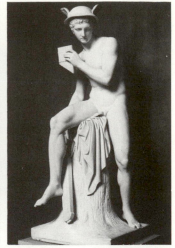

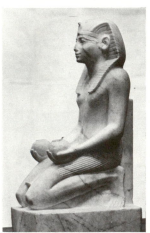

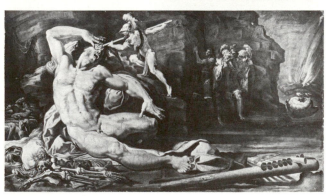

Top left: TOM THOMSON *Forest Undergrowth II.* 1915–16.
47¾×33 in (121·3×83·8 cm). NG, Canada, Gift of Mr and Mrs
H. R. Jackman, Toronto, 1967
Top centre: JAMES THORNHILL Ceiling of Painted Hall,
Greenwich Hospital. 1708–27.
Top right: BERTHOLD THORWALDSEN *Mercury.* 1818. Marble.
h. 67 in (170 cm). Thorwaldsen Museum, Copenhagen
Second row left: THUTMOSE III, Statuette of. Mid-18th dynasty.
Marble. h. 15¼ in (38·7 cm). Egyptian Museum, Cairo
Second row centre: TIAHUANACO Central figure from the
monolithic 'Gateway of the Sun'. *c.* AD 100–600. 12 ft 4 in×
11 ft 6 in (3·76×3·5 m). Lake Titicaca, Bolivia
Second row right: TIBET, ART OF Yamantaka in sexual union
with his consort. 17th century. Bronze. h. 9 in. (23 cm).
Gallery 43, London
Above: PELLEGRINO TIBALDI *Ulysses blinding Polyphemus.*
Detail from the Ulysses fresco cycle. 1554–5. Palazzo Poggio,
Bologna

Above left: T'IEN LUNG SHAN Budda. Cave XXI. Late 7th–early
8th century AD
Above right: TIBET, ART OF Tanka with five mandalas against a
background of stylised landscape and cloud. 18th century.
Gouache on cloth. 57×38 in (145×94 cm). John Dugger and
David Medalla, London

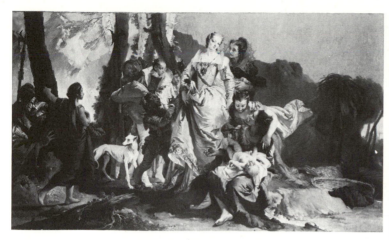

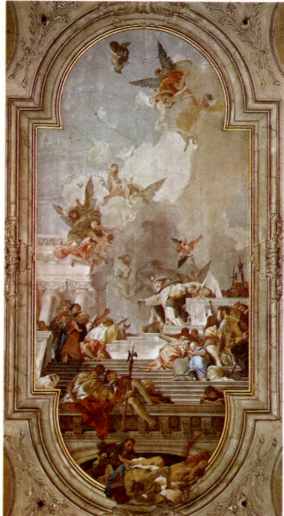

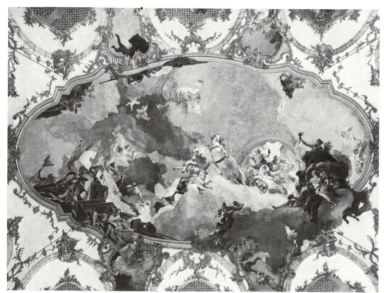

Top: GIAMBATTISTA TIEPOLO *The Finding of Moses.*
c. 1735. 77¾×133¾ in (197×340 cm). NG, Edinburgh
Centre: GIAMBATTISTA TIEPOLO *Apollo Conducting Beatrice & Burgundy to Frederick Barbarossa.* 1751–2. Fresco in the Kaisersaal, Würzburg Residenz
Above: JOE TILSON *Wood Relief No 17.* 1961. 36×48×2 in (91·2×121·9×5·1 cm). Tate

Top: GIAMBATTISTA TIEPOLO *The Institution of the Rosary.* 1737–9. Church of the Gesuati, Venice
Above left: JEAN TINGUELEY *Metà-Matic, No 8.* Motorised construction, iron and steel. 12×25 in (30·5×63·5 cm). Moderna Museet, Stockholm
Above right: TINO DA CAMAINO Wall tomb of Mary Valois. Marble. Sta Chiara, Naples

THOMA, Hans (1839–1924)

b. Bernau d. Karlsruhe. German artist who studied at Karlsruhe with Schirmer, and at Düsseldorf. In Paris (1868) he was influenced by the works of *Courbet and the *Barbizon painters. He worked mostly in Munich on genre, portraits and Black Forest landscapes. He became well known as a poet-painter.

THOMSON, Tom (1877–1917)

b. Nr Claremont, Ontario d. Canoe Lake, Algonquin Park. Canadian painter who was commercial artist in Seattle (1901–5) and Toronto (1905–14); painted full-time (1914–17). A leader of the Canadian 'National Movement', influenced by *Fauvism and *Art Nouveau, Thomson captured the fundamental nature of landscape in electrically intense colours and dynamic rhythmic patterns.

THORNHILL, Sir James (1675–1734)

b. Dorset d. Weymouth. English painter in the grand, illusionistic †Baroque manner, learnt from *Verrio and *Laguerre. He worked notably at Chatsworth (1707), St Paul's (1715–17) and on the allegorical cycles for the decoration of the Painted Hall at Greenwich Hospital (1708–27). Appointed *History Painter to George I (1718), he was knighted (1722) and entered Parliament the same year.

THORN PRIKKER, Johan see PRIKKER, Johan Thorn

THORWALDSEN, Berthold (1770–1844)

b. d. Copenhagen. Danish †Neo-classical sculptor who went to Italy twice (1796–1819 and 1820–38), working in an austere manner similar to *Canova. He designed the tomb of Pius VII (St Peter's).

THRASYMEDES (active c. 375 BC)

Greek sculptor who made the statue of Asklepios for the temple at Epidauros. The figure was seated and had a staff, a serpent and a dog. It appears on coins of Epidauros.

THULE see ESKIMO ART

THUTMOSE: SCULPTOR see BAK

THUTMOSE III (Tuthmosis)

Egyptian king of the 18th dynasty, during whose reign pharaonic military power and influence were at their height. Statues of Thutmose III and of his successor Amenhotpe II exemplify the refined yet simple style of sculpture that was much admired and imitated during the 3rd Intermediate Period.

THY (Ti)

Egyptian court official of the 5th dynasty, whose tomb at *Saqqâra is known for the liveliness and variety of its scenes of everyday occupations, skilfully executed in low relief.

TIAHUANACO

An influential culture (originating c. 100 BC) at a Megalithic site on Lake Titicaca in highland Bolivia. Tiahuanaco culture extended into southern Peru while a modified form developed at Huari in the north. In the highlands, Tiahuanaco art is noted for stone-carving, the most impressive monument being the famous Gateway of the Sun, carved with the figure of a god flanked by attendants, and on the coast textiles and painted pottery are significant. Decoration consists mainly of stylised feline and condor motifs which are stiff and rectilinear in form.

TIBALDI, Pellegrino (1527–96)

b. Puria in Valsolda d. Milan. Painter, sculptor and architect, one of the leading *Mannerists of the late 16th century. He was in Rome (c. 1545) where he assisted Perino del *Vaga with the decoration of the Sala del Consiglio in the Castel S. Angelo.

In Bologna (1554/5) he produced his *Ulysses* series for the Palazzo Poggia, a great feat of illusionism. He was in the service of Cardinal Carlo Borromeo (1561–86) as architect in Milan and Pavia. He took up painting again when he was invited to Spain by Philip II to execute frescoes in the Escorial. Producing a prodigious quantity of paintings there, he was largely responsible for establishing the Mannerist style in Spain.

TIBET, ART OF

Tibetan lamaistic art has never been fully classified either within the religion or by foreign researchers. The seemingly endless proliferation of iconographic form derives from the pantheons of several Indian *tantric Buddhist sects and the pre-Buddhist indigenous Bon religion. Variations in style are accounted for by artistic influences from the Bihar-Bengal empire of the Indian *Pala dynasty, from *Kashmir both during its *Gandhara phase and under the Karkota kings, from *Nepal, *Central Asia and †China. Political changes have augmented and modified the style and content of Tibetan art since Songtsengampo united the country (7th century AD) and took a Chinese and a Nepali wife, both of whom were Buddhists. In a nation of nomadic peoples, who of course had art traditions of their own, the lamaseries were the fixed centres of Buddhist art. The first of these was Samye in central Tibet, established in AD 799, the date from which canonical lamaist art may be said to begin. The art consists principally of paintings, both mural and in the form of *tankas* (painted scrolls or banners) and bronzes. To the outsider, its most striking themes are the Wrathful Deities who despite their terrifying appearance are in fact *chos skyong*, defenders of the faith, and the so-called *yab-yum* (father-mother) couples 'locked in union'. *Tankas* are made of cotton sized with a chalk and glue mixture and edged with Chinese silk. They are essentially objects of veneration or meditation, icons in a form more portable than metal figurines. As banners they might also be used to decorate lamaseries. The composition was drawn on the white surface in red or black by the master, who also noted which colour was to be applied to each area; the painting was done by his apprentices, using pure colours with no attempt at chiaroscuro. The colours were limited to a basic range of red ochre, red lac, yellow ochre, blue, indigo and soot-black, each having a symbolic value. The lines of Tibetan compositions with their complex interweaving and sudden open curves enclosing flat blocks of colour define not visual reality but a heraldic aspect of reality deeply apprehended. The Tibetan Book of the Dead reminds the hearer that all these images are reflections of aspects of himself and therefore not to be feared but transcended on the after-death voyage to the ultimate peace of *Nirvāna. The mandala which passes beyond the iconographic stage to that of pure diagrammatic abstraction to represent the universe as a series of circles contained within squares is the ultimate reduction of form in *tanka-* and mural-painting. The introduction of landscape, resulting from Chinese influence, was used in a merely cursory way in the figurative *tankas* of the western Guge region and was not fully integrated with more naturalistic narrative-painting until the 14th century. It is a remarkable feature of Eastern art that the Tibetan artist was able to represent the vast range of complexity of the lamaistic pantheon in plastic as well as graphic form. The swirling draperies, fiery head-dresses, fantastic monsters, even the mountains and clouds of the *tankas* are given tangible existence in the bronzes. These were generally produced by the *cire perdue method, most of the finest images consequently being unique; figurines of lesser quality were mass produced in reusable clay moulds. Gilding was held to increase the ritualistic as well as the intrinsic value of a piece. Other bronzes were painted in the symbolic colours of the *tanka*. The highest Buddha, *Bodhisattva and *Dharmapala forms are depicted in elaborate princely garments and five-pronged crowns, the lesser Buddhas and legendary saints wearing monastic robes either in the Indian fashion or with the characteristic Tibetan peaked hood. It is evident in the latter categories that the artist often used living models to

produce convincing portraits. The vision of the trance state, on the other hand, is powerfully manifest in the images of mythological deities; but the imagination of the craftsman is always controlled by strict iconographic precepts. An image of Yamantaka, the black buffalo-headed Death-destroyer, with his nine heads, sixteen legs and thirty-four hands each wielding a distinctly rendered tantric emblem, yet remains graceful, locked in symbolic union with his consort. The sexual imagery of lamaistic art basically expresses the mystic unity of the apparent duality of existence; more specifically it represents the union of compassionate means (Sanskrit: *upaya*, 'masculine') with wisdom (*prajna*, 'feminine') necessary for enlightenment. The emblem of the *dorje* (Sanskrit: *vajra*) or diamond-hard thunderbolt coupled with the lotus, a visual representation of the ancient formula *om mani padme hum* ('the jewel is in the lotus'), is the abstract symbol of the same concept.

T'IEN LUNG SHAN, Cave-temple at

A Buddhist cave-temple in Shansi province, China. The twenty-one major caves can be divided into three main groups. To the Eastern Wei (*c*. AD 530–40) belong Caves 2 and 3. Here the flat-patterned sculptures of the Northern Wei period at *Lung Mên have been developed into a broader figure style with greater attention to the representation of shape and volume. Caves 1, 10, 16, 8, belong to the Northern Ch'i period (AD 550–87). At this time the Buddha is shown with an almost tubular body with a seemingly transparent robe drawn tight across the chest. This interest in the form of the human body with less emphasis on drapery was probably the result of influences from Indian or South Asian sculpture as was the introduction of a profusion of minor decorative elements such as lotus flowers and garlands. The third phase of work at this site was in the early *T'ang period (AD 725–50). A growing attention to the realistic representation of the balance and shape of the different parts of the body and a greater unity in the design which again may have been stimulated by south Asian sculptural styles can be traced first in Caves 21 and 14, then in Caves 4, 6 and 18, and finally in Caves 5 and 17.

TIEPOLO Family
Giovanni Battista (Giambattista) (1696–1770)
Giovanni Domenico (1727–1804)
Lorenzo (1736–76)

Giambattista Tiepolo, b. Venice d. Madrid, was the last of the great Italian decorative painters, whose revolutionary fresco technique contrasts strangely with his residually †Baroque altarpieces. He studied under *Lazzarini but responded more to the *chiaroscuro of *Piazzetta, and subsequently to the lighter tonality and more varied formal vocabulary of *Veronese and Sebastiano *Ricci. Tiepolo never lacked commissions, and he travelled widely in northern Italy (1720s–30s), decorated the Kaisersaal at Würzburg (1750–3), and spent the last eight years of his life in Madrid. But though famous he was neither consistently nor universally admired. Tiepolo's luminous handling of fresco nevertheless ranks as one of the major technical advances of the century, and his essays in mildly satirical genre anticipate the more frivolous carnival-paintings of his sons. Domenico, b. d. Venice, and Lorenzo, b. Venice d. Madrid, who also assisted their father, both epitomise the century's drift away from the monumental, and it was a sad but characteristic epitaph on Giambattista that *Goethe should have preferred the rustic idylls of Domenico to the adjoining mythological frescoes of his father in the Villa Valmarana at Vicenza (1757).

TIKAR see BAMILEKE

TILSON, Joe (1928–)

b. London. English painter who studied at St Martin's School of Art (1949–52) and the Royal College of Art (1952–5). Worked in Spain and Italy. Early involvement with *Pop imagery, and principally a mixed-media artist he is deeply involved in making use of modern technological materials, and in redefining the function of art in society; he helped pioneer the multiple in England.

TIMOMACHOS OF BYZANTIUM (active 100/50 BC)

Greek painter who worked at the time of Julius Caesar. He is said by *Pliny to have 'restored the ancient dignity to the art of painting'.

TIMOTHEUS (active *c*. 375–350 BC)

One of the four sculptors of the *Mausoleum at Halicarnassus. He worked on the south side. His style is known from the two small pediments of the Temple of Asklepios at Epidauros. His light drapery clings closely to the figures and the cavernous folds of his heavy drapery provide deep shadows against which the outlines of the limbs stand out clearly. His faces have a 'sweet', wistful expression like those of *Kephisodotos.

TIMURID SCHOOL see HERAT SCHOOL

TINGUELY, Jean (1925–)

b. Fribourg. Swiss sculptor who studied in Basle (1941–5). In Paris (from 1951); he collaborated with *Rauschenberg and others in international 'Happenings' (from 1960). Tinguely's interest in sound and movement showed itself in his first constructions. He developed 'meta-matics' (1952), a fantasy technology producing machines with a built-in chance element – machines for producing paintings, self-destroying machines, etc. A half-humorous half-warning comment on the machine age, Tinguely's work follows *Duchamp's in challenging assumptions about art.

TING Yün-p'eng (active *c*. 1580–1638)

Chinese painter from Hsiu-ning, Anhui, who excelled in Buddhist figure subjects.

TINO DI CAMAINO (*c*. 1306–*c*. 1338)

b. Siena d. Naples. Italian sculptor active in Tuscany and Naples, a follower of Giovanni *Pisano. He was Capomaestro of both Florence and Siena Cathedrals and moved to Naples (1323). The type of wall-tomb which he developed elaborated the formulae of *Arnolfo di Cambio and Giovanni Pisano, producing a rich, many-layered design. His best sculpture, such as the figure of Antonio degli Orsi (Florence Cathedral), the *Madonna and Child* (Bargello, Florence) and the tomb of Mary of Valois (Sta Chiara, Naples), displays a sensitive and decorative style in which anatomy is simplified and rounded forms predominate.

TINTORETTO (ROBUSTI), Jacopo (1518–94)

b. d. Venice. Venetian painter, traditionally the pupil of *Titian and the latter's chief rival in Venice. Their styles are very dissimilar; Tintoretto only left Venice once for a few days, therefore his knowledge of other 16th-century masters largely came to him through engravings which meant that he freely interpreted the intentions of *Michelangelo and others. As a result he evolved an entirely personal language of form and expression, but he was essentially a *Mannerist. A delight in axial space and sharply receding vistas occurs equally in the relatively early *Finding of the Body of St Mark* (*c*. 1562, Brera) or the late *Last Supper* (1592–4, S. Giorgio Maggiore, Venice); also he revelled in dramatic foreshortening which astonished his contemporaries in *St Mark Liberating the Slave* (1548, Accademia, Venice). He was occupied in the decoration of the Scuola di S. Rocco (1564–88) which was central to his career as an artist and inspired *Ruskin to write some of the finest criticism in the English language. Here Tintoretto's visionary originality invested time-worn religious subjects with a fresh intensity and meaning. His forms were generally somewhat elongated and his colours were often sombre or silvery and were matched by a free technique which seems to conjure up, rather than describe, the forms, and in this he differs radically from Titian. The employment of a large body of assistants

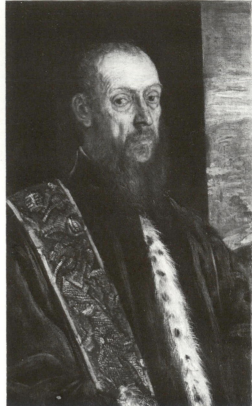

Top left: TINTORETTO *Last Supper*. 1592–4. 144×224 in (366×569 cm). S. Giorgio Maggiore, Venice
Top right: TINTORETTO *Vincenzo Morossini*. 1578–88. 33¾×20¾ in (86×53 cm). NG, London
Above: TINTORETTO *Massacre of the Innocents*. 1583–7. 166×215 in (421·9×546 cm). Scuola di S. Rocco, Venice

enabled him to undertake vast decorative schemes in the Doge's Palace, but he was scrupulous in the preparation of his works, considering the way the light would fall on the painting and making wax models of his figures. As a portraitist he was much in demand and popular with the Venetian authorities, but detested by his fellow artists as he undercut them in the matter of fees.

TISCHBEIN, Johan Heinrich Wilhelm (1751–1829)

b. Haina d. Eutin. German portraitist, successful in Holland and Berlin (1770s), but who preferred Italy, where he met *Goethe (*Goethe in the Campagna*, 1786–8, Frankfurt). His engravings of Sir William Hamilton's collection of Greek vases (1790s) were relevant to the †Neo-classical movement for their precise observations of antique detail.

TISI, Benvenuto see GAROFALO

Above: JAMES TISSOT *My Heart is Poised between the Two*. c. 1877. 15×21½ in (38·1×54·6 cm). Tate

TISSOT, James Jacques Joseph (1836–1902)

b. Nantes d. Buillon. French painter and etcher. An early archaicism reveals the influence of Henri Leys. He began a series of subjects from the fashionable side of modern life, often showing the influence of Japanese art (1864/5). He settled in London (1871) and exhibited at the *Grosvenor Gallery (from 1877).

JOHANN TISCHBEIN *Goethe in the Campagna*. 1787. 65×130½ in (165×330 cm). Frankfurt

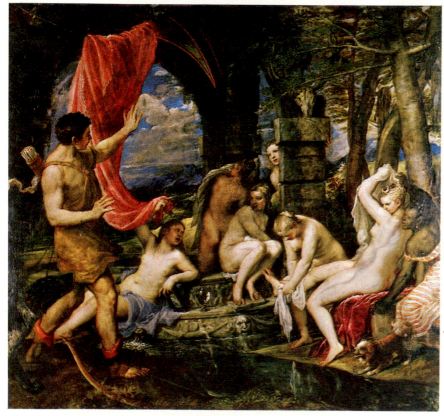

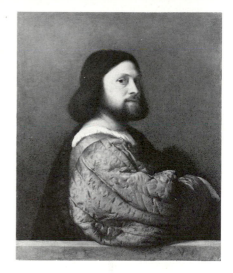

TITIAN
Top left: Entombment. c. 1526–32.
58¼×80¾ in (148×205 cm). Louvre
Top right: Pietà. c. 1573. 137¾×153½ in
(350×395 cm). Accademia, Venice
Above: Portrait of a Man
('*Ariosto*'). *c.* 1510. 32×26 in
(81·2×66·3 cm). NG, London
*Left: Acteon Surprising Diana
and Nymphs while Bathing.* 1559.
74¾×81½ in (190×207 cm). NG,
Edinburgh

TITIAN (Tiziano VECELLI) (*c.* 1487/90–1576)

b. Cadore d. Venice. Venetian painter, acknowledged as one of the greatest masters of the High †Renaissance. Trained in *Bellini's workshop with *Giorgione whom he assisted in the frescoes on the Fondaco dei Tedeschi (1508). Giorgione's early death (1510) and Bellini's retarded demise (1516) left the field open for Titian in Venice and his *Assunta* (1518, Frari, Venice) won universal approval and was the first Venetian altarpiece to rival the mature pictures of *Raphael in its bold design, naturalism, glowing colour and dramatic *chiaroscuro effects. This was followed (1520s–30s) by numerous sacred works where these qualities were directed to the expression of tragedy as well as joy, eg *Entombment* (Louvre). Meanwhile Alfonso d'Este invited him to embellish his *studiolo with scenes from Ovid's *Fasti* in which we see Titian's palette at its most sparkling. Later, from the 1540s, his hues become darker or the contrasts dimmer, the brushwork broader, the edges of the forms more blurred and their contours less

idealised and compact. He was in Rome (1545–6) where he painted *Paul III with his Nephews* (Naples) in which the scarifying psychological insight into their relationship gives fresh point to the Pope's plea on the unveiling of *Michelangelo's *Last Judgement*: 'Lord! Judge me not according to the sins of my youth.' He could also endow his sitters with a dignified pathos as in the portrait of Charles V (Munich) who employed him at the court at Augsburg (1548–51), honouring the artist with his friendship. Subsequently Titian devised a series of mythological nudes known as the *Poesie*, for Philip II's private delectation, as well as several religious works often instinct with a mood of tragic foreboding or exemplifying the religious exaltation of the Spanish monarch. Titian also knew *Vasari and his late figures often show his adoption of the small heads and elongated proportions favoured by the *Mannerists and most hauntingly exploited in the screaming Magdalene from Titian's last work the *Pietà* (Accademia, Venice).

TITO, Santi di (1536–1603)

b. Borgo San Sepolcro d. Florence. Studied first under *Bronzino and then under Baccio *Bandinelli, before going to Rome in order to study the *Antique, possibly at Bandinelli's suggestion. *Vasari says that he painted the Catafalque of Michelangelo as well as in the Vatican Belvedere. His mastery of architectural perspective was completely eclipsed by 17th-century developments.

TITUS, Arch of see ROME, Arch of Titus

TIV see NIGERIA, NORTHERN

TLATILCO

Pre-Classic period (c. 2000 BC–AD 300) site in the Valley of Mexico. Noted for painted pottery vessels and jars modelled in the form of animals and birds. Particularly characteristic are hand-made clay figurines with applied and painted decoration. They are usually female figures, but male figures, figures with two heads, and dancers, acrobats and dwarfs, also appear.

TLINGIT

*Northwest Coast Indian tribe occupying the border area between Alaska and British Columbia. The Tlingit were skilled woodcarvers, but they are noted particularly for fringed ceremonial blankets, woven from mountain goat wool and cedar-bark twine with stylised animal designs in black, yellow and blue, which were made by a sub-tribe, the Chilcat.

TOBA-SOJO

The Japanese monk Kakuyū (1053–1140) to whom the *Choju-giga* handscrolls are traditionally attributed. In fact the scrolls are from at least three different hands and no certain work of his survives.

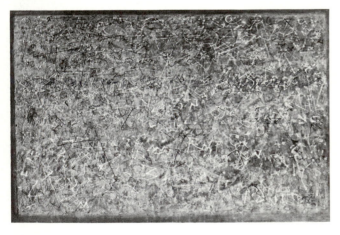

MARK TOBEY *Universal Field*. 1949. Tempera and pastel. 28×44 in (71·1×111·8 cm). Whitney Museum of American Art, New York

TOBEY, Mark (1890–)

b. Centerville, Wisconsin. Painter who studied and worked in New York (c. 1911–22); travelled extensively, especially in Paris, England and the Orient (c. 1925–38); settled in Seattle (1939), travelling occasionally. Influenced by Oriental art and thought, Tobey developed his characteristic 'white writing', rhythmic calligraphy first used in evoking cityscapes, then weaving abstract inner visions.

TOCQUE, Louis (1696–1772)

b. d. Paris. French portraitist, the son-in-law of *Nattier, who worked at the courts of Sweden, Russia and Denmark and wrote a treatise on portraiture (1750). He painted Marie Leczinska (1738). Much of his work, though fashionable, is rather shallow.

TODAIJI, The

A Buddhist temple of the Kegon sect in Nara Prefecture, Japan. Of the great Buddha of the *Nara period cast for this temple (AD 737) only a few engraved petals of the lotus throne now remain of the original work. The temple contains an important group of *Nara period clay sculptures: Shūkongōjin, the guardians of the four directions, a Gekko and Nikko and a Kichijōten. In *kanshitsu figures of *Nara date are a Fukūken-saku Kannon (AD 747), guardians of the four directions, and temple guardians. Early *Heian wooden sculptures are the figure of Rōben Sōjō the founder of the temple, and a Miroku; from the middle Heian is the 10th-century figure of Shōmen Kongō. Realistic sculptures of the *Kaikei School include the figure of Hachiman dressed as a priest, a standing Jizō, the temple guardians and a portrait sculpture of the priest Chōgen.

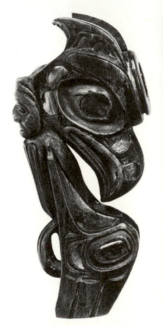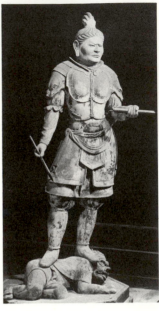

Above left: TLINGIT Carved wooden pipebowl in the form of an eagle's head, the rim lined with copper. Early 19th century, British Columbia, Stikine River. Inlaid with haliotis shell. l. 7¼ in (18·4 cm). Royal Scottish Museum
Above right: TODAIJI Guardian of the West. Nara period, mid-8th century AD. Clay. h. 5 ft 3⅛ in (1·60 m). Kōmoko-ten
Left: LOUIS TOCQUE *Mademoiselle de Coislin*. 31¼×25 in (79·5×63·5 cm). NG, London

TOGAN (Uukoku Tōgan) (1547–1618)

Japanese painter who claimed himself to be the successor to *Sesshū and founded a sub-school (the Unkoku School) which continued as a variation of the Suiboku School of the *Muromachi period.

TOHAKU (Hasegawa Tōhaku) (1539–1610)

One of the greatest painters of the *Momoyama period. Working at first in monochrome, he also started a studio for polychrome painting in rivalry to *Eitoku. His most famous works are the monochrome screens in the Tokyo National Museum and the doors now in Chishakuin, Kyōto.

TOLTEC

A warrior people who invaded Mexico from the north at the start of the Post-Classic period (*c.* AD 900), the Toltec took much of their culture from the people they conquered. Little survives of Toltec art apart from some characteristic pottery styles, and the architectural remains of Tula, their capital.

TOMA *see* DAN-NGERE

TOMLIN, Bradley Walker (1899–1953)

b. Syracuse, New York d. New York. Painter who studied at Syracuse University (1917–21) and in Paris (mid 1920s); taught in New York (1932–41). First painting realistically, then in discerning, disciplined *Cubism, Tomlin was converted by *Surrealist automatism and *Gottlieb to *Abstract Expressionist Action Painting, using subtle colour in broad, dancing, intertwined calligraphy.

TOMMASO DA MODENA (*c.* 1325–79)

b. d. Modena. Italian painter whose frescoes of a series of Dominican scholars seated in cells at their desks writing and reading and flanked by inscriptions in the Chapter House of S. Nicolò in Treviso, are reminiscent of manuscript-illuminations. His work in Bohemia (Karlstein Castle) for the Emperor Charles IV provides an instance of the Italian contacts and influence that are to be seen in 14th-century Bohemian painting.

TONDO

Italian: 'round'. A circular picture or relief.

Left: TONDO *Madonna and Child with St John* by Michelangelo. *c.* 1505–6. Marble relief. h. 46¼ in (117.5 cm). Royal Academy, London

Below: TOHAKU Maple Tree Doors. 1592. Sliding doors, colours on gold leaf. Entire panel 5 ft 9¾ in × 18 ft 2¼ in (177×554 cm). Chishakuin, Kyōto

TONE

The artist's term for light and dark. The degree of shading in a single colour, in a monochromatic picture, or by disregarding the colour in a picture and viewing it tonally as in a black and white engraved reproduction or in a photograph. The artist speaks of tonal values – the relative lightness and darkness of a subject.

TONGAN ISLANDS

A *Polynesian island group whose art is closely related to that of Samoa and *Fiji. Few examples of sculpture survive. Small figures worn as pendants were carved on the Haapai Islands from walrus ivory and sperm-whale tooth. Ivory suspension-hooks are carved with figures supposed to represent gods.

Left: TONGAN ISLANDS Double figure suspension hook. Ivory. h. 5¾ in (14.8 cm). Anthropological Museum, University of Aberdeen
Right: HENRY TONKS *Girl with a Parrot.* 1893. 18×12¼ in (45.7×31.1 cm). Tate

TONKS, Henry (1862–1937)

b. Solihull d. Chelsea. Originally a doctor, Tonks joined the teaching staff of the Slade School of Art, London (1893), where his emphasis on the discipline of draughtsmanship influenced a generation of students such as Mark *Gertler and Stanley *Spencer. Associated with rigid opposition to the avant-garde.

TONNANCOUR, Jacques Godefroy de (1917–)

b. Montreal. Canadian painter who studied in Montreal at Ecole des Beaux-Arts and Art Association with *Roberts; teaches in Montreal. Influenced by *Pellan, *Matisse and *Picasso, de Tonnancour's often *Surreal abstractions are characterised by delicate yet exciting line and airy painterliness, wit and delightful intimate vision, emotive without being expressionistic.

TOOROP, Charley (1891–1955)

b. Katwijk Aan Zee, Holland d. Bergen. Daughter of the Dutch *Symbolist painter Jan *Toorop she painted powerful, meticulously observed portraits of working-class men and women.

JAN TOOROP *O Grave, Where is thy Victory?* 1892. 23⅝×29⅝ in (60×75 cm). Rijksmuseum

TOOROP, Jan Theodore (1858–1928)

b. Java d. The Hague. A Dutch painter and designer of the *Symbolist movement. Exhibited with *Les Vingt (from 1884) before returning to Holland (1890). His first paintings showed the influence of *Moreau, replaced by a highly individual use

of Javanese motifs (after 1892) seen in stylised linear patterns which tended to increase the two-dimensional element, eg *The Three Brides* which also shows the prevailing melancholy of his works. Through reproductions published in the *Studio* magazine his influence spread to *Mackintosh and his circle in Glasgow. His work lost much of its formal and thematic tension after 1905.

TORCELLO CATHEDRAL

The mosaic decoration at the east end appears to be of two periods. The diaconicon and lower part of the main apse is in an early 12th-century style, while the *Virgin and Child* in the couch of the main apse is 13th century. The *Last Judgement* on the west wall may reflect a Byzantine design, but has been heavily restored; fragments however of the original work survive in the Torcello Museum which may be compared with early 13th-century mosaics in St Mark's, *Venice.

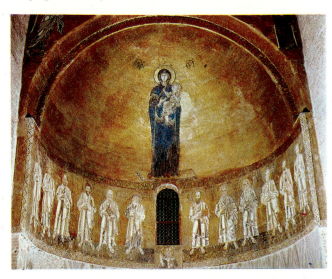

Top: TORCELLO CATHEDRAL *The Virgin and Child with Apostles.* Apse mosaic. 13th century
Above left: TORCELLO CATHEDRAL Detail from *The Last Judgement*
Above right: TORI SCHOOL Shaka triad by Tori. Asuka period, dated AD 623. Gilt bronze. h. (of seated figure) 34 in (86·5 cm). Hōryūji, Nara

TORI SCHOOL

This school is named after the Japanese sculptor Tori (active c. AD 600–30). The two works which are reliably attributed to Tori are the bronze images of Yakushi Nyorai and of Shaka Nyorai in the *Hōryūji. It is from *Lung Mên in North China that the long faces with so-called 'archaic' smiles, the emphasis on linear decoration in the form of the elaborate dress folds

and the overall frontal approach of these figures, is derived. These features were transmitted by way of the kingdom of Paekche in Korea where they were reinterpreted with a tendency to enlarge the heads of images and accentuate the symmetry of the drapery folds. Tori's contribution to this style lies in the rhythmically enlarged sweep of the folds of drapery, the sure composition of the elements of the sculpture and above all in the fine clarity of the casting of the bronzes.

TORII SCHOOL *see* KIKONOBU; UKIYO-E

TORRES GARCIA, Joaquín (1874–1949)

b. d. Montevideo. Painter who studied with Vinardell, Barcelona (1891–6); lived in New York (1920–2), Italy (1922–4) and Paris (1924–32); established El Taller, Montevideo (1934). Inspired by *Constructivism and pre-Hispanic art, his influential paintings are pictographs, using a geometric structure to compartmentalise symbols, hieroglyphics and ordinary scenes in a primitive style.

Above left: JOAQUIN TORRES GARCIA *Constructive City with Universal Man.* 1942. 32×40 in (81·3×101 cm). Manolita Pina de Torres Garcia Coll, Montevideo
Above right: TORRES STRAITS Mask. Turtle shell, human hair, twine and pigment. h. 16$\frac{1}{8}$ in (41 cm). Museum of Primitive Art, New York

Left: PIETRO TORRIGIANO Tomb of Henry VII and Elizabeth of York. 1512–18. Gilt bronze. Westminster Abbey

TORRES MENDEZ, Ramón (1809–85)

b. d. Colombia. Painter who was leader of Colombian School of Naturalism in 19th century. Although he was immensely popular for his portraits and miniatures, he is at his best in his vivid, lively genre paintings of Colombian life.

TORRES STRAITS

An art-style area comprising the numerous small islands between Australia and *New Guinea, and the delta of the Fly River. Most characteristic are turtle-shell masks and head-dresses worn at fertility and funerary rites.

TORRIGIANO, Pietro (1472–1528)

b. Florence d. Seville. Florentine sculptor, a pupil of *Bertoldo and a fellow student of *Michelangelo. He fled from Florence after breaking Michelangelo's nose. Subsequently he worked in the Netherlands, Spain and England where he produced his best-known work, the tomb of Henry VII and Elizabeth of

York (1512, Westminster Abbey). Using death-masks he cast full-length recumbent figures, with *putti, saints and figures in the surrounding grille. He also worked in Seville where he died at the hands of the Inquisition.

TORRITI, Jacopo (active late 13th and early 14th century)

In designing the apse mosaics in the great Roman basilicas of Sta Maria Maggiore and St John Lateran (now replaced by a 19th-century copy), he led the last revival of a craft which had long been traditional in Rome. In both works he was strongly influenced by existing late Roman mosaics, particularly in using the motif of luxuriant foliage, inhabited by birds, beasts and *putti. Beneath the *Coronation of the Virgin* (Sta Maria Maggiore) are scenes from her life, which show an essentially †Byzantine style, influenced by Roman and Tuscan developments. Frescoes of the Creation in the Upper Church of S. Francesco, *Assisi are attributed to Torriti and he probably also executed fresco cycles in Rome.

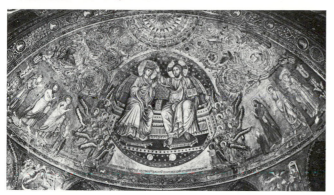

Above: JACOPO TORRITI
Coronation of the Virgin; Mosaic.
Sta Maria Maggiore, Rome

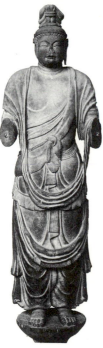

Left: TOSHODAIJI
Fukukensaku Kannon. Late
Nara period, 8th century AD.
Wood. h. 5 ft 8½ in (1·73 m).

TOSA SCHOOL

The Tosa family became official painters at the court of the Japanese emperor in the 15th century. Descended from the *Yamato-e, their style was developed by *Mitsunobu. Traditionally it was from Tosa Mitsuyoshi that the *Kanō School learned the art of colouring in the *Momoyama period. *Mitsuoki and his descendants were hereditary heads of the imperial studio, but the style degenerated into feebleness from the beginning of the Edo period. The *Rimpa School by-passed Tosa to look back to Yamato-ē, but the *Ukiyo-e School is clearly influenced by the Tosa.

TOSHODAIJI, The

A temple in Nara Prefecture, Japan (founded AD 759). It contains a portrait sculpture in *kanshitsu of the patriarch Ganjin who had lived there until AD 763. Other *Nara sculptures in *kanshitsu* are a seated figure of Rushana, a standing Yakushi Nyorai and a large figure of the Thousand-armed Kannon. Carved from single large blocks of wood, a technique developed in the Tōshōdaiji in the late 8th century, are a Fukūkensaku Kannon, a Kannon with a willow branch and a figure of Bonten. Continuing this style with the more massive figures of the early *Heian period are two standing figures of Yakushi Nyorai.

TOTEMIC ART: AUSTRALIAN *see* AUSTRALIAN ABORIGINAL ART

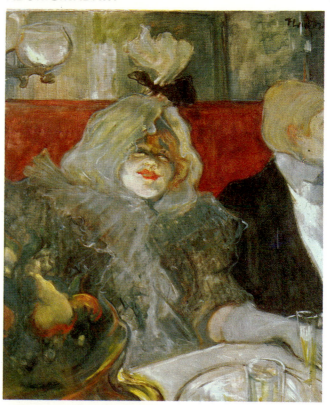

Above: HENRI DE
TOULOUSE-LAUTREC
*In a private Room at Le Rat
Mort.* 1899. 21½×17¾ in
(54·5×45 cm). Courtauld
Institute Galleries, London

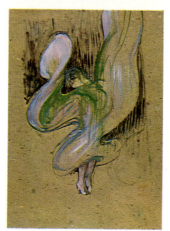

Left: HENRI DE TOULOUSE-
LAUTREC *Loie Fuller in the
Dance of the Veils.* 1893.
Oil on card. 24×17⅞ in
(61×44·1 cm). Musée
Toulouse-Lautrec, Albi

TOULOUSE-LAUTREC, Henri Marie Raymond de (1864–1901)

b. Albi d. Château de Malromé, Gironde. From an aristocratic family, financially independent, he was left deformed by two successive falls in his childhood. His brief but intense artistic activity began with instructions from the animal painter,

Princeteau, then in *Bonnat and Cormon's studios in Paris. But he profited more from his contacts with leading contemporary artists. †Impressionism lightened his palette, and his way of seeing was influenced by *Degas and Japanese prints. He did not belong to any movement, but frequently exhibited at the Salon des Indépendants. He moved to Montmartre (c. 1886), and its cabarets, music-halls, circus and brothels provided the spontaneous subject-matter of his paintings, drawings and popular lithograph posters. With superb draughtsmanship, large areas of flat colour and concentrated design, he conveyed a perceptive, if sometimes merciless, portrait of the society about him. During the last years of his life he was treated for severe alcoholism.

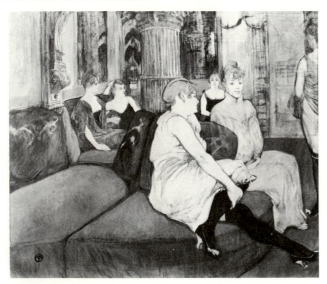

HENRI DE TOULOUSE-LAUTREC *The Salon in the rue des Moulins*. 1894. 43½×47 in (110×120 cm). Musée Toulouse-Lautrec, Albi

TOULOUSE, St Sernin

The sculpture in this pilgrimage church dates from the 1090s to about 1110. The *Christ in Majesty* and *Apostles* in the ambulatory are related to early reliefs at *Moissac. The *Porte Miègeville* with a *tympanum portraying the Ascension with figures of SS Peter and James in the *spandrels, shows a later development of this style resembling some of the work on *Puerta de la Platerías* in *Santiago de Compostela.

TOURNIER, Nicolas (1590–c. 1660)

b. Montbéliard. French religious, historical and genre painter often in the manner of *Caravaggio or *Manfredi, but in a more elegant idiom (*The Guardian Angel*, Narbonne Cathedral). His *Victory of Constantine* (Toulouse) emulates Giulio *Romano.

TOWN, Harold Barling (1924–)

b. Toronto. Canadian painter and printmaker who studied at Western Technical Institute and Ontario Art College, Toronto; was founder-member of *Painters Eleven (1953). Occasionally working figuratively, Town is best known for his 'single autographic prints' and abstract works, decorative, technically masterful, complex compositions of sharply contrasted and elaborately textured primitivist shapes.

TOWNE, Francis (c. 1739–1816)

b. Wigan d. London. English watercolour landscapist. He travelled through England, Italy and Switzerland, and is best known for his few imposing, almost abstract Alpine views, which are striking for their early date (1781).

TOYOHARU (Utagawa Toyoharu) (1735–1814)

Founder of the Utagawa sub-school of *Ukiyo-e.

TOYOHIRO (Utagawa Toyohiro) (1774–1829)

Japanese printmaker who also studied *Kanō style. Teacher of *Hiroshige.

TOYOKUNI (Utagawa Toyokuni) (1769–1825)

An important Japanese actor-print designer at the end of the 18th century, whose best work emulates *Sharaku, but who was extremely productive and often imitative, so his work is not a consistently high standard.

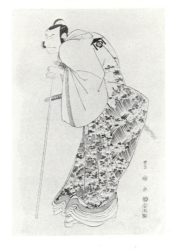

TOYOKUNI *Actor*. Late 18th century. Woodblock colour print. Oban, approx 14×10 in (25·4×35·6 cm). Ashmolean

TOYOKUNI III see KUNISADA

TRAJAN, Arch of see BENEVENTUM, Arch of Trajan

TRAJAN'S COLUMN see ROME, Column of Trajan

TRA-KIEU see CHAM ART

TRANSFER PAPER

Transfer paper can be used as an alternative to the direct method in *lithography. The artist makes a drawing upon prepared transfer paper with lithographic inks and crayons; the printer can then transfer the drawing on to a plate or stone. This avoids some of the limitations attendant upon drawing straight on to a stone or plate, and the final proof is not reversed, but the same way round as the drawing. Purists frown upon this method, but a real understanding between artist and printer can obtain fine results.

TRANSMITTED LIGHT

Light seen after passing through a translucent or transparent *medium. This may colour the light, or diffuse it, or affect it in any way. In painting the transmitted light passes through to the *ground, and is then reflected back to the spectator, being transmitted once more. Thus luminosity of colour will depend upon the clarity and thickness of each paint layer, the evenness of drying and compatibility of *pigment mixtures.

TRAU, Giovanni da see DALMATA

TREBIZOND, Haghia Sophia

Built as the main church of a monastery and as a mausoleum containing tombs of some of the Comnene rulers of Trebizond, still contains fragments of a fresco cycle which must have been executed between 1204 and 1282, probably soon after the middle of the century. The style can be taken as evidence of a workshop in Trebizond independent of, yet influenced by, current artistic developments in the rest of the Byzantine world.

TRES RICHES HEURES DU DUC DE BERRI see LIMBOURG BROTHERS

TREVELYAN, Julian (1910–)

b. Dorking, Surrey. Painter and engraver, studied at Atelier 17 in Paris. An eclectic, especially admiring *Klee, he was a member of the English *Surrealist group (1936–9) exhibiting at the London International Surrealist Exhibition. Since then he has painted *Expressionist landscapes and illustrated books. A member of the *London group (since 1949).

TRIBOLO, Niccolò (1500–50)

Italian sculptor. Trained under *Sansovino, he worked principally in Florence, but also in Rome, Pisa and Bologna. He assisted *Michelangelo in the Medici Chapel, and his work remained much indebted to him. The extravagant *contrapposto of the Virgin in the *Assumption* relief at S. Petronio, Bologna, is however an innovation. Under the patronage of Cosimo I (from 1537) Tribolo acquired fame as a garden sculptor. His fountains of the Labyrinth, Villa della Petraia, and of Hercules, Villa di Castello (in both of which he was assisted by Pierino da *Vinci) display a *Mannerist dramatic sense. A bronze statuette of considerable vivacity, *Pan*, is attributed to him.

TRIER, Hann (1915–)

b. Düsseldorf-Kaiserwerth. German painter who studied in Düsseldorf (1934–8). In his early work, cell-like enclaves of colour are almost obliterated by heavy black lines applied with a rhythmic, gestural force. His later work is calmer and more lyrical.

TRIPPENMEKER, Hans see ALDEGREVER, Heinrich

TRISTAN, Luis (c. 1586–1624)

b. d. Toledo. Spanish painter. Pupil of El *Greco, many of whose compositions he used, he was an important link between *Caravaggists like *Borgianni (in Toledo c. 1605) and *Velasquez. His compositions are fully †Baroque with closeness to nature combined with weight and poise of figures.

TRIUMPHAL ARCH

A Roman honorific monument erected over a road to commemorate a military victory. The earliest surviving arches consist of a simple mass of masonry pierced by a single arched opening flanked by half-columns, eg the arch at Rimini (27 BC) and the Arch of Titus at *Rome (81 BC). Later more elaborate arches with two smaller openings flanking the large central one were evolved, eg the Arch of Septimius Severus, *Rome and the Arch of *Constantine. Four-sided arches are sometimes found at the intersection of two roads, eg the Arch of Septimius Severus at *Leptis Magna, and the Arch of *Galerius at Salonika.

TROBRIAND ISLANDS see MASSIM

TROIS FRERES

†Palaeolithic site in Ariège, France comprising a long cave with many side galleries. There are more engravings than paintings which date from *Perigordian/*Aurignacian and *Magdalenian. Many engravings are superimposed so that some panels are completely confusing – not only Magdalenian over Perigordian but each over their own. The animals are mostly bison, reindeer and horse; there are also lions and two owls. The most famous figure is the 'Sorcerer', a human wearing the skin and antlers of a deer.

TROMPE L'OEIL see ILLUSIONISM

TROOST, Cornelis (1697–1750)

b. d. Amsterdam. Sometimes called the 'Dutch *Hogarth', a painter of portraits, *conversation- and theatre-pieces, Troost never attained the wit of Hogarth. He became well known through his group portrait, *Inspectors of the Collegium Medicum* (1724, Rijksmuseum).

TROY

Site in north-west Turkey, famous for its Homeric associations. Here the 19th-century archaeologist Heinrich Schliemann unearthed a spectacular collection of gold and silver jewellery and vessels and, wrongly assigning them to the Trojan War period, called them 'Priam's Treasure'. It has since been established that the treasure belongs to the Early Bronze Age and dates from the last centuries of the 3rd millennium BC. Trojan metalworkers of this period employed a variety of techniques. Hammering, soldering, sheathing, *repoussé and *cire perdue casting were practised, and semi-precious stones were frequently used, often in combination with filigree and granulated work. The contents of the royal tombs of *Alaca Hüyük in central Anatolia are roughly contemporary with these Trojan finds, and similar finds have been reported from Dorak, an inland north-western site. *See also* ANATOLIA, Art of

TROY, Jean François de (1697–1752)

b. Paris d. Rome. French painter who returned from Rome (c. 1705) to rival *Le Moyne with large historical or allegorical paintings. He later satisfied popular demand with *Rubensian *fêtes galantes (*Déjeuner de Huitres*, Chantilly) and Gobelins tapestry designs.

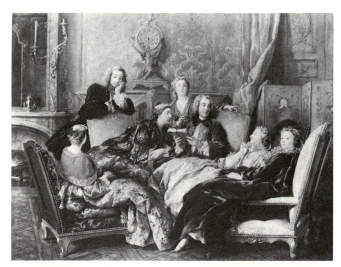

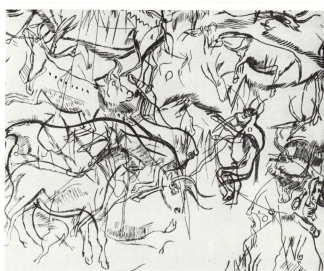

Top: JEAN DE TROY *La Lecture de Molière.* 28½×35¾ in (72·4×121·3 cm). Marchioness of Cholmondeley Coll
Above: TROIS FRERES Reconstruction by the Abbé Breuil of superimposed rock engravings from the Sanctuary

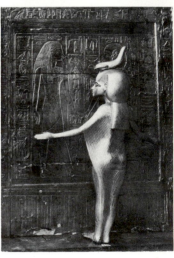

Top left: CONSTANT TROYON *The Return to the Farm.* 1859.
102⅜×153⅝ in (260×390 cm). Louvre
Top right: TUNG CH'I-CH'ANG *Mountains on a Clear Autumn
Day.* Handscroll. Ink on paper. Cleveland
Second row left: JOHN TRUMBULL *Battle of Bunker's Hill.*
1775. 25×34 in (63·5×86·4 cm). Yale University Art Gallery
Second row centre: WILLIAM TUCKER *Anabasis I.* 1963.
58¾×43¼×8⅜ in (149·2×109·9×22·3 cm). Tate
Second row right: TUN-HUANG *Avalokitesvara with a nun and a
male donor.* Dated 910. Ink and colours on silk. 30⅜×19¼ in
(77×48·9 cm). BM, London
Third row far left: TS'AO CHIH-PO *Rocks and Trees.* Ink on silk.
10¾×10⅝ in (27·3×27·1 cm). Art Museum, Princeton
Third row left: TUAMOTU ISLANDS Figure of the deity, Rongo.
Wood. h. 38¾ in (98·4 cm). Museum of Primitive Art, New York
Above left: TUNG YUAN *Wintry Forests on Lake Shores.* Ink on
silk. Kurokawa Institute, Hyoga, Japan
Above right: TUTANKHAMUN, tomb of. Goddess (Selqet) before
the king's shrine. Late 18th dynasty. Carved and gilt wood.
h. 35⅞ in (91 cm). Egyptian Museum, Cairo
Left: TUC D'AUDOUBERT Clay relief of bisons mating. h. (of
female) 24 in (61 cm)

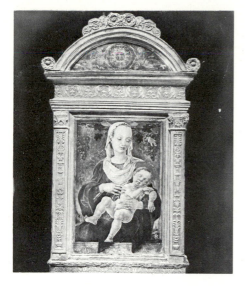

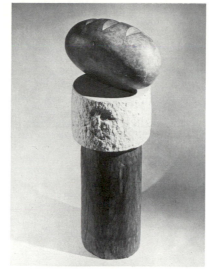

J. M. W. TURNER
Top right: Music Party, Petworth. c. 1835. 47¾×35⅝ in
(121·3×90·5 cm). Tate
Above left: Rain, Steam and Speed – The Great Western Railway.
1844. 35¾×48 in (91×122 cm). NG, London
Above right: Crossing the Brook. c. 1815. 76×65 in
(193×165·1 cm). Tate
Left: Buttermere Lake, with part of Cromack Water, Cumberland,
a Shower. 1798. 35×47 in (88·9×119 cm). Tate
Above: A Man Galloping over the Sands at Scarborough.
c. 1816–18. Pencil. 4½×7⅛ in (11·4×18·1 cm). BM, London

Top left: COSIMO TURA *Madonna with Sleeping Child. c.* 1460.
46⅞×23¼ in (119×59 cm). Accademia, Venice
Top centre: WILLIAM TURNBULL *Head.* 1960. 45¾×21¼×12 in
(116·2×54×30·5 cm). Tate

TROYON, Constant (1810–65)

b. Sèvres d. Paris. French artist who at first worked at the Sèvres porcelain factory. He took up landscape painting and exhibited (from 1833). He became one of the *Barbizon painters (1840s) and then in Holland discovered the 17th-century Dutch realists, such as *Potter and *Cuyp, who inspired his cattle-pictures.

TRUMBULL, John (1756–1843)

American painter, the son of the governor of Connecticut, who was aide-de-camp to Washington during the Revolution. He studied with *West in London (1780, 1784–9), visiting France; worked in America (1789–94, 1804–8, 1816–37) and England (1808–16); was a tyrannical President of the American Academy (c. 1816–35). Influenced by *David, Trumbull's Capitol paintings of the American Revolution are severely classical. His ability is best seen in his remarkable miniature portrait studies.

TRUMEAU

Pier supporting the lintel of a monumental doorway. The trumeau becomes important with the development, especially in 12th- and 13th-century France, of the façade of a church as the vehicle for sculpture. They may be plain, or carved as at *Moissac. In the †Gothic period they often become the centre-piece of the portal or façade, like the *Beau Dieu* at *Amiens.

TS'AO Chih-po (1272–1355)

Chinese painter from Sung-chiang, Kiangsu. A close friend of *Huang Kung-wang and of *Ni Tsan, Ts'ao Chih-po was a poet and painter of considerable stature, though his works did not attain the renown that theirs enjoyed. His surviving paintings, mainly in ink, show his brushwork to be descriptive and unassertive. He is at his best when portraying trees, as in the splendid *Two Pines* in the Palace Museum, Taiwan.

TSIMSHIAN see NORTHWEST COAST, AMERICAN INDIAN ART OF THE

TSOU I-kuei (1686–1772)

Chinese painter from Wu-hsi, Kiangsu. A high official and court painter, chiefly of plants and flowers.

TUAMOTU ISLANDS

Mangareva is the only island in this *Polynesian archipelago to produce sculpture. Seven carved figures are known which survived the destructive consequences of missionary zeal in the 19th century. These show a degree of naturalism not found elsewhere in Polynesia.

TUBE

The thin metal tube with a screw cap in which artists' paints are sold. The availability of ready-mixed paints in a variety of qualities and quantities in a handy portable tube has had a great effect upon the history of painting, particularly any form of *plein-air painting. The practice of supplying ready-mixed paint in tubes began in the second quarter of the 19th century.

TUC D'AUDOUBERT (Perigordian and Magdalenian)

†Palaeolithic site in Ariège, France, comprising a long cave without side galleries. At the very end are two clay bison leaning against a projecting rock. They are beautifully modelled and in very good condition, undoubtedly middle Magdalenian. Similar models were found at *Montespan. The cave also contains a few engravings.

TUCKER, William (1935–)

b. Cairo. English sculptor who trained at the Central School and St Martin's School of Art, London. Influenced by *Caro. Sometimes painted, his crucially proportioned objects evaluate the purely formal aspects of balance and control the surrounding conceptualised space.

TUNCAHUAN

Highland Ecuador pottery style (c. 500 BC–AD 500) consisting of negative-painted bowls and pedestal vessels decorated with geometric designs and animal motifs in black, red and cream.

TUNG Ch'i-ch'ang (1555–1636)

High Chinese official and connoisseur, from Sung-chiang, Kiangsu. Dissatisfied with the state of painting in his day, he sought to discover the secrets of *Sung and *Yüan painting through the study of surviving masterpieces. His own landscapes embody the principles he discovered in rather intellectual and abstract brushwork. His view of Chinese painting contrasts the scholar-painting tradition, traced back through *Shên Chou and the *Four Masters of late Yüan to *Chü-jan, *Tung Yüan and eventually *Wang Wei in the *T'ang, with that of the professionals, such as the *Chê School, *Ma Yüan and *Li Ssu-hsün, who were not to be followed. Likening the intuitive understanding of the scholars to the 'sudden enlightenment' of the Southern branch of Ch'an (Zen) Buddhism, he termed the two traditions 'Southern' and 'Northern' without references to actual geographic origins. Tung Ch'i-ch'ang's theories and methods, practised by his pupil *Wang Shih-min and others, were to have far-reaching consequences in later painting.

TUNG Yüan (active 10th century)

Chinese painter from Nanking, Kiangsu. A major landscape painter of the Five Dynasties, he was recognised by *Tung Ch'i-ch'ang as one of the greatest masters of the scholar-painting tradition. While *Li Ch'êng and *Fan K'uan painted the austere landscapes of North China, Tung Yüan portrayed the gentler contours and stretches of water of his native South, using long brushstrokes later called 'hemp-fibre' (ts'un). His brush method was followed by *Chü-jan, *Wu Chên and others.

TUN-HUANG, Buddhist painting at

The Caves of the One Thousand Buddhas at Tun-huang, in Kansu province, on China's westernmost border and near the junction of the two main routes across Central Asia, are a major repository of Buddhist painting and sculpture dating from the 5th to the 10th centuries AD and even later. The walls and ceilings of many of the caves bear paintings, among which some of the most interesting are those illustrating *jataka* (stories of the previous incarnations of the Buddha), in which different episodes from the same story are represented successively in a continuous landscape background. In the Mahāsattva *jataka*, the representation of the story occupies three registers on the same wall, being read from right to left, left to right, and right to left again. Such examples can be seen as prototypes in the evolution of the continuous Chinese landscape handscroll. Larger paintings, occupying a whole wall, are paradise scenes with large assemblies of Buddhist deities. In addition to the wall-paintings, a sealed library containing thousands of manuscripts and hundreds of paintings was discovered at the end of the 19th century. The paintings, dating principally from the 9th and 10th centuries, are on paper and silk. Many of them, brought back by the Stein and Pelliot expeditions, are now in the British Museum, New Delhi and Paris. They include banners depicting the life of the historical *Buddha, casual sketches and larger paintings of Buddhas and *Bodhisattvas, many with votive inscriptions and portraits of the donors. See also CENTRAL ASIA, Art of

TUTANKHAMUN

Insignificant Egyptian king of the late 18th dynasty, known principally through the discovery of his tomb with much of the contents intact. Of particular interest from an artistic standpoint are the four delicate goddesses from the canopic shrine, some ritual figures of deities, the king's innermost coffin and portrait-mask, the throne with its inlaid representation of a royal couple, and two of the many boxes, one with carved ivory panels, the other with painted scenes in miniature.

TURA, Cosimo (Cosmè) (1430–95)

b. Ferrara. Italian painter; Court Painter to Duke Borso d'Este (1452–86). His portraits of the d'Estes are lost. He was active in the Veneto and influenced by *Squarcione. His first extant works are paintings for the Cathedral of Ferrara (1496) and later he worked briefly in the Palazzo di Schifanoia. He painted several monumental cycles in Ferrara (1472–5). His style was influenced by *Mantegna, the Flemish and the Venetians and the mood of his late paintings typically ranges from melancholic to ecstatic.

TURCATO, Giulio (1912–)

b. Mantua. Italian painter who studied in Venice and works in Rome. He turned to abstraction (1947) and joined the *Fronte Nuova della Arti (1949). *Pop Art seems to be behind the somewhat whimsical use of figurative emblems and collage in his recent paintings and objects.

TURIN, Hours of

Book of Hours from the library of the Duc de Berry, painted at the end of the 14th century in a late *Gothic style deriving from Italy. Later additions to the manuscript (c. 1420, Museo Civico, Turin), showing a command of landscape and light have been attributed to Jan van *Eyck.

TURKISH PAINTING

The quality of Turkish Islamic painting has been underestimated for a long time. It has been considered by Orientalists to be no more than a provincial offshoot of the great Persian tradition of book-illumination. This is certainly not so, despite occasional technical and stylistic derivations from Persian miniatures. Turkish painting has a very bold and specific style of its own characterised by a preference for historical subject-matter, a general emphasis on the realistic detail and by extremely bold compositions based on primary colours. *See also* HUNER-NAME; OSMAN; LEVNI; SURNAME

TURNBULL, William (1922–)

b. Dundee, Scotland. Painter and sculptor who studied at the Slade School of Art, London. Having worked in wire or tenuous and finespun materials, Turnbull turned to making convex cylinders of wood and stone, balanced one on top of another as a totemic ensemble. These totems were simplified to irregular, telescopic cylinders, made to appear as delicate but plausible balancing acts (1960s).

TURNER, Joseph Mallord William (1775–1851)

b. d. London. English landscape painter of wide range and phenomenal energy and creativity. The son of a barber, he was very precocious, entering the Royal Academy Schools in 1789 and first exhibiting in 1790. He worked at Dr Monro's house (mid 1790s) with *Girtin, where both were influenced by John Robert *Cozens. A devotee of the sketching tour, Turner painted exclusively in watercolour until about 1796, when he began to experiment with oils, being influenced initially by *Claude and *Wilson. He became a Royal Academician (1802) and visited France to see the paintings looted by Napoleon, and although he admired *Poussin there, his work became increasingly †Romantic in feeling, and his lack of finish was increasingly decried. His journey included a visit to Switzerland, to which he frequently returned, especially in his later years, and whose mountains he depicted with cool brilliance. His visits to Italy (1819, 1828, ?1835 and 1840), and particularly the experience in Venice, served to develop his acute sensitivity to effects of light, in response to which he developed, in oils and watercolour, a technique of unprecedented freedom, subtlety and refinement, which, although later highly influential, was far in advance of its time, and resulted in Turner being generally bitterly attacked. In his later works all influences disappear and his observation of nature and boundless imagination become the only sources for astonishingly beautiful expressions of Romanticism. He bequeathed his unsold and his unfinished works to the British nation. Major paintings include: *Shipwreck* (1805), *Hannibal Crossing the Alps* (1812), *Frosty Morning* (1813), *Norham Castle* (c. 1835) (all Tate), *The Fighting Téméraire* (1839, NG, London), *The Slave Ship* (1840, Boston).

TURPENTINE

Spirit distilled from the resinous sap of pine trees. Its rate of evaporation is suitable for thinning paints and varnishes, allowing enough time for working the *mediums, yet drying sufficiently fast for convenience.

TWACHTMAN, John Henry (1853–1902)

b. Cincinnati, Ohio d. Gloucester, Massachusetts. Painter who studied with *Duveneck in Cincinnati, at National Academy of Design, in Munich, and in Paris at Académie Julian; taught at *Art Students' League (1889–1902); exhibited posthumously at *Armory Show (1913). Twachtman's †Impressionist landscapes are characteristically atmospheric, luminous lyrics, but late works surge towards more potent revelations.

JOHN HENRY TWACHTMAN *Snowbound*. 1885. $25\frac{1}{4} \times 30\frac{1}{8}$ in ($64 \cdot 1 \times 76 \cdot 5$ cm). Art Institute of Chicago

TWORKOV, Jack (1900–)

b. Biala, Poland. Painter who went to America (1913); studied at Columbia University (c. 1920–3), *Art Students' League and National Academy of Design (1923–5); taught at Black Mountain College and Yale University. Influenced by *De Kooning, Tworkov abandoned figurative work for *Abstract Expressionism. Despite bravura brushwork and bold colour, Tworkov's paintings evoke sweetness rather than stridency.

TYMPANUM

The area of masonry filling the space between the lintel and the arch of a doorway. The feature was known in antiquity, eg at *Pompeii and Ephesus. In the 11th century it began to assume importance as one of the places where relief sculpture could be deployed. The earliest dated is at Charlieu (1190). During the 12th century, sculpted tympana became increasingly elaborate, reaching a climax in the French cathedrals of the early 13th century. *See also* MOISSAC; CONQUES; CHARTRES; AMIENS; REIMS; VEZELAY

TYRANNICIDE GROUP

A sculptural group by Kritios and Nesiotes erected 477/476 BC in Athens to replace the group carved by *Antenor which had been carried away by the Persians. It consisted of two statues, one of Harmodios and the other of Aristogeiton, the heroes who slew the tyrant Hipparchos, and ended the Peisistratid tyranny. They are fine examples of striding figures in the *Severe Style. Roman copies exist.

TZARA, Tristan (1896–1963)

b. Roumania d. Paris. Roumanian poet and founder-member of the Zürich *Dada group (1916), Tzara became Dada's most brilliant impresario there and in Paris (after 1920). His *Manifeste Dada* (1918) is a good example of Dadaist anarchism. The startling imagery of his early poetry, eg *Vingt-Cinq Poèmes* (1918), foreshadows *Surrealist automatic poetry. He joined the Surrealist movement (1928) and later the Communist Party. In *Le Surréalisme et l'Après-guerre* (1947) he discusses the failure of Surrealism to reconcile poetic and ideological tradition.

U

UBERTINO, Francesco d' see BACCHIACCA

UBUD see BALI, ART OF

UCCELLO (DONI), Paolo (1397–1475)

b. d. Florence. Florentine painter, influenced by his master *Ghiberti, *International Gothic and the mosaicist *Giambono with whom he may have worked in Venice (1425–30). His most important frescoes are in Florence, including the *Genesis* scenes (c. 1431–6, c. 1450, Sta Maria Novella) which reveal his †Gothic love of animals and command of graceful line. The *Hawkwood Monument* (1436, Florence Cathedral) reflects his well-known mania for *perspective which is most imaginatively deployed in the *Deluge* (c. 1450, Sta Maria Novella). He executed the Medici trilogy the *Battle of San Romano* (c. 1456, Uffizi, Louvre, NG, London) where the sophisticated pattern of ornament and foliage recalls the Northern tapestries so much

admired in Italy. A man subject to depression, his late works are unequal, ranging in quality from the enchanting *Midnight Hunt* (c. 1460, Ashmolean) to the mechanically handled *predella the *Profanation of the Host* (1466, Urbino), justly criticised by his contemporaries.

UDEN, Lucas van (1595–1672)

b. d. Antwerp. Flemish landscape painter, influenced by *Rubens – the *Escorial* landscape (Fitzwilliam, Cambridge) is after a lost sketch by Rubens. His paintings, however, reflect an original interest in the rendering of landscape. The figures in his pictures were often painted by other Flemings, eg *Teniers. He was a prolific etcher and draughtsman.

UDINE, Martino da see PELLEGRINO DA SAN DANIELE

UECKER, Günther (1930–)

b. Wendorf, Mecklenburg. German *Kinetic artist who is a member, with Heinz *Mack and Otto *Piene, of *Zero Group. He uses spikes and nails to fragment a surface giving it a shimmering, insubstantial appearance which contradicts the nature of his material.

Right: GUNTHER UECKER *White Field.* 1964. Relief. 34¼×34¼×3 in (87×87×7 cm). Tate

Left: PAOLO UCCELLO *Niccolò Mauruzi da Tolentino at the Battle of S. Romano* (the Rout of S. Romano). c. 1456. 72×125¾ in (183×319·5 cm). NG, London *Bottom:* PAOLO UCCELLO *The Midnight Hunt.* c. 1460. 28¾×69⅝ in (73×177 cm). Ashmolean

UGLOW, Evan (1932–)

b. London. Painter who studied at Camberwell and Slade Schools of Art. His academic realist style demonstrates, especially in works from the nude figure, an erudite but personal technique which is expert in draughtsmanship and colour control.

UGOLINO DA SIENA (Ugolino di NERIO) (active 1st quarter 14th century)

Sienese painter whose major work is the now-dismembered High Altarpiece for Sta Croce. This Florentine commission shows the high regard accorded to Sienese polyptychs in other

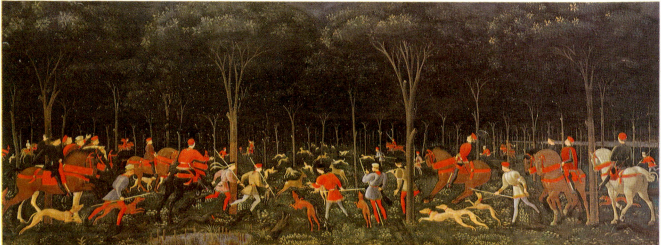

contemporary major art centres. The style and iconography almost duplicate *Duccio's *Maestà*, but the greater intensity of colour, often harsh and strident, is a personal feature.

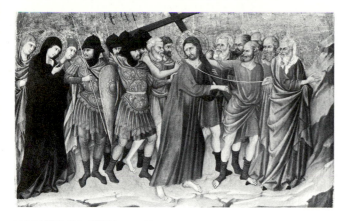

UGOLINO DA SIENA *The Way to Calvary*. 13½×21 in (34·5×53 cm). NG, London

UGOLINO DI NERIO *see* UGOLINO DA SIENA

UKIYO-E

The term 'Ukiyo-e' means literally 'paintings of the floating world'. This conjures up the expensive, pleasure-seeking demi-monde of the inhabitants and habitués of the Yoshiwara, the pleasure quarter of Edo (Tokyo). These were the newly rich merchant class, and the idle peace-time samurai. The tea-houses, brothels and theatres they frequented are pictured in books and broadsheets by the woodblock-print artists of the Ukiyo-e School. Also depicted are the 'pop heroes' of the day, the actors, often in costume, the courtesans and the pretty tea-house girls; sometimes these pictures are exaggeratedly obscene. The school arose to cater for this new market in the mid 17th century and was derived from a variety of sources, but most notably from the genre paintings that were an off-shoot of the *Kanō School and that were heavily tinged with *Tosa influence. The prints and books were ephemera and treated as such, and the school was much scorned by aesthetic-ally minded Japanese. In the mid 19th century, some prints reached Europe and their novelty excited the admiration of *Whistler and others, particularly in France, and led to a vogue of 'Japonaiseries'. The early (mid-17th-century) printmakers were essentially book-illustrators in black and white, but *Jihei and *Moronobu and his followers also made broad-sheets, and sometimes used hand-colouring. In the early 18th century the *Kaigetsudō group were painting actors and courtesans with a statuesque beauty that was not evident in the contemporary work of Torii *Kiyonobu, who was founder of a line of printmakers, himself concentrated on theatre-posters. His follower Okumura *Masanobu tempered his bombastic approach with a tenderness that was taken up by *Harunobu, *Koryusai, *Choshun and others. Where Masanobu and his contemporaries had been experimenting with two-colour and three-colour printing, Harunobu produced the first 'brocade print' or true colour print as we know it, in ten colours (1764). Harunobu's softness of touch was altered and extended by Katsukawa *Shunshō, who with Ippitsusai *Bunchō started a new fashion in actor prints that was to become central to Ukiyo-e thereafter. With the invention of the 'large head' (portrait bust) supposedly by *Shunei, portraiture took a new turn; *Sharaku produced his startling caricatures and *Utamaro his pretty girls. Torii *Kiyonaga had altered his school's style by absorbing some of Shunshō's ideas and he and *Shigemasa and his pupil Kitao *Masanobu gave a new grandeur to figures: this also influenced Sharaku, Utamaro, *Eishi and his contemporaries and also Utagawa *Toyokuni, a prolific designer of actor prints. *Hokusai was originally a pupil of Shunshō, but was truly original. He produced the first of his great *Fuji* series (1823), using landscape as a subject of its

own for the first time. This theme was taken up by *Hiroshige who thereafter specialised in landscape. The Utagawa School continued with *Kunisada (Toyokuni III) and *Kuniyoshi who specialised in historical and mythological scenes, often of battles. This period is often regarded as the decline of Ukiyo-e. *See also* MEIJI PERIOD

Left: UKIYO-E Panel of a Dancer. From a six-fold screen. Early 17th century. Colours on gold leaf. BM, London
Right: UMAYYAD PAINTING Wall decoration from Qusayr Amra, Jordan. First half 8th century

UMA *see* PARVATI

UMAYYAD PAINTING (661–750)

Paintings executed for Umayyad masters are found in the Bath-house of *Qusayr Amra (after 711) in the Jordanian desert and in the Palace of *Qasr al-Hayr al-Gharbi (723–7) in the Syrian desert. Fragments of paintings have been found elsewhere, particularly at the Palace of *Khirbat al-Mafjar in the Jordan valley (743–4). At these sites figure compositions occur, an indication that although figures were not shown in Islam in a religious context, no objection was raised to human representations as far as secular scenes were concerned, espe-cially in private apartments. In the Bath of Qusayr Amra there are wall-paintings of athletics, hunting, and female nudes, motifs all common in *Hellenistic traditions. Also Hellenistic in origin are the paintings of various personified Arts, with their titles written in Greek. Upon the dome of the calidarium of the Bath is a Zodiac, the interest in astrology being common to both Greeks and Arabs. In the audience hall of the Bath the paintings have almost disappeared. A figure of an enthroned ruler stood in a recess and upon an adjacent wall were six figures, identified by inscriptions as rulers defeated by the Muslims before 711. Alternative explanations of these paintings are given. One is that these figures represent the rulers conquered by Islam, gathered to pay homage to the enthroned ruler. Another is that the continuity of sanctified royal rule is transferred from the established holders of king-ship to the Umayyads who had recently seized power. The paintings at Qasr al-Hayr reveal Hellenistic elements, but there is also an important *Sassanian influence. The Hellenistic tradition is represented by the head of an earth goddess, a snake round her neck. This head appears in a medallion as part of a fresco painted upon a floor of the Palace. It is set amid foliage and figures of centaurs. The other fresco is divided into three separate horizontal bands, and all of the scenes are Sas-sanian in inspiration. They concern royal activities, with musicians in one scene, a rider hunting with a bow from a horse, and finally a hunting scene. The treatment of the faces in these frescoes is entirely Oriental.

UMAYYAD SCULPTURE

Islamic sculpture never developed into an art form concerned with the three-dimensional. Although the Umayyads borrowed from both the *Hellenistic and the Persian traditions, the Arabs only occasionally produced sculpture, and then as an ornamental adjunct to architecture in purely two-dimensional terms. After the fall of the Umayyads (750), sculpture virtually disappeared, reflecting the growing abhorrence in Islam for representations of the human figure, at least in a religious and public context. Figures and animals in carved plaster appear upon the walls of the Umayyad palaces of *Qasr al-Hayr al-Gharbi in the Syrian desert (723–7), and *Khirbat al-Mafjar in the Jordan valley (743–4). A figure was placed over the entrance to Qasr al-Hayr, identified as the Caliph Hisham. The figure is bearded and wears a long robe with stylised folds and a border with a bead pattern. The pose is rigid and symmetrical. A similar figure appeared above the entrance to the Bath at Khirbat al-Mafjar, in a carved plaster niche. It was once coloured. Although free-standing it is two-dimensional inasmuch as it is intended to be viewed only from the front. This characteristic is common to all the sculpture produced under the Umayyads. The Caliph figure at Khirbat al-Mafjar wears a long coat, and holds in his left hand the hilt of his sword. The origin of this type of figure is suggested to lay in *Sassanian rock reliefs, but an Arab-Parthian type of sculpture (3rd century AD), found at Hatra, is also connected with the Umayyad figures. Other figures at Khirbat al-Mafjar include figures dressed in military uniform, and also female figures with bare breasts, strongly modelled bodies and stylised folds in the robes. The eyes of all of the figures are schematically drawn and staring. In many cases a classical pose is identifiable, but the stylisation and sensuous treatment changes completely the character of the figures. Very many more figures of humans, animals and birds appear in high relief.

UNDERPAINTING

The first statement of the painting upon the white ground. This may be a thin monochromatic layer, or painted in pale *hues complementary to the finished work depending upon the artist's use of *reflected or *transmitted light and use of optical half-tones.

UNDERWOOD, Leon (1890–)

b. London. English sculptor, wood-engraver, painter and writer. Studied at the Regent Street Polytechnic (1907–10), Royal College of Art (1910–13) and Slade School of Art (1919–20). Credited with a substantial contribution to the modernist movement in England he has since reverted to the primacy of subject-matter.

UNKOKU SCHOOL see MOMOYAMA PERIOD; TOGAN

UNIT ONE

A group founded (1933) by Paul *Nash, it exhibited in London (1934) when a manifesto under this name appeared, edited by Herbert *Read. It claimed to represent the modern movement in English architecture, painting and sculpture, expressing a truly contemporary spirit.

UR, Standard of

This work comprises the inlaid decoration on two faces of a wooden box, part of the treasure from the Royal Tombs at Ur (c. 2500 BC). One side depicts the action of a campaign, the other the victory feast that followed. The narrative proceeds from the bottom to the top register in each case, and progressive action is shown in a series of 'stills', eg in the bottom register on the war panel, a chariot advances at a walk, then a trot and finally a gallop.

URARTU

An Iron Age kingdom in eastern *Anatolia and adjacent regions which reached the height of its power in the 9th-7th centuries BC. The Urartians were brilliant metalworkers who practised techniques including cire perdue casting, openwork, engraving, chasing, filigree and repousse. Excellent examples of their craftsmanship have been excavated: engraved bronze shields, helmets and quivers; fine bronze furniture decorated with ivory; and, most characteristic, great bronze cauldrons with cast bulls' or sirens' heads riveted to the rims. Cauldrons of this type were exported to *Phrygia and Greece, and as far afield as Italy, where they have been found in *Etruscan tombs. Fragments of wall-paintings have been discovered which, like much other Urartian art, show strong *Assyrian influence. In some relief sculpture, however, and especially in architecture and metalwork, there is much originality.

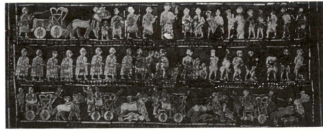

Top left: URARTU Bronze cauldron and tripod from Altintepe. 8th century BC. Archaeological Museum, Ankara
Top right: UTAMARO *Girl applying cosmetic to her neck.* Late 18th century. Woodblock colour print. Oban, approx 14×10 in (25.4×35.6 cm). Musée Guimet, Paris
Above: UR, Standard of. The 'War' side. c. 2600–2400 BC. Shell, red limestone and lapis lazuli inlaid into a bitumen base. h. 8 in (20.3 cm). BM, London

URBINO, Timoteo da see VITI

URHOBO see EDO

URNA

Sanskrit: literally 'woollen thread'; circle of hair between the eyebrows, one of the traditional marks of the man destined to greatness; more usually represented as a dot or 'third eye' on the forehead. Common to images of the Buddha and the Jina.

URUK see WARKA

USERHET see THEBAN TOMBS

USHNISHA

Sanskrit: literally 'turban'; pronounced cranial bump restricted to images of the Buddha; may appear as a chignon, a miniature *stupa or as a flame.

UTAGAWA SCHOOL see UKIYO-E

UTAMARO (Kitagawa Utamaro) (1753–1806)

One of the greatest figures in Japanese *Ukiyo-e, Utamaro is most famous for his portraits of women, which have a deceptively simple appealing beauty, unlike those of any other artist. He was imprisoned for 'seditious' prints depicting Hideyoshi (1804).

UTRECHT PSALTER

Probably copied from an †Early Christian model in the Abbey of Hautvillier near Reims (c. 850), this manuscript spent most of the Middle Ages in England where it played a decisive part in the formation of the *Anglo-Saxon drawing style. Three of no doubt several copies survive: the Canterbury Psalter, the *Eadwine Psalter and the *Paris Psalter. Covering the period from the early 11th to the end of the 12th century, they show not only how styles evolved, but also the peculiar veneration in which the prototype was held.

UTRECHT SCHOOL

A term usually applied to a group of 17th-century painters of this Dutch city who studied in Rome when young and were influenced by *Caravaggio. Returning to Utrecht (c. 1620) they modified Caravaggio's dark manner with a lighter palette and included subject-matter drawn from the Dutch and Flemish tradition. By the mid 1620s a kind of pastoral genre painting was also characteristic of the School. Leading members were *Honthorst, *Terbrugghen and *Baburen. Others belonging to the School were *Bor, Van Bijlert, *Bloemaert and *Stomer, and both Frans *Hals and *Vermeer were affected by it.

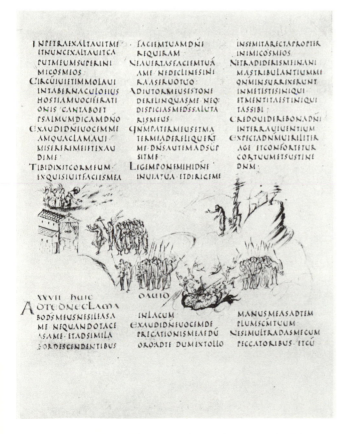

UTRECHT PSALTER *Unto thee will I cry, O Lord.* Psalm 28. 12¾×9¾ in (33×25 cm). University Library, Utrecht

UTRILLO, Maurice (1883–1955)

b. Paris d. Dax. French painter, the son of Suzanne *Valadon. Already an alcoholic at nineteen, he began painting with his mother's encouragement. Recognition came with the award of the Legion of Honour (1928). His best-known works are of Paris street scenes. These were painted from life or from postcards, mixing pigments with plaster accurately to reproduce the white-walled buildings on the canvas. Using a broad range of grey-white his portraits of the Montmartre streets contain a delicate mixture of fact and sentiment.

MAURICE UTRILLO *L'Impasse Cottin.* c. 1910. 24½×18⅛ in (62×46 cm). Musée National d'Art Moderne, Paris

VACUUM-FORMED PLASTICS

Sheets of rigid plastic material are heated to soften them and then sucked down by a vacuum over a relief form. When cold they retain the shape of the form in relief. This process is used both by modern sculptors to obtain multiple lightweight reliefs and by printmakers, who silk screen their design on to the sheet, and then combine it with the relief form.

VAGA, Perino del (Pietro BUONACCORSI) (1500–47)

b. Florence d. Rome. Italian painter whose early career in Rome brought him swift recognition. With Giulio *Romano, *Penni and *Giovanni da Udine he worked on the Vatican Loggie decorations under *Raphael's direction. Captured in the Sack of Rome, he was released after paying a high ransom and went to Genoa to decorate Andrea Doria's palace. Returning to Rome he executed various commissions. His work, while close to the Raphael School, has a colourful and ornamental quality which made him popular as a decorator in the *Mannerist style.

VAI *see* **BAMBARA ; MENDE**

VAILLANT, Wallerant (1623–77)

b. Lille d. Amsterdam. Flemish portraitist who settled in Amsterdam in the 1640s (1649, *Portrait of Jan Six*). He worked often in pastel and was among the first practitioners of mezzotint.

VAISHNAVA

Sanskrit: literally 'pertaining to *Vishnu'; cf. Shaiva.

VAJRAYANA

Sanskrit: literally 'thunderbolt-way'; name of a medieval *Mahāyāna Buddhist sect influenced by tantricism (*tantra).

VAKATAKAS *see* GUPTA CONTEMPORARY MINOR DYNASTIES

VALADON, Suzanne (1867–1938)

b. Limoges, France. A self-taught painter and the mother of Maurice *Utrillo, she modelled for both *Puvis de Chavannes and *Renoir. Valadon's talent was recognised by both *Toulouse-Lautrec and *Degas, although her strongly curved outline was more akin to *Gauguin's *Pont-Aven style.

JUAN DE VALDES LEAL *Triumph of Death*. Hospital de la Caridad, Seville.

VALDES LEAL, Juan de (1622–90)

b. d. Seville. Spanish religious painter who worked in Cordoba and Seville in his early career, and after 1660 exclusively in Seville, where he was President of the recently founded Academy (1663–6). His paintings were chiefly executed for religious orders such as the Jeronymites of Seville and the Carmelites of Cordoba and display a dramatic intensity in the handling of brilliant colour, flickering light and energetic movement.

VALENCIA

Central Venezuelan culture (*c.* AD 1000–1500) noted for stylised little monochrome pottery figurines with rectangular flat heads decorated with incised and relief decoration.

VALENTIN, LE, Moïse (1594–1632)

b. Boulogne d. Rome. French follower of *Caravaggio, in Rome from 1612. Like *Manfredi, he selected only certain aspects of Caravaggio's style, chiefly the picturesque. His *Martyrdom of SS Processus and Martinian* (1629/30, Vatican) for St Peter's is a grander, more †Baroque composition.

VALKENBORCH Family

Flemish family of landscape painters, the first generation of which (Lucas, and Martin I) fled from religious persecution and settled in Frankfurt (1566). Stylistically, all were dependent on Pieter *Brueghel. Martin I's son, Frederick (*c.* 1570–1623), settled in Nuremberg (1605) and painted, in addition to landscape, fairs, markets and town views, crowded with figures.

VALLEY OF THE KINGS

The burial-place of Egyptian kings of the 18th to 20th Dynasties, in the western hills behind *Thebes. The largest tomb is that of *Sety I, which has also the finest painted reliefs, while among others of interest are those of Amenhotpe II, Horemheb and Ramesses VI. In the neighbouring Valley of the Queens are the tombs of various queens and princes of the same period, including that of *Nofretiri.

VALLFOGONA, Pedro de *see* JOHAN

VALLOTTON, Félix Edouard (1865–1925)

b. Lausanne d. Paris. Swiss-French painter who at seventeen went to Paris, enrolled at the Académie Julian, and began to exhibit at the Salon of 1885 (*Portrait of M. Ursenbach*), and later at the Salon des Indépendants. He tried the *Pointillist manner of *Seurat, the intimism of the *Nabis and specialised in black and white woodcut illustrations (eg *Symbolist portraits in Rémy de Gourment's *Livre des Masques*).

VANDERBANK, John (1694–1739)

b. d. London. Son of John Vanderbank, Director of the Soho tapestry works (1689–1737). A noted portrait painter (eg *Queen Caroline*, 1736, Goodwood House) he started the fashion for *Rubens costume in female portraits. He also painted twenty small illustrations to *Don Quixote* (1731–6).

VAN DER LECK, Bart (1876–1958)

b. Utrecht. Dutch painter who studied in Amsterdam and attained a near-abstract style before meeting *Mondrian (1917). He was influential in formulating the *De Stijl aesthetic both through discussion and through his geometric style with its clear primary colours. He collaborated with *Van Doesburg on the first issue of *De Stijl*, but returned to representational painting (1918).

VANDERLYN, John (1775–1852)

b. d. Kingston, New York. Painter who studied with *Stuart, Philadelphia, and with Vincent, France; worked in Paris (1796–1801, 1803–15, from 1837), visiting Rome (1803–15). A †Neo-classical history and portrait painter influenced by *David, Vanderlyn displayed his brilliant, sculptural draughtsmanship best in his scandal-rousing nude *Ariadne*, worst in the icy *Marius*.

JOHN VANDERLYN *Ariadne Asleep on the Isle of Naxos*. 1814. 68×87 in (172·7×221 cm). Pennsylvania Academy of Fine Arts, Philadelphia

VAN DOESBURG, Theo (C. E. M. KUPPER)
(1883–1931)

b. Utrecht d. Davos. Painter and writer who took a leading role in founding and promoting the *De Stijl movement (1917–31), organising the *De Stijl* magazine (1917–31), lecturing in Germany, Italy, Belgium (1920) and at the *Bauhaus (1921–3). Under the pseudonyms 'I. K. Bonset' and 'Aldo Camini' he participated as poet in *Dadaism (1921–2). Tiring of the austerity of *Neo-Plasticism he introduced diagonals calling this style 'Elementarism'. Van Doesburg's paintings are monotonous transcriptions of his ideas, but his ideas, or rather his intensely enthusiastic argumentative personality contributed considerably to the development of modern art.

Above:
THEO VAN DOESBURG
Countercomposition and Dissonances No 16. 1925. 39⅜×70⅞ in (100×180 cm). Gemeente Museum, The Hague
Left: VAN DYCK
Charles I of England. c. 1635. 107×83½ in (271×212 cm). Louvre

Right: VINCENT VAN GOGH *Cypresses and Two Figures.* 1890. 36½×29 in (92×73 cm). Kröller-Müller Museum

VAN DONGEN, Kees (1877–1968)

b. Delfshaven d. Monaco. Dutch painter, who studied in Rotterdam. Early work influenced by *Rembrandt. Settled in Paris (1899). Exhibited with *Fauves at Salon d'Automne (1905) taking from them the style which lasted, with little variation, throughout his career. He portrayed the Parisian demi-monde and circuses with extravagant mockery. Exhibited with die *Brücke (1908). Achieved popularity as a society portrait painter.

VAN DYCK, Sir Anthony (1599–1641)

b. Antwerp d. London. Flemish painter, the pupil of van *Balen (1609/10) and assistant to *Rubens (1617/18). He entered the Antwerp Guild (1618) although he already had his own studio. Rubens was an important influence but his style was also formed by his own study of Italian art. During his Italian stay (1621–8, Genoa, Rome, Venice, Palermo) he acquired the subtle colour and soft modelling which mark his mature work. Although the religious paintings of his second Antwerp period (1628–32) owe much to Rubens in their gestures and lighting, they have a quiet mystical tone which is personal. After a brief trip to Holland (1632) Van Dyck went to London (which he had already visited 1620/1), where he was

knighted by Charles I. He tried to find work as a mythological painter, but soon turned completely to portraits, establishing himself as the perfect court painter, able to give his portraits of the king and the aristocracy both grace and dignity. In spite of frequent studio participation his English portraits are the culmination of his elegant nervous style.

VAN DYCK *Charles I of England and Henrietta of France.* 26×32⅜ (66×82 cm). Pitti

VAN GOGH, Vincent (1853–90)

b. Groot Zundert d. Auvers-sur-Oise. Most famous Dutch artist of the 19th century. Having worked for an art-dealer and taught in England he went to Borinage in Belgium to help the poor. He studied drawing in Brussels, and *Millet's peasant subjects greatly influenced him. In Paris (1886) †Impressionism and Japanese prints caused a radical change from his early

sombre-toned pictures (1885, *The Potato Eaters*). He went to Arles in Provence (1888). *Gauguin's visit to him ended in near tragedy and Van Gogh entered the hospital at Arles and then the mental asylum at Saint Rémy. His last months were spent at Auvers, where he shot himself. A master draughtsman, Van Gogh used line as well as colour to create his vibrant paintings which included landscapes (cypress-trees and orchards); portraits, including a long series of searching self-portraits; interiors; and still-lifes (sunflowers and irises). He has had a profound influence on the course of 20th-century art.

Top: VINCENT VAN GOGH *The Potato Eaters*. 1885. $28\frac{1}{2}\times37$ in (72×93 cm). Kröller-Müller Museum
Above left: VINCENT VAN GOGH *Self-portrait*. 1887. $12\frac{1}{2}\times9$ in (32×23 cm). Kröller-Müller Museum
Above right: JEAN-BAPTISTE VAN LOO *Diana and Endymion*. $87\frac{1}{2}\times68\frac{1}{2}$ in (222×173 cm). Louvre

VANISHING POINT

The point to which parallel lines on a picture plane appear to converge in the *perspective convention.

VAN LOO Family
Jean-Baptiste (1684–1745)
Carle (1705–65)
Louis-Michel (1707–71)

Flemish painters, settled in France. Jean-Baptiste, b. d. Aix, painted portraits in Paris (1720–37). Visiting London he was very successful, and influenced English painters. He retired to Aix (1742). Carle, b. Nice d. Paris, his brother and pupil, became Louis XV's Principal Painter (1762) and Academy Director (1763). He executed mainly decorative work. Louis-

Michel, b. Toulon d. Paris, was Jean-Baptiste's son and pupil and was Court Painter in Madrid (1736–52).

VANTONGERLOO, Georges (1886–1965)

b. Antwerp. Belgian sculptor, painter and architect who studied in Antwerp. Vantongerloo produced his first abstract sculptures in 1917, was a founder-member of *De Stijl (1917-21) and vice-president of the *Abstraction-Création group (1931–7). His rectangular block constructions influenced De Stijl architecture. He became more concerned with space and movement than solid forms, creating curved structures of wire or plexiglass (from 1938).

GEORGES VANTONGERLOO *Composition*. 1920. Concrete. h. $9\frac{7}{8}$ in (25 cm). Peggy Guggenheim Foundation, Venice

VANUCCI, Pietro see PERUGINO

VAN VELDE, Geer (1898–)

b. Nr Leiden. Dutch painter who worked chiefly in France. One-man shows at The Hague (1925, 1933 and 1937). An independent and impassioned artist, Van Velde's *Expressionistic canvases are created in terms of pure colour, which powerfully convey his pessimistic attitude to the world.

VANVITELLI (Gaspard van WITTEL) (1653–1736)

b. Utrecht d. Rome. Dutch topographical view painter who settled in Italy (1672). His landscapes derived ultimately from the Northern tradition of *Berckheyde, but later were influenced by *Pannini's *vedute.

VAPHIO CUPS (1600–1500 BC)

A pair of gold cups in the *Minoan style found at Vaphio in Laconia (now National Museum, Athens). The relief scenes show men unsuccessfully trying to trap wild bulls in a net.

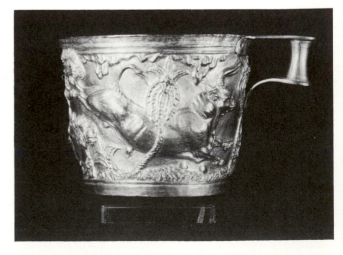

VAPHIO CUPS One of the pair showing a bull attacking a hunter and huntress. Gold. h. $3\frac{1}{2}$ in (9 cm). National Museum, Athens

VARCHI, Benedetto (1503–65)

b. Florence d. Monte Varchi. Italian writer on art. A Florentine intellectual of the Medici court, he delivered two lectures (1546) on the controversial theme (raised by *Leonardo's *Paragone*) of the comparative merits of painting and sculpture; he himself put them on equal footing, since both had the same aims in view. Subsequently (1547) he enquired the opinions of the artists *Vasari, *Bronzino, *Pontormo, Tasso, Francesco da Sangallo, *Tribolo, *Cellini and *Michelangelo, and published their replies (1549).

VARDANEGA, Gregorio (1923–)

b. Possagno, Italy. Italian *Kinetic artist who works in Paris. Since 1946 he has been interested in the effects of light on glass and perspex: *chromocinéticisme*. His perspex spheres are illuminated by revolving projections of coloured light: his 'boxes' are light superimpositions giving an illusion of three-dimensional space.

GREGORIO VARDANEGA *Circular chromatic spaces*. 1966–8. 39⅜×39⅜×18⅛ in (100×100×46 cm). Galerie Denise René, Paris

VARGAS, Luis de (1502–68)

b. d. Seville. Spanish painter who worked in Italy (1522–50) where he was especially influenced by Perino del *Vaga. On returning to Seville (1550) he became a leading *Mannerist painter, introducing the use of fresco. The *Nativity* fresco for Seville Cathedral (signed, 1555) although damaged, shows his overcrowded highlighted composition, and his *Michelangelesque figure style appears in the *Four Evangelists*. The *Epiphany* predella has a classicising architectural setting which dominates the figures, very much in the style of Giulio *Romano.

VARLEY, Frederick Horsman (1881–1969)

b. Sheffield, England d. Toronto. Painter who studied in Sheffield (c. 1892–9) and Antwerp (1900–2); did commercial art; emigrated to Toronto (1912); taught in Toronto, Vancouver and Ottawa; was founder-member of *Group of Seven (1920). Varley's work is consistently broad and painterly, both in his penetrating portraits and *Expressionist, exciting landscapes.

VARLEY, John (1778–1842)
Cornelius (1781–1873)

The Varley brothers, both b. d. London, were founder-members of the Water Colour Society (1804). John became a successful exhibitor and teacher – among his pupils were *Palmer, *Linnell and *Cox – and was well known as an astrologer. Cornelius was much less prolific and is chiefly remembered for the invention of the Graphic Telescope, his adaptation of the *camera lucida.

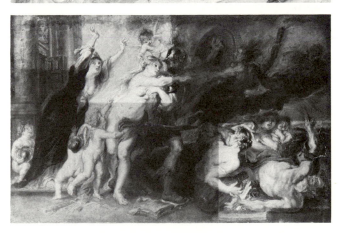

Top: JOHN VARLEY *Sea-piece with Fishing Boats in a Calm*. Watercolour. 9⅞×13¾ in (25·1×34·9 cm). Tate
Centre: FREDERICK VARLEY *The Ferry Boat, Vancouver*. Charles S. Band Coll, Toronto
Above: VARNISH *The Horrors of War* by Peter Paul Rubens showing varnish partially removed. NG, London

VARNISH

A solution of *resin in a spirit. The spirit evaporates, leaving a thin film of resin as a glossy protective waterproof coat. *See also* MASTIC VARNISH; MEGILP

VAROTARI, Alessandro *see* **PADOVANINO, IL**

VASARELY, Victor (1908–)

b. Pécs, Hungary. Painter who studied commercial art in Budapest. He moved to Paris (1930). A systematic exploration of the optical and emotional possibilities of various graphic means underlay his advertising work (1930–40) and his *Surrealist experiments (1940–7). He realised (by 1947) that by purely formal means he could create sensations which conveyed ideas about space, matter and energy of an essentially scientific kind. Being against art as culture Vasarely evolved a formal language, the components of which could be automatically repeated without conscious artistic arrangement, their serial variation creating a *Kinetic effect.

VICTOR VASARELY *Ond.* 1968. 20½ × 19¾ in (52 × 50 cm). Galerie Denise René, Paris

VASARI, Giorgio (1511–74)

b. Arezzo d. Florence. Italian *Mannerist painter, architect and art historian. He was given his first drawing lessons by his cousin, Luca *Signorelli, and an early humanist training by Passerini together with Alessandro and Ippolito de' Medici. Studying under *Bandinelli, he worked in the workshop of Andrea del *Sarto. He travelled extensively all over Italy, and executed grand commissions such as the *Life of Pope Paul III* (Palazzo della Cancellaria, Rome), with assistance from a large workshop. Responsible for the architectural refurbishment and decoration of the Palazzo Vecchio, he designed the *studiolo of Francesco I (1570–3), the quintessential study-room of the Renaissance man, arranged to display precious objects, sculpture and paintings. He was an impresario of the arts and founder of the Accademia del Disegno in Florence (1563). His fame lies in his *Libro di Disegni* (unfortunately dispersed) and more importantly *Le Vite de' più eccellenti Architetti, Pittori e Scultori*. This book outlines in highly subjective biographies the revival of art with the career of *Giotto and its progression to the 'perfect' work of his own contemporaries, most especially *Michelangelo, and includes a description of the art theories of his time.

VASCO, Grao *see* **FERNANDES, Vasco**

VASNETSOV, Victor (1848–1926)

b. Gouv, Wjatka d. Moscow. Russian painter, introduced to the *Abramtsevo colony (1879) where his scenery (*Little Snow-*

White, 1882, and *Snow Queen*, 1886) was influential in the revival of the medieval fairy-tale element in Russian art, and the integration of theatre décor with the production. Religious monumental painting was continued in his St Vladimir Church decoration in Kiev (1885–95), a commission won in competition with *Vrubel.

VAT KO, Cambodia (?6th century)

A remarkable statue from Vat Ko is that of Krishna Govardanadhara, the deity holding up a mountain to protect shepherds from a storm. The figure is not detached from the background, but the right hand on the hip, while the left arm supports the mountain, gives an impression of effortless strength. The style seems to owe more to the eastern Mediterranean than to the Indian sub-continent.

Left: GIORGIO VASARI *Lorenzo the Magnificent.* 35½ × 28⅜ in (90 × 72 cm). Uffizi
Right: VAT KO Krishna Govardanadhara. 6th century. Sandstone. h. 63 in (160 cm). National Museum, Phnom Penh

VAUGHAN, Keith (1912–)

b. Selsey Bill. English painter whose preoccupation is with human figures. His work is both sensuous and ambiguous. He has produced crowd scenes (since 1964) in which the individual figures are merged into a unified mass, yet retain their separate identities.

VAULT MOSAICS *see* **WALL MOSAICS**

VAZQUEZ CEBALLOS, Gregorio (1638–1711)

b. d. Bogotá. The most notable Colombian painter of the 17th century. His religious paintings (inclined to sentimentality) reflect *Murillo's style in their soft colour and tonal gradations. He also painted portraits, histories and allegorical still-lifes, and a ran a prolific workshop.

VECCHIETTA (Lorenzo di PIETRO) (1412–80)

b. Siena. Italian painter and sculptor, influenced by *Donatello's second sojourn in Siena and reflecting his fusion of Gothic tragic intensity and †Renaissance forms as exemplified in his *Risen Christ* (1477, Sta Maria della Scala, Siena).

VECELLI, Tiziano *see* **TITIAN**

VEDDER, Elihu (1836–1923)

b. New York d. Rome. Painter and illustrator who studied in Picot's atelier; worked in Paris and Italy (c. 1856–61), New York (1861–6), Paris (c. 1866) and Rome (from 1867). A literary mystic, Vedder is remembered for illustrating *The Rubá'iyát*. His private visionary mythological fantasies were first glowing and haunting, gradually becoming intricate, cold and mannered.

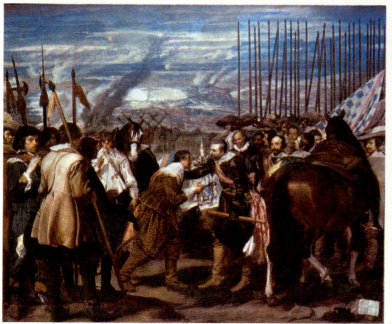

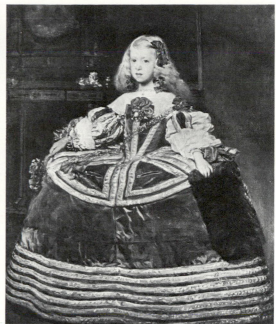

Above: DIEGO VELASQUEZ *Surrender at Breda.* 1634.
120¾×144¼ in (306·7×366·4 cm). NG, London
Above right: DIEGO VELASQUEZ *The Infanta Margarita in Blue.*
1659. 50×42 in (127×107 cm). KH, Vienna

VEDIC

Sanskrit: adjective formed artificially from Sanskrit *veda*,
literally 'knowledge', term for the most ancient Indian
religious texts (*c.* 1500 BC onwards). Vedic religion centred
round the ritual fire, animal and vegetable sacrifice and
propitiation of elemental deities.

VEDUTA

Italian: 'view'. The view-painters (*Vedutisti*) of 18th-century
Venice were the first Italians to paint accurate topographical
views as opposed to fantasy landscapes. Catering chiefly for
tourists who wanted a memento of the city, they were regarded
as inferior to the *history-painters.

VEEN, Maerten van *see* HEEMSKERCK

VEEN, Otto van (1556–1629)

b. Leiden d. Brussels. Flemish painter and poet, notable in
that he was the master of *Rubens. He himself was a pupil of
Lampsonius in Liège, whence he set out for Italy (1576).
There he studied with Federico *Zuccaro for five years, and
returned to Leiden (1584) to become Court Painter to
Alexander Farnese, Governor of the Netherlands. In Brussels
(1585) and Antwerp (1592), he was a prominent artist and
official, since he became Inspector of Finance (1612). Italian
influence can be seen in his *Mystical Marriage of St Catherine*
(Brussels), and it was through van Veen that Rubens first
became acquainted with Italian art.

VEHICLE

Another name for the *binding medium of paint.

VELASCO, José María (1840–1912)

b. Tematzcalzingo d. Mexico City. Painter who studied at
Academy of San Carlos (1858), where he taught (1868–73).
Mexico's greatest landscapist developed through three periods:
academic townscapes; more †Impressionistic, broader land-
scapes; most recognisably Mexican paintings, characterised
by a vast sense of space and exactitude in detail and light,
poetically evoking specific places.

JOSE MARIA VELASCO *The Valley of Mexico seen from the hill
of Guadalupe.* 1894. 30×41¾ in (76·2×106 cm). Museum of
Modern Art, Mexico City

VELASQUEZ, Diego Rodriguez de Silva y (1599–1660)

b. Seville d. Madrid. Spanish painter, with *Goya the greatest
Spanish portraitist. The pupil (1611–16) and son-in-law
(1618) of *Pacheco, Velasquez's early career in Seville shows
the influence of the woodcarver *Montañéz and *Caravag-
gesque paintings. The subjects are chiefly religious or
*bodegones. Called to Madrid (1623), Velasquez became
acquainted with the Italian paintings in the royal collection
and met *Rubens (1628). Apart from visits to Italy (1629–31,
1649–51), Velasquez was continually in the service of Philip IV
whose portrait and portraits of whose family he frequently
painted. The *Fraga Philip* (1644, Frick) or the large group,
Las Meninas ('Maids of Honour', 1656, Prado), show a sensi-
tive appreciation of character in a quiet style that contrasts
with the flamboyance of Rubens. Later painting few mytho-
logical or religious works, Velasquez's most famous subject-
picture is the *Surrender at Breda* (1634, Prado), for the Buen
Retiro Palace, Madrid, representing a Spanish victory in the
Netherlands. The *Rokeby Venus* (NG, London), *Pope
Innocent X* (1649–51, Doria Gallery, Rome) or the court
dwarf portraits (Prado) have, like so many of his paintings, a
realistic psychological insight that Velasquez complemented
with an increasing freedom of colour and brushwork.

VELDE, Adriaen van de (1636–72)

b. d. Amsterdam. Dutch landscape painter taught by his father Willem van de *Velde the Elder, then by *Wynants and *Wouwermans in Haarlem. His repertory included landscapes and Biblical scenes as well as seascapes.

VELDE, Esaias van de (c. 1591–1630)

b. Amsterdam d. The Hague. One of the founders of Dutch realistic landscape painting. Influenced by *Coninxloo and *Buytewech, van de Velde developed his own fresher and more direct vision. A basis of his composition was the use of a low horizon (Winter scene, NG, London).

Above: ESAIAS VAN DE VELDE View of Zieriksee. 10⅝×15¾ in (27×40 cm). Staatliche Museum, Berlin-Dahlem

Left: WILLEM VAN DE VELDE THE YOUNGER The Cannon Shot. c. 1660. 30⅞×26⅜ in (78·5×67 cm). Rijksmuseum

VELDE, Willem van de, the Elder (1611–93)
the Younger (1633–1707)

Dutch marine painters; the Elder, b. Leiden d. Greenwich, specialised in accurate records of boats, working officially for the States of Holland. They both went to England (1672) where they enjoyed the patronage of Charles II and the Duke of York. The Younger, b. Amsterdam d. London, more accomplished and versatile than his father, is probably Holland's most outstanding marine artist. His works are remarkable for their sensitive observation of light and atmosphere and his ships have the elegance of portraits. His style influenced most English marine artists down to and including *Turner.

VELLERT (FELAERT), Dirk Jacobsz
 (active c. 1511–44)

Glass painter and engraver, documented as a free master in Antwerp (1511), and a member of the Guild of St Luke (1518 and 1526). He was a prominent glass painter, connected with the *Antwerp Mannerists whose influence appears in his prints, such as The Flood (Bartsch 2). Examples of his glass painting can be seen in the windows of King's College Chapel, Cambridge (notably the east window). Known for his thickset, lively figures.

VELLORE see VIJAYANAGARA SCULPTURE

VELLUM

A very fine grade of *parchment.

VENICE, St Mark's

The present building is an 11th-century construction, but the mosaic decoration is piecemeal, and dates from the 12th to the 17th century with extensive restorations. The main campaign of decoration however, after the apse had been decorated in the early 12th century, started in the second half of the 12th century and continued through to the late 13th century. The styles are diverse and how far the various mosaic workshops engaged were teams brought in from the Byzantine Empire or else workers trained locally is unclear. The aim of the 13th-century patrons was partly to manufacture an Early Christian pedigree for Venice – hence the Genesis cupola copies an †Early Christian manuscript, probably the *Cotton Genesis, and the ciborium sculptures seem to have a similar source. This ambition probably accounts for the richness but lack of clarity of the programme.

Top: VENICE, St Mark's. Salome, bearing the head of John the Baptist, approaches Herod's table. Lunette mosaic. 13th century
Above: VENICE, St Mark's. The Entry into Jerusalem. 12th century

VENUS DE MILO

A standing nude female statue of Aphrodite by Agesandros (or Alexandros) of Antioch (active 2nd century BC). The head, which is in the 5th-century classical style, is turned slightly to the left, and the left knee is turned to the right – resulting in a somewhat unsatisfactory clash of rhythms. Round the hips hangs rather unstable-looking drapery. The work is an eclectic combination of old styles (Louvre.)

VERA CRUZ

A Mexican Classic period style (c. AD 300–900) centred upon the Gulf Coast site of El Tajín. Curious stone yokes and

palmate and axe forms, carved with elaborate decoration, are thought to be ceremonial representations of equipment worn in the ritual ball-game. Pottery figurines, sometimes with the features picked out in black pitch, are also typical.

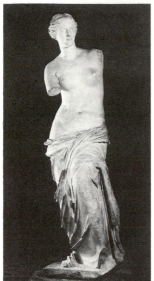

Left: VERA CRUZ Pottery figure of a woman. Traces of bitumen. Classic period, Mexico. h. 20½ in (55·2 cm). Royal Scottish Museum
Below left: VENUS DE MILO Marble. h. 6 ft 8 in (2·04 m). Louvre
Below: VERAGUAS Pendant ornament of cast 'tumbaga', a copper-gold alloy, in the form of a stylised condor seizing an alligator above a bat. Panamo. h. 2⅞ in (7·6 cm). Royal Scottish Museum

Right: JAN VERMEER *Officer and Laughing Girl.* c. 1657. 19⅞×18⅛ in (48×43 cm). Frick
Bottom right: JAN VERMEER *View of Delft.* c. 1658. 38⅞×46¾ in (98·5×117·5 cm). Mauritshuis, The Hague

VERAGUAS

Late Pre-Columbian culture in Panama characterised by monochrome pottery with looped tripod legs and modelled decoration, and distinctive ornaments made in *tumbaga*, a copper-gold alloy. A typical form are pendants representing eagles with flat outstretched wings.

VERELST, Simon (1644–1710/21)

b. The Hague d. London. Dutch still-life painter of fruit and flowers. He came to London and worked at the court of Charles II, where he was encouraged by the Duke of Buckingham to change to court portraiture.

VERESHCHAGIN, Vasili Vasilievitch (1842–1904)

b. Luibez, Novgorod d. Port Arthur. Russian painter who entered the St Petersburg Academy, but went to Paris to study with *Gérôme (1863). His contemporary war scenes emphasised the horror and futility of war by vivid details to promote his pacifist views. Today he is recognised more for his portraits of characteristic Eastern types (eg *A Mohammedan Servant*) encountered during his extensive travels in the Caucasus, Central Asia and India.

VERGOS Family (active throughout 15th century)

Family of Spanish painters active in Barcelona. Jaime the Elder (*d.* 1460) can be attributed no definite work, but his son Jaime the Younger (d. ?1503) probably painted the large retable in the Chapel of S. Agueda in Barcelona (1464). Of his two sons, Pablo (d. 1495) painted four large Prophet figures and the *Ordination of St Vincent* (all Barcelona Museum). Raphael collaborated with his father (Jaime the Younger) and with Pedro Alemany on large retables. The family's style is highly decorated and thoroughly †Gothic in its lack of anatomical and spatial precision.

VERKADE, Jan (1868–1946)

b. Zaandam d. Beuron, Germany. Dutch painter and member of the *Nabi group. He denied the paramount importance of oil painting as a vehicle for thought and emphasised the painting of wall surfaces. After the early influence of *Gauguin, he entered the Beuron Monastery (1894), evolving from *Synthetism to a Theory of Divine Proportions, carried out on the walls of abbeys and churches until his death.

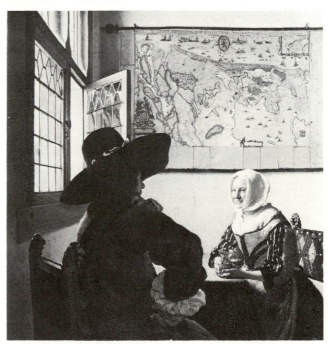

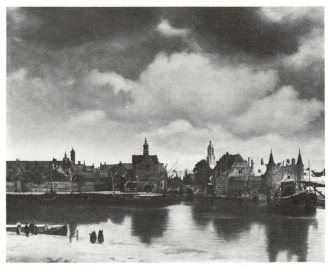

VERMEER, Jan (1632–75)

b. d. Delft. Dutch painter. Possibly a pupil of Carel Fabritius, he became a member of the Delft Guild (1653) and was Dean of the Guild (1663, 1670) but very few other facts are known about him. Only about forty paintings (mostly of genre

subjects) are generally accepted as his; only one of these, *The Procuress* (1656, Dresden), is certainly dated, and the others are usually difficult to place chronologically, although some paintings which show the influence of the Utrecht followers of *Caravaggio are generally considered early. His best work, however, transcends all influences, and is on a completely different level from that of any other Dutch genre painter. His acutely sensitive observation of the fall of light, his superbly convincing draughtsmanship and handling of perspective, his extraordinarily felicitous composition, his subtle characterisation, and his use of the purest blues and yellows to form colour harmonies of wondrously fresh beauty create works of the most precious and exquisitely ordered serenity.

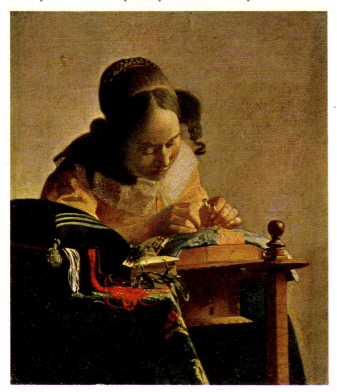

JAN VERMEER *The Lace-Maker. c.* 1664. 9½×8¼ in (24×21 cm). Louvre

VERMEYEN, Jan Cornelisz (c. 1500–59)

b. Beverwyck, nr Haarlem d. Brussels. Netherlandish painter and engraver. He was in Cambrai, working for Margaret of Austria and was employed by Charles V (1534), for whom he made designs of the Capture of Tunis which were later used as cartoons for tapestries (tapestries now Madrid, cartoons Belvedere, Rome). Little extant work, that which is dateable being eight engravings (c. 1545, 1546, 1555). Italian influence is apparent in his work, which is also close to Jan van *Scorel although less transparent, eg *Portrait of a Man* (AP, Munich).

VERNET, Claude-Joseph (1714–89)

b. Avignon d. Paris. French landscapist and marine painter; visiting Rome (1734) he evolved a picturesque style partly derived from *Claude. He was employed by Louis XV to paint a series of French ports (Musée de la Marine, Paris).

VERNET, Emile Jean Horace (1789–1863)

b. d. Paris. Grandson of Claude-Joseph *Vernet and son of Carle (1758–1836), Vernet was the most famous battle and animal painter of his generation. Employed by the Bonaparte family, and later by Louis-Philippe, he was Director of the French Academy in Rome (1828–34). He visited Algeria (1837) to gather more material for the great battle series at Versailles, and visited Russia (1838) to work on a Napoleonic picture for

the Tsar. His North African scenes are painted with verve, but more smoothly than those of *Delacroix.

Top: EMILE VERNET *The Lion Hunt.* 1836. 22½×32⅛ in (57×82 cm). Wallace

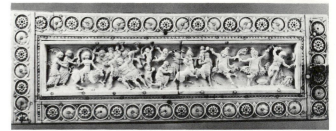

VEROLI CASKET Relief from the lid of the casket, showing Europa and the Bull. V & A, London

VEROLI CASKET

Perhaps the best of a large group of †Byzantine *ivories in casket form decorated with rosettes, it consists of panels depicting scenes from classical mythology. It was probably made in Constantinople in the late 10th or early 11th century. (V & A, London).

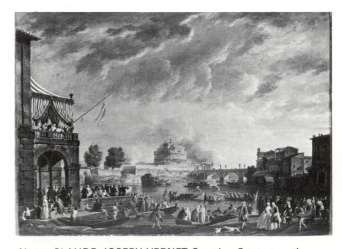

Above: CLAUDE-JOSEPH VERNET *Sporting Contest on the Tiber.* 1750. 39×53½ in (99×136 cm). NG, London

VERONA, S. Zeno

The Church of S. Zeno possesses the only surviving set of †Romanesque bronze doors in Italy north of the Apennines. They have more in common with German examples or with those at Novgorod than with southern Italy. The style of the Biblical scenes is less sophisticated than those of *Hildesheim.

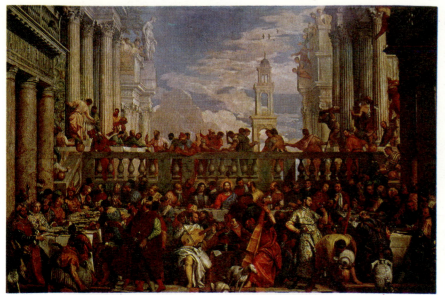

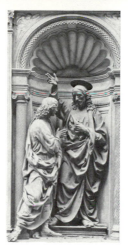

Above left: PAOLO VERONESE *Marriage at Cana.* 1562–3. 256×389 in (650·2×988 cm). Louvre
Above right: PAOLO VERONESE *The Finding of Moses. c.* 1510. 22⅛×17 in (56×43 cm). Prado
Far left: VERONA S. Zeno. Detail of the Tree of Jesse from the Bronze Doors. *c.* 1100
Near left: ANDREA DEL VERROCCHIO *The Incredulity of St Thomas.* 1465–83. Bronze. h. 90⅜ in (230 cm). Or S. Michele, Florence

VERRE *see* NIGERIA, NORTHERN

VERRIA, Church of the Saviour

This small basilica in North Greece possesses a complete cycle of church festival scenes dated 1315 and signed by Kaliergis, 'the best painter in Thessaly'. He was probably trained locally (?in Thessaloniki) and may have painted the Catholicon of Chilandari on *Mount Athos (1320s). An inscription in a Byzantine church advertising the painter is without parallel.

VERRIO, Antonio (1630–1707)

b. Lecce d. Hampton Court. Italian painter who came to England (1671). He executed huge decorative cycles in a late †Baroque manner and was made Court Painter (1684) after *Lely's death. He worked extensively for the Crown at Windsor Castle and Hampton Court, but also notably at Burghley (The Heaven Room) and at Chatsworth. He was immensely popular in England though his work, while dexterous, was often a little vacant.

VERROCCHIO, Andrea del (1435–88)

b. Florence d. Venice. Italian sculptor and painter active in Florence, he later moved to Venice. His only dated painting is a panel in Pistoia Cathedral. His sculpture was influenced by *Desiderio, *Pollaiuolo and *Castagno. The *Christ and St Thomas* (commissioned for Or San Michele, 1463) broke new ground, solving the problem of two figures in restricted space by their slight overlapping and the penetrating gesture of the Saint. The tomb of Giovanni and Piero de' Medici (completed 1472) in the Old Sacristy of S. Lorenzo is unique in that it is embellished solely with classical ornamental motifs. His bronze *David* (before 1476, Bargello, Florence) is a self-assured, confident and aristocratic characterisation of the Biblical hero. He completed the model for the horse of the Colleoni equestrian statue for Venice (1481). Little is known of his pictorial style. He collaborated with *Leonardo who studied with him and to whom the angel in the well-known painting the *Baptism* (*c.* 1470, Uffizi) is often attributed.

They include some secular panels dealing with the legend of Dietrich von Born (Theodoric the Great). The designs fall into two groups, and there was perhaps a twin interval in their execution. This is practically possible because they consist of plaques nailed to a wooden door rather than being cast as a whole.

VERONESE (CALLIARI) Paolo (1528–88)

b. Verona d. Venice. Italian painter and supreme decorator who worked mainly in Venice. Trained under Badile in Verona, he soon outstripped his local contemporaries moving away from their accepted classicism towards greater feats of illusionism and mastery of colour. His large canvases of mythological and Biblical scenes – such as the *Marriage at Cana* (1562–3, Louvre) – were chosen to display to best advantage the crowds of finely dressed figures in classical architectural settings painted in silvery tones contrasting with the luminous richness of the costumes. When charged by the Inquisition (1573) for impiously representing the Last Supper he defended his right to pictorial licence and merely changed the name to *Feast in the House of Levi*. All his work reflects the brilliance and pageantry of contemporary Venice and his *Triumph of Venice* is the first pictorial glorification of that State (1575–7, Doge's Palace). Often working in collaboration with architects, his frescoes in Palladio's Villa Maser are remarkable for the fresh informality of their landscapes and the witty *trompe l'œil effects of figures leaning over simulated balconies. A new humanity entered his last works, eg in the *Deposition* (Leningrad).

VERSPRONCK, Jan Cornelisz (1597–1662)

b. d. Haarlem. Dutch portraitist, taught by *Hals, his style is less painterly and spontaneous. He was later influenced by *Rembrandt particularly in group portraiture. His sitters, realistically rendered, were the Protestant bourgeois of Haarlem.

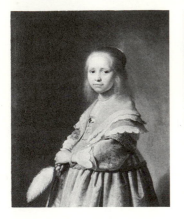

Left: JAN VERSPRONCK *Portrait of a Girl in a Light Blue Dress.* 1641. 32⅜×26⅛ in (82×66·5 cm). Rijksmuseum
Right: FLORIS VERSTER *Still-life with Bottles.* 1892. 38¼×27¾ in (97×70 cm). Kröller-Müller Museum

VERSTER, Floris Hendrik (1861–1927)

b Leiden. Dutch still-life painter and watercolourist, Verster was a student of *Breitner at the Hague Academy. *Toorop introduced him to *Les Vingt in Brussels (1891). His numerous paintings of flowers are in the manner of *Monet.

VERTUE, George (1684–1756)

b. d. London. English writer, collector and engraver, he studied at *Kneller's Academy. He assembled notes for a history of English painting, later used by Horace Walpole, which are a major source for the period (published 1913–21).

VEZELAY, Paule (1893–)

English artist who trained at the Slade School of Art (1912–14), and settled in Paris (1926). She became closely associated with the *Arps who influenced her work as it became abstract. Although she returned to England (1939) her collages, string and wire sculptures and paintings have always been more appreciated by French artists and critics.

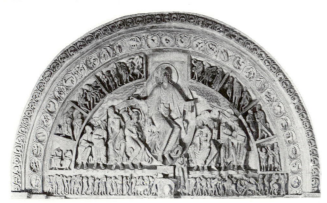

VEZELAY, Ste Madeleine The tympanum showing Christ as Redeemer. 1130s

VEZELAY, Ste Madeleine

This Burgundian abbey church contains some of the finest †Romanesque sculpture in France. The centrepiece of the rich sculptural complex is the *tympanum which dates from the 1130s. Christ as Redeemer radiates emanations of grace to his Apostles, who are thereby sent forth to preach to the nations of the earth, represented with monstrous characteristics, eg immense ears. The universality is stressed by the signs of the Zodiac and labours of the months. The figures at the top of the jambs prepare the way for the column figures of †Gothic portals.

VIANI, Alberto (1906–)

b. Quistello. Italian sculptor who studied at the Venice Academy and did not exhibit until 1946. His smooth, simplified marble torsos and *cycladic sculptures share the formalism of *Brancusi and *Arp. His recent work has become more monumental and abstract.

VICTORY OF SAMOTHRACE

A statue of a Winged Victory on the prow of a ship (early 2nd century BC). The transparent drapery of the figure gives the impression that the wind is fluttering through it. The statue is of the *Rhodian School, and has been ascribed to Pythokritos of Rhodes. (Louvre.)

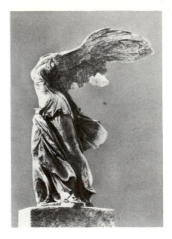

VICTORY OF SAMOTHRACE Early 2nd century BC. Marble h. 8 ft (2.45 m). Louvre

VIEIRA DA SILVA, Maria-Elena (1908–)

b. Lisbon. Painter who studied sculpture under *Bourdelle and works in Paris. Her frankly decorative, mosaic-like early works gave way to a more spatial stylishness. Her compositions are characterised by coloured segments divided by gestural linear networks, concentrated towards the centre and fading at the edges; apparent abstractions which are in fact disguised representations – wide city views with great depth.

JOSEPH-MARIE VIEN *La Marchande des Amours.* Château de Fontainebleau

VIEN, Joseph-Marie (1716–1809)

b. Montpellier d. Paris. French *history-painter; he visited Rome (1743) and participated in the †Neo-classical movement there. In France his classical forms contrast with prevailing †Rococo. An official of the Academy, he also taught *David.

VIETNAM, ART OF

Of the early art of Vietnam little is known: a few fragments from Dai-la-Thanh, some pieces of rather earlier date from Phat-tich, markedly T'ang in manner, and some fragments from Long-doi-son and Binh-son, again strongly under Chinese influence, with some minor *Cham elements, do not enable us to form any real assessment of its achievements. Once the conquest of Champa was completed in the 15th century, Ming styles dominated imperial art and it is only in the royal pagodas and tombs treated as a whole that we can see what the Vietnamese made of their Chinese models. Unlike the other peoples of South-East Asia, the Vietnamese seem never to have transmuted their foreign models into an art which attained a distinctive local style.

VIGARNY (BIGUERNY), Felipe (d. 1543)

b. Nr Langres, Burgundy d. Toledo. Spanish sculptor and architect whose reliefs, altars and tombs exhibit a style transitional between †Gothic and †Renaissance. His large reliefs in Burgos Cathedral (*Via Dolorosa*, 1498/9; *Crucifixion* and *Descent*, 1499/1513) are Gothic in composition and drapery treatment, but the volume of the figures, idealised heads and modelling of light and shade indicate Renaissance influence.

VIGEE-LEBRUN, Louise Elizabeth (1755–1842)

b. d. Paris. French portraitist, influenced greatly by *Greuze, she painted charming groups of women and children, full of sentiment. Her successful portrait of Marie-Antoinette gained her employment at court and she continued to work for the royal family until the Revolution. Thereafter she travelled extensively working for various European courts and patrons.

LOUISE VIGEE-LEBRUN
The Artist and her Daughter.
c. 1789. 41½×33½ in
(105·4×85·1 cm). Louvre

VIGNOLA, Jacopo Barozzi da (1507–73)

b. Vignola, nr Modena d. Rome. Central Italian architect, painter and writer on art. Famous now as the designer of the Gesù. In his own lifetime, and for the next two hundred years, his treatise *Regola delli Cinque Ordini d'Architettura* (1562) was the most widely read and closely followed volume, consulted by architects and painters alike who wished their classical orders to be correct. His knowledge of antiquity was gleaned in three ways: in his youth drawing antiques in Bologna; throughout his life in Rome (from the mid 1530s), and increased expressively when he accompanied *Primaticcio on his return to the French court (1541). There he met Serlio and *Cellini and entered one of the most sophisticated centres of *Mannerist culture of the time.

VIGNON, Claude (1593–1670)

b. Tours d. Paris. French *history-painter, taught by Lallemand. He went to Rome (1618), working there in a Neo-*Caravaggesque style based on *Vouet. Upon his return to France he came under the patronage of the court, and his work of this period shows a knowledge of *Rembrandt.

VIHARA

Sanskrit: literally 'recreation'; the name has come to be applied to monasteries, usually Buddhist.

VIJAYANAGARA SCULPTURE
Top left: Stylised foliage and crouching monsters. Composite pillar capital and abacus, Jambukeshvara temple, near Tiruchchirapalli. 17th century
Top right: Shiva as hunter from the mountains. Adikumbeshvara temple, Kumbakonam. 17th century
Above left: Rati, goddess of sensuality, mounted upon a parakeet. Varadaraja temple, Kanchi. 17th century
Above right: Colonnade of mounted warriors. Shrirangam temple, Tiruchchirapalli (Trichinopoly). 17th century

VIJAYANAGARA SCULPTURE (AD 1336–1565)

The southern Hindu empire of Vijayanagara was founded (1336) by Harihara. Although surrounded by hostile states, it expanded and endured for more than three hundred years. The mature sculptural style of Vijayanagara has been described as 'tortured', the stone being forced to comply with the fierce, fanatical demands of a beleaguered nationalistic religion. The sculptures of the period which are most widely known, and which embody the spirit of the time, are the colonnades of warriors seated on rearing stallions on the temples of Shrirangam, Vellore and elsewhere. The horses, ears pricked, mouths

gaping with the tightness of the bit, eyes bulging with the fury of the battle, are obviously the proud emblems of the militant state. The warriors, decked in princely finery and brandishing weapons, are similarly the heraldic symbols of a chivalric code, virtually elevated to the status of gods. In essence they are no less fantastic creations than the gigantic birds ridden by gods and goddesses which embellish other pillars in the same temples. One has the impression from every side – from the fiercely staring eyes of gods, warriors, animals and demons alike, from the grotesque monsters of nightmare which crouch upon the pillars, from the stiff, unnatural stylisation of natural motifs – of a restlessness, an underlying sense of insecurity which the tons of solid masonry and massive column-clusters do nothing to dispel. For all its negativity of emotion, however, the sculpture displays technical brilliance and inventiveness. The colossal *gopuras (gate-towers) and the towers of the temples themselves, are carved with tier after tier of gods, imitative of the sacred Himalayan slope on which the deities reside. These towers are the tallest structures erected by any Indian dynasty; the iconology involved in placing the hundreds of divine figures across the face of such structures astounds the imagination.

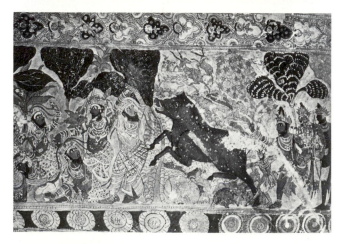

Top: VIJAYANAGARA SCULPTURE Part of the Hindo pantheon. Upper levels of the south gopuram, Minakshi temple, Madurai. 12th century
Above: VIJAYANAGARA PAINTING *The Boar Hunt. c.* 1540. Lepakshi Temple, Vijayanagara

VIJAYANAGARA PAINTING

The finest examples of this Indian school come from the Lepakshi Temple (*c.* AD 1540) near Hindupur, north of Bangalore. The themes are Shaivite and are depicted in friezes. The three-dimensional quality, a legacy of the *Cholas, is found only in the murals at Uchayappa Matha at Anegundi which are early examples of the Vijayanagara style. The Lepakshi figures are highly conventionalised, heavily ornamented, with tall, jewelled crowns, necklaces, anklets and so on, and are in almost full profile, but with torsos depicted frontally. The outlines, fluently drawn, are in black, while the colours, mainly reds, yellows and blues, are very strong.

VIKING ART see essay MIGRATION PERIOD ART

VILLARD DE HONNECOURT

This French architect compiled a sketchbook (*c.* 1225) which combined a wide range of interests. Drawings of existing or destroyed monuments, such as Laon and Cambrai Cathedrals, are mixed with sketches of both executed and unexecuted designs for *Reims Cathedral, imaginary designs for sculpture and manuscripts and scientific and technical drawings. Villard himself worked at Cambrai, and visited Hungary, and perhaps Bamberg and Palermo. Sketchbooks like his probably helped to disseminate Ile-de-France ideas about architecture throughout Europe.

Left: VILLARD DE HONNECOURT Page from his sketch-book. *c.* 1225. Bib Nat, Paris
Right: VILLENEUVE-LES-AVIGNON *Virgin and Child. c.* 1335. Polychrome ivory

VILLENEUVE-LES-AVIGNON, Ivory Group (*c.* 1335)

This free-standing group representing the Virgin and Child is carved from a single elephant tusk. The use of paint, eg gold-embroidered hems, was usual. The rigid pose of †Romanesque cult statues is dissolved into a more tender and decorative object, reminiscent of the new concept of the Virgin in the work of Ambrogio *Lorenzetti. *See also* IVORIES, Gothic

VILLON, Jacques (Gaston DUCHAMP) (1875–1963)

b. Damville d. Puteaux, Paris. French painter and engraver, the oldest member of the *Cubist movement, brother of Marcel *Duchamp and Raymond *Duchamp-Villon. His paintings were during the Cubist period dynamic in linear effect, yet carefully proportioned. Principally important, with

his brothers, for organising the important 'Section d'Or' exhibition (1912). His studio at Puteaux was the meeting-place for all the major artists.

Left: JACQUES VILLON *Mademoiselle Yvonne Duchamp.* 1913. 50¾×35 in (129×88·9 cm). Los Angeles County Museum, Gift of Anna Bing Arnold

Below: DAVID VINCKBOONS *Kermis.* c. 1610. 20½×36 in (52×91·5 cm). Gemäldegalerie, Dresden

VINCI, Leonardo da *see* LEONARDO

VINCI, Pierino da (1520/1 *or* 1530/1–1554)

Italian sculptor; briefly apprenticed to *Bandinelli and subsequently to *Tribolo, he assisted the latter on the Castello fountains. With the patronage of Luca Martini of the Medici court, he executed independently several marble sculptures, notably the *River God* (Louvre), in a less robust but more sensitive idiom than Tribolo's.

VINCKBOONS, David (1576–1632)

b. Mechlin d. Amsterdam. Dutch genre painter and print designer, who painted crowd and festival scenes like those of Pieter *Bruegel the Younger. He showed an early interest in nocturnal effects (before *Caravaggio's followers returned) and helped evolve the naturalistic landscape style in Holland.

VISCHER Family

Sculptors and metalworkers, active in Nuremberg (c. 1450–1550). Three generations were involved; Hermann the Elder (d. 1488), his son Peter the Elder (c. 1460–1529), and Peter's three sons, Hermann the Younger, Peter the Younger and Hans. Hermann the Elder was principally employed in the manufacture of bronze effigies and his most important work is a font at Wittenberg (1456). Peter the Elder was more gifted, and in his hands the family business aspired to higher levels of patronage. He was responsible for the design and part of the execution of the Shrine of St Sebaldus at Nuremberg (1508–19) and contributed King Arthur of Britain and Theodoric the Great to the worthies attending the tomb of the Emperor Maximilian at Innsbruck. Peter's sons probably completed many of their father's projects. In their own work they became increasingly aware of Italian ideas and played some part in introducing †Renaissance forms into Germany.

VISHNU

Hindu god of *Vedic origin; equal to *Shiva in cult popularity. Is the cosmogonic god who 'dreams' and sustains each new universe which is then constructed by *Brahma. Consorts are *Lakshmi, Bhu (earth goddess) and Sarasvati (goddess of learning). Cognisance is the eagle Garuda; attributes are lotus, conch-shell, mace and disk. Incarnates himself on earth in times of distress among men (eg as Krishna). There are ten 'official' such *avataras, the Buddha being assimilated to their number, but not the Jina (*Jaina).

VISHNUKUNDINS *see* GUPTA CONTEMPORARY MINOR DYNASTIES

VISIGOTHIC ART *see essay* MIGRATION PERIOD ART

VITALE DA BOLOGNA (active 1330–61)

The first important panel- and fresco-painter in Bologna, the centre of Italian manuscript illumination. He adapted Florentine and *Sienese achievements. The panels of the *Life of St Anthony Abbot,* crowded with incident and detail, show his highly individual treatment of surface pattern.

VITI, Timoteo (Timoteo da URBINO) (1469/70–1523)

b. d. Urbino. Italian painter, probably a pupil of Giovanni Santi (*Raphael's father). Beginning as a goldsmith, he apparently learnt painting in Francesco *Francia's workshop in Bologna; he returned to Urbino (1495). Indebted first to Francia and later to *Raphael, his style closely resembles *Signorelli's, and is at its most expressive in his drawings.

VITRUVIUS POLLIO (active c. 25 BC)

Roman architect and military engineer under Augustus. He is chiefly known for his treatise *De Architectura,* a work about architecture largely based on Greek and *Hellenistic architecture, with little reference to contemporary Roman buildings. It discusses town-planning (Book 1), building materials (2), temples and the 'orders' (3, 4), civic buildings (5), domestic buildings (6), pavements and decorative plasterwork (7), water-supplies (8), geometry, mensuration, etc (9), civil and military machines (10).

Left and right: PETER VISCHER THE ELDER Shrine of St Sebaldus (and detail). 1508–19. St Sebaldus, Nuremberg

VITTORIA, Alessandro (1525–1608)

b. Trent. Italian sculptor, employed in the workshop of *Sansovino in Venice (from 1543); breaking with Sansovino (1547), he also worked in Vicenza, Padua and Brescia. His sometimes facile sculptural style was much swayed by his admiration of *Michelangelo, eg particularly in the *Dying and Rebellious Slaves*, but progressed from superficial emulation to fuller understanding in *St Sebastian* (S. Salvatore, Venice).

VIVARINI Family
Antonio (*c.* 1415–1478/84)
Bartolommeo (*c.* 1432–99)
Alvise (*c.* 1445–1503/5)

Family of Italian painters; Antonio and Bartolommeo were brothers and Alvise was Antonio's son. They established a workshop at Murano which mainly produced elaborate polyptychs, carefully composed and highly finished. Antonio, b. Venice d. Murano, worked almost always in collaboration, first with *Giovanni d'Alemagna (eg *Coronation of the Virgin*, S. Pantaleone, Venice), and later with his brother Bartolommeo. Antonio's style, despite some attempt at volume, never emerged fully from a decorative †Gothic. Bartolommeo, b. d. Murano, developed in his independent work (1460s onwards) a sharper manner, akin to *Mantegna's (as in his *St Martin*, Accademia Carrara, Bergamo). The workshop employed increasing numbers of assistants. Alvise, b. d. Venice, trained there, probably under Bartolommeo, although his work was also influenced by *Antonello da Messina. He acquired a meticulous, glassy style of great purity (eg *St Anthony* and *St Clare* panels, Accademia, Venice).

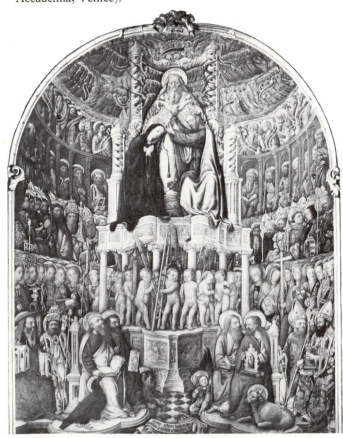

ANTONIO VIVARINI and GIOVANNI D'ALEMAGNA *The Coronation of the Virgin*. S. Pantaleone, Venice

VIVIN, Louis (1861–1936)

b. Hadol d. Paris. Postal clerk and amateur painter who devoted himself to full-time painting on retirement (1922).

His views of Paris, often based on postcards, are characterised by an obsessive, brick by brick, linear definition. They have a somewhat rigid, toy-like charm.

VIX, Krater of

A large bronze *krater, five feet four inches high, found in an Iron Age (6th century BC) tomb at Vix, near Châtillon-sur-Seine. It has two big volute handles adorned with gorgons' heads and the neck is decorated with a relief frieze of a row of two-wheeled chariots pulled by four horses and followed by helmeted hoplites carrying shields. The work is of exceptional quality and the krater is thought to be of Greek, perhaps *Corinthian, manufacture.

Left: ALVISE VIVARINI *St Anthony of Padua.* 11½×8¾ in (29×22 cm). Museo Correr, Venice
Right: VIX, Krater of. *c.* 525 BC. Bronze. h. 5 ft 4 in (1·64 cm). Châtillon-sur-Seine Museum

VLADIMIR-SUZDAL', Cathedral of the Dormition

This cathedral, in which the icon, the *Virgin of Vladimir*, was kept and the princes crowned, was twice frescoed in the 12th century. It was repainted by *Rublev and others with the *Last Judgement* (completed 1408). This emphasises the beauty and calm of the Christian Heaven, a humanitarian conception.

VLADIMIR-SUZDAL', St Demetrius

A stone church in the Palace of Vsevolod (built 1194–7). The exterior is sculpted all over with animals, saints and some narrative scenes, superficially reminiscent of *Aght'amar, but probably executed by imported workers trained in the †Romanesque West. Inside the church is a fragmentary *Last Judgement* of great quality, the work of Byzantine painters. Twelfth-century Vladimir could attract good artists from all Europe.

VLAMINCK, Maurice de (1876–1958)

b. Paris d. Rueil la Gadalière. French artist who knew *Derain from boyhood and met *Matisse (1901). The three painters were working in similar directions which led to the 'cages aux fauves' at the Salon d'Automne (1905). He is one of the more austere *Fauves, making greater use in his landscapes of harsh tonal contrasts and a mode of drawing derived from the agitation of *Van Gogh. He relinquished that style (1908) to follow more closely the ideas of *Cézanne, producing works of solidity and balanced composition.

VLIEGER, Simon de (1600–53)

b. Rotterdam d. Weesp. Dutch landscape and marine painter, he worked in Delft. Influenced by *Porcellis, his paintings of the 1630s are practically limited to different tones of grey.

VOGELHERD (Aurignacian *c.* 31,000–27,000 BC)

†Palaeolithic site in Germany with small figures of mammoth, horse, lion, bear and bison.

VON WIEGAND, Charmion (1900–)

b. Chicago. Painter and art critic who lived in New York (from *c.* 1920); began painting (1926); was President of American Abstract Artists (1951); travelled extensively. Her first paintings were child-like fantasies; influenced by *Mondrian (after 1940), she shifted to Mondrian-manqué *Neo-Plastic geometric abstraction.

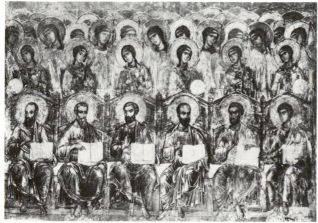

Top and centre: VLADIMIR-SUZDAL', St Demetrius. Last Judgement fresco (and detail). *c.* 1195
Above: MAURICE DE VLAMINCK *Houses at Chatou.* 1903. 32×39⅝ in (81·3×100·7 cm). Art Institute of Chicago

VORTICISM

A short-lived abstract movement in the English arts (1912–14). Its moving spirit was Wyndham *Lewis, who organised the group and wrote most of *Blast*, the puce-coloured cockleshell that was the movement's organ. Associated with it were *Nevinson, *Bomberg and *Roberts (painters); *Gaudier-Brzeska and *Epstein (sculptors); Eliot and Pound – who coined the word 'Vorticism' – and had poems in the first issue of *Blast*. Effectively terminated by World War I, it produced works equivalent to the most advanced continental ones.

VOS, Cornelis de (?1584–1651)

b. Hulst d. Antwerp. Flemish *history and portrait painter, his depictions of burghers are simple and unaffected. He contributed works (1636–8) to the Torre de la Parada with *Rubens, who influenced him considerably.

CORNELIS DE VOS *A Flemish Lady.* 48⅝×36¾ in (123×93 cm). Wallace

VOS, Marten de (1532–1603)

b. d. Antwerp. Flemish *Mannerist painter who went to Italy (1551) where he was a pupil of *Tintoretto. He returned to Antwerp (1558) and became master of the Guild of St Luke; was doyen of the Painters' Guild (1572). His importance is indicated by the quantity of engravings after his compositions. *St Luke Painting the Virgin* (1602, Antwerp) illustrates his typical exaggerated Italianate forms. This contrasts with his portraits which continue in the traditional native style.

SIMON VOUET *Wealth.* c. 1640. 67×48¾ in (170·2×123·8 cm). Louvre

VOUET, Simon (1590–1649)

b. d. Paris. French painter who, after visiting Constantinople and Venice, arrived in Rome (1614) where he was influenced

by *Caravaggio. Recalled to Paris by Louis XIII (1627), he was made First Painter to the King and abandoning his Caravaggesque style, he executed decorative paintings for the royal palaces and also altarpieces. His most ambitious decorations were in the houses of the great financiers, notably Chancellor Séguier's, in which he employed a tempered Italian †Baroque style.

VRANCKZ, Sebastien (1573–1647)

b. d. Antwerp. Flemish painter of battle scenes and domestic interiors. Despite heavy demand for his work he refused to employ assistants and pupils. His style is transitional between *Mannerism and 17th-century realism, combining close observation with over-detailed compositions.

VRELANT, Willem (before 1410–81)

b. Utrecht d. Bruges. Netherlandish miniaturist, recorded as buying his citizenship of Bruges (1456), and a founder of the guild of miniaturists and illustrators. One of the many who worked for Philip the Good in Bruges. The minature of *The Annunciation with Philip in Prayer* (*Treatise on the Annunciation*, 1461, Bibliothèque Royale, Brussels, MS 9270) indicates his stiff linear style.

VRIES, Adriaen de (c. 1550–1626)

b. ?The Hague d. Prague. Netherlandish sculptor and portrait painter who was a pupil of Giovanni da *Bologna in Florence. Worked for the Duke of Savoy, Charles Emmanuel, and was made Court Sculptor to Rudolph II (1601). The *Hercules* group from the fountain in Augsburg, in its Italianate fantasy and svelte figure style, shows his reliance on Bologna.

ADRIAEN DE VRIES Hercules Fountain. 1602. Bronze. Maximilianstrasse, Augsburg

VRIES, Hans Vredman de (1527–1604/23)

b. Leeuwarden d. Antwerp. Netherlandish painter, achitect and designer who studied painting in Amsterdam and then worked in Antwerp and Malines, as well as in Germany (c. 1586). He established a reputation for perspectival architectural paintings and for illustrations for perspectival treatises. Executed decorative works, such as designs for the triumphal entry of Charles V and Philip II into Antwerp.

VRIKSHAKA

Sanskrit: literally 'she of the tree'; in Indian mythology a female dryad, personification of the mysterious indwelling personality of trees; similar figures can be seen on *Indus Valley Civilisation seals.

VROOM, Cornelisz (1591–1661)

b. d. Haarlem. Dutch landscapist, son of Hendrik *Vroom, his activity begins in the 1620s. His paintings of dense forests influenced a second generation of artists particularly Jacob van *Ruisdael.

VROOM, Hendrick (1566–1640)

b. d. Haarlem. Dutch marine painter, he first travelled extensively in Europe as a faience painter. In Rome he was influenced by *Brill and returning to Holland became the first artist to specialise in marine subjects. He painted majestic battle-pieces of men-of-war and came to England to design a set of ten tapestries celebrating the defeat of the Spanish Armada.

Above: HENDRICK VROOM *Battle of Gibraltar.* $54\frac{1}{8} \times 74$ in (137·5×188 cm). Rijksmuseum

Left: MIKHAIL VRUBEL Sketch for Lermontov's 'The Demon'. Tretyakov Gallery, Moscow

VRUBEL, Mikhail Alexandrovitch (1856–1910)

b. Omsk d. St Petersburg. While a student at the St Petersburg Academy (1880–4), he assisted in the restoration of the 12th-century Church of St Cyril in Kiev, a task that familiarised him with the flat, rhythmic †Byzantine decorative surfaces that later characterised his own work (eg *The Dance of Tamara*, 1890). After a trip to Venice, he was commissioned to illustrate Lermontov's poem *The Demon* whose mystical symbolic theme haunted him for life that ended in a mental breakdown. He moved to Moscow (1889) where he was a member of the *Abramtsevo colony and contributed to the first *World of Art exhibitions. His monumental paintings, watercolours and pencil sketches won little recognition during his lifetime.

EDOUARD VUILLARD *The Conversation*. 1894. 83½×59⅞ in (212·1×121·6 cm). Musée National d'Art Moderne, Paris

VUILLARD, Edouard (1868–1940)

b. Cuiseaux d. La Baule. French painter who studied at the Académie Julian. As a *Nabi (1889–99) Vuillard experimented with abstract, decorative effects using flat *Synthetist shapes and later a dense overall patterning. His mural commissions executed in cool, acid, distemper colours retained this decorative awareness whereas his oil paintings became increasingly naturalistic, descriptive, even anecdotal. Light, for *Bonnard a source of colour, was for Vuillard a tonal means of carving out *Intimiste domestic interiors, cluttered caves preserving the flavour of the period.

VULCA OF VEII (active *c.* 490 BC)

*Etruscan sculptor who, according to *Pliny, sculpted the terracotta statue of Jupiter holding a thunderbolt in his right hand for the Temple of Jupiter on the Capitol at Rome. Several Etruscan statues have been found at Veii, and one of the best preserved of these, a statue of *Apollo, has been attributed to him.

WADSWORTH, Edward (1889–1949)

b. Cleckheaton d. London. English painter who studied at Bradford and the Slade School of Art. Exhibited in London with the *Vorticists (1912–14). Member of *Unit One (1933). His gentle, de *Chiricoesque tempera paintings of the 1930s were an important contribution to the English *Surrealist movement.

WALDMULLER, Ferdinand Georg (1793–1865)

b. Vienna d. Nr Baden. Austrian landscape painter, and major figure in the early naturalist phase often called *'Biedermeyer' painting. He painted scenery in the Wienerwald and Sicily, filling his compositions with brilliant sunlight. He also painted genre scenes and portraits.

WALDO, Samuel Lovett (1783–1861)

b. Windham, Connecticut d. New York. Painter who studied with Hartford portraitist (c. 1799), at Royal Academy Schools and with *West and *Copley in London (1806–8); settled in New York (1809); formed partnership with *Jewett (c. 1818). Waldo's early portraits were strong, perceptive and painterly, becoming merely capable and attractive after his partnership with Jewett.

WALKER, Dame Ethel (1861–1951)

b. Edinburgh d. London. Painter of portraits, flower-pieces, seascapes and decorative compositions. After early work, *Rembrandtesque in the dark richness of its tones, she adopted *Impressionism, achieving an art of vibrancy and spontaneity.

WALKER, Frederick (1840–75)

b. London d. Perthshire. English painter and illustrator. Worked for the *Cornhill* and other illustrated magazines (from 1860). His watercolours of idealised rustic subjects, in thick opaque paint, became very influential among other exhibitors at the Dudley Gallery, London. His large oil paintings of similar subjects impress with their monumentality.

WALKER, Horatio (1858–1938)

b. Listowel, Ontario d. Isle d'Orléans, Quebec. Canadian-American painter who studied first in Toronto, then in New York (1885); worked in New York and Paris. Deeply influenced by *Millet and the *Barbizon School, Walker painted landscapes and rural genre scenes with warm humanity in light-filled, luxuriant colour.

WALKER, John (1939–)

b. Birmingham. English abstract painter who uses rhomboid- and trapezium-shaped canvases noted for their length and use of cut-out shapes. He is interested in two themes, the 'floating form' and the 'static form' which he places against a single, sprayed-on, background colour.

Top: JOHN WALKER *Lesson I*. 1968. Acrylic. 103×242 in (261·6×614·6 cm). Tate
Above: EDWARD WADSWORTH *Dazzle Ships in Drydock at Liverpool*. 1921. 120×96 in (304·8×243·9 cm). NG, Canada

WALKER, Robert (1675–1758)

English portrait painter who worked in *Van Dyck's style, becoming recognised during Cromwell's rule. He painted several portraits of the Protector and fellow Parliamentarians. His articulation of the figure is often clumsy.

WALKOWITZ, Abraham (1880–1965)

b. Tuiemen, Russia d. New York. Painter who went to America; studied at National Academy of Design and in Paris with *Laurens at Académie Julian (1906–10); exhibited at *Armory Show (1913) and with *Stieglitz. Influenced by *Rodin and *Matisse, Walkowitz is remembered for loose, energetic drawings of Isadora Duncan, eventually abstracted to pure rhythm.

WALL, Brian (1931–)

b. London. Largely self-taught English sculptor who was assistant to *Hepworth (1954–8). He has taught at several London art schools. His assemblages of open steel volumes are joined by taut or solid bars which unify yet separate the various elements.

WALLIS, Alfred (1855–1942)

b. Devonport. English artist who began painting at the age of sixty-seven 'for company' after the death of his wife. His style is primitive, yet entirely convincing. He records the ships, sea and landscapes that he had known so intimately. He was discovered by *Nicholson and Christopher *Wood, whom he influenced.

ALFRED WALLIS *Boat Entering Harbour*. Private Collection

WALLIS, Henry (1830–1916)

b. London d. Croydon. English painter, studied in London and in Paris with *Gleyre, before exhibiting first at the Royal Academy (1854). Influenced by *Pre-Raphaelite techniques in the meticulously painted *Death of Chatterton* (1856) and by their approach to the modern subject, eg *The Stone Breaker* (1858). Later painted Eastern landscapes.

WALL MOSAICS, Classical

The earliest wall mosaics consisted of shells, pebbles and pieces of volcanic pumice applied to the walls and vaults of 1st-century BC grottoes. Attempts to add colour to this scheme led to the introduction of coloured glass *tesserae at the beginning of the 1st century AD. Glass was used extensively in the fountains at Pompeii. The technique was also used on vaults as is attested by a large vault mosaic in Nero's *Golden House. By the end of the 1st century AD the use had spread to baths too. During the 2nd and 3rd centuries AD they are found throughout the Roman Empire, notably in North Africa. They decorated not only fountains and baths, but also tombs and mithraea.

They are also found in 3rd-century Christian tombs. Not surprisingly, they also decorate the vaults of Early Christian buildings, such as Sta Costanza, *Rome. *See also* MOSAICS

WALL MOSAICS Mosaic fountain in the House of the Large Fountain, Pompeii. 3rd quarter of 1st century AD.

WALTER OF DURHAM

Active London, second half of 13th century. The King's Painter, his documentation is more extensive and informative than his surviving work. Walter is known to have painted the now almost indecipherable decorations on Queen Eleanor's tomb base (1290), and the coronation chair, and unspecified parts of the Painted Chamber at Westminster, of which the only records, since the fire (1834), are 19th-century copies. His style is therefore hard to reconstruct. The wall-paintings in the south transept and Chapel of St Faith in Westminster Abbey, have been attributed to Walter, and the problem of his connection with the *Westminster Retable must also be considered.

WALTON, Henry (1746–1813)

b. Dickleburgh, Norfolk d. London. English painter. Pupil of *Zoffany, he painted rather mediocre portraits (from 1771). He probably visited France, as strong echoes of *Greuze and *Chardin appear in his fine genre paintings, eg *Girl Plucking a Turkey* (1776, NG, London).

HENRY WALLIS *The Stone Breaker*. 1858. 25¾×31 in (65·4×78·7 cm). Birmingham

WANDERERS

A group of thirteen Russian artists headed by Kramskoi (1837–87) withdrew from the Academy of Fine Arts in protest against its conformist policy (1863). They called themselves 'Wanderers' because they put their ideals of 'bringing art to the people' into practice by forming the Society of Travelling Art Exhibitions (1870). These artists, like their contemporaries in music and literature, sought to justify their activity by making art useful to society: to explain life, comment on it, and arouse compassion for the common man. They emphasised realism in their work, and repudiated the philosophy of 'Art for Art's sake'. They included *Repin, *Serov and *Vereshchagin.

Above left: THE WANDERERS *Portrait of a miller* by Ivan Kramskoi. Leningrad
Above right: WAN FO SSU Stone figure of the Buddha of the Liang dynasty, AD 529. This should be compared with the later works of the Northern Chou (see adjacent illustration)
Right: WAN FO SSU Stone stele excavated at Wan Fo Ssu with a standing Buddha accompanied by Bodhisattvas and disciples. Liang dynasty. AD 523. h. 14½ in (36·2 cm).

WAN FO SSU, Sculpture at

More than two hundred sculptures have been excavated at the site of the Buddhist temple, the Wan Fo Ssŭ in Szechuan province, China. Of these a small group dating from the Liang (AD 502–57), the Northern Chou (AD 557–81) and the *T'ang (AD 618–906) periods are rare evidence of the styles of Buddhist sculpture in the southern part of China. In the first half of the 6th century two main styles are discernible. In one group steles with massed figures predominate. The figures wear robes falling in cascading patterns hiding the shape of the bodies and ending in fin-shaped points. A second type consists of standing figures of the Buddha in robes which, starting from a circular fold round the neck, fall in simple curved folds showing the shape of the body beneath and ending in small rounded pleats at the hem. This style had a wide influence on the more ponderous work of the Northern Chou period in the rest of western China.

WANG Chien (1598–1677)

Chinese painter from T'ai-ts'ang, Kiangsu, who, like *Wang Shih-min, studied the masters of *Sung and *Yüan, preferring the style of *Huang Kung-wang, but not attaining the same degree of fluency and breadth of ability as their joint pupil *Wang Hui.

WANG Fu (1362–1416)

Chinese painter from Wu-hsi, Kiangsu. Close in spirit and in style to the great masters of the *Yüan such as *Ni Tsan and *Wu Chên, his landscapes were not appreciated at court, but found favour with scholars. He was also a poet and noted bamboo-painter.

WANG Hsi-chih (303–79)

From Shantung province, China. Of a family distinguished over many generations for its calligraphers, Wang became China's most famous exponent of calligraphy. His writings in regular, running and cursive styles were collected and engraved for Emperor T'ai-tsung (reigned 626–49), and served as unsurpassed models for all later writers.

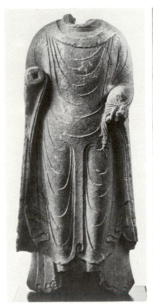
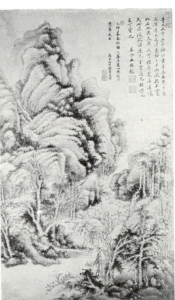

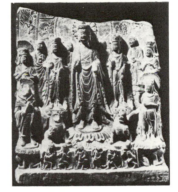

Above left: (WAN FO SSU) Standing Buddha. Northern Chou dynasty, c. AD 570. Stone. h. 28 in (71 cm). Buddhist sculptures of the Northern Chou period show the influence of the southern area, governed by the Liang (see previous illustration)
Above right: WANG HUI Landscape in the style of Wu Chen. 1675. Hanging scroll. Ink on paper. 26½ × 15½ in (67·2 × 39·3 cm). Mr and Mrs Earl Morse Coll, New York

WANG Hui (1632–1717)

Chinese painter from Ch'ang-shu, Kiangsu. The most versatile artist of his time, he evolved calligraphic idioms for a wide range of *Sung and *Yüan styles, under the tutelage of *Wang Shih-min and *Wang Chien. His best work was produced in the 1660s and 1670s. He was at court (1691–8), receiving signal favour from the emperor, but the paintings of his later years, though vigorous and prolific, lack the freshness of inspiration of his earlier works.

WANG Mêng (c. 1309–85)

Chinese painter from Wu-hsing, Chekiang, whose landscapes, termed 'dense and elegant' by Chinese writers on painting, are the most colourful among those of the *Four Masters of late Yüan. Of many later artists who were to follow his manner, it was *Wang Hui of the Ch'ing who was most successful in re-creating the rich texture of his brushwork. A group of tall pine trees, prominently placed, is almost a hall-mark of Wang Mêng subjects.

WANG Shen (1036–after 1089)

From T'ai-yüan, Shansi. Chinese landscape painter of the Northern *Sung, heir to the coloured style of *Li Ssu-hsün

and *Li Chao-tao. Few of his works have survived; those that do are monumental landscape compositions.

WANG Shih-min (1592–1680)

From T'ai-ts'ang, Kiangsu. Chinese painter and official, who, under *Tung Ch'i-ch'ang's tutelage, studied the surviving masterpieces of *Sung and *Yüan painting, producing an album of reduced copies of them, now in the Palace Museum, Taipei. Later, as a connoisseur, he in turn taught *Wang Hui. Wang Shih-min's own paintings are mainly landscapes in the style of *Huang Kung-wang, becoming more complex in composition in his later years.

WANG Wei (701–61)

From T'ai-yüan, Shansi. Wang Wei is equally famous in the *T'ang dynasty as painter and as poet. As a painter, he is traditionally the father of Chinese monochrome ink painting, as *Li Ssu-hsün is of the 'blue-green' manner. The Wang-ch'üan handscroll, showing Wang Wei's country villas, each spot described in a poem, survives in an engraved version of the 16th century and in many later copies. The *Portrait of Fu Shêng*, traditionally attributed to Wang Wei, shows a gentle and sensitive treatment, in contrast to the vigour of *Wu Tao-tzŭ.

WANG Yüan (active c. 1310–50)

Chinese painter from Hangchow, Chekiang. A pupil of *Chao Mêng-fu, he excelled in flower painting, in which he followed *Huang Ch'üan. He is said to have painted other subjects, landscapes and figures, but only some flower and bird paintings survive.

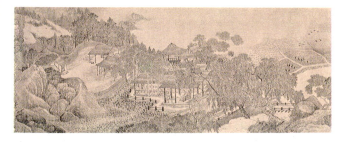

WANG YUAN-CH'I *Wang Ch'uan Villa*. Dated 1711. Detail of handscroll. Ink and colours on paper. Entire scroll 14×214⅝ in (35·7×545·1 cm). Mr and Mrs Earl Morse Coll, New York

WANG Yüan-ch'i (1642–1715)

Chinese painter from T'ai-ts'ang, Kiangsu. Grandson of *Wang Shih-min, he was the youngest and perhaps the most original of the Four Wangs. *Wang-ch'uan Villa*, done after an ancient painting of *Wang Wei's which survived only in stone-engraving, demonstrates both his unusual use of colour and the strong abstraction of his brushwork. While using Wang Wei's subject and basic composition, Wang Yüan-ch'i has transformed it into a form and style completely his own.

WARD, James (1769–1859)

b. London d. Cheshunt. English animal painter, taught by Raphael *Smith, he was influenced by *Morland. He became RA (1811). His dramatic scenes of fighting animals set in stormy landscapes reveal a †Romantic tension akin to *Géricault.

WARD, John Quincy Adams (1830–1910)

b. Nr Urbana, Ohio d. New York. Sculptor, first a foundry-designer, who studied with Brown, New York (1849–56); studied Indians in the West (1860); worked in Washington (1857–60) and New York (from 1861). Ward's portraits came alive in vigorously designed, selective, bold naturalism, comprehending bone, blood and soul. Ward was unusual in avoiding the standard sculptor's training in Europe consequently receiving †Neo-Classical influences at second-hand.

WAREGA (the Swahili pronunciation of 'Balega') see BALEGA

WARHOL, Andy (Andrew WARHOLA) (1928–)

b. Pittsburgh, Pennsylvania. Artist who studied at Carnegie Institute (1945–9); was commercial artist in New York (1949–60). Warhol is *Pop Art's most influential figure. First painting comic strips and advertisements, he then used commercial art's techniques and psychology, printing serigraphs of mass-media images symbolising the artificial consumer culture, eg movie stars and soup-cans. The technique reproduced reproductions, emphasising creativity's mechanisation, as the images emphasised emotion's mechanisation. Films made by Warhol's collective, the 'Factory', reproduce the same anti-art.

WARHOLA, Andrew see WARHOL

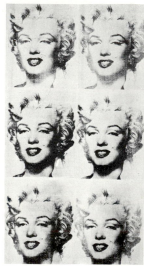

Top left: JOHN ADAMS WARD *Monument to Henry Ward Beecher*. 1891. Arts Commission of New York City
Top right: ANDY WARHOL *Marilyn Six-Pak*. 1962. Silkscreen. 43⅛×22⅜ in (109·5×56·9 cm). Carter Burden Coll, New York
Above: JAMES WARD *Gordale Scar, Yorkshire*. 1811–15. 131×166 in (332·7×421·6 cm). Louvre

WARKA

A great city and religious centre in Sumer (southern Mesopotamia) with monumental temples of the late 4th millennium BC, which has produced early examples of narrative relief and sculpture in the round. The *Warka Vase* depicts in ascending

registers the natural resources of the land, crops and herds, and a procession bringing offerings to the goddess Inanna. The *Warka Head* of white calcite is unique before 3000 BC in its size and in its naturalism. It originally bore an attached wig in some other material, and the eyes and eyebrows were inlaid.

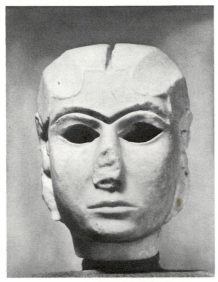

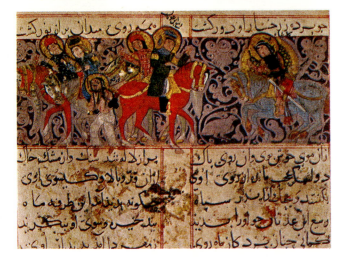

Top left: WARKA Alabaster vase. *c.* 3200–3000 BC. White marble. h. 7⅞ in (20 cm). Iraq Museum, Baghdad
Top right: WARKA Female head. *c.* 3200–3000 BC. White marble. h. 7⅞ in (20 cm). Iraq Museum, Baghdad
Above: WARQA WA GULSHAH MANUSCRIPT *Gulshah revealing herself to Warqa.* Early 13th century. 4¾ in (11·7 cm) Topkapi Sarayi Library, Istanbul

WARQA WA GULSHAH MANUSCRIPT
(late 12th–early 13th century)

Housed in the Topkapi Sarayi, this important Persian manuscript has seventy-one illustrations to the romantic narrative. Short stocky figures on steppe horses crowd the narrow horizontal painted areas, set in a single plane against a solid colour or an intricate ornamented back-drop. This sole manuscript, together with some fragments of wall-painting and the minai painted pottery, provide our only knowledge of Saljuq painting.

WASH

Thin dilution of colour in solvent, water or turpentine, which is transparent and allows previous and successive layers to be seen quite distinctly.

WASHKUK *see* SEPIK RIVER

WASHO *see* CALIFORNIA

WASMANN, Friedrich (1805–86)

b. Hamburg d. Meran. German painter who studied at Dresden and at Munich, where he worked with *Cornelius. In Rome (1830s) he joined the circle of the *Nazarenes and the best of his later works are portraits in an archaic, Nazarene-inspired style, usually small, and in oils and pencil.

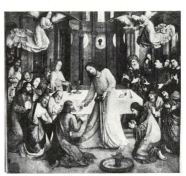

Left: FRIEDRICH WASMANN *The Painter's Mother and Sister.* *c.* 1844. 19⅜×15¼ in (49·1×38 cm). Kunsthalle, Hamburg
Right: JOOS VAN WASSENHOVE *Communion of the Apostles.* 1473–4. 113⅜×126 in (287·7×320 cm). Gall Naz delle Marche, Urbino

WASSENHOVE (GENT), Joos van (active 1460–c. 1480/5)

Flemish painter, master at Antwerp (1460) and at Ghent (1464) where he is recorded until 1469. Went to Rome (1475). He is usually identified with the Justus of Ghent who painted the *Communion of the Apostles* (1473/4, Urbino). Much of Joos's work has been claimed to be by Pedro *Berruguete who was probably not active in Italy. Joos's pre-Italian paintings are directly influenced by the main Netherlandish figures of his time. In Italy, although his work becomes more monumental he retains his touch for Northern detail and luminous effects.

WATERCOLOUR

Essentially composed of transparent *pigments bound in water-soluble *gum. If properly ground and mixed, the *pigment particles will adhere to the paper in the thinnest wash when dry.

WATKINS, Franklin Chenault (1894–)

b. New York. Painter who studied at Pennsylvania Academy; visited Europe (1923); lives in Philadelphia. Disdaining the mainstream of modern art, Watkins developed his personal vision in penetrating portraits, fresh still-lifes and *Expressionist, emotive, symbolic works that give new life to universal epic themes with radiant colour and dynamic form.

WATTEAU, Jean-Antoine (1684–1721)

b. Valenciennes d. Nogent-sur-Marne. Among the most perplexing painters of all time, Watteau's ambivalent response to the artistic heritage and the fashions of his own day even induced the *French Academy to invent a new category for him, as a painter of *fêtes galantes. He arrived in Paris (c. 1702) and worked first under *Gillot (1704/5) and then Claude *Audran, was made an Agrégé of the Academy (1712), and left Paris twice, once for Valenciennes (1709), and then for London (1719/20). His perennial theme is the transience of life and love, which he renders in Arcadian settings which combine some of the formal and colouristic preoccupations of *Rubens – whom Watteau copied exquisitely, in the Luxembourg – with the melancholy overtones of *Giorgione (eg *The Island of Cytherea,* 1717, Louvre and Berlin). But whether Watteau produces fêtes galantes, theatrical pastiches in the manner of

Gillot, or reverts to a kind of Flemish naturalism – as in his last picture, *L'Enseigne de Gersaint* (1719, Berlin) – his achievement resides in his successful synthesis of a stylised †Rococo idiom with a psychological insight worthy of the contemporary novelist, Marivaux.

Above: JEAN-ANTOINE WATTEAU *The Island of Cythera.* 1717. 51×76½ in (129·5×194·3 cm). Louvre
Left: JEAN-ANTOINE WATTEAU *Le Joli Gilles.* c. 1721. 72×59 in (182×149 cm). Louvre

Below: GEORGE FREDERICK WATTS *Orion.* 1896. 11¼×16⅜ in (28·6×41·6 cm). Wallace

WATTS, George Frederick (1817–1904)

b. London d. Compton. English painter and sculptor, gained little from formal education before going to Italy (1843), where he made a close study of Venetian 16th-century painting techniques. Having won two prizes in the competitions for murals to decorate the new Houses of Parliament, he was thereafter closely associated with the revival of mural-painting. In his work treated historical subjects and philosophical abstractions suggesting the evils of a materialist, industrial post-Darwinian society. Also a distinguished portraitist. Earnestness of purpose did not conceal a certain sensuousness in his art. His work is characterised by thick, scumbled paint, with a granular surface he also used for his sculpture.

WAX PAINTING *see* ENCAUSTIC PAINTING

WAX VARNISHES

Preferably made of beeswax in *resin *varnish and *turpentine. Wax varnishes are matt and flexible, and do not crack easily, but they do not afford complete protection to a picture and are very difficult to clean. Solvents spread the wax further into the surface and never clean it off entirely.

WAYANG

A flat or rounded puppet used in Indonesian theatrical performances. Then, by extension, the performance itself. The earliest form, *Wayang Beber*, was a scroll which was unrolled by the narrator. *Wayang Purwa* (or *Wayang Kulit*) is the best-known type, performed in front of a screen by a *dalang* who manipulates the puppets and speaks the dialogue. *Wayang Klitik* uses flat wooden puppets with leather arms; there is no screen. *Wayang Golek* uses three-dimensional stick puppets, elaborately dressed.

Above left: WAYANG PURWA Head of Kresna. h. (of complete puppet) 20 in (52 cm). BM, London
Above right: WAYANG GEDOG Kelama, Timjung Seta, Panji's adversary. h. (without stick) 20 in (51 cm). BM, London

Left: MAX WEBER *Adoration of the Moon.* 1944. 48×32 in (121·9×81·3 cm). Whitney Museum of American Art, New York

WEBER, Max (1881–1961)

b. Bialystok, Russia. Painter who emigrated to America (1891); studied at Pratt Institute (1898–1901) and in Paris with *Laurens and *Matisse (c. 1905–8); exhibited with *Stieglitz; wrote extensively. Influenced by *Cubism and primitive art, Weber painted both intensely coloured, formalised abstractions of urban subjects and introspective fantasies of Jewish life and legend.

WECHSELBERG CASTLE CHURCH

The early 13th-century rood-screen of this castle church is one of the finest surviving examples of this once ubiquitous feature of medieval church furniture. The style of the figures is already moving away from the conventional †Romanesque

presentation of the theme, eg at Brunswick and Halberstadt, towards the more theatrical interpretation found in the west choir-screen at *Naumburg.

WEENIX, Jan Baptist (1621–63)

b. Amsterdam d. Deutecum. Dutch still-life and landscape painter taught by *Bloemaert and Moyard. He was in Italy (1642) where he worked for Cardinal Pamphili, returning to Utrecht (1649).

WEI-CH'IH I-sêng (active 2nd half 7th century)

From Khotan. Foreigners to China at the *T'ang capital of Ch'ang-an, Wei-ch'ih I-sêng and his father Wei-ch'ih Po-na were celebrated painters of landscapes and Buddhist subjects, executing many wall-paintings in the temples of the capital.

WEINBERG, Elbert (1928–)

b. Hartford, Connecticut. Sculptor who studied at Hartford Art School (1946–8), Rhode Island School of Design (1948–51) and Yale University (1953–6); taught at latter two and Cooper Union; lives in Rome. Weinberg became known for his luxuriantly textured, elegantly expressive wood and bronze figures, lately reduced to more abstract, polished figure segments.

Left: ELBERT WEINBERG *The Angel of the Expulsion.* 1957. Bronze. $61\frac{1}{2} \times 26 \times 22$ in ($156 \cdot 2 \times 66 \times 55 \cdot 9$ cm). Whitney Museum of American Art, New York

Below: JULIAN ALDEN WEIR *Visiting Neighbours.* $24\frac{1}{2} \times 34$ in ($62 \cdot 2 \times 86 \cdot 4$ cm). Phillips Coll, Washington DC

WEIR, Julian Alden (1852–1919)

b. West Point, New York d. New York. Painter who studied with father, and in Paris with *Gérôme (1870s) and *Bastien-Lepage; taught at Cooper Union and *Art Students' League for twenty-five years; exhibited at *Armory Show (1913). His underplayed †Impressionist landscapes and figures are distant, subtle, truthful, and often charming, and his gentler approach is coming to be appreciated more than *Lawson's harsher style of Impressionism.

WEISSENBRUCH, Hendrik Johannes (1824–1903)
Johannes (1824–80)

b. d. The Hague. Dutch landscape painters and watercolourists. Hendrik was the pupil of van Hove, Johannes of Verveer. Their early interest in light effects on outdoor scenes associates them with the *Hague School. The French influence is especially apparent in the work of Hendrik, who often exhibited in Paris.

HENDRIK WEISSENBRUCH *Interior of a Cellar.* 1889. $15\frac{3}{8} \times 20\frac{1}{8}$ in (39×51 cm). Rijksmuseum

WELLS CATHEDRAL, Somerset

The west front of Wells Cathedral contains the largest surviving display of †Gothic sculpture in England. The arrangement is totally unlike that of contemporary French cathedrals, eg *Amiens, *Reims. It is basically a screen to contain isolated statues in niches. The sculptures (*c.* 1220–40) include scenes from the Old and New Testaments, a Coronation of the Virgin and a Resurrection.

WEN Cheng-ming (originally Wên Pi) (1470–1559)

Chinese painter from Soochow, Kiangsu. A follower of *Shên Chou, Wên is one of the greatest artists of *Ming, both in painting and calligraphy. Like Shên Chou, he worked in different styles, and there is a contrast between his lyrical landscapes of the lakes and hills round Soochow, and the vigorous rhythms of his studies of cypress trees. His large following includes many of his direct descendants, such as his sons Wên P'eng and Wên Chia, his nephew Wên Po-jen, grandson Wên Ts'ung-chien and others.

WEN Pi *see* WEN Cheng-ming

WEN T'ung (1018–79)

Chinese painter from Tzŭ-chou, Szechuan. He was a scholar (placed fifth in the *chin-shih* or doctoral examinations in 1049), official, and cousin and friend of *Su-Shih, who wrote very highly of his integrity. There had been painters of ink bamboo in the Five Dynasties and earlier still in the *T'ang, but Wên T'ung is universally acknowledged to have been the greatest master in this field.

WERDEN ABBEY CHURCH, Bronze Crucifix
(c. 1060)

This is the most important surviving piece of German bronze sculpture from the generation after Bernward's doors at *Hildesheim. The formal tradition is still that of †Ottonian art (compare the *Gero Crucifix in Cologne). The cross came to Werden from St Liudger at Helmstedt and was probably made in Lower Saxony.

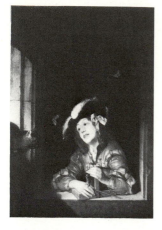 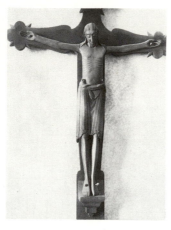

Left: ADRIAEN VAN DER WERFF *A Boy with a Mousetrap.* 7 9/16 × 5 1/4 in (19·2 × 13·3 cm). NG, London
Right: WERDEN CRUCIFIX *c.* 1060. Bronze. Werden Abbey Church

WERFF, Adriaen van der (1659–1722)

b. Kralinger Ambach d. Rotterdam. Dutch *history painter, he was taught by Eglon van der Neer. Active from 1676 his work reveals influences of French court painting. He was later employed at Düsseldorf.

WERNER, Theodor (1886–)

b. Würtemberg. German painter who studied at Stuttgart Academy (1908–9) and lived in Paris and Berlin. The physical surface of his paintings is important: he uses broken shapes, layers and scratches. Although a friend of *Miró and *Braque, he pursued an independent line.

WERVE, Claus de (active c. 1380–d. 1439)

d. Dijon. Netherlandish sculptor active in Haarlem, a nephew of *Sluter whose assistant and follower he was. He assisted with the angels on the great *Crucifixion* (1399–1401, Champmol). After Sluter's death he was commissioned to carry on his work, eg the tomb of Philip the Bold, which he finished (1410). Later served Philip the Good.

WESSELMANN, Tom (1931–)

b. Cincinnati, Ohio. Painter who studied at Herron College, University of Cincinnati, Art Academy of Cincinnati, Cooper Union; lives in New York. Wesselmann's huge *Pop paintings of isolated parts of nude women, rendered in cartoon style and reminiscent of film 'close-ups', symbolise women generally, seemingly more commercialised than erotic.

WEST, Benjamin (1738–1820)

b. Swarthmore, Pennsylvania d. London. American painter; after early training in America, West left for Europe (1760), spending three years in Italy, chiefly Rome. He settled in England (1763), becoming *History Painter to George III and second President of the *Royal Academy (1792). He painted historical canvases in a †Neo-classical style but sensationally introduced contemporary dress in his *Death of Wolfe* (1771, Ottawa). In later years his work became more †Romantic and more grandiose.

WEST INDIES *see* ARAWAK

WEST MEBON, Angkor, Cambodia

A fine example of Khmer bronze-work is the figure of a reclining *Vishnu which dates from the 11th century. He is shown sleeping the sleep of Cosmic Creation. Although only fragmentary the skill of the bronze-caster is clearly apparent as it is in the bronze head of a Shiva from Por Loboeuk.

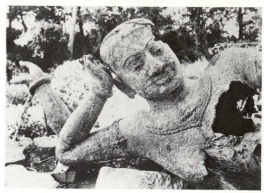

Above: WEST MEBON Reclining Vishnu. Mid-11th century. Bronze. h. 56 in (144 cm). National Museum, Phnom Penh

Left: WESTERN MEXICO Nayarit figure. Hollow pottery painted with a dark red slip. Classic period, Mexico. h. 13 in (33 cm). Royal Scottish Museum

WESTERN MEXICO

The art of this region consists mainly of a variety of pottery styles. From Nayarit and Jalisco come large hollow pottery figurines with painted detail, and lively groups illustrating scenes from daily life. Colima pottery illustrates similar subjects, and effigy vessels in the form of fat dogs with a spout in the tail come from this area. A cemetery at Chupicuaro has produced small solid figurines with applied detail, sometimes called 'pretty ladies', in addition to distinctive painted pottery vessels and larger figures. And in Guerrero highly stylised figures and masks carved in jade and serpentine appear.

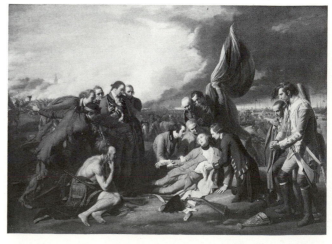

BENJAMIN WEST *The Death of Wolfe*. 1771. 59 1/2 × 84 in (151·1 × 213·4 cm). NG, Canada, Gift of the Duke of Westminster 1818

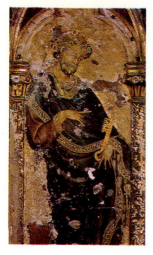
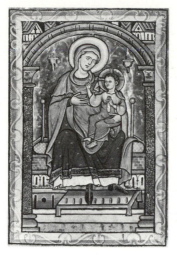

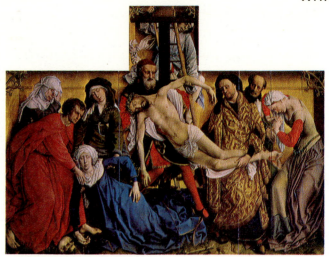

Left: WESTMINSTER ABBEY RETABLE *St Peter* (detail). 1260–70. Tempera with glass and gesso ornament. 19×6 in (48·3×15·2 cm). *Right:* WESTMINSTER PSALTER *Virgin and Child. c.* 1200. 9×6¼ in (23×16 cm). BM, London

WESTMINSTER ABBEY RETABLE

This panel, dating from the last quarter of the 13th century, is one of the few in England to survive the Reformation, and may originally have been the High Altarpiece of Westminster Abbey or the top of Edward the Confessor's shrine. Both the high quality of the painting, in which colour and light modelling is used, and the unique framing of geometric and architectural design, containing patterned glass and stuccoed cameos, pose problems of date and provenance. The painting style has been linked with France and Italy, or with English painting of the 1270s at Westminster Palace and in the Douce Apocalypse. Alternatively, comparison with the painting of St Faith's Chapel, and between the ornamentation of the retable frame and of Edmund Crouchback's tomb at Westminster, may suggest that the retable is English workmanship of about 1300. *See also* WALTER OF DURHAM

WESTMINSTER PSALTER

The Psalter was probably made at Westminster (*c.* 1200). It is preceded by five full-page paintings which include *Christ in Majesty* and *Virgin and Child.* The colours are rich and gold grounds are used. The solid, modelled figures of the Transitional style are heralded in some of the later work in the *Winchester Bible. (BM, London, Roy. 2A. xxii.)

WETTING AGENT

A detergent used to make water take to a surface more readily by breaking down its natural surface tension. Ox-gall was the traditional wetting agent, now synthetic detergents are used.

WEYDEN, Rogier van der (1399/1464)

b. Tournai d. Brussels. Netherlandish painter apprenticed to Robert *Campin in Tournai (1427–32); master there (1432). Recorded in Brussels (from 1435); City Painter (1436). Probably journeyed to Rome and Florence (1450). No paintings are strictly documented but the large *Deposition* (Prado) is generally acceptable as a starting-point for attributions. It serves to exemplify Rogier's lack of interest in spatial depth and his great emphasis upon the use of linear rhythms to help express the high emotional content of his work. He is less naturalistic and more psychological than his forerunners (eg *Seven Sacraments*, Brussels). In addition to a telling development in half-length religious groups (eg *Braque Triptych*, Louvre), Rogier invented the kind of diptych in which a donor on one wing prays to the Virgin and Child on the other (no example is now extant). The most influential Northern painter of the 15th century, Rogier's contribution was the invention of new contours, poses, compositions and colour juxtapositions for the furtherance of emotional expression.

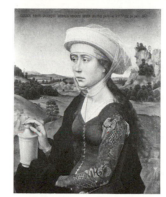

Above: ROGIER VAN DER WEYDEN *Deposition. c.* 1438. 86½×103 in (220×262 cm). Prado *Left:* ROGIER VAN DER WEYDEN *The Magdalen.* Wing from the Braque Triptych. 13⅜×10⅝ in (34×27 cm). Louvre

Below: JAMES ABBOTT McNEILL WHISTLER *Nocturne – Black and Gold. The Fire Wheel. c.* 1870. 21⅜×30 in (54·8×45·7 cm). Tate

WHEATLEY, Francis (1747–1801)

b. d. London. English painter, he was taught at the Royal Academy Schools. He painted elegant small-scale *conversation-pieces. From 1784 he produced sentimental domestic subjects in rural settings. He contributed to *Boydell's Shakespeare Gallery.

WHISTLER, James Abbott McNeill (1834–1903)

b. Lowell, Massachusetts d. London. Painter and printmaker who lived in Paris (*c.* 1855–9), working with *Gleyre; settled in London (1859); visited Valparaiso (1865–6), Venice (1879–80), Brittany and Paris (*c.* 1892–6); exhibited in Salon des Refusés (1863); wrote *The Gentle Art of Making Enemies.* Influenced by †Impressionism and Japanese prints, Whistler created intimate, decorative works, characterised by exquisite design and subdued tonalities. His portraits, eg *The White Girl*, emphasise mood and pattern more than personality, just as

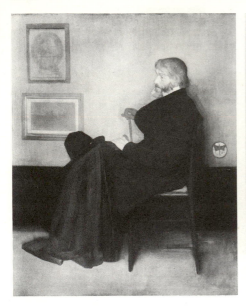

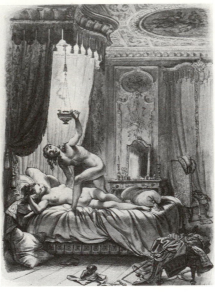

his *Thames* and *Venice* prints become luminous lyrics. Twilight and night were Whistler's poetic atmosphere, purest in the near-abstract *Nocturnes*, which sparked the *Ruskin lawsuit. Whistler's reputation for sharp wit contrasted with his mature work's muted softness; both made him the leader of the 'Art for Art's sake' aesthetes.

WHISTLER, Rex (1905–44)

b. Kent. English painter, book-illustrator and stage-designer who studied at the Slade School of Art. He painted a number of mural decorations of which the best known are those at the Tate Gallery. A competent and fashionable decorator of 18th-century and classical-type scenes, his work has considerable charm but little originality.

WHITE, John (active late 16th century)

One of the earliest colonial settlers, who sailed to Virginia from Plymouth with Richard Grenville's expedition (1585/6). He made drawings and watercolours recording the voyage and country. Engravings after these by De Brys appeared in the *Briefe and True Report of the new found land of Virginia* (Frankfurt, 1590). White's own style is primitive and lively, eg the watercolour *A Chief Herowan's Wyfe* (BM, London).

WHITELEY, Brett (1939–)

b. Sydney. Australian painter who studied in Sydney (1957–9), won a scholarship to Italy (1960) and settled in London (1961). Whiteley's painterly style, at first close to the St Ives School, has incorporated devices from *Pop Art.

WHITTREDGE, (Thomas) Worthington (1820–1910)

b. Nr Springfield, Ohio d. Summit, New Jersey. Painter who studied in Cincinnati (*c.* 1840), and in Europe, primarily in Düsseldorf and Rome (1849–59); worked in Cincinnati (*c.* 1840–9), New York (1859–80), and Summit (from 1880). His landscapes, associated with the *Hudson River School, are acutely observed, deeply felt, luminous poems in low-keyed tonalities.

WIEGAND, Charmion von see VON WIEGAND

WIERTZ, Antoine Joseph (1806–65)

b. Dinant d. Brussels. Belgian painter, studied in Antwerp and in Rome (from 1832), returning to Brussels and eventually taking advantage of the patronage offered by the newly independent state. Instead of treating subjects from Belgian history like de Keyser and Wappers, Wiertz painted apocalyptic visions on huge canvases, influenced by *Michelangelo and *Rubens, in a special studio built for him by the state. Some of

Above left: JAMES ABBOTT McNEILL WHISTLER *Thomas Carlyle.* 67⅜×56½ in (171·1×143·5 cm). Glasgow
Above centre: REX WHISTLER One of ten illustrations to 'Konigsmark'. 1940–1. 13¼×10 in (33·7×25·4 cm). Tate
Above right: JOHN WHITE Eskimo woman and baby. *c.* 1608. 9½×7¼ in (24·1×18·4 cm). BM, London

his paintings were designed to be viewed to the accompaniment of a concealed choir. In most of his works he adopted a high moral tone but was also adept at a melodramatic version of the Sublime, eg *Thoughts and Visions of a Severed Head* (1853/64).

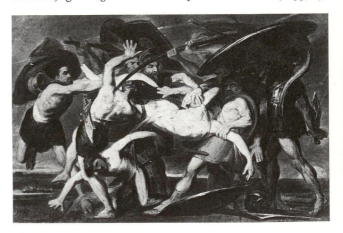

Above: ANTOINE WIERTZ *The Greeks and the Trojans contending for the body of Patroclus.* 1845. Wiertz Museum, Brussels

Left: BRETT WHITELEY *Drawing about Drawing* (from 'The Zoo'). 1965. Screenprint. 39⅛×26¾ in (99·3×67·9 cm). Marlborough Fine Art, London

WIFE OF NAKHTMIN

Egyptian lady of the late 18th dynasty, whose husband was active under *Tutankhamūn and his successor Ay. Her sadly mutilated statue, originally part of a group, is one of the most sophisticated pieces of pharaonic sculpture, the sensuous modelling of the body beneath the dress, and the lightly carved pleating of the linen, reflecting the influence of the *Amarna period.

WILDENS, Jan (1586–1653)

b. d. Antwerp. Flemish landscape painter, he was employed by *Rubens and *Snyders to paint backgrounds to their works. For a long time in Italy, his luminous colour came from *Brill, though he was later influenced by Rubens's landscapes.

WILIGELMO (GUGLIELMO) (active 1st quarter 12th century)

Responsible for the sculpture on the west front of Modena Cathedral. A frieze across the façade presents Genesis from the Creation to the Flood with thickset but animated figures on a plain ground. There is an interesting echo of this frieze on the †Romanesque façade of *Lincoln Cathedral. Wiligelmo's debt to Roman sculpture is clear but not slavish. Apulia is another probable source of his style. His placing of sculpture on the flat jambs of the doors is taken up later in *St Denis. *See also* BARI THRONE, Apulia

WILKIE, Sir David (1785–1841)

b. Cults, Fifeshire d. Nr Malta. Popular Scottish genre painter, he studied at Edinburgh and went to London (1805) entering the Royal Academy Schools; his paintings are of domestic subjects; small in scale they depend on Netherlandish painters *Teniers and *Ostade. He appealed through narratives like *The Blind Fiddler* (NG, London). He travelled widely in Europe (1825), seeing 17th-century Spanish masters who influenced his later style towards effects of greater breadth and contrast. He journeyed to Constantinople and the Holy Land (1840), dying at sea on the way back.

WILLENDORF (Eastern Gravettian)

†Palaeolithic site in Austria where a female figurine was discovered, carved in the round, the hair indicated but no face.

WILLIAM DE BRAILES (active mid 13th century)

Professional illuminator in minor orders as can be seen from the signed self-portraits like the one in the *Last Judgement* on a leaf from a manuscript (Fitzwilliam Museum, Cambridge) in which St Michael rescues him from the flames. Probably active in Oxford (1260). He worked with assistants who copied his style which is distinctive, lively and rather naïve. Although no longer †Romanesque, his work is not yet fully †Gothic.

WILLIAM OF DEVON, Bible of

English manuscript of the middle years of the 13th century named after its scribe ('Willelmus Devoniensis scripsit istum librum' – fol. 540). The flat-figure style, borders, architectural frames and general appearance are very close to contemporary French manuscripts. The marginal *grotesques to be seen round the Genesis initial are early examples of playful and irrelevant decoration popular particularly in the 14th century. (BM, London.) *See also* PUCELLE, Jean

WILLIAM, J. *see* JENNYS

WILLUMSEN, Jens Ferdinand (1863–1958)

b. Copenhagen. Danish artist, sculptor, architect and ceramist. He settled in Paris (1890) and became a significant follower of *Gauguin's *Synthetism in his paintings of Paris. Later in Spain, influenced by El *Greco, he developed an *Expressionist technique. His works are housed in a new museum near Copenhagen.

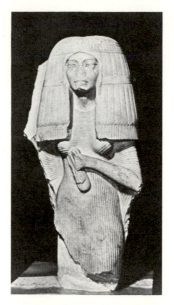

Left: WIFE OF NAKHTMIN Late 18th dynasty. Crystalline limestone heightened with red and black pigment. h. 33½ in (85 cm). Egyptian Museum, Cairo.

Below: WILIGELMO *Death of Cain.* 1st quarter 12th century. West front of Modena Cathedral.

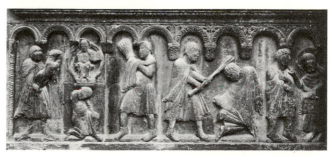

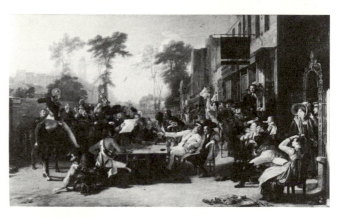

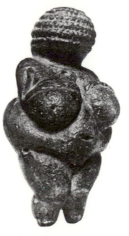

Above: DAVID WILKIE *Chelsea Pensioners Reading the Gazette of the Battle of Waterloo.* 1822. 36½×60½ in (92·7×153·7 cm). Apsley House, London

Left: WILLENDORF, Venus of. h. 4⅜ in (11 cm). Calcarous rock

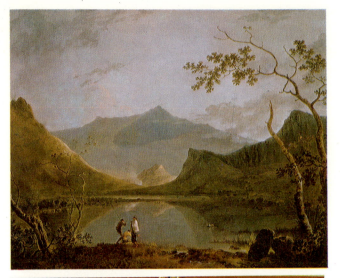

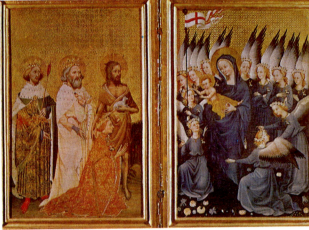

Top: RICHARD WILSON *Snowdon seen from across Llyn Nantil.*
?1776. $39\frac{1}{2} \times 50$ in (100×127 cm). Walker Art Gallery
Above: WILTON DIPTYCH *King Richard II being presented by his Patron Saints to the Virgin. c.* 1399. $18\frac{1}{2} \times 11\frac{7}{8}$ in (47×30 cm).
NG, London

WILSON, Richard (1714–82)

b. Penegoes, Montgomeryshire d. Colommendy. British landscape painter, he left Wales (1729) to study portraiture in London with Thomas Wright; it was as a portraitist that he visited Italy (1752). Here he met *Zuccarelli and *Vernet, the former suggesting that he paint landscapes. In Rome he took up *Claude's style, working in the hills of the Campagna, imbibing its special light effects. He returned to England (1756) and painted dramatic scenes like the *Niobe* (Earl of Ellesmere) as well as views of country-houses and further idealised landscapes, ranging from imaginary scenes similar to those he had painted in Italy to views of Welsh mountains.

WILTON DIPTYCH

No documentary evidence or stylistically comparable works exist to identify the date, purpose and nationality of this painting. Many conflicting theories, often concerning the heraldry in the diptych, have been evolved. The double panel shows King Richard II being presented to the Virgin and Child by his patron saints John the Baptist, Edward the Confessor and Edmund, king and martyr, and presumably dates from his reign (1377–99) although some say it is posthumous. The miniaturist style, exquisite colour and richly patterned and tooled surface suggest Italian or French work, but this unique painting may well represent an English version of the *International Gothic style. (NG, London).

WILTON, Joseph (1722–1803)

b. d. London. English sculptor, taught by *Pigalle in Paris; he was in Italy (1747–55). Influenced by †Neo-classicism in portraiture, his tomb of General Wolfe (1772, Westminster Abbey) shows the dying hero naked in contrast to *West's painting in which he appears in contemporary costume.

WINCHESTER BIBLE

This large Bible was produced in Winchester (*c.* 1160–80) and was the work of several artists. The earlier pages are still †Romanesque, like the so-called 'Master of the Leaping Figures' who painted in an animated version of the *Lambeth Bible style. Later artists show the classicising impact of such †Byzantine works as the Sicilian mosaics (*Palermo, *Cefalù).

WINCHESTER BIBLE *c.* 1150–60. Opening page of the Book of Jeremiah. Winchester Cathedral Library

WINCKELMANN, Johann Joachim (1717–68)

b. Steindall, Brandenburg d. Trieste. German scholar, apostle of †Neo-classicism and the first art historian. Born poor and spending years schoolmastering, he early developed a passion for classical antiquity. In Dresden he published *Reflections on the Painting and Sculpture of the Greeks* (1755), exalting the classical ideal as the product of ancient Greece. He went to Rome (1755), becoming Librarian to Cardinal Albani (1758) and championing *Mengs. He was also Keeper of Papal Antiquities and published his *History of Ancient Art* (1764). He was murdered.

WINTER, Fritz (1905–)

b. Attenbögge, Westphalia. German painter who studied under *Klee, *Kandinsky and *Schlemmer at the *Bauhaus (1927–30) and continues to work in Germany. Winter belongs to the *Blaue Reiter-Bauhaus tradition of Romantic abstraction. His paintings are intended as metaphors for natural forces.

WINTERHALTER, Franz Xaver (1806–73)

b. Black Forest d. Frankfurt. He studied first with his uncle, then at *Piloty's lithographic institute in Munich, but established himself as a portrait painter. He became celebrated for his increasingly dazzling portrayal of several European rulers: Napoleon III, Empress Eugénie, Queen Victoria and Consort, and Empress Elizabeth of Austria. He went to Paris (1834), and exhibited there and in London.

WITKIN, Isaac (1936–)

b. Johannesburg, South Africa. Came to England (1957) and studied at St Martin's School of Art (until 1960). Rejected the use of fibreglass for sheet-metal which proved ideal for his purpose of implying volume by the use of flat or curved surfaces. Has recently restricted himself to rectangular and cubic forms.

EMANUEL DE WITTE *Church Interior*. 74¾×63¾ in (190×162 cm). NG, Edinburgh

WITTE, Emanuel de (1607–92)

b. Alkmaar d. Amsterdam. Dutch painter taught by van *Aelst, he worked first as a portraitist later turning to architectural views. Sensitive to lighting within a building his church interiors are painted with remarkable verisimilitude.

WITTE, Pieter de (Pietro CANDID) (1548–1628)

b. Bruges d. Munich. Flemish painter who probably went at an early age to Italy, where he assisted Giorgio *Vasari with painting in the Vatican (Sala Reggia, begun 1570). Executed oil and fresco decorations in the Pitti Palace, as well as tapestry cartoons, and worked for Maximilian of Bavaria in Munich. *The Martyrdom of St Ursula* (1588, St Michael, Munich) shows his *Mannerist style.

WITTEL, Gaspard van *see* VANVITELLI

WITTEN, Hans *see* MASTER H. W.

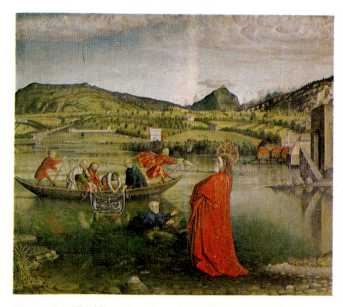

KONRAD WITZ *Miraculous Draught of Fishes*. 1444. 52×60 in (132×154 cm). Musée d'Art et d'Industrie, Geneva

WITZ, Konrad (1400/10–1444/6)

b. Rottweil d. Basle or Geneva. Swiss painter who produced his major works about the time of the Basle Councils (1431, 1443). First recorded in Basle (1431), married and became a burgher (1433). The *Heilspiegel Altarpiece* (c. 1435, one panel Dijon, one Berlin, six Kunstmuseum, Basle) on the theme of the Mirror of Human Salvation, has simplified, stocky, plastic figures with generalised drapery and strong colours. They are placed in enclosed spaces, with sharp lighting effects, eg *The Synagogue* (Basle). A more detailed naturalistic style developed in the *Altarpiece of St Peter* (signed and dated 1444, Musée d'Art et d'Histoire, Geneva). In the *Miraculous Draught of Fishes*, the stiff figures are set in a spacious landscape, actually studied from Lake Geneva. With his emphasis upon sculptural clarity and direct observation of real landscape locations, Witz was the most advanced Swiss painter of his day.

WOLFF, Gustav (1886–1934)

Self-taught sculptor, painter and writer. The geometric simplifications and rough finish of Wolff's block-like figures show the influence of primitive sculpture. Their rigid symmetry is offset by a hint of natural observed pose.

WOLGEMUT, Michael (1434–1519)

b. d. Nuremberg. German painter and woodcut-designer, an assistant of Hans *Pleydenwurff in Nuremberg. After the latter's death, he married his widow and took over the large workshop. *Dürer spent some time there (1486–90). The altarpiece of the Marienkirche, Zwickau (1479) illustrates his intense, naturalistic style, featuring carefully observed landscape. Netherlandish painters influenced him, as did Martin *Schongauer. Some six hundred of his woodcut illustrations were published in two works for the Nuremberg chronicle (c. 1491–4).

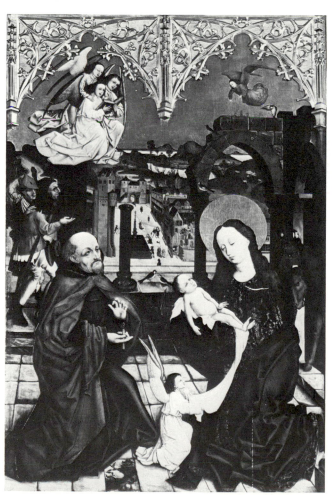

MICHAEL WOLGEMUT *Nativity*. 1479. Left wing of the High Altar. Marienkirche, Zwickau

WOLLASTON, John (active c. 1736–69)

b. d. England. Portraitist, trained as drapery painter in London, who worked in America (c. 1749–69), primarily in New York, Philadelphia and Southern cities. Influential in introducing †Rococo portraiture to America, Wollaston compensated for his frequently characterless, rigid, crude figures with delicately rendered textures, rich colour harmonies and fluid painterliness.

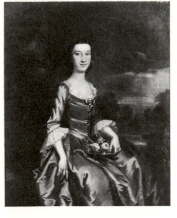

Left: JOHN WOLLASTON *Mrs Samuel Gouverneur.* c. 1750. The Henry Francis du Pont Winterthur Museum
Right: WOLFGANG WOLS *Don Juan.* Pen and watercolour. 5⅜×4 in (13·6×10 cm). Jean Roché Coll, Forcalquier

WOLS, Wolfgang Schulze (1913–51)

b. Berlin. German painter who studied photography briefly under *Moholy-Nagy at the *Bauhaus, travelling to Paris (1933) and beginning to paint six years later. Wols created fantastic constellations of biomorphic forms using an incredibly detailed line.

WOODBLOCK ILLUSTRATION AND PAINTING MANUALS IN CHINA

Woodcut illustrations were used from an early date in China. Many Buddhist examples, datable to the 9th and 10th centuries AD survive from the sealed library at *Tun-huang, and woodcuts often served as frontispieces to printed Buddhist *sutras*, both in China and Korea. Confucian works and popular romances were also illustrated with woodcuts, the latter especially in the late *Ming period, with Soochow as the principal centre in the 16th century. Besides these religious and narrative uses, woodcuts were also used in the realm of fine art. From the 14th century onwards, manuals appeared of ink bamboo and ink plum blossom, etc, paralleling the use of rubbings of famous calligraphic works, and reflecting the interests of the scholar-painter (*Su Shih). Painting manuals with woodcut examples continued to appear during the Ming dynasty (1368–1644). Printing in two or more colours, using a separate block for each colour, started towards the end of the 16th century. The *Ten Bamboo Studio Painting Manual* (1st edition 1633) contains some of the finest achievements in Chinese multi-colour woodblock-printing. It was followed by the *Mustard Seed Garden Painting Manual* (1679), with systematic illustration from individual brushstrokes and motifs to complete compositions in the styles of famous painters. Later editions cannot compare with the first editions of the above titles, as blocks became worn and were recut and the quality of the colour printing was lost. Popular woodcuts were also made locally throughout China for use at festivals, particularly the New Year. The ink outlines were printed on coarse paper, colour being added by means of stencils.

WOOD, Christopher (1901–30)

b. Knowsley, Liverpool d. Salisbury. English painter, mainly of figure compositions and landscapes. After some years

abroad particularly in Paris where he was influenced by *Rousseau and *Picasso, he achieved in the last months of his life an art of studied naïveté and brightness of colour.

WOODCUT

Printmaking block made by cutting with a knife into the plank surface of a wood block. The relief is printed from, not the grooves.

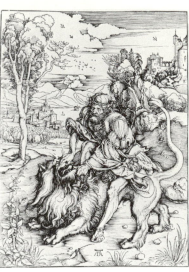

WOODCUT *Samson and the Lion* by Albrecht Dürer (and detail) c. 1497–98. 15×11 in (38×27·9 cm). BM, London

WOOD ENGRAVING *Lion* by Thomas Bewick (and detail). Printed on white satin. 8½×9¾ in (21·6×24·8 cm). V & A, London

WOOD ENGRAVING

Printing-block made by engraving into the end-grain of the block. The print is from the grooves as in metal-engraving.

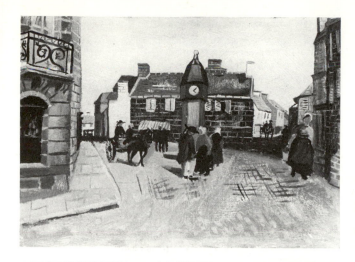

Top: CHRISTOPHER WOOD *Church at Treboul.* 1930. 28¾×36 in (73 ×91·4 cm). Tate
Above: GRANT WOOD *Dinner for Threshers.* 1933. 17¾×26¾ in (45·1×67·9 cm). Whitney Museum of American Art, New York

WOOD, Grant (1892–1942)

b. Anamosa, Iowa d. Iowa. Painter who studied at Chicago Art Institute, Minneapolis Handicraft School, in Paris and Munich. A leading Regionalist of *American Scene painting, Wood sought to embody his native Iowa with the austere clarity he saw in Flemish primitives, succeeding more with figures than in his unconvincingly stylised landscapes.

WOOD, Thomas Waterman (1823–1903)

b. Montpelier, Vermont d. New York. Painter who studied with *Harding, Boston (1846–7) and in Europe (1858–60); worked in Quebec, Washington (c. 1847–54), New York (1854–7), Baltimore (1856–8), Tennessee, Kentucky (1860–7) and New York (from c. 1867). From portraiture, Wood moved to genre painting, often depicting negroes realistically, working with tight, disciplined, discerning accuracy.

WOODVILLE, Richard Caton (1825–55)

b. Baltimore d. London. Genre painter who studied Dutch genre paintings in Gilmore Collection; studied and worked in Düsseldorf (1845–55), living largely in Paris and London from 1851. Woodville's clarity, solidity, unsullied colour, perception of space, light and character owe more to the influence of Dutch painting than to Düsseldorf's hard, wiry factualness.

WOOLNER, Thomas (1825–92)

d. London. English landscape and animal painter, in Italy a Royal Academy Schools student (from 1842), and a sculptor-

member of the *Pre-Raphaelites. His work rejected (1852), Woolner left for Australia but returned (1854). His bust of Tennyson and Carlyle and Browning portrait-medallions were not acclaimed. Exhibitor (1843–93) and member (1874) of the Royal Academy, he was appointed Professor of Sculpture (1877–9), but never lectured.

WOOTTON, John (c. 1686–1765)

d. London. English landscape and animal painter, in Italy during the 1720s, on his return he popularised the landscape style of *Dughet. He later specialised in hunting scenes and horse portraits for the gentry.

Above: JOHN WOOTTON *Members of the Beaufort Hunt.* 1744. 80¼×96½ in (204·5×245·1 cm). Tate

Left: FRITZ WOTRUBA *Standing figure.* 1949–50. Bronze. 14¼×4¾×4½ in (35·6×12·1×11·4 cm). Tate

WORLD OF ART (1890–1905)

An organisation of avant-garde Russian artists whose aim was to create an art-conscious intelligentsia in Russia and to contribute to the mainstream of Western culture. They held exhibitions of international modern art and published a magazine called *The World of Art*. Alexander *Benois, Leon *Bakst, Sergei Diaghilev, Nicholas *Roerich and Valentin *Serov were all involved in the enterprise.

WOTRUBA, Fritz (1907–)

b. Vienna. Sculptor who studied under Alfred Hanak in Vienna. He works directly in stone producing architectonic figurative sculpture.

WOUTERS, Rik (1882–1916)

b. Malines d. Amsterdam. Belgian painter and sculptor who studied in Malines and Brussels. Basically traditional, Wouter's work was enlivened and strengthened by the colouristic and structural innovations of *Cézanne and the *Fauves. Wouter's style depends upon the intimacy and consistency of his approach to everyday, domestic subjects.

PHILIPS WOUWERMAN *Halt of a Hunting Party.* 21×31⅞ in (53·4×81 cm). Dulwich College Picture Gallery

WOUWERMAN, Philips (1619–68)

b. d. Haarlem. Dutch landscapist and painter of cavalry skirmishes, he was taught by *Hals, but was influenced by the Italianate scenes of Il *Bamboccio. Immensely prolific his brightly painted scenes are full of incident. He often included a white horse somewhere in the picture.

WPA – Works Progress Administration – Federal Art Project (1935–43)

The Federal Art Project developed from three previous American Government projects to support artists during the Depression. Under it, approximately four thousand artists were salaried to do various jobs. These included: drawings and paintings of American decorative arts for *The Index of American Design*; photographing America; establishing and teaching in art education centres; making murals, easel-paintings and sculpture for public buildings. Because of the American emphasis of the Project, the best-known so-called 'WPA art' is the *American Scene mural-painting. Many politically radical artists, however, painted themes of social protest. Major influences on the muralists were †Renaissance fresco-painting, *Orozco and *Rivera. Although the general level of work was mediocre, there are notable exceptions, eg *Shahn and *Gorky. Since no distinction in employment was made between abstract and representational artists, such different artists as *Pollock, *De Kooning, *Biddle and *Gropper were involved. The Project had far-reaching results. First, it brought art to the people all over America. Second, it established a communal spirit among artists and kept them producing, without which the later development of *Abstract Expressionism, advanced figurative painting and the rebirth of graphic art would probably have been impossible.

WRIGHT, Joseph (1734–97)

b. d. Derby. English painter, he was taught by *Hudson in London returning to Derby (1758) to practise portraiture. During the 1760s he used the *Caravaggesque light of *Honthorst to animate realistic subjects of scientific experiments like the *Orrery* (Derby) set in dark interiors. In his works he reflects the speculative interests of his patrons, Wedgwood and Arkwright. He was in Italy (1774–6), returning to Bath in the hope of succeeding *Gainsborough, he finally settled in Derby (1779). He was made ARA (1781). Wright's work forms part of a regional renaissance.

WRIGHT, Michael (1623–1700)

b. Scotland d. London. English portrait painter taught by Jameson (1636) he was in Italy by 1647. He returned (1656/8). Following weakly *Dobson's manner for court portraits, he was later eclipsed by *Kneller.

WTTEWAEL, Joachim (1566–1638)

b. d. Utrecht. Dutch *history painter taught by Frans *Floris, he visited France and Italy. His paintings, following a *Mannerist idiom, are brightly coloured and figuratively complex. With *Bloemaert he made Utrecht an important artistic centre.

WU Chên (1280–1354)

Chinese landscape painter from Chia-hsing, Chekiang. One of the *Four Masters of late Yüan, his work derives from that of *Chü-jan. He used blunt brushstrokes which are nevertheless very descriptive of rolling hills and leafy trees. The theme of the fisherman, often accompanied by short poems about fishermen, is a favourite one, recalling his own life of hardship and retirement. He was also a master of ink bamboo.

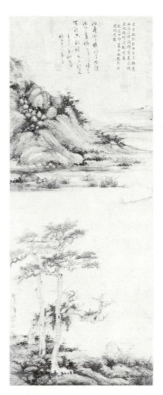

Left: WU CHEN *Fisherman on Lake Tung-t'ing.* Hanging scroll. Ink and colours on paper. 57⅝×23⅛ in (146·4×58·6 cm). National Palace Museum, Taiwan

Below: JOSEPH WRIGHT *Experiment with the Air Pump.* 1768. 72½×96 in (184·2×243·8 cm). Tate

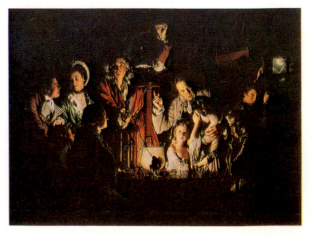

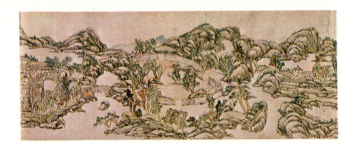

WU LI *Passing the summer at the Thatched Hall of Ink-well*. Dated 1679. Detail of handscroll. Ink on paper. Entire scroll 14¼×107¼ in (36·3×272·6 cm). Mr and Mrs Earl Morse Coll, New York

WU Li (1632–1718)

Chinese painter from Ch'ang-shu, Kiangsu. *Passing the Summer at the Thatched Hall of Ink-well* shows the artist in the landscape of his dreams. As with the Four Wangs, Wu Li's brushstrokes are animated by calligraphic rhythms. He became a Jesuit and was ordained as a priest (1688). At Macao he observed and commented on Western manners, but these seem to have had no influence on his painting.

WUNDERLICH, Otto (1927–)

b. Berlin. German artist who continues the *Expressionist tendency in German art in painting and lithography. His images are tortuously distorted to convey his agitated dream-world in a manner related to *Redon, but with a violence equal to that of *Dix. His outbursts shatter the mood of deep space and silence in which they are set, combining a sense of freedom with high technical control.

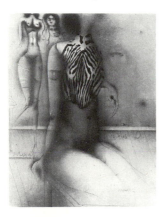

Left: OTTO WUNDERLICH *Zebra House*. 1969. 25⅝×19¾ in (65×50 cm). Galerie Brusberg, Hanover
Right: ANDREW WYETH *That Gentleman*. 1960. Tempera. 23½×47¾ in (59·7×90·8 cm) Dallas Museum of Fine Arts, Dallas Art Association Purchase

Below: WU WEI *Strolling Entertainers*. Detail of handscroll. Ink and colour on paper. Entire scroll 14¾×201⅝ in (37·5×512 cm). BM, London

WU Tao-tzŭ (active first half 8th century)

From Yang-chai, Honan. The dominant painter of his own time and the most important influence on Chinese figure-painters of the *Sung dynasty. The great temples of the *T'ang capital, Ch'ang-an, and other cities all had wall-paintings by him; none survive, but his style was evidently one of tremendous vitality and a vigorous flowing brush-line.

WU Wei (1459–1508)

Chinese painter from Chiang-hsia, Hupeh. A *Chê School painter, particularly of figures; his vigorous style derives ultimately from the inspiration of the great *T'ang figure-painter, *Wu Tao-tzŭ.

WYANT, Alexander Helwig (1836–92)

b. Port Washington, Ohio d. New York. Painter who visited *Inness (c. 1857); studied at National Academy of Design, in Düsseldorf (1865), and with Gude; worked largely in New York. Influenced by Inness and the *Barbizon School, Wyant abandoned the romantic realism of panoramic *Hudson River landscapes for more personal lyrics orchestrated in sonorous tones.

WYCK, Jan (1640–1700)

b. Haarlem d. London. Dutch painter taught by his father, Thomas Wyck whom he accompanied to England. There he specialized in battle paintings and hunting scenes, contributing designs to a book on hunting and falconry.

WYETH, Andrew Newell (1917–)

b. Chadd's Ford, Pennsylvania. Painter, son of illustrator; works in Pennsylvania and Maine. Deliberately obliterating any personal touch in his meticulous tempera technique, and deliberately remaining provincial, painting only the people and places he knows, Wyeth captures their physical presence and psychic undertones in strangely angled designs and uncannily precise details. He has also worked extensively in watercolour.

WYETH, Newell Convers (1882–1945)

b. Needham, Massachusetts. Painter and illustrator who studied in Massachusetts and with *Pyle; lived at Chadd's Ford and in Maine; was father/teacher of Andrew *Wyeth. With Pyle, Wyeth led the Brandywine school of illustration. Famed for historical and legendary works, Wyeth's exacting eye and dramatic imagination combined accuracy and fantasy.

JAN WYNANTS *Peasants Driving Cattle and Sheep by a Sandhill and Two Sportsmen with Dogs*. Late 1660s. 11¼×15 in (28·6×38·1 cm). NG, London

WYNANTS, Jan (1630/35–1684)

b. ?Haarlem d. Amsterdam. Dutch landscapist; he employed *Wouwerman and *Lingelbach to paint figures in his glittering scenes of dunes and beaches. His style, rich in colour, is typical of the generation of *Cuyp.

WYNTER, Bryan (1915–)

b. London. English painter who studied at the Slade School of Art and works in Cornwall. Inspired particularly by *Tobey and *Tomlin (1956), Wynter transformed his romantic landscapes into abstractions which he claims 'generate imagery rather than contain it'. Dense configurations of marks seem suspended behind the vertical confines of the picture plane.

XOANON

Term applied in Greek and Roman times to old and venerable statues of divinities. They were generally of wood, although they were sometimes of ivory, silver or marble. The word is usually used of small statues, but is sometimes applied to quite large cult statues and even the Wooden Horse of Troy. There are overtones of magic in the word and it is often associated with the mythical Daedalus.

YAKA see BAYAKA

YAKSHA

Nature-spirit, conceived of in Indian sculpture as a massive male presence; this pre-Buddhist folk-divinity was assimilated into early Buddhist art; the artistic form was also retained and used in certain minor Hindu images.

YAKUSHIJI, The

A Buddhist temple in Nara Prefecture, Japan. Bronze figures of Shō Kannon and Yakushi Nyorai with attendants illustrate the influence of Chinese sculpture in the early *Nara period. In the tradition of *portrait sculpture are the Shintō figures of the *Heian period representing the Empress Jingō, Nakatsuhime and the god Hachiman.

YAMATO-E *The Tale of Genji*. Detail from the Genji scroll. Late Heian period. h. 8¾ in (22 cm). Tokugawa Museum, Nagoya

YAMATO-E

In the 10th century the great innovation of using Japanese texts to be illustrated on handscrolls originated the Yamato-ē style, the court art of *Heian Japan. Stories such as the *Genji monogatari* are illustrated in a linear style with the outlines filled with colour. Scenes are very carefully built up so as to continue the narrative and yet isolate separate scenes. The conventions are strict: the view of the scene is diagonal from above and the roofs are removed from the houses. Facial

realism is minimal, with a simple hook for the nose and a single stroke for the eye, yet the character is evoked. Details of houses, clothes and interior decoration are carefully depicted. It is the Yamato-ē style that was continued by the *Tosa School and by the *Rimpa School after Sōtatsu.

YANEZ DE LE ALMEDINA, Fernando (d. 1550–60)

b. Almedina, La Mancha. Spanish painter, possibly a pupil of *Raphael or *Leonardo. By 1531 he gained a reputation as a great master in Spain. He executed an altarpiece in the Albornes Chapel, Cuenca Cathedral, which indicates his reliance on Leonardo and *Garofalo.

YAO Shou (1423–95)

From Chia-shan, Chekiang. Chinese landscape painter and calligrapher, using blunt brushstrokes close to those employed by *Wu Chên. He was a close friend of *Shên Chou.

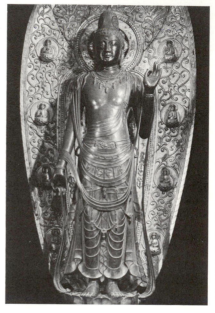

Left: YAKUSHIJI Sho Kannon. Nara period, late 7th–early 8th century AD. Bronze. h. 6 ft 3 in (1·90 m)
Right: YAO SHOU Prose Poem. Calligraphy, dated 1489. Detail of handscroll. Ink on paper. h. 12⅛ in (30·7 cm). Art Museum, Princeton

YAP see MICRONESIA, ART OF

YAQUT MUSTASEMI (d. 1300)

b. Baghdad. The famous calligrapher of the Abbasid Caliph Musta'sim (1242–58). He is known to be the first calligrapher who perfected *Naskhi and Thulth. He is also said to have written an enormous number of Qur'ans in his lifetime.

YAROSLAVL'

A rich industrial and trading city in Central Russia notably in the 17th century when its citizens filled numerous new churches with frescoes. These blend Russian and Western elements like the contemporary *Stroganov School and do not deserve to be dismissed as no more than folk-art.

YASUNOBU (1613–85)

A younger brother and collaborator of Kanō *Tannyū.

YAZILIKAYA

An open-air rock sanctuary near *Hattusas, the *Hittite capital. Dating from the Empire Period, it contains the best examples known of Hittite monumental relief sculpture. In the larger of two natural galleries, the Hittite pantheon is repre-

sented: two processions of gods and goddesses converge from opposite walls towards the supreme deities Teshub and Hebat. Many of the figures can be identified by an associated animal, weapon or carved hieroglyphs. In the smaller gallery a large relief shows Tudhalyas IV in the protective embrace of his god Sharruma – a distinctively Hittite pose. Yazilikaya was probably completed during the 13th century BC, with Hurrian influence on Hittite culture at its height. This may help to explain why the deities bear Hurrian names. *See also* ANATOLIA, Art of

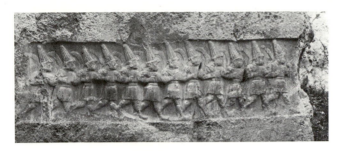

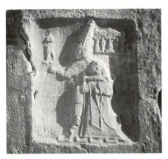

Above: YAZILIKAYA Procession of twelve gods. Relief from the inner chamber, c. 1350–1250 BC. h. (of figure) 30–34 in (about 80 cm)

Left: YAZILIKAYA King Tudhaliyas IV in the embrace of the god, Sharruma c. 1350–1250 BC

YEATS, Jack Butler (1871–1957)

b. Sligo d. Dublin. The brother of the poet W. B. Yeats he spent his childhood in Ireland until studying at the Westminster School of Art. His early works are scenes of his Irish childhood, but although his themes became increasingly literary, his style remained fundamentally narrative. He possessed an intensely romantic and patriotic temperament and his thickly painted canvases have considerable power and appeal.

YEH PULU *see* BALI, ART OF

YEN Hui (active 14th century)

From Chiang-shan, Chekiang. Chinese figure-painter, especially of Buddhist and Taoist subjects.

YEN Li-pen (d. 673)

From Wan-nien, Shensi. Chinese court painter of the early *T'ang dynasty (618–906); his father and brother were also painters. His surviving work is a major one: the *Portraits of Thirteen Emperors* handscroll (Boston). The emperors, each with attendants, are individually portrayed and successfully characterised, although necessarily Yen relied on earlier descriptions or portrayals for the emperors before his time.

YI Chōng (T'anŭn) (1578–1607)

Korean painter, a pupil of *Yi Sang-chwa. In his short life he established himself as a master of bamboo, executed in the Northern *Sung tradition. He also produced landscapes and studies of orchids.

YI In-mun (Yuch'un) (1745–1821)

Korean landscape painter, famous for a thirty-foot-long scroll, *Mountain and Rivers Without End* (Duksoo Palace Museum). His dry brush technique was combined with splashes of ink wash with a consummate control of colour tones.

YI In-sang (b. 1710)

Korean painter, poet and calligrapher. His best-known work is *Seated Figure Beneath a Pine Tree*. His landscapes owe much to the influence of *Chong Son.

YI Sang-bōm (Ch'ŏngjŏn) (1897–)

Korean painter who graduated from the Royal School of Fine Art (1918). He established the Ch'ŏngjŏn Institute and many leading Korean painters were his pupils. His own painting follows the traditional style.

YI Sang-chwa (active mid 16th century)

Korean painter who worked in the style of the Northern *Sung. His masterpiece is *Moon Viewing* (Duksoo Palace Museum).

YIN HUA HSIEN, Sculptures from

These are a group of Chinese Buddhist sculptures said to have been carved in the area of the border of the provinces of Shensi and Honan during the first half of the 6th century AD. They are all votive stelae in grey limestone, usually with three figures standing in part relief against a background slab, which representing the mandorla, culminates in a pointed arch. The plasticity of the figures often accompanied by *apsarases and garlands projecting from the slab form a contrast with the fine engraved designs on the flat stele. Examples are to be found in some major Western museums including the Freer Gallery in Washington and the Musée Guimet in Paris.

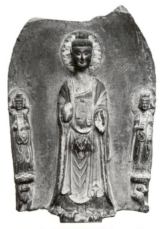

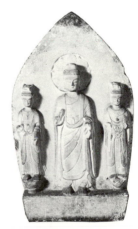

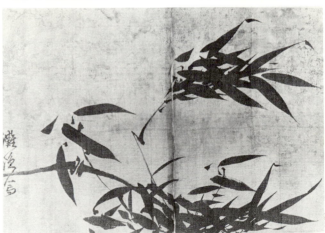

Top left: YIN HUA HSIEN Stele with relief figures of the Buddha and two Bodhisattvas. First half 6th century AD. h. 42 in (1·06 m). Freer Gallery of Art, Washington
Top right: YIN HUA HSIEN Stele of the Buddha with attendant Bodhisattvas. Eastern Wei dynasty, AD 534–550. h. 49¼ in (1·25 m)
Above: YI CHONG Bamboo. Ink on silk. 9½×9⅞ in (24×25 cm). P'yongyang Gallery of Art

YOKUT see CALIFORNIA

YORUBA

Perhaps the largest sculpture-producing people of Africa, and certainly among the richest in variety of forms, inhabiting south-west Nigeria and the neighbouring area of Dahomey stretching across into central Togo. There are several politically autonomous Yoruba kingdoms of which Oyo in the north-west and *Ife in the centre are the most important. All the kings of the Yoruba claim descent from Oduduwa who first climbed down from heaven at Ife to create the world. There are several virtually independent traditions of art co-existing among the Yoruba, ie sculpture in wood and ivory, in brass, in iron and in terracotta, as well as embroidery using glass beads, mural-painting and the stone figures of *Esie. Wooden figures are carved for the cults of Shango the thunder god, Eshu the god of perversity, Ifa the oracle, Ibeji twins, and others. Brass figures are cast for use in the secret Ogboni society, iron is wrought for Osanyin the god of medicine. There are three main mask types; Gelede the anti-witchcraft cult of the western Yoruba; Egungun the ancestral cult; and Epa a cult of uncertain significance in the north-east using helmet masks surmounted by a heavy superstructure. Many shrines have murals painted by women, often highly schematic or abstract. Sculpture is also put to secular use with doors carved in relief and veranda posts, especially in Ekiti the north-east Yoruba region. It is also from Ekiti that we have the most information about the identity and work of individual master-sculptors such as Areogun of Osi-Ilorin (d. 1954), Bangboye of Odo-Owa (possibly still alive), Agbonbiofe of Efon-Alaiye (d. c. 1945), Agunna of Ikole (d. c. 1945) and Olowe of Ise (d. 1939).

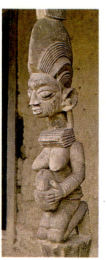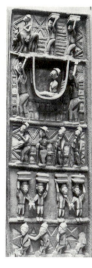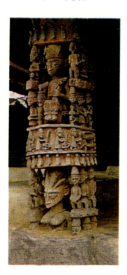

Left: YORUBA Door from the palace of the king of Ikere-Ekiti carved by Olowe of Ise about 1900. Wood. h. 82 in (213 cm). BM, London
Centre: YORUBA Veranda post at Obo Aiyegunle village carved by Areogun of Osi-Ilorin c. 1880–1954. Wood
Right: YORUBA Veranda post in the palace of the king of Ijero-Ekiti carved by Agunna of Ikole about 1915. Wood

YOSEGI SCULPTURE

A Japanese technique of wooden sculpture by which the different parts of Buddhist images were made up of a large number of separate pieces. A large statue could be made of many small blocks leaving a hollow in the centre; it would thus be comparatively light. This method was systematised by Jōchō in the late *Heian period. A *Kamakura example is the Kichijōten in the Jōruryji.

YOSHITOSHI (Taiso Yoshitoshi) (1839–92)

Japanese artist, one of the few to carry the *Ukiyo-e tradition on into the *Meiji period. He benefited from Western in-

fluences and used Western pigments in a uniquely successful way.

YSENBRANDT, Adriaen see ISENBRANDT

YU Chih-ting (1647–c. 1709)

Chinese painter from Yangchow, Kiangsu, renowned for his portraits and for figures executed in a graceful *pai-miao* (outline drawing) technique. He served for a few years at court in the reign of K'ang-hsi.

YUAN DYNASTY PAINTING

Under Mongol rule there was no imperial academy of painting, as there had been in the Northern and Southern *Sung. Academic styles declined or disappeared, not to be revived until the restoration of Chinese rule under the *Ming. At court, *Chao Meng-fu, unable to continue in retirement as tradition demanded of a servant of the old dynasty on the fall of the Sung, led the way in calligraphy and painting, taking the works of *T'ang masters as models. *Ch'ien Hsüan also followed earlier styles in his figure subjects, but it was the *Four Masters of late Yüan whose fluent brush and ink styles brought the spirit of early landscape painting within the scope of the literary man's brush. Many of their contemporaries, hermits, monks and scholars, were also painters of distinction. It became common for both the artist and his friends to add inscriptions on the picture area itself, thereby bringing both calligraphy and poetry into the aesthetic content of the painting. Thus the Yüan dynasty, despite the humiliation for China of an alien rule, was in painting a brilliant and innovative period.

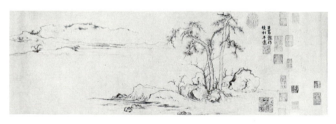

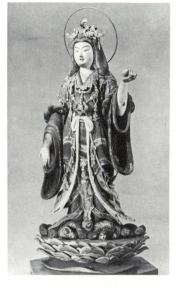

Above: YUAN DYNASTY PAINTING Twin Pines and Level Distance (detail) by Chao Meng-fu. Short handscroll, ink on paper. $10\frac{1}{2} \times 42\frac{1}{4}$ in (26·7×107·3 cm). C.C. Wang Coll, New York

Left: YOSEGI SCULPTURE Kichijō-ten. Late Heian period. Wood. h. $35\frac{1}{2}$ in (58·7 cm). Jōruriji, Kyōto

YUAN PERIOD SCULPTURE see CHU YUNG KUAN; FEI LAI FENG

YUN Shou-p'ing (1633–90)

Chinese painter from Wu-chin, Kiangsu. A lifelong friend of *Wang Hui, he is said to have given up painting landscape in deference to the latter's superior ability. He is therefore chiefly known and imitated as a flower painter, though landscape

paintings by him do exist, showing the same delicacy of colouring and grace of line as his flowers and his calligraphy.

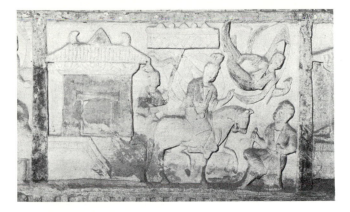

Above: YUNG KANG Relief of scenes from the life of the Buddha. Cave 6. Second half of 5th century AD

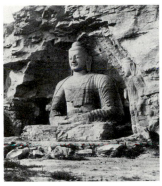

Left: YUN KANG Buddha from Cave 20. Second half of 5th century AD

YUN KANG, Cave-temples at

The important cave-temples of Yün Kang in Shensi province, China were hollowed out of the cliff-face and decorated with Buddhist images during a period of intense piety which followed the persecution of Buddhism (AD 446–54). The enterprise patronised by the Northern Wei imperial family, was, in its early stages, supervised by the head of the monks, T'an-yao. Three main phases are recognised. During the first period (AD 460–75) five caves, nos 16–20, each containing a colossal image between thirteen and fifteen metres high, were carved in honour of the reigning emperor and four past emperors. Apart from the main figure in Cave 16 the robes of the images, in the style characteristic of these decades, were shown clinging closely to the body with folds indicated by raised parallel lines. This same style of dress was used in the two pairs of Caves, 7 and 8, and 10 and 11. But here there were two important developments. Firstly, there was a new variety in the iconography, including such strange figures as the five-headed figure of Kumānakadeva in Cave 8. Secondly, a complicated architectural arrangement of tiered niches balancing each other was introduced. This ordered type of scheme continued into the second phase of work at the site (AD 475–90). The radical departure of this period lay in the new style of robe adopted in the paired Caves 5 and 6 and 1 and 2. Here the heavy stepped bands and the flaring fin-like ends of the robes overlay the figures with an insistent pattern. This style may have been derived from southern China. The third phase of work (AD 490–505) produced the caves at the western end of the site which were therefore contemporary with some of the sculptures at *Lung Mên. An increasingly two-dimensional rendering of the images is evident as the development of the stepped drapery style into elaborate patterns emphasised linear designs at the expense of representing shape and volume convincingly. *See also* KUNG HSIEN; MAI CHI SHAN

YUNKERS, Adja (1900–)

b. Riga. An international painter who studied in Leningrad, Berlin and Paris, and now works in New York. His painting is essentially formless and subjectless, his aim being to convey the constructive qualities of paint as such.

YURIEV-POLSKI, St George

This church (1230–4) near *Vladimir-Suzdal' was the last in the region to have its exterior covered with relief sculptures in a †Romanesque style. The Mongol invasions of Russia in the 1230s ended the artistic life of this region. The church collapsed and the sculptures were reused out of order in a 14th- or 15th-century reconstruction.

YUSHO (Kaiho Yūshō) (1533–1615)

Japanese painter, the son of an impoverished nobleman who became a monk and a pupil of *Motonobu. His work is characterised by an apparent simplicity of technique which relies on skilled brushwork and use of colour wash.

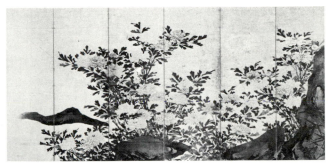

YUSHO *Paeonies.* Six-fold screen. *c.* 1595–1600. Colours on gold leaf. 70×14¼ in (177×361·3 cm). Myoshin–ji, Kyōto

Z

OSSIP ZADKINE *The Prophet.* 1914. Wood. h. 87½ in (219 cm). Musée de Peinture et de Sculpture, Grenoble

ZADKINE, Ossip (1890–1967)

b. Smolensk. Sculptor and engraver who studied in London (1906–8), before settling in Paris (1909). He worked under the influence of *Rodin and †Romanesque sculpture until 1912 when he met *Picasso and *Delaunay. Never a pure formalist, he emphasised expressive qualities, retaining a lyrical treatment of surface. With *The Three Musicians* (1924) he was liberated from *Cubism. Using softer, more personal forms he turned to mythological and human themes, expressing his horror of war with the *Destroyed City* (1951). He is often tempted by rhetorical gesture.

ZALCE, Alfredo (1908–)

b. Pátzcuaro. Painter and printmaker who studied at Academy of San Carlos; founded art schools; was Cultural Missionary, co-founder of Taller de Gráfica Popular and League of Revolutionary Writers and Artists. His work, always symbolising Mexico's life, struggle and suffering, shows a fine sense of solid, sculptural form and expressive gesture.

ZAMPIERI, Domenico see DOMENICHINO

ZAPOTEC

The Zapotec ceremonial centre of Monte Alban in Oaxaca, Mexico was active between AD 300 and 900 although its history is much older. Characteristic of Zapotec art are monochrome pottery funerary urns modelled in the form of figures wearing lavish headdresses and ornaments.

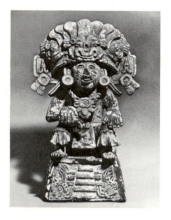

ZAPOTEC Brown pottery urn with traces of a white slip, in the form of a priest seated upon a pyramid. Classic period, Mexico. h. 17 in (43·2 cm). Royal Scottish Museum

ZEITBLOM, Bartholomaeus (Bartel) (1455/60–1522)

b. Nördlingen d. Ulm. German painter associated with *Herlin and *Schüchlin, whose daughter he married. His panels (before 1490) at Bingen show a statuesque immobile treatment of figures.

ZENGA

Zen (Chinese Ch'an) Buddhism has had a profound influence on all Japanese arts since the *Muromachi period. Teaching enlightenment through the flash of inspiration, it did not concentrate on learning or doctrine. Many Zen monks were painters, notably in the Muromachi period (eg *Sesshū, *Shūbun and *Minchō) but the term zenga tends to apply to later paintings in a rough, untutored style – often purposefully crude in technique – that in a few bold strokes summon up a thought. The monk *Hakuin produced simple and bold zenga, but perhaps the most celebrated executant was *Sengai whose paintings are usually profound but also often humorous.

ZERO GROUP

A loosely knit group of Kinetic artists concerned with articulating light and movement, organised from Düsseldorf (1960) by Heinz *Mack and Otto *Piene, and including Günther *Uecker. A magazine, Zero, was produced (up to 1961). The group recognised a debt to the Italian *Spatialists in their exhibition 'Homage to Fontana' at Documenta III, Kassel (1964).

ZESHIN (Shibata Zeshin) (1807–91)

Japanese *Shijō style artist, a pupil of *Nanrei, who excelled at lacquer-work, in meticulous workmanship and in lacquer-painting.

ZEUXIS (active late 5th century BC)

Greek painter from Heraklea, and contemporary of *Apollodoros of Athens. He is said to have discovered the 'relationship of light and shade'. The story was also told of him that when commissioned to paint a picture of Helen of Troy for the city of Acragas (modern Agrigento), he picked out the five most beautiful girls in the town and combined all their best features in the painting.

ZEVIO, Stefano da see STEFANO DA VERONA

ZICK, Januarius (1730–97)

b. Munich d. Ehrenbreitstein. German painter. He went to Rome from Paris meeting *Mengs (1758). Returning home he moved away from a narrative towards a †Baroque decorative style, working in the churches and palaces of Upper Swabia.

ZIEM, Félix François Georges Philibert (1821–1911)

b. Beaune d. Paris. French architectural student, Ziem began to paint watercolours in his spare time. He went to Italy (1841), then to Russia. In Paris he exhibited for the first time at the Salon of 1849 his View of Bosphorus and the Grand Canal, Venice, a city he visited yearly (1845–92) and which became the principal theme of his work, much in the manner of *Turner.

ZIMBABWE

The ruins in Rhodesia of medieval Bantu architecture in stone. Among the antiquities discovered there are soapstone figures and pillars surmounted by birds.

ZIMMERMAN, Johann Baptiste (1680–1758)

b. Nr Wessobrunn d. Munich. German painter and stuccoist; he introduced French †Rococo forms to the decorative repertory established by the *Asam brothers. Of a family of painters, he painted vast works, mostly for the court at Augsburg. He collaborated with his architect brother, Domenikus, on the pilgrimage churches of Bavaria.

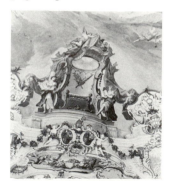

Left: JOHANN ZIMMERMAN Eternity's Throne. 1746–9. Fresco. Church of Die Wies, Bavaria

Below: ZIWIYE TREASURE Part of a gold pectoral. 8th–7th century BC Archaeological Museum, Teheran

ZIWIYE TREASURE

A hoard of gold, silver and ivory objects found at Ziwiye in Iranian Kurdistan (1947) and now dispersed between various museums of the world. The hoard belongs to the 8th and 7th centuries BC. Many of the objects are in an Assyrian style but others are related to the *Scythian animal style of the Russian steppes.

ZOFFANY, Johann (1733/5–1810)

b. Frankfurt d. Kew. German painter who studied in Rome and came to England (c. 1760). He is chiefly known for his *conversation-pieces, which at first involved famous actors, particularly Garrick, who saw the advertising possibilities and was Zoffany's host (1762). Zoffany then turned to domestic conversation-pieces, eg *Queen Charlotte and Children* (1766/7, Buckingham Palace). He became increasingly interested in meticulous detailing, and travelled to Florence (1772–6) and India (1783–9).

Top: JOHANN ZOFFANY *The Bradshaw Family*. Before 1769. 52×69 in (132×175 cm). Tate
Above: JOHANN ZOFFANY *John, 14th Lord Willoughby and his Family. c.* 1771. 39½×50¼ in (100·3×127·7 cm). Lord Willoughby de Broke Coll, London

ZOLA, Emile (1840–1902)

b. d. Paris. Novelist and journalist, one of the strongest and most popular supporters of *Manet and the †Impressionists, notably in his *Mon Salon* (1866). A boyhood intimate of *Cézanne at Aix, many of whose characteristics he embodied in the hero of his artist-novel, *L'Œuvre* (1886), to the disappointment of the painter and his friends. The double emphasis of realism and imagination in his aesthetic is summarised in the dictum that a work of art is 'a corner of creation seen through a temperament' (1865).

ZOPPO, Marco (c. 1432–78)

b. Cento d. Bologna. Italian painter, one of the exploited assistants of *Squarcione, whom he left (1455). Thereafter he worked in Venice and Bologna; the Paduan manner however continued to influence him. He owed much too to *Piero della Francesca and, later, to the Venetians; but his most important work, the polyptych in the Collegio di Spagna, Bologna, adds to an attempt at plasticity some fluency of line and delicacy of colour.

MARCO ZOPPO
Bishop-Saint. 19½×11¼ in (49·5×28·5 cm). NG, London

ZORACH, William (1887–1966)

b. Eurburg, Lithuania. Sculptor who emigrated to America (1891); studied in Cleveland, at National Academy of Design and *Art Students' League, where he taught (from 1929); visited Paris (1910–11); exhibited at *Armory Show (1913). An American pioneer of modern direct carving, respecting the original form of his medium, Zorach hewed simplified, monumental figures.

ZOUST, Gerard *see* SOEST

ZUCCA, Jacopo del *see* ZUCCHI

ZUCCARELLI, Francesco (1702–88)

b. Pitigliano d. Florence. Italian landscape painter who followed the style of Marco *Ricci. In Venice he was employed by Joseph Smith. From 1751 to 1771 he was chiefly in England where his Picturesque landscapes were a success.

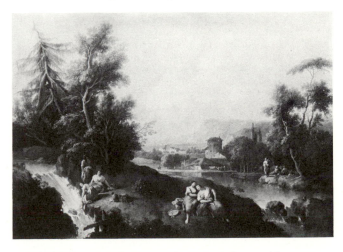

FRANCESCO ZUCCARELLI *Landscape with figures*. Museo Civico, Vincenza

ZUCCARO, Taddeo (1529–66)
Federico (1542–1609)

Italian *Mannerist painters, brothers. Taddeo, b. Sant' Angelo in Vado d. Rome, gained recognition as a façade painter. He studied under *Raphael and his work combines a pronounced naturalistic element with Raphaelesque Mannerism as in his *Conversion of St Paul*. His most important commission was the vast secular fresco cycle of the Farnese Chapel, Caprarola, celebrating the power of the Farnese family. Devised by Cardinal Alessandro Farnese, Taddeo developed this scheme into an intricate, illusionistic design. Federico b. Sant' Angelo in Vado d. Ancona, not only completed these decorations on his brother's death but also those of *Vasari in the Cathedral, Florence. His most important painting is *Barbarossa Making Obeisance to the Pope* (1582, Doge's Palace, Venice). He was the founder of the Academy of St Luke in Rome and the author of *Idea de' Pittori, scultore e architetti* (1608) a significant document of Mannerist art theory.

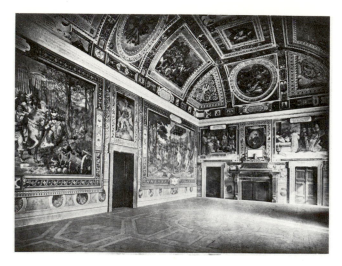

TADDEO ZUCCARO General view of the frescoes in the Sala dei Festi, Villa Farnese, Caprarola

ZUCCHI (del ZUCCA), Jacopo (1541/2–1589/90)

b. d. Florence. Italian painter, pupil and (1567–9) assistant of *Vasari in Rome. His first independent frescoes were for Cardinal Ferdinando de' Medici in Florence (1574); in the mid 1580s he executed the *Genealogy of the Gods* (Palazzo Rucellai, Rome). An eclectic painter, influenced by the Roman School, he produced crowded and exuberant compositions.

ZULOAGA, Ignacio (1870–1945)

b. Eibar d. Madrid. Academic painters of portraits, landscapes and Spanish subjects. His highly detailed style combines echoes of Spanish Old Masters in his compositions and use of plain backdrops with a 1930s period flavour.

ZULU

One of the major Bantu peoples of South Africa among whom a number of old wooden figures have been collected. Their significance is unknown.

ZURBARAN, Francisco de (1598–1664)

b. Estremadura d. Madrid. Spanish painter, who became Painter to the town of Seville (1628) remaining there for thirty years except for brief intervals. Influenced by *Caravaggio and the sculpture of *Montañez he evolved a realistic style, ascetic in quality; the cycles of the lives of S. Bonaventura and S. Peter Nolasco (Louvre and Prado) exemplify this manner. He painted *The Labours of Hercules* (1634) for Philip IV and was employed by the Carthusians at Jerez (1637–9). His later style suffered through the influence of *Murillo's sentimental work.

ZWOBODA, Jacques (1900–67)

b. Neuilly-sur-Seine. Sculptor who taught at the Académie Julian and at the School of Applied Arts in Paris. Using an *Expressionist style based on natural phenomena, like the shapes of bone or driftwood, he produced terracottas, basreliefs, interior decorations and monuments.

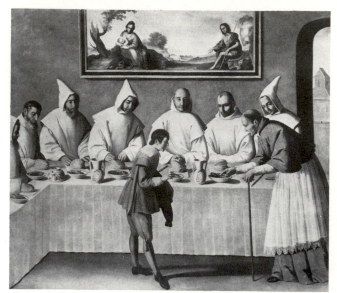

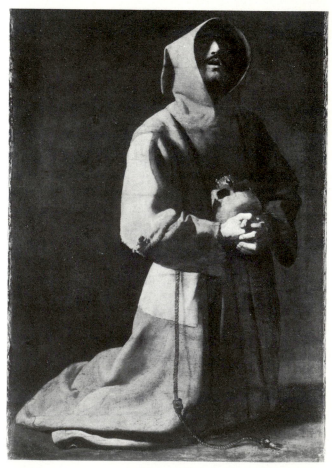

Top: FRANCISCO DE ZURBARAN *St Hugo in the Refectory. c.* 1633. 103×125 in (261·6×317·5 cm). Seville Museum
Above: FRANCISCO DE ZURBARAN *Monk at Prayer* (St Francis in Meditation). 60×39 in (152×99 cm). NG, London

Further Reading List

GENERAL REFERENCE WORKS
Salmi, M. (ed) *McGraw-Hill Encyclopedia of World Art*. 15 vols, New York, 1958–68
Myers, B. S. (ed) *McGraw-Hill Dictionary of Art*. 5 vols, New York, 1969
Pevsner, N. (ed) *The Pelican History of Art*. 38 vols, Harmondsworth, 1953 on . . .
Thieme, U. and Becker, F. (edd) *Allgemeines Lexikon der bildenden Künstler*. Leipzig, 1907–50

PALAEOLITHIC ART
Bandi, H. G. (and others) *The Art of the Stone Age : forty thousand years of rock art*. London, 1961
Breuil, H. *Four Hundred Centuries of Cave Art*. Montignac, 1952
Breuil, H. and Obermaier, H. *The cave of Altamira at Santillana del Mar*. Madrid, 1935
Graziosi, P. *Palaeolithic Art*. London, 1960
Hirn, Y. *The Origins of Art*. London, 1900
Sandars, N. K. *Prehistoric Art in Europe* (Pelican History of Art). Harmondsworth, 1968
Ucko, P. J. and Rosenfeld, A. *Palaeolithic Cave Art*. London, 1967
Windels, F. *The Lascaux Cave Paintings*. London, 1949

THE ANCIENT NEAR EAST
Akurgal, E. *The Art of the Hittites*. London, 1964
Frankfort, H. *The Art and Architecture of the Ancient Orient* (Pelican History of Art). Harmondsworth, 1954
Ghirshman, R. *Persia from the Origins to Alexander the Great*. London, 1964
Kenyon, J. M. *The Archaeology of the Holy Land*. London, 1964
Lloyd, S. *The Art of the Ancient Near East*. London, 1961
— *Early Highland Peoples of Anatolia*. London, 1967
Mellaart, J. *Earliest Civilizations of the Near East*. London, 1965
Moortgat, A. *The Art of Ancient Mesopotamia*. London, 1969
Parrot, A. *Sumer*. London, 1960
— *Nineveh and Babylon*. London, 1961
Porada, E. *The Art of Ancient Iran*. London, 1971
Strommenger, E. *The Art of Mesopotamia*. London, 1964
Woolley, L. *Mesopotamia and the Middle East*. London, 1961

EGYPTIAN ART
The Brooklyn Museum (B. V. Bothmer) *Egyptian Sculpture of the Late Period*. New York, 1960. Repr with additions, 1969
Harris, J. R. *Egyptian Art*. London, 1966
Iversen, E. *Canon and Proportions in Egyptian Art*. London, 1955
Kayser, H. *Ägyptisches Kunsthandwerk*. Braunschweig, 1969
Lange, K. and Hirmer, M. *Egypt : Architecture, Sculpture, Painting, in Three Thousand Years*. 4th ed, London/New York, 1968
Lucas, A. *Ancient Egyptian Materials and Industries*. 4th ed, London, 1962
Mekhitarian, A. *Egyptian Painting*. Geneva, 1954
Ranke, H. *The Art of Ancient Egypt : Architecture, Sculpture, Painting, Applied Art*. Vienna/London, 1936
Roullet, A. H. M. *The Egyptian and Egyptianizing Monuments of Imperial Rome*. Leiden, 1972
Schäfer, H. *Von Ägyptischer Kunst*. 4th ed, Wiesbaden, 1963. Revised English ed, London, 1973
Smith, W. S. *The Art and Architecture of Ancient Egypt* (Pelican History of Art). Harmondsworth, 1958 and 1966
Wessel, K. *Koptische Kunst : Die Spätantike in Ägypten*. Recklinghausen, 1963
Wolf, W. *Die Kunst Ägyptens : Gestalt und Geschichte*. Stuttgart, 1957

GREEK ART
Arias, P., Hirmer, M. and Sheston, B. B. *A History of Greek Vase Painting*. London, 1961
Boardman, J. *Greek Art*. London, 1964
Cook, R. M. *Greek Painted Pottery*. London, 1960
Higgins, R. *Minoan and Mycenean Art*. London, 1967
Lullies, R. and Hirmer, M. *Greek Sculpture*. London 1960
Mingazzini, P. *Greek Pottery Painting*. London, 1960

Pollitt, J. J. *The Art of Greece : 1400–31 BC* ('Sources and Documents in the History of Art' ed H. W. Janson). New Jersey, 1965
Richter, G. M. A. *A Handbook of Greek Art*. London, 1959
— *Kouroi : Archaic Greek Youths*. London, 1961

ROMAN ART
Bianchi Bandinelli, R. *Rome : the Centre of Power*. London, 1970
— *The End of the Empire : Roman Art AD 192–395*. London, 1972
Cary, M. *A History of Rome*. London, 1960
Haufmann, G. M. A. *Roman Art*. London, 1964
Maiuri, A. *Roman Painting*. Geneva, 1953
Scullard, H. H. *From the Gracchi to Nero*. London, 1959
Stenico, A. *Roman and Etruscan Painting*. London, 1963
Strong, Donald *The Classical World*. London, 1966
— *The Early Etruscans*. London, 1969
— *Roman Imperial Sculpture*. London, 1961
Strong, Eugenie *Roman Sculpture*. London, 1911
Wheeler, R. E. M. *Roman Art and Architecture*. London, 1964

EARLY CHRISTIAN AND BYZANTINE ART
Beckwith, J. *The Art of Constantinople*. London, 1961
Brown, P. *The World of Late Antiquity*. London, 1971
Browning, R. *Justinian and Theodora*. London, 1972
Demus, O. *The Mosaics of Norman Sicily*. London, 1949
— *Byzantine Art and the West*. New York, 1970
Grabar, A. *Christian Iconography : a study of its origins*. Princeton, 1968
Kahler, H. and Mango, C. *Sancta Sophia*. London, 1969
Kitzinger, E. *The Mosaics of Monreale*. Palermo, 1960
Kostof, S. K. *The Orthodox Baptistery of Ravenna*. Yale, 1965
Lazarev, V. N. *Old Russian Murals and Mosaics*. London, 1966
Mango, C. *The Art of the Byzantine Empire*. New Jersey, 1972
Oakeshott, W. *The Mosaics of Rome*. London, 1967
Rice, D. T. *The Art of Byzantium*. London, 1959
Simson, O. von *The Sacred Fortress : Byzantine Art and Statecraft in Ravenna*. Chicago, 1948
Weitzmann and others *Icons from South East Europe*. London, 1969

MEDIEVAL ART
Conant, K. J. *Carolingian and Romanesque Architecture, 800–1200* (Pelican History of Art). Harmondsworth, 1959
Crowe, J. A. and Cavalcaselle, G. B. *A History of Painting in Italy from the 2nd to the 16th century* (ed Douglas and Strong). London, 1903–14
Dodwell, C. R. *Painting in Europe, 800–1200* (Pelican History of Art). Harmondsworth, 1971
Frankl, P. *The Gothic : literary sources and interpretations through eight centuries*. Princeton, 1960
— *Gothic Architecture* (Pelican History of Art). Harmondsworth, 1962
Kidson, P. *The Medieval World*. London, 1967
Lasko, P. *Ars Sacra, 800–1200* (Pelican History of Art). Harmondsworth, 1972
Marle, R. van *The Development of the Italian Schools of Painting* (19 vols). The Hague, 1923–38
Mueller, T. *Sculpture in the Netherlands, Germany, France and Spain, 1400–1500* (Pelican History of Art). Harmondsworth, 1966
Porter, A. K. *Romanesque Sculpture of the Pilgrimage Roads*. 10 vols, Boston, 1923
Pope-Hennessy, J. An Introduction to Italian Sculpture. Vol I : *Italian Gothic Sculpture*. 2nd ed, London, 1972
Rickert, M. *Painting in Britain, the Middle Ages* (Pelican History of Art). Harmondsworth, 1954
Sauerlaender, W. *Gothic Sculpture in France, 1140–1270*. London, 1972
Stone, L. *Sculpture in Britain, the Middle Ages* (Pelican History of Art). 2nd ed, Harmondsworth, 1972
Swarzenski, H. *Monuments of Romanesque Art : the art of church treasures in north-western Europe*. 2nd ed, London 1967
Webb, G. F. *Architecture in Britain, the Middle Ages* (Pelican History of Art). Harmondsworth, 1956

White, J. *Art and Architecture in Italy, 1250–1400* (Pelican History of Art). Harmondsworth, 1966

RENAISSANCE ART

Benesch, O. *The Art of the Renaissance in Northern Europe.* Revised ed, London, 1967
Blunt, A. *Artistic Theory in Italy 1450–1600.* Oxford, 1962
Borsook, E. *Mural Painters of Tuscany from Cimabue to Andrea del Sarto.* London, 1960
Brion, M. *German Painting.* London, 1959
Chastel, A. *The Studios and Styles of the Renaissance: Italy 1460–1500.* London, 1966
Freedberg, S. J. *Painting in Italy 1500–1600* (Pelican History of Art). Harmondsworth, 1971
Friedlander, M. J. *From Van Eyck to Bruegel.* London, 1956
Gombrich, E. H. *Norm and Form.* London, 1966
— *Symbolic Images.* London, 1972
Gould, C. *An Introduction to Italian Renaissance Painting.* London, 1957
Green, V. H. H. *Renaissance and Reformation: A Survey of History 1450–1660.* London, 1964
Hartt, F. *A History of Italian Renaissance Art.* London, 1970
Hay, D. *Europe in the Fourteenth and Fifteenth Centuries.* London, 1966
Holt, E. G. (ed) *A Documentary History of Art.* Vols I and II. New York, 1957
Klein, R. and Lerner, H. (ed) *Italian Art 1500–1600.* New York, 1966
Kubler, G. and Soria, M. *Art and Architecture in Spain and Portugal and their American Dominions 1500–1800* (Pelican History of Art). Harmondsworth, 1959
Levey, M. *Early Renaissance.* Harmondsworth, 1967
Muller, T. *Sculpture in the Netherlands, Germany, France and Spain 1400–1500* (Pelican History of Art). Harmondsworth, 1959
Murray, L. *The High Renaissance.* London, 1967
— *The Late Renaissance and Mannerism.* London, 1967
Panofsky, E. *Early Netherlandish Painting.* 2 vols, Cambridge, Mass., 1953
Pope-Hennessy, J. *Italian Gothic Sculpture.* London, 1955
— *Italian High Renaissance and Baroque Sculpture.* 3 vols, London, 1963
— *Italian Renaissance Sculpture.* London, 1958
Post, C. R. *A History of Spanish Painting.* 14 vols, Cambridge, Mass., 1933–66
Ring, G. *A Century of French Painting 1400–1500.* London, 1949
Saxl, F. *A Heritage of Images.* Harmondsworth, 1970
Schevill, F. *Medieval and Renaissance Florence.* Vol II. New York, 1961
Seymour, C. *Sculpture in Italy 1400–1500* (Pelican History of Art). Harmondsworth, 1966
Shearman, J. *Mannerism.* Harmondsworth, 1967
Strange, A. *Deutsche Malerei der Gotik.* 11 vols, Berlin, 1934–61
Strong, R. *The Elizabethan Image: Painting in England 1540–1620* (exhib cat). London, 1969
Vespasiano, G. *The Renaissance Princes, Popes and Prelates.* New York, 1963
Von der Osten, G. and Vey, H. *Painting and Sculpture in Germany and the Netherlands 1500–1600* (Pelican History of Art). Harmondsworth, 1969
Whinney, M. *Early Flemish Painting.* London, 1969
White, J. *The Birth and Rebirth of Pictorial Space.* London, 1957
Wind, E. *Pagan Mysteries of the Renaissance.* London, 1958

THE 17TH AND 18TH CENTURIES IN EUROPE

Andrews, K. *The Nazarenes.* London, 1964
Blunt, A. F. *Art and Architecture in France, 1500–1700* (Pelican History of Art). 2nd ed, Harmondsworth, 1970
Bredius, A. revised by Gerson, H. *Rembrandt: The Complete Edition of the Paintings.* London, 1969
Eitner, L. *Neoclassicism and Romanticism, 1750–1850* (Sources and Documents in the History of Art, ed H. W. Janson). 2 vols, New Jersey, 1970
Engass, R. and Brown, J. *Italy and Spain 1600–1750* (Sources and Documents in the History of Art, ed H. W. Janson). New Jersey, 1970

Fletcher, J. *Rubens.* London, 1968
Friedlaender, W. *From David to Delacroix.* Cambridge, Mass., 1952
Gerson, H. and Ter Kuile, E. H. *Art and Architecture in Belgium 1600–1800* (Pelican History of Art). Harmondsworth, 1960
Haskell, F. *Patrons and Painters.* London, 1963
Honour, H. *Neo-Classicism.* Harmondsworth, 1968
Kalnein, W. G. and Levey, M. *Art and Architecture of the Eighteenth Century in France* (Pelican History of Art). Harmondsworth, 1972
Kitson, M. *The Age of Baroque.* London/New York, 1966–7
Levey, M. *From Rococo to Revolution.* London, 1966
— *Painting in Eighteenth-Century Venice.* London, 1959
Millar, O. and Whinney, M. D. *English Art, 1625–1714* (Oxford History of Art). Oxford, 1957
Reynolds, G. *Constable: The Natural Painter.* London, 1965
— *Turner.* London, 1969
Reynolds, Sir Joshua *Discourses on Art, 1769–90* (ed R. Wark). California, 1959
Rosenberg, J. *Rembrandt.* 2nd ed, London, 1964
Rosenberg J., Slive, S. and Ter Kuile, E. H. *Dutch Art and Architecture 1600–1800* (Pelican History of Art). Harmondsworth, 1966
Tapie, V. L. *The Age of Grandeur.* London, 1960
Waterhouse, E. K. *Italian Baroque Painting.* London, 1962
— *Painting in Britain 1530–1790* (Pelican History of Art). Harmondsworth, 1953
Whinney, M. D. *English Sculpture 1530–1830* (Pelican History of Art). Harmondsworth, 1964
Wittkower, R. *Art and Architecture in Italy 1600–1750* (Pelican History of Art). Harmondsworth, 1965

THE 19TH CENTURY IN EUROPE

Boase, T. S. R. *English Art 1800–1870.* Oxford, 1959
Boime, A. *The Academy and French Painting in the Nineteenth Century.* London, 1971
Chasse, C. *The Nabis and Their Period.* London, 1960
Hamilton, G. H. *Painting and Sculpture in Europe 1880–1940* (Pelican History of Art). Harmondsworth, 1972
Hardie, M. *Watercolour Painting in Britain.* 3 vols, London, 1966–8
Hofmann, W. *Art in the Nineteenth Century.* London, 1961
Jullien, P. *Dreamers of Decadence: Symbolist Painters of the 1890s.* London, 1971
Klingender, F. D. *Art and the Industrial Revolution* (ed Elton). London, 1968
Maas, J. *Victorian Painters.* London, 1969
Nicoll, J. *The Pre-Raphaelites.* London, 1970
Nochlin, L. *Realism.* Harmondsworth, 1971
Novotny, F. *Painting and Sculpture in Europe, 1780–1880* (Pelican History of Art). Harmondsworth, 1960
Oppé, A. P. 'Art' (in *Early Victorian England,* ed G. M. Young). London, 1963
Reynolds, G. *Painters of the Victorian Scene.* London, 1953
Rewald, J. *The History of Impressionism.* New York, 1961
— *Post-Impressionism from Van Gogh to Gauguin.* New York, 1962
Scharf, A. *Art and Photography.* London, 1968
Schmutzler, R. *Art Nouveau.* New York, 1962
Sloane, J. C. *French Painting between the Past and the Present.* Princeton, 1951
Whitley, W. T. *Art in England 1800–1820.* Cambridge, 1928
— *Art in England 1821–1837.* Cambridge, 1930

20TH-CENTURY ART

Barr, A. H. *Cubism and Abstract Art.* New York, 1936
— *Fantastic Art, Dada, Surrealism.* New York, 1947
Barrett, C. *Op Art.* London, 1970
Bowness, A. *Modern European Art.* London, 1972
Compton, M. *Pop Art.* London, 1969
Golding, J. *Cubism: A History and Analysis.* London, 1959
Goldwater, R. J. *Primitivism in Modern Painting.* New York, 1938
Gray, C. *The Great Experiment: Russian art 1863–1922.* London, 1962
Greenberg, C. *Art and Culture: critical essays.* Boston, 1961
Haftmann, W. *Painting in the 20th century.* 2 vols, London, 1960
Jaffé, H. L. C. *De Stijl, 1917–1931: the Dutch contribution to modern art.* Amsterdam, 1956
Jean, M. *The History of Surrealist Painting.* London, 1960

Kahnweiler, D. H. *The Rise of Cubism*. New York, 1949
Kulterman, U. *New Realism*. London, 1972
Martin, M. *Futurist Art and Theory 1909–1915*. Oxford, 1968
Myers, B. S. *The German Expressionists : A Generation in Revolt*. New York, 1957
Read, H. *Art Now : an introduction to the theory of modern painting and sculpture*. Revised and enlarged ed, London, 1960
Richter, H. *Dada : art and anti-art*. London, 1965
Rosenberg, R. *The Tradition of the New*. London, 1962
Rosenblum, R. *Cubism and Twentieth-Century Art*. London, 1960
Sandler, I. *Abstract Expressionism : the triumph of American painting*. London, 1970
Seuphor, M. *A Dictionary of Abstract Painting*. London, 1958
Selz, J. *Modern Sculpture : origins and evolution*. London, 1963
Wingler, H. M. *The Bauhaus : Weimar, Dessau, Berlin, Chicago*. Cambridge, Mass., 1969

AMERICAN ART
Baigell, M. *A History of American Painting*. New York, 1971
Brown, M. W. *The Story of the Armory Show*. Joseph H. Hirshhorn Foundation, 1963
Craven, W. *Sculpture in America*. New York, 1968
Dorra, H. *The American Muse*. London, 1961
Fielding, M. *Mantle Fielding's Dictionary of American Painters, Sculptors and Engravers*. New York, 1965
Flexner, J. T. *That Wilder Image : The Painting of America's Native School from Thomas Cole to Winslow Homer*. Boston, 1962
— *The Light of Distant Skies : 1760–1835*. New York, 1954
Geldzahler, H. *New York Painting and Sculpture : 1940–1970*. London, 1969
Groce, G. C. and Wallace, D. H. *The New York Historical Society's Dictionary of Artists in America 1564–1860*. Oxford/Yale, 1957
Larkin, O. W. *Art and Life in America*. New York, 1960
McCoubrey, J. W., Wright, L. B., Tatum, G. B. and Smith, R. C. *The Arts in America : The Colonial Period*. New York, 1966
Garrett, W. D., Norton, P. F., Gowans, A. and Butler, J. T. *The Arts in America : The Nineteenth Century*. New York, 1966
McLanathan, R. *The American Tradition in the Arts*. New York, 1968
Mendelowitz, D. M. *A History of American Art*. New York, 1970
Novak, B. *American Painting of the Nineteenth Century : Realism, Idealism and the American Experience*. London, 1969
Richardson, E. P. *Painting in America : The Story of 450 Years*. London, 1956
Rose, B. *American Art Since 1900 : A Critical History*. London, 1967
Selz, P. *New Images of Man*. Museum of Modern Art, N.Y., 1959

LATIN AMERICAN ART
Castedo, L. *A History of Latin American Art and Architecture from Pre-Columbian Times to the Present*. London, 1969
Fernandez, J. *A Guide to Mexican Art from Its Beginnings to the Present*. Chicago, 1969
Franco, J. *The Modern Culture of Latin America : Society and the Artist*. London, 1967
Messer, T. H. *The Emergent Decade : Latin American Painters and Painting in the 1960's*. London, 1966
Myers, B. S. *Mexican Painting in Our Time*. New York, 1956

CHINESE ART
Cahill, J. *Chinese Painting*. Lausanne, 1960
Ch'en Chih-mai *Chinese Calligraphers and their Art*. Melbourne, 1966
Contag, V. *Chinese Masters of the 17th Century*. London, 1969
Ecke, T. Y. *Chinese Calligraphy*. Philadelphia, 1971
Kodansha International (publ) *The Arts of China*. Vol I (ed Mary Tregear): *Neolithic Cultures to the T'ang dynasty, Recent Discoveries*; Vol II (ed A. C. Soper): *Buddhist Cave Temples, New Researches*; Vol III : *Paintings in Chinese Museums, New Collections*. Tokyo, 1968–70
Lee, S. E. *A History of Far Eastern Art*. New York, 1964
Sickman, L. and Soper, A. C. *The Art and Architecture of China* (Pelican History of Art). Harmondsworth, 1956. 3rd ed 1968
Sullivan, M. *Chinese Art in the 20th Century*. London, 1959
Swann, P. C. *Chinese Monumental Art*. London, 1963

Watson, W. *China before the Han Dynasty*. London, 1961
— *Chinese Art*. London, 1965
Whitfield, R. *In Pursuit of Antiquity*. Priceton, 1969

JAPANESE ART
Hillier, J. *The Japanese Print : a new approach*. London, 1960
Kidder, J. E. *The Birth of Japanese Art*. London, 1965
Kuno, T. *A Guide to Japanese Sculpture*. Tokyo, 1963
Lane, R. *Masters of the Japanese Print*. London, 1962
Morrison, A. *The Painters of Japan*. 2 vols, London, 1911
Paine, R. T. and Soper, A. *The Art and Architecture of Japan* (Pelican History of Art). Harmondsworth, 1955
Sansom, G. B. *A History of Japan*. 3 vols, London, 1961
Swann, P. *An Introduction to the Arts of Japan*. Oxford, 1958
Terukazu, A. *Japanese Painting*. Geneva, 1961
Watson, W. *Sculpture of Japan from the 5th to the 15th century*. London, 1959

KOREAN ART
Eckhardt, A. *A History of Korean Art*. London, 1929
Forman, W. and Bařinka, J. *The Art of Ancient Korea*. London, 1962
Gompertz, G. St G. M. *The National Art Treasures of Korea* (exhib cat). London, 1961
Osgood, C. *The Koreans and their Culture*. New York, 1951

ISLAMIC ART
The Cambridge History of Islam. 2 vols, Cambridge, 1970
Arberry, A. J. *The Legacy of Persia*. Oxford, 1953
Arnold, T. W. *Painting in Islam*. 2nd ed, Oxford, 1965
Arnold, T. W. and Guillaume, A. *The Legacy of Islam*. Oxford, 1931. New ed, 1972
Bosworth, C. E. *The Islamic Dynasties*. Edinburgh, 1967
Esin, E. *Turkish Miniature Painting*. Tokyo, 1960
Ettinghausen, R. *Arab Painting*. Lausanne, 1962
— *Turkish Miniatures from the Thirteenth to the Eighteenth Century*. New York, 1965
Grube, E. J. *The World of Islam*. London, 1966
Otto-Dorn, K. *L'Art de l'Islam*. Paris, 1964
Planhol, X. de *The World of Islam*. New York, 1959
Pope, A. U. *A Survey of Persian Art*. Oxford, 1939
Robinson, B. W. *Persian Painting*. London, 1952

SOUTH ASIA
(India, Pakistan, Sri Lanka, Nepal, Tibet)
Agrawala, V. S. *Indian Art*. Varanasi, 1965
Allchin, B. and R. *The Birth of Indian Civilisation*. Harmondsworth, 1968
Banerjea, J.-N. *The Development of Hindu Iconography*. Calcutta, 1956
Coomaraswamy, A. K. *History of Indian and Indonesian Art*. London, 1927; New York, 1965
— *Medieval Sinhalese Art*. Broad Campden, 1908
Fergusson, J. and Burgess, J. *Cave Temples of India*. London, 1880
Gucci, G. *Tibetan Painted Scrolls*. 3 vols, Rome, 1949
Kramisch, S. *The Art of India*. London, 1965
— *A Survey of Painting in the Deccan*. London, 1937
Rawson, P. *Indian Art*. London, 1972
Rowland, B. *The Art and Architecture of India* (Pelican History of Art). Harmondsworth, 1959
Rowland, B. and Coomaraswamy, A. K. *The Wall Paintings of India, Central Asia and Ceylon*. Boston, 1938
Sivaramamurti, C. *Indian Sculpture*. New Delhi, 1961
Smith, V. A. *History of Fine Art in India and Ceylon*. 3rd revised ed, Bombay, 1962
Thapar, R. *A History of India*. Vol I, Harmondsworth, 1966
Van Meurs, W. J. G. *Tibetan Temple Paintings*. Leiden, 1953
Waldschmidt, E. and R. *Nepal : Art Treasures from the Himalayas*. London, 1967
Zimmer, H. *Myths and Symbols in Indian Art and Civilisation*. New York, 1946

SOUTH-EAST ASIA
Christie, A. The Sea-locked Lands : the diverse cultural traditions of South East Asia. In *The Dawn of Civilisation*, ed S. Piggott. London, 1961

Covarrubias, M. *Island of Bali*. New York, 1965
Frederic, L. *The Temples and Sculpture of Southeast Asia*. London, 1965
Giteau, M. *Khmer Sculpture*. London, 1965
Groslier, B.-P. *Indochina*. London, 1963
Kempers, A. J. B. *Ancient Indonesian Art*. Cambridge, Mass., 1959
Rawson, P. *The Art of Southeast Asia*. London, 1967
Wagner, F. A. *Indonesia : the art of an island group*. London, 1959
Zimmer, H. *The Art of Indian Asia*. New York, 1951

PRE-COLUMBIAN ART
Bushnell, G. M. S. *Ancient Arts of the Americas*. London, 1965
— *Peru*. London, 1956
Disselhoff, H. D. and Linné, S. *The Art of Ancient America*. New York, 1961
Thompson, J. E. S. *The Rise and Fall of the Maya Civilization*. Norman, Okla, 1966
Wauchope, R. (ed) *Handbook of Middle American Indians*. Vols I–VI, Austin, Texas, 1964
Willey, G. R. *An Introduction to American Archaeology*. Vol I, New Jersey, 1966

NORTH AMERICAN INDIAN ART
Dockstader, F. J. *Indian Art in America*. Greenwich, 1962
Haberland, W. *North America*. London, 1968
Inverarity, R. B. *Art of the Northwest Coast Indians*. Berkeley, Calif, 1950
Lowie, R. H. *Indians of the Plains*. New York, 1954
Ray, D. J. *Artists of the Tundra and the Sea*. Seattle, 1961
Willey, G. R. *An Introduction to American Archaeology*. Vol II, New Jersey, 1971

AFRICAN ART
Allison, P. A. *African Stone Sculpture*. London, 1968
Atkins, G. (ed) *Manding Art and Civilization*. London, 1972
Biebuyck, D. (ed) *Tradition and Creativity in Tribal Art*. Los Angeles, 1969
Bradbury, R. S. *Ezomo's Ikegobo and the Benin Cult of the Hand*. 'Man', 1961

Carroll, K. *Yoruba Religious Carving*. London, 1967
Cole, H. *African Arts of Transformation*. Santa Barbara, 1970
Elisofon, E. and Fagg, W. B. *The Sculpture of Africa*. London, 1958
Fagg, W. B. *African Tribal Images*. Cleveland, 1968
Forman, W. and B., and Dark, P. C. P. *Benin Art*. London, 1960
Fraser, D. and Cole, H. *African Art and Leadership*. Wisconsin, 1972
Holy, L. and Darbois, D. *Masks and Figures from Eastern and Southern Africa*. London, 1967
Horton, R. *Kalabari Sculpture*. Lagos, 1965
Leiris, M. and Delange, J. *African Art*. London, 1968
Thompson, R. F. *Black Gods and Kings*. Los Angeles, 1971
Willcox, A. R. *The Rock Art of South Africa*. Johannesburg, 1963
Willett, F. *Ife in the History of West African Sculpture*. London, 1964
— *African Art*. London, 1971

OCEANIC ART
Barrow, T. *Maori Wood Sculpture of New Zealand*. Wellington, 1969
Bennett, L. P. *Art of the Dreamtime : Australian Aboriginal Arts*. Tokyo, 1973
Buhler, Barrow and Mountford *Art of the South Seas*. London, 1965
Dodd, E. *Polynesian Art*. New York, 1967
Force, R. W. and M. *The Fuller Collection of Pacific Art*. London, 1971
— *Art and Artifacts of the 18th century*. Honolulu, 1968
Forge, A. *Three Regions of Melanesian Art*. New York, 1960
Gerbrands, A. *Wow-Ipits : Woodcarvers of the Asmat People*. The Hague, 1967
Guiart, J. *The Arts of the South Pacific*. London, 1963
— *Oceanic Art*. London, 1968
Newton, D. *The Art of the Massim Area* (Museum of Primitive Art exhib cat). New York, 1967
— *Art Styles of the Papuan Gulf* (Museum of Primitive Art exhib cat). New York, 1961
Wardwell, A. *The Art of the Sepik River* (Chicago Art Institute exhib cat). Chicago, 1971
— *The Sculpture of Polynesia* (Chicago Art Institute exhib cat). Chicago, 1967

Index

Bardi family *see* Maso di Banco
Barna da Siena *see* Sienese painting
Barra, Didier *see* Desiderio, Monsù
Barry, Sir Charles *see* Pugin
Bartolini, Lorenzo *see* Greenough
Barzizza *see* Alberti
Bashō *see* Itcho
Basil, St *see* Icon
Basil I, Emperor *see* Gregory of Nazianzus
Basilius *see* Crusader Art
Baysunqur, Sultan *see* Herat School
Beckford, William *see* Cozens, John Robert
Bede, Cuthbert *see* Ruthwell Cross
Beer, Aert de *see* Lombard
Bembo, Pietro *see* Giorgione
Bendemann, E. *see* Düsseldorf School
Bentivoglio family *see* Costa
Bernhardt, Sarah *see* Mucha
Bernward, Bishop *see* Hildesheim; Werden
 Abbey Church
Berry, Jean, Duc de *see* Beauneveu;
 Jacquemart de Hesdin; Limbourg Brothers;
 Malouel; Turin, Hours of
Bevan, Robert *see* Pont Aven School
Bhauma kings *see* Ganga Dynasty
Bièfre, E. de *see* Düsseldorf School
Bijlert, Jan van *see* Utrecht School
Bléry, Eugène *see* Meryon
Boehm, Sir J. E. *see* Gilbert
Boisbaudron, LeCoq de *see* Legros, Alphonse
Bonaparte family *see* Vernet, Emile J. H.
 see also Napoleon I, Emperor
Bonnet, R. *see* Bali, Art of
Bonset, I. K. (pseud) *see* Van Doesburg
Borgia, Cesare *see* Leonardo da Vinci
Borglum, S. *see* Manship
Borromeo, Cardinal Carlo *see* Crespi, D.;
 Tibaldi
Borromini, Francesco *see* Rusconi
Boulanger, L. *see* Benson, F. W.; Dewing
Brandywine School of illustration *see* Pyle;
 Wyeth, N. C.
Breckenheimer, Johannes Henricus *see*
 Schelfhout
Breuer, Marcel *see* Bauhaus
Brihadratha, Emperor *see* Shunga and
 Kanva Dynasties
Briosco, Benedetto *see* Bambaia
Britton, John *see* Cattermole
Browere, Isaac *see* Mills
Brown, Capability *see* Picturesque, The
Bruant, Aristide *see* Steinlen
Buñuel, Luis *see* Dali
Burgundy, Dukes of *see* Bellechose; Clouet,
 Jean. *See also* Charles the Bold, John the
 Fearless, Philip the Bold, Philip the
 Good
Burke, Edmund *see* Barry; Picturesque, The
Butler, Samuel *see* Gessner

Cabaret Voltaire *see* Dada; Janco
Cabat, Louis *see* Fromentin
Camini, Aldo (pseud) *see* Van Doesburg
Campen, Jacob van *see* Saenredam
Carmichael, Franklin *see* Group of Seven
Carrière-Belleuse, A. E. *see* Rodin
Cartellier, P. *see* Rude
Casimir IV of Poland *see* Stoss
Castiglione, Giuseppe *see* Ch'ing Dynasty
 Painting
Catherine II, Empress *see* Benois; Doyen
Cavelier, Pierre-Jules *see* Barnard; Gilbert
Cazes, Pierre-Jacques *see* Chardin
Century Guild *see* Arts and Crafts Movement
Ceolfrid, Abbot of Jarrow *see* Amiatinus
 Codex
Chambers, Sir William *see* Chinoiserie
Chambray, Roland Fréart de *see* Errard
Chandragupta Maurya *see* Maurya Dynasty;
 Shunga and Kanva Dynasties
Chandragupta II *see* Gupta Contemporary
 Minor Dynasties; Gupta Dynasty
Chang Hsüan *see* Chou Wên-chü
Chantelou *see* Poussin
Chapu, H. *see* Blashfield
Chapus, Jean *see* Master of the Aix
 Annunciation
Chares of Lindos *see* Colossus of Rhodes
Charivari *see* Daumier; Gavarni
Charlemagne, Emperor *see* Lorsch Gospels
Charles IV, Emperor *see* Theodoric of
 Prague; Tommaso da Modena
Charles V, Emperor *see* Beauneveu; Blondel;
 Dürer; Leoni, L.; Leoni, P.; Machuca;
 Mone; Seisenegger; Titian; Vermeyen;
 Vries

Charles I of England *see* Gentileschi; Hoskins;
 Johnson; Lanier; Lely; Le Sueur; Mytens
 the Elder; Oliver, P.; Petitot; Pot; Steen-
 wyck; Van Dyck
Charles II of England *see* Cooper; Gibbons;
 Streeter; Velde; Verelst
Charles V of France *see* Beauneveu
Charles VII of France *see* Fouquet
Charles VIII of France *see* Bourdichon;
 Perréal
Charles IX of France *see* Clouet, F.;
 Corneille de Lyon
Charles II of Spain *see* Coello, C.; Giordano
Charles III of Spain *see* Melendez
Charles of Anjou *see* Arnolfo di Cambio;
 Pisano, N.
Charles I of Savoy *see* Colombe, Jean
Charles Emmanuel I of Savoy *see* Vries,
 Adriaen de
Charles the Bold of Burgundy *see* Goes;
 Mazerolles
Chassevent, M. J. C. *see* Merson
Cheng Ssu-hsiao *see* Chinese Flower and
 Animal Painting
Cheret, Jules *see* Beggarstaff Brothers;
 Larsson
Chigi, Agostino *see* Perugino
Chokunyu, Tanomura *see* Meiji Period;
 Nanga School
Christina, Queen of Sweden *see* Bartoli;
 Bellori
Chromocinéticisme *see* Vardanega
Chu Sui-liang *see* T'ang Dynasty Painting
Cicero *see* Kanachos
Circle magazine *see* Constructivism
Claude (glasspainter) *see* Marcillat
Claypole, James *see* Pratt
Clement IV, Pope *see* Oderisi
Clement VII, Pope *see* Conte; Montorsoli
Clement XI, Pope *see* Conca
Clément, Félix-Auguste *see* Rousseau,
 Henri J. F.
Cleve, Hendrick van *see* Hemessen, Jan
 Sanders van
Cock, Jerome *see* Bruegel, Pieter the Elder
Cogniet, Leon *see* Madrazo family; Meissonier
Colbert, Jean Baptiste *see* Académie Royale;
 Lebrun, Charles
Collo, Raffaellino da *see* Gherardi
Colonna, Vittoria *see* Michelangelo
Constant, Benjamin *see* Frieseke; Higgins
Constant (C. A. Nieuwenhuis) *see* Cobra
 Group; Corneille
Constantine I, Emperor *see* Catacomb
 Painting; Constantine, Arch of; Istanbul,
 Hagia Sophia; Rome, Sta Costanza;
 Sarcophagi, Early Christian
Constantine IX Monomachos, Emperor *see*
 Chios
Cook, James *see* Hodges
Cormon, Fernand *see* Anquetin; Bernard;
 Matisse; Toulouse-Lautrec
Cornaro, Caterina *see* Giorgione
Cornhill magazine *see* Doyle; Walker, F.
Corpora, Antonio *see* Fronte Nuove delle
 Arti
Costa, Giovanni *see* Macchiaioli
Coter, Colijn de *see* Engelbrechtsz
Coustou, Guillaume *see* Bouchardon;
 Roubiliac
Crabeth, Adrian Pietersz I *see* Swart van
 Groningen
Crane, C. B. *see* Mucha
Crawhall, Joseph *see* New English Art Club
Cromwell, Oliver *see* Cooper; Lely; Loggan;
 Walker, R.
Cruz, Juan *see* Haes
Cruz-Diez, Carlos *see* Nouvelle Tendance
Cyrus the Great *see* Pasargadae

Daiwaille, Jean-Augustin *see* Kruseman
Dalle Massagne *see* Quercia
D'Ancona, Vito *see* Macchiaioli
Dangelo, Sergio *see* Baj; Dova
Dante *see* Blake, W.; Capua Gate; Doré;
 Fuseli; Rossetti; Scheffer
Dantidurga Rashtrakuta *see* Rashtrakuta
 Dynasty
D'Archangelo, Allan *see* Pop Art
Dario da Treviso *see* Squarcione
Darius I the Great of Persia *see* Bisutun;
 Naqsh-i-Rustam; Persepolis
Darius III of Persia *see* Philoxenos of
 Eretria
Day, Lewis *see* Arts and Crafts Movement
Degotti Ignace Eugène Marie *see* Daguerre

Delvaux, Laurent *see* Scheemakers
Demetrios I Poliorketes of Macedonia *see*
 Colossus of Rhodes
Desvallière, G. *see* Dunoyer de Segonzac
Desvoge, François *see* Rude
Devi Chand *see* Bilaspur School
Diaghilev, Sergei *see* Bakst; Benois;
 Gontcharova; Larionov; Roerich;
 Tchelitchew; World of Art
Dickens, Charles *see* Browne, H. K. (Phiz)
Didier, Père, *see* Sérusier
Diez, Wilhelm von *see* Duveneck
Dilettanti Society *see* Knapton
Dinteville family *see* Chretien
Dirksz, Barend *see* Barendsz
Dombet, Guillaume *see* Master of the Aix
 Annunciation
Doria, Andrea *see* Vaga
Doria, Count *see* Lepine
Dosio, Giovan Antonio *see* Caccini
Dragon, Grubichy de *see* Segantini
Drolling, Martin *see* Henner
Dubbels, Hendrik *see* Backhuysen
Dughet, Jacques *see* Poussin, Nicolas
Dujardin, E. *see* Anquetin
DuMond, Frank V. *see* Speicher
Duret, F. *see* Dalou
Dutthagamani, King *see* Ceylon
Duveen, Joseph (Lord Duveen) *see* Berenson

Eadfrith, Bishop of Lindisfarne *see* Lindisfarne
 Gospel
Egbert, Archbishop of Trier *see* Master of
 the letters of St Gregory
Eliot, T. S. *see* Vorticism
Elizabeth I of England *see* Eworth; Gheeraerts,
 M. the Younger; Gower; Hilliard
Epifany *see* Theophanes the Greek
Erhart, Michel *see* Erhart
Esprit Nouveau, L' *see* Ozenfant
Este family *see* Cossa, Roberti
Este, Alfonso d' *see* Titian
Este, Beatrice d' *see* Solari
Este, Borso d' *see* Tura
Este, Isabella d' *see* Bellini, G., Costa
Este, Lionello d' *see* Pisanello
Esteren, Cornelis van *see* De Stijl
Estienne, Charles *see* Tachisme
Eupompos of Sikyon *see* Pamphilos
Eutychius *see* Ohrid
Evans, Edmund *see* Caldecott; Doyle;
 Greenaway

Falguière, J. A. J. *see* Macmonnies
Falk, Robert *see* Blue Rose Group
Farnese family *see* Cignani; Spada;
 Zuccaro, T.
Farnese, Cardinal Alessandro *see* Paul III,
 Pope
Farnese, Cardinal Alessandro *see* Carracci,
 Annibale
Farnese, Alexander (Governor of the
 Netherlands) *see* Veen, Otto Van
Fath Ali Shah *see* Qajar School
Ferdinand I, Emperor *see* Archimboldo;
 Seisenegger
Ferdinand IV of Naples *see* Hackert
Ferrara, Dukes of *see* Bono da Ferrara
Ferrari, Gaudenzio *see* Lomazzo
Finden, William *see* Browne, H. K.
Fiorentino, Jacopo *see* Machuca
Firdausi *see* Shah-nama
Flavin, Dan *see* Conceptual Art
Flower, Barnard *see* Cambridge, King's
 College chapel
Fluxus group *see* Beuys
Fontana, Prospero *see* Procaccino
Fougeron, André *see* Pignon
Fraiken, Charles-Auguste *see* Meunier
Francesco dai Libri *see* Girolamo dai Libri
Francia, Louis *see* Bonington
François I of France *see* Bourdichon;
 Bronzino; Caron; Cellini; Cleve; Fontaine-
 bleau, School of; Leonardo da Vinci;
 Perreal; Pilon; Primaticcio; Rosso, G. B.
Frankenthal School *see* Elsheimer
Frazee, John *see* Crawford, Thomas
Frederick II Hohenstaufen, Emperor *see*
 Capua Gate
Frederick III, Emperor *see* Bellini, G.;
 Gerhaerts van Leyden; Lochner
Frederick I of Prussia *see* Pesne
Frederick the Wise, Elector of Saxony *see*
 Cranach the Elder; Meit
Frederick, Prince of Wales *see* Mercier
Frederick Henry, Prince *see* Soutman